W9-AVI-038

THE
CREATIVE
IMPULSE

SEVENTH EDITION

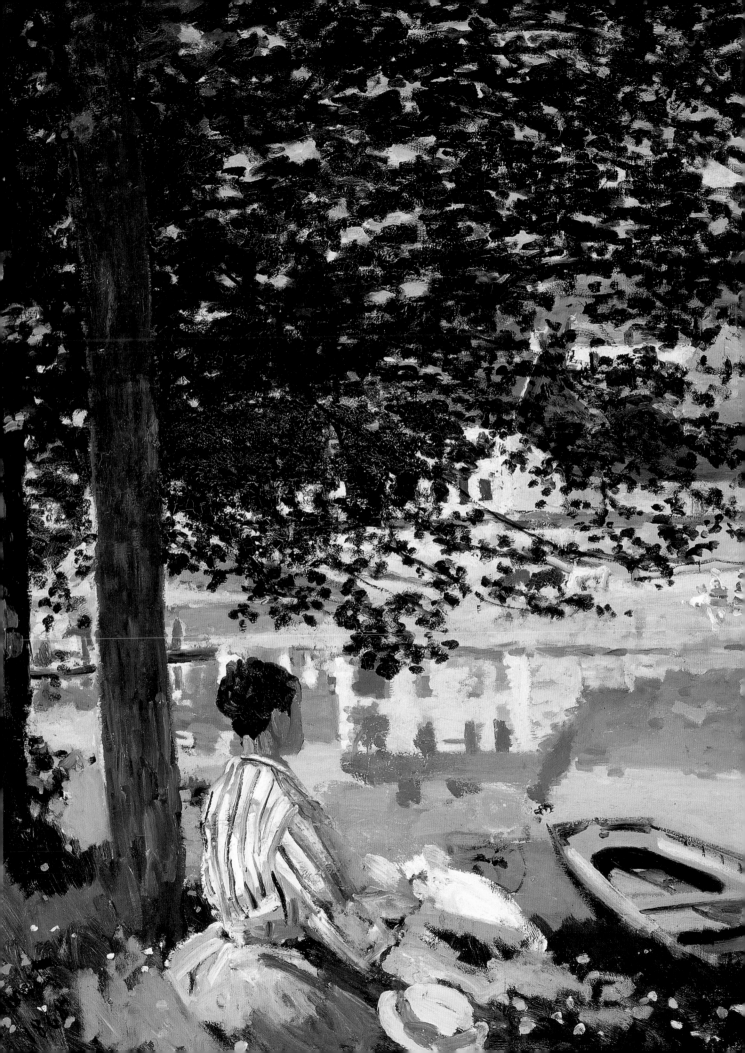

THE CREATIVE IMPULSE

An Introduction to the Arts

SEVENTH EDITION

DENNIS J. SPORRE

Prentice-Hall, Inc., Upper Saddle River, NJ 07458

Library of Congress Cataloging-in-Publication Data

Sporre, Dennis J.
 The creative impulse: an introduction to the arts / Dennis J. Sporre -- 7th ed.
 p. cm.
 Includes bibliographical references and index.
 ISBN 0-13-193680-8
 1. Arts--History. I. Title.

NX440.S67 2005
700--dc22 2004060025

"If we, citizens, do not support our artists,
then we sacrifice our imagination on the altar of
crude reality and we end up believing in nothing
and having worthless dreams."

Yann Martel, *Life of Pi*

Editor in Chief: Sarah Touborg
Acquisitions Editor: Amber Mackey
Editorial Assistant: Keri Molinari
Executive Marketing Manager: Sheryl Adams
Manufacturing Buyer: Sherry Lewis

Credits and acknowledgments borrowed from other sources and reproduced, with
permission, in this textbook appear on page 640.

**Copyright © 2005, 2003, 2000, 1996, 1993, 1990, 1987 by Pearson Education, Inc.,
Upper Saddle River, New Jersey, 07458. Pearson Prentice Hall.** All rights reserved.
Printed in China. This publication is protected by Copyright and permission should be
obtained from the publisher prior to any prohibited reproduction, storage in a retrieval
system, or transmission in any form or by any means, electronic, mechanical,
photocopying, recording, or likewise. For information regarding permission(s),
write to: Rights and Permissions Department.

Pearson Prentice Hall™ is a trademark of Pearson Education, Inc.
Pearson® is a registered trademark of Pearson plc.
Prentice Hall® is a registered trademark of Pearson Education, Inc.

Pearson Education LTD.
Pearson Education Australia PTY, Limited
Pearson Education Singapore, Pte. Ltd
Pearson Education North Asia Ltd
Pearson Education, Canada, Ltd
Pearson Educación de Mexico, S.A. de C.V.
Pearson Education–Japan
Pearson Education Malaysia, Pte. Ltd

This book was designed and produced by
Laurence King Publishing Ltd, London
www.laurenceking.co.uk

Every effort has been made to contact the copyright holders, but should there be any
errors or omissions, Laurence King Publishing Ltd would be pleased to insert the
appropriate acknowledgment in any subsequent printing of this publication.

Editor: Christine Davis
Picture Researcher: Fiona Kinnear
Typesetter: Marie Doherty
Designer: Andrew Shoolbred

Cover picture: Sandro Botticelli, *La Primavera* (Spring) (detail), c. 1478. Tempera on
panel, 6 ft 8 ins x 10 ft 4 ins (2.03 x 3.15 m). Uffizi Gallery, Florence.
Photo: © Quattrone, Florence.

Frontispiece: Claude Monet, *On the Seine at Bennecourt* (detail), 1868. Oil on canvas,
32 1/16 x 39 5/8 ins (81.5 x 100.7 cm). The Art Institute of Chicago (Mr. & Mrs. Potter
Palmer Collection). Photo: © 1998 The Art Institute of Chicago. All rights reserved.

PEARSON
Prentice
Hall

10 9 8 7 6 5 4 3 2 1
ISBN 0-13-193680-8

CONTENTS

PREFACE

This edition, the seventh, maintains *The Creative Impulse*'s overall focus and intent: to present an overview of the arts in the Western tradition in the contexts of the philosophy, religion, aesthetic theory, economics, and politics surrounding them. The text remains an historical introduction to the humanities from which the reader will gain a basic familiarity with major styles and their implications as well as a sense of the historical development of individual arts disciplines. The major focus of the text remains the arts and their interrelationships.

Another emphasis fundamental to the book also remains: an emphasis, by example, on the formal analysis of works of art, which supplements discussion of them. We do not analyze every work of art illustrated or mentioned, but analysis occurs frequently enough that, with a little encouragement from the instructor, students can infer how to see, hear, read, and put into words what makes a particular work of art tick, so to speak. Developing confidence in relating and responding to works of art—verbally and viscerally—is critical for students to carry an interest in the arts beyond the confines of the classroom and the timeframe of the course into the rest of their lives. That lifelong relationship with art forms the purpose of humanities and introductory art courses. When encountering an artwork for the first time we usually do not have access to biographical or contextual materials. We have only the artwork and the ability to confront it, either with or without confidence. Thus, the analyses, which examine how artworks work in terms of line, form, color, melody, plot, and so on, teach a means by which people can approach, respond to, and share artworks in an on-the-spot manner; the way we encounter works of art in real life.

The changes in this edition fall into three categories: general organization, writing style, and the Literature sections. Changes to the general organization comprise the following. We have divided the current Contexts and Concepts section of each chapter into distinct Contexts and Concepts subsections to draw stronger attention to generic concepts. We have added many new concepts to this part of the text. These relate to the basic styles and ideas in the Arts and Literature sections, and improve organizational unity and clarity while bolstering general content. In order to give stronger emphasis to ideas, strengthen unity, and enhance clarity, some sections have also been re-titled.

At the suggestion of some of the current users of the text, we have combined the former Chapters 8 and 9 (High Middle Ages and Late Middle Ages) into a single chapter. This brings the number of chapters in the book to seventeen and appears better suited to a "single chapter per week" organization of a teaching semester. It also provides us with the space to enhance the Literature sections. Based also on the feedback of current users, two features have been eliminated: How Art Works and Focal Point. Most of the material in the latter has moved to the appropriate section of the main body of the text. Chapter 17 has been brought up to date, and the Glossary has been substantially revised, with guides to pronunciation added throughout.

Relative to style, I have heavily edited the text with a general move from a passive to an active voice. Hopefully this will make the text more appealing to students and instructors. I have also clarified and strengthened the transitions and relationships between the Arts and Literature sections.

Upgrading the literature component of the text forms the primary focus of this edition. We have reorganized the Literature sections to parallel the styles and concepts discussed in the other Arts and Concepts sections. We have selected literary works on the basis of parallelism of style with regard to the other arts, in order to provide stronger chapter unity and clarity. More works of literature now appear in the text.

This book depends on a multitude of sources other than the general knowledge of its author. In the interest of readability and in recognition of the generalized purpose of this text, copious footnoting has been avoided. I hope the method chosen for presentation and documentation of the works of others meets the needs of both responsibility and practicality. The Further Reading section at the end of the book comprises the works used in the preparation of this text.

Dennis J. Sporre

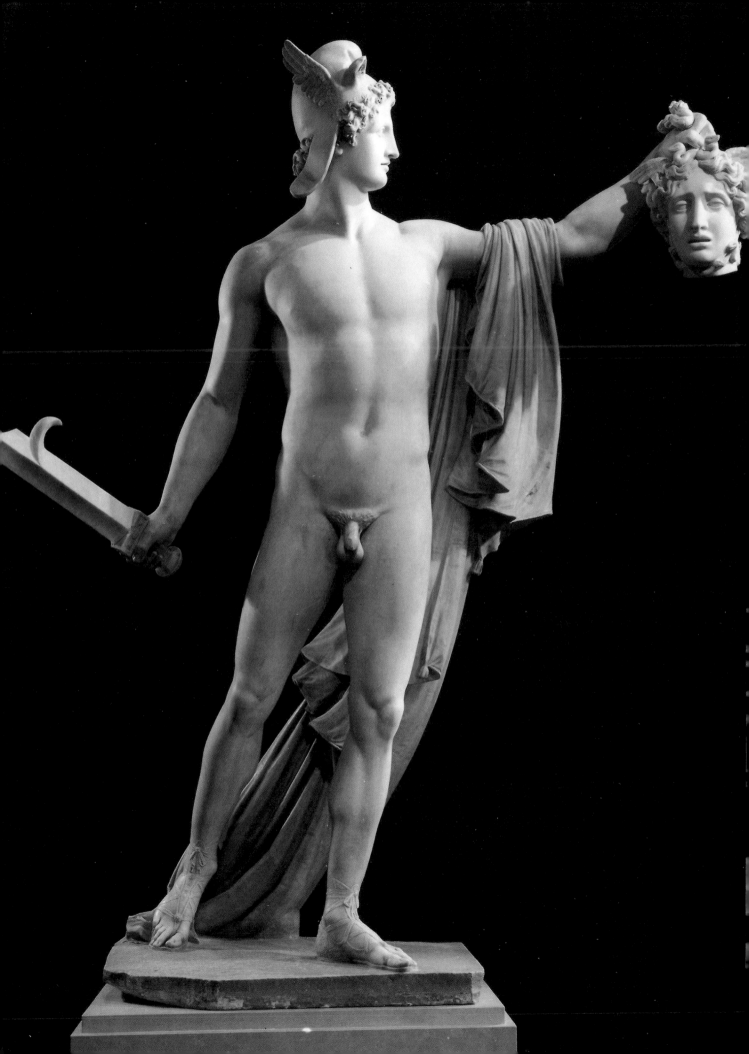

GETTING STARTED AND PUTTING THE ARTS IN CONTEXT

0.1 Antonio Canova, *Perseus Holding the Head of Medusa*, 1804–08. Marble, 7 ft 2⅝ ins (2.20 m) high. The Metropolitan Museum of Art, New York (Fletcher Fund) 1967.

GETTING STARTED

Getting Started takes us into the land of basic terminology and fundamental artistic concepts. In other words, we sample some of the things that help us to identify and communicate important characteristics appropriate to the works of two-dimensional art, sculpture, music, theatre, dance, literature, and cinema presented later in the text.

Although it may not appear so on first reading, the terms and concepts discussed here represent only a fraction of what we might study. The technical terms, undoubtedly, will call you to return to this section as you encounter works of art in the chapters that follow, especially when you seek to describe and compare paintings, musical selections, and so on, using accurate terminology.

TWO-DIMENSIONAL ART

Two-dimensional art consists of paintings, drawings, prints, and photographs, which differ from each other primarily in the technique of their execution. Probably, we respond initially to content—we first notice the apparent subject of the painting, drawing, print, or photograph. Such recognition usually triggers an emotional and intellectual response that leads us into the work's meaning. Beyond the recognition of content, however, lie the technical elements chosen by artists to make their vision appear the way they wish it to appear, and these include **media** and **composition**.

Media

The media of the two-dimensional arts comprise paintings, drawings, prints, and photography. Artists execute paintings and drawings with oils, watercolors, tempera, acrylics, ink, and pencils, to name just a few of the more obvious media. Each physical medium has its own particular characteristics. As an example, let us begin by looking at *oils*.

Oils, developed around the beginning of the fifteenth century, offer artists a broad range of color possibilities; they dry slowly and, therefore, allow reworking; they present many options for textural manipulation; and prove durable. Look at the texture in the brushwork of Van Gogh's (van-GOH or van GAHK) *Harvest at La Crau* (see Fig. **15.21**). This kind of manipulation exhibits a characteristic of oil. Whatever the physical medium—painting, drawing, print, or photograph—we can find identifiable characteristics that shape the final work of art. Had the artist chosen a different physical medium, the work—all other things being equal—would not look the same.

Composition

The second area that we can isolate and respond to involves artists' use of the *elements* and *principles of composition*. These make up the building blocks of two-dimensional works of art. Among others, these elements and principles include **line**, **form**, **color**, **repetition**, and **balance**.

Elements

Line constitutes the basic building block of visual design. In two-dimensional art, line has three physical characteristics: (1) a linear form in which length dominates over width, (2) a color edge, and (3) an implication of continued direction. Line as a linear form in which length dominates over width can be seen in several places in *Composition* (Fig. **0.2**) by Joan Miró (hoh-ahn mee-ROH). The figures defined by the thin outlines represent line's first characteristic. Second, as an edge, line defines the place where one object or plane stops and another begins, as in the Miró painting where the edges of the various color areas stop and the backgrounds begin. The third characteristic appears when no physical line exists but the painting carries the eye from one point to another by implication.

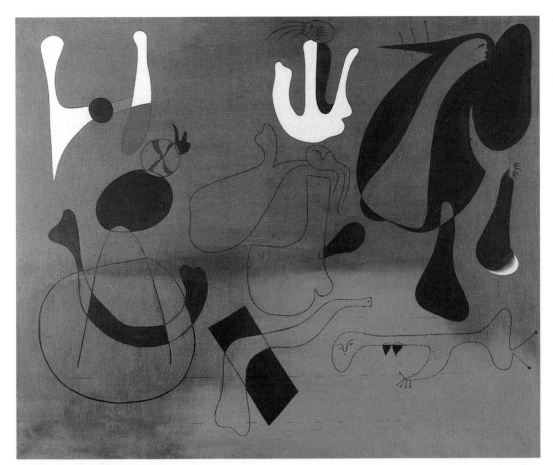

0.2 Joan Miró, *Composition*, 1933. Oil on canvas, 51⅛ × 64 ins (130.5 × 165 cm). Wadsworth Atheneum Museum of Art, Hartford, Connecticut. The Ella Gallup Sumner and Mary Catlin Sumner Collection Fund. © Succession Miró/DACS 2005.

Artists use line to control our vision, to create unity and emotional value, and ultimately to develop meaning. In pursuing those ends, and by employing the three characteristics noted above, artists find that line has one of two simple characteristics: curvedness or straightness. Whether expressed as a length-dominant, linear form, a color edge, or by implication, and whether simple or in combination, a line comprises a derivative of straightness or curvedness.

Form, sometimes called shape, relates closely to line in that line creates the space occupied by a form. When we perceive forms like trees or buildings, we note their details because of the line that composes them. *Color* as a compositional element involves a number of complex theories. Rather than discuss color theory, we will note only a few terms that help us in analyzing the works of art appearing in this text. We use the term **hue** to describe the basic colors of the spectrum (Fig. 0.3). The term **value** refers to the apparent grayness or whiteness of a color (Fig. 0.4). When we observe a work of art, we can, among other aspects of color, identify, respond to, and describe the breadth of the *palette*—how many different hues and values the artist has used—and the way the artist has used them.

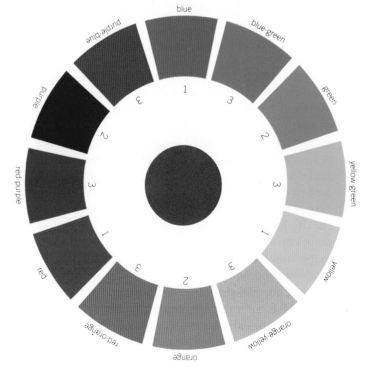

0.3 Color wheel.

13

▢ White			▢ W		
▢ High Light			▢ HL		▢ Yellow
▢ Light	Yellow-green ▢		▢ L		▢ Yellow-orange
▢ Medium Light	Green ▢		▢ ML		▢ Orange
▢ Medium (grey)	Blue-green ▢		▢ M		▢ Red-orange
■ High dark	Blue ▢		▢ MD		▢ Red
■ Dark	Blue-violet ▢		▢ D		▢ Red-violet
■ Low dark	Violet ▢		▢ LD		
■ Black			▢ B		

0.4 Value scale.

Principles

The principles of composition include *repetition* (the way in which the elements of the picture repeat or alternate) and *balance* (the way the picture stands on its axes). In Picasso's (pee-KAH-soh) *Girl Before a Mirror* (Fig. **0.6**), the artist has ordered the recurrence of elements in a regular manner. He has placed hard angles and soft curves side by side, and, in addition, has used two geometric forms, the oval and the diamond, over and over again to build up the forms of the work. He also has balanced the picture with nearly identical shapes on each side of the central axis. When identical shapes and colors appear on either side of the axis, it creates a condition called **symmetry**. Balance achieved by using unequal shapes, as demonstrated in Figures **0.2** and **0.6**, indicates **asymmetry**, the balancing of unlike objects—also known as psychological balance. If the artist uses repeated elements of the same size or importance, then we call the repetition regular. Differing size and/or importance creates repetition we call irregular.

TECHNIQUES

LINEAR PERSPECTIVE

Throughout the text, we will witness how two-dimensional artists utilize "deep space": the illusion of depth in their works. One of the methods for creating deep space, **linear perspective** (Fig. **0.5**), comprises the creation of the illusion of distance in a two-dimensional artwork through the convention of line and **foreshortening**: the illusion that parallel lines come together in the distance. Linear perspective (also called *scientific*, *mathematical one-point*, or *Renaissance perspective*) developed in fifteenth-century Italy (see Chapter 10). It uses mathematical formulas to construct illusionistic images in which all elements emanate from imaginary lines called *orthogonals* that converge in one or more *vanishing points* on a *horizon line*. Most people in the Euro-American cultures think of "linear perspective" as "**perspective**," because it represents their most familiar visual code.

0.5 Linear perspective.

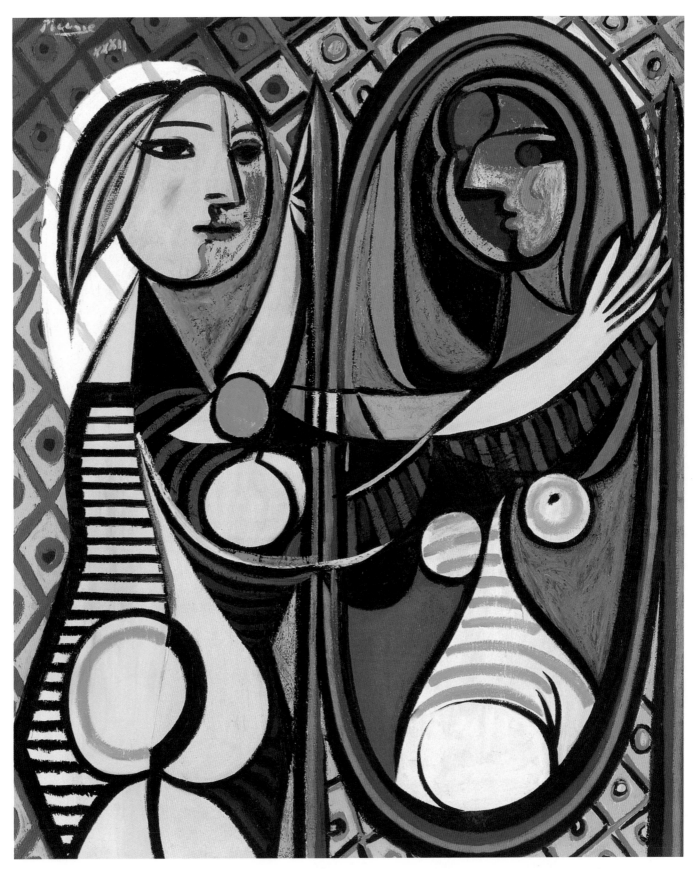

0.6 Pablo Picasso, *Girl Before a Mirror*, 1932. Oil on canvas, 64 × 51¼ ins (162.3 × 130.2 cm). Museum of Modern Art, New York (Gift of Mrs. Simon Guggenheim). © Succession Picasso/DACS 2005.

SCULPTURE

We approach **sculpture**, a medium of three dimensions (in addition to those qualities of composition just noted), by another element of composition called **mass**: the size, shape, and volume of the forms. Sculpture appeals to us by its size and by the appearance of weight and density in its materials.

Dimensionality

As we have noted, sculpture defines actual space. Sculpture may be **full-round, relief,** or **linear.** We can view full-round works—freestanding and fully three-dimensional—from any angle. Relief sculpture projects from a background and cannot be seen from all sides.

It maintains a two-dimensional quality, as compared to full-rounded sculpture. We call a relief sculpture that projects only slightly from its background, **low relief** or bas-relief (bah-ruh-LEEF). When figures protrude from the background by at least half their depth, we call them high relief or **haut-relief** (oh-ruh-LEEF). Linear sculpture emphasizes construction with thin, tubular items such as wire or neon tubing.

Texture

The surface treatment (called **texture**) of a work of sculpture is as important as its dimensionality. Michelangelo carved his monumental statue *David* (see Fig. **10.23**) from marble, but he made the stone seem alive and warm like living flesh by giving it a lustrous, polished texture.

TECHNIQUES

LOST-WAX CASTING

The **lost-wax** technique, sometimes known by the French term *cire-perdue* (seer pair-DOO), represents a method of casting sculpture using a wax model melted to leave the desired spaces in the mold. The technique probably began in Egypt. By 200 B.C.E., the technique had appeared in China and ancient Mesopotamia, and soon after that among the Benin people of Africa. It spread to Greece sometime in the late sixth century B.C.E.

The drawings indicated in Figure **0.7** illustrate the steps Benin sculptors would have utilized. The sculptor covered a heat-resistant "core" of clay—approximately the shape of the sculpture—with a layer of wax approximately the thickness of the final work. The sculptor carved the details in the wax. He then attached rods and a pouring cup made of wax to the model, and then covered the model, rods, and cup with thick layers of clay. When the clay dried, the artist heated the mold to melt the wax. He could then pour molten metal into the mold. When the molten metal had dried, the artist broke the clay mold and removed it, which meant that the sculpture could not be duplicated.

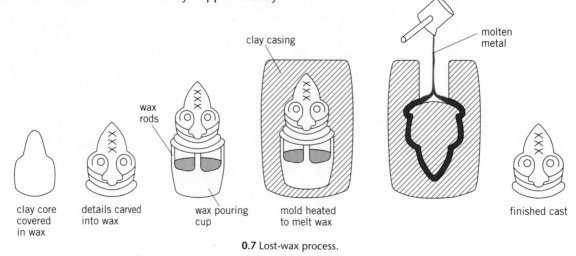

clay casing
molten metal
wax rods

clay core covered in wax details carved into wax wax pouring cup mold heated to melt wax finished cast

0.7 Lost-wax process.

ARCHITECTURE

Architecture, often described as the art of sheltering, combines aesthetic considerations with intensely practical ones. Our formal responses to architecture often involve the purpose of the building: a church, an office building, a residence, and so on. The way architects merge interior function with exterior form provides much of our encounter with works of architecture. Although a variety of fundamental technical elements exist in architecture, we will only discuss one: *structure*.

Architecture contains many systems of structure. As we travel through the centuries in our examination of human creativity, we witness examples of **post-and-lintel, cantilever, arch, bearing wall,** and **skeleton frame** structures. Laying horizontal pieces (**lintels**) across vertical supports (posts) gives us one of our oldest structural systems—post-and-lintel (see Fig. **4.25**). When unimpeded interior space became an architectural necessity, the arch gave architects an additional means of solving the practical problems involved. Whether used in **vaults** (arches joined end to end) or in **domes** (concentric arches), as we shall see in the great **Gothic**

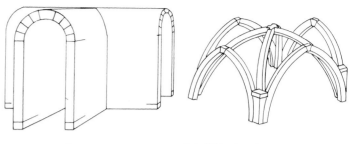

0.8 Groin vault. **0.9** Ribbed vault.

cathedrals of the Middle Ages or the dome of the Pantheon (see Fig. **4.21**), the arch opened interior space to usable proportions. When vaults cross at right angles, they create a **groin vault** (Fig. **0.8**). We call the protruding masonry that indicates a diagonal juncture of arches in a tunnel vault a **ribbed vault** (Fig. **0.9**). Cantilever, as exemplified in the Zarzuela (zahr-ZWAY-luh) Race Track (Fig. **0.10**), provided architects with dramatic means for expression, for here, unsupported, overhanging precipices define space.

The system of *bearing wall* has had ancient and modern applications. In it, the wall supports itself,

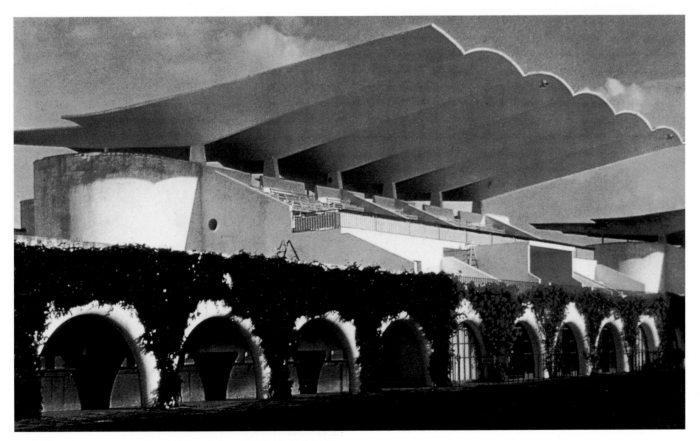

0.10 Eduardo Torroja, Grandstand, Zarzuela Race Track, Madrid, 1935.

0.11 Skeleton frame structures: A. Steel-cage construction; B. Balloon construction.

the floors, and the roof (thus forming the structure), as exemplified by log cabins and solid **masonry** buildings. We call continuous wall material (not joined or pieced together) **monolithic**.

Finally, skeleton frame structure uses a framework to support the building. The walls attach to the frame, thus forming an exterior skin. When skeleton framing makes

use of wood, as in house construction, we call the technique **balloon construction**. When metal forms the frame, as in skyscrapers, we call the technique **steel-cage construction** (Fig. 0.11).

MUSIC

Genres

Listening to music often begins with **genre** identification, simply because it helps us to know exactly what kind of composition we are hearing. Being aware that we are listening to a **symphony**—a large musical composition for **orchestra**, typically consisting of four separate sections called "movements"—provides us with different clues from a **mass**—a choral setting of the Roman Catholic service, the Mass. A **concerto** (kahn-CHAIR-toh), a composition for solo instrument with accompaniment,

TECHNIQUES

MUSICAL NOTATION

Musical notation comprises a system of writing music so the composer can communicate clearly to the performer the pitches and **rhythms** (among other things) of the piece. We need a brief familiarity with this method of communication because later in the text we illustrate characteristics of musical compositions with written notation.

Symbols, called *notes*, appear on a *staff*—five parallel lines on which each line and space represents a pitch (Fig. **0.12A**). The higher a note's placement on the staff, the higher the pitch. Seven of the twelve pitches of an **octave** in Western music reflect the first seven letters of the alphabet: A, B, C, D, E, F, G. The remaining five tones use two signs, the *sharp* sign (♯) and the *flat* sign (♭) (Fig. **0.12B**). A *clef* (in French, "key"), placed at the beginning of the staff, shows the pitch of each line and space (Figs. **0.12C** and **D**). Composers write music in different *keys*—each associated with the presence of a central note, scale, and chord—indicated by a *key signature* (Figs. **0.12E** and **F**). Composers indicate rhythms with notes indicating time values relative to each other (Fig. **0.12G**). The duration of silences in a musical piece is shown by a symbol called a *rest* (Fig. **0.12H**).

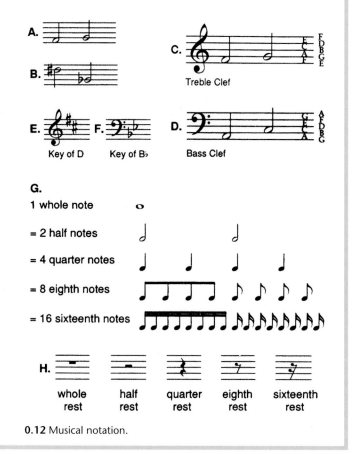

0.12 Musical notation.

gives us different experiences from an **opera** or **oratorio**, a large-scale choral work such as Handel's *Messiah* performed in concert form.

Melody and Form

Whatever the generic category, all music employs the same technical elements, of which **melody** and form are perhaps the two most obvious. We will introduce others at appropriate points in the text.

Melody comprises a succession of sounds with rhythmic and tonal organization. Any combination of musical tones constitutes a melody, but melody usually has particular qualities beyond a mere succession of sounds. Musical ideas, for example, come to us in melodies called **themes**; shorter versions, brief melodic or rhythmic ideas, are called **motives** or **motifs** (moh-TEEF).

Form, like the principles of composition in visual art, gives musical compositions shape and organization. Composers use form to arrange musical elements and relationships into successive events or sections. Basically, we can listen for two types of form: *closed* and *open*. Closed forms direct our attention back into the composition by restating at the end of a thematic section the element that formed the beginning. We often describe this pattern of development as ABA or AABA. The letters stand for specific thematic sections. Open form, on the other hand, uses repetition of thematic material as a departure point for further development, and the composition ends without repeating the opening section.

THEATRE

The word *theatre* comes from the Greek *theatron*—the part of the Greek theatre where the audience sat. Literally, it means "a place for seeing," but for the Greeks this implied much more than the sense experience of vision. To the Greeks, "to see" also might include comprehension and understanding. Thus, witnessing—seeing and hearing—a theatrical production meant feeling it with the emotions and mediating it with the intelligence of the mind, leading to an understanding of the importance of the play. Further, for the ancient Greeks, *theatron*, while a physical part of the theatre building, implied a non-physical place—a special state of being of those who together watched the lives of the persons of the drama. As a **performing art**, theatre represents an interpretive discipline, because between the playwright and the audience stand the director, the designers, and the actors.

Genres

As in music, our enjoyment of theatre grows by understanding the genre—the type of play—from which the performance evolves. We probably know the genres of **tragedy** and **comedy**, but there are others.

We commonly describe a tragedy as a play with an unhappy ending, and typically, tragic heroes make free choices that cause suffering and defeat or sometimes triumph out of defeat. Often, the hero—the *protagonist*—undergoes a struggle that ends disastrously. In many respects, comedy has more complexity than tragedy. Comedy embraces a wide range of theatrical approaches, and when defined in its broadest terms, comedy may not even involve laughter. Although we can say, probably with some accuracy, that humor forms the root of all comedy, many comedies employ **satire**, and comedies often treat serious themes while remaining basically lighthearted in spirit.

These and the other genres of theatre guide our expectations as we witness a production. If we know the genre in advance, our responses move according to those expectations. If we do not know the genre, we have to work it out as the production unfolds.

Plot, Character, and Visual Elements

Technically, theatrical productions are shaped to a large degree by *plot*—the structure of the play—the skeleton that gives it shape. The **plot** determines how a play works—how it moves from one moment to another, how conflicts occur, and, ultimately, how the play comes to an end.

Plays also turn on *character*: the motivating psychological makeup of the people in the play. Although many plays focus on visual elements such as settings, lighting, and costumes, we find theatre engrossing because of the way plays reflect human behavior and conflict in human decisions and actions. Thus, when we attend a performance of a play, our primary attention focuses on how dialogue reveals character and how actors portray actions. Most plays hinge on the actions and decisions of one major character, called the **protagonist,** and when we follow his or her development and the consequences of his or her actions, we are led to an understanding of the play's meaning.

The visual elements of a play comprise a number of factors including the relationship of the audience to the acting area—for example, the arena form in which the audience surrounds the stage area. Visual elements also include scenery, costumes, lighting, and actor movement.

LITERATURE

Literature operates through a system of language in which the words themselves trigger our understanding.

Genres

Like many of the other arts, we approach literature first through the formal door of its genres: **poetry**, **fiction**, nonfiction, and **drama**.

Poetry conveys a vivid imaginative sense of experience. It uses concentrated language, selected for its sound, suggestive power, and meaning, and employs specific technical devices such as **meter**, rhyme, and **metaphor**. Poetry divides essentially into **lyric** and narrative, formal and free verse. Narrative poetry tells a story; lyric poetry consists of brief, subjective treatments employing strong imagination, melody, and feeling to create a single, unified, and intense impression of the personal emotion of the poet. Formal poetry shows marked attention to arrangement and style typically with a de-emphasis on content. Free verse poetry utilizes the cadences of speech and image patterns rather than according to a regular metrical scheme. Thus, every poem can be categorized in one of these four groups: lyric/free verse, lyric/formal, narrative/formal, or narrative/free verse.

Fiction emerges from the author's imagination rather than from fact. Normally, it takes one of two approaches to its subject matter: realistic (the appearance of observable, true-to-life details) or nonrealistic (fantasy). Other literary forms such as narrative poetry, however, can also be fiction, and fictional elements can occur in forms such as biography and epic poetry. Traditionally, fiction divides into novels and short stories.

Nonfiction consists of literary works based mainly on fact rather than on the imagination, although nonfictional works may contain fictional elements. **Biography**, **essays**, and speeches comprise the major forms of nonfiction. Over the centuries, biography, a written account of a person's life, has taken many forms, including literary narratives, simple catalogues of achievement, and psychological portraits. Biographies of saints and other religious figures are called **hagiographies**. Traditionally, the essay consists of a short literary composition on a single subject, usually presenting the personal views of the author. Essays include many subforms and a variety of styles, but they uniformly present a personal point of view with a conscious attempt to achieve grace of expression. Characteristically, the best essays show clarity, good humor, wit, urbanity, and tolerance. Speeches such as Abraham Lincoln's "Gettysburg Address" and Martin Luther King's "I have a dream" mark an important category of nonfiction, as do historical articles and texts such as political legislation and newspaper articles.

Drama consists of a composition in prose or poetry intended to portray life or character or to tell a story, usually involving conflicts and emotions through action and dialogue. Typically, dramas are intended for theatrical production, and, as such, we treat them in this text within the category of theatre. However, we can classify many dramas in literature as "closet dramas"—dramas written for reading (rather than performance on a stage).

Point of View, Character, and Plot

In writing fiction, authors usually employ one of four **points of view**: (1) first person; (2) epistolary (the use of letters written by the characters); (3) third person; or (4) stream of consciousness (wherein a flow of thoughts and feelings comes from a specific character's psyche).

As in theatre, *character* also represents an important focus. The people in the work and their struggles with some important human problem give literature much of its appeal.

Plot in a work of literature may be a major or subordinate focus. Like theatrical plots, literary plots unfold the structure of the work and may come to a climax and resolution or leave the characters in a convenient place, allowing us to imagine their future lives continuing as their characters dictate.

Theme and Language

Most good stories have a dominant idea or *theme* by which writers shape the other elements. Although some critics argue that the quality of a theme is less important than what the author does with it, the best artworks usually comprise those in which the author takes a meaningful theme and develops it exceptionally.

In poetry, *language* that includes imagery—figures, which take words beyond their literal meaning, and metaphors, which give new implication to words—also provides an important focus.

CINEMA

A product of modern technology, cinema brings us into a world that, apart from a lack of three-dimensionality, we often mistake for reality. The most familiar genre, *narrative* film, tells a story, such as the films directed by Alfred Hitchcock (Fig. 0.13). Two other types of film also exist—documentary film and absolute film. *Documentary* film attempts to record actuality, using either a sociological or a journalistic approach, and typically does not use professional actors but records action as the event occurs. *Absolute* film exists for its own sake, for its record of movement or form. It does not use narrative techniques—although documentary techniques can occur in some instances. Created neither in the camera nor on location, directors create absolute film carefully, piece by piece, on the **editing** table or through special effects and multiple-printing techniques.

0.13 Alfred Hitchcock (director), *North by Northwest*, 1959. 136 minutes, MGM Studios, USA.

DANCE

Genres

Dance deals with the human form in time and space. It can follow one of several traditions: **ballet, modern dance**, world concert/**ritual**, **jazz dance**, and **folk dance**. *Ballet*, called classical or formal dance, has rich traditions and rests heavily on a set of prescribed movements and actions. In general, ballet comprises highly theatrical dance presentations consisting of solo dancers, duets, and choruses, or *corps de ballet* (kohr duh ba-LAY). According to the *Dance Encyclopedia*, "the reduction of human gesture to bare essentials, heightened and developed into meaningful patterns forms ballet's basic principle."

Modern dance encompasses a broad variety of highly individualized dance works limited to the twentieth and twenty-first centuries, essentially American in derivation, and antiballetic in philosophy. Modern dance rests on an emphasis on natural and spontaneous or uninhibited movement in strong contrast with the conventionalized and specified movement of the ballet. Although narrative elements often exist in modern dance, the form emphasizes them less than does traditional ballet. Modern dance also differs significantly from ballet in its use of the human body and interaction with the dance floor.

World concert/ritual dance, as a term, emerged from a plethora of scholarly arguments about how to label and define certain types of dance. It includes dances specific to a particular country and dances having ceremonial functions, formal characteristics, and particular prescribed procedures that pass from generation to generation. In scholarly terms, world concert/ritual dance differs from folk dance, but the boundaries often blur.

Jazz dance traces its origins to Africa prior to the arrival of African slaves on the American continent. Today it exists in a variety of forums including popular theatre, concert stage, movies, and television. The genre lacks a precise definition other than a vital, theatrical dance rooted in **jazz** and African heritage. Jazz dance relies heavily on improvisation and syncopation.

Folk dance, somewhat like folk music, comprises a body of group dances performed to traditional music. As in folk music, the creator (in this case, the *choreographer*) remains unknown. Folk dance began as a necessary or formative part of various cultures with characteristics identifiable with a given culture. Folk dances developed over a period of years, passing from one generation to another. Each folk dance has its prescribed movements, rhythms, music, and costumes. At its core, folk dancing

establishes an individual sense of participation in a society, tribe, or mass movement, and strengthens individuals' sense of belonging through collective dancing. On the other hand, however, folk dance often takes on the characteristics of concert dance—as many tourists can relate.

Line, Form, and Repetition

The compositional elements of line, form, and repetition apply to the human body in dance in exactly the same manner as they apply to painting and sculpture. As in all artworks occupying space, dance can create meaning by using horizontal line to suggest placidity, vertical line to suggest grandeur, and diagonal line to suggest movement. Dancers' bodies become like sculptures in motion as they move from one pose to another, and, because dancers move through time, the element of repetition serves a vital part of how choreographers put dances together and how we respond to them. Patterns of shapes and movement occur, and through them, like themes and variations in music, we find structure and meaning in dance works.

FEATURES

Pronunciation

Throughout the text, whenever a name or term (whose pronunciation may be problematical) appears for the first time, a pronunciation guide follows immediately in parentheses.

The system used in this book may sometimes appear awkward. For example, we indicate the long I sound (which comprises a diphthong of ah and ee) such as in die, eye, and by, by the letter Y when the syllable stands alone or precedes a consonant. The letter Y prior to a vowel maintains its yuh sound, as in young (yuhng). The letter G, when sounded "hard" as in go or guard, appears as GH. Again, it appears odd in some cases, such as ghoh-GHAN (Gauguin). Nonetheless, when one remembers that GH equals a hard G sound, the appearance yields successful pronunciation.

Capitalization indicates the principal stress syllable of a word or name. For example, the pronunciation of "fable" would appear as FAY-buhl. Typically, words comprising three or more syllables also have at least one syllable of secondary stress. We do not indicate these. More often than not, if we sound the primary stress, the secondary stresses fall almost automatically into place.

The system used in this book appears as follows:

A	cat	Ih	bit
Ah	cot	Ihng	sing
Aw	awe	Oh	foe
Air	air, pair	Oo	food
Awr	core	Ow	wow
Ay	bay	Oy	boy
Eh	bet	Uh	bug
Ee	see	U	wood
Gh	go	Zh	pleasure
Y	eye	Z	zip

Of course, no pronunciation guide can achieve complete accuracy; experts do not always agree on the pronunciation of names or terms. Some prefer Anglicization, and others prefer accuracy in adherence to the native tongue of the individual cited. Where it seems helpful, we include alternate pronunciations. The ultimate goal here is not to please everyone but to make it possible for everyone to feel comfortable in sharing ideas about concepts and artists knowing that they have grasped a reasonable pronunciation of the terms and names. Proper pronunciation creates empowerment.

Profiles

Profile boxes appear throughout the text in order to draw our attention to the biography of a prominent person in the chapter. Profile boxes give us a chance to get to know these people a little better, spending more time with them than regular treatment in the text might allow.

Technology

Throughout history, humans have made discoveries and then turned those discoveries into tools or other useful devices that enhance the quality of life. As the text suggests, being a human being isn't much different today from what it was thousands of years ago. On the other hand, the nature of our world, as the result of our technological advancement, is considerably different. Thus, in each chapter we have a feature box to highlight some important technology that developed during the time covered in that chapter.

Masterwork

In a text such as this, which discusses nearly a thousand works of art in painting, sculpture, architecture, theatre, literature, dance, music, and film, we occasionally need to

rest, to draw away from the flow of the material, and focus on a single, significant work of art. That is the purpose of the Masterwork boxes in each chapter. The presence of one particular work of art singled out as a Masterwork does not necessarily mean it is any better than the other works which have not been so designated. The works selected are "masterworks" by whatever criteria we wish to define that term, but the selection is not intended as a hierarchical ranking system.

A Dynamic World

The boxes in each chapter labeled "A Dynamic World" are intended to give us a taste of what was happening in the arts in a non-Western culture at the same time as the topics in the chapter occurred in the West. Although these boxes are brief, and to some may appear tokenistic, they remind us that there is a world beyond the Western one, and they give us another chance to apply our skills of perception and analysis. The artworks in the box may be similar to or quite different from the style of their Western counterparts. How they are similar or different is a question we should attempt to answer—using only the evidence of the art itself and the descriptive terminology we studied earlier in this section. The works of art in the Dynamic World boxes do have a relationship to the art of the chapter, and we can thereby see that relationship.

Maps and Timelines

Maps and timelines appear, mostly, at the beginning of each chapter. They contain information to help locate and correlate the art, history, philosophy, geography, etc. covered in the chapter. They can also be used to relate one chapter to another in time and place.

Chapter Opener

The opening pages of each chapter prepare you for what lies ahead. First, an outline of the chapter is given, followed by key terms and definitions that will help you to understand the material covered. A short essay connects ideas and issues in the chapter with today's problems and circumstances.

Chapter Review

At the end of each chapter a Chapter Review box helps you connect the information you have just studied. The Critical Thought section stimulates your critical thinking about material in the chapter, again tying it to today's themes and concerns. The Summary prompts your comprehension with statements concerning what you should be able to do, having studied the chapter. Each box ends with a directive for you to practice your use of terminology and understanding of concepts by comparing works of art.

Cybersources and Examples

Throughout the text and at the end of each chapter are web addresses for additional examples and further study. With regard to URLs for connecting to the World Wide Web, however, we need a warning. First, things change. A website active when this book went to press may no longer exist. (Wherever possible, works from major museums have been chosen, and those websites should remain active or should be accessible by finding the museum's home page through a standard search engine. Then, using the "collection" option will lead to an index from which the artist and work can be accessed.) Second, an initial attempt to link to a site may prove unsuccessful: "Unable to connect to remote host." Use this rule of thumb: try to connect to the site three successive times before trying another URL. Be careful to type the URL exactly. Any incorrect character will cause the connection to fail (capital letters matter).

In addition to the specific web addresses listed in the text, some general sites can provide a wealth of additional information. An easy and vast reference for visual art and architecture resides in the Artcyclopedia at http://www.artcyclopedia.com. Here, you can reference individual artists along with their artworks, and search by style, medium, subject, and nationality. Great Buildings Online at http://www.greatbuildings.com contains a treasure trove of architectural examples and information.

PUTTING THE ARTS IN CONTEXT

For centuries, scholars, philosophers, and aestheticians have debated without general resolution a definition of "art." The challenging range of arguments encompasses, among other considerations, opposing points of view that insist on one hand that "art" must meet a criterion of functionality—be of some societal use—and, on the other hand, that "art" exists for its own sake. Our purpose in this text is to survey rather than dispute. Thus, in these pages, we will not solve the dilemma of art's definition, despite the energizing effect that such a discussion might engender. We can, however, examine some characteristics of the arts that enhance our understanding.

This section—"Putting The Arts In Context"—treats four general subjects: (1) *The Arts and Ways of Knowing*, (2) *What Concerns Art?* (3) *The Functions of Art*, and (4) *Evaluating Works of Art*.

THE ARTS AND WAYS OF KNOWING

Humans constitute a creative species. Whether in science, politics, business, technology, or the arts, we depend on our creativity almost as much as anything else to meet the demands of daily life. Any book about the arts tells a story about us: our perceptions of the world as we have come to see and respond to it and the ways we have communicated our understandings to each other since the Ice Age, more than 35,000 years ago (see Fig. **1.5**, Cave chamber at Lascaux).

Our study in this text will focus on vocabulary and perception, as well as on history. First, however, we need to have an overview of where the arts fall within the general scope of human endeavor.

As we begin this text, learning more about our humanness through art, let us start with our current situation. That means two things. First, it means relying on the perceptive capabilities we already have. Applying our current abilities to perceive develops confidence in approaching works of art. Second, it means learning

how art fits into the general scheme of the way people examine, communicate, and respond to the world around them. A course in the arts, designed to fulfill a requirement for a specified curriculum, means that the arts fit into an academic context that separates the way people acquire knowledge. Consequently, our first step in this exploration of the arts places them in some kind of relationship with other categories of knowledge. Visual art, architecture, music, theatre, dance, and cinema belong in a broad category of pursuit called the "humanities," and that is where we begin.

We can define the humanities, as opposed, for example, to the sciences, as those aspects of culture that look into what it means to be human. The sciences seek essentially to describe reality whereas the humanities seek to express humankind's subjective experiences of reality, to interpret reality, to transform our interior experience into tangible forms, and to comment upon reality, to judge and evaluate. But despite our desire to categorize, we have few clear boundaries between the humanities and the sciences. The basic difference lies in the approach that separates investigation of the natural universe, technology, and social science from the search for truth about the universe undertaken by artists.

Within the educational system, the humanities traditionally have included the **fine arts** (painting, sculpture, architecture, music, theatre, dance, and cinema), literature, philosophy, and, sometimes, history. These subjects are all oriented toward exploring humanness, what human beings think and feel, what motivates their actions and shapes their thoughts.

In addition, change in the arts differs from change in the sciences, for example, in one significant way: new scientific discovery and technology usually displaces the old; but new art does not invalidate earlier human expression. Obviously, not all artistic approaches survive, but the art of Picasso cannot make the art of Rembrandt a curiosity of history the way that the theories of Einstein did the views of William Paley. Nonetheless, much about art has changed over the centuries. Using a spectrum developed by Susan Lacy in *Mapping the Terrain: New*

Genre Public Art (1995), we learn that at one time an artist may be an *experiencer*; at another, a *reporter*; at another, an *analyst*; and at still another time, an *activist*. Further, the nature of how art historians see art has changed over the centuries—for example, today we do not credit an artist's biography with all of the motivations for his or her work; and we now include works of art from previously marginalized groups such as women and minorities. These shifts in the disciplines of arts history itself form important considerations as we begin to understand the nature of art.

WHAT CONCERNS ART?

Among other considerations, art has typically concerned creativity, aesthetic communication, symbols, and the fine arts and crafts. Let's look briefly at each of these.

Creativity

Art has always evidenced a concern for creativity—bringing forth new forces and forms that cause change. How this functions remains subject for further debate. Nonetheless, something happens in which humankind takes chaos, formlessness, vagueness, and/or the unknown and crystallizes them into forms, designs, inventions, and ideas. Creativity underlies our existence. For example, creativity allows scientists to intuit a possible path to a cure for cancer, for example, or to invent a computer. The same process allows artists to find new ways to express ideas through processes in which creative action, thought, material, and technique combine to create something new, and that "new thing," often without words, triggers human experience: our response to the artwork. Creativity lets Peter Paul Rubens find a way to express sacred ideas in complex forms, lines, and colors (see Figs **12.9** and **12.10**), different from his Renaissance predecessors like Michelangelo (Chapter 10).

In the midst of this creative process rests the art medium. Although most people can readily acknowledge the traditional media—for example, painting, traditional sculpture, and printmaking—sometimes an artwork does not conform to expectations or experiences—for example, a gigantic installation in two parts, of blue and yellow umbrellas (see Fig. **17.22**).

Aesthetic Communication

Art usually involves communication. A common factor in art consists of a humanizing experience. Arguably, artists need other people with whom they can share their perceptions. When artworks and humans interact, many possibilities exist. Interaction may be casual and fleeting, as in the first meeting of two people, when one or both are not at all interested in each other. Similarly, an artist may not have much to say, or may not say it very well. For example, a poorly conceived and executed painting will probably not excite a viewer. On the other hand, with all conditions optimal, a profoundly exciting and meaningful experience may occur: the painting may treat a significant subject in a unique manner, the painter's skill in manipulating the medium may be excellent, and the viewer may be receptive. Or the interaction may fall somewhere between these two extremes. In any case, the experience remains a human one, fundamental to art.

Throughout history, artistic communication has involved *aesthetics*. Aesthetics involves the study of the nature of beauty and of art and comprises one of the five classical fields of philosophical inquiry—along with epistemology (the nature and origin of knowledge), ethics (the general nature of morals and of the specific moral choices to be made by the individual in relationship with others), logic (the principles of reasoning), and metaphysics (the nature of first principles and problems of ultimate reality). The term "aesthetics" (from the Greek for "sense perception") was coined by German philosopher Alexander Baumgarten in the mid-eighteenth century, but interest in what constitutes the beautiful and in the relationship between art and nature goes back at least to Plato and Aristotle, who saw art as *imitation* and beauty as the expression of a universal quality. In the late eighteenth century, the philosopher Immanuel Kant revolutionized aesthetics in his *Critique of Judgment* (1790) by viewing aesthetic appreciation not simply as the perception of intrinsic beauty, but as involving a judgment—subjective, but informed. Since Kant, the primary focus of aesthetics has shifted from the consideration of beauty *per se* to the nature of the artist, the role of art, and the relationship between the viewer and the work of art.

Symbols

Art also concerns symbols. Symbols represent something else. They often use a material object to suggest something less tangible or less obvious: a wedding ring, for example. Symbols differ from signs, which suggest a fact or condition. Signs remain what they denote. Symbols carry deeper, wider, and richer meanings. Look at Figure **0.14**. Some people might identify this figure as a sign, which looks like a plus sign in arithmetic. But the figure might also be a **Greek cross**, in which case it

0.14 Greek cross?

becomes a symbol because it suggests many images, meanings, and implications. Artworks use a variety of symbols in order to convey meaning. By using symbols, artworks can relay meanings that go well beyond the surface of the work and offer glimpses of the human condition that we cannot sufficiently describe in any other manner. Symbols make artworks into doorways leading to enriched meaning.

Fine and Applied Art

One last consideration in our movement toward understanding what art concerns involves the difference between the terms "fine art" and "applied art." People prize the "fine arts"—generally meaning painting, sculpture, and architecture—for their purely aesthetic qualities. We use the terms "applied art" and "decorative arts" to describe art forms that have a primarily decorative rather than expressive or emotional purpose. The applied arts may include architecture. The decorative arts include handicrafts by skilled artisans, for example ornamental work in metal, stone, wood, and glass as well as textiles, pottery, and bookbinding. The term may also encompass aspects of interior design. In addition, personal objects such as jewelry, weaponry, tools, and costumes fall into the category of the decorative arts. The term may extend, as well, to mechanical appliances and other products of industrial design. The term "decorative art" first appeared in 1791. We also consider many decorative arts, such as weaving, basketry, or pottery, "crafts," but the definitions of the terms remain somewhat arbitrary and without sharp distinction.

THE FUNCTIONS OF ART

Art can function in many different ways: as *entertainment*, as *political or social weapon*, as *therapy*, and as *artifact*. One function has no more importance than the others. Nor do they mutually exclude each other: a single artwork can pursue any or all of them. Nor do they form the only functions of art. Rather, they serve as indicators of how art has functioned in the past, and how it can function in the present. Like the types and styles of art we will examine later in the book, these four functions provide options for artists and depend on what artists wish to do with their artworks.

Entertainment

Plays, paintings, concerts, and so on can provide escape from everyday cares, treat us to a pleasant time, and engage us in social occasions; they entertain us. They also give us insights into our hopes and dreams, likes and dislikes, as well as other cultures; and we can find healing therapy in entertainment.

The function of any one artwork depends on us. An artwork in which one person finds only entertainment may function as a social and personal comment for someone else. A Mozart (pronounced MOHT-sahrt) symphony, for example, can relax us, but it may also comment on the life of the composer and/or the conditions of eighteenth-century Austria.

Political and Social Commentary

When art seeks to bring about political change or to modify the behavior of large groups of people, it has political or social functions. In ancient Rome, for example, the authorities used music and theatre to keep masses of people occupied in order to quell urban unrest. On the other hand, Roman playwrights used their plays to attack incompetent or corrupt officials. The Greek playwright Aristophanes used comedy in such plays as *The Birds* to attack the political ideas of the leaders of fourth-century B.C.E. Athenian society. In *Lysistrata* he attacked war by creating a story in which all the women of Athens go on a sex strike until Athens is rid of war and warmongers.

In late nineteenth-century Norway, Henrik Ibsen (IB-suhn) used his play *An Enemy of the People* (1882) as a platform for airing the issue of whether a government should ignore pollution in order to protect jobs or industry. In the United States in the twenty-first century, many artworks advance social and political causes and sensitize viewers, listeners, or readers to particular cultural situations.

Therapy

As therapy, art can help treat a variety of illnesses, both physical and mental. Role-playing, for example, frequently acts as a counseling tool in treating dysfunctional family situations. In this context, often called psychodrama, mentally ill patients act out their personal circumstances in order to find and cure the cause of their illness. This use of art as therapy focuses on the individual. However, art in a much broader context acts

as a healing agent for society's general illnesses as well. Artworks can illustrate society's failings and excesses in hopes of saving us from disaster. The laughter caused by comedy releases endorphins, chemicals produced by the brain, which strengthen the immune system.

Perhaps in a broader sense, we can say that art acts as therapy for all individuals by helping to repair lives or give new direction to them. One of the best examples of how art can do this appears in a simple, true anecdote we can call "Sam's story."

Many years ago a colleague laid on my desk a very expensive book about architecture. "From a student," he said. "Before or after grades?" I replied in my usual, insensitive, flip manner. After a pregnant pause and a bit of glaring, he told me "Sam's" story.

Sam, a construction worker, took our course, "Introduction to the Arts" as a night student. After the semester ended (and after grades were posted!) Sam brought the book to my colleague, who had taught the course. At that time, such a book probably cost at least a fourth of Sam's weekly salary.

"Why?" my colleague asked Sam.

"Because you changed my life," Sam replied. "Before this course I poured concrete day in and day out. It was concrete—you know, cement, sand, stone, et cetera—just concrete. After taking this course, I can't see just bland concrete anymore. Whenever I walk onto a job site, I see patterns, colors, lines, and forms. Whenever I look at a building, I see history. I go to places I'd never dreamed of going before, and I can't believe how dull my life really was without all the things I now see and hear. I just never knew there was so much out there."

My colleague said to me, "You know, this construction worker—'Joe Sixpack' we might have called him—a man's man, had tears in his eyes; he was so taken by what he'd found out about life through art." Art, thus, can act as a therapy for everyone.

Artifact

Art also functions as an **artifact**: a product that represents the ideas and technology of time and place. Artifacts, such as plays, paintings, poems, and buildings, connect us to our past. In this text, the function of art as artifact—as an example of a particular culture—takes on a central role.

When we examine art in the context of cultural artifact, we face the issue of artworks in religious ritual. We could even consider ritual as a separate function of art. Music, for example, often exists as part of a religious ceremony, and theatre—if seen as an occasion planned and intended for presentation—would include religious rituals as well as events that take place in playhouses.

Often, we have difficulty discerning when ritual stops and secular production starts—for example, ancient Greek tragedy seems clearly to have evolved from ritual. When ritual, planned and intended for presentation, uses traditionally artistic media like music, dance, and theatre, we can study it as "art" and artifact of its particular culture.

EVALUATING WORKS OF ART

Inevitably we want to conclude if an artwork is "any good." Whether rock music, a film, a play, a painting, or a classical symphony, we desire to make judgments about the quality of a work and they often vary from one extreme to the other.

Criticism should entail a detailed process of analysis to gain understanding and appreciation. Identifying the formal elements of an artwork—learning what to look for—makes up the first step. We describe an artwork by examining its many facets and then try to understand how they work together to create meaning or experience. We then try to verbalize about the meaning or experience. Only when we complete that process should we attempt judgment.

Value judgments remain intensely personal, although some opinions involve more expertise than others and thus represent more authoritative judgments. However, disagreements about quality can actually enhance, rather than confuse, the experience of a work of art if they result in an examination about why the differences might exist. In this way, we develop a deeper understanding of the artwork. Nonetheless, we can exercise criticism without involving any value judgment whatsoever. We can thoroughly analyze and dissect any work of art and describe what it comprises without making value judgments. For example, we can describe and analyze line, color, mass, balance, texture, composition, and/or message. We can observe how all these factors affect people and their responses. We can spend significant amounts of time and write at considerable length in such a process and never pass a value judgment at all.

Does this discussion mean all artworks have equal value? Not at all. It means that in order to understand what criticism involves, we must separate descriptive analysis, which can be satisfying in and of itself, from the act of passing value judgments. We may not like the work we have analyzed, but we may have understood something new. Passing judgment may play no role whatsoever in our understanding of an artwork. But we still exercise criticism.

Criticism forms a necessary part of understanding. We must investigate and describe. We must experience the need to know enough about the process, product, and

experience of art if we are to have perceptions that mean anything worthwhile to ourselves and if we are to have perceptions to share with others.

Types of Criticism

We can employ a number of ways to "criticize" or analyze works of art. Some are fairly straightforward, and some are relatively complex and theoretically involved. Let's begin with two *basic* types of criticism. These are *formal* criticism and *contextual* criticism. Once we have these concepts in hand, we can branch out a little to examine the theoretically involved and opposing critical theories of *structuralism* and *deconstruction*.

Formal Criticism

Formal criticism analyzes by applying only internal conditions or information—elements of line, form, color, balance, technique, melody, harmony, and so forth. Formal criticism approaches the artwork solely as an entity within itself and explains how the artist has taken these basic qualities and used them to build the work— how the employment of elements reveals style and makes the work affect the respondent. In so doing, we would develop a rather lengthy formal analysis of this artwork. In doing this, however, we would remain in our description and analysis strictly within the frame, so to speak. In other words, all of the conclusions we would reach about the work would come solely from evidence that exists in the work. In this formal approach, external information—about the artist, the times, the story behind the work, and so on—remains irrelevant. Consequently, the formal approach helps us analyze how an artwork operates and helps us decide why the artwork produces the response it does. Formal criticism exists in the work of the "New Critics" such as Allen Tate (1899–1979), who insisted on the intrinsic value of a work of art and focused attention on the work alone as an independent unit of meaning. As an example, we will do a brief analysis of Molière's (mohl-YAIR) comedy *Tartuffe* (tahr-TOOF; 1664):

Orgon, a rich bourgeois, has allowed a religious conman, Tartuffe, to gain complete hold over him. Tartuffe has moved into Orgon's house and tries to seduce Orgon's wife at the same time that he is planning to marry Orgon's daughter. Other characters unmask Tartuffe, and Orgon orders him out. Tartuffe seeks his revenge by claiming title to Orgon's house and blackmailing him with some secret papers. At the very last instant, the king's intervention foils Tartuffe's plans, and the play ends happily.

We have just described a story. Were we to go one step further and analyze the plot, we would look, among other things, for points at which *crises* occur and cause the characters to make important decisions; we would also want to know how those decisions moved the play from one point to the next. In addition, we would try to locate the extreme crisis—the *climax*. Meanwhile, we would discover auxiliary parts of the plot such as reversals: for example, when Tartuffe is discovered and the characters become aware of the true situation. Depending on how detailed our criticism became, we could work our way through each and every aspect of the plot. We might then devote some time to describing and analyzing the driving force—the character—of each person in the play and how the characters relate to each other. Has Molière created fully developed characters or types: do they seem to behave more or less like real individuals? In examining meaning, we would no doubt conclude that the play deals with religious hypocrisy, and that Molière had a particular point of view on that subject. In this approach, we find information about the playwright, previous performances, historic relationships, and so on irrelevant.

Contextual Criticism

By contrast, contextual criticism seeks meaning by examining related information "outside" the artwork, such as the artist's life, his or her culture, social, and political conditions and philosophies, public and critical reactions to the work, and so on. These can all be researched and applied to the work in order to enhance perception and understanding. This approach tends to view the artwork as an artifact generated from particular contextual needs, conditions, and/or attitudes. If we carry our criticism of *Tartuffe* in this direction, we would note that certain historical events help to clarify the play. For example, the object of Molière's attention was probably the Company of the Holy Sacrament, a secret, conspiratorial, and influential society in France at the time. Like many fanatical religious sects—including those of our own time—the society sought to enforce its own view of morality by spying on the lives of others and seeking out heresies, in this case, in the Roman Catholic Church. Its followers, religious fanatics, had a considerable effect on the lives of the citizenry at large. If we followed this path of criticism, we would pursue any and all such contextual matters that might illuminate or clarify what happens in the play.

Structuralism

Structuralism applies to the artwork a broader significance, insisting that individual phenomena—in this case artworks—can be understood *only* within the context of the overall structures of which they form a part. These structures represent universal sets of relationships that derive meaning from their contrasts

and interactions within a specific context. Structuralist criticism, associated with the French writer and critic Roland Barthes (BAHR-tuh; 1915–1980), derives by analogy from structural linguistics, which sees a "text" as a system of signs whose meaning derives from the pattern of their interactions rather than from any external reference. This approach opposes critical positions that seek to determine an artist's intent, for example. Thus, the meaning of a work of art lies not in what the artist may have had in mind, but in the patterns of contextual relationships that work within the artwork. Finally, structuralism, which shares some common roots with formal criticism, also opposes approaches, such as *deconstruction*, which deny the existence of uniform patterns and definite meanings.

Deconstruction

Deconstruction, associated with the French philosopher Jacques Derrida (dare-ee-DAH; 1930–2004), also originally grew from literary criticism, but has been applied to other disciplines. Derrida used the term "text," for example, to include any subject to which critical analysis can be applied. Deconstructing something means "taking it apart." The process of deconstruction implies drawing out all the threads of a work to identify its multitude of possible meanings, and, on the other hand, undoing the "constructs" of ideology or convention that have imposed meaning on the work. All of which leads to the conclusion that such things as a single meaning in a work of art do not exist, nor can the work claim any absolute truth. Inasmuch as a work can outlast its author, its meanings transcend any original intentions. In other words, the viewer brings as much to the work as the artist, and, thus, the work has no facts, only interpretations. The details of an artwork become only a sidebar to the interpretation that we, as viewers, bring to it based on our own experiences and circumstances.

Making Judgments

Now that we have defined criticism and noted some approaches we might take in pursuing it, we can move on to the final step—making value judgments.

Several approaches to the act of judgment exist. Two characteristics, however, apply to all artworks: construction and communication about our experiences as humans. Making a judgment about the quality of an artwork should address each of these.

Artisanship

Judging a work's artisanship means judging how it is crafted or constructed. Generally, such judgments require knowledge about the medium of the artwork. For example, we find it difficult to judge a musical symphony's construction without having some knowledge of musical composition. The same may be said of judging how well an artist crafts a painting, sculpture, building, or play. Nonetheless, some criteria exist that allow general judgment of works of art. These criteria include *clarity* and *interest*.

Applying the standard of clarity means deciding if the work has coherence. Even the most complex works of art need some handle that allows us to approach them and begin to understand how they work. This standard of judgment has stood the test of time. Artworks have been compared to onions in that the well-made ones allow respondents to peel away translucent layers, with each layer taking us closer to the core. Some people can peel away all the layers, and some people can peel away only one or two, but a masterfully crafted work of art has a coherence that allows a grasp on even the very surface layer.

Applying the standard of interest, like applying the standard of clarity, involves layers of devices or qualities that artists use to capture and hold our interest. Masterfully crafted works of art employ such devices and qualities. These qualities include (1) universality (the artist's ability to touch a common experience or feeling within us), (2) carefully developed structures or focal points that lead us where the artist intends us to go, and (3) freshness of approach that makes us curious to investigate further. When we watch a tired and trite mystery, we can guess the conclusion, the characters involve stale clichés, and we lose interest almost immediately. A masterfully crafted work will hold us— even if we know the story. Such represents the case with plays like Sophocles' *Oedipus the King* or Shakespeare's *Hamlet*.

If a work of art does not appear clear or interesting, we may wish to examine whether the fault lies in the work or in ourselves before rendering judgment.

Communication

Evaluating what an artwork attempts to say offers more immediate opportunity for judgment and less need for expertise. Johann Wolfgang von Goethe (GHUR-te), the nineteenth-century poet, novelist, and playwright, set out a basic, commonsense approach to communication. Because it provides an organized means for discovering an artwork's communication by progressing from analytical to judgmental functions, Goethe's approach helps us to end our discussion on criticism. Goethe posed three questions: What is the artist trying to say? Does he or she succeed? Was the artwork worth the effort? These questions focus on the artist's communication by making us identify, first, what was being attempted and, second, the artist's success in that attempt. Whether or not the project was worth the effort asks us to decide if the communication was important. Was it worthwhile?

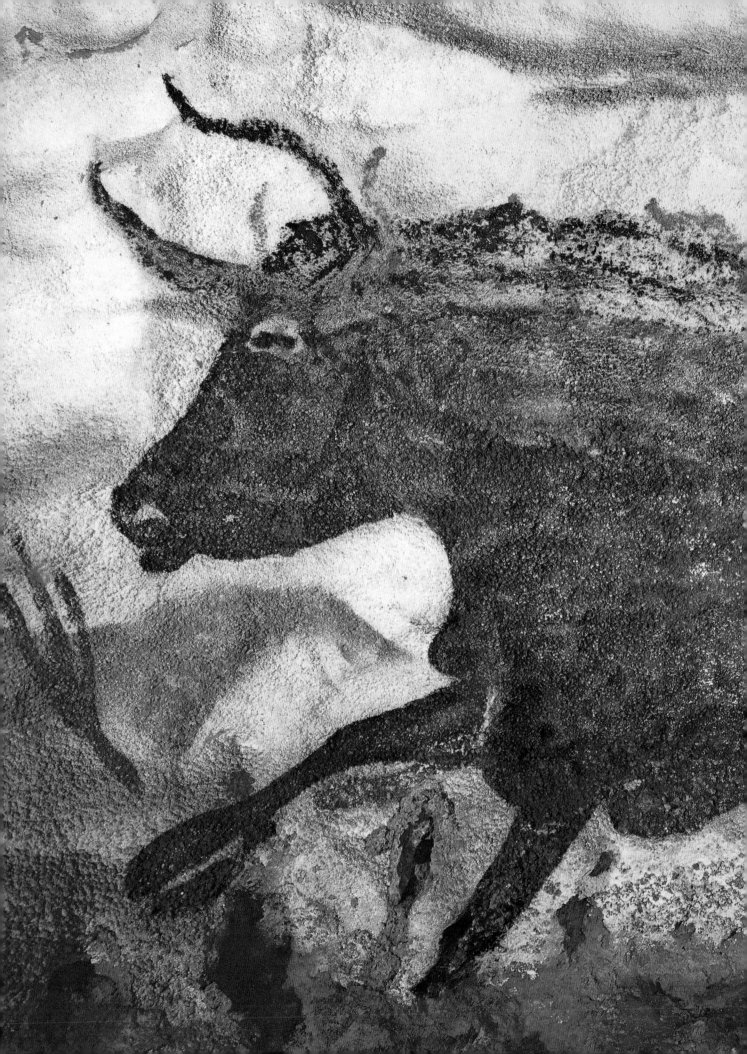

1 THE ANCIENT WORLD

— OUTLINE —

CONTEXTS AND CONCEPTS
- Contexts
 The Stone Age
 Mesopotamia
 TECHNOLOGY: The Invention of
 the Wheel
 Ancient Egypt
- Concepts
 Individuality and Symbols

Civilization
Religion
Literacy
Law

**THE ARTS OF THE ANCIENT
WORLD**
- Painting
 A DYNAMIC WORLD: Ancient China

- Sculpture
 MASTERWORK: The Tell Asmar
 Statues
 PROFILE: Akhenaton and Nefertiti
- Architecture
- Music
- Dance
- Literature

— VIEW —

ART: THE CREATIVE IMPULSE

This chapter takes us from the beginnings of humankind through the great civilization of ancient Egypt. What it shows us, among other things, is the interrelationship of humankind in its desire to create art—something that began when our ancestors still lived in caves. More than that, however, we will see that these three cultures—Ice Age humans, Mesopotamians, and ancient Egyptians—made choices about the ways in which they represented the figures of humans and animals. As a result, we can identify their representations and differentiate them from each other and from the representations of other cultures and times we will study in subsequent chapters. In addition, we will see relationships in the manners in which these cultures viewed death and the afterlife. Finally, we will note how, as early as ancient Mesopotamia and Egypt, literacy meant power.

— KEY TERMS —

PALEOLITHIC
The first stage of human culture, in which humans discovered fire, clothing, basic techniques for hunting and gathering, and simple social organization.

PANTHEON
A word meaning "all the gods."

CUNEIFORM
Sumerian writing involving two types of sign—one for syllables and one for words—and consisting of wedge marks and combinations of wedge marks pressed into damp clay.

PYRAMID
An Egyptian burial tomb of great size and scale containing hidden chambers.

1.1 Black bull, detail, c. 16,000–14,000 B.C.E.
Paint on limestone, 13 ft (3.96 m) long. Lascaux, France.

CONTEXTS AND CONCEPTS
Contexts

The Stone Age

The human journey began long before the chronicles of history. Several million years may have passed as humankind journeyed from prehistory to city life, civilization, and history. As humans evolved culturally, they adapted to a changing environment with creative discoveries and ingenious applications of those discoveries in technology and social inventions. They migrated across the globe.

The first stage of human culture, the Paleolithic (pay-lee-oh-LITH-ik) or Old Stone Age, reaches back beyond one million years B.C.E. Here, humans hunted and gathered. But in the Paleolithic period, humans discovered fire, clothing, basic techniques for hunting and gathering food, and simple social organization. Toward the end of the period, our ancestors probably began to think in artistic and religious terms (Map 1.1).

The second stage of human culture, the Neolithic period or New Stone Age, stretched between approximately 8000 B.C.E. and 3000 B.C.E., when people began to settle down and raise crops rather than hunt and gather. This phase, the agricultural, witnessed a dramatic improvement in stone tools and the ability to

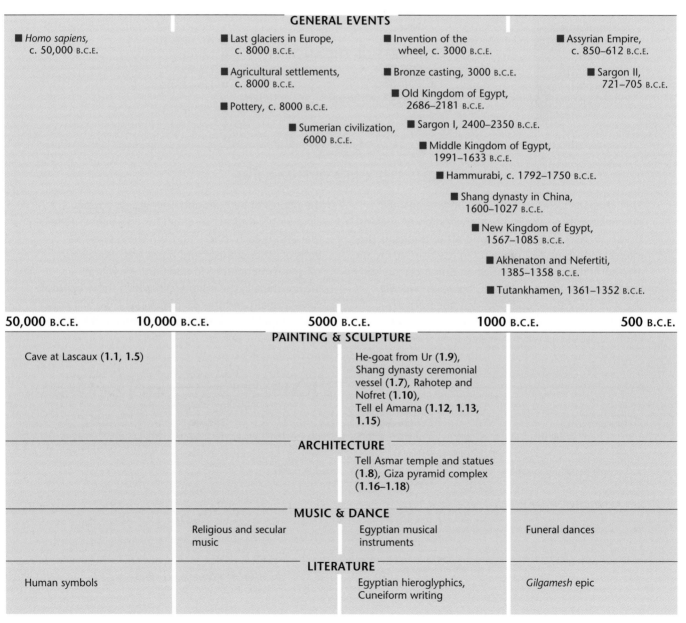

GENERAL EVENTS

- Homo sapiens, c. 50,000 B.C.E.
- Last glaciers in Europe, c. 8000 B.C.E.
- Agricultural settlements, c. 8000 B.C.E.
- Pottery, c. 8000 B.C.E.
- Sumerian civilization, 6000 B.C.E.
- Invention of the wheel, c. 3000 B.C.E.
- Bronze casting, 3000 B.C.E.
- Old Kingdom of Egypt, 2686–2181 B.C.E.
- Sargon I, 2400–2350 B.C.E.
- Middle Kingdom of Egypt, 1991–1633 B.C.E.
- Hammurabi, c. 1792–1750 B.C.E.
- Shang dynasty in China, 1600–1027 B.C.E.
- New Kingdom of Egypt, 1567–1085 B.C.E.
- Akhenaton and Nefertiti, 1385–1358 B.C.E.
- Tutankhamen, 1361–1352 B.C.E.
- Assyrian Empire, c. 850–612 B.C.E.
- Sargon II, 721–705 B.C.E.

50,000 B.C.E.	10,000 B.C.E.	5000 B.C.E.	1000 B.C.E.	500 B.C.E.
PAINTING & SCULPTURE				
Cave at Lascaux (1.1, 1.5)		He-goat from Ur (1.9), Shang dynasty ceremonial vessel (1.7), Rahotep and Nofret (1.10), Tell el Amarna (1.12, 1.13, 1.15)		
ARCHITECTURE				
		Tell Asmar temple and statues (1.8), Giza pyramid complex (1.16–1.18)		
MUSIC & DANCE				
	Religious and secular music	Egyptian musical instruments		Funeral dances
LITERATURE				
Human symbols		Egyptian hieroglyphics, Cuneiform writing		Gilgamesh epic

Timeline 1.1 The ancient world.

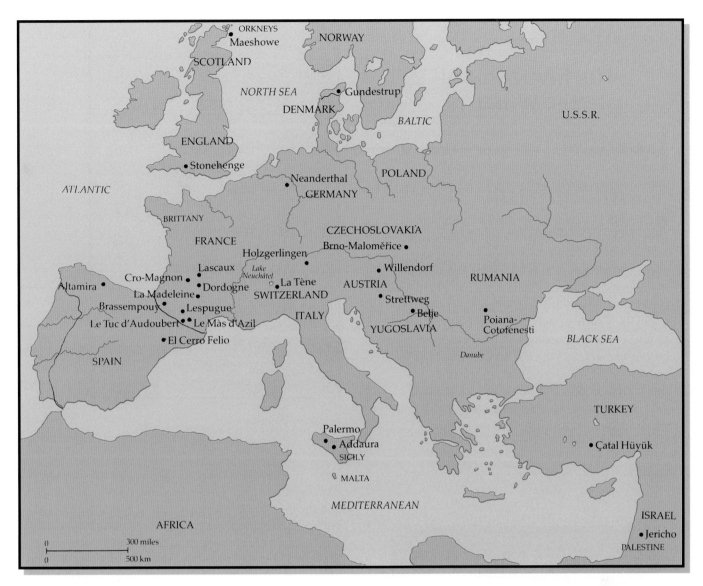

Map 1.1 Sites of prehistoric importance in Europe.

make pottery and textiles. Social structures changed as well, as humans learned how to live together in small villages.

In the New Stone Age humans began domesticating some of the animals they had been accustomed to chasing and killing. At first, New Stone Age people used these animals only for meat, but around 4000 B.C.E, some communities in and around the Middle East devised new ways to use their flocks and herds—for example, for milk, an important new food source. This forged the final link from our earliest, unknown ancestors to our earliest known ancestors, who emerged from the darkness of prehistory into the light of history and civilization. That link leads us from Europe to a place in the Middle East called Mesopotamia, and the Sumerians and Babylonians.

Mesopotamia

Mesopotamia consists of a wide swath of the Middle East encompassing the Fertile Crescent, the land "between the rivers"—the Tigris and the Euphrates, where prototype civilizations developed (Maps **1.2** and **1.3**). Around 6000 B.C.E, Sumer became the earliest recognizable culture to emerge in this area. The Sumerians (soo-MEER-ee-uhns) had a way of life similar to that of the other peoples in the region. They lived in villages and organized themselves around several important religious centers, which grew rapidly into cities.

As Sumerian civilization coalesced, the region remained in flux until the next great ruler emerged in the early 1700s B.C.E. This ruler was Hammurabi (hah-moo-RAH-bee). His capital was Babylon, and Babylon became the hub of the world—at least for a while. The first

TECHNOLOGY

THE INVENTION OF THE WHEEL

Insofar as Sumerians were capable of discerning scientific knowledge, they were also capable of applying that knowledge as technology. Sumerian mathematics employed a system of counting based on 60, and that system was used to measure time (we still have 60 minutes in 1 hour) and circles, divided into 360 degrees. The invention of number positioning—for example, 6 as a component of 6 or 60—made Sumerian mathematics unusually sophisticated. Mathematical calculation formed the basis for architectural endeavor, which, in turn, gave rise to higher levels of brick-making technology. Pottery was mass-produced and made the first known use of the potter's wheel. The wheel itself appeared as a transportation device in Sumer as early as 3000 B.C.E. By the same time, Sumerian technology had accomplished the casting of bronze and the invention of glass.

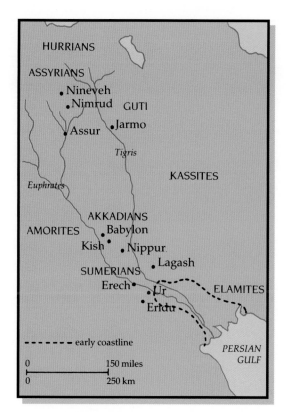

Map 1.2 Mesopotamia.

1.2 Ashurnasirpal II killing lions (detail), from the Palace of Ashurnasirpal II, Nimrud (Calah), Iraq, c. 850 B.C.E. Limestone, 3 ft 3 ins × 8 ft 4 ins (99 × 254 cm). British Museum, London.

Babylonian empire encompassed the lands from Sumer and the Persian Gulf to Assyria. It included the cities of Nineveh (NIHN-uh-vuh) and Nimrud (nim-ROOD) on the Tigris and Mari on the Euphrates, and extended up the Euphrates to present-day Aleppo (see Map 1.3). This empire, of approximately 70,000 square miles (181,300 square kilometers), rested on an elaborate, centralized, administrative system.

Ancient Egypt

In approximately the same time frame, another civilization developed, ancient Egypt. Protected by deserts and confined to a narrow river valley (see Map 1.3) its unique civilization depended upon the regular annual flooding of a single river, for each year, as the Nile overflowed its banks to deposit a rich and fertile silt on the surrounding fields, it bore witness to the rhythm of a beneficent natural order that would continue beyond the grave. Death—or, rather, everlasting life in the hereafter—formed the focus of the life and the arts of the Egyptians. Created mostly in the service of the cult of a god, or to glorify the power and wealth of a pharaoh, art and architecture centered on the provision of an eternal dwelling place for the dead. Egyptians celebrated life and recreated it in images intended to provide an eternal substitute for the mortal body.

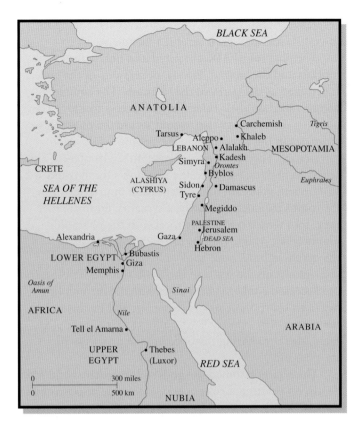

Map 1.3 Ancient Egypt and the Middle East.

Concepts

Individuality and Symbols

Some 50,000 years ago, humankind began to grasp the notions of selfhood and individuality. People began to make symbols as part of a strategy for comprehending reality and for telling each other what they discovered. They learned to make art in order to express more fully their belief in their unique essence. They became aware of death and buried their dead with care and reverence. They realized that they had a complex relationship with the world which had given birth to them in mystery, in which they lived in mystery, and from which they departed in mystery. Progress since that early time in technological and socioeconomic sophistication has been immense, but we are no more human now than they were then.

If we have any tendency to think of our prehistoric predecessors as somehow less human than ourselves, we need only to consider the profundity of their art to set our thinking straight. However, because we deal with prehistory—before recorded history—we can make only the broadest of conjectures, based on the slimmest of evidence. Studies of prehistoric societies and art leave us without a consensus on which to build, but even if we cannot accurately grasp all the whys or wherefores of the

artifacts that remain for us to study (see Introduction), we can appreciate the power of the individual human spirit they express.

Civilization

When villages evolved into cities, a stage of cultural development occurred, called **civilization**. Since that time, humans have engaged in complex cultures evolving around urban centers and empire building. They learned how to work with metals, to build monumental architecture, to write, to organize centralized bureaucracies, and to stratify social classes to ensure the survival of the group, for protection, and for control of the environment. Thus, in brief, we can say that to meet the definition of civilization, a culture involves five things: urban centers, a written language (implying a common language), trade or commerce, a common religion, and a centralized government.

Religion

We cannot reconstruct how humans lived during the latter half of the Old Stone Age, when the artistic achievements we study momentarily occurred. Some evidence exists to suggest that perhaps as early as 100,000 B.C.E. people had some sort of religion. Some historians have suggested that early humans worshipped the skulls of cave bears, whom they regarded as rivals for the spaces in which they lived. By 50,000 B.C.E., Neanderthal people buried their dead with ceremony and care, behavior suggesting a belief in the hereafter, for ancient people painted corpses with red ochre, positioned them with their knees raised and provided them with weapons. Such conjecture has no proof, but the evidence does suggest that religion emerged among the earliest examples of human capacity to think in the abstract. Art provided another example.

Religion and government shared a close relationship in Sumer. Religion permeated the social, political, and economic, as well as the spiritual and ethical life of society. A long **epic** poem, the *Gilgamesh* (GIL-guh-mesh) *Epic*, gives us an insight into this religion, central to the organization of Sumerian society. Sumerians had a long list of gods and by about 2250 B.C.E. worshipped a well-developed and generally accepted **pantheon** (PAN-thee-ahn). Temples sprang up throughout Sumer for the sacrifices thought necessary to ensure good harvests. It appears that each individual city had its own "supreme" god, and the local gods had their places in a larger **hierarchy** (HY-er-ahrk-ee). Like the Greeks later (see Chapter 2), the Sumerians gave human/animal attributes to their gods. The gods also had individual responsibilities: Ishtar was the goddess of love and procreation, for example. Sumerians had a god of the air, one of the water, one of the plow, and so on. Three male

gods at the top of the hierarchy demanded sacrifice and obedience. To those who obeyed the gods came the promise of prosperity and longevity. Elaborate and intricate rituals focused on cycles involving marriage and rebirth: a drama of creation witnessed in the changing seasons.

Sumerian religion concerned life, and it seems to have perceived the afterworld as a rather dismal place. Nonetheless, evidence suggests not only the practice of ritual suicide but also the belief that kings and queens would need a full complement of earthly possessions when they entered the next world.

Sumerian religion had important political ramifications as well. It ascribed ownership of all lands to the gods. The king was a king-priest, responsible to the gods alone. Below him, an elaborate class of priests enjoyed worldly power, privilege, and comfort, and to this class fell the responsibility for education and the writing of texts. And it is writing that undoubtedly represents the Sumerians' greatest contribution to the advancement of general civilization.

From the beginning Egyptian civilization identified the king with a god. At the time when Upper and Lower Egypt united (c. 3000 B.C.E.), the king held the status of the earthly manifestation of the god Horus, deity of the sky. The king, also considered the "Son of Ra," thus represented a direct link between the royal line and the creator sun god.

Egyptian religion comprised a complex combination of local and national gods, and in a cumulative process added new beliefs and gods over the thousands of years of Egyptian history. Two gods could be amalgamated and yet retain their separate entities. The same god could appear in various manifestations.

Religion played a central role in an Egyptian's personal and social life, as well as in civil organization. Egyptians considered death a doorway to an afterlife, in which the departed could cultivate his or her own portion of the nether worlds with water apportioned by the gods. Life continued for the dead as long as the corpse, or some material image of it, continued to exist. Careful burial in dry sand, which preserved the corpse, was therefore essential, as was skillful mummification. The art of embalming had reached a proficient level as early as 3000 B.C.E. Egyptians took great pains to ensure a long existence for the corpse, and mortuary buildings became the most important architectural features of the culture, reflecting their role as eternal homes. These tombs and burial places, rich in funereal imagery and narrative, have provided most of what we know of Egyptian history. Religious practice dictated that only good things be said of the departed, however. Thus the picture of a country populated by young, handsome, well-fed men and women, and ruled by beneficent pharaohs who inspired

reverence, optimism, and productivity, even among the lowest slaves, may need careful adjustment.

The pharaoh (FAIR-oh) acted as a link between mortals and the eternal. Priests, or servants of the god, functioned as delegates of the pharaoh. The common people relied on their ruler for their access to the afterlife: the offerings that would secure the pharaoh's existence in the afterlife held the people's only key to the eternal. Therefore, every Egyptian's self-interest relied on making sure that the pharaoh's tomb could sustain and maintain him. Images and inscriptions in the tombs included the lowliest servants, ensuring that they, too, would participate forever in the pharaoh's immortality. Magic charms for the revivification of the deceased king, once spoken by priests, became inscriptions on the walls of the tomb so that, if necessary, the deceased could read them. Eventually the nobility began to usurp these magic formulas, and by the end of the twenty-first century B.C.E., almost everyone copied them, thereby sharing the once unique privileges of the pharaoh.

The pharaoh joined the gods in the nether world after death. As befitting a ruler whose entourage also existed in the afterlife, he came to be associated with Osiris, king of the dead.

Literacy

Various primitive peoples had used picture writing to convey messages. Sumerian writing, however, initiated the use of qualitatively different pictorial symbols: the Sumerians (and later the Egyptians) used pictures to indicate the syllabic sounds that occurred in different words rather than simply to represent the objects themselves. We call Egyptian picture writing **hieroglyphic** (HY-roh-GLIH-fik; Fig. 1.3). Sumerian language consisted of monosyllables used in combination, and so Sumerian writing came to consist of two types of sign, one for syllables and one for words. Writing materials consisted of an unbaked clay tablet and a reed stylus, which, when pressed into the soft clay, produced a wedge-shaped mark. Wedges and combinations of wedges make up Sumerian writing (called "cuneiform," from the Latin *cuneus* (KYOO-nee-uhs), meaning "wedge") (Fig. 1.4).

Written language can cause many things to happen in a society, and it also reveals many things about that society. As well as opening up new possibilities for communication, it has a stabilizing effect on society, because it fixes the past by turning it into a documentable chronicle. In Sumer, records of irrigation patterns and practices, tax collections, and harvest and storage details were among the first things written down. Writing also serves as a tool of control and power. In the earliest times, the government and the priestly class of Sumer

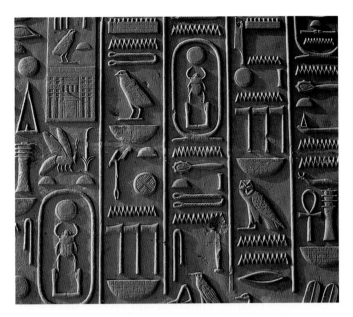

1.3 Egyptian hieroglyphics with dedicatory inscription to the god of Fertility, Amon-Min, c. 1950 B.C.E. Sandstone. "White Chapel" Sesostris I, Karnak, Egypt.

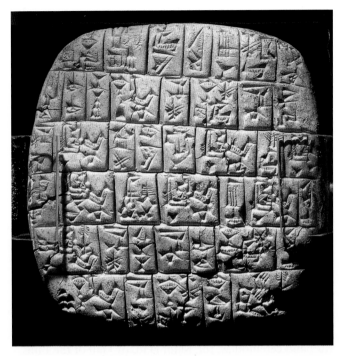

1.4 Clay tablet with cuneiform writing from Palace G, Elba, c. 2400 B.C.E. National Museum of Aleppo, Syria.

held a monopoly on literacy, and literacy served to strengthen their government.

Law

Babylonian society maintained its order through a wide-ranging judicial code, which we have come to call the Code of Hammurabi (after the Sumerian ruler, see p. 33). These laws consist of 282 articles, which address the legal questions of the time. The precept of "an eye for an eye" emerged as foremost in importance among the articles. Before Hammurabi's time, assessment of damages for bodily injury had a monetary basis—for example, a lost eye equaled sixty shekels. Under Hammurabi, the monetary system applied only to injury inflicted by a free man on one of lower status. If, however, the parties had equal status, exact retribution occurred: "An eye for an eye, a tooth for a tooth," and so forth. We do not know what retribution resulted from injury inflicted on a person of higher degree, but undoubtedly it had even greater severity. Hammurabi's pragmatic code evidenced a rigid class system. Only the rich escaped retributive mutilation by monetary payment. A sliding scale, based on ability to pay, determined compensation for medical expenses and legal fees.

The code, likewise, specifically spelled out the rights and place of women. A wife's purpose involved providing her husband with legitimate sons and heirs. Adultery (by a wife) carried a penalty of drowning for both wife and paramour. Men could have "secondary" or "temporary" wives as well as slave concubines. On the other hand, beyond the area of procreation, women remained largely independent. They could own property, run businesses, and lend and borrow money. A widow could remarry, which allowed for greater population growth than was possible in cultures where the wife had to throw herself on her husband's funeral pyre.

In essence, the Code of Hammurabi dealt with wages, divorce, fees for medical services, family matters, commerce, and land and property, which included slaves. Hammurabi, like the rulers who preceded him, was thought to take his authority and also his law from the gods. Thus, the concept of law as derived from extraordinary and supernatural powers continued unchallenged.

THE ARTS OF THE ANCIENT WORLD

In this section of every chapter, we examine the arts of the particular era. The organization is consistent throughout the chapters: First we examine painting (sometimes we call this section two-dimensional art because we include disciplines other than painting); then we look at sculpture, architecture, theatre, music, dance, and literature. In the last two chapters we add cinema. Occasionally a chapter might not include all the

disciplines because the period may not have notable activity to examine in a given discipline. In this chapter we begin with painting, turn to sculpture, examine architecture, note music and dance, and close with literature.

Painting

The Cave of Lascaux (lahs-KOH) in France lies slightly over a mile (about 2 kilometers) from the little town of Montignac, in the valley of the Vézère (vay-ZAIR) River. A group of children discovered it in 1940, while investigating a tree uprooted by a storm. They scrambled down a fissure into a world undisturbed for thousands of years. Authorities sealed the cave in 1963 to protect it from atmospheric damage, and visitors now see Lascaux II, an exact replica, sited in a quarry 600 feet (180 meters) away.

Perhaps a sanctuary for the performance of sacred rites and ceremonies, the Main Hall, or Hall of the Bulls (Fig. **1.5**), elicits a sense of power and grandeur. The thundering herd moves below a sky formed by the rolling contours of the stone ceiling of the cave, sweeping our

eyes forward as we travel into the cave itself. At the entrance of the main hall, the 8-foot (2.4-meter) "unicorn" begins a larger-than-lifesize montage of bulls, horses, and deer, which stand up to 12 feet (3.7 meters) tall. Their shapes intermingle with one another, and their colors radiate warmth and power. These magnificent creatures remind us that their creators were capable technicians who, with artistic skills at least equal to our own, captured the essence beneath the visible surface of their world. The paintings in the Main Hall emerged over a long period of time and were by a succession of artists, yet their cumulative effect in this 30- by 100-foot (9 by 30 meters) domed gallery seems that of a single work, carefully composed for maximum dramatic and communicative impact. We must remember, however, that we see the work, illuminated by electric floodlighting, very differently from the people by and for whom it was created, who could only ever see small areas at a time, lit by flickering stone lamps of oil or animal fat.

The painted tombs of Thebes provide most of our knowledge of Egyptian painting for the period of the New Kingdom, which lasted from around 1575 to 1000 B.C.E. This, like almost all Egyptian art, comprises funerary art—art made for the rituals of death—and it

1.5 Main Hall, or Hall of the Bulls, Lascaux, France.

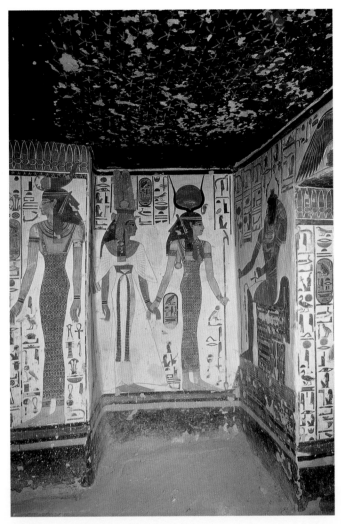

1.6 Queen Nefertari guided by Isis, from the tomb of Queen Nefertari at Thebes, Egypt. Relief wall painting. 1290–1224 B.C.E.

A DYNAMIC WORLD

ANCIENT CHINA

One thousand years after Sumerian artists created the magnificent golden goat (see Fig. **1.9**), and the Hebrews were enslaved in Egypt (see p. 143), the ancient Chinese had mastered bronze casting. The ceremonial vessel shown in Figure **1.7** comes from the Shang Dynasty, c. 1400 B.C.E., and exhibits craftsmanship of magnificent quality. Each line has perfectly perpendicular sides and a flat bottom, meeting at a precise 90-degree angle, in contrast, for example, with incising, which forms a groove. The animal representation reveals a vision unlike that of Western culture but similar to that of Pacific northwest Native American design, in which the animal appears as if it had been skinned and laid out with the pelt divided on either side of the nose. A rigid bilateral balance results. Deftly placed ridges and gaps play against graceful curves, and, although the designs are delicate, the overall impression exhibits solidity and stability.

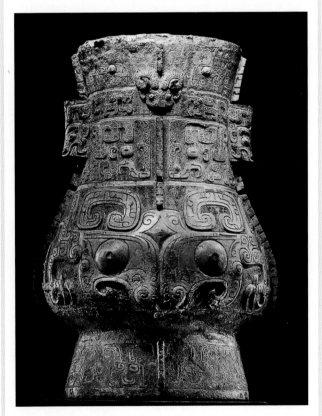

1.7 Shang Dynasty ritual wine vessel. Bronze, 16 × 11 ins (40.6 × 27.9 cm). The Nelson-Atkins Museum of Art, Kansas City, Missouri. (Purchase: Nelson Trust.)

reinforces the concept of religion as a pervasive force in Egyptian life (and death). For the first time, we find in these Theban tombs representations of the gods. The paintings also portray the vivacity and humor of daily life. Theban tombs portray workmen and peasants differently from those of previous periods in Egypt, particularly in the shape of the heads and in the garments worn.

Queen Nefertari's tomb (Fig. **1.6**) exemplifies a style of painting done in low relief, and it exhibits great elegance, charm, and vivacious color. A black base borders the composition, provides it with a solid anchor, and raises the main body of the painting well above the floor of the chamber. A black band forms the upper terminal accent of the central, recessed panel. The black ceiling, with ochre stars, ties the sky to the ground and unifies the entire composition. A small black band

MASTERWORK

THE TELL ASMAR STATUES

Undoubtedly the most striking features of these figures are their enormous, staring eyes, with their dramatic exaggeration. Representing the quasi-divine king Abu (AH-boo) (the large figure), a figure assumed to be his spouse, and a crowd of worshippers, the statues occupied places around the inner walls of an early temple, in prayer, awaiting the divine presence. The figures have great dignity, despite the stylization and somewhat rough execution. In addition to the staring eyes, our attention is drawn to the distinctive carving of the arms, which hang separate from the body. The closed, self-contained composition reflects prayer.

Certain geometric and expressive qualities characterize these statues. In typical Sumerian style, each form emerges from a cone or cylinder, and the arms and legs remain **stylized** and pipelike, rather than being lifelike depictions of the subtle curves of human limbs.

The god Abu and the mother goddess stand apart from the rest by their size and by the large diameter of their eyes. The meaning in these statues clearly bears out what we know of Mesopotamian religious thought. The gods were believed to be present in their images. The statues of the worshippers substituted for the real worshippers, even though no attempt appears to have been made to make the statues look like any particular individual: every detail is simplified, focusing attention on the remarkable eyes constructed from shell, lapis lazuli, and black limestone. The figures are made of gypsum, a very fragile material.

Large and expressive eyes appear to be a basic convention of Sumerian art—a convention found in other ancient art as well. Its basis remains unknown, but the idea of the eye as a source of power permeates ancient folk-wisdom. The eye could act as a hypnotizing, controlling force, for good or for evil—hence the term "evil eye," which we still use today. Symbolic references to the eye range from "windows of the soul" to the "all-seeing" vigilance of the gods.

The Sumerians used art, like language, to communicate through conventions. Just as cuneiform script condensed wider experiences and simplified pictures into signs, so Sumerian art took lifelikeness, as the artist perceived it, and reduced it to a few conventional forms, which, to those who understood the conventions, communicated larger truths about the world. These works establish social hierarchy and exist as clear examples of conventionalism in the arts.

1.8 Statues of worshippers and deities from the Square Temple at Tell Asmar, Iraq, c. 2750 B.C.E. Gypsum, tallest figure 30 ins (76 cm) high. Iraq Museum, Baghdad, and Oriental Institute, University of Chicago.

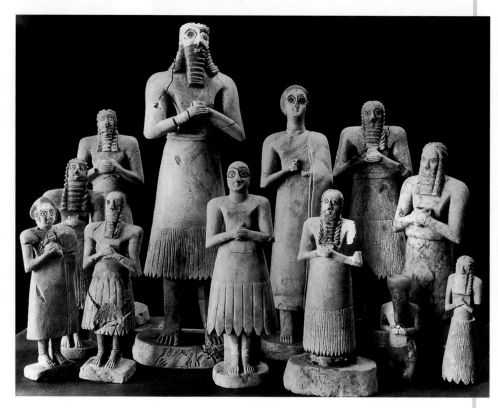

decorated with stars runs just below the upper motif on the left panel. A similar black band without the stars adorns the extreme right panel. The limited palette uses four hues, which never change in value throughout the work. Yet, the overall effect of this wall decoration remains one of great variety. The composition uses a conventionalized style which treats the human form in flat profile. The composition lies strictly on the surface. Eyes, hands, head, and feet show no attempt at lifelikeness. The fingers constitute extenuated designs elongating the arms to balance the elegant and sweeping lines of legs and feet. The matching figures of Selkis and Maat (extreme left and right) exhibit arms of unequal length and proportion.

Sculpture

Sumerian art progressed from stereotypical and anonymous portrayals to depictions of actual individuals, usually kings, portrayed in devotional acts rather than as warlords, thus emphasizing the interconnectedness of religion, king, and society at large. The famous statues from Tell Asmar (as-MAR) and the Temple of Abu illustrate this well (Fig. **1.8**).

But if roughness marks the depiction of the human figure in these votive statues, grace and delicacy emerged in works from the golden splendor of the Sumerian court. Inlaid in gold, the he-goat symbolizes the royal leadership of ancient Sumer and masculine fertility (Fig. **1.9**). Here, we glimpse an idea basic to Sumerian culture: the wisdom and perfection of divinity embodied in animal power. In this case, the goat represents an earthly manifestation of the god Tammuz, and his superhuman character is crisply and elegantly conveyed.

Sculpture constituted the major art form of the Egyptians. By 2700 B.C.E., sculptors had overcome many of the difficulties that plagued their predecessors. During those archaic times, religious tenets may have confounded sculptors, for many primitive peoples throughout history have regarded the lifelike portrayal of the human figure as dangerous. A close likeness of a person may have been thought capable of capturing the soul. Lifelikeness also presented technical problems. Early sculpture left detailing rough and simple. Sculptors seem to have relied on memory to portray the human form, rather than working from live models.

The sculpture of Prince Rahotep (RAH-hoh-tehp) and his wife Nofret (NOH-freht; Fig. **1.10**) has lifelike colors exemplifying the Egyptian tendency to use paint as a decorative surface for sculpture. The eyes of both figures consist of dull- and light-colored quartz. The eyelids are painted black. Both figures wear the costume of the time. As was customary, the skin tones of the woman appear

several shades lighter than those of the man. The kings of this time rose from peasant stock, an ancestry apparent in the sturdy, broad-shouldered, well-muscled physique of the prince. At the same time, his facial characteristics, particularly the eyes and expression, exhibit alertness, wisdom, strength, and capacity. The portrayal of Nofret expresses similar individuality.

The Egyptian admiration for the human body emerges clearly in both statues. Precise modeling and attention to detail appear in even the smallest items. Nofret's gown both covers and reveals the graceful contours of her body. Her facial features reveal an individual of less distinct character than her husband: she has a sensual and pampered face. She wears a wig shaped in the style of the day, but beneath the constricting headband we can see Nofret's much finer hair, parted in the center and swept back beneath the wig. The treatment of the hand held open against the body reveals not only the artist's skill and perceptiveness, but also the care and attention Nofret has bestowed on it. The delicate hand has small dimples decorating the fingers, and the nails exhibit extraordinary detail. The unpainted nails correctly depict a color lighter than skin tone.

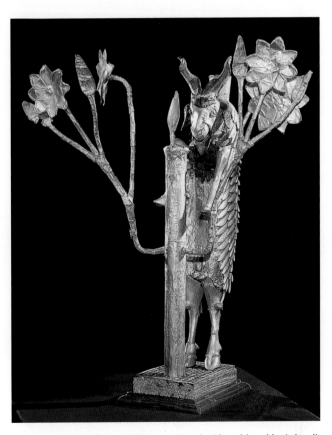

1.9 He-goat from Ur, c. 2600 B.C.E. Wood with gold and lapis lazuli overlay, 20 ins (50.8 cm) high. University Museum, University of Pennsylvania.

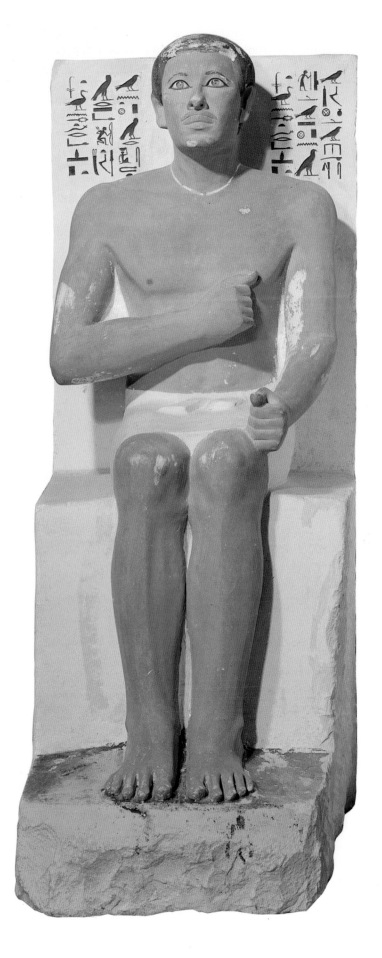

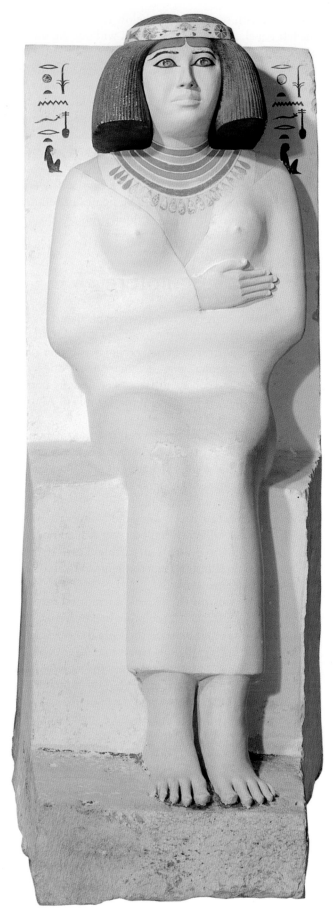

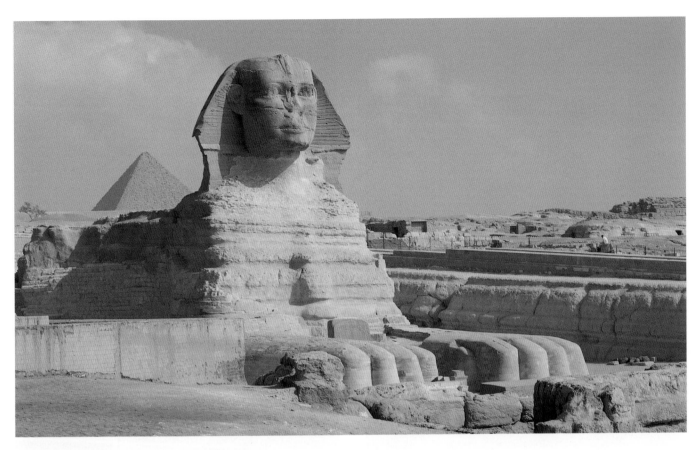

1.11 The Great Sphinx, Giza, Egypt, c. 2650 B.C.E.

Less than a century later and just to the immediate southeast of the site of the Great Pyramid of Cheops (see Figs **1.17** and **1.18**), Egyptian sculptors carved from the native rock a Great Sphinx (Fig. **1.11**). Here, as in the pyramids, we find an impressive symbol of the Egyptian belief in the divine kingship of the pharaoh and his embodiment of the sun god. The royal head rises from the body of a lion to a height of 65 feet (20 meters; equivalent to a six-story building). The features of the face probably reflected those of Pharaoh Chephren, whose pyramid sits behind the Great Sphinx (see Fig. **1.16**) and adjacent to the Great Pyramid of Cheops. Damaged in later times, the Great Sphinx marks the apex of pharaonic power.

The reign of Akhenaton (ahk-ehn-AH-tuhn; c. 1385–1358 B.C.E.) marked a break in the continuity of artistic style. The stiff poses of earlier art disappeared, replaced temporarily by a more natural form of representation (Fig. **1.12**). The pharaoh, moreover, was depicted in intimate scenes of domestic life, rather than in traditional ritual or military acts, no longer associates

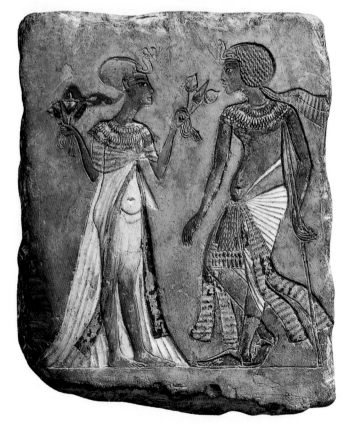

1.10 (opposite) Prince Rahotep and his wife Nofret from Maidum, c. 2580 B.C.E. Painted limestone, 3 ft 11½ ins (1.2 m) high. Egyptian Museum, Cairo.

1.12 *King Smenkhkare and Meritaten*, Tell el Amarna, Egypt, c. 1360 B.C.E. Painted limestone relief, about 5 ft (1.53 m) high. Staatliche Museen, Berlin.

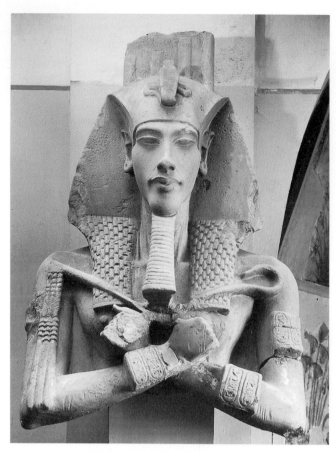

1.13 King Amenhotep IV, later Akhenaton, from a pillar statue in the temple of Aton near the temple of Amun at Karnak, 1364–1347 B.C.E. Sandstone, 13 ft (3.96 m) high, Egyptian Museum, Cairo.

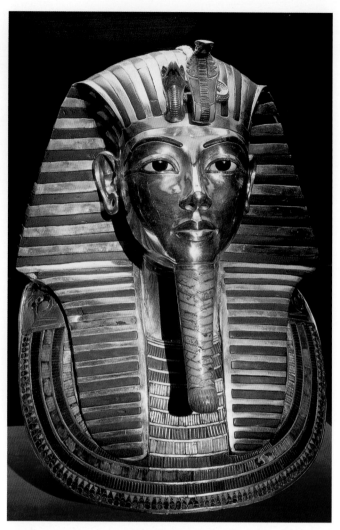

1.14 Funerary mask of Tutankhamun, c. 1337 B.C.E. Gold, semiprecious stones, glass, 21¼ × 15½ ins (54 × 39.5 cm). Egyptian Museum, Cairo.

with the traditional gods of Egypt. Rather, he and his queen worship the disc of the sun (the sun god Aten), whose rays end in hands that bless the royal pair or hold to their nostrils the *ankh*, the symbol of life.

In the fifth or sixth year of his reign, Akhenaton moved his court to the city of Tell el Amarna (uhm-AHR-nuh), newly constructed in the sandy desert on the east bank of the Nile. It was a new city for a new king intent on establishing a new order based on a new religion. The new city, Akhetaten (today, Tell el Amarna), Akenaton believed was the birthplace of Aten and had not been corrupted by worship of other gods. Akhenaton failed, and Tell el Amarna, abandoned at his death, was never built over again because it lay away from cultivated land. It thus provides us with an unspoiled record of Akhenaton's social and cultural vision.

Sculpture at Tell el Amarna departs from tradition. More secular, with less apparent emphasis on statues and reliefs for tombs and temples, it seems to have sought to represent the uniqueness of human beings through their faces (Fig. **1.15**). Amarna sculpture, although highly lifelike, transcends the merely natural and enters the

spiritual realm. The statue of Akhenaton shown in Figure **1.13** depicts the curious physical features of the king, and yet the stylization of the approach is also clear.

In relief sculptures the conventions of body proportions differ significantly from those of the other periods. In other periods, head and body proportions approach a ratio of 1:8. The figure thus totals nine head lengths from top to bottom. At Tell el Amarna, the figure totals seven to eight head lengths: in other words, the head is larger. Body proportions also differ: arms are thinner and hands larger. Abdominal and pelvic areas draw emphasis in contrast to the focus on the shoulders and upper torso of earlier periods.

Isolated from other periods by geographical and religious circumstance, the Tell el Amarna period encapsulates the artistic expressions of a single religious and philosophical concept.

PROFILE

AKHENATON AND NEFERTITI

Amenhotep IV, as Akhenaton was called before changing his name to reflect his god, was himself unusual. He possessed a "strange genius" for religious experience and its expression. His depictions show a misshapen body, an elongated head, and a drooping jaw. Yet the deep and penetrating eyes create the effect of brooding intensity.

In a hymn of praise to Aton, the sun god, thought to have been written by the king (see p. 49), Akhenaton exhibits a spirit of deep joy and devotion to the deity. In his lyrical description of the way the earth and humankind react to the rising and setting of the sun, we glimpse a man of sensitive character. His vision seems universal: Aton is not merely a god of Egypt, but of all people, and Akhenaton himself is the sole mediator between the two.

Nefertiti (neh-fuhr-TEE-tee; c. 1372–1350 B.C.E.; Fig. 1.15) was Akhenaton's Great Royal Wife. Scholars debate whether she was a princess from another land or an Egyptian. Those believing her of Egyptian origin remain themselves divided. One group claims she was the daughter of Aye and Tiy, and the other claims her as the oldest daughter of Amenhotep III and another wife besides Tiy, possibly Sitamun. Whatever her parentage, Nefertiti married Akhenaton and while living in Memphis gave birth to six daughters. Possibly, she also had sons, although no record has been found of this. Egyptian practice did not portray the male heirs as children. Possibly, she may have been the mother of Tutankhamun, the boy pharaoh who succeeded to the throne at the age of eleven and died nine years later. Nefertiti achieved a prominence unknown to other Egyptian queens. Her name is enclosed in a royal *cartouche* (a frame for a hieroglyphic inscription formed by a rope design surrounding an oval space), and there exist, in fact, more statues and drawings of her than of Akhenaton. Some have even claimed that Nefertiti, not Akhenaton, instigated the monotheistic religion of Aton. Around year fifteen of Akhenaton's reign, Nefertiti mysteriously disappeared from view.

Perhaps she died, but no indication of this exists. Some scholars think that she was banished for some reason, and lived the rest of her years in the northern palace, raising Tutankhamun. Whatever may have happened, her oldest daughter, Meritaten, replaced her, and Nefertiti disappeared from history. Akhenaton's own words describe Nefertiti: "The Hereditary Princess, Great of Favor, Mistress of Happiness, Gay with the two feathers, at hearing whose voice one rejoices, Soothing the heart of the king at home, pleased at all that is said, the Great and Beloved Wife of the King, Lady of the Two Lands, Neferu-aton Nefertiti, living forever."

1.15 *Nefertiti*, from Akhetaten (modern Tell el Amarna), c. 1348–1336/5 B.C.E. Limestone, 20 ins (51 cm) high. Staatliche Museen, Berlin.

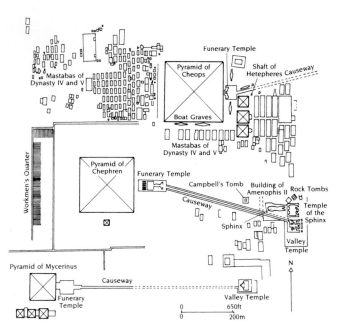

1.16 Plan of the Giza pyramid complex.

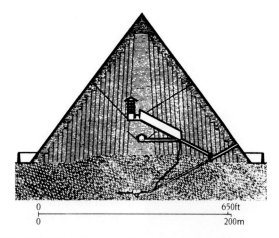

1.17 Longitudinal section, direction south–north, of the Great Pyramid of Cheops, Giza, Egypt, Dynasty IV (2680–2565 B.C.E.).

One of the most popular artifacts from ancient Egypt is an exquisite funerary mask from the tomb of Akhenaton's son Tutankhamun, discovered in the Valley of Kings near Thebes. The mask is of solid beaten gold inlaid with semiprecious stone and colored glass (Fig. **1.14**). Designed to cover the face of the king's mummy and record his likeness, it reveals the royal *nemes* (NEH-mehs) headdress with two flaps hanging down at the sides and a ribbon holding his braid at the back. The hood formed by the headdress reveals two symbolic creatures—divinities who protected Egypt.

Architecture

Pyramid building (c. 2700 B.C.E.) produced the most remarkable edifices of Egyptian civilization. Egypt's pyramids, the oldest existing buildings in the world, also rank among the world's largest structures. The largest stands taller than a forty-story building and covers an area greater than that of ten football fields. More than eighty pyramids still exist, and their once smooth limestone surfaces hide secret passageways and rooms. The pyramids of ancient Egypt served a vital purpose: to protect the pharaohs' bodies after death. Each pyramid originally held not only a pharaoh's preserved body but also all the goods he would need in his life after death.

Egyptian pyramids typically contained a temple complex constructed a short distance from the pyramid and connected by a causeway. The most elaborate example of the temple complex appears at Giza, with the pyramids of Kings Khufu, Khafre, and Menkaura built in close proximity (Fig. **1.16**). Beginning in the tenth century C.E., the entire Giza complex served as a source of building materials for the construction of Cairo, thus stripping all three pyramids of their original smooth outer facing of limestone.

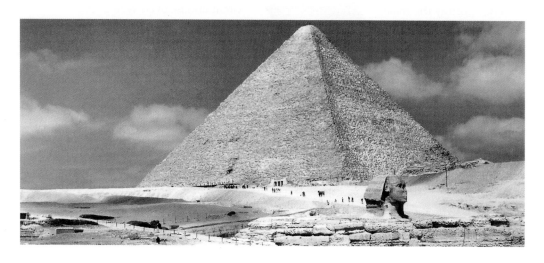

1.18 Great Pyramid of Cheops, Giza, Egypt, Dynasty IV (2680–2565 B.C.E.).

The three pyramids at Giza have a carefully planned layout. Each stands along the north–south meridian, with the faces of the pyramids pointing directly north, south, east, and west. The larger two rise neatly along a southwest diagonal, with the third slightly offset and smaller. Scholars assume that this peculiar layout was a deliberate choice made by the architects, but the reasons for such a choice (if one existed) remain mysterious. Perhaps they were part of a plan, not of individual pyramids, but a group symbolizing Orion's belt: a group of stars that the pyramids match precisely. The intensity of the stars reflects directly in the size of the pyramids.

The largest pyramid, that of Khufu, or Cheops (KEE-ahps; Fig. **1.18**), measures approximately 750 feet square (70 meters square) and rises at an angle of approximately 51 degrees to a height of 481 feet (147 meters). The burial chamber of the king lay hidden in the middle of the pyramid (Fig. **1.17**). Construction consisted of irregularly placed, rough-hewn stone blocks covered by a carefully dressed limestone facing, approximately 17 feet (5 meters) thick. The pyramid of Cheops' son Chephren (Khafre) originally measured 707 feet square (65 meters square), and rose, at an angle of 52 degrees, to a height of 471 feet (144 meters).

Music

The early Sumerians made music as an essential and lively part of their culture, and they had many musical instruments. Music fulfilled a variety of functions in Sumerian life. It seems to have been most popular as secular entertainment, but religious ceremonies also employed music. Surviving artifacts document solo performances, instrumental ensembles of single and mixed instruments, and solo and choral vocal music with instrumental accompaniment.

We can only speculate on what Sumerian music would have sounded like. Stringed instruments predominated, while percussion and rhythm instruments seem to have been less popular, and the trumpet had military application. Thus, we may assume that Sumerian music favored lyrical, soft, restrained tones, rather than loud, brash ones.

The modern world knows Egyptian musical instruments well: sculptures and paintings depict them, and fragments and even nearly complete instruments have been found. Harps, lyres, and numerous other stringed instruments, along with pipes, flutes, cymbals, and bells all appear in the storechest of the Egyptian musician. As in Mesopotamia, the basic instrument in the Egyptian scheme was probably the harp. Harps varied tremendously in size, complexity, shape, and ornamentation (Fig. **1.19**). Harps are depicted with four,

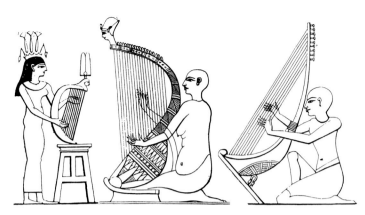

1.19 Egyptian harps.

seven, and ten strings. Some are very plain, others ornate and brightly colored. How much of this variety is real and how much lies in the imagination of the painter, we do not know, but the frequent depiction of the harp does assure us of its popularity. Wall paintings also indicate that the larger harps, some of which appear to stand nearly six feet tall, were played essentially in the same way as modern harps.

The tamboura (tuhm-BOO-ruh) of ancient Egypt had two basic shapes, one oval and the other with sides slightly incurved, like a modern violin or guitar. Illustrations show from two to four tuning pegs, and also indicate that the tamboura could be either with or without frets. Analysis of tambouras found with strings intact shows that the Egyptians used cat gut for stringing. Additional stringed instruments of innumerable shapes and sizes defy classification, but this variety certainly indicates that music held an important place among the arts of ancient Egypt.

Wind instruments varied widely in shape, size, and ornamentation. Small pipes made of reed with three, four, five, and more finger holes have been found in great quantity. Some of these appear to have been played by blowing directly across the opening at the end, and others seem to have required a reed, like the modern clarinet or oboe.

Dance

Dance formed some part of ancient Mesopotamian culture, although the evidence for its character remains scanty. In Sumer we find sacred dances of various forms. One form seems to have required a procession of singers, moving slowly to liturgies played on flutes. A second form employed dancers prostrating themselves before an altar. Mesopotamian bas-relief sculptures fairly commonly depict dancers in secular as well as sacred

contexts. The fire festival of the goddess of fertility, Ashtoreth, apparently witnessed drunken, orgiastic dancing involving self-mutilation with knives.

In Egypt, dance contributed significantly to the culture. Dances of a highly formal character had developed, and the love of dance finds wide testimony in tomb art. Dances called stride dances occur in both the harvest and run dances of the king. Stride dances typically have a forward thrust of motion based on motives (short, rhythmic themes). Several examples of stride dancing appear in funereal dances in which the dancers seem to take exaggerated, long strides, throwing the leg forward so as to break the life-destroying power of death. Fertility dances also formed a prominent part of Egyptian ritual dance, and we find images of women dancers covered in grape vines and swinging branches. A wall painting from the Middle Kingdom (c. 2200–1700 B.C.E.) depicts a fertility dance in which three women mime what the hieroglyphs call the wind. One dancer stands upright, the second bends under the outstretched arms of the first, and the third appears to be making a bridge.

Literature

In addition to the things we mentioned in the Concepts section of this chapter, literacy can also lead to literature. The oldest known story in the world comes to us from Sumer in ancient Mesopotamia. The *Gilgamesh* epic, an episodic tale of a hero's adventures, is from this era, although its most complete version dates from as late as the seventh century B.C.E. Gilgamesh (probably a real person) ruled at Uruk (OO-ruhk) during the first half of the third millennium B.C.E., although no historical evidence actually documents that. One fascinating part of this epic describes a flood, which parallels that in the story of Noah's Ark in the Bible. *Gilgamesh* represents a quest against nature, man, and the gods, and we can find numerous themes in its twelve tablets, including the role of women, who, while subservient to men, appear both compassionate and wise. Consistent with our comments about the concept of religion in ancient Mesopotamia, the epic also deals with the issues of worlds beyond this one—we encounter both a world of the dead and a place of the gods. *Gilgamesh* also treats the theme of responsibility: both in terms of Gilgamesh's responsibilities and the responsibilities of the gods.

Below is an excerpt from the very beginning of the text, which constitutes a kind of prologue that describes Gilamesh as a wise ruler who played an important role in recorded history. The "prologue" also describes him as a semi-divine mortal characterized by beauty, strength, and courage—and as an arrogant and oppressive ruler.

The Epic of Gilgamesh

Tablet I

He who has seen everything, *I will make known* (?) to the lands.
I will teach (?) about him who experienced all things,
. . . alike,
Anu granted him the totality of knowledge of *all*.
He saw the Secret, discovered the Hidden,
he brought information of (the time) before the Flood.
He went on a distant journey, pushing himself to exhaustion,
but then was brought to peace.
He carved on a stone stela all of his toils,
and built the wall of Uruk-Haven,
the wall of the sacred Eanna Temple, the holy sanctuary.
Look at its wall which gleams like *copper* (?),
inspect its inner wall, the likes of which no one can equal!
Take hold of the threshold stone—it dates from ancient times!
Go close to the Eanna Temple, the residence of Ishtar,
such as no later king or man ever equaled!
Go up on the wall of Uruk and walk around,
examine its foundation, inspect its brickwork thoroughly.
Is not (even the core of) the brick structure made of kiln-fired brick,
and did not the Seven Sages themselves lay out its plans?
One league city, one league palm gardens, one league lowlands, the
open area (?) of the Ishtar Temple,
three leagues and the open area (?) or Uruk it (the wall) encloses.

. . .

Take and read out from the lapis lazuli tablet
how Gilgamesh went through every hardship

Supreme over other kings, lordly in appearance,
he is the hero, born of Uruk, the goring wild bull.
He walks out in front, the leader,
and walks at the rear, trusted by his companions.
Mighty net, protector of his people,
raging flood-wave who destroys even walls of stone!

Egyptian funerary art extended to literature as well, and we find in *The Book of the Dead*, or more accurately, "Book of Going Forth by Day," a collection of ancient Egyptian mortuary texts (probably compiled and re-edited during the sixteenth century B.C.E.) comprising spells or magic formulas placed in tombs to protect and serve the deceased in the afterlife. These texts include works called the Coffin Texts that date to c. 2100 B.C.E., Pyramid Texts, dating to c. 2350, and other writings. Later compilations added other materials. In total, *The Book of the Dead* contains 200 chapters, but no single source contains them all. The title, *The Book of the Dead*, came from a German Egyptologist who published the first collection of the texts in 1842.

A brief excerpt entitled "Hymn to Osiris" illustrates:

The Egyptian Book of the Dead
The Papyrus Of Ani
Hymn to Osiris

Homage to thee, Osiris, Lord of eternity, King of the Gods, whose names are manifold, whose forms are holy, thou being of hidden form in the temples, whose Ka is holy. Thou art the governor of Tattu (Busiris), and also the mighty one in Sekhem (Letopolis). Thou art the Lord to whom praises are ascribed in the name of Ati, thou art the Prince of divine food in Anu. Thou art the Lord who is commemorated in Maati, the Hidden Soul, the Lord of Qerrt (Elephantine), the Ruler supreme in White Wall (Memphis). Thou art the Soul of Ra, his own body, and hast thy place of rest in Henensu (Herakleopolis). Thou art the beneficent one, and art praised in Nart. Thou makest thy soul to be raised up. Thou art the Lord of the Great House in Khemenu (Hermopolis). Thou art the mighty one of victories in Shas-hetep, the Lord of eternity, the Governor of Abydos. The path of his throne is in Ta-tcheser (a part of Abydos). Thy name is established in the mouths of men. Thou art the substance of Two Lands (Egypt). Thou art Tem, the feeder of Kau (Doubles), the Governor of the Companies of the gods. Thou art the beneficent Spirit among the spirits. The god of the Celestial Ocean (Nu) draweth from thee his waters. Thou sendest forth the north wind at eventide, and breath from thy nostrils to the satisfaction of thy heart. Thy heart reneweth its youth, thou producest the . . . The stars in the celestial heights are obedient unto thee, and the great doors of the sky open themselves before thee.

The reign of Akhenaton gave rise to a lovely poem, *The Hymn to the Aton*, the sun god. In it we find a testament to the omniscience of the one god in Akhenaton's pantheon. It expresses a deep reverence and awe from a pharaoh still considered to be a divine representative of the god himself. Note the mention of Akhenaton's wife Nefer-iti (Nefertiti).

The Hymn to the Aton
Accredited to Pharaoh Akhenaton

At daybreak, when thou arisest on the horizon,
When thou shinest as the Aton by day,
Thou drivest away the darkness
and givest thy rays.
The Two Lands are in festivity every day,
Awake and standing upon (their) feet,
For thou hast raised them up.
Washing their bodies, taking (their) clothing,
Their arms are (raised) in praise
at thy appearance.
All the world, they do their work.

All beasts are content with their pasturage;
Trees and plants are flourishing.

The birds which fly from their nests,
Their wings are (stretched) out
in praise to thy Ka.
All beasts spring upon (their) feet . . .
Whatever flies and alights,
They live when thou hast risen (for) them.
The ships are sailing north and south as well,
For every way is open at thy appearance.
The fish in the river dart before thy face;
Thy rays are in the midst of the great green sea.

Creator of seed in women,
Thou who makest fluid into man,
Who maintainest the son in the womb of his mother,
Who soothest him with that which
stills his weeping,
Thou nurse (even) in the womb,
Who givest breath to sustain all that he has made!
When he descends from the womb to breathe
On the day when he is born,
Thou openest his mouth completely,
Thou suppliest his necessities.
When the chick in the egg
speaks within the shell,
Thou givest him breath within it to maintain him.
When thou hast made him his fulfillment
within the egg, to break it,
He comes forth from the egg to speak
at his completed (time);
He walks upon his legs
when he comes forth from it.

How manifold it is, what thou hast made!
These are hidden from the face (of man).
O sole god, like whom there is no other!
Thou didst create the world
according to thy desire,
Whilst thou wert alone;
All men, cattle and wild beasts,
Whatever is on earth, going upon (its) feet,
And what is on high, flying with its wings.

The countries of Syria and Nubia, the land of Egypt, Thou
 settest every man in his place,
Thou suppliest their necessities:
Everyone has his food, and his time of life is reckoned.
Their tongues are separate in speech,
And their natures as well.
Their skins are distinguished,
As thou distinguishest the foreign peoples.
Thou makest a Nile in the underworld,
Thou bringest it forth as thou desirest
To maintain the people (of Egypt)
According as thou madest them from thyself,
The lord of all of them, wearying (himself)
with them,
The lord of every land, rising for them,
the Aton of the day, great of majesty.

All distant foreign countries,
thou makest their life (also),
For thou hast set a Nile in heaven,
That it may descend for them and make waves
upon the mountains,
Like the great green sea,
To water their fields in their towns.
How effective they are, thy plans,
O lord of eternity!
The Nile in heaven, it is for the foreign peoples
And for the beasts of every desert
that go upon (their) feet;
(While the true) Nile comes from the underworld
 for Egypt.

Thy rays suckle every meadow.
When thou risest, they live, they grow for thee.
Thou makest the seasons in order to rear
all that thou hast made,
The winter to cool them,
And the heat that they may taste thee.
Thou hast made the distant sky
in order to rise therein,
In order to see all that thou dost make.
Whilst thou wert alone,
Rising in the form as the living Aton,
Appearing shining, withdrawing or approaching,
Thou madest millions of forms of thyself alone.
Cities, town, fields, road, and river—

Every eye beholds thee over against them,
For thou art the Aton of the day
over the earth . . .

Thou art in my heart,
And is no other that knows thee
Save thy son Nefer-kheperu-Re Wa-en-Re,
For thou hast made him well-versed in thy plans and in thy
 strength.

The world came in to being by thy hand,
According as thou hast made them.
When thou hast risen they live,
When thou settest they die.
Thou art lifetime thy own self,
For one lives (only) through thee.
Eyes are (fixed) on beauty until thou settest.
All work is laid aside
when thou settest in the west.
(But) when (thou) risest (again),
[Everything is] made to flourish
for the king, . . .
Since thou didst found the earth
And raise them up for thy son,
Who came forth from thy body:
the King of Upper and Lower Egypt, . . .
Akh-en-Aton, . . . and the Chief Wife
of the King . . . Nefer-iti,
living and youthful forever and ever.

CHAPTER REVIEW

CRITICAL THOUGHT

This chapter took us back beyond the dawn of what we call civilization. Reviewing the characteristics we described as defining "civilization" can leave us wondering if those characteristics really have anything whatsoever to do with quality of life or other words with the same root, such as civil and civilized. In what ways do you think human behavior has changed over the centuries with regard to "civilized" behavior? Or does the concept of civilization have less to do with behavior than with demographics and political organization? In what ways does the art we have studied in this chapter address our needs today? Does it show us anything we need to learn in order to become more "human" ourselves?

Just as we described the Middle East, specifically Mesopotamia, as the "cradle of civilization," for complex reasons—including the presence of huge oil supplies—it has maintained a significant focus for the Western world since the Middle Ages. Originally, the Egyptian and Mesopotamian civilizations were essentially monarchial theocracies. How does the Middle East compare today? Which do you think is more important in achieving a resolution to the problems of the Middle East, religion or economics?

SUMMARY

Having read this chapter, you should be able to:

- Discuss the contention, and support your ideas with illustrations drawn from the art of the period, that earliest humans were as "fully human" as we are.
- Identify the characteristics of Stone Age, Mesopotamian, and Egyptian art by recognizing defining artistic characteristics.

- Explain the linkages between politics, religion, and art in Mesopotamian and Egyptian societies.
- Analyze (describe) the works of art illustrated in this chapter using appropriate terms, such as line and form. For example, how does the statue of Queen Nofret employ line in comparison with the statues from Tell Asmar?

CYBERSOURCES

- **Mesopotamian art:** http://www.oi.uchicago.edu/OI/MUS/HIGH/OI_Museum_Mesopotamia.html
 http://www.louvre.fr/anglais/collec/ao/meso.htm
- **Egyptian Art:** http://www.thebritishmuseum.ac.uk/aes/aeshome.html
 http://www.louvre.fr/anglais/collec/ae/ae_oeuv.htm

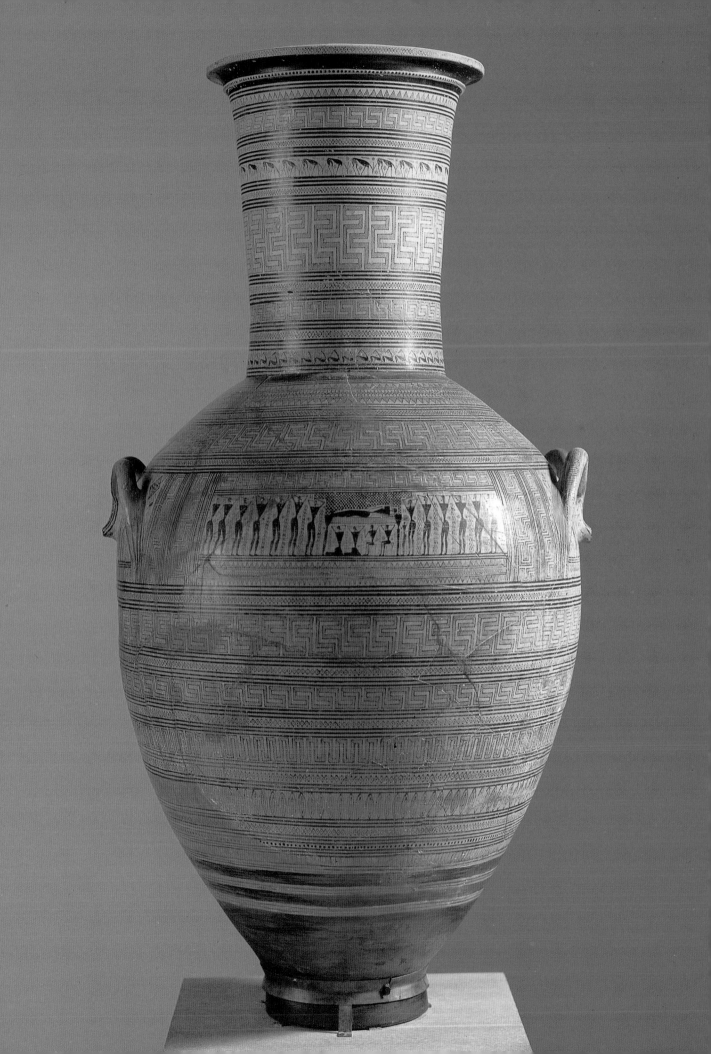

2 THE AEGEAN AND ARCHAIC GREECE

OUTLINE

VIEW

RELIGION: TYING SOCIETY TOGETHER

In the previous chapter, as in the chapter to come (indeed in many of the chapters which follow), religion plays a central role in the cultures and arts we examine. It seems that in addition to creative impulses, we also find relationships among peoples in their search for communion with a power or powers higher than themselves. Greek culture was no exception and, in fact, much of its cultural ethos derived from its religion. Such an observation leads to one other, and that is the question, what does hold a society together? Can a society survive without some unifying characteristic with which most of its citizens can identify?

KEY TERMS

POLIS
The basic Greek city-state, consisting of a collection of self-governing people.

ACROPOLIS
The "high city"—the elevated place in the center of the city occupied by the temples of the gods.

GEOMETRIC STYLE
A style of vase painting that made use of bold, simple, linear designs.

ARCHAIC STYLE
A style of two-dimensional and three-dimensional art. In two-dimensional art, it utilized a sense of three-dimensional space, whereas in sculpture, it consisted of figures that exhibit a stiff, frontal pose.

KOUROS
A term describing a freestanding statue of a nude male youth.

KORE
Describes a sculpture of a fully dressed female—that is, the female counterpart of the kouroi.

DORIC ORDER
Refers to a style of architecture employing columns capped by heavy lintels and a pedimented roof.

2.1 Geometric amphora, c. 760 B.C.E. National Archeological Museum, Athens.

CONTEXTS AND CONCEPTS
Contexts

We leave the cradle of civilization in the Middle East and turn northeastward to the Aegean Sea (Map **2.1**). Here the roots of Western civilization took hold. Undoubtedly, Egypt and Mesopotamia had an effect on the emerging culture of the region—the Greeks of the classical period noted this, and the latest holders of Mesopotamian power, the Persians, conquered parts of the Grecian world, including Athens—but before the "Greeks," others inhabited the region.

Minoans

Around 3000 B.C.E., while sizable cities arose in Mesopotamia, small towns on the island of Crete began to expand into large urban centers. The Minoan (mih-NOH-uhn) civilization, named after the legendary King Minos (MY-nuhs), emerged at this time, and by 1800 B.C.E. a great palace had arisen in the city of Knossos (NAHS-uhs) on Crete. We do not know much about the Minoans, but we can tell from the ruins of their palaces and their wall paintings that they were rich and adventurous. They depended on their naval power for defense, and their unfortified palaces consisted of elaborate complexes, with the private homes of the aristocracy and religious leaders clustered around them. These palaces had running water and elaborate drainage systems, and, below ground, storage areas containing large earthenware pots of grains, oil, and wine. They also had systems for cooling during the summer and heating in winter. Through trading posts around the Aegean, Minoan Crete carried on a lively and rewarding commerce as far away as Egypt, exporting pottery, bronze, olive oil, and timber.

Many well-preserved archeological sites allow us to deduce a certain amount of information about the Minoan lifestyle and culture, even though their writing has yet to be fully deciphered. Wall paintings, executed in brilliant colors, reveal portraits of royalty and scenes of nature. They reflect a flighty court life with high-born, bare-breasted ladies, bedecked in jewels, and strolling in lovely gardens. Sportive youths frolic and raise golden goblets of wine. Life was lavish in the labyrinthine palaces of Knossos, with their complex rooms and passageways. Bureaucrats abounded, but few soldiers, and Minoan civilization clearly had trade, not militarism or politics, at its center.

GENERAL EVENTS

- Minoan civilization, c. 3000–1500 B.C.E.
- Mycenaean traders in the Aegean, 1400–1200 B.C.E.
- Archaic period, 600–480 B.C.E.
- First Olympic games, 776 B.C.E.
- Destruction of Troy, c. 1260 B.C.E.
- Persian Empire, 600–330 B.C.E.
- Greek "Middle Ages," 1200–800 B.C.E.
- Persian War, 490–479 B.C.E.

3000 B.C.E.	1500 B.C.E.	1250 B.C.E.	750 B.C.E.	500 B.C.E.	350 B.C.E.
PAINTING & SCULPTURE					
		Boar Hunt (**2.4**), Lion Gate, Mycenae (**2.5**)	Dipylon Vase (**2.9**), Kouroi (**2.12**), Korai (**2.13, 2.14**)		Wrestlers (**2.7**), The Pan Painter, red figure krater (**2.8**), Perseus bowl (**2.10**), *Kritios Boy* (**2.15**)
ARCHITECTURE					
	Palace of Minos, Knossos (**2.3**)		Doric Order (**2.17**), Temple at Paestum (**2.18**)		
MUSIC & DANCE					
			Choric dance festivals, First tragic competitions, Development of modes		
LITERATURE					
Pictorial writing		Homer (*Iliad*, *Odyssey*), Hesiod (*Works and Days*)	Sappho of Lesbos, Pythagoras		

Timeline **2.1** Archaic Greece and the Aegean.

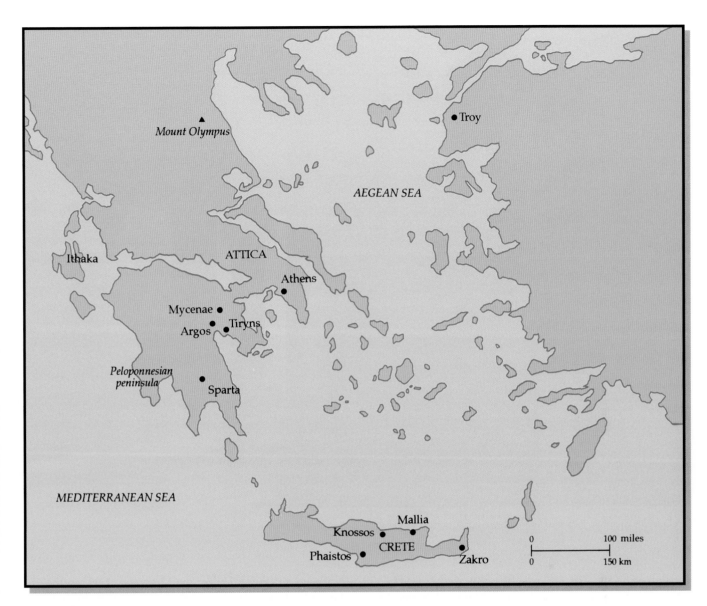

Map 2.1 The Aegean.

The Minoans were a wealthy, secure, and matriarchal civilization. If the so-called Palace of Minos (Figs **2.2** and **2.3**) represents them, they not only enjoyed comfort, but also created sophisticated elegance in decor and design. The palace had so many rooms that Greek myth called it the "labyrinth of the Minotaur (MIHN-oh-tohr)." The masonry walls had decorative murals and geometric motifs. Rectangular and circular **columns**, employed as supports, took the form of tapering wooden **shafts**, perhaps reflecting their origin as unworked treetrunks, with heavy, geometric capitals. They created a total impression of openness and lightness, combined with luxury and attention to detail.

The religion had a variety of gods, goddesses, and myths. Early versions of Athena—who later emerged as

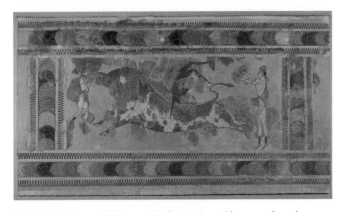

2.2 *Bull Jumping*, c. 1500 B.C.E. Wall painting with areas of modern reconstruction from the Palace of Minos at Knossos, Crete. Archaeological Museum, Iraklion, Crete.

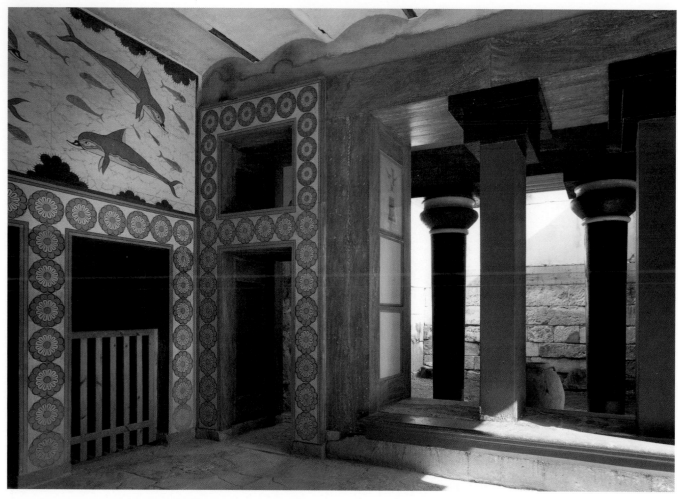

2.3 Queen's chamber, Palace of Minos at Knossos, Crete, C. 1500 B.C.E.

the patron goddess of Athens—first appeared here. The Minoans also had a cult of the sacred bull, celebrated by terrifying "bull dancing" or "bull leaping" (Fig. **2.2**), a rite performed by naked young men and women on the backs and over the horns of the bulls. This probably constituted the origin of the Minotaur of Greek legend.

Minoan culture, however, experienced a short-lived glory. By 1500 B.C.E., the Minoans had been swept into darkness, perhaps by a series of earthquakes and volcanic eruptions or perhaps merely through conquest by their neighbors. However, their influence appeared in a later civilization that also emerged in the Aegean, that of the Mycenaeans (my-SEEN-ee-uhns).

Mycenaeans

The Mycenaeans were early, barbaric, Indo-European conquerors who settled the rugged southeastern coastline of mainland Greece and who, by the fourteenth century B.C.E., had supplanted the Minoans as rulers of Crete. Homer called them "tamers of horses," because they fought from chariots, and they left the lands they

conquered in ruins. Unlike the Minoans, of whom the later Greeks were unaware, the Mycenaeans, through Homer, provided Greece with myths, legends, and heroes such as the mighty Achilles (uh-KIL-lees) in the *Iliad* (IHL-ee-uhd) and the wandering Odysseus (oh-DIHS-ee-uhs) in the *Odyssey* (AHD-ih-see). The Greeks also found in this people a source of ethics and moral order, and Homer's epics give a glimpse of a social organization in which the *oikos* (household domain) formed the center of economic and social power.

Although conquest seems to have been their main occupation, the Mycenaeans did engage in some trade, their traders traveling throughout the Mediterranean between 1400 and 1200 B.C.E. Above all, however, they were warriors, and maintained their rule by the strength of their military. Their soldiers and armada of ships reportedly conquered the legendary Troy and gave Homer the basis for his epic the *Iliad*, which we discuss in the Literature section later in this chapter.

A variety of local deities and household gods and goddesses, some of which appear also to have been

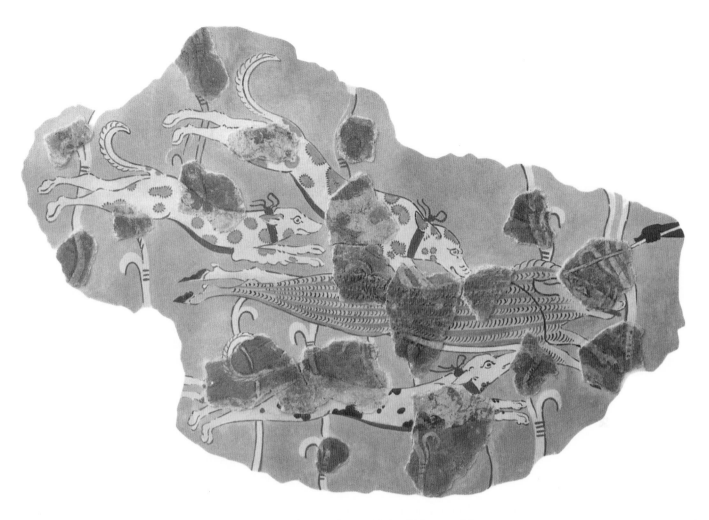

2.4 *Boar Hunt*, c. 1200 B.C.E. Wall painting from the palace at Tiryns, Greece. National Museum, Athens.

predecessors of Greek deities, were worshipped in caves and at natural shrines. Religious practice included burying the dead with honor, and, like the Egyptians, the Mycenaeans mummified corpses and buried them with precious objects.

The walls of Mycenaean palaces bear decorative paintings, which also represent the activities of the time. The *Boar Hunt* (Fig. **2.4**) shows a group of dogs, hunting as a pack and attacking their prey. Their collars, which appear tied around the neck, indicate domestication of the hounds. The hand and what looks like the lance of the hunter at the extreme right of the fragment indicate that the dogs have chased the boar into the vicinity of the hunters. This painting testifies not only to a successful hunt but also to the dog breeder, whose well-trained dogs carry out their owner's commands, thus giving us a glimpse of domestic life.

The most powerful city of Mycenae boasted a great palace complex and great wealth. The palaces of the Mycenaeans differed significantly from those of the Minoans, for they constituted fortresses constructed of

large, rough stone blocks placed at the center of a settlement on top of the highest hill. The individual boulders were so huge that the Greeks who viewed them centuries later called them "Cyclopean," believing that only cyclopes—mythological giants with one eye in the center of their foreheads—could have moved them.

The Lion Gate at the Palace of Mycenae (Fig. **2.5**) demonstrates the powerful effect of juxtaposing smoothly carved elements with the massive blocks of stone. In an alcove on top of the lintel, two lions, obviously intended as guardians, flank a tapering column similar to those found in Minoan palaces. The careful carving of the animals' musculature expresses strength, and it contrasts with the rough stone masonry, creating a slightly uncomfortable effect, reinforced by the cramped nature of the composition within the alcove. Yet, despite any roughness in the design, the execution shows remarkable skill, with tight jointure of the stone.

In spite of its great defenses and massively fortified palaces, the Mycenaean civilization collapsed shortly after 1200 B.C.E.

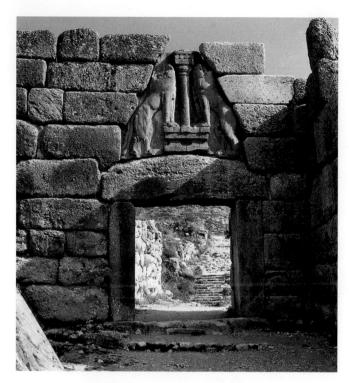

2.5 The Lion Gate, Mycenae, Greece, c. 1250 B.C.E.

The Dark Centuries

Between the time of the Mycenaean civilization, with its art and palaces, and that of the Greek city-states of the eighth century B.C.E., lies a historical vacuum of four centuries. Historians call this time the "Greek Middle Ages" or the "dark centuries," and during this period wave upon wave of Indo-European peoples filtered into the area and spread throughout Asia Minor. The building of palaces ceased and what little artistic activity existed— for example, pottery—remained crude. Although the Mycenaeans had writing, the skill seems to have vanished during this time. Life switched from fortified cities to isolated farming communities, and trade and commerce among communities isolated by the mountainous terrain stayed minimal if it did not cease altogether.

Nonetheless, life was not static nor all dark. During this time, iron replaced bronze for tools and weapons, significant changes occurred in burial practices, the political hierarchy shifted from kings to powerful families, and new peoples drifted into the valleys, to neighboring islands, and to the shores of Asia Minor. Toward the end of the eighth century B.C.E., gatherings of Greeks listened rapturously to the epic poems of Homer and Hesiod, looking back on the heroes of Mycenae. And indeed, they did look backward, because it seemed that all glory lay in the past, with little to look forward to.

TECHNOLOGY

THE OLIVE PRESS

Often, one of the interesting things about the record of history is not its claims, but the fact that particular individuals are recorded as having invented particular pieces of technology, and the Greeks had a great regard for technological innovation. The status of the technician in Greece was raised high—much more so than in neighboring Asiatic countries—and an interest in technology was respectable, with inventors being regarded as benefactors.

As Greek civilization spread through the Aegean and Mediterranean during the archaic age, trade became increasingly important. One of the few products that Greece, with its mountainous terrain and poor soil, could produce in sufficient abundance to export was olive oil, which, together with wine and pottery, became their principal export. Manufacturing oil in quantity required technological advances in the presses by which olive oil is produced. Initially, the oil was extracted in a simple beam press illustrated in relief sculpture and vase paintings, but later, pulleys and screws worked the beam to press the oil (Fig. **2.6**).

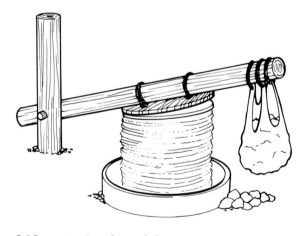

2.6 Reconstruction of an early beam press.

The Hellenes

A unifying spirit grew among the people of this region— they saw themselves as "Hellenes (heh-LEENZ)." All the different peoples of the area—for example, the Ionians, Dorians, and Aeulians—had a common language, which, although old, had only recently developed a written form.

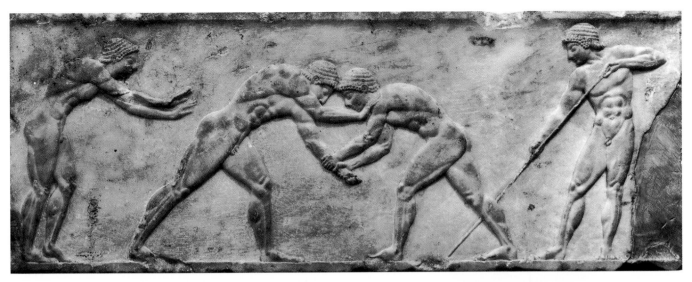

2.7 Wrestlers, from a statue base, c. 500 B.C.E. Marble, 12¼ ins (31.8 cm) high. National Archeological Museum, Athens.

The earliest surviving Greek written characters, found on a jug, date from 725 B.C.E. These characters appear to be adapted from Phoenician script, one example of the many outside influences, especially Middle Eastern (see Chapter 1), that helped to shape Greek culture.

The Hellenes used a common calendar, which dated from the first Olympic games in 776 B.C.E. These games embodied much more than a mere sporting event—they represented life's struggles ("athletics" derives from a Greek word for contest that also meant struggle), and they symbolized the joy found in toil and cost. The games constituted a time when Greeks could meet in a non-lethal context that recognized their larger cultural, linguistic, and religious identity. The contests existed purely for the honor of competing, with victory a sufficient prize. But although the victors gained nothing more than a simple wreath of wild olive leaves, the citizens of a victorious athlete's polis often complemented the simple prize with more lucrative ones, such as free meals for life. We can thus see that even as early as the very first Olympic games, the heralded spirit of amateur competition often raised in regard to the modern Olympics must be taken with a grain of salt. Only men and boys could compete in the five-day festival of the Olympic games, held every four years, at Olympia (married women were forbidden even to attend the games). They competed in the nude, and the principal event consisted of a foot race to honor Zeus (ZOOS), king of the gods (see the discussion on religion on p. 60). Later, boxing, wrestling (Fig. **2.7**), other field sports, and chariot racing were added. The first day of the Olympic festival witnessed peripheral events, such as poetry readings and art exhibitions, with the third day reserved for solemn religious sacrifices at the altar of Zeus.

Concepts

The Polis

The Greek city-states that developed at the beginning of what we call the archaic period (800–480 B.C.E.) were already well established and functioning by the time recorded history began, but we do know, at least, that they did not all spring up simultaneously. Each city, or polis (POH-lis; plural poleis), consisted of a collection of self-governing people. The Greeks referred to cities by the collective name of their citizens—thus, for example, Athens was "the Athenians." Each polis was surrounded by a group of villages and a rural territory, and each was self-governing, functioning as an independent state. No central, unifying government drew these cities together, and each polis developed its own ethos—a sense of self. Some, such as Athens, emerged as relatively peaceful, with a high esteem for the arts and philosophy. Others, such as Sparta, turned militaristic and seemingly indifferent to high culture.

All the cities formed their social orders on distinct class structures, with some people free and others slaves. Among free males there existed a clear demarcation between citizens and non-citizens: only citizens could participate in political decision-making, own land, or serve in wars. But access to citizenship could alter according to the city's circumstances at a given time.

Physically, the polis comprised two cities: a lower city, in which the people lived, and a high city, or *acropolis* (uh-KRAHP-oh-lis), an elevated place in the center of the city occupied by the temples of the gods. (This practice pre-dated the ways in which towns developed in the Middle Ages, when the cathedral rose

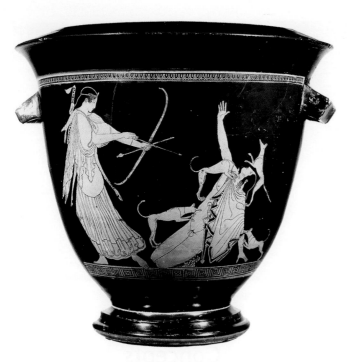

2.8 The Pan Painter, Attic red-figure krater showing Artemis shooting Actaeon, c. 470 B.C.E. 14⁹⁄₁₆ ins (37 cm) high. Museum of Fine Arts, Boston (James Fund and by Special Contribution).

on the highest elevation in the center of a city to symbolize the centrality and elevation of the Christian Church.) The citizens of the Greek polis owned the city, including the acropolis, and the pantheon of gods often formed more a focus of civic pride than of reverence.

Originally, the typical polis had an organization similar to the tribal structure brought down from the north by the invaders, whose tribes were governed by an aristocracy or council of leading families. Typically, the leading landowners were part of such an aristocracy, and, occasionally, a polis might have a "king," like that of the ancient Minoans or Mycenaeans. Power in the polis actually belonged, however, to the landowners and tribal leaders, and the concept of a king gradually faded away, replaced by a group of elected magistrates. In the seventh and sixth centuries B.C.E., the aristocracy went into decline, giving rise to a new degree of freedom. The rise of trade and the increasing wealth of the merchant class siphoned power from the landowners.

As the polis developed, land, money, and military service became important qualifications for political power. Farmers, merchants, and craftsmen who could afford to buy weapons—each member of the army was self-armed—demanded inclusion in political decision-making. Often, *tyrants*—spokesmen for the citizenry and quasi-rulers—arose from the ranks of the military. The word "tyrant" here does not have the negative connotations usually associated with it today.

By the end of the sixth century B.C.E., these unique Greek poleis were scattered throughout the Aegean and Mediterranean area. Although they did not match the cities of Egypt, Mesopotamia, or even Crete or Mycenae in wealth and splendor, they contained thriving populations living in simple houses who, as a group, built impressive temples, theatres, and stadiums.

We look back on the Greek poleis and call them "democracies," seeing them as the forebears of our own "democratic" form of government. They were, of course, far from democratic in the modern sense of the word, for only native-born, free, adult males of a specific economic standing were citizens, and so had any voice in government. Nevertheless, the polis was a democracy in that the rule lay in the hands of the many and not in the hands of a few or, as in the monarchies of ancient Egypt and Mesopotamia, in the hands of a god king.

The Olympian Gods

Greek thought and religion centered on this life. Ancient Greeks may often have looked for meaning in the order of the stars, but there, as on earth, the human mind formed "the measure of all things."

At the core of Greek religion lay a large family of gods. Their history in **myth** had been traced by the poet Homer in the *Iliad*. Greek religion had no holy books or scriptures. The stories of the gods were well known, however, through oral tradition and through writings such as Hesiod's *Theogony* (thee-AHG-oh-nee). These gods, called "Olympian" because they dwelt on the mythical (and also real) Mount Olympus, descended from a pair of older gods: Uranus (you-RAYN-uhs), representing the heavens, and Gaia (GAY-uh), representing the earth. But their genealogies grew from so many varied myths that, although central to Greek religion, they remain confusing, and, to some degree, confused. In addition to the central family of gods, the Greeks worshipped local deities who were thought to preside over certain human activities and to protect various specific geographical features such as streams and forests.

The Greeks represented their gods in human terms, sometimes superior to humans, sometimes worse than us. This constitutes a radical departure from, for example, the gods of Sumer and Babylonia, and the implication is clear: if the gods can be like humans, humans can also be godlike. Thus, an intimacy existed between the gods and their human companions, and life on earth for the Greeks appeared similar to that of the gods.

Homer had elaborated many of the often bizarre relationships of the gods in the Olympic pantheon, and some of the gods took shape from earlier religions of the Minoans and Mycenaeans, which may account for the confusing traits and characteristics. In the Greek pantheon, Zeus, the sky god, functioned as the king of

the gods on Mount Olympus. He hurled thunderbolts and presided over councils of gods. Endowed with a rapacious sexual appetite, Zeus sired both gods and mortals. Hera (HIH-ruh), Zeus' wife—and also his sister—functioned as the patron of women, who appealed to her for help. In legend, she also spent a good deal of time trying to keep an eye on her philandering husband. Zeus' two brothers, Poseidon (poh-SY-duhn) and Hades (HAY-deez), ruled the rest of the universe: Poseidon ruled the seas, waters, and earthquakes; while Hades ruled the underworld and land of the dead. Zeus had twin children, Apollo and Artemis (ART-uhm-ihs), who symbolized the sun and the moon, respectively. Apollo represented the intellect and reason, while Artemis functioned as patroness of childbirth and wild creatures (Fig. 2.8).

Zeus' other children included Athena, goddess of wisdom and patron of the city of Athens. She sprang, fully developed, from the head of Zeus, and the Greeks worshipped her as a virgin goddess. Ares, the god of war, engaged in an incestuous and adulterous liaison with his half-sister Aphrodite, goddess of love and beauty, who was married to another of Zeus' sons, Hephaestus (hih-FEHS-tuhs), the god of craftsmen. According to legend, Hephaestus was both ugly and lame. Another son of Zeus, Hermes (HUHR-meez), served as the gods' messenger and patron of merchants and thieves. Zeus' sister Hestia (HEHS-tee-uh) protected the hearth in the Greek home.

Two other important deities headed large cults. Demeter (dih-MEE-tuhr), sister of Zeus, goddess of the harvest, had the power to make the earth fertile and crops grow. Initiates from all over Greece traveled to Eleusis, a small village in Attica, to worship her in quiet dignity and to join her cult with its promise of immortality. In contrast, Dionysus (dih-ohn-EE-suhs), the god of wine and reveling, had devotees who participated wildly in search of rejuvenation and rebirth. His annual ceremonies in Athens gave birth to the festivals of drama we will study in the next chapter.

"Love of Wisdom"

The era of great Greek philosophers had not yet arrived, although the archaic period laid the groundwork for the rationalism and intellectual acuity that would blossom in the fifth century B.C.E. The word philosophy means "love of wisdom," and its practice developed into searches for the meaning and significance of the human condition. In the archaic period, philosophy first turned away from its roots in religion and began to apply reason to the discovery of the origins of the universe and the place of human beings in it.

In deference to the great philosopher of the Greek classical age still to come, succeeding generations have called the philosophers of the archaic period the *pre-Socratics*, a term that does not refer to any specific philosophic system, of which several existed during the archaic period. Undoubtedly, the best-known and, arguably, the most important was the system of philosophy developed by Pythagoras (pih-THAG-uh-ruhs) and called *Pythagoreanism*. In his search for truth, Pythagoras concluded that mathematical relationships were universal—that universal constants applied throughout life. For example, his deduction of what we call the Pythagorean theorem postulates that the square of the hypotenuse of a right-angled triangle equals the sum of the squares of the other two sides. We see this as a mathematical given, but Pythagoras rationalized that this mathematical truth revealed the larger, universal truth about the cosmos: that the universe has a single reality existing apart from substance. He called this the "harmony of spheres." He further believed that all living things were related. Beyond his philosophical contributions, his mathematical inquiries deduced the numerical relationships among musical harmonies, his research in this area forming the basis of contemporary musical practice that divides a musical scale into an octave or eight tones.

Another important school of pre-Socratic philosophy was that of the *atomists*. Led by Leucippus (loo-SIH-puhs) and Democritus (de-MAHK-rit-uhs; c. 460 B.C.E.), this system believed that the universe is an ultimate and unchangeable reality based on atoms—that is, small "indivisible" and invisible particles. A second quality of the universe constituted "the void" or nothingness. Of course, we recognize both the term and the definition of "atom" as a part of the twentieth-century physical science of quantum mechanics.

Other pre-Socratic schools included the *materialists*, headed by Thales (THAY-leez) of Miletus (c. 585 B.C.E.), who believed that water was the primary element underlying the changing world of nature. A century later, another materialist, Empedocles (ehm-PEHD-oh-klees) of Acragas (c. 495 B.C.E.), postulated that the elements of nature consisted of fire, earth, air, and water. Combined (love) and separated (war and strife), they accounted for the progress of creatures and of civilizations.

THE ARTS OF THE AEGEAN AND ARCHAIC GREECE

Painting

History has not been kind to whatever painting the Greeks might have done. Our artifactual evidence consists of vase paintings, and in this section we examine two of the earliest styles, the geometric (c. 900–700 B.C.E.) and

the **archaic** (c. 700–480 B.C.E.), which immediately preceded the classical style of the Golden Age of Athens that we study in the next chapter.

Geometric Style

Unlike modern fine-art ceramics, objects intended to convey beauty and comment on reality, the pots of Greece in this time served exclusively utilitarian purposes: cups, jugs, and vessels for storing and carrying water, wine, and oil. Vase painting thus, at best, constituted a minor art form among the Greeks.

Nevertheless these vessels do provide some insights into their time. By the eighth century B.C.E., vase painting progressed to a geometric phase. Figures **2.1** and **2.9** show geometric amphorae in which the design utilizes linearity, using zigzags, diamonds, and the meander or maze pattern. The vessels themselves have intricate shape and are large in size. Some examples stand nearly six feet (1.8 meters) high—so large, in fact, that they had to be constructed in sections.

Designs fill virtually every space on the vase. The decoration is composed in horizontal bands called

MASTERWORK

THE DIPYLON VASE

The Dipylon (DIHP-ih-lahn) Vase (Fig. **2.9**), from the eighth century B.C.E., was found in the Dipylon Cemetery in Athens. This pot and others like it served as grave monuments. Holes in the bottom allowed liquid offerings to filter down into the grave.

The vase in Figure **2.9** shows the body of the deceased lying on a funeral bier, surrounded by mourners. Also depicted on the vase is a funeral procession with warriors on foot and in chariots drawn by horses. Every human and animal figure in this complex design suggests a geometric shape harmonizing with the other elements on the vase. Although recognizable and narrative in purpose, the figures appear as just another type of ornamentation within the larger context of the overall design. They follow the convention of portraying the torso frontally while the head and legs show in profile; turning the head to the rear would denote a figure in motion.

On this vase, intricacy of detail occupies every inch of its surface, and the artist has organized that detail into carefully balanced horizontal bands, each displaying a different geometric pattern. With only a few shapes, the artist has created a tremendously detailed painting with a subtle and sophisticated balance and focus. The dark, wide bands on the base and at the bottom of the bowl ground the design and help the viewer to focus on the story of the dead person. The patterns at the top and bottom of the vase have completely different details and yet they seem harmonious. We can also note the balanced juxtaposition of straight lines and curves: the snake-like design and circles sit quite naturally alongside

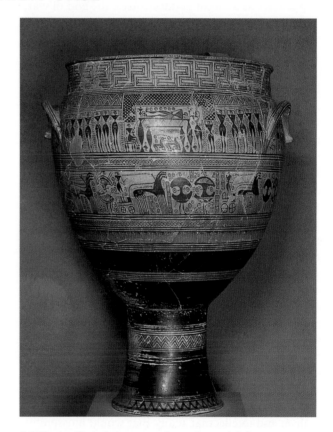

2.9 Dipylon Vase, Attic geometric amphora, eighth century B.C.E. 3 ft 6⅝ ins (1.08 m) high. Metropolitan Museum of Art, New York (Rogers Fund, 1914).

rectangles and triangles. Characteristic of its style, it fills every field with decoration and divides the surface into thirds with avoidance of overlapping.

registers. When it appears, the human form shows in silhouette, with the head, legs, and feet in profile while the torso faces forward. In general, geometric vase design expresses absolute symmetry.

Archaic Style

Figure representation remained two-dimensional until the middle of the sixth century B.C.E. Depiction remained full profile, or a full-frontal torso attached to legs in profile. The head, shown in profile, contained a full-frontal eye. Painters depicted fabric in a stiff and conventionalized manner. But by 500 B.C.E., artists were attempting to portray the body in a three-quarter position, between profile and full frontal. At the same time, a new feeling for three-dimensional space developed, and artists began to depict eyes more accurately. Fabric began to assume the drape and folds of real cloth. All these characteristics mark vase painting of the sixth century B.C.E., and they typify the various stages of the archaic style.

Individual vase painters' styles differed greatly from each other. We know some of these artists from their signatures. Others have been assigned names based on the subject or the location of their work: The Gorgon (GOHRG-uhn) Painter, for example (Fig. **2.10**), after the Gorgons that decorate his work. In this example of the sixth-century style, the design emerges in graduated registers, with an intricate and lovely geometric design as a focus on the middle band.

Red- and Black-Figure Pottery

Athenian pottery of this period can be divided into two types: black-figure and red-figure. In black-figure vases, the design appears in black against the light red clay background. Details are incised, and white and dark colors are added. White tends to be used for women's flesh and for old men's beards. Red is used for hair, horses' manes, and for parts of garments (see Fig. **2.10**).

Red-figure work, which first appears around 530 B.C.E., reverses the basic scheme, with the figures appearing in the natural red clay against a glazed black background (see Fig. **2.8**). Contours and other internal lines appear in glaze and often stand out in slight relief. In early red-figure work, artisans occasionally used incision for the contours of the hair, with touches of white and red. Other techniques that appeared in the fifth and fourth centuries B.C.E. include the use of palmettes and other motifs impressed in the clay and covered with black glaze. Both types used the same firing process.

Vase painters discovered that figures appeared more lifelike when shown in the natural red color of the terracotta, with the background filled in in black. At first, the change from black-figure to red-figure was tentative. Some vases appeared with red-figure work on one side

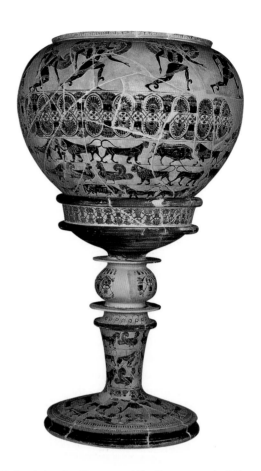

2.10 Attic bowl showing Perseus and the Gorgons, early sixth century B.C.E. 36½ ins (93 cm) high. Louvre, Paris.

and black-figure on the other. Red-figure pottery continued through the classical and late classical periods (see Chapter 3) and beyond.

Sculpture

Stone and metal have greater durability than pottery, and sculpture often surpasses all other art forms in its survival of the centuries. However, Greek sculpture does not exist in great quantity, and unfortunately, probably some of the greatest examples have been lost forever.

Most of the freestanding statues in the archaic style consist of nude youths known as *kouroi* (KOO-roy). The term means, simply, "male youth" (singular, **kouros** [KOO-rohs]). More than a hundred examples have survived. All exhibit a stiff, fully frontal pose. The head is raised, with eyes fixed to the front, and arms hang straight down at the sides, with the fists clenched. These statues emphasize physicality with broad shoulders, well developed pectoral muscles, and narrow waist. The legs show the musculature of a finely tuned athlete with solid

buttocks and hardened calves. Nevertheless, these figures are clearly not lifelike. The sculptor seems overconscious of the block of stone from which the figures have been cut. They have simplified features and rigid posture, despite the movement of one foot into the forward plane. In spite of these limitations, however, these works represent a sculptural innovation. They represent the first examples of truly freestanding stone sculpture. By freeing the statue of any support, the artist can represent the human form independently of any non-living matter. This accomplishment prepares the way for later, more successful representations of living beings.

Most of the kouroi served as funerary and temple art. Many of them had an artist signature: "So-and-so made me." We can only debate whether the statues represent humans or gods. The fact that all appear nude perhaps signifies a celebration of the physical perfection of youth and of the marvelous nature of the human body. The kouroi may also represent, more directly, the naked athletes who took part in the games loved by the Greeks. The Greeks explained the practice of competing in the nude by telling the story of a runner who dropped his loincloth and, thus unimpeded, won the race. Other more symbolic explanations of the nudity of these statues have been offered, but no one view has prevailed.

Two significant characteristics are exemplified by the kouros from around 600 B.C.E. shown in Figure **2.12**. First, although the sculptor made an obvious attempt to depict the human figure in a fairly lifelike manner, the figure does not represent a particular person. Rather, it represents a stereotype, or a symbol, and an idealization, perhaps of heroism. The sculpture, however, lacks refinement, a characteristic that helps to differentiate the archaic from the classical style.

The second characteristic is the attempt to indicate movement. Even though the sculpture stands firmly rooted, the left foot extends forward. This creates a greater sense of motion than if both feet appeared side by side in the same plane, yet the weight of the body remains equally divided between the two feet.

The kouros had a female counterpart in the *kore* (KOH-ray, plural korai, meaning "maidens"). These figures, always fully dressed, in other ways show far more variety than the kouroi. Some of these differences may stem from variations in regional dress, but clearly the sculptor's interest lies in the treatment of that dress, in the technical mastery required for an accurate depiction of cloth in stone.

Figure **2.13** shows a typical kore. In this delicate and refined portrayal, the sculptor shows a lightness of touch

A DYNAMIC WORLD

NATIVE AMERICA

We recognize the approach to human figures illustrated in the Greek sculptures of this chapter. Native American artists, however, developed a different set of conventions, as Figure **2.11** illustrates. Among the many tribes of Native Americans, there is no specific word equivalent for the term "art." In Native American culture, art is anything that is technically well done. The "artist" is simply someone who is better at a job than someone else. Only a few tribes had a group of professionals who earned a living producing what we would call art.

The earliest identifiable art in Mexico comes from the Olmec people—called the "rubber people"—and can be dated to the same period we are studying in this chapter, approximately 1000 B.C.E.

These people carved a number of subjects—for example, the delicate, baby-faced figure shown in Figure **2.11**. This finely carved figurine has a noticeably turned-down mouth, a facial feature that is a common characteristic of Olmec sculpture of this period. Even though much of the body is missing, we can see that the carefully carved details on the green-gray stone effigy make a powerful statement.

2.11 Fragment of carved stone figurine; Olmec-style head with trace of red paint inlay. Xochipala, Guerrero, Mexico, 1250–750 B.C.E. 3 × 1 ins (7.6 × 2.5 cm). National Museum of the American Indian, Smithsonian Institution.

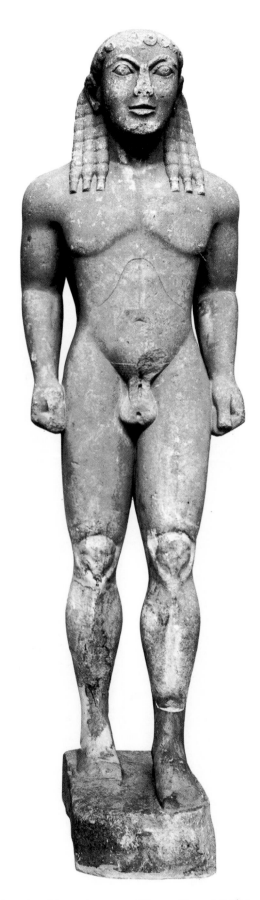

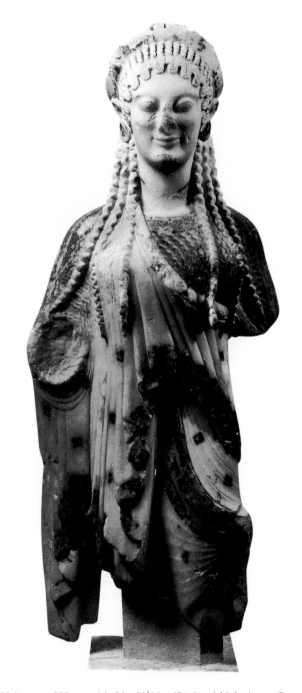

and delicacy, not only in the anatomical features but also in the precise folds of the robes, finely detailed jewelry, and stylized hair. These elements combine to give the statue a greater degree of lifelikeness than the kouroi we have examined.

In comparison with Figure **2.13**, the kore shown in Figure **2.14** lacks detail, but it thereby achieves cleaner, more graceful, lines. Although the heavy fabric disguises anatomical details, the body, with the waist emphasized,

2.12 Polymedes of Argos, kouros, c. 600 B.C.E. Stone, 6 ft 5½ ins (1.97 cm) high. Archeological Museum, Delphi, Greece.

2.13 Kore, c. 510 B.C.E. Marble, 21½ ins (54.6 cm) high. Acropolis Museum, Athens.

is convincingly present beneath the robes. The kore's smile exhibits more personality than the blank stare of many archaic statues, and the extension of the left arm forward into space indicates a new interest in movement outside the main block of the statue.

By the early fifth century B.C.E. the stiffness of the archaic style had begun to modify. The human form began to be portrayed with subtlety and to display movement. The transition began with the *Kritios Boy* (KRIHT-ee-ohs; Fig. **2.15**), named for its presumed sculptor. Here the body truly stands at rest while the head gently turns to one side rather than being fixed frontally. The artist has discovered the principle of weight shift— the way in which the body parts position themselves around the flexible axis of the spine. The *Kritios Boy* represents the first known portrayal of this important principle, and in it we can discern the beginnings of the classical style.

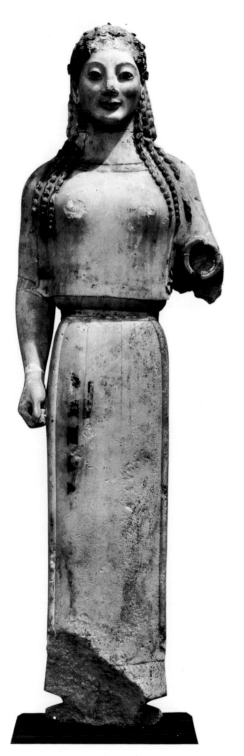

2.14 Kore in Dorian peplos, c. 530 B.C.E. Marble, 4 ft (1.22 m) high. Acropolis Museum, Athens.

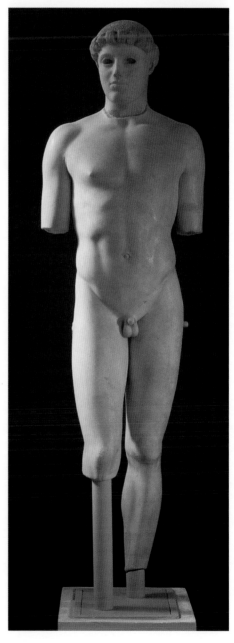

2.15 *Kritios Boy*, c. 480 B.C.E. Marble, about 34 ins (86 cm) high. Acropolis Museum, Athens.

Architecture

The archaic period witnessed the building of temples in a new adaptation of the post-and-lintel structure. The style employed imposing vertical posts or columns capped by heavy lintels and a **pedimented** roof, and it probably drew on elements of Egyptian, Mycenaean, and pre-archaic Greek structures—for example, the **fluted** or vertically grooved column used in Egypt nearly two thousand years earlier. The style of some of these temples, called Doric after one of the Hellenic peoples, the Dorians, seems well established by 600 B.C.E. Although the style itself changed over time, the early version had a cumbersome

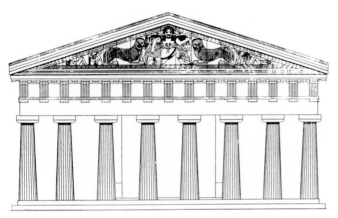

2.16 Reconstruction drawing of the west front of the Temple of Artemis, Corfu. [After Rodenwaldt.]

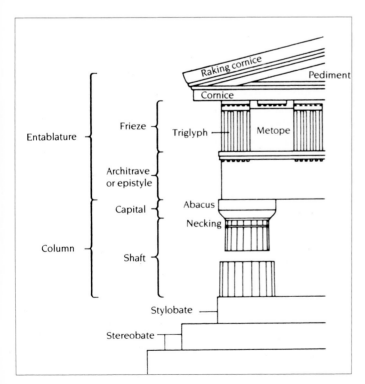

2.17 The Doric order.

appearance, with thick columns and blocky, oversized **capitals**. Many of its characteristics came from earlier wooden buildings. We can sense the qualities and details of the order by examining a reconstruction drawing of the west front of the Temple of Artemis at Corfu (Fig. **2.16**). In this example, tapering columns sit directly on the **stylobate** (STYL-uh-bayt) or uppermost element of the foundation. The fluted shaft, the tubular main trunk of the column, tapers inward as it rises. The shaft leads to a flared echinus (ehk-IHN-uhs), a round collar-like cushion between the shaft and a square **abacus** (AB-uh-kuhs): the slab at the top of the column on which the **architrave** (AR-kih-trayv), or bottom portion of the lintel, rests (Fig. **2.17**). In the **entablature** we can see a **frieze** or band of relief elements known as triglyphs and metopes (MEHT-uh-peez). Above the frieze rest two **cornices**, one horizontal and the other rising at an angle creating a triangular space called a pediment, often filled with relief sculptures (see Fig. **3.12**).

The best-preserved temple from this period, at Paestum (PEEHS-tuhm; Fig. **2.18**) in Italy, was dedicated to the goddess Hera. Here, the flaring of the columns seems exaggerated and the capitals unduly large, as if the

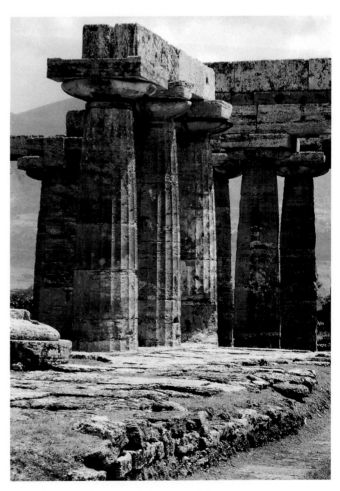

2.18 Corner of the temple at Paestum, Italy, c. 550 B.C.E.

architect feared that the lintels of the architrave would collapse if not supported along their length. The **proportion**, or relationship of the width of the columns to their height, gives the basilica a squat appearance with none of the grace of its classical successors.

Music

Although we cannot play any Greek music, because we simply do not know how to interpret the surviving records, we do know that music played a fundamental role in Greek life and education, and in Greek mythology, music had tremendous power to influence behavior. The gods themselves invented musical instruments, and the deities and heroes of Greek legend played them to remarkable effect. Apollo played the lyre (Fig. **2.19**), and Athena, the flute. Achilles, Homer's great hero of the *Iliad*, played proficiently.

Surviving records tell us that Greek music consisted of a series of modes, the equivalent of our **scales**. Each mode—for example, the Dorian and Phrygian—had a name and a particular characteristic sound, not unlike the difference between our major and minor scales, and the Greeks attributed certain behavioral outcomes to each mode. Just as we say that minor scales sound sad or exotic, the Greeks held that the Dorian mode exhibited strong, even warlike, feelings, while the Phrygian elicited more sensual emotions.

Each mode had a referent planet, day of the week, and guardian or patron deity:

Mode	Planet	Day	Patron deity
Mixolydian	Mercury	Wednesday	Hermes
Lydian	Venus	Friday	Zeus and Apollo
Phrygian	Sun	Sunday	Demeter and Aphrodite
Dorian	Mars	Tuesday	Hephaistos
Hypolydian	Jupiter	Thursday	Ares and Poseidon
Hypophrygian	Saturn	Saturday	Artemis and Hera
Hypodorian	Moon	Monday	Hestia

Attaching the days of the week to various musical modes represented a practice that we can trace back to Babylonia and Sumeria of ancient Mesopotamia (see Chapter 1).

The ancient Greeks attributed various ethical powers to music and claimed that music could affect character. We call this the Greek doctrine of *ethos*. Music in ancient Greece permeated society and embodied cultural values. For the ancient Greek, music, poetry, and dancing were inseparable. Music, thus, constituted an integrated art form, and Greek philosophers recognized its power and influence in their society, which led to the development of

2.19 Attributed to the Eucharides painter, amphora showing Apollo playing a lyre and Artemis holding an aulos before an altar, c. 490 B.C.E. 18½ ins (47 cm) high. Metropolitan Museum of Art, New York (Rogers Fund, 1907).

the doctrine of ethos. Although most of the major Greek philosophers believed in music's influence, they disagreed about the manner in which it worked and how it influenced people, as can be seen in the divergent opinions of Plato and Aristotle on the matter.

We have a fairly good picture of what Greek musical instruments looked like from vase paintings. Figure **2.19** illustrates the aulos, a double-reed instrument, and the lyre, a stringed instrument. The Greeks were particularly fond of vocal music, and instruments principally accompanied vocal music. The lyrics of songs have survived, and these include songs to celebrate acts by the various gods, from whom some mortal had gained special favor.

Dance

The ancient Greeks believed that the gods invented dancing. They believed that the gods offered this gift to some select mortals only, who in turn taught dancing to

the rest of humanity. The oldest Greek historical sources on dance come from Crete and the Minoan civilization, which cultivated music, song, and dance as part of their religious life and for their entertainment as well. The religious rituals of ancient Greece centered on dance. Beginning around 600 B.C.E., great festivals brought choruses of fifty dancers from each tribe together on special occasions for competitions. Most scholars agree that the Greek theatre developed directly from these dances. (The Greek tragic chorus had fifty members.)

Dance, music, and drama, inseparably entwined, all played a fundamental part in early (and classical) Greek philosophy, religion, and life. The term "dance" had a broader definition for the Greeks than it does for us. In fact, it denoted almost any kind of rhythmic movement. Just as dance and music were inseparable, so were dance and poetry. A Greek could dance a poem, using rhythmic movements of his hands, arms, body, face, and head to interpret the verses recited or sung by himself or another person.

Literature

Homer

Ancient Greece had a significant literary heritage that began with an oral tradition and progressed to written works. Homer (Fig. 2.20) represents the greatest of the Greek poets. Of his life we know virtually nothing. He probably lived in the ninth or eighth century B.C.E. Tradition also says he was blind. Relying on oral traditions he probably composed, but probably did not literally "write," the two greatest epic poems of ancient Greece, the *Iliad* and *Odyssey*. In poetic terms, these works act as symbols of Hellenistic unity and heroism. While they are sweeping stories, they also contain elegant poetry that probes human emotion as it deals with gods and heroic adventures.

These poems fall into the category of epic poetry, which means that they comprise long narrative poems using an elevated style of language. Scholars also distinguish between two types of epic. The first, "primary" (also called traditional or classical), draws its material from legends and traditions of an heroic age and part of the oral tradition of literature. The second type, "secondary," was written down from its inception and purposely created by accomplished poets who adapted characteristics of the traditional epic for specific literary or ideological purposes. Homer's *Iliad* and *Odyssey* fall into the category of primary epics; together they created the mythical history that later Greeks accepted as their historic heritage. They took the dark and unknown past and created in a literary, originally oral, form a cultural foundation for an entire people. They told of heroes and

described the gods. They depicted places and events, and they did so in a form that represented a supreme artistic achievement: epic poetry. Both poems deal with minor episodes in the story of the battle of Troy, which ended, with the destruction of the city, in about 1230 B.C.E.

Divided into twenty-four books, the *Odyssey* tells the story of Odysseus, king of Ithaca, as he travels home from the Trojan War to recover his house and kingdom.

The poem opens on the island of Orgygia (ohr-GHIJ-uh), where, ten years after the end of the Trojan War, Odysseus has been detained for seven years by the nymph Calypso. After setting the scene, the poem shifts to Ithaca, where Odysseus' wife, Penelope (pehn-EL-oh-pee), and son, Telemachus (tuh-LEHM-uh-kuhs), struggle to retain their authority during Odysseus' long absence. In Book V, Zeus orders Calypso to release Odysseus, and Odysseus sets sail on a raft, which is destroyed by Poseidon, god of

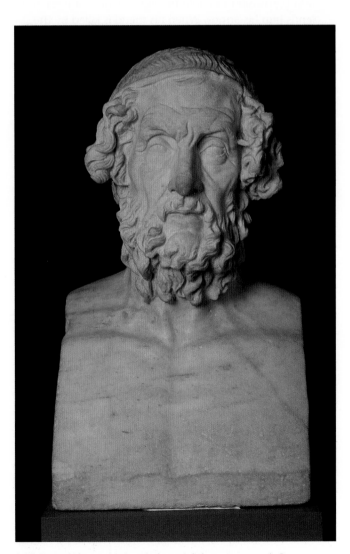

2.20 Bust of Homer (active ninth or eighth century B.C.E.), Roman, first–second century C.E. Stone. British Museum, London.

MASTERWORK

HOMER—THE *ILIAD*

Set in twenty-four books, and exploring the *heroic ideal* with all its contradictions, the *Iliad* begins with an explanation of the quarrel between King Agamemnon (ag-uh-MEM-nahn), commander of the Greek army, and Achilles, the Greeks' greatest warrior. When the action opens, the Greeks have been besieging Troy for nine years, trying to rescue Helen, wife of Agamemnon's brother Menelaus (mehn-uh-LAY-uhs), from Paris, one of the sons of the Trojan King Priam (PRY-uhm). As a result of his quarrel with Agamemnon, Achilles leaves the Greek forces, taking his followers with him. Without Achilles, the Greeks suffer many losses. Unable to bear it when the Trojans set fire to the Greek fleet, one of Achilles' close friends asks permission to rejoin the fight. Achilles agrees and lends him his armor. When his friend is killed by the Trojan hero Hector, Achilles exacts revenge by killing Hector. Hector's father, King Priam, asks Achilles for his son's body so that it can be properly buried. Achilles agrees, and his anger is assuaged. The work ends with Hector's funeral.

Homer develops events on the battlefield and behind the lines of both adversaries. From his descriptions, an elaborate evocation emerges of the splendor and tragedy of war and the inconsistencies of mortals and gods. The heroes are types, not real people, and their characters were established in legend long before they were described in this epic poem. In the poem we find a careful structure that alternates between individual encounters and mass movements of opposing armies. The battle poetry uses recurring elements and motifs, but it has subtle variety resulting from the highly individualized episodes. Even in translation we witness the elevated language style, highly formal poetry we see again in the next chapter, for example, in the dramatic verse of the classical tragedian Aeschylus. Here is a brief extract from Book XX:

So these now, the Achaians, beside the curved ships were arming around you, son of Peleus, insatiate of battle, while on the other side at the break of the plain the Trojans armed. But Zeus, from the many-folded peak of Olympos, told Themis to summon all the gods into assembly. She went everywhere, and told them to make their way to Zeus' house. There was no river who was not there, except only Ocean, there was not any one of the nymphs who live in the lovely groves, and the springs of rivers and grass of the meadows, who came not. 10

These all assembling into the house of Zeus cloud gathering
took places among the smooth-stone cloister walks which Hephaestus
had built for Zeus the father by his craftsmanship and contrivance.
So they were assembled within Zeus' house; and the shaker
of the earth did not fail to hear the goddess, but came up among them
from the sea, and sat in the midst of them, and asked Zeus of his counsel:
"Why, lord of the shining bolt, have you called the gods to assembly
once more? Are you deliberating Achaians and Trojans? For the onset of battle is almost broken to flame between them."
In turn Zeus who gathers the clouds spoke to him in answer:
"You have seen, shaker of the earth, the counsel within me, 20
and why I gathered you. I think of these men though they are dying.
Even so, I shall stay here upon the fold of Olympos
sitting still, watching, to pleasure my heart. Meanwhile all you others
go down, wherever you may go among the Achaians and Trojans
and give help to either side, as your own pleasure directs you,
for if we leave Achilles alone to fight with the Trojans
they will not even for a little hold off swift-footed Peleion.
For even before now they would tremble whenever they saw him,
and now, when his heart is grieved and angered for his companion's
death, I fear against destiny he may storm their fortress." 30
So spoke the son of Kronos and woke the incessant battle.

the sea, washing ashore on the land of the Phaeacians (FAY-uh-shuns). Odysseus recounts for the Phaeacians his adventures since leaving Troy: the land of the Lotus-Eaters; struggling with lotus-induced lethargy; blinding Polyphemus (pahl-ee-FEEM-uhs) the Cyclops, a son of Poseidon; losing eleven of his twelve ships; reaching the island of Circe (SUHR-see) the enchantress, who turned some of his companions into swine; visiting the Land of Departed Spirits and learning from the Theban seer Tiresias (teer-EE-see-uhs) how to calm Poseidon's wrath; encountering the Sirens, Scylla (SIHL-uh) and Charybdis (kuh-RIB-dis), and the Cattle of the Sun, which his companions, despite warnings, kill for food; finally, surviving, alone, the following storm and reaching Calypso's idyllic island.

The Phaeacians return Odysseus to Ithaca, where the goddess Athena (uh-THEEN-uh) disguises him as a beggar and he reveals his true identity to his son. Together they plot to rid their home of the suitors hounding Penelope. Still in disguise, Odysseus passes the clever test Penelope has devised to choose one of the suitors. After passing the test, Odysseus kills the suitors with the help of Telemachus and two faithful servants and is accepted by Penelope as her long-lost husband and as the king of Ithaca.

Sappho

The growth of individualism in Greece produced a new literature: personal lyric poetry. Ancient lyrics, anonymous and often intended for use in rituals, had been concerned with experiences common to all. But by the end of the seventh century B.C.E., poets appeared along the Ionian coast who tell us their names, and sing of themselves, their travels, military adventures, political contests, homesickness, drinking parties, poverty, hates, and loves.

The lyric poet Sappho (SAF-oh), born around 615 B.C.E., lived all her life on the island of Lesbos. She gathered around her a coterie of young women interested in poetry, and who may have been worshippers of the cult of Aphrodite. Many of Sappho's poems honor one or other of these young women.

We call Sappho a *lyrist* because, as was the custom of the time, she wrote her poems to be performed with the accompaniment of a lyre. Sappho composed her own music and refined the prevailing lyric meter to a point that we now know as *sapphic meter*. She innovated lyric poetry both in technique and style, becoming part of a new wave of Greek lyrists that moved from writing poetry from the point of view of gods and muses to the point of view of the individual. One of the first poets to write from the first person, she described love and loss as they affected her personally. Her style, sensual and melodic, primarily used songs of love, yearning, and

PROFILE

SAPPHO

One of the great Greek lyrists and few known female poets of the ancient world, Sappho, an aristocrat, married a prosperous merchant, and she had a daughter named Cleis. Her wealth afforded her the opportunity to live her life as she chose, and she chose to spend it studying the arts on the isle of Lesbos.

In the seventh century B.C.E., Lesbos served as a cultural center. Sappho spent most her time on the island, though she also traveled widely throughout Greece. Exiled for a time because of political activities in her family, she spent this time in Sicily. By this time well-known as a poet, she so honored the residents of Syracuse by her visit that they erected a statue to her. Sappho knew much honor in ancient times. Lesbos minted coins with her image during her own lifetime. Plato elevated her from the status of great lyric poet to one of the muses. Upon hearing one of her songs, Solon, himself an Athenian ruler, lawyer, and a poet, asked that he be taught the song "Because I want to learn it and die."

Although her work enjoyed great fame, it did not survive intact: only one of Sappho's poems remains in its entirety. All the rest exist solely as fragments. At one time, perhaps nine complete volumes of her poetry existed, but over the years neglect, natural disasters, and possibly some censorship took their toll. Late in the nineteenth century, however, manuscripts dating back to the eighth century C.E. were discovered in the Nile Valley, and some of these manuscripts contained pieces of her works. Many translations of these fragments have been made, and each offers a slightly different approach to her work. Translating Sappho's poetry poses significant challenge, in no small part because of the fragmented nature of the material.

reflection. Frequently females formed the objects of her affections—usually one of the women sent to her for education in the arts. She nurtured these women, wrote poems of love and adoration to them, and when they eventually left the island to be married, she composed their wedding songs. Sappho employs an emotional and

frank tone, her language simple and sensuous. In one of
her longer fragments, "He seems to be a God, that Man,"
much admired and imitated by later poets, she gazes
at a young bride sitting and laughing next to her
bridegroom and erupts with emotion. In "God's
Wildering Daughter," Sappho entreats Aphrodite,
the immortal child of the god Zeus.

God's Wildering Daughter
Sappho

God's wildering daughter deathless Aphrodite,
A whittled perplexity your bright abstruse chair,
With heartbreak, lady, and breathlessness
Tame not my heart.

But come down to me, as you came before,
For if ever I cried, and you heard and came,
Come now, of all times, leaving
Your father's golden house

In that chariot pulled by sparrows reined and bitted,
Swift in their flying, a quick blur aquiver,
Beautiful, high. They drew you across steep air
Down to the black earth:

Fast they came, and you behind them. O
Hilarious heart, your face all laughter.
Asking, What troubles you this time, why again
Do you call me down?

Asking, in your wild heart, who now
Must you have? Who is she that persuasion
Fetch her, enlist her, and put her into bounden love?
Sappho, who does you wrong?

If she balks, I promise, soon she'll chase,
If she's turned from gifts, now she'll give them.
And if she does not love you, she will love,
Helpless, she will love.

Come, then, loose me from cruelties.
Give my tethered heart its full desire.
Fulfill, and, come, lock your shield with mine
Throughout the siege.

Hesiod

Born at the end of the eighth century B.C.E., Hesiod (HEE-
see-uhd), the son of an emigrant farmer from Asia Minor,
depicts this hard life in his poem *Works and Days*.
Hesiod teaches the lesson that men must work, and he
sketches the work that occupies a peasant throughout the
year, recounting how an industrious farmer toils and how
work brings prosperity, in contrast to the ruin brought

about by idleness. He captures the changing seasons and
countryside with vivid word pictures. He also describes
life at sea, and concludes with a catechism detailing how
people should deal with each other. His style, similar to
Homer's, differs in subject matter, for rather than telling
of heroes and gods, Hesiod dwells on the mundane
and mortal.

Hesiod's most famous work, however, the *Theogony*,
traces the mythological history of the Greek gods. He
describes the rise of the earth out of chaos, the overthrow
of the Titans by Zeus, and the emergence of each god and
goddess. Scholars attempting to understand Greek art
and religion have found this work invaluable as a source
of information.

Aesop

We close this section with a brief look at perhaps the best
known poet of ancient Greece, whose existence, however,
probably consists only of legend: Aesop. Various citations
and traditions surround him, and attempts occurred even
in ancient Greece to establish him as an actual person.
Editors ascribe approximately 200 fables to him, such
as those of the turtle and the hare and the fox and the
grapes. Aesop marks the onset of the Western fable
tradition, but the Aesop fable of the hawk and the
nightingale appeared in Hesiod's work, and another
Greek poet, Archilochus (Ahr-KIHL-loh-kus), a seventh-
century B.C.E. warrior-poet often considered the greatest
poet after Homer, recounted similar tales in his works.
Fables like the fox and the grapes provide us with
examples of *accismus* (ak-SIHZ-muhs), a form of irony
in which a person feigns indifference to, or pretends to
refuse, something he or she really desires, as in the fox's
dismissal of the grapes.

The Fox and the Grapes
Aesop

One hot summer's day a Fox was strolling through an
orchard till he came to a bunch of Grapes just ripening on a
vine which had been trained over a lofty branch. "Just the
things to quench my thirst," quoth he. Drawing back a few
paces, he took a run and a jump, and just missed the bunch.
Turning around again with a One, Two, Three, he jumped
up, but with no greater success. Again and again he tried
after the tempting morsel, but at last had to give it up, and
walked away with his nose in the air, saying, "I am sure
they are sour."

"IT IS EASY TO DESPISE WHAT YOU CANNOT
GET."

CHAPTER REVIEW

CRITICAL THOUGHT

We have now arrived at the birthing place of Western culture. Here, in archaic Greece, politics, art, architecture, literature, music, and dance reveal themselves as *prototypes*. We begin to see things we recognize—not from history books or even museums, but on the streets of our own towns. That is what prototypes are: the original ideas or forms on which later ideas and forms are based. Some of our public buildings emulate the Greek original, and certainly our form of government grew from concepts basic to the polis. What draws our critical thinking in this regard centers upon the concept of democracy, specifically the concept of "one person, one vote." Noble in intent, such a means of governance has never fully existed. The United States constitutes a Republic, and the question occurs as to whether any kind of direct democracy could function in practical terms or even be prudent.

SUMMARY

After reading this chapter you should be able to:

- Identify and describe four pre-Socratic schools of philosophical thought.
- Characterize the Minoan, Mycenaean, and archaic Greek styles of architecture.
- Explain the differences among protogeometric, geometric, and archaic styles of pottery.
- Define the term polis and discuss its role as a fundamental concept in the Greek cultural ethos.
- Describe the characteristics of archaic Greek sculpture.
- Apply the elements and principles of composition to analyses and comparisons of archaic Greek, Egyptian, and Mesopotamian art and architecture.

CYBERSOURCES

http://witcombe.sbc.edu/ARTHgreece.html
http://harpy.uccs.edu/greek/archaicsculpt.html
http://www.mcad.edu/AICT/html/ancient/garchaic.html

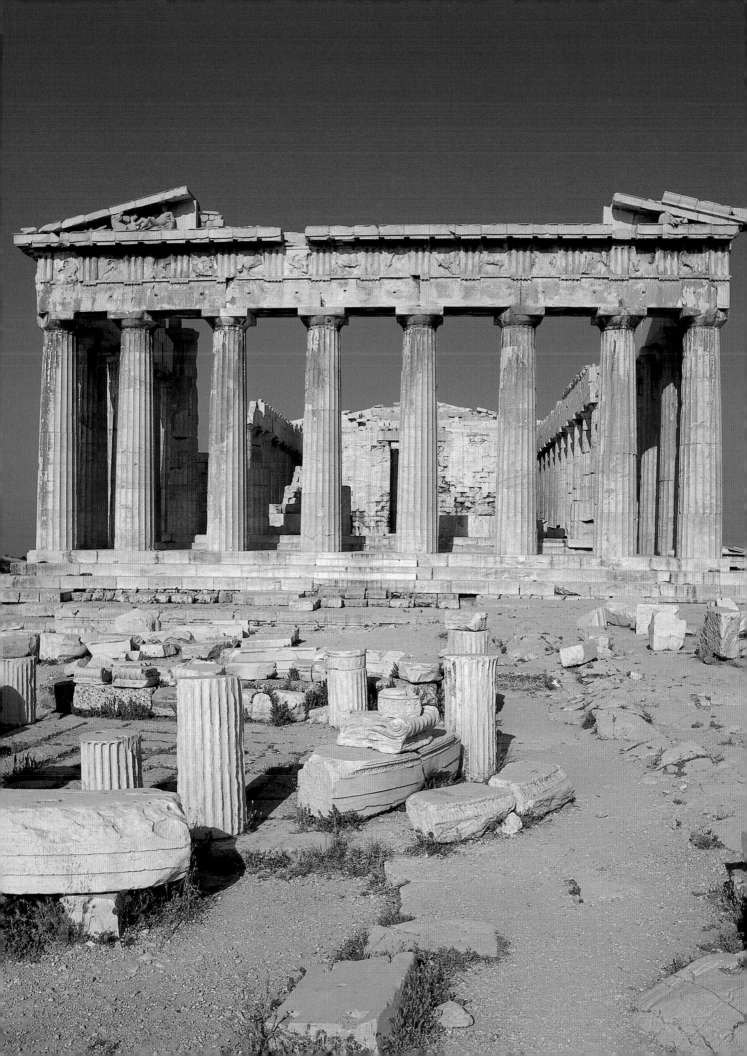

3 GREEK CLASSICISM AND HELLENISM

OUTLINE

VIEW

THE CLASSICAL IDEAL

In this chapter we study the foundations of Western civilization, which rest firmly on the bedrock of classicism. The term classicism denotes the ideals and styles of ancient Greece and Rome as embodied primarily in their arts. Almost universally, these ideals and styles have been translated into notions of simplicity, harmony, restraint, proportion, and reason. We are related to the Greeks by these ideals, and, in fact, as we read subsequent chapters, we will see Greek classical ideas recur again and again.

At times we will hear the classical/anti-classical struggle called the struggle between "form" and "feeling" or intellect versus emotion. That postulation means the struggle of artistic ideas in which appeal to rationality, simplicity, and restraint (form) comes up against ideals that appeal to emotion, complexity, and abandon (feeling). Classicism believes in the power of reason and searches for rational principles. Anti-classicism in its various styles promotes individualism and subjectivity.

KEY TERMS

OLIGARCHY
Government by the few, especially by a small faction of persons or families—as opposed to a democracy.

AESTHETICS
A branch of philosophy dealing with the nature of beauty and art and their relation to human beings.

CLASSICISM
A style of art relying on the fundamentals of simplicity, clarity of structure, and appeal to the intellect.

IONIC ORDER
One of the Greek architectural decorative and elevational conventions and systems of proportion, characterized by columns with scroll-like capitals and circular bases.

CORINTHIAN ORDER
One of the Greek architectural decorative and elevational conventions and systems of proportion, characterized by columns employing an elaborate leaf motif in the capital.

HELLENISTIC STYLE
An approach to art characterized by individuality, virtuosity, and emotion.

3.1 The Parthenon, Athens, 447–438 B.C.E.

CONTEXTS AND CONCEPTS

Contexts

The Persian War

The Persians, defeated by the Greeks at Marathon in 490 B.C.E., spent the next ten years regrouping under Xerxes I (zurk-zeez) and preparing for another invasion of the Greek mainland. That invasion took place in 480, when an army of perhaps as many as 60,000 men proved unstoppable, completely overrunning northern Greece. It must have been a frightening spectacle: Medes and Persians clad in leather breeches and fishtail iron jerkins, with short, powerful bows; Assyrians in bronze helmets and carrying long lances; Arabs in flowing robes; and Ethiopians in leopard and lion skins. A coalition army headed by the Spartans battled valiantly, at a narrow northern pass named Thermopylae (thuhr-MAHP-uh-lee)—the Hot Gates—which has gone down in history largely because a traitor revealed to the Persians how to take the defenders from the rear. As the Persian army moved steadily south, its fleet sailed north against southern Attica. The Persians took and destroyed Athens, and ultimate victory seemed a certainty.

The Greeks, however, fought on territory they knew well, they had brilliant leaders, and they were motivated by the desire to save their homeland. For years the Athenian Themistocles (thuh-MIS-tuh-kleez) had championed the Greek navy, and hundreds of new triremes (TRY-reemz, ships with three banks of oars; Fig. 3.2) had been built. These long warships, manned by disciplined citizen-sailors, took to the sea against the Persian fleet. The critical battle came off the port of Athens, near the small island of Salamis, where the triremes massed against the Persians, ramming them as Greek warriors swarmed aboard. The battle of Salamis proved a Greek triumph: they totally destroyed the Persian fleet and left the Persian army unsupported.

The Persian army wintered in Thessaly, and in 479 B.C.E. it marched south again. Under Spartan command, the Greek army emerged victorious at the

GENERAL EVENTS				
■ Battle of Marathon, 490 B.C.E.	■ Pericles, 450–429 B.C.E.		■ City-states defeated by Philip II, 338 B.C.E.	
■ Persian invasion, 480 B.C.E.	■ Peloponnesian War, 431–404 B.C.E.		■ Alexander the Great, 336–323 B.C.E.	
■ Delian League, 478 B.C.E.			■ Invasion of Persia, 334 B.C.E.	
			■ Library at Alexandria, 323 B.C.E.	
			■ Ptolemy I, 323 B.C.E.	
500 B.C.E	**450 B.C.E**	**400 B.C.E**	**300 B.C.E**	**100 B.C.E**
PAINTING & SCULPTURE				
Charioteer (**3.8**)	Achilles painter (**3.7**), Polyclitus, *Lance Bearer* (**3.9**), Myron, *Discus Thrower* (**3.11**), *The Fates, Parthenon* (**3.12**), *Riace Warrior* (**3.13**), Parthenon frieze (**3.25**)	Praxiteles (**3.14, 3.15**), Lysippus, *Scraper* (**3.16**)		*Nike of Samothrace* (**3.17**), *Dying Gaul* (**3.19**), Altar of Zeus, Pergamon (**3.26**)
ARCHITECTURE				
	Parthenon (**3.1, 3.24, 3.25**), Temple of Athena Nike, Acropolis (**3.21**)	Theatre at Epidaurus (**3.28, 3.29**)		Temple of Olympian Zeus (**3.22**)
THEATRE				
Aeschylus, Sophocles	Euripides, Aristophanes	Theatre at Epidaurus, Menander		
MUSIC & DANCE				
	Dionysiac cult revels			
LITERATURE & PHILOSOPHY				
	Herodotus, Protagoras, Socrates, Thucydides	Plato, Aristotle, Epicurus		Hippocrates, Zeno the Stoic, Theocritus

Timeline 3.1 Greek Classicism and Hellenism.

3.2 Reconstruction of a Greek trireme.

critical battle of Plataea (pluh-TAY-uh). The beaten Persians withdrew, never again to set foot in Greece. The Persian War did not end for another thirty years, but after the battles of Salamis in 480 and Plataea in 479, the "war" consisted largely of annual raids by the Greeks on coastal lands of the Persian Empire.

The "Golden Age" of Pericles

Claiming to be the saviors of Greece in the Persian Wars, the Athenians set about liberating the rest of the country. Several city states banded together with Athens to form the Delian (DEL-ee-uhn) League in 478 B.C.E. The league took its name from the Ionian island of Delos, where the group met and stored its money. The states made a contract, and the signatories agreed to follow a common foreign policy and to contribute ships and/or money, as Athens deemed necessary. Athens contributed the most money and commanded the fleet. A systematic liberation

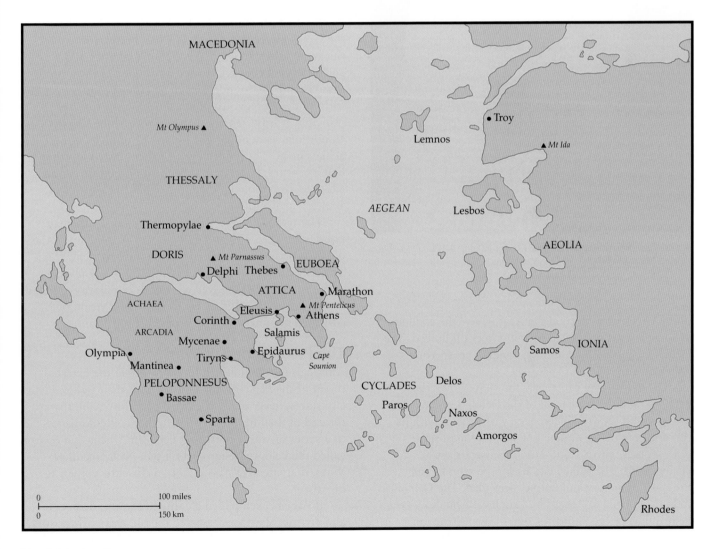

Map 3.1 Ancient Greece.

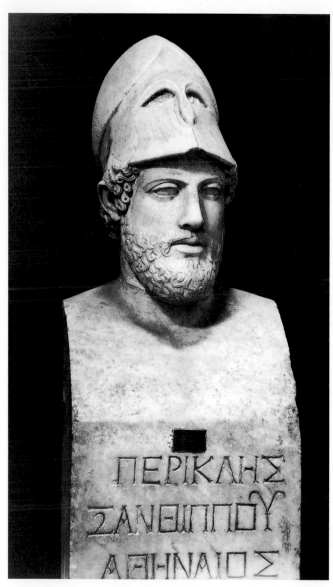

3.3 Kresilas, *Pericles*, Roman copy after original of c. 440 B.C.E. Marble, Vatican Museum, Rome.

of the Greek cities around the Aegean and the conquest of some islands populated by non-Greeks followed. The Delian League became, in fact, a highly prosperous Athenian empire.

The destruction of Athens, the victory over the Persians, and the formation of the Delian League helped to transform the young democracy of Athens, with its thriving commerce, unique religion, and inquisitive philosophies, into a culture of immense artistic achievement. The ruined city had to be rebuilt, and the spirit of victory and heroics prevailed. The Delian treasury, moved to Athens by Pericles (PAIR-ih-kleez), helped finance the immense costs of reconstruction.

Athens had witnessed a succession of rulers, and an interesting form of democracy had gradually emerged.

Historians estimate that when Pericles came to power, in 461 B.C.E., the population of Athens was approximately 230,000 people. About 40,000 of these were free male citizens; 40,000 were Athenian women; 50,000 were foreign born; and 100,000 were slaves. Athenian democracy, however, allowed only free male citizens to vote. The long-believed view that in the golden age of Athens, women, although honored as wives and mothers, had little freedom, has been disputed by some recent historians who claim that, although women were denied the right to vote, they otherwise associated with men as equals.

The tyrant, or ruler, wielded considerable power. This power emanated principally from ownership of land. Private estates provided not only for the tyrant's individual welfare, but also for the horses and arms necessary to make him a leader in warfare. The Greek tyrants seem in general to have been especially benevolent. Not necessarily aristocrats, their claims to leadership often came from their popularity among the citizens.

By the fifth century B.C.E., Athens was the richest of the Greek city-states. Greek law had been reformed by the great Athenian lawmaker Solon, and after 508 B.C.E., constitutional changes created a complex of institutions that became the foundations of an almost pure form of democracy. All political decisions came, in principle at least, from a majority vote of the citizens. Conditions were now right for an age of high cultural achievement. The golden age of Athens lasted less than half a century, but that middle third of the fifth century B.C.E. produced one of the most significant periods in Western civilization.

The tyrant Pericles (Fig. **3.3**) dominated Athenian politics between 450 and 429 B.C.E. A descendant of the old aristocracy, he flourished under the new democracy. The Athenian historian Thucydides (thoo-SID-ih-deez) wrote that Pericles enjoyed enormous popularity and had strong financial integrity. He clearly had a vision of Athenian greatness, and he brought it to fruition.

The Peloponnesian Wars

Although they had joined forces to defeat the external threat of the Persians, the Greeks, with their independent city-states, never really coexisted peacefully, and toward the end of the fifth century B.C.E., that contentiousness led to a series of wars of attrition between Athens and Sparta called the Peloponnesian (pel-oh-pah-NEEZ-ee-uhn) Wars, that effectively brought to a close the golden age of Athens.

If Athens exemplified a cultured society, democratic, and artistic, Sparta represented the old ways of warriors, courage, militarism, and oligarchy (AH-lih-gar-kee). Sparta, ruled by a council of elders, required its males to

live in barracks, as soldiers, until they were thirty years old. In reality, every citizen had to be a soldier, because Sparta's agriculture depended on the labor of subject peoples, who far outnumbered the Spartans. In order to keep the population subdued, Sparta's men had to remain militarily expert. Spartans constituted, in consequence, the best soldiers in all of Greece.

In 404 B.C.E., the Spartans gained victory. Athens and the Athenians were humiliated, losing their navy and being forced to watch their empire collapse. Sparta made Athens tear down the defenses that guarded and connected Athens to its port, and also put Athens under the control of a council of conspirators called the Thirty Tyrants.

Although Sparta achieved political dominance, it did not assume any kind of cultural leadership nor much longlasting influence. Athens regained its freedom almost immediately, and although politically weakened with its role as a political power diminished, it regained intellectual and aesthetic dominance.

The Hellenistic Age

Peace finally came to the Greek peninsula after the Macedonian conquest of the powerful King Philip II, who had seized the throne of Macedon in the middle of the fourth century. He assembled and trained a powerful army, conquered his neighbors, and involved himself in the tangled alliances of the Greeks. In 338 B.C.E., at the battle of Chaeronea, Philip and his army routed the combined army of Athens and Thebes.

Two years later, Philip's own men assassinated him, and his son, Alexander, ascended the throne as king and commander. A pupil of Aristotle, Alexander proved not only an able king and general, but also a man of sophisticated vision. Unlike his father, he was more interested in a world order than in mere conquest and

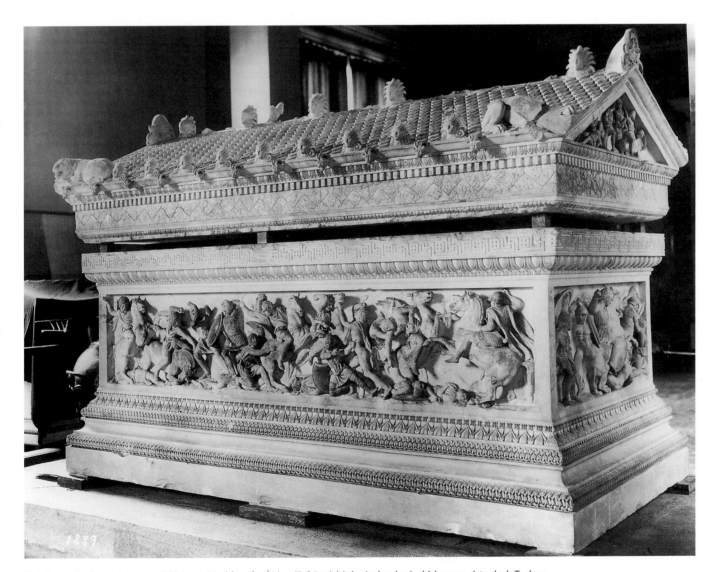

3.4 *Alexander Sarcophagus*, c. 310 B.C.E. Marble, 6ft 4½ ins (1.94 m) high. Archeological Museum, Istanbul, Turkey.

pillage. His rule began with a twelve-year expedition in which he led an army, one quarter of which was Greek, into Asia. The brilliant twenty-two-year-old carried Greek—Athenian—culture further afield than ever before. Alexander then defeated the Persian king, Darius (duh-REE-yuhs) III, at the battle of Issus (IH-suhs). From there, Alexander led his forces against the city of Tyre in Syria, and pressed on to Egypt where, in the delta of the Nile, he founded Alexandria, one of the most influential and important cities in the Hellenistic world. A second defeat of Darius and the subsequent sacking of his capital, Persepolis, resulted in Alexander's installation as successor to the Persian throne. After pushing as far as the River Indus in India, Alexander's army balked, and so, after following the Indus south to the Indian Ocean, Alexander returned across the great desert and ended his odyssey in Babylon. According to legend, when Alexander the Great could find no more worlds to conquer, he sat down and wept. In any case, his destiny fulfilled, Alexander died of a sudden fever in Babylon at the age of thirty-three (Fig. **3.4**). He had married a Persian princess, declared himself a king and a god, and founded twenty-five Greek city-states. Along the way, Alexander's soldiers married native women and established Greek customs, trade, administration, and artistry throughout half of Asia.

The success of Alexander's conquests depended to a great extent on his forceful personality. On his death, the empire began to crumble as regional fragmentation and struggles for power marked the post-Alexandrian or *Hellenistic* world. Nevertheless, the creation of so vast an empire fostered an internationalism of culture that persisted into, and was strengthened under, the Roman Empire. An important aspect of the Hellenistic period, which lasted into the Roman Empire, was *syncretism* (SIN-cruh-TIZ-um)—the fusion of diverse religious beliefs and practices. Commerce flourished, and international communication carried Greek thought and artistic influence to all parts of the known world. Intercultural relationships also blossomed: Buddhist sculpture in India, for example, shows signs of Greek influence, and the European pantheon of gods began to reflect Eastern emotionalism. Athens thus remained an important center for ideas and cultural accomplishments, in spite of the weakness of its commercial and military power.

The source of **Hellenistic** culture was Alexandria, at this time the greatest city in the world and endowed with phenomenal wealth. Legally it was a Greek city "by" not "in" Egypt. Brilliant writers and new literary forms emerged, and the ruling Ptolemies (TAH-loh-meez) patronized science and scholarship. Royal funds paid for many splendid buildings, including an enormous library, which became the focal point of the Hellenistic intellectual world.

TECHNOLOGY

HERO'S STEAM TURBINE

After the death of Alexander the Great, Ptolemy I became ruler of Egypt, proclaimed himself king, and gave himself the name Soter, or Savior. Despite a somewhat exaggerated view of his own importance, Ptolemy established what was essentially a research institute by founding the museum at Alexandria, the library of which was to become the most famous in the world. The museum attracted scholars from around the Hellenistic world to teach and to learn. One of these was Hero, whose tutor, Strato, had been a contemporary of Aristotle at the Lyceum in Athens. Hero compiled a textbook of engineering and invented a number of useful pieces of equipment, including a water clock. From his written account, it is clear that he gave a great deal of thought to maintaining an even flow of water into the mechanism so that it would keep accurate time. His steam turbine (Fig. **3.5**), which depended on the expansion of air and the vaporization of water when heated, could probably have been developed further to provide a useful source of power, but the machine appears to have been regarded merely as an entertaining toy.

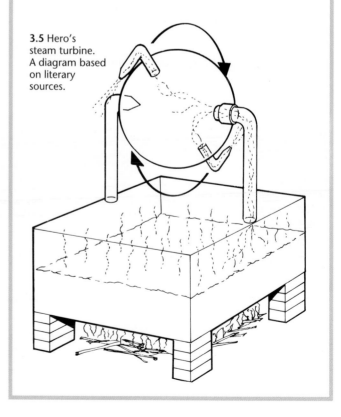

3.5 Hero's steam turbine. A diagram based on literary sources.

Concepts

Historia

The Greek intellect probed the mysteries of this world as well as the more ethereal realms that were the domain of the philosophers. Before the fifth century B.C.E., accounts of the past formed part of an oral tradition, more myth than fact, but at this time, history—the word derives from *historia*, meaning inquiry—became a written form, put together from careful research. The first to view history as a specialized discipline, Herodotus (huh-RAHD-uh-tuhs; c. 484–430 B.C.E.) believed in the superiority of Greek civilization and wrote nine great volumes of a work called *History of the Persian Wars*. The change from telling the narrative story in the form of epic or lyric poetry to relating it in a new descriptive form earned Herodotus the title "Father of History."

Although not an historian in our sense of the word—his writing tends to be filtered through the personalities of the people involved and he often invented inspiring speeches for kings and generals—he retained a neutrality and freedom from patriotic bias. He described the wars in colorful detail, seeking to show how human beings, in this case Greeks and Persians, settled their differences by resorting to arms, and he made full use of his tremendous powers of observation and recorded as much information as he could unearth, including conflicting points of view. He also examined the reliability of his sources and presented them so that his readers could draw their own conclusions about their veracity. However, he did not shy away from drawing his own conclusions about the causes of events. He believed that the present had its causes in the past, and his analysis of the Persian War concluded that the Greeks defeated the Persians because the Greeks were morally right and the Persians were morally wrong. The moral fault in the Persians lay in their **hubris** (HYOO-bris), or excessive pride and ambition. Herodotus' judgment also had a religious undertone, for he believed that the gods supported justice and truth and would ensure their victory. (We will discuss *History of the Persian Wars* further in the Literature section at the end of this chapter.)

Thucydides (thoo-SID-i-deez; d. c. 401 B.C.E.), who wrote a history of the Peloponnesian Wars, took history in a more subtle and thoughtful direction. He shared Herodotus' passion for the truth, and, although he had been an Athenian commander in the war, he dispassionately lists the foibles, follies, and errors made by the Athenians. Although it should be borne in mind that Thucydides was exiled from Athens for his failure as a naval commander early in the contest, his writing does not include self-justification. Rather, it reveals an unbiased compilation that strives to show human motives in ordinary events in order to draw a larger picture of history. He sought to instruct his readers so that they would be armed with knowledge when events of the past recurred—not in simplistic but in similar ways—in the future. (We will discuss *History of the Peloponnesian Wars* further in the Literature section at the end of this chapter.)

Greek intellects also turned to science and the natural world. Although they often erred in their observations, they also gave us many of our basic theories. Euclid's elements of geometry, for example, remained a standard text well into the twentieth century, and physicians still begin their careers by reciting the "oath" of the Greek physician Hippocrates (hip-AH-kruh-teez). Greek astronomers recognized that the earth was a sphere, and they even calculated its size and distance from the sun and moon through mathematics and trigonometry.

Sophistry

The middle of the fifth century B.C.E. marked the end of a cycle of constructive activity and the beginning of a period of criticism and skepticism. The attention turned toward humanity and ethics in a practical way. The rise of Sophistic philosophy demonstrated the contemporary concern of humankind, thinking in a relativistic way, challenging the existence of truth. All established beliefs and standards, whether religious, moral, or scientific, came under fire. Reason, the sophists argued, had led only to deception.

Skepticism emerged in an Athens torn by disputes and ruled by a form of democracy that depended on persuasion and practicality. Debating skills thus formed an absolute necessity, and these conditions produced teachers of rhetoric. Those who championed this new utilitarian art of persuasion, called Sophists, or "wise ones," advocated rhetoric, grammar, diction, and logical argument, as well as behind-the-scenes intrigue. They set up schools and charged high fees for their services—a most unethical act, according to traditional Greek thinking.

The outstanding Sophist, Protagoras (pro-TAG-uh-ruhs; c. 485–410 B.C.E.), reduced the entire mental life of the individual to perceptions, as expressed in his contention "Man is the measure of all things." According to Protagoras, knowledge, truth, and reality possess only a subjective existence—they are only opinions in each person's mind. No objective facts or real truths apply to all people. What seems true for one individual is true for that individual alone. Inasmuch as objectivity cannot be achieved, people must be content with subjective knowledge or mere opinion.

Protagoras based his conclusion that truth was relative on the observation that human knowledge of the *phenomenal* world (the world we sense) stays imperfect because human senses are imperfect. Further, Protagoras

maintained, even if human sense equipment were perfect, it would still be inadequate for accurately perceiving real objects. Therefore, humans can obtain only a partial knowledge based on partial experience, which is different for every human.

In his treatise *On the Gods*, Protagoras indicates that one "cannot feel sure that they [the gods] are, or that they are not, nor what they are like in figure, for there are many things that hinder sure knowledge, the obscurity of the subject and the shortness of human life." He then amplifies this religious doubt into a denial of any absolute truths at all. The individual person remains "the measure of all things, of things that are that they are, and of things that are not that they are not." Truth is therefore relative and subjective. What appears true to any given person at any given moment is true, and what appears as real is real so far as any one person is concerned. But one such truth cannot be measured against another.

Stoicism and Epicureanism

Stoicism, founded by Zeno (ZEEN-oh, c. 495–430 B.C.E.), held that humans were the incarnation of reason or *logos* (LOH-gohs), which produces and directs the world and gave a spark to the individual soul in the form of rationality. They defined the good life as that which follows reason, wisdom, and virtue, but the only way to achieve these goals lay through renunciation and asceticism. The Stoic tended to leave everything to God and to accept whatever came his way. Once one achieved this state of mind, one could disregard public opinion, misfortune, and even death: thus, one approached life with apathy. Stoicism maintained that happiness was the ultimate goal of the individual. It also stressed the importance of the senses in perceiving underlying moral law and the divine plan for the world. In the end, the Stoics perceived an ideal state, guided by *logos* and law, that included all humanity regardless of race, sex, nationality, or social standing. Stoicism proved a popular philosophy, especially among intellectuals and political leaders. Essentially Stoicism took an optimistic viewpoint that stood in strong contrast to the pessimism of the other philosophies of the time.

Epicurus (c. 342–270 B.C.E.) led Epicureans to a life of strict quietude. They concluded that human beings consisted of a temporary arrangement of atoms that dissolved at death. Because everything was temporary, the good life was simply an untroubled one. Wisdom dictated that one should avoid entanglements, maintain good health, tolerate pain, and accept death without fear. Epicurus founded a school in Athens, and his pupils, including women and slaves, gathered to discuss ideas. Epicureans believed that the senses could be relied upon to give an accurate picture of reality and that the mind functioned as a storehouse for those observations. Free will allowed humans to reach moral conclusions based on ethical constructs.

Cynicism and Skepticism

In the Hellenistic period four schools of thought vied for philosophical supremacy: Cynicism, Skepticism, Stoicism, and Epicureanism (ehp-i-kyoo-REE-uhn-izm). Led by Diogenes (dy-AH-jen-eez; c. 412–323 B.C.E.), the Cynics taught that humans are animals and that the good life lay simply in satisfying their animal needs. Since those needs can be troublesome, however, a wise person will have as few needs as possible but will disregard any social conventions that stand in the way of his own satisfaction. In other words, if a person wanted nothing, then he could lack nothing. The Cynics had little use for society as an organizing principle, believing that it stood in the way of individual freedom and independence, and they therefore isolated themselves as much as possible from society. Needless to say, Cynicism had little appeal either to the masses or the aristocracy.

Followers of Pyrrho (PEER-oh) of Elis, the Skeptics, asserted that nothing was certain and that the senses were completely unreliable as sources of knowledge. Ultimately, the only certainty was that truth was unachievable. They questioned everything and admitted the truth of nothing. For the Skeptic, everything was relative. Universal doubt ruled their world. Less popular, even, than Cynicism, Skepticism did make inroads in later times, particularly during the Roman era.

Mystery Cults

Hellenistic times were uncertain times, and human confidence in the ability to control anything waned. At such times, people tend to develop a belief that fate will do whatever fate will do and to adopt pietistic religious beliefs—beliefs in which emotionalism takes the place of intellectualism or rationalism. In the Hellenistic world, a variety of mystery cults emerged from the East and from Egypt. The cult of Dionysus, god of revelry and wine, was particularly appealing in Greece proper. To unite Egyptians and Greeks, Ptolemy I, founder of the Alexandrian Museum, invented a new god, Serapis (suh-RAY-pis), who became popular throughout the Hellenistic world. The cult of Isis proved another powerful mystery cult that spread throughout the Mediterranean world and, later, became one of the most antagonistic forces met by the early Christians. Originating in Egypt in the eighteenth century B.C.E., Isis, a nature goddess, became the prototype for all goddesses. In Egyptian mythology she was the faithful wife and sister of Osiris and mother of Horus. After Osiris was slain by their brother, Set, and his body scattered in pieces, Isis gathered the pieces together;

Osiris was then restored and became ruler of the dead. The legend symbolized the sun (Osiris) overwhelmed by night (Set), followed by the birth of the sun of a new day (Horus) from the eastern sky (Isis). Thus, as a religion, the cult of Isis emphasized resurrection after death: one of the characteristics that later put it into direct conflict with Christianity. Isis was universal mother and mistress of all magic, and her cult prevailed until the middle of the sixth century C.E. Probably, the appeal of the mystery cults lay in their mystery—in secret initiation rites that gave the member a special status and, thus, satisfied a universal need to belong.

Ethics

At the beginning of this book, in the section entitled "Putting the Arts in Context," we discussed aesthetic communication. In that discussion we noted the terms ethics and aesthetics as two of the five classical fields of philosophical inquiry. We defined ethics as the general nature of morals and of the specific moral choices to be made by the individual in relationship with others. We defined aesthetics as the study of the nature of beauty and of art. We now examine these concepts in more detail in the light of the lives and thoughts of the three men who gave them life in the tradition of Western thought: Socrates (SAH-kruh-teez), Plato (PLAY-toh), and Aristotle (AIR-ih-stah-tuhl). We begin with ethics and Socrates.

Socrates (c. 470–399 B.C.E.), the father of ethics and initiator of the Socratic method, called himself the "gadfly" of Athens. He did not hesitate to condemn the Sophists for their lack of belief in a universal moral and intellectual order, but he also opposed many of the traditional values of Athens. He called on Athenians to examine their own lives and to think seriously about the real meaning of life. Sitting in the agora, or marketplace, he questioned everyone who passed by about subjects ranging from justice to art. He had no qualms about cornering a judge and asking him to explain justice, or in forcing an artist to define art, and passionately defended the right of individuals—including himself—to speak freely. He gathered around him young people, challenging them to examine their lives, and discussing with them how society should be organized and how life should be lived. For Socrates, the unexamined life was not worth living.

At the center of Socrates' thinking lay the *psyche*: the mind or soul. This, he believed, was immortal and much more important than the body, which perished. Every individual had the responsibility to raise his or her psyche to its highest potential—to fill it with knowledge acquired through rigorous debate and contemplation of abstract virtues and moral values.

He believed that knowledge created virtuous behavior, and that those who did evil did so because they did not have knowledge—evil-doing clearly evidenced lack of knowledge.

As Plato reveals in his *dialogues*, Socrates' method involved questioning his students, and an inability to answer revealed the deficiency of their learning. His rigor particularly upset the elders of Athens who, in the years following the Peloponnesian Wars, believed Socrates a disruptive element in society, and many found evidence of blasphemy and even treason in his public arguments. In 399 B.C.E., they arrested Socrates for impiety and corrupting youth. He was tried by a jury, found guilty, and sentenced to death by drinking a cup of poisonous hemlock.

One of his mourners, a young man named Plato, was so moved by the apparent injustice of Socrates' death that he dedicated his life to immortalizing his teacher and explaining his philosophy.

Aesthetics
Plato
Born in Athens in 427 B.C.E., two years after the death of Pericles, Plato grew up during the years of the Peloponnesian Wars, which brought an end to the Athenian Empire. His family belonged to the old Athenian aristocracy, but it escaped the financial ruin that befell many Athenian aristocrats, and managed to give him a good education. He emerged a thoroughly well-rounded individual, a good athlete, with experience of painting, poetry, music, literature, and drama. He received military training and fought in the wars. Although well suited and well connected enough for a career in politics, Plato turned instead to philosophy and fell more and more under the influence of the teacher Socrates.

Plato's masterwork, *The Republic*, a series of dialogues involving Socrates, lays out Plato's concept of an ideal political state ruled one day by *philosopher kings*. His Theory of Forms, or Ideas, held that the material reality we humans perceive constitutes only a shoddy copy of an unconditionally perfect reality that mere mortals can never know through sensory experience.

After Socrates' execution for "corrupting Athenian youth," Plato concentrated entirely on philosophy. Anti-Socratic feeling ran high in Athens, and for ten years Plato found it expedient to live outside the city, writing many of the early dialogues during this period. Much of his aesthetic theory can be found in these dialogues, which follow Socrates' customary question-and-answer format.

Plato invented **aesthetics** as a branch of philosophy, and Western thought has been profoundly influenced by

his metaphysical approach to the philosophy of art. We find in Plato's dialogues a clear, though not very systematic, theory of art and beauty.

For Plato, art derived primarily from the skill of knowing and making, or *techne* (TEK-nay). Techne comprised the ability of an artist to command a medium, to know what the end result would be, and to know how to execute the artwork to achieve that result. The fundamental principles of techne were measurement and proportion. Standards of taste—what is good and what is beautiful—could not be considered unless the work had correct proportion and measure.

Plato's theory of beauty and the creation of beauty, or art, rests on his concept of imitation. According to Plato, the artist imitates the Ideal that exists beyond the universe. Indeed, the universe itself is only an imitation of Ideas, or unchanging Forms. This point, crucial to all Platonic thought, remains a challenging one. To simplify a complex notion, Ideas, or Forms, are reality. Everything on earth imitates reality. Ideas are thus not thoughts conceived by an individual human mind (or a divine one). Forms are rather the objects of thought. They exist independently, no matter whether, or what, we think of them.

The arts are practiced to create imitations of Forms. Plato mistrusted the arts, and especially drama, however, because the individual artist may fail to understand the ultimate reality, and may instead present merely an "appearance of perceivable nature." Therefore, art must be judged by the statesman, who "envisages the human community according to the Ideas of justice, the good, courage, temperance, and the beautiful."[1] In the end, proper art depends upon the "moral ends of the polis."

In addition to possessing technical ability and the ability to know and imitate Ideas, the artist must have a third quality, artistic inspiration. No one can ascend to the highest levels of artistry without divine inspiration and assistance. Plato calls artistry a form of "divine madness."

Aristotle

Born in 384 B.C.E., Aristotle (Fig. **3.6**) did not have Plato's advantages of birth. His family was middle-class, and his father was court physician to Amyntas of Macedon, grandfather of Alexander the Great. Aristotle, orphaned when he was quite young, gained a home and his education through the generosity of a family friend. When eighteen years old he became a student at Plato's Academy, where his affectations and self-absorption caused some trouble with the school's authorities. After Plato's death, Aristotle left the Academy and married. Around 343 B.C.E., he gained a favorable position as tutor to Alexander the Great. Aristotle sought to teach

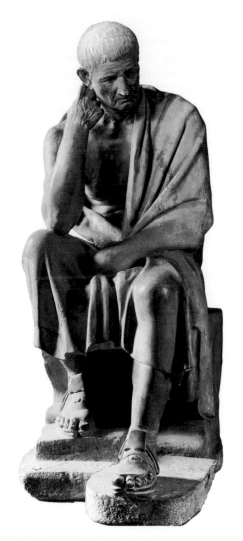

3.6 Aristotle (384–322 B.C.E.).

Alexander to revere all things Greek and despise anything barbarian (non-Greek).

When Alexander acceded to the throne in 336 B.C.E., Aristotle returned to Athens to set up his own school, the Lyceum (ly-SEE-uhm). Over the next twelve years he produced a prolific outpouring of writings as well as research in physics, astronomy, biology, physiology, anatomy, natural history, psychology, politics, ethics, logic, rhetoric, art, theology, and metaphysics. Aristotle's "is probably the only human intellect that has ever compassed at first hand and assimilated the whole body of existing knowledge on all subjects, and brought it within a single focus."[2]

Aristotle's writings on nature make him the world's first real scientist, although many of his conclusions have been superseded. In contrast to Plato, Aristotle believed that the material world is real and not a creation of eternal Forms. He taught that individual things combine form and matter in ways that determine

how they grow and change. He was also the founder of formal logic.

Aristotle's major aesthetic work, the *Poetics*, maintains that all the arts imitate nature, and that imitative character roots in human psychology. For Aristotle, the end of artistic creation determines the appropriate means for its realization. In order to assess the excellence of a work, we must determine whether the work has a perfection of form and a soundness of method that make it a satisfactory whole. The elements of composition must display symmetry, harmony, and definition, which we recognize as fundamentals of **classicism**.

Aristotle's theory differs considerably from Plato's. Plato insists that artistic imitation, especially tragedy, fuels the passions and misleads the seeker of truth. Aristotle, by contrast, believes that the arts repair deficiencies in nature and that tragic drama in particular makes a moral contribution. Therefore the arts are valuable and justifiable. Aristotle rejects Plato's notion of the centrality of beauty and erotic love, as well as his metaphysical idealism. He sees beauty as a property of an artwork rather than its purpose, whereas for Plato the search for beauty constitutes the proper end of art. He does agree with Plato "that art is a kind of *techne*, and that the most important human arts, such as music, painting, sculpture, and literature are imitative of human souls, bodies, and actions."[3]

The purpose of art, however, is not edification, nor the teaching of a moral lesson. The purpose of art is to give pleasure, and to the degree that it does that, it is good art. The pleasure Aristotle refers to comes when art excites our emotions and passions. These are then purged in response to the art and our souls lighten, delighted and healed. High art makes us think, of course, but the highest art must produce this **catharsis** (kuh-THAR-sis), or purging effect.

Art can also provide entertainment for the lower classes, who, he maintains, are incapable of appreciating high art properly. It is better that they enjoy some kind of art than none at all, and they are entitled to this pleasure. Thus, Aristotle's aesthetics encompassed both the higher and the lower arts. (We will read from the *Poetics* in the Literature section at the end of this chapter.)

Classicism and Hellenism

In a definitional sense, classicism is an artistic **style** and cultural perspective based on principles associated with the art and thought of ancient Greece and Rome. Specifically, this means a striving for harmony, order, reason, intellect, objectivity, and formal discipline. It contrasts with, for example, Romanticism (see Chapter 14) and other "anti-classical" styles and directions—for example the **baroque** and **rococo** (see Chapter 12)—that

emphasize bravura technique, imagination, emotion, and free expression. Artworks in the **classical** style represent idealized perfection rather than real life—for example, Myron's *Discus Thrower* (see Fig. **3.11**). As we will see, that represents an embodiment of an ideal of beauty, sculpted according to the aesthetic principles of proportion, balance, and unity of form. Classicism also constitutes an ideological viewpoint that reflects the idea of ancient Greece as the fount of civilization, later to be expanded to view Western European culture as its ultimate fulfillment.

Hellenism, which arguably could be defined as "anti-classical," moves away from classical principles and toward reflections of emotion and naturalistic depiction. We will find this especially true of the sculpture of the Hellenistic period.

THE ARTS OF THE CLASSICAL AND HELLENISTIC AGES
Painting

Fifth-century Athenian vase painting reflects some characteristics of earlier work, including the principally geometric nature of design. What distinguishes the classical style (*c.* 480–*c.* 335 B.C.E.) in vase painting (our only visual evidence of Greek two-dimensional art of this period) from earlier styles such as the archaic, is a new sense of **idealization** in figure depiction, which reflects a technical advance as well as a change in attitude (classicism). Many of the problems of foreshortening (the contracting of lines to produce an illusion of projection in space) had been solved. As a result, figures have a new sense of depth. The illusion could be strengthened in some cases by the use of light and shadow. Records imply that mural painters of this period were extremely skilled in representation, but we have no surviving examples to study. Vase painting does demonstrate, however, artists' concern for formal design—logic and balance in the organization of space.

In the fifth century B.C.E., many of the most talented artists engaged in sculpture, mural painting, and architecture. Nonetheless, vase painters such as the Achilles painter continued to express the idealism and dignity of the classical style. In Figure **3.7** the portrayal of the feet in the frontal position is significant, reflecting the new skill of foreshortening.

By the end of the fifth century B.C.E., vase painters had begun to break with the convention of putting all the figures along the base line: They sometimes suggested spatial depth by placing some figures higher than others.

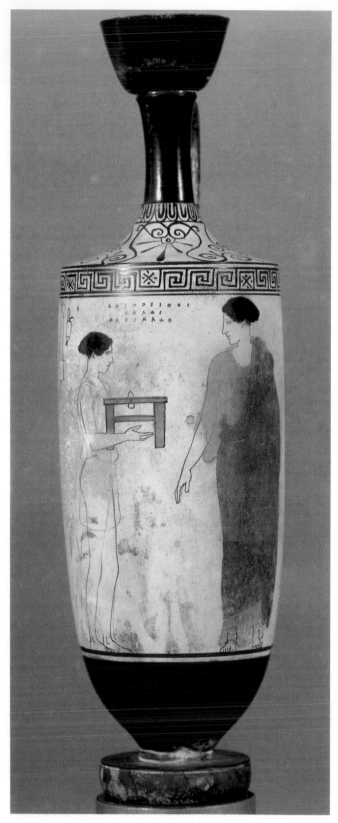

3.7 The Achilles painter, white ground lekythos from Gela, showing a woman and her maid, 440 B.C.E. 15⅛ ins (38.4 cm) high. Museum of Fine Arts, Boston (Francis Bartlett Donation of 1912).

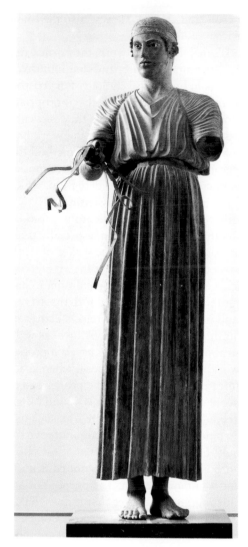

3.8 *Charioteer*, from the Sanctuary of Apollo, Delphi, c. 478 or 474 B.C.E. Bronze, lifesize. Archeological Museum, Delphi, Greece.

But not until the end of the next century did they completely abandon this convention.

In general, we can identify four characteristics that define the classical style in vase painting: (1) portrayal of figures in simple line drawings; (2) monochromatic **palette** or color scheme—for example, red on black or black on red; (3) palette dependent on earthen tones—for example, red; and (4) heroic and idealized subject matter.

Sculpture

Classical Style

Styles do not start on a given date and end on another, even in Athens during the rule of Pericles. Although much of what we can surmise about Greek classical sculpture actually comes from copies made at a later time, we know that the Greek classical style, especially in sculpture,

continually changed. One artist's works differ from another's even though, in general, they reflect the basic characteristics of classicism. In classical sculpture, the tenets of Greek philosophy reflect in the idealized, vigorous, youthful bodies that exhibit rational self-control and physical perfection.

From early in the fifth century B.C.E., we find an example of bronze sculpture representative of the new, developing classical style. The *Charioteer* from Delphi (Fig. **3.8**) records a victory in the games of 478 or 474 B.C.E. The figure shows elegant idealization, with subtle variation in the sleeves and drapery folds. The balance departs from **absolute symmetry**: the weight shifts slightly to one leg, and the head turns gently away from the center line. The excellent preservation of this statue allows full appreciation of the relaxed control of the sculptor. This figure once stood atop an altar. He has a

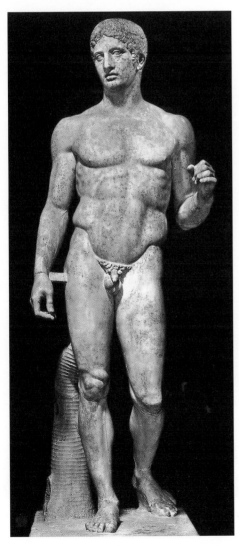

3.9 Polyclitus, *Lance Bearer* (*Doryphorus*), Roman copy after a bronze original of c. 450–440 B.C.E. Marble, 6 ft 6 ins (1.98 m) high. Museo Archeologico Nazionale, Naples, Italy.

A DYNAMIC WORLD

THE NOK STYLE OF AFRICA

For thousands of years, African artists and craftsmen have created objects of sophisticated vision and masterful technique. While the Greeks produced classical sculpture, on the Jos plateau of northern Nigeria, the Noks, a nonliterate culture of farmers, entered the Iron Age and developed their own accomplished artistic style. Working in terracotta, these artists produced boldly designed sculptures (Fig. **3.10**). Although they are stylized—with flattened noses and segmented lower eyelids, for example—each work reveals individualized character. Curiously, the unusual combination of human individuality and artistic stylization makes the works powerfully appealing. Probably, these heads are portraits of ancestors of the ruling class, because the technique and medium of execution seem to have been chosen to ensure permanence and for magical rather than artistic reasons.

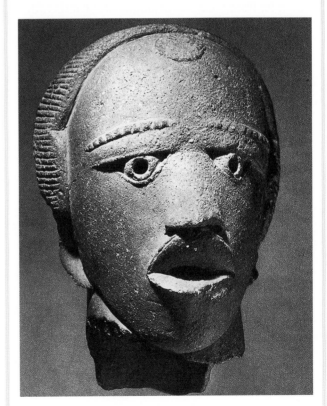

3.10 Head from Jemaa, c. 400 B.C.E. Terracotta, 10 ins (25 cm) high. National Museum, Lagos, Nigeria.

MASTERWORK

Myron—Discus Thrower

Myron's *Discus Thrower* (or *Discobolus;* Fig. 3.11), exemplifies the classical concern for restraint in its subdued vitality and subtle suggestion of movement coupled with balance. But it also expresses the sculptor's interest in the flesh of the idealized human form. This example of the *Discus Thrower* is, unfortunately, a much later marble copy. Myron cast his original in bronze, a medium that allowed more flexibility of pose than marble. A statue, as opposed to a relief sculpture, must stand on its own, and supporting the weight of the marble on a small area, such as one ankle, poses a significant structural problem. Metal has greater tensile strength (the ability to withstand twisting and bending), and thus this problem does not arise.

In *Discovery of the Mind: The Greek Origins of European Thought*, Bruno Snell writes: "If we want to describe the statues of the fifth century in the words of their age, we should say that they represent beautiful or perfect men, or, to use a phrase employed in the early lyrics for purposes of eulogy: 'god-like' men. Even for Plato the norm of judgment still rests with the gods, and not with men."[4] Even though Greek statuary may take the form of portraiture, the features remain idealized. Human beings may be the measure of all things, but in art the individual rises above human reality to the state of perfection found only in the gods.

Myron's representation of this young athlete contributes a sense of dynamism to Greek sculpture. Here Myron tackles a vexing problem for the sculptor: how to condense a series of movements into a single pose without making the sculpture appear static or frozen. His solution dramatically intersects two opposing arcs: one created by the downward sweep of the arms and shoulders, the other by the forward thrust of the thighs, torso, and head.

As is typical of Greek freestanding statues, Myron designed the *Discus Thrower* to be seen from one direction only. It represents thus a sort of freestanding, three-dimensional "super-relief." The beginnings of classical style represented by celebration of the powerful nude male figure grew from what we call the "severe style." Myron was trained in this style, and the suggestions of moral idealism, dignity, and self-control in the statue represent qualities inherent in classicism. However, the *Discus Thrower* marks a step forward, in

its increasing vitality of figure movement, a process we can trace from the frozen pose of the archaic kouros (see Fig. **2.12**), through the counterpoised balance of the *Kritios Boy* (see Fig. **2.15**), to Myron. Warm, full, and dynamic, Myron's human form achieves a new level of expressiveness and power, fully controlled and free of the unbridled emotion of later sculpture. For Myron, balanced composition remains the focus of the work, and form takes precedence over feeling.

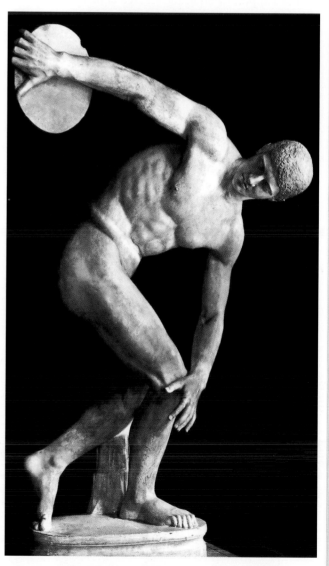

3.11 Myron, *Discus Thrower* (*Discobolus*), c. 450 B.C.E. Roman marble copy after a bronze original, lifesize. Museo Nazionale Romano, Rome.

stern look on his face, as do typical images of Greek classicism, as an expression of rational self-control.

However, the age of Greek classical style properly began with the sculptors Myron (MY-ruhn) and Polyclitus (pah-luh-KLY-tuhs) in the middle of the fifth century B.C.E. Both contributed to the development of cast metal sculpture. (The examples in Figures **3.9** and **3.11** comprise marble copies of bronze originals.) In his *Lance Bearer* (*Doryphorus*; Fig. **3.9**), Polyclitus sought the ideal proportions for a male athlete: the *Lance Bearer* thus represents *the* male athlete, not *a* male athlete. The body's weight shifts onto one leg in the *contrapposto* (cahn-truh-POHS-toh) stance. The resulting sense of relaxation, controlled motion, and subtle play of curves stands in contrast to the rigidity of the archaic style we witnessed in Chapter 2.

Polyclitus developed a set of rules for constructing the ideal human figure that he laid out in his treatise *The Canon* (*kanon* is the Greek word for "rule" or "law"). Probably, it was based on the ratios between some basic unit and the length of some body part or parts. Myron's best-known work is the *Discus Thrower* (see Masterwork).

The east pediment of the Parthenon once contained marvelous sculptural elements (Fig. **3.12**). The group of *Three Goddesses*, or *Fates*, now rests on display in the British Museum in London. (This group of sculptures is known as the "Elgin Marbles" [EL-ghin] after Lord Elgin, who removed them from the Parthenon between 1801 and 1803 and took them to London. British possession of these treasures is a continuing controversy between

Britain and Greece.) Originally, this group formed part of the architectural decoration high on the Parthenon. There, its diagonal curvilinearity would have offset the straight lines, and strong verticals and horizontals, of the temple. The scene depicted on this pediment illustrated the myth of the birth of Athena, patron goddess of Athens, from her father Zeus' head.

We can learn much from these battered but superb figures. Their brilliant arrangement within the geometric confines of the triangular pediment encloses curving lines that flow rhythmically through the reclining figures, leading the eyes naturally from one part to the next. The sophisticated treatment of the draperies of the female figures not only reinforces the simple lines of the whole but also reveals the perfected human female form beneath. These, and the Dionysus, rise beyond the merely specific and human, to the level of **symbols**, appropriate to their intended position on a temple.

Perhaps the most impressive sculptural finds of recent years are the two statues discovered in 1972 in the seabed off the coast of Riace, in southern Italy. Figure **3.13** shows one of these masterpieces, called the *Riace* (ree-AH-chay) *Warriors*. The statue has been restored, but it shows the bone and glass eyes, silver teeth, and copper lips and nipples that would have adorned many ancient Greek bronzes. The simplicity with which the imposing musculature emerges, and the confident handling of the **contrapposto**, mark the work of a great sculptor of the mid-fifth century B.C.E. Some scholars even claim that the statues can be identified as part of a set of thirteen

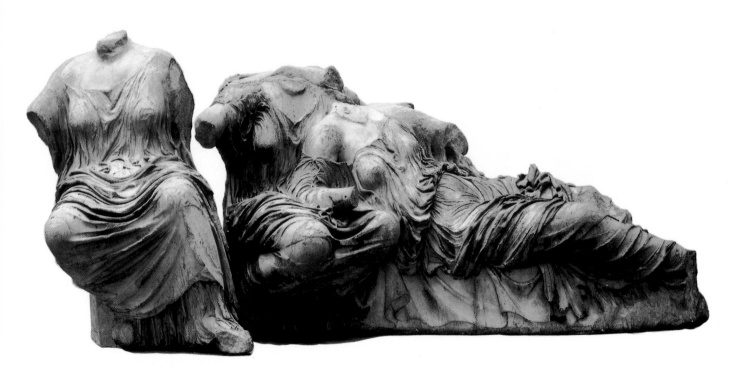

3.12 The *Fates*, from the east pediment of the Parthenon, c. 438–432 B.C.E. Marble, over lifesize. British Museum, London.

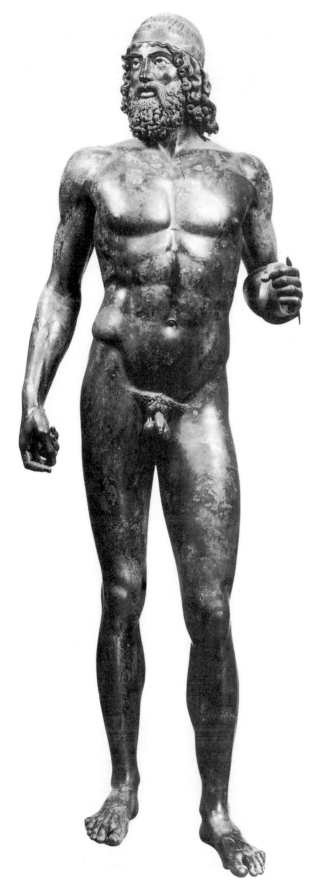

3.13 Phidias(?), *Riace Warrior*, fifth century B.C.E. Bronze with bone, glass-paste, silver, and copper inlaid. 6 ft 6⅓ ins (2 m) high. Museo Nazionale, Reggio Calabria, Italy.

3.14 Praxiteles, *Cnidian Aphrodite*, probably Hellenistic copy of fourth-century B.C.E. original. Marble, 5 ft ½ in (1.54 m) high. Metropolitan Museum of Art, New York (Fletcher Fund, 1952).

sculpted by Phidias (FID-ee-uhs), dedicated to the Athenian victory at Marathon in 490 B.C.E. They were probably shipwrecked around the first century B.C.E., on their way to Rome, having been plundered from Greece.

Late Classical Style

Sculpture of the fourth century B.C.E. changes toward greater emphasis on emotion. Praxiteles (prak-SIT-uh-leez) gained fame for the individuality, delicacy, elegance, and grace in his treatment of subjects, such as the *Cnidian Aphrodite* (NY-dee-uhn af-roh-DY-tee; Fig. **3.14**). (Note that this is again a copy; the original has never been found.) His work looks inward in a way that differs from the formal detachment of earlier sculptors. Originally, Aphrodite rested her weight on one foot: her body sways

3.15 Followers of Praxiteles, *Hermes and the Infant Dionysus*, probably a Roman copy after an original of c. 300–250 B.C.E. Marble with remnants of red paint on the lips and hair, 7 ft 1 in. (2.16 m) high. Archeological Museum, Olympia. Discovered in the rubble of the ruined Temple of Hera at Olympia in 1875, this statue is now widely accepted as a very good Roman copy.

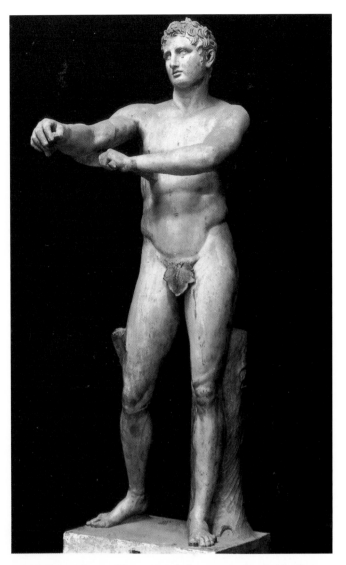

3.16 Lysippus, *Scraper* (*Apoxyomenos*), Roman copy, probably after a bronze original of c. 330 B.C.E. Marble, 6 ft 9 ins (2.06 m) high. Vatican Museum, Rome.

to the left in the famous Praxitelean S-curve. The sculptor minimized strain on the ankle of the sculpture by the attachment of the arm to drapery and a vase.

The elegance of the work of Praxiteles and his followers can also be seen in the *Hermes and the Infant Dionysus* (Fig. **3.15**). Although probably a copy, it nonetheless exhibits fine subtlety of modeling, detailed individuality, and sensuous beauty. The image stands, non-heroic, and the form, feminine.

From the late fourth century, the sculpture of Lysippus (ly-SIP-uhs), a favorite of Alexander the Great, displays a dignified naturalness and a new concept of space. His *Scraper* (Fig. **3.16**) illustrates an attempt to depict the figure in motion, in contrast to many of the poses we have seen previously. The *Scraper* treats a mundane subject—an athlete scraping dirt and oil from

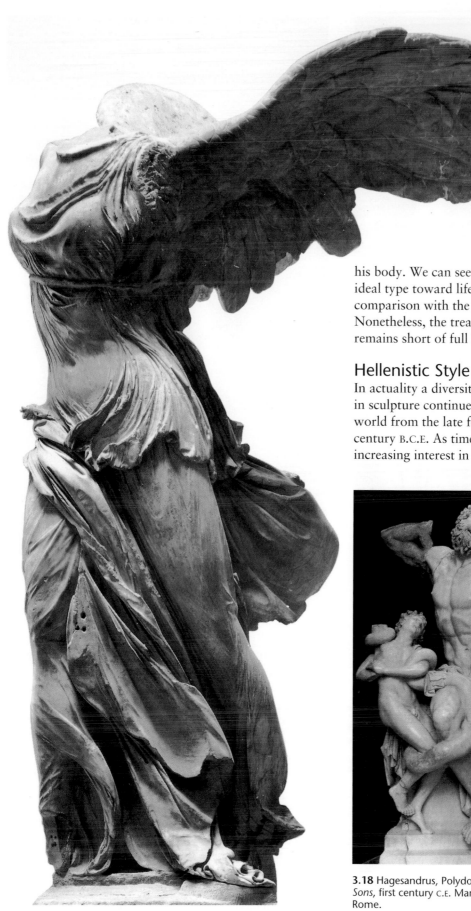

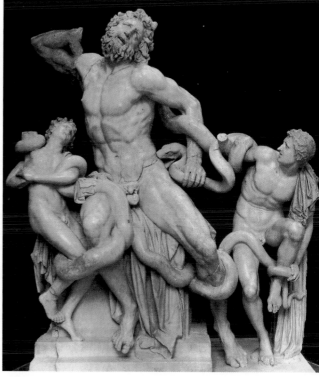

3.17 *Nike of Samothrace (Winged Victory)*, c. 190 B.C.E. Marble, 8 ft (2.44 m) high. Louvre, Paris.

his body. We can see how progress from a classically ideal type toward lifelikeness has progressed here in comparison with the works of Polyclitus (see Fig. **3.19**). Nonetheless, the treatment of the human form still remains short of full lifelikeness.

Hellenistic Style

In actuality a diversity of approaches, the Hellenistic style in sculpture continued to dominate the Mediterranean world from the late fourth century B.C.E. until the first century B.C.E. As time progressed, it began to reflect an increasing interest in the differences between individual

3.18 Hagesandrus, Polydorus, and Athenodorus, *Laocoön and his Two Sons*, first century C.E. Marble, 8 ft (2.44 m) high. Vatican Museum, Rome.

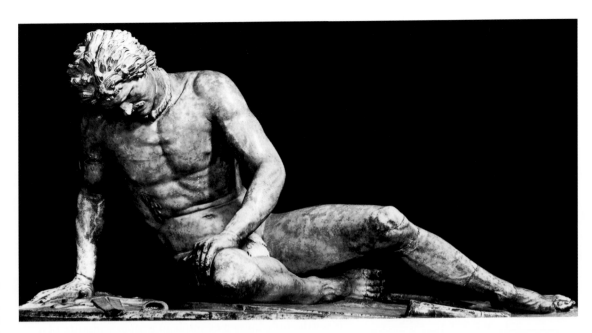

3.19 *Dying Gaul*, Roman copy of a bronze original of c. 230–220 B.C.E. Marble, lifesize. Museo Capitolino, Rome.

humans. Hellenistic sculptors turned away from idealization, often toward **pathos**, trivia, even banality, or flights of technical virtuosity. These characteristics appear in Figures **3.17**, **3.18** and **3.19**. The *Dying Gaul* (Fig. **3.19**), a powerful expression of emotion and pathos and a Roman copy of a statue from Pergamon, places the figure on a stage, as if acting out a drama. The noble warrior, a Gallic casualty in the war between Pergamon and barbarian invaders, slowly bleeds to death from a chest wound.

The *Nike of Samothrace* (NYK-ee; sam-oh-THRAYS), or *Winged Victory* (Fig. **3.17**), displays a dramatic virtuosity of technique. As the symbol of the victory of one of Alexander's successors, she is strong, heavy, and yet amazingly agile and graceful. The unsupported wings and flying garments represent an achievement one does not expect to find in a carved work of marble. The sculptor has treated stone with an almost painterly technique, creating highlights and shadows that intensify the dramatic swirl of the draperies. As a result, we sense the reality of the wind and sea into which she once faced.

The frequent Hellenistic theme of suffering receives violent treatment in the *Laocoön* (lay-AH-koh-ahn) group (Fig. **3.18**), attributed to three sculptors from the first century C.E., Hagesandrus (hag-uh-SAN-druhs), Polydorus (pah-lih-DOHR-uhs), and Athenodorus (ah-thehn-uh-DOHR-uhs). The Trojan priest Laocoön and his sons fight the strangling grip of sea serpents. According to Greek myth, this was Laocoön's punishment for defying Poseidon, god of the sea, by warning the Trojans of the Greek trick of the Trojan horse, in which soldiers were concealed. The expression of emotion flies almost unrestrained. The figures writhe

before our eyes, their straining muscles and bulging veins indicating mortal agony.

Architecture

Existing examples of Greek architecture offer a clear and consistent picture of the basic classical style, and nothing brings that picture so clearly to mind as the Greek temple. H.W. Janson makes an interesting point in *A Basic History of Art* when he suggests that the crystallization of the characteristics of a Greek temple is so complete that when we think of one Greek temple, we think of all Greek temples. Even so familiar a structure as a Gothic cathedral does not quite do this, because, despite the consistent form of the Gothic arch, it has such diverse applications that no one work can typify the many.

The classical Greek temple has a structure consisting of horizontal blocks of stone laid across vertical columns. This is called "post-and-lintel" structure. Not unique to Greece, the Greeks refined it to its highest aesthetic level. Structures of this type have some very basic problems. Stone has no great **tensile strength**, although it is high in **compressive strength** (the ability to withstand crushing). Downward thrust works against the tensile qualities of horizontal slabs (lintels) but for the compressive qualities of the vertical columns (posts). As a result, columns can be relatively delicate, whereas lintels must be massive.

This structural system allows for only limited open interior space. This posed no great problem for the Greeks, because they built their temples to be seen and used from the outside. The Greek climate does not drive worshippers inside a building. Thus, exterior structure and aesthetics remained the primary concern.

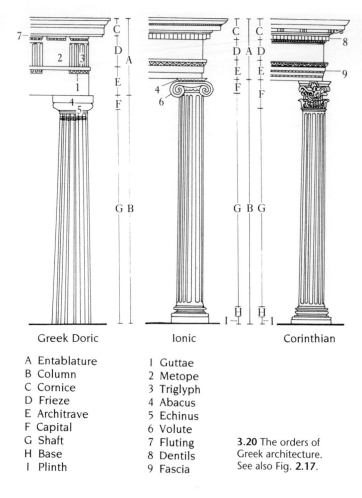

Greek Doric Ionic Corinthian

A Entablature
B Column
C Cornice
D Frieze
E Architrave
F Capital
G Shaft
H Base
I Plinth

1 Guttae
2 Metope
3 Triglyph
4 Abacus
5 Echinus
6 Volute
7 Fluting
8 Dentils
9 Fascia

3.20 The orders of Greek architecture. See also Fig. **2.17**.

Greek temples used three **orders**, **Doric**, **Ionic**, and **Corinthian**. These constitute not just decorative and elevational conventions, but systems of proportion. The first, as we noted in the last chapter, has archaic origins, although modified to suit classical style, as we see in the Parthenon (Figs **3.24** and **3.25**). The second is classical; the third, though of classical derivation, is of the later, Hellenistic style on which we have commented several times. As Figure **3.20** shows, simplicity characterizes Greek classical style, and the Doric and Ionic orders maintain clean lines even in their capitals. The Corinthian order has more ornate capitals. Taken in the context of an entire building, this detail may not seem significant. But columns, and particularly their capitals, give us convenient ways of identifying the order of a Greek temple. Differences also appear in column bases and the configuration of the lintels, but the capitals tell the story at a glance. The earlier of the two classical orders, the Doric (see Fig. **2.17**), has a massive appearance compared with the Ionic. The Ionic column, with its round base, rises above the baseline of the building. The flutings of the Ionic order, usually twenty-two per column, are

deeper and more widely separated than those of the Doric, giving it a more delicate appearance. Ionic capitals consist of paired spiral shaped forms, known as **volutes** (vuh-LOOTS). The Ionic architrave, or lintel, divides into three horizontal bands, which diminish in size downward, creating a sense of lightness, unlike the massive Doric architrave.

A final example of classical architecture takes us slightly beyond the classical period of the late fifth century B.C.E. Although no inscriptional information or other evidence provides a certain date for the Temple of Athena Nike (Fig. **3.21**), this small Ionic temple probably dates from the last quarter of the century. The pediments contained sculptures, but none of these has survived. What remain are sculptures from the frieze. The battle of Marathon of 490 B.C.E., the Athenians' greatest victory over the Persians, provides the subject matter for the frieze on the south side of the temple. It is "the only known example in temple sculpture of a conflict from near-contemporary rather than legendary history."[5] The battle had apparently assumed a legendary status even by 420 B.C.E.

The Temple of Olympian Zeus (Fig. **3.22**) illustrates the Hellenistic modifications of classical style in architecture. The scale and complexity of the building differ considerably from the Parthenon. Order, balance, moderation, and harmony remain, but these huge ruins reveal a change in proportions, with the use of slender and ornate Corinthian columns: temple architecture in this style sought to produce an overpowering emotional experience. It is the product of an empire rather than a reflection of the aspirations of a free people in a city-state. Begun by the architect Cossutius (koh-SOO-shuhs) for King Antiochus (an-TY-oh-kuhs) IV of Syria, this represents the first major Corinthian temple. Its elaborate detail pushed its completion date into the second century C.E. under the Roman emperor Hadrian. The ruins can only vaguely suggest the size and richness of the original building, surrounded by an immense walled precinct.

One center of Hellenistic power in Asia Minor, the city of Pergamon, provides an example of Hellenistic style that ranks as one of the major accomplishments of the time and was once considered one of the wonders of the then known world. The Altar of Zeus from the temple at Pergamon (Fig. **3.26**) was excavated in pieces beginning in 1873 and reassembled in a painstaking process that took more than fifty years. The altar, built by King Eumenes (YOO-mihn-eez) II, glorified the king and sought to impress the Greek world with Eumenes' contribution to the spread of Hellenism by his victories over the barbarians. The great frieze of the altar stands more than seven feet (2.1 meters) tall and runs for more than 450 feet (137 meters) around the entire perimeter

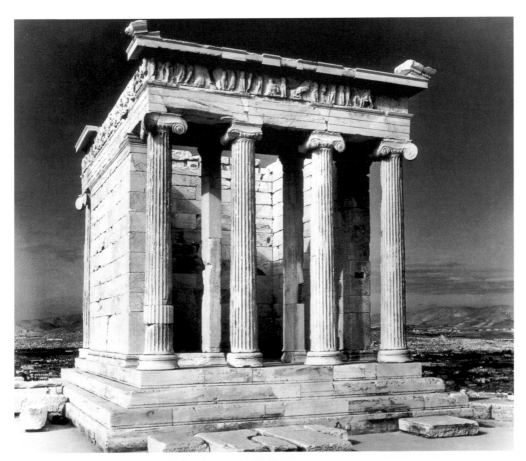

3.21 Temple of Athena Nike, Acropolis, Athens, (?)427–424 B.C.E.

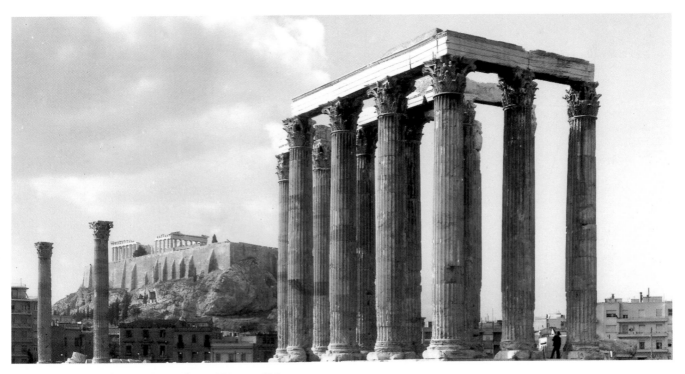

3.22 The Temple of Olympian Zeus, Athens, 174 B.C.E.–130 C.E.

MASTERWORK

THE PARTHENON

On the summit of the Acropolis at Athens (Figs **3.1** and **3.23**) stands the Parthenon, the greatest temple built by the Greeks and the prototype for all classical buildings thereafter. When the Persians sacked Athens in 480 B.C.E., they destroyed the existing temple and its sculpture. And when Pericles rebuilt the Acropolis later in the fifth century B.C.E. Athens was at its zenith, with the Parthenon as its crowning glory. The Parthenon (Figs **3.24** and **3.25**) exemplifies Greek classical architecture. Balance results from geometric symmetry, and the clean, simple lines represent a perfect balance of forces holding the composition together. For the Greeks, deities were only slightly superior to mortals, and in the Greek temple, deity and humanity met in an earthly rendezvous. This human-centered philosophy shows in the scale of the temple.

In plan, the Parthenon has short sides slightly less than half the length of the long sides. Its interior, or *naos*, divided into two parts, housed a 40-foot (12-meter) high ivory and gold statue of Athena. The temple has peripteral form (surrounded by a single row of columns). A specific convention determined the number of columns across the front and along the sides of the temple. The internal harmony of the design rests in the regular repetition of virtually unvaried forms. All the columns appear to be alike and spaced equidistantly. But at the corners the spacing adjusts to give a sense of grace and perfect balance, while preventing the monotony of unvaried repetition.

A great deal has been written about the "refinements" of the Parthenon—those features that seem to be intentional departures from strict geometric regularity. The slight bulge of the horizontal elements compensates for the eye's tendency to see a downward sagging when all elements are straight and parallel. Each column swells toward the middle by about 7 inches (18 centimeters), to compensate for the tendency of parallel vertical lines to appear to curve inward. We call this swelling **entasis**. The columns also tilt inward slightly at the top, in order to appear perpendicular. The stylobate rises toward the center so as not to appear to sag under the immense weight of the stone columns and roof. Even the white marble, which in other circumstances might appear stark, may have been chosen to reflect the intense Athenian sunlight. Parts of the temple were brightly painted.

3.23 Plan of the Acropolis, Athens.

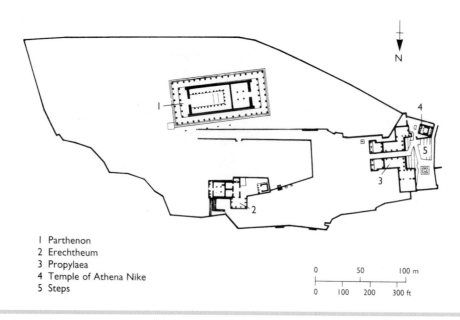

1 Parthenon
2 Erechtheum
3 Propylaea
4 Temple of Athena Nike
5 Steps

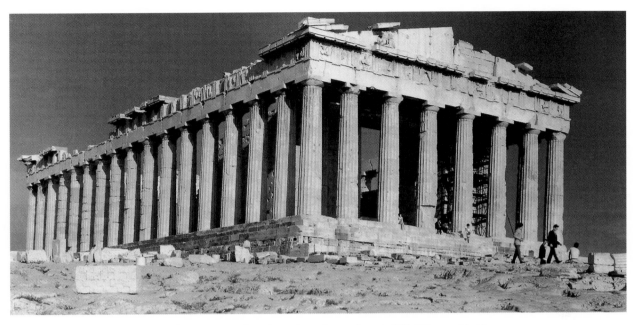

3.24 Ictinos and Callicrates, the Parthenon, Acropolis, Athens, from the northwest, 447–438 B.C.E. Marble.

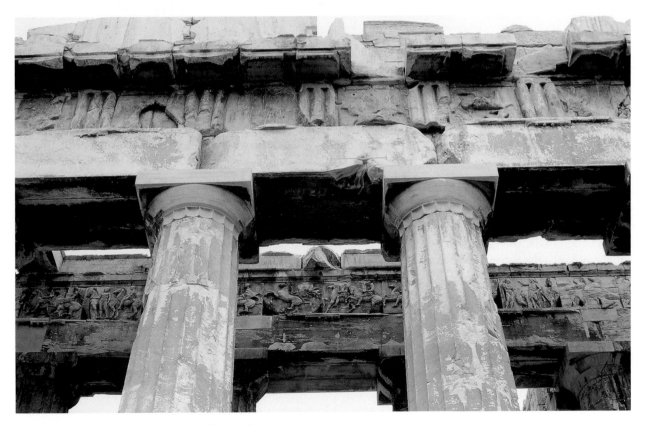

3.25 The Parthenon, frieze on the west cella, c. 440 B.C.E.

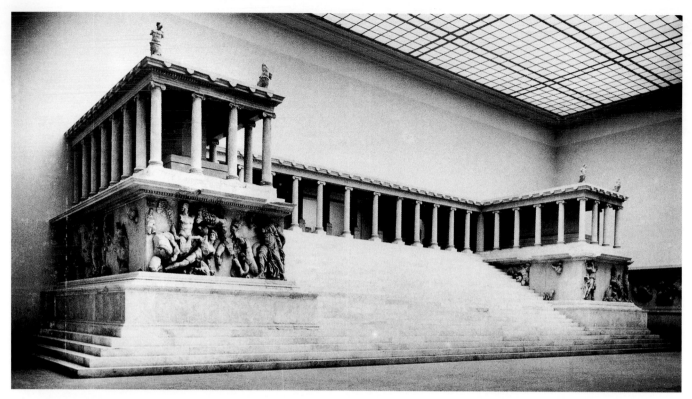

3.26 The west front of the Altar of Zeus, from the temple at Pergamon (restored), 197–159 B.C.E. Pergamonmuseum, Staatliche Museen, Berlin.

of the building. The frieze represents a radical departure from the design concept of the classical Greek temple. For example, in the Parthenon the **colonnade** serves as a part of the structure, supporting the entablature, which, in turn, elevates the frieze into a position of ethereal space and sustains the pediment and roof. In the Altar of Zeus, the frieze stands independently on a podium consisting of five steps. The colonnade retains no structural reason for being and becomes, rather, a unifying design device to give a boundary to the frieze.

The sculptures of the frieze narrate a typical battle between gods and giants, but the gods—now less potent in religious thought—symbolize qualities of good; the giants represent malevolent natural forces such as earthquakes and floods, and the portrayal symbolizes the struggle between the forces of light and the forces of darkness. An entire pantheon of gods emerges, including Zeus, Helios the sun god, Hemera the winged goddess of the day, Artemis, and Heracles. Below the frieze we find the names of the sculptors who executed this magnificent work.

The technical details of the frieze are nearly as interesting as the power of its scale and the intricacies of its proportion. Throughout, surface texture reflects great care. Cloth, saddles, belt buckles, and flesh have been patiently finished to create textures of the real objects. Also note the depth of the relief (haut-relief).

Theatre

In contrast to sculpture and painting, which used more-or-less lifelike images to portray the ideal, Greek classical theatre pursued the same ends through quite different means. The theatre of Periclean Athens used convention, in which neither scenery nor costumes employs representational details. The audience accepts descriptions in poetic dialogue, without demanding to see the objects described. Imagination is the key to this kind of theatre.

We think of theatre as entertainment—sometimes serious and profound—but entertainment, nonetheless. In ancient Greece the theatre was a vehicle for a communal expression of religious belief that employed music, dance, and drama. For the ancient Greek, the theatre implied a non-physical place—a special state of being for those who together watched the lives of the persons of the drama.

By the classical era, the early Dytherambic (dihth-er-AM-bik) dance festivals (religious celebrations dedicated to the god Dionysos [dy-oh-NY-suhs]), had evolved into a carefully structured dramatic event. Nonetheless, although the original altar in the center of the *orchestra*, or playing area, had disappeared, a vestigial space, recognized as the space of the altar, remained. The classical spirit that dominated the age gave these religious celebrations a fairly rigid structure. Greek tragedy, the major dramatic form of the time, consisted of an

introductory *prologos*, or prologue, a *parodos*, which marked the entrance of the chorus—a major feature of the drama—several episodes constituting the main action of the play, and the *exodus*, or conclusion, that followed the last song of the chorus.

Theatre productions in ancient Greece formed part of three annual religious festivals: the City Dionysia (dy-uh-NY-see-uh), the Rustic Dionysia, and the Lenaea (leh-NAY-uh). The first of these was a festival of tragic, and the last of comic, plays. The City Dionysia took place at the Theatre of Dionysus in Athens. Contests held at these festivals began in 534 B.C.E., before the classical era. Although we do not have most of the plays themselves, we do know the titles and the names of the authors who won the contests, from the earliest to the last. From inscriptions we know that three playwrights figured prominently and repeatedly as winners: Aeschylus (EHS-kih-luhs), Sophocles (SAHF-oh-kleez), and Euripides (yoo-RIP-i-deez). All the complete tragedies to survive were written by these playwrights—seven by Aeschylus, seven by Sophocles, and eighteen by Euripides.

Playwrights entering the contests for tragedy or comedy submitted their plays to a panel of presiding officers, who selected three winners for production. The early classical plays had only one actor, plus a chorus. At the time of selection, the playwright was assigned the chief actor and the patron who paid all the expenses for the production. The author served as also director, **choreographer**, and musical composer, and often played the leading role as well.

Tragedy
Aristotle's Theory of Tragedy

Aristotle's analysis of tragedy remains basic to dramatic theory and criticism, despite the fact that his ideas have often been misunderstood and misapplied over the past 2,400 years. Drawing principally on Sophocles as a model, Aristotle laid out in the *Poetics* the six elements of tragedy. In order of importance they are: (1) *plot*, the basic structure of the play, which includes such things as decision-points for the characters and a climax, or high point of action; (2) *character*, the people of the play and their motivating psychological characteristics; (3) *thought*, what we would call the ideas explored by the play; (4) *diction*, the words of the play and their style, e.g. prose or poetry; (5) *music* (sometimes translated *melody*), or what we would call the sounds of the production—for example, the manner in which the actors speak their lines, etc.; and (6) *spectacle*, all of the visual elements of the production, including scenery and costumes.

Plot, in tragedy, comprises far more than the simple storyline. For Aristotle, plot creates the basic structure of the play, just as form marks the cornerstone of classical design. The parts of plot give shape to the play with a

beginning (exposition), a middle (complication), and an end (**dénouement**), ensuring that the audience understands the progress of the drama. Additional points in the plot include *discoveries*, in which characters learn about themselves and others; *foreshadowing*, in which the playwright alerts the audience to future action; *reversals*, in which fortunes change; and *crises*, which create tension and make characters grow.

Aristotle sees tragedy as a form of drama in which a protagonist goes through a significant struggle which ends in disaster. However, the protagonist is always a heroic character, who gains a moral victory even in physical defeat. Tragedy therefore asserts the dignity of humanity, as well as the existence of larger moral forces. In the end, tragedy constitutes a positive experience, which evokes a catharsis, or purging, of pity and fear in the audience.

Aeschylus

At the time the *Kritios Boy* (see Fig. **2.15**) was created, Aeschylus, the most famous poet of Ancient Greece, began to write for the theatre. He wrote magnificent tragedies of high poetry and on lofty moral themes. For example, in *Agamemnon*, the first play in the *Oresteia* (or-es-TEE-uh) trilogy, Aeschylus' chorus warns that success and wealth are insufficient without goodness.

> Justice shines in sooty dwellings
> Loving the righteous way of life,
> But passes by with averted eyes
> The house whose lord has hands unclean,
> Be it built throughout of gold,
> Caring naught for the weight of praise
> Heaped upon wealth by the vain, but turning
> All alike to its proper end.[6]

Aeschylus poses questions that we still ask, such as: How responsible are we for our own actions? How subject are we to uncontrollable forces? His characters emerge larger than life, as types rather than individuals, in accordance with classical emphasis on the ideal. Yet in their strivings, as in their flaws, they remain also undeniably human. Aeschylus' casts for his early plays consist of one actor and a chorus of fifty, conforming to the convention of the time. Scholars credit him with the addition of a second actor, and, by the end of his long career, a third actor had been introduced and the chorus had been reduced to twelve. We see more of how classical themes, characters, and language work by examining, briefly, Aeschylus' play, *Prometheus*.

According to legend, Prometheus frustrated the plans of Zeus by giving fire to a race of mortals whom Zeus sought to destroy. Here we see classical Greek idealism at work: through reason, application, and vision, human beings can defy the gods and win. They are capable of nobility and infinite improvement. As punishment for his

PROFILE

AESCHYLUS
(C. 525–456 B.C.E.)

Aeschylus was the first and perhaps the greatest classical Greek tragedian. Together with Sophocles and Euripides, he is one of only three ancient Greek playwrights whose works have survived, and although he wrote fewer plays and won fewer contests than Sophocles, his contributions to the development of theatre remain enormous. His contributions to dramaturgy and production make him, if not the greatest writer, then certainly the most important person in Western theatre history. He was instrumental in establishing tragedy as a genre, and some have referred to him as "the creator of tragedy." According to Aristotle, Aeschylus added the second actor to tragic performance.

Born into an aristocratic family, he fought in the important battles of Marathon and Salamis (between the Greeks and the Persians), and his firsthand knowledge of battle infuses his works, which illumine the miseries—not the glories—of war. Apart from a few documented travels to as far as Sicily, we know little else of the life of this major figure in Western literature and theatre. He won his first contest in 484 B.C.E., and won at least thirteen first prizes at the major festivals. His victory total increased to twenty-eight after his death because Athens granted him the singular honor of competing through posthumous revivals. He may have written as many as ninety tragedies and satyr plays, although we know only eighty titles and only seven tragedies have survived.

The characters in Aeschylus' tragedies are "types" in the classically idealized mold. He treats history loosely and seeks to describe a broad religious view underwritten by patriotic exultation. He always remains within the controlled formality of the classic viewpoint, with its focus on intellect (form) as opposed to emotion (feeling), and he writes in an exalted style, using vocabulary clearly linked to the epic and lyric traditions of Homer (see Chapter 2). He handles the problems of evil and divine justice grandly and powerfully, and although his style may seem foreign to us, his questions and insights do not.

presumption, however, Zeus has Prometheus chained to a rock. In Prometheus' justification of what he did, he suggests that humankind, through technology and reason, can have dominion over nature.

Prometheus is a play unusual even for Aeschylus in its heavy dependence on dialogue and character, and in its lack of action. The hero stays motionless, chained to a rock. Nothing happens, only conversation between a parade of different people, through which the playwright reveals character and situation.

In this extract, the scene involves an exchange between Force, Violence, and Hephaestus, the fire god. Violence does not speak, however, because only two actors can have speaking roles. Force presents the situation:

> Far have we come to this far spot of earth,
> This narrow Scythian land, a desert all untrodden.
> God of the forge and fire, yours the task
> The Father laid upon you.
> To this high-piercing, headlong rock
> In adamantine chains that none can break
> Bind him—him here, who dared all things.
> Your flaming flower he stole to give to men,
> Fire, the master craftsman, through whose power
> All things are wrought, and for such error now
> He must repay the gods; be taught to yield
> To Zeus' lordship and to cease
> From his man-looking way.

Through speeches such as these, Aeschylus reveals the characters—Force as a villain, and Hephaestus as a weak but kindly fool. After Force, Violence, and Hephaestus exit, Prometheus appears. He may have been revealed on a low wagon, called an *eccyclema* (ehk-i-KLAY-muh), which was rolled out from the central door of the *skene*. He speaks:

> O air of heaven and swift winged winds,
> O running river waters,
> O never numbered laughter of sea waves,
> Earth, mother of all, eye of the sun, all-seeing,
> On you I call.
> Behold what I, a god, endure for gods.
> See in what tortures I must struggle
> Through countless years of time.
> This shame, these bonds, are put upon me
> By the new ruler of the gods.
> Sorrow enough in what is here and what is still to come.

And so the myth unfolds itself in high poetry as Prometheus discourses with the chorus, a group of kindly sea-nymphs, with Hermes, with Ocean, a humorous old busybody, and with Io, an ephemeral creature. When the dialogue has run its course, Prometheus declaims:

An end to words. Deeds now,
The world is shaken,
The deep and secret way of thunder
Is rent apart.
Fiery wreaths of lightning flash.
Whirlwinds toss the swirling dust.
The blasts of all the winds are battling in the air,
And sky and sea are one.
On me the tempest falls.
It does not make me tremble.
O holy Mother Earth, O air and sun,
Behold me. I am wronged.[7]

Prometheus, an idealistic exploration of human capacity, achievement, and power, emerged from the height of the golden age of Athens.

Sophocles

Sophocles' career overlapped with that of Aeschylus. With *Oedipus* (EH-dih-puhs or EE-dih-puhs) *the King*, his personal career reached its peak at the zenith of the Greek classical style. Sophocles' plots and characterizations illustrate a trend toward increasing **realism** similar to that in classical sculpture. The move toward realism did not involve any illusion of reality onstage, however, and even Euripides' plays, the least

MASTERWORK

SOPHOCLES—*OEDIPUS THE KING*

The story of Oedipus comprises one of the great legends of Western culture. When Sophocles used the legend in *Oedipus the King*, the story, familiar to all Athenians, had also formed the basis for plays by Aeschylus and Euripides.

At the beginning of the play, Oedipus is the beloved ruler of the city of Thebes, whose citizens have been stricken by a plague. Consulting the Delphic oracle, Oedipus learns that the plague will cease only when the murderer of Queen Jocasta's (joh-CAS-tuh) first husband, King Laius (LAY-uhs), has been found and punished for his deed. Oedipus resolves to find Laius' killer, only to discover that the old man he himself killed when he first approached Thebes as a youth, was none other than Laius. Finally, Oedipus learns the truth about himself and his past. Laius was Oedipus' father, and Jocasta, now Oedipus' wife and mother of his children, is, in fact, his mother. At the end, Jocasta hangs herself, and guilt-stricken Oedipus blinds himself with Jocasta's brooch pin.

The action moves from one moment of dramatic tension to another, rising to a climax. The protagonist, or central character, Oedipus, starts with no knowledge of his true identity. Slowly he discovers the truth about himself and the terrible deeds he has unknowingly committed: the murder of his father and marriage to his mother. However, his tragedy lies in the discovery of his guilt, rather than in the heinous acts themselves.

In *Oedipus*, Sophocles explores the reality of the dual nature we all share. He poses the eternal question,

can we control our destinies or are we the pawns of fate? In exploring this question, he vividly portrays the circumstances in which one's strengths become one's weaknesses. Oedipus' **hamartia** (huh-MAR-shuh), or **tragic flaw**, is the excessive pride, or *hubris* (HYOO-brihs), which drives him to pursue the truth, as a king—or a man—should, only to find the awful answer in himself.

In *Oedipus the King*, as well as in other Sophoclean and Aeschylean tragedies, we find the use of *stichomythia* (stihk-uh-MIHTH-ee-uh): dialogue involving a dispute presented in alternating lines. The playwright uses stichomythia as a device to indicate characters in vigorous contention or to heighten the emotional intensity of a scene. Characters, thus, may alternate in voicing opposing positions or take up the other character's words and suggest other meanings or develop a pun on them.

Although a tragedy, the play has a message of uplift and positive resolution. (We discussed this type of structure in the section on Aristotle's theory of tragedy.) When Oedipus recognizes his own helplessness in the face of the full horror of his past, he performs an act of contrition: he blinds himself, and then exiles himself. As grotesque as this may seem, it nevertheless releases Oedipus onto a higher plane of understanding. The chorus chants, "I was blind," while seeing with normal eyes, and Oedipus moans, "I now have nothing beautiful left to see in this world." Yet, being blind, Oedipus is now able to "see" the nobler, truer reality of his self-knowledge.

idealistic of the Greek tragedies, are not realistic as we understand the word.

Sophocles, certainly a less formal poet than Aeschylus, however, used more human themes, and his characters remain more subtle, although he explores the themes of human responsibility, dignity, and fate with the same intensity and high seriousness that we see in Aeschylus. His plots show increasing complexity, but within the formal restraints of the classical spirit.

Sophocles lived and wrote after the death of Pericles in 429 B.C.E., and he experienced the shame of Athenian defeat. Even so, his later plays did not shift toward emotionalism and interest in action. Classical Greek theatre consisted mostly of discussion and narration. The stories often dealt with bloodshed, but, though the play might lead up to the violence, and action resumed when it was over, blood was never shed on stage.

Euripides

Euripides was younger than Sophocles, although both died in 406 B.C.E. They did, however, compete with each other, despite the fact that their works have quite different styles. Euripides' plays carry realism further than any other Greek tragedies and deal more with psychological probings and individual emotions than with great events. His language, though still basically poetic, has greater lifelikeness and much less formality than that of his predecessors. Euripides also experiments with, or ignores, many of the conventions of his theatre, relying less heavily on the chorus. He also explores the mechanical potential of scenery shifting and questions the religion of the day in his plays. They are more **tragicomedies** than pure tragedies, and some critics have described many of them as **melodramas**. Euripides' play, *Hecuba*, depicts the bitter tragedy of the interrelationships between those who rule and those who obey. Writing at a time when failure of leadership had dragged Athens downward through a long war of attrition with Sparta. Euripides deals with myth, in this case, the story of the sack of Troy.

He relates two separate events, giving the plot an episodic character. Hecuba, the wife of Priam, king of Troy, whose city has at last fallen to the Greeks, endures first the slaughter of her daughter Polyxena (pahl-ee-ZEEN-uh) by the Greeks, then she discovers the body of her son, Polydorus, who has been murdered by Polymestor (pahl-ee-MEHS-tohr). Each of these events takes her one step further from grief and nearer to despair. She seeks the help of the Greek king, Agamemnon, in her quest for revenge on Polymestor, but receives only pity and the question, "What woman on this earth was ever cursed like this?" Hecuba replies in language less poetic and more realistic than that for example of Aeschylus's Prometheus:

There is none but goddess Suffering herself.

But let me tell you why I kneel
At your feet. And if my suffering seem just,
Then I must be content. But if otherwise,
Give me my revenge on that treacherous friend
Who flouted every god in heaven and in hell
To do this brutal murder.

At our table
He was our frequent guest; was counted first
Among our friends, respected and honoured by me,
Receiving every kindness that a man could meet—
And then, in cold deliberation killed
My son.

Murder may have its reasons, its motives,
But this—to refuse my son a grave, to throw him
To the sea, unburied! . . .

See me whole, observe
My wretchedness—

Once a queen, now
A slave; blessed with children, happy once,
Now old, childless, utterly alone,
Homeless, lost, unhappiest of women
On this earth . . .[8]

Step by step she moves inevitably toward her final acts of atrocity. The play focuses on how she must yield, one at a time, her values, her self-respect, and "the faith which makes her human." Underlying the play runs a stark condemnation of the logic of political necessity. When faced with power over which she has no control, she pleads the case of honor, decency, the gods, and moral law. All these appeals fail. As despair destroys her humanity, she passes beyond the reach of judgment. The chorus condemns the tragic waste of war and questions the necessity and logic of imperialism. Finally, Euripides attacks the gods themselves. Even if they exist, he implies, their justice lies so far removed from humans that it has no relevance.

Plays such as *The Bacchae* (BAHK-ee) reflect the changing Athenian spirit and dissatisfaction with contemporary events. Euripides was not particularly popular in his time, perhaps because of his less idealistic, less formal, and less conventional treatment of dramatic themes and characters. Was he perhaps too close to the reality of his age? His plays received higher praise in later years, however, and they remain unquestionably the most popular of the Greek tragedies today.

The transition from idealism, form, order, and restraint to greater realism and emotion represented by Euripides and Aeschylus parallels the changes we have

3.27 Greek statuette of a tragic actor, wearing a mask and a rich costume.

seen in painting, sculpture, and architecture. In all the arts, the idealization of classicism turned to the increasing realism of succeeding styles; restraint gave way to emotion, and form gave way to feeling.

Tragic Costume

If the plays of the Greek classical tragedy treated lofty themes with theatrical, poetic language, the style of the productions displayed no less formality, idealism, and convention. The larger-than-life characters were portrayed by actors, always men, in larger-than-life, conventionalized costumes. Actors and chorus wore bright robes, whose colors conveyed specific information to the audience. Padded robes increased the actor's size; and thick-soled boots called *kothurnoi* (koh-THUHR-noy) increased his height. Large masks with fixed, conventionalized expressions were readily identified by the sophisticated and knowledgeable audience (Fig. **3.27**). Height was further increased by an *onkos* (AHN-kohs), a wiglike protrusion on top of the mask.

Comedy

Classical tragedy had its complement in comedy. Athenians had a great love of comedy, and as we noted earlier in the chapter, comedy featured in the theatrical contests of the age. Although no comedies survive from the Periclean period, the late classical period immediately following it produced one of the genre's greatest playwrights, Aristophanes (air-ih-STAH-fuh-neez; c. 140–380 B.C.E.), of whose plays, eleven have reached us more or less intact. Aristophanes wrote with a sophisticated, biting satire on contemporary topics, often employing devices we would regard as obscene. In

Lysistrata (lih-sih-STRAH-tuh), for example, as we noted in the introductory material to this book, his plot revolves around a strike by the women of Athens who vow to withhold sex from their husbands until the authorities rid the city of war and warmongers. Productions of Aristophanes' comedies are still frequently staged, in translation of course, but because we have little familiarity with the personal and political targets of his invective, these modern productions are mere shadows of the impact they must have had at the turn of the fourth century B.C.E.

In the Hellenistic period a scant one hundred years later, comedy had become the staple of theatrical fare. We know even less about the genre in this period because only five, incomplete, plays by the playwright Menander (meh-NAN-duhr; c. 343–291 B.C.E.) survive. If these plays represent the time, then bawdiness ruled the day with pleasant and domestic situations the rule. Menander's plays exhibit superficiality and themes similar to twenty-first century sitcoms. Unlike Aristophanes, Menander writes almost totally without satire. Religion no longer played a role in the theatre, and the chorus had disappeared completely.

Theatre Layout and Form

Scholars do not agree about the exact layout of the classical Greek theatre building and the precise nature of the acting area and scenery. But we can summarize some of the architectural and archeological speculation, bearing in mind that it is only speculation.

The form of the Greek theatre owes much to its origins in the choral dances associated with the worship of Dionysus. In 534 B.C.E., Thespis is reported to have introduced a single actor to these dances. In 472 Aeschylus added a second actor, and in 458 Sophocles added a third. Throughout its history the Greek theatre had a large circular *orchestra*—the acting and dancing area—with the vestige of an altar at its center, and a semicircular *theatron* (THAY-uh-trahn)—auditorium or viewing place—usually cut into or occupying the slope of a hill. Since the actors played more than one role, they needed somewhere to change costume, and so a *skene* (SKEEN-ay)—scene-building or retiring place—was added. The process by which the skene developed into a raised stage remains somewhat obscure.

The earliest theatre still in existence, the Theatre of Dionysus, occupies the south slope of the Acropolis. It dates from the fifth century B.C.E., and witnessed the plays of Aeschylus, Sophocles, Euripides, and Aristophanes. Its current form dates from a period of reconstruction around 338–326 B.C.E. The theatre at Epidaurus (ehp-ih-DOHR-uhs; Figs **3.28** and **3.29**), the best preserved (built by Polyclitus the Younger about 350 B.C.E.), demonstrates the monumental character the theatre had assumed by

that time. The orchestra measures 66 feet (20 meters) in diameter, with an altar to Dionysus in the center and an **ambulatory** about two-thirds of the way up. Radiating stairways divide the auditorium, which comprises slightly more than a semicircle. The first or lowest row consisted

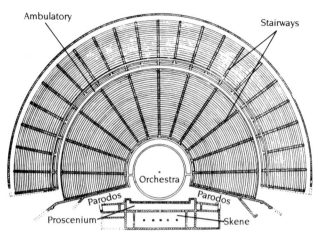

3.28 Plan of the theatre at Epidaurus, Greece, c. 350 B.C.E.

of stone seats for the dignitaries of Athens. These seats had backs and arm rests, some decorated with relief sculptures.

The design of theatres undoubtedly differed from place to place but time has removed most examples. The many theories about how Greek theatre productions worked, how scenery was used, and whether or not a raised stage existed, make fascinating reading.

The Hellenistic period (roughly the fourth century B.C.E. to the Roman infiltration, about 250 B.C.E.), experienced great expansion of the theatre in Greece. The general plan of the theatres did not change, but the *skene* frequently grew to two stories tall. After the chorus disappeared, in later Hellenistic times, a stage as high as twelve feet (3.6 meters) typified.

Music

As in the Archaic period (see Chapter 2), Greek music during the classical era consisted of a series of modes to which the Greeks attributed certain behavioural outcomes. The doctrine of *ethos* (see Chapter 2)

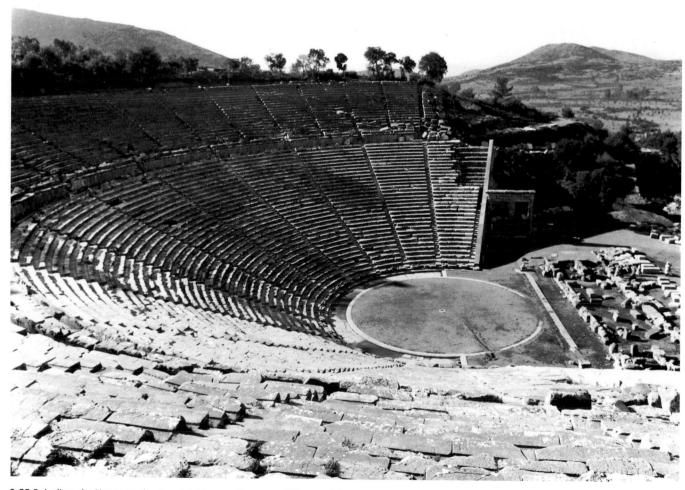

3.29 Polyclitus the Younger, theatre at Epidaurus, Greece, c. 350 B.C.E. Diameter 373 ft (114 m), orchestra 66 ft (20 m) across.

continued during this period, and music, dance, and poetry remained intertwined.

The spirit of contest popular among the Greeks extended to music. It was regarded as essential to life, and almost everyone in Athens participated. Perhaps the word "dilettante," an amateur lover of the arts, would best describe the average Athenian. Professionalism and professional artists, however, were held in low esteem, and Aristotle urged that skill in music stop short of the professional. Practice should develop talent only to the point where one could "delight in noble melodies and rhythms," as he says in the *Poetics*. He also discouraged excessive complexity. We should not infer too much from such an observation: complexity for the ancient Greeks would no doubt still be simplicity by our musical standards. It appears reasonably clear, for instance, that all Greek music of this era was **monophonic**—without **harmony**. "Complexity" might therefore mean technical difficulty, and perhaps melodic ornamentation.

Aristotle said that music should lead to noble thought, but some music in the Greek repertoire certainly led the other way. Rituals in praise of the god Dionysus exhibited emotion and frenzy, and music played an important role in these.

If Plato's *Republic* can be taken as an accurate guide, Greek music seems to have relied on convention. Most of the performances in Periclean Athens appear to have been improvised, which may seem at odds with formal order. However, "improvisation" should not be interpreted here as spontaneous or unrehearsed. The Greeks had formulas or rules concerning acceptable musical forms for nearly every occasion. So the musician, though free to seek the momentary inspiration of the Muses—the mythological sisters who presided over the arts—was constrained by all the rules applicable to the occasion.

Pythagoras taught that an understanding of numbers provided the key to an understanding of the spiritual and physical universe. Those views, expressed in music, as well as the other arts, led to a system of sounds and rhythms ordered by numbers. The **intervals** of the musical scale were determined by measuring vibrating strings. As a result, sounds in Greek music were calculated on relationships of 2 to 1 (one note having exactly double the vibrations per second as another—we call it an octave: middle C compared to C^1, for example); 5 to 1 (what we call a fifth—for example, the relationship between C and the G above), or perhaps, 4 to 1 (a fourth—for example, the relationship between C and the F above).

Dance

Dance in the age of Pericles reflected both classical and anti-classical styles. The dances of the Dionysiac cult revels, which may have decreased in popularity but certainly continued under Periclean rule, disregarded form, order, restraint, and idealization. They were characterized by emotional frenzy, not intellect. However, the philosophies of the era, the relationship of dance to music and drama, and the treatment of dance by Plato and Aristotle, indicate that those aspects of dance associated with the theatre, at least, must have reflected classical values.

Dance is an evanescent art form, however. Today, even with labanotation (lab-uh-noh-TAY-shun)—a system of writing down dance movements—we cannot know what a dance piece looks like if we do not see the

3.30 Statuette of a veiled dancer, c. 225–175 B.C.E. Bronze, 8⅛ ins (20.6 cm) high. Metropolitan Museum of Art, New York (Bequest of Walter C. Baker, 1972).

event. So the literary treatises, the musical fragments, and the archeological evidence from which so many have tried to reconstruct the dances of the Greeks give us very little information. In fact, the conventional nature of Greek art presents our most formidable obstacle. Some vase paintings and sculptures clearly depict dancers (Fig. 3.30), but we do not know the conventions that apply to these poses, and so we cannot reconstruct any actual dances.

Literature

We have already examined one of literature's genres, drama, when we discussed the theatre of classical Greece. Tragedy and the epic poetry of Homer (which we studied in Chapter 2) had significant influence on the history written by Herodotus noted in the *Historia* section earlier in this chapter. In the *History of the Persian Wars* Herodotus focuses on character, just as dramatists do. In Herodotus' eyes, the investigation of history centers on people rather than events. People cause things to happen, just as characters' decisions move plays forward. Like a dramatist, and very much like Homer, Herodotus delivers us insights into the feelings, motivations, moods, and emotions of the people of the history he writes through speeches. Like Homer, Herodotus composed long speeches in order to reveal the truth about the events reported upon. Herodotus did not think that his readers would believe that the speeches themselves comprised an accurate reflection of the characters' actual words. In developing his speeches, Herodotus uses two distinct types of language: formal and informal. We find in what scholars call set-piece debates, a high, formal language like the language of the tragedian Aeschylus. In other cases, he employs informal conversation, which in terms of our use of language, still constitutes poetic construction of classical standards.

We also noted Thucydides in the *Historia* section, and the comments we made about Herodotus also apply to Thucydides' *History of the Peloponnesian Wars*. The major difference, of course, lies in the fact that Thucydides' history has the author himself as the central character. He thoughtfully begins his "investigation or research" with a dialectic on his careful reliance on observable facts. In this case, dialectic means a systematic reasoning, development, or argument that juxtaposes contrasting or contradictory ideas and seeks to resolve their conflict. He wants to write the most honest account of the war possible, and, thus, to raise the war to its deserved level of importance.

We discussed Aristotle's poetics in some depth both in the section on Aesthetics and in the section on Tragedy. Let us let that discussion suffice and find additional points in this short selection from Aristotle's *Poetics*.

Poetics
Aristotle

Book V

Comedy is, as we have said, an imitation of characters of a lower type, not, however, in the full sense of the word bad, the Ludicrous being merely a subdivision of the ugly. It consists in some defect or ugliness which is not painful or destructive. To take an obvious example, the comic mask is ugly and distorted, but does not imply pain.

The successive changes through which Tragedy passed, and the authors of these changes, are well known, whereas Comedy has had no history, because it was not at first treated seriously. It was late before the Archon granted a comic chorus to a poet; the performers were till then voluntary. Comedy had already taken definite shape when comic poets, distinctively so called, are heard of. Who furnished it with masks, or prologues, or increased the number of actors—these and other similar details remain unknown. As for the plot, it came originally from Sicily; but of Athenian writers Crates was the first who, abandoning the 'iambic' or lampooning form, generalised his themes and plots.

Epic poetry agrees with Tragedy in so far as it is an imitation in verse of characters of a higher type. They differ, in that Epic poetry admits but one kind of meter, and is narrative in form. They differ, again, in their length: for Tragedy endeavours, as far as possible, to confine itself to a single revolution of the sun, or but slightly to exceed this limit; whereas the Epic action has no limits of time. This, then, is a second point of difference; though at first the same freedom was admitted in Tragedy as in Epic poetry.

Of their constituent parts some are common to both, some peculiar to Tragedy; whoever, therefore, knows what is good or bad Tragedy, knows also about Epic poetry. All the elements of an Epic poem are found in Tragedy, but the elements of a Tragedy are not all found in the Epic poem.

Earlier we also examined Plato and his philosophy. Plato lived during the post-Golden Age. He had become disillusioned with the Athenians' ability to govern themselves. The art and aesthetic contemporary to his age (late classical), as discussed earlier, lacked the moralizing pretense of the classical period. His ideas about education and politics, expounded in the *Republic,* express his view that only a select few can ascend from the "cave" of ignorance and achieve true knowledge. Plato's ideal society, a meritocratic aristocracy, has a ruling class selected from the ablest people of all backgrounds and both sexes. After education, composed of physical regimen and study of philosophy, the most qualified would be groomed for power, which they would inherit automatically at the age of fifty. These would be "philosopher kings" who would live communally, sharing food, lodging, and spouses and owning no property. It followed to Plato that because the philosopher kings would be guided by true knowledge, they would govern for the benefit of all.

Soldiers would comprise a separate, intermediary class above the lower orders of merchants, farmers, and artisans, who would own property, but within strict limits. For example, there would be no slaves, and anyone whose wealth grew more than fourfold would be compelled to give the rest to the state. In Plato's ideal state, when everyone did the task for which he or she was best suited, society would achieve the four cardinal virtues of wisdom (the philosopher kings), courage (soldiers), temperance (commoners), and justice (the state itself). The arts, in this scheme, were at best peripheral and at worst, dangerous, because beauty was but a pale reflection of the ideal—an imitation of an imitation.

The *Apology*, one of Plato's dialogues, gives his version of the speech Socrates gave in his own defense at his trial. Socrates was accused, and found guilty, of corrupting the youth of Athens and of believing in gods of his own devising rather than the gods of Athens.

Apology
Plato

Part I: Socrates' Defense Speech
(Section 2) The Old Accusers' Charges

And first, I have to reply to the older charges and to my first accusers, and then I will go on to the later ones. For of old I have had many accusers, who have accused me falsely to you during many years; and I am more afraid of them than of Anytus and his associates, who are dangerous, too, in their own way. But far more dangerous are the others, who began when you were children, and took possession of your minds with their falsehoods, telling of one Socrates, a wise man, who speculated about the heaven above, and searched into the earth beneath and made the worse appear the better cause. The disseminators of this tale are the accusers whom I dread; for their hearers are apt to fancy that such inquirers do not believe in the existence of the gods. And they are many, and their charges against me are of ancient date, and they were made by them in the days when you were more impressible than you are now—in childhood, or it may have been youth—and the cause when heard went by default, for there was none to answer. And hardest of all, I do not know and cannot tell the names of my accusers; unless in the chance case of a comic poet. All who from envy and malice have persuaded you—some of them having first convinced themselves—all this class of men are most difficult to deal with; for I cannot have them up here, and cross-examine them, and therefore I must simply fight with shadows in my own defense, and argue when there is no one who answers. I will ask you then to assume with me, as I was saying, that my opponents are of two kinds; one recent, the other ancient: and I hope that you will see the propriety of my answering the latter first, for these accusations you heard long before the others, and much oftener.

Well, then, I must make my defense, and endeavor to clear away in a short time, a slander which has lasted a long time. May I succeed, if to succeed be for my good and yours, or likely to avail me in my cause! The task is not an easy one: I quite understand the nature of it. And so leaving the event with God, in obedience to the law I will now make my defense.

I will begin at the beginning, and ask what is the accusation which has given rise to the slander of me, and in fact has encouraged Meletus to prefer this charge against me. Well, what do the slanderers say? They shall be my prosecutors, and I will sum up their words in an affidavit: "Socrates is an evildoer, and a curious person, who searches into things under the earth and in heaven, and he makes the worse appear the better cause; and he teaches the aforesaid doctrines to others." . . .

Although, if a man were really able to instruct mankind, to receive money for giving instruction would, in my opinion, be an honor to him. There is Gorgias of Leontium, and Prodicus of Ceos, and Hippias of Elis who go the round of the cities and are able to persuade the young men to leave their own citizens by whom they might be taught for nothing, and come to them whom they not only pay, but are thankful if they may be allowed to pay them. There is at this time a Parian philosopher residing in Athens, of whom I have heard; and I came to hear of him in this way:—I came across a man who has spent a world of money on the Sophists, Callias, the son of Hipponicus, and knowing that he had sons, I asked him: "Callias," I said, "if your two sons were foals or calves, there would be no difficulty in finding someone to put over them; we should hire a trainer of horses, or a farmer probably, who would improve and perfect them in their own proper virtue and excellence; but as they are human beings, whom are you thinking of placing over them? Is there any one who understands human and political virtue? You must have thought about the matter, for you have sons; is there any one?" "There is," he said. "Who is he?" said I; "and of what country? and what does he charge?" "Evenus the Parian," he replied, "he is the man, and his charge is five minae." Happy is Evenus, I said to myself, if he really has this wisdom, and teaches at such a moderate charge. Had I the same, I should have been very proud and conceited; but the truth is that I have no knowledge of the kind.

(Section 7) The Philosopher as Gadfly

And now, Athenians, I am not going to argue for my own sake, as you may think, but for yours, that you may not sin against the God by condemning me, who am his gift to you. For if you kill me you will not easily find a successor to me, who, if I may use such a ludicrous figure of speech, am a sort of gadfly, given to the state by God; and the state is a great and noble steed who is tardy in his motions owing to his very size, and requires to be stirred into life. I am that gadfly which God has attached to the state, and all day long and in all places am always fastening upon you, arousing and persuading and reproaching you. You will not easily find another like me, and therefore I would advise you to spare me. I dare say that you may feel out of temper (like the person who is suddenly awakened from sleep), and you think that you might easily strike me dead as Anytus

advises, and then you sleep on for the remainder of your lives, unless God in his care of you sent you another gadfly. When I say that I am given to you by God, the proof of my mission is this:—if I had been like other men, I should not have neglected all my own concerns or patiently seen the neglect of them during all these years, and have been doing yours, coming to you individually like a father or elder brother, exhorting you to regard virtue; such conduct, I say, would be unlike human nature. If I had gained anything, or if my exhortations had been paid, there would have been some sense in my doing so; but now, as you will perceive, not even the impudence of my accusers dares to say that I have ever exacted or sought pay of any one; of that they have no witness. And I have a sufficient witness to the truth of what I say—my poverty.

Arguably the greatest lyric poet of ancient Greece, Pindar (PIHN-duhr or PIHN-dahr; 518–c. 438 B.C.E.) wrote masterful choral odes to celebrate the victories achieved in the various official games throughout Greece. He enjoyed a high reputation in his lifetime throughout the Greek world. In total, Pindar wrote seventeen volumes of choral lyric poetry of every genre, only four of which survived complete.

An **ode** celebrates an occasion of public or private dignity employing a blending of emotion and general meditation. In ancient Greece, the word ōidē (ee-deh) or ode referred to a choric song usually accompanied by a dance. Choral odes also formed an integral part of Greek drama (see the Dance and Theatre sections). Pindar's odes divide into Olympian, Pythian, Isthmian, and Nemean—named for the games from which the victories he celebrated arose.

In a Pindaric ode we find a particular kind of three-part structure that contains a *strophe* (STROH-fee; two or more lines repeated as a unit), followed by a metrically similar *antistrophe* (an-TIH-stroh-fee). In the choral odes of Greek drama, each of these parts corresponded to a specific movement of the chorus as it performed that part. In the strophe they moved from right to left; in the antistrophe, they moved from left to right. The third part of the structure, the *epode* (EH-pohd) or summary, exhibited a different meter. In the *Isthmian Odes* that follow, the translator has indicated each of these parts. (The figures in square brackets within the text indicate line numbers in the Greek original.)

Isthmian Odes
Pindar

Isthmian 1
For Herodotus of Thebes, Chariot Race, ?458 B.C.E.

[str. 1]
My mother, Thebe of the golden shield, I shall place your interests above my lack of leisure. May rocky Delos, in

whose praises I have poured myself out, not be indignant at me. [5] What is dearer to good men than their noble parents? Yield, island of Apollo; indeed, with the help of the gods I shall accomplish the end of both graceful songs,

[ant. 1]
honoring in the dance both Phoebus with the unshorn hair, in wave-washed Ceos with its mariners, and the sea-dividing reef of the Isthmus. [10] Since the Isthmus gave to the people of Cadmus six garlands from her games, the glory of triumph for my fatherland, where Alcmena bore her fearless

[epode 1]
son, before whom the bold hounds of Geryon once trembled. But I, while I frame for Herodotus a prize of honor for his four-horse chariot, [15] and for managing the reins with his own hands and not another's, want to join him to the song of Castor or of Iolaus, for of all heroes they were the strongest charioteers, the one born in Sparta and the other in Thebes.

[str. 2]
And in the games they attempted the greatest number of contests, and adorned their homes with tripods [20] and caldrons and goblets of gold, tasting victorious garlands. Their excellence shines clearly, in the naked footraces and in the shield-clashing hoplite races,

[ant. 2]
and in all the deeds of their hands, in flinging the spear [25] and whenever they hurled the stone discus. For there was no pentathlon, but for each feat a separate prize was set up. Often crowning their hair with wreaths from these contests they appeared beside the streams of Dirce or near the Eurotas,

[epode 2]
[30] the son of Iphicles, who was of the same city as the race of the Sown Men, and the son of Tyndareus, dwelling among the Achaeans in his highland home of Therapne. Farewell. But I, arraying with song Poseidon and the sacred Isthmus and the shores of Onchestus, shall tell, along with the honors of this man, the very famous fortune of his father Asopodorus

In the first century B.C.E. a precursor of the modern novel arose in the Hellenistic world. We call these works Hellenistic romances, and they comprise adventure tales usually within a semi-historical setting. The plots center on a virtuous heroine and her valiant lover separated by innumerable obstacles created by wicked humans and natural catastrophes. In the end, however, all works out for the good, and the lovers reunite. These romances gave birth to such classic love stories as *Hero and Leander*, *Pyramus* (PEER-uh-muhs) and *Thisbe* (THIZ-bee), *Sappho and Phaon* (FAY-ahn), and *Daphnis and Chloe* (KLOH-ee).

CHAPTER REVIEW

CRITICAL THOUGHT

Given the complete defeat of Athens by Sparta and their different ways of life and philosophy, but the continuing influence of Athenian culture, we could conclude that artistic culture has more importance than power and conquest. One can certainly speculate on the kinds of social conditions necessary for a culture to flourish, provide adequately for its citizenry, and have a lasting positive impact on the future.

It may well be that Socrates has as much to say about life today as he had about life in Athens 2,400 years ago. Is an unexamined life not worth living? Would you like to be one of his students, pummeled constantly by questions designed to illumine your weaknesses, or would you rather sit in a classroom letting a professor lecture to you and provide you with the answers?

We often classify some people as "rational" and others as "emotional," putting classical principles into our personal relationships. Sometimes, we describe men as more logical or more mathematically inclined than women, who are then described as more intuitive and artistic. Is that an accurate way of assessing individuals? Perhaps we're more comfortable dealing with classicism in a less personal manner—for example, finding examples of classicism in the buildings of our campus and community or in the music we listen to. Obviously these are not Greek classical buildings or songs, because they were made long after the Greek classical period, but we easily recognize basic characteristics of classicism in them.

SUMMARY

After reading this chapter you should be able to:

- Explain the factors that coalesced to make Athens the cradle of Western civilization.
- Define and compare the several philosophical systems of the classical and Hellenistic eras.
- Identify works and artists, and characterize the visual art and architecture of the classical and post-classical periods.
- Compare Plato's and Aristotle's theories about art.
- Discuss Aristotle's theory of tragedy and its relationship to the major playwrights and production circumstances of the classical and post-classical periods.
- Describe the music and dance of the classical period.
- Apply the elements and principles of composition to analyze and compare individual works of art illustrated in this chapter.

CYBERSOURCES

http://harpy.uccs.edu/greek/classsculpt.html
http://harpy.uccs.edu/greek/lateclasssculpt.html
http://harpy.uccs.edu/greek/hellsculpt.html
http://web.kyoto-inet.or.jp./org/orion/eng/hst/greek.html

4 THE ROMAN PERIOD

OUTLINE

CONTEXTS AND CONCEPTS
- Contexts
 The Etruscans
 The Roman Republic
 The Roman Empire
- Concepts
 Roman Law
 Stoicism
 Neo-Platonism
 Divinities and Mystery Cults

Classicism
Utilitarianism and Pragmatism

THE ARTS OF THE ROMAN PERIOD
- Painting
 A DYNAMIC WORLD: Chinese Painting
- Sculpture
- Architecture

MASTERWORK: The Pantheon
TECHNOLOGY: Cement
- Theatre
 Comedy
 Blood Sport
- Music
- Dance
- Literature
 PROFILE: Vergil

VIEW

DEMOCRACY AND LAW

Is it better to have a participatory government (democracy), than to have a monarchial or dictatorial government? For the second time in our study, we now watch as citizens cope with governing themselves. In ancient Rome, as life and population became more expansive, complicated, and diverse, the governmental form itself became problematical. Amazingly, the citizens of Rome willingly gave up their democracy in favor of a dictator. We wonder what might have transpired to bring about such an event and think of modern parallels such as Germany under Adolf Hitler and the Nazis. We also wonder, as we examine how democracy succeeded and failed in cultures such as those of ancient Greece and Rome,

whether a country can become too large and too fragmented to sustain democracy. For example, could democracy ever work in a nation as large as modern China? Will the United States reach the point at which it is too diverse to continue as a representative democracy and still maintain any kind of social order?

Interestingly, however, as Rome grew and its emperors became all-powerful, it witnessed nearly two hundred years of peace and stability—the *Pax Romana*—and entered a period in which the rule of law flourished. So, is it governmental form or something else that gives a society a high quality of life?

KEY TERMS

S.P.Q.R.
—Senatus Populusque Romanus—The Senate and the Roman People.

PAX ROMANA
"The Roman Peace" was a 200-year span of stability during the Roman Empire, beginning with the Emperor Augustus.

TROMPE L'OEIL
"Trick of the eye" or "fool the eye," a two-dimensional artwork designed to make the viewer believe it is in three dimensions.

ENGAGED COLUMNS
Columns, often decorative, that are part of, and project from, a wall surface.

CELLA
The principal enclosed room of a Roman temple.

SARCOPHAGI (sahr-KAWF-uh-jy)
Stone coffins, a notable type of Roman sculpture.

MASONRY
Stone or brickwork, a structural architectural feature at which the Romans excelled.

4.1 *Gemma Augustea* (detail of the crowning of Augustus), early first century C.E. Onyx cameo, whole cameo 7½ × 9 ins (19 × 23 cm). Kunsthistorisches Museum, Vienna.

CONTEXTS AND CONCEPTS
Contexts

The Etruscans

The civilization that would become the Roman one arose at the same time as that of ancient Greece. By the sixth century B.C.E., Etruscan invaders who had come out of Asia by way of Greece dominated the Italian peninsula. The Etruscans brought to their new land a militaristic and practical society, an anthropomorphic conception of the deities, and arts roughly equivalent to those of archaic Greece, whose style had influenced them (Fig. 4.2). Roman legend held that Rome was founded in 753 B.C.E. by Romulus (RAHM-yoo-luhs), an orphan, who, with his twin brother, Remus (REEM-uhs), had been suckled by a wolf as the boys' foster-mother. One Etruscan religious cult revered wolves, and this legend further supports the idea that Roman civilization had Etruscan roots.

Toward the end of the sixth century B.C.E., Rome, an important location as a bridging point across the Tiber River, joined with other Latin cities in a revolt against Etruscan domination. In 509 B.C.E., according to Roman tradition, the last Etruscan king was expelled from Rome. This set the Romans on a 900-year course that would lead them to all corners of the then known world. Etruscan influence continued, however, and that influence and its inherited links with Greece carried forward in Rome the classical ideas that still permeate the Western approach to life today.

The Roman Republic

Once free of Etruscan domination, the Romans developed a republican form of government that lasted until the first century B.C.E. This political stability provided important continuity for other Roman institutions. The motto "S.P.Q.R."—*Senatus Populusque Romanus* (the Senate and the Roman People)—reflected the early Roman political and social order, and remained the watchword

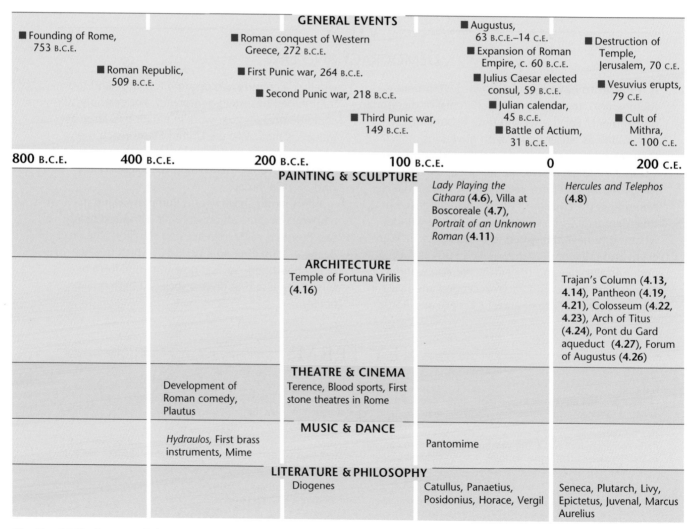

GENERAL EVENTS

- Founding of Rome, 753 B.C.E.
- Roman Republic, 509 B.C.E.
- Roman conquest of Western Greece, 272 B.C.E.
- First Punic war, 264 B.C.E.
- Second Punic war, 218 B.C.E.
- Third Punic war, 149 B.C.E.
- Augustus, 63 B.C.E.–14 C.E.
- Expansion of Roman Empire, c. 60 B.C.E.
- Julius Caesar elected consul, 59 B.C.E.
- Julian calendar, 45 B.C.E.
- Battle of Actium, 31 B.C.E.
- Destruction of Temple, Jerusalem, 70 C.E.
- Vesuvius erupts, 79 C.E.
- Cult of Mithra, c. 100 C.E.

800 B.C.E.	400 B.C.E.	200 B.C.E.	100 B.C.E.	0	200 C.E.

PAINTING & SCULPTURE

			Lady Playing the Cithara (**4.6**), Villa at Boscoreale (**4.7**), *Portrait of an Unknown Roman* (**4.11**)	*Hercules and Telephos* (**4.8**)

ARCHITECTURE

Temple of Fortuna Virilis (**4.16**)

Trajan's Column (**4.13**, **4.14**), Pantheon (**4.19**, **4.21**), Colosseum (**4.22**, **4.23**), Arch of Titus (**4.24**), Pont du Gard aqueduct (**4.27**), Forum of Augustus (**4.26**)

THEATRE & CINEMA

Development of Roman comedy, Plautus

Terence, Blood sports, First stone theatres in Rome

MUSIC & DANCE

Hydraulos, First brass instruments, Mime

Pantomime

LITERATURE & PHILOSOPHY

Diogenes

Catullus, Panaetius, Posidonius, Horace, Vergil

Seneca, Plutarch, Livy, Epictetus, Juvenal, Marcus Aurelius

Timeline 4.1 The Roman period.

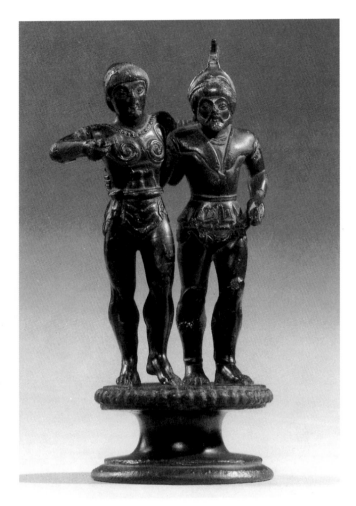

4.2 Etruscan warrior supporting a wounded comrade, early fifth century B.C.E. Bronze, 5¼ ins (13.4 cm) high (without base). Metropolitan Museum of Art, New York (Rogers Fund, 1947).

of Roman society until Imperial times. It meant that sovereignty rested in the people themselves, and not in any particular form of government. In many ways the Roman Republic functioned as a democracy. Decisions affecting society were made at assemblies, which all citizens attended to express their will. The Senate conducted the actual business of government, including the passage of legislation and the supervision of elected magistrates. Over the centuries, the greatest issues affecting Roman society played out as dramas between the people and the Senate.

The Senate itself, an hereditary institution, comprised an assembly of the heads, or *patres*, of old families and, later, of wealthy members of the citizenry, or *plebs*. The Senate's 300 members therefore represented old and new money, power, and social interest. We call such an arrangement a self-renewing oligarchy. The two most important officers who ruled the state, the *consuls*, were elected by the representative assemblies for one-year

terms, at the end of which they became members of the Senate.

In Rome, the rich ruled via the Senate with the general citizenry little more than peasants. By the third century B.C.E., the division between aristocrat and peasant widened appreciably, the former growing in riches and the latter sinking further and further into poverty. Yet as long as Rome remained reasonably small, the constitutional framework of the Republic held the social order together. It warded off revolution while permitting change and provided the body politic with reasonably well-trained leaders who knew how, above all else, to keep the Republic functioning and alive. In fact, the internal stability of the Republic made expansion possible, bringing about the next phase of Roman history.

Military Expansion

Roman expansion built on military conquest. Through conquest Rome gained political dominance in the Hellenistic world during the third and second centuries B.C.E. (Map **4.1**) The internationalization of culture, evident in Hellenic times, grew under the Romans. Later, Rome would extend its control throughout Europe and eventually as far as the British Isles.

By 272 B.C.E., the Romans had conquered western Greece. Then they took on Carthage, the other major power of the period, in the first of the Punic wars. Over the next hundred years, in three great stages, Rome and Carthage battled each other for control of the whole Mediterranean world. During the second Punic war, which began in 218 B.C.E., the Carthaginian general Hannibal marched his legions over the Alps into Italy. The end of the second Punic war in 202 B.C.E. left Rome in a position of advantage and at a watershed.

Rome had the choice either to consolidate order and security in the west by ridding itself of the Carthaginian threat or to expand toward the east. The Romans chose to move eastward, hoping to gain new riches from the conquered territories. The outcome, though unforeseen, left Rome overlord of the entire Hellenistic world. But with the third Punic war, which began in 149 B.C.E., Rome also accomplished its other objective: within three years it destroyed Carthage.

The Roman Civil War

The continuous state of war on the borders of the Roman provinces, as well as the practical requirements for effective government, led to an increase of power in the hands of the Roman Senate and a decrease in the participation of ordinary citizens. Unlike Athens, Rome had very little commerce or industry, and the quality of life in Rome came to depend directly upon the wealth of conquered regions brought back to Rome as spoils.

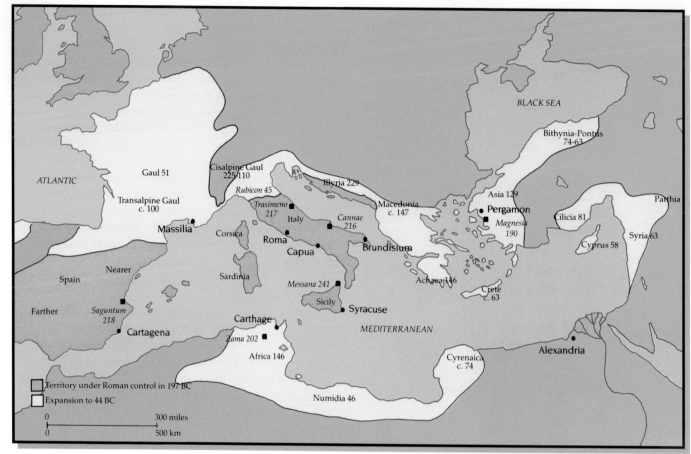

Map 4.1 The Roman Republic, showing important battles and dates (B.C.E.) that areas came under dominion.

The greatest danger to Rome did not lie in foreign wars, however, but in the threat of civil war. Conquests had made the Romans rich, and the *proconsuls* who governed the provinces took advantage of their positions, the availability of cheap land, slaves, and tribute money. Few could resist the temptation of corruption. They built vast estates and, in general, abused the poor, who became poorer. Rome itself became a Mecca for the rich and poor alike, and the widening gap between the two increased tension and bitterness among the masses. The violent excesses of generals who, having conquered the hinterlands, returned home with their armies intact exacerbated the situation. This produced a period of upheaval, which lasted from approximately 133 to 31 B.C.E. and brought the Roman Republic to a close.

During this time a succession of men attempted leadership. First came Marius (MAR-ee-uhs). Then came a power struggle in the late first century B.C.E. from which the dictator Sulla emerged, to be followed by Pompey (PAHM-pee).

In 59 B.C.E., Marius' nephew Julius Caesar (Caesar was the family name) was elected consul. During a five-year campaign against the Gauls, he kept a close watch on Roman politics. Corruption, intrigue, and murder disfigured public life and discredited the Senate. Having returned to Italy in 49 B.C.E., he declared war on Pompey by crossing the Rubicon River, which marked the limit of his province. By 44 B.C.E., he had returned to Rome in triumph and was voted dictator for life. His life ended only days later, however, on 15 March 44 B.C.E., at the hands of assassins in the Senate.

One of Caesar's most lasting achievements, the invention of the Julian calendar, gave us a year with 365 days, with an additional day every four years. The new calendar began on 1 January 45 B.C.E.

The Roman Empire
Augustus

If anyone hoped that the assassination of Julius Caesar would bring about the return of Republican rule, they must surely have been disappointed, for the political turbulence simply continued. Caesar's assassins and his old commanders battled for control, while orators like Cicero labored to save the old Republic. In the end, Julius Caesar's great nephew and adopted son Octavian—known to history as Augustus Caesar—outmaneuvered and outfought everyone.

The year after his uncle's death, Octavian and his allies of the Caesarian faction joined forces in an alliance called the Second Triumvirate. By means of intrigue and threat, they coerced the Senate into granting them—and their legions—the power to restore peace to the Roman state. In the battle of Philippi (fil-IP-y), in northern Greece in 42 B.C.E., Octavian and his allies defeated the conspirators who had assassinated Julius Caesar. However, peace did not result. Octavian split with his former allies, especially with Mark Antony, now Cleopatra's lover. In a climactic naval battle at Actium in 31 B.C.E., Octavian defeated Mark Antony. Antony's death and Octavian's victory effectively ended the Roman Civil War. In the thirty-seventh poem in his first book of *Odes*, the poet Horace wrote in response: *Nunc est bibendum nunc pede libero pulsanda tellus!* ("Now is the time for drinking, now, with unshackled foot, for dancing!"). Octavian took power, and Horace hailed him as "Caesar," which, for the first time, became an honorific title.

Gaius Julius Caesar Octavianus held both military command (*imperium*) and tribunician power (spokesperson for the people); he was both chief priest (*pontifex maximus*) and first citizen (*princeps*). He was also politically astute enough to adorn reality with palatable outward forms, replacing democracy with autocracy in a way that did not antagonize the public. He called on the services of culture, religion, literature, architecture, and the visual arts to help create a new picture of the world, with the result that there was a politically inspired aesthetic revolution, which led to the legalization of absolute power. In 27 B.C.E., Octavian formally divested himself of all authority. In response, the Senate and the people promptly gave it back to him, voting him the title Augustus (the Fortunate and Blessed). Although he was never officially "emperor" of Rome at all, within four years he had assumed complete power—including the right of veto over any law. The Republic was formally dead.

During the forty-five years that Augustus ruled (31 B.C.E.–14 C.E.), the Senate and popular assemblies continued to meet. However, the election of consuls, proconsuls, tribunes, and other officials required his blessing, the Senate was filled with Augustus' friends, and the popular assemblies seem to have lost all political function. As commander of the armies, he ruled all the vast territories of an empire that reached to the Rivers Rhine and Danube in what is now Germany.

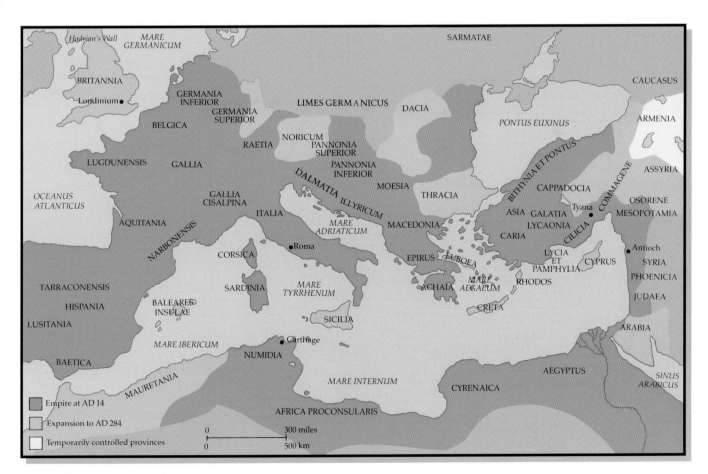

Map 4.2 The Roman Empire 14–284 C.E.

He commanded in the name of his uncle, Julius Caesar, and on the basis of his own military victories, claiming that he brought peace and order after a century of civil wars. He rebuilt temples to the Olympian gods, the "divine" Julius Caesar, and to "Rome and Augustus." He built roads, bridges, and aqueducts, established a sound currency, created the first full-time police force and firefighters, nurtured honest government, and maintained peace, which lasted nearly two hundred years.

Pax Romana

"The Roman Peace" (*Pax Romana*) brought under a single government a huge geographical area (Map **4.2**). The Augustan heritage carried forward during the first and second centuries by a number of excellent emperors—for example, Claudius, Trajan, Hadrian, and Marcus Aurelius. The city of Rome spread out across its "seven hills" (Fig. **4.3**) and Roman citizenship included the peoples of Italy and the far-flung provinces, which meant that they were equal to their conquerors and could serve in the army, the bureaucracy, and higher levels of government. Roman administration and Roman law kept order, prosperity, and peace intact. The Roman administrative system developed a closely supervised hierarchy of professional officials, who made the machinery of day-to-day living work for the people. At its height, the Roman Empire covered more than 3 million square miles (7.78 million square kilometers): just slightly less than the size of the United States of today, with a population of approximately 80 million. A system of roads reaching out from a central hub at Rome linked the entire empire. Wherever the Romans went, they took their culture. Roman theatres, for example, were built in Orange, France, and Sabratha in North Africa.

The age was not entirely free of calamities and tyrants—in the modern sense of the word. Along with good emperors came the insane Caligula (kuh-LIG-yoo-luh) and Nero, who crucified Christians and drove Gaul to revolt. Anyone who took up arms against Rome had their right hand severed as punishment. Overall, however, the empire enjoyed a time of peace and prosperity (Fig. **4.4**).

The best of times ended at the end of the reign of Marcus Aurelius (MAHR-kuhs oh-REEL-ee-uhs;

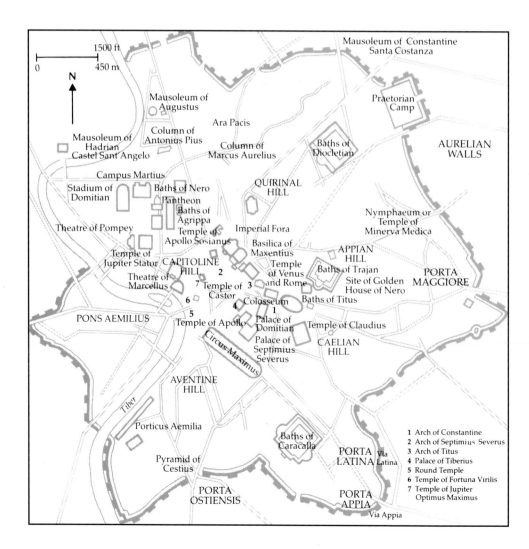

4.3 Imperial Rome.

THE ARTS OF THE ROMAN PERIOD
Painting

Very little Roman painting has survived. Most of what survives has bright colors, in **fresco**—painting on wet plaster that becomes a permanent part of the wall surface—and much of that art seems inspired by Greek classical and Hellenistic work. Many Greek artists and craftspeople were brought to Rome, and they produced most early Roman art, so, not surprisingly, Roman painting reflected classical and Hellenistic themes and styles, although certain uniquely Roman qualities were added. The illustrations that appear in this chapter may not be typical of Roman painting. They do, however, typify what survives.

In the painting of the *Lady Playing the Cithara* (Fig. **4.6**), attentive detail merges with an everyday subject matter. From this illustration we get a taste of Roman clothing, hair style, accessories, and furniture. The ornately turned legs of the chair and the gold embossing indicate careful and skilled craftsmanship as well as opulence. Notice how carefully and naturalistically the artist has rendered the folds of the fabric.

Roman wall painting may combine landscape representation with painted architectural detail (Fig. **4.7**). Often, the outdoor view appears as a panoramic vista seen through a **trompe l'oeil** (trahmp-LOY) window. The term "trompe l'oeil" means "trick of the eye" or "fool the eye," and artists employ it in two-dimensional artworks in order to give a fake impression of three-dimensionality. Here we see a Roman manifestation; in Chapter 10 the High Renaissance painter Michelangelo will also use this device. Rooms

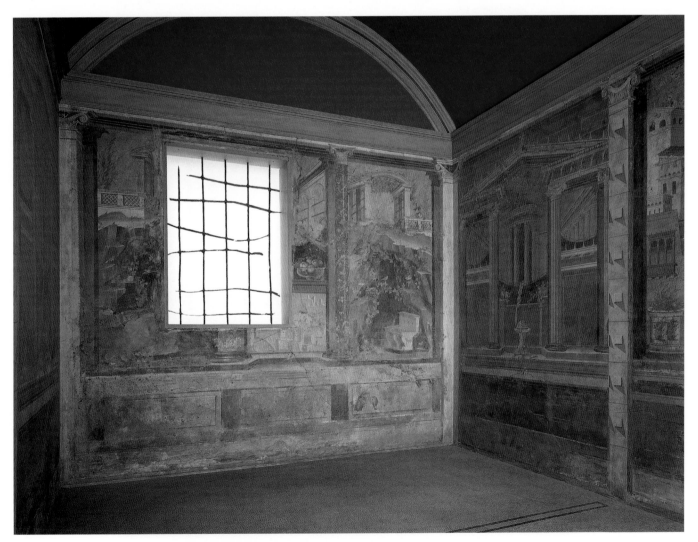

4.7 Bedroom from villa of P. Fannius Synistor (detail no. 7) at Boscoreale, Italy, showing painted decorations, c. 50 B.C.E. Fresco on lime plaster, average height 8 ft (2.44 m). Metropolitan Museum of Art, New York, Rogers Fund, 1903 (03.14.13).

painted in this style reflect the tastes of late Republican aristocratic society. They took as their models the opulence and stylishness of the late Hellenistic princely courts, which still held influence around the Mediterranean.

Although less well known than Pompeii (pohm-PAY-ee), the city of Herculaneum (hur-kyoo-LAY-nee-uhm) provides us with excellent examples of wall painting from the Roman Empire period, preserved by the ash and lava of Mount Vesuvius' cataclysmic eruption in 79 C.E. In these works, as well as in works from Pompeii, we see that, as in wall painting from the Republican era, brightly colored frescoes predominated. These works also share the lifelikeness of their predecessors. The wall painting

Hercules and Telephos (TEL-eh-fohs; Fig. **4.8**) uses highlight and shadow to create lifelike flesh and musculature as well as intricately detailed fabric in the Hellenistic style. Here we see mythical and heroic subject matter: Hercules' discovery of the infant Telephos in Arcadia. Hercules, the dynamic figure on the right, reveals warm flesh and sinewy musculature, full of life and warmth. In contrast, the personification of Arcadia, the semireclining figure, seems distant and remote—as cold as a piece of sculpture. The lion shows quick, rough brushstrokes, which stand in stark contrast to the smooth, delicate treatment of the doe in the lower left. Above Arcadia, a playful Pan with his pipes shows an almost offhand treatment, as flippant as his smirk.

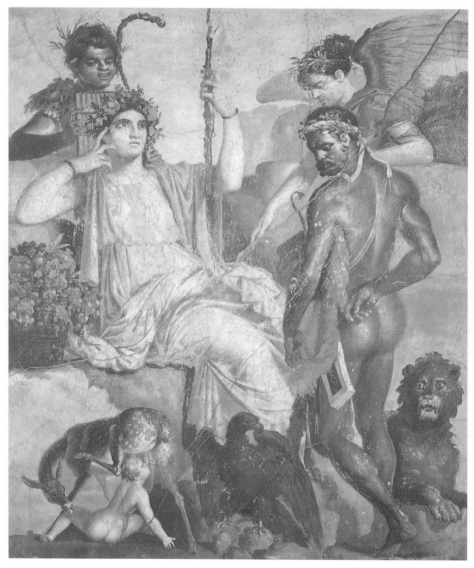

4.8 *Hercules and Telephos,* Roman copy of a Greek work of the second century B.C.E. Wall painting from Herculaneum, 5 ft 7½ ins (1.71 m) high. Museo Archeologico Nazionale, Naples, Italy.

A DYNAMIC WORLD

CHINESE PAINTING

At almost the same time as the Roman Empire, the Han dynasty gave China a great empire in the East. The two empires had much in common—both covered vast areas and contained tremendous populations, and in each power was concentrated in the hands of an emperor and an immense, centralized bureaucracy. Like Rome, China perceived itself as the only true civilization, surrounded by barbarians, and in both cases, a significant breakdown of authority occurred early in what we call the Christian era. Interestingly, the two great empires knew of, and, indirectly, traded with, each other.

The Han dynasty produced remarkable scholarship and artistry. Three styles of painting existed during the period of the Han dynasty that spanned the first century C.E. The first style was a rather formal and stiff style, very geometric and **hieratic** (somewhat like the Byzantine style of Chapter 6), in which the figures were flat and outlined. In contrast, the second style depicted lively action and deep space. The third was midway between the two previous styles, being more painterly and exhibiting movement and lively depictions of, for example, mythic beings, dragons, and rabbits. As can be seen in Figure **4.9**, a tile taken from the lintel and pediment of a Han tomb, masterfully rendered figures are drawn with brushstrokes that suggest liveliness and movement. The figures appear in three-quarter poses, which gives the painting a sense of depth and action, and the active line, with its diagonal sweeps, adds to the sense of action. The poses of the people suggest character—that is, the psychology of the figure portrayed—but although the use of pose and direction reflects a sophisticated approach and technique, the figures remain on the same baseline, with no sense of placement in deeper space.

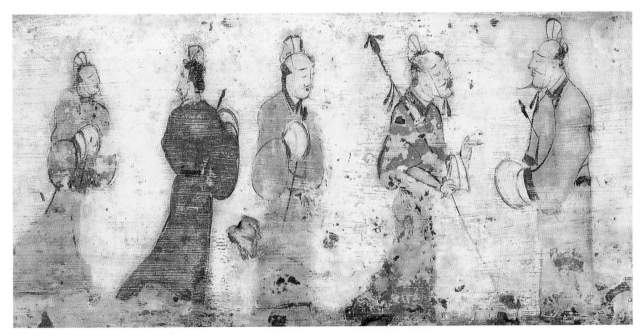

4.9 Lintel and pediment of tomb, Han dynasty, 50 B.C.E.–50 C.E. Earthenware, hollow tiles painted in ink and colors on a whitewashed ground, 28⅞ × 94¾ ins (73.3 × 240.7 cm). Museum of Fine Arts, Boston (Denman Waldo Ross Collection).

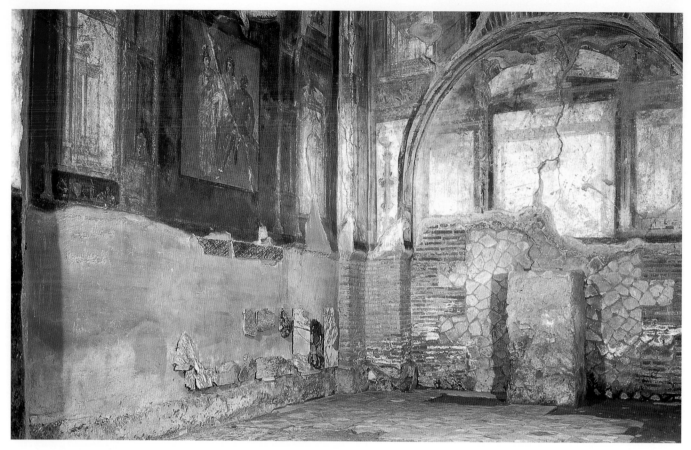

4.10 Wall decoration, c. 70–79 C.E. Wall painting, room dimensions 14 ft 2 ins × 13 ft 4 ins (4.32 × 4.06 m). Collegium of the Augustales, Herculaneum, Italy.

A second example from Herculaneum (Fig. **4.10**) exemplifies the Roman taste for forceful colors and the painted "architectural structuring" of large areas. Paintings form a permanent part of the wall and are "framed" with painted architectural detail. This particular painting comprised a shrine devoted to the cult of the emperor, and the central panel, which depicts the introduction of Hercules into Olympus in the presence of Minerva and Juno, is a metaphor for the divinity of the emperor.

All the illustrations of Roman wall decoration in this chapter, whether of the earlier Republican or of the Imperial period, demonstrate the colorfulness of Roman interior design. The style of the painting reveals theatricality, but it has a permanence, not only in that it forms an integral part of the wall, but also in that each panel contains an architecturally complete composition enclosed in a painted "frame."

Sculpture

Not all Roman art imitated Greek prototypes, although some Roman statues did. Some Roman sculpture

expresses a uniquely Roman vigor. Scholars do not always agree on what particular works of Roman sculpture mean or on why they were made. For example, the *Portrait of an Unknown Roman* (Fig. **4.11**) shows a "veristic" or highly lifelike representation. Etruscan–Roman religious practice undoubtedly had a strong influence. Portraits formed an integral part of household and ancestor worship, and the family often made wax death masks to remember a loved one. Wax does not ideally suit immortality, and possibly the bust in Figure **4.11** was made from a death mask. There may be more to this portrait, however, than mere accuracy. Some scholars point to an apparent emphasis on certain features which reinforces the ideas of ruggedness and character.

The straightforward lifelikeness of the Roman Republic modified during the Augustan period. Although Hellenistic influence grew strong by the late first century B.C.E., Greek classical influence predominated in some quarters, but with a Roman—a more pragmatic and individual—flavor. By the time of the Empire, classical influence had gained precedence. Augustus (Fig. **4.12**) boasted that when he came to power, Rome was a city of sundried bricks, and that

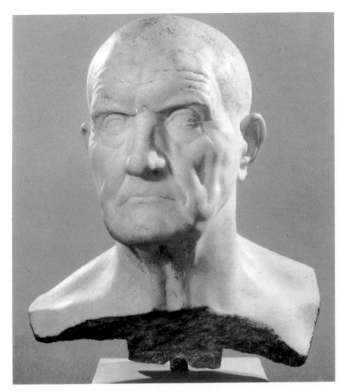

4.11 *Portrait of an Unknown Roman*, first century B.C.E. Marble, 14⅜ ins (36.5 cm) high. Metropolitan Museum of Art, New York (Rogers Fund, 1903).

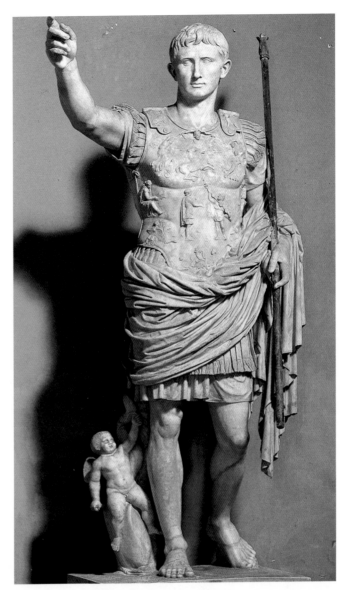

4.12 *Augustus in Armor*, Villa of Livia, Prima Porta, c. 20 B.C.E. Marble, 6 ft 8 ins (2.03 m) high. Vatican Museums, Rome.

when he left it, it had become a metropolis of marble. Greek classical form in sculpture revived and translated into vital forms for the Romans. The Greek concept of the "perfect body" held sway. The aesthetics of sculptural depiction thus remained Greek. The pose, rhythm, and movement of the body originated in the past.

At this time much sculpture portrayed the emperor. Emperors had been raised to the status of gods, perhaps because in so far-flung an empire it was useful for people to revere their leaders as superhuman.

Other sculptures told the story of a leader's accomplishments. Trajan's (TRAY-juhn) Column, erected in the Emperor's Forum, rose 128 feet (39 meters) above the pavement on an 18-foot (5.5-meter) base. Atop the 97-foot (30-meter) column stood a more than twice lifesize statue of Trajan (Fig. **4.13**). (Trajan's statue was later replaced by a figure of St Peter.) Inside the column, a staircase winds upward to the top. The outside, from bottom to top, exhibits a spiral band of relief sculpture (Fig. **4.14**). Trajan himself appears ninety times in the narration, each appearance marking the start of a new episode.

The sculpture relies on **symbolism** and convention, representing water by a waving line; mountains, by

jagged lines. Proportions remain stylized, and perspective, irrational.

We have touched already on the death mask as Roman funerary art. The intricate relief sculpture which decorated Roman **sarcophagi** (sahr-KAWF-uh-jy) shows the way that Roman art reflected private life. This type of sculpture emerged early in the second century C.E., when the practice of cremation fell out of favor. Marble sarcophagi were adorned with rich and varied relief decoration. Three major centers of sarcophagus production existed—Athens, Asia Minor, and Rome— and sarcophagi were often exported before completion and finished at the site. Attic sarcophagi had decoration

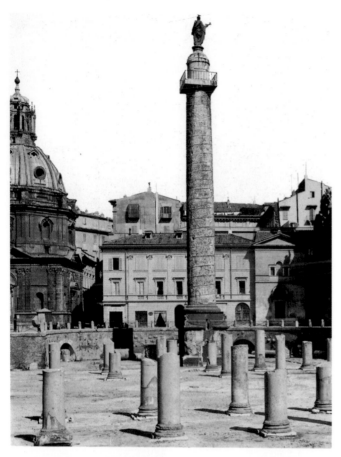

4.13 Apollodorus of Damascus, Trajan's Column and ruins of Basilica Ulpia, Rome. Trajan's Column, 106–13 C.E. Marble, base 18 ft (5.49 m) high, column 97 ft (29.57 m) high.

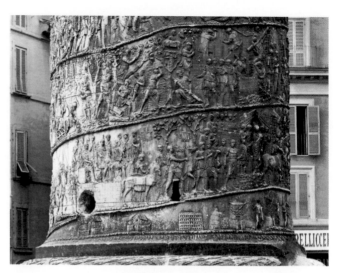

4.14 Trajan's Campaign against the Dacians, detail of Trajan's Column, 106–13 C.E. Marble, frieze band 4 ft 2 ins (1.27 m) high.

on all four sides, with scenes drawn from Greek mythology. They were typically carved in high relief, with a somber tone. Sarcophagi from Asia Minor had figures carved almost in the round, against a background of architectural detail. Roman sarcophagi were carved on three sides, with the fourth side designed to sit against a wall. The front typically showed a mythological scene, while the ends showed decorative motifs in low (bas-) relief (Fig. 4.15).

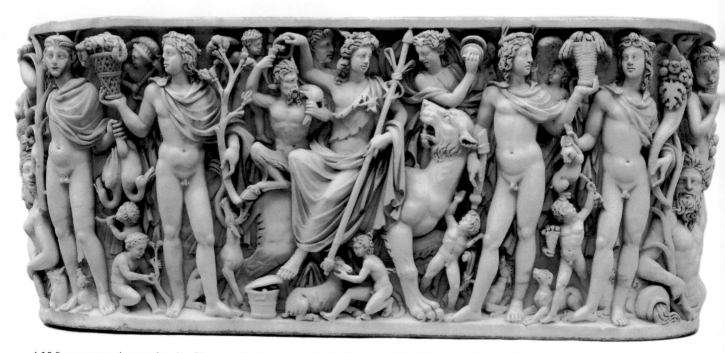

4.15 Roman sarcophagus, showing Dionysus, the Seasons, and other figures, c. 220–230 C.E. Marble, 7 ft 3¾ ins (2.23 m) long. Metropolitan Museum of Art, New York (Purchase, Joseph Pulitzer Bequest, 1995).

Architecture

Given the practicality of the Roman mind, not surprisingly we find a distinctive Roman style most evident in architecture. The clarity of form we found in the post-and-lintel structure of the classical Greek temple presents itself in the Roman arch, but while in Greek architectural composition the part subordinates to the whole, in Roman architecture each part often carries its own significance. As a result we can usually surmise the appearance of a whole structure from one element.

Little survives of the architecture of the Republican period, but the use of Corinthian features and the graceful lines of what remains suggest a strong Hellenistic influence. Notable differences, however exist. Hellenistic temples were built on an impressive scale (see Fig. **3.22**; Temple of the Olympian Zeus). Classical Greek temples were smaller, and Roman temples were smaller still, principally because Roman worship was mostly a private rather than a public matter.

Roman temple architecture employed **engaged columns**—columns partly embedded in the wall—and as a result, Roman temples lacked the open colonnades of their Greek counterparts, and this gave them a closed, slightly mysterious atmosphere. The Temple of Fortuna Virilis (Fig. **4.16**), which dates from the second century B.C.E., the earliest well-preserved example of its kind, shows Greek influence in the delicate Ionic columns and entablature, but Etruscan elements also exist in the deep porch and engaged columns necessitated by the wide **cella**, or main enclosed space. (The one-room cella departs from the Etruscan convention of three rooms.) The Romans used the cella for displaying trophies from military campaigns, as well as to house the image of the deity.

In the Augustan age at the beginning of the Imperial period, Roman architecture, like contemporary sculpture, took Greek classical style. This accounts to a large extent for the dearth of surviving buildings from previous eras

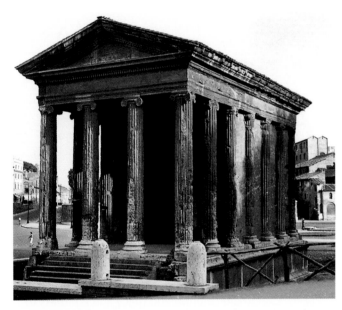

4.16 Temple of Fortuna Virilis, Rome, late second century B.C.E. Stone.

since old buildings were replaced with new ones, in the new style. Temples were built on Greek plans, but the proportions differ significantly from those of the classical Greek.

The first through the fourth centuries C.E. brought what we now typically identify as the "Roman style." The most significant characteristic of this style comprises the use of the arch as a structural element, in groin and **tunnel vaults** and **arcades** (Figs **4.17** and **4.18**; see also Fig. **0.8**). The Colosseum (Figs **4.22** and **4.23**), the best-known of Roman buildings and one of the most stylistically typical, could seat 50,000 spectators. A marvel of engineering, it combined an arcaded exterior with vaulted corridors. The circular sweep of its plan and the curves of the arches counter the vertical lines of the engaged columns flanking each arch. The columns at each level show different orders, and progress upward from heavy Doric columns, to Ionic ones, to lighter Corinthian ones at the top level.

4.17 Tunnel vault.

4.18 Arcade.

MASTERWORK

THE PANTHEON

As its name suggests, the Pantheon (PAN-thee-ahn; Figs **4.19**, **4.20**, and **4.21**), designed and built by Hadrian, honored all the gods. The structure brought together Roman engineering, pragmatism, and style in a domed temple of unprecedented scale.

Until the mid-nineteenth century, only two buildings had equalled the span of its dome, and during the Middle Ages, people suspected that demons might be holding up the roof of this pagan temple. Around the circular interior statues of the gods stood in **niches** (NIHCH-ehz) in the massive walls. Corinthian columns add grace and lightness to the lower level. Heavy horizontal moldings accentuate the feeling of open space under the huge dome. The dome itself reaches 143 feet (44 meters) in both diameter and height (from the floor to the **oculus**, or eye, the round opening at the top of the dome). The circular walls supporting the dome stand 20 feet (6 meters) thick and 70 feet (21 meters) high. Square

coffers on the underside of the dome give an added sense of lightness and reflect the framework into which concrete was poured. Originally the dome's interior had gilding to suggest "the golden dome of heaven."

In both plan and cross-section the Pantheon describes a perfect circle (Fig. **4.20**). From the exterior, we see a simple, sparsely adorned cylinder capped by a gently curving dome. We enter via a porch in the Hellenistic style with graceful Corinthian columns. Originally the porch had a series of steps and a rectangular forecourt, so what remains reflects only part of a larger, more complex original design.

Inside, both the scale and the detail overwhelm, but the way in which practical problems have been solved impresses equally. The drum and dome consist of solid monolithic concrete reinforced with bands of vitrified tile. Arches incorporated in the concrete collect and distribute the vertical gravity loads to the drum. The wall of the 20-foot-thick drum has alternating rectangular and curved niches cut into it,

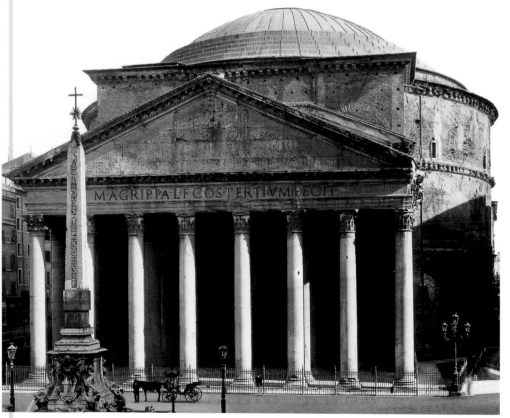

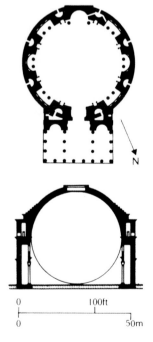

4.19 (*left*) Pantheon, Rome, c. 118–28 C.E. Marble, brick, and concrete.

4.20 (*above*) Plan and cross-section of the Pantheon, Rome.

thus forming a series of massive radial **buttresses**. Drains cut into the slightly concave floor of the building carry away any rain that falls through the oculus above.

What captures our immediate attention is the sense of space. In most Egyptian and Greek architecture, the focus rests on mass—the solids of the buildings. Here, despite the scale and beauty of the solids, the vast openness of the interior strikes us. This exemplifies Roman inventiveness and pragmatism at its best, yet the atmosphere of the building belies practical achievement with sublimity.

How could the Romans build such a colossal structure? Some historians argue that the key lies in a new building technology made possible by concrete containing a specific kind of cement newly developed near Naples. The secret, however, may lie in the mysterious rings around the dome. As a study at Princeton University suggests, they probably "perform a function similar to the buttresses of a Gothic cathedral. . . . The extra weight of the rings . . . helps stabilize the lower portion of the dome. Rather than functioning like a conventional dome, the Pantheon behaves like a circular array of arches, with the weight of the rings holding the end of each arch in place."[2]

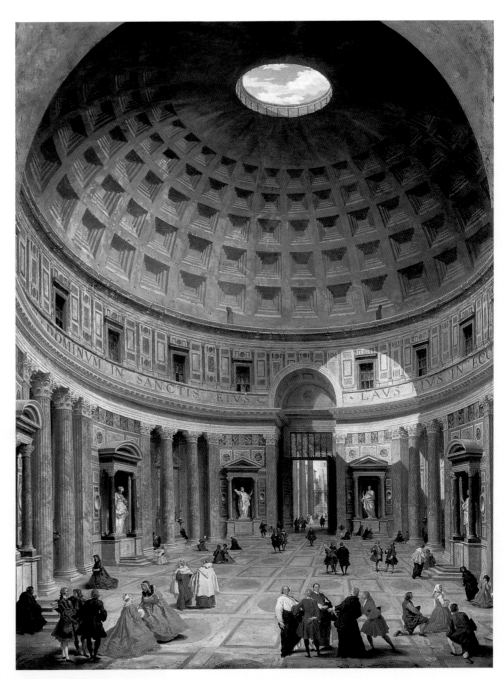

4.21 Giovanni Paolo Panini, *Interior of the Pantheon*, c. 1740. Oil on canvas, 4 ft 2 ins × 3 ft 3 ins (127 × 99 cm). National Gallery of Art, Washington D.C. (Samuel H. Kress Collection).

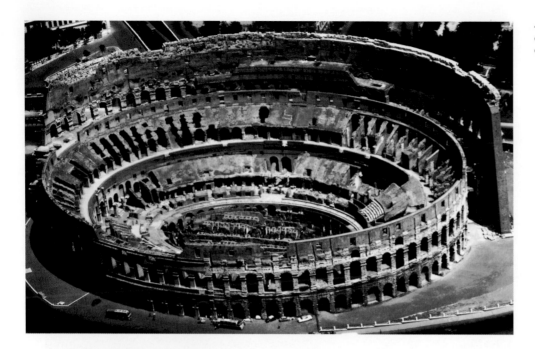

4.22 Colosseum, Rome, c. 70–82 C.E.. Stone and concrete, 159 ft (48.5 m) high.

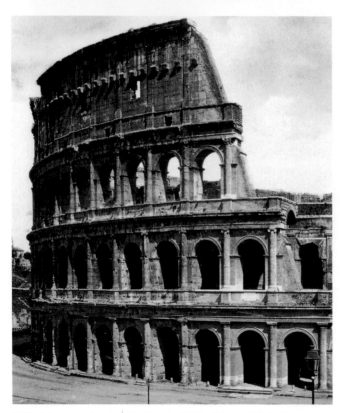

4.23 Colosseum, interior 616 ft 9 ins (188 m) long; 511 ft 10 ins (156 m) wide.

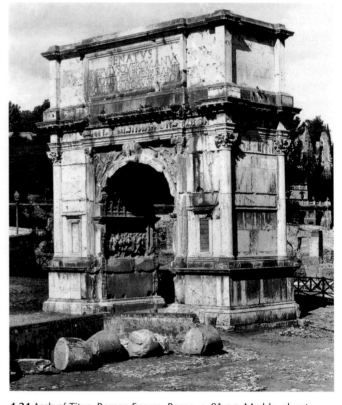

4.24 Arch of Titus, Roman Forum, Rome, c. 81 C.E. Marble, about 50 ft (15 m) high.

T E C H N O L O G Y

CEMENT

In their rapid conquests, the Romans learned quickly to appreciate and to copy other people's mechanical devices. The major contribution to technological development made by the Romans was probably their ability to absorb ideas and then to provide the administrative underpinnings to allow those ideas to be used to their fullest. Many technological practices are credited to Rome, but, in fairness, a large number of these had been invented and practiced elsewhere before the Romans acquired them. Even aqueducts, a much-vaunted Roman innovation, had seen predecessors in Greece, Assyria, Babylonia, Persia, and Egypt, and the same was true of drainage systems, which, as we noted, were part of the technology of Minoa. Roman roads were no better than those in Greece and Persia.

One of the truly original contributions of Rome to technology was the introduction of cement. In addition to its uses as a bonding material, the Romans discovered that it could be used in the making of **concrete**, which, when combined with a brick facing, allowed them to construct solid arches, thus

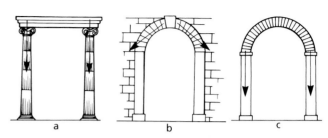

4.25 Diagram showing the stresses involved in (a) the Greek post and lintel; (b) a true arch; and (c) the Roman arch.

eliminating the need for buttressing (Fig. **4.25**). This type of arch was seen most frequently in the construction of aqueducts, but the development of the brick-and-concrete arch may also be considered a major Roman contribution to technology. Essentially, this consisted of a brick arch reinforced with a heavy infill of concrete. Once the concrete set, the arch became a vast lintel that exerted little lateral pressure. Thus, the pillars that supported it required no supporting buttresses.

Placed in the center of the city of Rome, the Colosseum hosted gladiatorial games and other spectator sports. Emperors competed with their predecessors to produce the most lavish spectacles there. The Colosseum was a new type of building, called an **amphitheatre**, which combined two semicircular theatres, facing each other, to form an arena surrounding an oval interior space. Originally, a system of poles and ropes supported awnings to shade spectators. The space below the arena contained animal enclosures, barracks for gladiators, and machines for raising and lowering scenery.

Roman triumphal arches are also impressive architectural monuments. The Roman classical style survives in a memorial to Titus (TY-tuhs), raised by his younger brother, Domitian (doh-MIH-shun).

The Arch of Titus (Fig. **4.24**) was a political gesture of homage to the accomplishments of Titus and his father, Vespasian, during the conquest of Jerusalem. The reliefs on the arch illustrate historical and allegorical events. Titus appears as *triumphator*, along with figures such as the *genius Senatus*, or spirit of the Senate, and the *genius populi Romani*, or spirit of the people of Rome. The richly and delicately ornamented façade of

this arch stands in marked contrast to its massive internal structure. This marks an important characteristic of Roman architecture, which distinguishes it from Greek principles that outwardly express the structure.

The Forum of Augustus in Rome (Fig. **4.26**) exemplifies monumental Imperial art at its classical and

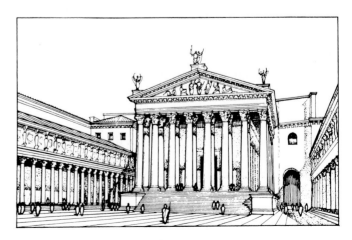

4.26 Temple of Mars the Avenger, Forum of Augustus, reconstruction view.

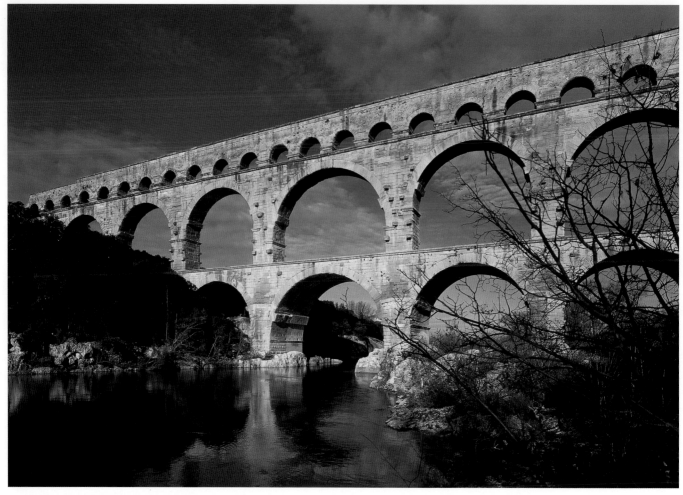

4.27 Roman aqueduct at the Pont du Gard, Nîmes, France.

utilitarian grandest. In both its conception and its dimensions, it speaks of greatness. Constructed from war booty, the Forum honors Mars the Avenger, to whom Octavian had made a vow during his wars against the assassins of Julius Caesar. The Forum's style reflects Augustus' view that in all the arts the Greeks had achieved perfection in the classical style. Yet, we can see that the Temple of Mars deviates slightly from the classic Greek proportions of the Parthenon (see Chapter 3) and adds Corinthian orders as well as sculptural embellishments on the roof above the pediment. Nonetheless, all this served to establish Augustus as the *summi viri*, or the greatest "among all the great men of Roman history."[3]

Roman engineering not only made heating and cooling possible within homes, but it also created huge masonry structures for channeling water tremendous distances. Aqueducts such as that of the Pont du Gard at Nîmes in France (Fig. **4.27**) remind us of just how ingenious and pragmatic the Romans were.

Theatre

Comedy

The Romans loved entertainment. Roman comedy was wild, unrestrained, lewd, and highly realistic. Accounts of stage events suggest that very little was left to the audience's imagination. Actors wore various masks, and grotesquely padded costumes.

As Roman comedy developed in the third and second centuries B.C.E., it borrowed much from Hellenistic comedy, with its large theatres, high stages, and elaborate scene buildings (see Chapter 3). The Romans liked comedy, and assimilated it quickly, and the importation of Greek comedy led to the rise of two of Rome's most important playwrights, Plautus (c. 254–184 B.C.E.) and Terence (c. 185–159 B.C.E.).

The twenty plays by Plautus (PLAW-tuhs) that survive provide a picture of a playwright who acted principally as a translator and adaptor. He copied Greek

originals, changing the locations to Rome and inserting details of Roman domestic life. He used character types, not individuals: the braggart soldier, the miser, the parasite, and the wily but mistreated slave. With their slapstick humor and "sight gags," Plautus' plays burst with farcical energy and appeal directly to the emotions, not the intellect. Although not particularly well written, they work well enough on stage.

Terence, better educated than Plautus and a more literary writer, enjoyed the support of a wealthy patron. In his six extant plays he appears capable of drawing universal situations and characters. Like Plautus, he had a great influence on the theatre of later ages, but he proved not particularly popular with Roman audiences, perhaps because he did not use banality and buffoonery.

Adhering to typical Roman pragmatism, theatre fulfilled an important social function in keeping the minds of the masses off their problems. Yet it also served as a forum in which the general public could address grievances to the bureaucracy. When an official of the state had betrayed his trust, when a wrong had been suffered, or when an impropriety of state had become flagrant, the bite of Roman satire could be fierce, direct, and penetrating.

Blood Sport

Although we may not think of it in formal terms as theatre, blood sport had most of the trappings of theatre for the Romans and for other Mediterranean cultures that embraced it. A typical "performance" opened with the *pompa* or procession which featured the trainers, sponsors, and, of course, the gladiators. The acts included "lesser" animal fights, and, finally, the intermissions when public executions took place. These intermission-executions had nothing directly to do with blood sport. The gladiatorial fights were the featured performances and the majority of gladiators, by the late Republic, were not slaves but volunteers who willingly forfeited their rights and property, and pledged not only to suffer intensely but to die fighting.

Although gladiators may have been considered monsters outside the arena, they displayed, or "performed," what it meant to be Roman while they fought. The concept of *virtus* (honor above life), a specifically male trait to the Romans, was most often applied to the gladiator who fought well or continued to struggle even after defeat. If a gladiator displayed these honorable traits but was clearly at the end of a losing bout, a display of *virtus* would enable him or her to raise one finger—the plea for clemency or mercy. Because Romans showed more interest in a good fight than in bloodshed for its own sake, they could, and it seems usually did, grant *missio* or clemency for combatants so that the gladiator could fight another day.

Interestingly, this need for gladiators to display *virtus* in victory as well as in defeat (as in "baring one's neck") caused more conservative Romans to find it difficult to appreciate the Christian concept of martyrdom. Marcus Aurelius, when witnessing Christians making, in his mind, a show out of their deaths, complained that "Christians were shameless exhibitionists in their zeal for martyrdom." Marcus Aurelius, the Stoic emperor we noted earlier, expressed in Stoic fashion that Christians essentially debased the games.

The animal fights, however, provide evidence of the most elaborate theatrical performances. They included elaborate costumes and stage props, and a strong interest in illusions which would accompany the performing of debased Greek myths. For example, in one documented case, in Rome, the myth of Icarus involved the illusion of flight. The "fantasy" abruptly shattered when the sorry individual came crashing back to earth—only to be met by a group of hungry lions.[4]

Music

Music was very popular among the Romans. Contemporary reports describe festivals, competitions, and virtuoso performances. Many Roman emperors were patrons of music, and Greek music teachers enjoyed popularity and high pay. Large choruses and orchestras performed regularly, and the *hydraulos* (hy-DRAWL-ohs), or water organ, proved a popular attraction at the Colosseum (Fig. 4.28). The *hydraulos* was apparently so loud that it could be heard a mile away, and the fact that it provided "background music" for the spectacles of feeding Christians to lions meant that it was banned from Christian churches for centuries.

Aristotle deplored professionalism in the pursuit of music. Music, he believed, existed for its own aesthetic qualities and as a moral force in character development. It was a measure of intelligence. The pragmatic Romans did not see it this way. Professional dexterity and *virtuosity* comprised social assets, and meaningless accomplishments, such as blowing the loudest tone or holding the longest note, drew great acclaim. Musical entertainment did fulfill an important social and political function for the Romans, however. As more and more people flocked to Rome from conquered territories, the numbers of the poor grew. The state began to provide entertainments to keep them occupied and under control. "Bread and circuses" became the answer to the dissatisfactions of the poor and the oppressed, and music also played an important role. As a result, music became less an individual pastime and more an exclusively professional activity.

4.28 Roman *hydraulos*, copy of graffito in the church of St Paul, Rome, fourth century C.E.

The Romans seem to have contributed little to musical practice or theory. They took their music direct from Greece after it became a Roman province in 146 B.C.E., adopting Greek instruments and theory. But they did invent some new instruments, principally brass trumpets and horns for military use.

Dance

The Romans created the unique dance form of **pantomime** invented by Pylades of Cilicia (PY-luh-deez; sil-IH-shuh) and Buthyllus (boo-THY-luhs) of Alexandria, around 22 B.C.E. They brought together a number of dance elements, some of which dated to prehistoric Greece. Although the words "**mime**" and "**pantomime**" sometimes appear interchangeably in our vocabulary, they constituted very different art forms. Pantomime was serious and interpretative. Some pictorial evidence suggests that a single dancer portrayed many

roles by changing costumes and masks. Wind, brass, and string instruments played as the dancer leapt, twisted, and performed acrobatic feats. The interpretation of delicate emotions also played a part. Pantomimes often had tragic themes, apparently taken from Greek and Roman tragedies and mythology. But many pantomimes also had a distinctly sexual orientation that some sources call pornographic.

This dance form fell into disfavor as its lewdness increased. Treated comically, lewdness may have been tolerable, even endearing. The same subject matter treated seriously, however, may have become tedious or obnoxious, even to the pragmatic (and decadent) Romans. The more notorious emperors, such as Nero and Caligula, apparently loved pantomime, as did certain of the populace. Eventually, however, pantomimists were forced out of the major cities to the provinces. These itinerant entertainers may have helped to keep theatrical dance alive through the Middle Ages and into the Renaissance.

Literature

The pragmatic early Romans did not produce any remarkable literature. When literature as an art form did become reasonably popular, Greek slaves nurtured it. The first literary works imitated Greek works, written in Greek. Educated Romans considered Latin a peasant language, with few words capable of expressing abstract notions. A Latin prose style and vocabulary for the expression of philosophical ideas had to wait.

We call the first great age of Latin literature, from approximately 70 to 43 B.C.E., the Ciceronian Age after Cicero, a great Roman statesman, orator, poet, critic, and philosopher. Cicero perfected the Latin language as a literary medium capable of expressing abstract and complicated thoughts with clarity. The Ciceronian Age and the Augustan Age that followed constitute the Golden Age of Latin literature. We have a wealth of persons and works to choose from, but we limit ourselves to nine: Vergil, Horace, Livy, Plutarch, Catullus, Lucretius, Petronius, Juvenal, and Apuleius. We could also include Marcus Aurelius, whose philosophy and works we noted earlier in the Concepts section of the chapter.

During his reign, Augustus commanded the poets Horace and Vergil to write verses glorifying the emperor, the origins of Rome, the simple honesty of rural Roman life, patriotism, and the glory of dying for one's country. Livy set about retelling Roman history in sweeping style. Vergil's *Aeneid*, an epic account of the journey of Aeneas from the ruins of Troy to the shores of Italy, far surpasses mere propaganda.

PROFILE

VERGIL (70–19 B.C.E.)

Rome's greatest poet, Publius Vergilius Maro, loved the rural countryside. Born a peasant, he focused the central force of his poetry on people. His writings also reveal his thorough education in Cremona, Milan, and Rome and the influence of the Epicureans and Stoics, central to the rhetoric and philosophy of his studies. Shy and retiring, he seems never to have participated in politics or the military; he remained a poet first and foremost. Nevertheless, he kept in close contact with current events, and his works often reflect an overview of contemporary Roman life.

His first work, the *Eclogues* (EK-lawgs), brought him immediate recognition and access to the exclusive literary circles of Rome. The following years, 37–30 B.C.E., he spent writing the *Georgics*, and occupied the remainder of his life with the *Aeneid* (ih-NEE-ihd; ee-NEE-ihd), which is to Rome what the *Iliad* and the *Odyssey* are to Greece.

The twelve books of the *Aeneid* tell the story of Rome, and in them Vergil sought to present to his readers the qualities of Roman character and Roman virtues that had made the city great. The first six books tell the story of Aeneas' wanderings—as Homer had told of Ulysses' travels in the *Odyssey*—and the final six books set the scenes of battle—as Homer did in the *Iliad*. Further internal similarities exist as well.

Vergil probably has had greater influence on literature and Western thought than any other classical poet. His poetry reflects consummate skill in the use of diction, rhythm, and word music. Above all, he captures a quality of the human condition, elevated to a grand scale, with which every human being can identify. At the time of his death, Vergil was highly troubled by the imperfections he found in the *Aeneid*, and he wanted to burn it. However, the Emperor Augustus refused to allow the work to be destroyed and had it published, with some minor revisions, two years after the poet's death.

Vergil (see Profile, left) in the *Aeneid* tells not only the story of the legendary founding of Rome by Aeneas of Troy, but further, as a kind of dual birth, the Roman unification of the world by Augustus—both events viewed as extraordinary tasks, glorious achievements, and divinely ordained necessities. Thus, as we noted in the discussion on the concepts of utilitarianism and pragmatism, Vergil serves practical ends with his narrative.

Vergil presents Aeneas as the founder of Roman greatness by making him the founder of Lavinium, the parent town of Alba Longa and Rome. Aeneas had been told, as he left the burning ruins of Troy, that he was fated to found a new city with a glorious destiny in the west.

In Book I, Aeneas, traveling to his fated destination, runs into foul weather which forces him to land his fleet on the coast of Libya, where he is welcomed by the widowed Dido, queen of Carthage. In Books II and III, Aeneas tells Dido of the natural and supernatural events that led him to her shore. In Book IV, Dido confesses her love for Aeneas. Aeneas, however, regretting his fate, must set sail again—forced to do so by the gods. Dido prepares to kill herself. Book V finds the Trojans journeying to Sicily, where they engage in a series of contests to commemorate the death of Aeneas' father, Anchises. Then they cast off again. Book VI tells of Aeneas' journey to the underworld and Elysium, where he meets the ghosts of Dido and Anchises. Aeneas learns of the destiny of Rome. In Books VII through XII, the Trojans reach the Tiber River and are received by Latinus, the king of the region. Spurred by the gods, other Latins resent Aeneas and the Trojans' arrival and the proposed marriage of Aeneas to Lavinia, daughter of Latinus. War ensues, but the Trojans, with the help of the Etruscans, emerge victorious. Aeneas marries Lavinia and founds Lavinium.

Here is a brief excerpt from the beginning of Book I:

> Arms and the man I sing, who first made way
> Predestined exile, from the Trojan shore
> To Italy, the blest Lavinian strand.
> Smitten by storms he was on land and sea
> By violence of Heaven, to satisfy
> Stern Juno's sleepless wrath; and much in war.
> He suffered, seeking at the last to found
> The city, and bring o'er his fathers' gods
> To safe abode in Latium; whence arose
> The Latin race, old Alba's reverend lords,
> And from her hills wide-walled, imperial Rome.[5]

Horace (b. 65 B.C.E.) was an outstanding Latin lyric poet and satirist (Fig. **4.29**). The most frequent themes of his *Odes* and verse *Epistles* include love, friendship, philosophy, and the art of poetry. The son of a former

slave, and educated in Rome, Horace traveled to Athens, where he attended lectures at the Academy. In the *Odes*, Horace represented himself as heir to earlier Greek lyric poets but displayed a sensitive, economical mastery all his own.

The Horatian odes, short lyric poems written in stanzas of two to four lines, give us a contrast with the odes of Pindar we studied in the last chapter. Whereas Pindar's odes contain lofty, heroic subjects and style, Horace's odes remain intimate and reflective. Nonetheless, Horace's work has discipline, elegance, and dignity. Horace uses a serious and serene tone with irony and melancholy frequent visitors, as well as gentle humor.

Odes
Horace

Book 1, Poem 1

Maecenas, born of monarch ancestors,
The shield at once and glory of my life!
There are who joy them in the Olympic strife
And love the dust they gather in the course;

The goal by hot wheels shunn'd, the famous prize,
Exalt them to the gods that rule mankind;
This joys, if rabbles fickle as the wind
Through triple grade of honours bid him rise,

That, if his granary has stored away
Of Libya's thousand floors the yield entire;
The man who digs his field as did his sire,
With honest pride, no Attalus may sway

By proffer'd wealth to tempt Myrtoan seas,
The timorous captain of a Cyprian bark.
The winds that make Icarian billows dark
The merchant fears, and hugs the rural ease

Of his own village home; but soon, ashamed
Of penury, he refits his batter'd craft.
There is, who thinks no scorn of Massic draught,
Who robs the daylight of an hour unblamed,

Now stretch'd beneath the arbute on the sward,
Now by some gentle river's sacred spring;
Some love the camp, the clarion's joyous ring,
And battle, by the mother's soul abhorr'd.

See, patient waiting in the clear keen air,
The hunter, thoughtless of his delicate bride,
Whether the trusty hounds a stag have eyed,
Or the fierce Marsian boar has burst the snare.

To me the artist's meed, the ivy wreath
Is very heaven: me the sweet cool of woods,
Where Satyrs frolic with the Nymphs, secludes
From rabble rout, so but Euterpe's breath

Fail not the flute, nor Polyhymnia fly
Averse from stringing new the Lesbian lyre.
O, write my name among that minstrel choir,
And my proud head shall strike upon the sky!

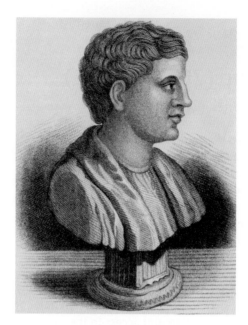

4.29 Horace (65–8 B.C.E.). Engraving.

We know little about Livy's life, and nothing about his family background. Probably he spent most of his life in Rome, and attracted the attention of Augustus while fairly young. Livy spent a lifetime on the composition of his history of Rome, composed of 142 Books. Unfortunately, only Books 21–45 survive, along with summaries of the books after Book 45. Unique among Roman historians, Livy took no part in politics. Thus, his writing seeks no historical explanations in political terms. He saw history in terms of human personalities and representative individuals rather than partisan politics. Together with Cicero and Tacitus (TAS-ih-tuhs), Livy set a new standard for Roman literary style by writing in Latin rather than Greek.

On the other hand, Plutarch (PLOO-tahrk; c. 46–after 119 C.E.) wrote in Greek and strongly influenced the evolution of the essay, biography, and historical writing in Europe between the sixteenth and nineteenth centuries. Plutarch's literary output was immense, but his popularity rests on his *Parallel Lives*, a series of biographies of famous Greeks and Romans, an example of which follows. We can see a visual representation of the story in a painting by Poussin from the seventeenth century (see Fig. **12.11**).

Parallel Lives
Plutarch

Phocion, c. 402–317 B.C.E.

. . . Although he was most gentle and humane in his disposition, his aspect was stern and forbidding, so that he was seldom accosted alone by any who were not intimate

with him. When Chares once made some remark on his frowning looks, the Athenians laughed at the jest. "My sullenness," said Phocion, "never yet made any of you sad, but these men's jollities have given you sorrow enough." In like manner Phocion's language, also, was full of instruction, abounding in happy maxims and wise thoughts, but admitted no embellishments to its austere and commanding brevity. Zeno said a philosopher should never speak till his words had been steeped in meaning; and such, it may be said, were Phocion's, crowding the greatest amount of significance into the smallest allowance of space. And to this probably, Polyeuctus, the Sphettian, referred, when he said that Demosthenes was, indeed, the best orator of his time, but Phocion the most powerful speaker.

His dead body was excluded from burial within the boundaries of the country, and none of the Athenians could light a funeral pile to burn the corpse; neither durst any of his friends venture to concern themselves about it. A certain Conopian, a man who used to do these offices for hire, took the body and carried it beyond Eleusis, and procuring fire from over the frontier of Megara, burned it. Phocion's wife, with her servant-maids, being present and assisting at the solemnity, raised there an empty tomb, and performed the customary libations, and gathering up the bones in her lap, and bringing them home by night, dug a place for them by the fireside in her house, saying, "Blessed hearth, to your custody I commit the remains of a good and brave man, and, I beseech you, protect and restore them to the sepulchre of his fathers, when the Athenians return to their right minds."

And, indeed, a very little time and their own sad experience soon informed them what an excellent governor, and how great an example and guardian of justice and of temperance they had bereft themselves of. And now they decreed him a statue of brass, and his bones to be buried honourably at the public charge.

Catullus (b. c. 84 B.C.E.) was a poet whose expressions of love and hatred are generally considered the finest lyric poetry of ancient Rome. The facts of Catullus' life are few, but the poet Ovid states that Catullus died young. His poetry reflects strong emotion and twenty-five of his poems portray an unhappy love affair with a woman named Clodia. Most of the poems are written in forms that served for inscriptions and dedications and as verse of light occasions, satirical comment, and elegant sentiment.

Here is one example:

If man can find rich consolation, remembering his
 good deeds and all he has done,
if he remembers his loyalty to others, nor abuses his
 religion by heartless betrayal
of friends to the anger of powerful gods,
then, my Catullus, the long years before you shall
 not sink in darkness with all hope gone,
wandering, dismayed, through the ruins of love.

All the devotion that man gives to man, you have
 given, Catullus,
your heart and your brain flowed into a love that
 was desolate, wasted, nor can it return.
But why, why do you crucify love and yourself
 through the years?
Take what the gods have to offer and standing
 serene, rise forth as a rock against darkening
 skies;
and yet you do nothing but grieve, sunken deep in
 your sorrow, Catullus,
for it is hard, hard to throw aside years lived in
 poisonous love that has tainted your brain
and must end.
If this seems impossible now, you must rise
to salvation. O gods of pity and mercy, descend and
 witness my sorrow, if ever
you have looked upon man in his hour of death, see
 me now in despair.
Tear this loathsome disease from my brain. Look, a
 subtle corruption has entered my bones,
no longer shall happiness flow through my veins like
 a river. No longer I pray
that she love me again, that her body be chaste, mine
forever.
Cleanse my soul of this sickness of love, give me
 power to rise, resurrected, to thrust love aside.
I have given my heart to the gods. O hear me,
 omnipotent heaven,
and ease me of love and its pain.

Titus Lucretius Carus (loo-KREE-shuhsh; fl. first century B.C.E.), a poet and philosopher, remains hidden as a person behind the curtain of history, apart from his poem *On the Nature of Things*. The Church Father, Jerome, refers to Lucretius with the indication of his birth in 94 B.C.E. or possibly 96 or 93 and notes that years later a love potion drove Lucretius insane. In the interval, Lucretius wrote several books, later emended by Cicero, and killed himself at age forty-four.

Very much influenced by Vergil, Lucretius speaks in his poem with compassion for an ignorant and unhappy human race. Lucretius has no use for seers who instill religious fears through threats of eternal punishment after death. He also indicates his distaste for what he considered false philosophers, among whom he numbered the Stoics, neo-Platonists, and Pythagoreans. He expresses his gratitude to Epicurus, who rejected religion and provided a scientific basis for understanding the world. The brief excerpt given overleaf opens the poem. In the prologue (Proem) to Book I, Lucretius begins with a highly formal invocation to the goddess Venus, goddess of love and beauty in Roman mythology (and identified with the Greek goddess Aphrodite), whom he calls "Mother of Rome" and invests with diverse characteristics and powers.

Lucretius
On the Nature of Things

Book I, Proem

Mother of Rome, delight of Gods and men,
Dear Venus that beneath the gliding stars
Makest to teem the many-voyaged main
And fruitful lands—for all of living things
Through thee alone are evermore conceived,
Through thee are risen to visit the great sun—
Before thee, Goddess, and thy coming on,
Flee stormy wind and massy cloud away,
For thee the daedal Earth bears scented flowers,
For thee waters of the unvexed deep
Smile, and the hollows of the serene sky
Glow with diffused radiance for thee!
For soon as comes the springtime face of day,
And procreant gales blow from the West unbarred,
First fowls of air, smit to the heart by thee,
Foretoken thy approach, O thou Divine,
And leap the wild herds round the happy fields
Or swim the bounding torrents. Thus amain,
Seized with the spell, all creatures follow thee
Whithersoever thou walkest forth to lead,
And thence through seas and mountains and swift streams,
Through leafy homes of birds and greening plains,
Kindling the lure of love in every breast,
Thou bringest the eternal generations forth,
Kind after kind. And since 'tis thou alone
Guidest the Cosmos, and without thee naught
Is risen to reach the shining shores of light,
Nor aught of joyful or of lovely born . . .

Gaius Petronius Arbiter (puh-TROH-nee-uhs-AHR-bih-tuhr; d. 66 C.E.), originally named Titus Petronius Niger, held a high position in Roman society, from which we assume he belonged to a wealthy, noble family. Tacitus, in his *Annals*, however, paints Petronius among a class of idle pleasure-seekers. Nonetheless, Petronius held important positions as Governor of Bithynia and, later, consul (first magistrate) of Rome. An intimate of the emperor Nero, he functioned as arbiter of taste ("director of elegance"), hence the epithet "Arbiter" added to his name.

Petronius' *Satyricon* constitutes a literary portrait of Roman society in the first century C.E., and it serves as one of the earliest examples of extended prose fiction. Written in an episodic style, the comic novel intersperses the adventures of the narrator and two friends with several unrelated stories and digressions during which the author gives his point of view on a variety of subjects.

A moralizing Stoicism runs throughout the literature of the Augustan period. In poetry, this Stoicism appeared as satire, which allowed writers to combine morality with popular appeal. Juvenal used satire to attack vice by describing it in graphic detail. Petronius produced satirical **picaresques** in verse and prose that were as readable as Juvenal's work, but free of their moralizing.

Juvenal (JOO-vuhn-uhl; 55/60–c. 127 C.E.), one of the most powerful Roman satiric poets, coined numerous phrases and epigrams we use today—for example, "bread and circuses" and "who will guard the guards themselves?" Apparently from a wealthy family, he served as an army officer and then had a career in the administrative services of the emperor Domitian (r. 81–96 C.E.). Embittered at his lack of promotion, he wrote a satire complaining that court favorites had an undue say in who was promoted. His satire succeeded in getting him banished and his property confiscated. He later returned to Rome, apparently penniless, but managed to achieve some small amount of wealth later in his life. He continued to write satires, remaining pessimistic in attitude, although his later work shows more human kindliness than at the beginning. His sixteen *Satires* deal with Roman life under emperors Domitian, Nerva, Trajan, and Hadrian. Juvenal served as a frequent source of quotation for the Church Father Tertullian, whom we study in the next chapter, who shared Juvenal's passionate indignation.

Juvenal's *Satires* address two main themes: the corruption of Roman society, and human brutality and folly. In Satire I he asserts that vice, crime, and the misuse of wealth have reached such a level that one cannot resist writing a satire about it, but because attacking powerful men in their lifetime poses great danger, he will use examples from among the dead.

Finally, Apuleius (ap-yuh-LEE-uhs; c. 124–c. 170) followed in the same tradition. Apuleius' *Golden Ass* is one of the earliest precursors of the novel. The author creates a fictional biography that describes how the central character is tried and condemned to death for the murder of three wineskins. Brought back to life by a sorceress, he tries to follow her in the form of a bird, but he is changed instead into an ass. The only cure for this affliction appears to be the procurement of some rose leaves, and in his search for these, he has bizarre and fantastic adventures.

CHAPTER REVIEW

CRITICAL THOUGHT

Remarkably, the Roman pragmatic genius for organization created a system that, although it certainly did not foster a cultural ethos like that of the Hellenes, nonetheless worked efficiently enough to ensure that, under a single government, the world knew relative peace and prosperity. Augustus Caesar proved one of the cleverest politicians of all history. In addition to knowing how to manipulate public opinion in order to achieve his own ends, he knew the power of art and literature in shaping a public persona and public opinion, much as today's media consultants and "spin-doctors" do. Augustus used art and literature to invent not only his own aura but that of Rome itself.

If we walk the streets of Rome today, we see a curious amalgam of the old and the new. The Colosseum's tattered remains rise shakily above a heavily traveled thoroughfare, and across the street we walk through the Roman Forum, whose fragmented remains surround us like giant tombstones in a quiet cemetery. In other places, we can look down into the ruins of the Empire and

marvel at how high the current street rises above the ground of 2,000 years ago. Elsewhere, Imperial ruins have simply been incorporated into later construction to create a curious timewarp.

The ruins of Pompeii and Herculaneum, as well as Rome, tell us that life—at least for some—during the Roman Empire must have been fairly pleasant. In the mild Mediterranean climate, homes of marble, centered on an open courtyard and richly decorated with wall paintings, would be inviting and comfortable, even by modern standards. The solid proportions of classical Greece must have suggested to Romans a sense of order and stability that seemed eternal. Of course, it was not—but then, neither were they. Were they aware of the subtle changes taking place around the edges of their society? Were they able to compare it with what it once was? Were they able to grasp when the zenith had been reached? In the twenty-first century, are we? Some people often compare the United States to Rome. Is that valid?

SUMMARY

After reading this chapter you should be able to:

- Characterize Roman Republican art and architecture and compare them with those of the Roman Empire.
- Discuss Roman theatrical, musical, and dance forms.
- Explain the philosophies of Seneca, Marcus Aurelius, Epictetus, and Plotinus.
- Identify the various aspects of Roman religions and cults.

- Describe the main directions of Roman literature and its writers.
- Apply the elements and principles of composition to analyze and compare individual works of Roman art and architecture.

CYBERSOURCES

http//harpy.uccs.edu/roman/html/augustus.html
http//harpy.uccs.edu/roman/html/pompeiislides.html
http://www.bc.edu/bc_org/avp/cas/fnart/arch/roman_arch.html
http://www.greatbuildings.com/places/italy.html

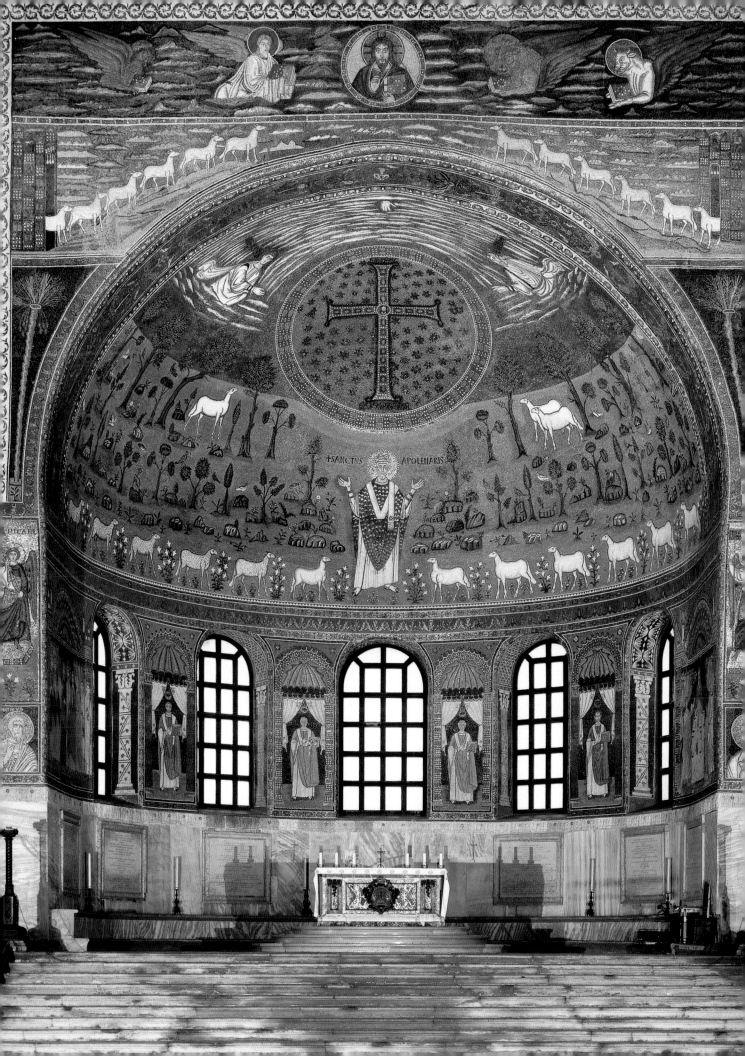

5 JUDAISM AND EARLY CHRISTIANITY

— OUTLINE —

— VIEW —

THE JUDEO-CHRISTIAN HERITAGE

The chapters of this textbook unfold more or less chronologically. At this point in our journey, however, we must halt our forward momentum to backtrack, because during the Roman Imperial period a different heritage—the Judeo-Christian—made a new and significant impact on Rome and on Western civilization. Judaism, already an important religion and culture in the Mediterranean, was, essentially, an Eastern religion. Out of it came a new religion, Christianity, whose translation by the Apostle Paul

into terms compatible with Greek thinking spread it throughout the Roman Empire, profoundly changing the course of Roman and European history. To pull these relationships together, we must return to the Middle East, some two thousand years before Augustus Caesar, and work our way forward again.

A relationship exists between Judaism and Christianity. In the early years their worship forms were indistinguishable, and many Christians believed that becoming a Christian meant first converting to Judaism.

— KEY TERMS —

TORAH
"The Teaching," the Old Testament books of Genesis, Exodus, Leviticus, Numbers, and Deuteronomy, which include statements of Jewish doctrine, practice, religion, and morals.

CLERESTORY
A row of windows in the upper part of a wall.

JUDAISM
The religious tradition and ethical system of the Jewish people: A group of beliefs and practices springing from a common identity, genealogy, and history. A cultural ethos as well as a spiritual practice.

BASILICA
A term that in Roman times referred to building function, usually a law court; it was later used by Christians to refer to church buildings and to a specific form of church buildings.

REBUS
A riddle composed of symbols suggesting the sounds they represent.

5.1 The apse, S. Apollinare in Classe, c. 540–47 C.E. Ravenna, Italy.

CONTEXTS AND CONCEPTS

The timeframe of this chapter brackets that of Chapters 1–4 in that it begins back in Mesopotamia (Chapter 1) in the second millennium B.C.E. with Abraham, the "father of nations," and ends in the fourth century C.E. with the late Roman Empire. During this timeframe we will witness the rise of a people known variously as Hebrews, Israelites, and Jews, the rise of Christianity, and the end of the Roman Empire.

Contexts

Hebrews, Israelites, and Jews
We know the people who wrote and collected the books of the Old Testament, the offspring of the Patriarchs,

variously as Hebrews, Israelites, and Jews. They began as an identifiable group around 1200 B.C.E., and they described themselves as both a religious and a national entity. The word *Hebrew* refers to Abraham's ethnic group. Eventually Abraham's descendants came to be called *Israel* (after Abraham's grandson).

Around 922 B.C.E., the kingdom of Israel divided and the Northern Kingdom was destroyed. When Babylon destroyed the surviving Southern Kingdom, Judah (named for its major tribe), in 587 B.C.E., the people of the nation of Judah went into captivity in Babylon. Later, the expression of Israelite religion became known as Judaism, from which came the words *Jew* and *Jewish*, meaning followers of Judaism and/or members of the ethnic group from which Judaism originated. We discuss this further in the Concepts section.

Timeline 5.1 Judaism and early Christianity.

The Patriarchs

The ancestors of Israel, seminomadic peoples from Mesopotamia, traced their history to a patriarch named Abram (later Abraham) who lived in "Ur of the Chaldees" in the second millennium B.C.E.

According to biblical tradition (Genesis/Exodus), Abram took his wife and household from the heathen environment of Haran and traveled to Canaan. Canaan held a particular spiritual appeal to Abram, because he believed the land there suitable for the fulfillment of a destiny to which he had been appointed by God. Canaan (KAY-nuhn), a secluded hill country, made it possible for Abram and his people to practice their religion in relative peace and isolation. On the other hand, Canaan lay quite close to important trade routes of the ancient world, and thus held a good position for spreading the new religion (Map **5.1**). Because they came from the other side of the Euphrates (yoo-FRAY-teez), Abram and his family were known as Hebrews, from a word meaning "the other side." Abram had a son, Isaac, through whose line of descent God's promises were seen to continue. Abram, at God's command (Genesis, chapter 22; Fig. **5.2**), nearly sacrificed his son Isaac.

In the late fourteenth century B.C.E. with the Hebrews in slavery in Egypt, a national liberator named Moses

5.2 *The Sacrifice of Isaac.* Mosaic. Beth-Alpha Synagogue.

arose. During one particularly cruel oppression, the Pharaoh ordered the slaughter of all Hebrew children. To avoid this, the mother of the infant Moses made a basket of bulrushes and set the baby afloat in the Nile near where Pharaoh's sister bathed. The princess found the baby, adopted him, and brought him up in the royal

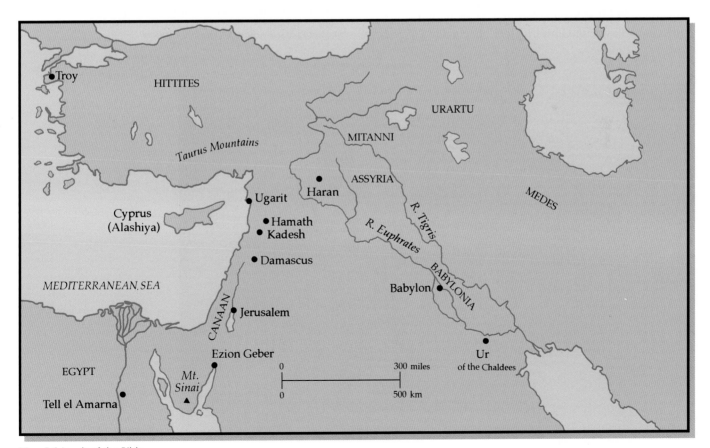

Map 5.1 Lands of the Bible.

court. However, when Moses killed an Egyptian he caught abusing an Israelite, he had to flee the country to Midian, east of Egypt, where he became a shepherd.

One day, while tending his flocks in the Sinai wilderness, he came to Mount Horeb, and there heard the voice of God coming from a burning bush not consumed by the fire. God ordered him to return to Egypt to deliver his brethren from bondage and lead them to the land of promise. Moses returned to Egypt. The enslaved Hebrews soon recognized Moses' message as authentic, but convincing the ruling Pharaoh proved another matter entirely. However, after a series of divine visitations, known as the ten plagues, Pharaoh's heart softened and he allowed the people of Israel to depart from Egypt, by biblical reckoning, approximately 1300 B.C.E. (Fig. **5.3**).

Moses led his people from Egypt toward the Sinai wilderness by way of the Red Sea, which they crossed by a miraculous parting of the waters (Fig. **5.4**). Pharaoh had changed his mind, and the Egyptian army followed in hot pursuit, but they were swallowed up as the sea crashed in upon them. The result of the miracle gave Moses' people a greater sensitivity to divine promise and action and inspired their faith to new heights. They saw the God of their fathers as he who saved them from bondage and would spare them from the hands of their enemies.

In the third month after their escape from Egypt, the Israelites arrived at Sinai, a burning desert with steep cliffs and volcanic mountains. Here, they made a

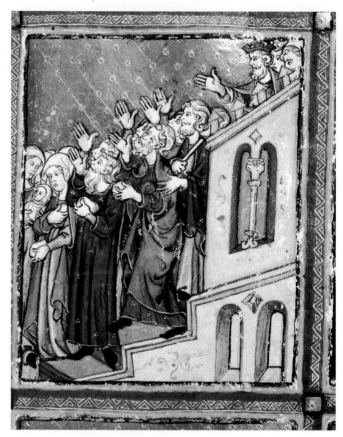

5.3 Miniature from the *Golden Haggadah* (Spanish), fourteenth century C.E. The Jews are portrayed leaving Egypt "with a high hand"—a Hebrew expression meaning "triumphantly," but here illustrated literally. British Museum, London.

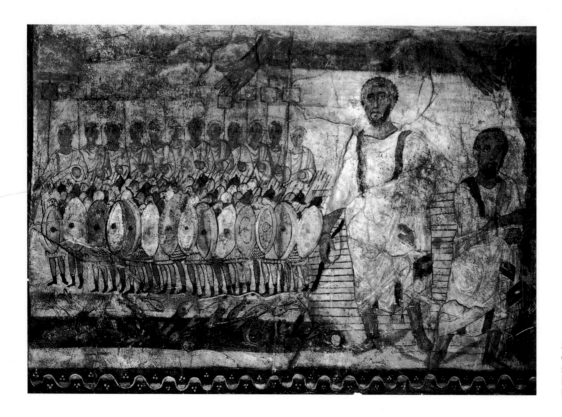

5.4 *Crossing the Red Sea*, c. 245 C.E. Fresco from the synagogue at Dura-Europos. National Archeological Museum, Damascus, Syria.

covenant with their God, YHWH (YAH-weh): He would be their God, and they would be his people. The Sinai covenant had its roots in Yahweh's covenant with Abraham, which, in turn, could be traced to the covenant with Noah, and, thereby, to a framework in which humanity, made in the image of God, must conform to the character of God. Because God is a creating God, humankind must also create and work with God in maintaining and developing the work God had committed, in the creation of the world, into human care. Obedience to God must express itself in obedience to his moral law: *justice* and *righteousness*. Thus, the selection of Israel as a people formed an important moment of universal history in the eyes of the Judaic tradition.

Ratification of God's covenant with Abraham came in a covenant with Israel at Sinai, expressed in the giving of the Ten Commandments, or Decalogue.

The Ten Commandments
(Deuteronomy 5:6–21)

1. You shall have no other gods before me.
2. You shall not make for yourself a graven image, or any likeness of any thing that is in heaven above, or that is on the earth beneath, or that is in the water under the earth. . . .
3. You shall not take the name of the Lord your God in vain. . . .
4. Observe the sabbath day, to keep it holy, as the Lord your God commanded you. . . .
5. Honor your father and your mother. . . .
6. You shall not murder.
7. Neither shall you commit adultery.
8. Neither shall you steal.
9. Neither shall you bear false witness against your neighbor.
10. Neither shall you covet your neighbor's wife . . . or anything that is your neighbor's.

From Conquest to Exile

Immediately after the exodus from Egypt, neither Israel as a nation nor the nations that occupied the land of Canaan were ready for a Hebrew invasion and conquest. The Egyptian empire remained strong, and the land of Canaan contained several vassal kings of Egypt capable of banding together to resist such an invasion. As a people fresh from servitude, the Israelites had not yet progressed to a point of unification and cohesion. They remained an undisciplined, spiritually immature, and fractious group. They therefore wandered in the wilderness of Sinai for forty years, and although the route they took cannot be traced, it was circuitous and subjected them to the privation and hardship of the desert. That time of difficulty hardened Israel into a strong, disciplined nation, with well-inculcated spiritual values.

Under the leadership of Joshua, the people of Israel conquered Canaan and organized themselves into a relatively stable political and religious entity. A period of anarchy followed Joshua's death, and "every man did what was right in his own eyes" (Judges 17:6). Too weak to resist infiltration by bordering tribes, Israelites soon began intermarrying with outsiders and turning away from Yahweh to idolatrous religious practices. To counteract this defection from the covenant, a series of twelve "Judges" arose and set about liberating Israel from her enemies and recalling the nation to the worship of Yahweh. But the judges—for example, Deborah and Gideon—were more local tribal heroes than national leaders, and by the time of Samuel, who had emerged as a judge, a new threat had arisen: the Philistines. In a devastating defeat, the Philistines succeeded in capturing the Ark of the Covenant, Israel's most sacred object. The shock of this defeat provided Samuel with the impetus needed to bring about further reforms and to achieve some sense of centralization, which led, in turn, to a great clamor for the appointment of a king. After initial resistance by Samuel and the careful delineation of the powers of the king, Saul emerged by common consent of the people, and became probably the first constitutional king in history.

Although unable to meet all the demands placed on him, Saul did free Israel from the Philistines and unified the nation. It lay to David, however, to consolidate the monarchy. The prophet Samuel chose David as the instrument of God, and at first David served as Saul's comforter and right arm, but David's immense popularity with the people made Saul jealous and vengeful. In the ensuing struggle, David became king, and Israel's golden age began. He unified the tribes of Israel and extended the kingdom from Phoenicia in the west to the Arabian Desert in the east, and from the River Orontes in the north to the Gulf of Aqaba in the south. He ultimately captured the Canaanite stronghold of Jerusalem, where he established a national and religious capital in which his son Solomon built the great Temple (see Profile, p. 146).

Following the death of Solomon, a dispute over succession split the nation into Northern and Southern Kingdoms, with Jerusalem remaining the capital of the Southern Kingdom. The division left the nation weakened, and in the eighth century B.C.E. the Northern Kingdom fell to the Assyrians. The period between Solomon and the Assyrian conquest of the Northern Kingdom, called Samaria, gave rise to the great prophet Isaiah. Subsequently, the exile and dispersion of the Northern peoples led to their being called the "Lost Tribes of Israel." In 587 B.C.E., the Babylonians conquered the Southern Kingdom, now called Judah, destroyed Solomon's Temple, and carried the people into the Babylonian Captivity.

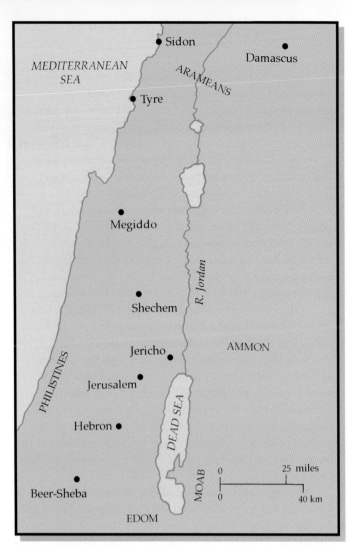

Map 5.2 Palestine.

At the end of the sixth century, Cyrus the Great led the Persian Empire to dominion in the Middle East. After conquering the Babylonians, Cyrus freed the Jews, as they were now called, and in 538 B.C.E. the first exiles returned from Babylon. In 515 they rebuilt the Temple, and the next hundred years witnessed the building projects and leadership of Nehemiah (nee-eh-MY-uh) and Ezra. It formed a time of spiritual revival and the renewal of religious rites and practices for the Jews, who believed that their God had rescued them. As a result, they established a theocracy—a government ruled by those believed to have special divine approval and direction. A group called the Pharisees (FAIR-ih-seez), mistakenly confused with the Sadducees (SA-jyoo-seez) in the New Testament, took responsibility for the preservation and codification of Jewish religious practice (the "Mishnah"), which had been centered, by law, around the Temple.

In 332 B.C.E., Alexander the Great conquered the region. After his death, the Hellenistic Empire was divided and Judah fell under a series of foreign rulers. At this time, Jewish visions of the apocalypse grew popular. Antiochus IV (an-TY-oh-kuhs), a descendant of the Seleucid (suh-LOO-sid) kings who ruled this part of the Hellenistic Empire after Alexander the Great's death, singled out and banned Jewish practice and culture in 168–167 B.C.E. As a result, a group of peasants, known as the Hasmoneans (haz-MOHN-ee-uhns), started a mini-rebellion. Two conflicting accounts of the period occur in Maccabees I and II. Initially regarded as saviors, the

PROFILE

SOLOMON (C. TENTH CENTURY B.C.E.)

Solomon, son of David and Bathsheba, ruled Israel for forty years during the second third of the tenth century B.C.E. In Hebrew the name meant "Yahweh's beloved," as indicated in the biblical book of 2 Samuel, 12:25. While David still ruled, he affirmed his commitment to make Solomon his successor. The priest Zadok, with the assistance of the prophet Nathan, installed Solomon as co-regent until David's death, when Solomon's brother Adonijah sought Bathsheba's support in his request to marry Abishag, who had served David in his old age. Regarding this move as a threat, Solomon had Adonijah executed, and he expelled others, seen as accomplices, from Jerusalem.

Solomon effected a political consolidation of Israel and created administrative districts that cut across old tribal lines. He also expanded Israel's international affairs, and his empire included trade routes that linked Africa, Asia, Arabia, and Asia Minor. Solomon's political and commercial activities brought much wealth and a cosmopolitan sophistication to the kingdom, and his wisdom "surpassed the wisdom of all the people of the east, and all the wisdom of Egypt" (1 Kings 4:30, Hebrews 5:10). The Bible ascribes seven hundred wives to Solomon, including many whom he undoubtedly married as part of political alliances. Solomon's extensive building program included stone cities as well as fortifications, and in Jerusalem, he built an elaborate palace complex and a temple. His reign brought the promises made to the patriarchs of Israel to fruition. On the other hand, the influx of foreign practices marks the beginning of a religious decay that increased internal dissent and external enemies.

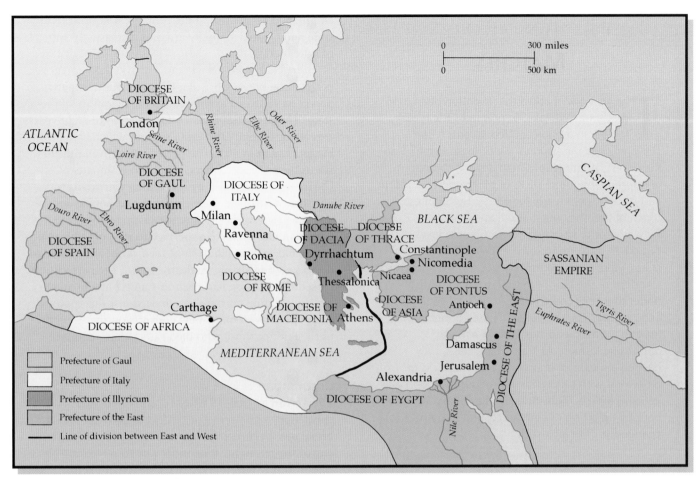

Map 5.3 The Roman Empire in the fourth century C.E.

Hasmoneans soon became even more of a threat to Jewish religious practice than Antiochus IV had been.

A brief uprising by the Maccabees under Judas Maccabeus (JOO-duhs mac-uh-BAY-uhs) brought a short period of independence around 165 B.C.E. Within a century, Israel fell under the rule of Rome. In 70 C.E., after an uprising in Jerusalem, the Romans sacked the city and destroyed the Temple. A small band of rebels held off the Romans for two years at a mountain fortress called Massada until it, too, fell in 73 C.E.

The Late Roman Empire

Christianity, of which we will speak in the Concepts section, spread to Rome early in the first century, brought there by nameless individuals who benefited from the freedom of travel that existed throughout the Empire during the *Pax Romana*.

Diocletian

The Roman Empire's crisis of the third century, which we discussed in Chapter 4, ended with the reforms brought about by two emperors, Diocletian and Constantine (KAHN-stuhn-teen), who also changed the fortunes of

Christianity. Diocletian (r. 284–305), born in the Balkans, rose to power through the ranks of the Roman army. Strong-willed and insisting on divine status, he took the image of emperor to grandiose heights—whenever in the presence of his subjects, for example, he separated himself from them by a wall of curtains. His self-image must have reflected the larger-than-life portrait necessary for him to cope with all the problems of the far-flung empire, in which anarchy ran rampant, barbarians threatened every border, and the army turned rebellious.

Nonetheless, Diocletian attacked the problems with a creative and organized plan that, eventually—if only temporarily—brought some stability and reasonable prosperity. He restructured the empire by installing a Tetrarchy, wherein four rulers shared imperial power: two senior Augusti supported by two junior Caesars. Diocletian reformed and strengthened the imperial bureaucracy, reformed taxation to effect greater equality, and attempted to control wages and prices. His most ambitious undertaking split the empire into two halves, east and west, with each half administered by an Augustus and a Caesar. He also divided the provinces into dioceses. The cumulative effect of splitting the

TECHNOLOGY

MATCHES

The year 577 marked the invention of an item that today we take for granted—the match. In 950, in a book entitled *Records of the Unworldly and the Strange*, the Chinese author T'ao Ku writes: "An ingenious man devised the system of impregnating little sticks of pinewood with sulfur and storing them ready for use. At the slightest touch of fire, they burst into flame." Actually, T'ao Ku was wrong. Matches were a Chinese invention, but credit must go to some impoverished court ladies, who, during a military siege in the shortlived kingdom of the Northern Ch'i, were so short of tinder that they could not start fires for cooking and heating. They therefore devised a means of making it possible to start fires in a more opportune fashion. As T'ao Ku indicates, they devised a means of impregnating little sticks of pinewood with sulfur. The marvelous invention was initially called a "light-bringing slave," but it rapidly became an article of commerce, and its name was changed to "fire inch-stick."

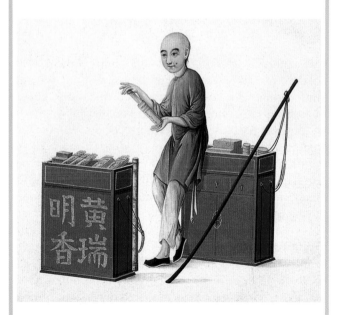

5.5 Pu Qua workshop, *A Boy Selling Pipe Lighters and Matches* (?), c. 1790. Watercolor on paper, 14⅛ × 17¼ ins (36 × 44 cm). Victoria & Albert Museum, London.

empire and restructuring the provinces centralized the state and created an awkward and increasingly large class of bureaucrats.

In his last years Diocletian embarked on a major persecution of the Christian Church, whose expanding power he regarded as a threat to the hierarchy of the state. The persecution lasted for a period of eight years, extending beyond Diocletian's reign, which ended with his retirement in 305. The persecution, given official status by a series of edicts, sought to eliminate Christianity altogether by forbidding Christians to worship, destroying their churches and books, and arresting their bishops. Anyone suspected of being a Christian had to make a sacrifice to the emperor, which amounted to a repudiation of their faith, and failure to do so was punishable by death. In 311 the persecution ceased. Its purpose had been to stamp out Christianity, but, by creating martyrs, it achieved just the opposite. Christianity won many new converts on the strength of the faith of those who died rather than renounce their beliefs.

Constantine

The Tetrarchy (teh-TRARK-ee) collapsed after Diocletian, and a series of civil wars between the tetrarchs broke out. Eventually, Constantine (r. 306–37), son of one of the tetrarchs, fought his way to power as sole emperor of Rome, and carried Diocletian's reforms to even greater lengths. Constantine established two capitals—one in Rome, the other in Byzantium, later named Constantinople in his honor—thereby creating two Roman empires, one in the West and one in the East. The latter lasted for another thousand years, the former for barely a century.

Constantine arranged an elaborate administrative system, split into four huge imperial prefectures, a dozen dioceses, and 120 separate provinces, which stretched from Britain to Egypt. He separated the civil bureaucracy from the army, which he reformed to strengthen the frontiers, and in order to keep the empire afloat financially, he levied a series of taxes that had the net effect of reducing many to near-slave status. One group, however, loved Constantine—the Christians. He legalized the Christian Church in Rome in 313, and it prospered under this new opportunity. Priests could be found in the army, and bishops at the imperial court. When Constantine moved his capital to Byzantium, he rebuilt the old city as a Christian center, renaming it Constantinople, and filling it with Christian churches and monuments. All the following emperors were Christian, and the faith had an unshakable hold on all levels of society, from peasant to aristocrat, the bureaucracy to the army.

The cumulative effects of the reforms introduced by Diocletian and Constantine enabled Rome to survive for

a century, but the benefits of Roman rule had reached a point at which most people in the empire may well have welcomed the barbarian incursions that ensued.

The Roman Empire did not fall on a specific date, but by 406 Roman defenses had deteriorated considerably, and a mixed horde of Germanic peoples, mostly Vandals, surged into the empire and made their way through Gaul into Spain. Capitalizing on the situation, Alaric attacked Italy and succeeded in sacking Rome itself in 410.

CONCEPTS

Judaism

Judaism consists of the religious tradition and ethical system of the Jewish people, who consider themselves descended from the patriarchs. Judaism comprises the oldest of the world's major religions, and its **monotheism** developed around 1300 B.C.E. We tend to think of religions as relatively singular, but Judaism consists of a group of beliefs and practices springing from a common identity, genealogy, and history. Jewish identity comes through birth, through the mother, rather than by acceptance of a faith. Judaism does accept converts, but does not proselytize. Therefore, Judaism comprises a cultural ethos as well as a spiritual practice. In fact, many Jews accept the Jewish culture and its ethical system but ignore or reject its religious observances.

Centered on the Hebrew Bible (Old Testament; see the Literature section at the end of this chapter), especially the first five books—called the Pentateuch (PEHN-tuh-took), Books of Moses, and/or Torah—the faith rests on the divine laws contained therein. A collection of writings on ethical, legal, and liturgical matters, as well as Jewish history (called the Talmud), supplements the Bible. The Talmud contains the "oral law" (*Mishnah*—injunctions believed revealed by God to Moses), and rabbinical interpretations and commentaries on the Mishnah (called *Gemara* [gheh-MAHR-uh]).

Jews base their faith on a series of covenants made between God and the patriarchs, beginning with Abraham and ending with Moses, in which God promises to bless and protect the Jewish people in return for their worship and obedience to his laws (the Ten Commandments). From this comes the Jewish understanding that they comprise the "chosen people," who have certain responsibilities because of God's special favor. Some of these responsibilities include the necessity to make ethical choices and to create a moral and just society. The covenant also promises Jews a home in the holy land. Biblical references to a Messiah ("anointed one") came to mean a savior who would reunite the Jews,

vanquish their enemies, and establish God's kingdom on earth. Christians believe that Jesus fulfilled the prophesy of Messiah. Jews do not accept that belief.

Judaism has no particular organization or hierarchy and no official clergy. Rabbis, however—traditionally religious teachers revered for their scholarship and wisdom—customarily maintain authority in spiritual matters, evolving into congregational pastors. Jews exercise individual and communal worship at home and in the synagogue, with communal services consisting of chanted prayers and readings from the Torah.

Since the fall of Jerusalem to the Romans, and the destruction of the Temple, the dispersion of Jews (Diaspora) from Palestine developed two separate communities in Europe, each with its own cultural patterns and Hebraic dialect. The Sephardic Jews constitute Arab-influenced, Ladino-speaking people who inhabited Spain and Portugal until their expulsion in the 1490s. Ashkenasi Jews speak Yiddish and descended from Roman-era Palestinians who settled in central and eastern Europe. Orthodox, Reform, and Conservative communities did not develop until the nineteenth century, and they hold divergent views on the importance of tradition and the divinity of scripture.

Christianity

Rooted in Judaism's post-exilic Messianic hopes, Christianity arose in what its central personage and its later believers professed as God's intervention in human history to establish a new covenant to supplant the covenant established with Moses. Jesus of Nazareth was the Christ—Messiah. As Christianity spread through the Roman world after the death of Jesus, Christology became an important and divisive issue among Christians. Exactly what was the nature of Jesus Christ: Man or God or some combination? And what was the relationship of God, Christ, and the Holy Spirit, about whom Jesus preached? These and other fundamental concepts brought Judaism, Rome, and the Western world together in a manner that has shaped humankind in the two thousand years since.

Jesus Christ and His Teachings

What we know of Jesus Christ comes from later writings called the gospels, the first four books of the New Testament of the Christian Bible. Jesus' early life remains unknown. The gospel of St Matthew includes a long genealogy tracing Jesus' ancestry to King David, and provides a number of stories about Jesus' birth, the Wise Men, the flight to Egypt, the slaughter of the innocents, the return to Israel, and the residence in Nazareth, but these provide few details of Jesus' life. In the gospel of

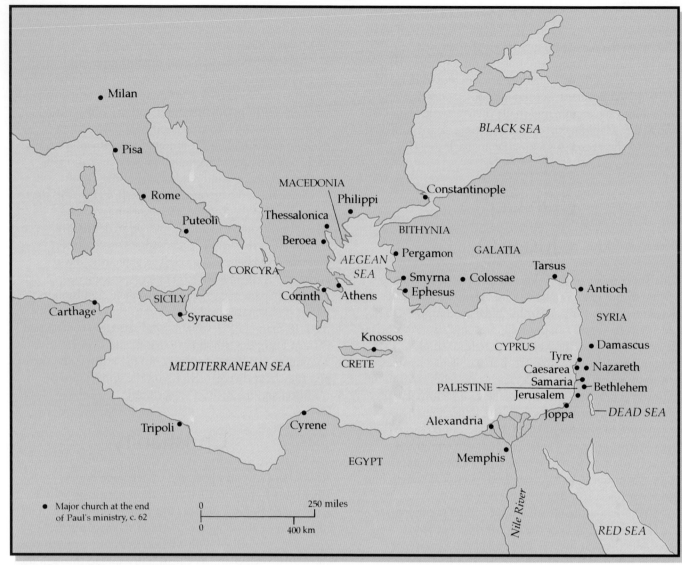

Map 5.4 The early Christian world.

St Luke (Fig. **5.6**) we find a poetic narration of the birth and connection between Jesus and John the Baptist through their mothers, Mary and her cousin Elizabeth, and we find historical figures such as King Herod, Caesar Augustus, Quirinius (kwir-IN-ee-uhs), governor of Syria, and a specific reference to Caesar's "first" enrollment. Correlating Herod's actual death in 4 B.C.E., Augustus' reign, and Jesus' birth story, and accommodating changes and corrections to the calendar that have occurred since, we get a birth date for Jesus at somewhere around 4 B.C.E.

With the exception of the story of Jesus in the Temple as a youth, no further information exists about him until he began his public ministry at age thirty. The gospel of St Mark is vague about whether Jesus was a carpenter—the reference could apply to Joseph, his father—and although he appears to have been a "teacher," no

indication exists of his formal education. He had close associations with women, which would have been unusual for a Jewish teacher at that time, and we conclude that he must have had a relatively normal and typical home life in his formative years.

The actual beginnings of Jesus' ministry also remain vague. Baptized by John the Baptist, whom the gospels portray as a harbinger of Jesus, Jesus shared John's message that the people of Israel must "repent" and return to the ways of God. During his ministry, Jesus called twelve disciples to share his teaching and healing ministry. The symbolic link with the twelve tribes of Israel undoubtedly was intentional.

The core of Jesus' teaching comprised the Kingdom of God. Although the significance of the Kingdom with regard to human activity is strong, Jesus used the symbol

Jesus' message was revolutionary. What he said and did—while not illegal by either Jewish or Roman standards—caused concern because it created unrest in the population. That, in first-century Palestine, made Jesus dangerous, and he was put to death in the Roman custom—crucified with other criminals on a hill called Golgotha (the place of the skull) outside the city of Jerusalem.

All four gospels maintain that on the third day after his death, Jesus rose from the dead and three of the Gospels maintain that Jesus, at various times, appeared to his disciples—not as a spirit, but in a solid body—before ascending into heaven. The Resurrection becomes for Christians not only a miracle, but also God's redeeming act in the salvation of the world.

The Apostolic Mission

Christianity spread principally because Jesus commanded his followers to carry on his commission from God. In the Synoptic Gospels—Matthew, Mark, and Luke—the charge is direct. After the Resurrection, Jesus appears to the disciples and tells them: "All authority in heaven and on earth has been given to me. Go therefore and make

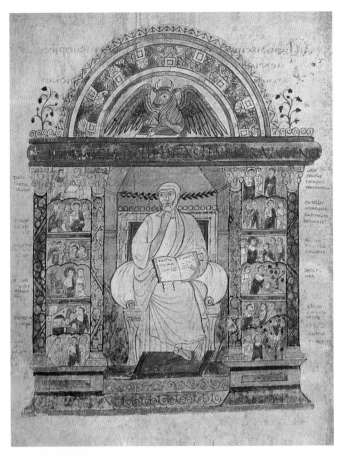

5.6 St Luke, from the presumed St Augustine Bible, sixth century C.E. Corpus Christi College, Cambridge, England.

as a means for revealing God himself. Through it, Jesus evokes God's active involvement in saving humankind and in establishing a reign of justice and peace. Above all, it reveals God's steadfast love and grace, offered to humankind without precondition. This complex teaching steps away from conventional Jewish thought in regard to the judgment of God on the human race—the end of the world or the Time of Tribulation in Jewish theology—which it says has already begun. The central focus of Jesus' ethic is love, based on the Judaic commandment: "Thou shalt love the Lord thy God with all thy heart, soul, mind, and strength, and thy neighbor as thyself." The call for repentance, like that of the Old Testament prophets, presupposes a tremendous distance between God and the daily life of his people. Hence, the need to repent, not just to polish up a few sinful acts, but to have a fundamental change of heart.

The gospels portray Jesus as a teacher, miracle worker, and friend of sinners (Fig. 5.7). He goes out of his way to associate with the poor, the downtrodden, and the socially unacceptable. His ministry proclaims that such people, not the righteous, constitute the special objects of God's love and care.

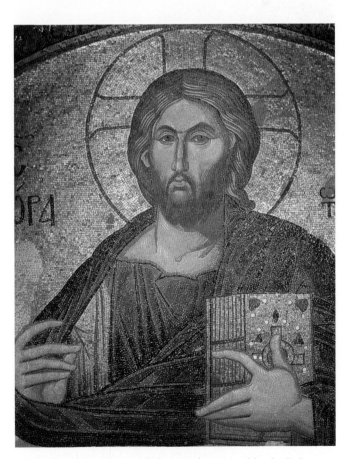

5.7 Christ as Pantocrator, early fourteenth century. Mosaic. Kariye Church, Istanbul, Turkey. Christ as Pantocrator (or Pantokrator) indicates Christ as judge of the world.

151

5.8 *St Peter*, third century C.E. Wall painting from a catacomb of SS. Pietro e Marcellino, Rome.

of Jesus, interpretations of his person and significance for the life of the Church. Arguably, the apostolic mission of Christianity, in fact, the very nature of Christianity as a religion (as opposed to the nature and teachings of Jesus Christ, which did not constitute a formal "religion"), depended on the contributions of St Paul (see the Literature section of this chapter). Some people go so far as to say that St Paul invented Christianity. Certainly, the development of theology that emerges from his Letter to the Romans in the New Testament proved fundamental, and his preaching and organizational activities throughout the Roman world formulated Christianity into terms compatible with the thought systems of the Hellenistic world.

The Early Christian Church

Like most emerging religions, Christianity felt an intense need to create institutions. Christianity was loosely organized and totally different in its theology from the religions around it. It needed a united front in order to grow and to make its way in a suspicious, pagan world. In the first centuries of its existence, Christians had shed each other's blood as various sects battled over questions of dogma, and this had to stop if the Church were to survive. In the thrust and counterthrust of all this, however, the emerging Church coalesced as a force coming together in a world that was mainly falling apart.

Why and how did Christianity survive? Its monotheism extended the Jewish heritage. The historical immediacy of its founder and the doctrines he taught appealed to men and women of the late Roman and post-Roman periods. In its extreme simplicity on the one hand and its subtlety on the other, Christianity had a multifaceted appeal that made it acceptable to the most lowly and illiterate people as well as those of sophistication and schooling.

We know little about the spread of Christianity through the Roman Empire. Conversions among the aristocracy and upper classes enhanced its chances of survival substantially, and by the end of the third century, Christians counted as a political force. Every city of consequence had a Christian community presided over by a bishop assisted by priests and deacons. Regarded as successors of the original apostles, bishops, chosen by their communities, decided theological disputes in councils.

Christianity encountered varying degrees of tolerance from the Roman state. In general, the Imperial government treated all the various religious practices in its diverse empire with an even hand. Occasionally, however, Christians suffered fierce persecution, mainly because they refused to worship the emperor as a divine being. In addition, their secret meetings and rites troubled the authoritarian government. Christians also abhorred

disciples of all nations, baptizing them in the name of the Father and of the Son and of the Holy Spirit, teaching them to observe all that I have commanded you" (Matthew 28:18a–20a). This commission assumes explicitly that the Way, as the followers called themselves immediately after the Resurrection, would spread beyond the confines of Judaism and include the Gentile world as well. Within a generation, the new name, Christian, had appeared, and an organized movement with appointed leaders took shape. We should note that in the beginning Jews and Jewish Christians (so-called "Nazarenes") were indistinguishable in religious practice and places of worship. The Romans, in fact, made no distinction between the two groups. Pointedly, one of the early divisions among Christians concerned the issue of whether or not one could become a Christian without first converting to Judaism.

Critical to the spread of Christianity was its own written canon. Serious questions about exactly who Jesus was and what the faith entailed needed to be settled, and many divisions within early Christianity occurred. The Bible of the earliest Christians was the Old Testament—the Jewish canon—and this was supplemented in Christian worship by oral apostolic accounts of the words

violence and refused to serve in the Roman army, which proved very difficult for the besieged state to tolerate.

As we noted, the last great persecution occurred under Diocletian (dy-uh-KLEE-shun) in 303. Shortly afterward, Constantine transformed Christianity into a favored religion in the Roman state. According to the bishop Eusebius (yoo-SEE-bee-uhs), Constantine reported that he had had a dream prior to the battle of Milvian Bridge against his co-ruler, the tetrarch Maxentius, which told him to send his soldiers into battle carrying standards marked with Christian symbols. Constantine did so, won the battle, and converted to Christianity. He later claimed that he was "brought to the faith by God to be the means of the faith's triumph." Christianity soon became the official religion of the empire.

Numerous privileges came with this new status. The Church could receive legacies, its clergy were exempt from taxation, and bishops could settle disputes of law in all civil cases in which a Christian was a party. In addition, the Church obtained the rights of sanctuary for its buildings—they became places of safety where a criminal could escape arrest or punishment.

After Constantine's conversion, the Church began to build up its own administration, adopting a structure similar to that of the civil bureaucracy. By the fourth century, each province had divided into bishoprics, with an archbishop at its head. The Church, however, had no centralized administration comparable to the Imperial government. The bishops of the four great cities of Rome, Jerusalem, Antioch, and Alexandria claimed special privilege because the Church in each of those cities was founded by the apostles. Rome, however, claimed supremacy both because it was founded by St Peter (Fig. 5.8), to whom Jesus had entrusted the building of the Church, and because it was the capital of the empire.

Yet the opportunities presented by the conversion of emperors to Christianity to some extent offset problems that stemmed from the same source. In return for championing the faith, the emperor expected the bishops to act as loyal servants of the Imperial crown. When theological disputes arose, the emperor often insisted on deciding the matter himself.

The Popes

References to the primacy of Rome can be found as early as the letters of St Ignatius in 110 and St Irenaeus around 185. The claim of the medieval popes to exercise complete authority over all of Christendom developed slowly, however. The bishops of Rome claimed supremacy because they were the heirs of St Peter and because their city was the capital. Other arguments included the sanctification of Rome by the blood of martyrs and its freedom from the contamination of the heresies that had touched other churches. Specific

acknowledgement of Rome's supremacy by a Church council first came in 344 from the Council of Sardica. The Council of Constantinople placed the bishop of Constantinople second after the bishop of Rome "because Constantinople is the New Rome." A series of strong and able bishops of Rome consolidated the move toward Rome's supremacy during the next century.

The argument put forward by the bishops of Rome in support of their case came to be known as the "Petrine theory," and perhaps its clearest formulation came from Pope Leo I (r. 440–61), a man with considerable administrative ability who played a significant role in civil affairs as well as religious ones. Leo twice helped the emperor to negotiate with the leaders of the barbarian armies that invaded Italy in 453 and 455. He affirmed that because all other apostles were subordinate to Peter, all other bishops were subordinate to the bishop of Rome, who had succeeded to Peter's see at Rome. In fact, nearly all Western Christians came to acknowledge the pope of Rome as head of the whole Church. The actual extent of his authority in temporal affairs and in affairs of Church governance remained unclear.

Early Christian Thought
Tertullian and Legalism

The study of medieval thought of the first millennium really amounts to the study of Christian thought. In order to understand the men and women of the early Middle Ages—how they might have seen the universe, and how that viewpoint translated into art—we must examine some of early Christian thought. Our examination focuses on two of its most important thinkers, Tertullian (tuhr-TUL-ee-uhn) and Augustine (aw-GUS-tuhn).

The main contribution of Tertullian (c. 160–230) to Christian thought lies in two areas. He founded the language of the Western Church, and he enunciated those aspects of its theology that marked a break with the East. His writings continued to influence Christianity even after his defection to Montanism destroyed his standing as a Catholic Father.

Probably the most important of Tertullian's writings comprises an elaborate analysis of the soul. His arguments lean heavily on Stoicism. He believed that the soul has length, breadth, and thickness, and although not identical with the body, it permeates all its parts, with its center lying in the heart. The soul controls the body, using the body as it wills. Yet, the soul remains spiritual, not material. For Tertullian, spirit and matter constituted two substances, different in nature but both equally real. Spirit, being indivisible, was therefore indestructible.

He based his notion of God and the Trinity on legal concepts. When Tertullian says that God has three parts, he means that God is "three persons in the legal sense, that is, three persons who share or own in common one

substance or property."[1] God is a personal sovereign, to whom all people are subject. Independent and omnipotent, God created the world out of nothing. On the question of one's proper relationship to God, Tertullian precisely defined God as an authority figure whom one approaches with humility and fear. "The fear of man is the honor of God. . . . Where there is no fear there is no amendment . . . How are you going to love unless you are afraid not to love?" Virtue thus comprises obedience to divine law springing from fear of punishment if the law is broken. In this and many other areas, Tertullian's legal training stands out. He also formulated an elaborate list of sins, including the seven deadly sins of idolatry, blasphemy, murder, adultery, fornication, false witness, and fraud.

By the time of Tertullian, the Church had begun to see this life as a mere probation for the life to come. Earthly life had no value in itself and possessed meaning only in that it provided the opportunity to lay up rewards in the life beyond the grave. Tertullian believed the supreme virtues consisted of humility and the spirit of otherworldliness, by which Christians could escape the perils of this life and be assured of enjoying the reward prepared for the saints in heaven.

St Augustine and Neo-Platonism

St Augustine (354–430) did not receive the sacrament of baptism until adulthood. His mother, a Christian, believed that if he were baptized as a child, the healing virtue of accepting the faith would be destroyed by the lusts of youth. Nonetheless, after a period of skepticism, and adherence to Manichaeism (MAN-ik-ee-iz-uhm)—a philosophy that combined Christianity with elements from other religions of the time—he received baptism into the Christian faith. He later became bishop of Hippo, in North Africa. A prolific writer, his works greatly influenced developing Christian thought. The *Confessions* and *City of God* remain the best known of his works.

Apparently Augustine found great inspiration in the writings of Plotinus (see p. 118), and he was highly influenced by Platonic and neo-Platonic thought. He recoiled from Tertullian's emphasis on the senses and the body, but shared Tertullian's belief in intuition as the source of knowledge concerning God, although Augustine's concept of intuition had an intellectual cast. The senses, he believed, give us unreliable images of the truth. Instead, our intuition, our **affective** thinking, has a certainty which springs from "the fact that it is of the very nature of reason to know the truth."[2] Knowledge constitutes inner illumination of the soul by God. Whatever we find intelligible is, therefore, certain. Knowledge comes from intuition and "confirms and amplifies the certainty of faith."[3]

Augustine argued that to doubt the existence of the soul in fact confirms its existence: in order to doubt we must think, and if we think, we therefore must be thinking beings, and therefore souls. Unlike Tertullian, Augustine thought the soul immaterial—a purely spiritual entity. Our power to grasp eternal and immaterial essences demonstrates this spiritual character, as well as its immortality.

His concept of original sin, as developed in *City of God*, held that all people are born to sin because of Adam's fall from grace when he disobeyed God in the Garden of Eden. Thus, we are "punished by being born to a state of sin and death, physical and spiritual, from which only Christ's passion and saving grace can redeem us." Augustine held that people were inherently bad and therefore did bad things.

Augustine attacked the question of predestination and divine foreknowledge—whether God's omniscience robs humans of free will. His conclusion, that free will is not a certainty, influenced later contributors to the debate, which continues among Christian theologians today.

Augustine's philosophy of art represents a radical shift from that of Plato and Aristotle, especially in the principles of art evaluation. Plato and Aristotle approach art from political and metaphysical points of view. Augustine approaches the subject from a Christian point of view. Scripture, not philosophy, acts as his guide. Augustine considers the production and consumption of art to hold the interest for the Church that Plato felt they held for the polis. The Christian and the pagan face the same questions about the function and purpose of art. Augustine, however, finds the answers in a strictly Christian context, in the teachings of scripture and tradition. For him, the answers exist in an understanding of God's relationship with the world, and in the mission of the Church in dealing with art. Augustine untiringly attempted to satisfy the requisites of faith while doing justice to the natural pleasures that art can provide.

Even when the basic conflict resolves, Augustine still has a problem in the immediate sensuous gratification of art. Although "divine order and harmony" are reflected in nature and to a degree in art, "perceptual objects tie the senses down to earthly things and prevent the mind from contemplating what is eternal and unchanging."[4] Art and beauty are thus guides for the soul. Those arts that depend least upon the senses best mirror the divine order.

The best teacher of all, however, is scripture. Properly interpreted, scripture provides the most direct knowledge of God's purpose and order, although the arts can contribute to our understanding as well. As long as art agrees with the tenets of faith and reflects the harmony of divine creation, it is justified.

THE ARTS OF JUDAISM AND EARLY CHRISTIANITY
Painting

Judaism

The biblical injunction against graven images means that little significant Jewish sculpture or painting exists. Occasionally, however, the injunctions were relaxed sufficiently to allow decoration, and the assembly hall wall of the synagogue at Dura-Europos represents one such example (Fig. **5.9**). Dating to approximately 250 C.E., this richly detailed account tells the history of the Chosen People and their covenant with the Lord, and attempts to put into pictures the traditions previously restricted to words. Unlike most paintings, there appears no unifying relationship among the details of this decoration. Animals, humans, buildings, and cult objects have exquisite portrayal, but we find nothing that would tell us how they relate to each other. It seems as if the artist assumed that the viewer would understand how these objects coalesce. Nevertheless, if the meaning is hidden, the execution is explicit, and we can find pleasure in the luster of the execution and the sophisticated depiction of details. Although less lifelike than the Roman wall decoration we have previously examined, these depictions reveal a concern with **plasticity**—three-dimensional space. Human and animal forms appear shaded and detailed in such a way as to give fullness to form and a sense of action and character. The figures are presentational and not intended for veneration or worship.

Christianity

The earliest Christian painting occurs in the catacombs of Rome. The catacombs served as underground cemeteries, for both Christians and Jews avoided public burial places dedicated to pagan deities. In addition, belief in the resurrection of the body meant that early Christians eschewed cremation, the norm for ordinary citizens in Rome. Wall paintings similar to that seen in Figure **5.10** often had multiple meanings. This work, which depicts men and women sitting at table with bread and wine, could represent the early Christian "love feast" (*agape*; AH-guh-pay), or it may represent Christ's first miracle—the wedding feast at Cana at which he turned water into wine. The obvious meaning was that of the sacrament of Holy Eucharist—the reenactment of the Last Supper.

The catacombs reveal much about early Christian thought and communal spirit. An otherworldly outlook can be seen in the example shown in Figure **5.11**, although here, again, the art itself has pre-Christian

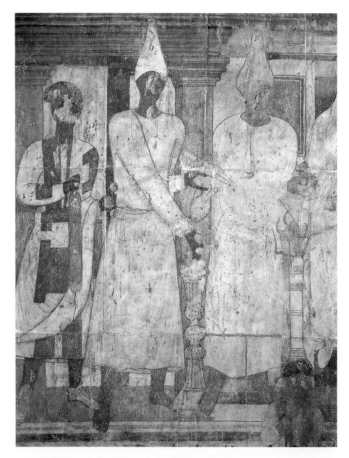

5.9 *The Sacrifice of Conon*, from the assembly hall of the synagogue at Dura-Europos, 245–56 C.E.. Mural. National Museum, Damascus.

5.10 *The Breaking of Bread*, late second century. Wall painting in the catacomb of Priscilla, Rome.

5.11 Painted ceiling, fourth century C.E. Catacombs of SS. Pietro e Marcellino, Rome.

influences. In this case, the ceiling divides into compartments, as we witnessed in earlier Roman wall painting (see Fig. 4.7). However, the artist, who had only modest ability, translates old forms into new meanings: the great circle represents the dome of heaven inscribed with the cross; the symbol of the good shepherd with a sheep on his shoulders, similar to the statue in Figure 5.17, adorns the central panel; and the semicircular panels tell the story of Jonah. The standing figures represent members of the Church, their hands raised in prayer for divine assistance.

Sculpture

Late Roman

Roman visual art of the period continued the practice of Augustan times in the celebration of emperors. The exaggeration of anatomical form for symbolic effect may also be seen in a colossal bust of Emperor Constantine (Fig. 5.12), a gigantic representation—the head stands over 8 feet (2.4 meters) tall—exhibiting a stark and expressive realism countered by caricatured, ill-proportioned intensity. This likeness is not a portrait of Constantine—it represents the artist's view both of Constantine's presentation of himself as emperor and of the office of emperor itself.

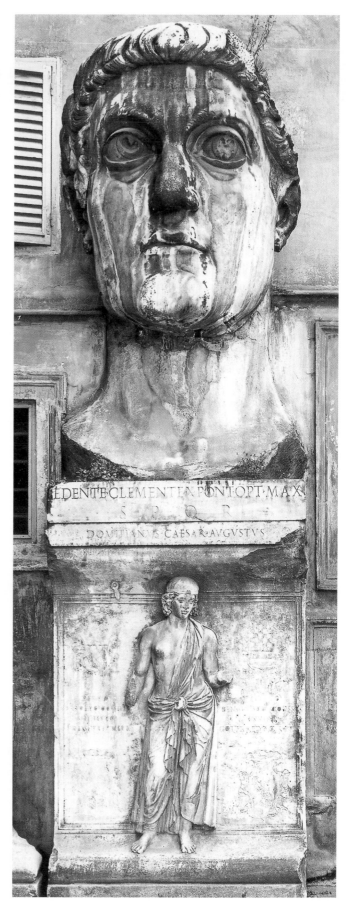

5.12 Head of Constantine the Great (originally part of a colossal seated statue), 313 C.E. Marble, 8 ft 6⅜ ins (2.61 m) high. Palazzo dei Conservatori, Rome.

Early Christian

One of the major questions debated by Christians for nearly eight hundred years centered on whether or not to depict the figure of Christ. The first visual symbols of Christianity were symbolic rather than representational, and they stemmed from the fact that, as members of a persecuted sect, Christians required some kind of arcane imagery that only they could identify. Perhaps the earliest Christian symbol, the *Chi-Rho* (ky-roh) monogram combines the first two letters of the word *Christos—XP—* in Greek. We see an artistic elaboration of the sign in Figure **5.13**, taken from a fourth-century sarcophagus. The *Chi-Rho* symbol stands at the center of a Roman triumphal wreath and above a cross. Doves, a symbol of the Holy Spirit and a reference to Jesus' baptism by John the Baptist, surround the monogram, which indicates the triumph of Christ over death, as two Roman soldiers, present at the crucifixion, sit below.

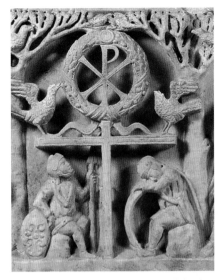

5.13 *Chi-Rho* monogram, detail of a sarcophagus, c. 340 C.E. Museo Pio Cristiano, Vatican Museums, Rome.

A DYNAMIC WORLD

SHINTO SCULPTURE IN JAPAN

Unlike the monotheism of Judaism, Shinto, or "Way of the Gods," Japan's indigenous religion, was a polytheistic nature cult without dogmas, scriptures, or images. At the same time as the late Roman Empire the graves of Japanese rulers were surrounded by moats and topped by huge burial mounds. One burial site near Osaka covers nearly 277 acres (112 hectares) in area and rises to a height of 110 feet (33.5 meters). Around the tombs, Shinto devotees erected terracotta tubes called *haniwa*. These stood 2 feet (61 centimeters) tall and were topped with human figures or heads or figures of animals. Tradition indicates that they were substitutes for

real humans who at one time had been slaughtered at the chieftain's funeral. The figure shown in Figure **5.14** reveals high stylization. There is absolutely no attempt to portray anatomically correct details. The effect is one of exaggeration for visual effect. As in the pictograms of Japanese writing, the ebbing and flowing of curvilinear line is most important. Unlike the carefully detailed lifelikeness of Roman wall painting and sculpture, Shinto sculpture of the period shows a logical simplicity that draws attention to materials and overall form rather than lays emphasis on internal compositional particulars.

5.14 *Haniwa* figure, c. 300–600 C.E. Terracotta, about 2 ft (61 cm) high. Musée Guimet, Paris.

5.15 The "fish" rebus for "Jesus Christ Son of God, Savior." Early Christian symbol.

In addition to the *Chi-Rho*, Christians used a number of other visual symbols—for example, the fish and the lamb. The fish comprised a *rebus*, a riddle composed of symbols suggesting the sound of the words they represent. The Greek word for fish, *ichthus*, provided the initials for the formula "Jesus Christ Son of God, Saviour." The rebus of two curved, intersecting lines created a means by which two Christians could secretly identify each other. One would trace a curve in the dirt. The other, if a Christian, would respond to create the sign of the fish (Fig. 5.15).

The lamb as a symbol referred to the metaphor used by John the Baptist, who described Christ as the "Lamb of God, which taketh away the sins of the world." Christ described himself as the "Good Shepherd" that "giveth his life for his sheep." The symbol of the lamb had been used in pagan art to represent benevolence or philanthropy, but it took a new meaning in Christianity and became one of the earliest artistic symbols in the faith (Fig. 5.16). In this early depiction of the Trinity, the diadem and *chlamys* (KLAH-mihs; a Greek mantle worn pinned at the shoulder) represent Christ the Son, the empty throne represents God the Father, and the dove represents the Holy Spirit. Probably in this depiction the lambs symbolize the classical virtue of beneficence rather than Christ.

The same holds true of a beautifully detailed statue entitled *The Good Shepherd* (Fig. 5.17). According to some scholars, depictions such as this, based on the injunctions we noted earlier, did not represent Christ but acquired Christian meaning only from their context in Christian tombs. In this particular case, the influence of classical Greek sculpture stands out. The detailing exhibits skill and lifelikeness, with the clothing hanging like real fabric rather than decoration.

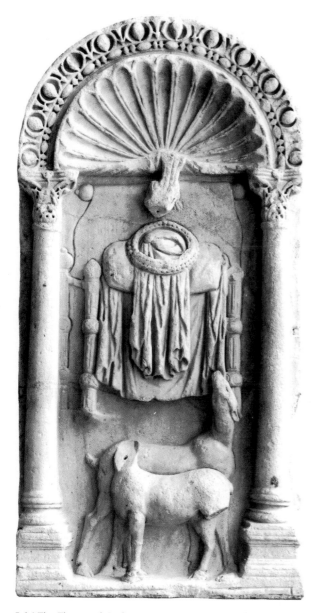

5.16 The Throne of God as a Trinitarian image, probably Constantinopolitan c. 400 C.E. Marble 65⅔ × 33 ins (167 × 84 cm). Stiftung Preussisches Kulturbesitz, Berlin-Dahlem, Germany.

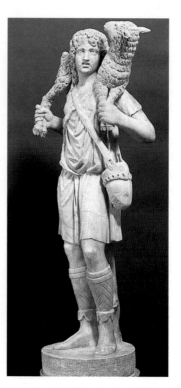

5.17 *The Good Shepherd*, c. 300 C.E. Marble, 36 ins (92 cm) high. Vatican Museums, Rome.

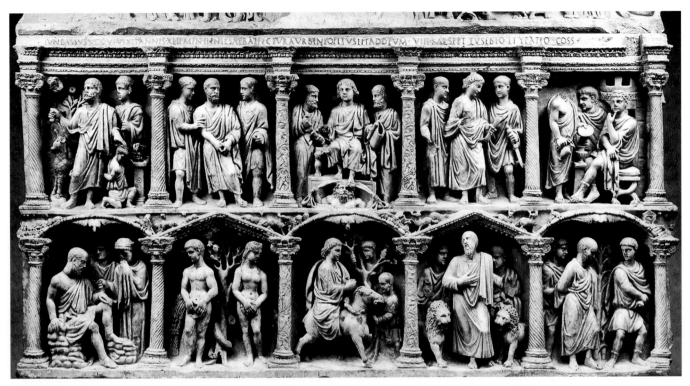

5.18 Sarcophagus of Junius Bassus, 359 C.E. Grottoes of St Peter, Vatican Museum, Rome.

The spread of Christianity among the ruling classes in Rome gave rise to personal expressions in Christian art, as can be seen in the sarcophagus of Junius Bassus (Fig. 5.18). Bassus was a prefect of the city of Rome, and his burial vault reflects a carefully designed creation. Two separate, elaborate arcades tell a variety of biblical stories, including those of the Hebrew children in the fiery furnace, the baptism of Christ, and the raising of Lazarus. The composition itself represents a sophisticated intricacy of high artistic quality. In the first place, the figures, although small, show delicate attention to detail. They stand away from the background, creating a sense of deep space between the **colonnettes**, and this gives each scene an individual identity. The middle scenes create a central axis, balanced by symmetrical treatments on either side.

In addition, the scenes themselves balance thematically. For example, at either end of the lower register, we find an afflicted Job and St Paul being led to execution. These parallel treatments not only represent redemption through suffering but also refer to Christ's suffering for the redemption of humankind. Christ himself occupies the central focal points of both registers. The bottom shows his triumphal entry into Jerusalem; the top, his enthronement between St Peter and St Paul. The enthronement signifies his regal triumph. Christ's feet rest on a canopy supported by the Roman sky god Coelus (CHAY-loos).

Architecture

Jerusalem

The Temple formed the religious structure in Jerusalem, the center of Israelite national life in the biblical period, beginning with the monarchy (tenth century B.C.E.) and continuing until its final destruction by the Roman legions in 70 C.E. The Temple Mount (Mt. Zion in Jerusalem) symbolized in prophecy and tradition, God's relationship with His people. The Masterwork feature (p. 160) tells its story.

The Roman Empire

By the third century C.E., Rome may have been in decline, but the opposite may be said for the ornateness of its architecture. Opulent buildings with excessive decoration arose throughout the Roman Empire, especially in Egypt, Syria, and Asia Minor, where Hellenistic architectural principles witnessed a revision to reflect Roman ideals—for example, axial symmetry (equality of form around a central axis) and logical sequence.

Even though much of the political power of the empire moved toward the East, Roman emperors still built their most lavish monuments in Rome. The best examples of Roman monumentality in architecture are the *thermae* or baths, represented by one of the most grandiose of these, the Baths of Diocletian (Fig. **5.24**). The interior proportions of the tepidarium or hall

MASTERWORK

THE TEMPLE OF JERUSALEM

The Temple of Jerusalem symbolized Israel's faith as early as its third king, Solomon, son of David (c. 1000 B.C.E.). Described in 1 Kings 5–9, the Temple of Solomon served primarily as the house of the Lord God—Yahweh—as opposed to a place to which common people came to worship. In fact, the general populace only had access to the Temple courts and not to the inside of the structure itself. Even the clergy did not have free access to the building. The inner sanctum remained off limits to everyone except the chief priest, and to him only on the Day of Atonement. Although the public did not have access to the Temple, it was very much a public building in all

senses, including politically and economically. Ancient Israel, although a monarchy, remained a theocracy, and the Temple played an important role in the organization and administration of the national community.

Two major rebuilding projects took place between its construction under Solomon and its ultimate destruction by the Romans in 70 C.E. (Fig. **5.21**), and we often find reference to the First, Second, and Third Temples. The Temple of Solomon is the First Temple, and we know it primarily from the description in 1 Kings 6–8 and a parallel account in 2 Chronicles 2–4. No trace of the first Jerusalem Temple exists archeologically. The basic shape of the Jerusalem Temple (Figs **5.19** and **5.20**) formed a rectangle subdivided laterally into three sections, each with the same interior width—20 cubits. The building measured 60 cubits long and 30 cubits high. A cubit equals approximately 20.9 inches (53 centimeters), so the Temple measured approximately 105 feet (32 meters) long, 35 feet (10.7 meters) wide, and 52 feet (15.8 meters) high. These comprise internal measurements given in 1 Kings, but the biblical book of Ezekiel gives a different set of dimensions—100 by 50 cubits. These, however, are probably external dimensions and include subsidiary rooms built around the Temple.

The Temple stood on a 6-cubit-high platform with a dominating entrance of huge wooden doors flanked by two bronze pillars, 18 cubits high, situated at the top of the ten stairs. The doors were decorated with carved palms, flowers, and cherubim—guardian winged beasts sometimes shown with human or animal faces. To enter the Temple, one passed through the first of its three sections, variously referred to as a "vestibule," "porch," "portico," or "entrance hall." The second section of the Temple, its main or largest room, measured 40 by 20 cubits and reaching a height of 30 cubits. The Hebrew word *hikhal* or *hekal* means that this room—the Temple's largest—was a "great house" or "holy place," and it signifies that the Temple was the "house of the Lord," an earthly dwelling place of the deity. A large, elaborate cypresswood doorway carved with cherubim and palm trees and overlaid with gold provided entry. Walls paneled with cedarwood exhibiting rich floral carvings had small rectangular

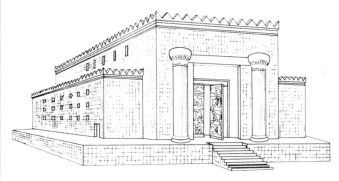

5.19 Reconstruction drawing of Solomon's Temple. The significance of the two bronze pillars is uncertain, but some scholars suggest that they may have represented the twin pillars of fire and smoke that guided the Israelites during their wanderings in the desert after the Exodus from Egypt.

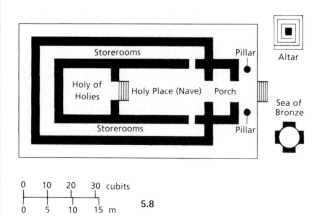

5.20 Ground plan of the Temple of Solomon.

windows at the top, through which light entered the space. In the room itself stood various sacred furnishings—ten large golden lampstands, an inlaid table for priestly offerings, and a cedarwood altar covered with gold.

From a staircase behind the altar one entered the Holy of Holies, the most sacred part of the Temple: a windowless cubicle, 20 by 20 by 20 cubits, which contained the Ark of the Covenant, the symbol of God's presence, which the Jews had carried with them from the wilderness. Two large cherubim flanked the Ark.

The symbolic nature of the Temple as a residence for God went beyond providing assurance to the Israelites that God was with them. Construction of the Temple was anticipated by David, who brought the Ark of the Covenant to Jerusalem and began assembling materials. Solomon gave great priority to completing the Temple. He assembled an enormous workforce and completed the job in a remarkably short time: seven years.

Construction of the Temple coincided with the institution of the monarchy and the emergence of Israel, for the only time in its existence, as an independent and dominant political power in the region. Thus, the Temple symbolized not only the presence of the Lord God, but also Israel's very national identity.

The Temple was rebuilt extravagantly by Herod beginning c. 20 B.C.E. (Fig. **5.23**); a reconstruction can be seen in Jerusalem (Fig. **5.22**).

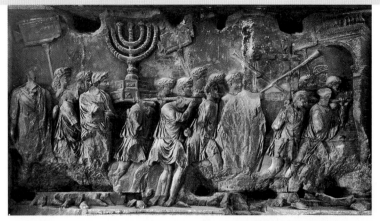

5.21 Destruction of the Temple, a detail from the Arch of Titus, showing the menorah procession, 81 C.E. (A menorah is a ceremonial seven-branched candelabrum of the Jewish temple symbolizing the seven days of the creation.) Marble, arch 47 ft 4 ins (14.43 m) high. Rome.

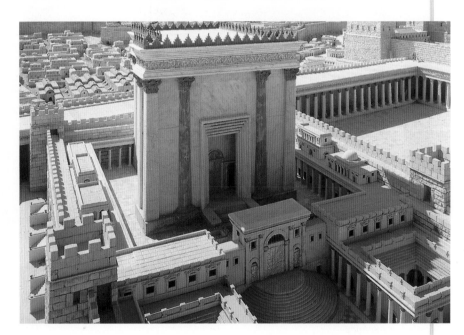

5.22 The third (Herod's) Temple, 20 B.C.E. (reconstruction). Jerusalem, Israel.

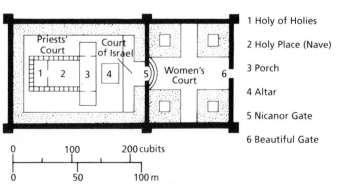

1 Holy of Holies

2 Holy Place (Nave)

3 Porch

4 Altar

5 Nicanor Gate

6 Beautiful Gate

5.23 Reconstruction of the third Temple: ground plan.

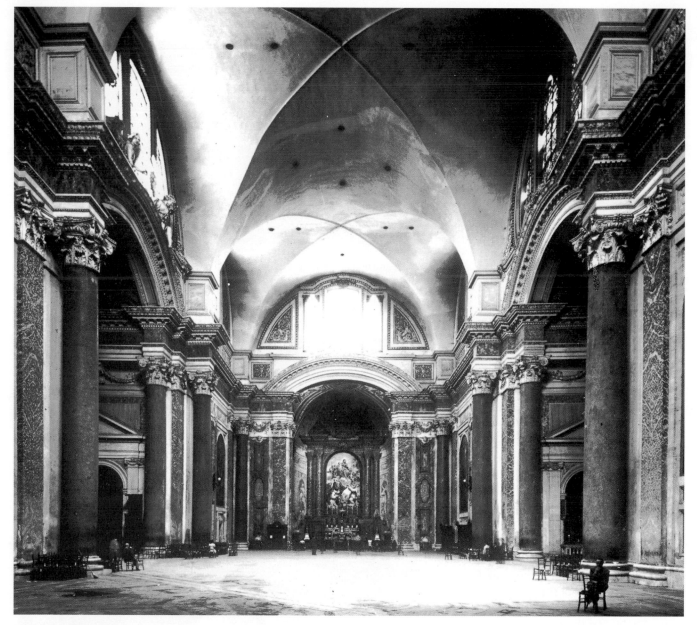

5.24 Tepidarium of the Baths of Diocletian, Rome, c. 298–305 C.E. (Converted by Michelangelo and others into the church of S. Maria degli Angeli.)

enclosed over 16,000 square feet (1,486 square meters). The space we see today has been diminished because of a later renovation that converted a section of the building to a church and raised the floor by 7 feet (2.1 meters). In its original form, the tepidarium contained huge openings that made it possible to see into adjacent spaces. The walls and ceilings, covered with mosaics and marble, reflected light entering the space through high windows, but the renovation replaced the reflective surfaces with plaster and paint and closed in the openings. Nonetheless, we can appreciate the vastness of this work, supported by 50-foot-high (15-meter) columns of Egyptian granite, supported by eight huge concrete piers.

Another building based on the shape of the Roman baths, particularly that of Diocletian, the Basilica of Constantine, exceeded Diocletian's Baths in height. In its time, it probably was the largest roofed building in Rome (Figs **5.25** and **5.26**), but today only the north aisle remains. The three groined vaults covering the **nave** and directing the thrust of force outward to four corners, made it possible to erect upper walls into which openings called **clerestory** (KLIR-stohr-ee) windows could be cut to allow light into the space. Thus, despite its tremendous size, the building must have had a light and airy atmosphere. This detail of design found use extensively from the Middle Ages onward.

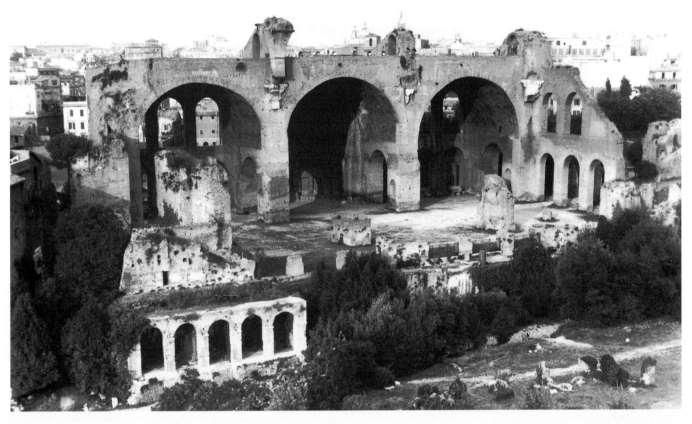

5.25 The Basilica of Constantine, Rome, c. 310–20 C.E.

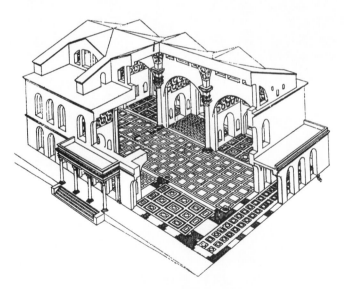

5.26 Reconstruction drawing of the Basilica of Constantine
(after Huelsen).

When Christianity became a state religion in Rome,
an explosion of building took place to accommodate the
need for places to worship. Previously, small groups of
the faithful had gathered as inconspicuously as possible
wherever practical and prudent for them to do so. Even
had it been safe to worship publicly, they needed no
building of any size to house so few people.
Respectability changed all that.

Early Christian architecture, like painting, adapted
existing Roman style. For the most part, churches took
the form of the Roman **basilica**. We tend to think of the
word "basilica" as referring specifically to Christian
structures, as in St Peter's Basilica in Rome. The term
originally referred to Roman law courts, whose form
the first large Christian churches took.

The original basilica had a specific architectural
design, to which Christian architects made some simple
alterations. Roman basilicas had many doors along the
sides of the building to facilitate entrances and exits.
Church ritual required the altar to be the focal point,
and so the entrance to the Christian basilica moved to the
end of the building, usually at the western end, to focus
attention down the long, relatively narrow nave to the
altar at the far end. Often a large archway reminiscent
of a Roman triumphal arch (which became a symbol of

5.27 Old St Peter's Basilica, Rome, c. 333 C.E. Reconstruction by Kenneth J. Conant, Francis Loeb Library, Harvard University, Cambridge, MA.

Christ's triumph over death) set off the altar, elevated to enhance sightlines from the congregation, who occupied a flat floor space.

The basic structure of a basilica (Figs **5.27** and **5.28**) has two or four long, parallel rows of columns, or piers, surrounded by an outer wall separated from the columns by an aisle. The central space, or nave, was heightened by a clerestory and a beam or simple truss roof describing an isosceles triangle of fairly low pitch. Low-pitched roofs covered the side aisles. The basilica was reasonably easy to build, yielding a nave width of 70 or 80 feet (21 or 24 meters). In contrast to later church styles, the basilica was not monumental by virtue of its height, although its early association with the law courts gave it an air of social authority. Interior parts and spaces had clear definition, and its form was stated in simple structural terms.

Another change occurred in the treatment of interior space as different from the exterior shell. In architectural design, two approaches to the interior–exterior problem exist. Either the exterior structure expresses and reveals the nature and quality of interior space and *vice versa*, or the exterior shell stays just that—a shell—in many

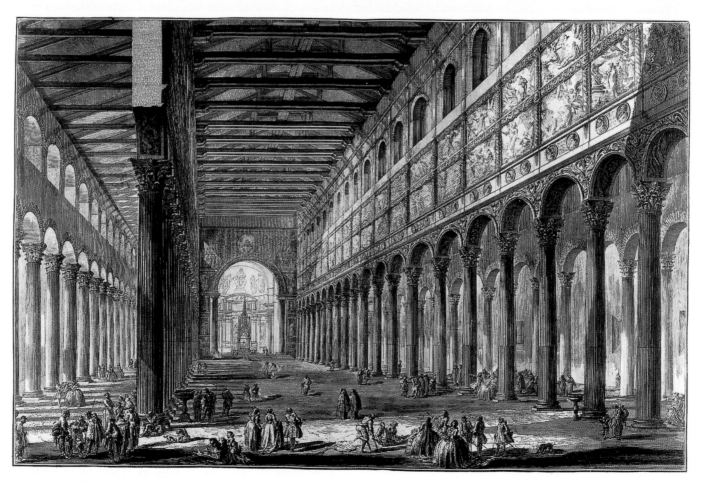

5.28 Interior of San Paolo Fuori le Mura, Rome, late fourth century. Engraving by Giambattista Piranesi (1720–78).

instances obscuring what lies inside. The basilica exemplified the latter style. Whether intentionally or not, it thus symbolizes the difference between the exterior world of the flesh and the interior world of the spirit.

Music and Dance

References to music and dance occur frequently in the Jewish scriptures. Genesis 4:21 refers to those who play the "lyre and the pipe." In Exodus 15:20–21:

Miriam the prophetess, the sister of Aaron, took a timbrel in her hand; and all the women went after her with timbrels and with dances.

And Miriam answered them, Sing ye to the Lord, for he hath triumphed gloriously; the horse and his rider hath he thrown into the sea.

The musicianship of David is documented in 1 Samuel 16:23. When King Saul was tormented, "David took the lyre and played it with his hand; so Saul was refreshed, and was well, and the evil spirit departed from him."

As with almost everything else we have noted, music in the late Roman period reflected Roman decline and Christian ascension. Just as St Paul took the Judaic and Eastern mystical traditions of Christian thought and shaped them into the logical processes of the Greco-Roman world, so early Christian music began to combine the music of Jewish worship with forms from the classical heritage. The early Christian Church rejected most of the music from the Greek, Hellenistic, and Roman traditions, considering music cultivated simply for enjoyment, together with any music or musical instrument associated with activities objectionable to the Church, unsuitable. The *hydraulos* (see Fig. 4.28), for example, was banned. On the whole, the music of the classical West was simpler than the more ornate elaborations of liturgical texts in the East, especially in congregations with a large Jewish contingent. The consequent intermingling of the two styles resulted in a rich pastiche of hymns and liturgy both vocal and instrumental. Nevertheless, a deep suspicion of instrumental music remained in many quarters with an outright rejection of it in others, because it recalled pagan customs. Disapproval of Roman or Greek music did not reflect a negative attitude toward music itself as much as a need to break ties with pagan traditions.

A reaction against the use of trained choruses, initially instituted to help lead congregations unfamiliar with the chanting of psalms, also occurred. When trained choruses sang, the congregation tended to sing less and the chorus more. In turn, this led to more complex music, which Church leaders eventually found undesirable. In 361 the Provincial Council of Laodicea (lay-oh-di-SEE-uh) ruled that each congregation could have only one paid cantor or performer. The leader sang a line of the psalm, and the congregation sang a second in response. The melody began with a single note for the first few words, changing for the final words to a half cadence. The congregation then sang the beginning of the response on the same note, concluding with a **cadence**. The early Church also used an **antiphonal** (an-TIF-oh-nuhl) style, in which singing alternated between two choruses.

We know that from earliest times music played a role in Christian worship, and because Christian services were modeled on Jewish synagogue services, it is likely that any music in them was linked closely to liturgical function. In Rome, Christian liturgy (literally, "the work of the people") included only chants and unaccompanied singing. In Antioch, however, a new form, the hymn, emerged via the Jewish synagogue and its songs. A song of praise to God, the hymn quickly spread throughout the Christian world as part of the liturgy that comprised the worship service, or Mass, in which the eucharist formed the focus.

Hymns came into the Western Church early in the fourth century. Some sources credit St Ambrose for this innovation, others credit Hilary, bishop of Poitiers (pwah-TYAY). Early hymns had poetic texts consisting of several verses, all of which used the same melody, which may have been taken from popular secular songs. The hymns, mostly syllabic (sil-A-bik)—each syllable sung on a single note—were intended to be sung by the congregations, not by a choir or a soloist. In style and content, early Church hymns tended to express personal, individual ideas, although other sections of the liturgy contained more formal, objective, and impersonal elements.

Another type of Church music at this time, the *alleluia*, presented an interesting contrast in style to the hymn. The *alleluia* had a **melismatic** style—there were many notes for each syllable of text—and it occurred after the verse of a psalm. The last syllable of the word was drawn out "in gladness of heart." Eastern in influence and emotional in appeal, the *alleluia* came to the Christian service directly from Jewish liturgy.

Literature

The literature of the late Roman Empire reflected a dispirited decline, parallel to that of the Empire in which it existed. Compared with earlier times, little work of any quality appeared—no experimentation with new forms, nor a major production of old forms occurred—and it seemed as if the only writers whose outlook was to the future and optimism were the Christians.

The Christian Bible, not widely available until 313, emerged as the most significant literature of the period. By the mid-second century, Irenaeus, a bishop of Lyon, had put forward a **canon** of twenty-one of the present twenty-seven books—the inclusion of Revelation raised considerable disagreement—and some books not at present in the Bible were often included. Church councils in Hippo (393) and Carthage (397) recognized the twenty-seven-book canon.

Although the Bible speaks to Judaic and Christian religious needs, it also contains some of the most vibrant literature of all time.

The Hebrew Bible

The word "bible" comes from the Greek word for book, and it refers to the town of Byblos, which exported the papyrus reed used in the ancient world for making books. The Jews compiled the history of their culture and religion into a collection of sacred writings later called scriptures. The compilation grew from the oral traditions of the Hebrew people and took shape over a period of years as it was assembled, transcribed, and verified by state officials and scholars. The Bible has been handed down in a variety of forms. The Hebrew Bible, often called the Masoretic Text (MT), contains a collection of twenty-four books written in Hebrew, with a few passages in Aramaic.

The earliest written Bible probably dates to the United Monarchy in the tenth century B.C.E. and consists of an assemblage of history, songs, stories, and prophecy. After the Babylonian Captivity, in the fifth century B.C.E., Jewish religious leaders and scholars carefully scrutinized the body of writings and established a canon—an officially accepted compilation—believed divinely inspired. The first canon consisted of the Torah or the Pentateuch, the first five books of the current Bible. The current Hebrew Bible, canonized by the Council of Jamnia in 90 C.E., contained three parts: The Law (Torah), the Prophets, and the Writings.

During the Hellenistic period major centers of Judaism existed in Syria, Asia Minor, Babylonia, and, particularly, in Alexandria, Egypt. Here, the Jewish Canon was translated into Greek and called the Septuagint, meaning "seventy" from the seventy scholars who supposedly worked on it.

The Torah

The Torah (TOH-ruh), meaning "the teaching," includes doctrine and practice, religion, and morals. It contains the books of Genesis, Exodus, Leviticus, Numbers, and Deuteronomy. The commandments, in addition to the Decalogue, sought to prepare Israel for a holy mission that the nation would be called upon to undertake in order to become "holy unto God." The preparation

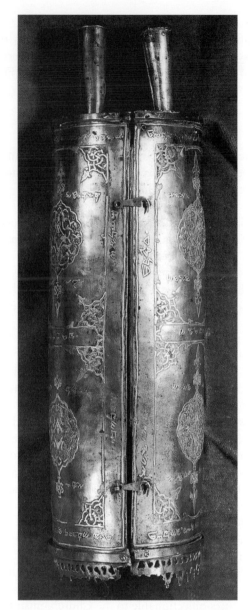

5.29 Joseph (maker, first name), Torah case from Damascus, Syria, 1565. Copper inlaid with silver, 32 ins (81.3 cm) high. Jewish Museum, New York.

entails a separation from everything opposed to the will of God and a dedication to his service. Thus, holiness meant religion and morality. In religion, the holiness of Israel meant abhorring idolatry and its associated practices, such as human sacrifice, sacred prostitution, divination, and magic. It also meant adopting a cult and ritual that were ennobling and elevating. In morals, holiness meant resisting the urges of nature that were self-serving and adopting an ethic in which service to others lay at the center of life. Consequently, the Torah, as given to Israel, prescribes two sets of laws that connect religion and morality: belief and practice. In their positive nature,

they intend to carry a dynamism that can transform individuals and, therefore, societies. Disregard of the law thus becomes not an individual but a social offense.

Fundamental to moral law in the Torah stand the two principles, mentioned earlier: justice and righteousness. These lie at the heart of humankind's creative cooperation with God. Justice meant the recognition of six fundamental rights: the right to live; the right of possession; the right to work; the right to clothing; the right to shelter; and the right of the person, which includes the right to leisure and liberty and the prohibition to hate, avenge, or bear a grudge. Righteousness manifested itself in the acceptance of duties—for example, concern for the poor, the weak, and the helpless, whether friend or foe—and although possession of earthly goods was a right, it was also a divine trust.

The Torah constitutes the uniqueness of the religion of Israel (Fig. 5.29). The distinct approach of the Torah to the conduct of human behavior comes by way of the heart. It speaks to the mind concerning duties, but applies itself to the heart in terms of the perversities of vices and evil. Torah embraces all of life and, thus, becomes a means for strengthening the supremacy of holy will and bringing all life into relationship with serving God. In the Torah we find, for example, the stories of the Creation, Adam and Eve, Noah and the Flood, Abraham and the sacrifice of Isaac, Joseph and the Coat of Many Colors, the Ten Commandments, and the law of "an eye for an eye" which we saw in The Code of Hammurabi (Chapter 1).

The Prophets

The Prophets include the Former Prophets—Joshua, Judges, Samuel, Kings—and the Latter Prophets—Isaiah, Jeremiah, Ezekiel (y-ZAY-uh; Jair-uh-MY-uh; ih-ZEEK-ee-uhl), and the twelve minor prophets. These books record the history of Israel and Judah and further develop Hebrew concepts of God, his nature, and the Hebrews' relationship to him. They tell the story of the conquest of Canaan, the Judges, and the United Monarchy, and describe the development of the theocratic state in the post-Babylonian Captivity period. They also tell the stories of the battle of Jericho (JAIR-ih-koh), Samson and Delilah, Daniel and the lions' den, King Saul, David and Goliath, and King Solomon and the Temple of Jerusalem. They contain the well-known images from Isaiah of the "suffering servant" and the saying, "They shall beat their swords into plowshares." Of course, this represents more than history. The prophets speak with the authority of God. We tend to think of a prophet as one who predicts the future, but such was not the case with the Hebrew prophets. The Prophets did speak of a coming time of peace and justice when the Messiah would come, but

their principal message was one of reconciliation of the Hebrew people with their God. The prophets called upon the people of Israel to return to the ways of the covenant with God and pointed out exactly how they had fallen short of the expectations of that covenant. In a sense, the prophets functioned as social critics. They admonished the people of Israel to remember the Law, which requires justice and decent treatment of the poor, and called on them to turn away from the self-indulgences of the current generation and to return to the compassionate behavior called for in the Torah.

Unlike the Levites (LEE-vyts)—the priestly tribe—whose divine function came as a result of their birth into the tribe of Levi, prophets were individuals called directly by God to preach his word to the nation. The life of a prophet had its difficulties, and prophets like Isaiah often resisted their initial calling. Accepting God's prophetic ministry often meant a violent death—railing against contemporary practice has never been popular.

During the long and peaceful reign of Jeroboam II (786–746 B.C.E.) Israel reached the apex of its national prosperity and territoriality. The Israelites believed that the prosperity and military success of the time proved God's favor toward them. They also believed that they deserved the benefits because they supported the official shrines. The prophet Amos entered this scene somewhere around 760–750 B.C.E. From a small Judean village, he received God's call to leave his life as a shepherd and preach a difficult message in the midst of good times. He denounced Israel and its neighbors for their reliance on military might, social injustice, rampant immorality, and shallow religious piety. His confrontation with the priest Amaziah (Amos 7:10–17) provides one of the most dramatic scenes in Hebrew prophecy. His preaching caused his expulsion from the royal sanctuary at Bethel and the admonition against preaching there again. So, Amos returned to Judah and wrote down the essence of his message, most likely in the form we now find it. Some sources attribute the writing down of Amos' prophesies to successors rather than the prophet himself, with some verses added during the Babylonian captivity.

The book falls into three parts: (1) Chapters 1 and 2 contain oracles against Israel's neighbors; (2) chapters 3–6 indict Israel for her sins and injustices; (3) chapters 7–9 provide visions of Israel's coming doom. His message remains simple, and his style and form reveal a full understanding of the prophetic role and message. Almost all of the speeches are short and to the point, more like announcements, asserting God's absolute sovereignty over mortals. Amos writes thoughtfully and emerges as a man well-traveled and full of fierce integrity. The writing has a poetic quality in a homey style imbedded with forceful imagery and rhythmic language.

The Writings

The Writings, which contain a variety of literary forms, including poetry and apocalyptic visions, consist of the biblical books of Psalms, Proverbs, Job, Song of Songs, Ruth, Lamentations, Ecclesiastes (ih-kleez-ee-AS-teez), Esther, Daniel, Ezra, Nehemiah, and Chronicles. The story of Job, for example, tells the story of a righteous man beset with calamity so that God can show Satan how a truly righteous man will respond to adversity. Satan maintains that a good man like Job is good only because he is blessed. Take away his comfort and he will curse God. The tale, like many, illustrates the qualities of righteous behavior more than it details the nature of God—although that occurs as well. In the book of Ruth we learn of the qualities of love, devotion, and loyalty: "Where you go, I will go. And where you lodge, I will lodge. Your people shall be my people, and your God, my God; where you die, I will die, and there I will be buried. May the Lord do so to me and more also if even death parts me from you" (Ruth 1:16–17). Certain texts within the Writings purport to be from the time of Solomon, but are actually products of the Hellenistic age. These texts include, among others, Song of Songs and Ecclesiastes. These contain words and concepts which would have been completely foreign to Jews from Solomon's time— for example, philosophy, chance/luck, and wisdom (*hachmah*).

The Psalms or Psalter forms the hymnal of ancient Israel. Most of the Psalms probably accompanied worship in the temple. We can divide them into various categories such as hymns, enthronement hymns, songs of Zion, laments, songs of trust, thanksgiving, sacred history, royal psalms, wisdom psalms, and liturgies. Here we include Psalm 22 (a psalm of David), and Psalms 130 and 133 (Songs of Ascent).

These psalms also contain a literary device called parallelism, which occurs in both prose and poetry. In parallelism, the writer arranges coordinate ideas in phrases, sentences, and paragraphs that balance one element with another of equal importance and similar wording. The repetition of sounds, meanings, and structures helps to order, emphasize, and illuminate relationships. Parallelism forms a prominent figure in Hebrew poetry, as well as most literatures of the ancient Middle East. Parallelism occurs in both Old and New Testaments, reflecting the influence of Hebrew poetry.

Psalm 22

My God, my God, why hast thou forsaken me?
 Why art thou so far from helping me, from the words of my groaning?
2 O my God, I cry by day, but thou dost not answer;
 and by night, but find no rest.
3 Yet thou art holy,
 enthroned on the praises of Israel.
4 In thee our fathers trusted;
 they trusted, and thou didst deliver them.
5 To thee they cried, and were saved;
 in thee they trusted, and were not disappointed.

6 But I am a worm, and no man;
 scorned by men, and despised by the people.
7 All those who see me mock at me,
 they make mouths at me, they wag their heads;
8 "He committed his cause to the LORD; let him deliver him,
 let him rescue him, for he delights in him!"

9 Yet thou art he who took me from the womb;
 thou didst keep me safe upon my mother's breasts.
10 Upon thee was I cast from my birth,
 and since my mother bore me thou hast been my God.
11 Be not far from me,
 for trouble is near
 and there is none to help.

12 Many bulls encompass me,
 strong bulls of Bashan surround me;
13 they open wide their mouths at me,
 like a ravening and roaring lion.
14 I am poured out like water,
 and all my bones are out of joint;
 my heart is like wax,
 it is melted within my breast;
15 my strength is dried up like a potsherd,
 and my tongue cleaves to my jaws;
 thou dost lay me in the dust of death.

16 Yea, dogs are round about me;
 a company of evildoers encircle me;
 they have pierced my hands and feet—
17 I can count all my bones—
 they stare and gloat over me;
18 They divide my garments among them,
 and for my raiment they cast lots.

19 But thou, O LORD, be not far off!
 O thou my help, hasten to my aid!
20 Deliver my soul from the sword,
 my life from the power of the dog!
21 Save me from the mouth of the lion,
 my afflicted soul from the horns of the wild oxen!
22 I will tell of thy name to my brethren;
 in the midst of the congregation I will praise thee:
23 You who fear the LORD, praise him!
 all you sons of Jacob, glorify him,
 and stand in awe of him, all you sons of Israel!
24 For he has not despised or abhorred
 the affliction of the afflicted;
 and he has not hid his face from him,
 but has heard, when he cried to him.

25 From thee comes my praise in the great congregation;
 my vows I will pay before those who fear him.
26 The afflicted shall eat and be satisfied;
 those who seek him shall praise the LORD!
 May your hearts live for ever!
27 All the ends of the earth shall remember
 and turn to the LORD;
 and all the families of the nations
 shall worship before him.
28 For dominion belongs to the LORD,
 and he rules over the nations.

29 Yea, to him shall all the proud of the earth bow down;
 before him shall bow all who go down to the dust,
 and he who cannot keep himself alive.
30 Posterity shall serve him;
 men shall tell of the LORD to the coming generation,
31 And proclaim his deliverance to a people yet unborn,
 that he has wrought it.

Psalm 130

Out of the depths I cry to thee, O LORD!
 Lord, hear my voice!
2 Let thy ears be attentive
 to the voice of my supplications!

3 If thou, O LORD, shouldst mark iniquities,
 Lord, who could stand?
4 But there is forgiveness with thee,
 that thou mayest be feared.

5 I wait for the LORD, my soul waits,
 and in his word I hope;
6 My soul waits for the LORD
 more than watchmen for the morning,
 more than watchmen for the morning.

7 O Israel, hope in the LORD!
 For with the LORD there is steadfast love,
 and with him is plenteous redemption.
8 And he will redeem Israel from all his iniquities.

Psalm 133

Behold, how good and pleasant it is
 when brothers dwell in unity!
2 It is like the precious oil upon the head,
 running down upon the beard,
 upon the beard of Aaron,
 running down on the collar of his robes!
3 It is like the dew of Hermon,
 which falls on the mountains of Zion!
 For there the LORD has commanded the blessing,
 life for evermore.

Apocalyptic Literature

Apocalyptic literature appears in both the Old and New Testaments. It expounds a prophetic revelation that particularly predicts the destruction of the world. Much apocalyptic literature, however, appears outside the Bible, and consists of a specific genre of literature that flourished from around 200 B.C.E. to 200 C.E. especially in Judaism and Christianity. Primarily, apocalyptic literature seeks to provide hope to people undergoing persecution or cultural upheaval. These works use cryptic language that, to believers, means the sudden, dramatic intervention of God in history on behalf of the faithful elect. Apocalyptic literature further details the terrifying events that will accompany God's powerful intervention in human affairs, for example, temporary rule by Satan, signs in the heavens, persecutions, wars, famines, and plagues. These works tend to focus on the future and the coming overthrow of evil, the coming (or second coming) of a messiah, and the establishment of the Kingdom of God and its resultant eternal peace and righteousness. In the Old Testament, the Book of Daniel, and in the New Testament, the Revelation to John, exemplify this genre.

The book of Revelation, or Apocalypse, closes the Christian scriptures, and its last chapters portray the fulfillment toward which the entire biblical message of redemption focuses. It contains powerful poetic imagery that appeals to the imagination. It represents a vision of its author, John. Probably, parts of the book were written before the fall of Jerusalem in 70 C.E., but the book apparently achieved its final form on the rocky island of Patmos (PAT-mohs), to which the author had been exiled by the Emperor Domitian. Over the centuries the Revelation to John has proved one of the most difficult and inspiring representations of God ever written.

The New Testament

The books of the New Testament, later adopted as the Christian canon, appeared within a period of less than one hundred years. They fall into four different literary forms. Four of them constitute the "*Gospels*," so-called because they tell the "good news" of Jesus Christ. Early Church *history* occurs in the Acts of the Apostles, an account of the spread of the Christian faith during the first thirty years after the Resurrection. Twenty-one of the books constitute epistles, or *letters*, written to various churches and individuals by the early evangelists. The last book of the New Testament (the book of Revelation) comprises an *apocalypse* (God's will for the future, as we just noted). We will examine two of these forms: the Gospels and the Letters (limited to those of St Paul).

The Gospels

The earliest of the four gospels, the Gospel of Mark, appeared around the year 70 C.E. The Gospels of Matthew and Luke use Mark as a source (each appeared ten to twenty years later than Mark), and because they have so much in common, we call them Synoptic Gospels—from the Greek word *synopsis*, a seeing together. Unlike the Synoptics, which tell mainly of Jesus'

public teaching and ministry, the Gospel according to John contains information concerning Jesus' early Judean ministry and extensive discussions with the disciples about the union of the Church with Christ.

One of the most beautiful hymns ever written is the Magnificat of Mary, from the Gospel of St Luke. In it, Mary responds to God's plan for her to bear his son, and it exemplifies the kind of obedience deemed righteous by both Jews and Christians. (The subject has served many artists through the centuries, and we see it beautifully portrayed in the *Annunciation* of Fra Angelico [ahn-JAY-lee-koh] (see Fig. **9.8**).) The passage is steeped in the Old Testament, and has a special kinship with Hannah's song of praise in 1 Samuel 2:1–10. Some commentators have seen the Magnificat as a revolutionary document because it speaks of three revolutions of God. First, it speaks of a moral revolution, because God will scatter the proud in the plans of their hearts. A basic tenet of Christianity holds that seeing oneself in the light of Christ deals a death blow to pride. Second, it speaks of a social revolution: "He casts down the mighty—he exalts the humble." Prestige and social labeling have no place in the new covenant. Third, it speaks of an economic revolution: "He has filled those who are hungry . . . he sends away empty those who are rich." There is no room here for an acquisitive society—that is, one in which people are out for as much as they can get. What the Magnificat argues for is a society in which no one dares to have too much while others have too little.[5]

Thus, within this poetry, there is a powerful upheaval—a revolution of thinking that is as applicable today as it was two thousand years ago. In Luke 1:46–56:

> And Mary said, "My soul magnifies the Lord, and my spirit has exulted in God, my Saviour, because he looked graciously on the humble estate of his servant. For—look you—from now on all generations shall call me blessed, for the Mighty One has done great things for me and his name is holy. His mercy is from generation to generation to those who fear him. He demonstrates his power with his arm. He scatters the proud in the plans of their hearts. He casts down the mighty from their seats of power. He exalts the humble. He fills those who are hungry with good things and he sends away empty those who are rich. He has helped Israel, his son, in that he has remembered his mercy—as he said to our fathers that he would—to Abraham and to his descendants forever."

The Letters

Much of basic Christian theology emerges from the letters section of the New Testament, a large proportion of which is attributed to St Paul. Probably the most important promulgator of Christian thought, Paul shaped the eastern tone of Judaic Christianity into the logical intellectual pattern of the Greek-thinking world of the Roman Empire.

The Apostle Paul was the most effective missionary of early Christianity and its first theologian. He is sometimes called the "second founder" of Christianity, having written more than one-fourth of the New Testament. His theology emerges from the many letters he wrote to the young churches throughout Asia Minor and Greece, but his Letter to the Romans probably stands as the greatest systemization of Christian theology ever produced. Although generally not a systematic theologian, Paul uses the Letter to the Romans as a means for establishing Christian dogma. While acknowledging his theological debt to Judaism, including his concept of righteousness, his cosmology—that is, his philosophy about the origin and shape of the universe—reflects that of the Hellenistic world. His belief that improper participation in the Lord's Supper causes sickness and death reflects ideas found in some of the Hellenistic cults. Above all, however, Paul stands as a biblical theologian, and he sought to interpret the revelation of the God of the Old Testament in the death and resurrection of Jesus Christ.

One of the central premises in Pauline theology, the concept of justification through faith, emerges in the Letters to the Romans and Corinthians, in which he argues that God moved first to save humankind and that nothing that humans can do—except believing in Jesus Christ as Lord—can earn them salvation. Also central to Paul's thinking is a kind of apocalyptic mysticism—an emphasis on the coming of the end of history. In this view, Paul accepts and affirms the ultimate triumph of God over evil.

All of this rests, of course, on the assumption that Jesus is Lord and Messiah, and, because Messiah has come, the end is at hand. The decisive event has occurred in the crucifixion and resurrection of Christ, and the cross becomes a central force in Paul's Christology—his definition of Christ. Through the crucifixion, God reveals his love for humankind and uses it as a propitiation for all sin. However, Paul's theology includes God's judgment. Humankind has failed to follow the word of God and lives enslaved by sin, which leads to death. The Law remains insufficient for redemption. Only God's grace, with its consequent gift of righteousness, can lead to eternal life. In Christ, God reveals his mercy to those who respond in faith.

Paul's theology is far more complex than this brief description can encompass, but his systematic explanation of who Christ is and what God intended in Christ has underpinned Christian thought and belief for

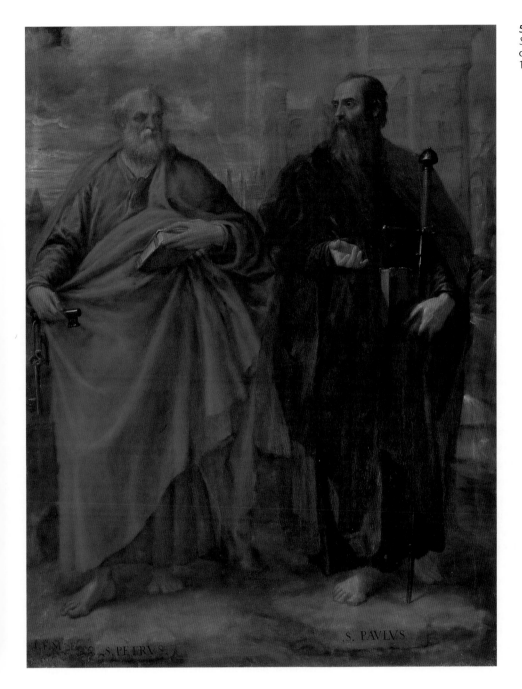

5.30 Juan Fernández de Navarrette, *St Peter and St Paul*, 1577. Oil on canvas, 7 ft 6½ ins × 6 ft (2.3 × 1.8 m), The Escorial.

nearly two thousand years. Paul explained his theology in a series of occasional letters written to specific local churches undergoing specific local problems. He intended them to be read to the entire congregation and he structured them according to the letter-writing standards of the day. They begin with an introductory salutation, followed by a statement of thanksgiving; then comes the main body of the letter, which addresses the major points of concern. Paul first treats questions of doctrine, then he uses persuasive exhortation in order to move the congregation to the action he desires of them, before ending the letter with a statement of his travel plans, a greeting, and benediction.

Paul's favorite form, the Hellenistic discourse known as the *diatribe*, has an argumentative structure, in which the correspondent raises a series of questions and then answers them. Because Paul dictated his letters, their style often emerges as awkward and, occasionally, difficult to comprehend. Complex sentences, which never seem to end, occur frequently, and thoughts are often truncated into incomplete sentences. When placed in the framework of modern practice, his cultural assumptions sometimes cause problems—for example, his comments in the Letters to the Corinthians about restricting the role of women. Scholars and clerics have been dealing with these issues for two millennia, but we must remember that the

letters address specific circumstances in specific locations. It has, for example, been suggested that the comments about women in Corinthians occurred in response to the fact that some women in Corinthian society were especially disruptive, and applying Paul's comments in general distorts their original intention.

Paul sees women in a role of equality: "Let the husband give to the wife all that is due to her; and in the same way let the wife give to the husband all that is due to him. A wife is not in absolute control of her own body, but her husband is. In the same way a husband is not in absolute control of his own, but his wife is. Do not deprive each other of each other's legitimate rights, unless it be by common agreement" (1 Corinthians 7:3–7).

The letters appeared in their current form after their collection toward the end of the first century. They represent the heart of Christian doctrine as shaped into canon by the early Church. Through Paul's inspiration and interpretation the Christian world has viewed the events described in the Gospels and chronicled in the Acts of the Apostles.

During his second missionary journey, Paul, accompanied by Silas and Timothy, went to Thessalonica, the capital of Macedonia, where, for three successive Sabbaths, he preached in the Jewish synagogue, proclaiming Jesus as Messiah and using scripture to prove the necessity of Jesus' death and resurrection. Many Jews, including recent Hellenistic converts to Judaism, were converted to Christianity by Paul, and as a result the leaders of the synagogue accused him of sedition, making it necessary for Paul and Silas to be spirited out of town by their friends. Concerned for the young Christian community in Thessalonica, which had been deprived of its leadership, persecuted by the synagogue, and subjected to some scurrilous attacks on Paul's character, motives, and authority, Paul sent Timothy to strengthen and encourage the Thessalonican church. When Timothy returned with good news about the faith and loyalty of the Christians in Thessalonica, Paul wrote the first letter to that congregation (The First Letter to the Thessalonians—1 Thessalonians). He expresses his

gratitude and joy at their perseverance, exhorts them to Christian conduct, and answers two questions that concerned them: Is a Christian deprived of the blessings of the Kingdom if he dies before the second coming of Christ? and When will Christ come in glory? Paul wrote 1 Thessalonians—the earliest of his correspondence—from Corinth around the year 50.

Among Paul's admonitions and theology come some truly great poetic passages that have endured the test of time and endeared themselves to millions. Perhaps the best example is the "Hymn of Love" from 1 Corinthians 13:

> I may speak with the tongues of men and of angels, but if I have not love, I am become no more than echoing brass or a clanging cymbal. I may have the gift of prophecy, I may understand all sacred secrets and all knowledge, I may have faith enough to remove mountains, but if I have not love I am nothing. I may dole out all that I have, I may surrender my body that I may be burned, but if I have not love it is no good to me.
>
> Love is patient; love is kind; love knows no envy; love is no braggart; it is not inflated with its own importance; it does not behave gracelessly; it does not insist on its rights; it never flies into a temper; it does not store up the memory of any wrong it has received; it finds no pleasure in evil-doing; it rejoices with the truth; it can endure anything; it is completely trusting; it never ceases to hope; it bears everything with triumphant fortitude.
>
> Love never fails. Whatever prophecies there are, they will vanish away. Whatever tongues there are, they will cease. Whatever knowledge we have, it will pass away. It is only part of the truth that we know now and only part of the truth that we can foretell to others. But when that which is complete shall come, that which is incomplete will vanish away. When I was a child I used to speak like a child; I used to think like a child; I used to reason like a child. When I became a man I put an end to childish things. Now we see only reflections in a mirror which leaves us with nothing but riddles to solve, but then we shall see face to face. Now I know in part; but then I will know even as I am known. Now faith, hope, love remain—these three; but the greatest of these is love.

CHAPTER REVIEW

CRITICAL THOUGHT

Judaism followed a challenging course from the Patriarchs through the Judges to the Monarchy. The story is one of a people to whom God revealed himself, with whom he made a covenant, and whom he led to nationhood. It is also the story of a recurring cycle of disobedience, contrition, and forgiveness centering on the constant struggle of humankind to follow its own dictates rather than those of a divine being—even one who performed mighty acts to show his power and his steadfast love for his chosen people. Much appears in the story of the Hebrews about theology and the emergence of monotheism, about the nature of revealed truth, about human obstinacy and self-will, and about the consequences of disobedience.

The theme of obedience moves from Judaism to Christianity in the first century, and we have seen it expressed beautifully in the Magnificat of Mary. The concept of obedience has proved difficult not only for devoted Christians; it is problematic in general, for it raises the question of the fundamental nature of the individual and of his or her "freedom" or "rights" to pursue individual happiness. Under what conditions should individuals submit to authority—religious or secular?

SUMMARY

After reading this chapter, you should be able to:

- Describe the history of the Jewish people, the rise of Christianity, and the impact of Judeo-Christian culture and religion on the Roman Empire.
- Discuss the major divisions of the Bible and relate them to the basic story and beliefs of Judaism and Christianity.
- Compare Augustine with Tertullian on the nature of the soul, and with Plato and Aristotle on the nature of art.

- Identify the reforms of Diocletian and Constantine and explain how these reforms rejuvenated the late Roman Empire and affected the spread of Christianity.
- Explain the relevance of the "Petrine Theory" to the development of the Western Christian Church.
- Identify and characterize Judaic, Christian, and late Roman art, architecture, and music.
- Apply the elements and principles of composition to describe, analyze, and compare individual works of art illustrated in the chapter.

CYBERSOURCES

http://harpy.uccs.edu/roman/html/archconslides.html
http://www.catacombe.roma.it/welcome.html

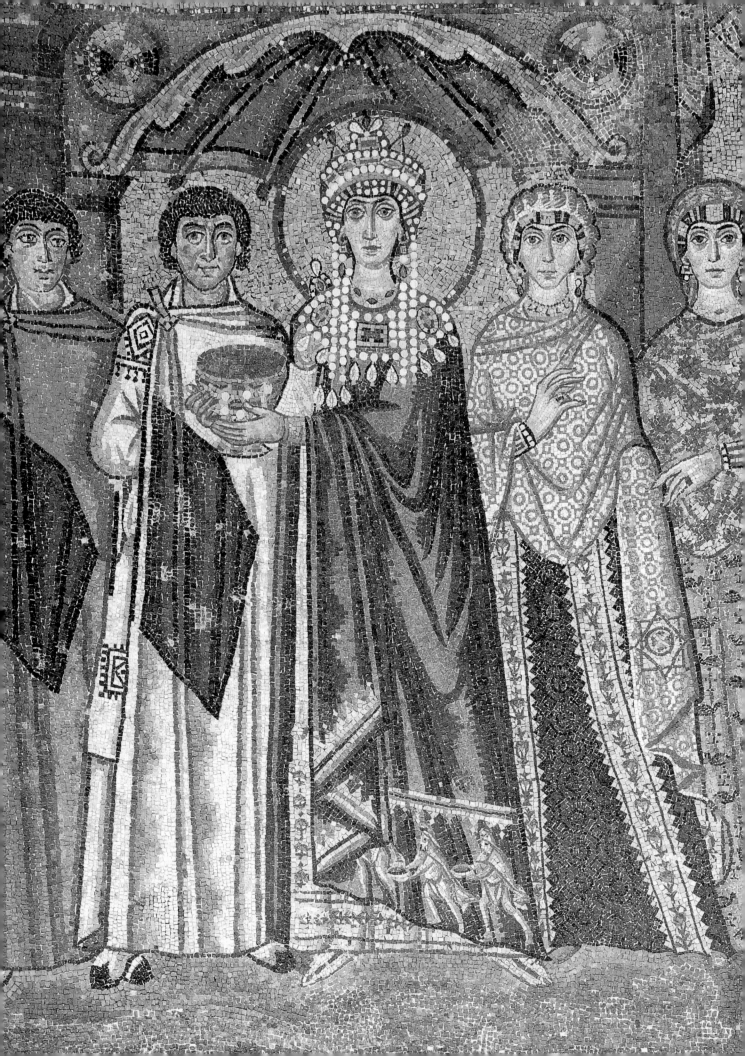

6 BYZANTIUM AND ISLAM

— OUTLINE —

CONTEXTS AND CONCEPTS
- Contexts
 Byzantium
 Muhammad and the Rise of Islam
 PROFILE: Muhammad
- Concepts
 Orthodoxy
 Islam
 Intellectualism
 Icons
 Byzantine Cultural Influence

THE ARTS OF BYZANTIUM AND ISLAM
- Painting, Mosaics, and Manuscript Illumination
 Byzantium
 Islam
- Sculpture
 MASTERWORK: The *Harbaville Triptych*
- Architecture
 Byzantium
 PROFILE: Anthemius of Tralles

TECHNOLOGY: Spanning Space with Triangles and Pots
 Islam
- Theatre, Music, and Dance
 Byzantium
 A DYNAMIC WORLD: Chinese Theatre
 Islam
- Literature
 Byzantium
 Islam

— VIEW —

CHURCH AND STATE

A number of critical issues will be explored in this chapter. These include major early factors that caused the split between the Eastern and Western Empires of Rome. Implicit in that split, although we sometimes barely acknowledge its importance, was the split of the Christian Church into Roman Catholicism and Eastern Orthodoxy. The split of the Roman Empire into East and West had profound implications for both the Christian religion and secular politics. Central to it all stood Byzantium or Constantinople. Later, Byzantium would connect not only East and West but also Christianity and Islam—in a geographical sense, if not a theological one. Byzantium occupies a pivotal geographical location, as critical today as one thousand years ago as the place where Islam, Eastern Orthodoxy, and Roman Catholicism meet. The overlapping and conflicts among Orthodox Christianity, Roman Catholicism, and Islam are as old as Byzantium and as recent as today's newscast.

— KEY TERMS —

ORTHODOXY
The practice of adhering to the accepted, traditional, and established religious, in this case Christian, faith.

HUMANISM
A philosophy concerned with human beings, their achievements, and interests, as opposed to abstract beings and problems of theology.

MOSAIC
A decorative work for walls, vaults, floors, or ceilings, composed of pieces of colored material set in plaster or cement.

HIERATIC STYLE
An artistic style of depicting sacred persons or offices: it means "holy" or "sacred" and its treatment of the proportions of the human body is elongated as opposed to naturalistic.

APSE
A large niche or niche-like space projecting from and expanding the interior space of a building.

HAJJ
A Muslim's sacred pilgrimage to Mecca.

6.1 Empress Theodora and attendants, c. 547. Detail of wall mosaic. San Vitale, Ravenna, Italy.

CONTEXTS AND CONCEPTS
Contexts

Byzantium

Astride the main land route from Europe to Asia and its riches, the city of Byzantium had great potential as a major metropolis. The city's defensible deep-water port, which controlled the passage between the Mediterranean and the Black Sea, and agriculturally fertile environs, made it into an ideal "New Rome"—precisely the objective of the emperor Constantine when he dedicated his new capital in 330 C.E. and changed its name to Constantinople (now known as Istanbul). The city prospered, becoming the center of Christian Orthodoxy and the source of a unique and intense style in the visual arts and architecture. When Rome fell to the Goths in 476, it had long since handed the torch of its civilization to Constantinople, which preserved and nurtured the arts and learning of the classical world, while Western Europe suffered the turmoil and destruction of wave upon wave of barbarian invasion.

Although we often consider the Eastern Empire of Byzantium as part of the Eastern world, its relationship with and influence on Western thought and art were highly significant. Here we examine the history and culture of the capital city of the Eastern Roman Empire from the year 330 until its conquest by the Muslim Turks in 1453. Parallel developments in the West appear in Chapters 7 and 8.

Constantine founded the Byzantine Empire on 11 May 330. On that day, Constantine made Byzantium the second capital of the Roman Empire, and renamed it Constantinople. The geographical location of the city, at the bridging point between Europe and Asia, made it an ideal center for trade, governance, and the development of the arts. The culture of the region at that time mixed Hellenistic tradition and Christian thought.

The separation of the Eastern Roman Empire from Rome and the Western Roman Empire became fact in 395. Emperor Theodosius the Great died in that year, and he divided his empire between his two sons, Arcadius and Honorus. While Eastern in many respects, Constantinople maintained its Roman traditions after the fall of the Roman Empire in 476 until the end of the sixth century. From then on, it followed its own independent course.

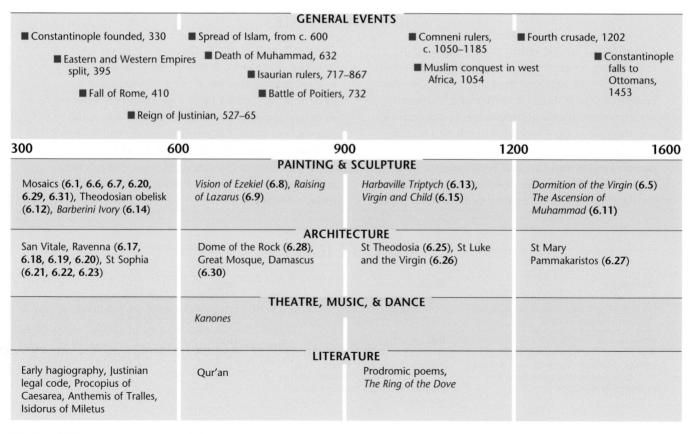

GENERAL EVENTS

- Constantinople founded, 330
- Eastern and Western Empires split, 395
- Fall of Rome, 410
- Reign of Justinian, 527–65
- Spread of Islam, from c. 600
- Death of Muhammad, 632
- Isaurian rulers, 717–867
- Battle of Poitiers, 732
- Comneni rulers, c. 1050–1185
- Muslim conquest in west Africa, 1054
- Fourth crusade, 1202
- Constantinople falls to Ottomans, 1453

300	600	900	1200	1600

PAINTING & SCULPTURE

Mosaics (**6.1, 6.6, 6.7, 6.20, 6.29, 6.31**), Theodosian obelisk (**6.12**), *Barberini Ivory* (**6.14**)	*Vision of Ezekiel* (**6.8**), *Raising of Lazarus* (**6.9**)	*Harbaville Triptych* (**6.13**), *Virgin and Child* (**6.15**)	*Dormition of the Virgin* (**6.5**) *The Ascension of Muhammad* (**6.11**)

ARCHITECTURE

San Vitale, Ravenna (**6.17, 6.18, 6.19, 6.20**), St Sophia (**6.21, 6.22, 6.23**)	Dome of the Rock (**6.28**), Great Mosque, Damascus (**6.30**)	St Theodosia (**6.25**), St Luke and the Virgin (**6.26**)	St Mary Pammakaristos (**6.27**)

THEATRE, MUSIC, & DANCE

	Kanones		

LITERATURE

Early hagiography, Justinian legal code, Procopius of Caesarea, Anthemis of Tralles, Isidorus of Miletus	Qur'an	Prodromic poems, *The Ring of the Dove*	

Timeline 6.1 Byzantium and the rise of Islam.

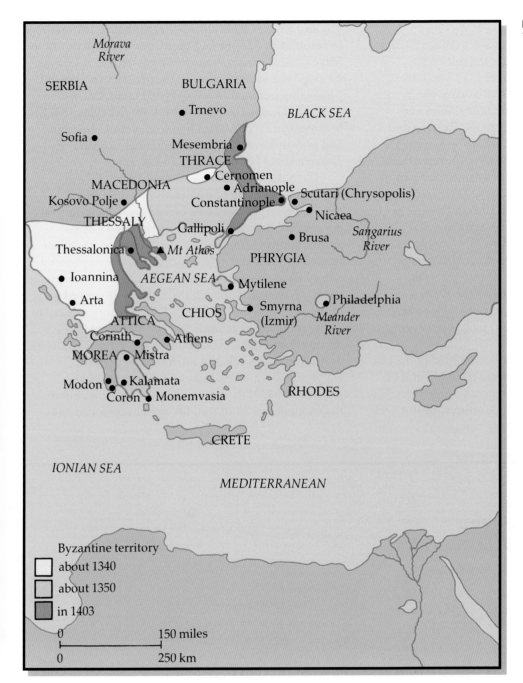

Map 6.1 The Byzantine Empire, 1340–1403.

Morava River

SERBIA

BULGARIA

● Trnevo

BLACK SEA

Sofia ●

Mesembria ●
THRACE

MACEDONIA
● Cernomen
● Adrianople
Scutari (Chrysopolis)
Kosovo Polje ●
Constantinople ● ●

THESSALY
Gallipoli ●
● Nicaea

Thessalonica ● ▲ Mt Athos
● Brusa
Sangarius River

PHRYGIA

● Ioannina AEGEAN SEA
● Mytilene

● Arta
● Philadelphia

CHIOS
● Smyrna (Izmir)
Meander River

ATTICA
Corinth ● ● Athens

MOREA ● Mistra

Modon ● ● Kalamata
Coron ● ● Monemvasia
RHODES

CRETE

IONIAN SEA

MEDITERRANEAN

Byzantine territory
☐ about 1340
☐ about 1350
☐ in 1403

0 150 miles
├───────┤
0 250 km

Two crises contributed to the distinctive character of the Eastern Empire. First, barbarians invaded Europe in the fifth century—the Visigoths, led by Alaric; the Huns, led by Attila; and the Ostrogoths, led by Theodoric. The barbarians successfully carved up the Western Empire, yet they could not make more than superficial inroads into the East. This gave the New Rome political supremacy. The second crisis concerned religion. During the fourth and fifth centuries, the Eastern Empire formed the seedbed of several "heresies" in the Christian Church. True to its Greek spirit, the Eastern Orthodox Church reveled in subtle theological metaphysics. This characteristic led to the development of ideas that conflicted with the official theology of the Church in Italy and eventually caused a schism between the Eastern and Roman Church establishments that persists to this day. Out of this schism emerged the important concept of a purely Eastern Empire. Its system of government embraced an absolute monarchy in the Eastern tradition. Its Church used the Greek language in its writings and rituals, and it closely linked itself with the government that ruled it. The Eastern Orthodox Church, perhaps because of such identification, still constitutes nationalistically centered divisions such as Greek Orthodox.

177

Justinian

The movement toward total separation from the Western Empire lost some momentum under the rule of the Emperor Justinian (juhs-TIN-ee-uhn; r. 527–65). He aspired to be Roman emperor as well as emperor in the East, and tried to promote both imperialism and Christianity. He claimed to be heir to the Caesars, and his great ambition was to re-establish Roman unity. He partly achieved this ambition as he reconquered Africa, Italy, Corsica, Sardinia, the Balearic Islands, and part of Spain (Map **6.2**). The Frankish kings of Gaul recognized his sovereignty, and as head of the Eastern Empire, he was also revered as Vicar of God on earth and champion of Orthodoxy.

In an attempt to hold his reconstructed empire together, Justinian sought a close alliance with the Roman papacy. As he concentrated on the West, however, he left the Eastern Empire vulnerable to hostile forces from the East, who tried to exploit this weakness over the following two centuries.

A major factor in Justinian's rule consisted of the role played by his wife, Empress Theodora (thee-oh-DOHR-ah; c. 500–548), whom some sources call "joint ruler." In his *Secret History*, Procopius of Caesarea (proh-COH-pee-uhs; seh-zuh-REE-uh) alleges that before her marriage to Justinian in 525 she had been an actress and prostitute. Some credence exists in the former assertion, at least, as we note later in the section on theatre. Her charms and personality undeniably exerted great influence over Justinian. During the Nika (NEE-kuh) Rebellion (532), her intervention prevented him from fleeing the capital and probably saved his crown, although scholars disagree about her popularity and acceptance.

The Nika (the word means conquer) Rebellion involved an uprising of thousands of citizens that occurred when two factions of soldiers, who were rival horseracing charioteers known as the blues and the greens, united to oppose Justinian's policies. Theodora refused to yield, and at her instigation, a young general named Belisarius led troops in a massacre of thousands in the Hippodrome. Although the rebellion destroyed parts of the city, Justinian's (or Theodora's) victory ushered in a new era of absolute imperial rule. Theodora also acted decisively on other public policy issues. After Theodora's death, Justinian's rule lost intensity and purpose.

Justinian's greatest legacy lies not in his brief reconstruction of the Roman Empire, however, but in the enormous work of recodifying the outmoded and

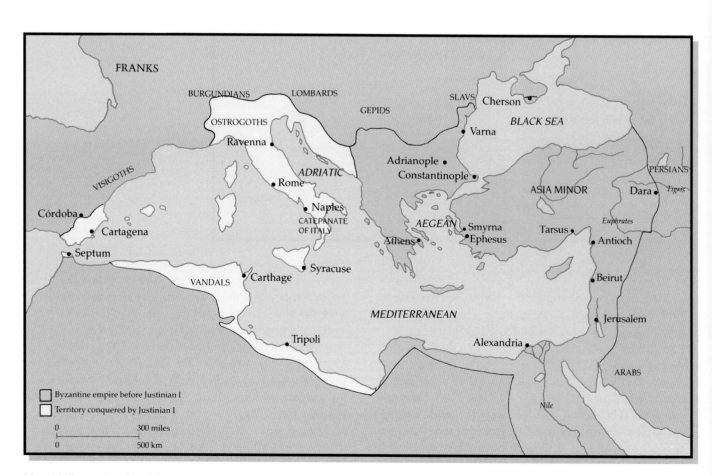

Map 6.2 The empire of Justinian I.

cumbersome apparatus of Roman law, which produced the *Corpus Juris Civilis* (KOR-puhs JOOR-is si-VIL-is), thus reducing the reference books needed by a Roman lawyer from 106 volumes to six. This recodification of the law greatly influenced Justinian's own and succeeding centuries.

Because Justinian's power was concentrated, his abilities great, and his spending extravagant, his death left the Eastern Empire severely weakened, both economically and militarily. Not until the advent of the Isaurian emperors in 717 did Byzantium recover, but critical changes resulted: Military leaders took all political power; Greek replaced Latin; and literary forms began to take on Eastern characteristics. Orthodox Christianity, with its emphasis on monastic retreat from worldly life, strengthened its hold on public affairs. In all areas of life, the breach with the Roman legacy widened. Out of all this arose a truly Eastern and enduring empire, militarily strong and efficiently organized.

The Isaurian Emperors and Iconoclasm
The task of stabilizing the Eastern Empire fell to the first oriental rulers to take control. The Isaurian (ih-SOR-ee-uhn) emperors ruled from 717 to 867. They had originally come from the distant mountains of Anatolia. The first ruler of the Isaurian dynasty, Leo III, drove the Arabs from Constantinople in 717. His successor, Constantine V, re-established control over important territories in Asia Minor, and fortified and consolidated the Balkan frontier. As they tried to minimize internal strife, the Isaurians concerned themselves with administrative order and the general welfare of their subjects.

From 717–867, the bureaucracy of the Empire thus became more closely associated with the imperial palace. An even briefer legal code, called the *Ecloga*, replaced Justinian's *Corpus*. The *Ecloga* (ehk-LOHG-uh) limited the traditional authority of the Roman *paterfamilias* (pah-tair-fah-MEE-lee-ahz), the male head of the household, by increasing rights for women and children. This new concept to Christian society made marriage no longer a dissoluble human contract, but, rather, an irrevocable sacrament. The oriental punishment of mutilation replaced the death penalty in criminal justice, reflecting at least some concern for rehabilitation.

This period also saw a violent conflict within the Christian Church known as the "iconoclastic controversy" and concerned the use of **icons** in the Eastern Church (see discussion in the Concepts section). Icons, or images, depicting the saints, the blessed Virgin, and God himself, by now occupied a special place in Orthodox churches. From the sixth century onward, these paintings and mosaics had been extremely important in Orthodox worship and teaching, but in the eighth century, many questioned their use, and those who opposed them maintained that icons were idols—they had become objects of worship in themselves, perverting the worship of God. They demanded the removal of icons, and on many occasions they used force to impose their will, hence the name *iconoclast*, meaning "icon-destroyer."

In 730 the emperor issued a proclamation forbidding the use of images in public worship. One reason for the edict appears to have been the belief that the Arab invasions and volcanic eruptions at the time indicated God's displeasure with Orthodox practices. The iconoclast movement gained formal approval by the council of bishops in 754. Over the next century, icons remained at the center of controversy, and their use ebbed and flowed, depending on the current emperor. Gradually, however, the "iconophiles," or "icon-lovers," gained ground. Persecution relaxed, and on the first Sunday of Lent in 843, a day still celebrated as an Orthodox feast-day, icons were permanently restored to their place in Eastern worship.

The resolution of the iconoclastic struggle and the establishment of a united empire under Charlemagne in the West in 800 finally set Byzantium on its own course. By the time of the Emperor Theophilus (thee-AH-fil-uhs; 829–92), the Byzantine court rivaled any in the world. The University of Constantinople, reorganized, in about 850, by Caesar Bordas, became a great intellectual center. The triumph of the iconophiles in 843 united the Orthodox Church, and strengthened its influence and character. The 150 years that followed the reign of Theophilus grew into a period of great prosperity and brilliance.

From Splendor to Destruction
Nothing in the West during this period remotely resembled the splendor and sophistication of Byzantium. In the East, unlike the West, religious and secular life closely intertwined. The visual arts flourished, and the subject matter was almost without exception religious. The Church calendar was inseparable from the court calendar. Moreover, the spectacle of court and Church ritual had a theatrical splendor, which reinforced the majesty of the empire and the place of the emperor as the vice-regent of God. Even the emperor's public appearances were staged. Seated behind a series of heavy curtains which were raised one by one, he was revealed only when the final curtain lifted. Yet despite its strong economic and commercial base, and its military strength, Constantinople could not withstand the trials ahead.

A slide into chaos paused for a time under the rule of the Comneni (kuhm-NEE-nee) emperors. The Comneni dynasty, which lasted until 1185, succeeded in ridding Greece of the Normans and defending the Empire against the Petchenegs, a group of southern Russian nomads.

PROFILE

MUHAMMAD (C. 570–632)

The name Muhammad means Praised One, and several common spellings of the name exist, including Mohammed and Mahomet. Muhammad was born in Mecca, but his father died before he was born, and his mother died shortly thereafter. Raised under the guardianship of his grandfather and, later, his uncle, Muhammad lived for a while with a desert tribe tending sheep and camels. Tradition maintains that he went with his uncle on caravans throughout Arabia and to Syria.

When twenty-five years old, Muhammad went to work for a wealthy widow, fifteen years older than he, whom he later married. They had two sons and four daughters, and although the sons died young, one of the daughters, Fatima (FAT-i-muh), married Ali, son of Abu Talib. Many Muslims trace their ancestry to Muhammad through his daughter in a genealogy called the Fatimid dynasty.

When Muhammad was thirty-five years old and living in Mecca, a flood damaged the most sacred shrine, the Kaaba (KAH-uh-buh). Because of his moral excellence, Muhammad was selected to put the sacred stone back into place. The angel Gabriel (Fig. **6.2**) later appeared to Muhammad in a vision and called him to serve as a prophet to proclaim God's message to his people. Although at first unsure of the vision, his wife convinced him of its validity. She became his first disciple. However, no further visions occurred, and Muhammad grew disheartened. Then, Gabriel appeared again and told him: "Arise and warn, magnify thy Lord . . . wait patiently for Him."

Muhammad began to preach periodically in public, and although, at first, most of the people who heard him ridiculed him, he gained a few followers. He continued preaching in Mecca until both his wife and son-in-law died, but the people of Mecca persecuted him for his claims and attacks on their way of life. In 622 C.E., therefore, he fled to Medina in the north. Muslims call that emigration the *Hegira* (huh-JY-ruh) and date their calendar from this year. In Medina he found a welcome, and most of the population converted. He eventually became both head of a religion and a political leader—his religious message became law, and he made a variety of changes in the legal system and customs to conform to the precepts of Islam.

6.2 The Archangel Gabriel. British Library, London.

At first it seems as though Muhammad expected Christians and Jews to recognize him as a prophet. Benevolent to them, he decreed that Jerusalem be faced in prayer. However, a conspiracy among Jews in Medina and Muhammad's enemies in Mecca caused him to drive them from the city and to organize a strictly Muslim society. In order to recognize the independence of the religion, he decreed that from that time onward his followers face Mecca in prayer, a practice still observed.

In 630 Muhammad and his followers attacked Mecca and successfully destroyed all the idols in the Kaaba, turning it into a mosque. In a gesture of reconciliation, Muhammad offered to pardon the people of Mecca, who accepted Islam and acknowledged Muhammad as a prophet. The two cities of Medina and Mecca became the sacred cities of the religion. Muhammad died in Medina (muh-DEE-nuh) two years later, and his tomb stands in the Prophet's Mosque there.

Venice had supplied naval assistance, however, and in return demanded important commercial concessions. Venetian influence and power increased immensely, while Byzantium could not recover its former strength, and internal struggles and conflicts proliferated.

In 1203 a crusade set out from the West for the Holy Land, but the Venetian contingent diverted it instead to Constantinople, whose wealth Venice wanted to plunder. In 1204 a riot provided the Crusaders with an excuse for sacking the city. This delivered the fatal blow to the Empire. The treasures of the city—books and works of art centuries old—were almost all destroyed or carried off. Central organization collapsed. Trying to preserve themselves, parts of the empire broke away. The Crusaders had stripped the empire of its strength, and it lay defenseless against the Ottoman Turks when they overran it in 1453.

We cannot overemphasize the importance of the sack of Constantinople. Two major results occurred: (1) the terrible slaughter of innocents stained the Crusades in the eyes of all Orthodox Christians—a further exacerbation of the rift between Eastern and Western Christianity; (2) the booty taken from Constantinople to Europe— especially to Venice—contained such value and quality that it formed the foundation for the Renaissance, providing models for artists across Europe—particularly in northern Italy.

Muhammad and the Rise of Islam

At the beginning of the seventh century C.E. a new force arose that would influence the Middle East, Byzantium, Europe, and, indeed the world. That force, Islam, emerged from the Arabian peninsula and the teachings and preaching of Muhammad. In the Concepts section of this chapter we will look at the religion of Islam in more detail, but together with what we know of Muhammad's life (see Profile) let us now examine some of the basic contextual conditions. When Muhammad, the prophet of Islam, started to preach, the historical conditions included great suffering among the poor—notably in the city of Mecca in southwestern Arabia. Most of the people worshiped a variety of gods and prayed to various idols and spirits. Muhammad taught a monotheistic message: There is only one God, who requires people to make Islam—to submit—to Him.

Muhammad began preaching in Mecca around 610 C.E., but his teaching did not immediately meet acceptance. A period of conflict followed in which forces loyal to Muhammad physically conquered those opposed to him. By the time of his death, his message and governance reigned supreme on the Arabian peninsula, and his followers acknowledged him as Prophet.

Islam spread rapidly throughout the Middle East and North Africa in the seventh and eighth centuries, beginning with conquests launched from Mecca and Medina (Map 6.3). After Muhammad's death, the Caliph Abu Bakr (KAYL-ihf AH-boo BAHK-uhr) and his successors encouraged jihad, or holy struggle, in order to expand the faith's sphere of influence. Within a century, an Islamic empire stretched from northern Spain to India, engulfing much of the Byzantine and Persian empires. The Muslims threatened to overrun Europe until Charles Martel (shahrl mahr-TEHL) defeated them at the battle of Poitiers (pwah-TYAY) or Tours (toor) in 732, forcing them back into Spain where they remained until the end of the fifteenth century. Their legacy remains not in their religion but in a significant collection of architecture, particularly in Spain, and in the medieval tradition of courtly love with its poetry and music (see Chapter 8).

A religion originally spread through political conquest, Islam appealed through its openness to everyone. Stressing the brotherhood of the faithful before God, regardless of race or culture, its Arab warriors, who started out to conquer the world for Allah, did not expect to make converts of conquered peoples. They expected the unbelievers to be obedient to them, the servants of the One True God. Muslims expected converts to become Arabs, and to submit to the social and legal precepts of the Muslim community (Fig. 6.3). As a result, the conquering Arabs resisted the usual fate of conquerors— absorbtion into the culture of the conquered.

During the Middle Ages in Europe, Muslims assumed responsibility for transmitting much of the classical knowledge of the ancient world. They excelled in mathematics and science, and produced proficient artists, writers, and architects.

CONCEPTS

Orthodoxy

Orthodoxy, or the theological tenets of the Orthodox Church—also called the Eastern Orthodox Church, constitutes one of the three major divisions of Christianity (along with Roman Catholicism and Protestantism). The word orthodoxy means "true belief" and rests on the concept of unerring authority of the dogma established by the seven General Ecumenical Councils of the early Christian Church. These dogmas include the incarnation of Jesus as god-in-man and the Trinity (the Trinitarian nature of God—three persons in one essence). According to Orthodox belief, God has both transcendence and immanence, ultimately unknowable, but present in this world in his "energies." Such energies provide active principles in human life. The Second Council of Nicaea in 787, the last of the Church councils recognized by the Orthodox churches, sustained the use of icons (religious images), as we noted in the

discussion about the iconoclastic struggle, stating that icons did not violate the biblical injunction against idolatry. Icon veneration forms a central part of Orthodox worship. Orthodox Christians see paintings depicting Christ and the saints as representations or symbols of spiritual reality and channels of divine blessing. Orthodox Christians do not see icons as objects of worship.

The Orthodox Church constitutes a communion of independent national churches and other *patriarchates* associated with the Church's ancient seats: Alexandria, Antioch, Jerusalem, and Constantinople (Byzantium)—now Istanbul. Each of the churches recognizes the ecclesiastical and liturgical authority of the Patriarch of Constantinople, but, unlike the Pope of Roman Catholicism, the Patriarch of Constantinople does not hold absolute power or claim infallibility. The Orthodox Church claims an unbroken line of historical Christianity traceable to the New Testament apostles. It descended from the Greek-speaking Church of the Byzantine Empire, and separated from the Western Church during the Middle Ages after a series of disputes and conflicts of doctrine concerning the nature of the Holy Spirit and the primacy of the Roman pope.

The liturgy of Orthodoxy, written by St John Chrysostom (KRIH-soh-stohm), dates to the fourth century and centers on the Eucharist (YOO-kah-rihst) (communion), as does the Roman Catholic Mass. Orthodoxy, however, differs from Catholicism in the following way: Catholics believe that the sacraments mediate between God and believer; Orthodoxy stresses personal communion with God. Orthodoxy, as illustrated in the hieratic style of Byzantine art we examine later in this chapter, has a more mystical character than Catholicism, with less emphasis on the clergy. Orthodoxy centers on a balance between scriptural authority and holy tradition, for example, the teachings of the Church Fathers, decrees of the General Councils, holy icons, and a sense of apostolic continuity.

Islam

Islam believes in one absolute and all-powerful God, known as Allah, the just and merciful creator of the universe. God desires that people repent and purify themselves so that they can attain Paradise after death. God communicates with the human race through prophets, and the predecessors of Muhammad were the Old Testament prophets and Jesus. Muhammad was the last of the prophets. Muslims respect Muhammad, but they do not worship him.

Like Judaism and Christianity, the Islamic faith teaches that parents should be honored, orphans and widows protected, and charity given to the poor. It proclaims faith in God, kindness, honesty, industry,

6.3 Symbol of Islam on Pakistan's national flag.

courage, and generosity. An Islamic wife has rights against her husband to protect her from abuse. Islam also teaches that life on earth represents a period of testing in preparation for an afterlife. Angels keep a record of individual good and bad deeds, and God's justice determines a person's reward. Death forms the gateway to eternal life, and at the last day, judgment occurs. The record book of each individual will be placed in the right hand of those who will go to heaven and in the left hand of the wicked who will go to hell. The descriptions of the agonies and tortures of hell are similar to those in the Bible, while heaven is a garden with flowing streams, delicious fruit, richly covered furniture, and beautiful maidens.

Islam requires all believers to perform five religious duties, known as the Five Pillars of Islam. First, believers must confirm their faith by reciting the *shahadah*: "I witness that there is no god but the God (Allah) and that Muhammad is his prophet." This affirmation must be made before witnesses and constitutes the only requirement for conversion to Islam. Second, Muslims must perform canonical worship five times a day. In a state of ritual purity, each Muslim must face Mecca and recite prescribed phrases while performing specific cycles of standing, bowing, sitting, and prostration. Third, Muslims must fast during the holy month of Ramadan, the ninth month in the Islamic lunar calendar. The fast entails abstaining from food and drink from dawn to sunset—usually accompanied by intensified prayer and worship. The end of Ramadan constitutes a major celebration with a feast and holiday called Eid al-Fitr. Fourth, believers must make a yearly payment of *zalaat*, a set percentage of each adult's wealth, to help the poor. Shiites give an additional amount to support their clergy. Fifth, at least once in their lifetime, if possible, a believer must perform the *hajj*, the annual pilgrimage to Mecca. The *hajj* memorializes the willingness of the prophet Abraham to sacrifice his son Isaac for God. Celebrated as part of the *hajj*, the feast of the Sacrifice represents the most important Muslim holiday.

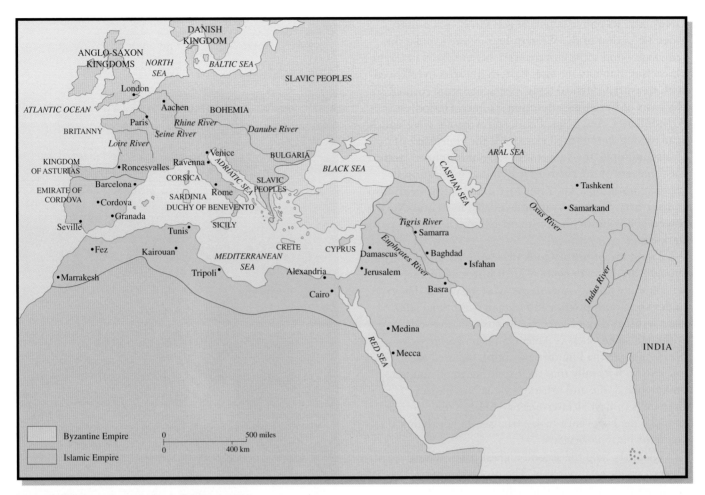

Map 6.3 The Byzantine and Islamic Empires, c. 814.

Muslims pray five times daily: at dawn, noon, in the afternoon, in the evening, and at nightfall. A crier or muezzin (myoo-EHZ-in) announces prayer time from a tower, or minaret, in the mosque, the Muslim place of worship, meaning a place of kneeling. Noon prayer occurs in the mosque. Immediately before prayer, Muslims wash their face, hands, and feet. Friday constitutes a day similar to the Jewish Sabbath and the Christian Sunday. During prayer, the leader faces Mecca, and the men stand in rows behind him, with women standing behind the men. Prayers include bowing from the hips and kneeling with one's face to the ground. Friday prayers include a sermon. Islam does not have an organized priesthood—any virtuous and able Muslim can lead prayers—but most mosques have an imam, or leader, who functions as the chief officer of the mosque and leads the people in prayer.

Early in its history, Islam split between the Sunnites (SOON-yts) and Shiites (SHEE-yts), and this split has persisted. The original split occurred over the caliphate, the crowning institution of the theocratic structure of Islam: the placement of both religious and political leadership in the hands of a single ruler. The caliphs or the successors, or deputies, of Muhammad, claimed authority on their descent from the families of the Prophet or his early associates. Although secularism has modified the unity somewhat, in theory the civil law in Muslim countries does not separate from religious law; religion governs all aspects of life. There have developed some four different systems of interpretation of the law in Sunnite Islam, all regarded as orthodox. Islamic philosophy is in effect part theology; rationalism and mysticism both grew up in Islam, but were equally absorbed.

Intellectualism

Nowhere in the medieval world preserved the classical tradition better than Constantinople. Although heir to the Roman Empire, the Eastern Empire descended directly from classical Greece. The Greek cities of Athens, Antioch, and Alexandria all lay within its borders. Constantinople itself was to all intents and purposes a

Greek city. Its native language was Greek—at a time when no nation of the Western Empire even spoke the language—and so its citizens were better versed in Greek classicism than anyone else. Eastern libraries overflowed with treasured classical texts. Greek literature formed the basis of Byzantine education. Homer, Hesiod, Aristophanes, Aeschylus, Plato, and Aristotle were widely read among the cultured classes. At the University of Constantinople, the "consuls of the philosophers" and the "masters of the rhetoricians" found inspiration in classical traditions. The same love of antiquity seems also to have been felt by private individuals. Even at its very lowest ebb, Constantinople never fell into a cultural dark age.

The study of history took pride of place in Byzantine thought. In the sixth century great historians arose, who stood without equal in the Western world. They understood both politics and human psychology and their writings display superb composition and style. Although some, such as Anna Comnena (cuhm-NEH-nuh; see the Literature section), imitated the ancients so faithfully that their style became cramped and involved, she and others, such as Nicephorus Bryennius (nih-SEH-fawr-uhs bry-EH-nee-uhs), sought to make the historian's task a true art, rather than a sterile recitation of events.

Theology held the second highest place among Eastern intellectual pursuits. The proliferation of theological literature undoubtedly rose from the seemingly endless heresies that troubled Byzantium and required defenses of Orthodoxy. Numerous works pursued scriptural commentary, and the development of monasticism produced a new genre: mystical literature. Classical rhetoric influenced religious speaking, which became very popular.

In the realm of philosophy, Platonic thought re-emerged in the University of Constantinople during the eleventh century. The intellectual accomplishments of the Eastern Empire influenced the West considerably. The Byzantine conception of imperial power, which derived from the Justinian Code, had a profound effect on emerging Western ideas of absolute monarchy. The law of Justinian was brought to Italy, and by the eleventh century, law schools in Rome, Ravenna, and Bologna taught its doctrines. Here Frederick Barbarossa (bahr-buh-ROH-suh) found strong arguments for establishing his imperial claims in the middle of the twelfth century. In the thirteenth century, scholars in Bologna provided the bases on which the Emperor Frederick II Hohenstaufen (HOH-en-shtow-fen) proclaimed himself "law incarnate upon earth," and justified "his right to order ecclesiastical affairs as freely as the secular interests of his empire."[1] In the same tradition, the king of France later declared himself "above the law."

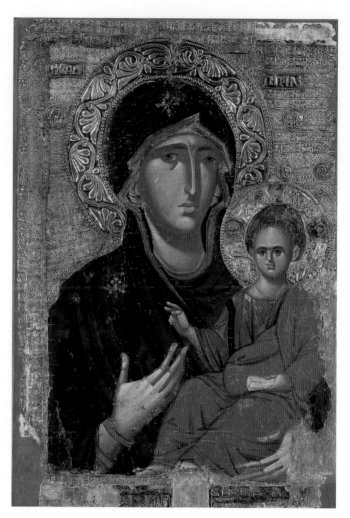

6.4 *Mary, Mother of God "Hodegetria" (Indicator of the Way)*, icon, thirteenth century. Tempera on wood. 39¼ × 29 ins (92 × 68 cm). St Clement's, Ohrid, Macedonia.

Theological accomplishment in the Eastern Orthodox Church exceeded that in the West, at least until the twelfth century. Its influence emerges in the works of many Western theologians, among them Thomas Aquinas (uh-KWY-nuhs). French literature and legend also display strong links with Byzantine sources, and particularly its hagiography (hay-ghee-AHG-ruh-fee or hay-jee-), or descriptions of lives of the saints.

Other Byzantine legacies included the promulgation of Aristotelian philosophy and a strong current of **humanism**, both of which figured prominently in the Renaissance of the mid-fifteenth century in Western Europe, centered on Italy. Platonic doctrine had taken a place of honor in the University of Constantinople in the eleventh century, and from there Platonic thought spread, first to Florence, in Italy, and then to the rest of Europe. The Greek scholars who left Constantinople after its sack and came to Italy brought Byzantine humanism with them. Humanism enjoyed great currency during the

thirteenth and early fourteenth centuries in Europe. These scholars also brought many important Greek manuscripts, and rekindled an appreciation of Greek intellectual accomplishment in the West. We study Humanism in greater detail in Chapter 9.

Icons

The term *icon* applies variously to the devotional panel paintings produced under the auspices of the Orthodox Church. Icons, like the paintings and sculptures of the Western Church during the Middle Ages (see Chapters 7 and 8), sought to convey the main points of the liturgy to a largely illiterate congregation. As the fourth-century theologian St Gregory of Nyssa explained, "The silent painting speaks on the walls and does much good." Unlike the Church art of the West, however, icons in the Eastern Church did not provide straightforward illustrations of biblical events. Rather, they provided objects of veneration—sacred objects or spiritual tools— that allowed the faithful to commune directly with God. As a result, Church authorities strictly enforced their format. The approved format discouraged creativity and personal interpretation and made a direct attempt to preserve the structure of earlier models. Consequently, some compositions survived unaltered for centuries.

Symbolism displaces perspective and lifelikeness in the composition of these objects, which, to the post-Renaissance eye (see Chapters 9–11), leaves an unfair impression of "primitiveness." The theory and tradition of holy icons rose from the belief that St Luke had made paintings of the Virgin holding the infant Jesus (Fig. **6.4**). Stylistically, however, they derive from Egyptian funereal portraits of the second century C.E. The earliest surviving icons date to the sixth century, discovered at St Catherine's monastery on Mount Sinai.

Byzantine Cultural Influence

As we approach the next section, The Arts of Byzantium and Islam, we can make the following observations about the relationship between Byzantine art and Byzantine culture and its influence: (1) The power and expressiveness of the figures in Byzantine art suggest the strength and vitality of Byzantine traditions; (2) Rich materials, such as gold, indicate a culture of great wealth; (3) The great variety in subject matter, media, and types of art reveals a culture of taste and sophistication as well as tremendous artistic skill among artists themselves; (4) The presence of classical themes and style proves the importance of the classical heritage in Byzantine culture; (5) The presence of Byzantine artistic style in cultures as far removed as Russia, Europe, and the Middle East indicates the vast expanse of Byzantine cultural influence.

THE ARTS OF BYZANTIUM AND ISLAM
Painting, Mosaics, and Manuscript Illumination

Byzantium

Fundamental to the visual art of the Eastern Empire lies the idea that art can be used to interpret as well as to represent its subject matter. Byzantine art was conservative, and, for the most part, anonymous and impersonal. The artist remained clearly subordinate to the work. Much of **Byzantine** art remains undated, and questions about how styles developed and where they came from stay unresolved. We can, however, draw a few general conclusions with regard to Byzantine art (which, we must remember, encompasses nearly a thousand years of history and, thereby, several shifts in style). First, the **content** of Byzantine art focuses on human figures. Those figures reveal three main elements: (1) *holy figures*— Christ, the Virgin Mary, the saints, and the apostles with bishops and angels portrayed in their company; (2) *the emperor*—believed to be divinely sanctioned by God; (3) *the classical heritage*—images of cherubs, mythological heroes, gods and goddesses, and personifications of virtues. In addition, the form of Byzantine two-dimensional art increasingly reflected a consciously derived spirituality.

The ostentation of the Imperial court influenced artistic style, and artists depicted Christ and the saints as frozen in immobile poses and garbed in regal purples. The vestiges of classical purity in the sixth century ended in lacy ornamentation.

The period of Justinian marks an apparently deliberate break with the past. What we describe as the distinctly "Byzantine style," with its characteristic abstraction and its focus on spirituality, began to take shape in the fifth and sixth centuries. Throughout the seventh century, classicism and decorative abstraction intermingled freely.

By the eleventh century, Byzantine wall painting and mosaics had developed a hierarchical (hy-er-ARK-i-kuhl) formula with a reduced emphasis on narrative. The Church represented the kingdom of God, and as one moves up the hierarchy, one encounters figures ranging from human to the divine. Placement of figures in the composition depended upon religious, not spatial, relationships. Artists depicted figures strictly two-dimensionally, but with elegance and decoration. In twelfth- and especially in thirteenth-century art, this approach intensifies, detailed with architectural

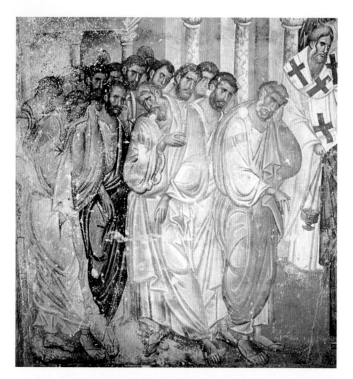

6.5 *Dormition of the Virgin* (detail), 1258–64. Fresco. Church of the Trinity, Sopoćani, Yugoslavia.

backdrops, flowing garments, and elongated but dynamic figures (Fig. **6.5**). This fresco depicts the death and assumption into heaven of the Virgin Mary, a subject known as the Dormition (sleep) of the Virgin. The fourteenth century produced small-scale, crowded works with highly narrative space confused by irrational perspective, and distorted figures with small heads and feet. This creates an effect of intense spirituality.

Hieratic Style

In the middle centuries of the Empire, a style known as *hieratic* (hy-er-AT-ik), meaning here "holy" or "sacred," emerged, consisting of formal, almost rigid images. (Do not confuse this style with the hierarchical formula just discussed.) Less intended to represent real life than to inspire reverence and meditation, it employed a canon of proportion that a man should measure nine heads in height (seven heads gives a lifelike proportion). The hairline fell one nose length above the forehead. In addition, "if the man is naked, four noses' lengths are needed for half his width."

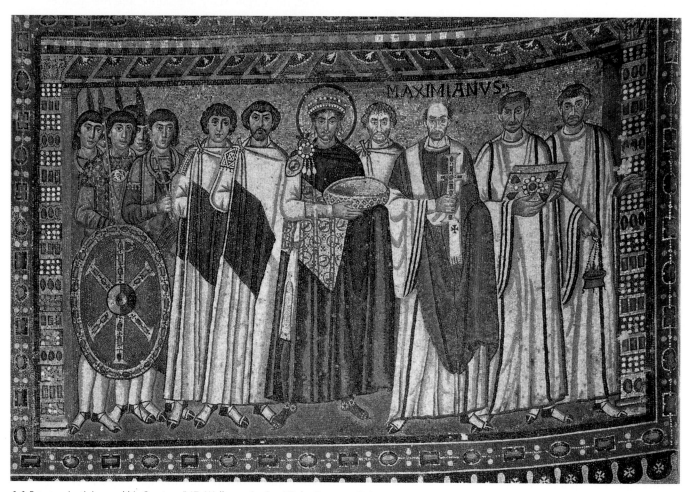

6.6 *Emperor Justinian and his Court*, c. 547. Wall mosaic, San Vitale, Ravenna, Italy.

By the thirteenth century, mosaics had returned to more naturalistic depictions, but they did not lose the clear sense of the spiritual apparent in the much earlier Ravenna mosaic of Emperor Justinian and his court (Fig. 6.6). The hieratic style also occurs in other media, for example, in the *Harbaville Triptych* (TRIP-tik; see Fig. 6.13) and *Virgin and Child* ivories (see Fig. 6.15). In both, we see the formality, frontal poses, and slight elongation of forms that are typical of this style.

When artists depicted the emperor in Byzantine art, we may note any of several characteristics. The emperor may be shown in the presence of Christ to validate his supreme powers. One or several exclusive attributes of the emperor may be present—for example: (1) red shoes decorated with jewels; (2) a long purple robe overlaid

with a scarf covered with jeweled patterns; (3) a crown from which a strand of pearls suspends on each side of the face (called a *pendulia*); (4) a scepter.

Mosaic

Covering a period of a thousand turbulent years, Byzantine art contains a complex repertoire of styles. When Constantine established his capital at Constantinople, a group of artists and craftsmen, trained in other centers, already worked there. When these people set to work on Constantine's artistic projects, they naturally rendered their subjects in a manner quite different from the Roman style.

We see one of the earliest examples of two-dimensional art in a **mosaic** floor in the Imperial Palace of Constantinople. Mosaic served as a characteristic Byzantine medium, and Figure 6.7 shows an example whose finely detailed execution allows for an essentially lifelike style. The mosaics depict figures, buildings, and scenes, unconnected with each other, presented against a white background. The grandeur and elegance of these works reveal Greek classical influence. Although the figures appear fairly lifelike, the absence of background and shadow indicates that pictorial reality was neither intended nor important. Rather, each figure has a mystical, **abstract**, clearly unclassical feel.

The wall mosaic *Abraham's Hospitality and the Sacrifice of Isaac* (see Fig. 6.20) demonstrates, by Byzantine standards, a relaxed lifelikeness, in contrast to a depiction of Justinian and his court (Fig. 6.6), which shows the more typically Byzantine orientalized style, with figures posed rigidly and facing forward. Mosaics clearly link the Church to the Byzantine court, reflecting again the connection of the emperor to the Faith, of Christianity to the state, and the concept of the "Divine Emperor." Justinian (Fig. 6.6) and Theodora (Fig. 6.1) appear in these portrayals like Christ and the Virgin. The two mosaics face each other behind the high altar of San Vitale. In Figure 6.6 the emperor has a halo with a red border, wears a regal purple robe, and presents a golden bowl to Christ, pictured in the semidome above the mosaic (see Fig. 6.18).

Manuscript Illumination

In addition to the mosaics that decorated palaces and the wealthier churches, manuscript illumination and wall painting formed important Byzantine media. From the period immediately after the iconoclastic controversy come exquisite manuscript illuminations. The rich colors show masterful control and delicacy, giving assured shading and elegant detail.

The scenes shown in Figures 6.8 and 6.9 tell stories. *The Vision of Ezekiel* treats the story from the Old Testament in four separate panels. Continuity results

6.7 A seated "philosopher," early sixth century. Floor mosaic, Imperial Palace, Istanbul, Turkey.

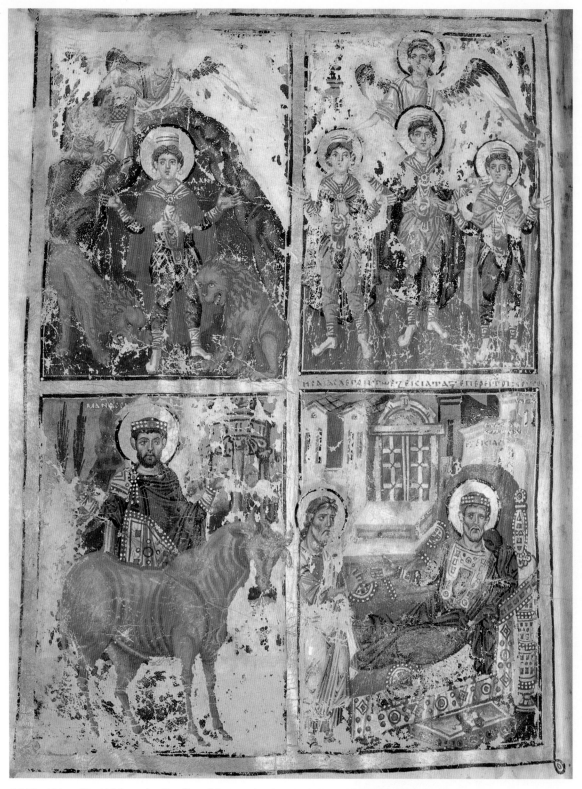

6.8 *The Vision of Ezekiel*, from the Homilies of Gregory Nazianzus, 867–86. Bibliothèque Nationale, Paris.

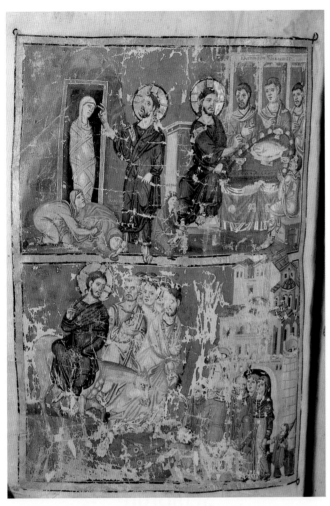

6.9 *The Raising of Lazarus and the Entry into Jerusalem,* from the Homilies of Gregory Nazianzus, 867–86. 16⅛ × 12 ins (41 × 30.5 cm). Bibliothèque Nationale, Paris.

6.10 Al-Qasim ibn 'Ali al-Hariri, *Maqamat al-Hariri* (a book of stories), 1323. Mesopotamian manuscript, Oriental Collection, British Library, London.

from some part of each scene (except the last) breaking through its border into the neutral space between the panels. In the upper right corner, one picture actually breaks into the adjoining scene. Figure **6.9** unfolds its narrative in two registers, depicting the New Testament stories of Jesus raising Lazarus from the dead, and of his entry into Jerusalem shortly afterward. The technique, called "continuous narration," has the episodes laid out across the top, then continuing in the bottom register. Much in these works shows classical derivation, and yet the treatment of space, with its crowded figures, its concentration on the surface plane, and lack of rational linear perspective, remains entirely Byzantine.

Islam

Theoretically, Islam prohibits depiction of all human and animal figures, but in reality, images appear widespread:

the only prohibition seems to have been on those objects intended for public display. In the courts of the caliphs, for example, images of living things were commonplace. They were considered harmless if they did not cast a shadow, were small in scale, or appeared on everyday objects.

A continuity of visual art seems to have occurred during the early years of Islam through the illustration of scientific texts. The Arabs obtained manuscripts from Byzantium, and had tremendous interest in Greek science. The result was a plethora of texts translated into Arabic. Arab scholars also copied illustrations from original Greek works. Typical of the illustration drawn in Arab manuscripts, a pen-and-ink sketch, perhaps from a Mesopotamian manuscript of the fourteenth century (Fig. **6.10**), has a clear presentation, with many of the strokes seeming to act as accents. The lines flow freely in subtle curvilinear movements to establish a comfortable rhythm across the page. In very simple line, the artist captures human character, thus showing a strong observational ability. The witty flavor of the drawing goes far beyond mere illustration.

Even before Islam, Arab traders had penetrated the Far East, and as a result Chinese influence can be seen throughout the Middle East particularly in the emergence of religious subjects for visual art. The Mongol rulers understood the Buddhist tradition in Chinese art and brought that interest to Islamic art—ignoring their predecessors' reluctance to pictorialize Muhammad. Thus, in the fourteenth century painting that depicted narratives about Muhammad became quite common.

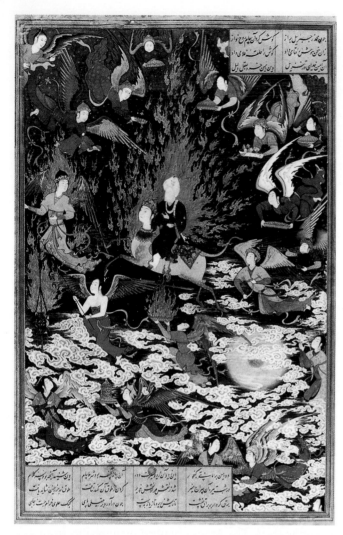

6.11 Unknown illustrator, *The Ascension of Muhammad*, 1539–43. Persian manuscript. Oriental Collection, British Library, London.

6.12 Base of the Theodosian obelisk, c. 395. Marble, about 13 ft 11 ins (4.2 m) high. Hippodrome, Istanbul, Turkey.

Chinese influences work strongly in an Islamic manuscript illustration from sixteenth-century Persia. *The Ascension of Muhammad* (Fig. **6.11**) tells the story from the Qur'an, in which Muhammad ascends into Paradise after "a journey by night . . . to the remote place of worship." The reference in the Qur'an was later expanded upon: Muhammad ascended from Jerusalem under the guidance of the Angel Gabriel, rising through seven heavens and meeting Adam, Abraham, Moses, and Jesus before coming into the presence of God.

Muhammad rides a curiously oriental centaur—a mythological beast with a horse's body and the head of a man. The surrounding angels have oriental faces, and the composition seems to divide along the diagonal axis— also similar to some oriental works. The crescent-shaped figures appear to swirl in an elliptical path around Muhammad, and the artist shows a sophisticated color composition by carrying the predominant colors of one

section into another section—for example, the white of the clouds carries into the upper parts of the painting in small details of trim and in the lighter flesh tones; reds that provide an encircling motif in the upper portion are carried into the lower section, where they accent rather than dominate.

Sculpture

Sculpture developed in the same historical context as the two-dimensional arts. Early works include sculptural vignettes illustrating Old and New Testament themes of salvation and life after death. For two centuries or so, the old art of Roman portrait sculpture held sway. But by the end of the fourth century, styles had begun to change. In Figure **6.12**, the base of an obelisk set up by Theodosius I, the frontal poses of figures, the ranks in which they are grouped, and the large, accentuated heads reflect oriental influence. Oriental and classically inspired works existed alongside each other in this period. Large-scale sculpture virtually disappeared from Byzantine art after the fifth century. Small-scale reliefs in ivory and metal continued in abundance, however. The clear-cut, precise style of Greek carving later became an outstanding characteristic of Byzantine sculpture. As in painting, sculpture took a classical turn after the iconoclastic struggle, but with an added awareness of the spiritual side of human beauty.

Ivory, traditionally a precious material, proved very popular in Byzantium. The number of carved works in different styles provides evidence of the various influences and degrees of technical ability in the Eastern Empire. Many of the ivories take **diptych** (DIP-tik) form: two

MASTERWORK

THE *HARBAVILLE TRIPTYCH*

The tenth and eleventh centuries have left us the greatest number of ivory objects, many decorated with small, elegant reliefs. In secular art, ivory caskets covered with minute carvings proved the most popular form. Byzantine ivory carvers of the time showed remarkable ease and skill in imitating classical models. The same technique occurred in small-scale reliefs of religious subjects. The *Harbaville Triptych* (Fig. **6.13**) provides an exquisite example.

The **triptych**, probably intended as a portable altar or shrine, has two wings that folded shut for traveling, across the center panel. In the top center Christ sits enthroned and flanked by John the Baptist and the

Virgin Mary, who plead for mercy on behalf of all humanity. Five of the apostles appear below. The two registers of the central panel are divided by an ornament repeated, with the addition of rosettes at the bottom border, and three heads in the top border. On either side of Christ's head appear medallions depicting angels holding symbols of the sun and moon. The figures have hieratic formality and solemnity, yet the depiction exhibits a certain softness that may result from a strong classical influence.

The figures stand on a plain, flat ground, ornamented only by the lettering of their names beside the heads. The side wings contain portraits of four soldier saints and four bishop saints. Between the levels are bust-length portraits of other saints. All the saints wear the dress of various civilian dignitaries. The triptych thus aligns the powers of Church and State,

within the hierarchical formula of Byzantine art: each personage has his or her own place in the divine hierarchy, with Christ at the top. This work and others from the same period belong to a class of works known as "Romanus," after a plaque in the Bibliothèque Nationale in Paris that shows Christ crowning the Emperor Romanus IV and his empress, Eudocia. The works of this Romanus school of ivory carvers are identifiable by style but they also have a particular iconographic peculiarity. The cross in Christ's **nimbus**, or halo, shows the usual rectangular outline, but a pearled border has been added to both cross and nimbus. Similarly fine workmanship adorns the mosaics and painting of the time; in fact, stylistic developments in the ivories were closely associated with those in painting.

6.13 The *Harbaville Triptych*, interior, late tenth century. Ivory, 9½ ins (24.2 cm) high, central panel 5⅝ ins (14.2 cm) wide. Louvre, Paris.

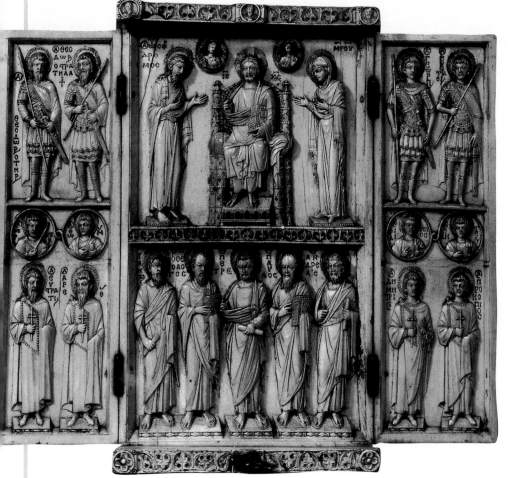

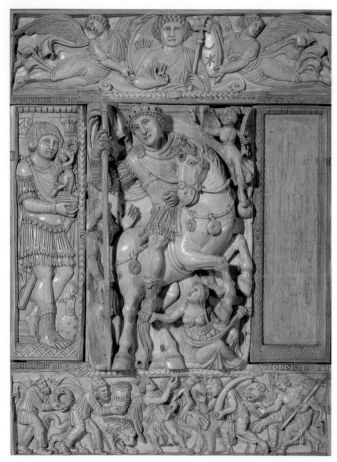

6.14 *Barberini Ivory*, showing a mounted emperor, c. 500. Ivory, 13½ × 10½ ins (34.1 × 26.6 cm). Louvre, Paris.

panels. The *Barberini Ivory* (bahr-bair-EE-nee; Fig. **6.14**) a work of five separate pieces (one of which is missing) shows at the center an emperor depicted on horseback. To the side stands a consul in military costume, and above is a bust of Christ with winged victories on either side. The long panel at the bottom depicts Gothic emissaries on the left side and emissaries from India on the right; interestingly, the latter carry elephant tusks—the source of the artist's material. The work has the rounded features and brilliant high-relief technique typical of the period. The portrait of the emperor is individualized and recognizable. Later ivories show a more delicate elegance and a highly finished style.

The only known Byzantine freestanding sculpture in ivory, the tenth-century *Virgin and Child* (Fig. **6.15**), shows exquisitely falling drapery and a highly finished surface. The facial features, hands, and torsos display characteristic hieratic elongation.

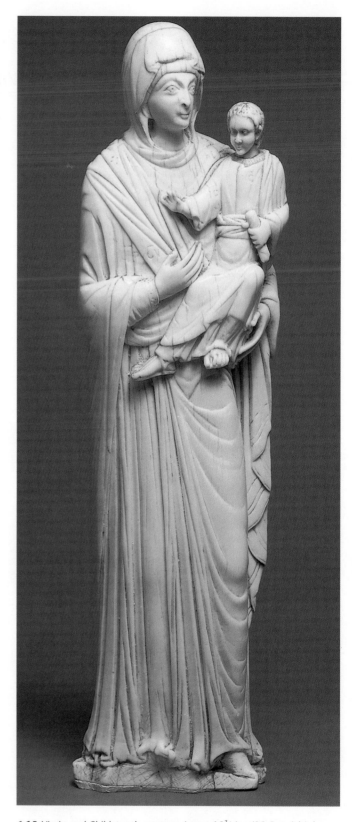

6.15 *Virgin and Child*, tenth century. Ivory, 12⅞ ins (32.5 cm) high. Victoria & Albert Museum, London.

TECHNOLOGY

SPANNING SPACE WITH TRIANGLES AND POTS

The ingenuity of human achievement is often revealed in the subtleties of invention that have allowed architects to create great open spaces under remarkably heavy materials such as stone and cement. We have seen this in the great dome of the Pantheon of Rome, and now we see it in what is still the largest dome ever created, St Sophia in Constantinople. It is a reminder that what was best in the West came from the uninterrupted Roman building tradition of that city. In 537, when Western Europe was at its most barbaric, Justinian's great brickwork cathedral was dedicated. What made it remarkable was the invention of a device to transfer the weight of a great dome downward—not on a cylindrical tub as in the Pantheon, but through a triangular device called a **pendentive** (pehn-DEHN-tihv; Fig. **6.16**)—to the corners of a square tower, 180 feet (55 meters) above the ground. Dedicated to the Divine Wisdom, St Sophia illustrates the sublime ingenuity of humankind.

In another of Justinian's marvels, as we have noted, Byzantine influence and technological creativity reflects itself in the church of San Vitale in Ravenna (Fig. **6.17**). Here, in order to compensate for the potentially crushing weight of a solid dome, the architect used hollow earthenware pots for construction. Thus, space was enclosed without utilizing a base so cumbersome as to ruin the aesthetic considerations of lightness and beauty. Whether in soaring domes or towers that reach 110 stories into the air, technological inventiveness has always lain at the heart of new dimensions in architecture. None has superseded the marvels of Byzantium, where, in addition to unsurpassed domes, stone was jointed with such precision that some buildings did not require mortar.

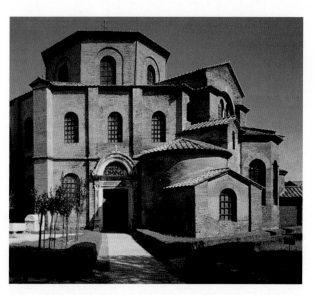

6.17 Façade of San Vitale, Ravenna, Italy.

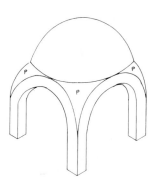

6.16 Dome with pendentives (P).

Architecture

Byzantium

The Emperor Justinian's personality dominated the architecture of the early years of the Eastern Empire. Royal patronage encouraged artistry, but the arts clearly reflected the source of that encouragement. Justinian sought to glorify Justinian, and, in a remarkably creative way, the arts and architecture of the age succeeded in doing just that. The results of his efforts can be seen both in the West (see Figs **6.6** and **6.17**) and in the East (see

Figs **6.21–6.23**): two great edifices, exemplified by the church of San Vitale (sahn vee-TAH-lay) in Ravenna and the monumental Hagia Sophia (HAH-juh soh-FEE-uh), Church of St Sophia, in Constantinople.

San Vitale in Ravenna (Figs **6.17–6.19**), the major Justinian monument in the West, probably rose as a testament to the power of Orthodoxy in the declining kingdom of the Ostrogoths. The church consists of two concentric octagons (see Fig. **6.19**). The hemispherical dome, 100 feet (30 meters) above the floor, rises from a drum above the inner octagon, which is pierced with windows that flood the interior with light. Below, eight

large piers alternate with columned niches to define precisely the central space and to create an intricate, many-layered design. The narthex sits at an odd angle. Two possible explanations for this exist: the practical one contends that the narthex paralleled a then-existing street; a more spiritual one says that the narthex sought to force worshippers to reorient themselves on entering, thereby facilitating the transition from the outside world to the spiritual one.

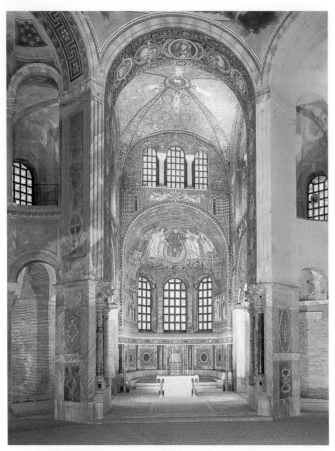

6.18 San Vitale, Ravenna, Italy, 526–47. Interior, looking east.

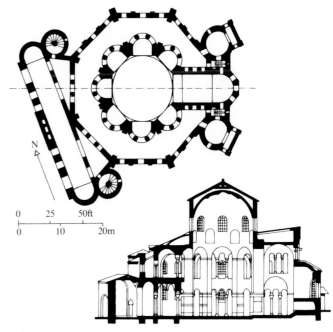

6.19 Plan and transverse section of San Vitale, Ravenna, Italy.

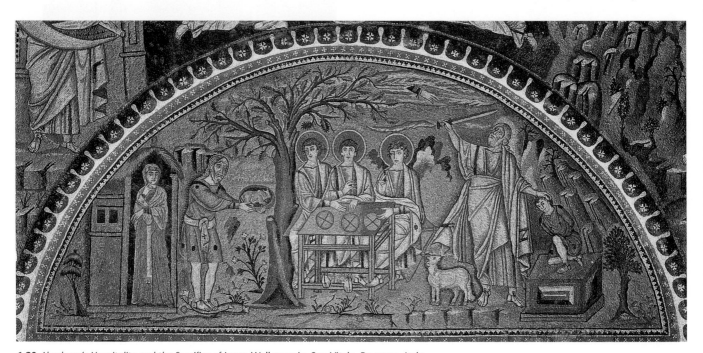

6.20 *Abraham's Hospitality and the Sacrifice of Isaac.* Wall mosaic, San Vitale, Ravenna, Italy.

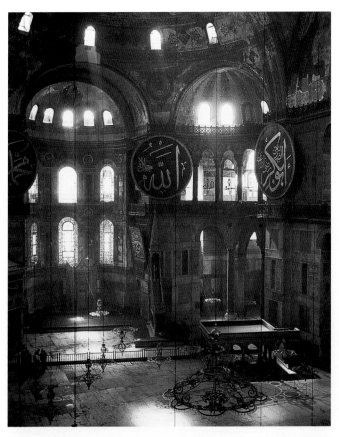

6.21 St Sophia, Istanbul, Turkey, 532–7. Interior view.

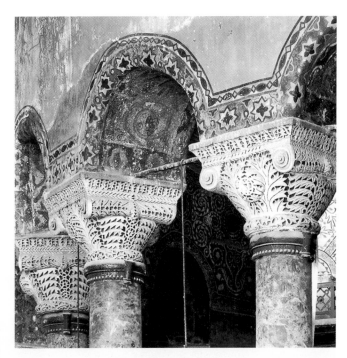

6.22 Capitals in St Sophia, Istanbul, Turkey.

On the second level of the ambulatory was a special gallery reserved for women—a standard feature of Byzantine churches. The intricate internal spatial design gives the visitor an ever-changing vista of arches within arches, linking flat walls and curved spaces. All the aisles and galleries contrast strikingly with the calm area under the dome. The clerestory light reflects off the mosaic tiles with great richness. In fact, new construction techniques in the vaulting allowed for windows on every level and opened the sanctuary to much more light than had previously been possible.

If San Vitale praises the emperor and Orthodoxy in the West, St Sophia proves a crowning monument to his achievement in the East (Figs **6.21–6.23**). St Sophia characterizes the Justinian Byzantine style in its use of well-rehearsed Roman vaulting techniques combined with Hellenistic principles of design and geometry, resulting in a building of an orientalized, antique style. We have to imagine the Church of St Sophia without its four minarets. These were added after the Muslims conquered Byzantium and converted the building to a mosque. Today St Sophia is a museum, and no picture can prepare you for the breathtaking nature of its scale. After nearly fifteen hundred years, its dome still represents one of the greatest engineering feats of human history.

Built to replace an earlier basilica, St Sophia was for a long time the largest church in the world. It was completed in only five years and ten months, between 532 and 537. The speed of the work, together with Byzantine masonry techniques, in which courses of brick alternate with courses of mortar as thick as, or thicker than, the bricks, caused great weight to be placed on insufficiently dry mortar. As a result, arches buckled, and buttresses had to be erected almost at once. The additional effects of two earthquakes caused the eastern arch and part of the dome itself to fall in 557.

The flatness of a dome so large—110 feet (33.5 meters) in diameter—remains unique, as does the delicate proportioning of the vaults that support such great weight. Basic to the conception is the elevated central area, with its picture of heaven in the dome and its large, open, and functional spaces. The building could hold large numbers of worshippers in a transcendental environment, where thoughts at once rise to a spiritual sphere. "It seemed as if the vault of heaven were suspended above one," wrote Procopius.

The capitals of the columns in St Sophia (Fig. **6.22**) illustrate a style totally Byzantine. The deeply undercut ornament shows originality and technical mastery.

After Justinian's death, the construction of public churches all but ceased. The palace comprised the only important building project. Yet the churches built at this time became models for later Byzantine architecture. The general form of these early churches, such as that of St Clement in Ankara, consists of a central dome and a

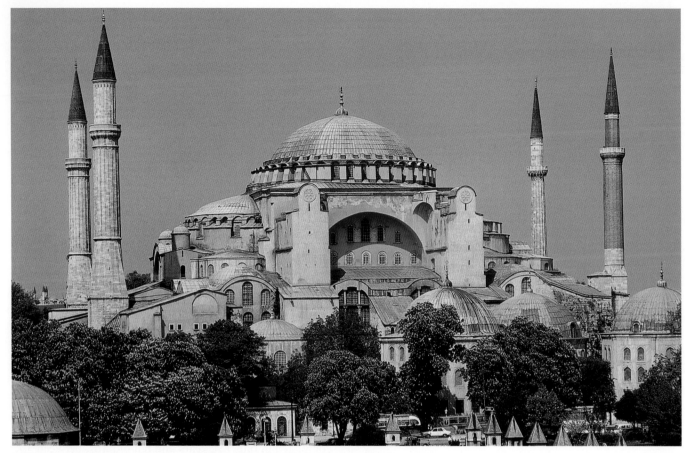

6.23 Anthemius of Tralles and Isidorus of Miletus, St Sophia, Istanbul, Turkey, 532–7.

PROFILE

ANTHEMIUS OF TRALLES (C. SIXTH CENTURY)

It may seem strange to include a profile about someone like Anthemius of Tralles (an-THEE-mee-us), about whom we know virtually nothing. However, the fact that we know his name at all testifies to the vision and profound quality of his architectural work. During this period of history, individual artists—especially architects—did not gain fame. Their work stood as an expression, usually religious, that glorified God, the emperor, or the Church, and individualism, as we know it in artistic work, had ceased. However, we know of Anthemius. Although not an architect or master mason by training, he wrote a treatise on the geometry of conical sections, had a knowledge of projective geometry, and knew of the mechanical inventions of Archimedes (ark-ih-MEE-deez), a Greek mathematician, physicist, and inventor who lived in the third century B.C.E.

Anthemius' lasting fame, however, came as a result of his design for what constituted at the time, and still remains, one of the greatest architectural accomplishments of history—the church of St Sophia in Constantinople (Fig. **6.23**). Commissioned by the emperor Justinian, Anthemius designed a building that, in the words of Justinian's court historian, Procopius, "through the harmony of its measurements . . . is distinguished by indescribable beauty."

Inasmuch as Anthemius was a mathematician, it does not surprise us to discover that he and his partner, Isidorus of Miletus (also a mathematician), based the design for St Sophia on a sphere standing upon a circle. To Anthemius, architecture implied the "application of geometry to solid matter," and his designs brought to Constantinople a completely new approach to architecture by showing an inventive structure of form that stood entirely outside the Roman tradition. Such a departure reveals a profound intellect and great courage.

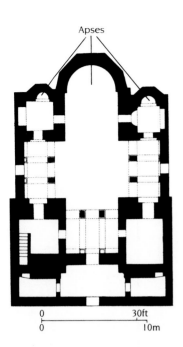

Apses

6.24 Ground plan of the church of St Clement, Ankara, Turkey.

group of three **apses** at the east end (Fig. **6.24**). The entire space describes a cross-in-square layout, which, again, we see in later churches. The cross-in-square is outlined on the ground plan: look outward from the center to the end of each of the transverse arms, the lower arm of the nave, and the upper arm just to the edge of the circular apse at top center.

The churches constructed in the two or three centuries after St Clement's employed the classical principles of harmony among their parts, and composition to express human aspirations. St Theodosia (Fig. **6.25**) reflects typical Byzantine design with its vertical drums comprising apses and a series of flattened domes, including that over the central part of the structure. We glimpse the dome above the central pavilion at the top. The church's vertical striving and precise symmetry give it an elegant solidity. Delicate, arched niches and grilled windows tend to counter the heaviness of the walls.

As Byzantine power waned, the vigor and scale of new church construction reduced. The ground plans became smaller, and in partial compensation, height

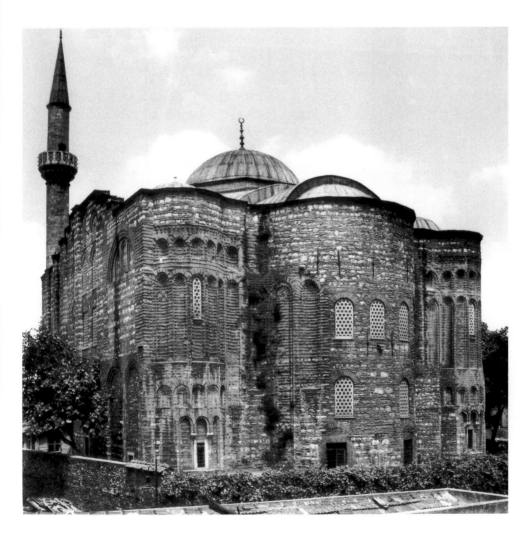

6.25 St Theodosia, Istanbul, Turkey, c. 1000.

6.26 Churches of St Luke and the Virgin, Stiris, Turkey, eleventh century.

6.27 St Mary Pammakaristos, Istanbul, Turkey, thirteenth century.

increased. Greater emphasis was also placed on the appearance of the exterior, with decorative surface treatment of the brickwork or masonry of the walls (Figs **6.26** and **6.27**). Another characteristic of later church building, the addition of churches or chapels to existing ones, resulted in very different forms from the organized massing of the single-domed church. The elaborate detail and frequent changes of plane that these additions created give us a fascinating surface with which to interreact, as the churches of St Luke and the Virgin illustrate (Fig. **6.26**). Here, verticality or upward striving line seems much less apparent—the strength of horizontal elements and the shorter apses give the impression of much more squatness.

The interiors of these churches appear elegant, jewel-like, sumptuous, glowing with color, and heavily decorated. We reach them through narthexes, and sometimes side porches, that create a spatial and visual transition from the outside world to the interior. The spaces of the church flow smoothly from one to another and are carefully designed to meet liturgical needs. A deep, vaulted sanctuary and apse house the altar. Chambers adjoin the apse on either side. Just beyond the eastern columns, a screen painted with icons stands across the sanctuary. The entire effect of the mosaic-covered vaults, elaborate ecclesiastical vestments, chants,

6.28 Dome of the Rock, Jerusalem, late seventh century.

6.29 Detail of mosaic decoration, Dome of the Rock, Jerusalem, Israel, 691–2.

ancient rites, and incense was designed to create for the worshipper the spiritual and physical sense of another world.

Islam

The first major example of Islamic architecture did not appear until 691, when work began on the Dome of the Rock in Jerusalem (Fig. **6.28**). Built near the site of the Temple of Solomon, it was begun by Islamic emperors who were direct descendants of the Prophet's companions. Shaped as an octagon, they designed it as a special holy place—not an ordinary mosque. Inside, it contains two concentric ambulatories, walkways, surrounding a central space capped by the dome. The mosque sits on a site also revered by Jews as the tomb of Adam and the place where Abraham prepared to sacrifice Isaac. According to Muslim tradition, it also constitutes the place from which Muhammad ascended into heaven. Written accounts suggest that it was built to overshadow a sacred temple of similar construction on the other side of Jerusalem—the Holy Sepulchre. Caliph Abd al-Malik (AHB-uhd al-mah-leek) wanted a monument that would outshine the Christian churches of the area, and, perhaps, the Kaaba in Mecca. The exterior was later decorated with the glazed blue tiles that give the façade its dazzling appearance; the inside glitters with gold, glass, and mother-of-pearl, in multicolored mosaics. A detail of the richly intricate mosaics of the Dome of the Rock in Jerusalem appears in Figure **6.29**. This symmetrical

pattern in deep red and gold, highlighted with accents of white and purple, illustrates the skill and delicacy that Muslim artists brought to this form. Undoubtedly, the Dome of the Rock was intended to speak to Christians as well as Muslims, distracting the former from the splendor of Christian churches. Inside the mosque an inscription reads: "The Messiah Jesus Son of Mary is only an apostle of God, and His Word which he conveyed into Mary, and a Spirit proceeding from Him. Believe therefore in God and his apostles and say not 'Three.' It will be better for you. God is only one God. Far be it from his glory that He should have a son."

The Great Mosque of Damascus presents another excellent example of Islamic architecture (Fig. **6.30**). When the Muslims captured Damascus in 635, they adapted the precinct of a pagan temple, which had been converted into a Christian church, into an open-air mosque. Seventy years later, al-Walid demolished the church and set about building the largest mosque in Islam. The only feature of the original buildings left standing was the Roman wall, although the four original towers metamorphosed into the first minarets, from which muezzins called the faithful to prayer. Unfortunately, the centuries have not been kind to the Great Mosque. Sacked a number of times, it has lost much of the splendor of its lavish decorations. However, we can see some of its grandeur in the arcaded courtyard, with fine, gold-inlaid detailing visible in the returns of the arches (Fig. **6.30**). Inside, colorful mosaics (Fig. **6.31**) express great subtlety of detail and texture. These works rank among the most accomplished of mosaics and were probably produced by Byzantine craftsmen.

Theatre, Music, and Dance

Byzantium

The Byzantines undoubtedly attended the theatre. Ruins of Hellenistic theatres have been found throughout the Eastern Empire. Justinian's wife, Theodora, was an actress, and theatrical spectacles surrounded the life of the Imperial court. Historic references cite an exodus of

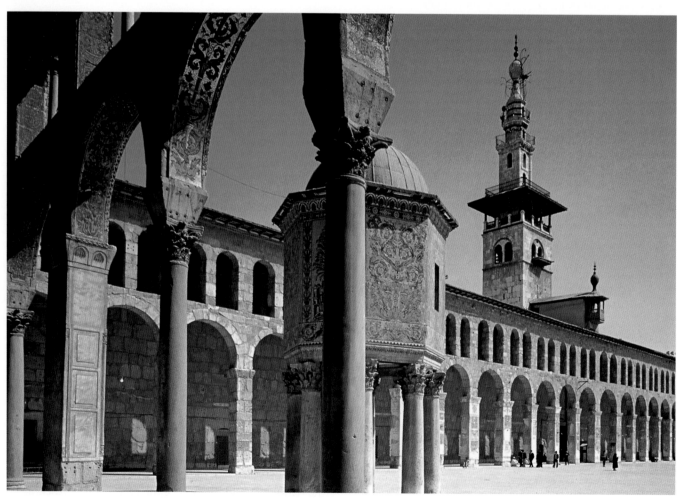

6.30 Great Mosque, Damascus, Syria. Courtyard looking west, c. 715.

6.31 Detail of mosaic decoration, Great Mosque, Damascus, c. 715.

actors and playwrights from Byzantium at the time of the Turkish conquest.

But what of theatre itself? The period between the fall of Rome and the late Middle Ages witnessed the virtual extinction of theatre in both East and West, except in its most rudimentary form. The Byzantine preference for artistic anonymity might account for the absence of dramas, and the literature of Byzantium certainly excluded drama from its priorities. In a society dominated by the Christian Church, the kind of debased spectacles popular in the late years of the Roman Empire could have enjoyed no favor. The moral tone prohibited senators by law from marrying actresses: Justinian had to change this law in order to marry Theodora. We hear of professional actors in Byzantium as late as the seventh century, but after that formal theatre performances seem to have disappeared. As one commentator puts it, "In the East problems more serious soon set people thinking of things sterner than merry supper-parties with groups of dancing girls."[2]

Throughout the Middle Ages, critical remarks to the effect that it was "better to please God than the actors" suggest that some form of performance art continued, however, and this likely applied to Byzantium. Mime,

and some form of pantomime, probably formed the only types of theatrical activity.

Before reaching Europe, the Christian Church spread throughout Asia Minor, accumulating musical elements on its way. Byzantium appears to have acquired much of its musical heritage from the monasteries and churches of Syria, where the development of antiphonal psalmody and the use of hymns originated. Clear evidence of hymn singing can be found in the New Testament, both in the Gospels and in the letters of Paul and James, and in the writings of Pliny the Younger in Bithynia and Asia Minor in the second century. Some early Christian hymns probably used folk melodies. Thus there seem to have been both Eastern and Greek influences on early Christian music.

Although no music manuscripts survive from this period, the strong traditions of the Greek Orthodox, Russian, and other Eastern Churches still preserve what must be a flavor of the Byzantine chants that served as their models. Based on Syrian melodies and incorporating short responses between verses of the psalms, an independent hymnody gradually developed. Byzantine hymns had an elaborate structure, which stood in contrast to the simple hymns of the Western Church.

One type, developed in the eighth to tenth centuries, based on sixth-century hymns, was called *kanones* (kuh-NAHN-ehs). Its texts consisted of commentaries based on passages from the Bible. Its melodies, also not entirely original, used a principle common to Eastern music but unfamiliar in the West. Rather than building a new melody from the tones in a scale, Eastern singers constructed melody out of a series of short given motifs, which they chose and combined. Some motifs were designed for beginnings, some for middles, some for endings, and some for links. There were standard ornamental formulas, and originality in performance depended on the combination, variation, and ornamentation of the motifs. Byzantine music had eight forms, or *echoi* (EHK-oy). These *echoi* played a fundamental part in the development of Western music. Our knowledge of them is limited, however, by the fact that in the Byzantine Church music passed down through oral tradition for centuries before being written down.

Undoubtedly Eastern music had a contemplative, even mystical, character and a degree of complexity quite in keeping with the character of Eastern thought.

References to dance occur from time to time throughout this period. Whether we should consider Byzantine dance as an artistic form remains problematical, however. We know of two situations, at least, in which dance occurred. Some form of dancing apparently took place as part of religious services, but we do not know any details of its content or purpose. A second form of dancing provided entertainment. This was

A DYNAMIC WORLD

CHINESE THEATRE

At the time that East was separating from West in Rome, Confucius put to death an entire troupe of actors who took part in a play that violated his teaching.

Chinese drama forbade women on stage. All female roles in Chinese theatre were played by men, who mimicked the teetering style of walking that resulted from the practice of footbinding among the upper classes, and utilized a device called *tsai jiao* (tsy-jow) to keep the actor "on point"—in the balletic sense—throughout the performance.

Costume and makeup played a significant and symbolic role in Chinese theatre. Color, especially, portrayed emotion and social standing. Chinese theatrical costume, like its scenery, did not attempt to depict historical accuracy. Styles and periods mixed freely so as to create dramatic effect and reinforce nuances. Like the American movie genre the Western, in which the "good guys"

wore white hats, and the "bad guys" black ones, in Chinese theatre, the good guys wore square hats, and the bad guys, round ones.

6.32 Chinese theatre performance in progress.

probably a vestige of the Roman pantomime (see Chapter 4), in which case it would have exhibited subtlety of movement and expression. Pantomime occurred throughout the Byzantine Empire, either as solo performances at fairs and village festivals or using small traveling bands.

Islam

In the early years of Islam, specifically during the period of the four caliphs (representatives of Muhammad), who ruled from the Prophet's death (632) until 661, music held the unenviable position of "forbidden pleasure" (*malahi*). The caliphs saw music as at odds with the religious values of Islam and equated it with sensuality, frivolity, and luxury. By the following Umayyad dynasty (661–750), music regained a favorable role in Islamic society, emerging from its previously suppressed position in a court that actively supported the arts and sciences.

In many cases, the music of Persia influenced Arabic music, and vice versa. In Spain, a new style of music arose as a direct result of Islamic influence. In the period from 750 until 1258, known as the Abbasid dynasty, every educated individual had the obligation to master music. Later, Islamic music again fell out of favor, and in the ninth century, a musical theorist named Al-Kindi (al-KIHN-dee; 790–874) brought Arabic music under the influence of Greek musical theory.

Islamic music functioned primarily as court entertainment, both as vocal presentation or accompaniment for dancing by professional dancers. Music also functioned as part of Islamic religious ritual, used to call worshippers to prayer, for chanting verses of the Qur'an, and as hymns. Music also accompanies the solemn repetition of the name of God in the Muslim worship service.

Literature

Byzantium

Most Greek Byzantine literature treats religious subjects, much of it hagiographic—covering the life stories of saints and other religious figures. In addition, sermons, liturgical books, poetry, theology, devotional works, scriptural commentaries, and so on exist. Of the thousands of volumes that have survived, only a few hundred treat secular subjects.

To understand Byzantine literature, we need to know something about Byzantine aesthetic taste, which was quite different from our own. Modern readers do not obtain much pleasure from Byzantine literature, because we expect to find quite different qualities in what we read: we like originality of thought and expression. Educated Byzantines did not like surprise. They liked clichés. Where we value clarity and directness, they admired elaboration and verbiage.

Byzantine literature falls into three principal genres. The first is historiography. This is not the history we speak of when we refer to a chronicled record of events. That comprised a separate activity in Byzantium. Historiography is, rather, a specific literary genre, related to rhetoric. Written in ancient Greek, it imitates ancient models and interprets events and their influence on each other. As Theophanes Continuatus wrote: "The body of history is indeed mute and empty if it is deprived of the cause of actions." Probably the best-known of the Byzantine historiographers, Procopius of Caesarea, wrote broad, sweeping narratives, modeled on the work of the Athenian historian Thucydides.

Anna Comnena (b. 1083), however, emerges as one of the best writers of history of the age. The eldest daughter of Alexius Comnenus, Emperor of Constantinople (1081–1118), she received, as typified Byzantine princesses, an excellent education in the Greek classics, history, geography, mythology, and even philosophy. Involved in an unsuccessful attempt to place her husband on the throne after her father's death, she retired with her mother, the Empress Irene, to a monastery that the latter had founded, and wrote the fifteen books of her famous *Alexiad*. Finished by 1148, it describes the career of her father, from 1069 to his death in 1118; and thus continues her husband's "Historical Materials," which ends in 1079. The *Alexiad* long served as a source of information for historians of the Byzantine Empire and for writers on the First Crusade. She acts as the historian of the fortunes of the Comneni family. Her personal knowledge informs her observations through acquaintance with public affairs that she owed to her high rank, but she also made use of diplomatic correspondence, the reports of her father's generals and soldiers, and the imperial archives. She provides a stirring picture of the mental and physical energy of her hero-father, the Emperor Alexius, and helps us to recognize the tremendous difficulties that confronted Byzantine emperors of this period.

As a true Byzantine Comnena sees the Crusades strictly from the standpoint of Constantinople, and thoroughly detests all Latins. The chronology of the work lacks accuracy, and she delights in describing scenes of splendor, great state actions, audiences, and feasts. She also includes court gossip and uses the devices of satire and detraction, but leaves untreated matters such as financial, military, and constitutional issues. Her language utilizes reminiscences and conscious attempts at Greek classical elegance, but, perhaps because her models, such as Thucydides, lay so far in the past, the results are often strained. She avoids foreign names and vulgar terms as unfit for the pen of an historian.

Alexiad
Anna Comnena

Book X
Second Battle with Heresy: The Cuman War: First Crusade (1094–97)
(excerpt)

I

And now the notorious Nilus appeared, shortly after the condemnation of Italus' dogmas, and sweeping over the church like a flood of wickedness, brought restlessness into many a soul, and plunged a number in the eddies of his heterodoxy. (This man sprung I know not whence, had learnt to impersonate virtue very cleverly, and frequented the capital for a while, and alone in a corner, I presume, with God and himself, he had devoted himself to the study of the Holy Scriptures. He was quite uninitiated into Hellenic culture, and never even had a teacher who might from the start have explained to him the deep meanings of the Divine writings; and although he had studied the writings of the saints very closely, yet through never having learnt the art of reasoning he went astray about the meaning of the writings. He had seduced a far from ignoble body of followers, and insinuated himself into some of the big houses as self-elected teacher, partly because of his evident virtue and his austere morals, and partly because of the knowledge which seemed perhaps latent in him.

. . . The Emperor was not unaware of all this and when he heard of the man, he purposed giving him speedy help and sent for him. He blamed him severely for his audacity and ignorance and, after censuring him on several points, he instructed him clearly in the doctrine of the hypostatical union of the divine and human word, and set before him the manner of the change and taught him how the assumption of human nature was made divine by grace from above. But Nilus clung tenaciously to his own false doctrine, and was quite ready to suffer ill-treatment, torture and imprisonment, or even the maiming of his body, rather than refrain from teaching that the assumption of human nature had been made divine by nature. . . . What happened

next? The Emperor . . . decided to check the onward course of this evil, so he assembled the heads of the church and suggested holding a public synod to deal with these men. . . . Next he expounded them with a clear voice, and upheld them by further arguments. What was the result? In order to release people's minds from this corrupt doctrine, the synod imposed on Nilus a perpetual anathema, and proclaimed the hypostatical union according to the tradition of the Fathers more emphatically. Soon after this, or rather about the same time, Blachernites was also punished for holding improper opinions, alien to the church's teachings, although he was an ordained priest. For he had consorted with the Enthusiasts and became infected with their mischievous doctrines, led many astray, undermined great houses in the capital, and promulgated his impious doctrines. After he had been frequently brought before, and instructed by the Emperor, and yet would not abandon his own pernicious doctrine, the Emperor handed him also over to the church. As after a lengthy examination they too recognized him to be incorrigible, they condemned him and his doctrines to a perpetual anathema.

The bulk of Byzantine literature belongs to the second genre, hagiography. Many of these texts on the lives of the saints survive, most of them written in ecclesiastical Greek. They consist of anecdotes about the saints, as well as full life-histories, which had been preserved by Egyptian monks. The anecdotal accounts circulated by word of mouth before their collection in books. The stories told of supernatural deeds attributed to monks, and stressed the moral precepts they followed in their lives. Principally designed to praise the behavior of its subject, a "life" usually follows a specific rhetorical format. The writer first proclaims embarrassment at undertaking a task so great; then describes and praises the birthplace (if worthy of note) or the nation of the subject's birth; next comes a description of the family, but only if glorious; then the subject's birth and any miraculous signs accompanying it, real or invented, are noted; finally, in carefully organized subdivisions, physical appearance, education, upbringing, deeds, and so on, are described. This outline, or schema, made it easy to develop biographies of saints about whom little was known or who may never have existed. The "lives" make interesting, if somewhat predictable reading, and they provided heroes and heroines for the medieval world. Written in simple language, they sought as wide an audience as possible.

The third genre comprised literature written in the vernacular, or language of the common people. The earliest works of this sort, the Prodromic poems, date to the first half of the twelfth century. Attributed to the court poet Theodore Prodromos, they may have been written by several authors.

These poems employ a popular verse-form based on fifteen syllables and appear as complaints directed to the

Emperors John II and Manuel I and other members of the Comneni family. One of the poems tells the story of a hen-pecked husband; another, the story of the father of a large family who cannot make ends meet on his small salary. These works, largely humorous, tend toward monotony and repetition and the coinage of bizarre words. Romances of chivalric knights, maidens, witches, and dragons in the fashion of the Western Empire also proved popular. Epic poems that told heroic tales of the eastern border between Byzantium and the Arabs in the ninth and tenth centuries also found favor.

Much of Byzantine literature, however, remains solemn, even somber in mood. Its writers seem most at home with themes of calamity, death, and the precariousness of human existence.

Islam
Prose

Probably the most familiar Islamic literature, aside from the Qur'an, is a collection of tales called *The Arabian Nights* or *The Thousand and One Nights*. These tales accumulated during the Middle Ages, and as early as the tenth century they formed part of the oral traditions of Islam in the Near East. Over the years more tales were added, including a unifying device called a **framing tale**, which placed all the separate stories within a larger framework. By around 1450, the work had assumed its final form.

The framing tale recounts the story of a jealous Sultan who, convinced that all women were unfaithful, married a new wife each evening and put her to death the following morning. A new bride, Shaharazad, or Scheherazade, gained a reprieve by beginning a story on her wedding night and artfully maintaining the Sultan's curiosity. She gained a reprieve for one thousand and one nights—during which she produced three male heirs—after which the Sultan abandoned his original practice. The tales capture the spirit of Islamic life, its exotic setting, and sensuality. Although no particular moral purpose underlies the stories, they have a moral code. The tales cover a variety of subjects and range from fact to fiction. They include stories of camel trains, desert riders, and insistent calls to prayers. They are supernatural, aristocratic, romantic, bawdy, and satiric.

They contain the popular figures of Aladdin, Sinbad the Sailor, and Ali Baba. One of the best known tales of *The Thousand and One Nights*, "Ali Baba and the Forty Thieves," tells the story of Ali Baba, a poor woodcutter who secretly watches as forty thieves hide their loot in a cave. The door to the cave opens only on the command "Open, Sesame!" Later, Ali returns to the cave, uses the magic phrase, steals the loot, and lives a prosperous life.

Poetry

Poetry before the age of Muhammad and Islam (known to Muslims as the Age of Ignorance) formed the most prestigious literary category and the chief cultural institution of the Arabic-speaking world. Muslims rejected the traditions of this period, but to some degree those customs lived on in poetry, which held on to the old, pre-Islamic literary styles. Poetry had served as the archive of the Arabic tribes' traditions and values, and as the record of their battles: it constituted a source of pride, a weapon of war, a form of competition, and a means of entertainment. Arabs took this poetic heritage, along with their language and religion, to the territories they conquered. This meant that Persians, Egyptians, Berbers, and Jews fell under the cloak of ancient Arabian classics and, in fact, composed new poetry in the Arabic language and tribal spirit. Against this heritage stood the new religion, Islam, demanding loyalty to a community of believers rather than to a tribe and holding up before its believers ideals of spirituality, asceticism, humble submission to God, and religious scholarship. At first the Bedouin resisted these ideals as contrary to their way of life. Muhammad in turn denounced Arabic poetry as the embodiment of paganism, and its ideals as the antithesis of religion: "As for the poets, the erring follow them. Hast thou not seen how they stray in every valley, and how they say that which they do not do?"

After Muhammad's death, official Islam accommodated poetry uneasily. When Arabic poetry eventually did find a place in the religion of Islam, it saw only limited purposes and survived mostly as an Arabic element in a Muslim world. In the early ninth century asceticism (*zuhdiyat*) emerged, in which elements of Islam and of the older Middle Eastern culture combined to produce a kind of poetry that asserted living in awareness of death and renouncing the vanities of material pleasures. The Qur'an's "end of the world and humanity" message (eschatology [ehs-kuh-TAHL-uh-jee]) itself formed the driving force behind this denunciation of worldly pleasures for a life dedicated to contemplation of death and service to God. Some scholars assert that the Qur'an had inherited many of these ideas from Christianity and the monks of the Byzantine Middle East. In addition, much of the contents of the ascetic poetry displays a pessimistic attitude toward life that was widespread in the ancient cultures of the region. The poetry cultivated by early Muslim ascetics had gnomic (aphoristic verse containing short, memorable statements) characteristics.

Abu al-'Atahiyah (ah-BOOL-ah-TAH-hee-yuh; 748–c. 825), the first Arab poet to break with the traditions of the pre-Islamic poets of the desert, used a freer and simpler language of the village. His family, non-Arabs (*Mawlas*), lived in poverty, which prevented him

from receiving a formal education. Some scholars suggest that this accounts for his original and untraditional style. His *ghazels* (lyric poems) gained him favor with the reigning caliph. His later reputation rested on a collection of ascetic poems, the *Zuhdiyat*, which express his social resentment of the rich and powerful. In the poems, the arrogant rich receive their punishment in the horrors of death. His message found a popular reception among the masses.

Ibn Hazm (ihb-uhn-KAHZ-uhm; 994–1064), earned fame as a writer, historian, jurist, theologian, and poet in Islamic Spain. His support for the Umayyad claimants to the office of caliph earned him frequent imprisonment. His writing displays a deep appreciation for the Arabic language, and he used it skillfully in both poetry and prose. One outstanding example is *The Ring of the Dove*, in which he deals subtly with human psychology in a book about the art of love. He details love as an attribute and an accident. He deftly lists the different categories of falling in love: while asleep; through a description; at first sight, and so on. The author's perspective on the art of love does not necessarily include endorsement of the examples he cites. His stance merely rests in examining examples from others' lives, whether sinful or not. Perhaps we glean his true feelings from the last two chapters of the book: "The Vileness of Sinning" and "The Virtue of Continence."

The Qur'an

The Qur'an (Arabic, "the Recital") comprises the sacred scripture of Islam, and Muslims regard it as the infallible Word of God: a flawless record of an eternal tablet preserved in Heaven, revealed over a period of twenty years to the Prophet Muhammad. At first, Muhammad's followers memorized the intermittent revelations and recited them in ritual prayers. Although some verses were written down in Muhammad's lifetime, they did not achieve their present, authoritative, form until the reign of the third caliph. For the Muslim community, the Qur'an forms the ultimate source of knowledge and continuing inspiration for life.

Consisting of 114 *surahs* or chapters of unequal length, the entire Qur'an has a length somewhat shorter than the Christian New Testament. The earliest surahs belong to the Meccan period and comprise the shortest chapters. They exhibit a dynamic rhymed prose. Later surahs are longer and more prosaic. In the current version of the Qur'an, the arrangement falls according to length, with the shortest surahs placed last. In essence, the current order reverses the chronological order of the original text. The early surahs issue a call to moral and religious obedience in view of the coming Day of Judgment. The later, Medina surahs give directions for the establishment of a social order agreeable to the moral

life called for by God. The Qur'an presents a forceful vision of a single, all-powerful, and merciful God. Muslims believe it to comprise God's final revelation which is given in a vivid language capable of being fully understood only in the original Arabic. Figure **6.33** illustrates a page from the Qur'an showing decorative calligraphy, known as *Kufic* script, one of the earliest and most beautiful of Arabic calligraphy styles and developed in order to give proper honor to the written text of the Qur'an.

The Qur'an places God as the absolute creator and sustainer of an ordered universe that mirrors his absolute power, wisdom, and authority. It details the consequences of God's ultimate judgment on each individual: the joys of the gardens of Paradise and the punishment and horrors of Hell.

Interpreting the Qur'an properly remains central to all schools of Islamic thought. *Tafsir*, a special branch of learning, focuses on the Qur'an. Translations have traditionally been forbidden, and any translations are still viewed as paraphrases to assist in understanding the actual scripture. We include below excerpts from two surahs. *Surah 4* ("Women") addresses issues pertinent to Arabic society at the time of Muhammad: that of a code of conduct protecting the legal rights of women and assuring care for the poor and unfortunate. *Surah 55* ("The Merciful") draws a portrait of the glory of God and the anger awaiting sinners.

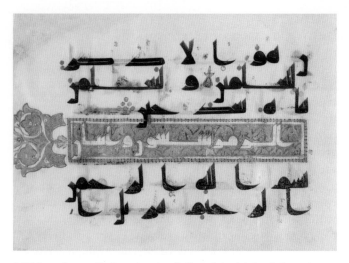

6.33 Page from a Qur'an, showing Kufic script, eighth–ninth century. Freer Gallery of Art, Smithsonian Institution, Washington D.C. Purchase. F1930 60r.

Surah 4, 1–5

"The Women"

In the name of Allah, the Beneficent, the Merciful.

4.1: O people! be careful of (your duty to) your Lord, Who created you from a single being and created its mate of the same (kind) and spread from these two, many men and women; and be careful of (your duty to) Allah, by Whom you demand one of another (your rights), and (to) the ties of relationship; surely Allah ever watches over you.

4.2: And give to the orphans their property, and do not substitute worthless (things) for (their) good (ones), and do not devour their property (as an addition) to your own property; this is surely a great crime.

4.3: And if you fear that you cannot act equitably towards orphans, then marry such women as seem good to you, two and three and four; but if you fear that you will not do justice (between them), then (marry) only one or what your right hands possess; this is more proper, that you may not deviate from the right course.

4.4: And give women their dowries as a free gift, but if they of themselves be pleased to give up to you a portion of it, then eat it with enjoyment and with wholesome result.

4.5: And do not give away your property which Allah has made for you a (means of) support to the weak of understanding, and maintain them out of (the profits of) it, and clothe them and speak to them words of honest advice.

Surah 55, 1–16

"The Beneficent"

In the name of Allah, the Beneficent, the Merciful.

55.1: The Beneficent God,

55.2: Taught the Qur'an.

55.3: He created man,

55.4: Taught him the mode of expression.

55.5: The sun and the moon follow a reckoning.

55.6: And the herbs and the trees do adore (Him).

55.7: And the heaven, He raised it high, and He made the balance

55.8: That you may not be inordinate in respect of the measure.

55.9: And keep up the balance with equity and do not make the measure deficient.

55.10: And the earth, He has set it for living creatures;

55.11: Therein is fruit and palms having sheathed clusters,

55.12: And the grain with (its) husk and fragrance.

55.13: Which then of the bounties of your Lord will you deny?

55.14: He created man from dry clay like earthen vessels,

55.15: And He created the jinn of a flame of fire.

55.16: Which then of the bounties of your Lord will you deny?

CHAPTER REVIEW

CRITICAL THOUGHT

Looking at a map of the region, we get a clear picture of Byzantium's pivotal location—the point where, today, Islam, Roman Catholicism, and Eastern Orthodoxy touch and where the Middle East, Europe, and Asia meet. Byzantium, because of that location, became a vital center of creative ingenuity and artistic vitality, producing, at the same time as it nurtured Greek and Roman classicism, a new and distinct approach to art—an approach whose uniqueness renders it easily recognizable and powerful a thousand years after the fact.

Byzantium also has been a flashpoint. Islam, Christianity, and Judaism trace their heritages to a common ancestor. Judaism is fundamental to Christianity, and Jesus plays a prominent role in the Islamic faith, especially its view of the end of the world. Islam, Christianity, and Judaism rest on the premise of "revealed truth"—a set of holy scriptures in which the single God of the universe is claimed to have revealed his nature and his will directly to an individual or individuals who have, then, passed that revealed truth on to others. Why is it that "revealed truth" appears to cause such discord among cultures that value so many basic principles, including peace, in common?

SUMMARY

After reading this chapter, you will be able to:

- Relate the history of Byzantium to Eastern Orthodoxy, Greek classicism, and intellectual development in the West.
- Identify and describe the basic characteristics of Byzantine art, architecture, literature, theatre, music, and dance.
- Explain the basic precepts and spread of Islam.
- Discuss Islamic art and architecture and relate them to the tenets of the faith.

- Define hieratic style and characterize its qualities in two- and three-dimensional art.
- Apply the elements and principles of composition to analyze and compare the works of art and architecture illustrated in this chapter.

CYBERSOURCES

http://www.artcyclopedia.com/history/byzantine.html
http://www.hp.uab.edu/image_archive/ebyzantine/
http://www.metmuseum.org/collections/department.asp?dep=14

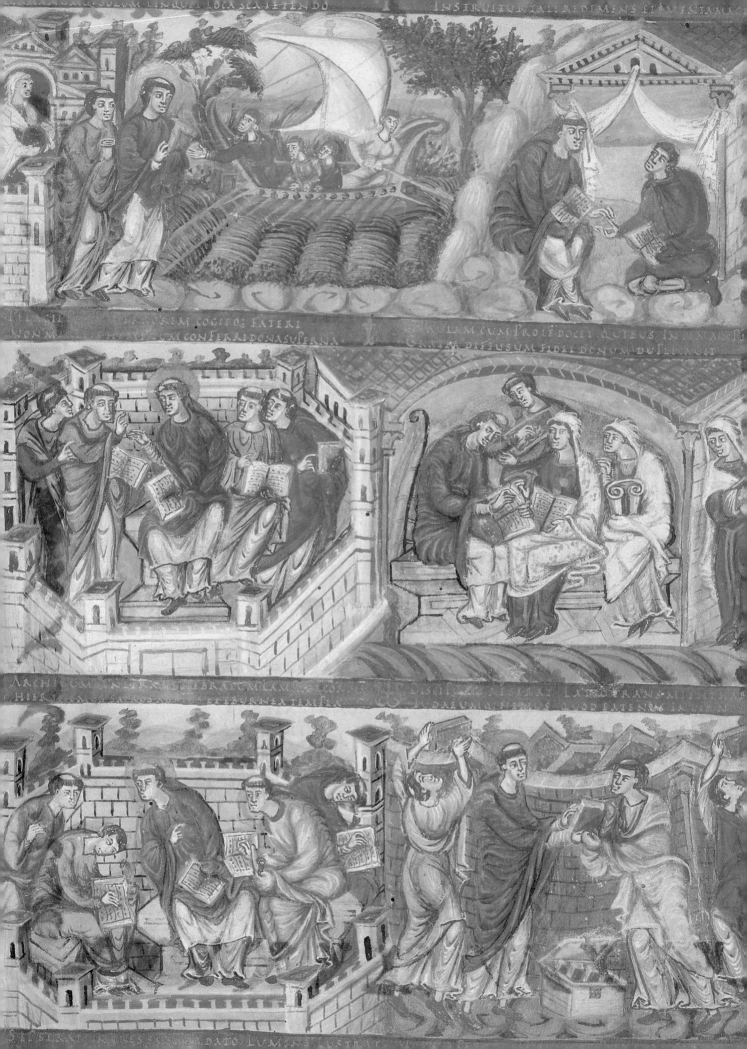

ILLLGIL DE SUBEM COGITO: FATERI

INSTRUCTUR TALI REDIMENS ET EVENTA MAG

7 THE EARLY MIDDLE AGES
THE MONASTIC AND FEUDAL ROMANESQUE PERIOD

OUTLINE

CONCEPTS AND CONTEXTS
- Contexts
 The Middle Ages
 The Medieval Church
 PROFILE: Pope Gregory I, the Great
 Charlemagne's Empire
- Concepts
 Monasticism
 Mysticism
 Asceticism and Sufism
 Feudalism

TECHNOLOGY: The Viking Ships
The Carolingian Renaissance

THE ARTS OF THE EARLY MIDDLE AGES
- Painting
- Sculpture
 A DYNAMIC WORLD: Igbo-Ukwu
- Architecture
 MASTERWORK: The Bronze Doors of Hildesheim Cathedral

- Theatre
- Music
 Sacred Music
 PROFILE: Hildegard of Bingen
 Secular Music
- Dance
- Literature
 Legends
 Poets and Scholars

VIEW

CARPE DIEM

Pope Gregory I, the Great, believed that the world would not last much longer. Thus he saw his decisions as affecting only the immediate future. What is the best timescale in which to view decisions? Some people say, "carpe diem," meaning "seize the day!"—today may be the only day we have, so we should make the most of it. The critical phrase is, of course, "make the most," and our reaction hinges on how we define "most." One

person's interpretation of carpe diem might be "eat, drink, and be merry, for tomorrow you may die," but to another, making the most of a day may mean doing as much good as we can for others.

In the early Middle Ages, people slaved for the lord of the manor in a system called feudalism. Although feudalism may have disappeared, feudal thinking has not. Many have world-views centered only on themselves and events immediate to them.

KEY TERMS

MIDDLE AGES
The time in Western European history that occurred between Antiquity (Chapters 1–5) and the Renaissance (Chapters 9–11), from approximately 476 C.E. to c. 1450.

FEUDALISM
A political and economic system in Europe from the ninth to about the fifteenth century, based on the relation of lord to vassal.

MONASTICISM
(From the Greek *monos*, meaning "single" or "alone.") Usually refers to a way of life in which an ideal of perfection or a higher level of religious experience is pursued through living together in a community.

ROMANESQUE STYLE
A style that flourished throughout Western Europe from about 1050 to about 1200. The word Romanesque originally meant "in the Roman manner."

GREGORIAN CHANT, PLAINSONG, OR PLAINCHANT
The name commonly given to the monodic (single melodic line) vocal liturgical music of the Christian Catholic churches.

7.1 Scenes from the life of St Paul, from the Bible of Charles the Bald, c. 875–7. San Paolo Fuori le Mura, Rome.

CONTEXTS AND CONCEPTS
Contexts

The Middle Ages

We have come to use the name the Middle Ages for the period that began with the fall of Rome and closed with the Renaissance in Italy. The years from around 200 C.E. to the middle of the sixth century we often call the *Early Christian* period. We have already looked at part of this period, and our examination continues in this chapter. Some people occasionally use the term *Dark Ages* to describe the years between 550 and 750. The *Carolingian and Ottonian* period occurred from 750 to 1000; the *Romanesque*, from 1000 to 1150. The High Middle Ages (Chapter 8) included the *High Gothic*, from 1150 to 1400, and the *late Gothic* period from 1300 to around 1450, which overlaps High Gothic and formed a time of transition when the flower of the Renaissance began to bloom. This chapter takes us from approximately 500 to 1150, or from the Dark Ages through to the artistic style called Romanesque. We must remember, however, that ideas drive history, not dates. Dates give us a convenient sequence by which we can remember when ideas or events occurred, but as we shall see, new ideas often take hold in one location long before the old ideas expire elsewhere.

People of the Renaissance called the thousand years between the fifth and the fifteenth centuries the Middle Ages or medieval period on the theory that nothing—or worse than nothing—happened between the classical perfection of Greece and Rome and the revival of classical humanism in the fifteenth century.

Pessimism and disillusionment had increased in ancient Rome, and this mood, summed up in a Roman epitaph—*non fui, non sum, non curo*, "I was not; I am not; I care not"—continued into the Middle Ages. Civic, secular government had all but ceased to exist. When Constantine I founded the second capital of the Roman Empire at Constantinople, he set in motion a division that became permanent in 395. In the West, the cloak of internationalism, which had loosely united the Mediterranean world since Alexander, fell apart.

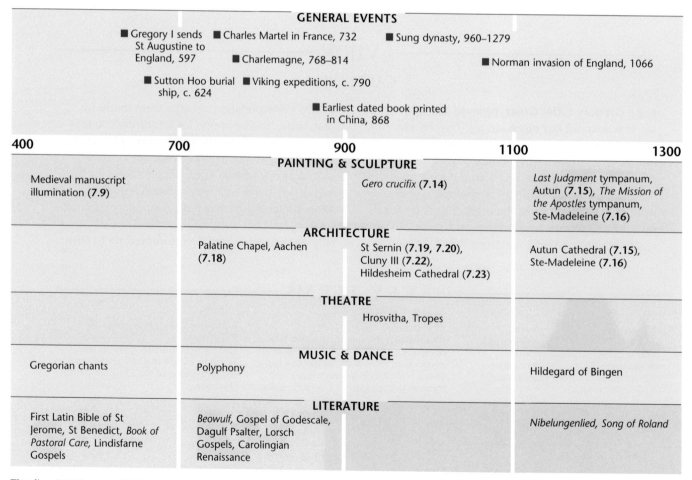

GENERAL EVENTS

- Gregory I sends St Augustine to England, 597
- Charles Martel in France, 732
- Sung dynasty, 960–1279
- Charlemagne, 768–814
- Norman invasion of England, 1066
- Sutton Hoo burial ship, c. 624
- Viking expeditions, c. 790
- Earliest dated book printed in China, 868

	400	700	900	1100	1300
PAINTING & SCULPTURE	Medieval manuscript illumination (7.9)		*Gero crucifix* (7.14)	*Last Judgment* tympanum, Autun (7.15), *The Mission of the Apostles* tympanum, Ste-Madeleine (7.16)	
ARCHITECTURE		Palatine Chapel, Aachen (7.18)	St Sernin (7.19, 7.20), Cluny III (7.22), Hildesheim Cathedral (7.23)	Autun Cathedral (7.15), Ste-Madeleine (7.16)	
THEATRE			Hrosvitha, Tropes		
MUSIC & DANCE	Gregorian chants	Polyphony		Hildegard of Bingen	
LITERATURE	First Latin Bible of St Jerome, St Benedict, *Book of Pastoral Care*, Lindisfarne Gospels	*Beowulf*, Gospel of Godescale, Dagulf Psalter, Lorsch Gospels, Carolingian Renaissance		*Nibelungenlied*, *Song of Roland*	

Timeline 7.1 The early Middle Ages.

It became a case of "every locality and every people for themselves." Nations as we know them did not exist. Borders changed from day to day as one or another people wandered into the nebulously defined territory of its neighbors, bringing confusion and war.

The Medieval Church
Devils and Division
The devil, as a symbol of the powers of darkness and evil, arose as a strong force in medieval thinking, and the Church manipulated those fears as it sought, often fanatically, to convert the pagan world of the early Middle Ages. The promise of heaven and the prospect of the fires of hell rang as constant themes of the times. Ever-present devils and demons fostered a certain fascination as well as fear—as we shall see in medieval theatre, for example, the devil often had the best part.

The Church, itself divided, did little to reduce the isolation and ignorance of its followers. Very early, the clergy separated into two groups, one consisting of the regular clergy, monks, and others who preferred to withdraw into a cloistered life—a lifestyle that greatly appealed to many intellectuals as well—and the other consisting of the secular clergy—the Pope, bishops, and parish priests who served in society at large. This division confined learning and philosophy to monasteries, and withheld intellectual activity from the broader world. Inquiry among both groups remained rigidly restricted. Detailed and unquestioned dogma, deemed essential to the Church's mission of conversion—and, indeed, to its very survival—helped create a medieval world of barricades, physical, spiritual, and intellectual. Each man, woman, and institution retreated behind whatever barricade he, she, or it found safest.

The Roman Papacy
By the middle of the sixth century, it appeared likely that the Roman Church and its pope would simply become tools of Byzantine Imperial policy. Rome appeared to have been demoted to a peripheral status as a mere center of Catholic Christianity, with little actual power or influence. Rome was rescued from potential demise by one of the greatest pontiffs in the history of the Roman Church, Gregory I (the Great), pope between 590 and 604. Gregory showed great abilities as a ruler and teacher that significantly affected numerous aspects of the Church and society. His land reforms and his administration of estates that had been given to the Church revitalized Church income, relieved famine, and provided money for churches, hospitals, and schools. His influence spread from Rome to the rest of Italy and beyond. One of the most important tasks he undertook involved sponsoring St Augustine in his mission to convert England in 597. Known as the "Apostle of the English," Augustine (not to

PROFILE

POPE GREGORY I, THE GREAT (540–604)

We know nothing about Pope Gregory's early years and education. He rose to the position of prefect of the city of Rome, but left politics and founded the Monastery of St Andrew in Rome. Pope Pelagius II sent Gregory to Constantinople—then the seat of Roman Imperial government—as ambassador, and his experiences and the contacts he made over six years in that position proved invaluable. When Pelagius died in 590, the Church elected Gregory pope.

One of the major difficulties confronting the new pope lay in the conflict over the Roman ideology of emperor as divinity on earth. In such a scheme, the pope was merely another patriarch. While he had served as ambassador in Constantinople, Gregory had gained a realistic understanding of the political situations of the day, and he recognized the delicacy of the pope's relationship to the secular, Imperial government.

7.2 Pope Gregory I, the Great (540–604).

Gregory wisely turned his attention to Western Europe, a domain that lay outside Imperial jurisdiction, where he could push the claim of the supremacy of the Church of Rome without any interference from Constantinople.

One of his major missionary achievements, the conversion of England, began in 597 with the mission of St Augustine. Gregory also supported St Benedict, leading to the development of Benedictine monasticism. His extraordinary administrative abilities brought most of Europe and North Africa under Roman papal authority, and he provided the driving force in the unification of much of Church doctrine and practice, exercising in all these ways a tremendous influence throughout the Western world.

211

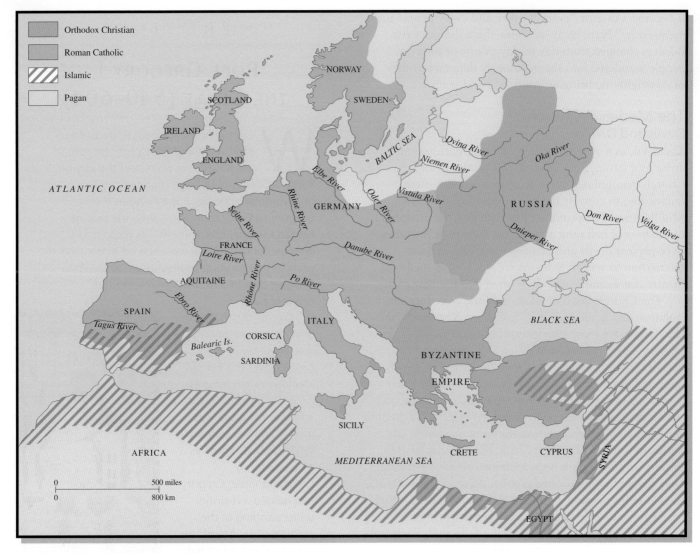

Map 7.1 Medieval Christianity and Islam.

be confused with Augustine of Hippo) founded the Christian Church in southern England and became the first archbishop of Canterbury. He led a mission of several dozen monks to England to preach and convert the English, and founded Christ Church and the Monastery of Saints Peter and Paul. The most significant of Gregory's written works, his *Book of Pastoral Care*, spoke idealistically of the way a bishop should live and how he should care for his flock.

As a result of Gregory's efforts, Rome regained its position of primacy among the Western Christian Churches. Despite the long-term results of Gregory's actions, he did not himself consider that he was building for the future. He believed that the Second Coming of Christ was near, and he merely did what he thought had to be done in what little time remained. Thus, unintentionally, he built a base for an enduring Church and a dominant papacy of wealth and prestige.

Charlemagne's Empire

In 732, the threat of Islam and the Moorish conquest was repelled by Charles Martel at the battle of Poitiers n France. The succeeding age, called the Carolingian period, under his grandson Charlemagne—the name means "Charles the Great"—saw the first significant centralized political organization since the fall of Rome.

Charlemagne (SHAHR-luh-mayn; r. 768–814), a giant of a man for the time, stood well over 6 feet (1.8 meters) tall. A mighty warrior, womanizer, drinker, glutton (Fig. **7.3**), and semiliterate, he kept a slate beside his bed so that he could practice the letters of the alphabet. He spent most of his reign at war, in the process coalescing a large empire that ran from northern Spain to western Germany and northern Italy, with modern-day France as its center.

Grateful for his help against barbarian intruders and political enemies in Rome, in 800 C.E., Pope Leo III

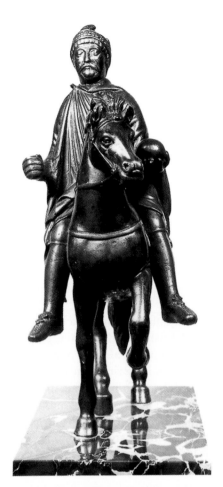

7.3 So-called *Statuette of Charlemagne*, c. 860–70. Bronze cast and gilt, 9¼ ins (23.5 cm) high. Louvre, Paris.

crowned Charlemagne Holy Roman Emperor and hailed him as "Pious Augustus, crowned by God." Charlemagne retained the office until his death, but he was hardly an heir to the Caesars. Nonetheless, his endless warfare spread Christianity and Frankish rule across western Europe. Despite his own lack of learning, he briefly revived interest in art, antiquity, and learning.

Charlemagne's reign succeeded in slowing—perhaps halting—the long decline of Europe, and it illumined a pathway whereby peace and prosperity might be restored. However, the heir to the Carolingian throne did not have Charlemagne's physical strength or his strength of will. Less than thirty years after his death, his grandsons divided the kingdom into three.

We need to note here how "conversion" to Christianity worked in this time. Unlike today, in the Middle Ages individual converts did not necessarily "choose" their religion freely. When a liege lord converted to, in this case, Christianity, all of his vassals followed by rule of law. One "became a Christian" because one's liege lord did. This does not mean that people did not eventually develop sincere beliefs, but it does mean that official "conversion" preceded commitment.

Concepts

Monasticism

Seeking refuge from the temptations and tribulations of the medieval world, monks, nuns, some aristocrats, and others sought refuge behind the walls of perhaps the most typical example of medieval life—the monastery and the convent, which formed outposts of order and charity. Often, too, they proved well-organized and productive centers of agriculture. Monasteries and nunneries arose in the centers of non-Christian populations as means of converting pagans to Christianity. If monastery life offered an escape from some of the tribulations of the secular world, it did not permit an escape from rigor and hard work. Pious men and women of the monastic communities combined labor in the fields with religious thought, meditation, prayer, and other activities, such as copying sacred scripts and creating beautiful manuscript illuminations. Monks, who took vows of poverty, chastity, and obedience, renouncing all worldly goods, family life, and the pleasures of the senses, owned nothing—not even their own wills. They were subject to a strict discipline under the authority of the abbot and the

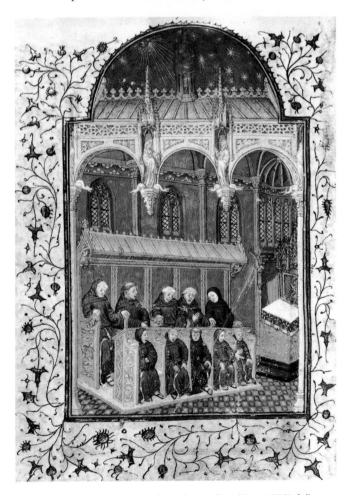

7.4 Monks in choir. Illustration from Cotton Domitian, A XVII, folio 122v. British Library, London.

will of God (Fig. 7.4) (see the section on Asceticism which follows).

Within the walls of the monastery, everything necessary for bodily and spiritual existence was provided, and the monastery sought full independence from all secular authority and life. In the monastery, a fine example being the great monastery at Cluny (see Figs 7.21 and 7.22), the ascetic world and the secular world often rubbed shoulders, however. In addition to clerics and contemplatives, Cluny, for example, often harbored criminals seeking refuge from secular authorities.

Life for the Cluniac monk exemplified life in the cloistered communities of Europe in general. Religious contemplation alternated with other religious duties, and the abbey church witnessed prayer and worship day and night. Prayers occurred according to the appointed hours of liturgy, running from sunrise to sunset in a form similar to the following:

2:00 a.m. Rise
2:10–3:30 Nocturns (matins). The first office of prayer
3:30–5:00 Individual study and contemplation
5:00–5:45 Lauds (morning prayer)
5:45–8:15 Prime (an office of prayer); private reading; Mass; or breakfast, depending on the season
8:25–2:30 Work, separated by the offices of Tierce, Sext, and None (third, sixth, and ninth hours)
2:30–3:15 Dinner
3:15–4:15 Private reading and contemplation
4:15–4:45 Vespers; Compline (night prayers)
5:15–6:00 Retire for the night

The daily schedule, or *horarium* (hohr-AR-ee-uhm), changed somewhat for Feast Days and to allow for the longer days of the summer months.

Many monasteries also served as centers for pilgrimages, and travelers as well as pious pilgrims came for veneration and overnight accommodation to those monasteries that contained sacred relics. A hospice, or guest house, provided lodging, especially for visitors during the pilgrimage season, and barns, stables, and places for blacksmithing often complemented the components of a monastic community.

The earliest communal monasteries preceded the fall of the Western Roman Empire. St Martin founded Ligugé in 360. But the greatest influence of all came from St Benedict of Nursia (c. 480–550), who formulated the most widely adopted of all monastic rules, the Benedictine.

Mysticism

Many new religious orders appeared during this period. A key figure in the changing religious thought was Bernard of Clairvaux (klair-VOH; 1090–1153), a young nobleman, who entered the order of Cîteaux (see-TOH), or the Cistercians, the most influential new monastic movement of the twelfth century.

An enthusiast, perhaps even a fanatic, Bernard entertained no doubts that he held correct views. He eagerly fought with anyone who disagreed with him, and those individuals included the most influential clerics and philosophers of the times, such as the scholar and theologian Peter Abelard (AB-uh-lahrd), whom we will note later in this chapter, and Abbot Suger (soo-ZHAY) of St Denis, the primary force in the emergence of Gothic style, which we study in the next chapter. At the same time, Bernard could show great consideration and common sense. He treated his monks with patience and forgiveness, and reportedly turned down the Duke of Burgundy's request to become a monk by saying that the world had many virtuous monks but few pious dukes.

Bernard's religious teaching set a new tone for twelfth-century Christianity through its emphasis on a more mystical and personal sense of piety than had existed previously. In his writings he described a way of "ascent to God," consisting of four stages of love by which a soul could gain union with God. In his sermons for the common people, he treated more ordinary themes and vividly retold familiar stories from the New Testament. Rather than treating Jesus, Mary, and the apostles as remote images, Bernard described them as living personalities. Bernard's preaching proved an important stimulant for the emergence and spread of the Mary cults that mark the significant attitude shift from the feudal mentality we read of in this chapter to the softer, more ethereal atmosphere of the high Gothic period we study in Chapter 8.

Mysticism, championed by St Bernard, involves the search for a direct experience of divinity or ultimate reality. It plays a role in all major religions, although it varies in its relationship to the mainstream of many faiths, often appearing esoteric or unorthodox. As suggested earlier, mysticism distinguishes from standard worship by its emphasis on personal experience as opposed to scripture or ritual. Adherents see it as available solely to those particularly dedicated or holy. The word mysticism shares the same Greek root as the word "mystery," which refers to secret knowledge. In Christianity, Islam, and Judaism, "union with God" as we described in St Bernard's theology, means something akin to true knowledge of rather than an equality with or entering into the Godhead. In Eastern religions such as Buddhism and Hinduism, the mystic seeks true merging of the soul with the Absolute.

Mysticism involves prayer, meditation, and contemplation, often helped by ascetic practice (see below). Mystical experiences often include infusions of

light, feelings of joy and wonder; a sense of wholeness and utter freedom. (We can see this aspect in Gian Lorenzo Bernini's [bair-NEE-nee] sculpture, *The Ecstasy of St Theresa* [see Fig. **12.18**], a product of the emotionalist baroque period of the seventeenth century.) Mystical experience, although ultimately personal, typically reflects specific elements of the scriptural or devotional imagery of the individual's religious tradition.

Asceticism and Sufism

The lifestyle of the monk and nun comprised the way of *asceticism* (uh-SEHT-uh-sihnz-uhm)—a life of austerity and self-discipline. Reflecting religious thought of the time, monks and nuns considered earthly existence a mere preparation for the eternal life to come. In order to develop the thoughts and actions required for that life they renounced the distractions of the world, seeking instead a disciplined but rich inner life of the spirit, which, they believed, could come only through poverty, chastity, and humility. In general, then, we can cast asceticism as a principle of self-denial for the purpose of attaining a heightened state of spiritual awareness, intellectual sharpness, or, even, physical ability. The term comes from the Greek language, meaning "hermit" and "exercise." First applied to soldiers and athletes, it later described religious practice such as the monastic life just noted. Sometimes the renunciation of physical pleasures and material comforts includes not merely abstinence from pleasure but actual self-inflicted suffering—harsh living conditions, fasting, or mortifying the flesh.

Asceticism seeks to achieve a state of harmony that its practitioners believe impossible when one has too much involvement in everyday life. We can view asceticism as a foil to another means for achieving harmony in existence, namely moderation or temperance. These two pursuits often run in cycles. For example, Aristotle (see Chapter 3) taught the principle of the Golden Mean. That gave way to the asceticism of the Stoics (see Chapters 3 and 4). In non-Western cultures, again as an example, the ascetic rigors of ancient Hinduism gave way to the "Middle Path" of Buddhism. Moderation and temperance seek a balance between competing worldly and spiritual claims, while asceticism disdains the world, viewing it as a corrupting influence that one must purge in order to free the spirit. Asceticism existed as a part of Christian practice from the beginning, but later became moderated to the point that nowadays it only occurs in particular sects, cults, and members of the clergy.

In Islam, the mystical direction of the faith, including asceticism, pertains to a wide variety of practices, doctrines, and sects, one of which, *Sufism*, a diverse direction, typically follows renunciation of the self, fervent devotional practices, and the conviction that love of God manifests the ultimate truth of human existence

7.5 The whirling dance of the Sufi dervish.

and the way to the highest state of awareness. Sufism developed in Islam in the Middle Ages as a reaction against the legalistic emphasis of traditional Islam and the worldly luxury of the caliphs. The term *sufi* means "wool-wearer," and probably derives from the ascetic practices of early Sufis, many of whom wore woolen clothing. Some Sufic practices and beliefs have been considered blasphemous by Muslims who believe that since observance of Islamic law is the most important duty, obedience to God is elevated above love of God. On the other hand, some Sufis regard Islamic law as an empty ritual. The majority of Sufis, however, believe that observance of Islamic law follows naturally from a genuine love of God, much as St Augustine (see Chapter 6) espoused "love God and do as you please," which meant that if one truly loved God, what one pleases to do would of necessity fall within God's will for one's life.

Most Sufis hold that the key to approaching God lies in relinquishing consciousness of self, the main source of suffering and delusion. Closeness to God results from self-denial and intense devotional practices, which include prayer, meditation, recitation of the ninety-nine names of God, or ecstatic trances such as those achieved in the whirling dance of the sects of *dervishes* or *fakirs* (Fig 7.5).

Feudalism
Feudal Lords
Perhaps the main reason why centralized authority had difficulty taking hold in the Middle Ages concerned a societal system called *feudalism* (FYOO-duhl-iz-uhm). The real political powers in Europe in the Middle Ages, the dukes, counts, knights, and other warrior lords, linked together in a loose confederation of units, each one small enough to be governed by one man. Because no

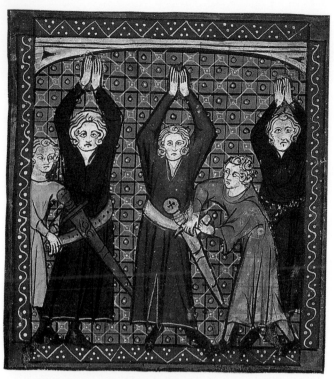

7.6 The girding-on of swords, part of an increasingly formalized ritual associated with the making of a knight. MS D XI fol 134 vi. British Library, London.

powerful authority ultimately controlled the individual parts, the system encouraged bloodshed and warfare as feudal lords continually raided each other to increase their wealth and property.

Feudalism comprised a system of military service and land ownership that created a pyramid of political and military power. Under this system, the less powerful knights sought protection and economic support from more powerful knights who, thus, served as their feudal lords, or *seigneurs* (sehn-YUHR), and who required military service, money, and political support from their vassals. Although feudalism stood on a system of vassalage, by which barons were responsible to, or vassals of, kings, sufficient power to effect real control rarely existed at any level above the individual landholder.

The *oath of fealty* was performed at a solemn and symbolic ceremony. The vassal knelt, put his hands between those of his lord, and pledged allegiance to the lord, promising a certain number of days of military service each year and specific sums of money on occasions such as the knighting of the lord's son (Fig. 7.6) or the marriage of the lord's daughter, or ransom for the lord himself if he were captured by his enemies. To complete the ceremony, the lord would present to the vassal a piece of earth or a sprig from a tree to symbolize the lord's grant of a fief—a parcel of land including villages of serfs to work it.

Serfs and Women

Feudal society comprised a thick network of contractual relationships that linked the highest to the lowest in the realm. The lowest in the realm, a serf, led a life of ignorance and destitution, and of subservience to the manor's lord. Serfs did the work of the manor, and in return paid the lord for the privilege. All law enforcement and punishment occurred within the manor, and no serf could marry without the lord's consent. In the strictest sense of the ancient world, serfs were not slaves, but they were bound to the land of the estate for life, and, bound to the land, they remained bound to the lord of the manor for as long as the lord owned it. In return, the lord was obliged to provide guardianship for his serfs— provide basic necessities and care for them in their old age, should they reach it.

Drudgery marked the daily life of the village. People lived in one-room, sparsely furnished huts with earthen floors. They shared the hut with members of the family, chickens, and whatever other animals may have been theirs, and at night the entire family slept huddled together on straw bedding. In the spring, life took a decided turn for the worse, for typically the fall's harvest barely lasted the winter, and it was too early in the growing season for new crops to mature. As a result, starvation in the springtime provided a constant threat, as did raids by other, equally hungry, people who formed raiding parties of barbarians or other local barons. Disease intruded as a constant companion, and there were no doctors (Fig. 7.7). All told, the medieval serf could only resign himself to his fate and trudge on from day to day, hopeful that death would release him into a better condition.

Women played a central role at every level of medieval society. In the manor house as well as the village hut, the family formed the core of the social order, and among serfs, it also provided the central production unit. Women shared the burdens of daily existence, caring for children and animals and working small vegetable plots near the hut. They prepared food, made clothing, and helped with the harvest. Their life expectancy was short.

On the other hand, women of the manor often shared ruling functions and responsibilities. For those born into the aristocracy, the power structure, again, was based on the family. The system depended on inheritance and marriage, and because women could inherit, they often owned vast estates. As wives of feudal barons, women often faced the necessity of managing the manor in its entirety while the lord left for long periods, fighting wars on behalf of his liege lord.

Women could also find individual identity and authority in the Church. If the burdens of secular life proved overpowering, women could "take the veil" by entering a convent. A wealthy woman could establish her

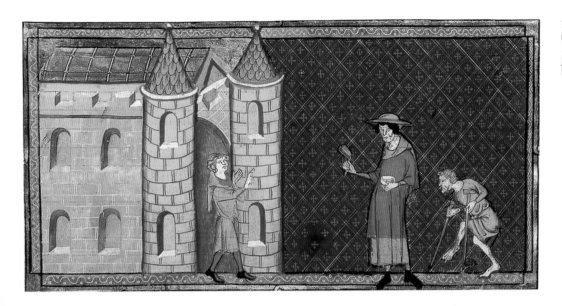

7.7 Leprosy, from the manuscript *Miroir historial de Vincent de Beauvais*, trans. by Jean de Vignay, 1330–50. Bibliothèque Nationale, Paris.

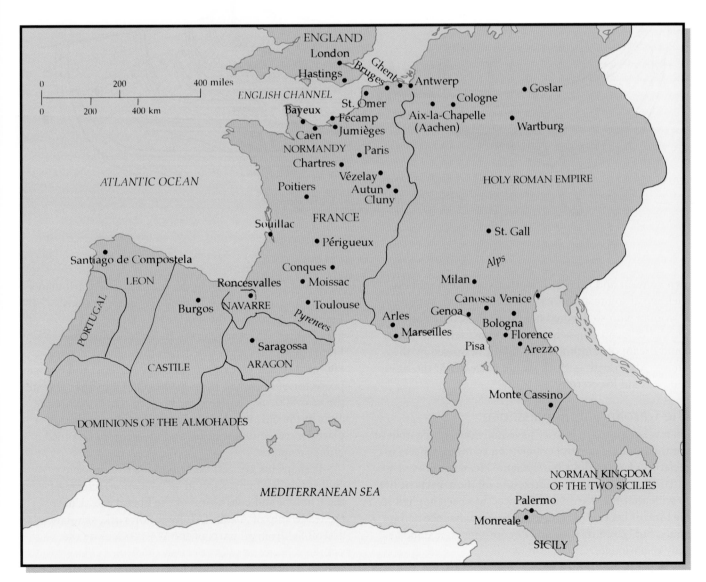

Map 7.2 Europe in the early twelfth century.

TECHNOLOGY

THE VIKING SHIPS

While feudal Europe struggled and while Charlemagne was emerging as Holy Roman Emperor, the Vikings of Scandinavia were sailing as far as the shores of North America, preceding Columbus to the New World by more than six hundred years. Their means of transport was the Viking ship (Fig. **7.8**), and its construction and use prove that these hearty and hardy peoples were as skillful in their technology as they were warlike and adventurous. The vessel had a true keel, a single steering-oar with a tiller handle, well-raked—that is, angled—stem- and stern-posts, sixteen rowing ports cut into each side, and a square-sail rigged on a single mast amidships. Light and buoyant, they were called long-ships because their length was such a striking feature, exceeding the beam by more than five to one. In time, the Viking ships grew until they had thirty and even sixty oars to a side. It was in these large vessels that the Vikings made their raids, conquests, and far-reaching explorations to Russia and America.

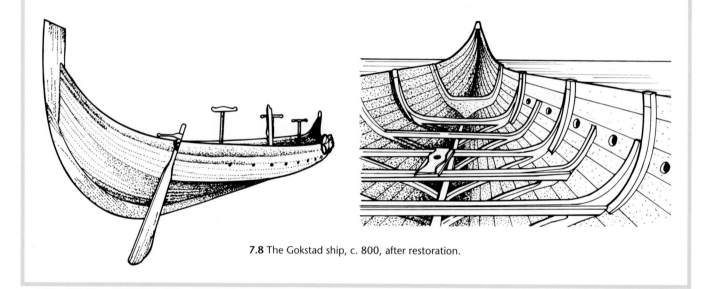

7.8 The Gokstad ship, c. 800, after restoration.

own convent and become a mother superior or abbess, wielding absolute authority over her subservient nuns. A woman who so devoted her life to the Church and worked diligently on behalf of it and her fellow humans could dream of sainthood—an honor bestowed by the Church after death—which would place her at the right hand of God for eternity.

The Carolingian Renaissance

On few occasions in history have individuals been able to put their individual temperament on so many aspects of society and art as did Charlemagne. His reign proved so all-encompassing and his interest in all the aspects of life so wide that the word "renaissance" has been applied to the time of his rule. The Carolingian renaissance had its limits, but, given its time and circumstances, it stands as truly remarkable.

When Pepin III died in 768, his two sons, Charles and Carloman, succeeded him. Carloman died three years later, and Charles, denying the succession of Carloman's infant sons, acquired for himself the entire Frankish Empire. Carrying on the work of his father and grandfather, Charlemagne set about subduing the Frankish peoples and other tribes throughout Europe. He ruled over a vast empire of many nations, and became protector of Pope Leo III in Rome. On Christmas Day in the year 800, as Charlemagne knelt in prayer before the altar in the old church of St Peter, Pope Leo suddenly placed a crown on his head, and the people acclaimed him as emperor.

Perhaps his greatest contributions to European civilization lay in his support of education, reform of the Church, and cultivation of the liberal arts. Under the leadership of Alcuin (AL-kwin) of York, scholars assembled from all parts of the West to reunite the scattered fragments of the classical heritage. The classical revival initiated by Charlemagne served as part of his attempt to revive the Roman Empire.

THE ARTS OF THE EARLY MIDDLE AGES

Painting

Early Christian painting adopted local styles. The tomb paintings in the catacombs of Rome, for example, took Roman style but incorporated Christian symbolism. Roman Christians were converted Roman pagans, and their paintings had a frankly practical intent. In its earliest phases, before Constantine, Christian painting constituted a secret art in a secret place, and its function simply affirmed the faith of the follower on his or her tomb.

We often find in early Christian painting a primitive quality—probably more a reflection of lack of technical ability than anything else. The need to pictorialize the faith came foremost. Artistic skill had little importance.

Christian painting developed in several stages. From the beginning, it reflected the absolute belief in another, superior, existence in which individual believers retained their identity. Painting served as a tangible expression of faith. Later, it made the rites of the Church more vivid. Its final role depicted and recorded Christian history and tradition. From the start, it included a code of symbolism whose meaning could be grasped only by a fellow Christian.

As the Roman world first split and then fell apart, plunging the West into chaos, painting became once again a private art, more an intellectual pursuit than an inspiration to the faithful. A new and exquisite form of two-dimensional art emerged, not on canvases or church walls, but on the beautifully illustrated pages of scholarly Church manuscripts. By the time Christianity had sufficient status to come into the open, a dramatic change had occurred in the format of written texts. Rolls of papyrus had been replaced by more convenient and durable parchment pages bound together between hard, protective covers, known as a *codex*. Although scrolls continued to be used for special occasions throughout the Middle Ages, they now consisted of stitched parchment.

The only illustrated manuscript of the New Testament in Latin to survive from this early period, a copy of the Gospels, probably came to England in 597 with St Augustine, the first archbishop of Canterbury and a missionary from Pope Gregory the Great. (Again, this Augustine is not to be confused with the earlier St Augustine of Hippo.) Only two full-page miniatures from this work survive, one of which (see Fig. 5.6) shows St Luke and twelve scenes from his Gospel. In this full-page frontispiece, we see the saint seated in the foreground within an arched border. In the sides of the

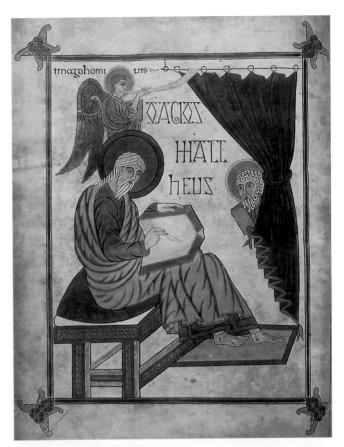

7.9 St Matthew, from the Lindisfarne Gospels, before 698. 13½ × 9¾ ins (34.3 × 24.8 cm). British Library, London.

frame appear little compartments portraying events, including the story of the washing of feet, with an unbearded Peter. The rich colors and detailing of this miniature rival those of the wall mosaics and decorations of Byzantium. The artistic quality of the St Augustine Gospels does not rise very high, however, in that the figure proportions are inaccurate, the medium is handled loosely, and details are carelessly executed. Perhaps the early Church did not consider it worthwhile to send a more valuable book to the still largely heathen England.

Nonetheless, this work provides an interesting example of an early *picture cycle*, and it typifies certain stylistic qualities that became more marked in medieval painting and sculpture. Compositions remain close and nervous: figures bump against each other amid an atmosphere of frenetic energy. We feel a certain discomfort emanating from these "walled-in" and crowded scenes, which perhaps mirror the closed-in world of the medieval illustrator.

An Irish contribution to medieval manuscript illumination appears in Figure 7.9. Here the figures appear flat and almost ornamental, though precisely and delicately rendered. Highlight and shadow give a sense of

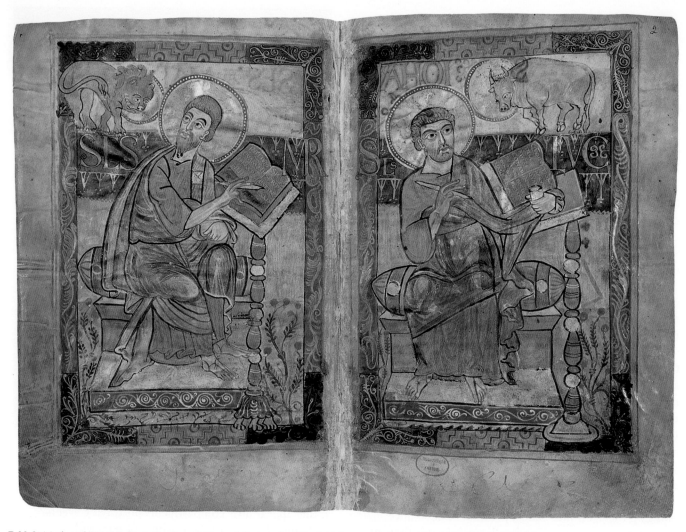

7.10 St Mark and St Luke, from the Gospel Book of Godescale, 781–3. Vellum, each page 12¼ × 8¼ ins (31.3 × 21 cm). Bibliothèque Nationale, Paris.

depth in the curtain, and oblique treatment of the bench suggests space. Accurate linear perspective proved unknown to these artists. The work has a limited and subtle palette. Of note here, the frontal treatment of the angel's eye contrasts the head, which appears in profile. The figures are also outlined. The carefully composed picture controls both color and form to achieve a pleasing balance.

Carolingian manuscript illuminations also provide striking examples of early medieval painting. As an official court art, book illumination enjoyed the sponsorship of the king, his relatives, associates, and officers of state. One exemplary product of the time, the Gospel Book of Godescale (GOHD-uhs-kal; Fig. 7.10) probably reflects Byzantine models: the evangelists have lean, bearded faces, and the cloth of their garments reveals a rudimentary attempt at modeling, with light and dark stripes representing the highlight and shadow of the folds. Unlike the Gospel Book of Godescale, the Bible of

7.11 Hinged shoulder clasp from the ship burial at Sutton Hoo, England, Anglo-Saxon, c. 625–30 C.E. Gold decorated with garnets and millefiore glass. British Museum, London.

Charles The Bald (see Fig. **7.1**) tells its story in a series of registers (bands). The stories are biblical, but the settings, contemporary. The illustration does, however, attempt shading and dimensionality. Despite its somewhat symmetrical design and compartmentalism, the work still exhibits a crowded nervousness characteristic of medieval work.

From the fifth to the eleventh centuries, a tremendous wealth of artistic work emerged in several nontraditional areas. Life generally floated in a state of flux throughout Europe in the early Middle Ages, and nonmonastic nomadic people turned much of their artistic energy to ordinary and portable media. Clothing, jewelry, and ships, for example, all exhibited the artistry of the Germanic, Irish, and Scandinavian peoples (Fig **7.11**).

Emotionalism in art increased as the approach of the millennium sounded its trumpet of expected doom. The fact that the world did not end on 1 January 1001 reduced this feeling only slightly. Emotionalism was strengthened further by an influx of Eastern art when Otto II married a Byzantine princess. The Germanic Ottonians (Otto I, Otto II, and Otto III), crowned by the Pope, ruled in the guise of a universal empire and attempted to control the still struggling Church. The resulting conflict between emperor and pope, coupled with the developing feudal and monastic system, ensured Europe's continued fragmentation and isolationism. A combination of Roman, Carolingian, and Byzantine characteristics typifies Ottonian manuscript illustration. Despite the crowding and an inherent appeal to feeling, such work testifies to the increasingly outward-looking approach of the early years of the second millennium.

Sculpture

Sculpture played only a very minor role in the centuries between the collapse of the Roman Empire and the rise of the **Romanesque** style in the eleventh century. The fact that the Old Testament prohibited graven images may have been partly responsible for this. The association of statuary with pagan societies, notably Rome, remained fresh in the memory of the Church. Thus, when Christian sculpture emerged, it was largely funerary and not monumental. The earliest examples are all sarcophagi.

The works of the palace school at Charlemagne's court reflect an effort to revive classical style by copying sculpture from the late antique period. Classical influence continued to be nurtured, perhaps because Charlemagne's political opposition to the Byzantine Empire led him to reject its artistic style as well. The so-called *Statuette of Charlemagne* (see Fig. **7.3**), for example, clearly imitates a classical model.

The ivories of this period most clearly show both the classicizing trend and the artistry of the time. Although derived from antique models, these works show great individuality. The ivory covers of the Dagulf Psalter (Fig. **7.12**) bear a close resemblance to Roman work. Commissioned as a gift for Pope Adrian I, the figures and ornamentation on this cover stand stilted and lifeless. The artist showed little attempt at creating three-dimensional space, although the figures themselves appear in high relief. Composition in each panel appears organized around a central area, to which interior line directs the viewer's eye. This focus emerges from the direction in which the figures themselves look. The scenes show crowding, but not freneticism. The figures have strange proportions, almost dwarf-like, with heavy rounded heads, long torsos, and short legs. Hairstyles reflect the late Roman Imperial period.

The ivory cover of the ninth-century Lorsch (lohrsh) Gospels (see Fig. **7.13**), on the other hand, is an exact replica of a sixth-century design. The images in the upper register, the layout, and the rounded faces in the figure depiction clearly show its kinship with the *Barberini Ivory* (see Fig. **6.14**). The Roman arches in each of the three middle panels testify to the classical derivation of the Lorsch Gospels. In the center panel sits the Virgin Mary, enthroned, with the infant Christ and surrounded by saints. The face of the Christ Child is that of a wise adult, a common medieval practice. The risen Christ appears encircled in the top register and flanked by heraldic angels. The lower register shows scenes from the nativity. So the Gospel cover reads chronologically from birth to Resurrection in *hierarchical* fashion (see Chapter 6).

Some of the most beautiful sculptural work of the Christian era after Constantine resembles manuscript illumination in its small-scale, miniature-like detail. Its restless, linear style, eloquent with emotion, reflects very precise detail.

Especially poignant is the *Gero* (GAIR-oh) *crucifix* (Fig. **7.14**). The lifelikeness of the crucified Christ, whose downward- and forward-sagging body pulls against the nails, and the emotion with which it is rendered, prove very compelling. The muscle striations on the right arm and chest, the bulging belly, and the rendering of cloth are particularly expressive. This work has a hardness of surface. We recognize the form as human, but the flesh, hair, and cloth do not have the soft texture we might expect. The face is a mask of agony, but no less full of pathos for that. An intense spirituality reflects the mysticism (see Concepts section) prevalent in the Middle Ages. The *Gero crucifix* depicts a suffering Christ whose agony parallels the spirit of the times. This portrayal contrasts markedly with the *Christus Rex* crucifixes that became popular later (and frequently seen today), in

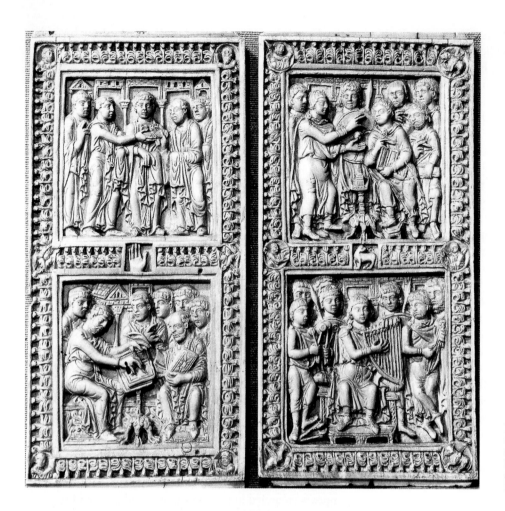

7.12 (*left*) Cover of the Dagulf Psalter, showing David in various scenes, 783–95. Ivory, each leaf 6⅝ × 3¼ ins (16.8 × 8.3 cm). Louvre, Paris.

7.13 (*opposite*) Back of the Lorsch Gospels, showing the Virgin and Child between Zacharias and John the Baptist, c. 810. Ivory, 15⅛ × 10⅝ ins (38.4 × 27 cm). Victoria & Albert Museum, London.

7.14 *Gero crucifix*, 969–76. Oak, 6 ft 1⅜ ins (1.87 m) high. Cologne Cathedral, Germany.

which Christ on the cross represents a victorious, resurrected King.

Like the architecture of the period, we call the sculpture of the eleventh and early twelfth centuries Romanesque. In the case of sculpture, the label refers more to an era than to a style. Examples of sculpture remain so diverse that we probably could not group them under a single label, were it not for the fact that most of them take the form of decorative elements attached to Romanesque architecture.

We can, however, draw some general conclusions about Romanesque sculpture. First, it associates with Romanesque architecture; second, it is stone; third, it is monumental. The last characteristic represents a distinct departure from previous sculptural style. **Monumental** stone sculpture had all but disappeared in the fifth century. Its reemergence across Europe at the end of the eleventh century over such a short period seems remarkable. The emergence of sculptural decoration indicated at least the beginning of dissemination of knowledge from the cloistered world of the monastery to the general populace. Romanesque sculpture attached to the exteriors of buildings where the lay worshipper could see it and respond to it. The relationship of this artistic

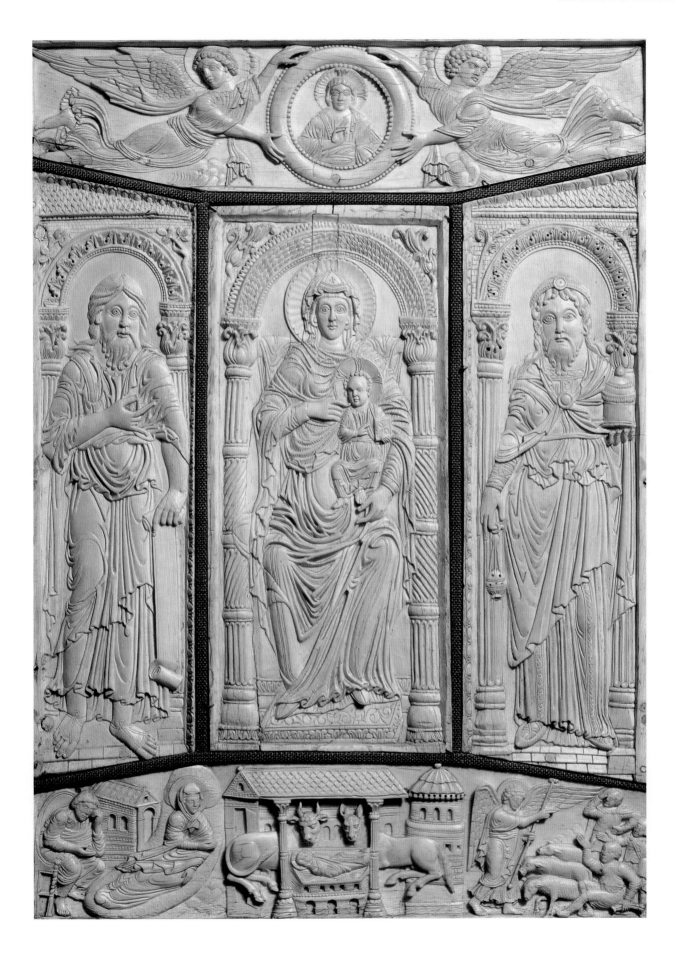

7.15 Gislebertus, *Last Judgment* tympanum, west porch, c. 1130–35. Autun Cathedral, France.

7.16 *The Mission of the Apostles* tympanum of central portal of narthex, 1120–32. Ste-Madeleine, Vézelay, France.

development to the increase in religious zeal among the laity was probably strong. In works such as the *Last Judgment* **tympanum** (TIM-puh-nuhm) of Autun (Fig. 7.15), the illiterate masses could now read the message of the Church, an opportunity previously reserved for the clergy. The message of this carved scene is quite clear. In the center of the composition, framed by a Roman-style arch, stands an awe-inspiring figure of Christ. Next to him, malproportioned figures writhe in various degrees of torment. The inscription of the artist, Gislebertus (jeez-luh-BAIR-tuhs), tells us that their purpose was "to let this horror appal those bound by earthly sin." Evil still held centrality in medieval thought, and in this twelfth-century scene devils share the stage with Christ, attempting to tip the scales of judgment in their favor and gleefully pushing the damned into the flaming pit.

Another Romanesque tympanum comes from the central portal of the narthex of the abbey and pilgrim church of Sainte-Madeleine, Vézelay (vay-zeh-LAY), in Burgundy (Fig. 7.16). The story depicts the mission of the apostles and became especially meaningful to medieval Christians at the time of the Crusades (see Chapter 8). Here the artist proclaimed the duty of every Christian to spread the gospel to the ends of the earth. At the center of the tympanum, a rather elongated figure of Christ spreads his arms, from which emanate the rays of the Holy Spirit, empowering the apostles, who carry the scriptures as tokens of their mission. Around the border range a plethora of representatives of the heathen world. The signs of the zodiac and labors appropriate to the months of the year frame the arch, stressing that the preaching of the faith is an ongoing, year-round responsibility without end.

A DYNAMIC WORLD

IGBO-UKWU

During Europe's early Middle Ages, African artists and artisans not only used but mastered bronze, and a remarkable example of that mastery is in a ritual water-pot found in the village of Igbo-Ukwu in eastern Nigeria (Fig. **7.17**).

The level of skill achieved by ninth- and tenth-century Africans in this object is astounding. In the first place, it was cast using the same sophisticated *cire-perdue* (lost-wax) method employed in casting the bronze doors of Hildesheim Cathedral (see Fig. **7.23**). This method involves the

making of a wax model around which a mold is placed. The mold is heated, the wax melts and runs out of the mold, and the void is then filled with the molten metal that forms the finished work. This leaded bronze artifact has amazing virtuosity. The ritual water-pot stands enclosed in a net of simulated rope. The knots and delicate striations are perfect, and the graceful design of its recurved lines and flaring base by themselves are exquisite. This is a design and execution of immense sophistication of both technique and vision.

7.17 Roped pot on a stand, from Igbo-Ukwu, ninth to tenth centuries. Leaded bronze, 12½ ins (32 cm) high. National Museum, Lagos, Nigeria.

Architecture

The first great burst of architectural activity in the Middle Ages occurred as part of the Carolingian Renaissance and reflected Charlemagne's drive for a united empire. Charlemagne carefully chose bishops for his kingdom who would assist in the building program he envisaged, and almost immediately new construction began across the empire.

He returned to his capital, Aachen, or Aix-la-Chapelle, from visits to Italy not only with visions of Roman monuments, but also with a belief that majesty and permanence must be symbolized in impressive architecture.

Some difficult architectural facts of life, however, tempered the realization of these dreams. Charlemagne took as his model the church of San Vitale in Ravenna (see Figs 6.17–6.19), which had been built by Justinian in the Byzantine style. All Charlemagne's materials, including columns and bronze gratings, had to be transported over the Alps from Italy to Aachen in Germany. Skilled stonemasons were few and far between, but the task was, nevertheless, accomplished.

The Palatine Chapel at Aachen (Fig. 7.18), built as Charlemagne's tomb-house, shone as the jewel in his crown. The interior reveals the grandeur and style of this building. Designed by a Frankish architect, Odo of Metz, the Palatine Chapel has very little of the spatial subtlety of San Vitale, however. It exudes less mystery, and the space itself seems more constricted, with the emphasis on verticality rather than openness. The rounded arches and thick, rectangular pillars supporting the dome create massiveness, which slender, decorative columns cannot offset. Part of the building's sense of massiveness comes from its material: rubble faced with stone for the vault. Charlemagne's throne sat in the first gallery above the door and looked down and across the central space to the altar.

During Charlemagne's reign, then, we find a true architectural renaissance, modified as it may have been to serve the grand design and political ambitions of the emperor. The recreation of antiquity in the arts and humanities made visible and intelligible the dream of a resurrected Roman Empire, with Charlemagne at its head.

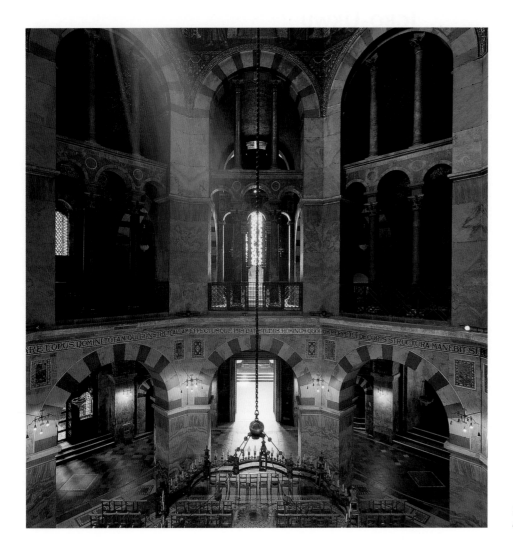

7.18 Palatine Chapel of Charlemagne, Aachen, Germany 792–805.

As Charlemagne's empire in the ninth century, and then the tenth century, passed, a new and radical style in architecture emerged. Unlike its counterparts in painting and sculpture, Romanesque architecture had a fairly identifiable style, despite its diversity. The Romanesque took hold throughout Europe in a relatively short period of time. When people of the Renaissance saw its curved arches over doorways and windows throughout Europe, they saw a style that was pre-Gothic and post-Roman—but like the Roman. Therefore, they called it "Romanesque." With its arched doorways and windows, this style appears massive, static, and comparatively lightless, which seems further to reflect the barricaded mentality and lifestyle generally associated with the Middle Ages.

The Romanesque style nonetheless exemplified the power and wealth of the Church militant and triumphant. If the style mirrored the social and intellectual system that produced it, it also reflected a new religious fervor and a turning of the Church toward its growing flock. Romanesque churches were larger than earlier ones; we can see their scale in Figures **7.19** and **7.20**. St Sernin (san Sair-NAN) reflects a heavy elegance and complexity we have not previously seen. The plan of the church describes a **Latin cross**, a cross with the lower staff longer than the arms. (Recall the cross-in-square, or Greek cross design, of Byzantine churches in Chapter 6.) The side aisles extend beyond the **crossing** to create an ambulatory, or walking space so that pilgrims, most of whom were on their way to Spain, could walk around the altar without disturbing the service.

One additional change consisted of a roof made of stone, whereas earlier buildings had wooden roofs. As we view the magnificent vaulted interior, we wonder how successfully the architect reconciled the conflicts between engineering, material properties, and aesthetics. Given the properties of stone and the increased force of added height, did he try to push his skills to the edge, in order to create a breathtaking interior? Did he aim to reflect the glory of God or the ability of humanity?

Returning to the exterior view, we can see how some of the stress of the high vaulting diffused. In a complex series of vaults, transverse arches, and bays, the tremendous weight and outward thrust of the central vault transferred to the ground, leaving a high and unencumbered central space. If we compare this structural system with the post-and-lintel structure of the ancient Greeks (see Chapters 2 and 3) and consider the compressive and tensile properties of stone, we can see why the arch forms a superior structural device for creating open space. Because of the weight and the distribution of stress, this style permits only very small windows. So, although the fortress-like, lightless qualities

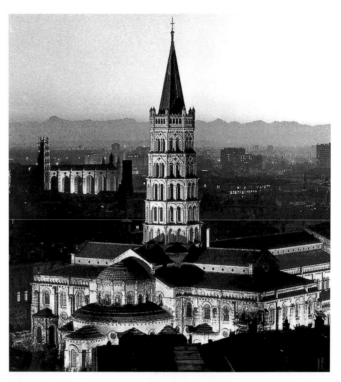

7.19 St Sernin, Toulouse, France, c. 1080–1120.

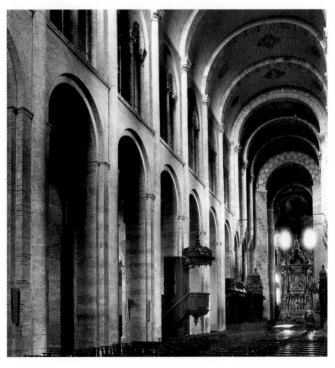

7.20 Interior of the nave at St Sernin, Toulouse, France, c. 1080–1120.

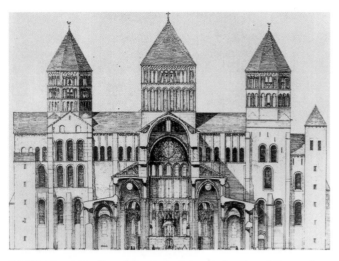

7.21 Transverse section of the nave, and west elevation of the great transept of the Abbey Church, Cluny III, France, 1088–1130.

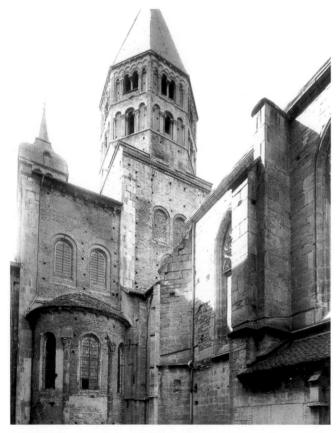

7.22 Exterior of southwest transept of Cluny III.

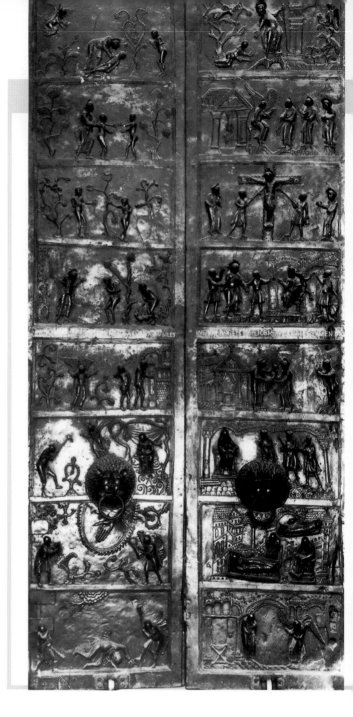

of Romanesque architecture reflect the spirit of their time, they also had a practical explanation.

The tenth-century church of Cluny, known as Cluny II, inspired numerous buildings throughout the West in the eleventh century. When it became too small, a new church, Cluny III, was begun in 1088. It remained the largest church in Christendom until the rebuild of St Peter's in Rome in the sixteenth century. Although Cluny III (Figs **7.21** and **7.22**), was badly damaged during the French Revolution, we know that the nave, which had double aisles, the double **transepts**, and the choir with an ambulatory all had enormous scale. The arcades of the nave had pointed arches, and the interior housed magnificent wall paintings. Protruding apses and numerous towers adorned the exterior.

MASTERWORK

THE BRONZE DOORS OF HILDESHEIM CATHEDRAL

During Bernward of Hildesheim's years as bishop (993–1022), the city of Hildesheim became a center for manuscript painting and other arts. Bernward's patronage, however, remained largely confined to the area of metalwork, in particular, the bronze doors of the Hildesheim (hil-duh-SHYM) Cathedral (Fig. **7.23**) cast by the *cire-perdue* (sihr-pair-DOO), or **lost-wax**, process.

The building of the Abbey Church of St Michael at Hildesheim formed part of Bishop Bernward's plan to make the town a center of learning. The doors for the south portal of St Michael's were completed in 1015 and probably installed before 1035. Apparently cast in one piece, Hildesheim's doors are the first in a succession of figured bronze doors throughout the Middle Ages and the Renaissance, a tradition that culminated in Ghiberti's *Gates of Paradise* for the Baptistery in Florence (see Chapter 9). The massive doors of Hildesheim also represent a return to larger scale sculpture typical of the Romanesque period.

The scenes portrayed on Bernward's doors tell biblical stories in a carefully arranged order. The number of scenes depicted—sixteen—exemplifies medieval number symbolism. (Sixteen is the number of the Gospels multiplied by itself.) Reading from top to bottom, the scenes pair so that the left door unfolds the Old Testament story of the fall, and the right, the New

Testament story of the redemption. For example, *The Temptation of Adam and Eve* (third from the top, left), which depicts the fall from grace, purposely aligns with the *Crucifixion* (third from the top, right), which illustrates the redemption of humankind. The scenes remind us of manuscript illustration, and they tell their stories with a simple directness. In the fourth panel from the top on the left, an angry God reproaches Adam and Eve. His angry glare magnifies his accusatory, pointing finger, and Adam and Eve cower under his condemnation. As the sinners try to shield their nakedness, Adam points to Eve, passing to her the blame for his transgression; she, in turn, looks downward, and with her left hand points an accusing finger at the serpent.

The scenes strike us with their strong sense of composition and physical movement. Every set of images, against a plain background of open space, speaks forcefully in dumb show. The doors tell their story in medieval fashion, as a vivid but silent drama, effectively communicating the message of the Christian faith to a largely illiterate public. Replace these simple scenes with a clergy-actor, and we have the beginnings of liturgical drama (see the Theatre section below). Just as the mystics of the Middle Ages understood communication through the intuition and nonrational emotions, so the artists of the period understood the raw power and effectiveness of the simple nonverbal image.

7.23 Doors of Hildesheim Cathedral, 1015. Bronze, 16 ft 6 ins (5.03 m) high. Hildesheim, Germany.

Theatre

Scholars used to argue that theatre ceased to exist in the Western world for a period of several hundred years. However, two pieces of evidence suggest that theatrical productions continued. The first consists of the presence of wandering entertainers (see Chapter 8) including mimists, jugglers, bear baiters, acrobats, wrestlers, and storytellers. The propensity of human beings for acting out or mimicking actions and events seems too compelling to deny its existence amid the entertainments we know existed in this era. We do not know, however, how such entertainments presented themselves during the early Middle Ages. They may have consisted simply of the acting out of a story silently or the reading of a play

script, rather than the formal presentations that we today know as "theatre."

Our second piece of evidence proves more conclusively that theatre existed. Writings from north Africa argue that mime continued there and it is probable that if it still existed in north Africa, it also existed in Europe. The king of Spain in the seventh century refers to the popularity of old Roman festival plays at marriages and feasts, adding that members of the clergy should leave when these were performed. In France in the ninth century, the Council of Tours and the Council of Aix-la-Chapelle (EKS-lah-shah-PEHL) ruled that the clergy should witness neither plays nor the obscenities of actors. These railings of the Church against the theatre certainly suggest its existence. Charlemagne added his powerful

backing in defense of the clergy by ruling that no actor could wear a priest's robe under penalty of corporal punishment or banishment. This edict has been taken by some as evidence of theatrical presentation and also, perhaps inaccurately, as evidence of the beginnings of liturgical drama. If this were the case, the prohibition would imply the use of actors other than the clergy in Church drama.

In the tenth century, the German nun Hrosvitha (hrohs-VEET-ah) wrote six plays based on comedies by Terence. We do not know if Hrosvitha's plays were performed, but if they were, the audience would have been restricted to the other nuns in the convent.

We are sure, however, that liturgical drama began as an elaboration of the Roman Catholic Mass, probably in France. These elaborations, called **tropes**, took place on ceremonial occasions, especially at Easter, the dramatic highlight of the Church year. Records at Winchester in southern England dating from the late tenth century tell of a trope in which priests acted out the discovery of Jesus' empty tomb by his followers on Easter morning.

The first dramatic trope was the "Quem Quaeritis" trope. This earliest Easter trope dates from 925, and the dialogue was:

Angels: Whom seek ye in the tomb, O Christians?
The Three Marys: Jesus of Nazareth, the crucified, O Heavenly Beings.
Angels: He is not here, he is risen as he foretold. Go and announce that he is risen from the tomb.

So theatre, along with all the other arts, except dance, was adopted by the Church and became an instrument of God in an age of faith and demons.

Music

Sacred Music
Gregorian Chant
By around the year 500, a body of sacred—religious—music called chant, *plainchant*, or **plainsong**, had been developed for use in Christian worship services. (The terms, along with **Gregorian chant**, are commonly used as synonyms, although detailed study reveals differences.) Chant was vocal and took the form of a single melodic line (*monophony;* muh-NAH-foh-nee) using notes relatively near each other on the musical scale. The haunting, undulating character of early chant possibly points to Near Eastern origins. Chants used a flexible tempo with unmeasured rhythms following the natural accents of normal Latin speech. Two types of chant settings existed. In one, called *syllabic*, each syllable of the chant occupied one note. In the other, called melismatic (mehl-iz-MAT-ik), each syllable spread over

several notes. "Kyrie Eleison" lets us sense the flavor of the undulating and ethereal melody of the melismatic type. The Kyrie is one of the five parts of the *mass ordinary*—texts that remain the same from day to day throughout most of the Church year. The other parts of the Mass are the *Gloria* (Glory be to God on high), *Credo* (I believe . . .), *Sanctus* (Holy, holy, holy, Lord God of Hosts), and *Agnus Dei* (O Lamb of God that takest away the sins of the world). The Kyrie entreats, "Kyrie eleison" (Lord have mercy upon us), "Christe eleison" (Christ have mercy upon us), "Kyrie eleison" (Lord have mercy upon us). These sections, sung by the choir, alternate with the affirmation, "Hodie Christus Resurrexit" (Today Christ is Risen), sung by a soloist, which gives the piece an ABABA structure.

We often call **plainchant** Gregorian chant because Pope Gregory I (540–604) supervised the selection of melodies and texts he thought most appropriate and compiled them for Church services. Although Pope Gregory did not invent plainchant, his contributions of selection and codification were such that it acquired his name.

Polyphony: Organum
At some time between the eighth and tenth centuries, monks in monastery choirs began to add a second melodic line to the chant. At first, the additional line paralleled the original at the interval of a fourth or a fifth. We call medieval music that consists of Gregorian chant and an additional melodic line (or lines) **organum** (OHR-guh-nuhm). Between the tenth and the thirteenth centuries, organum became truly **polyphonic**. As time progressed, the independent melodies became more and more independent of each other and differed rhythmically as well as melodically.

Secular Music
The Middle Ages also witnessed a growth in secular music—that is, not related to the Church. As might be expected, secular music used vernacular texts—texts in the language of the common people, as opposed to the Latin of Church music. The subject matter mostly concerned love, but other topics also proved popular. Medieval secular song was probably mostly **strophic** (STROHF-ik) (composed of several stanzas that were sung to the same melody).

Musical instruments of this era (Fig. **7.24**) included the lyre, the harp, and a bowed instrument called the vielle, or fiedel (the viol, or fiddle). The psaltery, similar to a zither, the lute, the flute, the shawm, a reed instrument like an oboe, trumpets, horns, drums, and bagpipes all proved popular as did small, portable organs, despite the instrument's unpleasant associations with the Roman persecution of Christians, and the organ eventually found its way into the medieval church.

PROFILE

HILDEGARD OF BINGEN (1098–1179)

One of the significant musical and literary figures of the time, Hildegard of Bingen was educated at the Benedictine cloister of Disibodenberg and became prioress there in 1136. Having experienced visions since childhood, at age forty-three she consulted her confessor, who in turn reported the matter to the archbishop of Mainz. A committee of theologians subsequently confirmed the authenticity of her visions, and appointed a monk to help her record them in writing. The finished work, *Scivias* (1141–52), consisted of twenty-six visions, prophetic, symbolic, and apocalyptic in form. In around 1147, Hildegard left Disibodenberg to found a new convent, where she continued to prophesy, to record her visions in writing, and perform her musical plays.

Hildegard is the first composer whose biography we know. She wrote music and texts to her songs, mostly liturgical plainchant honoring saints and the Virgin Mary. She believed that music recaptured the original joy and beauty of paradise and that music was invented and musical instruments made in order to worship God appropriately. She wrote in the plainchant tradition of a single vocal melodic line that we have just discussed. She wrote seventy-seven chants and the first musical drama in history, which she entitled "The Ritual of the Virtues."

Hildegard of Bingen's music was written for performance by the nuns of the convent she headed. She combined all her music into a cycle called "The Symphony of the Harmony of the Heavenly Revelations," from which the "Lauds of Saint Ursula" provides one example. This music uses three sopranos accompanied by an instrumental drone, which serves as a sustained bass above which the voices soar in the chantlike melody. It celebrates St Ursula who, according to legend, was martyred with eleven thousand virgins in Cologne. Her "*Kyrie Eleison*" provides a comparison with the Kyrie noted under the Gregorian Chant section above.

Hildegard believed that many times a day, humans fall out of sorts and lose their way. Music provided the sacred technology that could best redirect human hearts toward heaven. It could integrate mind, heart, and body and heal discord.

Hildegard's numerous other writings include a morality play, a book of saints' lives, two treatises on medicine and natural history, and extensive correspondence, in which are to be found further prophecies and allegorical treatises. Her lyrical poetry, gathered in "The Symphony of the Harmony of the Heavenly Revelations" (*Symphonia armonie celestium revelationum*), consists of seventy-seven poems (all with music), and together they form a liturgical **cycle**.

7.24 *Medieval Minstrels playing to Nobleman*, MS. Fr 13096 fol. 46. Bibliothèque Nationale, Paris.

Dance

Dancing did not surrender to the dictates of Christianity in the early Middle Ages. Church writings continue to condemn dancing from Constantine's time to the eleventh century and beyond. St Augustine complained that it was better to dig ditches on the Sabbath than to dance a "Choric Reigen" (RY-gehn; a type of "round dance").

Even when Christianity gained a firm hold, it could not eradicate ritualistic dancing completely. It appears that a certain unspoken compromise occurred. Dancing continued because people will continue to do what gives them pleasure, Church or not, the threat of damnation notwithstanding. But the pagan contexts of dance were put aside. The Christian Church made many such compromises with life as it found it.

Any dance in this period, however, was largely spontaneous and took no account of a performer/ audience relationship. Such dancing responded to a

chaotic and frightening world in which people were reduced to their baser selves. Later, demonic dances, dances of death, and animal mummeries would take on a more formal, presentational character—Death as a dancer appeared frequently as a medieval image.

Theatrical dance remained alive, however, through successors to the Roman pantomimes. Dancers appeared at fairs and festivals, performing nearly always for the peasants—rarely for the nobility.

Literature

We divide this section into two parts, Legends and Poets and Scholars. This reflects the fact that out of the medieval period came three important epics whose poets we either do not know or cannot be sure of.

Legends

The nature of the three epic poems places them into the category of legends because of their form and content. The first, although not the oldest, the *Nibelungenlied*, dates to around 1200, which puts it at the very end of the time frame of this chapter, if not slightly into that of the next. Nonetheless, its legendary subject matter suits our discussion here. *Nibelungenlied* means "Song of the Nibelungs" or "Song of the People of the Mists." The *Nibelungenlied* consist of heroic stories of northern peoples, a rich mixture of history, magic, and myth. Ten complete and twenty incomplete manuscripts of the *Nibelungenlied*, folk tales of thirty-nine adventures, commencing with that of the hero Siegfried, son of Siegmund, king of the Netherworld, make up the work.

The poem begins by introducing Kriemhild (KREEM-hilt), a Burgundian princess of Worms, and Siegfried (SEEG-freed), a prince from the lower Rhine determined to woo her. When he arrives in Worms, he is identified by Hagen (HAHG-ehn), a henchman of Kriemhild's brother King Gunther. Hagen then recounts Siegfried's earlier heroic deeds, including his acquisition of a treasure. When the Danes and Saxons declare war, Siegfried leads the Burgundians and distinguishes himself in battle. Upon his return, he meets Kriemhild, and their affections develop during his residence at court.

Hearing of the contest for Brunhild, a queen of outstanding strength and beauty who may be won only by a man capable of matching her athletic prowess, Gunther decides to woo her. He enlists the aid of Siegfried, to whom he promises the hand of Kriemhild if successful. By trickery the two men defeat Brunhild, and she accepts Gunther as her husband. Siegfried and Kriemhild then marry as promised, but Brunhild has suspicions. The two queens soon quarrel, and Kriemhild

reveals how Brunhild was deceived. Hagen sides with Brunhild and kills Siegfried.

During these events, Brunhild drops almost unnoticed out of the story. Siegfried's funeral takes place with great ceremony, and the griefstricken Kriemhild remains at Worms, though for a long time estranged from Gunther and Hagen. Siegfried's treasure returns to Worms, but Hagen sinks the treasure in the Rhine.

The second part of the poem deals principally with the conflict between Hagen and Kriemhild and her vengeance against the Burgundians. Etzel (Attila), king of the Huns, asks the hand of Kriemhild, who accepts. After many years, she persuades Etzel to invite her brothers and Hagen to his court. Though Hagen is wary, they all go, and carnage ensues. Kriemhild has Gunther killed and then, with Siegfried's sword, she slays the bound and defenseless Hagen. Kriemhild herself is slain by a knight named Hildebrand.

The favorite Old English epic, *Beowulf* (BAY-oh-wuhlf; c. 725), is the earliest extant poem in a modern European language. Composed by an unknown author, it falls into separate episodes that incorporate old legends. The poem employs unrhymed **alliterative** verse. Its three folk stories center on the hero, Beowulf, and his exploits against the monster Grendel (GREHN-duhl), Grendel's mother—a hideous water hag—and a fire-breathing dragon. In the poem, the "battle-brave" Beowulf crosses the sea from "Geatland" (possibly Sweden) to the land of the Danes and frees that country from a terrible ogre, Grendel. In revenge, the ogre's mother carries off a king's councillor. Beowulf follows her to her lair under the waters of a lake and slays her. Beowulf becomes king of the Geats and rules for half a century. He is fatally wounded when he battles a fire-breathing dragon. Mourned by his subjects, he is buried under a great barrow, or mound.

Another popular poem, the *Chanson de Roland* or "Song of Roland," tells of Charlemagne. The poem dates to around 1100 and is probably by a Norman poet named Turold, whose name is mentioned in the last line of the poem. It tells the story of the historical battle of Roncesvalles, fought in 778 between the armies of Charlemagne and the Saracens of Saragossa in the Pyrenees mountains between France and Spain. In reality, the battle was little more than a skirmish against the Basques, but the poet turns the event into a heroic encounter on the level of the Greek battle of Thermopylae (see Chapter 3).

The poem has a direct and sober style. It focuses on the clash between the recklessly courageous Roland and his more cautious friend Oliver, a conflict that illustrates divergent views of feudal loyalty.

The poem begins as Charlemagne, having conquered all of Spain except Saragossa, receives overtures from the

Saracen king. In response, Charlemagne sends the knight Ganelon to negotiate peace terms, but Ganelon, Roland's stepfather, is angry because Roland proposed him for the dangerous task, and he conspires with the Saracens to achieve Roland's death. On his return to Charlemagne's camp, Ganelon ensures that Roland will command the rear guard of the army as it withdraws from Spain. As the army crosses the Pyrenees, an overwhelming Saracen force surrounds the rear guard at the pass of Roncesvalles.

The headstrong Roland, preoccupied with valor, rejects his friend Oliver's advice to blow his horn and summon help from the rest of Charlemagne's army. The battle ensues, and the valiant French soldiers fight until only a handful remain alive. Finally, the horn sounds, but it is too late to save Oliver or Roland, who is fatally wounded in error by a blow from a blinded Oliver. However, the arriving army can avenge the heroic vassals.

When Charlemagne returns to France, he breaks the news to Aude, Roland's fiancée and Oliver's sister, who falls dead at the news. The poem ends with the trial and execution of Ganelon.

These three epics reflect the rugged character of the early Middle Ages. They concentrate on specific details rather than abstract principles. The language seems somewhat harsh, lacking the elegant idealism we found in the epics of Homer and Vergil. The stories take precedence over the manner of their telling, just as Romanesque architecture appears more about the process of building than an expression of a sentiment or philosophy such as we find in Gothic architecture in our next chapter. The barricaded mentality of the times gives us impregnable fortresses and a feudal, men-at-arms feeling rather than either an intellectual or spiritual sense. The *Nibelungenlied*, *Beowulf*, and *Chanson de Roland* remind us of "guy flicks" rather than high poetry.

To prove that not all legendary literature treated great battles and legendary heroes seriously, we close this section with a short look at a comic, rowdy, Irish account of a rivalry among Ulster warriors. Dating to the eighth century, *Bricriu's Feast* (BRIHK-rooz) comprises one of the longest hero tales of the *Ulster Cycle*, a group of legends and tales dealing with the heroic age of the Ulaid, a people of northeastern Ireland. The stories, set in the first century B.C.E., found their way into writing from the oral tradition between the eighth and twelfth centuries, preserved, finally, in the twelfth-century *Book of the Dun Cow*. The tales use prose for their narratives and verse for scenes of heightened emotion.

Bricriu's Feast relates the story of Bricriu, a trickster who promises the hero's portion of his feast to three different champions. This causes a violent dispute leading to a series of contests. A giant carrying an ax challenges the three champions to behead him in exchange for a chance to behead them in turn. On successive nights, the first two champions behead the giant, who then replaces his head, leaves, and returns only to find the champions gone. On the third night, the champion, Cu Chulainn (kuh-HOO-luhn), beheads the giant and, true to the bargain, places his own head on the block. The giant, really the wizard Cu Roi in disguise, proclaims Cu Chulainn the first hero of Ulster.

Poets and Scholars

St Jerome (c. 342–c. 420) lived at the same time as St Augustine of Hippo, and his writings assumed a position of primary importance in the last years of the Roman Empire. Familiar with the classical writers, St Jerome found the style of the Christian scriptures somewhat crude. He had a dream, however, in which Christ reproached him and accused him of being more a Ciceronian than a Christian. As a result, Jerome resolved to spend the rest of his life in the study of the sacred books. He made a famous translation of the Bible into Latin, called the Vulgate Bible, and assisted by Jewish scholars, he also translated the Old Testament from the Hebrew.

It seems clear that in the early Middle Ages—with the notable exception of the Carolingian court—the politically powerful cared little for culture, and for the most part could neither read nor write. The monastic community, and particularly the Benedictine monks, however, took it upon themselves to preserve and copy important books and manuscripts. St Benedict (c. 480–550) emerged as one of the few great scholars of the early years (that some call the Dark Ages) of the period.

The Muslims had come into contact with Greek culture when they invaded Egypt, and they brought it with them to Spain, where literature flourished. The schools they set up in Cordoba studied Aristotle and Plato alongside the Qur'an. Toledo and Seville also functioned as centers of learning. The Islamic philosopher, astronomer, and writer, Averroes (ah-VAIR-oh-eez; 1126–98; Fig. 7.25), devoted himself to law, medicine, mathematics, philosophy, and theology. He played an important part in the political history of Andalusia in Spain. Originally enjoying court favor, he later fell under the edict against philosophers, and was banished. Many of his works in logic and metaphysics were destroyed. His "Commentaries" on Aristotle and his treatises on theology reach us either in Latin or Hebrew translations. His work proved influential in the philosophical and scientific interpretation of Aristotle, whom Averroes held in great esteem.

Averroes' greatest influence came as a commentator. His doctrines had a varying fortune in Christian schools. At first they found some agreement, then, gradually, their

7.25 Portrait of Averroes (Ibn Rushd). Drawing after a fresco by Raphael.

incompatibility with Christian teaching became apparent. During the Renaissance they emerged once again into temporary favor. His commentaries, however, had immediate and lasting success. St Thomas Aquinas used the "Grand Commentary" of Averroes as his model, apparently the first scholar to adopt that style of exposition. Although Aquinas refuted the errors of Averroes, and devoted special treatises to that purpose, he always spoke of the Arabian commentator as one who had misinterpreted the Aristotelian tradition, but whose words nevertheless deserved respect and consideration. Later, however, the Christian Church cast Averroes as "the arch-enemy of the faith."

Marie de France (mah-REE-duh-frahns; fl. late twelfth century) created verse narratives, called lays or *lais*, on romantic and magical themes and perhaps provided inspiration for the music of the later trouvères (see Chapter 8). A lay is a short, medieval French romance. Her poem, *Chevrefoil* ("The Honeysuckle") relates an episode in the story of Tristan and Isolde (ee-ZOHL-duh), a medieval love-romance based on the Celtic legend of an actual Pictish king. The lay employs an octosyllabic or line of eight syllables and an irregular rhyme scheme.

Peter Abelard (AB-uh-lahrd; 1079–1142) emerges as a figure of philosophy, poetry, and romance. His lifelong correspondence and late-in-life love affair with his pupil Héloïse (ay-loh-EEZ) account for the romantic element, although the consequences of the affair included a child and secret marriage, and Abelard's castration by Héloïse's

angry relatives. Héloïse became a nun, head of a new community called the Paraclete, and Abelard became abbot of the same community. As such he created a rule and justification of the nun's way of life, in which he emphasized the virtue of literary study. In the early 1130s, he and Héloïse composed a collection of their own love letters and religious correspondence.

Philosophically, Abelard denied the Platonic assertion (see Chapter 3) that objects represent merely imperfect imitations of universal ideal models to which they owe their reality. Rather, he took what we might call a realist approach, arguing for the concrete nature of reality. In other words, objects, as we know them, have real individuality which makes each object a substance "in its own right." Beyond this, Abelard argued that universals do exist and comprise the "form of the universe" as conceived by the mind of God. These universals form patterns, or types, after which individual substances are created and which make these substances the kinds of things they are.

Called "moderate realism" or, sometimes, "conceptualism" (although that term usually applies to later philosophy), Abelard's views were adopted and modified by St Thomas Aquinas (see Chapter 8), and in this revised form they constitute part of Roman Catholic Church dogma today. Abelard believed that philosophy had a duty to define Christian doctrine and to make it intelligible. He also believed that philosophers should be free to criticize theology and to reject beliefs contrary to reason.

Abelard regarded Christianity as a way of life, but he tolerated other religions as well. He considered Socrates and Plato "inspired." According to Abelard, the essence of Christianity lay not in its dogma but in the way Christ had lived his life. Those who lived prior to Jesus were, in a sense, already Christians if they had lived the kind of life Christ did. Good or evil in terms of individual acts stemmed from whether they were "solely . . . well or ill-intended," as he argued in his treatise *Know Thyself*.

Hildegard of Bingen (see Profile, p. 231) wrote her lyrical poetry (seventy-seven poems, all of them with music) in the form of a liturgical cycle, a collection treating the same theme. These hymns and sequences honor the saints, virgins, and Mary. Hildegard wrote in the plainchant tradition of a single vocal melodic line, a tradition common in the liturgical singing of her time. Her *Book of Divine Works* expounds her theology of microcosm and macrocosm: humans both as the peak of God's creation and as a mirror through which the splendor of the macrocosm is reflected.

CHAPTER REVIEW

CRITICAL THOUGHT

Debates often arise about questions such as these: Does art really mirror its times, or is it purely a result of some internal necessity of the artist? Should it be useful or does it exist for its own sake? In this chapter we have made more than a little of the relationships between the barricaded mentality of the political times, the nervous and crowded spaces of the visual art, the heavy fortress-like nature of architecture, and the cumbersome style of literature. Can you think of examples of how the visual art, music, drama, architecture, and literature of our time make similar statements? What is your viewpoint on art as a reflection of society?

SUMMARY

After reading this chapter, you will be able to:

- Identify and define the divisions of the Middle Ages.
- Describe the role of the Christian Church and monasticism in the life of the times.
- Characterize the music of the early Middle Ages, identify its forms, and discuss the role of Pope Gregory I in its development.
- Understand how the Carolingian renaissance affected politics, religion, and the arts and architecture of the period.

- Discuss feudalism as a social system.
- Explain the nature of theatre, dance, and literature and cite specific writers and works with regard to literature.
- Characterize the Romanesque style in visual art and architecture.
- Apply the elements and principles of composition to analyze and compare specific works of art and architecture illustrated in this chapter.

CYBERSOURCES

http://www.mcad.edu/AICT/html/medieval/march_rom.html
http://www.bc.edu/bc_org/avp/cas/fnart/arch/romanesque_arch.html
http://web.kyoto-inet.or.jp/org/orion/eng/hst/romanesq.html
http://www.encyclopedia.com/html/N/Normanar.asp
http://www.historylearningsite.co.uk/medieval_church_architecture.htm

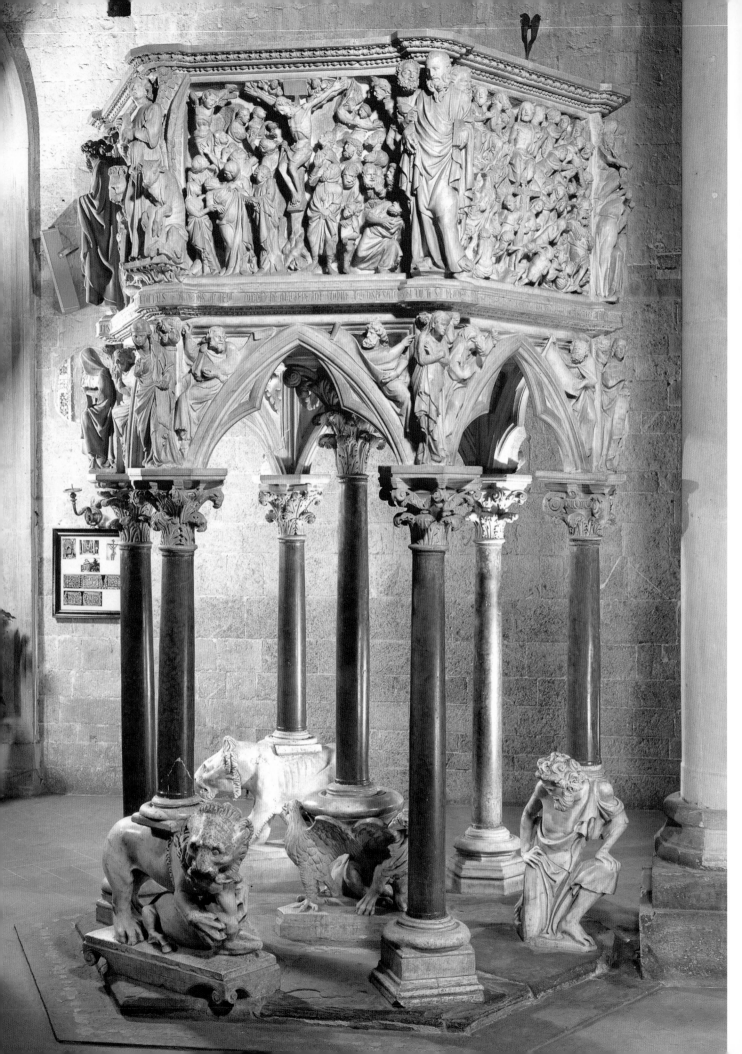

8 THE HIGH MIDDLE AGES
THE GOTHIC AGE

OUTLINE

VIEW

INDIVIDUALISM

We all desire to be thought of as individuals of worth and to have some semblance of control in our lives. In the twelfth century, men and women found a new interest in themselves as individuals: individuals who had some further purpose on earth than merely getting through this "vale of tears" and into the eternal happiness of heaven beyond the grave. People began to see themselves as important and as having a relationship with the world of the past. New "personalist" elements entered devotion,

philosophy, theology, and literature. Individualism meant a degree of control over one's existence and the sphere around it. Such characteristics applied especially to the ongoing conflict between the Christian Church and secular leaders, but it had an interesting twist. In our society, we find the issue of separation of Church and state essentially one of keeping the Church out of the affairs of state. In the High Middle Ages, the reverse occurred: the local secular rulers wanted to oversee the Church.

KEY TERMS

CHIVALRY
A more feminine point of view in ethics and personal conduct, as compared to feudalism.

ALLEGORY
Expression by means of symbols to make a more effective generalization or moral commentary about human existence than could be achieved by direct or literal means.

GOTHIC STYLE
A synthesis of medieval intellect, spirituality, and engineering—in architecture characterized by the pointed arch.

MEASURED RHYTHM
Music employing definite time values and precise meters.

MYSTERY PLAY
A medieval religious play produced by occupational guilds.

SECULARISM
The rejection of religion and religious considerations.

PIETÀ
A sculpture or painting of the dead Christ supported by Mary.

ARS NOVA
"New Art," referring to changes in music occurring in the fourteenth century.

8.1 Giovanni Pisano, pulpit, begun 1297. Marble, Sant'Andrea, Pistoia, Italy.

CONTEXTS AND CONCEPTS
Contexts

In the Contexts section of this chapter we will discuss five major topics: the Social Order, the Hundred Years' War, the Plague, the Great Schism, and the Crusades. These topics will take us on a wide-ranging journey.

The Social Order
Our examination of the social order of the High Middle Ages focuses on four areas: Cities, the Middle Class, Monarchies, and Universities.

Cities
Humanity in the late Middle Ages seemed to undergo a spiritual and intellectual revival that had a profound effect on the creative spirit. In the feudal Romanesque era, around the year 1000, Europe consisted of stone fortresses on hills and mud huts in cramped villages. Two centuries later, the world had transformed. This transformation of medieval societies sprang largely from the resurgence of cities, for which three main factors proved responsible—agricultural improvements, population growth, and the revival of trade.

Although primitive, the manorial system of feudalism did produce important agricultural improvements, including a three-field system of crop rotation. After the year 1000, the proportion of land under cultivation increased tremendously and the increase in the food supply enabled an increase in the population of Europe.

The primary cause of the rebirth of cities, however, consisted of a revival of trade in the eleventh, twelfth, and thirteenth centuries. Soldiers returning from the Crusades, which we discuss later in this section, brought tales of the East and marvelous goods that caught the fancy of nobles and commoners alike. Merchant and craft guilds—trade associations of dealers in, or makers of, products from cloth to metals—dominated trading cities. Gradually, cities developed independent political authorities—for example, magistrates and city councils—although they were elected only by business people. At the heart of the city lay the doers of business—craft guilds, their masters, assistants, and apprentices; merchants who required stevedores, porters, muleteers, and so on. In addition, priests, students, lawyers, runaway serfs, and others flocked to the cities in search of employment and protection. The city offered a new hope of escape from enslavement to the land, and thousands flocked there.

The Middle Class
As the commercial class grew richer, it also gained power, filling the vacuum that existed between nobility and peasantry. However, no order gives up power easily, and struggles, sometimes violent, pitted burgher against nobleman. The Crusades ruined many feudal landholders, and a taste of potential power and wealth strengthened the resolve of the "middle-class" citizens. They needed a more dynamic society than feudalism could offer, so they threw their weight and power into strengthening monarchies that favored them. Thus, an emerging middle class (between nobility and peasantry) played a vital role in a changing social order that would see more centralized administration, stabilization, and rudimentary democracy.

Monarchies
The explosion of economic activity led to the reestablishment of centralized power in the hands of medieval kings. Under their aegis a new form of government itself evolved. Fundamentally, medieval monarchs faced the problem of replacing feudal law with royal law and taxing what amounted to a nation. Solving such problems required compromises, and the most successful monarchs—in England and France—paid for their growing power by granting rights to representative bodies that spoke for the primary classes of medieval society: the nobility, the Church, and the wealthy new cities and towns.

Some monarchs proved more successful at statecraft than others. In the feudal period, Duke William, the Bastard of Normandy, invaded and conquered England in 1066, gaining for himself the title William I the Conqueror (r. 1066–87). As king of England, he gave the country greater centralized government than it had ever known, and under his successors, Henry I and Henry II, England developed its system of common law, the royal council, and the exchequer (treasury). By the end of the twelfth century, England had the strongest monarchial government in Europe.

France had two significant monarchs during the period covered by this chapter. The first, Philip Augustus (1180–1223), proved France's most successful medieval monarch. He used his position to gain power over the nobility and to develop an effective, independent royal administrative system that included a strengthened legal system. Unlike William I of England, Philip Augustus did not conquer any foreign lands. He did, however, overcome rebellious feudal barons in the south of France, and he won from Henry II of England parts of western France that had known English rule since the time of William the Conqueror. Thus, under Philip Augustus' rule, France tripled in size and replaced the Holy Roman Empire as the most powerful entity in continental Europe.

The strong but pious Louis IX (1215–70), who reigned from 1226, gave France the prestige of a saint in

its royal lineage. Although Louis did not hesitate to increase royal power, issue edicts without consultation, or tamper with the legal system, he possessed great strength of character and medieval Christian virtue. He had such a reputation for justice, which he often meted out sitting under an oak tree, that he earned the title, Louis the Just. He also performed great acts of spiritual character, such as washing lepers' feet, for which the Church canonized him only thirty years after his death. His saintly life had done much to solidify his power.

Universities

Many universities gained their charters in the twelfth and thirteenth centuries—for example, Oxford University in England, the University of Salamanca in Spain, the University of Bologna in Italy, and the University of Paris in France. A number of these had existed previously in association with monasteries, but their formal chartering made the public more aware of them.

Unlike today's universities, medieval universities had no buildings or classrooms; instead, they consisted of guilds of scholars and teachers who gathered their students together wherever space permitted. Students came from all over Europe, for example, to hear the lectures at the University of Paris by teachers such as William of Champeaux (sham-POH; 1070–1121), and later, Peter Abelard. University life spawned people with trained minds who sought knowledge for its own sake and who could not accept a society that walled itself in and rigidly resisted any questioning of authority. In Paris, by the late twelfth century, the arts had become a prelude to the study of theology.

The rise of universities at this particular time came as a result of a number of factors. This period witnessed, as

GENERAL EVENTS

1100	1200	1300	1400	1500

- First Crusade, 1095
- Eleanor of Aquitaine, 1122–1204
- Muslims conquer Jerusalem, 1187
- Second Crusade, 1147
- Third Crusade, 1189
- Fourth Crusade, 1202
- Franciscans founded, 1209
- Louis IX, 1215–70
- Dominicans founded, 1216
- Papacy to Avignon, 1309
- Hundred Years' War begins, 1337
- Black Death (or Plague) in Europe, 1348–50
- Battle of Poitiers, 1356
- Ming dynasty in China, 1368–1644
- Great Schism, 1378
- Mechanical clocks, 1380
- Joan of Arc, 1412–31
- Wars of the Roses, 1485–1509

PAINTING & SCULPTURE

Tympanum, Saint-Denis (8.15)	Cimabue (8.10, 8.38), Manuscript illumination (8.9)	Pisano (8.20), Giotto (8.11, 8.13), Duccio (8.12), Lorenzetti (8.14), Sluter (8.19)		

ARCHITECTURE

Abbey Church of Saint-Denis (8.15, 8.23, 8.25)	Chartres Cathedral (8.22, 8.27, 8.28), Notre Dame (8.24)	Doge's Palace (8.29), Hallenkirchen, St Sebold (8.30)		

THEATRE

Mystery, miracle, and morality plays			*Everyman*	

MUSIC & DANCE

Léonin, Pérotin		Philippe de Vitry, *Danse macabre* (de Machaut), *Ars nova* (Francesco Landini)		

LITERATURE

Chrétien de Troyes	Psalter of St Louis, Douce Apocalypse, St Francis of Assisi, Thomas Aquinas, Dante, Marguerite Porète	Boccaccio, St Catherine of Siena, Froissart, Chaucer, Julian of Norwich, Margery Kempe	Christine de Pisan	

Timeline 8.1 The High and Late Middle Ages.

8.2 Medieval scholars studying in Latin, Hebrew, and Arabic at a school in Sicily, c. 1200.

we will note in more detail momentarily, rediscovery of texts from the classical world, especially the works of Aristotle, which came to the West through Muslim sources in Spain (Fig. 8.2). In addition, a large amount of mathematical and scientific material came to the attention of European scholars, again largely through contact with Muslim scholars. Further, for example in Bologna, legal studies received new impetus. All of this, coupled with the exploding population of the new cities and the consequent complexity of life, created a demand for a new, intellectual class who could bolster the cultural and socioeconomic foundations of medieval society.

The Hundred Years' War

The Hundred Years' War really lasted more than one hundred years. It consisted of an intermittent struggle between England and France which involved periodic fighting over the question of English fiefs in France, fighting that had begun in the twelfth century. The series of ongoing battles concerned a number of issues, including the rightful succession to the French crown, and are traditionally thought to have begun in 1337 and lasted until 1453.

In the medieval world, one king might, in fact, serve as the vassal of another king if the first king inherited land that lay within the claim of the second. Such occurred in Europe, particularly in England and France after William I, the Conqueror and Duke of Normandy, had conquered and become king of England in 1066. William's successor English kings laid claim to portions of France, and marriages and other alliances complicated the picture. We call the ensuing conflict the Hundred Years' War.

As in modern warfare, medieval wars occasionally consisted of massed armies pitted in battles, a victory in which might prove decisive. More often, however, they consisted of lengthy and expensive sieges of important

fortified cities (Fig. 8.4). For approximately twenty-seven years from 1337, the English kept a military presence in France, but did not gain much territory in the process, although they won some battles—for example, at Crécy (kray-SEE) in 1346 and Poitiers (pwah-TYAY) in 1356. The French then offered a settlement to the English granting full sovereignty over lands formerly held.

In 1429, inspired by Joan of Arc (see Profile, p. 242), the French broke the English siege of Orléans (awr-lee-AWN). While the War of the Roses preoccupied the English at home, France conquered Normandy and Aquitaine, and by 1453, Calais remained as the only English territory in France, and that too was relinquished in 1458. The end of the Hundred Years' War heralded the end of English adventurism on the Continent and contributed to a new sense of national identity in western Europe.

The Plague

Known as the Black Death, the catastrophic plague that ravaged Europe between 1348 and 1350 consisted of a combination of bubonic and pneumonic plagues. The epidemic, which eventually claimed more than 2.5 million lives, originated in China and spread to Europe probably by traders. The first cases of the disease occurred in the Crimea, then in Mediterranean ports in Sicily, north Africa, Italy, Spain, and France, before engulfing the European continent and England. Although it officially came to an end after three years, outbreaks recurred for the next fifty years.

The devastation from the disease appeared to have no logic—for example, Milan and Flanders suffered little, while other places, such as Tuscany and Aragon, suffered decimation. Those areas with the densest populations— for example, large cities and monasteries—suffered most. Neither rank nor station offered sanctuary—kings, queens, princes, and archbishops felt the sting of the plague's effects as much as peasants and merchants. In total, nearly one-third of the entire population of Europe died from the disease in the three-year period. By 1400, for example, the population of England had declined to one-half of what it had been a century before, and chroniclers estimated that the disease completely wiped out a thousand English villages.

The plague had wide ramifications. Commerce slumped temporarily, but more importantly, the death of so many people made cultivation of the land nearly impossible. In order to stay afloat, many landowners had to begin to pay wages and to substitute money rents in lieu of labor services. The shortage of workers thus led to an increase in wages for both peasants and artisans and tended to break down the previous stratification of society. In short, the devastating effects of the plague changed the landscape of Europe.

TECHNOLOGY

A BETTER HORSE COLLAR

In the Middle Ages, the horse came into its own as a technological tool. Horsepower was the most universally available source of power known to humankind, although in the medieval period, the horse was seen primarily as a means of carrying knights and their retinue. However, the horse offered potential for both transportation and agriculture. The first horse harnesses unsuccessfully used the ox yoke as a model, but horses do not have the prominent and powerful shoulders of the ox. The next step consisted of a breast-band, which held the harness down by means of a strap passing between the legs to a girth-band. This device chafed the horse, and, when heavy loads were pulled, the breast-band caused choking pressure on the horse's neck and windpipe. Even the ingenious Romans had not been able to invent a useful means for hitching a horse to wagon or plow. In the twelfth century, however, three main improvements occurred. Shafts, which could be attached well down the breast-band, came into common use. Next, traces—that is, side straps or chains to connect the animal to what it is pulling—served in the same way as shafts to bring the pressure to the middle of the breast-band, and made it possible to use horses in file, as opposed to side by side. However, the most important invention was that of the padded horse collar. This stiff apparatus replaced the breast-band and made it possible for the horse's power to be multiplied by as much as five times over the old method. Thus, the horse came into its own as a technological device. Modern horse carts were developed in France, and the horse replaced the ox for pulling plows and carriages. As a result, effective agriculture and land-based trade were just a step away.

8.3 Two-wheeled cart, from the Luttrell Psalter.

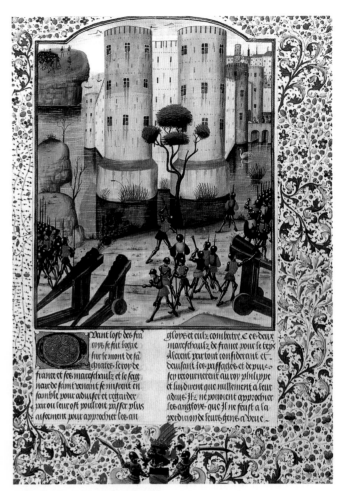

8.4 Jean de Wavrin, *Chroniques d'Angleterre*, showing cannons used as siege weapons, fifteenth century. Bibliothèque Nationale, Paris.

The Great Schism

By the end of the Black Death, religious penitents commonly took to the roads, flagellating each other and prophesying the end of the world. The *dance of death* (see the Dance section) emerged with skeletal figures leading knights, burghers, and peasants to the grave. The increasing secularism in government, which separated the Church from the European monarchies, did not diminish the weight of medieval Christianity on the lives of individuals. The simple faith of someone like St Joan stood side by side with the fanaticism of the Inquisition and the burning of witches and heretics. Pogroms against Jews and the persecution of all individuals believed in league with Satan occurred regularly. Charged with maintaining the purity of Christian thought, the Holy Office of Inquisition used any means necessary—including torture—to obtain confessions from all those accused of heresy. Those branded as enemies of Christ and unrepentant found themselves turned over to the civil authorities and burned alive.

PROFILE

JOAN OF ARC (1412–31)

It is fair to say that Christianity was the heart of medieval European culture, and the life and death of Joan of Arc (Fig. **8.5**) illustrate that circumstance poignantly. Born in a small village in northeastern France, St Joan was a pious but illiterate woman growing up in the middle of the Hundred Years' War. When she was seventeen years old, she began to hear heavenly voices telling her to save her country from the unending ravages of war. With childlike belief and obedience, she left home and family and traveled to the court of King Charles VII. The king was a particularly uninspiring presence—and, at the time, uncrowned—but somehow Joan was able to pick him out from the hundreds of his courtiers. Her simple faith and straight-forwardness convinced the unhappy monarch that she should be allowed to join the French army, which was massing for a major battle with the English.

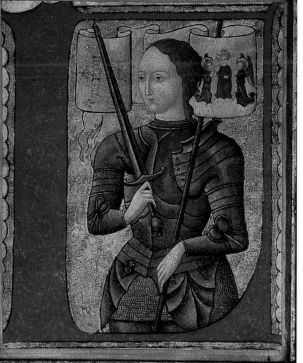

8.5 Joan of Arc (1412–31).

Her presence among the troops lifted their morale and inspired them to victory after victory, from breaking the siege at Orléans to the battle of Reims. After the victory at Reims, Charles was formally crowned at the cathedral there in 1429. Victories inspired by The Maid, as she was universally called, provided a focus for the French, who rallied to the support of the newly crowned and anointed king. After Charles' coronation, Joan ceased hearing her voices. That, for her, meant that her mission had ended, and she wished to return home. The king, however, recognized the powerful symbol she represented and kept her in his service, sending her to lead the French troops marching on Paris, which was still held by the English. The attack failed, and Joan was captured by England's Burgundian allies and sold to the English.

Joan was tried for witchcraft by an ecclesiastical court subservient to the English, found guilty, and burned at the stake in Rouen on 30 May 1431.

Twenty-five years later she was declared innocent by the Inquisition, after a lengthy re-trial process which began shortly after the French finally drove the English from Rouen, thereby allowing access to the documents and witnesses associated with her trial. The presiding Inquisitor, Jean Bréhal, ruled that the original trial had been tainted by fraud, illegal procedures, and intimidation of both the defendant and many of the clergy who had taken part, and described Joan, therefore, as a martyr. After the usual lengthy delay associated with the sluggish process of canonization, the Church beatified her on 11 April 1909 and canonized her as a saint on 16 May 1920.

Although her public career lasted only two years, half of which was spent in prison after her capture, Joan remains one of the most potent symbols of the age: mystical, charismatic, faithful, courageous, and enigmatic. Although she did not actually command troops, she knew exactly when and where to make her appearance felt in order to inspire and turn the tide of battle. She believed completely in her voices—St Catherine and the archangel Michael—and obediently followed their commands, regardless of the circumstances. In many ways, this obedience to the faith was typical of the times. She said that her voices called her a "daughter of God," and no one questioned the powers that drove her, although the English called her "a disciple and limb of the Fiend."

These excesses went hand in hand with sincere and deep mystical faith among the laity. By this time the Christian Church had well established its creeds, resulting in a faith that was much more elaborate than the simple virtues of Pauline (referring to St Paul) Christianity (faith in Christ, hope of salvation, and charity toward one's fellow human beings). The medieval Church recognized seven deadly sins (compare the discussion of Tertullian, Chapter 5): pride, greed, envy, sexual self-indulgence, violence, laziness, and gluttony. Religious duties formed essential parts of life. The sacraments brought the Church into the events of everyday life. They also provided penance and absolution for sins, conferred spiritual powers on ordained clergy, and celebrated the communion of believers with their savior in the central Christian mystery of the Mass.

In the fourteenth century, the papacy fell to its nadir. The once mighty and independent popes came under the influence of the French kings, who moved the papal see to Avignon (ah-veen-YAWN) in southern France. The force of the French monarchs humiliated the office of pope and caused what we call the Great Schism in 1378. During this schism, groups supporting diverse claimants to the papal throne fought each other, and for several decades two and even three aspirants to the papacy fought with and excommunicated each other in what bewildered lay people saw as a complete degradation of the Church. In 1417 the Council of Constance, convened by the Holy Roman Emperor, deposed three pretenders and reunified the papal see at Rome.

The tragedy of the Great Schism, also called the Babylonian Captivity (a term paralleling the Avignon papacy with the Hebrews' captivity in Babylon), brought increased demands for reform, especially to free the papacy from the control of French monarchs. In England in the mid-fourteenth century, the reformer John Wycliffe (WY-klihf; 1328?–84) sought to cleanse the Church of its worldliness. He argued for the abolition of all Church property, the subjugation of the Church to secular authority, and the denial of papal authority, although his greatest achievement proved the inspiration of a scholarly translation of the first Bible in English. The Church branded Wycliffe's followers as heretics. Secular authority thus persecuted and punished them. Wycliffe's influence spread as far as Bohemia via reformers in the Holy Roman Empire who had met him at Oxford University. In the hands of pietistic Christians and evangelical preachers and theologians such as John Huss (huhs; c. 1369–1415), the reform movement spread. Huss, to whom modern-day Moravian Brethren trace their heritage, accepted some of Wycliffe's teachings and rejected others. He attended the Council of Constance, but, again, the Church authorities held his views as heretical and burned him at the stake. His martyrdom

inspired his followers, many of whom, wealthy nobles, in turn used his beliefs as a vehicle for Czech nationalism against the German emperors and the Roman Church.

The Crusades

Many have the notion that the Crusades featured knights in shining armor setting out on glorious quests to free the Holy Land from Infidels. Far from romantic quests, however, the Crusades do illustrate a new and practical energy and optimism in Europe as it crossed the millennium. As early as the tenth century, in the feudal period (see Chapter 7), popes had sent armies against the Saracens in Italy. By the end of the eleventh century, the Church promulgated several reasons why a Christian army might march against the Muslims. Constantinople had been rescued from the Turks, and a healing of the East–West split seemed possible. Furthermore, pilgrimages to the Holy Land as a form of penance had become increasingly popular in an age of religious zeal, and the safety of pilgrims provided ample reason for interference by the popes. A more practical benefit closer to home involved the removal of troublesome nobles from the local scene. An opportunity arose at the Council of Clermont in 1095. When envoys of the Eastern Emperor Alexis Comnenus (see Chapter 6) supposedly asked Pope Urban II for aid, Urban set about mounting a crusading army. In response to his call, astonishingly, thousands came forward to take up the cross. Men, women, and children—even the disabled—clamored to take part, and all, nobles included, went marching as to war (Maps 8.1 and 8.2).

The reasons for the First Crusade went far beyond its political and military objectives. Its impetus rose from the religious enthusiasm of those who made up the crusading army. In hand with the mysticism and asceticism of the time, which we examined in Chapter 7, people wanted to make significant sacrifices for their faith. The idea of a crusading army generated such a tremendous emotional response that even the Pope could not control it. Itinerant preachers heralded an upcoming Crusade in their revival meetings. No one cared about the practical problems— this constituted an act of faith and piety. The infidels would scatter in fear before the banner of the cross. The walls of fortresses would come tumbling down like those of the biblical Jericho. The First Crusade ultimately led to the capture of Jerusalem and a bloody massacre. The Second Crusade set out in 1147 but ended in disarray and defeat. After that, Europe lost its enthusiasm for such ventures, but only for a generation.

The Muslims, for whom Jerusalem also constituted holy ground, gathered their forces and set about driving out the Christians. On 3 October 1187, led by Saladin, the Muslims reconquered Jerusalem, ending eighty-three years of Christian rule. The news shocked Europe, and

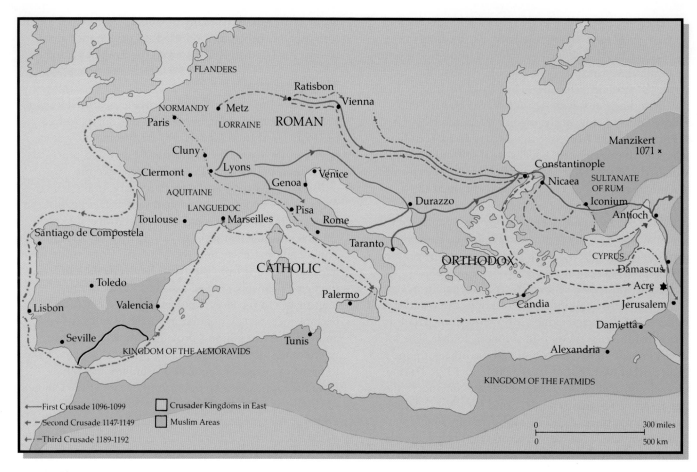

Map 8.1 The Crusades.

again the Pope took the opportunity to attempt to make peace among warring nobles in Europe by sending them on a Crusade. Henry II of England and his son Richard, Philip Augustus of France, and Frederick Barbarossa of Germany all took up the cross. Well-planned, well-financed, and led by the most powerful rulers of Europe, the Third Crusade set off in high spirits, with high expectations. But one disaster after another befell the crusaders. As their sole major accomplishment, they managed to capture Acre after a two-year siege. The Fourth Crusade (1202–04), diverted by the ambitions of the Doge of Venice (see discussion on the Doge's palace, p. 262), succeeded in capturing Constantinople, massacring its inhabitants, and establishing a Latin empire in Byzantium (which had not been the point of the venture). The Fifth (1218–21), Sixth (1248–54), and Seventh (1270) Crusades ended up in Egypt or in Tunis, where St Louis of France himself died of the plague. When the last Christian stronghold, Acre, fell to the Muslims in 1291, Europe could muster no coherent response.

The Crusaders conducted themselves despicably, their behavior denounced by St Bernard. They ravaged the countries through which they marched—including Christian countries. In 1096 they killed upward of 8,000 Jews in the Rhineland of what is now Germany. They despoiled their own economies and lands. Richard the Lionheart said, "I will sell the city of London if I can find a buyer." Nonetheless, the Crusades masked deeper motivations: the Crusaders' religious fervor was mixed with the resentments of a society suffering the effects, for example, of famine and plague. Alongside the religious zealot and the well-fed knight came a horde of paupers trying to sublimate a miserable existence. "Children's Crusades," "People's Crusades," and "Shepherds' Crusades," for example, continued long after the official campaigns had ended. Jerusalem rose like the visionary city of Revelation, where Christ beckoned.

The Crusades, however, had wide-reaching effects. They reopened the eastern Mediterranean to trade and travel. Italian port cities like Genoa and Venice flourished. The Roman Catholic Church witnessed a consolidation of its collective identity under the popes. The exploits of heroes provided a vast reservoir of material for medieval romance, philosophy, and literature. On the other hand, the misconduct of the

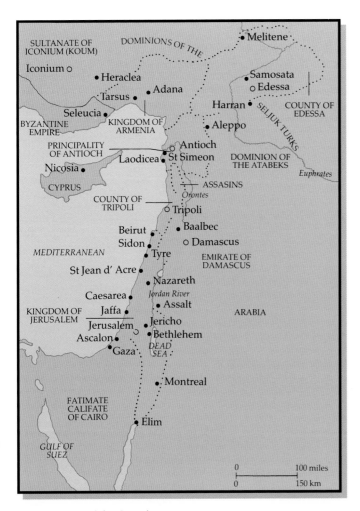

Map 8.2 Areas of the Crusades.

proves a good example of how well women accepted and accomplished these tasks, by ranking as one of the period's most significant rulers. Society, as a result, assumed a gentler, more civil tone than that of the rough code of feudalism. Elaborate codes of conduct and etiquette emerged, which culminated in "courts of love," and gave rise to a literary form called the romance (see the Literature section), whose subject matter treated chivalric adventure and religious allegories.

The courtly tradition had an important impact on religious philosophy as well. The feudal period fixated on death and devils, as we noted in Chapter 7, faith notwithstanding. As time passed, however, a warmer

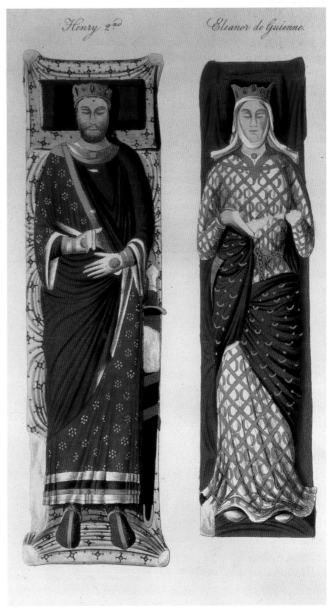

8.6 Effigies of Eleanor of Aquitaine and her husband, Henry II of England. Nineteenth-century lithograph.

"Latins" so disgusted the Greeks that it rendered reunification of Christianity impossible. Finally, of course, the Crusades built an unbreachable wall between Christians and Muslims, with Christians viewed as barbaric aggressors and, ultimately, losers.

CONCEPTS

Chivalry
The end of the twelfth century witnessed another medieval phenomenon resulting in a change of attitude that permeated society, the Church, and the arts. We cast feudalism as a masculine, "men-at-arms" code of behavior. Slowly, however, a distinctly feminine point of view emerged in ethics and personal conduct—that of chivalry and the courtly tradition. Men, away from home and castle for long periods of time, whether trading or warring, left the running of their households and domestic matters and manners to women. Eleanor of Aquitaine (AH-kwih-tayn; c. 1122–1204) (Fig. 8.6)

feeling emerged, a quality of mercy. Christ the Savior and Mary, his compassionate mother, became the focal points of faith. We will see this change clearly in the arts of the time.

Although chivalry introduced a "feminine" ethos into the High Middle Ages, and although some important women such as Eleanor of Aquitaine emerged, in general, women lost many of the independent opportunities and positions of authority they had earlier enjoyed.

In its earliest formulation, chivalry meant mostly the virtues of war—courage, skill with weapons, fairness to one's foes, and loyalty to one's liege lord (Fig. 8.8). However, under the guidance of medieval women, the chivalric code, as just noted, turned to a code of courtly love. The truly chivalrous knight protected women and loved, served, and revered a particular lady, although from afar. Women paid for the services of minstrels, troubadours, and trouvères, and these wandering entertainers suited the tastes of their benefactresses. They composed and sang songs of love, praising knights who served their ladies well.

Secularism

By the fourteenth century, revelation and reason, and God and the state had grown apart into separate spheres of authority, neither subject to the other. Such a separation, of what had previously constituted the full realm of the Church marked the beginning of secularism—a rejection of religion and religious considerations. Individual nations—rather than feudal states or holy empires—had arisen throughout Europe, although it overstates the case to maintain that religion and matters of state had totally divorced. They intermingled freely when the opportunity proved convenient; but they clashed severely when questions of power and authority arose. Secularism had artistic as well as political and religious implications. During the High Middle Ages, secular arts gradually gained prominence, respectability, and significance. All of this, however, represents at this time more a matter of transition, or a shifting emphasis, than an outright reversal of values.

Aristotelianism

The rediscovery of Aristotle by Western scholars in the thirteenth century marked a new era in Christian thought. With the exception of Aristotle's treatises on logic, called the *Organon*, his writings remained inaccessible in the West until the late twelfth century. Their reintroduction created turmoil. Some centers of education, such as the University of Paris, forbade Aristotle's metaphysics and physics. Others championed Aristotelian thought. These scholars asserted the eternity of the world and denied the existence of divine providence and the foreknowledge of contingent events. In the middle of the spectrum, thinkers

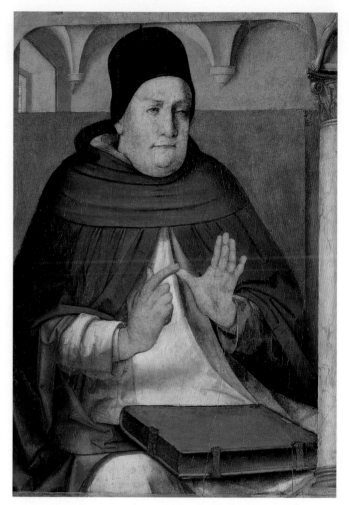

8.7 Joos van Gent and Pedro Berruguete, *Portrait of Thomas Aquinas*, c. 1475. Oil on panel, 44⅞ × 30 ins (114 × 76 cm). Louvre, Paris.

such as Albertus Magnus (1206?–80), though orthodox in their acceptance of the traditional Christian faith, regarded the rediscovery of Aristotle in a wholly positive light. Albertus transmitted his thinking to his first pupil, Thomas Aquinas (1227–74; Fig. 8.7).

In his youth, Aquinas joined the newly formed mendicant Order of Preachers, the Dominican Order. This led him to Paris to study with Albertus, the master teacher of the Dominicans. A prolific writer, Aquinas produced philosophical and theological works and commentaries on Aristotle and the Bible, drawing on the Islamic scholar, Averroes (see p. 233), for some of his Aristotelian work. Like Albertus, Aquinas held to "modernist" thinking, and he sought to reinterpret the Christian system in the light of Aristotle—in other words, to synthesize Christian theology and Aristotelian thought. He believed that the philosophy of Aristotle would prove acceptable to intelligent men and women, and further, that if Christianity were to maintain the confidence of

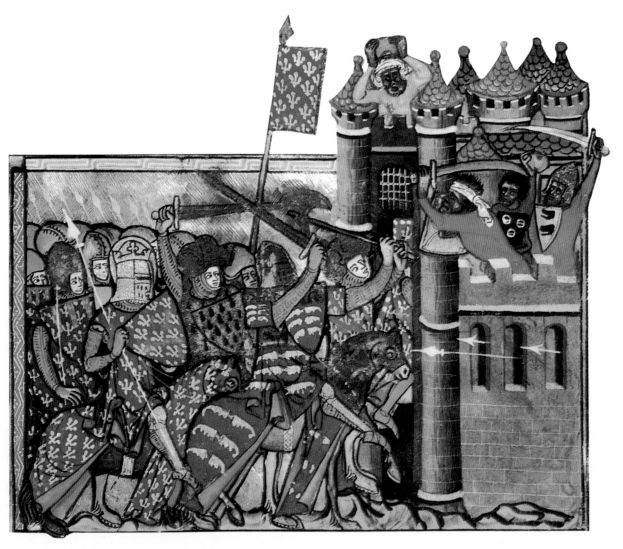

8.8 French knights, commanded by King Louis XI, taking the Egyptian city of Damietta during the Seventh Crusade (1249). MS Fr. 13568. Fol. 83. Bibliothèque Nationale, Paris.

educated people, it would have to come to terms with and accommodate Aristotle. Nonetheless, Aquinas, a very devout and orthodox Roman Catholic, had no wish to sacrifice Christian truth, whether to Aristotle or any other philosopher.

In dealing with Aristotle, God, and the universe, Aquinas carefully defined the fields of theology and philosophy. He limited philosophy to whatever lay open to argument, and stated its purpose as establishing such truth as could be discovered and demonstrated by human reason. Theology, on the other hand, he restricted to the "content of faith," or "revealed truth," which lies beyond the ability of reason to discern or demonstrate, and "about which there can be no argument." Nonetheless, some areas overlapped.

Aquinas concentrated on philosophical proofs of God's existence and nature. The existence of God could be proved by reason, he thought, and Aristotle had

inadvertently done just that. The qualities, to which Aristotle reduced all the activities of the universe, become intelligible only when one believes in an unmovable, self-existent form of being whose "sheer perfection sets the whole world moving in pursuit of it."

Industrialization

The drastic reduction of population resulting from wars and the plague changed the basic shape of the European economy. Wages rose, production declined, and the cost of goods spiraled upward. Consumers and landowners suffered from inflationary pressures, encouraging many landowners to turn to less labor-intensive use of their lands, such as raising sheep rather than growing crops. Governments across Europe attempted to control the situation by imposing price and wage controls.

The precarious living conditions fomented violent class struggles, conflicts between peasants and

landowners, clashes between craft guilds and merchants, and anticlerical outbursts as well. The Church occupied a privileged position—not only did it pay no taxes, but the clergy benefited through the payment of tithes—gaining it further resentment. Although social unrest accomplished little—those protesting had little power and a well-armed officialdom could easily subdue them—the upheavals ultimately created a better standard of living for everyone. Workers earned higher wages, merchants benefited from higher prices, and landowners profited from new uses of their resources. A new class of entrepreneurs also emerged, who established more effective business practices and encouraged innovation and mechanization (Fig. 8.9). The textile industry, for example, changed significantly. Previous textile centers, such as Flanders, lost their sources and faced new competition from Germany and Poland, while England stopped exporting raw wool and began to export finished cloth.

In many respects—for example mining, metallurgy, printing (Johann Gutenberg [GHOOT-ehn-burgh; 1400?–68?] introduced the printing press with movable type around 1450), and shipbuilding—industry became more efficient because of the switch from labor-intensive practices to technology. Demand for iron products—especially weapons, armor, and horseshoes—provided a spur to that industry. Rag paper, invented by the Chinese and perfected by the Arabs, spread from Spain throughout Europe. Together these conditions drastically changed the course of events in Europe. Printing and publishing industries arose, profoundly affecting literature and education.

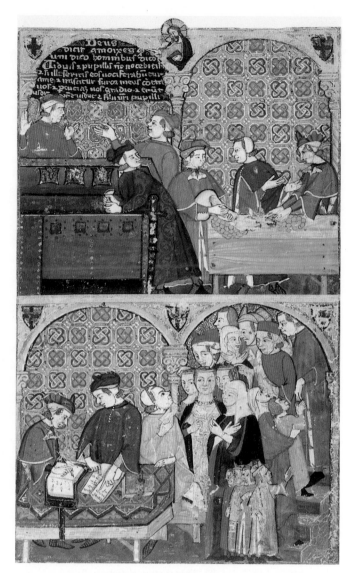

8.9 Banking scenes, miniature from *De septem vitiis*, Italian, late fourteenth century. British Museum, London.

THE ARTS OF THE HIGH MIDDLE AGES

Painting

In the twelfth and thirteenth centuries, traditional fresco painting returned to prominence. Manuscript illumination also continued. Two-dimensional art flowed from one style into another without any clearly dominant identity emerging. Nonetheless, the predominance of Gothic style in architecture makes it possible to identify some characteristics by which we can tie two-dimensional art to Gothic style. First, we find the beginnings of three-dimensionality in figure depiction. Second, we find a striving to give figures mobility and life within an emerging three-dimensional portrayal of space, and space represents the essence of Gothic style. Gothic painters and illuminators had not mastered perspective, and their

compositions do not exhibit the spatial rationality of later works. But if we compare these painters with their earlier medieval predecessors, we discover that they have more or less broken free from the frozen two-dimensionality of earlier styles. Gothic style also exhibits spirituality, lyricism, and a new sense of individuality. In other words, it favors mercy over irrevocable judgment, shows less crowding and freneticism—its figures do not entangle each other. Gothic style in two-dimensional art represented a changing character with many variations.

We see these characteristics represented repeatedly in manuscript illustration stretching into this period. Manuscript illuminators typically stylized body parts such as hands and heads, and used decorous treatment of fabric juxtaposed against linear items such as furniture,

248

leaving the works with a sense of tension. As noted in the manuscript illuminations studied in the last chapter, arrangements seem almost careless. The illuminators intend symmetry, but their imprecision seems to fall short of achieving it. As we saw, rudimentary attempts at lifelikeness and three-dimensionality appear through the use of highlight and shadow, but figures still seem out of balance in their interior spaces. Nonetheless, by the Gothic age, figures seem to have space to move and do not crowd their borders.

The end of the thirteenth century produced an outburst of creative activity in Italy destined to influence future painting profoundly. When the Fourth Crusade sacked Constantinople in 1204, it reinvigorated the Byzantine influence in Italian painting that had stayed alive during the earlier years though never strayed further north. The "neo-Byzantine" style, or "Greek manner," prevailed in Italy throughout the thirteenth century, and when the Gothic style of northern Europe mixed with the "Greek manner," it produced a revolutionary approach exemplified by Giotto (JAH-toh; c. 1266–1336/7), as we shall see shortly. First, however, we need to examine two artists, one who represents the Greek manner, Cimabue (chee-mah-BOO-ay; c. 1250–1302), and one who provides a transition into the Gothic style, Duccio (DOOT-choh; c. 1255–1319).

Cimabue created very large tempera panels. Tempera comprises a painting medium in which egg yolk acts as a binder for the pigment, and artists usually applied it to panels prepared with a coating of gesso, a smooth mixture of ground chalk or plaster and glue. An application of gold leaf and an underpainting in green or brown preceded the application of the tempera paint. Cimabue painted panels larger than anything that had been attempted in the East, and they further differed from Byzantine works (see Chapter 6) in the severity of their design and expression. The very form of *Madonna Enthroned* (Fig. 8.10) embodies an upward-striving monumentality, and the gabled (triangular) shape differs from anything done in Byzantium. Designed for the high altar of the church of Santa Trinità (tree-nee-TAH), the work rises over 12 feet (3.7 meters) in height. Its hierarchical design (see Chapter 6) venerates the Virgin Mary (as we discussed earlier in the section on chivalry) and places her at the very top center, surrounded by angels, with the Christ Child supported on her lap. Below her elaborate throne, four half-length prophets display their scrolls.

The verticality of the composition draws reinforcement from rows of inlaid wood in the throne and from ranks of angels rising, one behind the other, on either side. The figures in the top rank bend inward to reinforce both the painting's exterior form and the focus on the Virgin's face. The delicate folds of the blue mantle and

dark red robe, highlighted with gold, encircle the upper torso, drawing attention to the Madonna's face and to the Child. In a convention also appropriate to the theology of the time, the painting depicts the Christ Child as a wise and omniscient presence, with a patriarchal face older than his infant years. The clean precision of the execution gives the work a fineness and lightness that recall Byzantine mosaics.

A few years later, the Italian artist Duccio portrayed the same subject matter in a similar scheme but with significant differences (Fig. 8.12). Duccio softens the frozen, Byzantine linearity of Cimabue—his roundness

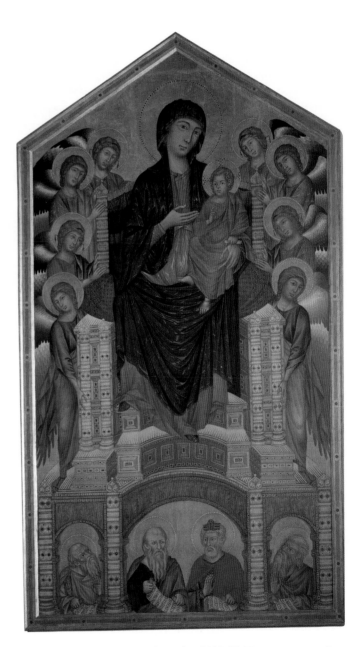

8.10 Cimabue, *Madonna Enthroned*, c. 1280–90. Tempera on wood, about. 12 ft 7½ ins × 7 ft 4 ins (3.84 × 2.24 cm). Uffizi Gallery, Florence, Italy.

MASTERWORK

GIOTTO—*THE LAMENTATION*

A new sense of space, three-dimensionality, and mobility are clear in Giotto's masterpiece *The Lamentation* (Fig. **8.11**). The figures are skillfully grouped in a simple, coherent scene. Giotto's fabrics retain a decorative quality from an earlier time, but they also show an increased realism. Although the figures are crowded, they still seem free to move within the space. For all its emotion and intensity, the fresco remains human, individualized, and controlled. What makes the fresco so compelling is Giotto's unique mastery of three-dimensional space. He employs **aerial perspective**—that is, the use of haze and indistinction to create a sense of distance—for the background, but unlike other painters, who created deep space behind the primary focal plane, Giotto brings the horizon to our eye-level. As a result, we can move into a three-dimensional space that also moves out to us.

In summary, Giotto was a radical innovator whose dramatic departures made him among the giants of visual art and overshadowed those who followed immediately in his footsteps.

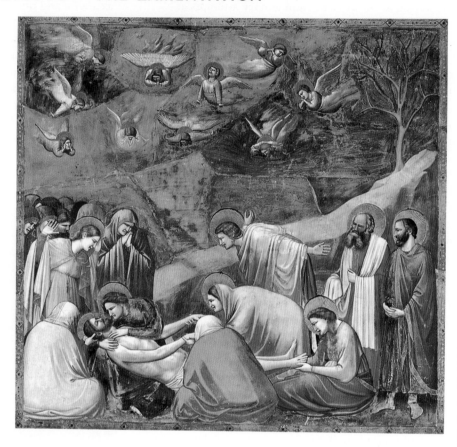

8.11 Giotto, *The Lamentation*, 1305–06. Fresco, 7 ft 7 ins × 7 ft 9 ins (2.31 × 2.36 m). Arena Chapel, Padua, Italy.

of form and treatment of fabric reflect Roman characteristics—and gives it a Gothic three-dimensionality. The tender emotion exchanged between mother and child stands in contrast with Cimabue's formal, outward stares of the principal figures. The Sienese called this painting the maestà (mah-ays-TAH) or "majesty," thus identifying the Virgin's role as Queen of Heaven. Unlike Cimabue's vertical composition, Duccio's work flows outward in a horizontal format, increasing the size of the celestial court and adding small compartments with scenes from the lives of Christ and the Madonna. The composition itself reflects a new

treatment of space, giving us the sense that space envelopes the figures rather than the figures sitting on the front edge of a two-dimensional plane.

Despite the advances of Cimabue and Duccio, it remained for Giotto to take far bolder and more dramatic steps. Perhaps less close to the Greek manner than his predecessors, Giotto undertook wall painting on a monumental scale (see Masterwork, *The Lamentation*, Fig. **8.11**). He also painted in tempera on panel. Giotto's treatment of the same subject as Duccio and Cimabue—*Madonna Enthroned* (Fig. **8.13**)—gives us another means by which we can learn to identify the subtleties of style

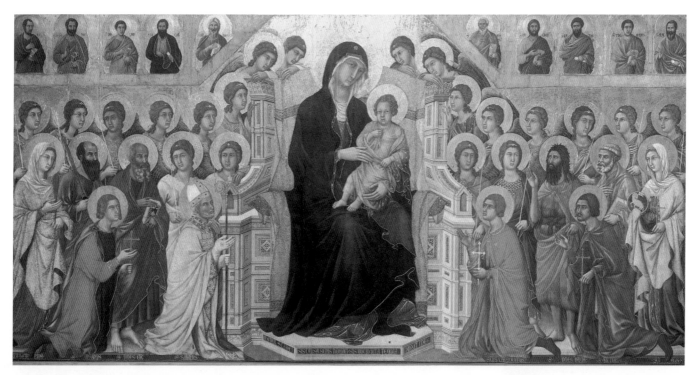

8.12 Duccio, *Madonna Enthroned*, center of the *Maestà* altar, 1308–11. Tempera on panel, 6 ft 10½ ins (2.1 m) high. Museo dell' Opera del Duomo, Siena, Italy.

that differentiate one artistic vision from another. In the first place, we find in Giotto's treatment a greater simplification of the subject matter and supporting details. The central focus has even more humanity, warmth, and three-dimensionality than the other two works, and it has a sense of drama, heightened by the fact that Giotto takes a lower viewpoint—the viewpoint of the observer relative to the space in the painting—than Duccio or Cimabue. Giotto innovates by defining the actual confines of the painting more by the figures than by the architectural details, and although such a perspective tends to lessen depth of space, it nevertheless gives a more dynamic quality to the work. The figures come to life for the viewer.

Giotto created what amounted to an entirely new treatment of space, giving the surface of the painting a new appearance. In the past, composition tended to lead the eye from one specific form to another. Giotto, by contrast, takes our eye and allows us to grasp the entire work at one time, and the composition achieves an inner unity through strong simple groupings of figures.

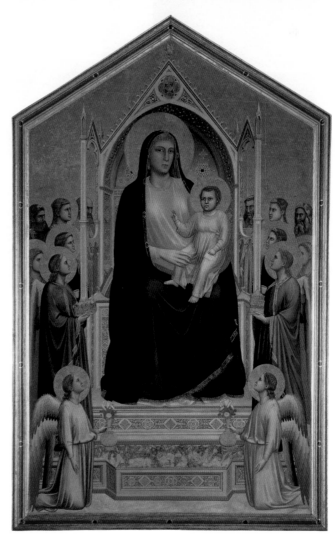

8.13 Giotto, *Madonna Enthroned*, c. 1310. Tempera on panel, 10 ft 8 ins × 6 ft 8 ins (3.25 × 2.04 m). Uffizi Gallery, Florence, Italy.

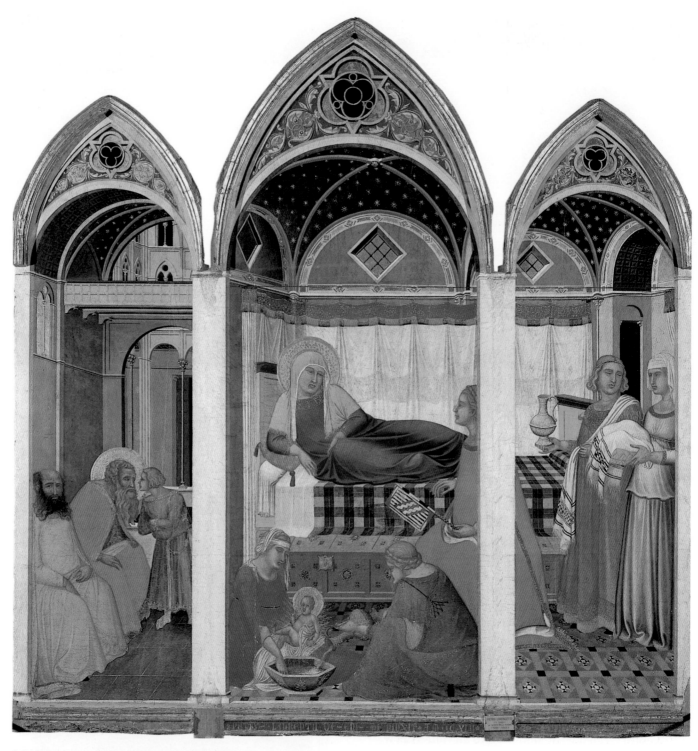

8.14 Pietro Lorenzetti, *The Birth of the Virgin*, 1342. Panel painting, 6 ft 1½ ins × 6 ft ½ in (1.87 × 1.84 m). Museo dell'Opera Metropolitana, Siena, Italy.

The throne, based on Italian Gothic architecture, encloses the Madonna and cuts her off from the background. In another innovation, Giotto takes great pains to create a fake texture in the colored marble surfaces. The creation of false textures had not been used in painting since early Christian times, and Giotto's reintroduction of this approach attests to his familiarity with ancient Roman wall paintings similar to those we studied in Chapter 4.

Pietro Lorenzetti (lawr-ehn-ZEHT-tee; -ZAY-tee; d. c. 1348), an artist who followed Giotto, succeeded in creating his own revolutionary approach to space. *The Birth of the Virgin* (Fig. **8.14**) represents a bold attempt to solve the problems of space and to create a unified and flowing compositional picture. In contrast to Giotto's sculptural space, we find a new sense of architectural picture space. The highlight and shadow flesh out the lifelike figures, faces, and garments, with the treatment of draping fabric in the gowns in the right panel showing precise attention to detail. We have a sense of looking in on a scene in progress, rather than at a flat, frozen rendering. The scene has a relaxed atmosphere, drawing the eye across the work in a lyrical sweep. The artist has spaced the figures comfortably, and the whole picture, which continues behind the columns separating the panels, spreads throughout the triptych (a devotional picture with a central panel and two flanking, hinged wings).

Sculpture

Gothic sculpture again reveals the changes in attitude of the period. It portrays serenity, idealism, and simple lifelikeness. Gothic sculpture, like painting, reflects a more human quality than its predecessors. Life now seems more valuable. The vale of tears, death, and damnation gives way to conceptions of Christ as a benevolent teacher, and of God as awesome in his beauty rather than in his vengeance. Visual images carry over a distance with greater distinctness and show a new order, symmetry, and clarity. The figures of Gothic sculpture step out of their material and stand away from their backgrounds.

Schools of sculpture developed throughout France. Thus, although individual stone carvers worked alone, their links with a particular school gave their works the character of that school. The work from Reims (rans), for example, had an almost classical quality; that from Paris showed a dogmatic and intellectual quality, perhaps reflecting the role of Paris as a university city. As time went on, sculpture became more lifelike. Spiritual meaning gave way to everyday appeal, and sculpture increasingly reflected secular interests, both middle-class and aristocratic.

Compositional unity also changed over time. Early Gothic sculpture remained subordinate to the overall design of the building. Later work began to claim attention on its own.

The content of Gothic sculpture also bears noting. Like most church art, it was *didactic* (designed to teach) with straightforward lessons, as illustrated by the Last Judgment tympanum above the central portal of Saint-Denis Cathedral (Fig. **8.15**). Christ the judge dominates everything. He reveals his two natures as Son of God and Son of Man. As judge, he summons the dead to appear from the grave, depicted in the lintel below his feet. We also see him at the moment of crucifixion with outstretched arms and his right side bared, showing the mark of the spear. Surrounding the central figure we see angels trumpeting the awakening of the dead, scenes of Heaven and Hell awaiting the blessed and the damned, and the Apostles, seated together to represent the Last Judgment. They converse with each other in their role as teachers.

Other lessons of Gothic cathedral sculpture have significant complexity with far less obvious messages. Some scholars believe that this art exhibits specific, arcane conventions, codes, and sacred mathematical calculations. These formulas govern positioning, grouping, numbers, and symmetry. For example, the numbers three, four, and seven symbolize the Trinity, the Gospels, the Sacraments, and the Deadly Sins (the last two both number seven). The placement of figures around Christ shows their relative importance, with the position on Christ's right hand being the most important. These codes and symbols, consistent with the tendency toward mysticism, as well as finding allegorical and hidden meanings in holy sources, grew more and more complex as time went on.

The sculptures of Chartres (shahrt) Cathedral, which bracket nearly a century from 1145 to 1220, illustrate the transition from early to High Gothic clearly. The attenuated figures of the **jamb** statues in Figure **8.16**, from the middle of the twelfth century, display a relaxed serenity, idealism, and simple lifelikeness. They form an integral part of the portal columns, but they also emerge from them, each in its own space. Each figure has a particular human dignity despite the idealization. Cloth drapes easily over the bodies. Detail remains somewhat formal and shallow, but we now see the human figure beneath the fabric, in contrast to earlier works that used fabric merely as a surface decoration.

As human as these figures may appear, the figures from less than a century later show their humanity in a much more profound manner (Fig. **8.17**). Here we see the characteristics of the High Gothic style, or Gothic classicism. These figures have only the most tenuous connection to the building. The figures exhibit subtle

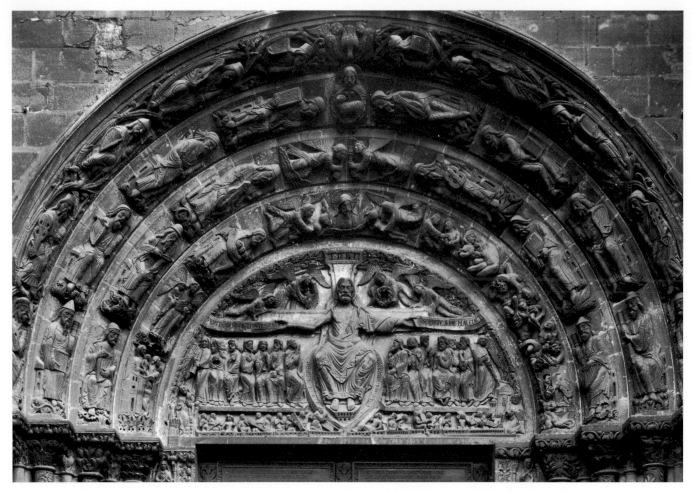

8.15 The tympanum of the west portal, west façade, Saint-Denis. (All heads are nineteenth-century restorations.)

S-curves reminiscent of the ancient Greek sculptor Praxiteles (see Chapter 3) looking more lifelike and less like rigid perpendicular columns than their cousins on the west portal. Fabric drapes more naturally, with deeper and softer folds. In contrast with the idealized portraits of the earlier period, these figures have the features of specific individuals, and they express qualities of spirituality and determinism.

Toward the end of the thirteenth century, the tendency of Gothic sculpture to take traditional Christian themes and give them emotional appeal applied to objects designed to enhance private worship. We call this type of object *Andachtsbild* (AHN-dahkts-bihlt), using the German word because Germanic artists played a leading role in its development. We find its strongest example in the **pietà** (pee-ay-TAH), which derives from the Latin word *pietas*, meaning both "pity" and "piety"; its main representation shows the grieving Virgin Mary holding the dead Christ in her arms. The pietà supplements popular Madonna and Child representations in painting, although nothing in scripture suggests that the Virgin

Mary ever held the body of the crucified Christ in her arms. This tragic scene—full of deep emotion—represents a complete invention of the time. The emotion typical of this genre of sculpture stands out poignantly in a German work from the early fourteenth century (Fig. **8.18**). Here lifelikeness subordinates to emotion achieved through stylization and exaggeration. The forms of Mary and Jesus look remarkably like puppets, and Christ's wounds are exaggerated to grotesque proportions for effect. The work clearly asks the viewer to identify with the horror and grief felt by the Mother of God (compare this with Michelangelo's Renaissance portrayal in Figure **10.22**).

Claus Sluter (SLOO-tuhr; c. 1350–1405) represents a form of Gothic style that reached a climax in northern Europe around the year 1400. Called the International Gothic style—the prevailing style of the late fourteenth century, and popular well into the fifteenth—it portrayed charming or touching subjects in graceful poses with kindly facial expressions and a concern for lifelike details. We see an example of Sluter's work in the portal of the Chartreuse de Champmol at Dijon (shahr-TRUHZ duh

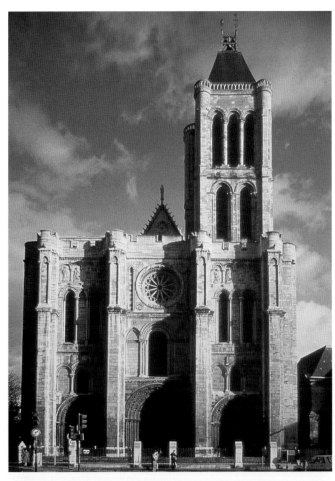

8.23 Exterior of the Abbey Church of Saint-Denis, near Paris, 1137–44.

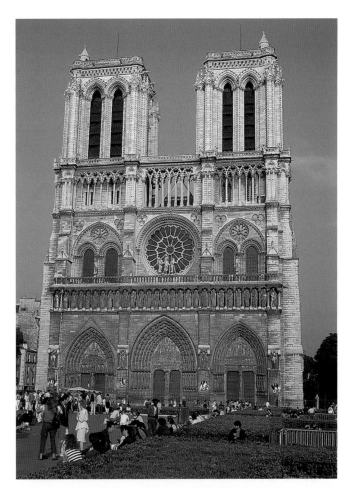

8.24 Notre Dame, Paris, west front, 1163–1250.

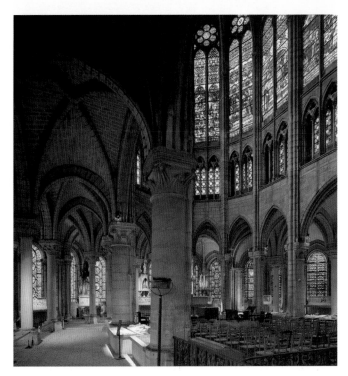

8.25 Interior of the Abbey Church of Saint-Denis.

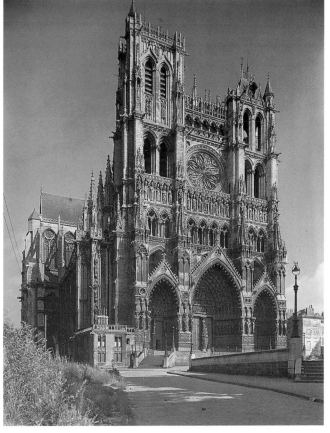

8.26 Amiens Cathedral, France, west front, c. 1220–59.

MASTERWORK

THE STAINED GLASS OF CHARTRES CATHEDRAL

A major difference between the Gothic style and the Romanesque lies in the **fenestration** (fen-uh-STRAY-shuhn). Windows that take the form of sparkling jewels of stained glass, such as the *Notre Dame de Belle Verrière* (nuh-truh dahm duh behl vair-YAIR; "Our Lady of the Beautiful Window"), pierce Gothic-style walls (Fig. **8.27**). Stained-glass windows replaced the wall paintings of the Romanesque and the mosaics of the Byzantine styles. Their ethereal, multicolored light further mysticized the spiritual experience of the medieval worshipper. Light now became an additional property for artistic manipulation and design. The loveliness and intricacy typical of the art of medieval stained glass also appears in the rose window of the north transept of Chartres Cathedral (Fig. **8.28**). In the center, the Virgin Mary sits with the Christ Child on her knee. Around her panels appear grouped together in a series of twelve, an important symbolic number in the Middle Ages (the twelve tribes of Israel and the twelve disciples, for example). Angels, archangels, and four white doves represent the Gospel and the Holy Spirit. In the squares appear the kings of Israel, named by St Matthew as the ancestors of Joseph, while the prophets sit on the outer edge of the window. Every element in the design leads the eye to the focal center, the Virgin and Child. It thereby draws together the Old and New Testaments and Jesus as a descendant of Adam through King David and as the Messiah culminating the old Covenant with the New.

We cannot overemphasize the importance of stained-glass windows in Gothic cathedrals. They

8.27 *Notre Dame de Belle Verrière*, Chartres Cathedral, France.

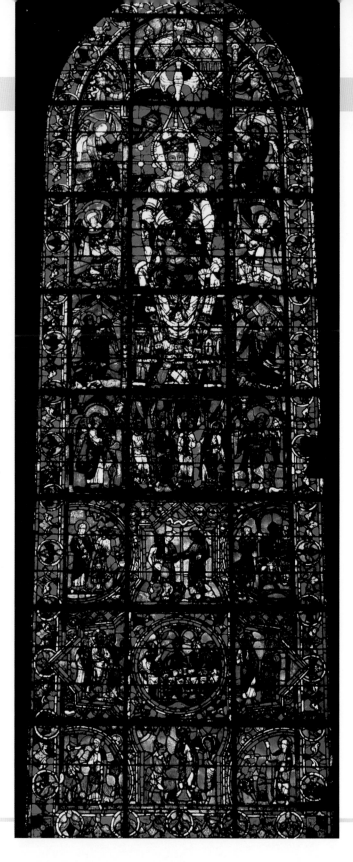

cathedral in Europe's greatest city of the age. Its name (meaning "Our Lady") also reflects the Mary-veneration we have noted before. Notre Dame reflects a highly mathematical design—each level equals the one below it, and its three-part division symbolizes the Trinity. Arcs (the radii of which equal the width of the building) drawn from the lower corners meet at the top of the circular window at the second level. The composition, thus, draws the eye inward and slowly upward.

The Cathedral at Amiens (ah-mee-AHN; Fig. 8.26) has a similar scale and proportion to Notre Dame, but rather than producing a sense of power, it remains delicate. Greater detailing focuses our attention on space rather than flat stone. Both cathedrals divide into three

carefully control the light entering the sanctuary, and the quality of that light reinforces a marvelous sense of mystery. With the walls of the Romanesque style replaced by the space and light of the Gothic style, these windows take the place of wall paintings in telling the story of the Gospels and the saints.

8.28 Chartres Cathedral, France, rose window, north transept, c. 1230. 42 ft 8 ins (13 m) in diameter.

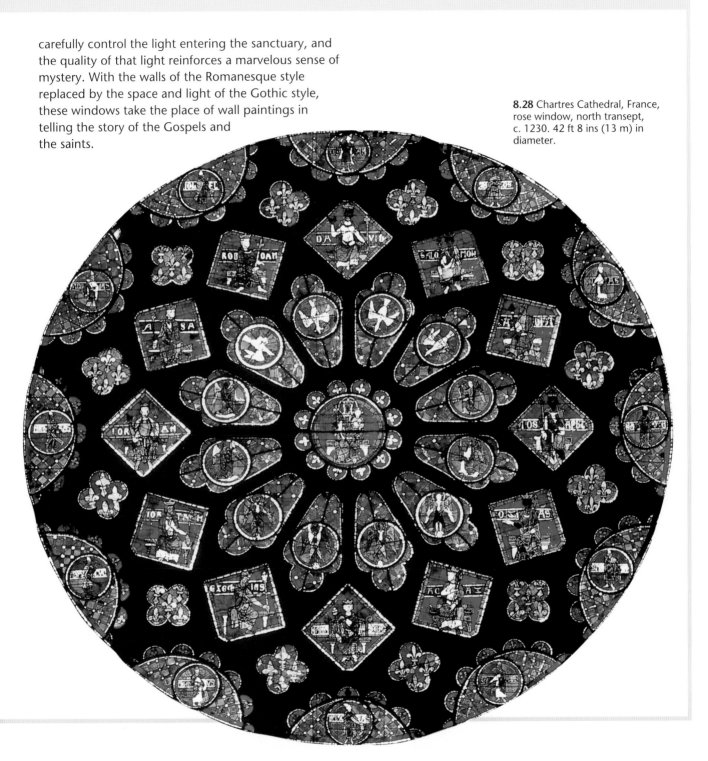

obvious horizontal and vertical sections of roughly the same proportion. Notre Dame appears to rest heavily on its lowest section, the proportions of which diminish by the horizontal band of sculptures above the portal. Amiens, on the other hand, carries its portals upward to the full height of the lower section. In fact, the lines of the central portal, much larger than the central portal of

Notre Dame, combine with the lines of the side portals to form a pyramid whose apex penetrates into the section above.

In Germany, the Gothic style in architecture took much longer to gain a foothold than in other parts of Europe. Most characteristic of the German interpretation of the Gothic style, the hall church or *Hallenkirche*

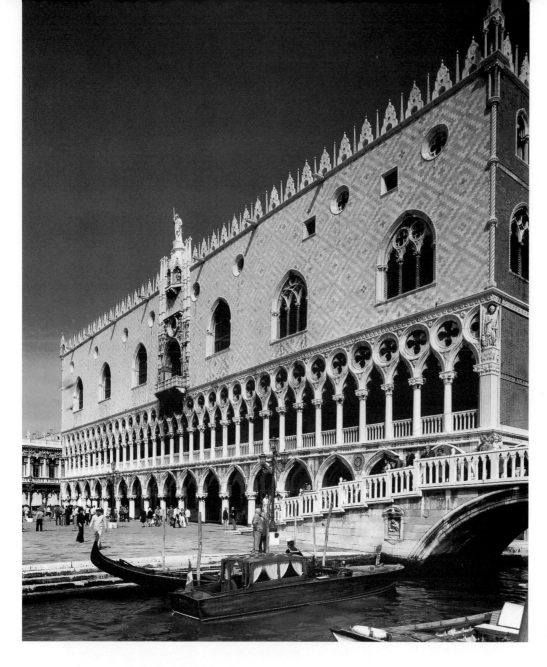

8.29 The Doge's Palace, Venice, Italy, c. 1345–1438.

(HAHL-ehn-kersh) has aisles and nave of the same height, unlike the more traditional Gothic style with high naves and lower aisles in order to allow for clerestory windows in the nave. The large hall choir added to the Church of St Sebald in Nuremberg (Fig. **8.30**) illustrates a typical hallenkirche. Here graceful bundles of columns rise toward pointed arches, flaring outward at the last second into a series of ribs. The tall lancet windows add lightness and delicacy to the feeling of openness that results from the slender columns and seemingly unimpeded space. The design has a simple tone with nothing to interrupt the eye as it travels up the unadorned vertical line to narrow vaults that belie the open expanse below.

The Gothic style also appeared in secular buildings, and we capture glimpses of a late application in Venice, where a unique version of the style developed in the

fourteenth century, particularly in non-religious buildings. The Doge's (dohzh) Palace (Fig. **8.29**) represents a delightful direction in architecture developed specifically for the palaces of the rich and powerful merchant class. Begun in the 1340s, the palace served as a large meeting hall for the *Maggior Consiglio* (MAHG-jawr kohn-SEEL-yoh), the elective assembly of the Republic of Venice. Remarkably for this period, the building has a sense of openness and tranquility, and the absence of fortification reflects the relative peace that the republic enjoyed at the time. The solidity of the upper stories above the open colonnades and an apparent lack of mathematical proportion between upper and lower stories give an almost top-heavy appearance, and the rather squat proportions of the lower arcade detract from the delicacy of the overall design. The curious asymmetry of the façade's fenestration draws attention and piques

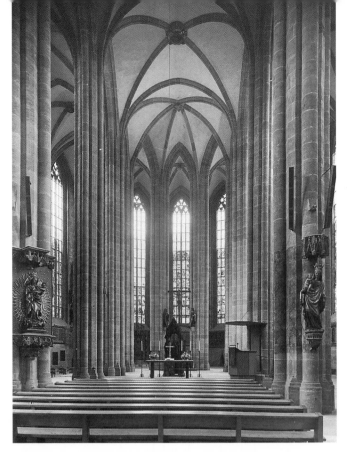

8.30 Choir of church of St Sebald, Nuremberg, Germany, 1361–72.

curiosity. Eastern influences join gracefully with Gothic arches in patterned brickwork. The result illustrates a particularly Venetian inventiveness seen often in the city, as European and Moorish influences intermix.

Theatre

As the Middle Ages progressed, drama associated with the Church followed the example of painting and included more and more Church-related material. Earliest Church drama, the *trope*, comprised a simple elaboration and illustration of the Mass. The subject matter of later drama included Bible stories (mystery plays), lives of the saints (miracle plays), and didactic allegories (morality plays), which had characters such as Lust, Pride, Sloth, Gluttony, and Hatred.

Mystery plays take their name from the Latin word meaning "service" or "occupation" rather than from the word for "mystery." The designation probably refers to the production of religious plays by the occupational guilds of the Middle Ages rather than the "mysteries" of revelation. Dating from the twelfth century, *The Representation of Adam*, the oldest known French mystery play, had three parts, each with written dialogue:

A DYNAMIC WORLD

NOH THEATRE OF JAPAN

Japanese Noh drama came of age in the fourteenth century. Buddhist monks used it as a teaching tool in much the same way as the Christian Church used medieval miracle, mystery, and morality plays. Slowly it became more and more secularized.

Noh drama is performed on a simple, almost bare stage and, like classical Greek tragedy (see Chapter 3), uses only two actors. Also, as in classical Greek drama, actors wear elaborate masks and costumes, men play women's roles (Fig. **8.31**), and a chorus functions as a narrator. Actors chant the highly poetic dialogue to orchestral, musical accompaniment. All the actions suggest rather than depict, which gives the drama its sense of stylization and conventionality, and symbolism and restraint characterize both acting and staging.

The tone of the plays tends to be serious. The plays are usually short, and an evening's performance encompasses several plays interspersed with comic burlesques called *Kyogen* ("crazy words").

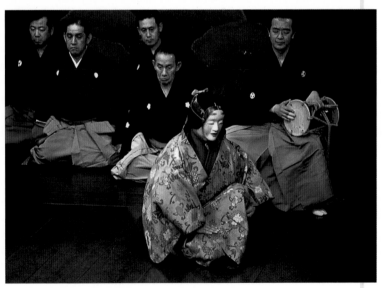

8.31 Performance at the Noh Theatre of the Kongo School, Kyoto.

The Fall of Adam and Eve, the Murder of Abel, and the Prophecies of Christ. Latin instructions, which indicated scenery, costumes, and even actors' gestures, were written into the play: "Paradise shall be situated in a rather prominent place, and is to be hung all around with draperies and silk curtains."

Miracle plays presented a real or fictitious account of the life, miracles, or martyrdom of a saint. Almost all the surviving miracle plays concern either the Virgin Mary or St Nicholas, the fourth-century bishop of Myra in Asia Minor, both of whom had active cults during the Middle Ages. The Mary plays consistently involve her coming to the aid of all who invoke her, be they worthy or wanton. The Nicholas play, similarly, usually chronicle the deliverance of a Crusader or the conversion of a Saracen king.

Tropes, performed in the church sanctuaries, used niches around the church as specific scenic locations. On special occasions, cycles of plays were performed, and the congregation moved to see different parts of the cycle. These dramatizations quickly became very popular.

Over the years, production standards for the same plays changed drastically. At first, only priests performed the roles; later laymen were allowed to act in liturgical drama. Boys usually played female roles, but some evidence suggests that women did participate occasionally. The popularity of Church drama soon made it impractical, if not impossible, to contain the audience within the church building. Evidence also suggests that as laymen assumed a greater role, certain vulgarities appeared. Comedy and comic characters appeared, even in the Easter tropes. For example, on their way to Jesus' tomb, the three Marys stop to buy ointments and cloths from a merchant. This merchant developed into one of the earliest medieval comic characters. The most popular comic character of all, of course, was the devil.

Church drama eventually moved outside the sanctuary. As medieval drama moved out of the church—first to the west porch of the church and then to the city squares—various production practices developed. In France and Italy, the stationary stage decoration of the church interior became a *mansion stage* (Fig. 8.32), so-called because the different areas represented "mansions," or houses. The specific configuration of the mansion stage differed from location to location. In Italy, it was rectangular and linear, designed to be viewed from one or two sides. In some parts of France, *arena staging*, in which the audience completely surrounded the stage area, occurred. Whatever the specific application, the mansion stage had a particular set of aesthetic conventions. The individual mansions depicted their locations realistically. At the same time, areas between the mansions could serve as any location. When the action of a play moved away from a specific mansion,

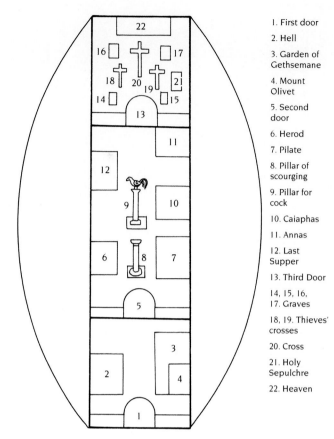

8.32 Plan of a medieval mansion stage, showing the mansions in the Donaueschingen Mystery Play, Germany.

1. First door
2. Hell
3. Garden of Gethsemane
4. Mount Olivet
5. Second door
6. Herod
7. Pilate
8. Pillar of scourging
9. Pillar for cock
10. Caiaphas
11. Annas
12. Last Supper
13. Third Door
14, 15, 16, 17. Graves
18, 19. Thieves' crosses
20. Cross
21. Holy Sepulchre
22. Heaven

the aesthetic became conventional, just as we saw in classical Greek theatre: the stage could represent any place, as opposed to the representation of place found in the mansion. The text of the play conveyed where the action occurred, and the audience then imagined that locale.

Hell, or hellmouth—the mouth of hell into which sinners were cast—proved the most popular feature of medieval theatre. Audiences demanded more and more realism and complexity in the depiction of hellmouth. Descriptions of devils amid smoke and fire, pulling sinners into the mouth of hell, often the jaws of a dragon-like monster typified (Fig. 8.33). One source describes a hellmouth so complicated that it took seventeen people to operate it. Some plays, *Antecriste* and *Domes Daye*, for example, clearly intended to frighten. But in the late Middle Ages, even vividly depicted hellmouths seem to have had comic rather than fearsome intentions. Plays of the period are humorous and compassionate, clearly reflecting the cultural change in attitude.

In England and parts of France and the Netherlands, another staging style developed. Rather than move the audience or set up all the locations in different places on a mansion stage, theatre rolled to the audience on a

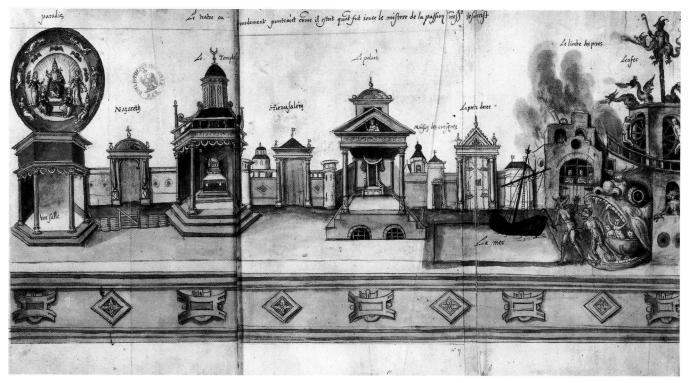

8.33 The Valenciennes Mystery Play, 1547. Contemporary drawing. Bibliothèque Nationale, Paris.

succession of pageant wagons, like the floats of a modern parade. Each wagon carried the set for a specific part of the play cycle. Many of these very elaborate wagons stood two stories tall, with curtains for entrances and exits like a modern theatre. In some cases, a flat wagon combined with an elaborate background wagon to provide a playing area. This type of production appeared mostly in cities where narrow wagons were needed to negotiate narrow streets. At intersections where more space existed, wagons coupled together and crowds gathered to watch a segment of the play. When the segment finished, the wagon moved on, and was shortly replaced by another wagon, which served as the setting for another short play in the cycle.

Theatre, often a static art, proves far more resistant to change than the other arts, which tend to evolve around the vision of a single artist. Theatre, more a group expression, gets caught in its own inertia, and that, certainly occurred in the late Middle Ages. However, one of the most enduring plays, still performed and enjoyed in modern times, came out of this era. No one knows for certain when it originated, because it circulated through the oral tradition before finally appearing in print. Nonetheless, the most famous play of this era—indeed, of the entire Middle Ages—is *Everyman*, an anonymous *morality* play.

Death summons Everyman to his final judgment. Everyman then seeks, as companions on his journey to judgment, the qualities (characters) of Fellowship, Kindred, Cousin, and Goods. Each refuses to join him. He finally asks Good Deeds, but Good Deeds is too weak from neglect to make the journey. Seeking advice from Knowledge, Everyman is told to do penance—an act that revives Good Deeds, who then takes up the journey with Everyman. Along the way, Five Wits also deserts him as he nears the grave. Good Deeds, however, stays with him until the end.

Music

Perhaps as a response to the increasing complexity and additional stability of life, music grew more formal in notation and structure, and also increased in textural complexity. Improvisation had formed the basis of musical composition. Gradually musicians felt the need to write down compositions—as opposed to making up each piece anew along certain melodic patterns with every performance.

The usual way of transmitting music was from performer to performer and teacher to student. Standardized musical notation, however, made it possible for the composer to transmit ideas direct to the performer. The role of the performer thus changed, making him or her a vehicle of transmission and interpretation in the process of musical communication.

In the twelfth century, as Gothic architecture spread out from the Île de France, composers in Paris developed innovations in rhythm. Two composers associated with the cathedral of Notre Dame employed *measured rhythm*, which had definite time values and precise meters. The first of these, Léonin (lay-uh-NAN; c. 1135–1200), used a type of chant for two voices called *organum duplum* (AWR-gah-nuhm DOO-pluhm), in which the lower voice, called the *tenor* (from Latin *tenere*, "to hold"—and not associated with today's tenor, male voice), slowly moved over long held notes, while a higher voice, called the *duplum*, moved more quickly with more notes through the text.

A generation later, Pérotin (pay-ruh-TAN; c. 1170–1236) became the first known composer to use more than two voices in his compositions. In Pérotin's, as in Léonin's work, we find the use of a *cantus firmus* (kan-tuhs FUHR-muhs), or fixed melody—a chant used as the basis for polyphony. Above the fixed melody (*tenor*), in Pérotin's case, we might find two or three additional voices—*organum triplum* or *organum quadruplum*.

Alongside sacred music existed secular songs such as ballades (bahl-LAHD) and rondeaux (rahn-DOH). These vernacular songs used set forms and proved easy to listen to and direct in appeal. Some had a dance-like triple meter. The tradition of the courtly troubadour and the wandering entertainer flourished in the chivalric manner, and the courtly approach found in music and poetry an exquisite forum for its love-centered philosophy.

The fourteenth century witnessed a distinct change in musical style. The new style, called *ars nova* (ahrz NOH-vuh) or "new art," took its name from the title of a book by Philippe de Vitry (vee-TREE; 1291–1361). Music of the *ars nova* expressed more diversity than past music in its harmonies and rhythms. By the early fourteenth century, a new system of musical notation had emerged that allowed a composer to specify nearly any rhythmic pattern. Composers could subdivide beats into two as well as three, and **syncopation** assumed an important role.

Ars nova remained primarily a secular movement because the characteristics of its rhythmic vibrancy did not meet the Church's expectations for worship, and early in the century, the Church forbade any musical elaboration of the Mass that might alter the character of the chant. This had the effect of stifling polyphonic development in sacred music.

France provided the first great exponent of *ars nova* in the priest, poet, and composer, Guillaume de Machaut (ghee-YOHM duh mah-SHOH; 1300–77) who served in the court of King John of Bohemia. Machaut's music in the new style had a smoothness and sweetness, and made increasing use of polyphony. He also used a new

8.34 Examples of cadences.

structural form that gave his compositions unity of style, the *isorhythm*, which repeats phrases in their rhythm but not necessarily in their melody. He also used short fragments of melody to create unity. This technique provided the structural underpinnings for his *Notre Dame* Mass for four voices, written c. 1364 and marking the first complete polyphonic setting of the Mass ordinary by a known composer.

In addition, because his music had a fundamental smoothness and consonance, Machaut could use dissonance for emotional effect. For example, as the words of the Mass describe the crucifixion, the composer underscores them with discordant notes, thereby creating not only beauty but emotional expressiveness.

Machaut also wrote secular poems, often with music, much as the sacred composer Hildegard of Bingen had done (see p. 231). He used a characteristic texture of a solo voice with two instrumental parts forming an accompaniment. Each of his phrases comes to a definite end, called a *cadence* (Fig. **8.34**), sometimes simple and sometimes quite ornamental. An inventive craftsman, Machaut cared as much about the sound of his music as he did about its structure. He followed his watchwords of beauty and feeling, and he once indicated that words and music without true feeling created falsity.

The most celebrated Italian composer of the fourteenth century, Francesco Landini (lahn-DEE-nee; d. 1397), illustrates the new secular impetus of the time. Blind from childhood and a famous organist, poet, and scholar, Landini composed exclusively Italian songs for two or three voices that deal with subjects as diverse as nature, love, morality, and politics. For example, he composed *Ecco la primavera* (AY-koh lah pree-mah-VAY-rah; "Spring has Come") as a *balata* (bah-LAH-tah), an Italian poetic and musical form that originated as a dance-song. The text speaks of the joys of springtime, and its lively rhythms result from the use of syncopation.

Dance

Dance always functioned as part of medieval religious and secular activity, but with the exception of pantomime, examples of which have perished, theatre

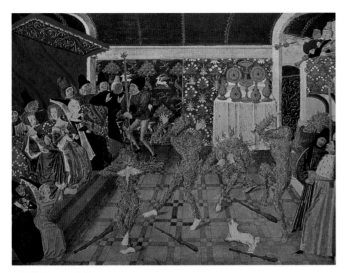

8.35 Netherlandish School, *The Bal des Ardents,* 1393. Illuminated manuscript on vellum. MS Harl. 4380, fol. 1. The British Library, London.

dance played a less important role than forms of group dancing. Fascinating illustrations survive of the "ring dance," for example, in which twelve dancers representing the apostles and the zodiac danced in a circle. Amid the ravages of the plague, the *danse macabre* (dahns mah-KAHB), or dance of death, appeared. Whipped by hysteria, people danced in a frenzy until some dropped dead of exhaustion. *Choreomania* (kawr-ee-oh-MAYN-ee-uh), an English version of the *danse macabre*, seems to have expressed a kind of group psychosis in the throes of which the participants engaged in all kinds of demented behavior, including self-flagellation. Numerous folk and court dances also existed.

The chivalric courtly tradition gave a rebirth to theatre dance. Dances performed at court used instrumental accompaniment. A certain degree of expressiveness and spontaneity marked these court dances (Fig. 8.35), but increasingly they conformed to specific rules. Dance performed in the course of court theatricals employed professional entertainers. The performances depended to a large degree upon the guiding hand of the dancing master—more like a square-dance caller than a ballet master or choreographer.

Literature

Literature of the High Middle Ages reflected, as did the other arts, what some call a Gothic dualism: the pulling apart of ideas split between religion and secularism. Thus, for our investigation, we will divide literature into those two categories.

Religion

Despite a growing secularization in society, the mysticism of the earlier Middle Ages remained very much alive, as Joan of Arc demonstrated. We can see it clearly in the lives and works of four women, Marguerite Porète, Margery Kempe, Catherine of Siena, and Julian of Norwich.

Marguerite Porète (d. 1306) wrote *Le Miroir des simples âmes* (*Mirror of Simple Souls*) sometime between 1296 and 1306. Her verse and commentary form a dialogue between Love, Reason, and the Soul and suggest that the individual moves through seven stages of spiritual growth as it progresses toward union with God. Porète argues that in the last stage the soul need not concern itself with Masses, penance, sermons, fasts, or prayer. Her book was condemned in 1306 and was burned in her presence.

Two years later, accused of continuing to make copies of her book available to others, she was imprisoned in Paris, tried for heresy, and burned at the stake.

The Mirror of Simple Souls, sprawling and episodic, changes quickly from narrative to dialogue. The main speakers, personifications of "Love," "Reason," and "the Soul," discuss sublime matters as one might hear lively discussions on the street: "Oh, for god's sake, love, what are you saying?"; "Reason, you'll always be half-blind"; "Oh, you sheep, how crude is your understanding!" This excerpt is taken from the introduction.

The Mirror of Simple Souls
Marguerite Porète

Introduction

You who would read this book,
if you indeed wish to grasp it,
think about what you say,
for it is very difficult to comprehend;
humility, who is keeper of the treasury of
 knowledge
and the mother of the other Virtues,
Must overtake you.

Theologians and other clerks,
you will not have the intellect for it,
no matter how brilliant your abilities,
if you do not proceed humbly
and make Love and Faith, together,
cause you to rise above Reason
[since] they are the ladies of the house.
. . .
Humble, then your wisdom
which is based on Reason,
and place all your fidelity
in those things which are given
by Love, illuminated through Faith.
And thus you will understand this book
which makes the Soul live by love.

Margery Kempe (c. 1373–1440) was one of the most profound mystics and visionaries of the Middle Ages. Born in Bishop's Lynn, in Norfolk, England, Margery saw herself as a saint who claimed to be on terms with God. Her writings, however, indicate that she had normal conversations with her neighbors and friends.

A pilgrim, she made numerous trips abroad. Although she was illiterate and did not keep any notes or diaries until the end of her life, she possessed an incredible memory, but sometimes she would mistake the sequence of certain events. Her writings contain valuable insights into the details of everyday life in medieval Europe.

The England Margery knew was economically and politically corrupt. The aristocracy lived in incredible luxury while the remainder of English society dwelt amid filth and rubbish. The plague was endemic, and everyone, including the wealthy, suffered the ills of lice, fleas, mites, bedbugs, internal parasites, and rats.

Margery lived during the period of Chaucer and Froissart, but no evidence exists that she had even heard of them. About twenty, she married the burgess of Lynn, John Kempe, also in his twenties. John Kempe, the son of a successful merchant and public official, was also said to be very charming and affectionate. She bore him fourteen children.

Margery made numerous contacts with notable people throughout Europe. People began to hear about her visions and ideologies. She had even been accused of

PROFILE

GEOFFREY CHAUCER (C. 1340–1400)

Born in London, Geoffrey Chaucer (CHAW-sir) came from a prosperous family of vintners who were occasionally connected to the King's court (Fig. **8.36**). We know little of his education, although we do know that he learned Latin and French.

Although we know him as a writer, he appears mainly to have been a successful government employee with a long career as courtier, diplomat, and public servant. In 1359 he was captured and held for ransom while on a military expedition to France. He married in 1366. He traveled in Spain, and entertained in song, stories, and music at the court of the king of England. Traveling to Italy on the king's business he encountered the works of Dante and Boccaccio, and these probably influenced his poetry, especially *The Canterbury Tales*.

Between 1374 and 1386, he created three major works: *The House of Fame*, *The Parliament of Fowls*, and *Troilus and Criseyde*. He wrote his best-known work, *The Canterbury Tales*, over a period of years, mostly after 1387. The large scheme for this work included a band of thirty pilgrims on a journey from the Tabard Inn in Southwark, south of the Thames from London, to the shrine of Thomas à Becket in Canterbury and back again. Each pilgrim had to tell two stories when going and two while returning, but the final work included only twenty-four stories, some of which remain unfinished. The tales are funny, satirical, ironic, insightful, and individualistic in character development; some are philosophical, some thoughtful, and others serious. Altogether, they paint a broad portrait of fourteenth-century life and expectations. The framework resembles that of Boccaccio's *Decameron*, which Chaucer knew, but Chaucer's cultivated irony and robust comedy remain unprecedented.

8.36 Geoffrey Chaucer (c. 1340–1400).

8.37 St Catherine of Siena (1347–80).

heresy, but her powerful friends backed her during heresy trials. As time passed, Margery suffered continual harassment as a heretic. She and her husband spent much time moving around and enduring one heresy trial after another. This all changed during the Great Fire of Lynn in 1421. The town was threatened with total destruction. Priests and other religious figures said that if Margery was indeed under the care of God, then she could save Lynn. Three days later a blizzard came, putting the fire out. People no longer persecuted her after this miracle.

In 1431, Margery followed the news of the trial of Joan of Arc, and only the illness of her husband kept her from going to Joan's aid.

The Book of Margery Kempe
(Transcribed by John F. Tinkler)

On a night, as this creature [i.e. Margery] lay in her bed with her husband, she heard a sound of melancholy so sweet and delectable, that she thought she had been in Paradise, and therewith she started out of her bed and said:

Alas, that ever I did sin! It is full merry in Heaven.

This melody was so sweet that it surpassed all melody that ever might be heard in this world, without any comparison, and caused her, when she heard any mirth or melody afterwards, to have full plenteous and abundant tears of high devotion, with great sobbings and sighings after the bliss of Heaven, not dreading the shames and the spites of this wretched world. Ever after this inspiration, she had in her mind the mirth and the melody that was in Heaven, so much, that she could not well restrain herself from speaking thereof, for wherever she was in any company she would say oftentimes: It is full merry in Heaven.

And they that knew her behaviour beforetime, and now heard her speaking so much of the bliss of Heaven, said to her:

Why speak ye so of the mirth that is in Heaven? Ye know it not, and ye have not been there, any more than we. And were wroth with her, for she would not hear nor speak of worldly things as they did, and as she did beforetime.

And after this time she had never desired to commune fleshly with her husband, for the debt of matrimony was so abominable to her that she would rather, she thought, have eaten or drunk the ooze and the muck in the gutter than consent to any fleshly communing, save only for obedience.

Catherine of Siena (1347–80; Fig. 8.37) was an Italian Dominican, mystic and diplomat, Doctor of the Church. In response to a vision she entered public life and in 1376 influenced Pope Gregory XI to end the Babylonian Captivity of the papacy (see p. 243) and return to Rome. She later served as papal ambassador to Florence. Catherine caused a spiritual revival almost everywhere she went, and her mysticism contains an overwhelming love of God and humanity. *The Dialogue* is a remarkable mystical work.

The Dialogue of the Seraphic Virgin Catherine of Siena
Catherine of Siena

Dictated by her, while in a state of ecstasy,
to her secretaries, and completed
in the year of our Lord 1370

A Treatise of Prayer

Of the means which the soul takes to arrive at pure and generous love; and here begins the Treatise of Prayer. "When the soul has passed through the doctrine of Christ crucified, with true love of virtue and hatred of vice, and has arrived at the house of self-knowledge and entered therein, she remains, with her door barred, in watching and constant prayer, separated entirely from the consolations of the world. Why does she thus shut herself in? She does so from fear, knowing her own imperfections, and also from the desire, which she has, of arriving at pure and generous love. And because she sees and knows well that in no other

way can she arrive thereat, she waits, with a lively faith for my arrival, through increase of grace in her. How is a lively faith to be recognized? By perseverance in virtue, and by the fact that the soul never turns back for anything, whatever it be, nor rises from holy prayer, for any reason except (note well) for obedience or charity's sake. For no other reason ought she to leave off prayer, for, during the time ordained for prayer, the Devil is wont to arrive in the soul, causing much more conflict and trouble than when the soul is not occupied in prayer. This he does in order that holy prayer may become tedious to the soul, tempting her often with these words: 'This prayer avails you nothing, for you need attend to nothing except your vocal prayers.' He acts thus in order that, becoming wearied and confused in mind, she may abandon the exercise of prayer, which is a weapon with which the soul can defend herself from every adversary, if grasped with the hand of love, by the arm of free choice in the light of the Holy Faith."

Julian of Norwich (1342–1416) was a celebrated mystic, whose *Revelations of Divine Love* provide one of the most remarkable insights into the medieval religious experience. According to her report, on 13 May 1373, she was healed of a serious illness after experiencing a series of visions of Christ's suffering and of the Blessed Virgin, about which she wrote two accounts; the second version composed twenty or thirty years after the first. *The Revelations* treats some of the most profound mysteries of Christianity: predestination, foreknowledge of God, and the existence of evil. Clear and deep in its perception, the work possesses beautiful sincerity and expression.

<div align="center">

Revelations of Divine Love
Recorded by Julian, anchoress at Norwich
Anno Domini 1371

In lumine tuo videbimus lumen.

</div>

First Revelation—Of His precious crowning with thorns; and therewith was comprehended and specified the Trinity, with the Incarnation, and unity betwixt God and man's soul; with many fair shewings of endless wisdom and teachings of love: in which all the Shewings that follow be grounded and oned.

Second Revelation—The changing of colour of His fair face in token of His dear worthy Passion.

Third Revelation—That our Lord God, Almighty Wisdom, All-Love, right as verily as He hath made everything that is, all-so verily He doeth and worketh all-thing that is done.

Fourth Revelation—The scourging of His tender body, with plenteous shedding of His blood.

Fifth Revelation—That the Fiend is overcome by the precious Passion of Christ.

Sixth Revelation—The worshipful thanking by our Lord God in which He rewardeth His blessed servants in Heaven.

Seventh Revelation—[Our] often feeling of weal and woe; with ghostly understanding that we are kept all as securely in Love in woe as in weal, by the Goodness of God.

Eighth Revelation—Of the last pains of Christ, and His cruel dying.

Ninth Revelation—Of the pleasing which is in the Blissful Trinity by the hard Passion of Christ and His rueful dying: in which joy and pleasing He willeth that we be solaced and mirthed with Him, till when we come to the fulness in Heaven.

Tenth Revelation—Our Lord Jesus sheweth in love His blissful heart even cloven in two, rejoicing.[1]

Undoubtedly the greatest poet of the age, Dante Alighieri (ah-lee-GYAY-ree; 1265–1321) wrote a few lyric poems and told the story of his passion for his unattainable love, Beatrice, in *La Vita Nuova*, but the *Divine Comedy* formed the major work of his life. Its description of heaven, hell, and purgatory presents a vision of the state of souls after death told in an **allegory**—a dramatic device in which the superficial sense accompanies a deeper or more profound meaning. It works on several levels to demonstrate the human need for spiritual illumination and guidance. On a literal level, it describes the author's fears as a sinner and his hopes for eternal life. On deeper levels, it represents the quandaries and character of medieval society faced with, for example, balancing classicism and Christianity. Part of Dante's significance lies in the fact that he elevated vernacular Italian to the status of a rich, expressive language suitable for poetry. Writers no longer needed to use Latin.

Dante, an aristocrat, was educated in both classical and Christian works. As with many Florentine office-holders and literati, Dante suffered exile when his political allies fell from power. Banished from Florence for life in 1301, he used the years of his exile, in which he suffered deprivation and poverty, to compose *The Comedy (Commedia)*. Actually, Dante gave the work a particularly personal title: *The Comedy of Dante Alighieri, A Florentine by Birth but not in Behavior*. He called it a comedy because, according to him, it had a happy ending and used the language of the people. Recognition of the superb character of the work caused later admirers to affix the word "Divine," which has remained since. The poem has three book-length parts, detailed in Figure 8.39.

In the *Comedy*, Dante narrates his fictional travels through three realms of the Christian afterlife, beginning on Good Friday 1300. For the first two parts of the journey, he is accompanied by the Roman poet Vergil, from whose work *The Aeneid* Dante drew considerable inspiration. Vergil represents human reason and the

PROFILE

ST FRANCIS OF ASSISI (1181/2–1226)

Francis (Fig. **8.38**) was baptized Giovanni di Pietro di Bernardone (Joh-VAH-nee dee pee-AY-troe dee bur-nahr-DOE-nay; his name was later changed to Francesco [Frahn-CHAYZ-koh]), the son of a cloth merchant. He learned to read and write Latin as a child and later learned to speak some French. In 1202 he participated in the war between Assisi and Perugia, was taken prisoner, and held for nearly a year. On his release, he was seriously ill, but he recovered and sought to serve in the army again in late 1205. However, after a vision told him to return to Assisi and await a call to a new kind of knighthood, he devoted himself to solitude and prayer in order to know the will of God. This began his conversion, which consisted of a number of episodes. He renounced material goods and family ties and embraced a life of poverty.

Although he was a layman, he began to preach the gospel. He attracted a number of disciples and devised a rule of life for them, based on the Gospel of Matthew: "Take no gold, nor silver, nor money in your belts, no bag for your journey" (Matthew 10:9–11). When the number of disciples, called friars, reached twelve, they went to Rome, where Pope Innocent III gave his blessing to their rule of life. This event, on 16 April 1209, marked the formal beginning of the

8.38 Cimabue, *Enthroned Madonna with St Francis* (detail), 1280. Fresco, lower church of San Francisco, Assisi, Italy.

Franciscan order. The Franciscans preached in the streets and, gradually, the order grew and spread throughout Italy.

Perhaps the most powerful experience of Francis' life occurred in the summer of 1224, when he went to the mountain retreat of La Verna to celebrate the feast of the Assumption of the Virgin and to prepare for St Michael's day with a forty-day fast. He prayed that he might know how best to please God. Opening the Gospels to find an answer, he came three times to the Passion of Christ. Then, as he prayed, he saw a figure coming toward him from heaven. It had the form of a seraph and smiled at him. Francis felt both joy and deep sorrow because of Christ's crucifixion. He understood that by God's providence he would be made like the crucified Christ through conformity of mind and heart. After the vision was over, Francis was marked with the *stigmata* of the Crucified—Francis' body actually showed marks resembling the wounds on the body of Christ. Francis tried to hide the marks for the remainder of his life. He lived for only another two years, and was blind and in constant pain. After his death, his stigmata were announced to the order by letter. One of the most venerated religious figures of his time, he was made a saint on 15 July 1228.

classical culture. In the first part, Dante descends into Hell, where he hears the damned tell of their sins against God and moral law. In the second part, Dante stands in Purgatory, where lesser sinners do penance while awaiting their entrance into heaven. In Purgatory, Vergil turns over Dante's guidance to Beatrice (Italian for "blessing"), Dante's symbol of the eternal female and of spiritualized love and Christian culture. She also represents divine revelation, and, therefore, stands superior to Vergil. She guides Dante into Paradise, where he finds the souls of the saved divided into three groups: lay people, the active, and the contemplative. Nine categories of angels inhabit the closest circles to the throne of God.

As occurs often in medieval arts, Dante's *Comedy* contains symbolic numbers. The structure of the work breaks into one hundred cantos. The first canto serves as an introduction, and the three major parts each have thirty-three cantos. A common symbol for the Christian Trinity (Father, Son, and Holy Spirit) appears. The poem uses a three-line verse form called *terza rima* (TAIRT-zah REE-mah), which has an interlocking rhyme scheme in three-line stanzas—for example ABA, BCB, CDC, DED, and so on, ending in a rhymed couplet. Multiples of three occur in the nine regions, plus a vestibule of Hell and Purgatory. Paradise contains nine heavens plus the highest heaven (*Empyrean*; ehm-PEER-ee-ahn). In Hell, the damned divide into three groups: those who sinned by

DANTE'S *COMEDY*

HELL
The Anteroom of the Neutrals
Circle 1: The Virtuous Pagans (Limbo)
Circle 2: The Lascivious
Circle 3: The Gluttonous
Circle 4: The Greedy and the Wasteful
Circle 5: The Wrathful
Circle 6: The Heretics
Circle 7: The Violent against Others, Self,
 God/Nature/and Art
Circle 8: The Fraudulent
Circle 9: The Lake of the Treacherous against kindred,
 country, guests, lords, and benefactors

PURGATORY
*Ante-Purgatory: The Excommunicated/The Lazy/The
Unabsolved/Negligent Rulers*
The Terraces of the Mount of Purgatory
1. The Proud
2. The Envious
3. The Wrathful
4. The Slothful
5. The Avaricious
6. The Gluttonous
7. The Lascivious
The Earthly Paradise

PARADISE
1. The Moon: The Faithful who were inconstant
2. Mercury: Service marred by ambition
3. Venus: Love marred by lust
4. The Sun: Wisdom; the theologians
5. Mars: Courage; the just warriors
6. Jupiter: Justice; the great rulers
7. Saturn: Temperance; the contemplatives and mystics
8. The Fixed Stars: The Church Triumphant
9. The Primum Mobile: The Order of Angels
10. The Empyrean Heavens: Angels, Saints, The Virgin,
 and the Holy Trinity

8.39 The structure of Dante's *Divine Comedy*.

incontinence, by violence, or by fraud. In Purgatory, those who wait divide in three ways depending on how they acted in relation to love. Paradise contains nine categories of angels. Here is a short selection from *Inferno*:

<div align="center">

(Circle Two) Canto V

The Carnal

</div>

So we went down to the second ledge alone;
 a smaller circle of so much greater pain
 the voice of the damned rose in a bestial moan.
There Minos sits, grinning, grotesque, and hale.

He examines each lost soul as it arrives
 and delivers his verdict with his coiling tail.
That is to say, when the ill-fated soul
 appears before him it confesses all,
 and that grim sorter of the dark and foul
decides which place in Hell shall be its end,
 then wraps his twitching tail about himself
 one coil for each degree it must descend.

Secularism

The change in outlook that accompanied the code of chivalry brought with it a new, popular form of poetry called the *romance*. These romances formed long narratives about knights and ladies. The name itself, like Romanesque, comes from a later age that mistakenly thought that these poems sought to imitate Roman literary forms. Chivalric and sentimental, the romance often drew its subjects from classical legends, from Celtic myths of King Arthur and the knights of the Round Table, and the exploits of Charlemagne and his knights.

Perhaps the first treatment of Arthur and Camelot came from Chrétien de Troyes (krayt-YAHN duh TWAH; c. 1148–90). In this prototype, the simple story we know from the musical *Camelot*, the author elaborates through many episodes and complications with religious and courtly themes. In the end, Lancelot rescues Guinevere but, on the way, suffers misadventure after misadventure, from which he learns humility in order to love Guinevere with absolute obedience. The fact that the author clearly parallels Lancelot's adventures with the suffering and death of Jesus exemplifies the Gothic dualism we mentioned earlier and gives the work a disturbing character that borders on sacrilege. In addition, the moral neutrality with which the author treats Guinevere's adultery—a deadly sin in the eyes of the medieval Church—troubled many people. The unacceptability of Chrétien's perspective rises in a late English version of the story, Thomas Malory's *Le Morte d'Arthur*, which directly blames the collapse of Arthur's court on Lancelot and Guinevere's passions.

Christine de Pisan (pee-ZAHN; c. 1365–1463), a prolific and versatile French poet and author, wrote numerous diverse poems of courtly love and several works championing women. Her father served as astrologer to Charles V, and Christine spent her childhood at the French court. At age fifteen she married Estienne de Castel, who became court secretary. Ten years later, after her husband's death, she began writing in order to support herself and her three young children. Her first poems were ballades of lost love written in memory of her husband. Immediately successful, she continued writing in a variety of forms, expressing her feelings with grace and sincerity (Fig. 8.40). In total, she wrote ten volumes in verse, including "Letter to the

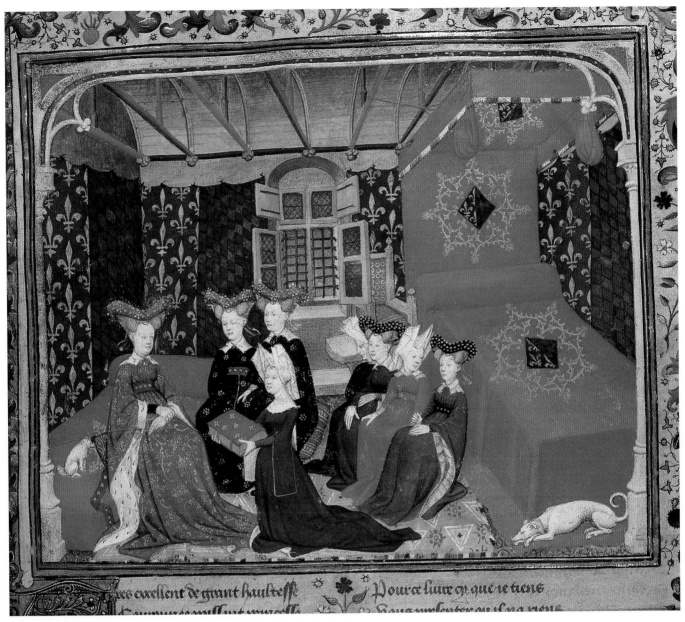

8.40 Illuminated manuscript of Christine de Pisan presenting her poems to Isabel of Bavaria. MS. Harl. 4431 fol. 3. Min. The British Library, London.

God of Loves" (1399), in which she defended women against the attacks of Jean de Meun in his satire *Roman de la Rose*.

Christine's prose works include *The Book of the City of Ladies* (1405), in which she described women known for their heroism and virtue. Another prose work, *The Book of Three Virtues* (1405), was a sequel to *The Book of the City of Ladies*, which classified women's roles in medieval society and detailed moral instructions for women in various social circumstances. Her life's story, *L'Avision de Christine* (1405), was an allegorical reply to her detractors. At the request of the regent, she wrote a biography of the deceased king (*Book of the Deeds and*

Good Morals of the Wise King Charles V). A first-hand view of the king and his court, this and her eight other prose works revealed her outstanding breadth of knowledge.

Her final work, written in 1429, comprised a lyrical and joyous piece inspired by the victories of Joan of Arc. It is the only such French-language work written during Joan's lifetime.

The late Middle Ages—especially the fourteenth century—provided a transition between medieval thought and the **Renaissance** to come. In literature, especially, stirrings of ideas more Renaissance than medieval occurred. In the fourteenth century, Italian writers such

as Petrarch (PEE-trahrk) and Boccaccio (boh-KAHT-choh) began to take the works of ancient writers in a new direction. (Because his ideas have significant relation to the attitudes of the Renaissance and humanism, we will study Petrarch in the next chapter.) They borrowed ideas, stories, figures of speech, and general style, and tried to recreate ancient poetic and prose styles. In so doing, they provided a more penetrating investigation and analysis of ancient literature and art than their medieval predecessors had achieved, and accomplished an ordered plan, integrated structure, symmetry, and lofty style, which fourteenth-century writers believed represented classical beauty. Various rules emerged—for example, the epic must begin in the middle of the plot, must contain supernatural elements, and must end with a victory for the hero.

Giovanni Boccaccio (1313–75), a life-long friend of Petrarch, and a man of this world, took inspiration from and dedicated his early works to his consuming passion, Fiammetta. Nonetheless, the *Decameron* (1358) completely overshadows all that went before.

In the framing tale, ten young people flee from the plague in Florence in 1348 to sit out the danger in the countryside. To amuse themselves, they tell one hundred stories. The first tale from Day One tells of a lively day spent in witty conversation. Days Two and Three are tales of adventure. Day Four presents unhappy love, and Day Five treats the same subject in a somewhat lighter vein. Day Six returns to the happiness of Day One, and

Days Seven, Eight, and Nine cover laughter, trickery, and license. Day Ten ties the foregoing themes together in a conclusion. In total, the *Decameron* extols the virtue of humankind, proposing that to be noble, one must accept life as one finds it, without bitterness. Above all, one must accept the responsibility for, and consequences of, one's own actions.

Finally, and in contrast to emerging ideas pointing toward the Renaissance, a popular genre of literature during this period, the medieval chronicle, told history in a "romantic" way and in the language of the country. The *Chronicles of England, France, and Spain* by the French writer Jean Froissart (fwah-SAHR; c. 1333–1400) exemplifies this genre. Froissart's work covers the history of the fourteenth century and the wars between England and France. He did not write it as a factual account, but "to encourage all valorous hearts and to show them honorable examples."

Froissart loved the ideals of knighthood and its heroic deeds, and his sympathies always resided with the lordly knights. In his "history," however, Froissart allowed his imagination free rein to fill in details when he was unable to find the facts. He never let accuracy stand in the way of a good story. To collect his tales, he wandered on horseback throughout Europe, his trusty greyhound tagging along behind. He talked to squires, knights, heralds, and pages, gathering their recollections and sometimes fanciful tales of both the court and the battlefield.

CHAPTER REVIEW

CRITICAL THOUGHT

During the High Middle Ages, profound changes took place in Europe, not only in its institutions but also in the way it viewed matters both earthly and eternal. This was a time of flux. Barricades were coming down and light flowed into every corner of human existence. Universities were born, and people such as St Thomas Aquinas remolded and shaped the tenets of Christian faith. Mysticism continued, and literature gave birth to a new genre, called "courtly romance," and a major poet, named Dante.

Like the Greek temple, Gothic architecture—particularly the Gothic cathedral—has come to symbolize an entire era and to form an important prototype for building not only churches but also other structures in our contemporary world. With similar characteristics in line, form, balance, and unity, Gothic sculpture and two-dimensional art mirror their architectural kindred. Music and theatre embarked on new paths as well, as the "old" gave way to the "new."

SUMMARY

After reading this chapter, you will be able to:

- Explain the changes affecting secular and religious life in the High Middle Ages by citing specific individuals, trends, and conditions.
- Describe the literature of the period, including the courtly romance and Dante's *Divine Comedy*.
- Understand and discuss the attitudes, reflections, and general characteristics of Gothic architecture, painting, and sculpture, including how Gothic style differs from Romanesque and how Gothic style changed from early to late.
- Characterize the theatre and music of the High Middle Ages, including their forms and presentation.

- Apply the elements and principles of composition to analyze and compare works of art and architecture illustrated in this chapter.
- Describe *ars nova* and its principal exponent.
- Identify the major writers of the time and their works, including general characteristics and themes.
- Discuss the effects of the plague, the Hundred Years' War, and the Great Schism on European society, commerce, and religion.

CYBERSOURCES

http://witcombe.sbc.edu/ARTHmedieval.html#Gothic
http://www.artcyclopedia.com/history/gothic.html
http://www.beloit.edu/~arthist/historyofart/gothic/gothic.htm
http://www.ibiblio.org/wm/paint/tl/gothic

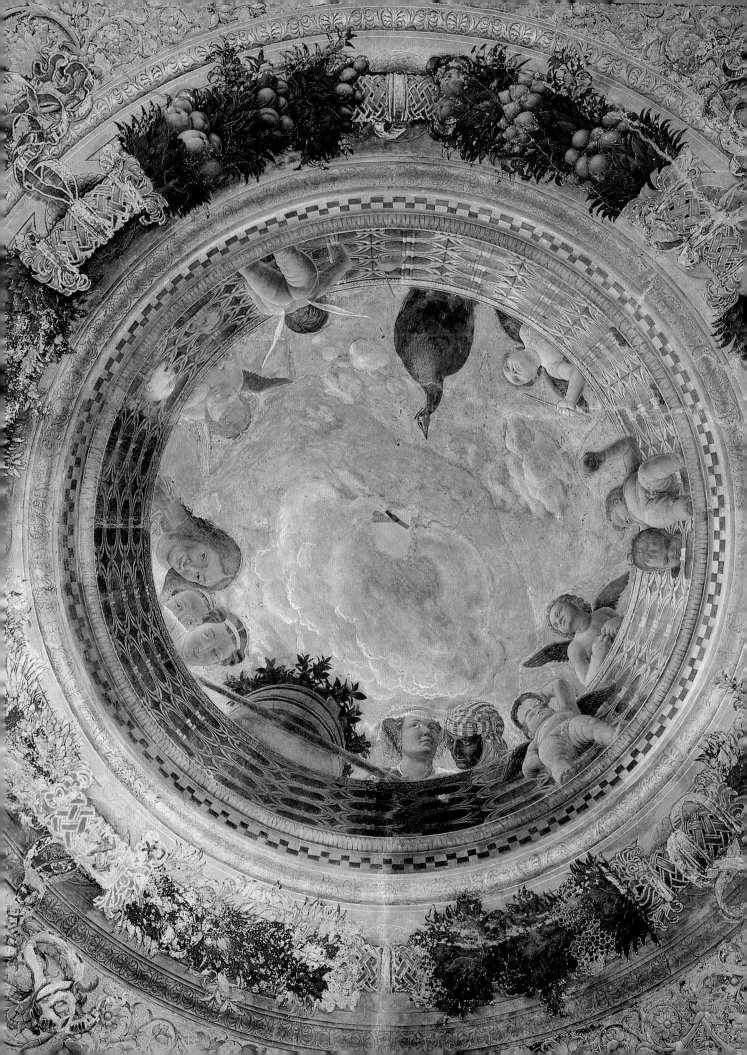

9 THE EARLY RENAISSANCE

VIEW

THE BEST OF TIMES?

The people of the Renaissance saw themselves as witnesses to the rebirth of the best of culture—the classical—after a long darkness that they labeled the "Middle Ages." Humans like to think highly of themselves and their ideas, and they like to classify other humans by fitting them into generalized, neat little boxes.

Another common human tendency that ties us to our ancient predecessors is the tendency of the elderly to look back to "the good old days," to bemoan the disrespect shown by youth, and to see the circumstances of youth as the forerunners of doom and disaster. Equally commonly, youth tend to see the values and activities of their elders as stuffy, old-fashioned, and hopelessly ridiculous. Undoubtedly, no age has been the "best of times," as some maintain, nor has any age been the "worst of all worlds" that others bemoan. Perhaps it promotes health to believe that the world has "progressed" beyond the previous generation. What does not promote health is for one generation to discount the value of another and to fail to learn from it. When we cease to learn, we die.

KEY TERMS

RENAISSANCE
Includes among its many possible meanings, "rebirth."

CAPITALISM
An economic system pursuing market freedom.

VERISIMILITUDE
Lifelikeness or the nearness to truth.

PERSPECTIVE
The rational portrayal of depth in a work of art either through linear or atmospheric means.

FARCE
A type of low comedy characterized by slapstick.

SOTTIE
A bawdy burlesque type of theatrical performance.

9.1 Andrea Mantegna, detail of the ceiling of the Camera degli Sposi, 1474. Fresco. Ducal Palace, Mantua, Italy.

CONTEXTS AND CONCEPTS

Contexts

The Renaissance

The Renaissance was explicitly seen by its leaders as a rebirth of our understanding of ourselves as social and creative beings. "Out of the sick Gothic night our eyes are opened to the glorious touch of the sun," was how the writer Rabelais (RAB-uh-lay) expressed what most of his educated contemporaries felt. Florence, called the "New Athens," the crucible of the Renaissance in Italy, redefined the fine arts, or "liberal arts," as art, in contrast to their status as crafts in the Middle Ages. Now accepted among the intellectual disciplines, the arts became an essential part of learning and literary culture. Artists, architects, composers, and writers gained confidence from their new status and from the technical mastery they achieved. For the first time, it seemed possible not merely to imitate the works of the classical world, but to surpass them.

Definitions of the Renaissance have been debated for centuries. The word certainly describes a new sense of self and self-awareness felt by western European people, who had come to see themselves as no longer part of the "Middle Ages." But deciding where and how the Renaissance began, and what specifically it was, is as difficult as answering the question of where and how it ended—if it ended at all.

In the middle of the nineteenth century, a Swiss historian, Jacob Burckhardt, began formal "Renaissance studies." He maintained—thus agreeing with fifteenth-century Italians—that an actual rebirth of ideas began in the 1400s after centuries of stagnation, and asserted that in Italy during the fourteenth century, a new spirit of inquiry and understanding arose in which the classical world of Greece and Rome again became the inspiration for a superior civilization.

However, many scholars in the mid-twentieth century felt that Burckhardt's viewpoint over-simplified things, and that the period did nothing more than naturally extend the previous times—that is, the clear break identified by Burckhardt had not occurred. The apparent change that took place in the fifteenth century consisted more of a shift in cultural and educational emphasis than a new discovery of the past. In addition, the Renaissance, rather than a monolithic period, comprised three or more periods, each with its own circumstances and—to a large degree—its own characteristics. Thus, we can identify an early Renaissance, particularly that occurring in Florence; a High Renaissance, specifically in Rome and Venice; and a Renaissance that occurred outside Italy,

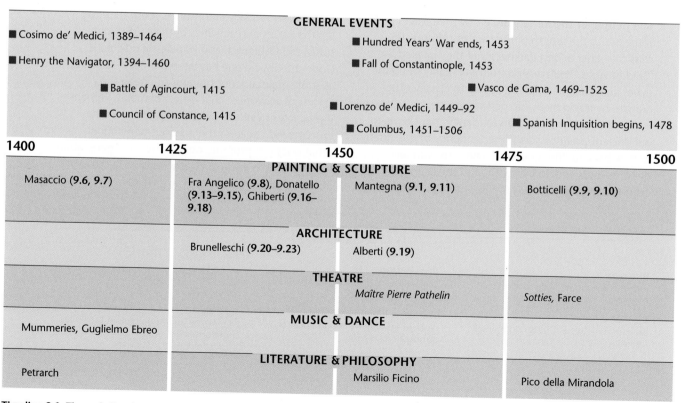

GENERAL EVENTS

■ Cosimo de' Medici, 1389–1464

■ Henry the Navigator, 1394–1460

■ Battle of Agincourt, 1415

■ Council of Constance, 1415

■ Hundred Years' War ends, 1453

■ Fall of Constantinople, 1453

■ Vasco de Gama, 1469–1525

■ Lorenzo de' Medici, 1449–92

■ Columbus, 1451–1506

■ Spanish Inquisition begins, 1478

| 1400 | 1425 | 1450 | 1475 | 1500 |

PAINTING & SCULPTURE

Masaccio (9.6, 9.7) | Fra Angelico (9.8), Donatello (9.13–9.15), Ghiberti (9.16–9.18) | Mantegna (9.1, 9.11) | Botticelli (9.9, 9.10)

ARCHITECTURE

Brunelleschi (9.20–9.23) | Alberti (9.19)

THEATRE

Maître Pierre Pathelin | Sotties, Farce

MUSIC & DANCE

Mummeries, Guglielmo Ebreo

LITERATURE & PHILOSOPHY

Petrarch | Marsilio Ficino | Pico della Mirandola

Timeline 9.1 The early Renaissance.

Chapter 7, Charlemagne had already rekindled an interest in antiquity, and indeed, in some quarters, such an interest had never been extinguished. For example, as we also noted, the German nun Hrosvitha had access to Terence and used his works as models for her plays, and scholars had studied Aristotle in the late Middle Ages. However, fifteenth-century interest in classical antiquity grew more intense and widespread than before, and these men and women felt that they had found kindred spirits in the Greeks and Romans. The Roman emphasis on civic responsibility and intellectual competence helped revivify the social order, and many people desired to reinterpret the ancient writings, which many believed had been corrupted in the service of Church dogma.

Aristotle's work offered an appealing balance of active living and sober reflection, and the Greeks of Periclean Athens gave an idealized model of humankind that could, for example, be expressed in painting and sculpture. These ideals of nobility, intellect, and physical perfection led to new conceptions of what constituted beauty. As scholars pursued an understanding of classical art and architecture, they became enamored of measuring things. "True proportions" emerged with the discovery in 1414 of *De Architectura*, by the Roman architect Vitruvius (Fig. 9.5). Scientific curiosity and concern for detail led to a fascination with anatomy, and scientific investigation led to a new system of mechanical perspective. All this measuring and codifying produced a set of rules of proportion and balance, and unity, form, and perfect proportion were codified as a set of laws, to which Michelangelo, as we shall see in Chapter 10, objected strongly.

The World Discovered

To the already complex social order the Renaissance now added a thirst for new discovery of all kinds, scientific, technological, and geographic. The dream of human flight emerged in Leonardo da Vinci's remarkable designs for complex flying machines. Renaissance scholars sought the answers to all questions, and they took empirical approaches to their inquiry rather than using the tools of faith and philosophy. As a result, forward-looking science and backward-looking traditional values commonly clashed. Spirited inquiry often raised more questions than it could answer, and the questions and conflicts that flowed from this inquiry had unsettling and destabilizing effects.

Technology significantly changed the character of this era. The printing press allowed the writings of the humanists (see p. 282) as well as the literature of Greece and Rome to be rapidly and widely disseminated. Availability of textbooks at reasonable prices revolutionized education and gave rise to *scholas*, similar

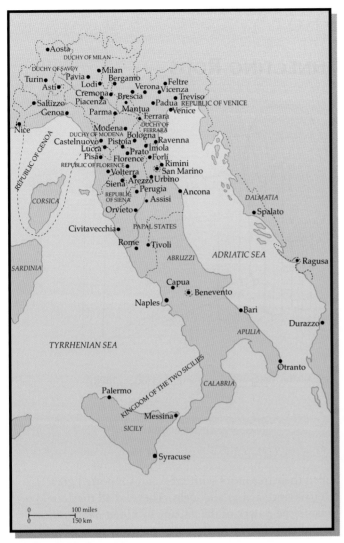

Map 9.1 Renaissance Italy.

particularly in the northern European states, and highly influenced by—or at least related to—the Protestant Reformation.

In the last thirty years, a third viewpoint has emerged, which attests that the word "Renaissance" constitutes strictly an educational and artistic label and is not particularly applicable to politics and society at large. According to this viewpoint, any label such as "Renaissance" does not do justice to the complex issues and circumstances that arose in such a diverse area as Europe over a period as long as two hundred years.

Whatever the circumstances, we will examine the Renaissance in three chapters: the early Renaissance in this chapter, the High and late Renaissance and Mannerism in Chapter 10, and the Renaissance in the North in Chapter 11.

The revived interest in antiquity normally associated with the Renaissance was not its first revival. As seen in

<div style="background:gray">TECHNOLOGY</div>

FLYWHEELS AND CONNECTING RODS

The development of the machine and belief in its almost infinite possibilities represent one of the fundamental characteristics of the Renaissance. The most brilliant minds of the time went to work to invent machinery for industrial purposes, for games, and for war, and an interesting aspect of such development is that it lay principally in the realm of speculative thinking. Even before practical applications were discovered, machines were created for the pure joy of inventing them and of solving difficult problems. Nonetheless, practical applications came close on the heels of speculative thinking, and perhaps the most important mechanical development of the fifteenth century was the invention of the crank-and-connecting-rod system. Unknown in the medieval period, this system allows the transformation of continuous circular movement into straight-line, alternating, back-and-forth movement (Fig. **9.2**).

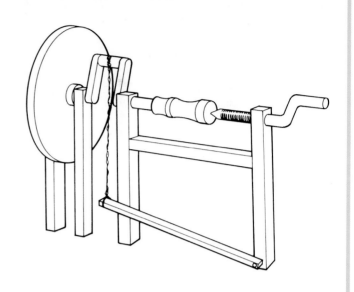

9.2 A lathe, designed by Leonardo da Vinci, c. 1500.

to our public schools. This brought a higher level of education to a wider segment of society.

Technology, science, curiosity, and increased individual self-confidence took humankind to the furthest reaches of the globe. Renaissance explorers vastly increased the geographical knowledge of the age. In 1486, Bartolomeu Diaz (DEE-ahz) sailed down the coast of Africa, ending the isolation of the Mediterranean world. Six years later, Columbus sailed to the West Indies. In 1499, Vasco da Gama completed a two-year voyage around the horn of Africa to India. At the turn of the sixteenth century Balboa reached the Pacific Ocean.

The Papal States

After the Council of Constance ended the Great Schism (see Chapter 8), the papacy made a concerted effort to regain its power and control. By the middle of the fifteenth century it had succeeded, with a large area of central Italy known as the Papal States (see Map **9.1**). Three popes in particular—Nicholas V (r. 1447–55), Pius II (r. 1458–64), and Sixtus IV (r. 1471–84)—as well as their successors, called the Renaissance popes, expended great time, wealth, and energy in consolidating the Papal States. This often included diplomacy and war, and such activities brought the Church directly down to the level of the world around it. The Renaissance popes

filled their treasuries with art—and supported great Renaissance artists and ideas. They did all they could to ensure the power of the papacy by filling papal offices with loyal self-seekers, usually their relatives. Although some benefits did come to humanity through the intrigues and escapades of these popes, the benefits occurred mostly in worldly realms rather than in spiritual ones. For example, Nicholas V founded the Vatican Library, filled it with priceless manuscripts, brought major scholars to Rome, and supported their research. He also rebuilt most of the city.

Classical scholarship also emerged as the forte of Pius II, and his renown as a poet contributed significantly to his election. Also a clever politician, he understood the dynamics of power and intrigue. However, his accomplishments as pope seem limited to the ability to fill Rome with intellectuals and artists.

Less intellectual and learned than his immediate predecessors, Sixtus IV, likewise, made his mark in other than spiritual areas. Nonetheless, this skilled intriguer, who actively engaged in the feud between the Medicis (MEH-deh-chees) and Pazzis (PAHT-zees) in Florence and the plot to kill Lorenzo de' Medici, did manage to oversee the construction of the Sistine Chapel. His active patronage of art and architecture helped to turn Rome into one of the most beautiful cities of the world.

Italian City-States

Like Greece in earlier times, Italy did not have a national political identity but consisted of a collection of independent city-states that were forever at war with each other: in the north the Republic of Venice, the Duchy of Milan, and the Republic of Florence; in the south the Kingdom of Naples, which included the island of Sicily. In between lay the Papal States. Of course, other important states existed, such as Ferrara, Savoy, Genoa, Urbino (Fig. **9.3**), and Modena, but the five states just mentioned dominated the political and cultural map (see Map **9.1**).

At about the same time as the Hundred Years' War came to an end and Constantinople fell—and probably in response to the threat from outside that these two events presaged—the northern states of Florence, Venice, and Milan achieved a significant, if fragile, peace accord in the Peace of Lodi (1454). When Naples joined the pact, Italy gained nearly half a century of relative peace.

However, while the agreement at Lodi may have brought peace among the city-states, it did not necessarily create peace within them. The second half of the fifteenth century saw the fall of more republican forms of government and the rise of autocracy, principally in the guise of ruling families. The story of Florence illustrates the perfidy and turmoil that beset all of Italy at this time. One of the most ironic outcomes of the context of the period emerges in the cultural outpouring of art and architecture that exhibits peace and stability, totally belying its milieu.

The Quattrocento in Florence

In a manner not entirely unlike Athens, the Italian city of Florence formed a crucible for Renaissance thought and, particularly, artistic endeavor during the fifteenth century—the *quattrocento* (KWAH-troh-CHAIN-toh) as Italians call it—the 1400s. A population of 50,000 may not seem large by today's standards, but at the time, Florence had the largest population in Europe. Before the Black Death its population numbered 100,000, and at the time, London and Paris contained roughly 20,000 people each. Based on commerce, Florence comprised a democracy far more advanced than Europe had seen since Athens in the fifth century B.C.E., the Age of Pericles (see Chapter 3). During the first quarter of the Quattrocento, Florence controlled all of Tuscany from Lucca to Siena, including the ports of Pisa and Livorno. The city's constitution spread political power among a large group of responsible citizens, and it contained legal devices to prevent political parties developing or a single family gaining dominance.

Notwithstanding the city's constitution, in a few short years the Medici—a family of bankers—under Cosimo de' Medici (1389–1464), produced a hereditary

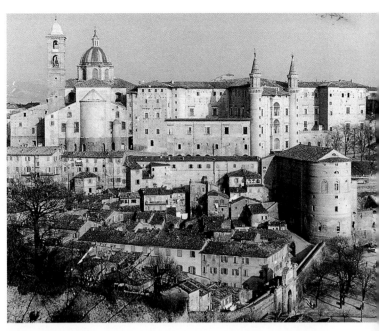

9.3 Luciano Laurana and Francesco di Giorgio, Palazzo Ducale, Urbino, Italy, 1466–c. 1481.

chain of almost absolutist power. For thirty years, Cosimo de' Medici was the most influential man in Florence, opening banks throughout Italy and Europe and founding an Academy for the study of Plato, under the direction of Marsilio Ficino (see p. 283). He actively supported the arts, collected Roman coins and prints, and loved gardening. Although under some pressure to assume complete power in Florence, as he undoubtedly could have done, he remained an ordinary citizen all his life. He held high office often, but no more often than any other leading citizen. His son, Piero, lived mostly in his father's shadow.

While the Florentines respected Cosimo and accepted Piero, they felt more affection for Lorenzo (1449–92). He had a natural charm and dashing style, which appealed to the people of Florence, and was a well-educated youth, fluent in the classics, who loved art as well as sport (Fig. **9.4**). Although it was still a democracy at heart, Florence gave Lorenzo an influence that occasionally upset the balance of the state. His period of influence coincided with a military threat from Naples and Rome and with economic decline, which hit the Medici hard personally, forcing Lorenzo to close branches of the bank in Milan and Bruges. Lorenzo moved to strengthen Florence's government and did so by resurrecting his grandfather's idea of a Senate. As a result, a Council of Seventy assumed power in Florence, its members holding their position for life. Although Lorenzo proposed the council, the Florentines themselves approved it, hoping that it would provide a decision-

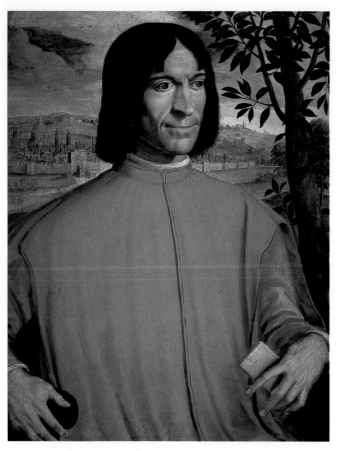

9.4 Lorenzo de' Medici (1449–92).

number of whom assumed that Lorenzo had more power than, in fact, he did. He had to tread a delicate path in all his relationships, both domestic and foreign, and his diplomacy was often hampered by his insecure position as a banker. The family's political prestige made it uniquely liable to requests from rulers for loans, and although his fortunes were not totally dependent on the bank, Lorenzo had less access than his father or grandfather to free money by which to extend his influence. His whole political career was marked by intrigues and difficult situations—including major confrontations with Pope Sixtus IV.

Lorenzo the man, as distinct from Lorenzo the politician, draws our attention, however. He undertook a staggering range of activities, in addition to his political activities—he ran the largest international bank in Europe, managed four country estates and a townhouse, planted botanical gardens, raised cows, bred racehorses, looked after his children's education, did charitable work for the Church, read Plato, bought art, played the lyre and the organ, possessed a theoretical and practical knowledge of architecture, and wrote music and poetry. Some of his friends thought that he was a better poet than Dante and Petrarch, because, as a Platonist, he had a deeper insight into the nature of love and reality.

Concepts

Humanism

We can trace the roots of humanism to the slowly developing separation of organized religion and the state in the fourteenth century, specifically to Italy and the writings of Petrarch around 1341. Petrarch plays a pivotal role in the transition from medieval to Renaissance thought, and his writings exhibit significant differences from those of Dante, for example (see Chapter 8). Petrarch rejected medieval philosophy, as we shall note in the Literature section of this chapter. Although he had a passion for classical literature and Roman antiquity, he clung to the religious thought of the Middle Ages. He felt guilty about admiring the things learned from pagan philosophers, and he found Dante's connection between the good of this world and that of the next impossible. On the other hand, his real love of learning made him reject the intellectual tradition of the Middle Ages, earning him the title Father of Humanism. From Italy, Petrarch's ideas spread throughout the Western world.

Humanism as a philosophy did not, as some have ventured, deny God or faith. Rather, it attempted to discover humankind's own earthly fulfillment, perfectly expressed in the biblical idea: "O Adam, you may have

making body that would prove equal to the needs of the times.

One of the council's first acts was to institute progressive taxation, which hit the rich very heavily. Lorenzo's taxes amounted to double those disproportionate taxes that Cosimo had paid. Looking back on Lorenzo's place in the political scheme of Florence, one finds that, even though he was sometimes called a "tyrant," there were real limits to his power. He certainly had considerable personal influence—his diarist described him as a man who "with a single gesture was able to bend all the other citizens to his will"—but he seems never to have stepped beyond constitutional bounds. When another plot to assassinate him was uncovered in 1481, however, the *signoria* passed a law making any attempt on Lorenzo's life a crime against the state.

Perhaps the most important factor in his rise to power was the role he inherited in foreign policy. Good personal relationships with other rulers had been one of his grandfather's strengths, and it was misjudgment in this area that led to Lorenzo's son's exile in 1494 and the family's temporary decline. Lorenzo had met and favorably impressed many heads of state in Italy, a large

whatever you shall desire." The medieval view of life as a vale of tears, with no purpose other than preparing for salvation and the afterlife, gave way to a more liberating ideal of people playing important roles in this world.

Concern for diversity and individuality had emerged in the late Middle Ages, when expanding horizons and the increasing complexity of life provoked a new debate about human responsibility for a stable moral order and for the management of events. Such a discussion yielded a philosophy consistent with Christian principles, which focused on the dignity and intrinsic value of the individual. Human beings, both good and ultimately perfectible, could find worldly fulfillment and intellectual satisfaction. Humanism developed an increasing distaste for dogma, and embraced a figurative interpretation of the scriptures and an attitude of tolerance toward all viewpoints.

When Constantinople fell to the Ottomans in 1453, an influx of Byzantine scholars carrying with them precious ancient manuscripts made Italy a center for the study of Greek literature, language, and philosophy, especially of Platonic and neo-Platonic philosophy. Cosimo de' Medici established the Platonic Academy at one of his villas near Florence, and, under the direction of Marsilio Ficino (fee-CHEE-noh; 1433–99), this academy set about the examination of Platonic thought and the reinterpretations of Plato, called neo-Platonism, that earlier had influenced Christian theology. Ficino's commentary on Plato's *Symposium* enhances our understanding of the originality of Italian humanism and the new direction it gave the arts. It demonstrates the interest in interpreting ancient texts, myths, and stories according to an elaborate allegorizing. (See the Literature section.)

Ficino's student Pico della Mirandola (PEE-koh DEL-lah mee-RAHN-doh-lah; 1463–94) produced one of the Renaissance's most important documents of humanist thought, *De hominis dignitate oratio* ("Oration on the Dignity of Man"). This work reflected Pico's syncretistic method of taking the best elements from other philosophies and combining them in his own work. A brilliant but precocious child and the son of a prince of the small territory of Mirandola, Pico received a thorough humanistic education at home. Convinced that all human knowledge could be combined into basic truths, he set out to master all forms of knowledge. He mastered the Greek and Latin classics and Aristotelian philosophy, and learned the Hebrew, Aramaic, and Arabic languages. After being introduced to the Hebrew kabbala (cabbala), an occult theosophy based on an esoteric interpretation of Hebrew scriptures and widely transmitted in medieval Europe, he became the first Christian scholar to use kabbalistic doctrine in support of Christian theology. When twenty years old, he proposed nine hundred

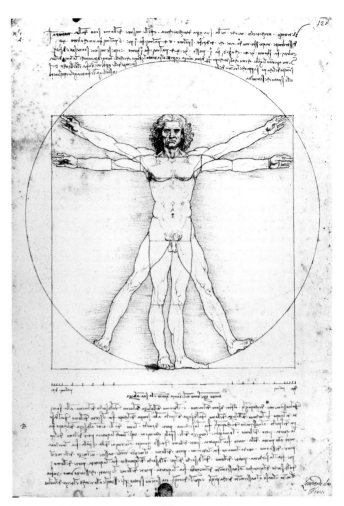

9.5 Leonardo da Vinci, *Vitruvian Man*, c. 1485–90. Pen and ink, 13½ × 9⅝ ins (34.3 × 24.5 cm). Academy, Venice, Italy.

theses—intellectual propositions—that, he asserted, quantified all human knowledge, and in 1486 he invited scholars from all of Europe to Rome for a public disputation, for which he composed his celebrated *Oratio*. However, a papal commission pronounced thirteen of his theses as heretical and Pope Innocent VIII forbade the assembly.

Despite producing an *Apologia* for the theses, Pico prudently fled to France, whereupon he was arrested. After a brief period in prison, he returned to Florence, affiliating with the Platonic Academy and living under the protection of the Florentine prince Lorenzo de' Medici. In 1492 Pope Alexander VI absolved him of the charge of heresy and toward the end of his life he fell under the influence of the orthodox Christian monk Savonarola, the enemy of Lorenzo and, later, a martyr.

Pico began an unfinished treatise against the enemies of the Church, which included a critique of the deficiencies of astrology. Religious rather than scientific, it nevertheless influenced the seventeenth-century scientist

Johannes Kepler, whose studies of planetary movements proved basic to modern astronomy.

Individualism

In its broadest sense, individualism consists of any theory that places the value, autonomy, and benefit of the individual above that of a group, whether a Church or nation, or that makes the individual the prime focus of a social system. This stands in contrast, for example, to collectivism, which constitutes a principle or system in which ownership and control of production and distribution rests with the people collectively. We may think of collectivism in its strictest definition as an economic and political matter (socialism and communism) or as a religious and social principle such as occurs in cults, and so on. In the modern sense, individualism forms the heart of Renaissance humanism, which stressed, as we suggested, personal dignity and accomplishment. Individualism also formed a central core of the Protestant Reformation, part of the Renaissance matrix that we study in Chapter 11, stressing humankind's ability to have unmediated communion with God and personal responsibility for one's own salvation. The term "individualism" did not appear until the nineteenth century in France where it had a negative connotation, suggesting an emphasis on private interests at the expense of society—a characteristic that Alexis de Tocqueville found alarmingly present in the United States.

During the Renaissance, however, individualism often manifested itself in the pursuit of personal prestige through art, and was exemplified by the commissioning of artists by wealthy families to build memorial chapels and churches as well as make paintings and sculptures. The rise of the individual portrait as a subject for art reflects individualism, as does the treatment of individuals in paintings and sculptures, as we note later in this chapter. The development of individual personality also reflects individualism, and we shall discuss this in more detail in the next chapter when we examine Michelangelo. All told, when we study any example of art and literature from the Renaissance, we find in it a new-found sense of individualism and a definite departure from the sense of art we witnessed in the Middle Ages.

Scientific Naturalism

The Renaissance produced a new way of looking at the world itself, and we witness the expression of what we can call scientific naturalism in almost every aspect of Renaissance endeavor. In essence, naturalism focuses on observable reality and stresses scientific accuracy in the representation of human life and society. We find scientific naturalism in the "measuring" of ancient buildings to establish proper proportion, in the study of anatomy to exhibit the correct structural forms of the body under its external appearance, and in the presentation of human and architectural forms properly seated in their environment. From such a desire came the discovery of mechanical perspective (see Getting Started). Perhaps the culmination of scientific naturalism in visual art came with Leonardo da Vinci (see Chapter 10), who considered painting a science and sculpture a mechanical art.

Musicians in the Renaissance applied scientific methodology to their compositions in such areas as rhythm, for example. In general, we may say that Renaissance scientific naturalism changed the subject matter of art as well as its intention, placing the focus squarely on the observation and delight of things in this world, as opposed to the otherworldliness of medieval art.

Capitalism

In all facets of society, the Renaissance placed new emphasis on the individual and on individual achievement. The rising middle classes, with their new-found wealth and power, quickly discovered that, salvation or not, life offered a great deal more if one had a good house, good clothes, good food, and reasonable control over one's own existence. Such comfort seemed to stem directly from material wealth, and so, amid all other aspects of Renaissance life and perfectly in tune with them, a new economic system of *capitalism*, or mercantilism developed. To a large degree, capitalism pursued wealth and power as its goals. In its broadest, and perhaps lowest, form, it constitutes a corporate endeavor with insatiable goals. Capitalism during the Renaissance did not develop fully. In contrast to medieval feudalism, capitalism offered a person reasonable freedom to pursue a better material standard of living to the extent of his or her wits and abilities. Capitalism challenged Renaissance men and women to pursue their own individual goals. As a result, economic activity exploded in the trading of goods and services previously unavailable or unheard of.

Capitalism depends on the creation of markets as well as the supply of goods, in contrast with the guild system, which produced only what appeared necessary. Therefore, it encouraged an increasing diversification of occupations and social positions. It flourished best in urban settings, and home and the workplace now tended to separate. Expansion of trade, capitalism, and commerce in the fourteenth and fifteenth centuries brought high prosperity to four locations in western Europe in particular—northern Italy, southern Germany, the Low Countries (now Belgium and the Netherlands), and England (see Map **9.2**).

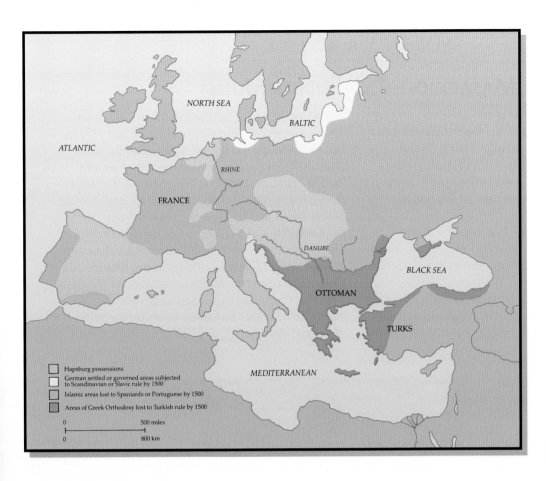

Map 9.2 Renaissance Europe.

THE ARTS OF THE EARLY RENAISSANCE

Painting

The Masaccian Heritage

Scientific naturalism, as we just noted, produced a style of painting obviously different from what we have thus far seen. While the content of paintings might treat religious themes, the manner of expression turned toward earthly observation and the application of mechanical perspective to the field of the painting changed the ethereal tone of medieval works to a new "reality" that appeared as things appear in real life. We find the champion of this new style of painting in Tommaso di Giovanni, better known as Masaccio (mah-ZAH-coh or mah-ZAHT-choh; 1401–29), who joined the painters' guild in Florence in 1422, where he worked for four years, before moving to Pisa for two years, and then to Rome, where he died, probably of malaria, in 1429. The hallmark of

Masaccio's invention and development of a "new" style lies in the way he employs deep space and rational foreshortening or perspective in his figures. In collaboration with the Florentine artist Masolino (c. 1383–1432), Masaccio was summoned in 1425 to create a series of frescoes for the Brancacci Chapel of the Church of Santa Maria del Carmine in Florence. Among these works rose Masaccio's acknowledged masterpiece, *The Tribute Money* (Fig. 9.6).

Masaccio's works have a gravity and monumentality that make them larger than lifesize. The use of deep perspective, plasticity, and modeling to create dramatic contrasts gives solidity to the figures and unifies the paintings. Atmospheric perspective enhances the deep spatial naturalism. Figures appear strong, detailed, and very human. At the same time, the composition carefully subordinates the parts of the painting to the whole.

We can see the maturation of Masaccio's style in a second work, *The Holy Trinity* (Fig. 9.7), in the Church of Santa Maria Novella in Florence. Here, Masaccio states the central doctrine of Christianity in a full-frontal,

MASTERWORK

MASACCIO—*THE TRIBUTE MONEY*

Masaccio's perception of the universe exploded into life in the decoration of the chapel of the Brancacci family in the Church of Santa Maria del Carmine in Florence. Late Renaissance artists such as Michelangelo came to view these frescoes and to study the new art developed by Masaccio.

The most famous of these frescoes, *The Tribute Money* (Fig. **9.6**) makes full use of the new discovery of linear perspective, as the rounded figures move freely in unencumbered deep space. *The Tribute Money* employs continuous narration, where a series of events unfolds across a single picture. Here Masaccio depicts a New Testament story from Matthew (17:24–27).

In the center, Christ instructs Peter to catch a fish, whose mouth will contain the tribute money for the tax collector. On the far left, Peter takes the coin from the fish's mouth; on the right he gives it to the tax collector. Masaccio has changed the story somewhat, so that the tax collector appears directly before Christ and the apostles, who are not "at home," but in a landscape of the Arno Valley. Masaccio's choice of subject matter may relate to a debate over taxation going on at the time in Florence. A contemporary interpretation of the fresco held that Christ had instructed all people, including clerics, to pay taxes to earthly rulers for the support of military defense.

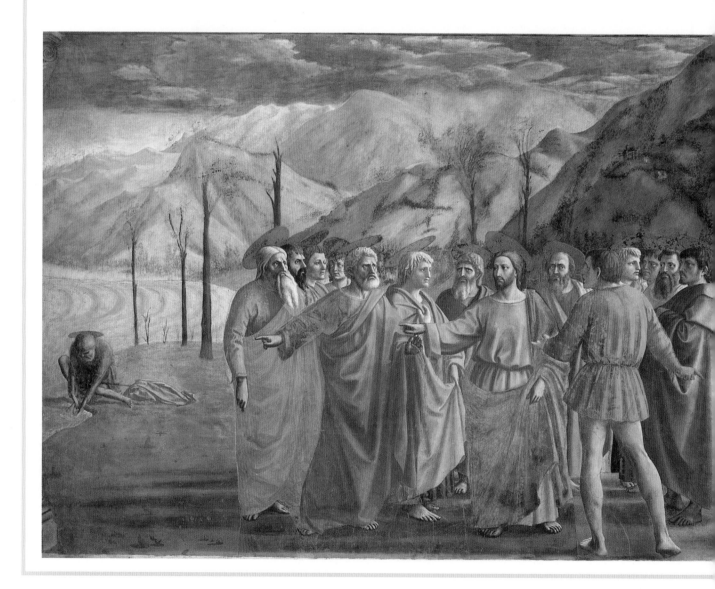

The figures in this fresco appear like "clothed nudes," dressed in fabric which falls like real cloth. Weight and volume reveal an entirely new approach. Each figure stands in classical *contrapposto* stance, and although the sense of motion remains unremarkable, the accurate rendering of the feet and the anatomically correct weight distribution make these the first painted figures to seem to stand solidly on the ground. The narrative comes across through pantomimic gestures and intense glances. Nonetheless, the figures do encapsulate an astonishing energy and reality. Comparing these figures with those of Botticelli, later in the chapter, we see that while Botticelli reveals form and volume through line,

Masaccio uses the play of light and shade (modeling) on an object. To do this, the artist establishes a consistent source for the light, inside or outside the painting, which strikes the figures. That source might be the sun or a candle, for example, but the artist must then render the objects in the painting so that all highlights and shadows occur consistently as if caused by that single light source. Masaccio does not include a light source in the fresco itself; instead, he uses a window in the nearby chapel to act as a light source, and the highlights and shadows appear accordingly (compare Rembrandt's *The Night Watch*, Fig. **12.12**). In addition, the figures form a circular and three-dimensional grouping rather than a flat line across the surface of the work. Even the haloes of the apostles appear in the new perspective and overlap at odd angles.

Masaccio knew no expectation of historical accuracy in works of art. He sets his scene locally and clothes some of his figures in Italian Renaissance costume. Until the eighteenth century, history was considered irrelevant to art. The apostles appear as Florentine "men in the street," and they have sympathetic and human features.

Compositionally, the single vanishing point, which controls the linear perspective, sits at the head of Christ. In addition, Masaccio has rediscovered aerial (atmospheric) perspective, indicating distance through diminution of light and blurring of outlines. We can also see Masaccio's skill in handling landscape as well as figures which shows a previously unknown skill and seldom rivaled grandeur. As one art historian describes it:

> The background is filled with soft atmosphere. Misty patches of woodland are sketched near the banks. Masaccio's brush moves with an ease and freedom unexampled in Italian art since ancient Roman times. It represents not hairs but hair, not leaves but foliage, not waves but water, not physical entities but optical impressions. . . . Each stroke of Masaccio's brush, in fact, is equivalent to a separate reflection of light on the retina.[1]

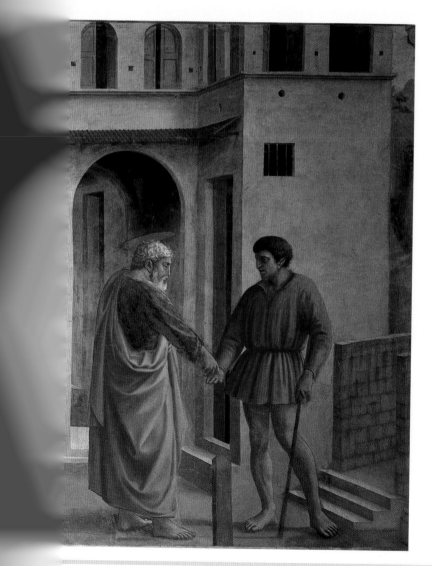

9.6 Masaccio, *The Tribute Money*, c. 1427. Fresco (after restoration 1989), 8 ft 4 ins × 19 ft 8 ins (2.54 × 5.9 m). Santa Maria del Carmine, Florence, Italy.

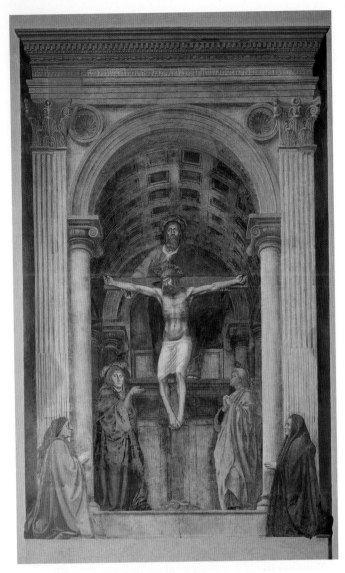

9.7 Masaccio, *The Holy Trinity*, c. 1426–7. Fresco, 21 ft 10½ ins × 10 ft 5 ins (6.67 × 3.17 m). Santa Maria Novella, Florence, Italy.

His son, steadying the cross with His hands while staring out at the rest of the universe. The dove of the Holy Spirit floats between the heads of Father and Son. Mary, the mother of Christ, looks out at us and gestures to us, indicating the sacrifice of her son. St John, the only disciple present at the Crucifixion, looks on, lost in the mystery. The figures at the lower corners of the painting, outside the niche, may be contemporary Florentines, and their coloration gives Masaccio a way of interjecting diagonal line to increase the sense of dynamics in the work. Black robes tie Mary and the feminine figure together, as do the red robes of the gentleman and St John. Thus, two, crossing, implied diagonals join at the feet of Christ.

The entire painting shows a deliberate concern for lifelikeness. Even the nails of the cross protrude according to the perspective of the chapel. Masaccio renders each body part with absolutely precise anatomical detail and accuracy.

However revolutionary and important Masaccio may have been in retrospect, his influence on his contemporaries appears relatively modest. His ideas did, however, strike a spark in some—for example, Fra Angelico (frah ahn-JAY-lee-koh)—and Italian painting moved in the 1430s, 1440s, and 1450s toward a more common Renaissance style, called the second Renaissance style. This, the era of the Medicis, witnessed humanistically oriented patrons of art who commissioned buildings, statues, portraits, and altarpieces to fit their new classical tastes. The laws of Florence forbade luxury and display in personal finery, but the tone allowed for a new life of ease and grace.

Fra Angelico (c. 1400–55) lived a life of piety and humility. Born Guido di Pietro, he appears to have become an accomplished painter before taking vows in the Dominican Order as Fra Giovanni da Fiesole. Once a friar, he served his order as a prolific artist in San Domenico, Fiesole, and in San Marco, Florence. Eventually, he became prior of San Marco, and before his death he was widely known as "the angelic painter"— hence the name by which we know him, Fra Angelico. His *Annunciation*, his most popular and best-known work (Fig. 9.8), dates to the 1430s. Fra Angelico created it as the altarpiece for San Domenico, Cortona, and we should see it within the context of monastic setting and contemplation. (It now hangs in a museum in Cortona.)

A portico of slender Corinthian columns provides the setting as the angel comes to Mary. The delicacy of the columns and the simplicity of the capital details lend delicacy and classical appropriateness to the simple faith and obedience of the Virgin. Angelico divides the canvas into thirds. The arches on the picture plane occupy two-thirds of the work; the receding arcade occupies the remainder. Mary sits on a chair decorated with gold

single **vanishing point** perspective rendering, which places the crucified Christ at the center of the statement. The fresco uses the viewer's eye level as the horizontal line, and the coffered **barrel vault** of the painted niche therefore recedes dramatically, as if we were gazing up into actual three-dimensional space. The linear angles of the T-shaped cross and the body and outstretched arms of Christ stand in dramatic juxtaposition to the rounded arch of the architectural frame and the ceiling of the vault itself. Masaccio carries the blood red colors of the architrave and cornice down through the arch, its capitals, the undergarment of God, and the figures at the lower corners, thereby achieving a unification and central focal area by virtue of this encirclement of color. The symbolism reflects the dead Christ (*Christus mortus*), sacrificed for humankind by God, who stands behind

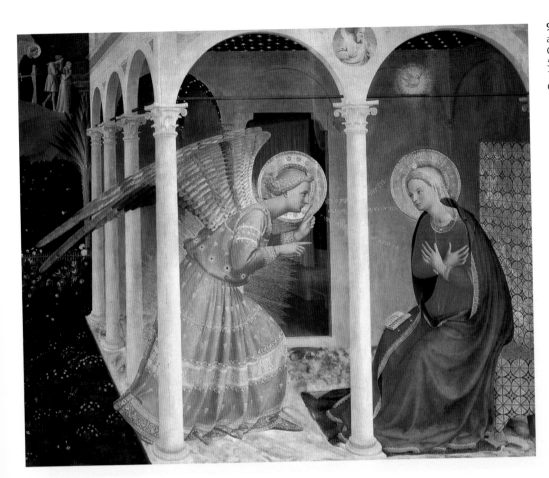

9.8 Fra Angelico, *Annunciation*, altarpiece for San Domenico, Cortona, c. 1434. Panel, 5 ft 3 ins × 5 ft 11 ins (1.6 × 1.8 m). Museo Diocesano, Cortona, Italy.

brocade, and the angel, genuflecting before the seated presence, enters the portico. Fra Angelico prints the angel's words so that they appear to come out of his mouth, running from left to right. Mary's reply—"Behold the handmaiden of the Lord; be it unto me according to thy word" (Luke 1:38)—appears upside down, so that it must be read from Mary toward the angel. The dove of the Holy Spirit floats directly above Mary's head under a blue, star-filled ceiling. The prophet Isaiah looks down from a medallion above the column that separates the two figures. The garden at the left symbolizes Mary's virginity and also represents the Garden of Eden, from which God politely expels a weeping Adam and Eve at the rear. The inclusion of the Eden scene here expresses Christian prophecy and doctrine that Christ would become the "new Adam" and Mary would be the second Eve.

Adam and Eve appear fully clothed in the garments God gave them, and the entire scene lacks dramatic power. Fra Angelico renders his figures three-dimensionally, but barely. The highlight and shadow contrasts remain subdued, and the scene takes on an ethereal lightness as Mary crosses her hands over her breast in acceptance of God's request. Nonetheless, the rendering speaks of plasticity—however refined—even if the celebrated human anatomy of Renaissance depiction does not show through the clothing. Deep space occurs here, as the arcade recedes to a vanishing point on an imagined horizon drawn across the center of the picture. Fra Angelico has captured the spiritual beauty of the moment with a simple and delicate use of line, form, and color. The perfectly drawn hands of the angel, for example, give us a taste of the mastery of medium and execution that accompanies the profound simplicity of the story.

Lyricism

By the last third of the fifteenth century, most of the originators of Renaissance art had died. Florence had been briefly visited by Leonardo da Vinci, whose work—including that done in Florence—belongs to a category that we will pursue in the next chapter. The essences of the new art were well known and well established, and artists turned for further exploration to other avenues. One of these avenues turns inward, toward the life of the spirit and in its search creates a lyrical expression, more poetic than anything we have seen thus far. Outward reality loses favor to more abstract values, and classical intellect sublimates (despite use of classical subjects) into a more emotional introspection. This tradition emerges in

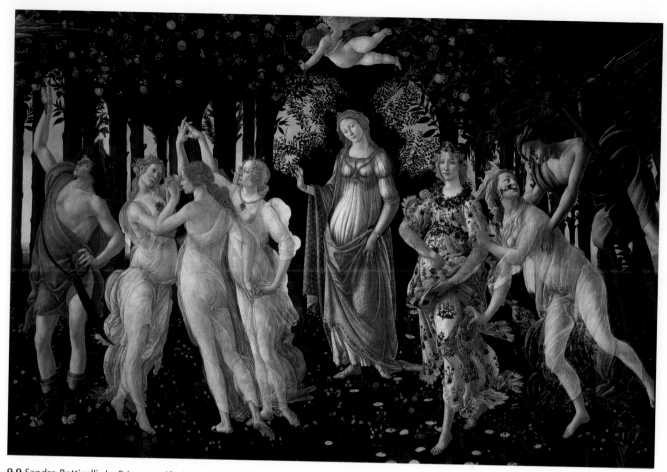

9.9 Sandro Botticelli, *La Primavera* (*Spring*), c. 1478. Tempera on panel, 6 ft 8 ins × 10 ft 4 ins (2.03 × 3.15 m). Uffizi Gallery, Florence, Italy.

the paintings of Sandro Botticelli (bawt-tee-CHAY-lee; c. 1445–1510). The linear quality of *La Primavera* or *Spring* (Fig. **9.9**) suggests an artist apparently unconcerned with deep space or subtle plasticity in light and shade. Instead, the forms emerge through outline. The composition moves gently across the picture, through a combination of gently undulating curved lines, with focal areas in each grouping. Mercury, the Three Graces, Venus, Flora, Spring, and Zephyrus—each part of this human, mythical composition carries its own emotion: contemplation, sadness, or happiness. The subject matter seems classical and non-Christian, but, in fact, the painting uses allegory to equate Venus with the Virgin Mary. Beyond its immediate qualities, the painting has a deeper symbolism, relating also to the Medici family, the patron rulers of Florence.

Botticelli's anatomically simple figures show little concern with detailed musculature, and although he renders the figures three-dimensionally and shades them subtly, they seem almost weightless, floating in space without anatomical definition.

In a fascinating portrayal of a rather ugly mythological tale, Botticelli painted one of his most familiar works, *The Birth of Venus* (Fig. **9.10**). The story depicts the mythical birth of Venus from the sea, which had been fertilized by the severed genitals of Uranus. An allegory, it symbolizes the birth of beauty in the minds of humankind with ideas fertilized by divinity. Yet, out of this myth, Botticelli creates a lyrical and poetic picture of grace and beauty. Venus rises from a rather artificial sea and perches on a floating sea shell. The very picture of innocent beauty, perfect in form, delicate in tone, and naive in expression, she stares innocently out at nothing in particular, covering herself modestly with her hands and long, golden hair. Her weight appears suspended not in or even on the shell: she stays in place held almost magically by unseen forces, as the wind gods blow her to shore, where she will be robed by the waiting figure of Hour. Flowers float in the air, and the entire scene defies the trends of the Renaissance style we have previously explored. No deep space exists here. The background of water does not recede; rather, it piles upward just behind the picture plane, the waves suggested stylistically by V-shaped white lines.

The work of the Italian master Andrea Mantegna (mahn-TEN-yah; 1431–1506) illustrates the early

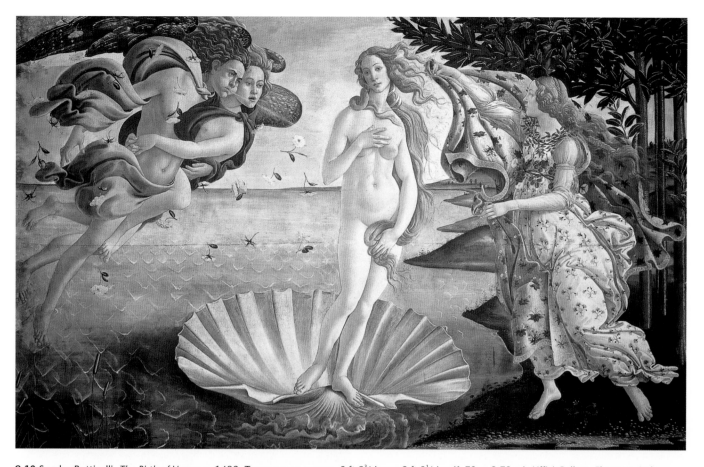

9.10 Sandro Botticelli, *The Birth of Venus*, c. 1482. Tempera on canvas, 5 ft 8¾ ins × 9 ft 3½ ins (1.72 × 2.78 m). Uffizi Gallery, Florence, Italy.

Renaissance period in the north of Italy. *St James Led to Execution* (Fig. **9.11**; see also Fig. **9.1**) presents us with a breathtaking example of early Italian Renaissance monumentalism. Here the forces of scale, **chiaroscuro** (kee-ahr-ur-SKOOR-oh, the use of highlight and shadow to create dimensionality), perspective, detail, unity, and drama emerge strongly. Much of the effect of this work comes from the artist's placement of the **horizon line**—the assumed eye level of the viewer—below the lower border of the painting. Thus, we look up at sharply lifelike buildings receding down a curving street and figures that tower above us as if we were peering at them from a manhole. Mantegna's classical knowledge shows in the details of the triumphal arch and the soldiers' costumes. In his handling of perspective, however, he deliberately sacrifices the strict accuracy of mechanical reality for dramatic effect.

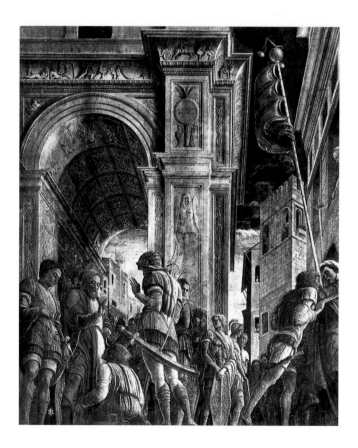

9.11 Andrea Mantegna, *St James Led to Execution*, c. 1455. Fresco. Ovetari Chapel, Church of the Eremitani, Padua, Italy (destroyed 1944).

A DYNAMIC WORLD

CHINESE PAINTING

During the Western Renaissance, Chinese Ming Dynasty painting reflected ostentation, detail, and dramatic presentation. In a work by Lu Chi entitled *Winter* (Fig. **9.12**) strong contrasts, copious detail, hard color edges, and conflicting diagonals create strong action, exaggeration, and intensity. Curvilinear treatment of line instills a broad, sweeping, and yet reasonably soft dynamic, while open spaces and hard-edged outlining impart power and substance to the work. At the same time, an immense amount of delicate detail—for example, in the pheasant, the blossoms, and some of the smaller branches—is captured. Thus, the contrasts—that is, lights and darks, hard edges and curved lines, broad spaces and delicate details—create mystery, opulence, and deep space, similar to Renaissance Italian painting.

9.12 Lu Chi, *Winter*, c. 1500. Hanging scroll, ink and color on silk, 5 ft 9 ins (1.75 m) high. National Museum, Tokyo.

Sculpture

Early Renaissance sculptors had developed the skills to create images of great lifelikeness, but their goal differed from the Greeks, who idealized the human form. Renaissance sculptors found their ideal in individuality—the glorious individual, even if not quite the perfect individual—and sculpture of this style presented a particularly clear-eyed and uncompromising view of humankind: complex, balanced, and full of action.

While relief sculpture found new ways of representing deep space through the systematic use of perspective, freestanding sculpture, long out of favor, now returned to dominance. Scientific inquiry and an interest in anatomy reflected in sculpture as well as painting. The nude, full of character and charged with energy, reappeared for the first time since ancient times. Artists approached the human form layer by layer, through an understanding of its skeletal and muscular framework, and even when clothed, fifteenth-century sculpture revealed the body under the surface.

The greatest masterpieces of fifteenth-century Italian Renaissance sculpture came from the unsurpassed master of the age, Donatello (dah-nuh-TEL-oh; 1386–1466).

Donato di Niccolò Bardi, known later as Donatello, saw life and reality in terms much different from his predecessors and contemporaries. Fascinated by the optical qualities of form and by the intense inner life of his subjects, he produced amazingly dramatic and forceful works. His new approach vividly emerges in the statue of *St George* (Fig. **9.14**). Carved for a guild of armorers and sword makers, who could not afford a work cast in bronze, *St George* differed from the way we now see it in the Bargello Museum. Originally, the figure bore evidence of the products of the guild—a helmet and jutting sword—attached to the statue by holes drilled in the back of the head and a socket attached to the right hand. Nevertheless, as it now stands, the figure reveals a tautness of line in the pointed shapes of the shield, armored feet, and drapery. The facial expression reflects a lifelike human quality—not idealism. Sensitivity, reflectiveness, and delicate features make this figure a hero of everyday proportions and not a godlike warrior out of mythology. Here humanism works in art, illustrating how flesh and blood people react in crisis.

Over the next twenty years, Donatello's style was refined, and from that refinement came his magnificent *David* (Fig. **9.13**), the first freestanding nude since classical times, although, like most classical figures, *David* is partially clothed. The figure exhibits a return to classical *contrapposto* stance in its refined form, but the armor and helmet, and the bony elbows and adolescent features, invest him with a highly individual presence. The work symbolizes Christ's triumph over Satan, and the laurel crown on the helmet and the laurel wreath on

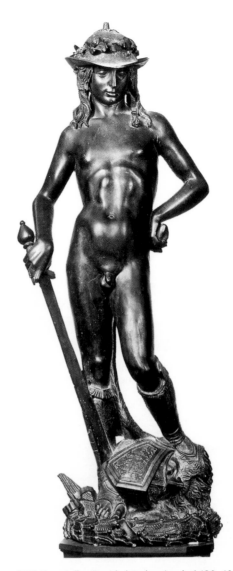

9.13 Donatello, *David*, dated variously 1430–40. Bronze, 5 ft 2¼ ins (1.58 m) high. Museo Nazionale del Bargello, Florence, Italy.

which the work stands allude to the Medici family, in whose palace the statue was displayed in 1469.

Perhaps Donatello's greatest achievement, the *Equestrian Monument to Gattamelata* (Fig. **9.15**) reflects a larger-than-life monument to a deceased general. In it we see the influence of Roman monumental statuary, but Donatello creates a unique concentration on both human and animal anatomy. The viewer does not focus on the powerful mass of the horse, however, but on the overpowering presence of the person astride it. The triangular composition anticipates the geometric approach to sculpture in the High Renaissance (see Chapter 10).

In 1401 the Opera, the Board of Works, of the Baptistery of Florence's Cathedral conducted a competition for relief sculptures for the north doors of the Baptistery. Seven sculptors competed, including Lorenzo Ghiberti (ghee-BAIR-tee; c. 1381–1455), a

9.14 Donatello, *St George*, 1415. Marble, 3ft 7½ ins × 2 ft 3 ins (109 × 67 cm). Museo Nazionale del Bargello, Florence, Italy.

9.15 Donatello, *Equestrian Monument to Gattamelata*, 1445–50. Bronze, about 11 × 13 ft (3.4 × 4 m). Piazza del Santo, Padua, Italy.

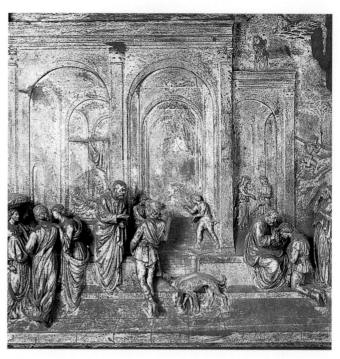

9.16 Lorenzo Ghiberti, *The Story of Jacob and Esau*, panel of *The Gates of Paradise*, c. 1435. Gilt bronze, 31¼ ins (79.4 cm) square. Baptistery, Florence, Italy.

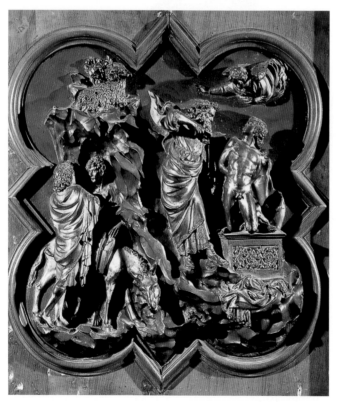

9.17 Lorenzo Ghiberti, *Sacrifice of Isaac*, 1402. Gilt bronze, 21 × 17½ ins (53 × 44 cm). Museo Nazionale del Bargello, Florence, Italy.

contemporary of Donatello. The award went to Ghiberti, who was only twenty years old at the time. In his subject, the sacrifice of Isaac by his father, Abraham, at the Lord's command, Ghiberti explores the moment Isaac kneels on the altar with Abraham ready to put the knife to his throat. The archangel intervenes, and we see the ram that the Lord provides as a substitute sacrifice as well as the two servants and the ass drinking water from a rock. The work symbolizes the divine intervention that delivers the Chosen People from catastrophe, including the substitute victim and the miraculous appearance of water.

Ghiberti's story flows with sweeping curves (Fig. 9.17). Abraham reaches around his son and grasps him by the left shoulder. The boy gazes expectantly at his father, while the angel remains in the heavens, not touching the obedient patriarch. The emphases appear spiritual rather than physical, while the overtones of the work give us a sequence of curvilinear rhythms in which the principal axis runs across the diagonal to provide energy and tension. Ghiberti trained as a painter and had not yet joined any guild—especially not the metalworkers' guild—but he shows profound and sophisticated handling of the metal. The project occupied Ghiberti from 1403 until 1424, and in the process, the Opera changed its mind about the subject matter, and Ghiberti found himself faced with the task of depicting the New Testament. The subject of Abraham and Isaac had to wait for the third set of doors.

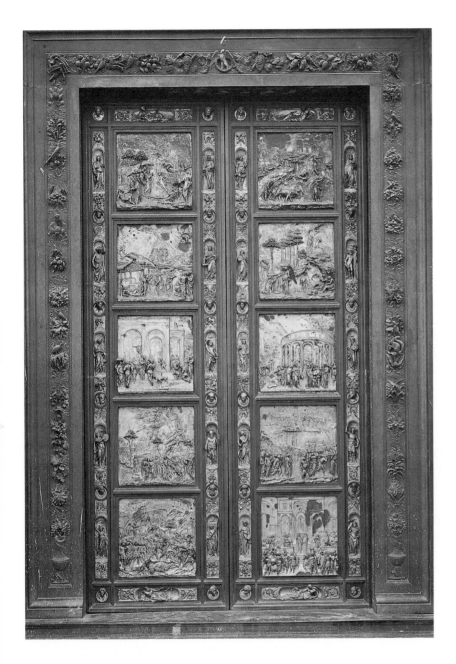

9.18 Lorenzo Ghiberti, *The Gates of Paradise*, 1424–52. Gilt bronze, about 17 ft (5.2 m) high. Baptistery, Florence, Italy.

Perhaps the major breakthrough of Renaissance art came in the discovery of principles for depicting perspective mechanically and, thus, naturalistically. This new means of spatial representation produced a visually convincing and attractive means of depicting objects in space and imbuing them with qualities that gave their relationship to the distant horizon rationality. We can see these principles at work in Ghiberti's *The Gates of Paradise* for the east doors of the Florence Baptistery (Fig. **9.18**). Commissioned in 1425, these great doors bear ten scenes. The sculptor freely uses each gilded square as if it were the canvas of a painting. In so doing, Ghiberti employed perspective to bring to relief sculpture a totally new sense of deep space. The title of the doors apparently comes from the fact that they open on the *paradiso* (pahr-

uh-DEE-soh), the area between the Baptistery and the entrance to the Cathedral. Michelangelo reportedly remarked that the doors were worthy to be the Gates of Paradise, and the name stuck.

Each panel depicts an incident from the Old Testament. The rational perspective and the defined relief give the scenes a remarkable sense of space in which the picture plane seems almost fully round and free of the background. For example, in *The Story of Jacob and Esau* (Fig. **9.16**) Ghiberti created beautiful surfaces with delicate and careful detail, and used receding arcades to portray depth and perspective. This sculptural work takes on the characteristics of a Renaissance painting. The exacting detail and bold relief of these scenes took Ghiberti twenty-one years to complete.

295

Architecture

In the early fifteenth century, a new style of art arose among artists in Florence. This style sought to capture the forms and ideas of the ancient Greeks and Romans, dedicated to human principles and potentials rather than to ecclesiastical ones. It contained three significant stylistic departures from medieval architecture. First, architects revived classical models, but they did so along mechanical lines. They measured ruins of Roman buildings and translated the proportions into Renaissance buildings, so that, for example, Roman arches became geometric devices by which formally derived designs could be superimposed on new buildings. Second, decorative detail—nonstructural ornamentation—on the façades of buildings now came into favor. Third, a radical change occurred in the outer expression of structure. The outward form of a building previously closely related to its structural systems—the structural supports of the building—but in the Renaissance, supporting elements, such as posts and lintels, masonry, and arches, disappeared from view. External appearance no longer subordinated to structural concerns; it took on a life of its own.

First among the formulators of the theoretical principles of the new style was Leon Battista Alberti (al-BAIR-tee; 1404–72), whose books appeared some twenty years after implementation of the innovations. Alberti, a scholar, writer, architect, and composer, dominated the second half of the fifteenth century. His treatise *Concerning Architecture* drew on Vitruvius and provided a scholarly approach to architecture that influenced Western building for centuries. His scientific approach to sculpture and painting, as well as to architecture, encompassed theories on Roman antiquity and tended to reduce aesthetics to rules.

The problems confronting Renaissance architects differed from those facing their predecessors, however. An expanding range of types of buildings—for example, townhouses, hospitals, and business establishments—required adaptation of classical forms to meet specific practical needs. Alberti claimed that art was easier for the ancients because they had models to imitate and from which they could learn. Therefore, he asserted, the fame of Renaissance artists ought to be that much greater if they discovered unheard-of and never before seen arts and sciences without benefit of models or teachers.

In meeting these new needs, Renaissance architects applied classical detail to a wide range of forms and structures, many of which were basically nonclassical. For example, Alberti himself used a system of classical details on a nonclassical building in his design of the Palazzo Rucellai (puh-LAHT-zoh roo-CHAYL-y;

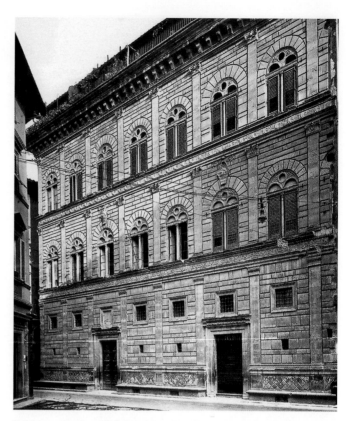

9.19 Leon Battista Alberti, Palazzo Rucellai, c. 1452–70.

Fig. 9.19), which reminds us of the Roman Colosseum in its alternating arches and attached columns of changing orders.

For Alberti, the supreme example of the new art appeared in the dome of the Cathedral of Florence (Fig. 9.20), then being completed by Filippo Brunelleschi (fee-LEEP-poh broo-nuhl-ES-kee; 1377–1446). Its great dome had been appended to a Gothic building. According to Alberti, the construction of such a great dome, without great quantities of wood, seemed impossible even for that time and, thus, surely "unknown and unthought of among the Ancients."

Brunelleschi's dome rose amid the most turbulent of times, dominating the skyline of Florence and the surrounding valley of the River Arno. After studying the remains of ancient architecture in Rome, Brunelleschi returned to Florence with his own ideas on how to utilize ancient elements in contemporary ways. Actually, Brunelleschi had been involved, at least peripherally, in the design of the original building at the turn of the fifteenth century, for in 1417 he had been hired as an advisor to the building committee and spent three years building a model to complete the project. The model accepted, the task of finishing the project began. The nature of the existing structure hampered Brunelleschi: the overall plan of the cathedral, begun in the fourteenth

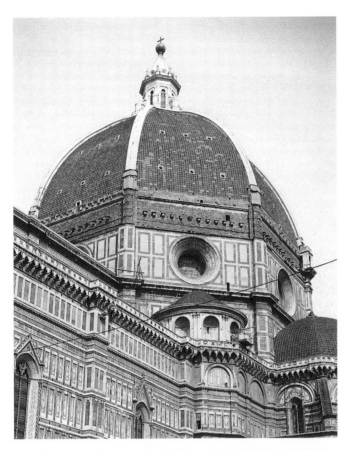

9.20 Filippo Brunelleschi, dome of Florence Cathedral, Italy, 1420–36.

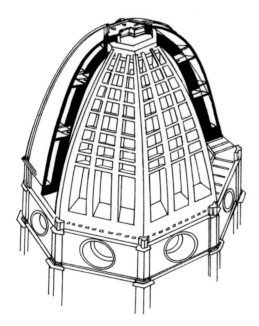

9.21 Schematic of Brunelleschi's dome for Florence Cathedral.

century, could not be changed, and this included an octagonal base for the dome itself, whose shape has an immense tension that resembles a Gothic arch more than a classical dome. Eight massive ribs (Fig. **9.21**), like the spokes of an umbrella, seem held together at the top by the marble **lantern**, designed to admit light into the interior. Construction began in 1420 and was completed in 1436, but the lantern was not completed until late in the century. Instead, an octagonal oculus or "eye," like that of the Pantheon (see Fig. **4.21**), sufficed temporarily. Brunelleschi's dome rises 180 feet (55 meters) into the air, its height apparent from both the outside and inside. If we compare it with the Pantheon, Brunelleschi's departure from tradition emerges clearer. The dome of the Pantheon impresses us only from the inside of the building, because its massive exterior supporting structure clutters the visual experience. The phenomenal height of Brunelleschi's dome impresses, because the architect hid the supporting elements, such as girdles and lightweight ribbing. The result emphasizes the primacy of the visual experience. Thus, the dome becomes related to a work of sculpture.

One of the most striking examples of Brunelleschi's exploration of the new style in architecture, the Hospital of the Innocents, or Foundling Hospital (Ospedali degli Innocenti), in Florence (Fig. **9.22**) (a new building), tells us something about the human flavor of the times. Although orphanages existed, the Republic of Florence decided to provide care for a growing number of foundlings from infancy to the age of eighteen, and this care included housing, food, education, and vocational training. Sitting on one side of an open square, even today it provides a refreshing sight with its harmonious arcade of Roman arches supported by Corinthian columns. In its graceful simplicity the design of the façade reflects Brunelleschi's science of measure and proportion. The unbroken entablature reinforces the horizontal placidity of the composition, aided by the curvilinear arches, carried into the wall of the building itself, and by the circular medallions of infants placed between each arch. Windows that sit above the keystone of each arch enhance symmetry and elegance.

The plan of the building, which, incidentally, Brunelleschi drew for the builders—something never done previously—instead of using a model, employs two geometric forms: the cube and the hemisphere. The distance between the centers of the columns equals that between the center of a column and the wall of the building. The same distance equals the height from the floor of the **loggia** (LOH-gee-uh; a roofed open arcade) to the point where two arches meet. All these precisely calculated measurements dealt with the difficult factor of π that is required for measuring circles. The distance from the cornice, on which the windows rest, to the base of the

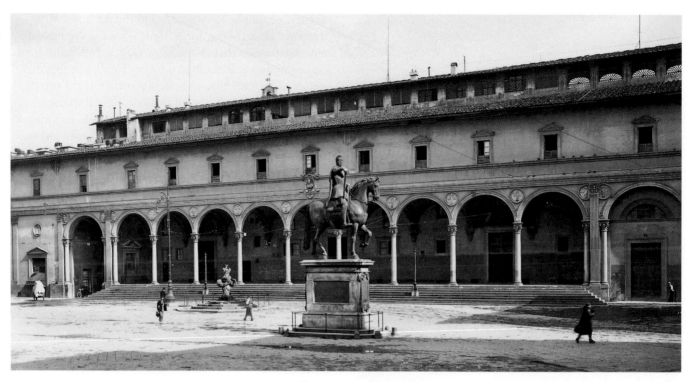

9.22 Filippo Brunelleschi, Foundling Hospital, Florence, Italy, designed 1419, built 1421–44.

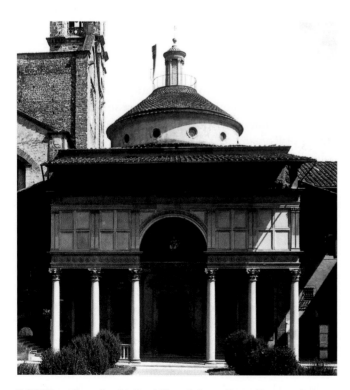

9.23 Filippo Brunelleschi, Pazzi Chapel, Santa Croce, Florence, Italy, c. 1440–61.

architrave equals the distance from the base of the architrave to the junction point of the arches. Half this distance established the width of the smaller doors and windows. Brunelleschi calculated every relationship in the building mathematically, based on the proportions of one to two, one to five, and two to five. The symbolism of Christ, the second member of the Trinity, the five wounds of Christ, and the Ten Commandments is obvious.

The culminating achievement of Brunelleschi's career, although not finished until after his death, came in the intimate and lovely chapter house of Santa Croce (KRO-chay), known as the Pazzi Chapel, commissioned by the rich and powerful Pazzi family (Fig. **9.23**). The chapel again illustrates the use of classical ornamentation, and its walls serve as a plain background for a wealth of surface decoration. Concern for proportion and geometric design seems clear, but the overall composition does not slavishly follow arithmetical considerations. Rather, the Pazzi Chapel reflects Brunelleschi's classical aesthetics. A rectangular structure, three stories tall, twice as long as wide, it served as a meeting place for the Franciscan chapter of Santa Croce. The second story contains the arches and pendentives that support a star-vaulted dome, which culminates in a temple lantern. The dramatic central portal thrusts its Roman arch upward through the plane of the flanking colonnade. The intricate Corinthian capitals create a pleasing transition from graceful columns to decorative architrave.

Theatre

Often resistant to change, theatre in much of Europe during the time of the early Renaissance retained its medieval characteristics. In France, for example, the *Confrérie de la Passion* (kahn-fray-REE duh lah pah-see-AWN), a professional theatre company, under license from Charles VI, continued to produce mystery plays in France throughout the fifteenth century. Their cycle of plays representing *The Mystery of the Old Testament* consisted of 44,325 verses and took twenty performances to complete. *The Mystery of the New Testament* consisted of 34,574 verses. A third cycle, *The Acts of the Apostles*, rounded out the *Confrérie*'s repertoire and took forty days to present in its entirety.

But the French also developed a new secular form, the *sottie* (soh-TEE), consisting of short theatrical entertainments woven into the yearly festivals of the Feast of the Ass and the Feast of the Fools. These festivals originated partly in pagan rites and comprised bawdy burlesques of the Roman Catholic Mass. A person called the "bishop," "archbishop," or "pope of fools" celebrated a mock Mass with a great deal of jumping around, buffoonery, and noise. Participants wore strange costumes (or nothing at all), and the entire affair accompanied much drinking and carousing. One of the most popular of the *sotties* written for the Feasts, Pierre Gringoire's *Play of the Prince of the Fools*, debuted in Paris in 1512 at the request of Louis XII to inflame the populace against Pope Julius II.

At the same time, a more substantial French theatrical form also emerged—the **farce**. The farce constitutes a specific theatre genre still practiced today. It can be seen also as an exaggerated form of comedy in which, however, the accent is on physical action rather than dialogue. The farce represented a genre fully developed as a play form. Actors performed farces as independent performances, in contrast to the *sottie*, which served as between-the-acts entertainment. A popular French farce of the day, *Maître Pierre Pathélin* (MEHT-ruh pee-AIR pah-tay-LEHN; 1470), still sees occasional performance today.

Renaissance ideas did reach the stage in Italy in the Quattrocento, although the early Renaissance remained primarily a time of visual art and architecture. Perhaps because of that fact, the impact of the Renaissance on theatre took the form of elaborate explorations of mechanical perspective applied to stage scenery, but the height of this phenomenon did not occur until the sixteenth century. We will study it in detail in the next chapter. The Italian political philosopher Niccolò Machiavelli (see Profile, p. 301) probably gained greater fame among his peers as a playwright, and his late work, *Mandragola* (*The Mandrake*), gives us an excellent example of the typical Italian comedy of the time. The plot involves a wealthy merchant, Nicias, and his beautiful wife, Lucretia. A young man, Callimaco, learns of Lucretia's beauty and wants to become her lover. Callimaco learns that the couple have had difficulty conceiving a child, and, disguised as a doctor, tells Nicias that he can produce a potion from the mandrake plant that, if taken by Lucretia, will help her conceive. However, Callimaco informs Nicias, the first man to have intercourse with her after she takes the potion will die. Callimaco says that he knows a young man who will consent to have sex with Lucretia and bear the consequences of death. Nicias agrees and convinces Lucretia to go along. Callimaco disguises himself yet again, and gets his way. Witty and fully appropriate to the subject matter treated by the ancient Greeks, the play reveals the Renaissance spirit as well as the genius of its author.

Music

The establishment of the Academy in Florence, and its interest in things classical, encouraged much speculation and interest among the scholars of Florence, and music played an important part in Florentine life. Lorenzo de' Medici founded a school of music that attracted performers from all over Europe, and music triggered the emergence of a new genre, theatre dance, as we shall see momentarily. The supervisor of the Academy, Marsilio Ficino, had a profound interest in the music of the Greeks and the role of music in society as expressed in the writings of Plato and Aristotle, who saw music as contributing to moral order. Ficino tried to reconstruct at least the metrical, if not the modal, character of classical Greek and Roman music.

In the Renaissance, the ideal of the "universal man" led to the expectation that all educated persons took training in music. Musicians performed in churches, towns, and at courts. Church choirs increased in size during the fifteenth century. The Papal Choir in Rome, for example, grew from ten to twenty-four singers during the period. Again, in keeping with the sense of the age, patronage for music shifted from church to court, with nobles competing to hire the best composers and musicians. A typical Italian court might have from ten to sixty musicians, including singers and instrumentalists. Women found favored places as singers at several Italian courts. And, true to the spirit of individualism of the Renaissance, composers rose from anonymity to individual recognition and the highest status and pay yet known.

Typically, vocal music held a higher station than instrumental music, reflecting humanism's deep interest in

language. Composers, as we will note in greater detail in the next two chapters, wrote to enhance the text's meaning and emotion. This stands in stark contrast to medieval music in which composers had little interest in the emotion of a text. What we consider Renaissance style in music developed largely in the Low Countries of Northern Europe, and we will take up that subject in Chapter 11. Chapters 10 and 11 will introduce us to the major figures in Renaissance music as well as its notable genres such as motets and madrigals.

Dance

Out of the same northern Italian courts that supported Renaissance painting and sculpture came the foundations of theatre dance. Indeed, the visual and geometric characteristics of dance as we know it today are firmly rooted in the developments of the Italian Renaissance. Dance moved from a social milieu (Fig. 9.24) to a theatrical one as the Italians, especially in Florence, began to create patterns in body movements. As in all the arts, dance showed an increasing concern for "rules" and conventionalized vocabulary.

Mummeries, pageants, and other performances dating back to the traveling pantomimes of the Middle Ages emerged as formal dance in the elaborate entertainments of fifteenth-century Italian courts. Spectacular displays, they remained more social than theatrical. Concern for perfection, for individual expression, dignity, and grace, created a vocabulary for dance steps and a choreography of dance patterns and designs. Courtly surroundings added refinement and restraint, and the dancing master assumed greater importance and control as he designed elegant movements. Increasingly, dance emerged as something to watch rather than something to do.

An important milestone in theatrical dance occurred at this time. Guglielmo Ebreo of Pesaro (goo-lee-EHL-moh ay-BRAY-oh; pay-SAHR-oh) wrote one of the first compilations of dance description and theory. As he tried to record this complex and visually oriented activity, he stressed memory as one of the essential ingredients of the dancer's art. His observation isolated the most critical element of dance tradition, one that even today keeps dance alive and enables it to be transmitted from generation to generation of dancers. Film and labanotation have still not replaced the personal memory by which the traditions of dance are passed along.

Guglielmo's work provided a clear record of formal dance. He strove to bring dance out of the disrepute into which it had fallen in the bawdy pantomimes of previous eras and to make it fully acceptable from an aesthetic standpoint. For Guglielmo, dance comprised an art of grace and beauty.

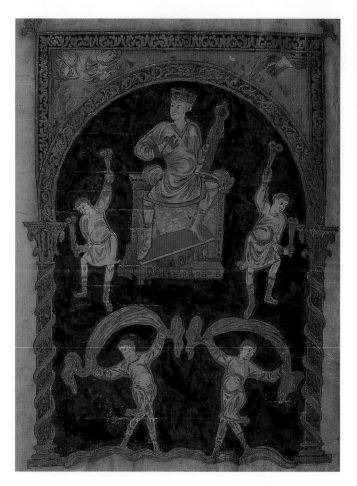

9.24 *King David and Four Dancers* from the golden psalter, St Gall, second half of ninth century. Stiftsbibliothèque, St Gallen, Switzerland.

Literature

The fifteenth century saw mostly a continuation of medieval literary forms, but that does not exclude the presence of Renaissance humanism in writers such as Petrarch, Lorenzo de' Medici, Nicolò Machiavelli (Fig. 9.25), and Pico de Mirandola. The "Father of Humanism," the Italian poet Petrarch (1304–74), wrote in both Latin and his native Tuscan dialect. He plays the role of a key figure in the transition from medieval to Renaissance thought. His writings differ significantly from those of his contemporary, Dante (see Chapter 8), for example, and overflow with complaints about "the dangers and apprehensions I have suffered." Contrary to what he wrote, however, Petrarch enjoyed the favor of the great men and women of his day. He flourished at the papal court at Avignon. But Petrarch could not reconcile his own conflicting aspirations and interests into a workable existence: he desired solitude and quiet, but stayed continually active. Although he adored celebrity status, he attacked the superficiality of the world around him and longed for the monastic life.

Petrarch is well known for his love poems to Laura, written over a period of about twenty years: he wrote more than 300 Italian sonnets to her, as well as other short lyrics and one long poem. Petrarch developed the **sonnet** form to its highest expression, to the degree that we now call this form the **Petrarchan** (sometimes, Italian) **sonnet**. A fixed verse form, it contains fourteen lines. Typically they treat a variety of moods and subjects, but particularly the poet's intense psychological reactions to his beloved. The fourteen lines divide into eight lines (the *octave*) rhymed ABBAABBA followed by six lines (the *sestet*) with a variable rhyme scheme mainly CDECDE or CDCDCD. The first eight lines usually present the theme or problem in the poem, and the final six present a change in thought or resolution of the problem. The sonnet form developed in Italy in the thirteenth century, and, as we said, reached its highest form of expression in Petrarch. Imported into England, it adapted to create the

form now called a **Shakespearean sonnet** (see Chapter 11). Here is an example:

Canzone VI
So Wayward is the madness of Desire
Petrarch

So wayward is the madness of desire
In following her who turns from me in flight,
And who, at liberty, like air or light,
My love-encumbered chase eludes like fire,
That when the more I call, the more aspire
To point the safer path by left or right,
The less it heeds; to curb or to excite
Avails not: Love drives faster, fiercer, higher!
Thus, the triumphant bit between its teeth,
I must remain incapable and mute,
That while against my will it speeds my death
Straight to that laurel whose most fatal fruit,
Instead of healing, spreads its bitter breath
And nourishes the pain it should uproot.

PROFILE

NICCOLÒ MACHIAVELLI (1469–1527)

Italian political philosopher, statesman, poet, playwright, and thinker Niccolò Machiavelli (nee-coh-LOH mah-kee-ah-VAY-lee) earned an undeservedly unsavory reputation because of his insights on political power and human nature. Born into a wealthy and important Florentine family, Machiavelli learned from an early age "to do without before he learned to enjoy," as he later wrote.

The Prince represents Machiavelli's political theory. Written in the form of advice to a new ruler, it tells how to found a state and to maintain himself in power. The blunt nature of the maxims has given Machiavelli a reputation for immorality but many find in his theories merely a sense of the reality of humans and their political situations. These theories do not deal with life as it should be; rather, within the framework of their objectives, they describe life as Machiavelli saw it. It seems likely that he was not the cold, cynical, and irreligious man he is often accused of being. Above all, his theories seek the good of the public. He dreamed and hoped for the ideal prince who could rescue and restore Italy from the conflagration in which the times and the people of those times had embroiled it. The prince to whom Machiavelli directs his theoretical advice would have to deal with human nature and harsh realities as Machiavelli found them in Renaissance Italy.

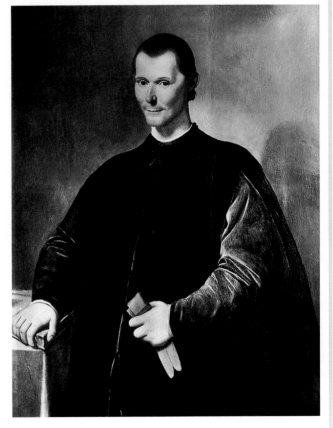

9.25 Niccolò Machiavelli (1469–1527). Painting by Santi di Tito. Palazzo Vecchio, Florence, Italy.

The poem has a stylistic elegance and strives for perfection of form in the classical tradition such as we have seen in Roman writers like Ovid, Vergil, and Horace. Petrarch tried to revive classical literature, considering classical culture a model or ideal against which to measure other civilizations, including his own. He had an insatiable love of learning, for which he gained the epithet "Father of Humanism," having significantly influenced those who followed. He rejected medieval philosophy and also found science wanting as a way of achieving a "happy life." As a humanist, he placed emphasis on human achievement, but did so without rejecting religious faith or spirituality. Human achievement, then, reflected the crowning glory of God's creation.

Lorenzo de' Medici ("the Magnificent") provided a new thrust for popular literature in the native Tuscan dialect, which he defended in a commentary on his own sonnets. He also composed lyrics for traditional folk tunes and encouraged others to do the same. His sonnets, as well as popular verses, reflect sophistication, beauty, and stylistic excellence. They exhibit spontaneity, humor, and charm. His "carnivale songs" express lyrical fluidity and polish. The "carnivale songs" comprise a part of an Italian tradition of secular music. Performed by masked men and boys during the pre-Lenten Carnival, a celebration of the return of spring, they often contained double-entendres and light obscenities, and mocked social customs. Most of the texts employ strophic form (using the same music for each verse), but some are through-composed (using new music for each verse).

Pico della Mirandola's "Oration on the Dignity of Man" expresses fundamentally the ideas of the Italian Renaissance. In eloquent prose, Pico centers attention on human capacity and perspective. He intended the "Oration" as a preface to a compendium of all the intellectual achievements of humanity, and, in a sense, as a reflection of his own massive intellect and accomplishment. In the work, he places humanity at the center of the universe (compare the Greek "Man as the Measure of all things," Chapter 3), calling humankind "the intermediary between creatures, the intimate of higher beings and the king of lower beings, the interpreter of nature by the sharpness of his senses, by the questing curiosity of his reason, and by the light of his intelligence, the interval between eternity and the flow of time." Humankind can either soar to the heights of divine higher beings or fall to the level of the brute beast. We see this reflection repeatedly in the thought and works of the Renaissance, and will examine it at its height in the High Renaissance, explored in Chapter 10.

Oration on the Dignity of Man
(Excerpt)
Pico della Mirandola

I have read in the records of the Arabians, reverend Fathers, that Abdala the Saracen, when questioned as to what on this stage of the world, as it were, could be seen most worthy of wonder, replied: "There is nothing to be seen more wonderful than man." In agreement with this opinion is the saying of Hermes Trismegistus: "A great miracle, Asclepius, is man." But when I weighed the reason for these maxims, the many grounds for the excellence of human nature reported by many men failed to satisfy me—that man is the intermediary between creatures, the intimate of the gods, the king of the lower beings, by the acuteness of his senses, by the discernment of his reason, and by the light of his intelligence the interpreter of nature, the interval between fixed eternity and fleeting time, and (as the Persians say), the bond, nay, rather, the marriage song of the world, on David's testimony but little lower than the angels. Admittedly great though these reasons be, they are not the principal grounds, that is, those which may rightfully claim for themselves the privilege of the highest admiration. For why should we not admire more the angels themselves and the blessed choirs of heaven? At last it seems to me I have come to understand why man is the most fortunate of creatures and consequently worthy of all admiration and what precisely is that rank which is his lot in the universal chain of Being—a rank to be envied not only by brutes but even by the stars and by minds beyond this world. It is a matter past faith and a wondrous one. Why should it not be? For it is on this very account that man is rightly called and judged a great miracle and a wonderful creature indeed. . . .

. . . God the Father, the supreme Architect, had already built this cosmic home we behold, the most sacred temple of His godhead, by the laws of His mysterious wisdom. The region above the heavens He had adorned with Intelligences, the heavenly spheres He had quickened with eternal souls, and the excrementary and filthy parts of the lower world He had filled with a multitude of animals of every kind. But, when the work was finished, the Craftsman kept wishing that there were someone to ponder the plan of so great a work, to love its beauty, and to wonder at its vastness. Therefore, when everything was done (as Moses and Timaeus bear witness), He finally took thought concerning the creation of man.

CHAPTER REVIEW

CRITICAL THOUGHT

Without doubt the world changed, although it is equally certain that no one woke up one morning and said, "Today is the dawn of the Renaissance!" Evaluations that categorize times usually come with the vision of hindsight, which we, of course, have. Looking back on the Renaissance, we have the luxury of speculating on whether or why we should call it the Renaissance and to examine changes that occurred in how people lived, in the way the political map emerged, and in how people went about doing business and exploring their world. One of the ways in which things were different was in the sheer amount of activity occurring, coupled with the manner in which men and women pushed open the frontiers of their spiritual, psychological, and physical worlds.

The Renaissance definitely saw a tremendous outpouring of creative activity clearly marked by new ways of exploring subject matter in visual art, and expressed by form and structure in architecture. Dance entered the scene as an art rather than an activity, and theatre found itself mired in the old while puttering with the new.

Understanding Renaissance art means understanding the work of its artists. It means being able to look at the work of one artist and compare its qualities with that of other artists of the same or other periods and of other styles. For example, we should be able to point out the characteristics that differentiate the east doors of the Baptistery of the Florence Cathedral from the bronze doors of Hildesheim Cathedral (see Fig. **7.21**) and to understand why Masaccio and Botticelli, for example, reflect new ways of painting, compared to Giotto.

SUMMARY

After reading this chapter, you will be able to:

- Describe specific qualities that represent Renaissance art and architecture, identify the individual artists who contributed to the tradition, and explain how, within the artworks themselves, artists applied those innovations.
- Identify new forms and plays in Renaissance theatre.
- Discuss the rise of dance from a group activity to a formal art, with specific references to the individual responsible.
- Explain the geographical, economic, political, and philosophical circumstances of the Renaissance—as well as understand the implications of the term "Renaissance" itself.
- Apply the elements and principles of composition to analyze and compare specific works of art and architecture illustrated in the text.

CYBERSOURCES

http://www.artcyclopedia.com/history/early-renaissance.html
http://www.greatbuildings.com/architects.html

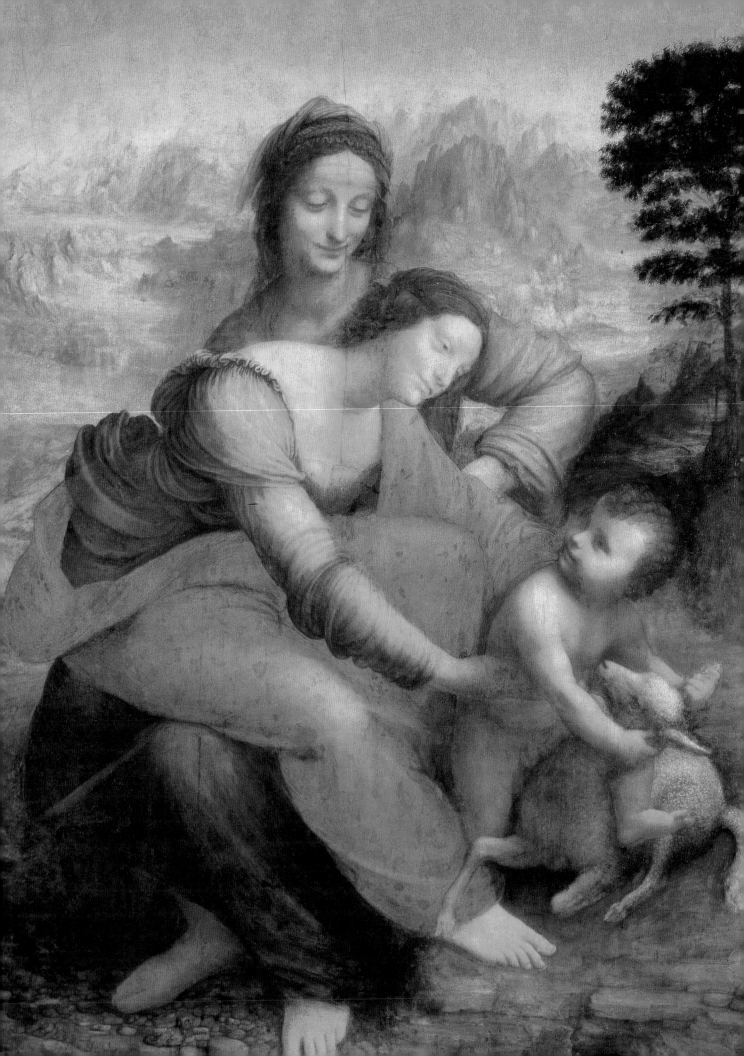

10 THE HIGH RENAISSANCE AND MANNERISM

OUTLINE

VIEW

HOW TO BE REMEMBERED

When we use the word Renaissance, which of course includes the High Renaissance, on which we focus in this chapter, we identify an important historical period by the nature of its art and ideas. Isn't it interesting that the means by which we identify historical periods often have to do with art and culture? No one discounts the importance of business, science, and so on, but rarely do we identify historical eras by material pursuits of this sort.

When we look at the remarkable accomplishments of human history, regardless of the field in which they occurred, we inevitably encounter individuals who possess qualities that place them outside the ordinary. These people have something to "say" and "say" it well. They avow the unique rather than the cliché, and they know that being remembered requires something more than outlandish behavior and good PR.

KEY TERMS

TERRIBILITÀ
Genius, an awesome force, a concept akin to sublimity, a supreme confidence.

HIGH RENAISSANCE
The time from around 1495 until around 1520, primarily in Rome and characterized by the works of Michelangelo, Raphael, and Leonardo da Vinci.

CONQUISTADORS (conquerors)
The early Spanish explorers of the New World.

SFUMATO
A blending of light and shadow practiced by Leonardo da Vinci.

MANNERISM
A movement in art characterized by a "mannered" or affected appearance of subjects.

COMMEDIA DELL'ARTE
A Renaissance theatre type performed by troupes of actors wearing masks and employing improvised plots and stock characters.

10.1 Leonardo da Vinci, *Virgin and Child with St Anne*, 1508–10. Oil on panel, 5 ft 6⅛ ins × 4 ft 3¼ ins (1.68 × 1.3 m). Louvre, Paris.

CONTEXTS AND CONCEPTS

Contexts

The Expanding World

In July 1497, Vasco da Gama sailed from Lisbon, Portugal, with two well-armed ships. In November 1497, he rounded the Cape of Good Hope, the southern tip of Africa. By May of 1498, he had reached India, where he found people living in rich principalities and used to trading with Persian and Arab merchants. Despite difficulties, he managed to load his ships with spices and precious stones and to return to Portugal. Although he lost half his fleet and men on the way, he proved beyond doubt that a sea route to India existed and that it could prove practical and profitable. Less than a year later, Pedro Alvares Cabral left Portugal with fifteen heavily armed ships and 1,500 men, determined to make Portugal a major trading power in the Indian Ocean. However, on his way down the coast of Africa, he sailed too far west and ended up on the coast of Brazil, which he promptly claimed for Portugal.

By 1515 Portugal dominated the main spice-producing region of the world, and Portuguese sailors found their way to Japan as well. In the wake of the traders came Christian missionaries, and in 1559 the Japanese welcomed a Jesuit mission to the imperial capital at Kyoto. In 1569 a powerful Christian convert gave the Jesuits the town of Nagasaki, which became their major base. By the end of the century, Japan claimed over 300,000 Christians, and although Portuguese attempts to gain entry into China did not succeed, by the mid-sixteenth century, Portugal had established a tremendous commercial empire stretching across four continents.

After Christopher Columbus had shown the way, the rate of exploration of the world increased rapidly. Among those who descended on the Americas came restless men and ex-soldiers looking for easy wealth and fame. Such an individual, Vasco de Balboa, led a revolt against the governor of a new settlement on the coast of South America, and then set out up the coast and, crossing the Isthmus of Panama, a passage from north to south, sighted the Pacific Ocean in 1515.

Also among the footloose adventurers of the time, Hernando Cortés (kohr-TEHZ) typified the early explorers and *conquistadors* (conquerors). He had heard stories of a rich and mighty kingdom and determined to find it. He founded the settlement of Veracruz ("True

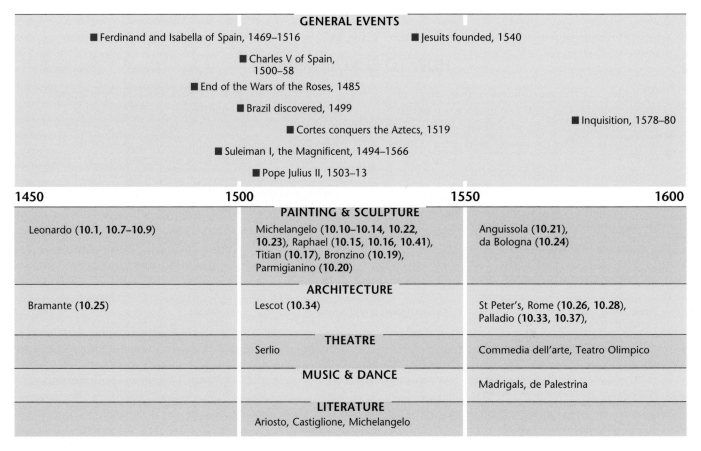

Timeline 10.1 The High Renaissance and Mannerism.

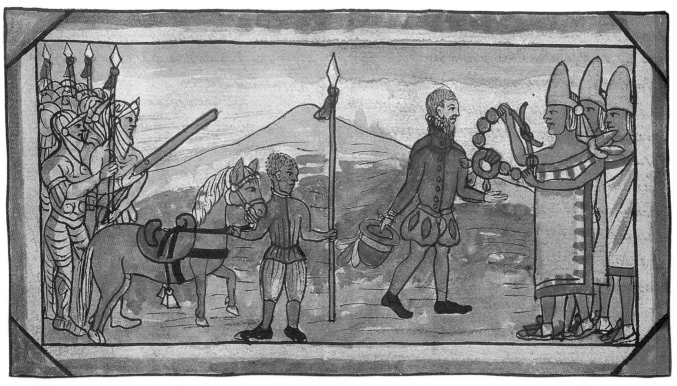

10.2 *Indians Giving Cortés a Neckband*, illustration from Diego Duran, *Historia de las Indias*. Biblioteca Nacional, Madrid.

Cross"), now in Mexico, and received a commission to continue his search for the mysterious kingdom. He set out in 1519 with six hundred men, sixteen horses, ten small guns, and thirteen muskets, determined to attack and overthrow the Aztec empire, for which task he gained the help of the native peoples whom the Aztecs had conquered and who turned on the Aztec ruler, Montezuma. Cortés seized Montezuma, who had welcomed the Spaniards and heaped gifts upon them, and thus caused a riot in which the Aztec ruler was killed and the Spanish were driven from Tenochtitlán (tehn-awch-teet-LAHN), a city of 300,000 residents. But undeterred, and aided by his native allies, Cortés laid siege to the city. Eighty days later, it surrendered, and Cortés stood master of the entire realm of Mexico (Fig. 10.2).

In a few short years, therefore, curiosity and individual self-confidence had taken humankind to the furthest reaches of the planet to explore and exploit it for the benefit of the kingdoms of Europe. The full implications of a round world fell upon Renaissance men and women in 1522, when Magellan (or more accurately, the remnants of his crew) completed his three-year voyage around the world. That is not to say that exploration and discovery saw enthusiastic support. Much resistance to change existed then, as today, with great fear of venturing beyond the realm of the known and comfortable.

The Papal States

Having been a plaything of the great powers of Europe, the Church wished to secure independence by increasing its temporal and political strength. It looked for leadership not among saints and scholars, but among administrators and politicians, seeking worldly men of powerful personality and toughness who could make quick decisions. The power of the papacy began to grow through worldly measures—such as war and diplomacy— and that reinforced the need for popes who could maintain such dominions. Popes such as Alexander VI and Julius II came to power. Alexander VI, whose lusts were repellent even in an age renowned for toleration, proved a hard-knuckled diplomat and an excellent administrator in the dogged pursuance of policies that he believed necessary for the Church—specifically, temporal power expressed in dominion over central Italy.

Even as pope, Julius II loved war, often mounting his horse in full armor to hear the bloody sounds of battle. The Renaissance popes proved tough, practical, worldly men, concerned with power. Like their secular counterparts, they did not wish to be outdone in the display of their wealth and greatness. They spent lavishly to construct vast churches, huge palaces, and magnificent fountains, and hired the best artists and artisans, collected the best antiques, the most expensive jewels, and the most

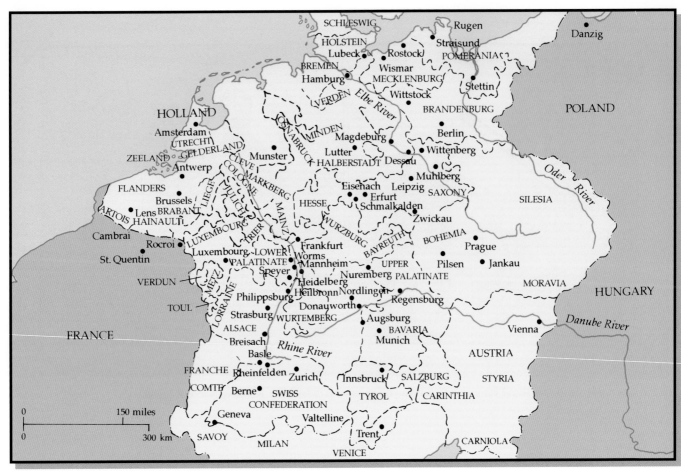

Map 10.1 The Holy Roman Empire.

remarkable books and manuscripts. Such things, like armies, were the necessities of state—whatever the cost.

Perhaps the triumph of the Renaissance papacy came in the coronation of Lorenzo de' Medici's son Giovanni as Leo X in 1513. Subtle, intuitive, sophisticated, charming, generous, affable, and discreet in his private life, he maintained a wide variety of intellectual interests. Raised in the luxury of the Medici family at its peak, he had no qualms about displays of riches and pageantry. Rome increased in splendor, the pope increased in majesty, and all around, violence, turmoil, and intrigue abounded among the French, the Milanese, and the Spanish. However, the Church now depended on vast influxes of money to support its extravagance and required new taxes, the worst of which, the sale of indulgences, would become one of the many causes leading to the Reformation in northern Europe that we will discuss in Chapter 11.

The Spanish invasion of Rome in 1527 (the "Sack of Rome") effectively brought the extravagances of the Renaissance to an end. The invasion, mounted by Charles V, Holy Roman Emperor (whom we discuss below), formed part of Charles' grand scheme to enlarge the influence of the Spanish Empire, then the largest in the world. The rise of Protestantism and the shock of the devastation of Rome led to a sterner spirit in the Church and papacy.

Spain's Golden Century

Ferdinand and Isabella may appear the best-known sovereigns of Spain because they financed the voyage of Christopher Columbus. In Spanish history, however, they rise as the rulers who finally expelled the Moorish conquerors of Spain, unified the country, and made it one of the great powers of Europe. By asserting Italian territorial claims, negotiating a French alliance, and marrying their children into the royal houses of England and the Holy Roman Empire, they made their country by the end of the fifteenth century one of the most powerful in Europe. In the following century, the Spanish Empire grew to the largest in the world.

The sixteenth century, called the *siglo de oro* ("golden century"), owed much of its glitter to the Americas—although silver, not gold, underlay its richness. Charles V (r. 1516–56), the grandson of Ferdinand and Isabella, Holy Roman Emperor, king of Spain, and lord of the

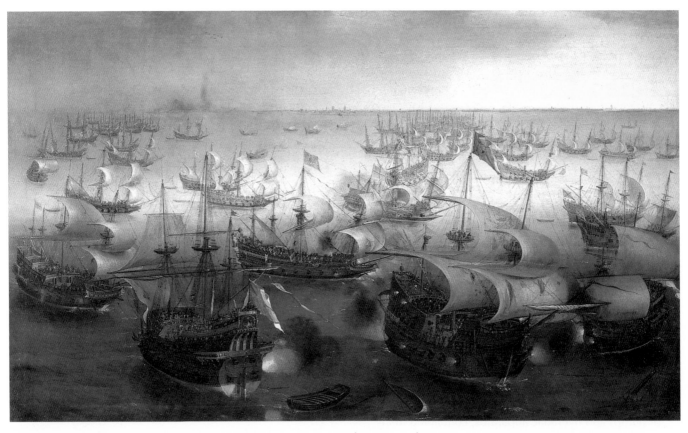

10.3 Hendrik Cornelisz Vroom, *The Sea Battle*, c. 1600. Oil on canvas, 3 ft 1¼ ins × 5 ft 1⅛ ins (91 × 153 cm). Landesmuseum Ferdinandeum, Innsbruck, Austria.

Netherlands, much of Italy, Mexico, Peru, and elsewhere, was undoubtedly the most powerful ruler in Europe. Yet, by the end of his life, he had retired to a monastery, a broken old man who had failed to achieve his purpose— for three principal reasons.

The first of these, the Protestant Reformation, disrupted Germany. The second, the Ottoman invasion, caused the Hungarian monarchy to collapse and gave Charles an eastern warfront, thus drawing his attention and his resources away from France and Italy. The third was a constant conflict with France, which persisted in its vain attempts to conquer Italy and entered into an alliance with the enemies of Christendom, the Turks. Nonetheless, Charles did win the domination of Italy and fought the Turks to a standstill, while France fell victim to its own internal religious wars between Catholics and Huguenots (HYOO-guh-nawts; French Protestants). However, in his own eyes, Charles had failed to make the Holy Roman Empire the undisputable power he had hoped, and the behavior of his troops shamed him when they conquered Rome. In October 1555 he abdicated the Spanish throne, and transferred the administration of his Spanish possessions to his son Philip. The following year,

he resigned the Imperial Crown to his brother Ferdinand, and retired to Spain.

Philip II (r. 1556–98) had even greater ambitions than his father. A fervent Catholic, he made Spain the sword and shield of the Counter-Reformation. An autocrat by temperament, he tried to impress his will on the vast Spanish Empire, and, as he inherited the best armies in Europe and the largest revenues in the world, it appeared that, unlike his father, he would succeed in dominating the entire Western world. It did not happen.

The growing Protestant powers of Europe allied themselves against him: England under Elizabeth I, the French Huguenots, and the Netherlands. As we discuss in Chapter 11, the cause remained as much political as religious. Although Philip had some military successes, especially against the Turks, his critical battles failed—for example, the attempted invasion of England that led to the catastrophic defeat of the Spanish Armada (Fig. **10.3**). Although outnumbered, the more maneuverable English ships capitalized on conditions that kept the Spanish flotilla bunched together. Darting in and about, they decimated the Spanish Armada. Philip's attempts to crush a revolt in the Netherlands ended in 1609 with Dutch

TECHNOLOGY

LEONARDO: TURNING THE SCREW

Leonardo's notebooks mark the beginning of scientific work that had conspicuous results at the hands of Galileo and Kepler (see Chapter 12). They also mark the beginning of modern treatises on hydraulics and applied mechanics. Although new ideas were not confined to Leonardo, his lifetime represents a definite transition, and his efforts contributed significantly to change. Graphic record became his consuming passion, and important notes and trivial jottings went down on paper, often on the same sheet. The earliest material we have dates from 1488, and thereafter he apparently kept all his ideas in notebooks, which were a complete record of his mental activity and were intended to be a series of treatises: on painting, on the nature, weight, and motion of water, on impacts, on weight, on moments of energy, and on the elements of machinery. There is also material on human anatomy and the anatomy of the horse, and notes on a treatise on machinery, including a complete series of mills with arrangements for the use of all the sources of power—wind, water, horses, treadmills, and cranks turned by men. There are drawings of all forms of pumps and hydraulic apparatus, containing many new features for the application of power. There is a fairly comprehensive series of drawings of machinery for the textile industry and the manufacture of metals.

In essence, the notebooks record existing apparati and Leonardo's attempts to apply the principles known to him to new problems. Thus, Leonardo left a record highly characteristic of an inventor: positive accomplishments, complete projects, and rough sketches of new mechanical concepts not carried through to completion.

We tend to think of Leonardo's notebooks as containing lofty and imaginative ventures well ahead of their time, and, indeed, many were. However, they also contain down-to-earth ideas—for example, Leonardo invented simple and practical devices for cutting screws and nuts. The notebooks contain sketches for three distinct sets of apparatus: two sets designed for cutting screws on wooden spindles or in wooden nuts and one piece of apparatus designed for preparing molds for casting and polishing bronze screws. The most interesting of these devices (Figs **10.4** and **10.5**) involve the process of cutting the nut and the spindles. To cut the nut, a hole is made in a block (*m*) the gross diameter of the screw. A strip of metal (*ab*) is nailed over one end of the hole so that it projects over it by one-half the breadth of a finger. The screw (*rf*) must then be cut appropriately to the thread to be made in the nut, and a steel point is set in the spindle. The thread of the screw turning against the strip (*ab*) draws the spindle into the nut and the cutter (*cd*) makes the thread in the nut. Describing the operation of the spindle cutter is even more complicated and arcane, and so we will suffice with appreciating the basic design and the fact that the great genius of Leonardo, which could envisage the elements of flight—although he could not bring them to practical conclusion—could also concern itself with the everyday practicality of cutting screws and nuts—which he could bring to practical usage. In the end, who is to say which may have been more important to the history and accomplishment of humankind?

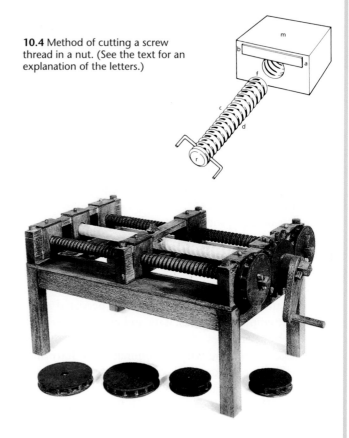

10.4 Method of cutting a screw thread in a nut. (See the text for an explanation of the letters.)

10.5 A spindle cutter (a model reconstructed from Leonardo's Notebooks). An elaborate device for cutting screw spindles. Science Museum, London.

independence. Thus, in one generation, the most powerful empire in the world went from ascendancy to eclipse, and by the end of the sixteenth century, Spain had gone from a Golden Age into an insignificant footnote to subsequent European history.

The Ottoman Turks

In essence, the powers of Europe in the early sixteenth century stood disunited and in conflict. The Ottoman Turks, on the other hand, represented a united and formidable fighting force. Their major asset, a well-disciplined army, struck fear into the hearts of the opposition, but the army also showed one of the major

characteristics of the Turks—toleration. Most of the peoples in the Ottoman Empire remained Jewish or Christian, and the Turks left them to the unhindered practice of their own religions, provided that they paid tribute money for the sultan's military campaigns and turned over their male children to his service. The conscripted children were raised as Muslims, trained for the army, and then sent throughout the Empire.

The sultan to whom fell this dynamic and, perhaps, overextended empire, Suleiman (SOO-lay-mahn) I, the Magnificent (1494–1566), succeeded his father in 1520 and became one of the greatest rulers of the sixteenth century (Fig. **10.6**). He was a warrior, but also a cultured and learned man, a lover of the arts, and a lawgiver. In one of his first acts as sultan he demanded tribute from young King Louis II of Bohemia (now part of the Czech Republic) and Hungary. When Louis refused, Suleiman invaded Hungary and captured Belgrade. In a later offensive in 1526, the Turks defeated Louis's forces at Mohacs, and reached the border of the Hapsburg Empire (the Hapsburgs, an aristocratic German family, ruled the Austrian and Holy Roman Empires). Louis drowned in the fight, and Suleiman prepared to assault the Hapsburg capital, Vienna. The Turks, beaten back, and faced with the onset of winter, overextended supply lines, and trouble elsewhere, retreated, and in 1533 agreed to a truce. Because of renewed conflict over the succession to the throne of the buffer state of Transylvania, the Turks succeeded in consolidating their hold on the Balkans and two-thirds of Hungary. By the middle of the century, the Ottoman Empire had secure borders, and by the time Suleiman died in 1566, it extended unbroken from the Black Sea to the Persian Gulf. Despite continued conflicts with the Hapsburgs and with Spain, the Ottoman Empire changed little in the rest of the century.

CONCEPTS

Classicism

In Chapters 3 and 4 we discussed classicism with regard to the arts and attitudes of the ancient Greeks and Romans and associated it with the view that ancient Greece represented the font of Western civilization. Specifically, we defined classicism as a striving for harmony, order, reason, intellect, objectivity, and formal discipline and contrasted it with styles that emphasized bravura technique, imagination, emotion, and free expression. Artworks in the classical style represent idealized perfection rather than "real life." This idealization represents in one sense how the arts of the **High Renaissance** moved into different territory from the arts of the early Renaissance, which we described as having scientific naturalism as one of their objectives.

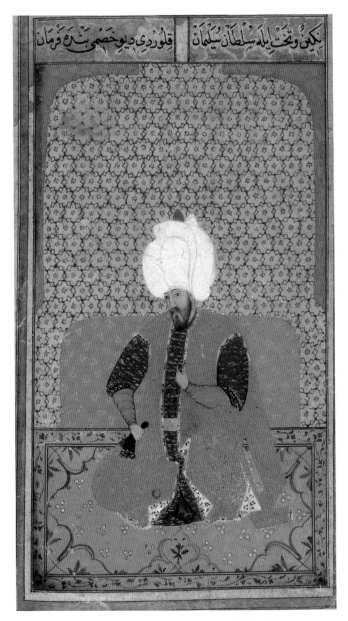

10.6 Suleiman I, the Magnificent (1494–1566). British Library, London.

Both early and High Renaissance looked to the classical Greek and Roman styles as models, but in the High Renaissance the sense of idealism fully associated with classicism came to the fore in opposition to the focus on life as it looks to the eye and the fascination with newly discovered mechanical perspective prevalent in the early Renaissance. Thus, we see a change from the impressive perspective mechanics of Andrea Mantegna's *St James Led to Execution* (see Fig. **9.11**) to the idealized conception of beauty (far beyond a realistic portrait) expressed in Michelangelo's *David* (see Fig. **10.23**).

The High Renaissance

The Quattrocento proved an important crucible for Renaissance thought and activity, but the apex of the Renaissance came in the late fifteenth and early sixteenth centuries, as a newly reestablished papal authority called artists to Rome. We call this time (approximately 1495 to 1527) the High Renaissance because the term "high" when applied to artistic styles or movements signifies an advancement toward an acme or fullest extent, specifically a late, fully developed, or most creative stage or period. As we have just discussed, differences did exist between the earlier Renaissance style and the goals and outcomes of artists of the High Renaissance, and the period, although centering in Rome, had applications far and wide. A new concept, that of genius, also proved important to this period. In particular, we might argue that everything done in the visual arts, especially in Italy between 1495 and 1527, was subordinated beneath the overwhelming genius of two men, Leonardo da Vinci (VEEN-chee or VIHN-chee) and Michelangelo Buonarroti (mee-keh-LAHN-jay-loh bwho-nah-ROHT-ee).

By 1500 the courts of the Italian princes had become centers of cultural activity and patronage. Machiavelli, who thought the leaders of these centers soft and effeminate, accused them of living in an unreal world. However, the Italian courtiers needed artists, writers, and musicians to pursue their lofty ideals of beauty. They now regarded the arts of the early Renaissance as vulgar and naïve, and demanded a more aristocratic, dignified, and lofty art; this partly accounts for the new style found in the works of playwrights and painters. The wealth of the popes and their desire to rebuild Rome on a grand scale also contributed to the shift in style and the emergence of Rome as the center of patronage. Music came of age as a major art form. Ancient Roman sculptural and architectural style was revived. In addition, scholars and artists rediscovered ancient sculptures such as the *Laocoön* (see Fig. **3.18**), and because the artists of this period had such a rich immediate inheritance from the early Renaissance, but believed that they had developed even further, they considered themselves on an equal footing with the artists of classical antiquity. Their

approach to the antique in arts and letters, therefore, differed from that of their early Rennaissance predecessors—as did their world.

Mannerism

The term **Mannerism** comes from the Italian *maniera*, which, in the sixteenth century, meant, among other things, charm, grace, and playfulness. So, when we apply the term to the art that developed in the years after the High Renaissance, we find art existing for its own sake as opposed to the idealized nature that applied to High Renaissance conventions. Use of the term in art circles through the centuries has differed and ranged from, for example, the seventeenth century when the term disparagingly suggested superficiality, excessive ornateness, frivolity, or lack of serious intent, to the nineteenth century when the term applied to any late sixteenth-century art that did not adhere to classical principles. For our purposes, we can adopt the view point expressed by Marilyn Stokstad: "Mannerism is considered the stylistic movement that emerged at about the same time as the classical [High] Renaissance but had its own aims, rhythms, and sources of influence, which often allowed artistic scope for considerable experimentation and individual expression."[1]

We thus ought not to consider Mannerism as a single style but, rather, see it—much as we will come to see styles like post-impressionism, modernism, and postmodernism—as a diverse application with certain common characteristics, in this case, virtuosity, sophistication, elegance of composition, and "fearless manipulations or distortions of accepted conventions of form" (Stokstad). Other scholars have suggested contextual relationships for Mannerism, including a reflection of the shattered world precipitated by the Sack of Rome by the Spanish in 1527, as well as a dilemma faced by artists who looked at their immediate predecessors, Leonardo da Vinci, Michelangelo, and Raphael, and recognized that a golden age had gone before and that they stood no chance of improving on the technique or vision of that age. Thus, finding themselves at a crossroads, they decided to take for granted the work of their predecessors in such areas as linear and atmospheric perspective and correct rendering of form, and then break all the rules as dramatically as they could.

For our purposes, we will view Mannerism with the same eye as we do other styles. We will watch it emerge just before the time the High Renaissance ended, and note that it had a different set of aims, characteristics, and influences. In contrast to the arts of the Renaissance and High Renaissance, Mannerism, arguably, allowed for greater flexibility of experimentation. Like the other Renaissance arts, Mannerism enjoyed court patronage.

Although it was diverse and widespread among the arts, our space allows only a limited exploration of this style, principally in painting and, to a lesser degree, in sculpture and architecture.

THE ARTS OF THE HIGH RENAISSANCE AND MANNERISM

Painting

High Renaissance painting sought a universal ideal achieved through impressive themes and styles. Tricks of perspective or stunning renditions of anatomy, staples of the early Renaissance, no longer sufficed. Figures emerged as types again, rather than individuals—godlike human beings in the Greek classical tradition. Artists and writers of the High Renaissance sought to capture the essence of classical art and literature without resorting to copying, which would have captured only the externals. They tried to emulate rather than imitate. As a result, High Renaissance art idealizes all forms and delights in composition. It shows stability without immobility, variety without confusion, and definition without dullness. High Renaissance artists carefully observed how the ancients borrowed motifs from nature, and then set out to develop a system of mathematically defined proportion and compositional beauty emanating from a harmony of parts. This faith in harmonious proportions reflected a belief among artists, writers, and composers that the world of nature, not to mention the universe, also possessed perfect order.

This human-centered attitude also included a certain artificiality and emotionalism that reflected the conflicts of the times. High Renaissance style departed from previous styles in its meticulous composition, based almost exclusively on geometric devices. Compositions closed—line, color, and form kept the viewer's eye continually redirected into the work, as opposed to leading the eye off the canvas—and the organizing principle of a painting rested usually on a geometric shape, such as a triangle or an oval.

The High Renaissance in Rome
The resurgence of the papacy and its desire to make Rome the epicenter of the world meant that Rome played the starring role in artistic endeavor during the third of a century ascribed to this period. In painting, three titans stood over all the rest: Leonardo da Vinci, Michelangelo, and Raphael.

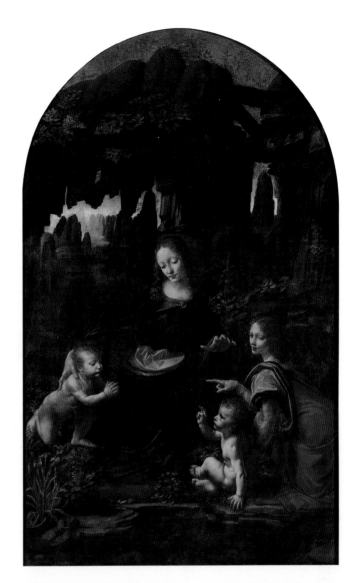

10.7 Leonardo da Vinci, *The Madonna of the Rocks* (*Virgin of the Rocks*), c. 1485. Oil on panel, 6 ft 3 ins × 3 ft 7 ins (1.91 × 1.09 m). Louvre, Paris.

Leonardo da Vinci
The work of Leonardo da Vinci (1452–1519) has an ethereal quality which he achieved by blending light and shadow, a technique called **sfumato** (sfoo-MAHT-oh). His figures hover between reality and illusion as one form disappears into another, with only the highlighted portions emerging. In *The Madonna of the Rocks* (Fig. **10.7**), Leonardo interprets the doctrine of the Immaculate Conception, which proposed that Mary remained freed from original sin by the Immaculate Conception in order to be a worthy vessel for the incarnation of Christ. Mary sits in the midst of a dark world and shines forth from it. She protects the Infant Christ, who blesses John the Baptist, to whom the angel points. The gestures and eye direction create movement

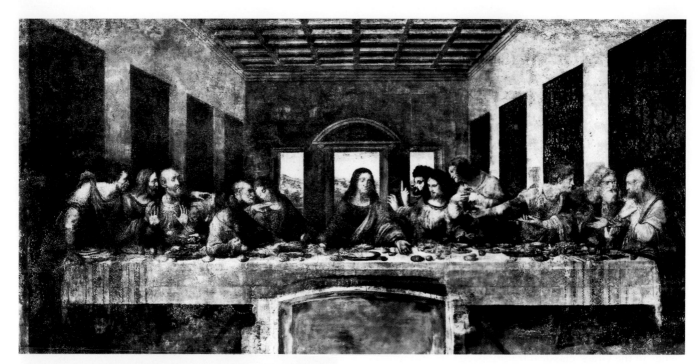

10.8 Leonardo da Vinci, *The Last Supper*, c. 1495–08. Mural painting, 15 ft 1⅛ ins × 28 ft 10½ ins (4.6 × 8.56 m). Santa Maria delle Grazie, Milan, Italy.

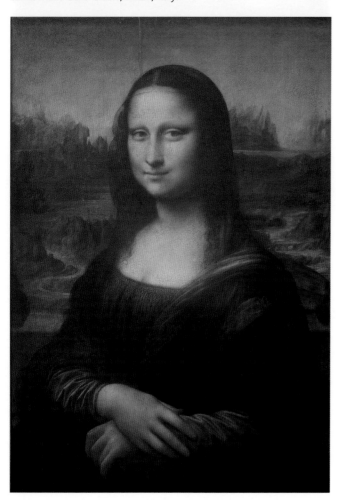

10.9 Leonardo da Vinci, *Mona Lisa*, c. 1503–05. Oil on panel, 30 × 21 ins (76.2 × 53.3 cm). Louvre, Paris.

around the perimeter of a single central triangle outlined in light. Leonardo takes the central triangle and gives it enough depth to make it a three-dimensional pyramid of considerable weight. He uses light and shade delicately, even though the highlights and shadows do not flow from a consistent light source. The portrayal of rocks, foliage, and cloth displays meticulous attention to detail.

The Last Supper (Fig. **10.8**) captures the moment at which the apostles respond with disbelief to Christ's prophecy that "one of you shall betray me." Leonardo's choice of medium proved most unfortunate because, unlike fresco, his own mixtures of oil, varnish, and pigments did not suit the damp wall. The painting began to flake and perish as early as 1517. Since then it has been clouded by retouching, defaced by a door cut through the wall at Christ's feet, and bombed during World War II. Miraculously, it survives, having undergone a recent renovation.

In *The Last Supper*, human figures, not architecture, take focus. Christ dominates the center of the painting. All lines, actual and implied, lead outward from his face, pause at various subordinate focal areas, reverse direction at the edges of the work, and return to the central figure. Various postures, gestures, and groupings of the disciples direct the eye from point to point. Figures emerge from the architectural background in strongly accented relief with much psychological drama in the mathematical format. Yet, despite the drama, the mood in this work and others stays calm, belying the turbulence of Leonardo's own personality and his times.

Leonardo reverts to the pyramid as the basis of the composition in his *Virgin and Child with St Anne* (see Fig. **10.1**). The Virgin Mary sits on the lap of her mother, St Anne. St Anne forms the apex of the triangle whose right side flows downward to the Christ Child, who embraces a lamb, symbolic of his sacrificial death.

The famous *Mona Lisa* (Fig. **10.9**), painted at about the same time as the *Virgin and Child with St Anne,* draws us not so much by the subject as by the background. As if to emphasize the serenity of the subject, and in common with the *Virgin and Child with St Anne*, the background reveals an exciting mountain setting, full of dramatic crags and peaks, winding roads which disappear, and exquisitely detailed natural forms receding into the mists. The composition shows unusual treatment of the full torso with the hands and arms pictured, completing the unity of the gentle spiral turn. Three-quarters of the figure emerges, not just a bust. This marked a new format in Italian portraiture and provided a model followed ever since. The result, a larger, grander, and more natural portrait, reflects the new sense of human dignity implicit in Renaissance idealism.

Michelangelo

Perhaps the dominant figure of the High Renaissance, Michelangelo Buonarroti (1475–1564) had a very different character from Leonardo. Leonardo was a skeptic, Michelangelo a man of great faith. Science and natural objects fascinated Leonardo. Michelangelo showed little interest in anything other than the human form.

Michelangelo's Sistine Chapel ceiling (Figs **10.10**, **10.12**, **10.13**, and **10.14**) perfectly exemplifies the ambition and genius of this era. In each of the triangles along the sides of the chapel, the ancestors of Christ await the Redeemer. Between them, amid *trompe l'oeil* architectural elements, stand the sages of antiquity (remember that we have seen trompe l'oeil—"trick the eye"—architectural detailing before, in the wall paintings of ancient Pompeii and Herculaneum [Chapter 4]). Michelangelo uses his immense skill in this regard to give the chapel ceiling a rich and falsely three-dimensional character. However, the human figures and their story— not the architectural detail—take focus here. In the corners, Michelangelo depicts various biblical stories, and across the center of the ceiling he unfolds the episodes of Genesis. The creation of Adam captures the moment of fulfillment (Fig. **10.10**). The human forms display sculpturally modeled anatomical detail. God stretches outward from his angels to a reclining, but dynamic Adam, awaiting the divine infusion, the spark of the soul. The fingers do not touch, but we can anticipate the electrifying power of God's physical contact with a mortal man.

The Sistine Chapel ceiling creates a breathtaking visual panoply. We cannot get a comprehensive view of the whole of the ceiling from any point in the chapel. If we look upward and read the scenes back toward the altar, the prophets and sibyls appear on their sides. If we view one side as upright, the other appears upside down. These opposing directions are held together by the

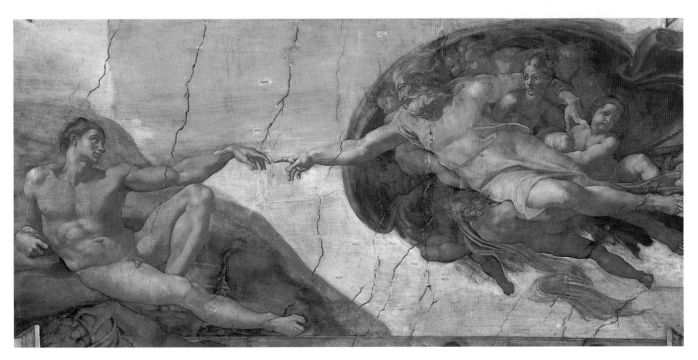

10.10 Michelangelo, *The Creation of Adam*, detail from the Sistine Chapel ceiling, 1508–12. Fresco. Vatican, Rome.

PROFILE

MICHELANGELO (1475–1564)

Sculptor, painter, architect, and poet, Michelangelo remains one of the world's greatest artists. Born Michelangelo Buonarroti, he came from a respectable Florentine family and when twelve years old became an apprentice to the Florentine painter Domenico Ghirlandaio. Even before his apprenticeship had ended, Michelangelo turned away from painting to sculpture, and he gained the attention of Florence's ruler, Lorenzo de' Medici, the Magnificent, who invited the young Michelangelo to stay at his palace. During these early years, Michelangelo became a master of anatomy.

In 1494, after the Medici family fell from power, Michelangelo traveled. He spent five years in Rome and enjoyed his first success as a sculptor with a lifesize statue of the Roman wine god, Bacchus. He carved his magnificent *Pietà*—the dead Christ in the lap of his mother—when he was twenty-three years old (see Fig. **10.22**), and this larger-than-lifesize work established him as a leading sculptor of his time.

He returned to Florence for four years in 1501, and there met Leonardo da Vinci. Florence commissioned both artists to work on large battle scenes for the walls of the city hall. Leonardo never finished his scenes, and Michelangelo's are lost, and we know of them only through sketches and copies made by other artists. According to some sources, during this time Michelangelo learned from Leonardo how to depict flowing and active movement in the human form, and the style developed during these years in Florence stayed with him for the rest of his life.

By 1505 Michelangelo returned to Rome, beginning a series of grand, large-scale works under the patronage of Pope Julius II. Over the next forty years he struggled unsuccessfully to complete the first of these colossal endeavors, Pope Julius' tomb. The second, the Sistine Chapel in the Vatican (Figs **10.12**, **10.13**, and **10.14**) became Michelangelo's most famous work, with *David* (see Fig. **10.23**) a close second.

Between 1515 and 1534 he returned to Florence, working for the Medici family, who had returned to power. There, he designed and sculpted tombs for two Medici princes and began the Medici chapel in which the tombs were placed. He left Florence and the unfinished chapel in 1534. Returning to Rome, he painted the fresco *The Last Judgment* for Pope Paul III on the altar wall of the Sistine Chapel, and the pope appointed him supervising architect of St Peter's Church in Rome. Earlier in this period he designed a square for the civic center of Rome, which symbolized Rome as the center of the world.

During the last years of his life, Michelangelo's religious faith deepened, and he produced not only the complicated and somber frescoes of the Pauline Chapel in the Vatican but also a considerable amount of poetry (see Literature section, p. 337). A *pietà*, which he designed for his own tomb, remains among the few sculptural works attempted in his late years. After his death in 1564, his body was returned to Florence for burial.

Michelangelo's ideal, the full realization of individuality, reflected his own unique genius. He epitomized the quality of *terribilità*, a supreme confidence that allows a person to accept no authority but his or her own genius. Critical of his own work, he envied Raphael, disliked Leonardo, and clashed constantly with his patrons, yet in his letters he expresses a real sympathy and concern for those close to him. His works reveal a deep understanding of humanity and reflect a neo-Platonic philosophy. He captures the Platonic idea of potential energy, imprisoned in the earthly body, and he believed, as did Plato, that the image from the artist's hand must spring from the idea in his or her mind. The idea forms reality, and it is revealed by the genius of the artist. The artist does not create the ideas, but finds them in the natural world, which reflects the absolute idea: beauty. Thus, to the neo-Platonist, when art imitates nature, it reveals truths hidden within nature.

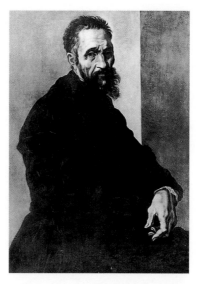

10.11 Michelangelo (1475–1564). Painting by Giuliano Bugiardini. Uffizi Gallery, Florence, Italy.

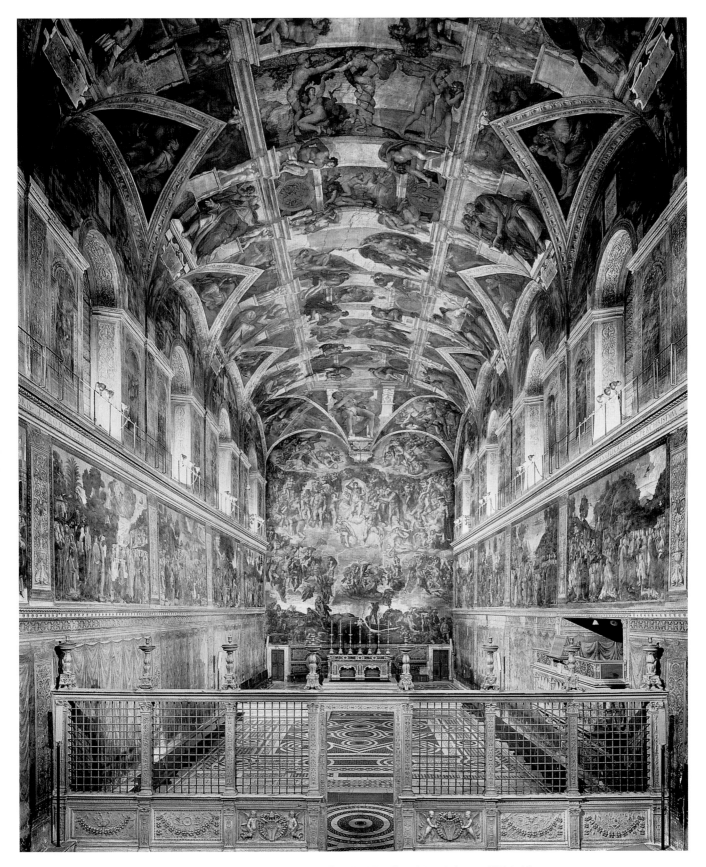

10.12 Michelangelo, Sistine Chapel, Vatican, Rome, showing the ceiling (1508–12) and *Last Judgment* (1534–41).

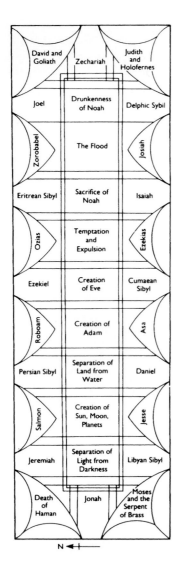

10.13 Diagram of scenes from the Sistine Chapel ceiling.

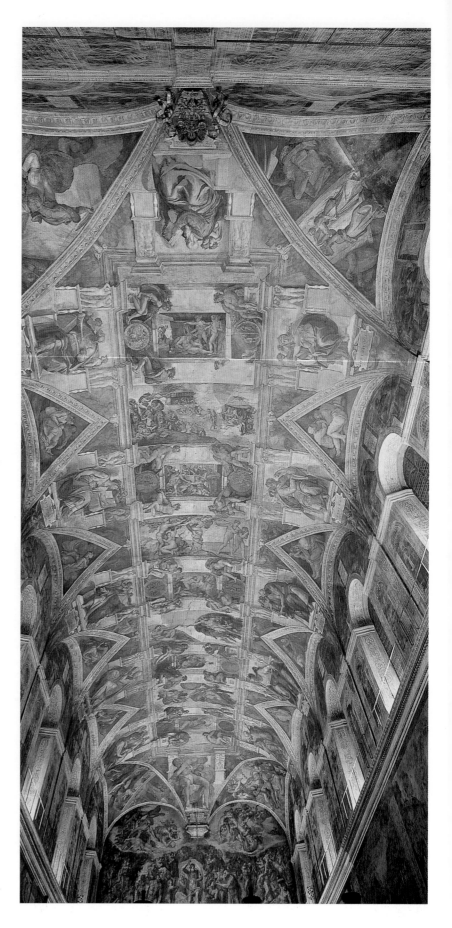

10.14 Michelangelo, Sistine Chapel ceiling, 1508–12. Fresco, 44 × 128 ft (13.41 × 39 m). Vatican, Rome.

structure of simulated architecture, whose transverse arches and diagonal bands separate the painted vault compartments. Nudes appear at the intersections and tie the composition together because they can be read either with the prophets and sibyls below them or with the Genesis scenes, at whose corners they appear. We thus see a prime example of the basic High Renaissance principle of composition unified by the interaction of component elements.

Raphael

Raphael (rah-fah-EL; 1483–1520), generally regarded as the third painter in the High Renaissance triumvirate, did not reach the same level of genius and accomplishment as Leonardo and Michelangelo. In *The Alba Madonna* (Fig. 10.15), the strong central triangle appears within the geometric parameters of a tondo, or circular shape. Strong, parallel horizontal lines counteract the tendency of a circle to roll (visually). The solid baseline of the central triangle emerges in the leg of the infant John the Baptist (left), the foot of the Christ Child, the folds of the

Madonna's robes, and the rock and shadow at the right. The left side of the central triangle comprises the eyes of all three figures and carries along the back of the infant John to the border. The right side of the triangle runs along the edge of the Madonna's robe, joining the horizontal shadow at the right border.

Within this formula, Raphael depicts a comfortable, subtly modeled, and idealized Mary and Christ Child with soft and warm textures. Raphael's treatment of skin creates an almost tactile sensation—we can almost discern the warm blood flowing beneath it, a characteristic relatively new to two-dimensional art. Raphael's figures express lively power, and his mastery of three-dimensional form and deep space is unsurpassed.

10.15 Raphael, *The Alba Madonna*, c. 1510. Canvas (originally oil on panel), 37¼ ins (94.5 cm) in diameter. National Gallery of Art, Washington D.C. (Andrew W. Mellon Collection).

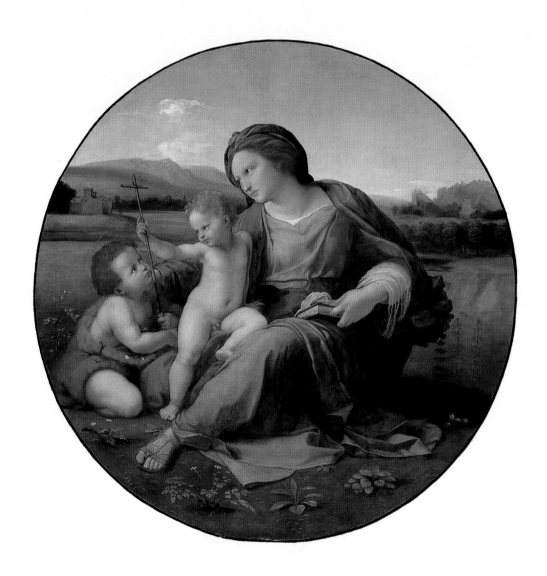

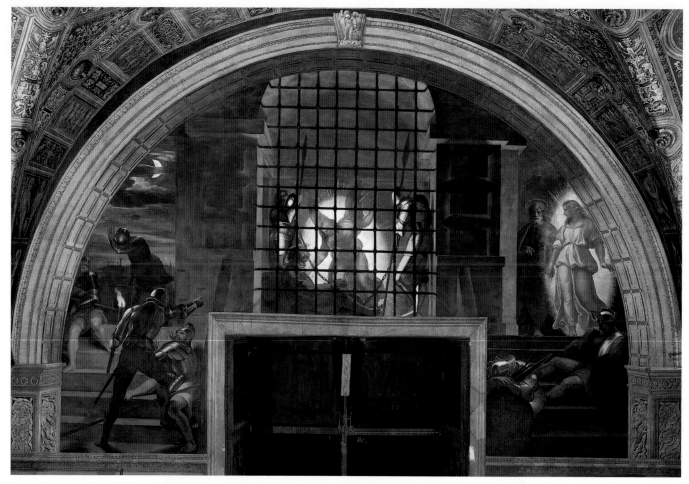

10.16 Raphael, *The Deliverance of St Peter*, 1512–14. Fresco. Stanza dell'Eliodoro, Vatican, Rome.

In *The Deliverance of St Peter* (Fig. **10.16**) Raphael again accepted the challenge of a constraining space. To accommodate the intrusion of the window into the semicircular area of the wall, Raphael divided the composition into three sections representing the three phases of the miracle of St Peter's escape from prison. The intense light shining from the center section emphasizes the expressiveness of this depiction.

The High Renaissance in Venice

Tiziano Vecelli, known in English as Titian (TISH-uhn; 1488?–1576), made one of the most crucial discoveries in the history of art. The art historian Frederick Hartt describes it this way: "He was the first man in modern times to free the brush from the task of exact description of tactile surfaces, volumes, and details, and to convert it into a vehicle for the direct perception of light through color and for the unimpeded expression of feeling."[2] This new type of brushwork exists in the *Assumption of the Virgin* (Fig. **10.17**) but remains in the background. Long before he died, he used the technique on entire paintings, and so did most other painters in Venice.

Part of Titian's unique technique lay in the way in which he built up pigment from a reddish ground through many layers of glaze, which lent warmth to all the colors of the painting. The glazes toned down colors that the artist believed too demanding and gave depth and richness to the work. Glazing made many of the colors and shadows seem "miraculously suspended." Titian may have used as many as thirty or forty layers of glaze on a single painting.

Titian's *Assumption of the Virgin* exudes an almost fiery glow from the underpainting, and our eyes move upward from the base of the picture, which forms the eye level, to a hovering Madonna who is lifted on a cloud by a host of **putti** or cherubs. Above her, emerging from a flaming yellow and orange sky—which boils in undulating brushstrokes and angelic faces—rests the figure of God. The circular sweep of the painting's arched top and the encircling angels separate the Virgin from the outstretched hands of the apostles by means of compositional psychology as well as space, which is almost breached by the raised arm of the foreground figure.

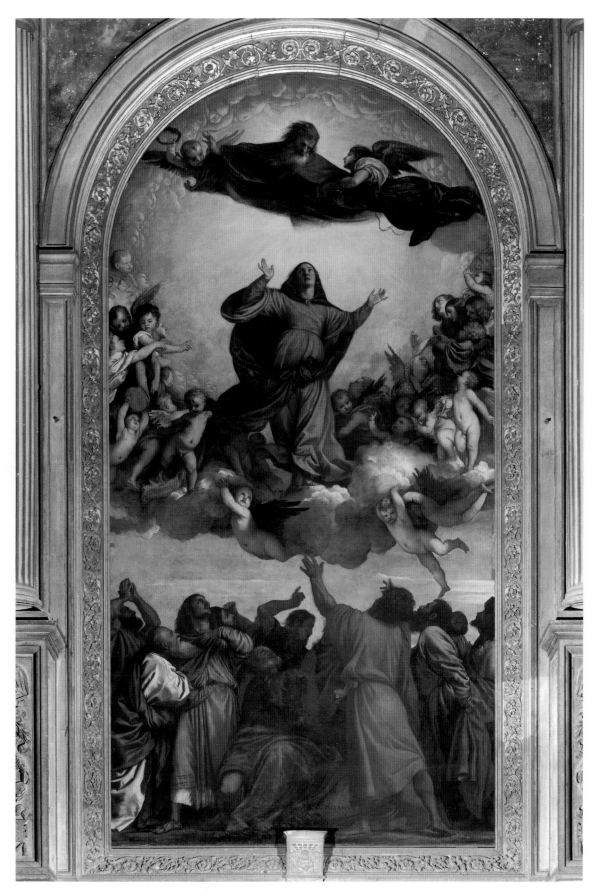

10.17 Titian, *Assumption of the Virgin*, 1516–18. Panel, 22 ft 6 ins × 11ft 10 ins (6.9 × 3.6 m). Santa Maria Gloriosa dei Frari, Venice, Italy.

Mannerism

Papal patronage had assembled great genius in Rome at the turn of the sixteenth century. It had also ignited and supported a brilliant fire of human genius in the arts. The Spanish invasion and Sack of Rome doused the flame of Italian art in 1527 and scattered its ashes across Europe, contributing to the disillusionment and turmoil of religious and political strife that marked the next seventy years.

Mannerist paintings seem formal and inward-looking. Their oddly proportioned forms, icy stares, and subjective viewpoint make them puzzling yet intriguing. Nevertheless, we find an appealing modernism in their emotional, sensitive, subtle, and elegant content. At the same time, Mannerism has an intellectual component that distorts reality, alters space, and makes often obscure cultural allusions. Anti-classical emotionalism and the abandonment of classical balance and form, alongside clear underpinnings of formality and geometry, suggest the troubled nature of this style and the times in which it flourished.

Bronzino's (brahn-ZEEN-oh) *Portrait of a Young Man* (Fig. **10.19**) makes the point. A strong High Renaissance central triangle dominates the basic composition of this work. Its lines, however, have a nervous and unstable quality—incongruous, juxtaposed

A DYNAMIC WORLD

PAINTING IN INDIA

An example of painting from India's Mughal Dynasty of the sixteenth century gives us a good comparison with Western art of the High Renaissance. Between the sixteenth and eighteenth centuries significant achievements came from the kingdom, which centered on Delhi. The painting shown here comes from a major manuscript, *The Romance of Amir Hamza*, which was produced during the reign of the great Mughal ruler Akbar (1542–1605), a Muslim who tried to create a synthesis of Hinduism and Islam. These paintings, done on fine linen, unify Persian and Indian images into a Mughal style. Typical of Indian art, they depict their subjects in fairly lifelike detail, with bold colors and dynamic composition.

The hero of *Alam Shah Closing the Dam at Shishan Pass* (Fig. **10.18**) takes the predominant position at the top of the work. Indian painting makes little use of the natural perspective that was so critical to Renaissance painting. This painting exists solely on the surface plane, but although the images are fragmented, the composition balances psychologically. A strong diagonal, moving from upper left to lower right, counters an opposite diagonal from lower left to upper right. Each segment of the painting carries its own narrative content, and the pieces of the composition fit together like multicolored tiles of a mosaic. The work is unified by its underlying and framing use of gold, and the "frame" is part of the painting itself.

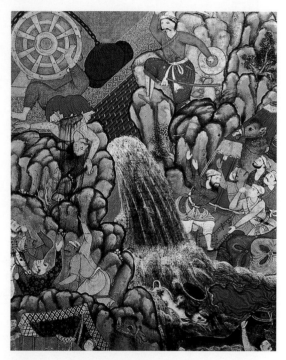

10.18 *Alam Shah Closing the Dam at Shishan Pass* (leaf from *The Romance of Amir Hamza*), Mughal, c. 1570. Color and gold on cotton, 27⅛ × 20½ ins (69 × 52.2 cm). Cleveland Museum of Art (Gift of George P. Bickford).

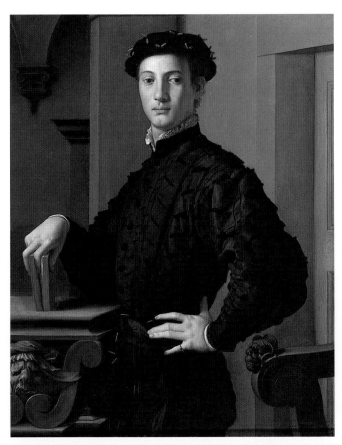

10.19 Bronzino (Agnolo di Cosimo di Mariano), *Portrait of a Young Man*, c. 1535–40. Oil on wood, 37⅝ × 29½ ins (95.6 × 73 cm). Metropolitan Museum of Art, New York (Bequest of Mrs. H.O. Havemeyer, 1929).

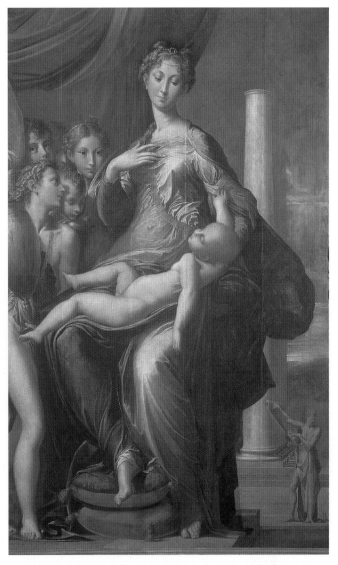

10.20 Parmigianino, *Madonna with the Long Neck*, c. 1534. Oil on canvas, 7ft 1 in × 4 ft 4 ins (2.16 × 1.32 m). Uffizi Gallery, Florence, Italy.

rectangular and curved forms create an uneasy feeling. The greens and blacks of the painting impress us as very cold, and the starkness of the background adds to the feeling of discomfort as do harsh shadows and cold skin quality. Light and shade create some dimension, but the absence of perspective brings background objects inappropriately into the forward plane of the picture. The human form remains attenuated and dispro-portionate. The young man's head seems too small for his body, and particularly for his hands. Finally, his pose and affected stare typify the artificiality that gave this movement its name. We can see a clearly similar treatment of form and color in Parmigianino's (pahr-mee-jah-NEE-noh) *Madonna with the Long Neck*

(Fig. **10.20**)—that quality of elongation associated with Mannerism. The line, color, and proportions of the painting have an exotic, ethereal, and almost "other-worldly" appearance, especially the Christ Child. If we hearken back to the basic triangle of High Renaissance composition, we find none of that here. The long, exposed leg at the painting's left border creates a disjointed angle as it meets the foot of Jesus. Simplicity of composition has been replaced by a myriad of detail so complex that every square inch of the painting reveals something intriguing and captivating.

The daughter of a northern Italian nobleman who gave each of his six daughters the same classical education as his sons received, Sophonisba Anguissola

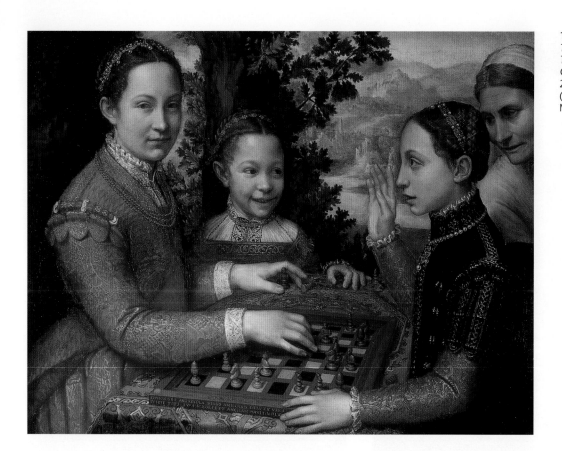

10.21 Sophonisba Anguissola, *The Sisters of the Artist and Their Governess (The Chess Game)*, 1555. Oil on canvas, 28⅜ × 38³⁄₁₆ ins (72 × 97 cm). National Museum, Poznan, Poland.

(ahn-gwee-SOH-lah; 1528–1625) impressed Michelangelo with her drawing. She also impressed others and in 1560 the Queen of Spain offered Sophonisba the post of an official court painter, an office she held for twenty years. She excelled at portraiture, and her study of three of her sisters and their governess (Fig. **10.21**) anticipates the later highly popular group portraits of people involved in everyday activities. Here two of the sisters engage in a game of chess while a younger sister and the governess watch. Although we find the work perhaps less mannered than the Bronzino or Parmigianino, we see that it lacks the deeply spatial feeling of the preceding Renaissance and High Renaissance. It appears staged and slightly discomforting with its absence of solidly grounded geometrical compositional devices.

Sculpture

Michelangelo broke with earlier Renaissance artists in his insistence that measurement subordinate to judgment. He believed that measurement and proportion should be kept "in the eyes." This rationale for genius to do what it

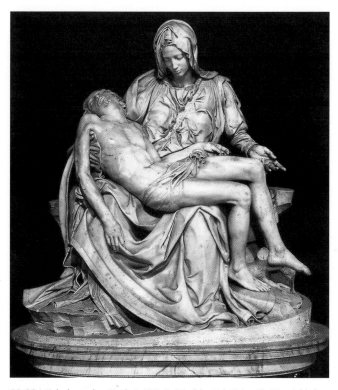

10.22 Michelangelo, *Pietà*, 1498–9. Marble, 5 ft 9 ins (1.75 m) high. St Peter's, Rome.

MASTERWORK

MICHELANGELO—*DAVID*

Towering some 18 feet (5.5 meters) above the floor, Michelangelo's *David* awesomely exemplifies *terribilità*. This nude champion exudes a pent-up energy, as the body seems to exist merely as an earthly prison for the soul. The upper body moves in opposition to the lower. The viewer's eye moves downward from the right arm and leg, then upward along the left arm. The entire figure seeks to break free from its confinement through thrust and counter-thrust.

Much of the effect of the *David*—the bulging muscles, exaggerated rib cage, heavy hair, undercut eyes, and frowning brow—results from the fact that these features were intended to be read from a distance. Michelangelo originally planned the work to stand high above the ground on a buttress for Florence Cathedral. Instead, the city leaders, believing it too magnificent for so high a placement, put it in front of the Palazzo Vecchio (pah-LAHT-soh VEHK-kee-oh). It also had to be protected from the rain, since the soft marble rapidly began to deteriorate.

Politically, *David* symbolized the valiant Florentine Republic. It also stood for all of humanity, elevated to a new and superhuman power, beauty, and grandeur. However, its revolutionary "total and triumphant nudity," which reflected Michelangelo's belief in the divinity of the human body, kept it hidden from the public for two months. When it did appear, a brass girdle with twenty-eight copper leaves hung around the waist.

Inspired by the Hellenistic sculptures he had seen in Rome, Michelangelo set out in pursuit of an emotion-charged, heroic ideal. The scale, musculature, emotion, and stunning beauty and power of those earlier works became a part of Michelangelo's style. In contrast to the Hellenistic approach, in which the "body 'acts' out the spirit's agony" (compare the *Laocoön*, by Hagesandrus, Polydorus, and Athenodorus shown in Figure **3.18**), *David* remains stable but tense.

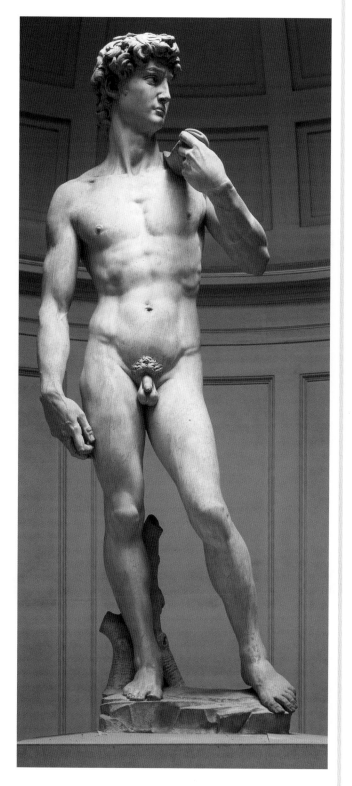

10.23 Michelangelo, *David*, 1501–04. Marble, 14 ft 3 ins (4.1 m) high. Academy, Florence, Italy.

exquisite softness, and the expressive sway of drape reinforces the compositional line of the work. Emotion and energy are captured within the contrasting forces of form, line, and texture.

The late sixteenth century produced relatively little sculpture of major significance. The twisting, elongated form of *Mercury* (Fig. **10.24**) by Giovanni da Bologna (joh-VAHN-ee dah boh-LOH-nyuh; 1529–1608), however, shows us qualities equivalent to the Mannerist tendencies in painting of the same era. The affected pose, the upward-striving line, the linear emphasis, and the nearly total detachment from earth suggest tension and nervous energy. Mercury races through the air seeking the escape of flight, supported by a puff of breath from a mask symbolizing the wind.

Architecture

At the turn of the sixteenth century, architecture saw Christian and classical ideas come into balance. At the same time, it moved away from its insistence on decorative surface detail and toward a greater concern for space and volume. The shift of patronage from the local

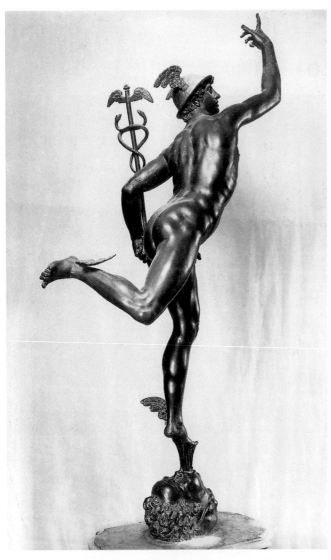

10.24 Giovanni da Bologna, *Mercury*, c. 1567. Bronze, 5 ft 9 ins (1.75 m) high. Museo Nazionale del Bargello, Florence, Italy.

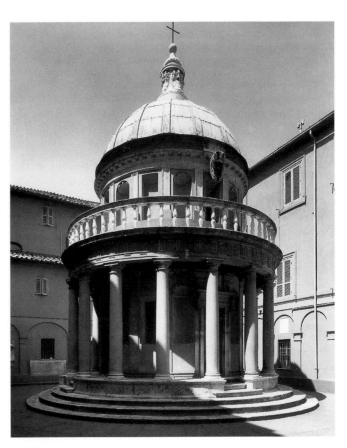

10.25 Donato Bramante, the Tempietto, authorized 1502, completed after 1511. San Pietro in Montorio, Rome.

would, free from any pre-established "rules," enabled him to produce works such as *David* (Fig. **10.23**), a colossal figure and the earliest monumental sculpture of the High Renaissance.

The quiet simplicity of the *Pietà* (Fig. **10.22**), Michelangelo's only signed work, stands in contrast to the energy of *David*. Here High Renaissance triangularity contrasts with what many believe to be a late medieval subject matter and figure treatment. The size of the Madonna compared to Jesus reflects the cult of the Virgin characteristic of the late medieval period.

Beyond these considerations, however, lies the absolute perfection of surface texture. Michelangelo's polish has so enlivened the marble that it seems to assume the warmth of real human flesh. Skin becomes even more sensuous in its contrast to rough stone. Cloth has an

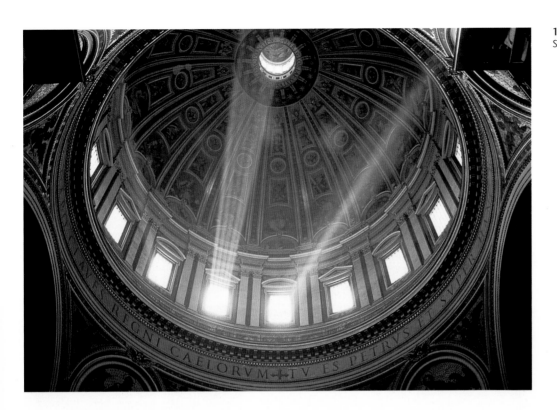

10.26 Interior of the dome of St Peter's, Rome.

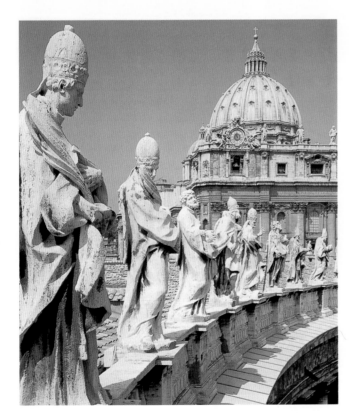

10.27 Gian Lorenzo Bernini, statues on the colonnade of St Peter's Square, Rome; colonnade designed 1657.

rulers to the Roman Catholic Church, which drew visual artists—painters, sculptors, and architects—to Rome, also brought to architecture a more formal, monumental, and serious High Renaissance style perfectly exemplified by Bramante's (brah-MAHNT-ay) Tempietto (temp-ee-YET-toh) or "little temple" (Fig. **10.25**). Pope Julius II wanted all Roman basilica-form churches replaced by magnificent monuments that would overshadow the remains of Imperial Rome, and the Tempietto emerged as part of this plan. The building, authorized in 1502, occupies the spot where St Peter was believed to have been crucified.

In contrast to the Corinthian and Ionic details that had been popular, Bramante chose for the Tempietto the more severe Doric order. The circular plan, however, gave him a new flexibility. The culmination of this style appears in Bramante's design for St Peter's, a design later revised by Michelangelo and finished, later still, by Giacomo della Porta (JAH-coh-moh day-lah-POHR-tah; see Figs **10.28**, **10.30**, **10.31**, and **10.32**). The geometrical and symmetrical design of St Peter's inscribed a circle and square, over which perched a tremendous dome surrounded by four lesser domes.

The magnificence of the Vatican lies in its scale, its detail, and, above all, in the enormous dome of St Peter's (Figs **10.26** and **10.28**), the focal point as seen from the outside. Renaissance domes sought to provide large sculptural forms against the skyline, so architects raised them on tall cylinders and often placed large central lanterns at their tops. The dome of St Peter's, a double

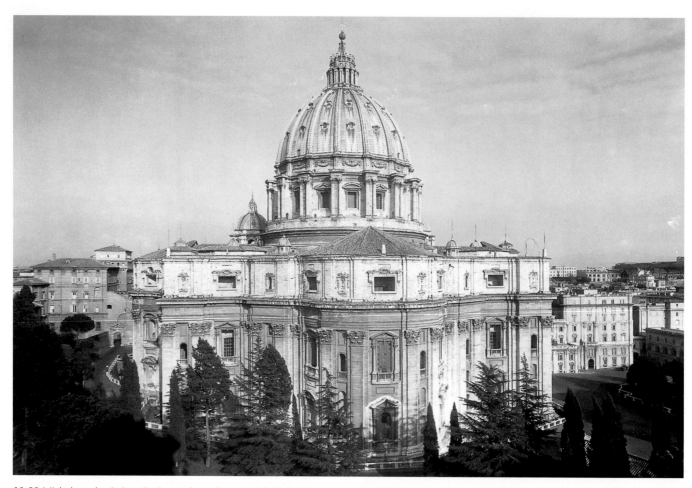

10.28 Michelangelo, St Peter's, Rome, from the west, 1546–64 (dome completed by Giacomo della Porta, 1590).

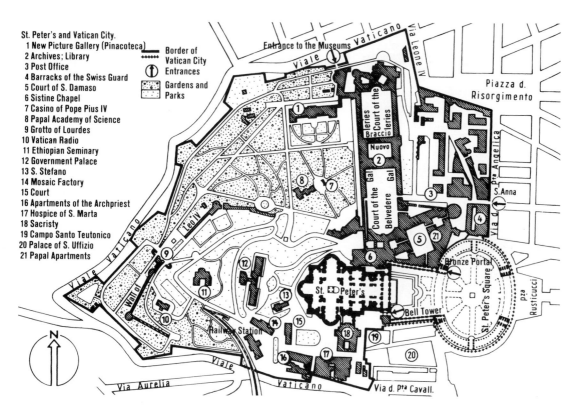

St. Peter's and Vatican City.
1 New Picture Gallery (Pinacoteca)
2 Archives; Library
3 Post Office
4 Barracks of the Swiss Guard
5 Court of S. Damaso
6 Sistine Chapel
7 Casino of Pope Pius IV
8 Papal Academy of Science
9 Grotto of Lourdes
10 Vatican Radio
11 Ethiopian Seminary
12 Government Palace
13 S. Stefano
14 Mosaic Factory
15 Court
16 Apartments of the Archpriest
17 Hospice of S. Marta
18 Sacristy
19 Campo Santo Teutonico
20 Palace of S. Uffizio
21 Papal Apartments

⊢⊢⊢⊢ Border of Vatican City
Entrances
Gardens and Parks

10.29 Plan of the Vatican and St Peter's, Rome.

shell of brick and stone, weighs hundreds of tons and caused critical structural problems. St Peter's lacks the solid surrounding walls of the Pantheon, and the supporting structure does little to stop the outward spread as the weight of the dome pushes downward and outward. Cracking occurred almost immediately, and the builders placed a series of massive chains around the base of the dome to hold it in position.

The entire complex of the Vatican, with St Peter's as its focal point, comprises a vast scheme of parks, gardens, fountains, and buildings (Fig. **10.29**). The colonnades of St Peter's Square have 140 majestic statues of popes, bishops, and apostles by Bernini (Fig. **10.27**). Larger than life and harmonious in design, these works reach upward and create a finishing touch to the square, the façade, and the dome.

Plans for replacement of the original basilica of Old St Peter's occurred under Nicholas V (r. 1447–55) in the fifteenth century, but Julius II (r. 1503–13) actually decided to put those plans into effect. Julius commissioned Donato Bramante to construct the new basilica. Bramante's design called for a building in the form of a Greek cross (Fig. **10.30**): "an harmonious arrangement of architectural forms" in an "image of bright amplitude and picturesque liveliness."

When Bramante died in 1514, two of his assistants and Raphael continued his work. However, liturgical considerations required an elongated structure, and these and other changes evoked severe criticism from Michelangelo. Pope Paul III (r. 1534–49) persuaded Michelangelo to become chief architect. Michelangelo set aside liturgical considerations and returned to Bramante's original conceptions, which he described as "clear and pure, full of light . . . whoever distances himself from Bramante, also distances himself from the truth" (Fig. **10.31**). Michelangelo's project came to completion in May of 1590, as the last stone was added to the dome, and a High Mass was celebrated. Further work was completed by Giacomo Della Porta and Domenico Fontana after Michelangelo's death. Full completion of the basilica as it stands today had to wait for the direction of yet more architects, including Carlo Maderno. Maderno yielded to the wishes of the cardinals to change the original form of the Greek cross to a Latin cross (Fig. **10.32**). As a result, the Renaissance design of Michelangelo and Bramante, with its central altar, gave way to Maderno's design of a travertine façade of gigantic proportions and sober elegance. His extension of the basilica proved influential in the development of baroque architecture. The project saw final completion in 1615.

In the vicinity of Venice, which in some ways benefited from the Sack of Rome, the architect Andrea Palladio (pahl-LAH-dee-oh; 1518–80) developed theories

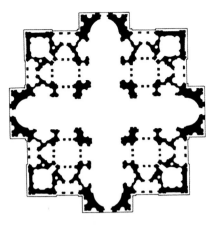

10.30 Bramante's design for St Peter's, 1506.

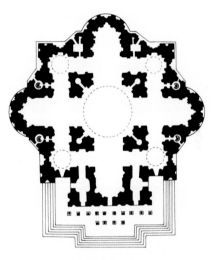

10.31 Michelangelo's design for St Peter's, 1547.

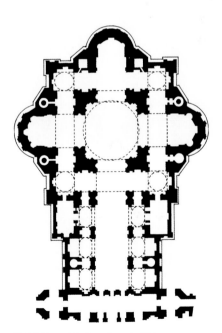

10.32 Plan of St Peter's as built to Michelangelo's design, with alterations by Carlo Maderno, 1606–15.

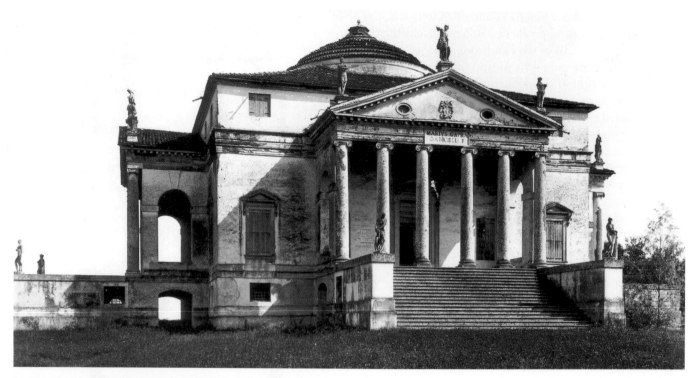

10.33 Andrea Palladio, Villa Rotonda, Vicenza, Italy, begun 1567–9.

10.34 Pierre Lescot, exterior façade of the Square Court of the Louvre, Paris, begun 1546.

and built buildings that would influence architecture through the ages. He designed villas and palaces that reflected his clients' individuality and pride in their worldly possessions. The Villa Rotonda in Vicenza (Fig. 10.33) shows strong classical influences, combining Greek and Roman details. The porticos carry freestanding Ionic columns, and the dome reminds us of the Pantheon. The rooms of the villa surround the central rotunda symmetrically. Palladio's mathematical combination of cubes and circles reflects the Renaissance, but he has cleansed the exterior surfaces of detail, placing the decorative sculpture above, in anticipation of baroque treatments. The Villa Rotonda (a nickname for its actual title, Villa Capra) is organized around the idea of a classical temple portico, but actually has four porticoes—one for each point of the compass. Palladio explained his designs in his *Four Books on Architecture* (1570), which proved highly influential in establishing canons later used in various "revival" periods. Thomas Jefferson's Monticello in the United States represents an excellent example of Palladian influence (see Fig. 13.25).

By the late sixteenth century, architecture had taken on Mannerist tendencies, especially in France under King Francis I. The Lescot (lehs-KOH) wing of the Louvre Palace (Fig. 10.34) has a discomfiting design of superficial detail and unusual proportions, with strange juxtapositions of curvilinearity and rectilinearity. Here we find a continuation of decorative detail applied to exterior

wall surfaces in the Renaissance fashion. However, careful mathematical proportions have been replaced by a flattened dome and dissimilar treatments of the shallow arches. The helmet-like dome stands in awkward contrast to the pediment of the central section and wears a sort of crown, perched nervously on top. The relief sculptures of the top level of the central section stand far too large for comfort in their architectural context.

Theatre

Renaissance drama in Italy, like painting, tended not to reflect the discordant political cloak-and-dagger atmosphere of its surroundings. Italian playwrights chose mostly to write tender, sentimental, pastoral comedies, in a graceful, witty, and polished style, and the drama, theatre of the aristocracy, produced elaborate trappings, usually at court (Fig. **10.36**), although sometimes in public squares under courtly sponsorship. No permanent theatres existed at the time, and the surviving Roman theatre buildings stood in such disrepair that they were unusable. When, rather late in the day, the theatre of the late Renaissance era finally caught the Renaissance spirit, it developed in ways that had a great impact on theatre in every part of Europe.

In Italy, two important developments occurred: one a new form of theatre building, the other painted scenery. Both contributed to changing aesthetics and style in formal theatre production. Vitruvius, the Roman architect and historian, provided the source of plans for new theatre buildings in Italy.

10.35 Sebastiano Serlio, stage setting from *D'Architettura*, 1540–51.

The discovery of mechanical perspective found its way into the theatre in the sixteenth century. The designs of Sebastiano Serlio (SAIR-lee-oh; Fig. **10.35**) illustrate some of this new painted scenery. Just as in early Renaissance paintings, the visual effect of falsified perspective "tricks" comes from mechanical principles. From a point slightly upstage of the actual playing area, the scenery gets smaller and smaller to an imaginary vanishing point. The effect induces a sense of great depth when, in reality, the set recedes only a few feet. Of course, the actors were restricted to a narrow playing area adjacent to the full-size downstage wings. If the actors had moved upstage, they would have towered over the buildings. Stage settings grew more and more elaborate, and a new "opening" usually brought an audience to see not a new play, but, rather, the new accomplishments of the set designer.

Scholars once thought of Palladio's Teatro Olimpico (tay-AHT-troh oh-LIM-pee-koh; Fig. **10.37**) as the model for modern theatre but now believe that our theatre derived from the Teatro Farnese at Parma. The most significant change in the theatre of this era, a move to enclose the dramatic action within a "picture frame," or **proscenium**, placed the audience on only one side of the stage watching the action through a rectangular or arched opening. The term "picture-frame stage" applies appropriately, in respect of both what it resembled and of the painting traditions of the era.

10.36 Baldassare Peruzzi, stage design, probably for *La Calendria*, 1514.

10.37 Andrea Palladio, Teatro Olimpico, stage, Vicenza, Italy, 1580–04.

Also competing for the attention of the public, Italy's unique commedia dell'arte (kohm-MAY-dee-ah del AHR-tay) developed parallel to the traditions of the regular theatre, and it enjoyed tremendous popular support. Most singularly, it featured the actor rather than the script.

Commedia dell'arte had four specific characteristics. The first was improvisation. Even though fully fledged productions had plots and subplots, actors completely improvised dialogue within the plot outline, or *scenario*. A few works were serious, and some pastoral, but most were comic. The acting style appears to have been natural, though the actors needed good entrance and exit lines as well as repartee.

The second characteristic was the use of stock characters—young lovers, old fathers, braggart soldiers, and comic servants, or *zanni* (ZAH-nee). All wore stock costumes, which the audience could easily identify. Actors portraying these roles required great skill, physical dexterity, and timing, since a large part of the

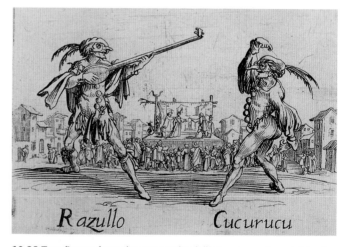

10.38 Two figures from the commedia dell'arte, copy of an etching by the engraver Jacques Callot.

humor was visual. The famous actor who played Scaramouche, Tiberio Fiorilli, could apparently still box another actor's ears with his foot at the age of eighty-three. Actors in the commedia also had to dance, sing, and perform acrobatics. Somersaulting without spilling a glass of wine, for example, seems to have brought down the house.

A third characteristic was the use of mime and pantomime. All characters except the lovers and the serving maid wore masks, and attitudes were communicated through gestures (Fig. **10.38**).

Finally, commedia actors traveled in companies, and each member of the company played the same role over and over again. The practice remained so pervasive that actors often lost their own identities. Many actors even changed their original names to those of the stage personages they portrayed.

From the mid-sixteenth to the mid-seventeenth centuries, troupes of commedia actors traveled throughout Europe. They enjoyed tremendous influence and popularity but commedia remained an Italian form, although its characters and situations found their way into the theatre of other nations. By the end of the seventeenth century, commedia had, to all intents and purposes, disappeared. One final fact to note: commedia dell'arte introduced women into the theatre as equals. Their roles were as important as, and often more important than, those of men; women, not boys, played the female parts.

Spain's *siglo de oro* witnessed a golden age of Spanish drama and literature as well—one that lasted into the late seventeenth century. During this period Spain saw the creation of a national theatre, started around 1550 by Lope de Rueda (roo-AY-dah; c. 1510–65) and brought to its ultimate fruition by Lope de Vega (VAY-gah; 1562–1635). Spanish theatre, like theatre elsewhere, had both sacred and secular components. During the sixteenth century three festivals (called the *Corpus Christie*) emphasized the Church's power. These festivals witnessed a type of play similar to the morality plays, also typically done in cycles, of the medieval period in the rest of Europe. Called *autos sacramentales* (OW-tohz sah-crah-main-TAHL-ayz), these plays featured human and supernatural characters and used wagons as stages.

Spanish secular theatre emerged around 1500, and is credited to Juan del Encina (ahn-THEE-nah; 1468?–1529/30), the first Spanish dramatist to write specifically for performance. By 1550, a Spanish professional theatre had emerged under the direction of Lope de Rueda, an actor and author, considered the father of Spanish professional theatre.

As noted, a truly national theatre came to fruition under the aegis of the playwright Lope de Vega (Lope Felix da Vega Carpio), credited with having written as many as 1,800 plays and several hundred shorter dramatic pieces, of which 431 plays and fifty shorter pieces have survived. He wrote two types of dramas, both utilizing Spanish settings: a heroic, historical type of play based on some national story or legend, and a cloak-and-dagger drama of contemporary manners and intrigue. His plays treat a variety of themes with clearly defined actions, suspense, and conflict (usually surrounding the claims of love and honor). They typically end happily and represent every rank and condition of people. He excelled in creating female characters. In the cloak-and-dagger plays we typically find gallants and ladies falling in and out of love, the "point of honor," and a parallel plot line featuring servants who imitate or parody the main action. The *gracioso*, a sort of extended simpleton, exercises his wit and common sense in commenting on the follies of his social superiors—a kind of comic servant we later find in the plays of Molière, for example (see Chapter 12). Plays such as *The Gardener's Dog* still find entertaining production.

Music

Renaissance music differed from the late medieval style particularly in features such as greater melodic and rhythmic integration, a more extended range, broader texture, and subjection to harmonic principles of order. In the sixteenth century, this integrated style produced distinct vocal and instrumental idioms, and vocal music, under the influence of humanism, became increasingly intent on expressing a text. In fact, vocal music, because of the humanistic interest in language, emerged as a more important musical idiom than instrumental music. Renaissance composers tried to enhance the meaning and emotion of the written text. In doing so, they often used what we call **word painting**—for example, if a text described a descent, then the music might utilize a descending melodic line. In sum, however, and despite the increased sense of emotion, Renaissance music remained restrained and balanced: avoiding extreme contrasts in **dynamics**, tone color, or rhythm.

The texture of Renaissance music stayed mostly polyphonic, with imitation among the voices fairly common. **Homophony** also existed, especially in light music such as dance. In addition, the musical texture of a piece might vary, with the contrast used to highlight the particular emotion of the composition.

Sacred Choral Music

Although the Sack of Rome by Charles V destroyed the city, its musical traditions survived, and the papal chapel continued as one of the central musical forces in Europe. There, the career of Giovanni Pierluigi da Palestrina (pal-

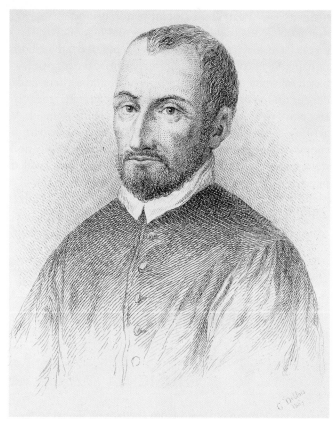

10.39 Giovanni Pierluigi da Palestrina (c. 1526–94).

es-TREEN-uh; c. 1526–94) flourished. Palestrina (Fig. **10.39**) enjoyed the grace and favor of popes and cardinals. Director of the Julian Chapel Choir from 1551 to 1555, he became a singer in the pontifical choir in the latter year and began to compose for the papal chapel. Because he was married, however, he was forced to leave his post when Pope Paul IV imposed a stricter discipline in choral appointments.

Palestrina's works are exclusively vocal and almost totally liturgical, the only exceptions being a single book of madrigals and a collection of spiritual madrigals. He wrote 105 masses and became the most celebrated composer of his time, his name synonymous with Counter-Reformation polyphony. (We will discuss the Counter-Reformation in Chapter 13.)

Palestrina's *Pope Marcellus* Mass, dedicated to Pope Marcellus II, who reigned briefly in 1555, when Palestrina sang in the Papal Choir, uses six voice parts (a cappella—without accompaniment): soprano, alto, two tenors, and two basses. Earlier we examined a *Kyrie* from Gregorian chant. Let's now examine the Kyrie from Palestrina's *Pope Marcellus* Mass (Fig. **10.40**).

The Kyrie has a rich, polyphonic texture, in which the six voices imitate each other. The rounded melodic contours evoke images of the Gregorian chant. The melody moves in the top voice, the *cantus* or soprano line. The Kyrie has the traditional three sections we discussed in Chapter 7:

1. *Kyrie eleison.* Lord, have mercy upon us.
2. *Christe eleison.* Christ, have mercy upon us.
3. *Kyrie eleison.* Lord, have mercy upon us.

The words of this brief text repeat with different melodic treatments and express calm supplication. Each section ends with all voices coming together on sustained chords.

Another important form of Renaissance sacred music, the *motet*, is like the Mass in style, but shorter. The Renaissance **motet**, a polyphonic choral work, sets to a Latin text other than the Ordinary (unchanging part) of the Mass. We will examine the motet in greater detail, along with its most prominent composer, Josquin des Prez, in the next chapter.

10.40 Giovanni Pierluigi da Palestrina, Kyrie from the *Pope Marcellus* Mass (published 1567).

Secular Choral Music

The sixteenth century witnessed the development of previous forms into the *madrigal*, a setting of lyric poetry for four or five voices. The term **madrigal** applies to two important types of secular vocal music. One type was cultivated exclusively in fourteenth-century Italy; the other developed anew and flourished in Italy during the sixteenth century during an explosion of Italian poetry. Poetically, the sixteenth-century madrigal normally comprises a text of from three to fourteen lines (of seven and eleven syllables in no particular order) arranged in a rhyme scheme of the poet's choosing. The musical setting emphasizes the mood and meaning of individual words and phrases of the text rather than formal structure.

Madrigals used as few as three and as many as eight parts, although, in general, before 1650 a four-part texture predominated. After that, a five-part texture predominated. Madrigals often used solo voices, one per part, but also employed instruments substituting for some of the voices or doubling the various parts. By the second half of the sixteenth century, the madrigal had become established as the dominant form of secular music in Italy and the rest of Europe. Among the madrigal composers of the time, we find no less a figure than Michelangelo.

Instrumental Music

In the sixteenth century, musical instruments rose above their old role of merely reinforcing voice parts, and instrumental music developed an independence from vocal music (although instrumental music still remained subordinate to vocal music). Previously, instruments tended to accompany voices or to play music originally intended for the voice. In the sixteenth century, more music appeared expressly written for instruments, and music exploited the qualities of individual instruments. Much instrumental music was written for dancing, an extremely popular form of entertainment (see the Dance section of Chapter 9).

A new treatment of instrumental sound occurred in music written for the *vihuela*, a type of guitar, and the harpsichord. The lute (a guitar-like instrument with a pear-shaped body) had great popularity. In the later part of the century, Mannerism reacted against the complicated texture of polyphony and sought to revive Greek musical practice with its emphasis on simplicity.

Renaissance musicians differentiated between two general types of instruments: soft, indoor instruments—such as the lute and the recorder (an early flute)—and loud, outdoor instruments—such as trumpets and the shawm (a predecessor of the oboe). Interestingly, Renaissance composers did not indicate which instruments they desired, and the same work might be played by one set of instruments on one occasion and by something quite different on another.

Literature

The sixteenth century witnessed the climax and close of what amounted to an Italian monopoly in Renaissance literature. The influence of the Italian Renaissance spread to the rest of Europe, reaching France in the middle third of the century and England in the last third of the century. The common factor everywhere was imitation of the classics. In Italy the writers of the High Renaissance appeared apparently indifferent to the tragic social and political events to which they bore witness. In the last chapter, we noted something of Machiavelli's view—that of limited hope—but others reacted with bland unconcern and ironic humor. Most, like Castiglione, chose to ignore political unpleasantness. However, after the Spanish Sack of Rome in 1527, literature, with perhaps the exception of Torquato Tasso, slipped into mediocrity.

In commenting on the High Renaissance (see the Concepts section of this chapter), we noted the importance of the princely courts. In essence, the typical Renaissance state had a monarchial rather than democratic form of government, thus producing a plethora of courtly, aristocratic social circumstances.

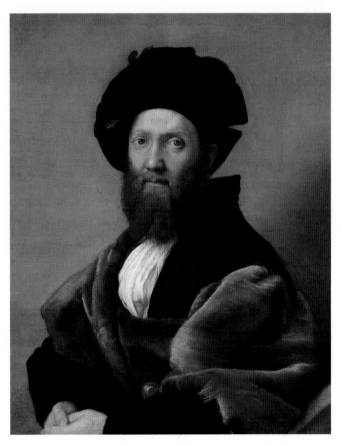

10.41 Raphael, *Count Baldassare Castiglione*, 1514. Oil transferred from wood to canvas, 2 ft 9¾ ins × 2 ft 3½ ins (82 × 66 cm). Louvre, Paris.

Amid this Renaissance feature, rose its most ardent and insightful commentator.

The Conte Baldassare Castiglione (bahl-dahs-SAH-ray kahs-teel-YOH-nay; 1478–1529), himself the perfect courtier (Fig. **10.41**), wrote *Il Cortegiano* or *The Courtier,* which became a universal guide to "goodly manners" and "civil conversation" of the court of the duchy of Urbino. In effect, he functioned as the arbiter of courtly behavior for all of Europe. In this influential work, Castiglione suggests, through an imagined dialogue, a picture of an artistically ordered society, in which cultivated Italians regard social living as a fine art.

Castiglione, raised at the court of Duke Sforza of Milan, studied Greek, Latin, and Italian poetry, music, painting, and horsemanship. His portrait reveals a handsome, intelligent man, who entered the service of the duke of Urbino in 1504, thereby entering an environment with a fabulous library that functioned as the rendezvous of European scholars and artists. As a diplomat, he visited England, became an advisor of Pope Leo X, and papal nuncio of Pope Clement VII to the court of the Holy Roman Emperor Charles V. When the Emperor's troops sacked Rome, Castiglione became the subject of numerous rumors of treason.

The particular character of *The Courtier* lies in the scientifically naturalistic manner in which the conversations occur and the way in which the various opinions of the participants appear. Above all, *The Courtier* propounds the humanist's ultimate ideals—of men and women of intellectual refinement, cultural grace, moral stability, spiritual insight, and social consciousness. It provided a model of the ideal Renaissance society, but its values seem timeless: true worth is determined "by character and intellect rather than by birth." The excerpt that follows, although brief, illustrates both the context of the time and the content of Castiglione's work.

The Courtier
Baldassare Castiglione

On Women

Leaving aside, therefore, those virtues of the mind which she must have in common with the courtier, such as prudence, magnanimity, continence and many others besides, and also the qualities that are common to all kinds of women, such as goodness and discretion, the ability to take good care, if she is married, of her husband's belongings and house and children, and the virtues belonging to a good mother, I say that the lady who is at Court should properly have, before all else, a certain pleasing affability whereby she will know how to entertain graciously every kind of man with charming and honest

10.42 Michelangelo, Sonnet 64, relating the physical torments of painting the Sistine Chapel. From *Rimi di Michelangelo Buonarotti*, 1511.

conversation, suited to the time and the place and the rank of the person with whom she is talking. And her sense and modest behavior, and the candor that ought to inform all her actions, should be accompanied by a quick and vivacious spirit by which she shows her freedom from boorishness; but with such a virtuous manner that she makes herself thought no less chaste, prudent and benign than she is pleasing, witty and discreet. Thus she must observe a certain difficult mean, composed as it were of contrasting qualities, and take care not to stray beyond certain fixed limits. Nor in her desire to be thought chaste and virtuous, should she appear withdrawn or run off if she dislikes the company she finds herself in or thinks the conversation improper. For it might easily be thought that she was pretending to be straitlaced simply to hide something she feared others could find out about her; and in any case, unsociable manners are always deplorable.

Ludovico Ariosto (loo-doh-VEE-koh ah-ree-AWS-toh; 1474–1533) was a courtier of the house of Este at Ferrara, and served in the civil and diplomatic service, as well as court poet. Classically trained, he wrote most of his work in Latin until he was twenty-five years old. His father died when he was twenty-six, and he assumed responsibility for providing for his four brothers and five sisters. He spent fourteen years as confidential secretary to Cardinal d'Este, and during this time he traveled throughout Italy on political missions. In 1518, he entered the service of the cardinal's brother, the duke of Ferrara, eventually becoming the duke's director of entertainment. Under Ariosto's supervision, the court enjoyed pageants and dramatic productions, Ariosto himself designing the theatre and scenery and writing a number of the plays. As early as 1505 he began his masterpiece, *Orlando Furioso*, forty cantos (sections) of which appeared in 1516. For nearly thirty years he continued to revise the work, which became one of the most influential poems of the Renaissance. *Orlando Furioso* ("Roland in a Mad Fury") is a romantic epic—its forty-six cantos total over 1,200 pages—of "Loves and Ladies, Knights and Arms . . . Of Curtesies, and many a Daring Feat." Ariosto depended heavily on the Greco-Roman tradition of Homer and Vergil, and borrowed incidents, character types, and rhetorical devices, such as the catalogue of troops and extended simile. Designed for a sophisticated audience, it employs an ottava rima (a stanza of eight lines rhyming ABABABCC), and it has a polished, graceful style. It became a bestseller throughout Europe.

Orlando Furioso captivated its sixteenth-century readers with its elements of supernatural trips to the moon, allegorical incidents that taught modesty and chastity, and romantic adventure. However, the characters remain shallow and two-dimensional, for Ariosto made no attempt to probe the depths of human behavior or to tackle important issues. Nonetheless, he carefully works out individual incidents and carries them through to a climax, after which he takes up the next issue. All loose threads are tied together at the end. *Orlando Furioso* served the Renaissance as a model of the large-scale narrative poem written with technical skill, smoothness, and the gracefulness typical of the classics. Ariosto spent most of his adult life writing and revising this masterpiece.

Amidst the poets of the time we find the titan Michelangelo, who wrote more than 300 sonnets to add to his work as a sculptor, painter, architect, and musical composer. His sonnets comprise a remarkable autobiography (Fig. **10.42**). They make us a spectator to the struggles of his life and his passions. He wrote a number of letters that reveal something about himself, but not usually anything profound: a few quarrels about money and commissions. His sonnets, however, reveal more of the man, and we find them jotted down at odd moments, sometimes in the margins of his sketches, and revealing some particular relevant feeling or spontaneous idea. The following sonnet, which illustrates his poetry, forms one of a set of seven sonnets by Michelangelo set to music by the twentieth-century English composer Benjamin Britten. The musical work uses the sonnets in their original Italian, and so we present the Italian first, followed by an English translation. Notice that the Italian employs the form and rhyme scheme of the Petrarchan sonnet we studied in Chapter 9. The English version does not.

Sonnet XVI
Michelangelo

Taken from Benjamin Britten's
Seven Sonnets of Michelangelo, no. 1, Op. 22.

Sì come nella penna e nell'inchiostro
È l'alto e 'l basso e 'l mediocre stile,
E ne' marmi l'immagin ricca e vile,
Secondo che 'l sa trar l'ingegno nostro;
Così, signor mie car, nel petto vostro,
Quante l'orgoglio, è forse ogni atto umile:
Ma io sol quel c'a me proprio è e simile
Ne traggo, come fuor nel viso mostro.

Chi semina sospir, lacrime e doglie,
(L'umor dal ciel terreste, schietto e solo,
A vari semi vario si converte),
Però pianto e dolor ne miete e coglie;
Chi mira alta beltà con sì gran duolo,
Dubbie speranze, e pene acerbe e certe.

English translation:

Just as in pen and ink
there is a high, low, and medium style,
and in marble are images rich and vile,
according to the art with which we fashion it,
so, my dear lord, in your heart,

along with pride, are perhaps some humble thoughts:
but I draw thence only what is proper for myself
in accordance with what my features show.

Who sows sighs, tears and lamentations
(dew from heaven on earth, pure and simple,
converts itself differently to varied seeds)
will reap and gather tears and sorrow;
he who gazes upon exalted beauty with such pain
will have doubtful hopes and bitter, certain sorrows.

The sonnet as a poetic form found great popularity in the High Renaissance, and we also find it among the poets of the Golden Age of Spain. Here are two more examples. The first, by Gutierre de Cetina (thay-TEE-nah; 1520?–1557?) draws on classical and Italian poetry, using the Italianate meters of the Petrarchan sonnet. Cetina freely translated from Petrarch in his poetry, but his sonnets, considered his finest work, show an elegance and facile meter all their own. Again, we present the poem in its original Spanish, utilizing the Petrarchan rhyme scheme followed by a loose English translation not employing the form.

Soneto
Gutierre de Cetina

"Como al pastor que en la ardiente hora estiva
la verde sombra, el fresco aire agrada,
y como a la sedienta su manada
alegra alguna fuente de agua viva,

así a mi árbol do se note o escriba
mi nombre en la corteza delicada
alegra, y ruego a Amor que sea guardada
la planta porque el nombre eterno viva.

Ni menos se deschace el hielo mío,
Vandalio, ante tu ardor, cual suele nieve
a la esfera del sol ser derretida."

Así decía Dórida en el río
mirando su beldad, y el viento leve
llevó la voz que apenas fue entendida.

English translation:

"Like a shepherd who amidst the fiery heat of day
delights in leafy shadows or fresh breezes
or when his thirsty flocks have joy
in finding fonts of water pure and sweet;

So my tree rejoices when my name is writ
in letters plain or symbols in its fragile bark.
God of Love keep this tree safe
so that the name may live eternally.

And yet my heart of ice will not melt down
howe'er you burn, Vandalio;
I am no melting snow neath Phoebus' rays!"

So spoke proud Dorida as in the stream
she gazed upon her beauty, but her voice,
caught by the wind, grew fainter than a dream.

The poet/playwright Lope de Vega also wrote sonnets in the Italian, Petrarchan style, and we close this section and the chapter with yet another example—first in the original Spanish and then in rough, English translation. Lope de Vega's poetic output proved as prodigious as his dramatic. He wrote 1,587 sonnets, and like Michelangelo's, they provide a meaningful autobiography of his entire emotional life. In this example, the mention of Daedalus refers to the mythological architect and sculptor reputed to have built, among other things, the Labyrinth for King Minos of Crete (see Chapter 2). Daedalus later fell out of favor with Minos and was imprisoned. To escape, he made wings for himself and his son, Icarus, out of wax and feathers. Daedalus escaped to Sicily, but Icarus flew too close to the sun, the feathers melted, and he fell into the sea and drowned. The story as depicted by Pieter Bruegel the Elder appears in Figure 11.10.

Rimas, Soneto I
Lope de Vega

Versos de amor, conceptos esparcidos
engendrados del alma en mis cuidados,
partos de mis sentidos abrasados,
con más dolor que libertad nacidos;

expósitos al mundo en que perdidos,
tan rotos anduvistes y trocados
que solo donde fuistes engendrados
fuérades por la sangre conocidos:

pues que le hurtáis el laberinto a Creta,
a Dédalo los altos pensamientos,
la furia al mar, las llamas al abismo,

si aquel áspid hermoso no os aceta,
dejad la tierra, entretened los vientos,
descansaréis en vuestro centro miso.

English translation:

Poetry of love, dispersed concepts
engendered by my soul upon my worries,
delivered of my smoldering senses' womb
and with more pain than freedom surely born;

Abandoned to the world in which so lost,
so tortured and transformed you wandered free
that only in the place you were conceived
would you be known at all by your own blood:

for since you steal the labyrinth from Crete,
from Daedalus his highly soaring thoughts,
from sea the fury, from the abyss its fire,

if that exquisite asp won't take you in,
then leave the earth, go to amuse the winds,
and thus to rest in your true home.

CHAPTER REVIEW

CRITICAL THOUGHT

In the introduction to this book, we talked about two qualities we could examine in judging the quality of a work of art. One of them was craft: how well the artwork was made. The second was the uniqueness of its message or vision. In previous chapters we have seen many superbly crafted and profoundly communicative works of art. Among the makers of these works, arguably, Michelangelo and Leonardo da Vinci rank at the top. If you have mastered the material of this text, you ought to be able to support the previous assertion—whether you agree with it or not—citing specific qualities of communication and craftsmanship as well as comparative examples well sprinkled with the proper terminology from the introduction to underscore your argument.

Finally, let's consider the larger question of art and its context. We look at the magnificent accomplishments of the artists of the High Renaissance and place them in the context of political events. If art is the mirror of its time, how do these artistic accomplishments reflect the social and political environment that gave them birth?

SUMMARY

After reading this chapter, you will be able to:

- Characterize the world of the sixteenth century and identify individuals and accomplishments that shaped it.
- Compare the qualities and characteristics that define High Renaissance art and architecture and contrast those with the qualities and characteristics of Mannerism.
- Describe the literary works of Castiglione and Ariosto.

- Identify the major musical developments of the era and describe the work of Palestrina.
- Discuss the theatre of the High Renaissance, relating specifically the nature and qualities of commedia dell'arte.
- Apply the elements and principles of composition to analyze and compare works of art and architecture illustrated in this chapter.

CYBERSOURCES

http://www.artcyclopedia.com/history/high-renaissance.html
http://www.artcyclopedia.com/history/mannerism.html
http://www.greatbuildings.com/architects.html
http://sonnets.spanish.sbc.edu

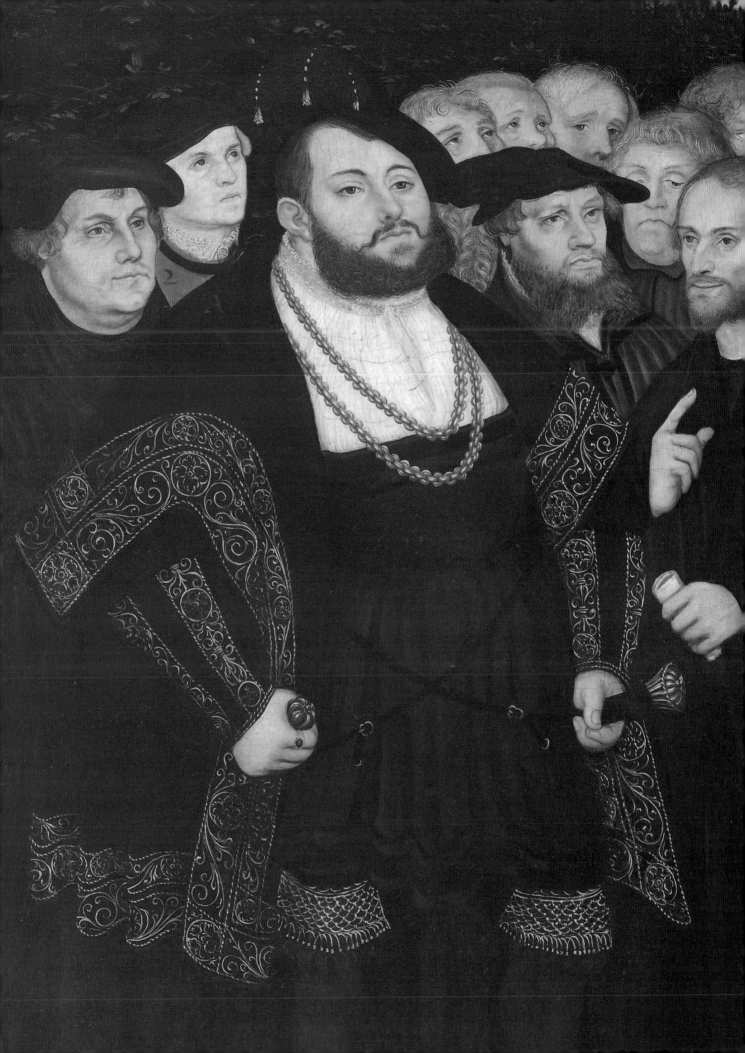

11 RENAISSANCE AND REFORMATION IN NORTHERN EUROPE

OUTLINE

CONTEXTS AND CONCEPTS
- Contexts
 The Reformation
 PROFILE: Martin Luther
 Science
 TECHNOLOGY: Naval Artillery
- Concepts
 Christian Humanism
 Utopianism

THE ARTS OF THE RENAISSANCE AND REFORMATION IN THE NORTH
- Painting
 Flanders
 The Netherlands
 Germany
 A DYNAMIC WORLD: Ming Dynasty
 Porcelain
 France
 England
- Architecture
- Theatre
 MASTERWORK: Shakespeare—*Hamlet*
- Music
 Flanders
 Germany
 France
 England
- Dance
- Literature

VIEW

RELIGION AND POLITICS

As seems clear from contemporary events in the United States, politics and religion are hardly ever easy to separate. Part of the Reformation of the sixteenth century had to do with questions regarding the mix of civil and religious authority, and the theocracies of Switzerland illustrate the solution proposed by some who wanted separation from the authority of the Roman Church. In places such as Germany, things were less certain. Some areas remained loyal to Rome, while others found it expedient in a more secular realm to do away with Roman authority altogether. England had no Reformation in the strict sense of the word, merely a semantic argument over who should function as head of the Church. As we will see, however, the Reformation, like much of the crusading religion seen today, has, perhaps, more to do with power and politics than with faith.

KEY TERMS

AERIAL PERSPECTIVE
The use of atmosphere to create a sense of deep space in a painting.

THE REFORMATION
Political and religious conflicts that led to the establishment of Protestant sects in the Christian Church.

THEOCRACY
Government run by religious leaders.

TRANSUBSTANTIATION
The belief in the Roman Catholic Church that the communion elements of bread and wine actually become the body and blood of Christ.

DEPOSITION SCENE
A work of art portraying the removal of Christ's body from the cross.

LIEDER
German secular songs.

WOODCUT
A block of wood with an engraved design, and a print made from such a block.

CHORALE
A hymn tune.

DIPTYCH
A form in which two images (usually paintings on panel or reliefs) are hinged together.

11.1 Lucas Cranach the Younger, *Martin Luther and the Wittenberg Reformers* (detail), c. 1543. Oil on wood, 27⅝ × 15⅝ ins (70 × 40 cm). Toledo Museum of Art, Toledo, Ohio.

CONTEXTS AND CONCEPTS
Contexts

The Reformation

In this chapter we turn our attention to the north of Europe and examine roughly the same time in history that we pursued in Chapters 9 and 10. What we see represents a confluence of economic, political, and religious conflicts that, for ease of reference, we call the Reformation. It took place at the same time as the "Renaissance" and represented the most shattering and lasting blow the Christian Church has perhaps ever experienced outside the East/West split of the early Church (see Chapter 7). Of course, it did not just appear out of the blue, but was, rather, the climax of centuries of sectarian agitation—in the fourteenth century, for example, English cries for reform and resentment of papal authority led to an English translation of the Bible. But reform and separation stand worlds apart, and we must realize that the Reformation did not begin as an attempt to start a new branch of Christianity, but as a sincere attempt to reform serious religious problems in the Roman Catholic Church.

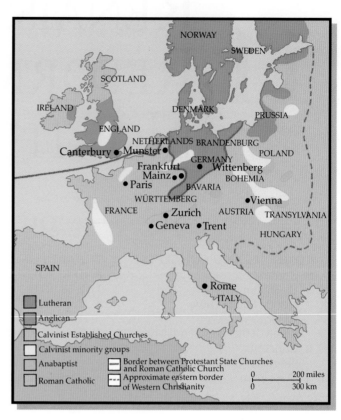

Map 11.1 Religious divisions in sixteenth-century Europe.

GENERAL EVENTS

- Copernicus, 1473–1543
- Luther, 1483–1546
- Henry VIII of England, 1491–1547
- Francis I of France, 1494–1547
- Pope Leo X, 1513–21
- Vesalius, 1514–64
- Mary Tudor, 1516–58
- Elizabeth I of England, 1533–1603
- Edward VI of England, 1537–53
- Dissolution of the monasteries in England, 1536

	1400	1450	1500	1525	1550	1600
PAINTING & SCULPTURE	van Eyck (11.7), van der Weyden (11.8)		Bosch (11.9), Dürer (11.11–11.13), Grünewald (11.14), Altdorfer (11.15), Clouet (11.18)	Cranach the Younger (11.1), Cranach the Elder (11.2), Holbein (11.17, 11.19)		Bruegel the Elder (11.10)
ARCHITECTURE						Smythson
THEATRE						Shakespeare, Globe Theatre, Marlowe
MUSIC & DANCE	Dufay		Josquin des Prez	Janequin, Walter		Caroso, Byrd, Morley
LITERATURE			Erasmus	Zwingli, More, Calvin		Montaigne, Sidney, Spenser

Timeline 11.1 Renaissance and Reformation in northern Europe.

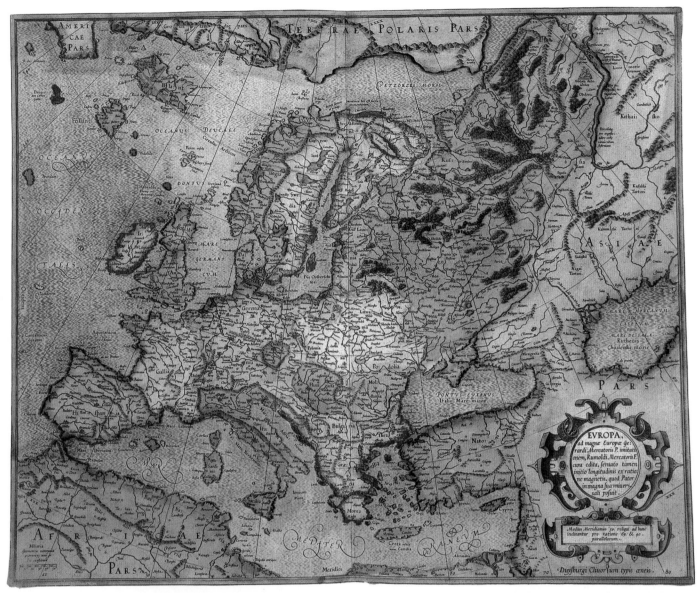

Map 11.2 Map of Europe from the *Atlas sive cosmo graphicae* published by Gerard Mercator, Duisburg, 1585. Royal Geographical Society, London.

Throughout Roman Catholic Europe, the huge body of clergy had amassed considerable tax-free wealth, at which secular governments chafed, particularly because the Church, in return, taxed the secular sector heavily. Widespread popular resentment of central ecclesiastical authority strengthened from political stability, even in areas still essentially feudal. In addition, many people found existing Church dogma indefensible. As we noted in Chapter 8, some early opposition occurred among the followers of John Huss in eastern Europe. A break with Rome—political rather than religious—occurred in England under Henry VIII in a dispute over central authority, and resulted in the confiscation of all Roman Church property in the Act of Dissolution (1536).

Reformers

The Reformation movement centered on three individuals and a number of religious (in addition to political) issues. The individuals were Martin Luther (see Profile, p. 344), Ulrich Zwingli (TSVING-lee; 1484–1531), and John Calvin (1509–64). The issues leading to the formal breaks with the Roman Catholic Church included indulgences, biblically based ritual and practices, the relationship of body and spirit, grace, predestination, and transubstantiation. In the next few pages we will see how these three reformers took these basic issues and ended up with three different results, including the establishment of two Protestant *theocracies*—a merger of the Church and State in which the State became the guardian of public conduct.

PROFILE

MARTIN LUTHER (1483–1546)

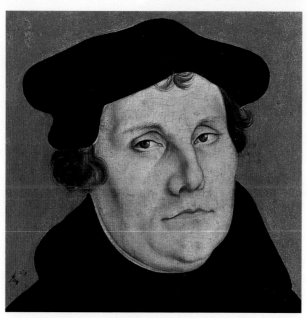

11.2 Lucas Cranach the Elder, *Martin Luther*, 1529. Oil on wood, 14¾ × 9 ins (37 × 23 cm). Uffizi, Florence, Italy. (Detail.)

creature as himself, and he grew to hate a God who demanded love but made it impossible for his children to approach Him without fear and awe.

For the next six years he lectured and preached, and gradually came to realize that humankind could not possibly draw near to God of their own free will, because human nature had been corrupted by original sin and, thus, was driven irrevocably toward evil. To Luther, a human being trying to attain salvation through his or her own efforts was like a badly made clay pot trying to reshape itself. The potter—God—must intervene. Humans could do little but wait for the divine spark to set them alight and burn out their sin. God could not be forced to intervene, but because God had sent Christ into the world, hope existed for all sinners. Faith was essential, and through faith came salvation. In effect, Luther had rediscovered St Paul (see Chapter 5) and St Augustine (see Chapter 7), but his discovery made him aware of the Holy Spirit's work and that his self-loathing formed the first step in his regeneration.

The son of a copper miner from Saxony, in what is now Germany, Luther (1483–1546; Fig. **11.2**) was born into a financially strapped family. In 1497 he went to a school in Magdeburg run by the Brethren of the Common Life, and in 1505 he earned a Master of Arts degree from Erfurt University. Erfurt was a stronghold of those "schoolmen" whom Erasmus so detested. These scholars believed in the existence of an uncrossable gap between reason and revelation and that human limitation and finite knowledge could never understand the divine. Knowledge of God obtained only by revelation, the main source of which remained the Bible. Luther, obsessive about his own sinfulness, responded eagerly to the idea of the apartness of God. In 1505 he entered the Augustinian friary at Erfurt, whose friars kept a strict discipline. Even in this dedicated order, Luther distinguished himself by his extreme asceticism—the renunciation of the comforts of society and austere self-discipline—even though he found little peace in rigorous discipline and confession. Brought up to believe that humans could gradually make themselves acceptable to God through the sacraments and the performance of good works, he believed that God could never love such a sinful

11.3 Luther nailing his Theses to the church door. Engraving.

We begin with Martin Luther, whose protests began with his reaction to the sale of indulgences, a lucrative Church business based on the belief that the Church had built up a "surplus of merits" which it could sell to the truly penitent to release them from part of their required penance, an outward sign of their inward repentance. He took offense that people such as Prince Albert Hohenzollern (HOH-en-tsohl-urn), acting on behalf of the pope, persuaded credulous men and women that the purchase of an indulgence would buy pardon from sin. To Luther, the Church denied its very reason for existence by selling indulgences. God could not be fooled nor the Last Judgment averted by the possession of a piece of paper with a papal seal on it.

In October 1517, Luther boldly fastened what have come to be known as the Ninety-five Theses to the door of the town church in Wittenberg, where they would be seen by all visitors (Fig. **11.3**). Although he made his opinions clear, he avoided making a direct attack on papal authority. Rather, he blamed the local emissary selling the indulgences, indicating that if the pope knew of the tricks being used to sell the indulgences, he would let St Peter's collapse rather than use tainted money to build it.

The Theses were quickly translated from their original Latin and disseminated throughout Germany. Again, the printing press contributed in spreading material that would earlier probably have gone unnoticed. The reaction surprised Luther, and he tried to withdraw the Theses—now public property. The pope called Luther to Rome to answer charges of heresy and rebellion against ecclesiastical authority.

Although he did not want an open break with Rome, he stood absolutely convinced of the rightness of his own arguments and caught up in the outpouring of emotion that they had stirred up. Politics came to Luther's aid. Emperor Maximilian died in 1519, and for the next six months, until the election of Charles V, the Elector of Saxony was a much-courted man (and also Luther's protector). He managed to enable Luther to escape any judgment. In the meantime, Luther became something of a national hero, against whom any German ruler would have had great difficulty taking action.

The die was cast, and over the next year, Luther put his thoughts into a program of fundamental reform in several widely selling works. These included *Sermon on the Mass*, in which he argued that Christ's sacrifice on the cross had been made once and for all, and there could, therefore, be no re-enacting it, as priests claimed took place in the Mass.

At issue here stood the fact that priests offered the sacrifice by communing with both bread and wine, whereas the laity were restricted to bread alone. He amplified some of these themes in *An Appeal to the German Nation*, in which he made a call to national and anti-clerical feeling, arguing that if the Church were the community of all believers and not merely the ordained minority, secular authority had a duty to intervene and redress abuses if the Church refused to do so. Because the Bible made no mention of popes or papal taxes, no one need submit to the former nor pay the latter. He also went on to consider the issues of monasticism, spiritually empty pilgrimages, and clerical celibacy, all of which stood outside scripture.

Charles V issued a proclamation condemning Luther's ideas and forbidding their publication, but he granted Luther a safe-conduct pass to Worms to defend himself publicly before the Diet due to assemble there. The emperor hoped that Luther would either submit to the display of authority at Worms or be so intemperate in his reply that public opinion would turn against him. Luther did neither. His response to the charges against him was so temperate and well reasoned that he came away in public triumph, deeply impressing people with his appeals to conscience. He replied to his inquisitors with the famous words: "Here I stand—I cannot do otherwise." Nonetheless, the emperor had the obligation to ban Luther, an act enforced by edict. Luther left Worms hurriedly, was promptly "kidnapped" by his old protector, the Elector of Saxony, and taken to Wartburg Castle so that he could deny any knowledge of him and escape the need to enforce the emperor's edict. The wheels of revolution had begun to spin and would not stop. Religious protest turned into political revolt.

The second reformer, Ulrich Zwingli, a Swiss, had studied at humanist universities in Basel and Vienna before accepting the position of parish priest in the principal church of Zurich (Fig. **11.4**). For Zwingli, true faith demanded active commitment, and he believed his task was to preach and teach the pure gospel as he saw it. He came to these conclusions even before he heard of Martin Luther, whose stand against indulgences Zwingli approved. After studying writings by both Luther and Huss, Zwingli launched his own reform movement, beginning with all the practices of the Church not specifically authorized in the Bible. In 1523 he published a series of articles condemning *transubstantiation*, pilgrimages, fasts, and papal supremacy. The city council of Zurich, impressed by his logic, ordered a public debate between Zwingli and a representative of the Catholic Church. Zwingli carried the day, and the council ordered public Bible reading and vernacular prayers. They denounced clerical celibacy, dissolved all religious houses, and abolished the Mass, replacing it with a simple communion service in which preaching and prayers played the major role.

Zwingli also found no biblical authority for ritual and images, and here he differed with Luther, who

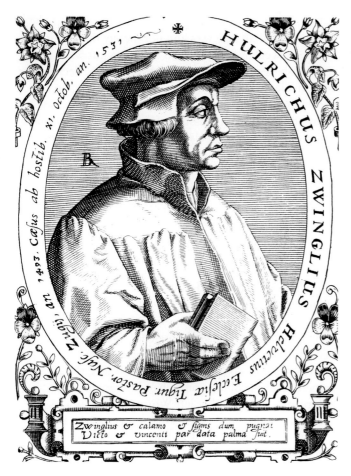

11.4 Ulrich Zwingli (1484–1531).

In 1529, five of the Swiss cantons that had remained loyal to the Catholic Church formed a coalition to bring the Protestant rebellion to a close by force. The original conflict was shortlived, but fighting erupted two years later. Zwingli, who had no qualms about fighting force with force, accompanied the Protestant army as chaplain. He was wounded, taken prisoner, and executed.

The third, and probably the most famous reformer of the generation after Luther, John Calvin of Geneva (Fig. **11.5**), came to prominence in the 1530s. Calvin was a very different character from Luther. A sophisticated Frenchman, trained in humanism and law in addition to theology, Calvin lacked Luther's passion and eloquence but instead had shrewd organizational abilities and a careful logic. In contrast to Luther's corpulence, Calvin looked the part of a fanatical ascetic, with a thin face, hollow eyes, and long, scraggly beard.

Like Zwingli, Calvin succeeded in establishing a Swiss Protestant theocracy in the city-state of Geneva, and his militant preaching inspired Protestants all over Europe. In terms of theology, Calvin stood very close to Luther, the differences between them more matters of emphasis than of substance. Calvin stressed the omnipotence of God, and he placed the doctrine of predestination of souls to Heaven or Hell at the center of his belief system. Salvation came through faith alone, but because faith remained a gift of God, it was not given to all but only to those whom God had predestined for eternal life. He declared that the scriptures existed as the only source of guidance on matters of faith and that errors in the Church remained errors regardless of how much tradition they had behind them. Calvin believed in only two sacraments—baptism and eucharist (YOO-kuh-rist)—because these were the only ones found in the Bible. Like Zwingli and Luther, he rejected transubstantiation, but stood closer to Luther than to Zwingli because he believed that some sort of "real presence" existed in the eucharist. He recorded most of his theology in his great book *The Institutes of the Christian Religion*, first published in 1536 and revised in later editions to contain more emphasis on the organization of the Church. Read everywhere by Protestants, it established Geneva as the Protestant ideal of a Christian community.

Geneva had just overthrown the dukes of Savoy, but had not joined the Swiss confederation. Calvin's zealots gained political power and, like Zurich, Geneva became a theocracy, ruled by Calvinist pastors, who, in turn, submitted to Calvin. Life in Geneva proved austere and rigorous. Puritanical and moral legislation formed its governance, with sermons the staple of life, reflecting Calvin's rather inflexible vision of a world divided into the saved and the damned. Calvinist Protestants saw themselves as the builders of the New Jerusalem on earth.

believed that the physical and spiritual comprised two aspects of the same divine nature. In his *Commentary on the True and False Religion* Zwingli asserted that: "Body and spirit are such essentially different things that whichever one you take, it cannot be the other." Thus, he contended that no trace of the real presence of God existed in the consecrated sacraments and that communion remained merely the commemoration of Christ's sacrifice. Any hint that the real presence of Christ existed in the elements—whether asserted by the Catholic Church or Luther—was pure superstition. Zwingli's theology admitted the need for grace, but it put greater emphasis on the law of God revealed in the Bible and that Christ gave humankind the will to obey. Therefore, not only the Church but also the State must create the necessary conditions for Christian life. Zwingli believed in a *theocracy* (see p. 343), and the government of Zurich established a court of morals to oversee public conduct and punish any backsliders. In the end, Zwingli's major contribution to the Protestant Reformation consisted of the evangelical reform of individual lives, effected under the aegis of the civil government.

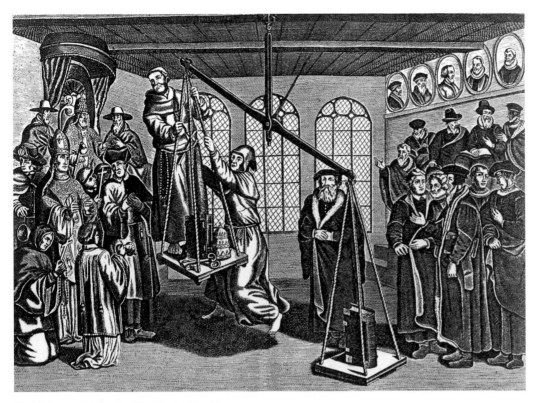

11.5 Calvin weighing the Bible against Popish pomp.

They required church attendance, punished heresy by death, and saw the pope as the Antichrist. The fervency of such crusading faith fueled religious revolutions across Europe, and it spread to the Huguenots in France and the Dutch Reformed Church in the Netherlands. Its successors emerged in English Puritans, such as Oliver Cromwell in the seventeenth century, and the fiery Scottish Presbyterian followers of John Knox. It even spread across the Atlantic Ocean to the early Puritan settlers of America.

Calvin's ultimate influence went beyond the bounds of religion to economics. His call for a capitalistic spirit based on unceasing labor in gainful pursuits for the glory of God may well have inspired the disciplined, rigorous drive that made Calvinist Huguenots and Puritans among the most successful businessmen in France and England, respectively. Some scholars suggest that Calvinism may have contributed importantly to the growth of the capitalist system in the West.

Science

Into the religious upheaval of the late Renaissance and its human-centered universe burst the revelations of scientific discovery. This scientific revival, which came hard on the heels of religious reformation, revealed itself in two different forms represented in two different books, both published in 1543. Both books and their authors,

however dissimilar, had a decisive impact on the scientific movement. The first, *On the Fabric of the Human Body* by Andreas Vesalius (vuh-SAY-lee-uhs; 1514–64), used descriptive reporting and skillful illustrations to render the structures of the human body in space in a way that represents the first step toward photographic realism in science. Vesalius, an ambitious and popular teacher at the University of Padua (at the time increasingly important as a center for the teaching of medicine), impacted on science as the founder of a method of investigation. Vesalius greatly improved the range and precision of knowledge of the structure of the human body. He had explored the body more thoroughly than anyone before, and that exploration proved an essential foundation for the rational physiology that followed in the seventeenth century.

The second book also published in 1543, *On the Revolutions of the Celestial Orbs*, by Nicholas Copernicus (1473–1543) of Poland, comprised a work of philosophy and technical mathematics. Copernicus, an ecclesiastical administrator who had nurtured his great idea for nearly forty years, did not make observations himself and did not use others' observations, nor did he aim at predictive accuracy. His impact lay in the way he exploited a great new principle—that in the system of the heavens exists a perfect reciprocity between sun-centered systems and earth-centered systems. Copernicus believed

TECHNOLOGY

NAVAL ARTILLERY

A major technological change in the fifteenth century was the improvement of cannons and the development of lighter weapons, which, particularly, benefited naval artillery. However, the evolution of naval artillery depended on another peculiar factor on board ship. The first cannons, which were iron, were placed on a wooden cradle, and sailing ships were able to carry these cannons because they had space along the decks. Cannons were placed in a pivoting form (Fig. **11.6**) attached to the framework of the bulwarks. These small-caliber guns were used to attack personnel on the deck and castles of an enemy ship, but they were not sufficiently powerful to damage the hull of a ship. The tops of ships could be equipped with as many as 200 cannons, and such large numbers often proved of great menace to the crew and the rigging. Larger caliber cannons that were capable of attacking the hulls of ships, demolishing their tops, and sinking them, were so heavy that placing them on the deck or castles made the ships unstable. Sailing vessels are stable only when their weight topside is compensated for by ballast in the hold. Heavy cannons on deck would have required massive amounts of ballast.

At the beginning of the sixteenth century, the plan of merchant ships was altered to produce a warship capable of supporting the weight of the artillery, counterbalanced by ballast. Around 1500 a man from Brest named Descharges (day-SHAHRZH) had the idea of placing the cannon on a lower deck and opening gunports for the artillery. Positioning guns in this way shielded them from the firing of lighter deck cannon on an opposing ship (Fig. **11.6**). Thus, the beginning of the sixteenth century marks a turning point in naval warfare, and eighty-eight years later, one of the most significant naval battles of all time—that is, the defeat of the Spanish Armada by the English—brought this development to a new level of importance.

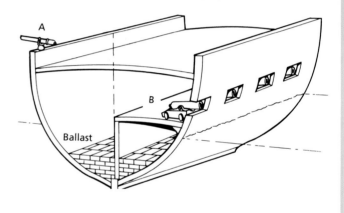

11.6 A. Deck cannon mounted on pivoting form. B. Cannon placed on lower deck, behind closable gunports.

in a sun-centered system not because he observed it or drew his conclusions by scientific evidence, but rather because he believed that the earth was associated with a number of planets for reasons of simplicity, order, and harmony. The conclusions in his book had actually existed for nearly a generation, but merely as an elegant but inherently implausible mathematical model. Copernicus, in fact, had no interest in the practical reform of astronomy nor in making new discoveries in the heavens. A mathematician, he made no claim for himself other than the right to philosophize about what more or less likely forms universal reality. His "discovery" remained a theoretical one, totally without a factual basis—however accurate. Although not immediately accepted, Copernican theory—the formulation of a *heliocentric*, or sun-centered, universe— transformed the world and humankind's perception of itself and its God, and devastated those whose view of

reality placed humankind as the ultimate being in an earth-centered universe. The implications of such an exposition remain difficult for us to comprehend in terms of its impact on the religious views of the times.

Concepts

Christian Humanism

Humanism did much to prepare the way for the Reformation, although the two should not be identified too closely. The influence of the humanists appears most clearly in their techniques of studying language, which they gained through their interest in classical literature, and in their work on the Bible and texts by the Church Fathers. They compared the contemporary Church unfavorably with early Christianity, noting the hair-splitting of scholars, the hierarchical structure, and

the secular activities of the clergy, and they campaigned for reform, seeking a return to the simple good news of the Gospel for moral living and for peace. Humanism existed primarily as an intellectual movement, whose followers preferred religious contemplation to political action.

One major doctrinal difference rose between the humanists and the reformers, however: humanists believed in the fundamental goodness of the human race and ignored Augustine's teaching on original sin, and remained, therefore, positive about human development based on a combination of Christianity and the classics. Luther, on the other hand, emphasized faith as the way to salvation from sin, while Calvin focused on predestination: God chose those whom he would save. Another point of great significance to the humanists concerned the inwardness of religion. They regarded the external aspects of worship, such as festivals, sacraments, music, and imagery, as less important than inner belief. For example, long before Luther raised the issue, Erasmus (ihr-AZ-muhs) expressed doubt about whether the sacraments of bread and wine actually turned into the body and blood of Jesus in the service of the Mass or simply represented them, although he distanced himself from the Protestant reformers so as not to endanger the unity of the Christian Church.

Erasmus believed in the simplicity of the Bible, and had difficulty with scholars who turned it into an involved puzzle to which they alone claimed the key—thereby barring ordinary men and women from direct inspiration from the scriptures. Erasmus wanted the Bible translated into the vernacular so all literate people could read it for themselves. Erasmus wanted to see a massive program of education from which, he believed, would emerge a universal Christian community. Although a gigantic task, such an ideal program could come to fruition, Erasmus believed, because the Church had sufficient wealth—if only it would rethink its priorities and cut waste. To accomplish his goals, Erasmus appealed to the princes of Europe to take the lead in reforming the Church wherever the Church refused to reform itself. He also urged the princes to stay out of war, which bred un-Christian attitudes, such as anger and cruelty, and wasted huge sums of money that could better be spent on education.

Utopianism

Utopianism envisions a perfect society that rejects many of the aspects of the current society. The Englishman Thomas More coined the term, which constitutes a play on the Greek words for "no place" and "good place." In his *Utopia* (1516), which we will discuss in the Literature section, he describes an ideal commonwealth where the inhabitants own all property in common, individual interests yield to the common good, and all have access to education. Such factors describe the opposite conditions to those of England during More's time. More's book began a long tradition of social criticism in fiction, through which more people could be reached than occurred with typical essays and tracts. In fact, by cloaking social criticism in the guise of fantasy, such works avoided political censure.

In this chapter we have already seen other forms of utopianism in the idealistic visions of Erasmus and in the more practical experiments of the theocracies of Calvin and Zwingli. Throughout history, utopian philosophies—Plato's *Republic* is among the earliest (see Chapter 3)—have risen and fallen with the times, including our own. Utopianism does not constitute a unified school of thought, but it has typically (though not always) shared a set of common characteristics, including communal ownership, egalitarianism, and an immutable set of just and rational laws. Plato's *Republic* consisted of a meritocratic aristocracy ruled by a group of "philosopher kings." We will see other examples of utopianism later in this text, including the philosophies of Rousseau, Hegel, and Marx. The United States has seen any number of examples of utopianism, reflecting the idea of America as a land of new beginnings and counter to the country's strong sense of individualism, in such societies as the Mennonites in the 1600s and the Shakers in the 1700s—both religious in nature.

THE ARTS OF THE RENAISSANCE AND REFORMATION IN THE NORTH
Painting

Flanders
Flemish painting of the fifteenth century was revolutionary. Flemish painters achieved pictorial naturalism through rational perspective. They controlled line, form, and color painstakingly to create subtle, varied, three-dimensional representations.

Part of the drastic change in Flemish painting stemmed from a new development in painting media—oil paint. The versatile properties of oil paints gave Flemish painters new opportunities to vary surface texture and brilliance, and to create far greater subtlety of form. Oils allowed the blending of color areas because they remained wet and could be worked on the canvas for a while. Egg tempera, the earlier medium, dried almost immediately upon application.

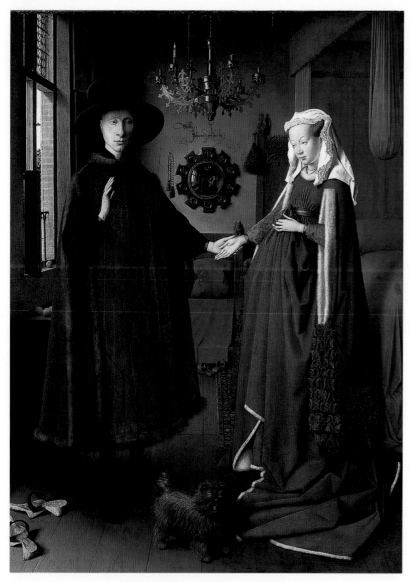

11.7 Jan van Eyck, *The Arnolfini Marriage (Giovanni Arnolfini and his Bride)*, 1434. Oil on panel, 33 × 22½ ins (83.8 × 57.1 cm). National Gallery, London.

Gradual transitions between color areas made possible by oil paints allowed fifteenth-century Flemish painters to refine aerial or **atmospheric perspective**—the increasingly hazy appearance of the objects farthest from the viewer. This helped them to control this effective indicator of deep space. Blending between color areas also helped them achieve realistic modeling, or light and shade, by which all objects assume three-dimensionality. Without highlight and shadow, the appearance of life-like relief disappears. Early fifteenth-century Flemish painters used sophisticated light and shade, not only to heighten three-dimensionality, but also to achieve perceptual unity in their compositions. Pictures without consistent light sources or without natural shadows on surrounding objects create very strange effects, even if they depict individual forms very accurately. The new skill in creating natural three-dimensionality separated fifteenth-century Flemish style from the Gothic style and tied it to the Renaissance.

"The prince of painters of our age," recorded one of his contemporaries in describing Jan van Eyck (yahn vahn-YKE; c. 1390–1441), whose work advances the new naturalism of the age. Although we know little about his life, he seems to have been an active and highly placed functionary of the Duke of Burgundy. On one of his trips in the duke's service, van Eyck visited Italy, where he met Masaccio and other Florentine artists. Without doubt, van Eyck stands as one of the greatest artists of any age, and he brought a new "reality" to painting. Jan van Eyck's *The Arnolfini Marriage* (ahrn-ohl-FEEN-

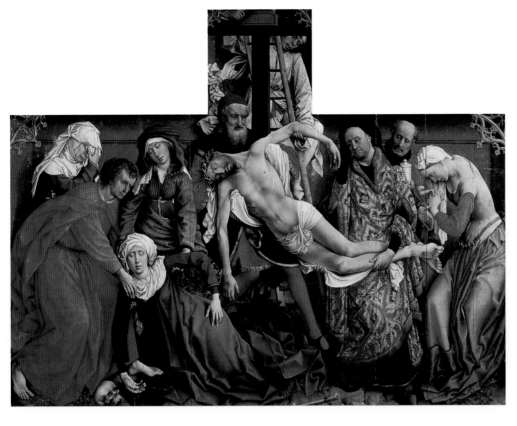

11.8 Rogier van der Weyden, *The Descent from the Cross*, c. 1435. Oil on panel, 7 ft 2⅝ ins × 8 ft ⅞ ins (2.2 × 2.46 m). Museo del Prado, Madrid.

ee; Fig. **11.7**) uses strong perspective in the bedroom to create a sense of great depth. All forms achieve three-dimensionality through subtle color blending and softened shadow edges. Natural highlights originate from the window, and this ties the figures and objects together.

As lifelike as this painting appears, however, it remains a selective portrayal: an artist's vision of an event, a portrayal clearly staged for pictorial purposes. The location of objects, the drape of fabric, and the nature of the figures themselves stand beyond reality. Van Eyck's work achieves what much art does—it gives the surface appearance of reality while revealing a deeper essence of the scene or the subject matter, in this case, man, woman, marriage, and their place within Christian society and philosophy.

Many observers suggest that this work contains an elaborate symbolism commenting on marriage and the marriage ceremony. The artist has signed the painting in legal script above the mirror "Johannes de Eyck fuit hic, 1434" (Jan van Eyck was here, 1434), and in fact, we can see the artist and another witness reflected in the mirror. The burning candle, part of the oath-taking ceremony, symbolizes marriage, the dog represents marital faith, and the figure on the bedhead, St Margaret, represents the patron saint of childbirth. Considerable debate exists about the accuracy or appropriateness of all

these symbols and whether the bride is pregnant or not. Inasmuch as clothing design and posture of the period emphasized the stomach, most experts agree she is not.

Although slightly different in style from van Eyck's work, Rogier van der Weyden's (VY-duhn) *The Descent from the Cross* (Fig. **11.8**) displays softly shaded forms and three-dimensionality, with surface reality quite unlike that of Gothic style. Carefully controlled line and form create soft, undulating S-curves around the borders and diagonally through the center. The painter explores the full range of the color spectrum, from reds and golds to blues and greens, and the full extent of the value scale from dark to light. Composition, balance, and unity remain extremely subtle. The figures appear almost in the manner of statues, yet the shallow drapery folds exhibit a nervous broken linearity.

This painting strikes us with its individualized presentation of human emotion. Each character displays a particularized reaction to the emotion-charged situation. These figures emerge not as types but as individual people so fully portrayed that we might expect to encounter them on the street.

The Netherlands

Around 1500 the tradition started by Jan van Eyck diminished as ideas came to the Netherlands, with

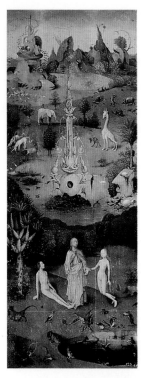
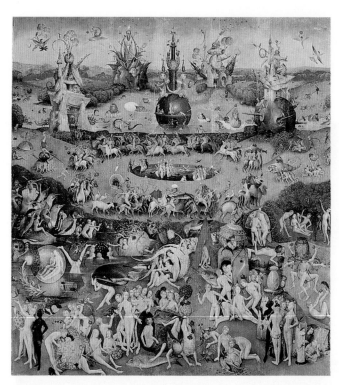
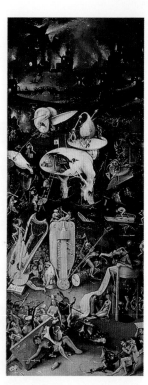

11.9 Hieronymus Bosch, *The Garden of Earthly Delights*, triptych, left panel *Garden of Eden*, center panel *The World Before the Flood*, right panel *Hell*, c. 1505. Side panels 86 × 36 ins (218.5 × 91.5 cm), center panel 86 × 76 ins (218.5 × 195 cm). Museo del Prado, Madrid.

trade, from Italy. It became a period of crisis and change for painters, and both the grand style of the High Renaissance and the emotional Mannerist movement that followed made strong inroads into the art of the country. However, the two greatest painters of the time in the Netherlands seem to have remained solidly apart from the styles of sixteenth-century Italy. The first of these painters, Hieronymus Bosch (hay-RAW-nee-mus bawsh or baws; c. 1450–1516), painted fantastic works comprising all we know about him, and we do not even know when he painted them. Bosch exists as an intriguing figure for a number of different reasons. First, as we noted, we know nothing about him as a human being. Second, his work bears an amazing likeness to the images of the twentieth-century surrealists whom we will encounter in Chapter 16. Third, his imagery lends itself to fascinating psychological probing and speculation. Fourth, the complexity and imagery of his most famous work *The Garden of Earthly Delights* (Fig. **11.9**) has fueled almost feverish rumors of some connection with heretical sects. However, what little evidence exists suggests that Bosch was an orthodox Roman Catholic, and we do know that the Catholic monarch Philip II of Spain admired his work.

Bosch clearly had tremendous imaginative powers. Had that not been the case, he could not have created the fantastic depictions present in *Garden of Earthly Delights*. This illustration comprises the central panel of

a three-panelled work. The left panel, called *The Creation of Eve*, contains a fairly straightforward portrayal, but, like the central panel, it contains images that might remind us of Dr Seuss. However, the large central panel, measuring more than 7 feet (2.1 meters) by more than 6 feet (1.8 meters), takes us into a much more complex and mystifying world. Without exaggeration, we could probably spend the remainder of this book trying to describe each of the little scenarios present in this portrayal. Bosch's choice of color alone would lead us into a miasma of analysis and speculation. The vibrant pinks played against darkened blues draw the picture together and give emphases that run throughout. Of course, the figure groupings fascinate, too. They consist of youthful, thin, muscle-less individuals frolicking naked amid gigantic fruits, clams, fish, and so on. Other animals parade in line around the work. Although no explicit sexual activity appears, the clearly erotic images have sexual connotations in several languages. But what probably we find most arresting about the work remains the collection of strange "machines" such as the one that sits in the center of the lake in the background. What could Bosch have had in mind here? Does he depict a paradise in which everyone may freely engage in their sexual fascinations, or does he make a statement about earthly life wherein sexual desire forms the central force in human thought? One reading of the painting suggests a condemnation of erotic activity—but

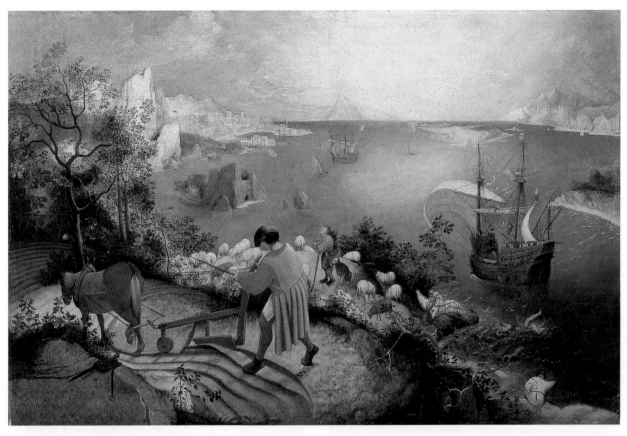

11.10 Pieter Bruegel the Elder, *Landscape with the Fall of Icarus*, c. 1554–5. Oil on panel (transferred to canvas), 2 ft 5 ins × 3 ft 8⅛ ins (74 × 112 cm). Musées Royaux des Beaux-Arts, Brussels.

all the while one wonders about Bosch's obvious fascination with it.

The second Netherlandish painter of note, the sixteenth-century master Pieter Bruegel (PEE-tuhr BROY-guhl) the Elder (c. 1525/30–69), traveled extensively in Italy, where he developed a deep love for the beauty of the southern Italian countryside as well as a mastery of Italian painting styles, and France in the 1550s. Bruegel then worked in Antwerp and Brussels. A close follower of Bosch, he was influenced by Bosch's pessimism and fantasy, and although his work avoided the nudes of Renaissance Italian art, it captured its harmony of space and form and infused it with a northern European perspective on life. We can see the Italian influence in the colorful *Landscape with the Fall of Icarus* (IK-uh-ruhs; Fig. **11.10**). The painting tells the story from Greek mythology of Icarus, who, against the advice of his father, flew so high that the wax of his wings was melted by the sun. Icarus, a popular symbol in Italian art, represented unbridled ambition and gave artists an opportunity to depict the human body in flight or falling. In Bruegel's portrayal, Icarus emerges as hardly more than a sidebar. In fact, were it not for the title

of the painting, we probably would barely notice him at all. His only manifestation in the painting, his legs, are almost totally submerged with the rest of him under the water at the lower right. Bruegel gives us a warm and comfortable depiction of a farmer plowing his field, a singing shepherd, and an elegant ship, its sails billowing in the freshening breeze. Mountains the color of huge icebergs reach into a bright sky at the far horizon, and, as in Altdorfer's *Battle* (see Fig. **11.15**), we see the earth's curvature from our elevated vantage point.

The fact that no one pays the slightest attention to Icarus probably relates to an old German and Netherlandish proverb that says "When a man dies no plow stops." It may be that Bruegel reflected the belief of a group of Antwerp humanists—to which he reportedly belonged—that humans, driven to sin by foolishness, try foolishly to escape the inevitable cycle of nature.

Although Bruegel pursues Italian ambience and, in his deep perspectives, Italian spatial interests, he lacks the fully rounded, human figures of the Renaissance in this portrayal. The folds of the plowman's tunic emerge stiff

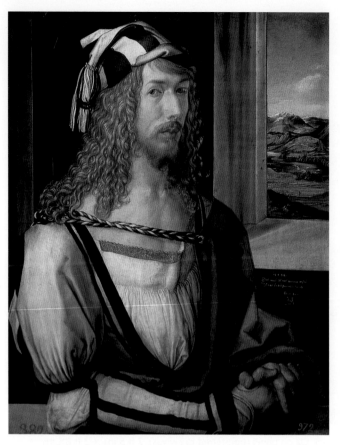

11.11 Albrecht Dürer, *Self-portrait*, 1498. Oil on wood, 20¾ × 16⅛ ins (52 × 41 cm). Museo del Prado, Madrid.

Albrecht Dürer (AHL-brekt DYUR-ur; 1471–1528), whom many regard as Germany's greatest artist, could be viewed as the Leonardo of the northern Renaissance (Fig. **11.11**). Both were transitional figures and, at the same time, innovators. Dürer shared Leonardo's deep curiosity about the natural world, a curiosity expressed especially in his drawings, which explore the human figure and physiognomy, animals, plants, and landscapes. Like Leonardo, Dürer explored aesthetic theory and wrote a treatise on proportion. Also like Leonardo, Dürer was gracious, handsome, famous, courted throughout Europe, and respected by his fellow artists. Unlike Leonardo, however, Dürer worked principally as an engraver and was tortured by religious problems.

The son of a Nuremberg goldsmith, Dürer studied with Michael Wolgemut (VOHL-ge-moot; 1434–1519), whose studio produced a large number of altarpieces, portraits, and **woodcuts** for book illustration. Here Dürer gained his grounding in drawing and painting, and in the techniques of woodcut and copperplate **engraving** in

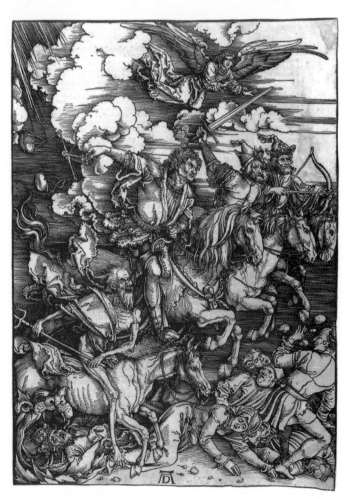

11.12 Albrecht Dürer, *The Four Horsemen of the Apocalypse*, c. 1497–8. Woodcut, 15½ × 11¹⁄₁₆ ins (39.4 × 28.1 cm). Museum of Fine Arts, Boston (Bequest of Francis Bullard, 1913).

and elementary, the furrows of the field lie flattened like steps in the sunbaked ground, and the stylized trees have minimal chiaroscuro with painterly foliage applied by stippling—dabbing with the point of the brush. Overall, the work stands closer to Bosch than to anything Italian. If we were to examine more of Bruegel's works, we would conclude that his delights in flights of fantasy in his images draw him even closer to Bosch, and that he has a sense of macabre pessimism.

Germany

As early as the late Middle Ages, southern Germany sat at the center of a thriving trade axis that connected the Netherlands with Italy. This economic activity gave rise to rich merchant oligarchies and semi-independent city-states modeled on the Italian pattern. Throughout Europe, much of the wealth created in centers such as the Netherlands and Germany was used for the encouragement of arts and letters. By the late fifteenth century important artists such as Albrecht Dürer followed the trade routes back and forth to Italy, and helped to bring the Renaissance to northern Europe.

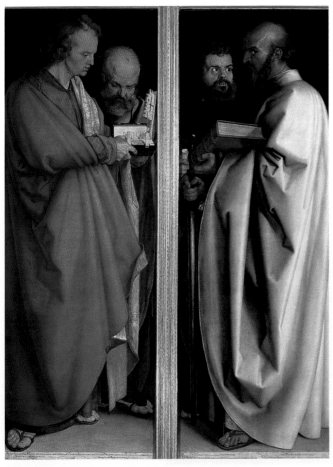

11.13 Albrecht Dürer, *Four Apostles*, 1526. Oil on wood, each panel 7 ft 2 ins × 2 ft 6 ins (215 × 76 cm). Altepinakothek, Munich, Germany.

which he achieved his greatest works. These media allowed his work wide distribution and purchase by individuals of modest means, a process that made Dürer rich.

Rogier van der Weyden's **deposition** scene, *The Descent from the Cross* (see Fig. **11.8**), uses a linear style that greatly influenced Dürer—especially his masterly woodcuts and engravings. In contrast to the works of van der Weyden, however, Dürer's works reflect the tensions present in northern Europe at the end of the fifteenth century and in the early sixteenth century. The emotion of *The Four Horsemen of the Apocalypse* (Fig. **11.12**), for example, and its medieval preoccupation with superstition, famine, fear, and death typify German art of this period, and it places Dürer at the pivot point between medieval and Renaissance styles. *The Four Horsemen of the Apocalypse*, the fourth work in a series of woodcuts, presents a frightening vision of doomsday and the omens leading up to it, as described in the Revelation of St John, the last book of the Bible. In the foreground, Death

tramples a bishop, and working toward the background, Famine swings scales, War brandishes a sword, and Pestilence draws a bow. Underneath, trampled by the horses' hoofs, lies the human race. The crowding and angularity of shapes remind us of late Gothic style, and yet the perspective foreshortening and three-dimensionality of figures reflects the influence of the Italian Renaissance. We can read human character and emotion in the faces of the figures, which humanize them and give them a sense of reality and a proximity to life that adds depth to the meaning of the work.

The technique of the woodcut gives the work its particular quality. The picture emerges by building up individual lines, formed when the artist cuts into the block of wood, leaving only exposed edges to which ink will be applied and then pressed onto the paper. Dürer shows remarkable skill in creating lines of tremendous delicacy, which combine into a poignantly complex picture. Notice in particular his treatment of the horses— Death rides an emaciated old nag, while the other three horsemen sit astride powerfully muscular steeds. The power of the print emerges from both its technical and aesthetic aspects—the complexity of the linear expression of the woodcut gives the work some of its frenetic quality, but powerful diagonal sweeps add to the composition, as does the raw emotional terror of the human elements.

Dürer's last major work, a painting entitled the *Four Apostles* (Fig. **11.13**), is a diptych—two panels— portraying John and Peter in the left panel and Mark (not an apostle), and Paul in the right. Dürer originally intended the panels as the wings of a triptych, of which the central panel would show the Madonna and Child with saints. However, the effects of the Reformation made such a rendering impossible in Nuremberg in 1526, and so the piece remained uncompleted. When Dürer presented the panels to the city council, he gave them inscriptions of Luther's translation of the New Testament that warned all who read them not to confuse human error for the will of God. Dürer enthusiastically supported the Lutheran Reformation, agreeing with Luther's views on papal supremacy, but he found equally repugnant some of the extreme positions of those Protestants who advocated radical experiments, including polygamy.

Luther's Reformation had a deep impact on the painter Matthias Grünewald (mah-TEE-ahs GROON-eh-vahlt; c. 1475–1528), probably born Mathis Gothardt. The name Grünewald, by which posterity knows him, came from his first biographer, the seventeenth-century writer Joachim von Sandart. An artist, architect, and hydraulic engineer, Grünewald never went to Italy. Second only to Dürer among Germany's great artists, Grünewald remained relatively faithful to earlier

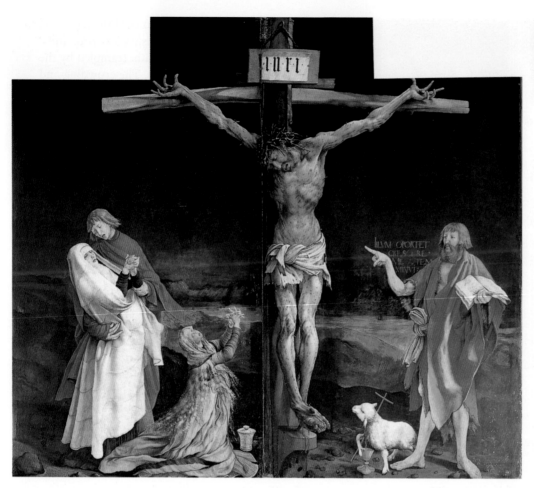

11.14 Matthias Grünewald, *Crucifixion*, central panel of the Isenheim altarpiece, c. 1513–15. Oil on wood, 8 ft × 10 ft 1 in (2.44 × 3.07 m). Unterlindenmuseum, Colmar, France.

traditions. He apparently knew of Dürer, and some of Dürer's influence appears in Grünewald's work. For example, the figure of the Virgin in the Isenheim **altarpiece** (IHZ-en-hym; Fig. **11.14**) recalls a famous watercolor by Dürer. Nonetheless, although Grünewald retains the emotional expressiveness of the medieval period, he did learn how to handle space and perspective and how to treat flesh from the Italians of the Renaissance. The Isenheim altarpiece, Grünewald's greatest work, was painted between 1512 and 1515 for the church of the Hospital of Saint Anthony in Isenheim near Colmar, France. It takes the form of an elaborate series of painted wings for a carved wooden shrine. The *Crucifixion* occupies the outermost wings and appears when the altarpiece is closed. The picture's tragic intensity amplifies through the stark roughness of the cross itself: two freshly hewn logs. We can feel the weight of the body of Christ and the agony of pain in the grotesquely upraised fingers and the bending of the crossbar under the weight of the inert body of the dead Christ. Everything about the rendering puts us in mind of the torment of such a death—the arm bones seem almost torn from their sockets, and the crown of thorns, unlike the neat circular arrangements often depicted, consists of

a misshapen mass of thorns thrust down over the entire head. Christ's face appears ghastly grayish-green: the pallor of death. The body, a mass of scars and scratches, exudes deep red drops of blood, the feet punctured by a giant spike.

The figure of Christ is accompanied by John the Baptist, above whose pointing finger appear the words "He must increase, but I must decrease" (John 3:30). Next to John stands the Lamb of God, holding a cross and pulling a chalice to its breast. Mary Magdalene throws herself at the feet of the cross, while St John the Evangelist holds the Virgin Mary, who has fainted from grief. Grünewald sets the figures of the scene in stark contrast to a greenish-black sky. The emotionalism of the painting must have been particularly moving to the patients of the hospital, who were brought before it daily and who must have recognized in it the message that Christ understood their suffering because of the extreme nature of his own. In this painting, Grünewald has raised the grotesque to the level of the tragic and, as a result, has created a painting of great appeal and beauty.

Similar to Grünewald in imaginative power we find the painter Albrecht Altdorfer (AHLT-dorf-ur; 1480–1538). Born in Regensburg, a beautiful Bavarian

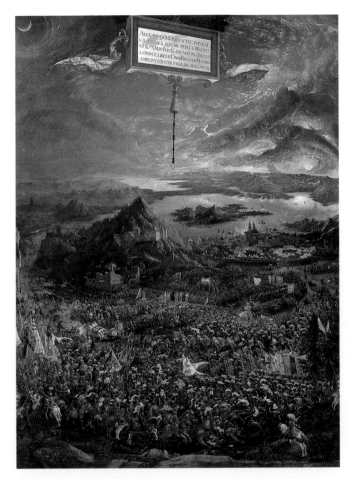

11.15 Albrecht Altdorfer, *Battle of Alexander and Darius on the Issus*, 1529. Oil on wood, 5 ft 3¼ ins × 4 ft (1.58 × 1.20 m). Altepinakothek, Munich, Germany.

city on the Danube, Altdorfer had a special gift and affinity for landscape. In his most famous painting, *Battle of Alexander and Darius on the Issus* (Fig. **11.15**), he portrays the ancient battle between Darius III of Persia and Alexander the Great in 333 B.C.E. depicted as if it were a modern battle, probably the battle of Ravenna in 1512 or the battle of Pavia in 1525. Altdorfer has painted here thousands of individual soldiers in a space barely 5 feet (1.5 meters) high and 4 feet (1.2 meters) wide.

In contrast with some of the massive perspectives of the Italian Renaissance that we have examined, Altdorfer takes us up high for our perspective vantage point. From here we get a bird's eye glimpse of the solid mass of soldiers coming toward us out of a fantasy landscape that recedes without benefit of atmospheric perspective to the edge of the earth, whose very curvature we can see, almost as if we were astronauts gazing at earth from space. Our eyes drift freely from point to point; very little in the subject of the painting—the battle—holds our attention. A few fluttering flags create focal points, but the human element fades in the swarm of thousands of indistinguishable bodies. The glorious landscape and its

A DYNAMIC WORLD

MING DYNASTY PORCELAIN

At the time of the Western Reformation, the Ming dynasty in China produced exquisite porcelain, by which the dynasty is primarily known today. The classic period of the familiar blue-and-white porcelains occurred between the years 1426 and 1435, characterized by clarity of detail and variety of shapes. Over the next one hundred years, works were enriched by adding multicolored enamels to the basic blue. The result of this development, which occurred in the late sixteenth century, can be seen in a five-color enamel jar (Fig. **11.16**) from the reign of Wan Li (1573–1619). The complex process of adding layers of color called for refined designs and repeated firings in the kiln. The white ground and blue designs came first and were glazed and fired. Over this fired glaze, the decoration was completed in red, green, yellow, and brown, and the work was then refired. The entire process required several firings and resulted in a rich, delicate ceramic. The freely painted narrative scenes and floral compositions have charm, grace, and appeal. Their shapes tend to be slightly irregular, which gives a uniqueness and human quality that adds warmth to their otherwise perfect execution.

11.16 Covered jar, mark of Wan Li, c. 1600. Porcelain, 4 ins (10.2 cm) high. Cleveland Museum of Art (John L. Severance Fund).

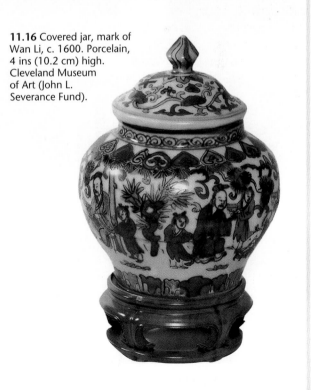

rugged mountains, alpine lakes, swirling clouds, and glowing sunrise emerge to steal our attention from the human spectacle. A tablet with a lengthy Latin inscription and unfurling pennant floats over the scene, hung theatrically and magically in the sky. The stunning effect of the overall work stems from its absolute graphic clarity and accuracy. Each detail emerges crystal clear from foreground to background, and the perspective depiction of castles and armies winding away from us is nothing short of remarkable.

France

In Chapter 10, touching on the style known as Mannerism, we briefly considered architecture in France in an examination of the Lescot Wing of the Louvre (see Fig. 10.34). We now return to that country for more exploration of the sixteenth century to see how the Renaissance outside Italy affected the artistic qualities of this country.

The impetus of the Italian Renaissance came to France, at least in part, from the insistence of King Francis I (r. 1515–47), who greatly admired the achievements of Italian Renaissance art. He invaded

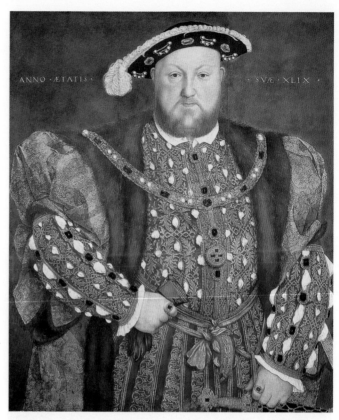

11.17 Hans Holbein the Younger, *Henry VIII in Wedding Dress*, 1540. Oil on panel, 35½ × 30 ins (89 × 75 cm). Galleria Nazionale d'Arte Antica, Rome.

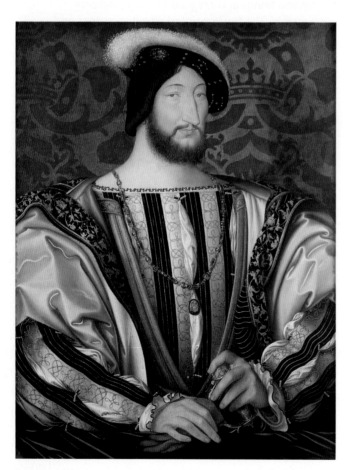

11.18 Jean Clouet, *Francis I*, c. 1525–30. Tempera and oil on wood, 38¼ × 29½ ins (96 × 74 cm). Louvre, Paris.

Italy—with only modest success and a disastrous ending—and had a continuing confrontation with the forces of Charles V of Spain and the Holy Roman Empire, but this did open France to the ideas of the Italian Renaissance. Francis tried to coax Italian artists to his court, and Leonardo da Vinci actually spent two years there toward the end of his life. Francis wanted his patronage of the arts to rival that of the greatest Italian princes, but in fact, all the Renaissance that Francis got was its successor, Mannerism.

Although France produced no artists of stature in the sixteenth century, the court of Francis I enjoyed the talents of French portraitists such as Jean Clouet (KLOO-ay; c. 1485–1541). Clouet's portraits of the king (Fig. 11.18), painted between 1525 and 1530, reveal a self-indulgent, calculating character of a man notorious for his sexual affairs. Nonetheless, the likeness of the king remains stiff and formal, exhibiting the same kind of distorted, mannered appearance we saw in Bronzino's *Portrait of a Young Man* (see Fig. 10.19). The line and form of the foreground clash with the décor of the background, and the brocade and stripes of the costume lead the eye downward to focus on the king's left hand, which seems to toy nervously with his poniard.

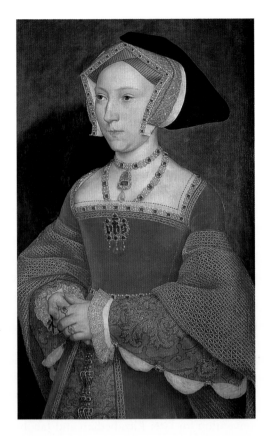

11.19 Hans Holbein the Younger, *Jane Seymour*, 1536. Oil on wood, 26¾ × 19 ins (66 × 48 cm). Kunsthistorisches Museum, Vienna.

England

A German painter whose work in London made him the favorite of Henry VIII, Hans Holbein (HOHL-byn) the Younger (c. 1497–1543), came from a family of Augsburg painters, all of whose reputations he eclipsed.

He traveled widely in France and Italy and was strongly influenced by the work of Mantegna and Leonardo (see Chapter 10). It is possible that Holbein's letter of introduction to Henry VIII came from Erasmus, who was impressed by the young artist's promise. Erasmus did provide Holbein a letter of introduction to Sir Thomas More, who became the artist's principal patron and protector during his first visit to England, when Holbein undertook an ambitious portrait of Sir Thomas More and his family, a work that has not survived. Shortly after arriving in England for the second time in 1532, Holbein became court painter to Henry VIII, who set him up in a studio in St James's Palace. Holbein painted a series of portraits of the king, including that seen in Figure **11.17**. Holbein has such control of technique here that Henry almost comes to life in all his obesity and obsessive temperament. In an equally sensitive portrayal of Jane Seymour (Fig. **11.19**), the artist's vibrancy, control, and acute observation give us the sense that we know this person, who appears almost ready to leave the canvas and join us in polite conversation.

Architecture

The pre-eminent English architect of the period, Robert Smythson (c. 1535–1614), created the stately house, Wollaton Hall, near Nottingham (Fig. **11.20**). Designed for the Sheriff of Nottingham, Sir Francis Willoughby, and completed in 1588 (the year of the English defeat of the Spanish Armada), it shows Italian influences dating to Serlio (see Chapter 10), but utilizes an unique application of the style. The tall, forceful central hall employs clerestory windows for illumination, topped by a turreted

11.20 Exterior of Wollaton Hall, Nottingham, UK, 1588.

chamber that rises above the ornamented façade like an overweight crown—compare the Lescot façade of the Louvre, Figure **10.34**. The proportions established by such a design stand totally without precedent. Equally fanciful toppings on the wings, whose gables resemble the façades of Renaissance Italian churches and bell gables of the Netherlands, flank the central hall. Smythson's design reminds us of the fantasy worlds of Bosch and Breughel, and the epic poem, *The Faerie Queen* by Edmund Spenser, which we will note in the Literature section.

Theatre

For theatre during the time of the Northern Renaissance and Reformation, we must turn to England and lead with its greatest playwright, William Shakespeare (1564–1616). Shakespeare represents the love of drama during the Elizabethan Age (the reign of Elizabeth I—1533–1603; r. 1558–1603), in which the theatres of London witnessed the patronage of lords and commoners alike. They sought and found, usually in the same play, action, spectacle, comedy, character, and intellectual stimulation deeply reflective of the human condition. Shakespeare's appreciation of the Italian Renaissance appears in the settings of many of his plays. With true Renaissance breadth, Shakespeare went back into history, both British and classical, and far beyond, to the fantasy world of *The Tempest*. Like most playwrights of his age, Shakespeare wrote for a specific professional company, of which he became a partial owner. The need for new plays to keep the company alive from season to season provided much of the impetus for his prolific output.

Shakespeare's plays fall into three genres: comedies, tragedies, and histories. The third category represents a particularly Elizabethan type. England's prosperity and rising greatness, accentuated by the defeat of the Spanish Armada, led to a tremendous popular interest in English history, and Shakespeare's history plays represent large-scale dramatizations and glorifications of events that took place between 1200 and 1550. An occasional tragedy—*Julius Caesar*, for example—called on history, and he often set his comedies in Renaissance Italy—for example, *The Taming of the Shrew*—but the true "histories" have a particular flavor and type identified by titles referring to English kings—for example, *Richard II*, *Henry V*, and so on. King Lear was a mythical English king, but the play of that title comprises a tragedy rather than a "history."

A robust, peculiarly Elizabethan quality exists in Shakespeare's plays. The ideas expressed in them have a universal appeal because of his understanding of human motivation and character, and his ability to probe deeply into emotion. The plays reflect life and love, action and nationalism, and they present those qualities in a magnificent poetry that explores and expands the English language in unrivaled fashion. Shakespeare's use of tone, color, and complex or new word meanings gives his plays a musical as well as dramatic quality, which appeals to every generation.

The English dramatist Christopher Marlowe, a contemporary of Shakespeare, obtained a bachelor's degree from Corpus Christi College, Cambridge, in 1584, progressing to the master's degree after some difficulty about irregular attendance and a letter from the Privy Council certifying the worthwhileness of his government employment, part of which had taken him abroad as a member of the Queen's secret service. Thereafter, he resided in London and wrote actively for the theatre. Unorthodox in religious belief and behavior, he was attacked as an atheist and also sentenced to prison for a brawl in which someone was killed. He died in a quarrel over a tavern bill on 1 May 1593, at the age of twenty-nine.

Marlowe wrote a number of plays, two of which have earned acclaim—*Tamburlaine* (TAM-buhr-layn) *the Great* and *Doctor Faustus* (FOW-stuhs). His earliest play, *Tamburlaine the Great* (1587), established blank verse as the convention for later Elizabethan and Jacobean playwrights. This verse form consists of nonrhyming lines of **iambic** pentameter—lines of five metrical feet in which each foot has two syllables, the second one generally bearing the rhythmic stress. The play itself has two parts, the second part—as Marlowe explains in its prologue—having been written as a result of the popularity of the first. The play tells the story of Tamburlaine's quest for power and luxury and possession of beauty, as he rises from being an obscure shepherd to a powerful conqueror. By Part II, the fairly sympathetic hero of Part I becomes cruel and obsessed with power; he succumbs to a fatal illness, a victim of his own weakness. In this tale, Marlowe paints an amazingly three-dimensional picture of grandeur and impotence.

Marlowe's most famous play, first published in 1604, *The Tragical History of the Life and Death of Doctor Faustus*, or simply *Doctor Faustus*, tells the tale of human temptation, fall, and damnation in richly poetic language.

Marlowe's source appears to have been an English translation of the German legend of Faustus that appeared in England at that time. The plot centers on the scholar Faust, who despairs of the limitations of his own learning and of all human knowledge. He turns to magic, and makes a contract with Mephistophilis, a minor devil. They agree that Mephistophilis will assist Faust and be his slave for twenty-four years. After that, Mephistophilis will claim Faust's soul, and Faust will be damned for eternity. So for twenty-four years, Faust uses his powers to the full, from playing practical jokes to calling back

MASTERWORK

SHAKESPEARE—*HAMLET*

Hamlet, Shakespeare's most famous play (first performed in 1601 and published in 1603), calls on a widespread legend in northern Europe, and Shakespeare's source for the play may have been Belleforest's *Histoires Tragiques* (1559). Shakespeare's play may also have used as a source a lost play supposedly by Thomas Kyd, usually referred to as the *Ur-Hamlet*. Shakespeare's *Hamlet*, however, has its own unique central element in Hamlet's tragic flaw, his hesitation to avenge his father's murder.

At the beginning of the play, Hamlet mourns the death of his father, who has been murdered, and also laments his mother's marriage to his uncle Claudius within a month of his father's death. Hamlet's father's ghost appears to Hamlet, telling him that he was poisoned by Claudius and asking him to avenge his death. Hamlet hesitates, requiring further evidence of foul play. His uncertainty and hesitancy make him increasingly moody, and everyone believes that Hamlet is going mad. The pompous old courtier Polonius believes Hamlet is lovesick over his daughter Ophelia.

Despite Claudius' apparent guilt, Hamlet still cannot act. Nevertheless, he terrorizes his mother and kills the eavesdropping Polonius. Fearing for his life, Claudius sends Hamlet to England with his friends Rosencrantz and Guildenstern, who have orders to have Hamlet killed. Discovering the orders, Hamlet arranges to have his friends killed instead. Returning to Denmark, Hamlet learns that Ophelia has killed herself, and her brother Laertes has vowed vengeance on Hamlet for Polonius' death. Claudius happily arranges the duel. Both Hamlet and Laertes are struck by the sword that Claudius has had dipped in poison. Gertrude mistakenly drinks from the cup of poison intended for Hamlet. Before Hamlet dies, he fatally stabs Claudius.

In the play, Shakespeare appears to suggest that traditional beliefs about revenge are over-simplified, arguing that revenge does not solve evil if evil lies in a complex situation: "The time is out of joint; O cursed spite/That ever I was born to set it right" (V.i.189–90). He also seems to maintain that revenge itself is morally wrong. In *Hamlet*, as well as the other tragedies (*Othello, King Lear,* and *Macbeth*), Shakespeare explores with great psychological subtlety how the personality flaws in the protagonist lead almost inevitably to his own destruction and the destruction of those around him.

Hamlet
William Shakespeare
Act 3, Sc. 1

Hamlet:

> To be, or not to be: that is the question:
> Whether 'tis nobler in the mind to suffer
> The slings and arrows of outrageous fortune,
> Or to take arms against a sea of troubles,
> And by opposing end them? To die: to sleep:
> No more; and by a sleep to say we end
> The heartache and the thousand natural shocks
> That flesh is heir to,—'tis a consummation
> Devoutly to be wish'd. To die, to sleep;
> To sleep: perchance to dream: ay, there's the rub:
> For in that sleep of death what dreams may come,
> When we have shuffled off this mortal coil,
> Must give us pause: there's the respect
> That makes calamity of so long life;
> For who would bear the whips and scorns of time,
> The oppressor's wrong, the proud man's
> contumely,
> The pangs of despised love, the law's delay,
> The insolence of office and the spurns
> That patient merit of the unworthy takes,
> When he himself might his quietus make
> With a bare bodkin? Who would fardels bear,
> To grunt and sweat under a weary life,
> But that the dread of something after death,
> The undiscover'd country from whose bourn
> No traveller returns, puzzles the will
> And makes us rather bear those ills we have
> Than fly to others that we know not of?
> Thus conscience does make cowards of us all;
> And thus the native hue of resolution
> Is sicklied o'er with the pale cast of thought,
> And enterprises of great pith and moment
> With this regard their currents turn awry,
> And lose the name of action.

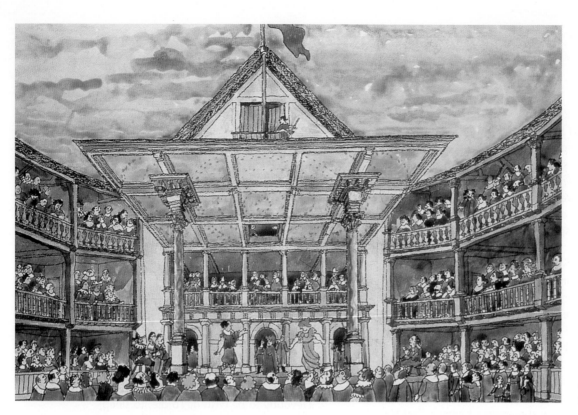

11.21 The second Globe Theatre, as reconstructed, c. 1614.

Helen of Troy. On the last night, he waits in agony and terror. In the end, Mephistophilis comes and carries him off to hell. Marlowe's love of sound permeates his works, and if his character development is occasionally weak, the heroic grandeur of his action has the universal qualities of Aeschylus and Sophocles.

Ben Jonson's comedy stands in contrast to Marlowe's heroic tragedy. The play *Every Man in his Humor* documents the lives of a group of Elizabethan eccentrics. Jonson's wit and pen were sharp, and his tolerance was low. His plays were often vicious caricatures of contemporary individuals.

The structure of Elizabethan theatre buildings is familiar, even though documentation is fairly sketchy (Fig. **11.21**). In general, we assume that the audience surrounded the stage on three sides, an inheritance from earlier times when stages were erected in the enclosed courtyards of inns. By 1576 buildings housing the professional theatre existed in London. They were round or octagonal in shape ("This wooden O," according to Shakespeare in *Henry V*). A cross-section of society attended them, from commoners in the "pit," or standing area around the stage, to nobility in the galleries, a seating area under a roof. Situated against one wall of the circular building, the stage may or may not have been protected by a canopy, but the great spectacle of Elizabethan drama remained, by and large, an outdoor event. Theatres, constructed of wood, saw fire as a constant threat and a frequent reality. Johannes de Witt,

from whose accounts of a trip to London in 1596 we derive nearly all our knowledge of the physical theatre of the era, claimed that the Swan Theatre could seat 3,000 spectators.

Music

Flanders

Like their Italian counterparts, the aristocracy of Flanders were active patrons of the arts, and the painter Jan van Eyck, for example, benefited greatly from their patronage. As part of their courtly entourage, the courts retained a group of musicians to provide entertainment and chapel music. Musicians frequently came from elsewhere, thus contributing to the cosmopolitan character of the Flemish courts and disseminating Flemish influence throughout Europe.

Flemish composers, widely educated and thoroughly aware of the world around them, made significant contributions to the development of four-part harmony. They gave greater independence to the lower lines, in particular. The bass part, independent for the first time, typified this style of composition. By the end of the Renaissance, all parts usually imitated each other using consistent, measured rhythm. They came together only at the ends of sections for cadences, the musical equivalents of punctuation marks, so that, for the first time in history, Flemish music used a true four-part texture.

11.22 Josquin des Prez (c. 1440–1521).

Guillaume Dufay and Josquin des Prez emerged as the most prominent composers. Dufay (1400–74) had been a member of the Papal Chapel at Rome and Florence, and had traveled extensively in Europe. Thus he brought to Flanders a wealth of knowledge and experience. Within his lifetime, he was hailed as one of the great composers of the era. He wrote prolifically, and a wealth of his work has been published in modern editions. His style is relatively straightforward compared with the complexity of much late Gothic music. Dufay's sacred motets, based on the chant *Salve regina* (sahl-vay ray-JEEN-uh), formed the basis for numerous later polyphonic settings of the Mass. He also wrote many secular songs in the standard medieval forms, such as rondeaux and ballads, of which about eighty have survived.

Patronage and secular influence on music continued. The printing press granted music, like the written word, easy transmission. More music than ever before was composed, and people started to identify composers as individuals. Composers strove to achieve an "ideal" sound, by which they meant four or more voice lines of similar and compatible **timbres** (as opposed to the contrasting timbres of earlier periods). Small groups of singers on each part replaced the earlier soloists. Composers concentrated on making each work a unified whole. The practice of combining texts in different

languages within one piece died out. Composers gave much more attention to the relationship of music and text, and clarity of communication became one of the objectives of music. The values of the day made an unaccompanied vocal ensemble the ideal vehicle for musical communication.

Perhaps the most influential and widely published composer of the early sixteenth century, Josquin des Prez (zhohs-KAN day PRAY; c. 1440–1521; Fig. **11.22**), trained in Milan, Rome, and Florence, among other places. Josquin brought to Flanders a rich Renaissance heritage. Compared to Michelangelo and called the "father of musicians," he wrote about seventy secular songs of a light, homophonic nature, but his chief contribution lay in the development of polyphony, especially in his Masses and motets. Imitation became an important structural feature—for each group of words, a short musical theme would be presented in one voice and then be restated (imitated) in the other voices. He sometimes used another structural device, the repetition of sections of music, in which an opening section (A) is followed by new material (B), and restates in a third section (A). This became known as ABA form. Josquin's music flows freely with varied rhythms and a full, rich sound. Above all, emotion shines through.

Josquin's *Déploration sur la mort de Johannes Ockeghem (Regret over the death of Johannes Ockeghem*; c. 1497) uses voices in five parts, doubled by viols. In this piece, each new line of text starts a new imitation. One voice or pair of voices leads and then the other voices imitate the lead as the piece builds. We can hear plainchant in the tenor voice, and the uppermost voice, called the *superius*, sounds particularly melodious. The piece contains "text painting," wherein the music tries to emulate the emotions of the text, and in the second part Josquin utilizes homophonic texture. The text, written by the French poet and historian Jean Molinet (muh-lan-NAY; d. 1507), contains moving imagery entreating mythological forest voices and professional singers of the world to change their ordinary songs for lamentations. The text calls Ockeghem a true treasure (a pun—Ockeghem was treasurer of his monastery) and master of his craft. Great is their sorrow to see him covered with earth. The second part of the

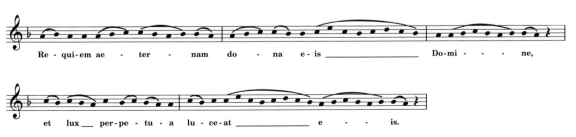

11.23 Josquin des Prez, *Déploration sur la mort de Johannes Ockeghem*, c. 1497. Excerpt from Part 2.

piece urges Ockeghem's disciples to drape themselves in mourning garments—including Josquin himself as well as other composers, having lost their "good father": "May he rest in peace, Amen" (*Requiescat in pace, Amen*). The tenor voice of the *Déploration* sings the chant from the beginning of the funeral mass (Fig. **11.23**).

Germany

Unlike Zwingli and Calvin, who either removed music from worship entirely or severely limited its use, Martin Luther saw music as an integral part of liturgical worship. The hallmark of the Reformation—the primacy of the Word of God as revealed in the Bible—was to be heard, obeyed, and incorporated into daily life. The Swiss reformers distrusted music because it had a power of its own that they believed could subvert the Word of God. Music also had secular connections—often with immoral connotations—that made Zwingli and Calvin nervous. Luther, on the other hand, saw music in a more positive light and believed that it could function for the glorification of God. He found in music a connection to the prophets, who he believed used music to proclaim truth through psalms and song.

The Lutheran Reformation, therefore, brought many changes to Church music. Even after the separation, Lutheran music continued to have many Roman Catholic characteristics, including some Latin texts and plainsong chants. The chorale (Kirchenlied; KUHR-shuhn-leed), or hymn tune, however, emerged as the most important musical contribution of the Lutheran Reformation. Modern hymns, many of which date back to Martin Luther for both text and tune, illustrate this form. Our four-part harmonies came later. Originally, the chorale consisted of a single melody, stemming from the chant or folk song (Volkslied; FOHLKs-leed), and a text. The congregation sang in unison and without accompaniment. The liturgical experience that developed in Lutheran churches, particularly in Wittenberg under Luther's leadership, contributed a rich and varied combination of Latin and German, traditional monody and contemporary polyphony, the music of Catholic and Lutheran composers, and choral and organ music, all held together by congregational hymnody.

Lutheranism also contributed a considerable body of polyphonic choral settings, many from Luther's principal collaborator, Johann Walter (VAHL-tuhr; 1496–1574). These settings vary tremendously in style and source, some of them based on German secular songs and some on Flemish motets. Polyphony, a complex texture, does not, however, lend itself ideally for congregational singing, and polyphonic settings uniformly used only the choir. By the end of the sixteenth century, Lutheran congregational singing had changed again, with the organ now given an expanded role. The congregation sang the melody, no longer unaccompanied—an organ played harmonic parts.

Also in Germany in the late fifteenth century, the Renaissance spirit, with its secular traditions, produced polyphonic songs. These predominantly three-part secular songs provided much of the melodic basis for the church hymns of Lutheranism after the Reformation with Heinrich Isaac (1450–1517) probably the first and most notable German composer of this era. The frequent usage and refashioning of this type of composition emerges in one of Isaac's most famous works, "Innsbruck, I Must Leave Thee." Isaac changed the original folk love song into a polyphonic piece with words by the Emperor Maximilian. Later, he used the melody in his own sacred work, the *Missa Carminum*. The song then became widely known in another adaptation under the sacred title, "O World, I Now Must Leave Thee." Even Johann Sebastian Bach used the *Innsbruck Lied* in the *St Matthew Passion*.

France

Paris retained its importance as a musical center for centuries. By the mid-sixteenth century, a new French style of music had emerged. In the late 1520s, thanks to mass printing, vast quantities of music, written by composers living and working in and around Paris and representing a markedly different style, began to appear. One of the greatest French composers of the time, Clément Janequin (ZHAN-nih-kan; c. 1485–1560), associated with a new kind of chanson (song), known as the Parisian chanson, which represented a genre that perfectly captured the elegant simplicity and rational spirit of French musicians.

Janequin's works typically express the vivacious and irreverent side of the French character. Today we best remember Janequin for his long descriptive chansons—for example, *Le chant des oiseaux* (*The Song of the Birds*)—in which he explored a particular theme—in this instance bird songs, but also battles, hunts, street cries, and ladies' gossip—that allowed him to make a virtuoso display of onomatopoeia (words that sound like their reference). *The Song of the Birds* uses a series of slow-moving chords to frame a rich jumble of elaborate animal noises which make up the central point of this amusing piece.

England

In sixteenth-century England, London afforded the opportunity for all kinds of musical composition and performance; the center of music printing, it sheltered foreign and domestic musicians and instrument makers. The monarch supported the best musicians both secular and sacred.

In the field of sacred music, the Chapel Royal provided the dominant force, although during the early

and mid-sixteenth century, the liturgical tradition in the Chapel was unstable. The Church of England's formal separation from the Roman Catholic communion in 1534 under Henry VIII had political rather than doctrinal causes, and, therefore, caused no immediate change in liturgy or music. In 1544, Archbishop Thomas Cranmer published an English version of the litany which adapted the traditional chants to the vernacular, and a second version of the service, published in the same year, had settings of the chants for five voices. Between the reigns of Henry VIII and Elizabeth I—during the brief but tempestuous reigns of Edward VI (1547–53) and Mary Tudor (1553–8)—great doctrinal swings took place. In 1549, shortly after Edward VI became king, the Act of Uniformity decreed that the liturgy as prescribed in the *English Book of Common Prayer* should be used in all services. A year later John Merbecke issued his *Booke of Common Praier*, which included traditional chants and new monophonic music for the service. These compositions contained melodies that nicely matched the English words.

The reign of Mary Tudor saw the re-establishment of Roman Catholicism, but the accession of Elizabeth I in 1558, and the return of the Puritan faction, brought the restoration of English rites, and the Church of England acquired its present form. In Elizabeth's time, a period when church music witnessed bitter attack by the English followers of Calvin, the Chapel Royal remained the most important bastion of elaborate ritual. However, the Chapel Royal reflected the monarch's will, and the reformers could do little, as the monarch functioned as head of the English Church. During Elizabeth I's reign, therefore, the Chapel Royal stabilized as an institution, and the Elizabethan "golden age of church music" began. Elizabeth showed greater preference for the elaborate ritual of Catholicism than for the austerity of the Puritans, recognizing perhaps that ceremony and trappings could glorify not only God but also the supreme Head of the Church of England as well. In addition, political reasons for maintaining some vestiges of Catholicism rather than adopting wholeheartedly the simplicity of the Calvinists existed, for the powerful Catholic monarchies of Europe took reassurance from the appearance, at least, that England had not been totally subverted by the Reformers.

Elizabeth I specifically allowed Latin to continue in those collegiate chapels and churches where the language was familiar to the congregations. However, the result of her influence saw the creation of an entirely new body of English church music. The first years of her reign witnessed an attempt to build a more impressive repertory than had existed previously, and the burden of that task fell on the shoulders of the composer William Byrd (1543–1623). Byrd displayed a multifaceted musical personality, and his range, versatility, and superb quality set him apart from his contemporaries. He excelled in virtually every form—Latin Masses, motets, English anthems and services, songs and madrigals, and music for stringed and keyboard instruments. He proved a pivotal figure in English music—at the same time the last great composer in the rich tradition of Catholic polyphony and the first of the Elizabethan golden age.

Byrd spent most of his professional life as organist for the Chapel Royal, and served the court for nearly fifty years. Interestingly, he remained a Catholic all his life, surviving in a Protestant country that was, at times, deeply hostile to his religion. Nonetheless, he felt secure enough to compose and publish music for the Catholic liturgy even as he maintained an important position in the Anglican Church and provided music for its services. His settings were often grave, penitential, and supplicatory. Earlier English composers—such as Byrd's predecessor as organist at the Chapel Royal, Thomas Tallis—used imitative techniques and laid out their points in perfectly symmetrical patterns. Byrd adopted more flexible procedures and introduced successive voices irregularly, to give his counterpoint greater interest and complexity. Many of his motets are unusually long, and this allowed him to expand his themes and show them off in various combinations. His later motets incorporated a wide range of textures and styles, with a greater use of chromaticism and antiphonal effects, and livelier, more varied rhythms.

Some of Byrd's finest music includes complete services for the Anglican Church, including settings of the morning and evening canticles and the communion service. Byrd's services employed the note-against-note **counterpoint** that Archbishop Thomas Cranmer had recommended to Henry VIII as the only appropriate style for church music. They also used florid counterpoint and explored fully the possible combinations of its two five-voiced choirs. The rich density and imitative texture of his Great Service make it one of the grandest in the Anglican tradition.

At the same time, another English composer, Thomas Morley (1557–1603), excelled in a type of Renaissance secular music called the *ballett* (or *fa-la*), a simpler type of composition than the madrigal (see p. 335). The ballett was a dancelike song for several solo voices. Mostly homophonic (in contrast to much Renaissance music, which was polyphonic), the ballett had the melody in the highest voice. It repeated the same music for each stanza of the poem and used the syllables *fa-la* as a refrain. Morley's *Now is the Month of Maying* remains one of the most widely performed of all the balletts. It describes courtship and flirtation during the springtime:

> Now is the month of maying,
> When merry lads are playing, fa la.

Each with his bonny lass
Upon the greeny grass. Fa la.

The spring, clad all in gladness,
Doth laugh at winter's sadness, fa la.
And to the bagpipe's sound
The nymphs tread out their ground. Fa la.

Fie then! why sit we musing,
Youth's sweet delight refusing? Fa la.
Say, dainty nymphs and speak,
Shall we play barley break? Fa la.

Most of the piece is homophonic in texture, but the *fa-la* section ending the second part of each verse has very graceful polyphonic imitation among the voices.

Dance

European indoor court entertainments of the early and mid-sixteenth century often took the form of "dinner ballets." These long and lavish entertainments had interludes called *entrées*, between the courses. Often the mythological characters in these *entrées* (ahn-TRAYZ) corresponded to the dishes served in the meal. Poseidon, god of the sea, for example, would accompany the fish course.

Courtly dancing in Europe, and especially in Italy, turned more and more professional in the late sixteenth

11.24 Fabrizio Caroso (b. c. 1553). Contemporary engraving. The New York Public Library (Cia Fornaroli Collection).

century. Skilled professionals performed on a raised stage, then left the stage to perform in the center of the banquet hall, joined by members of court. During this period, dancing technique improved and more complicated rhythms appeared. All of these changes were faithfully recorded by Fabrizio Caroso (fahb-REET-zee-oh kah-ROH-soh; Fig. **11.24**).

Formal ballet came of age as an art form under the aegis of the powerful Catherine de' Medici (1519–89), great-granddaughter of Lorenzo the Magnificent. Love of spectacle permeated the French court, and lavish entertainments, some of which nearly bankrupted the shaky French treasury, marked important events, such as the marriage of Catherine's eldest son, Francis II, to Mary, Queen of Scots. Although sources vary on just how these spectaculars developed into the ballet, we can be sure that either *Le Ballet de Polonais* (1572) or the *Ballet Comique de la Reine* (1581) marked the real beginning of formal Western ballet tradition.

Le Ballet de Polonais, the "Polish Ballet," with music by Orlando di Lasso saw a production in the great hall of the Palace of the Tuileries on a temporary stage with steps leading to the hall floor. The audience surrounded three sides of the stage and joined the dancers at the end of the performance in "general dancing."

This extravaganza had a mixture of biblical and mythological sources. It had original music, poetry, and song, and Italian Renaissance scenic devices overwhelmed the audience with fountains and aquatic machines. Over ten thousand spectators witnessed this event, which cost 3.5 million francs. It ran from ten in the evening to four the next morning. Probably the most significant aspect of the *Ballet Comique* consisted of its use of a single dramatic story line throughout.

Literature

Earlier in the chapter we examined Desiderius Erasmus as a formational Christian humanist in the period leading to the Reformation. The greatest scholar of the northern Renaissance (Fig. **11.25**), he also edited the New Testament and wrote about classical literature. The illegitimate son of a priest and a physician's daughter, he found an opening for his talents in the Church, as did many able boys from poor backgrounds. He became an Augustinian canon and was ordained a priest in 1492. Given the opportunity to study the classics and granted leave to study in Paris, he came into contact with humanist groups and learned to dislike scholastic theology.

While in Venice, he joined the informal academy around the printer Aldus Manutius and deepened his knowledge of Greek and Latin classical literature. He began to write, and books such as the *Adages*, a

collection of several thousand pithy sayings drawn from the classics, and *In Praise of Folly*, a satire on the affectations and vices of contemporary society, gained him a reputation throughout Europe. In 1516 his edition of the Greek New Testament accompanied by his own Latin translation was published. This landmark in biblical studies for the first time gave scholars the original text of the Church's fundamental document. His efforts were not universally well received, however, and scholars of the old school—those who studied the Bible only at second hand through various commentaries and glossaries of theologians—considered him a threat to their authority. Their feelings were well founded, because, in 1519, in the preface to the second edition of his Greek New Testament, he openly attacked what he called "schoolmen" and their sterile "scholasticism." Following the example of other humanists, he called for new techniques of critical study to obtain a more profound understanding of the Bible and the early Church Fathers.

Erasmus wrote *In Praise of Folly* or *The Praise of Folly* as a satire that begins as a scholarly frivolity but becomes a full-scale irony as it warmly praises folly in the manner of the Greek satirist Lucian (see Chapter 3). The piece represents the best example of a new form of Renaissance satire. Erasmus ends the piece with a straightforward statement of Christian ideals that Erasmus shared with his friend Thomas More.

As the Reformation raged on, a literary assault on religion came from Michel de Montaigne (mee-SHEL duh mohn-TAYN; 1533–92). Born at his family's ancestral castle in southwestern France, as soon as he could talk he came under the tutelage of a German preceptor, who knew no French and used Latin exclusively when instructing his infant pupil. As Montaigne matured, he derived his philosophy from the classical forms of self-discipline he found in Socrates and the Stoics. After studying law, he served in the Parliament of Bordeaux, and when thirty-seven he retired to the château of Montaigne to write his Essays, the first two books of which appeared in 1580. After travels to Rome and a period as mayor of Bordeaux, he again retired to the château to write. A third edition of the Essays appeared posthumously in 1595.

Montaigne found religions of worship and mystical revelation incomprehensible, whether Greek or Christian. On the other hand, he granted the mind and body "their ordinary comforts." Sobriety, self-control, and the acceptance of reason formed the basis of his outlook, and his skepticism resulted from his observation that humans comprise essentially changeable, "undulating and diverse" individuals, incapable of attaining truth. Neither science, nor reason, nor philosophy can guide humankind, the obedient servant of customs, prejudices, self-interest, and fanaticism. Men and women remain the

11.25 Hans Holbein the Younger, *Erasmus of Rotterdam*, 1523. Oil on wood, 17¼ × 13⅛ ins (43 × 33 cm). Louvre, Paris.

victims of circumstances and of the impressions that circumstances make. Such a view of humankind runs throughout the essays and constitutes their central theme.

According to Montaigne, education ultimately enables humans to understand themselves and things as they are and to live more harmoniously. His morality lay outside the conventions of the times, because he drew most of it from Seneca (p. 118) and Plutarch (p. 136), who treated ethical and moral questions in an easy-going manner. A "congenital dislike of straining" forms the core of Montaigne's character. His ninety-five essays drift from one topic to another, with no discernible order, and the titles include "On Fleas" and "On the Habit of Wearing Clothes." Emerson, in his *Representative Men*, summed up Montaigne's appeal: "There have been men with deeper insight; but, one would say, never a man with such abundance of thoughts: he is never dull, never insincere, and has the genius to make the reader care for all that he cares for." Montaigne's skepticism and seeking of understanding through self-examination led to the title *Essais* (French for Essays—meaning "Attempts"), which implies a project of trial and error or tentative exploration. Montaigne's book inaugurated the term

essay for the short prose composition treating a given subject in a rather informal and personal manner.

In England, Renaissance literature flowered during the last quarter of the sixteenth century. Under Elizabeth I England entered a period of political and social stability that engendered a mood of optimism and readiness to experiment in cultural matters.

Lyric poetry enjoyed wide popularity, and the ability to compose a sonnet or to coin an original and witty phrase was regarded as essential in any courtier, while the growing and increasingly prosperous middle class—no longer confined to the large towns, but extending throughout the shires and country towns—demanded increasingly sophisticated entertainment. At the same time, a large and educated readership, women as well as men, also developed. Writers and booksellers quickly responded to this new market. An early and notable testament to this upsurge in interest came in Sir Philip Sidney's *A Defense of Poesie* (published posthumously in 1595), a brilliant and forceful polemic, which laid claim to the cultural high ground for verse. Sidney (1554–86), in many ways the model English Renaissance courtier and man of letters—considered the ideal gentleman of his day—had read widely and judiciously in ancient Italian and French literature. His sonnets, best represented in *Astrophel and Stella*, perfectly embodied the delicacy, elegance, wit, and expressiveness of contemporary writing.

The mantle of Elizabethan poetry falls, however, on the shoulders of Edmund Spenser (c. 1552–99). Born in London to middle-class parents, and well educated in humanist disciplines and the classics, he also studied English composition and drama. He received two degrees from Cambridge University, where he developed a deep love of poetry and made a wide group of friends who turned out to be both intellectually stimulating and politically useful. Although he enjoyed aristocratic patronage, poetry, although popular, seemed not at the time a particularly desirable career, and he published his first work *The Shepheardes Calendar*, dedicated to Philip Sidney, under a pseudonym in 1579. Meticulously symmetrical, it reveals Spenser's impulse toward experimentation in verse types resulting in a quaint and moderately charming poem, in which a group of shepherds, representing Spenser and his friends, reveal their ideas about love, poetry, and religious feeling. Writing did not give Spenser a steady income, and in 1580 he took a position in Ireland as private secretary to the new governor, Lord Grey of Wilton. Spenser lived in Ireland for the rest of his life, regarding himself as an exile and having little sympathy with the Irish. He approved of Lord Grey's cruel policy of military plunder and portrayed him sympathetically in *The Faerie Queene* and a report on the *View of the Present State of Ireland*.

The *Faerie Queene* circulated in manuscript form long before publication and earned wide admiration. In 1589 Spenser returned to London with Sir Walter Raleigh, who had read *The Faerie Queene* and who represented for Spenser a way to patronage and position. When the first parts appeared in 1590, the work was dedicated to the "most mighty and magnificent" Empress Elizabeth, "the greatest Gloriana," the heroine of the poem. The work made Spenser famous, and he gained a small pension from it. However, he failed to gain either an important position or a patron, and he returned to Ireland disillusioned. Over the years, he published many more poems and enjoyed great fame, but had little material benefit. Although skillful in fashioning a new literature from the classics, Chaucer, and the French and Italian Renaissance poets, today Spenser remains one of the least-read of the great English poets.

William Shakespeare, in addition to his dramatic works, also left a remarkable sequence of sonnets, that literary form we have followed since ancient times. Shakespeare's sonnets push the resources of the English language to great extremes. The Shakespearean sonnet adapts the Petrarchan sonnet (see p. 301) and has fourteen lines grouped into three quatrains (four lines) and a couplet, with a rhyme scheme of ABAB CDCD EFEF GG as Sonnet XIX illustrates. Here Shakespeare uses intriguing imagery to address the effects of aging: blunting the lion's paws; making the earth devour her own sweet brood; plucking keen teeth from the fierce tiger's jaws, and burning the phoenix in her blood (the phoenix was an Egyptian mythological creature that consumed itself by fire after 500 years, and rose renewed from its ashes); creating age lines with an antique pen. He solves the dilemma by countering time with the ageless nature of literature.

Sonnet XIX
William Shakespeare

Devouring Time, blunt thou the lion's paws,
And make the earth devour her own sweet brood;
Pluck the keen teeth from the fierce tiger's jaws,
And burn the long-lived phoenix in her blood.

Make glad and sorry seasons as thou fleets,
And do whate'er thou wilt, swift-footed Time,
To the wide world and all her fading sweets;
But I forbid thee one most heinous crime:

O, carve not with thy hours my love's fair brow,
Nor draw no lines there with thine antique pen;
Him in thy course untainted do allow
For beauty's pattern to succeeding men.

Yet, do thy worst, old Time: despite thy wrong,
My love shall in my verse ever live young.

CHAPTER REVIEW

CRITICAL THOUGHT

When we survey the religious map of the world today, we find that Roman Catholicism, by far, remains the largest Christian division. In many countries, however, the Roman Catholic Church represents a small minority of those people who call themselves Christian. The pain and separation of the Reformation remains as strong a schism today as in the sixteenth century. Divisions between Protestants and Catholics have been eased by the ecumenical movement of the last thirty years, but some Protestant denominations remain as anti-Catholic as ever.

As we have seen, the Reformation comprised a complex affair, often religious, but equally often political, that went far beyond the simple corruption of the Roman Catholic hierarchy during the Renaissance and revealed some truly profound divisions involving important issues of dogma. We spent a good deal of space on the personages and issues of the Reformation, and we should understand the fundamental, driving circumstances as well as the eventual outcomes. We also witnessed a new force arising and putting a new spin on events of the sixteenth century: science in the modern sense of the word. Finally, as always, we examined art, architecture, music, dance, theatre, and literature as they developed in parallel with the events and arts we examined in the last two chapters. Again, our movement through our textbook has become sideways rather than forward.

SUMMARY

After reading this chapter, you will be able to:

- Identify and explain the political and religious conditions that led to the Reformation, including the theological and dogmatic contentions of Erasmus, Luther, Zwingli, Calvin, and Montaigne.
- Discuss the contributions to science of Vesalius and Copernicus.
- Characterize the work of Dürer, Grünewald, Altdorfer, Hieronymus Bosch, and Pieter Breugel the Elder.
- Explain the music of Flanders and Lutheranism, *Lieder* and the Parisian chanson.
- Detail the rise of courtly dance and ballet.
- Trace the Tudor heritage in England by discussing its history, visual art, architecture, theatre, and music.
- Apply the elements and principles of composition to analyze and compare individual works of art and architecture illustrated in this chapter.

CYBERSOURCES

http://www.artcyclopedia.com/history/northern-renaissance.html
http://www.classicalarchives.com

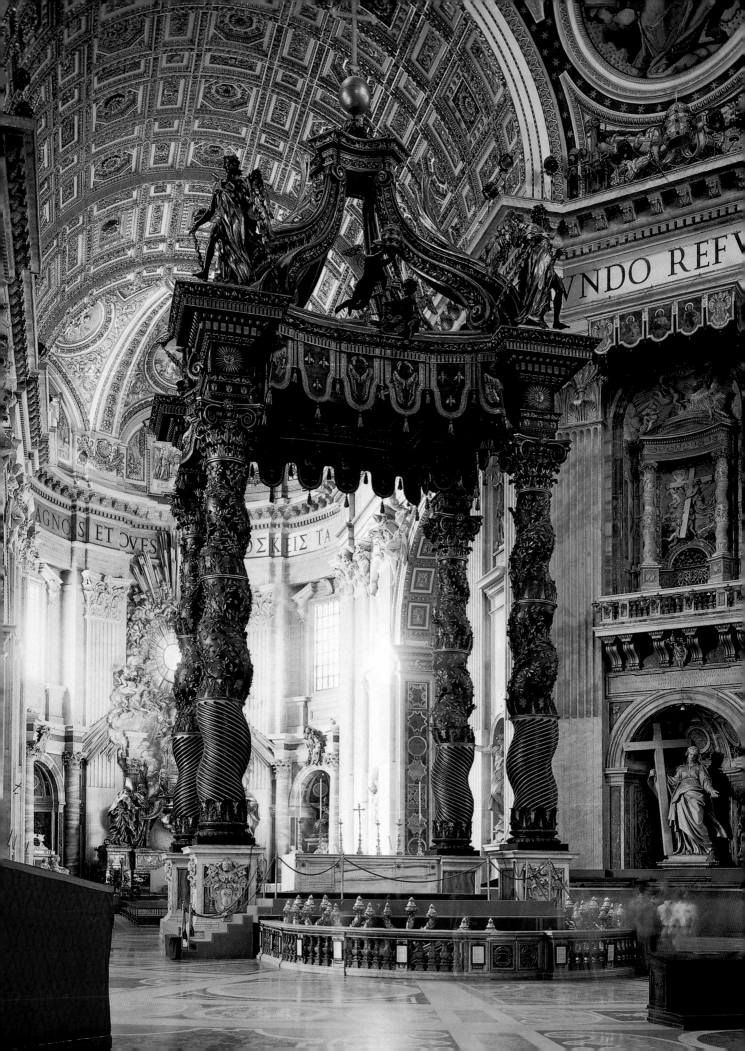

12 THE BAROQUE AGE

OUTLINE

CONTEXTS AND CONCEPTS
- Contexts
 The Catholic and Counter-Reformation
 The Wars of Religion
 The Scientific Revolution
 TECHNOLOGY: Standardized Measurement
- Concepts
 Academicism
 Scientific Rationalism
 Social Contract
 Absolutism

THE ARTS OF THE BAROQUE AGE
- Painting
 Italy
 Spain
 Flanders
 France
 The Netherlands
 MASTERWORK: Rembrandt—*The Night Watch*
- Sculpture
- Architecture
 A DYNAMIC WORLD: The Taj Mahal

MASTERWORK: St Paul's Cathedral
PROFILE: Sir Christopher Wren
- Theatre
- Music
 Instrumental Music
 Vocal Music
 MASTERWORK: Bach—*Ein Feste Burg*
 PROFILE: Johann Sebastian Bach
 Opera
- Dance
- Literature
 Spain
 England

VIEW

LOGICAL THOUGHT

Induction and deduction are two means of developing logical conclusions. Both are rational—that is, they rely on systematic order and progression—but they approach the development of conclusions from opposite directions. Induction begins with specifics and deduces generalities. Deduction relies on intuitive thinking. In other words, it intuits that some general condition exists, then the observer investigates to see if that general condition can be supported by sufficient details to be conclusive.

In both cases—induction and deduction—the conclusions will stand the test of replication—retesting the hypothesis yields the same conclusions. Induction and deduction re-emerged in the seventeenth century as bases for drawing conclusions. They form the foundation of logical thought and remain as important today as they were four hundred or two thousand years ago. Without the ability to draw logical conclusions from the evidence at hand, we cannot solve problems. It's as simple as that.

KEY TERMS

SYSTEMATIC RATIONALISM
An attempt to provide an unchanging fabric to life whose relevance to particulars could be deduced by inquiry.

INDUCTION
A mode of inquiry that reaches conclusions by moving from specifics to generalities.

DEDUCTION
A mode of inquiry that reaches conclusions by moving from generalities to specifics.

COUNTER-REFORMATION
An internal reform based on the desire for spiritual regeneration in the Roman Catholic Church from the mid-sixteenth to the early seventeenth centuries.

ABSOLUTISM
Government with power vested in the hands of an absolute monarch.

BAROQUE STYLE
A pluralistic style in the arts that exhibited, among other characteristics, ornateness and emotionalism.

OPERA
A type of music/drama.

NEOCLASSICISM
A variety of styles that borrow classical themes and motifs. In the seventeenth century it manifested itself in French theatre.

12.1 Gian Lorenzo Bernini, *Baldacchino* in St Peter's, Rome, 1624–33. Gilded bronze, about 100 ft (30 m) high.

CONTEXTS AND CONCEPTS

Contexts

The Catholic and Counter-Reformation

The desire for spiritual regeneration in the Roman Catholic Church in the late fifteenth and early sixteenth centuries eventually led to internal reform. This process, often called the Counter-Reformation, took shape in the 1540s and 1550s in loyalty to the pope and opposition to Protestant doctrines and practices. In addition, however, a Catholic Reformation existed that comprised more than a reaction against Protestantism, for the impulse for renovation, purification, and an internal rebirth of Catholic sensibility. It existed for more than half a century before it transformed the papacy and made possible the codification of doctrine and discipline by the Council of Trent. We should remember that Erasmus and the Christian humanists whom we studied in Chapter 11 sought Catholic reform. Others, also, held closely to the older traditions, and wished the Catholic Church to make a positive contribution to the contemporary age. Catholic theologians, dating back to St Augustine and St Thomas Aquinas (see Chapter 8), had tried to reconcile the omnipotence of an Almighty God and human free will, and the Catholic Reformation also drew some of its inspiration from late medieval mysticism. Thus, the spirit of renewal worked among those who would remain loyal to the ongoing institution of Roman Catholicism. The desire for a more spiritual, more relevant, and less worldly religion affected Catholic and Protestant alike, and at first it seemed unclear that the result would lead to the split that followed. However, as the gap between the two points of view widened in the 1550s, attitudes became more entrenched, open conflict occurred, and differences rather than similarities strengthened. By the time of the Council of Trent (1545–63), which addressed a number of doctrinal issues relevant to the Protestant Reformation, Roman Catholicism set out to make the definition of doctrine between Catholics and Protestants as clear as possible, and in so doing, many aspects of Catholicism themselves obviated with the result that, between 1550 and 1650, orthodoxy rose above universality—an outcome probably necessary if the Church were to survive.

GENERAL EVENTS

- Philip II of Spain, 1527–98
- Elizabeth I of England, 1533–1603
- Founding of Jesuits, 1540
- Council of Trent, 1545–63
- Galileo, 1564–1642
- Kepler, 1571–1630
- Thirty Years' War, 1618–48
- Louis XIV of France, 1638–1715
- Civil War in England, 1642–8
- Newton, 1642–1727
- Restoration of the monarchy (Charles II) in England, 1660
- Plague and fire of London, 1666

1540	1600	1650	1700	1750

PAINTING & SCULPTURE

1540	1600	1650
Caravaggio (12.6, 12.7)	Bernini (12.1, 12.17, 12.18), El Greco (12.8), Rubens (12.9, 12.10), Poussin (12.11), Rembrandt (12.12)	van Ruisdael (12.14), Vermeer (12.15), Ruysch (12.16), Coysevox (12.19), Puget (12.20)

ARCHITECTURE

della Porta (12.21, 12.23)	Wren (12.29–12.32)	Palace of Versailles (12.24–12.28)

THEATRE

	Corneille, Molière, Racine	

MUSIC & DANCE

	Monteverdi, Buxtehude, Peri	Scarlatti, Racine, Beauchamps	Bach, Vivaldi, Purcell, Handel

LITERATURE

	Bacon, Descartes, Cervantes, Metaphysical poets, Milton	Hobbes, Dryden, Locke, Behn	Defoe

Timeline 12.1 The baroque age.

The reformation of the Catholic Church depended on a change in the papacy, since, given its structure and hierarchy, the pope provided the only possible source of necessary leadership. During the pontificate of Paul III (r. 1534–49) the papal court reformed, and reformers gained commanding positions in the Church, from which they and their successors guided the Catholic Reformation. Pope Paul reinstituted the medieval Inquisition and established a board of censors, the Index of Forbidden Books, by means of which he hoped to meet the Protestant threat head on. He also recognized a new order, called the Society of Jesus, the Jesuits. Organized in 1540 by a Spanish knight and future saint, Ignatius Loyola (ig-NAY-shuhs loy-OH-luh; 1491–1556), the members of this order became the Church's most militant agents of the Counter-Reformation, and the order proved the greatest missionary order in the history of the Church. However, the most important action taken by Paul III consisted of calling the Council of Trent, which met off and on for twenty years in the 1540s, 1550s, and 1560s (Fig. **12.2**).

Pope Paul began the council at the cathedral in the city of Trent, a small imperial city deep in the southern Alps, in 1542. Some thirty bishops and fifty theologians assembled for the opening ceremony in December 1545, and although the pope took no active part, his views were well known and fully represented. The papal secretariat provided continuity to the council, whose participants, by the time it recessed, numbered around 270. One of the important agreements of the council comprised the reaffirmation that the pope outranked the general council, with the result that none of its resolutions could take effect until approved by the pope. Ultimately, the Council of Trent carried the reforming impulse from the pope to the Church at large, with decrees on doctrine and discipline providing stiff penalties for immorality and corruption. The council formed new seminaries in order to produce a better educated priesthood, and it also reaffirmed traditional Catholic views on all the theological points the Protestants had attacked.

The final session of the Council of Trent took place in 1562–3. Its main achievement placed emphasis on the quality of the clergy and the role of bishops, in contrast to the Protestants, who, with their belief in the priesthood of all believers, downgraded the role of clergy and either did away with bishops altogether or severely limited their functions. The Counter-Reformation strengthened both clergy and bishops so that they could give leadership to the laity. And herein lies the fundamental difference between the two stands. Protestants put individual conscience and the Bible first. Catholics insisted that conscience and the Scriptures must be interpreted by the Church in light of its own traditions and understanding. Although the Council of Trent did not transform the Catholic Church immediately, it did mark a turning point, and the combination of new religious orders, the Inquisition, and a spiritually regenerated papacy gave Catholics a new certainty of belief and practice that they lacked previously.

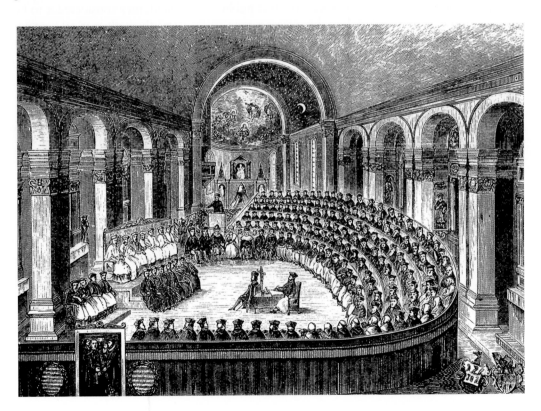

12.2 The Council of Trent, 1545.

The Wars of Religion

Unfortunately, the clash of theological ideas and their casting in the political crucible of the time created one of the bloodiest periods in European history. Religious wars began in the sixteenth century in such conflicts as the Peasants' War in Germany, and they recurred with varying degrees of intensity in the Thirty Years' War in central Europe and in the seventeenth-century English Puritan Revolution. However, the height of the violence came between 1560 and 1600, with a bitter war in the Netherlands between Calvinist Protestants and Spanish Catholics, an equally horrific conflict in France between the Huguenots and the Catholic League, and the global Anglo-Spanish naval war. During these passionate unheavals, Protestant mobs vandalized Catholic cathedrals, the Inquisition tortured and burned at the stake anyone deemed heretical, Luther approved the execution of the extremist Anabaptists, and Calvin martyred the religious eccentric Michael Servetus. These religious wars between Protestants and Catholics continued into the 1600s, lasting into the middle of the century, when they, at last, burned themselves out.

The Scientific Revolution

The latter part of the sixteenth century marked the dissolution of what we can call the Aristotelian consensus. Since the fourth century B.C.E., Aristotle's views on the natural world had served as the basic model, but the revival in science that we noted in Chapter 11 with the works of Copernicus and Vesalius gathered strength in the seventeenth century with the first public teaching of modern natural philosophy, accompanied by experimental demonstrations, at the University of Utrecht in 1672.

In the baroque age of the seventeenth century, we witness the profound and prototypical thought and work of several individuals whom we discuss in the paragraphs that follow: Francis Bacon, Galileo Galilei, Johannes Kepler, René Descartes, and Isaac Newton.

The English writer Francis Bacon (1561–1626) reflected the Renaissance hope that humankind could discover all things knowable about the universe through the use of reason, which, he believed, formed the path to knowledge. Knowledge, in turn, meant power, and the ultimate power, human domination of nature, achievable through an understanding of natural laws. Bacon was one of the first to describe the modern scientific method, a method based on *induction*—the progression from specifics to generalities. Fundamental to this process rest the examination of negative instances and a critical spirit, which prevent the inquirer from jumping to unwarranted conclusions. The verification of conclusions by continual observation and experiment also proves essential. The task of science, Bacon believed, was to conquer nature by obeying it, while the task of poetry was to conquer nature by freeing the mind from obedience to nature and releasing it into its own world where the mind reshapes nature. In Bacon's own words in the *Advancement of Learning* (1605): "Therefore, poetry was ever thought to have some participation of divineness, because it doth raise and erect the mind by submitting the show of things to the desires of the mind, whereas reason doth buckle and bow the mind unto the nature of things." Here we have as good a statement as any of the dichotomy between the intellect and the imagination, the separation of ways of knowing that has obsessed artists and thinkers ever since.

A prolific writer, Bacon's talents ranged from the scientific to the poetic. His *Essays* remain masterpieces of English literature, and his philosophy employs a methodology that anticipated modern inquiry. Born into a family that had access to power and prestige, after studying law, he entered politics and became a member of the English Parliament, becoming attorney general and lord chancellor under King James I. In 1618 he rose to the peerage. Not above treachery, however, he fell from grace as rapidly as he had risen.

Galileo (ga-lih-LAY-oh; 1564–1642), an Italian astronomer and physicist, emphasized the characteristics of mathematics, believing that the "Book of Nature" appeared in the language of geometry. In his view, the mathematical proof of a proposition comprised the best proof. These kinds of assertions were new, for although the ancients had regarded mathematical reasoning as valid, they considered it to be inappropriate outside strictly mathematical contexts. Recognizing that mathematical principles depended on physical premises, the ancients rejected mathematics as a guide to truth. Galileo did much to establish not only the mathematical approach to discovery but also the sound premises that could strengthen conclusions.

Galileo made other significant scientific advances. For example, he built the first astronomical telescope and observed for the first time the mountains on the moon, sunspots, the rings of Saturn, the moons of Jupiter, and the stellar composition of the Milky Way. He also made earthly discoveries—for example, the law of the acceleration of falling bodies and the principle of the pendulum. Unfortunately for Galileo, the Church, which still supported the Aristotelian concept of a fixed earth, objected to his experiments and conclusions, and in 1633 the Inquisition arrested him and charged him with false teaching. Under threat of torture, Galileo recanted his discoveries. He died a broken man.

Galileo's *Dialogue Concerning the Two Chief Systems of the World* reveals his thought through the device of an imaginary discussion among three men: Salviati, an intellectual who appears to speak for Galileo;

Sagredo, a wealthy nobleman seeking truth; and Simplicio, an Aristotelian philosopher who poses ineffectual arguments that Salviati debunks. The discussion, centered around the Ptolemaic and Copernican (see Chapter 11) views of the world, emerges over a period of four days. On day one, they discuss celestial and terrestrial matter. Day two brings a discussion of motion; day three, the annual movement of the earth around the sun as well as the apparent lack of motion of the stars. On day four, Salviati attempts to show how a combination of the earth's orbital motion and daily rotation cause the tides. He uses the example of water redistributing itself in response to acceleration.

The German mathematician Johannes Kepler (1571–1630) added to the scientific revolution by proposing the three laws of planetary motion. He had devoted himself to the study of the heliocentric universe, and his first treatise, *On the Motion of Mars*, propounded his solution as to what kept planets in their orbits. He proposed his first planetary law: planets move around the sun in elliptical orbits rather than circles. His second law, given in precise mathematical formulae, accounted for the variable speed of planetary motion by asserting that nearness to the sun affected speed: the closer to the sun, the faster the speed. A few years later, he published his third law of planetary motion: the squares of the length of time for each planet's orbit equal the same ratios as the cubes of their respective mean distances from the sun. Thus, he affirmed the conclusion of a regular solar system organized by mathematically determined relationships.

The French philosopher and mathematician René Descartes (ren-AY day-KART; 1596–1650), who created

TECHNOLOGY

STANDARDIZED MEASUREMENT

The standardization of measures had interested several scientists whose attention had been attracted by Galileo's observations on the pendulum. The phenomenon inspired them to choose the length of the pendulum that beats the second as a "natural and universal" unit of measure, but before they could do so, it was necessary to determine that the amplitude of oscillations did not vary from place to place. This concern led to the painstaking construction by the abbot Gabriel Mouton (moo-TAWN), the permanent priest of the Church of Saint-Jean at Lyon in France, of a system of measurement based on the unit of linear measure related to the size of the earth. He borrowed the definition of this unit from the thousandth part of the angular minute—that is, from the thousandth part of the nautical mile of 1,852 millimeters. This unit was called the *virga* (Fig. **12.3**).

In addition, Abbot Mouton subjected the multiples and submultiples of the unit to decimal division. The idea had considerable scope, and the introduction of decimal numeration into the metric system played a vital role in its expansion throughout the world. Although Mouton's terminology was never accepted into the metric system, the concept of a universal unit was continued into the eighteenth century, and the actual creation of a decimal metric system finally occurred in 1790.

In the seventeenth century, scientists were conscious of the importance of standardized units of measure in their research, and they recognized the need to increase the precision of the results of measurement. Although we take such precision for granted, they had to define new units of measurement previously unknown: measurements of time, temperature, pressure, and so on. Revolutionary views gradually gained ground, but only when there was a unified system of measurement could such a basic concept become an effective instrument of the scientific and technological revolution.

Centesima						
10	Decima					
100	10	Virgula				
1,000	100	10	Virga			
10,000	1,000	100	10	Decuria		
100,000	10,000	1,000	100	10	Centuria	
1,000,000	100,000	10,000	1,000	100	10	Milliare

12.3 Mouton's table of standard measurement terminology.

12.4 Frans Hals, *René Descartes*, after 1649. Oil on canvas, 30¾ × 26¾ ins (78.1 × 67.9 cm). Louvre, Paris.

12.5 Anonymous, *Sir Isaac Newton*. Trinity College, Cambridge, UK.

a metaphysical theory and complete system of nature that explained all phenomena, promised an unfailing method of discovery (Fig. **12.4**). He opposed the belief that experimental method led to knowledge, arguing instead for a purely mathematical approach in science. His insights in the field of biology serve as an illustration. For two thousand years, the question of what makes the body internally active, able to respond, to move, to speak, and so on, had been answered by "the spirits," with much elaboration on the three basic spirits of natural, vital, and animal. Descartes held that the principle of movement lay in motion, of which an unending and unchanging quantity resided in the universe. Some of the constancy of motion that Descartes found in the universe appeared obvious in the apparently perpetual motion of large bodies such as planets, but he also found it in the invisible motions of the smallest particles of matter. Thus, for

Descartes, understanding the physical make-up of the universe began with concepts about matter. His primary belief about matter was that it occupied time and space. The Descartian or *Cartesian* (kahrt-EEZH-uhn) model universe suggested that planets, being solidified minor stars, formed a closed system—original matter had changed in form, but no matter or motion had ever been added. Descartes arrived at his laws of nature *deductively*—they moved from the general to the particular, with their conclusions following necessarily from the premises. His scientific system began with the certainty of the existence of mind and of God, and then worked outward to embrace universal truths or laws of nature detectable by reason. His entire system was both rational and systematic: it aimed to provide an unchanging fabric whose relevance to particulars could be deduced by inquiry. This means that not only may one expect the universe to be rationally ordered but that this rationality may be mathematically realized. In essence, Descartes laid the foundations for an age of systematic rationalism and encapsulated it in a statement, the gist of Cartesianism: *cogito ergo sum*, "I think, therefore I am."

In his *Discourse on Method* (1637), he postulated four steps for approaching knowledge: (1) accept nothing as true unless it is self-evident; (2) split problems into manageable parts; (3) solve problems by starting with the simplest and moving to the most complex; and (4) review and re-examine the solutions.

The English mathematician Sir Isaac Newton (1642–1727) tied together the emerging scientific discoveries into a coherent whole (Fig. **12.5**). At the center of his theory lay the law of universal gravitation: every particle of matter in the universe, from planets in their orbits to falling bodies on earth, attracts every other particle of matter with a force called gravity. In his *Mathematical Principles of Natural Philosophy* (1687), Newton asserted that gravitational force varies directly with the sum of the mass of objects and inversely with the square of the distance between them. In Newton's scheme, the sun held each of its planets in its gravitational pull and each, in turn, influenced, however lightly, the sun and the other planets. Similarly, the earth interacted with its moon. The effect created a harmonious system, in which each body attracted the others.

One of the important characteristics of Newton's system lay in his refusal to speculate on why the universe operated as it did. Thus, he effectively separated science from metaphysics or theology, two areas previously intertwined with "scientific" matters. The publication of his *Principia*, the familiar title of *Mathematical Principles*, made him the world's authority, and it represented the culmination of the scientific revolution that brought the world into the modern age.

Concepts

Academicism

The concept of academicism revolves around the attempt of a government to control and arbitrate art and taste. It arose formally in the establishment of the first French Academy by Louis XIV, who, along with his minister, Colbert, believed that art played too important a role in society to be left exclusively in the hands of artists. So, Louis established an administrative organization headed by the king and a director that transmitted its standards through professors, members, and associates to students. In this way, "approved" principles, theories, and practical knowledge found their way into the general mainstream of art and culture. The organization encompassed academies of Language and Literature, Painting and Sculpture, Architecture, and Music. The king and the heads of these academies strictly controlled patronage including artistic commissions, appointments, titles, licenses, degrees, pensions, prizes, entrance to art schools, and who exhibited at the salons. Thus, the academies formed an important cultural arm of *absolutism*, which we discuss below.

Although we might find the idea of such strict control anathema to our democratic, egalitarian views, the French Academy actually succeeded quite remarkably in its time. It brought artistic dominance from Italy to France, where it remained until quite recent times, particularly in visual art and architecture.

Scientific Rationalism

The term "scientific rationalism" employs two concepts, both related. Rationalism holds to the position that reason represents a better path to knowledge than experience or observation. In essence, it has come to insist that valid knowledge, especially scientific knowledge, results from sense experience informed by rational thought, as distinct from non-rational sources such as intuition or supernatural revelation. Rationalism, as we have discussed in previous chapters, can be traced back to the ancient Greeks, but found its way into medieval scholasticism in the belief that reason and faith remain compatible. Its contemporary roots lay in the thought of Descartes, among others, in the seventeenth century. As we have noted, Descartes embraced the tools of mathematical logic as the only trustworthy means of

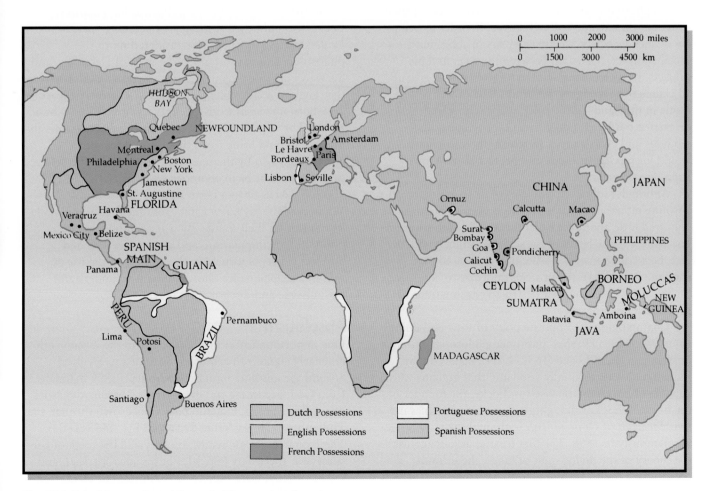

Map 12.1 Colonial possessions at the end of the seventeenth century.

understanding truth. The central pillar of rationalist thought insists that knowledge can rest on a secure foundation through *reason*.

Reason, therefore, dictates a scientific method (the first term of the concept "scientific rationalism") based on induction from empirical evidence and the experimental verification of theoretical hypotheses. Thus, any valid knowledge must result from testing and confirmation using objective methodology free from guesswork and personal or cultural biases. As we noted, Francis Bacon outlined what became the foundation for the scientific method in his *Novum Organum* in 1620.

Social Contract

Thomas Hobbes (1588–1679) attempted to synthesize a universal philosophy based on geometric design. His best-known work, *Leviathan* (1651), espoused a rather pessimistic theory of government based on the assumption that humans are driven by two forces: the fear of death, and the quest for power. Hobbes believed that unless some overarching supreme power restrained humans against these two drives, life would deteriorate into a short, ugly circumstance. His ultimate solution rested on a civil society under the rule of one man, and he thought that once humans saw the awfulness of their situation, they would willingly agree. In order to bring about such a society, the first step lay in achieving a social contract, drawn up between the ruler and his subjects. In such a contract, the subjects would give up all claims to sovereignty, while absolute power would reside in the hands of the ruler, whose commands would be carried out by all under his authority, including religious and civic leaders. In return, the sovereign would keep peace at home and protect his country from outside enemies.

Although Hobbes' formula appears to argue for an absolute monarchy, that was not necessarily his aim. He cared little about the exact form of an authoritarian government—the result of his social contract could, in fact, be a commonwealth—because he desired that enough power be vested in a central figure to contravene the negative forces and self-destructive inclinations he found in human nature.

Championing the opposite point of view and doing so in response to Hobbes' published philosophy another Englishman, John Locke (1632–1704), believed that humankind was essentially good and that humans were capable of governing themselves. Locke, the founder of the *liberal* school of thought, laid out his principles in two *Treatises of Government*, both published anonymously in 1690. The first treatise argues against the theory of the divine right of kings; the second constructs a model for popular self-government. Locke's ideal political system had a government limited by laws,

subject to the will of the people, and serving to protect life and property.

Locke shared Hobbes' view of the necessity of some form of social contract in order to counter the violent and disorderly forces inevitable in the natural state of things. However, he rejected the idea that people should abrogate their sovereignty to an absolute ruler, arguing instead that humans, reasonable by nature, should maintain their basic rights, including life and property, and enter into contracts with each other to create a limited form of government that had no other purpose than the protection of life and property. This would work, in Locke's view, because humans are, he thought, basically decent and law-abiding.

Locke would give individuals the right to choose their rulers and to expect that the rulers would govern justly. If they did not, the governed reserved the right to remove them by whatever means necessary and reclaim their natural rights. In addition, no ruler should have absolute authority. All authority should be held in check by a separation of powers and a series of balances within the government. We can, of course, recognize in Locke's thinking many of the bases of government that would emerge in the next century in the United States.

In the same year that he published his *Treatises*, Locke also published *An Essay Concerning Human Understanding* in which he considered more philosophical questions along the lines of Descartes, and his views provide a contrast with Cartesian philosophy that gives us a convenient summary. Descartes believed in an inborn universal truth—people intuitively know basic truths. The application of systematic, intellectual thought processes could bring forth these truths without corrupting them by the senses. In contrast, Locke believed that the mind at birth comprised a *tabula rasa* (TAHB-yoo-luh RAHS-uh)—a clean slate or "erased table." Whatever humans knew came from the senses and made its imprint on their minds. By using methods such as evaluation, manipulation, and so on, raw data and abstract concepts formed in the mind, and the use of reason and experience allows humans to understand the universe and discern what is real.

Absolutism

One important aspect of political life in the seventeenth and early eighteenth centuries, absolutism, revolved around the absolute monarch, who received a mandate from God, according to "divine right." Strong dynasties controlled Europe. England passed its crown through the Tudors from Henry VII to Elizabeth I (r. 1558–1603). The monarchy as an institution survived the reign of her successor, the Stuart James I, but his son Charles I, and the monarchy, were toppled by Cromwell in 1642. However, Charles II was restored in 1660, and the

country returned to continental style and elegance. This elegant opulence, perhaps the hallmark of the age, and personified in France's Louis XIV, the Sun King (r. 1643–1715), made any previous Roman Catholic encouragement of the arts look meager by comparison.

The first half of the seventeenth century saw the consolidation of secular control over religious affairs in the European states. Absolutism made it difficult to envisage a society that did not follow the religion of its sovereign and it proved politically advantageous for rulers to clothe themselves with divine right. The Protestant movements, which taught that truth and sovereignty lay in the Bible alone, continued nonetheless to defy the state Churches. In states where royal power proved strongest, dissent went underground or into asylum elsewhere, and yet, in all cases, religious dissent became a powerful force, especially in countries such as Germany, where it coupled with social, political, and economic forces.

Even where Catholicism remained as the state religion, power struggles between absolute monarchs and popes continued to rage. It seems clear that by 1650 the papacy no longer exercised authority over international affairs. During the rule of Pope Innocent X (r. 1644–55), the European states refused to comply with papal demands that no peace be made with the Protestants.

The triumph of the absolutist state over the Church best appears in France. Jean Armand du Plessis, duke of Richelieu (ree-shel-YOO), and a cardinal, held the post of chief minister to Louis XIII (r. 1610–43) from 1624 to 1642. Richelieu sought to strengthen the monarchy, and, after a bitter conflict, he succeeded in subduing the Huguenots (French Protestants) in 1628. The Peace of Alais in 1629 concluded the last of the religious wars, and deprived the Huguenots of their political and military rights, although their civil and religious rights remained protected under the Edict of Nantes (NAHNT). Thereafter, the Huguenots strongly supported the monarchy. The grip of royal absolutism continued to tighten under Cardinal Mazarin, chief minister of Louis XIV from 1643 to 1661. The upper nobility tried to break its hold, but, partially because of the refusal of the Huguenots to participate, their attempts failed. When Mazarin died in 1661 at the end of the war with Spain, Louis XIV assumed complete control of France. Armed with the spirit of "one God, one king, one faith," he took the Jesuits' advice and, in a swift reversal, initiated a program of persecuting the Huguenots. In 1685, he revoked the Edict of Nantes, thereby forcing them either to become Catholics or leave the country.

When Louis XIV came into conflict with the papacy, it looked as if he would respond by establishing a national church in France, similar to that established by Henry VIII in England. However, Louis found it to his advantage not to break with Rome, and he pulled back. Articles drawn up to limit the authority of the pope in France remained unenforced, although they continued as part of the law.

THE ARTS OF THE BAROQUE ERA
Painting

Painting in the baroque (buh-ROHK) style appealed to the emotions and to a desire for magnificence through opulent ornamentation. At the same time, it adopted systematic and rational composition in which ornamentation unified through variation on a single theme. Realism (lifelikeness using selected details) replaced beauty as the objective for painting. Color and grandeur took emphasis, as well as dramatic use of light and shade (chiaroscuro). In much of baroque art, sophisticated organizational schemes carefully subordinate and merge one part into the next to create a complex but unified whole. Open composition symbolizes the notion of an expansive universe: the viewer's eye travels off the canvas to a wider reality. The human figure, as an object or focus in painting, could be monumental in full Renaissance fashion, but it could also now be a minuscule figure in a landscape, part of, but subordinate to, a vast universe. Baroque style often exhibited intensely active compositions that emphasized feeling rather than form, and emotion rather than the intellect. Like its cousin of the nineteenth century, Romanticism, the baroque exalted intuition, inspiration, and the genius of human creativity as reactions against the rationalistic classicism of Renaissance and High Renaissance styles. Having said that, however, we must caution that baroque art was also diverse and pluralistic. Its artworks do not conform to a simple mold, as the examples that follow illustrate.

Baroque painting had a variety of applications. It glorified the Church and religious sentiment, both Catholic and Protestant; it portrayed the magnificence of secular wealth, both noble and bourgeois; and it stressed the themes of absolutism and individualism as well. Virtuosity emerged, as each artist sought to establish a personal style. But as a general phenomenon, the baroque style spread widely throughout the continent, and it was used by most European artists during the period 1600 to 1725.

In examining painting of the baroque style, we will wend our way across Europe pausing in Italy, Spain, Flanders, France, and The Netherlands and visiting the

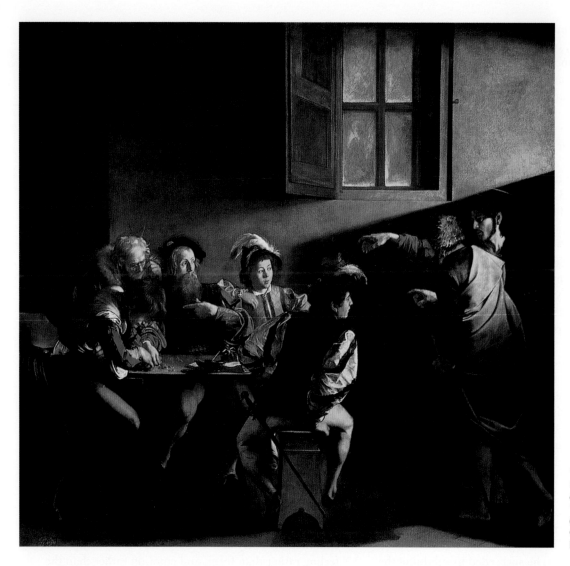

12.6 Caravaggio, *The Calling of St Matthew*, c. 1596–8. Oil on canvas, 11 ft 1 in × 11 ft 5 ins (3.38 × 3.48 m). Contarelli Chapel, San Luigi dei Francesi, Rome.

artists Caravaggio, El Greco, Rubens, Poussin, Rembrandt, Van Ruisdael, Vermeer, and Ruysch.

Italy

In Rome—the center of the early baroque—papal patronage and the spirit of the Catholic (and Counter-) Reformation brought artists together to make Rome the "most beautiful city of the entire Christian world." Caravaggio (kah-rah-VAHJ-joh; 1569–1609), probably the most significant of the Roman baroque painters, shows us in two of his works his extraordinary style, in which naturalism is carried to new heights. In *The Calling of St Matthew* (Fig. **12.6**), highlight and shadow create a dramatic portrayal of the moment when the future apostle receives divine grace. This religious subject, however, appears in contemporary terms. The painter turns away from idealized forms, and instead presents us with a mundane scene. The call from Christ streams, with dynamic chiaroscuro, across the groups of figures,

emphasized by the powerful gesture of Christ to Matthew. This painting expresses one of the central themes of Counter-Reformation belief: that faith and grace remain open to all, and that spiritual understanding consists of a personal, and overpowering, emotional experience.

We see the same emotional dynamism in *The Death of the Virgin* (Fig. **12.7**). Here again, the painter depicts real, almost common people, rather than idealized figures. The picture shows the corpse of the Virgin Mary, surrounded by the mourning disciples and friends of Christ. She appears laid out awkwardly and unceremoniously, with all the grim reality of death apparent. Her feet are left uncovered, which was considered indecent in the early seventeenth century. A curtain drapes over the entire scene, as if to frame it like a theatrical setting. As in *The Calling of St Matthew*, a harsh light streams across the tableau, emphasizing the figure of the Virgin and creating dynamic broken patterns of light and shade.

and framed within the composition, as was usual in the High Renaissance, here the frame cuts the picture. The emotional disturbance this suggests further heightens the attenuated form of St Jerome himself.

El Greco's predominantly monochromatic shades of red-brown in this painting belong to the "warm" end of the color spectrum. However, his characteristic use of strongly highlighted forms—the highlight is pure white, as opposed to a higher value of the base hue—sharpens the contrasts, and this, too, intensifies the emotional tone of the work. The obvious brushwork in many places encourages the viewer to look beneath the surface reality of the painting into a special truth within.

Flanders

The term "aristocratic baroque" describes art generally in the baroque style that reflected the visions and purposes of an aristocracy that at this time had become

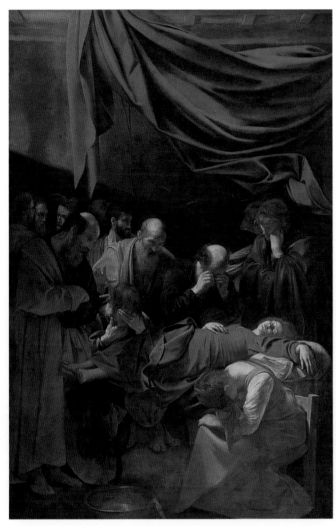

12.7 Caravaggio, *The Death of the Virgin*, 1605–06. Oil on canvas, 12 ft 1 in × 8 ft ½ in (3.69 × 2.45 m). Louvre, Paris.

Caravaggio had frequent conflicts with the Church, and, in the case of *The Death of the Virgin*, the Roman parish of Santa Maria del Popolo rejected the finished painting. The duke of Mantua subsequently purchased the work, on the advice of Peter Paul Rubens (see p. 382), his court painter. Before Caravaggio's controversial painting left Rome, however, it went on public display for a week so that all Rome could see it.

Spain

Although sometimes identified with Mannerism, El Greco (el GREHK-oh; 1541–1614), a Spanish painter born in Crete (hence the name El Greco, "the Greek"), exemplified the intense, inward-looking subjectivity and mysticism of the Counter-Reformation. In his *St Jerome* (Fig. **12.8**), space seems compressed. Forms pile on top of each other in two-dimensional, as opposed to deep, space. Rather than having the subject complete

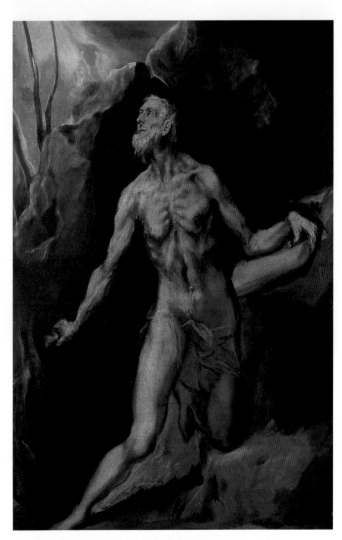

12.8 El Greco (Domenikos Theotokopoulos), *St Jerome*, c. 1610–14. Oil on canvas, 5 ft 6¼ ins × 3 ft 7½ ins (1.68 × 1.11 m). National Gallery of Art, Washington D.C. (Chester Dale Collection).

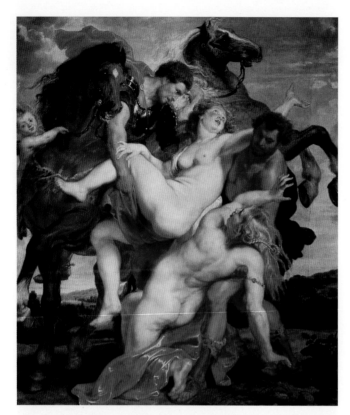

12.9 Peter Paul Rubens, *Rape of the Daughters of Leucippus*, c. 1648. Oil on canvas, 7 ft 3 ins × 6 ft 10 ins (2.21 × 2.08 m). Alte Pinakothek, Munich.

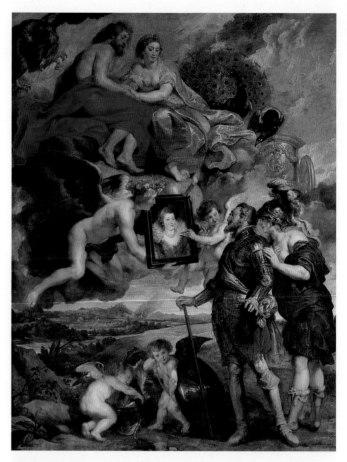

12.10 Peter Paul Rubens, *Henry IV Receiving the Portrait of Maria de' Medici*, 1622–5. Oil on canvas, 13 ft × 9 ft 8 ins (3.96 × 2.95 m). Louvre, Paris.

increasingly aware that its power was threatened by the growing bourgeoisie or middle class.

Peter Paul Rubens (ROO-behns; 1577–1640) is noted for his vast, overwhelming paintings and fleshy female nudes (Fig. **12.9**). In 1621–5 he painted a series of works as a commission from Maria de' Medici, widow of the French King Henry IV and regent during the minority of her son Louis XIII. *Henry IV Receiving the Portrait of Maria de' Medici* (Fig. **12.10**), one of twenty-one canvases, gives an allegorized version of the queen's life. In this painting, we see Rubens' ornate, curvilinear composition, lively action, and complex color. Rich in detail, each finely rendered part is subordinate to the whole. Typical of Rubens, the corpulent cupids (*putti*; poot-tee) and female flesh have a sense of softness and warmth that we find in the work of few other artists, and the warm colors have deep, rich blues pulled throughout the picture. The composition sweeps from upper left to lower right, circling around the rectangular frame of Maria's portrait at the juncture of the vertical, horizontal, and diagonal axes. A strong contrast enhances dynamics between lights and darks, and between lively and more subdued tones. The painting seems to swirl before our eyes, and Rubens leads the eye around the painting, even occasionally escaping the frame altogether. Nevertheless,

Rubens' sophisticated composition, beneath all this complexity, holds the base of the painting solidly in place and leads the eye to the smiling face of its subject. The overall effect of this painting, its richness, glamor, and optimism, appeals directly to the emotions rather than to the intellect.

The classical allegory of the painting has the aging king, whose helmet and shield are being stolen by the cupids, advised by the mythical Minerva to accept the Florentine princess as his second bride. Mercury presents Maria's portrait, and Juno and Jupiter look on approvingly. The painting depicts happy promises of divine intervention, radiant health, and grandeur.

Rubens produced works at a great rate, primarily because he virtually ran a painting factory, with numerous artists and apprentices assisting in his work. He priced his paintings on the basis of their size and according to how much actual work he did on them personally. Nevertheless, his unique style emerges from every painting, and even an observer untrained in art history can recognize his works. Clearly, artistic value here lies in the conception, not merely in the handiwork.

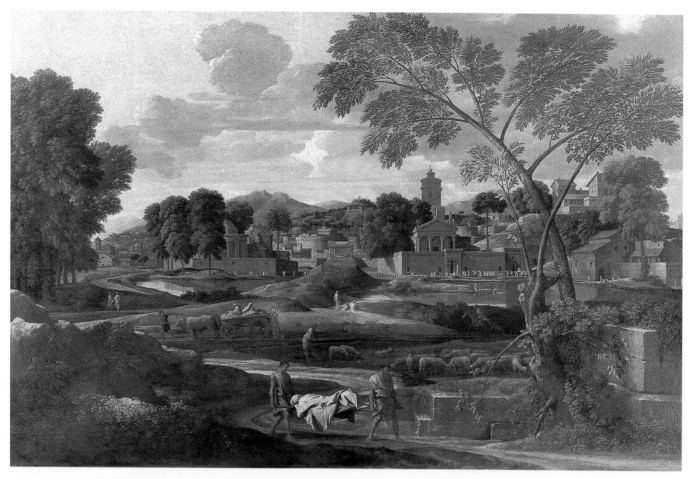

12.11 Nicolas Poussin, *Landscape with the Burial of Phocion*, 1648. Oil on canvas, 3 ft 11 ins × 5 ft 10 ins (1.2 × 1.78 m). Louvre, Paris.

France

Nicolas Poussin (poo-SAHN; 1593–1663) often chose his subjects from the literature of antiquity. In *Landscape with the Burial of Phocion* (Fig. **12.11**), he takes a theme from Plutarch's story (see p. 136) about an ancient Athenian hero wrongly put to death but then given a state funeral. In the foreground, we see the hero's corpse carried away, having been denied burial on Athenian soil. Poussin gives the white-shrouded corpse centre stage in the scene, but it seems almost insignificant in the total vista.

The landscape overpowers the human forms here. Isolated at the bottom of the picture, perhaps symbolizing his isolation and rejection in the story, the hero seems a very minor focus. Instead, the eye of the viewer moves up and into the background, an overwhelming stretch of deep space, depicted with intricate and graphic clarity as far as the eye can see. Poussin uses no atmospheric perspective here. The objects farthest away appear as clearly depicted as those in the **foreground**. The various planes of the composition lead the viewer methodically from side to side, working toward the background one plane at a time. The composition, rich in human, natural, and architectural details, pleases the eye.

Although the *Landscape with the Burial of Phocion* seems more subdued than Rubens' work, in every way the details in this painting appear no less complex. The scheme consists of systematically interrelated pieces, in typically rational baroque fashion. Also typical of the baroque, strong highlight plays against strong shadow. Although the picture does not represent a real place, Poussin has depicted the architecture very precisely. He studied Vitruvius, the Roman architectural historian, and Vitruvius' accounts form the source of this detail.

The Netherlands

Art in the bourgeois baroque style reflected the visions and objectives of the new and wealthy middle class. The wealth and opulent lifestyle of the bourgeoisie sometimes exceeded that of the aristocracy, resulting in a power struggle.

Born in Leiden, Rembrandt van Rijn (REM-brant fahn RYN; 1606–69) trained under local artists and then moved to Amsterdam. His early and rapid success gained

MASTERWORK

REMBRANDT—*THE NIGHT WATCH*

The huge canvas now in the Rijksmuseum in Amsterdam represents only a portion of the original group portrait *The Night Watch* (Fig. **12.12**), cut down in the eighteenth century to fit into a space in Amsterdam Town Hall. So it happens that it no longer shows the bridge over which the members of the watch were about to cross.

Group portraits, especially of military units, were popular at the time. Usually the company posed in a social setting, such as a gathering around a banquet table, but Rembrandt chose to break with the norm and portrayed the company, led by Captain Cocq, as if it were out on duty. The resulting scene shows great vigor and dramatic intensity, true to the baroque spirit.

As a dramatic scene, the painting plays a virtuoso performance of baroque lighting and movement. Nothing regular or mechanical occurs in it. Rembrandt presents a celebration of chaos, symbolic of a free people. Some of the figures fade into the shadows. Others stand hidden by the gestures of those placed in front of them.

Cleaning the work revealed the vivid color of the original. The painting now appears a good deal brighter than when it was named in the nineteenth century. Yet its dramatic highlights and shadows reflect no natural light source whatsoever, and no analysis of the light reveals the source of illumination in the painting. Some experts suggest that perhaps the painting depicts a "day watch," with the intense light at the center of the work being morning sunlight. An examination of the highlights and shadows in the painting, however, shows that Rembrandt used light for dramatic purposes only. While the figures appear realistically, no such claim can be made for the light sources.

Rembrandt's genius lay in depicting human emotions and characters. He suggests detail without including it, and we find him taking this approach in *The Night Watch*. Here he concentrates on atmosphere and implication. As in most baroque art, the artist invites the viewer to share in an emotional experience, to enter in, rather than to observe.

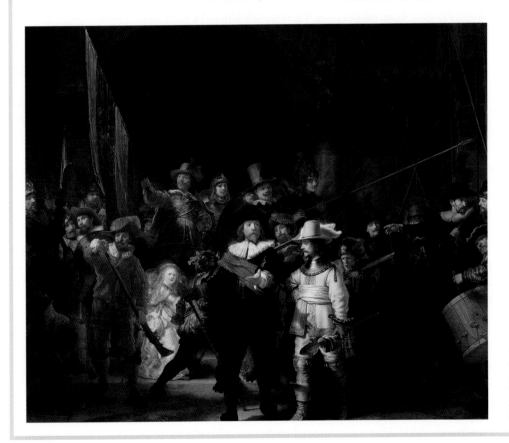

12.12 Rembrandt van Rijn, *The Night Watch* (*The Company of Captain Frans Banning Cocq*), 1642. Oil on canvas, 12 ft 2 ins × 14 ft 7 ins (3.7 × 4.45 m). Rijksmuseum, Amsterdam.

him many commissions and students—more, in fact, than he could handle. In contrast to the work of Rubens, Rembrandt's art is by, for, and about the middle class. Indeed, Rembrandt became what we could call the first "capitalist" artist. The quality of art could be gauged, he believed, not only on its own merits but also by its value on the open market. He reportedly spent huge sums of money buying his own works in order to increase their value.

Rembrandt's genius lay in delivering the depths of human emotion and psychology in the most dramatic terms. Unlike Rubens, for example, Rembrandt uses suggestion rather than great detail. After all, the human spirit is intangible—it can never be portrayed, only

alluded to. Thus in Rembrandt's work we find atmosphere, shadow, and implication creating emotion.

The deposition scene *The Descent from the Cross* (Fig. **12.13**) has a certain sense of richness. (Once thought to be by Rembrandt himself, it is now believed to be by a member of his workshop.) The artist uses only reds, golds, and red-browns except for the robe of the figure pressing into Christ's body. Contrasts emerge and forms are revealed through changes in value. The work uses open composition—lines escape the frame at the left arm of the cross and in the half-forms at the lower right border. The horizontal line of the darkened sky subtly carries off the canvas, middle right. A strong central

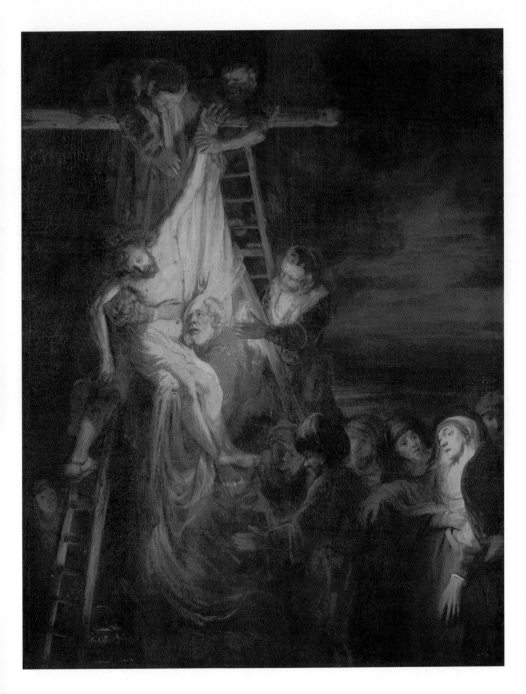

12.13 Workshop of Rembrandt van Rijn, *The Descent from the Cross*, c. 1652. Oil on canvas. 4 ft 8¼ ins × 3 ft 7¾ ins (1.43 × 1.11 m). National Gallery of Art, Washington D.C. (Widener Collection).

385

12.14 Jacob van Ruisdael, *The Jewish Cemetery*, c. 1655. Oil on canvas, 4 ft 8 ins × 6 ft 2¼ ins (1.42 × 1.89 m). Detroit Institute of Arts (Gift of Julius H. Haass, in memory of his brother Dr Ernest W. Haass).

triangle holds the composition together. From a dark, shadowed base, the artist delineates the triangle by the highlighted figure on the lower right and the ladder at the lower left. Christ's upstretched arm completes the apex of the triangle.

Rembrandt's emotional subject matter probably proved hard for most collectors to cope with. More to the taste of the new, general marketplace were the subjects of the emerging landscape painters. *The Jewish Cemetery* (Fig. **12.14**), a painting by Jacob van Ruisdael (RYZ-dahl, ROWS-dahl; 1628–82), appeals to the emotions with its rich detail and atmosphere, light and shade, and grandiose scale.

The large painting, nearly 5 feet (1.5 meters) high and more than 6 feet (1.8 meters) wide, depicts a graveyard, along with the medieval ruins, that casts a melancholy spell over the work. The absence of human life in the

painting, in a statement similar to Poussin's de-emphasis on Phocion, suggests its insignificance in the universe. The ruins suggest that even the traces of human presence shall also pass away. Highlight and shadow lead the eye around the composition, but not in any consecutive way. The eye's path is broken, or at least disturbed, by changes of direction, for example, in the tree trunk across the stream and in the stark tree limbs. Nature broods over both the scene and the wider universe outside the frame.

Virtually forgotten until the nineteenth century, Jan Vermeer (vuhr-MIHR; 1632–75), like Rembrandt, probed great depths of feeling in his works with masterful control of light and shade. His painting *The Girl with a Red Hat* (Fig. **12.15**) not only creates plasticity—three-dimensionality—but also heightens the dramatic effect of a rather simple subject. Vermeer takes chiaroscuro

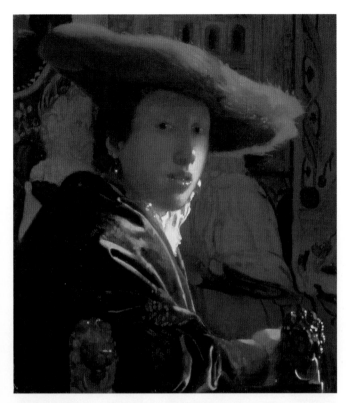

12.15 Jan Vermeer, The *Girl with a Red Hat*, c. 1665 (detail). Oil on panel, 9⅛ × 7⅛ ins (23 × 18 cm). National Gallery of Art, Washington D.C. (Andrew W. Mellon Collection).

12.16 Rachel Ruysch. *Flower Still Life*, after 1700. Oil on canvas, 29⅞ × 23⅞ ins (75.6 × 60.6 cm). Toledo Museum of Art, Ohio.

(Italian for "light and shade") and develops strong emotional and compositional value contrasts. The highlights, falling as they do, establish a basic compositional triangle extending from shoulder to cheek, down to the hand, and then across the sleeve and back to the shoulder. A dynamic flare of red encircles the subject's face with a feathery nimbus (halo) that draws our attention, surprisingly, not to the red hat, but to the eyes and liquid, half-opened mouth: as if she were about to speak to us.

The Dutch had a long tradition of flower painting, and this tradition reached its apex in the long career of Rachel Ruysch (rysh; 1663–1750). In *Flower Still Life* (Fig. **12.16**) she uses stunning color harmonies and value contrasts as well as subtle tones to create an active asymmetrical composition that sweeps diagonally across the canvas. Each tiny piece of the picture, whether vase, table, flower petal, or stem, holds a variety of sensual appeals and draws the eye for further investigation, and yet each of these parts sublimates to the overall grand design of the painting: a practice we continually see in baroque art. In Dutch flower painting, the artists almost never presented straightforward depictions. Rather, they made color sketches and studied scientifically accurate color illustrations in botanical publications. From

sketches and notebooks artists like Ruysch composed still lifes that utilized a variety of flowers that could never bloom at the same time. Further, in the fifteenth century flowers had great religious symbolism, particularly with regard to the Virgin Mary. Perhaps less specifically symbolic, baroque flower painting used the short blooming life of flowers as a symbol for the fleeting nature of beauty and human life.

Sculpture

The splendor of Counter-Reformation baroque was particularly apparent in sculpture. Forms and space exploded with an energy that carried beyond the confines of the work. As in painting, sculpture directed the viewer's vision inward and invited participation rather than neutral observation. Feeling created the focus. Baroque sculpture tended to treat space pictorially, almost like a painting, to describe action scenes rather than single sculptural forms. To see this, we turn first to the work of Gian Lorenzo Bernini (jahn lohr-EHN-zoh buhr-NEEN-ee; 1598–1680).

12.17 (*below*) Gian Lorenzo Bernini, *David*, 1623. Marble, 5 ft 7 ins (1.70 m) high. Galleria Borghese, Rome.

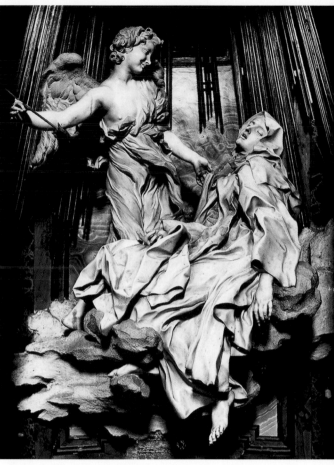

12.18 (*above*) Gian Lorenzo Bernini, *The Ecstasy of St Theresa*, 1645–52. Marble, about 11 ft 6 ins (3.5 m) high. Cornaro Chapel, Santa Maria della Vittoria, Rome.

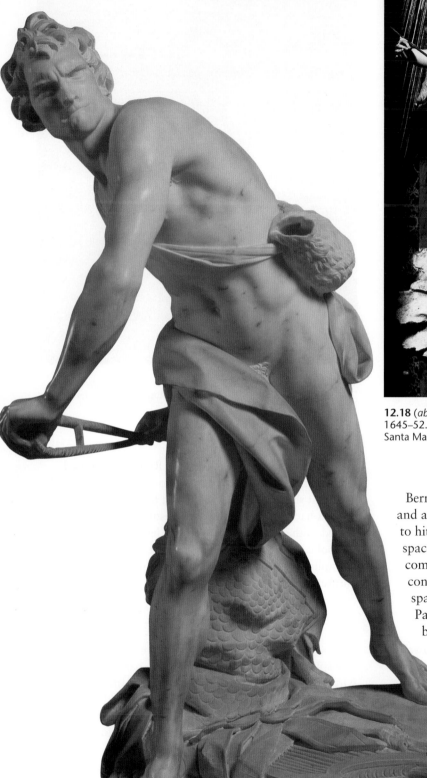

Bernini's *David* (Fig. **12.17**) exudes a sense of power and action as he curls to unleash the stone from his sling to hit Goliath, lurking somewhere outside the statue's space. This represents a new type of sculptural composition. Rather than having a sense of self-containment, this work forcefully intrudes into the space of the viewer. Made for the nephew of Pope Paul V, the sculpture is based on the athletic figures by Carracci on the ceiling of the Palazzo Farnese in Rome. Our eyes sweep upward along a diagonally curved line, propelled outward in the direction of David's concentrated expression. Repetition of the curving lines carries movement throughout the work. The viewer participates emotionally, feels the drama, and responds to the sensuous contours of the fully articulated muscles. Bernini's David seems to flex and contract in the moment of action, rather than expressing the pent-up energy of Michelangelo's giant-slayer (see Fig. **10.23**).

The Ecstasy of St Theresa (Fig. **12.18**), a fully developed "painting" in sculptural form, represents an experience described by St Theresa, one of the saints of the Counter-Reformation, of an angel piercing her heart with a golden flaming arrow: "The pain was so great that I screamed aloud; but at the same time I felt such infinite sweetness that I wished the pain to last forever." Accentuated by golden rays, the figure embodies St Theresa's ecstasy. Typical of baroque sculptural design, the lines of the draperies swirl diagonally, creating circular movement. Each element slips into the next in an unbroken chain, and every aspect of the work suggests motion. Figures float upward and draperies billow from an imaginary wind. Deep recesses and contours establish strong highlights and shadows, which further heighten the drama. The "picture" forces the viewer's involvement in an overwhelming emotional and religious experience. Bernini's Baldacchino (bahl-dah-KEEN-oh) and the interior of St Peter's Cathedral also illustrate the ornate and complex forms of the Counter-Reformation baroque style (see Fig. **12.1**).

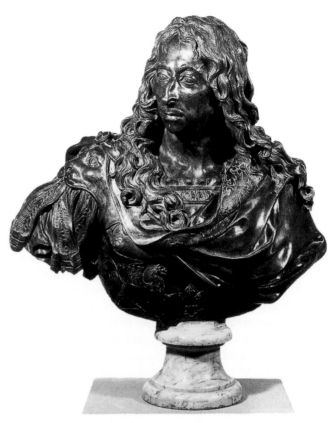

12.19 Antoine Coysevox, *The Great Condé*, 1688. Bronze, 23 ins (58.4 cm) high. Louvre, Paris.

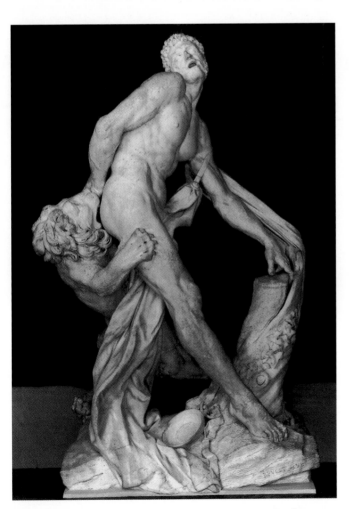

12.20 Pierre Puget, *Milo of Crotona*, 1671–83. Marble, 8 ft 10½ ins (2.71 m) high. Louvre, Paris.

Pierre Puget's (pue-ZHAY; 1620–94) *Milo of Crotona* (Fig. **12.20**) seems possessed by its own physical strength. The statue depicts Milo, the Olympic wrestling champion, who challenged the god Apollo. His punishment for daring to challenge the gods was death. The powerful hero, with his hand caught in a split treestump, appears to scream helplessly while mauled by a lion. Neither classical idealism nor reason has any part in this portrayal—it portrays pure physical pain and torment. The figure twists, caught in the violent agonies of pain and imminent death. The skin, about to tear under the pressure of the lion's claws—in an instant will split open. The sweeping and intersecting arcs of the composition create intense energy of a kind that recalls the Laocoön group (see Fig. **3.18**).

Portrait busts of the period, such as those by the French sculptor Antoine Coysevox (kwahz-VOH; 1640–1720), also attempt an emotional portrayal of their subjects. *The Great Condé* (Fig. **12.19**) uses dynamic line and strong and emphatic features to express the energy of the sitter. What, at first glance, appears to be a portrait turns on deeper analysis into an intricate swirling of action unified by a repetition of curvilinearity that sweeps in widening circles around the face, whose intensity and contrasting texture draw the eye.

Architecture

The baroque style in architecture emphasized the same contrasts between light and shade and the same action, emotion, opulence, and ornamentation as the other visual arts of the period. Because of its scale, however, the result created dramatic spectacle. Giacomo della Porta (JAH-koh-moh dehl-lah-POHR-tah; 1540–1602; Figs 12.21 and 12.23) designed the Church of Il Gesù (eel jay-ZOO), the mother church of the Jesuit order, founded in 1534. It had a profound influence on later church architecture, especially in Latin America. This church truly represents the spirit of the Counter-Reformation. Il Gesù, a compact basilica, eliminates side aisles, literally forcing the congregation into a large, hall-like space directly in view of the altar. Della Porta's façade (Fig. 12.21) boldly repeats its row of double **pilasters** on a smaller scale at the second level. Scroll-shaped buttresses create the transition from the wider first level to the crowning pediment of the second. The design reflects the influences of Alberti, Palladio, and Michelangelo, but it remains unique in its skillful synthesis of these influences.

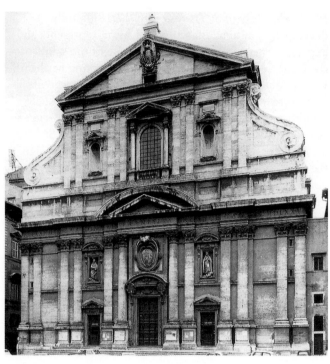

12.21 Giacomo della Porta, west front of Il Gesù, Rome, 1568–84.

A DYNAMIC WORLD

THE TAJ MAHAL

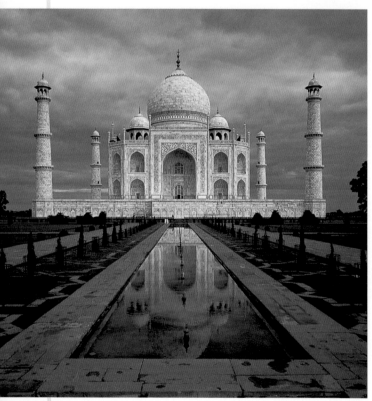

Like Louis XIV, the Islamic Mughal (moo-GAHL) emperors of India were patrons of architecture, and the most famous of all Indian architectural accomplishments also qualifies as an example of splendid aristocratic art—the Taj Mahal at Agra (Fig. 12.22). However, the Taj Mahal blends Islamic and indigenous Indian styles. The tomb, built by Shah Jahan as a mausoleum for his favorite wife, Mumtaz Mahal (1593–1631), was entirely without precedent in Islam, and it is possible that the building also was intended as an allegory of the day of Resurrection, for the building is a symbolic replica of the throne of God. Four intersecting waterways in the garden by which one approaches the Taj symbolized the four flowing Rivers of Paradise as described in the Qur'an. The scale of the building is immense, yet the details are exquisitely refined, and the proportions are well balanced and symmetrical. The effect of this huge, white octagonal structure with its impressive dome and flanking minarets is nothing short of breathtaking.

12.22 Ustad Ahmad Lahori (architect), the Taj Mahal, Agra, India, 1632–48.

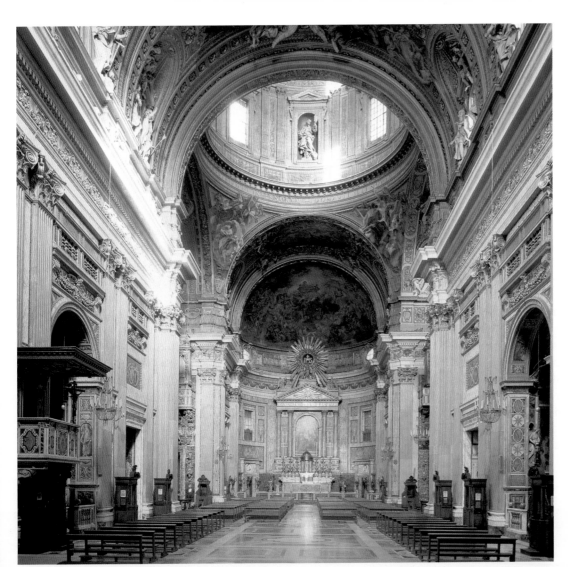

Probably no monarch better personified the baroque era than Louis XIV, and probably no work of art better represents the magnificence and grandeur of the aristocratic baroque style than the grand design of the Palace of Versailles (vair-SY), along with its sculpture and grounds. The great Versailles complex grew from the modest hunting lodge of Louis XIII into the grand palace of the Sun King over a number of years, involving several architects.

The Versailles château, rebuilt in 1631 by Philibert Le Roy (luh WAH), had its façade decorated by Louis Le Vau (luh VOH; 1612–70) with bricks and stone, sculpture, wrought iron, and gilt lead. In 1668 Louis XIV ordered Le Vau to enlarge the building by enclosing it in a stone envelope containing the king's and queen's apartments (Fig. **12.24**). The city side of the château thus retains the spirit of Louis XIII, while the park side reflects classical influence. François d'Orbay (dohr-BAY) and, later, Jules Hardouin-Mansart (ar-DWAN mahn-ZAHR; 1646–1708) expanded the château into a palace whose west façade extends over 2,000 feet (610 meters)

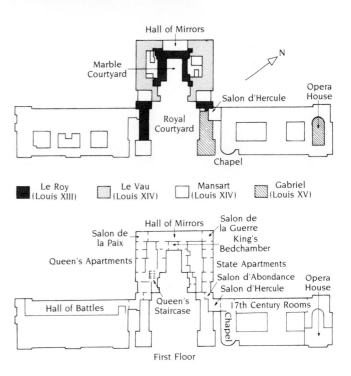

12.24 Plans of the Palace of Versailles, France, 1669–85.

(Fig. **12.25**). The palace became Louis XIV's permanent residence in 1682. French royalty stood at the height of its power, and Versailles symbolized the monarchy and the divine right of kings. As a symbol and in practical fact, Versailles played a fundamental role in keeping France stable. Its symbolism as a magnificent testament to royal centrality and to France's sense of nationalism seems fairly obvious. As a practical device, Versailles served the purpose of pulling the aristocracy out of Paris, where they could foment discontent, and isolated them where Louis XIV could keep his eye on them and keep them busy. Versailles further served as a giant economic engine to develop and export French taste and the French luxury trades.

As much care, elegance, and precision were employed on the interior as on the exterior. With the aim of supporting French craftsmen and merchants, Louis XIV had his court live in unparalleled luxury. He also decided to put permanent furnishings in his château, something previously unheard of, resulting in a fantastically rich and beautiful interior. Royal workshops produced mirrors (Fig. **12.26**), tapestries, and brocades of the highest quality, and these goods became highly sought after all over Europe. Le Brun (1619–90) coordinated all the decoration and furnishing of the royal residences, and supervised everything for the state apartments, such as the statues, the painted ceilings, and the silver pieces of furniture.

The apartments of the palace boast a splendor and wealth previously unseen. Each room was dedicated to one of the planetary gods. In one of the apartments, the Salon d'Abondance, we find a typically ostentatious and metaphor-laden exploration. For example, the ceiling shows an allegorical figure of Magnificence, whose scepter and cornucopia symbolize the royal prerogatives of power and provision. Around Magnificence appear Immortality and the Fine Arts, symbolized by a winged figure.

The grounds of Versailles (Figs **12.27** and **12.28**) teem with fountains and statues. The magnificent Fountain of Apollo by Tuby (too-BEE; Fig. **12.28**), which sits astride the east-west axis of the grounds, was originally covered with gold. The sculpture, executed from a drawing by Le Brun and inspired by a painting by Albani, continues the allegorical glorification of *Le Roi Soleil* (luh WAH soh-LAY), representing the break of day, as the sun-god rises in his chariot from the waters. Apollo represented the perfect symbol for the Sun King,

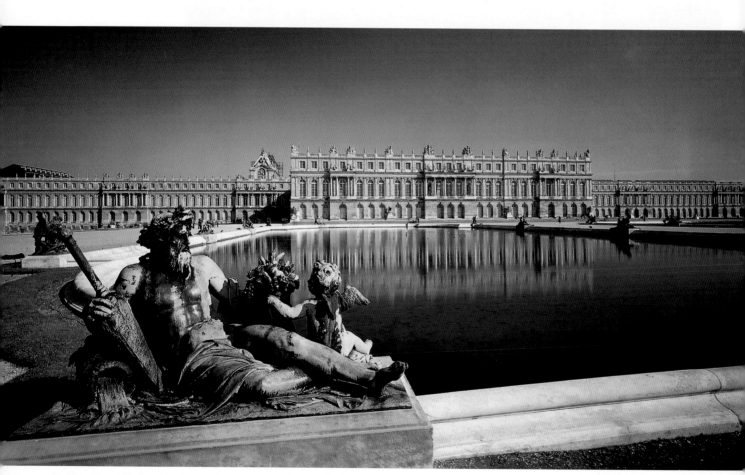

12.25 Louis Le Vau and Jules Hardouin-Mansart, garden façade. Palace of Versailles, 1669–85.

12.26 Jules Hardouin-Mansart and
Charles Le Brun, Hall of Mirrors,
Palace of Versailles, begun 1678.

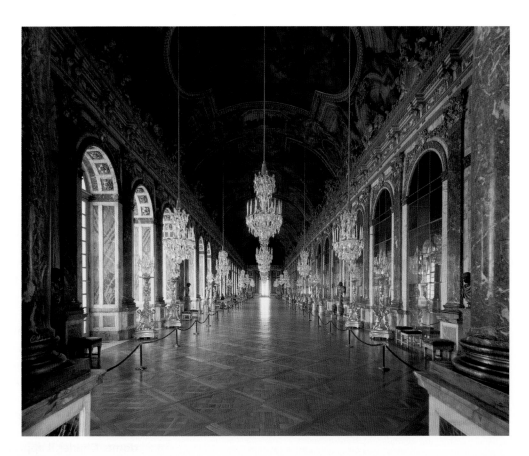

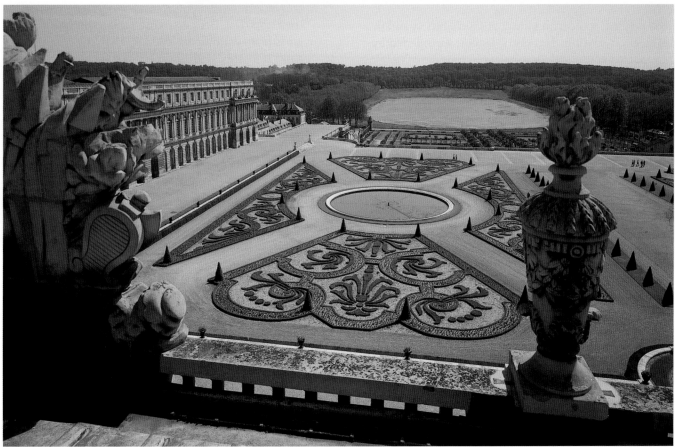

12.27 The Parterre du Midi, Palace of Versailles.

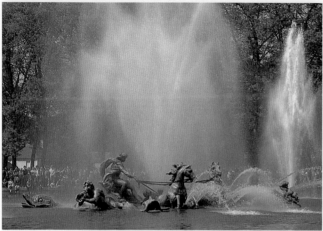

12.28 The Fountain of Apollo, Palace of Versailles.

who reigned, some maintained, at God's behest and in his stead, in glorious baroque splendor, surrounded by rational yet emotional art, opulent in tone, and complex in design.

The baroque influence of the court of Louis XIV came to England with the Restoration of Charles II in 1660. Over the next fifty years, London witnessed numerous significant building projects directed by its most notable architect, Christopher Wren (rehn; 1632–1723). Two of these projects, St Paul's Cathedral and Hampton Court, illustrate the intricate but restrained complexity of English baroque style. The impact of Wren's genius, obvious in his designs, reflects in an inscription in St Paul's: "If you seek a monument, look around you." On a smaller scale than St Paul's but equally expressive of the English baroque is Wren's garden façade for Hampton Court Palace (Fig. 12.32). His additions to this Tudor building, built by Cardinal Wolsey (WOHL-zee) in the sixteenth century, sought to make it a rival of Louis XIV's Palace of Versailles. In comparing the two, we conclude that the English approach to the style yields a more restrained result. The seemingly straightforward overall design of this façade, commissioned in 1689, during the reign of William and Mary, actually contains a sophisticated interrelationship of merging patterns and details. Wren uses clean lines and his silhouette lacks the visual interruption of statuary present in the Versailles

MASTERWORK

WREN—ST PAUL'S CATHEDRAL

Christopher Wren was invited to restore old St Paul's Cathedral, a Gothic structure to which Wren intended to affix a mighty dome, before the Great Fire of London. After the fire, however, only a small part of the nave remained, and even Wren's genius could not save the old church. Wren, surveyor-general of London and responsible for the cathedral as well as the king's palaces and other government properties, set about the task of designing a new St Paul's (Figs 12.29, 12.30, and 12.31).

The authorities rejected Wren's first plan outright as too untraditional. For example, it had no aisles to the choir, or eastern arm, and no proper nave. Wren had attempted in this first design to come up with a cathedral which would be inexpensive and yet handsome, but the authorities insisted that the country's prestige lay at stake and that no expense should be spared. A second, more ambitious design followed a classical pattern, crowned with a huge dome. Charles II approved this plan but the church commissioners did not. A third design barely gained their approval. Here Wren used the traditional Latin cross plan, with the nave longer than the choir, two short transepts, and a dome and spire atop the crossing (Fig. 12.31).

Once approved, with allowances for "modifications," the entire project ground to a halt because of the difficulty of demolishing the pillars of the old church. After unsuccessful attempts to blast them down with gunpowder, Wren finally resorted to the battering ram technique used against castles in the Middle Ages.

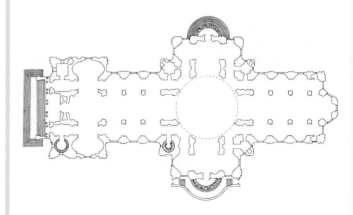

12.29 Plan of St Paul's Cathedral, London.

Renaissance geometric design and Greek and Roman detail all mark the cathedral. The drum of the dome echoes Bramante's Tempietto (see Fig. **10.25**) in the arrangement of its columns, and reflects Michelangelo's St Peter's in its verticality. The exterior façade has a subtle elegance, with ornate detail. The many imitations of Wren's design attest to its genius. The interior, as in all of Wren's designs, emphasizes linear, structural elements such as arches, frames, and circles. Somewhat cold in comparison with baroque churches of the continent, St Paul's Anglican heritage clearly refuses extensive ornamentation and gilding. The nave has a strong sense of movement that draws the worshipper forward toward the high altar. At the very center of the cathedral (the Crossing) the eye rises to the underside of the great dome, decorated with monochrome paintings by Sir James Thornhill depicting the life of St Paul. Wren opposed the decision to paint the dome. He wanted it decorated with brilliant mosaic like St Peter's in Rome.

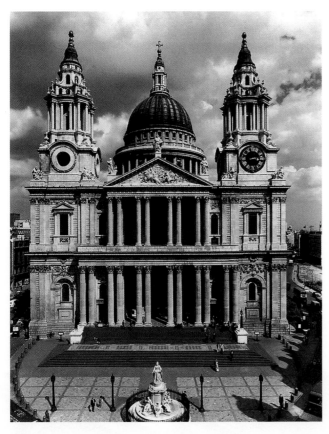

12.30 Christopher Wren, St Paul's Cathedral, London, 1675–1710. Façade.

After a day of "relentless battering," the old church succumbed, and in November 1673 work began on the new building.

The new cathedral has an overall length of 515 feet (157 meters) and a width of 248 feet (76 meters). Its dome measures 112 feet (34 meters) in diameter and stands 365 feet (111 meters) tall at the top of the cross. The lantern and cross alone weigh 700 tons while the dome and its superstructure weigh 64,000 tons. Like the architects of the Pantheon and St Peter's in Rome (see Figs **4.21** and **10.28**), Wren faced seemingly endless problems with supporting the tremendous load of the dome. In an ingenious solution he constructed the dome of nothing more than a timber shell covered in lead, supported by a brick cone. This lightened the weight of the dome to a fraction of what it would have been and allowed Wren to create a wonderful silhouette on the outside, while an inner dome gave the correct proportion to the interior (Fig. **12.31**). It was a solution never before used.

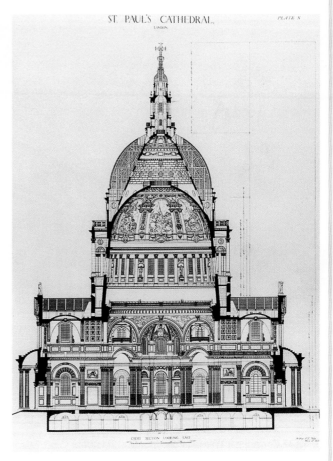

12.31 Christopher Wren, St Paul's Cathedral, London, 1675–1710. Cross-section looking east.

PROFILE

SIR CHRISTOPHER WREN (1632–1723)

Sir Christopher Wren, a child prodigy in mathematics and natural science, had earned a master's degree from Oxford and spent three years studying and researching astronomy by age twenty-one. He spent the years from 1657 to 1673 as professor of astronomy, first at Gresham College, London, and then at Oxford.

His first architectural designs came in 1663, when he designed the chapel at Pembroke College, Cambridge, and the Sheldonian Theatre, Oxford. In the same year, he was appointed to advise on the repair of old St Paul's Cathedral (see Masterwork, p. 394). Essentially self-taught as an architect, he used a nine-month visit to France in 1665–6 as a sabbatical for future architectural preparation. The Great Fire of London in 1666 left not only St Paul's Cathedral available for his talents but also destroyed three-fourths of London, and he responded to the challenge with an

extensive plan for rebuilding the City—the central, one-square-mile heart of contemporary London. He was appointed as surveyor-general of works for the City, and, although his plan for rebuilding the City was not accepted, he was put in charge of all royal and governmental building in England. He either drew up or authorized plans for rebuilding fifty-two London churches. The major project was, of course, the rebuilding of St Paul's Cathedral, from 1673 to 1710. He also designed the palaces at Winchester and Kensington and oversaw the rebuilding of Hampton Court (Fig. 12.32). His style finds its roots in the Italian Renaissance and reflects the classical restraint that characterizes English baroque style and separates it from the more flamboyant baroque of the European continent.

Knighted in 1673, Wren also served as a member of Parliament in 1685–7 and 1701–2.

12.32 Christopher Wren, garden façade of Hampton Court Palace, UK, c. 1690.

palace. Line, repetition, and balance in this façade not only create a pleasing impression, they also form a perceptual exercise using decorative devices to combine groupings of windows into subgroups. For example, the seven windows of the central portion of the façade—the center window capped by a pedimented cornice and the three windows flanking it—subdivide into two groups of three by use of the circular windows and the decorative designs above the single windows flanking the central window. Wren chose red brick to harmonize with the original palace, while contrasting dressed stone emphasizes the central features of the façade and creates richness and variety. Wren's use of circular windows—an unusual touch—probably reflects French influence.

Theatre

Between the years 1550 and 1720, France developed a significant theatrical tradition that scholars have called "French neoclassicism." (Remember that labels sometimes seem contradictory. French neoclassicism in the theatre relates, especially in its later years, to the baroque style in music and visual art. The labels "classicism" and "neoclassicism" also describe later developments in both music and the visual arts, and we must keep all this straight.)

We have already noted in the previous chapter the support that Francis I gave to Renaissance ideas. Despite this, French theatre remained essentially medieval until after he died in 1547. In 1548, however, a strange combination of Protestant and Catholic attitudes resulted in the legal suppression of all religious drama. Freed from its religious competition, secular drama turned to Renaissance classicism. The French also rediscovered Sophocles, Euripides, Aristophanes, and Menander, and this return to the ancients fostered specific academic rules for "acceptable" drama. In the French theatre, plays had to fit a structural and spatial mold called, after Aristotle's formula, "the Unities." The spirit of classical drama now evaporated as its substance was forced into artificial confines of time and space. The academies found no play acceptable unless it conformed to two specific rules: the action had to occur in a single location and to encompass no more than twenty-four hours. Had French antiquarians studied classical Greek dramas, of course, they would have discovered many violations of the Unities. Perhaps as a result of this rulemaking, little French tragedy of consequence occurred during the period of England's great dramatic achievement. But, as in Italy and England, this era produced rich scenic invention and extravagant productions.

Pierre Corneille (kohr-NAY; 1606–84) managed to conform somewhat to these arbitrary and misinterpreted conventions and yet write great plays. In 1635 he produced a masterpiece, *Le Cid* (luh SEED). His characterizations were original, his themes grand and heroic, and his language richly poetic. However, he violated the Unities, and Cardinal Richelieu, France's official arbiter of taste, and the subservient Académie Française, condemned the play. Corneille continued to write, and his late work served as a vehicle for imported Italian scenery and stage machinery. The form and quality of Corneille's tragedies strongly influenced a second important playwright of this era, Jean Racine (rah-SEEN; 1639–99). *Phèdre* (FED-ruh), perhaps his best work, illustrates the tragic intensity, powerful but controlled emotion, compressed poetry, subtle psychology, and carefully developed plots that mark the best examples of French neoclassical drama.

Molière (1622–73) provided a comic counterpoint to the great achievements of the French tragedians. Early in his career he joined a professional company, a family of actors named Béjart. His earliest productions took place in indoor tennis courts, whose size and shape made them easily adaptable to theatre (hence the term "tennis-court theatre"). For over thirteen years, Molière toured France with the Béjarts (bay-ZHAHR), as an actor and manager, until a crucial appearance before Louis XIV launched his career as a playwright.

Tartuffe, *The Misanthrope*, and *The Bourgeois Gentleman* brought new esteem to French comedy. Highly regarded comedy appears rarely in the history of the theatre. Molière's instinct for penetrating human psychology, fast-paced action, crisp language, and gentle but effective mockery of human foibles earned him a foremost place in theatre history. Not only were Molière's comedies dramatic masterpieces, but they also stood up to the potentially overpowering baroque scenic conventions of Louis XIV's theatre at Versailles. His plays challenged the painted backgrounds and elaborate machinery of Italian scene designers and emerged triumphant.

The scenic simplicity of the theatre in Elizabethan England, which put all the acting in front of an unchanging architectural façade, gave way to opulent spectaculars called English court masques (mahsks) during the reign of Charles I in the early years of the seventeenth century. Essentially, the court masque constituted a game for the nobility, an indoor extravagance which had developed earlier in the sixteenth century, probably influenced by its visually resplendent cousins in Italy. Short on literary merit, the English masque, nonetheless, reflected monarchial splendor through a dramatic spectacle.

Banqueting halls of palaces were transformed into spaces with large stages equipped with complex scenery and scene-changing apparatus for the masques. These

12.33 Inigo Jones, "The Whole Heaven" in *Salmacida Spolia*, 1640. Collection of the Duke of Devonshire, Chatsworth, UK.

stages allowed manipulation of scenery from below the stage. The actors played on a protruding area in front of (as opposed to amid) the drops and wings (a type of staging called forestage-façade). The English court masque had direct links with the scenic style of Andrea Palladio and Sebastiano Serlio in Italy (see Chapter 10). The architect Inigo Jones (1573–1652), the most influential English stage designer of the time, freely imitated Italian perspective, using elaborate stage machines and effects (Fig. **12.33**).

This "baroque-like" style in English theatre ended when Cromwell's zealots overthrew the monarchy in 1642. Theatres closed and productions ceased until the Restoration of Charles II in 1660. (Opera provided a handsome substitute, however.) When Charles returned from exile in France, he brought with him the continental style current in the French court. One result, a sophisticated comedy of manners known as "Restoration comedy," focused on the adventures of "people of quality" and reflected their intrigues, manners, and idiosyncratic dispositions. The verbal wit of this style of comedy often satirized the morality of the bourgeoisie.

Music

Baroque music, like its visual cousins, in many cases reflected the needs of churches, which used its emotional and theatrical qualities to make worship more attractive and appealing. The new scientific approaches of Galileo and Newton, for example, and the rationalism, sensuality, materialism, and spirituality of the times also found themselves manifested in art and music.

The term *baroque* refers to music written during the period extending approximately from 1600 to 1750. The term itself originally referred to a large, irregularly shaped pearl of the kind often used in the extremely fanciful jewelry of the post-Renaissance period, and music of this style was as luscious, ornate, and emotionally appealing as its siblings of painting, sculpture, and architecture.

Baroque composers began to write for specific instruments, or for voices, in contrast to earlier music that might be either sung or played. They also brought to their music new kinds of action and tension, for example, quick, strong contrasts in tone color or volume, and strict rhythms juxtaposed against free rhythms. Gradually during the time of this style, a system evolved whereby the relationship between keys was established in an orderly way. Thus, the baroque era in music played a crucial role in the development of the modern musical language. The baroque era perfected the major/minor tonality and a corresponding way of thinking about chords and harmonic progression. Baroque composers turned away from **contrapuntal** equality of voices as a musical ideal, turning instead to a focus on the outer lines of a piece: the highest voice (melody) and the lowest voice (bass). The era witnessed the crafting of an impressive body of purely instrumental music and the birth and explosive popularity of opera. In contrast to the organization of the other sections, and in keeping with the way we have treated music in

previous chapters, we will divide this section not by country, but by three genres: instrumental music, vocal music, and opera.

Instrumental Music

As baroque composers began to write specifically for individual voices and instruments, instrumental music assumed a new importance. Composers explored a wide range of possibilities for individual instruments, and the instruments themselves underwent technical development. For one thing, instruments had to be made so they could play in any **key**. Before the baroque era, an instrument such as the harpsichord required retuning for each new piece in a new key. Equal **temperament** established the convention we accept without question, that each half-step in a musical scale is equidistant from the one preceding or following it. Musicians did not immediately see this as desirable, and Johann Sebastian Bach (bahk) composed a series of two sets of preludes and fugues in all possible keys (*The Well-Tempered Clavier* (klah-VEER), Part I, 1722; Part II, 1740) to illustrate the virtues of the new system.

As a result of these developments, a wealth of keyboard music emerged during this era. The **fugue**, with its formal structure and strict imitation, best demonstrates the complexity and virtuosity of this music, and the highest point in its development came, once again, in the work of J.S. Bach, the leading composer of the baroque age. His instrumental compositions range from simple dances, arranged into groups as **suites**, to the famous pieces for solo violin and solo cello, which to this day represent some of the most complex and technically challenging works in the repertoire. Bach's keyboard music alone includes over six hundred organ pieces based on chorale tunes, and hundreds of other harpsichord and organ works in all the contemporary instrumental forms.

Another of the forms contributed to Western music by the baroque age, the concerto, uses two or more dissimilar musical forces—for example, one or more soloists playing opposite an orchestra. Basically, three types of concerto emerged from the early seventeenth century, when the concerto became largely an orchestral form: (1) the *orchestral concerto*, in which differences in texture or treatment mark the different groups of instruments; (2) the **concerto grosso**, in which a small group called the *concertino* stand out from the main force, called the *tutti* or *ripieno* (meaning "remainder" or "filling"); (3) the *solo concerto*, for one instrument and orchestra.

One of the masters of the concerto, Antonio Vivaldi (vee-VAHL-dee; 1678–1741), composed for specific occasions and usually for a specific company of performers. He wrote prolifically: some 450 concertos,

twenty-three sinfonias, seventy-five sonatas, forty-nine operas, and numerous cantatas, motets, and oratorios. About two-thirds of his concertos are for solo instrument and orchestra and one-third are concerti grossi.

Probably his most familiar solo concerto is "Spring," one of four works in Op. 8 *The Seasons* (1725), an early example of **program music**, written to illustrate an external idea (in contrast with **absolute music**, which presents purely musical ideas). In "Spring," a series of individual pieces interlock to form an ornate whole. In the first movement (allegro), Vivaldi alternates an opening theme (A) with sections that depict bird song, a flowing brook, a storm, and the birds' return (ABACADAEA). Theme A is known as a *ritornello* (ri-tohr-NEL-loh), from the Italian "to return," and we call this alternating pattern **ritornello form**. Within the solo part we find elaborate melodic ornamentation. For example, on a simple ascending scale of five notes, the composer added ornamental notes, and thus the ascending scale becomes a melodic pattern of perhaps as many as twenty tones—a musical equivalent of the complex ornamental visual detail seen in baroque painting, sculpture, and architecture.

The term "**sonata**" (suh-NAHT-uh) comprises one of the most elastic terms in music and has been used to denote many different musical forms. We will confine our discussion to its place in the baroque era. The word itself comes from the Italian *sonare* (to sound), and came into use during the baroque era to indicate any piece played on instruments, as distinct from the vocal *cantata* (kuhn-TAHT-uh), which means "sung." Its most popular treatment during the seventeenth century became known as the *trio sonata*, with two high, intertwining parts for violins or flutes, or oboes, played above a bass part for cello or bassoon. Usually an organist or harpsichordist played along to reinforce the bass and fill in harmonies indicated by symbols written in the bass part (a practice called "figured bass").

The violin came to the fore in the baroque era, replacing the viol, which had previously been the primary bowed string instrument. The violin, fully explored as a solo instrument, also witnessed its physical perfection. From the late seventeenth and early eighteenth centuries came the greatest violins ever built. Made of maple, pine, and ebony by such craftsmen as Antonio Stradivari (strah-dee-VAH-ree; 1644–1737), these remarkable instruments fetch enormous sums of money today. Despite our best scientific attempts, they have never been matched in their superb qualities, the secrets of which died with Stradivari. Not only does a violin have similarity to the human voice in timbre, but a well-made violin has an individual personality. It assumes certain qualities of its environment and of the performer. It responds sensitively to external factors such as

temperature and humidity, and getting the best from it depends upon care from its owner, not to mention skill and musicianship.

The baroque age in music, in its harmonies, structures, and forms, laid the groundwork for the music of the eras to come, including our own.

Vocal Music

As we just noted, the Italian word **cantata** denotes "sung." It comprises vocal compositions with instrumental accompaniment, with several movements based on related text segments. It developed from monody, or solo singing with a predominant vocal line, centering on a text, to which the music played a subservient role. These works, which consisted of many short, contrasting sections, were far less spectacular than opera, and performed without costumes or scenery. Most cantatas employed solo soprano voice, although many used other voices and groups of voices. Two types of cantatas existed during the baroque era, the secular and the religious. The secular Italian cantata had become, by 1650, a piece alternating two or three **recitatives** and **arias**, usually for soprano voice and accompaniment.

The high point of the Italian cantata came in the works of Alessandro Scarlatti (skar-LAT-ee; 1660–1725), who composed more than six hundred of them. Typically

MASTERWORK

BACH—EIN FESTE BURG

J.S. Bach's Cantata No. 80, *Ein feste Burg ist unser Gott* ("A Mighty Fortress is our God"), originated in a chorale written by Martin Luther (Luther probably wrote both words and music). The chorale stands as a centerpiece of Protestant hymnology. Luther's words and melody appear in the first, second, fifth, and last movements. Salomo Franck, Bach's favorite librettist, wrote the remainder of the text. The first movement (Fig. **12.34**), a choral fugue, states the familiar theme and text:

> A mighty fortress is our God,
> A good defense and weapon;
> He helps free us from all the troubles
> That have now befallen us.
> Our ever evil foe,
> In earnest plots against us,
> With great strength and cunning
> He prepares his dreadful plans.
> Earth holds none like him.

The final movement rounds off the cantata. Luther's chorale now uses Bach's own four-part harmonization. Instruments double each voice, and the simple, powerful melody stands out against the lower parts:

> Das Wort, sie sollen lassen stehen
> und kein Dank dazu haben.
> Er ist bei uns wohl auf dem Plan
> mit seinem Geist und Gaben.
> Nehmen sie uns den Leib,
> Gut, Her, Kind und Weib,
> lass fahren dahin
> sie haben kein Gewinn
> das Reich muss uns doch bleiben.

Now let the Word of God abide
 without further thought.
He is firmly on our side
 with His spirit and strength.
Though they deprive us of life,
Wealth, honor, child, and wife,
 we will not complain.
 It will avail them nothing
For God's kingdom must prevail.

This contrasts with the first movement in which Bach treats each line of the chorale tune *Ein' feste Burg* fugally, culminating in a long-note canon between oboes and continuo:

Line 1—Ein' feste Burg ist unser Gott—Canon.
Line 2—Ein'gute Wehr und Waffen—Canon.
Line 3—Er hilft uns frei aus aller Not—Canon.
Line 4—Die uns jetz hat betroffen—Canon.
Line 5—Der alte böse Feind—Canon.
Line 6—Mit Ernst er's jetzt meint—Canon.
Line 7—Groß' Macht und viel' List—Canon.
Line 8—Sein' grausam' Rüstung is—Canon.
Line 9—Auf Erd' ist nicht sein'sgleichen—Canon.

12.34 J.S. Bach, *Ein feste Burg ist unser Gott*, from Cantata xlo. 80.

PROFILE

JOHANN SEBASTIAN BACH (1685–1750)

Although currently considered one of the giants of music, Johann Sebastian Bach was considered old-fashioned during his lifetime, and his works lay virtually dormant after his death. Not until the nineteenth century did he gain recognition as one of the greatest composers of the Western world. He was born in Thuringia, in what is now Germany, and when he was ten years old both his parents died. His oldest brother, Johann Christoph, took responsibility for raising and teaching him, and Johann Sebastian became a choirboy at the Michaelskirche in Luneburg at age fifteen. He studied the organ and gained an appointment as organist at Neukirche in Arnstadt, where he remained for four years. Then he took a similar post at Muhlhausen at about the same time as he married his cousin Maria Barbara Bach. One year later, he took the position of court organist at Weimar, remaining there until 1717, when Prince Leopold of Kothen hired him as his musical director. While serving as musical director to Prince Leopold, Bach completed his famous Brandenberg Concertos (commissioned by the margrave of Brandenburg) in 1721.

In 1720 Bach's wife died, and one year later he married Anna Magdalena Wilcken. In 1723 he moved to Leipzig as the city's musical director at the school attached to St Thomas' Church, and among his responsibilities to the city, he supplied performers for four churches. In 1747 he played at Potsdam for Frederick II the Great of Prussia but shortly thereafter his eyesight began to fail, and he went blind just before his death in 1750.

Bach's output as a composer was prodigious but also required as part of his responsibilities, especially at Leipzig. Over his career, he wrote more than two hundred cantatas, the *Mass in B Minor*, and three settings of the Passion story, works that illustrate Bach's deep religious faith. His sacred music allowed him to explore and communicate the profound mysteries of the Christian faith and to glorify God. His cantatas typify the baroque exploration of wide-ranging emotional development. They range from ecstatic expressions of joy to profound meditations on death. The *St Matthew Passion,* for example, tells the story of the trial and crucifixion of Jesus. Written in German rather than the traditional Latin, the Passions express Bach's devotion to Lutheranism.

In addition to his sacred works, Bach wrote a tremendous amount of important music for harpsichord and organ, including the forty-eight Preludes and Fugues, called *The Well-Tempered Clavier,* and the *Goldberg Variations.* In the fugues, he develops a single theme, which is then imitated among the polyphonically developed voices of the composition. Among his many instrumental works are twenty concertos and twelve unaccompanied sonatas for violin and cello.

Scarlatti's cantatas begin with a short "arioso" section, somewhere between recitative and aria (a set-piece song). A recitative follows, then a full aria, a second recitative, and a final aria in the opening key. Scarlatti's moods tended toward the melancholic and tender, and his composition elegant and refined. The theme of almost all of his works is love, and particularly its betrayal.

In Germany, the cantata comprised a sacred work that grew out of the Lutheran chorale. Its most accomplished composers were Johann Sebastian Bach (1685–1750) and Dietrich Buxtehude (BUHKS-te-hoo-de; c. 1637–1707), of whom Bach is by far the greater. As a choirmaster, Bach had a professional obligation to compose a new cantata weekly, and between 1704 and 1740, he composed more than two hundred. His cantatas primarily used contrapuntal texture, usually written for up to four soloists and a four-part chorus.

Bach's work represents one of the great responses of Protestant art to the challenge of the Counter-Reformation. His sacred music achieves extraordinary power as a humane, heartfelt expression of faith. Never theatrical, its drama derives from an inner striving, a hard-won triumph over doubt and death.

A major development in seventeenth-century music, the *oratorio*, combined a sacred subject with a narrative poetic text. Like the opera, it had a broad scale, high drama, and soloists to portray specific characters. Like the cantata, it was designed for concert performances, without scenery or costume.

Oratorio began in Italy in the early seventeenth century, but all accomplishments pale in comparison with the works of the greatest master of the oratorio, George Frederick Handel (HAHN-duhl; 1685–1759). Although German by birth, he lived much of his life in England and

12.35 G.F. Handel, *Hallelujah Chorus*.

wrote his oratorios in English. His works continue to enjoy wide popularity, and each year his *Messiah* has thousands of performances around the world.

Most of Handel's oratorios use a highly dramatic structure, containing exposition, conflict or complication, and *dénouement* (day-noo-MAWN) or resolution sections. All but two, *Israel in Egypt* and *Messiah*, could be staged in full operatic tradition. Handel wrote the most popular of all oratorios, *Messiah* (1741), in twenty-four days. The work has three parts: the birth of Jesus; Jesus' death and resurrection; and the redemption of humanity. The music comprises an overture, choruses, recitatives, and arias, written for small orchestra, chorus, and soloists. The choruses provide some of the world's best-loved music, including the famous *Hallelujah Chorus*.

The *Hallelujah Chorus* comprises the climax of the second part (Fig. **12.35**). The text proclaims a victorious Lord, whose host is an army with banners. Handel creates infinite variety by sudden changes of texture among monophony, polyphony, and homophony. Words and phrases repeat over and over again. In unison the voices and instruments proclaim, "For the Lord God Omnipotent reigneth." Polyphony marks the repeated exclamations of "Hallelujah" and yields to homophony in the hymn-like *The kingdom of this world*.

Opera

The word *opera* means "work" in Italian, short for the Italian *opera in musica*. Opera exemplifies the baroque spirit in many ways. Whether we consider it music with theatre or theatre with music, opera combines a number of complex art forms into one big, ornate, and even more complex system greater than and different from the sum of its parts: music, drama, dance, visual art (scenery and costumes), and architecture (since an opera house represents a unique architectural entity). And in particular, in true baroque spirit, opera represents primarily an overwhelming emotional experience. The earliest operas included roles for *castrati* (kuh-STRAHT-ee), male singers castrated in boyhood so their voices would remain in the soprano and contralto range. This created adult voices of unusual strength and clarity, and castrati played many male heroic roles.

Opera began in Italy in musical discussions among a small group of nobles, poets, and composers who began meeting regularly in Florence around 1575. This group, known as the *Camerata* (meaning "fellowship" or "society"), wished to develop a new vocal style based on the music of ancient Greek tragedy. Inasmuch as no Greek examples had survived, they based their theories on literary accounts, suggesting that Greek dramas had been sung in a style halfway between singing and speech. The Camerata wanted their new style to resemble the intonations and rhythms of speech, and they called the new style *recitative* ("recited").

The operas themselves grew out of late fifteenth-century madrigals. Many of these madrigals, some called "madrigal comedies" and some called *intermedi*, appeared between the acts of theatre productions. Fairly dramatic, they included pastoral scenes, narrative reflections, and amorous adventures. They gave rise to a new style of solo singing, as opposed to ensemble singing. In 1600, an Italian singer–composer, Jacopo Peri (YAH-koh-poh PAY-ree; 1561–1633), took a contemporary pastoral drama, *Eurydice* (yoo-RID-i-see) and set it to music. Peri's work is the first surviving opera.

Claudio Monteverdi (mohn-tay-VAIR-dee) took a firmer hand to the new art form. In *Orfeo* (OHR-fay-oh; 1607), he expanded the same mythological subject matter, the story of Orpheus and Eurydice, into a full, five-act structure—the academies considered five classically "correct"—and gave it richer, more substantial music with much stronger emotional effect. The mood swung widely through contrasting passages of louds and softs. *Orfeo* had highly embellished and ornamental melodic lines. The orchestra consisted of approximately forty instruments, including brass, woodwind, strings, and continuo. The grandiose scenic designs of the great Bibiena family, one of which appears in Figure **12.36**, suggests the spectacular staging of this and other baroque operas. Monteverdi's innovation was the dramatic prototype of what we know today, and we rightly call him the "father of opera."

Opera in England finds a fine representative in perhaps England's greatest composer, Henry Purcell (c. 1659–95). Born in London, son to one of King Charles II's household musicians, Purcell took an appointment at age twenty as organist at Westminster Abbey. His compositions run the gamut of types required by all his appointments: orchestral suites and dances, chamber music for royal enjoyment, odes, and other ceremonial pieces for state occasions, anthems and other works for the Church. Purcell greatly loved the theatre, but Cromwell's Commonwealth government closed them all. The restoration of the English monarchy in 1660, under Charles II, brought with it an explosion of theatrical works, including dozens of new plays and

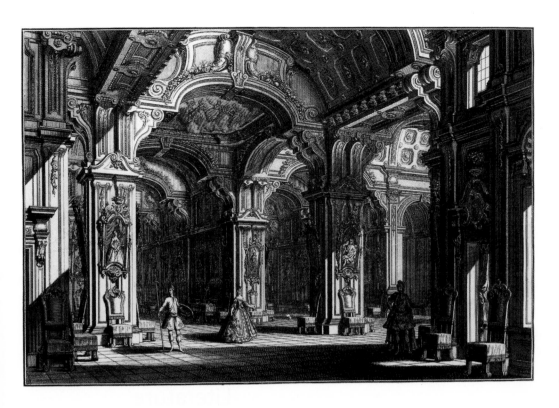

12.36 Giuseppe Galli de Bibiena, design for an opera, 1719. Contemporary engraving. Metropolitan Museum of Art, New York (The Elisha Whittelsey Collection, The Elisha Whittelsey Fund, 1951).

operas. This accorded with Purcell's love, and during the last fifteen years of his life he wrote a dozen large-scale music-theatre works, incidental music for more than forty plays, and hundreds of individual songs and dances. His opera *Dido and Aeneas* (1689), based on the *Aeneid* of Vergil (see p. 134), is quite different from the recitative-and-aria Italian operas of the time. Although shorter than these, it has deeper characterizations, breezy choruses, and a spectacular "Sorceress scene." "Dido's Lament" from Act II is illustrative. Dido learns that Aeneas will leave her to pursue his destiny. Grief-stricken, she prepares to kill herself. In the recitative she seeks support from her attendant, Belinda. She sings over an unvarying chromatic bass figure her heart-rending final lament:

Recitative: Thy hand, Belinda; darkness shades me.
 On thy bosom let me rest.
 More I would, but Death invades me.
 Death is now a welcome guest.

Aria: When I am laid in earth,
 May my wrongs create
 No trouble in thy breast.
 Remember me, but ah! forget my fate.

The aria has a slow, mournful character creating its impact by a steady downward fall from its opening note to its closing one. A recurring bass pattern repeats in five-bar cycles. We call this kind of bass, *basso ostinato* ("obstinate bass").

Dance

During the reign of Henry IV (1589–1610), over eighty ballets were performed at the French court. In a ballet in 1615, "30 genii, suspended in the air, heralded the coming of Minerva, the Queen of Spain . . . Forty persons were on the stage at once, 30 high in the air, and six suspended in mid-air; all of these dancing and singing at the same time."[1] Later, under Louis XIII, a fairly typical ballet of the period, the *Mountain Ballet*, had five great allegorical mountains on stage: the Windy, the Resounding, the Luminous, the Shadowy, and the Alps. A character, Fame, disguised as an old woman, explained the story, and the "quadrilles of dancers," in flesh-colored costumes with windmills on their heads (representing the winds), competed with other allegorical characters for the "Field of Glory." Such work typically consisted of a series of dances dramatizing a common theme.

By the late seventeenth century, baroque art consolidated in the court of Louis XIV. A great patron of painting, sculpture, theatre, and architecture, Louis also brought ballet into full participation in the splendor of the era. An avid dancer, Louis studied for over twenty years with the dancing master Pierre Beauchamps (boh-SHAHMP), credited with inventing the basic dance positions of classical ballet. Louis's title, *Le Roi Soleil* or the "Sun King," certainly indicates his behavior and his political philosophy, but it actually derived from his favorite childhood role, that of Apollo the sun-god in

Le Ballet de la Nuit, which he danced at the age of fourteen. Mazarin (MA-zah-rehn), Louis's first minister, exploited this splendid dance role to promote the young monarch.

Louis employed a team of professional artists to produce ballet and opera at court, and the playwright Molière was active in these grand collaborative efforts. Usually the plots for French ballets came from classical mythology and the works themselves constituted a series of verses, music, and dance. The style of dancing, at least in these works, appears fairly simple and controlled with symmetrical and harmonious gestures. The theatrical trappings were opulent. The emotionality of the baroque style precludes neither formality nor restraint. One must also bear in mind that the costume of the era included elaborate wigs. Any movements that threatened to knock one's wig askew would, after all, have been impractical and awkward.

Ballet formally institutionalized when Louis XIV founded the Académie Royale de Danse in 1661. Louis

12.37 Jean Louis Bérain (1638–1711), *Dame en habit de ballet.* Contemporary engraving. The New York Public Library.

appointed thirteen dancing masters to the Académie to "re-establish the art in its perfections." Ten years later, the Académie Royale de Danse merged with a newly established Académie Royale de Musique. Both schools had use of the theatre of the Palais Royal, which had been occupied by Molière's company. Its proscenium stage altered forever the aesthetic relationship of ballet and its audience. Choreography required design for an audience on one side only. Such designs focused on the "open" position, still basic to formal ballet choreography today.

Establishment of the Royal Academy of Dance led to prescribed "rules" for positions and movements. It also led to the full art form, in which women took the stage as professional ballerinas for the first time in 1681 (Fig. **12.37**). The stage of the Palais Royal, which did not allow access to the auditorium, placed the final barricade between the professional artist and the "noble amateur" of the previous eras. As the baroque era came to a close in the early eighteenth century, the foundations of ballet as a formal art stood firmly in place.

Literature

Literature in the baroque style, like its counterparts in visual and performing art, took prevalence in most Western countries from the late sixteenth to the early eighteenth centuries. Like its visual cousins, it reflected complexity and elaborate form and often utilized bizarre, calculatedly ingenious, and occasionally intentionally ambiguous imagery. Our examination of literature in the baroque style visits Spain and England where, especially regarding the fiction genre of the novel, important events occurred.

Spain

The baroque period witnessed the development of the novel. An early form of this genre existed in Elizabethan England, but the first exploration of its full potential as a literary form came from the Spanish pen of poet, playwright, and novelist Miguel Cervantes (thair-BAHN-tayz or suhr-VAHN-teez; 1547–1616). A seasoned soldier and sailor, Cervantes suffered a crippling wound to his left hand during the battle of Lepanto, against the Turks, in 1571. Unsuccessful as a playwright, he took a series of government jobs and began writing poetry and short stories. The first part of *Don Quixote* (1605) met with instant success and, although it did not gain Cervantes riches, it did put him in the recognizable first rank of men of literature of the time.

Don Quixote recounts the adventures of a comically self-deluded knight. The novel, a parody of the chivalric romances of an earlier age, eloquently laments a lost time of innocence and moral clarity. Nonetheless, it describes

in realistic imagery the exploits of an elderly knight who, befuddled by reading romances, ventures forth on his old horse Rosinante, with his pragmatic squire, Sancho Panza, to find adventure. Along the way he finds love in the peasant Dulcinea (duhl-sih-NAY-uh). *Don Quixote* proved a fundamental stepping stone in the development of the novel, and influenced, among others, the English novelist, Daniel Defoe, whom we discuss below.

The Spanish poet Luis de Góngora (GHAWN-ghoh-rah; 1561–1627) remains one of the most influential poets of his time. His baroque, convoluted style, known as *gongorismo*, found a raft of inept imitators who so exaggerated it that Góngora's reputation suffered for centuries. He wrote successfully in several light poetic genres, including folk ballads, short lyric poems, and sonnets. His longer works utilized a very difficult and purposely complex style that provoked scorn and ridicule. His style introduced Latinisms of vocabulary and syntax and exceedingly complex imagery and mythological allusions. We will illustrate his less complex poetic style with another example of the sonnet. Compare the rhythms and rhymes with those of Shakespeare (see p. 368), Michelangelo (see p. 337), and Petrarch (see p. 301). Again, we introduce the poem in its original Spanish, followed by an English translation that does not follow the rhyme or rhythm scheme of the original.

Soneto
Luis de Góngora

Señora doña Puente segoviano
cuyos ojos están llorando arena,
si es por el río, muy enhorabuena,
aunque estáis para viuda muy galena.

De estangurria murió. No hay castellana
lavandera que no llore de pena,
y fulano sotillo se condena
de olmos negros a loba luterana.

Bien es verdad que dicen los doctores
que no es muerto, sino que del estío
le causan parasismo los calores;

que a los primeros del diciembre frio,
de sus mulas harán estos señores
que los orines den Saluda al río.

English translation:

Dear lady, Mrs Segoviano Bridge,
whose eyes are now reduced to weeping sand,
if you cry for the river, you're in luck,
though for a widow you're quite elegant.

It died of bladder blockage. In Castille
no washerwoman will not cry in grief;
your busy pleasure island's now condemned
to black elms cloaked within a mourning sheath.

It's very true that all the doctors say
that it's not dead, that in the summertime
the heat can make you faint, or sweat, or shiver,

and that when cold December comes again,
these learnèd men will make sure that their mules'
life-giving drops give health back to the river.

England

After the golden age of the late sixteenth century, the mood in England darkened noticeably with the death of Queen Elizabeth in 1603. Political instability and economic difficulties threatened, and the finest writing turned away from love—almost the exclusive theme of the Elizabethans—to an often anguished inner questioning. This turn led to the rise of the metaphysical poets, who wrote in a highly intellectualized, bold, ingenious, complex, and subtle style—again, typical of the baroque. The metaphysical poets utilized paradox, deliberate harshness or rigidity of expression, and probed into the analysis of emotion. Metaphysical poetry blended emotion and intellectualism, characterized by sometimes forced juxtaposition of seemingly unconnected ideas intended to startle the reader to think through the argument of the poem. Bold literary devices, especially irony and paradox, reinforced a dramatic directness of the language employed, which followed the natural rhythms of everyday speech.

Metaphysical poetry's most notable work came from John Donne (duhn; 1573–1631; Fig. **12.38**). Donne's early love sonnets rank among the most urgently erotic poems in the language, but the work of his later years relentlessly explores the meaning of an intelligent person's relationship with the soul and with God. We perhaps know him best from his poem, "Death, Be Not Proud."

Death, Be Not Proud
John Donne

Death, be not proud, though some have callèd thee
Mighty and dreadful, for thou art not so;
For those whom thou think'st thou dost overthrow
Die not, poor Death, nor yet canst thou kill me.
From rest and sleep, which but thy pictures be,
Much pleasure; then from thee much more must flow,
And soonest our best men with thee do go,
Rest of their bones, and soul's delivery.
Thou'rt slave to fate, chance, kings, and desperate men,
And dost with poison, war, and sickness dwell;
And poppy or charms can make us sleep as well
And better than thy stroke; why swell'st thou then?
One short sleep past, we wake eternally,
And death shall be no more: Death, thou shalt die.

Notice that Donne retains the classical form we have now seen so often. He chides death as ineffectual, no more effective than drugs, subject to all sorts of vagaries,

12.38 Portrait of John Donne, 1572–1631.
Engraving by A. Duncan.

and subject to the ultimate defeat of the Resurrection (Donne was Dean of St Paul's Cathedral in London).

Also exemplary of the metaphysical poets, George Herbert (1593–1633) wrote in masterful metrical form using allegory and homely analogy, with unwavering religious devotion running through his works. A clergyman, he never intended his poems for publication, but we can see in "Love Bade Me Welcome" not only the characteristics just noted, but also a great intellect and passion.

Love Bade Me Welcome
George Herbert

Love bade me welcome; yet my soul drew back,
 Guilty of dust and sin.
But quick-eyed Love, observing me grow slack
 From my first entrance in,
Drew nearer to me, sweetly questioning
 If I lacked any thing.

"A guest," I answered, "worthy to be here";
 Love said, "You shall be he."
"I the unkind, ungrateful? Ah my dear,
 I cannot look on thee."
Love took my hand, and smiling did reply,
 "Who made the eyes but I?"

"Truth, Lord, but I have marred them: let my shame
 Go where it doth deserve."
"And know you not," says Love, "who bore the blame?"
 "My dear, then I will serve."
"You must sit down," says Love, "and taste my meat."
 So I did sit and eat.

Many of the methods of the metaphysical poets were further developed by Andrew Marvell (1621–78), and his *Horatian Ode* in praise of Oliver Cromwell marks the return of poets and poetry to the political stage. His contemporary John Milton (1608–74) was also deeply committed to the parliamentarian cause. In old age, blind, solitary, and disappointed by the failure of his political ideals, he wrote his masterpiece, *Paradise Lost*. His richly Latinate language is deeply musical, confident, and powerful. His themes are epic, tragic, and uncompromisingly Protestant.

With the Restoration of Charles II, in 1660, which had so embittered Milton, the seriousness and quality of poetic output declined. Cynical and licentious verse became typical of these shallow years. The Glorious Revolution of 1688, when a new royal family came over from the Low Countries, marked a decisive change. At this point, the middle classes had broken the power of the absolute monarch and the influence of the court. The confidence and pragmatism of this new "Augustan" age found a voice in John Dryden (1631–1700), whose satirical *Absalom and Achitophel* marked a new role for the poet as a witty and entertaining critic of his age.

Writers in both France and England began to experiment with a versatile new form, which, because of its extended length and realistic language, seemed ideally suited to the treatment of contemporary and everyday themes. The Englishman Daniel Defoe (dee-FOH; 1660–1731) set the direction that the European novel would take. His *Robinson Crusoe* remains widely read to this day, and his *Moll Flanders* defined the novel's voice and audience for the age. Subsequent novels involved imaginary biographies or autobiographies set in contemporary society. The central figure would be a man or, more commonly, a woman, with whom the reader (usually female) would identify.

Aphra Behn (1640–89), the first Englishwoman known to have earned her living by writing, earned praise for it from the modern writer Virginia Woolf (see p. 516) in *A Room of One's Own*. Her novel *Oroonoko* (1688) tells the story of an enslaved African prince whom Behn knew in South America. This work proved highly influential in the development of the English novel. She also wrote poetry and plays, among which is *The Forc'd Marriage* (1677). Her comedies—for example, *The Rover* (two parts—1677 and 1681) were witty, vivacious, full of social satire focused on sexual relations, and highly successful. She wrote many popular novels and, due to her charm and generosity, had a wide circle of friends. Her relative freedom as a woman professional writer, however, and her use of lewd language and daring themes made her the object of scandal.

CHAPTER REVIEW

CRITICAL THOUGHT

When we listen to a musical piece by J. S. Bach or G. F. Handel, we hear exactly what "baroque" means. It seems as if the composer uses more notes per second than we have ever heard before. If he wants to go from one tone to another, he takes five tones to get there—Mozart, whom we will meet in the next chapter, would take only one—but that is precisely what baroque style is all about: it is big, ornate, and emotional, cramming everything possible into the smallest possible space. Yet at the same time, it does so in an extremely rational way—emotional, but not irrational—which takes us back to one of the principles we noted briefly at the beginning of the chapter: systematic or scientific rationalism. It sounds almost like a contradiction to assert that something can be intensely emotional and free, yet also be controlled and rational. The ornately decorous details of baroque art and music fit within a complex but rational organization all carefully thought out and systematic. The rational organization allows the emotional content to mean something to us. If it were all emotion, we would get lost, because the work would engender chaos, and be unable to communicate.

SUMMARY

After reading this chapter, you will be able to:

- Understand and differentiate between the theories and discoveries of Francis Bacon, Galileo, Kepler, Descartes, and Isaac Newton.
- Describe and contrast the philosophies of Thomas Hobbes and John Locke, and contrast Locke and Descartes on the nature of knowledge of truth.
- Relate the Counter-Reformation, Council of Trent, religious upheaval, and the rise of absolutism in Europe.
- Characterize baroque art, sculpture, and architecture by defining major divisions such as "aristocratic baroque" and identifying major artists, architects, and their works.
- Discuss baroque music, theatre, and dance, including major forms, composers, playwrights, and performance conditions.
- Apply the elements and principles of composition to analyze and compare works of art and architecture illustrated in this chapter.

CYBERSOURCES

http://www.artcylcopedia.com/history/baroque.html
http://www.greatbuildings.com/buildings.html
http://www.gutenberg.net

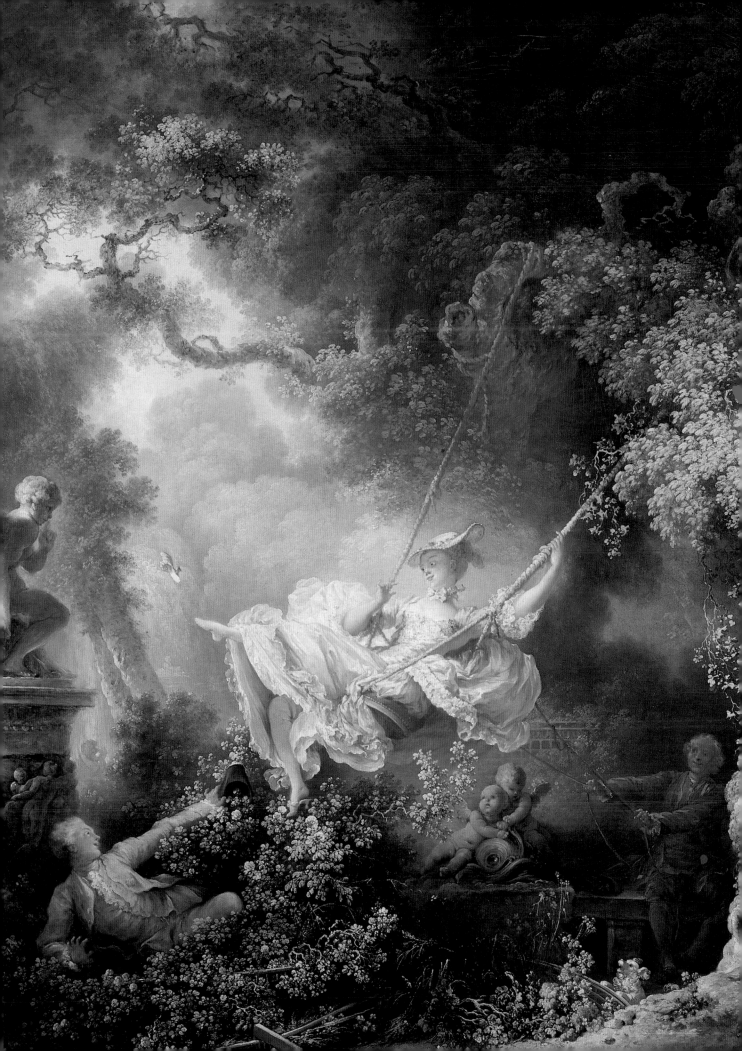

13 THE ENLIGHTENMENT

OUTLINE

VIEW

SWINGING BETWEEN TWO POLES

The eighteenth century represents the insurgence of the common people. Government, social policy, intellectual matters, and the arts took the masses into account, which had not previously been the case. Aristocrats fell from favor, and a new social fabric and way of looking at life emerged with the new republics of Europe and America. Even classical music turned toward mass audiences. Something like modern society emerged.

We now have come far enough in our journey to recognize trends—not only social but artistic as well. In the eighteenth century the social pendulum, to which we alluded in the previous paragraph, swung between the poles of monarchial—if beneficent—absolutism and rudimentary democracy (between the ideas of Locke and Hobbes discussed in the last chapter); the artistic swung between classicism and anti-classicism. At one pole, classicism, form and content leaned toward intellectual restraint and careful order, and at the other pole, toward emotionalism: "form versus feeling" as it has been described. The pendulum swings from baroque through rococo, a new style, toward classicism. Very soon, it will reverse once more.

KEY TERMS

ENLIGHTENMENT
A faith in science, in human rights arising from natural law, in human reason, and progress.

ENLIGHTENED DESPOTISM
Rule by an "absolute" monarch who holds "enlightened" views regarding his or her relationship to his or her subjects.

PHILOSOPHES
Popularizers who culled thought from great books and translated it into simple terms.

ROCOCO STYLE
A decorous and sensitive style in the arts.

GENRE
A term usually meaning "type," but in the eighteenth century it refers to works of art dealing with mundane subjects.

CLASSICAL STYLE
In music refers to the works and style of Mozart and Haydn, particularly.

PRE-ROMANTIC STYLE
A style in literature referring to the works of Henry Fielding, Jean-Jacques Rousseau, Goethe, and others who anticipated the anti-classical literary style of the next century.

13.1 Jean-Honoré Fragonard, *The Swing*, c. 1768–9. Oil on canvas, 32 × 25½ ins (83 × 66 cm). Wallace Collection, London.

CONTEXTS AND CONCEPTS
Contexts

The Enlightenment

The eighteenth century has often been called the "Age of Enlightenment," but century marks prove arbitrary boundaries that tell us very little about history or art. Styles, philosophies, and politics come and go for a variety of reasons. We have already pushed halfway through the eighteenth century in some areas, without encountering any natural barriers—J.S. Bach, for example, lived and worked until 1750. We can say that eighteenth-century enlightenment grew out of various seventeenth-century ideas that fell on more or less fertile soil at different times in different places. We should also note—very strongly—that Europe, our primary focus, did not exist in a vacuum in the eighteenth century but as

desirable as inclusion of other areas might be, we simply do not have the space for it.

Seventeenth- and eighteenth-century thought saw people as rational beings in a universe governed by some systematic natural law. Some believed that law an extension of God's law. Others held that natural law stood by itself. Natural law extended to include international law, and accords emerged in which sovereign nations, bound by no higher authority, could work together for a common good.

Faith in science, in human rights arising from the natural law, in human reason, and in progress, formed touchstones of eighteenth-century thought. The idea of *progress* drew on the assumption that the conditions of life could only improve with time and that each generation made life even better for those following. Some scholars—the "ancients"—held that the works of the Greeks and Romans had never been surpassed. Others—the "moderns"—held that science, art,

GENERAL EVENTS

■ Frederick II, the Great, 1712–86 ■ War of Austrian Succession, 1740–8 ■ First iron bridge, 1779

■ Maria Theresa of Austria, 1717–80 ■ Pompeii excavated, 1748

■ Humanitarianism, c. 1720 ■ Diderot's *Encyclopedia* published, 1751–76

■ Herculaneum excavated, 1738 ■ Watt's steam engine, 1769

■ George III of England, 1738–1820 ■ Louis XVI, 1754–93 ■ French Revolution, 1789

■ American Revolution, 1765–88

1700	1725	1750	1775	1800	1850
PAINTING & SCULPTURE					
Watteau (13.6)	Hogarth (13.8, 13.9), Chardin (13.12)	Fragonard (13.1), Boucher (13.7)	Gainsborough (13.10, 13.11), David (13.13, 13,14), Falconet (13.15), Clodion (13.16)	Canova (13.17)	
ARCHITECTURE					
de Cuvilliès (13.19)	Krohne (13.18), von Knobelsdorff (13.20–13.22)	Miles Brewton House (13.24)		Jefferson (13.23, 13.25)	
THEATRE					
Beginning of American theatre	Gay				
MUSIC & DANCE					
Couperin	Carmago, Sallé	C.P.E. Bach	Haydn, Mozart	Beethoven	
LITERATURE					
Pope	Swift, Fielding	Johnson, Rousseau, Hume, Kant, Diderot, Voltaire, Baumgarten, Goldsmith, Winkelmann, Herder	Schiller, Adam Smith, Paine, Wollstonecraft, Goethe		

Timeline 13.1 The Enlightenment.

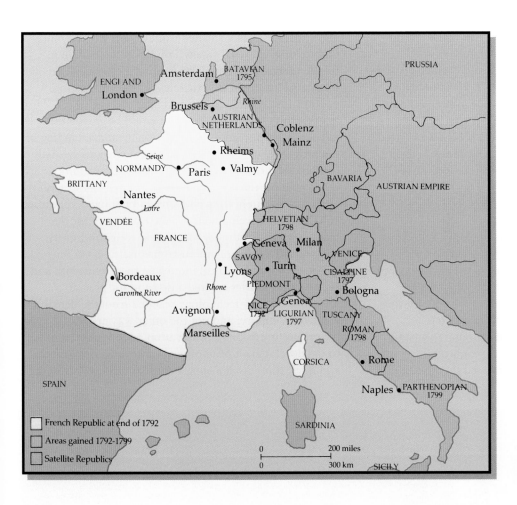

Map 13.1 Europe in the eighteenth century.

literature, and the inventions of their own age represented improvement because they built upon the achievements of their predecessors.

Enlightenment, reason, and progress are secular ideas, and the age grew increasingly secular. Politics and business superseded religion, wresting leadership away from the Church, of whatever denomination. Toleration increased and persecution and the imposition of corporal punishment for religious, political, or criminal offenses grew less common as the era progressed.

The rapid increase in scientific discovery that followed Newton's work resulted in the development of new disciplines. Physics, astronomy, and mathematics remained primary, but quiet categorizing replaced fragmented inquiry. The vast body of information gathered during the late Renaissance period needed codification. New sciences of mineralogy, botany, and zoology developed. First came classification of fossils, then that of rocks, minerals, and plants. Carolus Linnaeus, the botanist, and Georges Buffon, the zoologist, pioneered their fields. Antoine Lavoisier correctly explained the chemical process of combustion. He also isolated hydrogen and oxygen as the two component elements of water, and postulated that although matter may alter its state, its mass always remains the same.

Frederick II of Hohenzollern (HOH-ehn-tzahl-uhrn; 1712–86) exemplified a monarch who ruled with the best interests of the people in general at heart. Probably the "enlightened" state of Frederick's reign kept him in power while the other monarchs of Europe had their powers curtailed, as in England, or were guillotined, as in France. Thus, in the Age of Enlightenment, this enlightened despot represents the age.

"The philosopher of Sans Souci" (sahn soo-SEE), as he was known (we discuss his palace, Sans Souci, in the Architecture section of this chapter), gloried in his reputation as a reformer. His reforms produced a system of administration known as the "Prussian General Law." In all areas of Prussian (see Map **13.1**) life, whether in criminal law, agriculture, the Church, schools, forestry, mining, manufacturing, trade, or shipping, through skillful manipulation of his administrators, he carried out reforms true to the enlightened spirit of the age. His insight, vision, and flexibility made his government dynamic and responsive. Such genius undoubtedly kept Frederick clear of the troubles that beset Marie Antoinette and Louis XVI of France.

Frederick II began a long career as a patron of the arts as soon as he came to the throne. His many achievements, and his enthusiasm and musical

sophistication, created an atmosphere in which music could flourish. He held auditions, commissioned composers, evaluated compositions, and decided artistic policy. His spirit of *Aufklärung* (OWF-klahr-oong), or Enlightenment, set the intellectual tone in Berlin, and stimulated a tremendous amount of writing and discussion of music and musical theory. He also exerted considerable influence on composers such as J.S. Bach and C.P.E. Bach. Frederick often held concerts at his grand Sans Souci Palace in Potsdam (Fig. **13.2**).

Technology

Science went hand in hand with technology. Telescopes and microscopes improved. The barometer and the thermometer were invented, as well as the air pump and the steam engine. The invention of the steam engine gave rise to other machines, and paved the way for the Industrial Revolution at the end of the century.

The use of coal fuel in place of charcoal to smelt iron revolutionized metallurgy in the early eighteenth century. Strong coke fuel tremendously increased the capacity of blast furnaces. Coke-smelted iron initially proved more impure than charcoal-smelted iron, but the puddling furnace solved that problem. Around 1740 Benjamin Huntsman invented the crucible melting and casting process. Using hard coke as fuel achieved higher temperatures, and a greater blast could be gained using tall chimneys instead of bellows. A new understanding of the properties of oxygen and chemical reagents created further advances. These improvements in metallurgy made possible the later use of iron and steel as structural elements, first in bridges and later in buildings. They also enhanced the development of new machinery for the manufacture of yet other machinery, tools, and finely constructed hardware and instruments.

Scientific and medical inquiry in the seventeenth and eighteenth centuries created a demand for precise instruments. New technology resulted from the demand created by inquiry, and not the other way around. A need for greater precision in observation and measurement led to the development of improved surveying, astronomical, and navigation instruments, as well as refinements in the

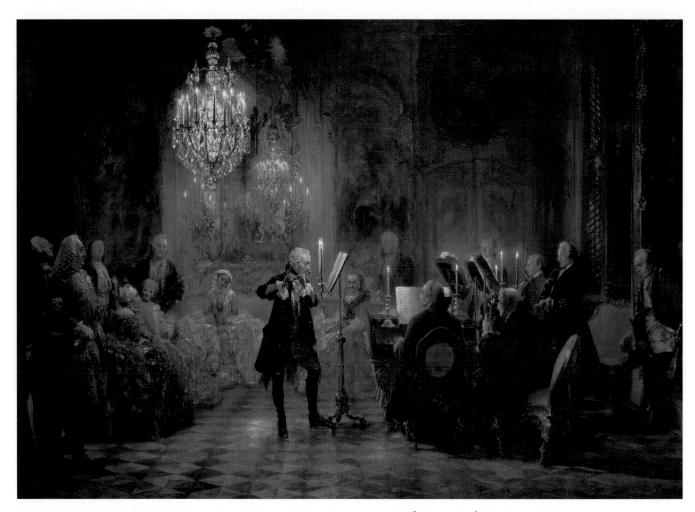

13.2 Adolf von Menzel, *Frederick's Flute Concert at Sans Souci*, 1852. Oil on canvas, 4 ft 7⅞ ins × 6 ft 8¾ ins (1.42 × 2.05 m). Staatliche Museen Preussischer Kulturbesitz, Nationalgalerie, Berlin.

TECHNOLOGY

JAMES WATT AND THE STEAM ENGINE

Strictly speaking, the work of James Watt (1736–1819) on the steam engine was more a critical revision and study of an existing machine than a new composition. However, his scientific and critical innovations were so significant that science views it as a strategic invention. Watt's specific contribution lay in the concept of a separate condensing chamber for an engine invented by Thomas Newcomen and the problem of heat loss through the cooling and heating of the cylinder. The primary concept of a condensing chamber came to Watt on his regular Sunday walk. He saw that steam was an elastic body, which would rush into a vacuum, and if there were a connection between the cylinder and an exhausting vehicle, the steam would rush into it and be condensed without cooling the cylinder. He began testing his possible solution to the problem the next day with the apparatus shown in Figure **13.3**. His model proved highly efficient and demonstrated the soundness of the fundamental principles.

Watt worked rapidly from that point, refining his basic design in larger models, until he had developed a steam engine in the accurate sense of the word, and the result became a well-designed machine based on a sound scientific perception of the properties of steam. Watt's concept of the engine quickly carried him beyond the limits of current facilities for machine building, and many of the parts he required presented problems that no existing ironmakers could solve. Consequently, the attempt to build a working steam engine was postponed until after Watt secured a patent for it in 1769. Even with financial assistance, however, Watt was unable to pay for the construction of the engine and he was forced into bankruptcy.

13.3 James Watt's experimental condensing chamber. Water heated in a closed container (A) produced steam, which traveled through tubes (B and H) into chambers (C and K), moderated by valves (F), to create force to move pistons (D and J) and raise weight (E).

thermometer and the barometer. Advances in the skills and materials used in the manufacture of instruments, resulted in greater specialization and the creation of craft shops. These included advances in making optical glass, which, in turn, led to the development of better lenses for use in telescopes and compound microscopes.

Improvements in precision tooling affected clockmaking and tools such as the lathe. The introduction of cams and templates allowed even greater accuracy and intricacy in production. An instrument called the dividing engine made it possible to graduate a circle by mechanical means, and to graduate scales on surveying and navigational instruments accurately.

The field of engineering in the seventeenth and eighteenth centuries saw advances in hydraulics, road building, and bridge construction. The control of water flow in canals improved by the development of an extremely accurate bubble-tube leveling device. The surveyor's level with a telescopic sight proved another productive invention. Bridge building improved by modifications to the construction of pier foundations, and the first iron bridge was completed at Coalbrookdale, England, in 1779.

The introduction of power machinery revolutionized the English textile industry in the late eighteenth century, but the steam engine, undoubtedly the most significant invention of the period, replaced human, animal, wind, and water power with machine power. It changed the course of history. The first full-scale steam engine had been developed in England in 1699, and early steam engines were used to drain mine shafts. By the mid-eighteenth century, some wealthy people used steam engines to pump domestic water supplies, but James Watt's invention of the separate condenser in 1769 brought steam engines to new levels of practicality and productivity. Further modifications primed the engine for

Map 13.2 America in the eighteenth century.

its role as cornerstone of the Industrial Revolution. In 1800, when the patent for Watt's engine expired, new high-pressure steam engines tackled a variety of new tasks, most notably in the first successful steam locomotive in 1804. By 1820, the steam engine could generate an estimated 1,000 horsepower, hailing the Industrial Revolution.

Economics and Politics

The same spirit of challenge and questioning also applied to economics. Critics of mercantilistic government regulation and control, called "physiocrats," from the Greek *physis*, meaning "nature," saw nature as the single source of all wealth. Agriculture, forestry, and mining grew in importance relative to manufacturing. Physiocratic theory also advocated a *laissez-faire* (LEHS-say-FAIR) approach to economic endeavor. In other words, physiocrats believed that production and distribution were best handled without government interference. Government should abandon supervision so that nature and enterprising individuals could co-operate in the production of the greatest possible wealth. General physiocratic ideas saw refinement and

codification in Adam Smith's *Wealth of Nations* (1776). Smith (1723–90), a Scotsman, argued that the basic factor in production was human labor (rather than nature). He believed that enlightened self-interest, without government intervention, stood sufficient to inspire individuals to produce wealth on an unheard-of scale.

On the political scene, the German states saw turmoil and flux in the eighteenth century. In 1701 Frederick I (1657–1713) became King in Prussia (the word "in" rather than "of" was used to placate Poland, which occupied West Prussia). Frederick's major political stronghold lay in a small area called Brandenburg. However, Frederick's family, the Hohenzollern, soon came to dominate the whole of Prussia. Frederick's son, King Frederick William I (r. 1713–40), perfected the structure of the army and the German civil service.

Frederick William was a notable eccentric. For example, he compelled anyone he suspected of having wealth to build a fine residence to improve the appearance of his city. He also had a craze for tall soldiers, whom he recruited from all over Europe, thereby making his palace guard a cadre of coddled giants. Frederick William's son, later Frederick II, had a rigorous training in the army and civil service.

When Frederick II assumed the throne on his father's death in 1740, he brought to it a detailed knowledge of the Prussian service, together with an intense love of arts and literature. A person of immense ambition, he turned his sights very quickly on neighboring Austria. Austria's House of Hapsburg was ruled by Charles VI, who died in 1740. His daughter, the Archduchess Maria Theresa, became ruler of all the Hapsburg territories, many of which were the subject of disputed claims of possession. Scenting opportunity, Frederick II promptly marched into Austrian territory. A tug-of-war-and-peace between Austria and Prussia followed. Both countries emerged from these hostilities strong and socially stable, and both became centers of artistic, literary, and intellectual activity in the second half of the eighteenth century.

Frederick II, an "enlightened" and humanitarian ruler, a "benevolent despot," championed thinkers throughout Europe and reformed German institutions so that they could better render service to all classes of society, especially the poor and oppressed (in strong contrast to Louis XV and XVI of France). When he died in 1786, he left behind a strong country, if only a very small one.

Meanwhile, in England, King George III (1738–1820; r. 1760–1820) presided over the American Revolution. The major internal revolution in England came in 1688 leading to the contractual monarchy of William and

PROFILE

MARIA THERESA (1717–80)

Maria Theresa, like her nemesis, Frederick II, an enlightened despot, succeeded to the Hapsburg lands as empress in 1740. Her succession was contested in the War of the Austrian Succession, in which she lost Silesia to Prussia but secured the election of her husband as emperor. She carried out agrarian reforms and centralized the administration. During her reign, Vienna developed as a center for music and the arts. Called "the most human of the Hapsburgs," Maria Theresa proved a key figure in the complex politics of Europe in the 1700s. Her father, the Holy Roman Emperor Charles VI, tried to ensure her succession to his domains, and she devoted much of her life to the fight to keep her lands.

Maria Theresa became at the age of twenty-three archduchess of Austria and queen of Bohemia and Hungary. She also inherited outlying possessions of the house of Austria in Italy and the Netherlands. Various powers hoped to add to their territories at the expense of the inexperienced queen. Most determined of all her enemies was young Frederick II, King of Prussia.

Maria Theresa's father, the last of the direct male line of the Austrian Hapsburgs, had no sons, and the Hapsburg law forbade women to inherit Hapsburg lands. In order to secure his oldest daughter's succession, he drew up a revision of the law, called the Pragmatic Sanction. After long negotiations, he persuaded all the major powers of Europe—including Prussia—to agree to this international treaty. Before coming to the throne, Maria Theresa married Duke Francis of Lorraine. Maria Theresa had been on the throne only two months when Frederick marched his army southward into Silesia, the fertile valley of the Oder River that stretched southeastward from his own Brandenburg. Her Hungarian subjects failed in their attempts to expel Frederick from Silesia.

Maria Theresa's pride and her devout Roman Catholicism made her determined to recover her lost province from Protestant Prussia. She formed an alliance with Russia and then set about to win France as an ally against Prussia. To continue this complicated exchange of allegiances, Frederick then entered into an alliance with Great Britain.

To strengthen the alliance with France, she married her youngest (of sixteen children) daughter, Marie Antoinette, to the heir to the French throne. Her oldest son, Joseph II, assisted her in the government after the death of her husband. She carried out many reforms to strengthen the unity of her lands. She ruled as an absolute monarch, but she proved one of the enlightened despots of the eighteenth century. She died in Vienna on 28 November 1780. Joseph II succeeded her.

Mary. In France, Louis XV (1710–74; r. 1715–74) and his grandson, Louis XVI, along with his wife, Marie Antoinette (1755–93), saw revolution. The complexities of the French Revolution (1789), which lie beyond our scope here, led from wars throughout Europe and a second revolution in 1792, through an "Emergency Republic," the "Terror," the Directory, Napoleon's *coup d'état* (koo-day-TAH) in 1799, to a new and politically explosive century in Europe. The French Revolution had important effects on the arts. In particular, the Royal Academy's dictatorial control over the production of fine art ended, at least temporarily. Exhibitions opened democratically to all artists, and the Academy itself was reconstituted as the Institut de France. The baroque and rococo styles associated with the French monarchy faded, and attention turned to edifying art that would glorify virtue—the models of which people found in classical antiquity.

CONCEPTS

Rationalism

We have witnessed in previous chapters how philosophy, theology, natural sciences, and mathematics moved toward rationalism in René Descartes's (see Chapter 12) belief that human reason can solve every problem that the mind can entertain. He also peeled philosophy away from theology and allied it with the natural sciences and mathematics, rejecting all that could not be proved. As we move to the eighteenth century, rationalism comes increasingly to the fore and reaches an important milestone in the philosophy of Immanuel Kant (kahnt; 1724–1804). Kant also played an important role in aesthetic theory, and we will examine that shortly. Now, we examine Kant's basic philosophy.

Kant, a German philosopher, undermined the status of metaphysics, revolutionized epistemology (the division

of philosophy that investigates the nature and origin of knowledge), and sought to provide a rational basis for ethics and aesthetics. He sought primarily to synthesize rationalism (the belief that reason forms the prime source of knowledge and of spiritual truth) and empiricism (the belief that experience, especially of the senses, forms the only source of knowledge). Much of his work attempted to produce a logically coherent basis for natural science that took into account the *skepticism* of David Hume (1711–76)—the doctrine that absolute knowledge is impossible and that inquiry must comprise a process of doubting to achieve only relative certainty. To state his case, Kant wrote *Critique of Pure Reason* (1781), in which he proposed that we can have no direct knowledge of the material world. He distinguished, however, between the empirical—our sensory perceptions—and the transcendental, which permits knowledge by virtue of a set of preexisting (*a priori*) concepts (categories of the understanding) that give order and form to experience.

Another rationalist and influential figure in the mid-eighteenth century, Jean-Jacques Rousseau (roo-SOH; 1712–72), propounded a theory of government so purely rationalistic that it had no connection whatever with the experience of history. To Rousseau, human beings comprised essentially unhappy, feeble, and frustrated beings trapped in a social environment of their own making. He believed people could be happy and free only in a "state of nature," or, at most, in a small and simple community. Such a philosophy stands completely in contrast to that of Diderot, who held that only accumulated knowledge would liberate humanity.

Indeed, the Enlightenment proved an age of contrasts. Rousseau, an anarchist, did not believe in government of any kind. He wrote on politics, therefore, not to improve government but because he lived in an age of political speculation and believed he had the power to deal with every problem. His *Social Contract* (1762), in utterly rationalistic fashion, reasserted Locke's propositions about the social contract (see Chapter 12), sovereignty of the people, and the right of revolution. More importantly, he took Locke's concept of primitive humanity and converted such people into "noble savages" who had been subjected to progressive degradation by an advancing civilization. In an age turning to rational, intellectual classicism, Rousseau sowed the seeds of Romanticism, which flowered in the next century. He also sounded the call for revolution: the opening sentence of the *Social Contract* reads, "Man was born free, and everywhere he is in chains," a thought that predates Karl Marx by about a century.

Aesthetics

We noted earlier in the text that aesthetics involves the study of the nature of beauty and of art, and derives from

the Greek word for "sense perception." Shortly, we will see how Alexander Baumgarten coined the term—not inventing a new field of inquiry, for such study dates at least to the ancient Greeks, but giving these studies a formal name.

Immanuel Kant revolutionized aesthetics in his *Critique of Judgment* (1790), in which he laid out his aesthetic theory disputing the conventional viewpoint, which dated to ancient Greece, that what we see in a beautiful object constitutes its inherent quality of "beauty." In Kant's view, although we may perceive beauty and may find the appearance of a design in nature, we cannot assume either an attitude of "beauty" independent of the beautiful object or the existence of a "designer." For Kant, the beautiful comprises whatever gives us "disinterested pleasure"—contemplative delight free from the active ordering of the understanding. The appreciation of art or natural splendor comes from a person's own judgment; any apparently universal nature results from the universality of human nature and imagination and not any universal existence of ideal beauty.

Humanitarianism

The Enlightenment concerned more than philosophy and invention. Enlightened thought led to an active desire, called *humanitarianism*, to raise the downtrodden from the low social circumstances into which ignorance and tyranny had cast them. All men and women had a right, as rational creatures, to dignity and happiness. This desire to elevate the social circumstances of all people led to an examination and questioning of political, judicial, economic, and ecclesiastical institutions.

The ideas of the Enlightenment spread largely through the efforts of the *philosophes* (FIL-oh-sawf). Although this term suggests philosophy, the philosophes were not philosophers in the usual sense of the word. Rather, they were popularizers or publicists. Men of letters, they culled thought from great books and translated it into simple terms understandable by a reading public. In France, the most serious of all the philosophe enterprises produced the *Encyclopedia*, edited by Denis Diderot (deed-ROH; 1713–84). The seventeen-volume *Encyclopedia*, which took from 1751 to 1772 to complete, formed a compendium of scientific, technical, and historical knowledge, incorporating a good deal of social criticism. Voltaire and Rousseau both contributed to it.

No philosophe undertook such a vocal or universal attack on contemporary institutions as Voltaire (1697–1778; originally François-Marie Arouet; see Profile). We can easily see Voltaire as an aggressive, churlish skeptic, who had nothing positive to offer as a substitute for the ills he found everywhere. In fact, his

PROFILE

VOLTAIRE (1694–1778)

Voltaire (vohl-TAIR) ranged widely through French literature during the years of the Enlightenment and leading up to the French Revolution. Born into a middle-class Parisian family, he lost his mother when he was seven and believed that his real father was not his legal one. A rebel from authority, he grew up in the company of his freethinking godfather, the Abbé de Châteauneuf, and always maintained a clear sense of reality and a positive outlook. His schooling, at the Jesuit College of Louis-le-Grand in Paris, nurtured his love of literature, theatre, and social life, but the school's religious instruction left him skeptical. The period around 1709 saw the last years of Louis XIV accompanied by military disasters and religious persecution, events that left an indelible impression on the young Voltaire, although he continued to admire Louis XIV and to believe that kings represented agents of progress.

His wit and desire to pursue a career in literature, coupled with the peculiar circumstances of the years after Louis XIV, in which the literary salon formed the center of French society, soon brought Voltaire into social prominence. However, when he mocked the Regent, he found himself imprisoned for a year in the Bastille. Nonetheless, he saw himself as the Vergil of French literature and set about the serious task of writing, soon landing back in favor. A two-year visit to England made him acquainted with the writings of Sir Isaac Newton and John Locke and gave him a greater appreciation of English literature, and he returned to France determined to use England as a model for his compatriots. Careful investments made Voltaire a wealthy man, and this allowed him to proceed on literary and social ventures of his choice. He wrote several mediocre tragedies before turning to writing history. His histories read like novels, and as he wrote, he increasingly began to insert philosophy into his texts.

However, his profound insights were not appreciated by his contemporaries, and under threat of arrest he retreated to the château of Madame du Chatelet, with whom he spent the next several years. He also enjoyed the companionship of the enlightened Prussian despot Frederick II, the Great, and frequently visited Frederick's palace at Sans Souci (see p. 428).

However, the French court remained hostile. Voltaire committed several personal indiscretions and some of his plays failed miserably, forcing him to lead a restless existence that eventually made him ill. In despair after the death of Madame du Chatelet, he returned to Germany at the invitation of Frederick II. Controversy seemed to follow him, however, and by 1753 he fell out of favor with Frederick and was forbidden to return to Paris. He retired to Geneva, where he completed two major historical studies but also became embroiled in religious controversy with the Calvinists (see Chapter 11).

During this time, Voltaire wrote his most famous work, *Candide* (1758). Then he purchased an estate on the French–Swiss border, which afforded him safe haven from whichever police were after him at the time. This began the most active period of his life. Although constantly embroiled in minor feuds over everything from land titles to liberation for the serfs, he enjoyed worldly fame and played constant host to international celebrities. He used his fame to speak out on anything and everything—especially the Church—and he fought vigorously for religious toleration, material prosperity, respect for the rights of all humans, and the abolition of torture and useless punishments. He continued to write for the theatre, and this brought about his triumphant return to Paris in 1778. However, the excitement proved too great, and his health suffered irreparably. He died on 30 May that same year.

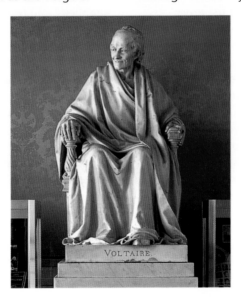

13.4 Jean-Antoine Houdon, *Voltaire*, 1781. Marble, 20 ins (51 cm) high. Victoria & Albert Museum, London.

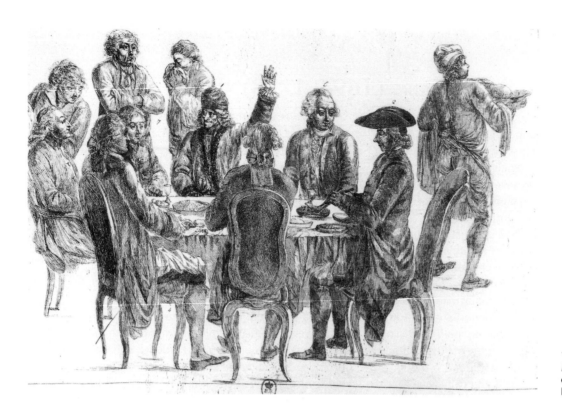

13.5 Jean Huber, *The Philosophes at Supper*, c. 1750. Engraving. Bibliothèque Nationale, Paris.

championship of deism contributed greatly to improved religious toleration. His stinging wit broadened awareness of and reaction against witch-burnings, torture, and other such abuses of human rights. Without question, his popularizing of knowledge and his broad program of social reform helped to bring about the French Revolution, which cast out the old absolutist order once and for all.

Classicism

The death of Louis XIV in 1715 brought to a close a magnificent French courtly tradition that had championed baroque art (although the German baroque continued well into the eighteenth century). The French court and aristocracy moved to more modest surroundings, to intimate, elegant townhouses and salons, a milieu entirely different from the vastness and opulence of the Palace of Versailles. Charm, manners, and finesse replaced previous standards of social behavior. Enlightenment society sought refinement of detail and décor, and delicacy in everything. "Sociability" became the credo of early eighteenth-century France and the rest of Europe.

Classical influences dating from the Renaissance continued, principally because enlightened individuals considered a "classical education" essential for all members of the upper classes. The excavation of the ruins of the Roman city of Pompeii, found virtually intact, in 1748 caused a wave of excitement. The ancient city of Herculaneum (hur-kyoo-LAYN-ee-uhm) had been partly excavated in 1738. Amid this revived interest came

Alexander Baumgarten's significant book, *Aesthetica* (1750–8). For the first time the word "aesthetics" was used to mean "the study of beauty and theory of art." Then, in 1764, came Johann Winckelmann's (VING-kuhl-mahn) *History of Ancient Art*, in which the author described the essential qualities of Greek art as "a noble simplicity and tranquil loftiness . . . a beautiful proportion, order, and harmony."

These values brought the arts of the eighteenth century out of the baroque era. Herculaneum, Pompeii, aesthetic theory, and a return to antiquity and the simplicity of nature—classicism—closed a century marked by war and revolution, rationalism, and skepticism.

Feminism

Feminism comprises a social, political, and cultural movement designed to achieve equal rights and status for women in all areas of life. In its most radical form feminism seeks to establish a new order in which men no longer call the shots nor form the standard for gauging normality and equality. Feminism does not involve only a single set of ideologies, but, rather, constitutes a diverse set of perspectives on the origin and constitution of gender and sexuality, the historical and structural foundations of male power and women's subjugation, and the best means for emancipating women. We tend to think of feminism as a modern—twentieth-century— phenomenon, but, of course, the struggle dates to pre- history. We already saw it in Aristophanes' play *Lysistrata* (411 B.C.E.), in which women go on a sex strike

to rid Athens of war and warmongers. Modern feminism dates to the Enlightenment and the eighteenth century, particularly in the writings of Mary Wollstonecraft, whom we study in the Literature section of this chapter. Her passionate advocacy of educational and social equality for women proved groundbreaking and influential. So, we see, as part of the Enlightenment, a thrust to bring equality for women, as part of the general push for humanitarian and egalitarian status across western Europe and the United States. The term "feminism" did not actually appear until the nineteenth century during the widespread suffragist movement in England and the United States that sought to gain for women the right to vote and other civil rights.

THE ARTS OF THE ENLIGHTENMENT

We move now to the arts of the Enlightenment. In previous chapters we have had the luxury of spending the entire chapter on, usually, a single style. As we enter the

modern world, in a time whose ideas spawned democracy across the Western world, we pick up the pace somewhat, as did the world itself. Not only will we examine the arts of painting, sculpture, architecture, theatre, music, dance, and literature, but we will follow several emerging styles and directions. Thus, in painting, for example, we find the century of the Enlightenment producing a new style, called rococo, a new nationalistic approach, which we call the English School, and yet another new and contrasting style called neoclassicism. First, we examine rococo style.

Painting

Rococo Style

The change from the splendor of courtly life to the style of the small salon and the intimate townhouse was reflected in a new style of painting called "rococo" (ruh-KOH-koh or roh-kuh-KOH). People sometimes describe rococo as an inconsequential version of baroque—with some justification. Some paintings of this style display fussy detail, complex composition, and a certain

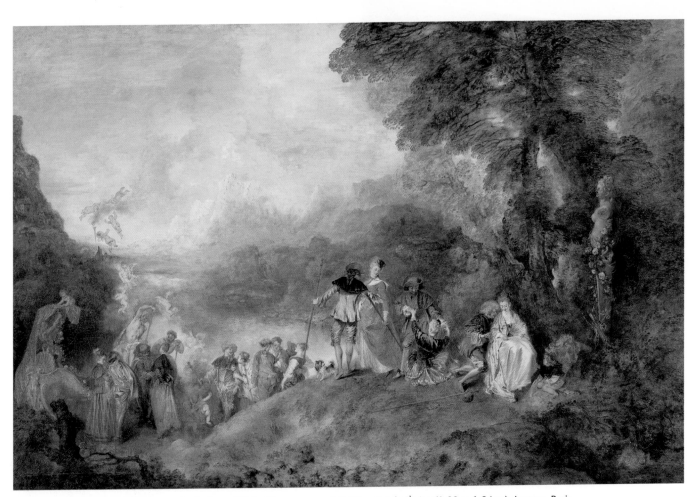

13.6 Antoine Watteau, *Embarkation for Cythera*, 1717. Oil on canvas, 4 ft 3 ins × 6 ft 4½ ins (1.29 × 1.94 m). Louvre, Paris.

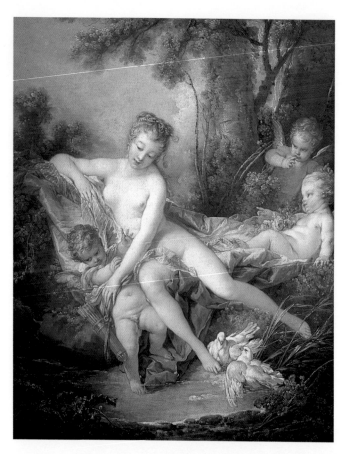

13.7 François Boucher, *Venus Consoling Love*, 1751. Oil on canvas, 3 ft 6⅛ ins × 2 ft 9⅜ ins (1.07 × 0.85 m). National Gallery of Art, Washington D.C. (Chester Dale Collection).

aristocracy. Watteau's work, although sentimental, is not particularly frivolous. *Embarkation for Cythera* (Fig. **13.6**) idealizes the social graces of the high-born classes. Cythera is a mythological land of enchantment, the island of Venus, and Watteau portrays aristocrats idling away their time in amorous pursuits as they wait to leave for that faraway place.

Soft color areas and hazy atmosphere add the qualities of fantasy to the landscape. An undulating line underscores the human figures, all posed in slightly affected attitudes. Each group of doll-like couples engages in graceful conversation and amorous games. An armless bust of Venus presides over the delicate scene. Watteau's fussy details and decorative treatment of clothing contrast with the diffused quality of the background. But underlying this fantasy lies a deep, poetic melancholy.

The slightly later work of François Boucher (boo-SHAY; 1703–70) continues in the rococo tradition. His work even more fully exemplifies the decorative, mundane, and somewhat erotic painting popular in the early and mid-eighteenth century. As a protégé of Madame de Pompadour, the mistress of King Louis XV, Boucher enjoyed great popularity. His work has highly decorative surface detail and portrays pastoral and mythological settings such as *Venus Consoling Love* (Fig. **13.7**). Boucher's figures almost always appear amid exquisitely detailed drapery. His nearly flawless technique and painterly virtuosity create fussily pretty works, the subjects of which compete with their decorative backgrounds for attention. Compared with the power, sweep, and grandeur of baroque painting, Boucher's work appears gentle and shallow. Here, each of the intricate and delicate details takes on a separate focus of its own and leads the eye in a disorderly fashion first in one direction and then another.

Characteristic of later rococo style, *The Swing* (see Fig. **13.1**) by Jean-Honoré Fragonard (frah-goh-NAR; 1732–1806) is an "intrigue" picture. A young gentleman has enticed an unsuspecting old cleric to swing the gentleman's sweetheart higher and higher so that he, strategically placed, can catch a glimpse of her exposed limbs. The young lady, perfectly aware of his trick, gladly joins in the game, kicking off her shoe toward the statue of the god of discretion, who holds his finger to his lips in an admonishment of silence. The scene exudes frivolous naughtiness and sensuality, with lush foliage, foaming petticoats, and luxurious colors.

The English School
The Enlightenment brought forth in England several directions of approach which we now pause to examine. We will find in England three avenues of pursuit: humanitarian satire, landscape painting, and portraiture.

superficiality. To dismiss all early eighteenth-century work thus would be wrong, however.

Rococo reflected its time. Essentially decorative and nonfunctional, like the declining aristocracy it represented, its intimate grace, charm, and delicate superficiality reflect the social ideals and manners of the age. Informality replaced formality in life and in painting. People found the heavy academic character of the baroque of Louis XIV lacking in feeling and sensitivity. Deeply dramatic action now transmuted into lively effervescence and melodrama. Love, friendship, sentiment, pleasure, and sincerity emerged as predominant themes. None of these characteristics conflicts significantly with the overall tone of the Enlightenment and its major goal: refinement. The arts of the period could dignify the human spirit through social and moral consciousness as well as through the graceful sentiments of friendship and love. Delicacy and informality did not have to imply limp or empty sentimentality.

The rococo paintings of Antoine Watteau (wah-TOH; 1683–1721) represent many of the changing values of the

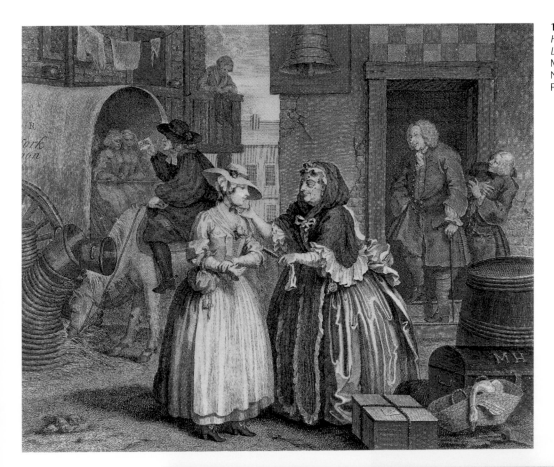

13.8 William Hogarth, *The Harlot's Progress: Arrival in London*, 1731. Engraving. Metropolitan Museum of Art, New York (Harris Brisbane Dick Fund, 1932).

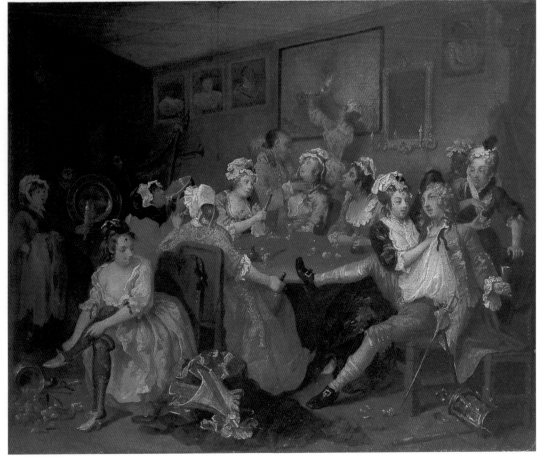

13.9 William Hogarth, *The Rake's Progress: The Orgy*, 1733–4. Oil on canvas, 24½ × 29½ ins (62.2 × 75 cm). By courtesy of the Trustees of Sir John Soane's Museum, London.

The aristocratic frivolity of rococo style found a heavy counterbalance in the biting satire and social comment of enlightened humanitarians such as William Hogarth (1697–1764). In England during the 1730s, Hogarth portrayed dramatic scenes on moral subjects. His *Rake's Progress* and *Harlot's Progress* series attempt to correct raging social ills and to instill solid middle-class values. Hogarth attacked the foppery of the aristocracy, drunkenness, and social cruelty. In *The Harlot's Progress* series (Fig. **13.8**), the prostitute, a victim of circumstances, arrives in London, her employer seduces her, and she ends up in Bridewell Prison. Hogarth blames her final fate more on human cruelty than on her sins. The same may be said of *The Rake's Progress*, which in a series of six tableaux, portrays the downfall of a foolish young man from comfortable circumstances. This series moves through several views of the young man as he

sinks lower and lower into corruption (Fig. **13.9**) until he ends up in the Bedlam insane asylum.

Hogarth intended his criticism of social conditions as an incitement to action, a purpose characteristic of eighteenth-century humanitarians. The fact that his paintings were made into engravings and widely sold to the public as prints illustrates the popularity of attacks on the social institutions of the day.

One of the most influential English painters of the time, Thomas Gainsborough (1727–88) painted landscapes that bridge the gap between the baroque and Romantic styles, and his portraits exhibit sensitive elegance. Gainsborough's full-length portraits of lords and ladies (Fig. **13.10**) have a unique freshness and lyric grace. Occasionally art critics object to the lack of structure in his attenuated, almost weightless figures; however, such objections fade away when confronted by the beauty of Gainsborough's color and the delicacy of his touch.

His landscapes reveal a freshness typically associated with the English approach to painting. In *The Market Cart* (Fig. **13.11**) we find a delicate use of wash reminiscent of Watteau. Here the painter explores tonalities and shapes that express a deep and almost

13.10 Thomas Gainsborough, *The Hon. Mrs Graham*, c. 1777. Oil on canvas, 7 ft 9⅜ ins × 5 ft ¾ in (2.37 × 1.54 m). National Gallery of Scotland.

13.11 Thomas Gainsborough, *The Market Cart*, 1786–7. Oil on canvas, 6 ft ½ in × 5 ft ¼ in (1.84 × 1.53 m). Tate Gallery, London.

mystical response to nature. Although the subject remains pastoral, the composition has an unusual energy that derives from its diagonal character. The twisted and gnarled tree forms on the right border lead the viewer's eye up and to the left, to be caught by the downward circling line of the trees and clouds in the background and returned on the diagonal. The human figures in the picture create little interest—although warmly rendered, they are not individuals, and their forms remain indistinct. We see them, rather, as subordinate to the forces of nature which ebb and flow around and through them.

Genre

Another vein running through the rich soil of the eighteenth century, genre painting, takes mundane objects and raises them to aesthetic heights as objects of fine art and aesthetic consequence.

A fresh bourgeois flavor emerges in the mundane subjects of France's Jean-Baptiste Siméon Chardin (shahr-DAN; 1699–1779), whose paintings show an interest in the servants and life "below stairs" in well-to-do households. The finest still life and *genre* painter of his

time, he continued the tradition of the Dutch masters of the previous century. His early works are almost exclusively still-lifes, and *Menu de Gras* (men-oo-duh grah; Fig. **13.12**) illustrates how everyday items could be raised to a level of unsuspected beauty.

The artist invests each item—cooking pot, ladle, pitcher, bottles, cork, a piece of meat, and other small things—with intense significance, as richness of texture and color combined with careful composition and the use of chiaroscuro make these humble items somehow noble. The eye moves slowly from point to point, carefully directed by shapes and angles, color and highlight. The work itself controls the speed at which we view it. Each new focus demands that we pause and savor its richness. Chardin urges us to look beneath our surface impressions of these objects into their deeper reality.

Neoclassicism

The discovery of the ruins of Pompeii, Winckelmann's interpretation of Greek classicism, Rousseau's "noble savage," and Baumgarten's aesthetics sent the interests of late eighteenth-century artists and thinkers back into antiquity, and in particular, into nature. We call this

13.12 Jean-Baptiste Siméon Chardin, *Menu de Gras*, 1731. Oil on canvas, 13 × 16⅛ ins (33 × 41 cm). Louvre, Paris.

MASTERWORK

DAVID—*THE OATH OF THE HORATII*

David's famous painting *The Oath of the Horatii* (Fig. **13.13**) concerns the conflict between love and patriotism. In legend, the leaders of the Roman and Alban armies, on the verge of battle, decide to resolve their conflicts by means of an organized combat between three representatives from each side. The three Horatius brothers represented Rome; the Curatius sons represented the Albans. A sister of the Horatii was the fiancée of one of the Curatius brothers. David's painting depicts the Horatii as they swear on their swords to win or die for Rome, disregarding the anguish of their sister.

The work captures a directness and an intensity of expression that played an important role in Romanticism. But the starkness of outline, the strong geometric composition (which juxtaposes straight line in the men and curved line in the women), and the smooth color areas and gradations hold it to the more formal, classical tradition. *The Oath of the Horatii* reflects the style of academic neoclassicism. The scene takes place in a shallow picture box, defined by a severely simple architectural framework. The costumes reflect historical accuracy. The musculature, even of the women, lacks warmth or softness.

Ironically, King Louis XVI admired and purchased David's work. David, on the other hand, directed his revolutionary cries against Louis XVI, and, as a member of the French Revolutionary Convention, sentenced Louis to death.

13.13 Jacques-Louis David, *The Oath of the Horatii*, 1784–5. Oil on canvas, about 11 × 14 ft (3.35 × 4.27 m).

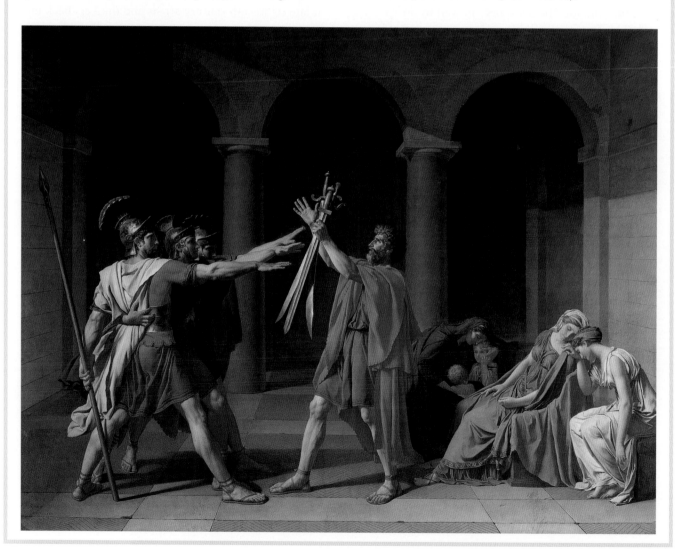

return to classical qualities "**neoclassicism**" or "new" classicism. In it we find the emphasis on formal design and idealism we noted in classical Greece in Chapter 3 and yet another direction to which the pendulum of the Enlightenment could swing.

A principal proponent of *neoclassicism* in painting, Jacques-Louis David (dah-VEED; 1748–1825) illustrates the newly perceived grandeur of antiquity, as reflected in his subject matter, composition, and historical accuracy. Propagandist in tone—he sought to inspire French patriotism and democracy—his paintings have a strong, simple compositional unity. In both *The Death of Socrates* (Fig. **13.14**) and *The Oath of the Horatii* (see Fig. **13.13**), David exploits his political ideas using Greek and Roman themes. In both cases, the subjects suggest a devotion to ideals so strong that one should be prepared to die in their defense. David's values emerge dramatically clear in his sparse, simple composition.

David's neoclassicism did more than copy ancient works. He used classical detail, stories, and principles selectively, and frequently adapted them to suit his own artistic purposes.

Sculpture

Rococo sculpture did not have the monumental scale of its predecessors. Rather, in the spirit of decoration that marked the era, sculpture often took the form of graceful porcelain and metal figurines. Falconet's *Madame de Pompadour as the Venus of the Doves* (Fig. **13.15**) fully captures the erotic sensuality, delicacy, lively intelligence, and charm of the rococo heritage. The unpretentious nudity indicates the complete comfort and naturalness the eighteenth century found in affairs of the flesh. Rococo techniques for conveying surface textures, detail, and line in sculpture display mastery of the medium. If this style, and the society it exemplifies, lacks profundity, it does show technical achievement.

Claude Michel, known as Clodion, created dynamic miniatures such as the *Satyr and Bacchante* (Fig. **13.16**). His groups of accurately modeled figures in erotic abandon emerge all the fresher and more alluring by his knowing use of pinkish terracotta as if it were actually pulsating flesh, rendering each incipient embrace "forever warm and still to be enjoyed."

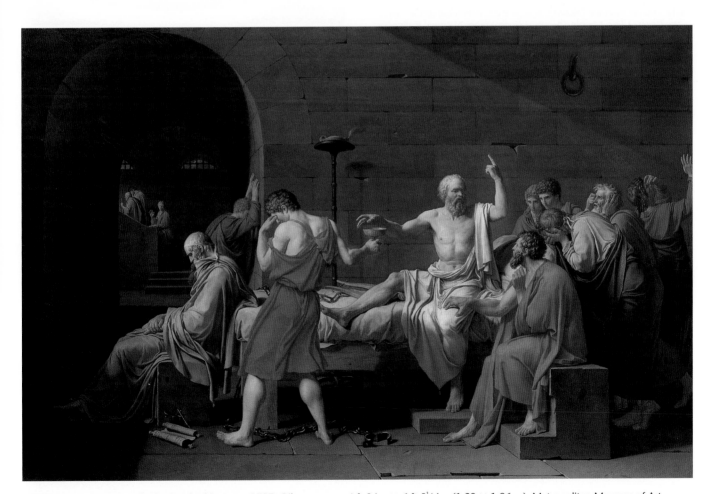

13.14 Jacques-Louis David, *The Death of Socrates*, 1787. Oil on canvas, 4 ft 3 ins × 6 ft 5¼ ins (1.29 × 1.96 m). Metropolitan Museum of Art, New York. (31.45) Catherine Lorillard Wolfe Collection, Wolfe Fund, 1931.

13.15 Étienne-Maurice Falconet, *Madame de Pompadour as the Venus of the Doves*, 1782. Marble, 29½ ins (75 cm) high. National Gallery of Art, Washington D.C. (Samuel H. Kress Collection).

13.16 Clodion (Claude Michel), *Satyr and Bacchante*, c. 1775. Terracotta, 23¼ ins (59 cm) high. Metropolitan Museum of Art, New York (Bequest of Benjamin Altman, 1913).

13.17 Antonio Canova, *Pauline Borghese as Venus Victrix*, 1808. Marble, lifesize. Galleria Borghese, Rome.

Antonio Canova (kah-NOV-ah; 1757–1822), the ablest of the neoclassical sculptors, shows in his works influences of the rococo style. *Pauline Borghese as Venus Victrix* (Fig. **13.17**), for which Napoleon's sister sat as model, uses a classical pose and proportions. Line, costume, and hairstyle reflect the ancients, but sensuous texture, individualized expression, and fussy lifelike detail suggest other approaches. At the same time, this work remains almost two-dimensional. Canova seems unconcerned with the sculpture from any angle other than a straight-on view.

Architecture

Unlike most previous architectural styles, rococo stayed principally a style of interior design. Its refinement and decorativeness applied to furniture and décor more than to exterior structure or even detail. By now, even the aristocracy lived in attached row houses, and townhouses quite simply have virtually no exteriors to design. Attention turned to interiors, where the difference between opulence and delicacy was apparent. Figure **13.18** shows a polygonal music room characteristic of German rococo. Its broken wall surfaces display stucco decoration of floral branches that creates a pseudonatural effect. In Venice, curved leg furniture, cornices, and gilded carvings were the fashion. French designer Jean

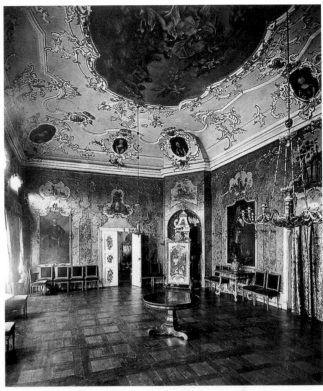

13.18 G.H. Krohne, music room, Thuringer Museum, Eisenach, Germany, 1742–51.

13.19 Jean-François de Cuvilliès, The Pagodenburg, c. 1722. Schloss Nymphenburg, Munich, Germany.

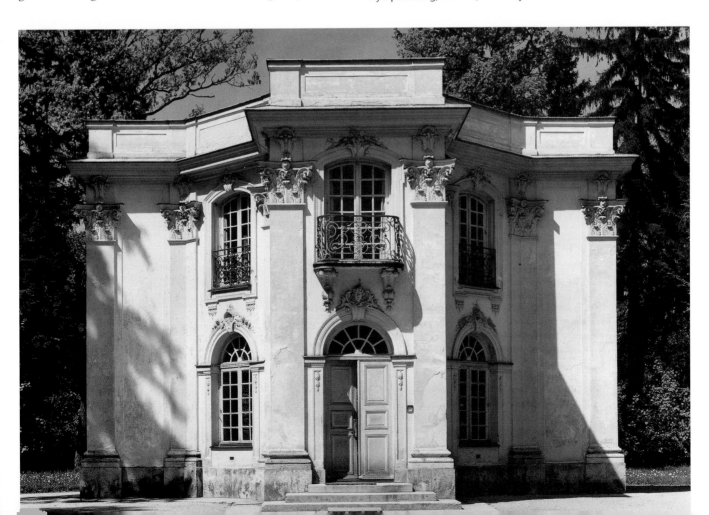

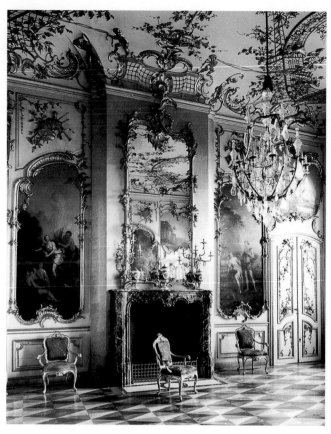

13.20 Georg Wenzelaus von Knobelsdorff, interior of music room, Sans Souci, Potsdam, Germany, 1745–7.

François de Cuvilliès (kue-vee-EHS; 1695–1768) combined refinement, lightness, and reduced scale to produce a pleasant atmosphere of grace and propriety (Fig. **13.19**).

The Sans Souci Palace in Potsdam (now in Germany) represents the rococo phase of eighteenth-century German art (Figs **13.20–13.22**). Designed by George Knobelsdorff, the palace indicates both an increasing German receptivity to French rococo style and an amplification of Italian baroque style. Planned as a retreat for a philosopher-king, Sans Souci, which means "carefree," provided Frederick with a summer palace where he could work, think, and entertain the intellectual élite of Europe in seclusion and privacy. Voltaire was one of his guests.

Like Versailles, San Souci had a formal design, as the garden front illustrates (Fig. **13.21**). Frederick designed the original plan, and it included terraces faced with glass houses curved to catch the sun's rays from different angles. The entrance way and entrance hall of the palace interior show a return to classical tradition with their curving colonnades and Corinthian columns (Fig. **13.22**). These classical features provide a curious counterpoint to the richness and delicacy of the rococo interior. Sans Souci monumentalizes the vision of an enlightened monarch who reflected eighteenth-century ideals. Although a critic of his own German

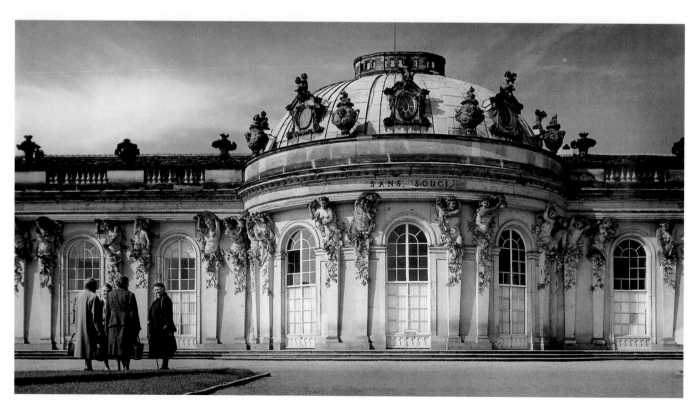

13.21 Georg Wenzelaus von Knobelsdorff, garden front of Sans Souci.

culture, he nonetheless brought about a rich period of German artistry.

English architecture of the early eighteenth century shared in these rococo refinements, but its style differed in many ways from that of the continent. The late seventeenth and early eighteenth centuries in England produced a so-called "Georgian style"—the name refers to Kings George I, II, and III, whose reigns the style partially encompassed. Georgian style, however, constituted more a kind of vernacular neoclassicism. Its relationship to rococo can be seen mainly in its refinement and delicacy. Georgian architecture developed from the English baroque style of Christopher Wren, which had also been more restrained and classical than the florid baroque style of the continent. Georgian architecture found particularly popularity in the American South.

In the mid-eighteenth century, the aims of architecture altered to embrace the complex philosophical concerns of the Enlightenment. The result produced a series of styles and sub-styles broadly referred to also as "neoclassical." Excavations at Herculaneum and Pompeii, philosophical concepts of progress, the aesthetics of Baumgarten, and the writings of Winckelmann all expressed and created a new view of antiquity. Neoclassicism thus formed a new way of examining the past: rather than seeing the past as a single, continuous cultural flow broken by a medieval collapse of classical values, theoreticians of the eighteenth century saw history as a series of separate compartments—Antiquity, the Middle Ages, the Renaissance, and so on.

Three important approaches emerged as a result of this new idea. The archeological school saw the present as continually enriched by persistent inquiry into the past. In other words, history was the story of progress. The second, eclectic, approach saw the artist as someone who could choose among styles, or, more importantly, combine elements of various styles. A third, modernist, approach viewed the present as unique and, therefore, capable of expression in its own terms. Each of these three concepts profoundly influenced eighteenth-century architecture and bore importantly on the other arts. From this time forward, the basic premises of art changed fundamentally.

Neoclassicism in architecture alludes to all three concepts, and encompasses a variety of treatments and terminologies. The identifiable forms of Greece and Rome emerge basic to it, of course. It also took considerable impetus from the *Essai sur l'architecture* (1753) by the Abbé Laugier (ah-BAY lo-ZHAY). Laugier's strictly rationalistic work expressed neoclassicism in a nutshell. Discarding all architectural language developed since the Renaissance, he urged the architect to seek truth in the architectural principles of the ancient world and to use those principles to design modern buildings. Laugier's neoclassicism descended directly from the Greeks, with only passing reference to the Romans.

In Italy, the architect Giambattista Piranesi (pee-rahn-AY-zee; 1720–78) was incensed by Laugier's arguments, which placed Greece above Rome. He retaliated with an overwhelmingly detailed work, *Della Magnificenza ed Architettura dei Romani*, which professed to prove the superiority of Rome over Greece. This quarrel aside, both Piranesi and Laugier instigated the neoclassical tradition, and in general, this revival of classicism in architecture, with its high moral seriousness, in many quarters marked a revolt against the frivolity of the rococo.

In America, neoclassicism had special meaning, as the colonies struggled to rid themselves of the monarchial rule of George III of England. For the revolutionary colonists, classicism meant Greece, and Greece meant democracy. The designs of colonial architect Thomas Jefferson (Figs **13.23** and **13.25**) reflect the ideas of this period. Jefferson was highly influenced by Palladio (see Chapter 10), whose popularity had soared during the significant period of English villa architecture, between 1710 and 1750. In a uniquely eighteenth-century way, Jefferson looked at architecture objectively, within the framework of contemporary thought. Strongly influenced by Lockean ideas of natural law, Jefferson believed that the architecture of antiquity embodied indisputable natural principles, and he made Palladian reconstructions of the Roman temple the foundation for his theory of

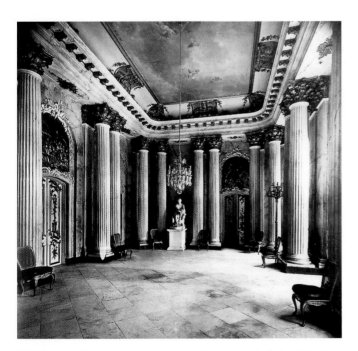

13.22 Georg Wenzelaus von Knobelsdorff, entrance hall, Sans Souci.

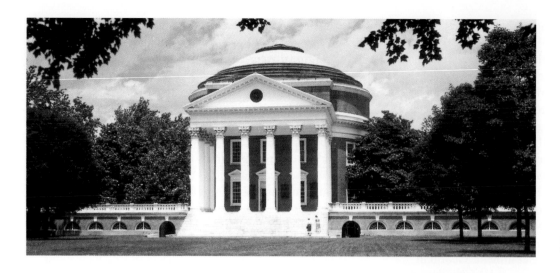

13.23 Thomas Jefferson, Rotunda of the University of Virginia, 1819–28.

architecture. His country house, Monticello, consists of a central structure with attached Doric porticos, or porches, and short, low wings attached to the center by continuing Doric entablatures. The simplicity and refinement of Jefferson's statement here goes beyond mere reconstruction of classical prototypes, and appeals directly to the viewer's intellect and sensibilities.

Throughout the United States, and particularly in the South, the classical revival found frequent expression. In Charleston, South Carolina, the Miles Brewton House provides us with one of the finest examples of American Georgian architecture (Fig. **13.24**). The large pedimented portico, supported by Ionic columns, indicates the boldness of American neoclassicism.

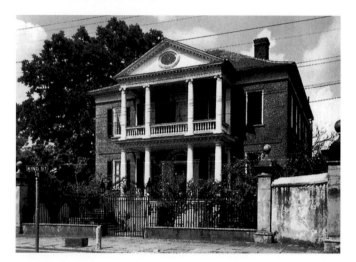

13.24 Miles Brewton House, Charleston, South Carolina (architect unknown), c. 1769.

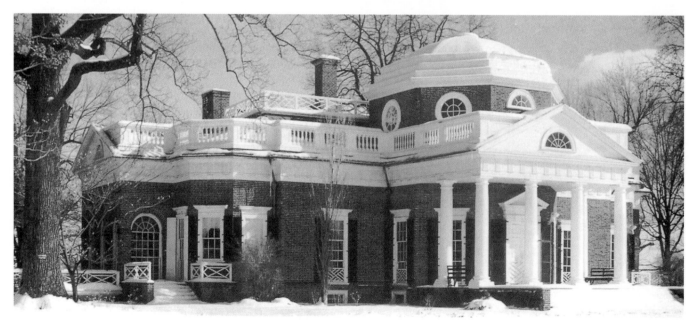

13.25 Thomas Jefferson, Monticello, Charlottesville, Virginia, 1770–84; rebuilt 1796–1800.

Theatre

Despite a shift of interest to the novel, the eighteenth century saw the growth of a remarkable nationalism in the theatre. Britain, France, and the United States each contributed.

Britain

The character of British audiences changed, and the theatre changed with it. Queen Anne did not care for the theatre, and George I, a German who did not speak English well, could not understand it. Audiences in England increasingly tended toward well-to-do middle-class tradespeople. One effect of this shifted the emphasis of comedy toward sentiment.

Undoubtedly the most popular theatre form in early eighteenth-century London was the *ballad opera*. The best of these, John Gay's *Beggar's Opera* (1728), caricatured a bribery scandal involving the British prime minister Sir Robert Walpole, and it created a social scandal. *The Beggar's Opera* was not the only theatrical piece to burlesque the corruption of Walpole, and as a result of these attacks, Walpole successfully convinced Parliament to institute the Licensing Act of 1737. This act limited legal theatrical production to three theatres, Drury Lane, Covent Garden, and Haymarket, and gave the Lord Chamberlain the right to censor any play.

Production style remained refined, however, and the theatre in London retained its elegant but intimate physical size and scale, in contrast to the mammoth opera

A DYNAMIC WORLD

JAPANESE KABUKI THEATRE

Like Western theatre, Japanese Kabuki theatre (originating approximately 400 years ago) has changed significantly over the centuries because of its ability to adapt and incorporate aspects of other theatre traditions (Fig. **13.26**). It has borrowed freely from Noh drama (see p. 263), and from the popular Japanese puppet theatre. Kabuki originated as middle class theatre and was held in contempt by Samurai and the court.

The earliest Kabuki plays were simple sketches. Two-act plays did not appear until the mid-seventeenth century. By the mid-eighteenth century plays had grown to eleven acts, and took an entire day to perform. Productions continue to be lengthy, although the practice of the day-long performance of the eighteenth century has been pared back to two five-hour performances per day.

Kabuki plays tend to be melodramas focusing on climactic moments as opposed to plots, and in that sense, Kabuki has a strong parallel with the "sensation-scene" focus of the Western melodramas of the nineteenth century. However, the connections between scenes in Kabuki plays tend to be rather vague—in contrast to the Western melodrama, whose development follows a causal scheme. Because actors do not speak, a narrator and chorus play predominant roles in Kabuki productions. The narrator describes the scene, comments on the action, and even speaks portions of the dialogue. Every location is portrayed scenically, and the scenery is changed in full view of the audience.

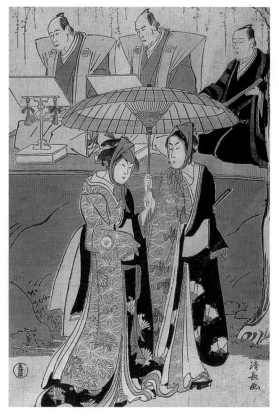

13.26 Torii Kayonaga, *Kabuki Scene with Part of the Chorus*, c. 1783. Color woodblock print, 14½ × 10 ins (36.5 × 25.5 cm). British Library, London.

houses that flourished elsewhere. The playing area consisted of a forestage, the sides of which contained doorways for entrances and exits by the actors. Above these were boxes for spectators. Wing and drop scenery—flat, painted pieces used strictly as background—stood upstage, behind a proscenium arch. Lighting consisted of wax candles in chandeliers over the audience. As might be expected, fire hovered as a constant danger, and smoke from the candles an irritating nuisance.

America

In colonial America, the arts, and the theatre especially, came up squarely against unbending Puritan austerity. Sometime between 1699 and 1702, however, Richard Hunter gained permission from the acting governor of the province of New York to present plays in the city of New York. In 1703, an English actor named Anthony Ashton landed at Charleston, South Carolina. He was "full of Lice, Shame, Poverty, Nakedness, and Hunger," and to survive became "Player and Poet." Eventually he found his way to New York, where he spent the winter "acting, writing, courting, and fighting." Perhaps as a consequence, the Province forbade "play acting and other forms of disreputable entertainment" in 1709.

Notwithstanding this inauspicious start, American theatre struggled forward. The first recorded theatre was built in Williamsburg, Virginia, in 1716, and housed a performing company for the next several years. Philadelphia and New York developed lively theatre traditions as well (Fig. **13.27**). For the most part, theatre in America merely extended the British stage, and English touring companies provided most of the fare. Theatres themselves appear to have been small and closely modeled upon provincial English theatres with their raked stages, proscenium arches, painted scenery, and apron forestages flanked by entrance doors. Four hundred seats seems to have been about average. The front curtain rose and fell at the beginning and end of each act, but the numerous scene changes within the acts took place in full view of the audience.

Companies from London, usually comedy troupes, came to Williamsburg annually for an eleven-month season. By 1766, touring British companies played the entire eastern seaboard from New York, Philadelphia, and Annapolis to Charleston. A milestone passed on 24 April 1767, when the American Company, which was, in fact, British, presented Thomas Godfrey's *The Prince of Parthia*, the first play written by an American to receive a professional production.

France

French drama had one final blaze of brilliance before the Revolution, in the plays of Pierre de Beaumarchais (boh-mahr-SHAY; 1732–99). His two most famous works,

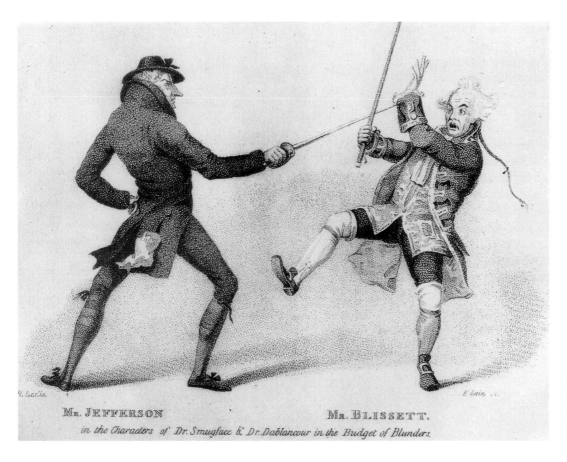

MR. JEFFERSON MR. BLISSETT.
in the Characters of Dr. Smugface & Dr. Dablancour in the Budget of Blunders.

13.27 Joseph Jefferson and Francis Blissett in *The Budget of Blunders*, at the John Street Theatre, c. 1796. Contemporary engraving. The New York Public Library.

The Barber of Seville (1775) and *The Marriage of Figaro* (1784), comprise entertaining comedies built upon the traditions of neoclassicism dating back to Corneille's tragedy *Le Cid* (1636). In fact, at the last moment Beaumarchais expanded *The Barber of Seville* into a neoclassical five act structure, which only added ponderousness to a fine play. However, criticism on the opening night caused him to rewrite it with four acts, which restored the play's original sparkle. The plots of both *The Barber of Seville* and *The Marriage of Figaro* presaged the coming Revolution, and the nine years between the works saw a dramatically changed audience perception of this message. *The Barber of Seville* was enjoyed and received calmly but, by 1784, the French audience regarded the criticisms directed against the characters in the play seriously as an indictment of society as a whole. When the Revolution came, its horrors left the French stage bare during the final ten years of the eighteenth century.

Music

Pre-Classical Style
As French court society and its baroque arts slipped from favor, the ornamentation, delicacy, prettiness, and pleasant artificiality of the rococo style came to music as well as to painting and sculpture. Musicians improvised "decorations" in their performances, and the practice was so common that many composers purposely left their melodic lines bare in order to allow performers the opportunity for playful trills and other ornaments. The purpose of music was to entertain and to charm.

François Couperin (koo-pur-AN; 1668–1733) exemplified the musical spirit of his time, but he also retained sufficient of his baroque roots to avoid excessive sentimentality or completely artificial decoration. Nevertheless, his works remain appropriate to salon performance, and do not limit any one piece or movement to one emotion. He shows a pleasant blending of logic and rationality with emotion and delicacy, in true rococo fashion.

Couperin, part of a uniquely French school of keyboard music, specialized in long dance suites, so-called "genre pieces," contrapuntal works with highly ornamented introductions, and overtures similar to those found in French opera. Many of the pieces—miniatures—replace the grand sweep of the baroque era by an abundance of short melodic phrases with much repetition and profuse ornamentation.

Expressive Style
A second style of music, the *Expressive style*, paralleled the rococo style and formed a transitional stage between baroque and classical. This Expressive style (more literally, "sensitive" style), or *empfindsamer Stil* (emp-finnt-ZAH-mair shteel), came from Germany. It permitted a freer expression of emotions than the baroque, largely by allowing a variety of moods to occur within a single movement. Composers reduced polyphonic complexities, and introduced different themes, with harmonic and rhythmic contrasts. With the simple and highly original expressive style composers had the freedom to use rhythmic contrasts, original melodies, and new nuances and shading of loud and soft with the goal of a carefully proportioned, logical, unified whole, whose parts remained clear and carefully articulated.

The principal exponent of the *empfindsamer Stil* was Carl Philipp Emanuel Bach (1714–88), one of J.S. Bach's sons. His position between the baroque and classical styles has led some scholars to call him the "founder" of the classical style. For many years he worked as court harpsichordist to Frederick II, and his keyboard works generally emerge as his most important compositions. He understood music as an art of the emotions, and believed it very important that the player be involved personally in each performance.

Classical Style
In 1785 Michel Paul de Chabanon (shahb-ah-NOHN) wrote: "Today there is but one music in all of Europe." He meant that music appealed not only to the aristocracy but to the middle classes as well. Egalitarian tendencies and the popular ideals of the philosophes had also influenced artists, who now sought larger audiences. Pleasure had become a legitimate artistic purpose. Eighteenth-century rationalism saw excessive ornamentation and excessive complexity (both baroque characteristics) as not appealing to a wide audience on its own terms. Those sentiments, which coincided with the discoveries of Pompeii and the ideas of Winckelmann and Baumgarten, prompted a move toward order, simplicity, and careful attention to form. We call this style in music *classical* (the term was not applied until the nineteenth century), rather than neoclassical or classical revival, because although the other arts returned, more or less, to Greek and Roman prototypes, music had no known classical antecedents to revive. Music thus turned to classical ideals, though not to classical models.

The classical style in music had, among others, five basic characteristics: 1) variety and contrast in *mood*. In contrast to the baroque style, which typically deals with a single emotion, classical pieces typically explore contrasts between moods. There may be contrasting moods within movements and also within themes, as well. Changes in mood may be gradual or sudden; they are, however, as

one might expect of a style called "classical," well controlled, unified, and logical; 2) flexibility of *rhythm*. Classical music explores a wide variety of rhythms, utilizing unexpected pauses, syncopations, and frequent changes from long to shorter notes. As in mood, changes in rhythm may be sudden or gradual; 3) a predominantly homophonic *texture*. Nonetheless, texture also is flexible, with sudden and gradual shifts from one texture to another. In general, the texture of classical pieces is simpler than the baroque. However, a work may begin homophonically, with a melody and simple accompaniment, and then shift to complex polyphony featuring two simultaneous melodies or melodic fragments imitated among the instruments; 4) memorable *melody*. The themes of classical music tend to be very tuneful, and often have a folk or popular flavor. Classical melodies tend toward balance and symmetry, again what one would expect of "classical" works as we have seen them since the Athenian Greeks. Frequently, classical themes have two phrases of equal length. The second phrase often begins like the first but ends more decisively; 5) gradual changes in *dynamics*, in contrast to baroque music, which employs sudden changes in dynamics (*step dynamics*). One of the consequences of this direction in composition replaced the harpsichord with the piano, a more capable instrument in handling the subtlety of classical dynamic patterns.

Classical Forms

The classical style in music found expression in a number of forms. We will examine four of them: **sonata form**, the symphony, **theme and variations**, and minuet and trio. "Sonata" denotes many different musical forms, from a short piece for a single instrument to complex works in many sections or movements, for a large ensemble. By the middle of the eighteenth century, however, the sonata for one or two keyboard instruments, or for another instrument accompanied by keyboard, emerged as an instrumental genre comparable to the symphony, which we discuss momentarily. These genres share a flexible multi-movement design that music analysts call the *sonata cycle*. The term *sonata form* refers to the form of a *single movement* and should not be confused with the term *sonata*, which describes a composition made of several **movements**. The sonata form, the most important musical structure of the classical period, appeared in symphonies, sonatas, and other genres mostly in the first movement, although sometimes in other movements as well. Sonata form has three main sections: **exposition** (where themes are presented), **development** (where themes are treated in new ways), and **recapitulation** (where the themes return). These three sections are often followed by a concluding section, the **coda** (Italian for "tail"). The three main sections comprise an ABA design.

The second classical form for our examination, the symphony, takes its name from the Latin *symphonia* (based in turn on a Greek word), meaning "a sounding together." In practical terms, a symphony is an extended, ambitious composition typically lasting between twenty and forty-five minutes and exploring the broad range of tone colors and dynamics of the classical orchestra. Franz Josef Haydn (see below) began composing symphonies in the classical sense about 1757. In his long life he solidified and enriched symphonic style, culminating in a set of twelve works composed for London in 1791–5 (called the "Salomon Symphonies," after the German impresario J.P. Salomon, who, in 1790, persuaded Haydn to go to England). Haydn wrote 104 symphonies (some scholars put the number higher), widely performed and imitated during his lifetime. Wolfgang Amadeus Mozart wrote forty-one symphonies, and his last six—No. 35 in D ("Haffner"), No. 36 in C ("Linz"), No. 38 in D ("Prague"), No. 39 in E flat, No. 40 in G Minor, and No. 41 in C ("Jupiter")—have complex design and rich orchestration, wedding formal perfection and expressive depth. Ludwig van Beethoven wrote only nine symphonies (1800–24), but in them he greatly increased the form's weight and size.

The classical orchestra, which performed the classical symphony, was typified by the supreme orchestra of the time, the court orchestra at Mannheim (mahn-HYM), Germany, which flourished in the third quarter of the century. It had approximately thirty string players and helped to standardize the remaining instrumental complement, specifically, two flutes, two oboes, two bassoons, two horns, two trumpets, two kettledrums, and a new instrument, the clarinet. Beethoven increased the technical demands on every instrument and occasionally enlarged the classical orchestra by writing parts for piccolo, trombones, and contrabassoon. The finale of his Symphony No. 9 also requires triangle, cymbals, and bass drum (in addition to choral voices).

Although the sonata and symphony proved the most important musical forms of this period, others existed as well. One form, called *theme and variations*, appeared widely as an independent piece or as one movement of a symphony, sonata, or string quartet. In a theme and variations the theme (a basic musical idea) repeats over and over, each time with some change—for example, mood, rhythm, dynamics and so on.

A form known as *minuet and trio*, or just *minuet*, often occurs as the third movement of a symphony, string quartet, or other work. The form originated as a stately dance, but classical style uses it purely for listening. It has triple meter and, usually, a moderate tempo. Its ABA form consists of a minuet (A), trio (B), and minuet (A). The trio (B) section utilizes fewer instruments than the

minuet (A) sections. Another musical form popular in the classical time was the *rondo*. This features a melodic main theme (A) that returns several times, alternating with other themes. Other forms, for example the concerto, witnessed their own transformation into classical characteristics.

Classical Composers

The Austrian-born Franz Josef Haydn (1732–1809) pioneered the development of the symphony from a short, simple work into a longer, more sophisticated one. Haydn's diverse and numerous symphonies range from light and simple, to serious and sophisticated.

Many of Haydn's early symphonies use the preclassical, fast-slow-fast three-movement form. These usually consist of an opening *allegro*, followed by an *andante* in a related key, and close with a rapid dance-like movement in triple meter. Other early works use four movements, the first of which has a slow tempo. In contrast, the Symphony No. 3 in G major (c. 1762) has a typical four-movement structure beginning with a fast tempo: I *allegro*, II *andante moderato*, III minuet and trio, and IV *allegro*. The third movement, the minuet and trio, represents a new feature, found in nearly every classical symphony. Haydn's minuets contain very charming music, often emphasizing instrumental color in the trio.

Among his late works, his most famous symphony, No. 94 in G major (1792), commonly known as the "Surprise" Symphony contains in its second movement a simple, charming theme and the dramatic musical surprise that gives the work its popular name. The movement uses a theme and variations form (AA'A''A'''A'''')—the apostrophes represent a **variation** of the original material. The tempo is *andante*, and the orchestra begins with a soft statement of the theme. After presenting the theme a second time, even more quietly, Haydn inserts a tremendous *fortissimo* (very loud) chord. This constitutes the surprise. With the exception of the "surprise," this movement remains typical in its use of a melody based on the two main harmonies of Western music, the **tonic** or home chord, and the dominant chord.

In the opening movement of this four-movement work, Haydn uses sonata form preceded by a pastoral introduction, marked *adagio cantabile*—in a slow, singing style, in triple meter. The introductory material alternates between the strings and the woodwind.

The tempo switches to *vivace assai*—very fast—and the strings quietly introduce the first theme in G major (Fig. **13.28**).

The last note of the theme is marked *f*, or *forte* (loud). At this point, the full orchestra joins the violins in a lively section. Just before a pause, the orchestra plays a short prefatory phrase which will recur throughout the movement (Fig. **13.29**).

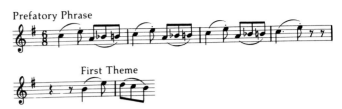

13.28 Franz Josef Haydn, Symphony No. 94 in G major, first theme of first movement.

Prefatory Phrase

First Theme

13.29 Franz Josef Haydn, Symphony No. 94 in G major, prefatory phrase, first movement.

The first theme then reappears, with a slightly altered rhythmic pattern. This marks a **bridge**, or transition passage, to a new key, the dominant, D major. A quick series of scales in the violins and flutes leads to the introduction of the second theme, a lyrical theme with trills and a falling motif. The exposition section closes with a short scale figure and repeated notes, and then the entire exposition is repeated.

The development section opens with a variation of the first theme and then goes through a series of key and dynamic changes.

The recapitulation starts—as recapitulations always do—with a return to the first theme in the original key. A passage based on motifs from the first theme, a repeat and brief development of the first theme, a pause, and finally, another repeat of the first theme follow. Then the second theme appears again, now in the home key, and the movement closes with a short scale passage and a strong cadence.

Wolfgang Amadeus Mozart (1756–91), also an Austrian, had performed at the court of Empress Maria Theresa at the age of six. Throughout the classical period, aristocratic patronage was essential for musicians to earn a living, although the middle classes provided a progressively larger portion of commissions, pupil fees, and concert attendance. Financial insecurity dogged Mozart's short career (he died at the age of thirty-five).

His early symphonies were simple and relatively short, like those of Haydn, while his later works grew longer and more complex. His last three symphonies generally appear among his greatest masterpieces, with Symphony No. 40 in G minor often referred to as the typical classical symphony. This work, along with Nos. 39 and 41, have clear order and restraint, yet they exhibit a tremendous emotional urgency, which many scholars cite as the beginning of the Romantic style.

13.30 Wolfgang Amadeus Mozart, Symphony No. 40 in G minor, first theme of first movement.

13.31 Wolfgang Amadeus Mozart, Symphony No. 40 in G minor, first theme of fourth movement.

The first of the four movements of Symphony No. 40, written in sonata form, begins *allegro molto*. The violins state the first theme above a soft chordal accompaniment, which establishes the tonic key of G minor (Fig. **13.30**). Three short motifs repeat throughout the piece.

The liveliness of the lower strings accentuates the restlessness of the rhythm. The second theme in the woodwinds and strings provides a relaxing contrast. In a contrasting key, the relative major, B flat, it flows smoothly, each phrase beginning with a gliding movement down a **chromatic scale**. A codetta echoes the basic motif on various instruments and finishes with a cadence in B flat major. In most performances the entire exposition section repeats, giving the movement an AABA form.

The development section concentrates on the basic three-note motif and explores the possibilities of the opening theme. This somewhat brief section has lots of drama. The recapitulation restates the first theme in the home key, and then the second theme, also in G minor rather than in the original major. This gives the ending a more mournful character than the equivalent section in the exposition. A coda in the original key ends the movement.

The second movement, *andante*, in E flat major, also uses sonata form. The first theme of the movement passes successively among the violas, second violins, and first violins. The horns provide a rich background. Unlike the first movement, no strong contrast exists between the first and second themes. They emerge in E flat major and B flat major—the standard contrast of keys in a movement that starts in a major key. The development changes key further, moving into the minor, then returns to the home key with a dialogue among the woodwinds. This movement features many graceful embellishments, which were popular with the Austrian court.

The third movement, *allegretto*, returns to G minor and the emotional tension of the first movement. The triple meter—a minuet and trio—typifies the third movement. This creates a lively piece with symmetrically arranged phrases and strong cross-rhythms. The trio changes key to G major and has a more relaxed mood.

The finale, *allegro assai*, uses a compact sonata form. The violins state the subject in G minor and create a

"rocket theme"—an upward thrusting arpeggio (Fig. **13.31**).

The violins play the second, contrasting theme in the related key of B flat major, and the woodwinds pick it up and embellish it. Mozart creates a very dramatic development in this movement. The rocket motif bounces from instrument to instrument, creating a highly complex texture, which is increased by rapid **modulation** through several remote keys. The recapitulation returns, of course, to the home key of G minor, with subtle restatement and variation.

In a totally different vein, the final movement of Mozart's Sonata No. 11 for piano in A has always been a popular favorite. Called the "Turkish Rondo," it has an exotic or "Turkish" character underlined by the main theme in A minor (Fig. **13.32**) that reappears throughout the rondo, softly.

Ludwig van Beethoven (1770–1827), often considered a singular transitional figure between classicism and Romanticism, could easily appear in the next chapter. Beethoven wanted to expand the classical symphonic form to accommodate greater emotional character. The typical classical symphony has movements with contrasting and unrelated themes. Beethoven moved toward a single thematic development throughout, thereby achieving a unity of emotion in the whole work.

Beethoven's works differ significantly from those of Haydn and Mozart. More dramatic, they use changing dynamics for starker emotional effects. Silence pursues both dramatic and structural ends. Beethoven lengthened the development section of sonata form and did the same to his codas, many of which take on characteristics of a second development section.

13.32 Wolfgang Amadeus Mozart, Sonata No. 11 for piano in A (K. 331) ("Turkish Rondo").

13.33 Ludwig van Beethoven, Symphony No. 5, first theme of first movement.

13.34 Ludwig van Beethoven, Piano Sonata in C minor, Op. 13, first theme of third movement.

He also changed traditional numbers of and relationships among movements, especially in the unusual Symphony No. 6, which has no break between the fourth and fifth movements. In the Symphony No. 5, no break occurs between the third and fourth movements. In some of his four-movement works, he changed the traditional third movement minuet and trio to a scherzo and trio of significantly livelier character. Beethoven's symphonies draw heavily on imagery, for example heroism in Symphony No. 3 and pastoral settings in Symphony No. 6. The famous Symphony No. 5 in C minor, for example, begins with a motif that Beethoven described as "fate knocking at the door" (Fig. **13.33**). The first movement (*allegro con brio*) develops according to typical sonata form, the second and contrasting movement (*andante con moto*) uses theme-and-variation form, and the third movement (*allegro*) employs a scherzo and trio in triple meter. Movement number four returns to *allegro* and to sonata form.

Beethoven's nine symphonies became progressively more Romantic, and the Ninth explodes as a gigantic work of tremendous power. Its finale includes a chorus singing the text of Schiller's *Ode to Joy*.

Undoubtedly one of Beethoven's loveliest and most popular works, the Piano Sonata in C minor, Op. 13 (the "Pathétique"), published in 1799, has three movements. The first movement, *grave, allegro di molto e con brio*, uses sonata form. The strong tempo contrast between the opening *grave* (very slow) passages and the *allegro* heightens the drama of the movement. The second movement, marked *adagio cantabile*, has a slow, singing style, in the contrasting key of A flat major.

The third movement, in the home key of C minor has ABACABA structure known as **rondo** form—it has a recurrent theme, and similar structure to baroque ritornello form. It opens its first, or A, section with a lively theme in duple meter (Fig. **13.34**).

Classical style may have had a simpler character and a more symmetrical structure than baroque style, but it did not sacrifice any of its energy or quality. In the same way that Greek simplicity in architecture, for example, kept its sophistication and interest in pursuing mathematical form and symmetry, so classical music kept its dynamism and sophistication in its pursuit of form and reason. Classical style moved as comfortably toward Romanticism as it had moved away from baroque.

Dance

"The only way to make ballet more popular is to lengthen the dances and shorten the *danseuses*' [female dancers'] skirts." This opinion was attributed to the composer Campra. With the courtly splendor of Louis XIV's Versailles left behind, one of the most significant obstacles to the further development of the ballerina's art remained costume. Floor-length skirts did not allow freedom of movement, and, as a result, *danseurs* (male dancers) played the prominent roles at the turn of the eighteenth century. In 1730, one of those curious accidents of history occurred, which helped to change the course of ballet and bring the ballerina into pre-eminence.

Marie Anne Cupis de Camargo (kahm-ar-GOH; 1710–70) was such a brilliant dancer that her mentor, Mademoiselle Prevost, tried to keep her hidden among the *corps de ballet*. During one particular performance, however, a male dancer failed to make his entrance and Camargo quickly stepped forward to dance his role—superbly. Her footwork was so dazzling that, in order to feature it more fully, she raised her skirts a discreet inch or two above the ankle! Her forte was the *entrechat* (ahn-trah-SHAHT), a movement in which the dancer jumps straight up and rapidly crosses the legs or at least beats the feet together, as many times as possible, while in the air. The move is still a technical achievement especially favored by male dancers. Voltaire indicated that Camargo was the first woman to dance like a man—the first ballerina to display the technical skills and brilliance previously associated with *danseurs*.

Another significant stylistic change came about through the ballerina Marie Sallé (sah-YAY; Fig. **13.35**). Her studies in mime and drama led her to believe that the style prevalent in Paris was too formal and repetitious. So, in the early 1730s, she broke her contract with the Paris Opéra (an act punishable by imprisonment), and took up residence in London. She danced with an expressive style, rather than a series of "leaps and frolics," and in 1734, in her famous *Pygmalion*, she wore simple draperies rather than the traditional panniers (wide extensions of the skirt at the hips), and her hair flowed freely rather than being piled up on top of her head. The contrast between the styles of Camargo and Sallé illustrates an early example of the instant changeability of balletic style. A flashy technique that

13.35 After Lancret, *Marie Sallé*, 1730. Engraving. The New York Public Library.

becomes boring can quickly be relieved by a shift to expressiveness. When emotion becomes melodramatic, the pendulum can swing back to technique.

We have no way of identifying the technical characteristics of eighteenth-century ballet, but its mythological subject matter in the first half of the century stands consistent with that of painting, sculpture, and music. Significant in earlier works, most of which were produced in London by the dancing master John Weaver, was the use of movement to communicate a story. These early attempts to integrate movement and dramatic content brought forth *ballet d'action* (bah-LAY dahk-SHUHN) in the last half of the century. Its popularity helped to separate this form from the sprawling *ballet à entrée*. It also reinforced ballet's independence from opera and drama. *Ballet d'action* contained an evolving classical concern for unity. Its emphasis on drama stood in contrast to the focus on display of *ballet à entrée*.

The primary moving force in this new form, Jean-Georges Noverre (noh-VAIR; 1727–1810), wrote influential *Letters on Dancing and Ballets* (1760),

indicating that ballets should be unified works in which all elements contribute to the main theme. For Noverre, ballet was a dramatic spectacle, a play without words. Its content communicated through expressive movement. Music should be "written to fit each phrase and thought," and technical virtuosity for its own sake, or for the purposes of display, should be discouraged. Noverre thought that ballet should study other arts and draw upon natural forms of movement in order to be "a faithful likeness of beautiful Nature." He also argued for costumes that enhanced rather than impeded movement, and his ballets exemplified "psychological realism."

Along with other arts, ballet grew more popular, and, by 1789, ballet themes, like those of painting, began to include subjects beyond mythology. Ordinary country life provided topics for rustic ballets. These attempts at realism undoubtedly left much to be desired. They do serve, however, to illustrate trends toward egalitarianism in France and England, especially.

As the eighteenth century came to a close, Charles Didelot (deed-LOH; 1767–1837) changed the course of ballet forever. First, he introduced tights, which simplified the line and form of dance costume. Next, he set the ballet world on its ear by attaching ballerinas to wires in *Zephyr and Flora* (1796) and flying them in and out of the scene. According to some sources, Didelot's wires allowed ballerinas to pause, resting effortlessly on the tips of their toes. The new line of the body created by that single effect instantly creates a dramatic change in the aesthetics of a dance. That change was as obvious then as it is now. Soon ballerinas were dancing *en pointe* without using wires. With this change, an entirely new age in dance had begun, and ballet in the style we recognize had germinated.

Literature

The literature of the Enlightenment reflected many of the same modifications as did the other arts. We will divide this section into six parts, four of which, Rococo, Neoclassicism, Genre, and Pre-Romantic, reflect mostly stylistic matters. The other two divisions, Humanitarianism and Feminism, represent concepts from the era that we defined and have witnessed previously in the chapter in the other arts.

Rococo

Alexander Pope (1688–1744; Fig. **13.36**) gave new meaning to the term "wit." The most brilliant satirist of an age in which satire constituted a major art form, his rhymed couplets hit home, in poems such as *The Rape of the Lock* (1712), with devastating poise and accuracy.

13.36 Portrait of Alexander Pope (1688–1744), c. 1754. Engraving.

The poem, based on an actual incident, sought to reconcile the families estranged by the incident. It tells the story of a young woman who has a lock of her hair stolen by a young man. Pope writes of the event—a rather trivial one—in terms usually reserved for highly important incidents, for example, the war between the Athenians and the Trojans in ancient Greece. *The Rape of the Lock* juxtaposes a wide variety of literary allusions and ironic comments on contemporary society. Pope's idolatry of classical values and his contempt for a society that fell short of them also led him to write a mock-heroic poem, *The Dunciad*, an epic on dunces, and he filled it with profound moral anger.

His *An Essay on Criticism* (1733–4), a poem on the art of writing, explores philosophy in heroic couplets and iambic pentameter. Pope conceived it as part of a larger work that he never completed. The poem has four epistles, the first of which, included below, surveys relations between humanity and the universe. The second epistle discusses humans as individuals. The third takes up the relationship between individuals and society, and the fourth questions the potential of the individual for happiness. The poem places the universe in a hierarchy of being. Humans, because of their ability to reason, stand above animals and plants in the hierarchy.

An Essay on Man
Alexander Pope

Epistle 1: Of the Nature and State of Man,
With Respect to the Universe

ARGUMENT

Of Man in the abstract. I. That we can judge only with regard to our own system, being ignorant of the relations of systems and things. II. That Man is not to be deemed imperfect, but a Being suited to his place and rank in the creation, agreeable to the general order of things, and conformable to ends and relations to him unknown. III. That it is partly upon his ignorance of future events, and partly upon the hope of a future state, that all his happiness in the present depends. IV. The pride of aiming at more knowledge, and pretending to more perfection, the cause of man's error and misery. The impiety of putting himself in the place of God, and judging of the fitness or unfitness, perfection or imperfection, justice or injustice of his dispensations. V. The absurdity of conceiting himself the final cause of creation, or expecting that perfection in the moral world which is not in the natural. VI. The unreasonableness of his complaints against Providence, while, on the one hand, he demands the perfections of the angels, and, on the other, the bodily qualifications of the brutes; though to possess any of the sensitive faculties in a higher degree, would render him miserable. VII. That throughout the whole visible world, an universal order and gradation in the sensual and mental faculties is observed, which causes a subordination of creature to creature, and of all creatures to Man. The gradations of Sense, Instinct, Thought, Reflection, Reason; that Reason alone countervails all the other faculties. VIII. How much further this order and subordination of living creatures may extend above and below us; were any part of which broken, not that part only, but the whole connected creation must be destroyed. IX. The extravagance, madness, and pride of such a desire. X. The consequence of all, the absolute submission due to Providence, both as to our present and future state.

Awake, my St. John! leave all meaner things
To low ambition, and the pride of Kings.
Let us, since life can little more supply
Than just to look about us and to die,
Expatiate free o'er all this scene of man;
A mighty maze! but not without a plan;
A wild, where weeds and flow'rs promiscuous shoot,
Or garden, tempting with forbidden fruit.
Together let us beat this ample field,
Try what the open, what the covert yield;
The latent tracts, the giddy heights, explore
Of all who blindly creep or sightless soar;
Eye Nature's walks, shoot folly as it flies,
And catch the manners living as they rise;
Laugh where we must, be candid where we can,
But vindicate the ways of God to man.

I.

Say first, of God above, or Man below,
What can we reason, but from what we know?
Of man what see we but his station here,
From which to reason, or to which refer?
Thro' worlds unnumber'd tho' the God be known,
'Tis ours to trace him only in our own.
He, who thro' vast immensity can pierce,
See worlds on worlds compose one universe,
Observe how system into system runs,
What other planets circle other suns,
What varied being peoples every star,
May tell why Heav'n has made us as we are.
But of this frame, the bearings, and the ties,
The strong connections, nice dependencies,
Gradations just, has thy pervading soul
Look'd thro'? or can a part contain the whole?
Is the great chain that draws all to agree,
And drawn supports, upheld by God, or thee?

Pope's name often links with that of Jonathan Swift (1667–1745), an Anglo-Irish satirist and churchman who shared many of Pope's concerns. Perhaps even more bitter than Pope, Swift mocked pompous pragmatism and woolly-headed idealism equally in his masterwork, *Gulliver's Travels* (1726). In this four-part novel he tells the story of Lemuel Gulliver, a surgeon and sea captain shipwrecked on Lilliput, inhabited by people six inches tall. Another famous prose work, *A Modest Proposal*, took satire to the very edge of horror. Here Swift argues with chilling mock-seriousness that the English should solve the "Irish problem" by eating the babies of the Irish poor.

A Modest Proposal
Jonathan Swift

For Preventing the Children of Poor People in Ireland from Being a Burden to Their Parents or Country, and for Making Them Beneficial to the Public

It is a melancholy object to those who walk through this great town or travel in the country, when they see the streets, the roads and cabin doors, crowded with beggars of the female sex, followed by three, four, or six children, all in rags and importuning every passenger for an alms. These mothers, instead of being able to work for their honest livelihood, are forced to employ all their time in strolling to beg sustenance for their helpless infants, who, as they grow up, either turn thieves for want of work, or leave their dear native country to fight for the Pretender in Spain, or sell themselves to the Barbadoes.

I think it is agreed by all parties that this prodigious number of children in the arms, or on the backs, or at the heels of their mothers, and frequently of their fathers, is in the present deplorable state of the kingdom a very great additional grievance; and, therefore, whoever could find out a fair, cheap, and easy method of making these children sound, useful members of the commonwealth would deserve so well of the public as to have his statue set up for a preserver of the nation.

But my intention is very far from being confined to provide only for the children of professed beggars; it is of a much greater extent, and shall take in the whole number of infants at a certain age who are born of parents in effect as little able to support them as those who demand our charity in the streets.

As to my own part, having turned my thoughts for many years upon this important subject, and maturely weighed the several schemes of other projectors, I have always found them grossly mistaken in the computation. It is true, a child just dropped from its dam may be supported by her milk for a solar year, with little other nourishment; at most not above the value of two shillings, which the mother may certainly get, or the value in scraps, by her lawful occupation of begging; and it is exactly at one year old that I propose to provide for them in such a manner as instead of being a charge upon their parents or the parish, or wanting food and raiment for the rest of their lives, they shall on the contrary contribute to the feeding, and partly to the clothing, of many thousands.

There is likewise another great advantage in my scheme, that it will prevent those voluntary abortions, and that horrid practice of women murdering their bastard children, alas, too frequent among us, sacrificing the poor innocent babes, I doubt more to avoid the expense than the shame, which would move tears and pity in the most savage and inhuman breast.

The number of souls in this kingdom being usually reckoned one million and a half, of these I calculate there may be about two hundred thousand couples whose wives are breeders; from which number I subtract thirty thousand couples who are able to maintain their own children, although I apprehend there cannot be so many, under the present distresses of the kingdom; but this being granted, there will remain an hundred and seventy thousand breeders. I again subtract fifty thousand for those women who miscarry, or whose children die by accident or disease within the year. There only remain an hundred and twenty thousand children of poor parents annually born. The question therefore is, how this number shall be reared and provided for, which, as I have already said, under the present situation of affairs, is utterly impossible by all the methods hitherto proposed. For we can neither employ them in handicraft or agriculture; we neither build houses (I mean in the country) nor cultivate land. They can very seldom pick up a livelihood by stealing, till they arrive at six years old, except where they are of towardly parts, although I confess they learn the rudiments much earlier, during which time they can however be properly looked upon only as probationers, as I have been informed by a principal gentleman in the county of Cavan, who protested to me that he never knew above one or two instances under the age of six, even in a part of the kingdom so renowned for the quickest proficiency in that art. . . .

Some persons of a desponding spirit are in great concern about that vast number of poor people who are aged,

diseased, or maimed, and I have been desired to employ my thoughts what course may be taken to ease the nation of so grievous an encumbrance. But I am not in the least pain upon that matter, because it is very well known that they are every day dying and rotting by cold and famine, and filth and vermin, as fast as can be reasonably expected. And as to the young laborers, they are now in almost as hopeful a condition. They cannot get work and consequently pine away for want of nourishment to a degree that if at any time they are accidentally hired to common labor, they have not strength to perform it; and thus the country and themselves are happily delivered from the evils to come.

I have too long digressed, and therefore shall return to my subject. I think the advantages by the proposal which I have made are obvious and many, as well as of the highest importance. . . .

Therefore I repeat, let no man talk to me of these and the like expedients, till he hath at least some glimpse of hope that there will ever be some hearty and sincere attempt to put them into practice.

But as to my self, having been wearied out for many years with offering vain, idle, visionary thoughts, and at length utterly despairing of success, I fortunately fell upon this proposal, which, as it is wholly new, so it hath something solid and real, and no expense and little trouble, full in our own power, and whereby we can incur no danger in disobliging England. For this kind of commodity will not bear exportation, the flesh being of too tender a consistence to admit a long continuance in salt, although perhaps I could name a country which would be glad to eat up our whole nation without it.

After all, I am not so violently bent upon my own opinion as to reject any offer proposed by wise men, which shall be found equally innocent, cheap, easy, and effectual. But before something of that kind shall be advanced in contradiction to my scheme, and offering a better, I desire the author or authors will be pleased maturely to consider two points. First, as things now stand, how they will be able to find food and raiment for an hundred thousand useless mouths and backs. And secondly, there being a round million of creatures in human figure throughout this kingdom, whose sole subsistence put into a common stock would leave them in debt two millions of pounds sterling, adding those who are beggars by profession to the bulk of farmers, cottagers, and laborers, and their wives and children who are beggars in effect: I desire those politicians who dislike my overture, and may perhaps be so bold as to attempt an answer, that they will first ask the parents of these mortals whether they would not at this day think it a great happiness to have been sold for food at a year old in the manner I prescribe, and thereby have avoided such a perpetual scene of misfortunes as they have since gone through by the oppression of landlords, the impossibility of paying rent without money or trade, the want of common sustenance, with neither house nor clothes to cover them from the inclemencies of the weather, and the most inevitable

prospect of entailing the like or greater miseries upon their breed for ever.

I profess, in the sincerity of my heart, that I have not the least personal interest in endeavoring to promote this necessary work, having no other motive than the public good of my country, by advancing our trade, providing for infants, relieving the poor, and giving some pleasure to the rich. I have no children by which I can propose to get a single penny; the youngest being nine years old, and my wife past childbearing.

The rococo style with its lightheartedness, grace, and wit also found a disciple in Voltaire (see Profile, p. 417), as his satirical novel, *Candide* (1759), illustrates. In the novel Voltaire rather savagely denounces the kind of metaphysical optimism espoused by some philosophers of the time. In so doing, Voltaire reveals a terrible world of horror and folly.

The book tells the story of the naïve Candide, who sees and suffers so much misfortune that he ultimately rejects the philosophy of his tutor, Dr Pangloss, who claims that "all is for the best in this best of all possible worlds." In a rather somber setting, Candide and his companions, Pangloss, Cunegonde (Candide's beloved), and the servant Cacambo, show a definite instinct for survival. Having endured a multitude of catastrophes, they finally retire to a simple life on a simple farm, discovering in the process that the secret of happiness lies in cultivating one's garden: a practical philosophy that excludes excessive idealism and uncertain metaphysics.

Neoclassicism

Alexander Pope also served as a model for an American poet, Phillis Wheatley (c. 1753–84). Perhaps of Fulani origin, in or near the current nation of Senegal, she came to America, captive, on the slaver *Phillis*. At the age of seven she was sold to John Wheatley, a Boston merchant. Recognizing her talent, the Wheatleys taught her to read and write not only in English but also in Latin. She read poetry, and at the age of fourteen, began to write. Her elegy on the death of George Whitefield (1770) brought her acclaim. With the 1772 publication of her *Poems on Various Subjects* in England, Phillis Wheatley's fame spread in Europe as well as America. Freed from slavery in 1773, she remained with the Wheatley family as a servant and died in poverty. Her poetry follows neoclassical style, has African influences, and reflects Christian concerns for morality and piety. In the short poem "On Virtue," the poet's language invokes imagery, figures, and allegory to make the moral quality of virtue a "bright jewel" and imbue it with personal characteristics. The unrhymed lines of the poem flow freely in iambic pentameter.

On Virtue
Phillis Wheatley

O Thou bright jewel in my aim I strive
To comprehend thee. Thine own words declare
Wisdom is higher than a fool can reach.
I cease to wonder, and no more attempt
Thine height t'explore, or fathom thy profound.
But, O my soul, sink not into despair,
Virtue is near thee, and with gentle hand
Would now embrace thee, hovers o'er thine head.
Fain would the heav'n-born soul with her converse,
Then seek, then court her for her promis'd bliss.
Auspicious queen, thine heav'nly pinions spread,
And lead celestial *Chastity* along;
Lo! now her sacred retinue descends,
Array'd in glory from the orbs above.
Attend me, *Virtue*, thro' my youthful years!
O leave me not to the false joys of time!
But guide my steps to endless life and bliss.
Greatness, or *Goodness*, say what I shall call thee,
To give an higher appellation still,
Teach me a better strain, a nobler lay,
O thou, enthron'd with Cherubs in the realms of day!

Humanitarianism

In an age of enlightenment, humanitarianism, democratic ideals, moral reformation, and broad mass appeal found outlets in pamphlets and essays. These became vital forces in literary endeavors. In the American colonies, Thomas Paine (1737–1809) turned his energies to writing pamphlets in support of the libertarian ideals of the times. An Englishman, he worked for the American movement toward independence, and later wrote *The Rights of Man* (1792) in support of the French Revolution. Banished from Britain and imprisoned in France, he died in poverty in the United States.

We often call the mid-eighteenth century the "Age of Johnson," after Samuel Johnson (1709–84), who began his literary career as a sort of odd-job journalist, writing for a newspaper. His principal achievements emerged from his work as a lexicographer and essayist: the 208 *Rambler* essays cover a huge variety of topics, including "Folly of Anger: Misery of a Peevish Old Age" and "Advantages of Mediocrity: an Eastern Fable." These essays promoted the glory of God and the writer's salvation. In 1758 Johnson began the *Idler Essays*, a weekly contribution to a newspaper called the *Universal Chronicle*. In these essays we find the moralistic, reforming tone still present, but with an increasingly comic element.

Feminism

English pamphleteer and novelist Mary Wollstonecraft (1759–97) published outspoken views on the role of women in society and on the role education played in oppressing women. She set out her ideas in the pamphlet *Thoughts on the Education of Daughters* (1787). Her most famous work, *A Vindication of the Rights of Women* (1792), stands as one of the major documents in the history of women's writing. She attacked the "mistaken notion of female excellence" she saw in contemporary attitudes about "femininity," and she argued that women were not naturally submissive, but taught to be so, confined to "smiling under the lash at which [they] dare not snarl." We see her attitudes in her preface to the novel, *Maria, or The Wrongs of Woman*:

Maria
or
The Wrongs of Woman
Mary Wollstonecraft

(After the edition of 1798)

Author's Preface

The wrongs of woman, like the wrongs of the oppressed part of mankind, may be deemed necessary by their oppressors: but surely there are a few, who will dare to advance before the improvement of the age, and grant that my sketches are not the abortion of a distempered fancy, or the strong delineations of a wounded heart.

In writing this novel, I have rather endeavoured to portray passions than manners.

In many instances I could have made the incidents more dramatic, would I have sacrificed my main object, the desire of exhibiting the misery and oppression, peculiar to women, that arise out of the partial laws and customs of society.

In the invention of the story, this view restrained my fancy; and the history ought rather to be considered, as of woman, than of an individual.

The sentiments I have embodied.

In many works of this species, the hero is allowed to be mortal, and to become wise and virtuous as well as happy, by a train of events and circumstances. The heroines, on the contrary, are to be born immaculate, and to act like goddesses of wisdom, just come forth highly finished Minervas from the head of Jove.

[The following is an extract of a letter from the author to a friend, to whom she communicated her manuscript.]

For my part, I cannot suppose any situation more distressing, than for a woman of sensibility, with an improving mind, to be bound to such a man as I have described for life; obliged to renounce all the humanizing affections, and to avoid cultivating her taste, lest her perception of grace and refinement of sentiment, should sharpen to agony the pangs of disappointment. Love, in which the imagination mingles its bewitching colouring, must be fostered by delicacy. I should despise, or rather call her an ordinary woman, who could endure such a husband as I have sketched.

These appear to me (matrimonial despotism of heart and conduct) to be the peculiar Wrongs of Woman, because they degrade the mind. What are termed great misfortunes,

may more forcibly impress the mind of common readers; they have more of what may justly be termed stage-effect; but it is the delineation of finer sensations, which, in my opinion, constitutes the merit of our best novels. This is what I have in view; and to show the wrongs of different classes of women, equally oppressive, though, from the difference of education, necessarily various.

Genre

Contemporary literature also reflected the eighteenth-century focus on the commonplace that we saw in the genre paintings of the day. Common ordinary occurrences frequently appear as symbols of a higher reality. The work of Oliver Goldsmith (1730–74), the prominent British eighteenth-century poet and playwright, illustrates this quite clearly. Goldsmith grew up in the village of Lissoy, where his father was vicar, and *The Deserted Village*, written in 1770, describes the sights and personalities of Lissoy:

> Sweet Auburn! Loveliest village of the plain
> Where health and plenty cheered the laboring swain;
> Where smiling spring its earliest visit paid,
> And parting summer's lingering blooms delayed.
> Dear lovely bowers of innocence and ease,
> Seats of my youth, where every sport could please;
> How often have I loitered o'er thy green,
> Where humble happiness endeared each scene!

Goldsmith's portrait of the old village parson includes a lovely simile.

> To them his heart, his love, his griefs were given,
> But all his serious thoughts had rest in heaven.
> As some tall cliff that lifts its awful form,
> Swells from the vale, and midway leaves the storm,
> External sunshine settles on its head.

Finally, great tenderness appears in the way he describes his dream of ending his life amid the scenes in which it had begun.

> In all my wanderings round this world of care,
> In all my griefs—and God has given my share—
> I still had hopes, my latest hours to crown,
> Amid these humble bowers to lay me down,
> To husband out life's taper at the close,
> And keep the flame from wasting by repose. . . .
> And as an hare whom hounds and horns pursue,
> Pants to the place from which at first she flew,
> I still had hopes my long vexations past,
> Here to return—and die at home at last.

Pre-Romantic

Here we face one of the challenging issues of the entire classical/Romantic relationship. As we stated very early in this book, history has seen a swinging back and forth between classicism and what we, for want of better terms, called "anti-classicism," one of whose forms is Romanticism. Things in the arts and life in general, however, rarely prove simple, and the relationship between classical ideals—form—and anti-classical ideals—feeling—proves the point. As we already have witnessed, the words themselves have diverse aspects and uses. In point of fact, in art the form of a work can be classical while the content and expression reflect Romantic ideas. As we previously stated, just because a work is "classical" does not make it void of emotion. Likewise, because a work may be classified as "Romantic" or "baroque" (both fundamentally anti-classical in spirit) does not rob it of logical organization.

In addition, the term "Romanticism," as we suggest in the next chapter, can refer to a specific compositional style c. 1830, but it also refers to a longlived cultural movement that began in the eighteenth century and of which some scholars now see "neoclassicism" as a sub-category.

From roughly the 1740s to the 1780s, the pre-Romantic movement moved away from the grandeur, austerity, nobility, idealization, and elevated sentiments of neoclassicism toward a simpler, more sincere, personal, and more natural form of expression.

The decline of drama and the rise of the novel in the eighteenth century marked a significant shift in literature. The life of Henry Fielding (1707–54) mirrored this transition as he moved from a distinguished career in the theatre—he had written about twenty-five plays, mostly satirical and topical comedies—to become a pre-eminent novelist. His first full novel, *Joseph Andrews* (1742), portrays one of the first memorable characters in English fiction—an idealistic and inconsistent hero who constantly falls into ridiculous adventures. Fielding called his novel a "comic prose epic," remarkable for its structure as well as its humor and its satire. His most famous novel remains *Tom Jones* (1749), a splendid romp which ranks among the greatest works in English literature.

One of the most influential of the pre-Romantic writers in France, Jean-Jacques Rousseau, placed a new emphasis on emotion rather than reason, on sympathy rather than rational understanding. Other English pre-Romantics included the novelists Matthew Gregory Lewis (*The Monk*, 1796), Horace Walpole (1717–97), and Mrs Radcliffe (1764–1823), who catered to the public taste for Gothic tales of dark castles and shining heroism in medieval settings.

The German Johann Gottfried von Herder (HAIR-dur; 1744–1803) also contributed to the pre-Romantic movement. Herder's essays, *German Way and German Art* (1773), have been called the "manifesto of German *Sturm und Drang*" ("storm and stress").

In his greatest work, *Ideas on the Philosophy of the History of Mankind* (1784–91), he analyzed nationalism and prescribed a way of reviving "a national feeling through school, books, and newspapers using the national language." Among the major exponents of *Sturm und Drang* were Johann Wolfgang von Goethe (GUHR-tuh; 1749–1832) and Friedrich von Schiller (SHIL-ur; 1759–1805). They advocated freedom and a return to nature, and took Shakespeare and Jean-Jacques Rousseau as their models. They exalted the individual, personal experience, genius, and creative imagination.

Goethe, perhaps the most influential man of letters of his era, provided in 1773 the *Sturm und Drang* movement with its first major drama, *Götz von Berlichingen* (gehrts fon BAIR-lik-ing-uhn), which Goethe wrote in conscious imitation of Shakespeare. He followed with the movement's first novel, *Die Leiden des jungen Werthers* (dee LY-ten des YOONG-en VAIR-tuhrs; "The Sorrows of Young Werther"). In Werther, a sensitive, ill-fated protagonist, Goethe created the prototype of the Romantic hero. Goethe also chronicled the Faust legend (see p. 360 for a discussion of Christopher Marlowe's treatment of the Faust story). Part I of Goethe's sweeping, two-part dramatic poem *Faust* was published in 1808 and Part II in 1832, after the author's death. *Faust* constituted the supreme work of Goethe's later years and many people consider it Germany's greatest contribution to world literature.

Part I details the magician Faust's despair, his pact with Mephistopheles, and his love for Gretchen. Part II covers Faust's life at court, the wooing and winning of Helen of Troy, and his purification and salvation. Occasionally described as formless because of its array of lyric, epic, dramatic, operatic, and balletic elements, the work was probably conceived not as a play but as a dramatic poem.

Goethe's friendship and correspondence with the poet Friedrich von Schiller solidified his aesthetic theories. Schiller, in his plays, examined the inward freedom of the soul that enables the individual to rise above physical frailties and the pressure of material conditions. His first poetic drama, *Don Carlos* (1787), helped establish blank verse as the recognized medium of German poetic drama. He gave jubilant expression to a mood of contentment in his hymn "Ode to Joy," which Ludwig van Beethoven used for the choral movement of his Ninth Symphony. Schiller wrote extensively on the character of aesthetic activity, its function in society, and its relation to moral experience in essays on moral grace and dignity and on the sublime, as well as an essay on the distinction between two types of poetic creativity.

CHAPTER REVIEW

CRITICAL THOUGHT

The concept of the "enlightened despot" emerges importantly with regard to this period. This century did away with the "absolute monarchs," although the "enlightened despots" survived. The concept describes a condition of social order that seemed to work—at least at the time. Power, although not absolute, rested in a monarch: therefore, things got done. The enlightened attitude of the monarch, however, made it possible to meet the needs of even the lowest, most humble individual in society—order was kept, and the basic conditions and rights of humans were respected and maintained. Life seemed pretty good on the whole—at least in the German

states in the eighteenth century. In France, on the other hand, the roughshod ways of absolute monarchy caused a mass uprising in which the aristocracy was not only overthrown but exterminated under the guillotine. Once the mob controlled France, however, conditions got even worse, and chaos reigned. Eventually this rude sort of democracy led to the emergence, not of a king, but of a dictator—Napoleon—leading some to speculate that enlightened despotism proved a better form of government than democracy. Where do the "rights" of individuals stop and the "rights" of society begin?

SUMMARY

After reading this chapter, you will be able to:

- Relate the politics, economics, and technology of the eighteenth century to the condition of the general social order in Europe and America.
- Describe the philosophes and the nature of philosophy during the Enlightenment.
- Discuss the prevalent aesthetics of the time and apply specific events, publications, and people to your discussion.
- Characterize the rococo, neoclassical, and other approaches to visual art and architecture with specific reference to individual artists and works of art.

- Identify individual writers of the Enlightenment period and their works.
- Define classical style and its antecedents in music with reference to particular developments, forms, composers, and works.
- Explain the nature of theatre and dance during the eighteenth century by outlining specific conditions and developments, as well as individuals.
- Apply the elements and principles of composition to analyze and compare individual works of art and architecture illustrated in this chapter.

CYBERSOURCES

http://www.artcyclopedia.com/history/rococo.html
http://www.artcyclopedia.com/history/neoclassicism.html
http://www.greatbuildings.com/buildings.html
http://www.classicalarchives.com/
http://www.gutenberg.net/

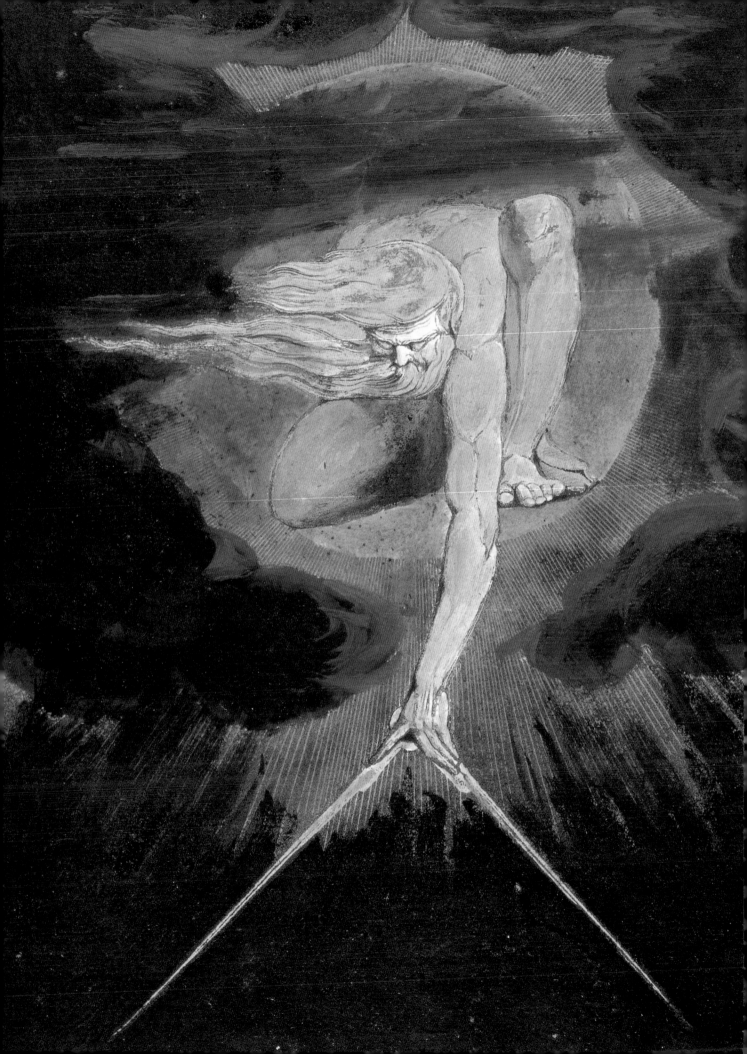

14 THE ROMANTIC AGE

— OUTLINE —

— VIEW —

VALIDATING SUBJECTIVE EXPERIENCES

"The Romantic Age," the title of this chapter, refers to the style and direction of art, literature, and philosophy of the late eighteenth and nineteenth centuries, and, in this context, the word Romantic has a different connotation from our customary use. Of course, the word means "having to do with romance"—a love affair—but it also has to do with a romance, which is a long narrative story dealing with the exploits of a chivalrous hero. Romantic also means "having to do with romanticism," an assertion of subjective experience and feeling in opposition to the form and objectivity of classicism. Thus, when we speak of the Romantic age, we speak of living, thinking, perceiving, and communicating with a focus on subjectivity rather than objectivity. We are about to watch the classical/anti-classical pendulum swing again, and this time it will swing further than ever toward emotionalism. The temperament of the artist becomes a filter through which we view the world, and the only limits that are placed on art are the practicalities of the artistic disciplines themselves.

— KEY TERMS —

INDUSTRIAL REVOLUTION
Social and economic changes brought about when extensive mechanization resulted in a shift from home manufacturing to large-scale factory production.

IDEALISM
A philosophy contending that the nature of reality is the nature of the mind—that is, ideal.

ROMANTICISM
A literary and artistic movement that sought to assert the validity of subjective experience.

MARXISM
The body of ideas developed by Karl Marx, forming the basic tenets of modern socialism and communism.

PROGRAM MUSIC
Musical works built around a non-musical story.

MELODRAMA
A type of theatre characterized by sensationalism and sentimentality.

14.1 William Blake, *The Ancient of Days*, frontispiece of *Europe, A Prophecy*, 1794. Metal relief etching. Yale Center for British Art, Paul Mellon Collection.

CONTEXTS AND CONCEPTS
Contexts

Technology

The early years of the nineteenth century saw wide experimentation with sources and uses of energy. Gas generally served as a fuel and for illumination. Yet the pursuit of technical efficiency proved so effective that before the century concluded, electricity had replaced gas as a source of light.

Important developments in engine design took place in the first two decades of the nineteenth century. The early steam engine could generate only enough steam pressure to drive one cylinder at one pressure, and although water turbines proved much more efficient, they could be installed only near moving water. It took only a few years to find the path to a more efficient engine, however, and by the second decade of the century, a successful compound engine emerged. The principal use of the compound steam engine was in ocean-going ships, and because the engine required less fuel, the cargo capacity of the ships increased proportionately. Later developments included steam turbines and internal combustion engines.

By the mid-nineteenth century, the world's entire transportation system had undergone a complete revolution. New technology also revolutionized industrial processes. Steam engines ran sawmills, printing presses, pumping stations, and hundreds of other kinds of machinery, and further inventions and discoveries followed on the heels of steam power. Electricity, too, saw fairly wide use before the century ended, at least in the urban centers. The discovery of electricity made the telegraph possible in 1832. Telegraph lines spanned continents and, in 1866, joined them via the first transatlantic cable. The telephone came in 1876, and by 1895, radio-telegraphy stood ready for twentieth-century development.

GENERAL EVENTS

- Napoleon Bonaparte, 1769–1821
- Congress, 1814–15
- Battle of Waterloo, 1815
- Queen Victoria in Britain, 1819–1901
- Year of Revolutions in Europe, 1848
- Milling machine, 1855
- US Civil War, 1861–5
- Vatican Council, 1869–70

1800	1825	1850	1875	1900

PAINTING & SCULPTURE

1800	1825	1850	1875
Géricault (**14.4**), Ingres (**14.5**), Goya (**14.6**), Hokusai (**14.8**)	Turner (**14.7**), Delacroix (**14.9**), Corot (**14.10**), Bonheur (**14.11**)		

ARCHITECTURE

1800	1825	1850	1875
Nash (**14.12**)	Barry and Pugin (**14.13**)	Paxton (**14.14**)	

THEATRE

1800	1825	1850	1875
	Hugo, Dumas	Kean, Melodrama	

MUSIC & DANCE

1800	1825	1850	1875
Schubert, Mendelssohn	Berlioz, Chopin, Taglioni, Rossini, Meyerbeer, Gautier	Offenbach, Tchaikovsky, Thomas, Gounod, Wagner, Verdi, Strauss, Petipa	Brahms

LITERATURE

1800	1825	1850	1875
Fichte, Hegel, Schelling, Wordsworth, Coleridge, Blake, Austen, Scott, Byron, Keats, Shelley	Comte, Schopenhauer, Brontë, Balzac, Dickens, Poe	Darwin, Marx, Whitman, Flambert	Spencer, James

Timeline 14.1 The Romantic age.

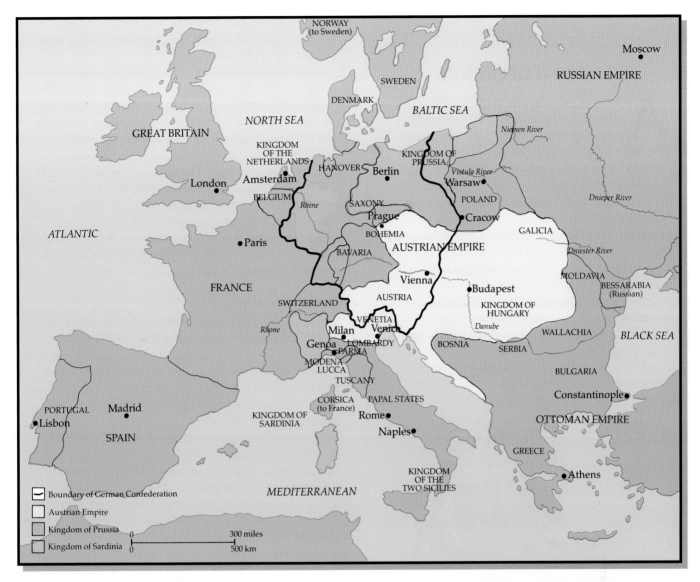

Map 14.1 The industrialized world in the nineteenth century.

Mining production increased when new explosives, based on nitroglycerine, and more powerful hoisting and pumping equipment evolved, making ore extraction and separation more efficient. These improvements were eclipsed, however, by the flotation method devised by the Bessel brothers in 1877. Significant improvements in smelting furnaces, such as the blast furnace and the "wet process" of Joseph Hall, along with Nasmyth's steam hammer, improved production of iron and steel.

In America, a new process for producing what became known as "Bessemer steel" soon made wrought iron obsolete and provided high-quality steel for rails, ships and, late in the century, building beams and girders. Further refinements of the "open hearth" steel process produced even higher quality, more economical steel. The development of the rolling mill made possible more and

more applications, including cable for suspension bridges. The most famous use of suspension cable at the time, the Brooklyn Bridge, arose in 1883.

A major problem in food distribution had been the shipment and storage of perishables. Natural ice served worldwide for large-scale refrigeration early in the nineteenth century, but shortly after the middle of the century, the development of ice cabinets the size of railroad cars and improved tools for harvesting ice meant that perishable goods could be refrigerated, and frozen goods could even be shipped across the American continent.

The mid-point of the century witnessed the discovery of the pasteurization process, eliminating several milk-borne diseases. Largely as a result of the experiments of Nicholas Appert, early in the nineteenth century, the use

TECHNOLOGY

EXACT TOLERANCE

All areas of industry saw the invention and design of new machines and machine tools throughout the century. One of these was the milling machine (Fig. **14.2**), whose rotary cutting edges made possible the manufacture of parts of exact tolerance that could be interchanged in a single product. This idea of interchangeable parts is called the "American System," and is generally attributed to Eli Whitney. The armaments industry also began to use a new grinding machine that enabled machinists to shape metal parts as opposed to merely polishing or sharpening them. Further experiments refined the accuracy of grinding wheels and improved their abrasive surfaces. A new turret lathe made it possible to use several tools on a workpiece. Advances of this sort made possible a "second generation" of machine tools in the industrialized West.

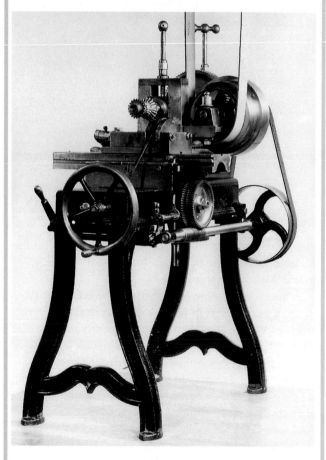

14.2 F.A. Pratt and Amos Whitney, the Lincoln Miller, 1855. Smithsonian Institution, Washington D.C.

of heat in preserving food gave rise to the canning industry, and by the late 1840s, hermetic sealing saw widespread application.

Another major aspect of the technological revolution emerged in the harnessing of electricity. By the nineteenth century, the wet battery provided a source for the continuous flow of current. Electrical energy gradually spread to heating, lighting, and mechanical energy. Experiments produced a practical filament for an incandescent light bulb. The electric-powered streetcar rendered horsecars obsolete by 1888. By 1895 Niagara Falls had been harnessed for hydroelectric power. Elsewhere, long transmission lines and transformers carried electrical power throughout the Western world. By the turn of the twentieth century, the Western world had been fully mechanized.

Social Changes

The Industrial Revolution began in Britain and, at the conclusion of the Napoleonic wars in 1815, spread to France and the rest of Europe. It gained momentum as it spread, and irrevocably altered the fabric of civilization. By 1871, the year of the first unification of Germany, major industrial centers had been established all over Europe.

Coal and iron production gave Britain, Germany, France, and Belgium the lead in European industry. But vast resources of coal, iron, and other raw materials, more than all Europe had, soon propelled the United States into a position of economic dominance. Throughout the Western world, centers of heavy industry grew up near the sources of raw materials and transportation routes. Colonial expansion provided world markets for new goods. Wealth increased enormously, and although the effects of investment affected every level of society, the principal effect of industrialization proved the centralization of economic control in the hands of a relatively small class of capitalists. Populations grew as the mortality rate went down. A new class of machine workers, "blue-collar workers," or labor, emerged.

Drawn from pre-industrial home industries and farms, the new machine-worker class lived and worked in deplorable conditions. No longer their own masters, they became virtual slaves. Unable to help themselves, they remained subject to severe organizing restrictions, hampered by lack of education, and threatened constantly by the prospect of unemployment. Slums, tenements, and horrifying living conditions awaited them. The middle classes, caught up in their own aspirations to wealth and political power, largely ignored their plight.

The middle class now turned toward Liberalism, a political program dedicated to advancing religious toleration and reducing the authority of a dominant Church, reducing the power of the monarch or the

aristocracy through constitutional means, and removing provincial economic barriers through nationalism. In other words, Liberalism built its political program on those movements that would enhance middle-class power. It gained widespread support, and became the political watchword of the age. The middle-class program reflected a *laissez-faire*, or "Let people do as they please," economic policy.

A new code of morality stressed individual freedom. The "free man" emerged as the model of what one could achieve only by standing on one's own feet and creating one's own destiny. Individual freedom came by struggle and eventual triumph. The unfit—the degraded masses—perished; the fit—a few rugged individuals—survived.

The masses, however, wanted to count too. In order for them to do so, two conditions had to be met. They needed a basic education, and they needed basic confidence in themselves. Only Prussia had a public school system that provided mass education. Britain and France did nothing about this until the 1870s and 1880s. In the United States local support for public education began as early as the 1820s, but even the concept of mass education did not take root until mid-century, and compulsory elementary education did not appear until toward the end of the nineteenth century.

Many different solutions to the working-class problem emerged—philanthropy, utopianism, and, most important of all, the socialism of Karl Marx. Gradually, and not without bloodshed, workers acquired the right to form unions. But only in the second half of the nineteenth century did laborers begin to unionize, and thereby to promote their own interests.

The Victorian Age

As we now reach what we can call the modern era, changes begin to occur rapidly, with the result that we find much overlapping of times and movements, particularly in the arts. The Romantic Age, as we title this chapter, with reference to a style and philosophy that lasted nearly the entire century, also overlapped other styles and philosophies which we discuss in the next chapter. In addition to the Romantic Age, we often refer to the nineteenth century as the Age of Industry. We also hear the period called the Victorian Age. The Victorian Age, referring to the reign of Queen Victoria of Great Britain, lasted from the 1830s to 1901. It produced a significant thrust in literature that reflected a reaction against Romanticism. The Victorian Age also concerned itself with Darwin's "evolution" and all the issues of faith, morality, and scientific knowledge that follow Darwin's assertions. Further, the Victorian Age represents the overly embellished styles that occurred in domestic architecture, dress, and literature, and it formed a

crucible from which women writers began to move to the forefront in recognition and acknowledgement.

British confidence soared to great heights in the middle decades of the nineteenth century. They then began to use the term "Victorian" to describe the era in which they lived, demonstrating a consciousness that their values dominated a distinct period. New technologies and new economies combined with social stability and traditional values. Parliament and the monarchy symbolized continuity, stability, and tradition in changing times.

Concepts

Marxism

Karl Marx (marks; 1818–83), a German economist, philosopher, and revolutionist, developed the body of ideas known as Marxism, and together with Friedrich Engels (ENG-ehls), he formed the basic tenets of modern socialism and communism. As a university student, Marx was strongly influenced by the ideas of Hegel and by a group of radical students who tried to use Hegelian thought in a movement against organized religion and the Prussian aristocracy. Later, Marx turned to a book called *The Essence of Christianity*, written by Ludwig Feuerbach, and adapted its central thesis—that if religion were abolished, human beings could overcome their alienation—to argue for the abolition of private property. According to Marx, private property caused humans to work only for themselves, not for the good of their species. He further argued that alienation had an economic base, and he called for a communist society to overcome the dehumanizing effect of private property. Still later, with the collaboration of his friend Engels, Marx declared in *The Communist Manifesto* (1848) that all history reflected class struggles. Under capitalism, the conflict between the working class and the business class would end in a new, communist society. In 1867, Marx published the first volume of *Das Kapital* (the second and third volumes appeared after Marx's death), a monumental politico-economic study arguing that all history was determined by humanity's relationship to material wealth and that governments served only the interests of the ruling class. He reiterated his prediction of revolution ending first in socialism and then communism. The method of analysis in *Das Kapital* became the theoretical basis for modern socialism and communism.

Evolution

Scientific attention turned both to investigating the atom and formulating theories of evolution. Evolution as a unifying concept in science dated back to the Greeks, but

now, Sir Charles Lyell (1797–1875) became the first to coordinate earth studies, and his *Principles of Geology* (1830) provided an important base for evolutionary thinking. In 1859 Charles Darwin (1809–82) put forward the concept of natural selection as the explanation of species development in *The Origin of Species*. Darwin's theories obtained a practical base when Gregor Mendel's (MEHN-duhl) work on inheritance, originally done in 1866, was rediscovered and developed in 1900. Evolution emerged as the framework that the science of biology would use for the foreseeable future.

Inevitably, evolution clashed with Christianity. After the initial shock, many Protestant denominations came to grips with the principles of evolution. This was easier for Protestants than for Roman Catholics because, essentially, Protestants recognized the right of individuals to make private judgments, while Catholics had to accept doctrinal control. At the same time that evolutionary doctrine first emerged, some Protestant scholars acknowledged the Bible as a compilation of human writings over a period of time, written under real, historical circumstances and not dictated, word for word, by God. Of course, some Christian groups condemned these notions as just as evil as Darwinism. Nevertheless, Protestantism, in general, gradually arrived at a "modern" outlook. Pope Pius IX, on the other hand, rejected evolution in his *Syllabus of Errors* (1864), and the Vatican Council of 1870 declared papal infallibility. The Church maintained a position of intransigence on the subject of evolution throughout the papacy of Leo XIII (1878–1903).

Idealism

In the late eighteenth century, Immanuel Kant (see Chapter 13) put forward a dualistic metaphysics that distinguished between a knowable world of sense perceptions and an unknowable world of essences. This reconciliation of philosophical extremes led to a nineteenth-century philosophy focused on the emotions. According to Kant, the real world, so far as humans could possibly rationalize it, comprised a mental reconstruction, an ideal world of the understanding; thus, the nature of reality is of the nature of the mind—ideal. Hence the doctrines were called *Kantian idealism*.

Such an idealistic appeal was also called *Romanticism* (see p. 455), and this reaction against eighteenth-century rationalism permeated both philosophy and the arts. Other German idealists—Johann Fichte (FIK-te; 1762–1814) and Friedrich Schelling (1775–1854), for example—rejected Kant's dualism, and developed an absolute system, based on emotion, that asserted the oneness of God and nature. However, nineteenth-century idealism, or Romanticism, culminated in the work of Georg Wilhelm Friedrich Hegel (HAY-gul 1770–1831), who believed that both God and

humankind possessed unfolding and expanding energy. Hegelian philosophy combined German idealism with a belief in evolutionary development and viewed the course of human history optimistically.

Hegel's philosophy viewed "reality" as spirit, or mind. Hegel believed art to be *one* ultimate form, but not *the* ultimate form, of mind. Philosophy was the final form, while art remained a preliminary "step toward truth."

According to Hegel, the objective of art is beauty, which is, in turn, a means for expressing truth. He defined beauty as the "sensuous appearance of the Idea, or the show of the Absolute Concept. The Concept which shows itself for itself is art."[1] Hegel believed classical art constituted the format whereby the ideal content "reaches the highest level that sensuous, imaginative material can correctly express." Classical art comprises the perfection of artistic beauty, and the essence of classical art, for Hegel, is sculpture. Hegel conceived of sculpture in the same way as the classical Greeks did—as the expression of the human form which alone can "reveal Spirit in sensuous fashion."

This assertion refers to the ideas of Kant and Winckelmann. Kant maintained that human beings alone can conceive of an ideal of beauty, and Winckelmann saw Greek sculpture as the perfection of beauty. Hegel went beyond Kant and Winckelmann to suggest that "Greek religion realized a concept of the divine which harmonized the ethical and the natural. Hence the Greek gods, the subject of Greek sculpture, are the perfect expression of a religion of art itself."

Finally, Romantic art evolves content to such a degree that it contains "more than any sensuous imaginative material can expressly embody." Being subjective, the content of Romantic art comprises the "Absolute that knows itself in its own spirituality." As Hegel attempts to reconcile this concept with the Christian concept of God, he ranks Romantic art in three progressively more spiritual forms. First comes painting, second, music, and third, poetry, the most spiritual and universal of all the arts, which includes within itself all the others.

The idealism of Schelling, Fichte, and Hegel witnessed a challenge by Arthur Schopenhauer (SHOH-pen-how-uhr; 1788–1860), who saw the world as a gigantic machine operating according to its unchanging law. Schopenhauer recognized no Creator, no benevolent Father, only a tyrannical and unfathomable First Cause. If we call Hegel an optimist, then we must call Schopenhauer a pessimist of the highest order.

Positivism and Materialism

Unlike the Germans, who focused on coping with metaphysical issues, the British and French focused on philosophical explanations of the emerging, mechanized world. To them, what lay beyond this world was beyond

knowledge and, therefore, inconsequential. Philosophers such as the Frenchman Auguste Comte (kawhnt; 1798–1857), saw the nineteenth century as an era of science; Comte regarded philosophy's task as the sorting out of factual details of worldly existence rather than the solution of riddles of an unknown universe. This philosophy was called "positivism," and later formed the basis for the science of sociology.

Across the channel in Britain, Herbert Spencer (1820–1903) expounded a philosophy of evolutionary "materialism," in which Darwin's theory of evolution provided the framework for the study of society as much as nature. Spencer believed that a struggle for existence and "survival of the fittest" formed fundamental social processes, and that the human mind, ethics, social organization, and economics were "exactly what they ought to be."

Internationalism

Mechanization, especially in transportation and communications, made the nineteenth century an international age while, at the same time, nations strove for individual power (Fig. 14.3). Communication networks bridged distances, and increasing numbers of international agreements emerged. All this sat against fierce and imperialistic competition for raw materials and marketplaces. The nations of the Western world depended upon armaments to secure and protect their advances. In the late nineteenth century, various pragmatic alliances and treaties were forged under the guise of cooperation, but, in fact, they cast the die for war, an ever-present specter in European existence.

The times bubbled with turbulence and frustration. France, for example, had an entire generation of young men raised in an era of patriotic and military fervor under Napoleon. After his defeat, they vegetated in a country ruined by war and controlled by a weak, conservative government. Feelings of isolation and alienation increased. The suffering, isolated, sensitive youth, personified by Goethe's Werther (see p. 444), became the Romantic hero. Curiosity about the supernatural ran rampant with escape to Utopia a common goal. Those who saw salvation in a "return to nature" saw nature, on the one hand, as the ultimate source of reason, and, on the other, as a boundless, completely free environment in which all emotions could be freely expressed. This latter idea forged a core for Romanticism.

Patronage

The role of the artist changed significantly in the nineteenth century. For the first time, art could exist without the support of significant aristocratic and religious commissions and patronage. In fact, artists deliberately resisted patronage, which imposed unwelcome limits on individual expression.

Artists enjoyed a new place in the social order. Much art turned individualistic and increasingly critical of society and its institutions. A huge gap opened between rebellious personal expression and established values, whether of a critic or of society at large, and this prompted some artists to try out increasingly personal and experimental techniques. In many cases, artists, and particularly visual artists, were barred from the world with which they needed to communicate. The traditional academies that controlled formal exhibitions would not hang their works, and commercial galleries, and hence the public, would not buy them. As a result, many artists became the social outcasts, the starving Romantic heroes, of public legend. We can find these "starving artists"—a poet, painter, philosopher, and musician—explored in Puccini's opera *La Bohème* (The Bohemians), and the "bohemian lifestyle" remains a phrase that connotes such a way of living.

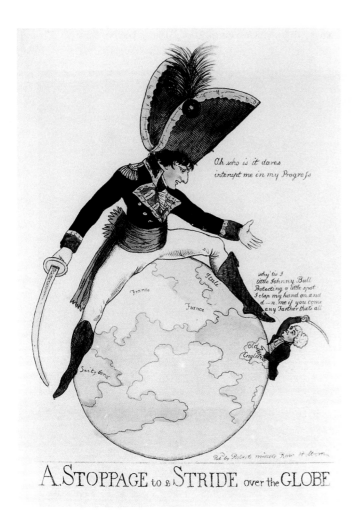

Ah, who is it dares interrupt me in my Progress

why 'tis I little Johnny Bull Protecting a little spot I clap my hand on and d—n me if you come any farther that's all

France

Italy

France

old England

Switzerland

A STOPPAGE to a STRIDE over the GLOBE

14.3 Anonymous cartoon, "A stoppage to a stride over the globe," showing Napoleon's expansion checked by the English, c. 1810.

MASTERWORK

GÉRICAULT—THE RAFT OF THE "MEDUSA"

The Raft of the "Medusa" (Fig. **14.4**) by Théodore Géricault illustrates both an emerging rebellion against classicism in painting and a growing criticism of social institutions in general. The painting tells a story of governmental incompetence that resulted in tragedy. In 1816, the French government allowed an unseaworthy ship, the Medusa, to leave port, and it was wrecked. Aboard a makeshift raft, the survivors endured tremendous suffering, and were eventually driven to cannibalism. In preparing for the work, Géricault interviewed the survivors, read newspaper accounts, and went so far as to paint corpses and the heads of guillotined criminals.

In contrast to David's ordered, two-dimensional paintings (see Fig. **13.13**, The Oath of The Horatii), for example, Géricault used complex and fragmented compositional structures. For example, he chose to base the design on two triangles rather than a strong central triangle. In The Raft of the "Medusa" the left triangle's apex, the makeshift mast, points back toward despair and death. The other triangle moves up to the right to the figure waving the fabric, pointing toward hope and life as a rescue ship appears in the distance.

Géricault captures the precise moment at which survivors sight the rescue ship. The play of light and shade heightens the dramatic effect, and the composition builds upward from the bodies of the dead and dying in the foreground to the dynamic group whose final energies summon forth to support the figure waving to the ship.

14.4 Théodore Géricault, The Raft of the "Medusa", 1819. Oil on canvas, 16 ft × 23 ft 6 ins (4.91 × 7.16 m). Louvre, Paris.

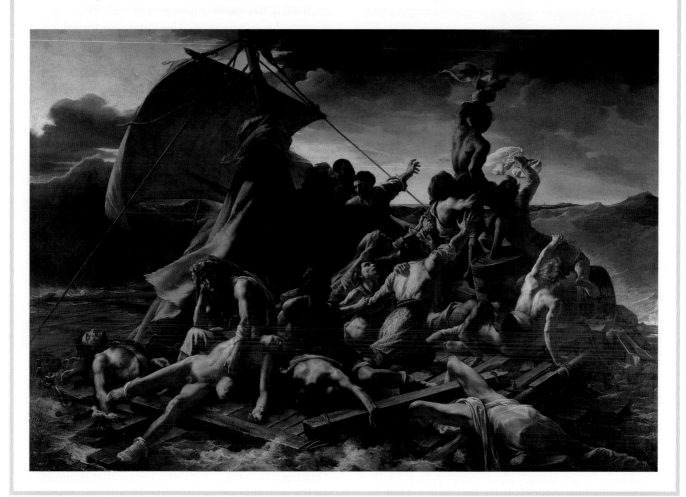

Romanticism

In practice, **Romanticism** comprised a rebellion against the neoclassicism we studied in Chapter 13. Throughout the chapter we will highlight aspects of Romanticism, but let's lay some foundation here. Romanticism emphasized *individualism*, imagination, free expression of feeling, communion with nature, and the idea of the creative artist as visionary genius. Romanticism saw the artist as possessing ultimate insight into fundamental reality and revealing it, through impassioned self-expression, in a work of art that embodies, however imperfectly, a sublime ideal that transcends the ordinary world. Nature, wild and unspoiled, often served as a metaphor for that idealism, and some saw art as the highest form of human endeavor.

Individualism served as one of the basic tenets of Romanticism, and, as we have discussed before, the theory of individualism places the value, autonomy, and benefit of the individual over that of the group, society, or nation. It makes the individual the prime unit in the social system. It forms the opposite of collectivism or communism. To indicate how terms can change in implication and application, individualism forms the heart of "liberalism" just mentioned—the conviction that the primary role of government is to protect and promote the rights and endeavors of individuals. Liberalism also embraces *laissez-faire* economics, which argues that the best working of the marketplace occurs through the free operation of competitive self-interest. In today's politics, these two tenets seem at odds in terms of the labels "conservative" and "liberal" placed on those who adhere to them.

In social theory, individualism views all social activity as ultimately comprising individual acts. Individualism forms the core of Romanticism's belief in the uniqueness of each human being, and it finds its origins in the Renaissance idea of humanism (see p. 282) and in the Protestant Reformation, which stressed the idea of each human's ability to intercede without mediator (priest) to God and each individual's personal responsibility for individual salvation.

In the pages that follow, as we study the arts of the Romantic age, we will witness a diversity that almost seems inconsistent with a single style. We should, however, expect that because of the insistence we have given to the high individualism of the age. We will see nature, subjectivity, fragmentation, and escapes into the past, including a past that looks very much like the classicism that Romanticism supposedly reacts against. The Romantic artist, however, made no distinctions in the "far away and long ago," among Greek and Roman orders, Gothic arches, or Turkish exoticism. To reiterate, the pendulum has swung into the realm of feeling, with no limits implied.

THE ARTS OF THE ROMANTIC AGE
Painting

Many painters willingly championed the cause of Romanticism. The Romantic style had an emotional appeal, and its subjects tended toward the picturesque, including nature, Gothic images, and often, the macabre. In seeking to break the geometric principles of classical composition, Romantic compositions moved toward fragmentation of images, with the intention of dramatizing, personalizing, and escaping into imagination. Such painting strove to subordinate formal content to expressive intent, and to express an intense introversion. As the writer Émile Zola said: "A work of art is part of the universe as seen through a temperament." Many Romantic painters merit note, but a look at the work of seven painters should provide a general overview of the movement.

In many ways, Jean-Auguste-Dominique Ingres (ANG-gruh; 1780–1867) pursued the physical and intellectual perfection initiated by David (see Chapter 13). Ingres's work illustrates the complex relationships and occasional conflicts between neoclassicism and Romanticism, as we mentioned in the last chapter. Painted in 1814, Ingres's *La Grande Odalisque* or *Harem Girl* (Fig. 14.5) has been called both neoclassical and Romantic, and in many ways it represents both styles and their relationships. Ingres professed to despise Romanticism, and yet the proportions he gives his subject matter, and the subject matter itself, exude individual style and a Romantic longing for exotic times and places. His textures, too, emerge sensuous and emotional, yet his line stays simple, his palette, cool, and his spatial effects, geometric. The linear rhythms of this painting, however, seem very precise and calculated and, perhaps, classical in their appeal.

Théodore Géricault (tay-oh-DOHR zhay-ree-KOH; 1791–1824), an important early French Romantic, offers us a fully developed example of the Romantic hero: a brilliant prodigy, a champion of the downtrodden, and an early death. A Romantic in his art as well, although greatly influenced by David, Géricault departed drastically from his master in his brushwork. David insisted that the surface of a painting should be smooth and that the brushwork should not show. Géricault uses the visual impact of the strokes themselves to communicate mood. He accepted the heroic view of human struggle that characterized this period, and his paintings frequently treat the human struggle against the violent forces of nature. His famous painting *The Raft of*

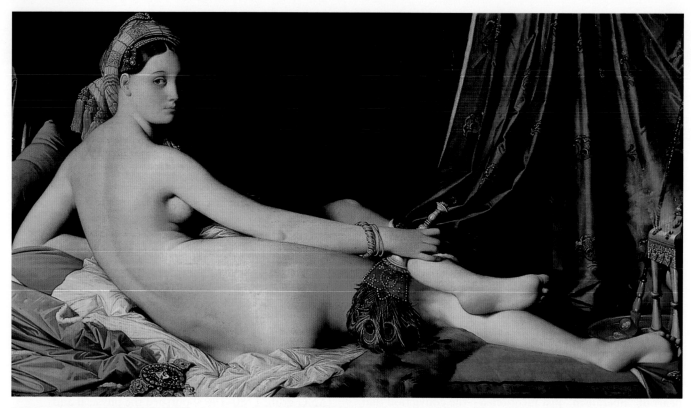

14.5 Jean-Auguste-Dominique Ingres, *La Grande Odalisque* (*Harem Girl*), 1814. Oil on canvas, 36¼ × 63¼ ins (92 × 160.6 cm). Louvre, Paris.

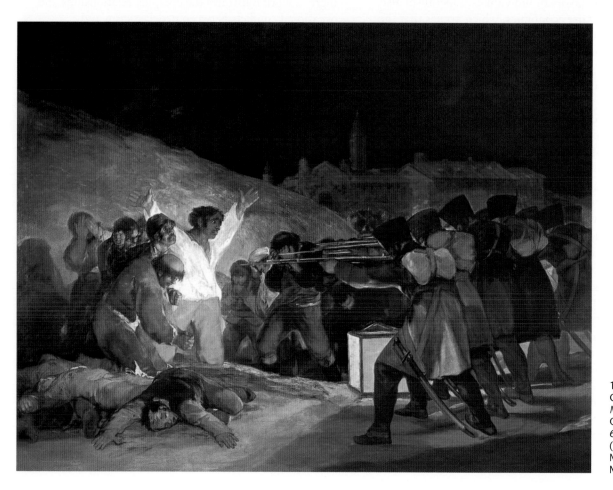

14.6 Francisco de Goya, *The Third of May 1808*, 1814. Oil on canvas, 8 ft 6 ins × 11 ft 4 ins (2.6 × 3.45 m). Museo del Prado, Madrid.

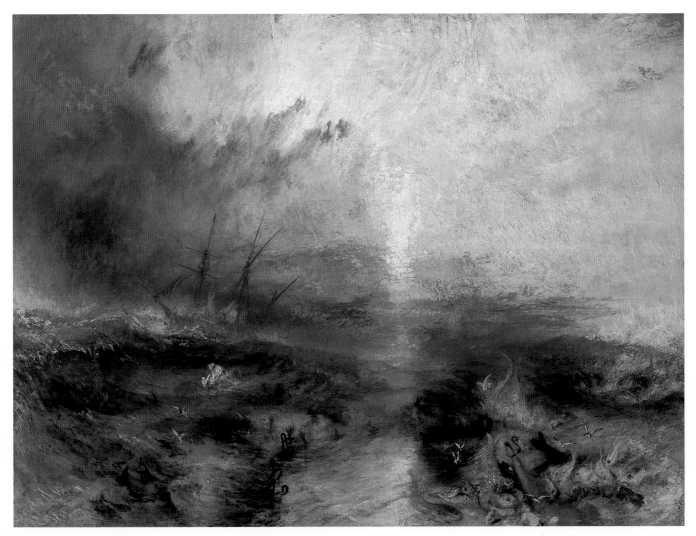

14.7 Joseph Mallord William Turner, *The Slave Ship* (*Slavers Throwing Overboard the Dead and Dying, Typhoon Coming On*), 1840. Oil on canvas, 35¾ × 48¼ ins (90.8 × 122.6 cm). Museum of Fine Arts, Boston (Henry Lillie Pierce Fund).

the "*Medusa*" (Fig. **14.4**) reflects Michelangelo's work in its turbulence and grandeur.

The Spanish painter and printmaker Francisco de Goya (frahn-THEES-koh day GOY-ah; 1746–1828) used his paintings to attack the abuses perpetrated by governments, both the Spanish and the French. His highly imaginative and often nightmarish works capture the emotional character of humanity and nature, and frequently their malevolence.

The Third of May 1808 (Fig. **14.6**) tells a true story. On that date, the citizens of Madrid rebelled against the invading army of Napoleon which, in response, arbitrarily arrested and summarily executed them. Using compositional devices even more fragmented than those of Géricault, Goya captured the climactic moment in the story. We cannot escape the focal point of the painting, the man in white, about to die. Goya's strong value contrasts force the eye back to the victim; only the lantern behind the soldiers keeps the composition in balance.

Goya leads us beyond the death of individuals here. These figures do not represent naturalistically depicted people. Instead, Goya makes a powerful social and emotional statement. Napoleon's soldiers, not even human types, have their faces hidden, and their rigid, repeated forms strike a line of subhuman automatons. The murky quality of the background strengthens the value contrasts in the painting and this charges the emotional drama of the scene. Color areas have hard edges, and a stark line of light running diagonally from the oversized lantern to the lower border irrevocably separates executioners and victims. Goya has no sympathy for French soldiers as human beings here. His subjectivity fills the painting, as emotional as the irrational behavior he wished to condemn.

The Englishman J.M.W. Turner (1775–1851) indulged in a subjectivity even beyond that of his Romantic contemporaries, and his work foreshadows the dissolving image of twentieth-century painting.

The Romantic painter John Constable described Turner's works as "airy visions painted with tinted steam." *The Slave Ship* (Fig. **14.7**) visualizes a passage in James Thomson's poem *The Seasons* which describes how sharks follow a slave ship in a storm, "lured by the scent of steaming crowds of rank disease, and death." The poem, based on an actual event, describes the captain of a slave ship dumping his human cargo into the sea when disease broke out below decks.

Turner's work demonstrates the elements of Romantic painting. His disjointed diagonals contribute to an overall fragmentation of the composition. His space exhibits deep three-dimensionality. The turbulence of the event pictured is reflected in the loose painting technique. The sea and sky appear transparent, and the brushstrokes energetic and spontaneous. Expression dominates form and content, and a sense of doom prevails.

Eugène Delacroix (duh-lah-KWAH; 1798–1863) employed color, light, and shade to capture the climactic moments of high emotion. In *The 28th July: Liberty Leading the People* (Fig. **14.9**), Delacroix shows the allegorical figure of Liberty bearing aloft the tricolor flag of France and leading the charge of a freedom-loving common people. Lights and darks provide strong and dramatic contrasts. The red, white, and blue of the French flag symbolize patriotism, purity, and freedom, and as Delacroix picks up these colors throughout the work, they also serve to balance and unify the scene.

Jean-Baptiste-Camille Corot (koh-ROH; 1796–1875), often described as a "Romantic naturalist," stood among the first to execute finished paintings out-of-doors rather than in the studio. He wanted to recreate the full luminosity of nature and to capture the natural effect of visual perception: how the eye focuses on detail and how peripheral vision actually works. In *Volterra* (Fig. **14.10**), he strives to this true-to-life visual effect by reducing the graphic clarity of all details except those of the central objects which he presents very clearly, just as our eyes perceive clearly only those objects on which we focus at the moment, while everything else in our field of vision stays relatively out of focus. Corot's works, spontaneous and subjective, retain a formal order to balance that spontaneity.

Rosa Bonheur (bawn-UHR; 1822–99), certainly the most popular woman painter of her time, has been labeled both a "realist" and a "Romantic" in style. She painted mostly animals and their raw energy. "Wading in pools of blood," as she put it, she studied animal anatomy even in slaughter houses, although not particularly interested in animal psychology. *Plowing in the Nivernais* (nee-vair-NAY; Fig. **14.11**) captures the tremendous power of the oxen on which European agriculture had depended before the Industrial Revolution. The beasts appear almost monumental, with each detail precisely executed. The painting clearly reveals Bonheur's reverence for the dignity of labor and her vision of human beings in harmony with nature.

A DYNAMIC WORLD

JAPANESE PAINTING

In the nineteenth century, as Japan began to look westward, the style of the country's two-dimensional art began to evolve, and the style has emotional similarities to European Romanticism. Illustrative is the work of Katsushika Hokusai (hoh-KU-sy; 1760–1849). In the landscape *The Great Wave off Kanazawa*, for example (Fig. **14.8**), Hokusai produces a boldly colored rendering that is neither naturalistic nor idealized. While Mount Fuji reposes calmly in the background, the great wave breaks over the boats with raging fury, and the foam reaches out like grasping fingers to crash down on the fragile craft. There is a new sense of directness here. Hokusai's response to natural forms has a Romantic sweep although his decorative patterning rests firmly within the traditions of Japanese art.

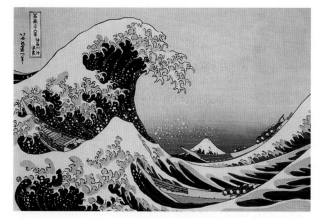

14.8 Katsushika Hokusai, *The Great Wave off Kanazawa*, 1823–9. Polychrome woodblock print, 10 × 14¾ ins (25.5 × 37.5 cm). Victoria & Albert Museum, London.

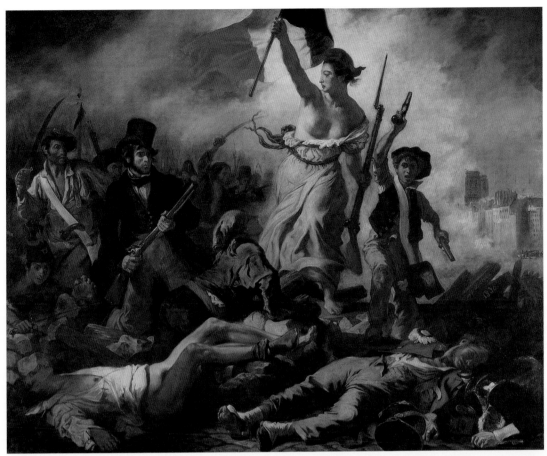

14.9 Eugène Delacroix, *The 28th July: Liberty Leading the People*, 1830. Oil on canvas, 8 ft 6 ins × 10 ft 7 ins (2.59 × 3.25 m). Louvre, Paris.

14.10 Jean-Baptiste-Camille Corot, *Volterra*, 1843. Oil on canvas, 18½ × 32¼ ins (47 × 82 cm). Louvre, Paris.

PROFILE

ROSA BONHEUR (1822–99)

One of the most significant and prominent artists of the time, Rosa Bonheur focused her artistic attention almost solely on animals. Born in Bordeaux, France, the eldest of four children of an amateur painter, after early instruction from her father, she studied with Léon Cogniet at the École des Beaux-Arts in Paris, and rather early on began to specialize in animal subjects, studying them wherever she could. Her early paintings won awards in Paris, and in 1848, she won a first-class medal for *Plowing in the Nivernais* (Fig. **14.11**). By 1853 her work had reached full maturity, and she received high acclaim in Europe and the United States. Her paintings, much admired, became widely known through engraved copies. Also well known as a sculptor, she is often classified as a "realist" in style (see Chapter 15). Her animal subjects led to her success among contemporary French sculptors.

Rosa Bonheur had an independent spirit and fought to gain acceptance on a level equal to that of male artists of the time. Her ability and popularity earned her the title of Chevalier of the Legion of Honor in 1865, and she was the first woman to receive the Grand Cross of the Legion. Befriended by Queen Victoria of Britain, who became her patron, Bonheur rose as a favorite among the British aristocracy, although she spent her last years in France, and died near Fontainebleau in 1899.

14.11 Rosa Bonheur, *Plowing in the Nivernais*, 1849. Oil on canvas, 5 ft 9 ins × 8 ft 8 ins (1.75 × 2.64 m). Musée Nationale du Château de Fontainebleau, France.

Architecture

Romantic architecture also borrowed styles from other eras and produced a vast array of buildings that revived Gothic motifs and reflected fantasy. This style has come to be known as "picturesque." Eastern influence and whimsy abounded in John Nash's Royal Pavilion in Brighton, in the south of England (Fig. **14.12**), with its onion-shaped domes, minarets, and horseshoe arches. "Picturesque" also describes the most famous example of Romantic architecture, the Houses of Parliament (Fig. **14.13**), a building that demonstrates one significant architectural concept we can describe as "modern." The exterior walls function simply as a screen, and have nothing to say about structure, interior design, or function. The inside has absolutely no spatial relationship

14.12 John Nash, Royal Pavilion, Brighton, England, remodeled 1815–23.

14.13 Sir Charles Barry and Augustus Welby Northmore Pugin, Houses of Parliament, London, 1839–52.

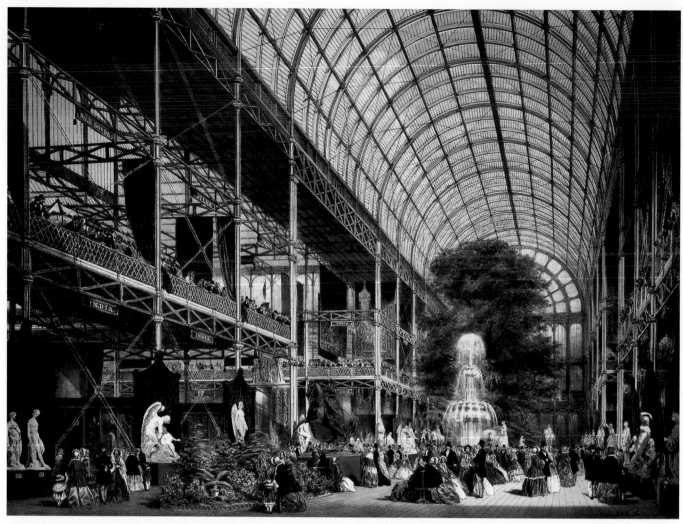

14.14 Sir Joseph Paxton, Crystal Palace, London, 1851.

to the outside. The strong contrast of forms and asymmetrical balance also suggest the modern.

The nineteenth century, an age of industry, proved also an age of experimentation and new materials. In architecture, steel and glass came to the fore. At first, an architect needed much courage actually to display the support materials as part of the design itself. The Crystal Palace in London (Fig. **14.14**) exemplified the nineteenth-century fascination with new materials and concepts. Built for the Great Exhibition of 1851, this mammoth structure arose in the space of nine months. It defined space by a three-dimensional grid of iron stanchions and girders, designed specifically for mass production and rapid assembly. (In this case, also disassembly—the entire structure was disassembled and rebuilt in 1852–4 at Sydenham.) Like the Houses of Parliament, the Crystal Palace demonstrated the divergence of the function of a building (as reflected in the arrangement of its interior spaces), its surface decoration, and its structure. A new style of building had arrived.

Theatre

"The play-going world of the West End is at this moment occupied in rubbing its eyes, that it may recover completely from the dazzle of Thursday last, when, a mid the acclamations of Queen Victoria's subjects, King Richard the Second was enthroned at the Princess's Theatre." Thus began the reviewer's comments in *The Spectator*, 14 March 1857. The dazzle of scenery, revivals, and a pot-pourri of uncertain accomplishments helped a stumbling theatre to keep up with the other arts that flourished through the early years of the nineteenth century.

Popularism and Historicism
Romanticism as a philosophy of art proved its own worst enemy in the theatre. Artists sought new forms to express great truths, and they strove to free themselves from neoclassical rules and restraints. They did, however, admire Shakespeare as an example of new ideals and as

a symbol of freedom from structural confinement. Intuition reigned, and the artistic genius set apart from everyday people and above normal constraints. As a result, Romantic writers had no use for any guide but their own imagination.

Unfortunately, the theatre operates within some rather specific limits. Many nineteenth-century playwrights penned unstageable and/or unplayable scripts, and great writers could not or would not abide by constraints of the stage, while the hacks, yielding to popular taste, could not resist overindulgence in phony emotionalism, melodrama, and stage gimmickry. As a result, the best Romantic theatre performances came from the pen of William Shakespeare, whose work witnessed revival in a great rush of nineteenth-century antiquarianism.

Poor as it may have been in original drama, however, the Romantic period did succeed in loosening the arbitrary rules of neoclassical convention. Thus, it paved the way for a new theatrical era in the later years of the century.

The audiences of the nineteenth century played a significant part in determining what took the stage. Royal patronage evaporated, and box office receipts alone paid the bills. A rising middle class had swelled the eighteenth-century audience and changed its character. Then, in the nineteenth century, the lower classes began attending the theatre. The Industrial Revolution had created larger urban populations and expanded public education to a degree. As feelings of egalitarianism spread throughout Europe and America, theatre audiences grew, and theatre building flourished.

To appeal to this diverse audience, theatre managers had to put on plays for the popular as well as the sophisticated taste if they wanted to make money, so to offer something for everyone, an evening's theatre program might contain several types of fare and last over five hours: to predictable consequences. Fewer and fewer sophisticated patrons chose to attend, and the quality of the productions declined.

By 1850, theatres began to specialize, and sophisticated playgoers returned to certain theatres, although the multipart production remained typical until nearly the turn of the twentieth century. Audience demand remained high, and theatre continued to expand.

The early nineteenth-century theatre had some very particular characteristics. First of all, it involved the repertory company, with a set group of actors, including stars, which stayed in one place and staged several productions during a given season (quite unlike contemporary Broadway professional theatre, in which each play is produced and cast independently and runs for as long as it shows a profit). Gradually, better-known actors capitalized on their reputations and began to go on tour, starring in local productions and featuring their most famous roles. A craze for visiting stars developed, and the most famous actors began to make world tours. This increase in touring stars led to an increase in touring companies, and, in the United States especially, these companies, with their star attractions and complete sets of costumes and scenery, formed a regular feature of the landscape. By 1886 America could boast 282 touring companies. At the same time, local resident companies lessened in popularity, except in Germany, where a series of local, state-run theatres emerged.

After the Civil War a number of African American theatre companies emerged, featuring artists such as Anna and Emma Hyers, classically trained actors from California. In 1884, J.A. Arneaux founded the Astor Place Company of Colored Tragedians, who performed a repertory of Shakespearean plays. By the turn of the twentieth century, African Americans had made notable contributions to straight drama in the works of such playwrights as William Edgar Easton, who wrote historical plays.

Although theatre design by now showed great diversity, some general similarities existed. Principally, the changes in nineteenth-century stages and staging came from increased interest in historical accuracy and popular demand for depiction rather than convention. Before the eighteenth century, history had been considered irrelevant to art. Knowledge of antiquity that began with archeological excavations in Pompeii, however, aroused curiosity, and the Romantic dream of escape to the long ago and far away suggested that the stage picture of exotic places should be somehow believable. At first, such detail appeared inconsistently, but, by 1823, some productions claimed that they were entirely historical in every respect.

Attempts at historical accuracy had begun as early as 1801, and in France, Victor Hugo (HUE-ghoh or yoo-GHOH) and Alexandre Dumas (doo-MAH) *père* insisted on historically accurate settings and costumes during the early years of the century. However, Charles Kean (1811–68) brought the spectacle of antiquarianism in the London theatre to fruition in the 1850s (Fig. **14.15**).

The onset of accuracy as a standard for production led to three-dimensionality in settings and away from drop and wing scenery to the box set. The stage floor was leveled—since the Renaissance it had been raked—and new methods of shifting and rigging were devised to meet specific staging problems. Over a period of years, all elements of the production integrated, much in the spirit of Wagner's totally unified artwork, the **Gesamtkunstwerk** (see p. 470). The distraction of numerous scene changes disappeared by closing the curtain.

14.15 Charles Kean's production of Shakespeare's *Richard II*, London, 1857. Between Acts III and IV, the Entry of Bolingbroke into London. Contemporary watercolor by Thomas Grieve. Victoria & Albert Museum, London.

Melodrama

On the popular side, nineteenth-century theatre developed a Romantically exaggerated form called "melodrama." Typically this kind of theatre employs sensationalism and sentimentality. Characters remain stereotyped, and everything and everyone tends to all good or all evil. Plots are sentimental and the action exaggerated. Regardless of circumstances, good must be rewarded and evil punished. Often also some form of comic relief appeared, usually through a minor character. The action of melodrama progresses at the whim of the villain, and the hero must endure episode after episode of trial and suffering. Suspense is imperative, and a reversal at the end obligatory.

The term "melodrama" implies music and drama, and, in the nineteenth century, these plays were accompanied by a musical score tailored to the emotional or dynamic character of the scene similar to music usage in films and television programs today, with the added attractions of incidental songs and dances used as curtain raisers and *entr'acte* entertainment.

Melodrama saw great popularity throughout Europe and the United States. *Uncle Tom's Cabin*, based on the novel by Harriet Beecher Stowe (1852), took the stage by storm. Stowe opposed the stage version, but copyright laws did not exist to protect her. The play does retain her complex themes of slavery, religion, and love. The action involves a number of episodes, some rather loosely connected. Characteristic of melodrama, *Uncle Tom's Cabin* places considerable emphasis on spectacle, the most popular of which at the time constituted Eliza's crossing of the ice with mules, horses, and bloodhounds in pursuit.

Music

In an era of Romantic subjectivity, music provided the medium in which many found an unrivaled opportunity to express emotion. In trying to express human emotion, Romantic music made stylistic changes to classical music, and although Romanticism amounted to rebellion in many of the arts, in music it involved a more gradual and natural extension of classical principles.

As in painting, spontaneity replaced control, but music put its primary emphasis in this era on beautiful, lyrical, and expressive melody. Phrases grew longer, more irregular, and more complex than in classical music. Much Romantic rhythm remained traditional, but experiments produced new meters and patterns. Emotional conflict often reflected in juxtaposition of different meters, and rhythmic irregularity grew increasingly common as the century progressed.

Romantic composers emphasized colorful harmonies and instrumentation, seeing harmony as a means of expression, and any previous "laws" regarding key relationships as breakable to achieve striking emotional effects. Harmonies grew increasingly complex, and traditional distinctions between major and minor keys blurred in chromatic harmonies, complicated chords, and modulations to distant keys. In fact, some composers used key changes so frequently that their compositions constitute virtually nothing but whirls of continuous modulation.

As composers sought to disrupt the listener's expectations, more and more dissonance occurred, until it became a principal focus. Composers explored dissonance for its own sake, as a strong stimulant of emotional response rather than merely as a decorative way to get to the traditional tonic chord. By the end of the Romantic period, the exhaustion of chromatic usage and dissonance had led to a search for a completely different type of tonal system.

Exploring musical color to elicit feeling stood as important to the Romantic musician as to the painter. Interest in tonal color, or timbre, led to great diversity in vocal and instrumental performance, and the music of this period abounds with solo works and exhibits a tremendous increase in the size and diversity of the orchestra. We have many options in how we might go about exploring Romantic music, none of which we could pursue exhaustively. We will proceed by isolating some major genres and, within them, noting major composers as we pass.

Lieder

In many ways, the "**art song**," or *Lied*, characterized Romantic music. A composition for solo voice with piano

accompaniment and poetic text allowed for a variety of lyrical and dramatic expressions and linked music directly with literature.

The burst of German lyric poetry, especially that which we called pre-Romantic (see Chapter 13), encouraged the growth of *Lieder*. Literary nuances affected music, and music added deeper emotional implications to the poem. This partnership had various results: some *Lieder* were complex, others simple; some were structured, others freely composed. The pieces themselves depended on a close relationship between the piano and the voice. In many ways, the piano played an inseparable part of the experience, and certainly it served as more than accompaniment, for the piano explored mood and established rhythmic and thematic material, and sometimes had solo passages of its own. The interdependency of the song and its accompaniment is basic to the art song.

The earliest, and perhaps the most important, composer of *Lieder*, Franz Schubert (SHOO-bairt; 1797–1828), epitomized the Romantic view of the artist's desperate and isolated condition. Known only among a close circle of friends and musicians, Schubert composed almost one thousand works, from symphonies to sonatas and operas, to Masses, choral compositions, and *Lieder*. None of his work was publicly performed, however, until the year of his death. He took his *Lieder* texts from a wide variety of poems, and in each case the melodic contours, harmonies, rhythms, and structures of the music were determined by the poem.

Schubert's song *Der Erlkönig* (The Erlking, 1815; Fig. **14.16**) provides an excellent example both of Schubert's work and of Romantic music in general. The song consists of a musical setting of a poem about the supernatural by Goethe (see Chapter 13). Schubert uses a through-composed setting—he writes new music for each stanza—in order to capture the poem's mounting excitement. The piano plays the role of an important partner in transmitting the mood of the piece, creating tension with rapid octaves and menacing bass motif. Imaginative variety in the music allows Schubert's soloist to sound like several characters in the dramatic development.

Who rides so late through the night and the wind?
It is the father with his child;
He folds the boy close in his arms,
He clasps him securely, he holds him warmly.

"My son, why do you hide your face so anxiously?"
"Father, don't you see the Erlking?
The Erlking with his crown and his train?"
"My son, it's a streak of mist."

"Dear child, come, go with me!
I'll play the prettiest games with you.

14.16 Franz Schubert, from *The Erlking*.

Many-colored flowers grow along the shore;
My mother has many golden garments."

"My father, my father, and don't you hear
The Erlking whispering promises to me?"
"Be quiet, stay quiet, my child;
The wind is rustling in the dead leaves."

"My handsome boy, will you come with me?
My daughters shall wait upon you;
My daughters lead off in the dance every night,
And cradle and dance and sing you to sleep."

"My father, my father, and don't you see there
The Erlking's daughters in the shadows?"
"My son, my son, I see it clearly;
The old willows look so gray."

"I love you, your beautiful figure delights me!
And if you are not willing, then I shall use force!"
"My father, my father, now he is taking hold of me!
The Erlking has hurt me!"

The father shudders, he rides swiftly on;
He holds in his arms the groaning child,
He reaches the courtyard weary and anxious:
In his arms the child was dead.

Translated by Philip L. Miller

Piano Works

The development of the art song depended in no small way on nineteenth-century improvements in piano design. The instrument for which Schubert wrote had a much warmer, richer tone than earlier pianos, and improvements in pedal technique made sustained tones possible and gave the instrument greater lyrical potential.

Such flexibility made the piano an excellent instrument for accompaniment, and, more importantly, made it an almost ideal solo instrument. As a result, new works arose solely for the piano, ranging from short, intimate pieces, similar to *Lieder*, to larger works designed to exhibit great virtuosity in performance. Franz Schubert wrote such pieces, as did Franz Liszt (frahnts lihst; 1811–86). Liszt, one of the most celebrated pianists of the nineteenth century, proved one of its most innovative composers. He enthralled audiences with his expressive, dramatic playing, and taught most of the major pianists of the next generation. He also influenced Richard Wagner and Richard Strauss. His piano works include six *Paganini Études* (1851), concertos, and twenty *Hungarian Rhapsodies* based on Hungarian urban

popular music rather than folk music. The technical demands of Liszt's compositions, and the rather florid way he performed them, gave rise to a **theatricality**, the primary purpose of which was to impress audiences with flashy presentation. This fitted well with the Romantic concept of the artist as hero.

The compositions of Frédéric Chopin (shoh-PAN; 1810–49) showed somewhat more restraint. Chopin wrote almost exclusively for the piano. Each of his études, or studies, explored a single technical problem, usually set around a single motif. More than simple exercises, these works explored the possibilities of the instrument and became short tone poems in their own right. A second group of compositions included short intimate works such as **preludes**, nocturnes, and impromptus, and dances such as waltzes, polonaises, and mazurkas. (Chopin was Polish but lived in France, and Polish folk music had a particularly strong influence on him.) A final class of larger works included scherzos, ballades, and fantasies. Many of Chopin's highly individual compositions stand without precedent. His style almost totally ignores standard form. His melodies are lyrical, and his moods vary.

Chopin's nocturnes, or night pieces, remain among his most celebrated works. His Nocturne in E flat major Op. 9, No. 2 (1833) illustrates the structure and style of this sort of mood piece well. It has a number of sections, with a main theme alternating with a second until both give way to a third. The piece has a complex AA'BA''BA'''CC' structure in *andante* tempo, a moderate, walking speed, and begins with the most important theme (Fig. **14.17**).

The melody rises very gracefully and lyrically over its supporting chords. The contours of the melody alternately use pitches close together and widely spaced. The theme states, then immediately repeats with ornamentation. The second theme begins in the dominant key of B flat major and returns to E flat for a more elaborate repeat of the first theme. The second theme restates, followed by an even more elaborate restatement of the first theme, leading to a dramatic climax in the home key. A third theme occurs and then repeats more elaborately in the tonic key. The work ends with a short cadenza, which builds through a crescendo and finishes pianissimo, very softly.

Program Music

One of the new ways in which Romantic composers structured their longer works was to build them around a non-musical story, a picture, or some other idea. We call music of this sort "descriptive." When the idea is quite specific and closely followed throughout the piece, we call the music "programmatic" or "program music."

14.17 Frédéric Chopin, Nocturne in E flat major, Op. 9, No. 2, first theme.

These techniques were not entirely new—we have already noted the descriptive elements in Beethoven's "Pastoral" Symphony—but the Romantics found them particularly attractive and employed them with great gusto. A nonmusical idea allowed composers to rid themselves of formal structure altogether. Of course, actual practice varied tremendously—some used programmatic material as their only structural device, while others subordinated a program idea to formal structure. Nevertheless, we know the Romantic period as the "age of program music." Among the best-known composers of program music were Hector Berlioz (BAIR-lee-ohz; 1803–69) and Richard Strauss (strows; 1864–1949).

Berlioz's *Symphonie Fantastique* (1830) employed a single motif, called an **idée fixe** (ee-DAY feex), to tie the five movements of the work together. The story behind the musical piece involves a hero who has poisoned himself because of unrequited love. However, the drug only sends him into semi-consciousness, in which he has visions. Throughout these visions the recurrent musical theme (the *idée fixe*) symbolizes his beloved. Movement 1 consists of "Reveries" and "Passions." Movement 2 represents "A Ball." "In the Country" is movement 3, in which he imagines a pastoral scene. In movement 4, "March to the Scaffold," (Fig. **14.18**) he dreams he has killed his beloved and is about to be executed. The *idée fixe* returns at the end of the movement, abruptly shattered by the fall of the axe. The final movement

14.18 Hector Berlioz, from the *Symphonie Fantastique*, fourth movement: A. "March to the Scaffold;" B. *idée fixe*.

describes a "Dream of a Witches' Sabbath" in grotesque and orgiastic musical imagery.

Not all program music depends for its interest upon an understanding of its text. Many people believe, however, that the tone poems, or symphonic poems, of Richard Strauss require an understanding of the story. His *Don Juan* (dohn whahn), *Till Eulenspiegel* (tihl oil-ehn-SHPEEG-ehl), and *Don Quixote* (dohn kee-HOH-tay) draw such detailed material from specific legends that program explanations and comments are integral to the works and help to give them coherence. In *Till Eulenspiegels lustige Streiche* (*Till Eulenspiegel's Merry Pranks*), Strauss tells the legendary German story of Till Eulenspiegel and his practical jokes. Strauss traces Till through three escapades, all musically identifiable. His critics then confront Till and, ultimately, execute him.

Symphonies

Beethoven's powerful symphonies strongly influenced nineteenth-century composers. Schubert, whom we just discussed as a composer of *Lieder*, wrote eight symphonies, one of which, the so-called "Unfinished" (B Minor) has a darkly Romantic style. Hector Berlioz's *Symphonie Fantastique* (see above) illustrated that a symphony could be written in an entirely different manner from Beethoven's. Felix Mendelssohn (MEN-dehl-suhn; 1809–47) followed classical tradition in most of his symphonies, but we should note that although composers followed classical form in many Romantic symphonies, they used the form more as a means to a Romantically expressive end and not for its own sake.

An outstanding example of the Romantic symphony, Brahms' (brahmz) Symphony No. 3 in F major (1883), in four movements, calls for pairs of flutes, oboes, clarinets, a bassoon, a contrabassoon, four horns, two trumpets, three trombones, two timpani, and strings—not an adventurous grouping of instruments for the period. Composed in sonata form, the first movement, *allegro con brio* (fast with spirit), begins in F major (Fig. **14.19**).

The exposition section closes with a return to the opening motif and meter, employing rising scales and arpeggios. Then, following classical tradition, the exposition repeats. The development section uses both the principal themes, with changes in tonal colors, dynamics, and modulation.

The recapitulation opens with a forceful restatement of the opening motif, followed by a restatement and further development of materials from the exposition. Then comes a lengthy coda, again announced by the opening motif, based on the first theme. A final, quiet, restatement of the opening motif and first phrase of the theme brings the first movement to an end.

Trends

The Romantic period also gave birth to new trends in music. The roots of such movements went deep into the past, but composers also wrote with the political circumstances of the century in mind. Folk tunes appear in these works as themes, as do local rhythms and harmonies. The exaltation of national identity stayed consistent with Romantic requirements, and it occurs in the music of nineteenth-century Russia, Bohemia, Spain, Britain, Scandinavia, Germany, and Austria.

Of all the composers of the Romantic period, the Russian Peter Ilyich Tchaikovsky (chy-KAWF-skee; 1840–93) has enjoyed the greatest popularity with his "1812 Overture" perhaps topping the list, followed closely by his *Nutcracker* ballet. In his First Symphony, he imitates the lyricism of Russian folk song, and the traits of the nineteenth-century Russian salon song followed in his Fifth and Sixth Symphonies.

The **symphonic poem**, an offshoot of the symphony proper, a term invented by Franz Liszt, describes a series of orchestral works he wrote which take their musical form and rhetoric from nonabstract ideas, some of them poetic and others visual. Other composers followed Liszt's lead, and the model proved especially popular in topics stemming from nationalistic sources, among them Smetana (SMET-ah-nah; *My Country*), Dvořák (DVOR-zhahk; *The Noonday Witch*), Borodin (bor-oh-DEEN; *In the Steppes of Central Asia*), Sibelius (sib-AYL-ee-us; *Tapiola*), and Elgar (EL-gahr; *Falstaff*).

Choral Music

Vocal music ranged from solo to massive ensemble works. Romantic composers found that the emotional requirements of the style, with diverse timbres and lyricism of the human voice, served them well. Almost every major composer of the era wrote some form of vocal music. Franz Schubert wrote Masses, the most notable of which is the Mass in A flat major. Felix Mendelssohn's *Elijah* stands beside Handel's *Messiah* and Haydn's *Creation* as a masterpiece of oratorio. Hector Berlioz marshaled full Romantic power for his *Requiem*, which called for 210 voices, a large orchestra, and four brass bands.

One of the most enduringly popular choral works of the Romantic period, Brahms' *Ein Deutsches Requiem* (*A German Requiem*) employs selected texts from the

14.19 Johannes Brahms, Symphony No. 3 in F major, opening motif of first movement.

PROFILE

JOHANNES BRAHMS (1833–97)

Although born into an impoverished family, Johannes Brahms appears to have had a relatively happy childhood. His father, an itinerant musician, eked out a meager living playing the horn and double bass in taverns and night clubs. The family lived in the slums of Hamburg, Germany, but despite their economic hardships, they retained close and loving family relationships. Early in life, Johannes showed evidence of considerable musical talent, and the eminent piano teacher Eduard Marxsen agreed to teach him without pay.

By age twenty, Brahms had gained acclaim as a pianist and accepted an invitation to participate in a concert tour with the Hungarian violinist Eduard Remenyi. The event, invaluable to the young Brahms, introduced him to Franz Liszt and Robert Schumann, and through Schumann's efforts Brahms published several of his compositions, which opened the door to the wider artistic world and launched his prolific career. Brahms gained experience as musical director at the little court of Detmold and as founder and director of a women's chorus in Hamburg, for which he wrote several choral works. His musical creativity showed a deep love of folk music and a sensitivity of expression. He mastered German *Lieder* (see p. 464) and remained devoted to the Romantic style throughout his career, notwithstanding his fondness for clarity of structure and form based in the classical style of the previous century.

Although Brahms wanted to stay in Hamburg, he was passed over for a position, and, feeling betrayed and neglected by his native town's rejection, he moved to Vienna. That city's rich musical ambience enriched his talent and experience, and he gained tremendous success, serving as director of the Vienna Singakademie and as conductor of the Society of Friends of Music. In 1875, he resigned his positions and spent the rest of his days in creative endeavors. For the next twenty-two years, he sacrificed his personal life in pursuit of his career, and the results gained him—in his own lifetime—recognition as one of the world's greatest artists.

Brahms' work spanned several idioms, from solo piano compositions and chamber music to full orchestral works and choral pieces, such as the renowned *German Requiem*, first performed in 1869. Never interested in music for the stage nor in program music, he reveled in symphonic compositions ruled by purely musical ideas (absolute music). See page 467 for a discussion of Brahms' Symphony No. 3 in F major.

14.20 Johannes Brahms in 1894.

Bible, in contrast with the Latin liturgy of traditional requiems, Brahms' work emerges not so much a Mass for the dead as a consolation for the living. Principally a choral work, it has minimal solos: two for baritone and one for soprano—but very expressive vocal and instrumental writing. Soaring melodic lines and rich harmonies weave thick textures. After the chorus sings "All mortal flesh is as the grass," the orchestra suggests fields of grass moving in the wind. The lyrical movement, "How lovely is thy dwelling place," soars with emotion.

Brahms' *Requiem* begins and ends with moving passages aimed directly at the living: "Blest are they that mourn." Hope and consolation underlie the entire work.

Brahms' choral music relies on lyricism and vocal beauty. The composer explored the voice as a human voice, and not as another instrument or some other mechanism unaffected by any restrictions, as other composers have done. He writes his parts and chooses his words so that no voice has to sing outside its natural range or technical capacity.

Opera

We can sum up the spirit and style of Romanticism in that perfect synthesis of all the arts, opera. Three countries, France (especially Paris), Italy, and Germany, dominated the development of opera.

Paris occupied an important position in Romantic opera during the first half of the nineteenth century. The spectacular quality of opera and the size of its auditoriums had made it an effective vehicle for propaganda during the Revolution, and as an art form, opera enjoyed great popular appeal among the rising and influential middle classes.

A new type of opera, called "grand opera," emerged early in the nineteenth century, principally through the efforts of Louis Veron, a businessman, the playwright Eugène Scribe (screeb), and Giacomo Meyerbeer (JAH-koh-moh MY-ur-bair), a composer. These three broke away from classical themes and subject matter and staged spectacular productions with crowd scenes, ballets, choruses, and fantastic scenery, written around medieval and contemporary themes. Meyerbeer (1791–1864), a German, studied Italian opera in Venice and produced French opera in Paris. *Robert the Devil* and *The Huguenots* typify Meyerbeer's extravagant style; they achieved great popular success, although the composer Schumann called *The Huguenots* "a conglomeration of monstrosities." Berlioz's *The Trojans*, written in the late 1850s, was more classically based and more musically controlled. At the same time, Jacques Offenbach (AW-fen-bahk; 1819–80) brought to the stage a lighter style, in which spoken dialogue mixed with the music. This type of opera, called *opéra comique*, has serious intent despite what the French word *comique* might suggest. A satirical and light form of opera, it uses vaudeville humor to satirize other operas, popular events, and so forth. In between the styles of Meyerbeer and Offenbach there occurred a third form of Romantic opera, lyric opera. Ambroise Thomas (1811–96) and Charles Gounod (goo-NOH; 1818–93) turned to Romantic drama and fantasy for their plots. Thomas's *Mignon* contains highly lyrical passages, and Gounod's *Faust*, based on Goethe's play, stresses melodic beauty.

Early Romantic opera in Italy featured the **bel canto** style, which emphasizes beauty of sound, and the works of Gioacchino Rossini (rohs-SEE-nee; 1792–1868) epitomize this feature. Rossini's *The Barber of Seville* takes melodic singing to new heights with light, ornamented, and highly appealing work, particularly for his soprano voices.

Great artists often stand apart from or astride general stylistic trends while they explore their own themes, as was the case with the Italian composer Giuseppe Verdi (VAIR-dee; 1813–1901). With Verdi, opera exploded as truly a human drama, expressed through simple, beautiful melody.

In what we might describe as typical of Romanticism, Verdi dared to make an operatic hero out of a hunchbacked court jester—Rigoletto—whose only redeeming quality seems to be his great love for his daughter, Gilda. Rigoletto's master, the licentious duke of Mantua, while posing as a poor student, wins Gilda's love. When the duke seduces the innocent girl, Rigoletto plots his death. Despite the seduction, Gilda loves the dissolute duke and ultimately gives her life to save his. Virtue does not triumph in this opera.

Act Three contains one of the most popular of all operatic arias, *La donna è mobile* ("Woman is fickle"; Fig. **14.21**):

Woman is fickle
Like a feather in the wind,
She changes her words
And her thoughts.
Always a lovable
And lovely face,
Weeping or laughing,
Is lying.
Woman is fickle, etc.
The man's always wretched
Who believes in her,
Who recklessly entrusts
His heart to her!
And yet no one who never
Drinks love on that breast
Ever feels
Entirely happy!
Woman is fickle, etc.

Late in his career, Verdi wrote works such as *Aïda* (1871), grand operas of spectacular proportions built upon tightly woven dramatic structures. Finally, in a third phase, he produced operas based on Shakespearean plays. *Otello* (1887) contrasts tragedy and *opera buffa*—comic opera, not *opéra comique*—and explores subtle balances among voices and orchestra, together with strong melodic development.

Richard Wagner (REEK-art VAHG-nuhr; 1813–83), one of the masters of Romantic opera, drew heavily on

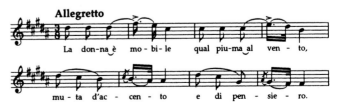

14.21 Giuseppe Verdi, *La donna è mobile*, from *Rigoletto* (1851).

German mythology. At the heart of Wagner's artistry lay a philosophy that has affected the stage from the mid-nineteenth century to the present day. He laid out his ideas principally in two books, *Art and Revolution* (1849) and *Opera and Drama* (1851). Wagner's philosophy centered on the *Gesamtkunstwerk* (geh-ZAMT-koonst-VAIRK), a comprehensive work of art in which music, poetry, and scenery play subservient roles to the central generating idea. For Wagner, the total unity of all elements remained supremely important. In line with German Romantic philosophy, which gives music supremacy over the other arts, music has the predominant role in Wagner's operas. Dramatic meaning unfolds through the **Leitmotif**, for which Wagner is famous, although he did not invent it. A *Leitmotif* (LYT-moh-TEEF) is a musical theme tied to an idea, a person, or an object. Whenever that idea, person, or object appears on stage or comes to mind in the action, we hear that theme. Juxtaposing *Leitmotifs* gives the audience an idea of relationships between their subjects. *Leitmotifs* also give the composer building blocks to use for development, recapitulation, and unification.

Each of Wagner's magnificent operas deserves detailed attention. Anything we might say here by way of description or analysis would be insignificant compared to the dramatic power these works exhibit in full production. Even recordings cannot approach the tremendous effect of these works when experienced on stage in an opera house.

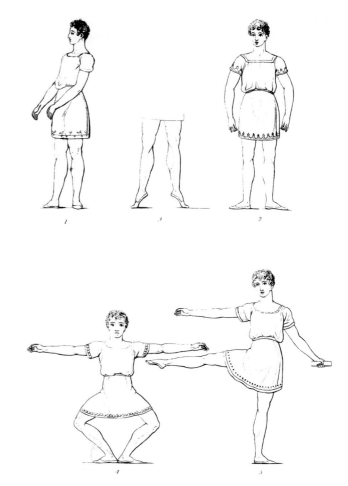

14.22 Illustrations from *The Art of Dancing*, 1820, by Carlo Blasis. The New York Public Library.

Dance

In a totally unrehearsed move, a ballerina leaped from the tomb on which she posed and narrowly escaped a piece of falling scenery. This and other disasters plagued the opening night performance of Meyerbeer's *Robert the Devil* in 1831. The novelty of tenors falling into trapdoors, and falling stagelights and scenery, however, was eclipsed by the startling novelty of the choreography for this opera. Romantic ballet stood at hand. To varying degrees, all the arts turned against the often cold formality of classicism and neoclassicism. The subjective (not the objective) viewpoint and feeling (rather than reason) sought release.

Two sources help us to understand the Romantic ballet, the writings of Théophile Gautier (tay-oh-FEEL goh-tee-AY) and Carlo Blasis (BLAH-zees). Gautier (1811–72), a poet and critic, held first of all that beauty was truth, a central Romantic conception. Gautier believed that dance acted as visual stimulation to show "beautiful forms in graceful attitudes." Dancing for Gautier created a living painting or sculpture—"physical pleasure and feminine beauty." This exclusive focus on

ballerinas placed sensual enjoyment and eroticism squarely at the center of his aesthetics. Gautier had significant influence and it accounted for the central role of the ballerina in Romantic ballet. Male dancers were relegated to the background, strength being the only grace permissible to them.

The second general premise for Romantic ballet came from *Code of Terpsichore* (tuhrp-SIHK-kuh-ree) by Carlo Blasis (1803–78). Blasis, a former dancer and more systematic and specific than Gautier, held principles covering training, structure, and positioning. Everything in the ballet required a beginning, a middle, and an ending. The basic "attitude" in dance, modeled on Bologna's statue of *Mercury* (see Fig. **10.24**), comprised standing on one leg with the other brought up behind at a 90-degree angle with the knee bent. The dancer needed to display the human figure with taste and elegance. If the dancer trained each part of the body, the result would be grace without affectation. From Blasis comes the turned-out position, still fundamental to ballet today (Fig. **14.22**). These broad principles provided the framework, and, to a great extent, a summary, of objectives for

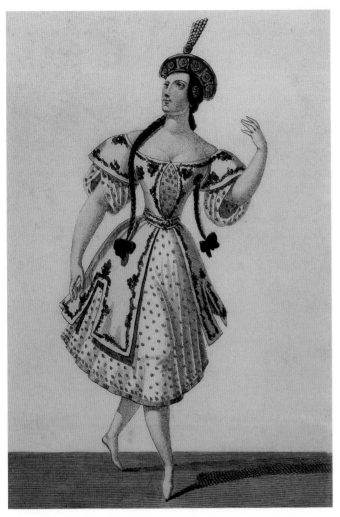

14.23 Marie Taglioni (1804–84). Engraving, 1834. The New York Public Library.

Romantic ballet: delicate ballerinas, lightly poised, costumed in soft tulle, and moving *en pointe*, with elegant grace.

The first truly Romantic ballet, *Robert the Devil* told the story of Duke Robert of Normandy, his love for a princess, and an encounter with the devil. The ballet contains ghosts, bacchanalian dancing, and a spectral figure who was danced by Marie Taglioni (tahl-ee-OHN-ee; Fig. **14.23**).

Taglioni went on to star in perhaps the most famous of all Romantic ballets, *La Sylphide* (lah sihl-FEED; 1832). Here the plot centered on the tragic impossibility of love between a mortal and a supernatural being. A spirit of the air, a sylph, falls in love with a young Scot on his wedding day. Torn between his real fiancée and his ideal, the sylph, he deserts his fiancée to run off with the spirit. A witch gives him a scarf, and, unaware of its enchantment, he ties it around the spirit's waist. Immediately her wings fall off and she dies. She drifts away to sylphs' heaven. The young man, disconsolate and alone, sees his fiancée passing in the distance with a new lover on the way to her wedding. The Scottish setting was exotic, at least to Parisians. Gaslight provided a ghostly, moonlit mood in the darkened auditorium. Taglioni danced the role of La Sylphide like "a creature of mist drifting over the stage" (assisted by flying machinery). Her lightness, delicacy, and modest grace established the standard for Romantic style in dancing. The story, exotic design, and mood-evoking lighting completed the production style, a style that prevailed for the next forty years—"moonbeams and gossamer," as some have described it.

Choreographers of Romantic ballet sought magic and escape in fantasies and legends. Ballets about elves and nymphs enjoyed great popularity, as did ballets about madness, sleepwalking, and opium dreams. Unusual subject matter came to the fore. For example, harem wives revolt against their oppressors with the help of the "Spirit of Womankind" in Filippo Taglioni's *The Revolt in the Harem*, possibly the first ballet about the emancipation of women. Women appeared not only as performers and as subjects of the dance, however. They also began to come to prominence as choreographers.

The ballet *Giselle* (zhee-ZEL; 1841) marks the height of Romantic achievement. With its many fine dancing roles, both for women and for men, it has been a favorite of ballet companies since its first production.

The ballet has two acts; Act I is in sunlight, and Act II in moonlight. During a vine festival in a Rhineland village, Giselle, a frail peasant girl in love with a mysterious young man, discovers that the object of her affection is Albrecht, Count of Silesia. Albrecht is already engaged to a noblewoman. Giselle is shattered. She goes mad, turns from her deceitful lover, tries to commit suicide, swoons, and falls dead. In Act II, Giselle is summoned from her grave, deep in the forest, by Myrthe (MUHR-te), Queen of the Wilis (VIHL-ihs), spirits of women who, having died unhappy in love, are condemned to lead men to destruction. (The word *wili* comes from a Slavic word for "vampire.") When a repentant Albrecht comes to bring flowers to Giselle's grave, Myrthe orders her to dance him to his death. Instead, Giselle protects Albrecht until the first rays of dawn break Myrthe's power.

In St Petersburg, Russia, in 1862, an English ballet called the *Daughter of Pharaoh*, choreographed by Marius Petipa (mahr-ee-OOS peh-tee-PAH), sent Russian audiences into rapture. Petipa had come to Russia from France in 1842, and he remained a central figure in Russian ballet for almost sixty years. By the middle of the nineteenth century, ballet companies flourished in Moscow and St Petersburg. Dancers enjoyed positions of high esteem in Russia, in sharp contrast to their situation in the rest of Europe.

In Russia, the influence of Petipa carried Russian ballet forward in a quasi-Romantic style. He shared the sentimental taste of his time, but his works often contained very strange elements and numerous anachronisms. Minor characters might wear costumes suggesting period or locale, but the stars wore conventional garb, often of classical derivation. Prima ballerinas often appeared in stylish contemporary coiffures and jewels, even when playing the role of a slave. *Divertissements* (dee-vair-TEES-mawn)—light entertainments—were often inserted into a ballet. Petipa included many different kinds of dance in his ballets—classical, character, and folk dance. His creative approach more than compensated for his anachronisms. As some have said in his defense, "No one criticized Shakespeare for having Antony and Cleopatra speak in blank verse."

From this Russian school came the ever-popular *Nutcracker* and *Swan Lake*, the scores for both composed by Tchaikovsky. *Swan Lake* first appeared in 1877 by the Moscow Bolshoi (BOHL-shoy or buhl-SHOY) and *Nutcracker* in 1892. *Swan Lake* popularized the *fouetté* (foo-eh-TAY), or whipping turn, introduced by the ballerina Pierina Legnani in Petipa's *Cinderella* and incorporated for her in *Swan Lake*. In one scene, Legnani danced thirty-two consecutive *fouettés*, and to this day that number remains mandatory.

Literature

Romanticism in Europe

In literature, we recall that Romanticism as a fully developed style had related developments in the late eighteenth century that we called pre-Romanticism (see Chapter 13). In English literature, Romanticism proper began in the late 1790s with the publication of William Wordsworth and Samuel Coleridges's *Lyrical Ballads*. In Wordsworth's "Preface" to the second edition (1800), he described poetry as "the spontaneous overflow of powerful feelings." This sentiment underscored the English Romantic movement in poetry.

William Wordsworth (1770–1850) saw transcendental and often indefinable significance in commonplace and everyday things. His worship of nature and the harmony he felt existed between people and nature led him to create a new and individual world of Romantic beauty.

In 1795 he met Samuel Taylor Coleridge (1772–1834), another British poet, and in working with Coleridge, Wordsworth found that his life and writing suddenly opened up. Out of this relationship came the Lyrical Ballads, which Wordsworth published anonymously along with four poems by Coleridge. Among these ballads, *Tintern Abbey* describes

Wordsworth's love of nature most explicitly. That love first emerges as the animal passion of a wild young boy, then as a restorative and moral influence, and finally as a mystical communion with an eternal truth.

Lines Composed a Few Miles above Tintern Abbey
(excerpt)
William Wordsworth

Five years have passed; five summers, with the length
Of five long winters! and again I hear
These waters, rolling from their mountain-springs
With a sweet inland murmur.—Once again
Do I behold these steep and lofty cliffs,
Which on a wild secluded scene impress
Thoughts of more deep seclusion; and connect
The landscape with the quiet of the sky.
The day is come when I again repose
Here, under this dark sycamore, and view
These plots of cottage-ground, these orchard-tufts,
Which, at this season, with their unripe fruits,
Are clad in one green hue, and lose themselves
Mid groves and copses. Once again I see
These hedge-rows, hardly hedge-rows, little lines
Of sportive wood run wild; these pastoral farms
Green to the very door; and wreathes of smoke
Sent up, in silence, from among the trees,
With some uncertain notice, as might seem,
Of vagrant dwellers in the houseless woods,
Or of some hermit's cave, where by his fire
The hermit sits alone.

Samuel Taylor Coleridge, who characterized aesthetic experience as the "willing suspension of disbelief," had planned to set up a utopian society on the banks of the Susquehanna River in Pennsylvania, in the United States. That never came to pass. Coleridge early set about developing a new, informal mode in poetry that used a conversational tone and rhythm to unify a work. We remember him best, perhaps by his poem, *The Rime of the Ancient Mariner*, a seven-part work that appeared in *Lyrical Ballads*. Another poem included in that volume, *Frost at Midnight* uses Coleridge's pioneering, new informal mode with its conversational tone and rhythm to achieve unity. He composed the four-stanza poem in the winter of 1798 while in the presence of his sleeping son, Hartley. The soliloquy starts with a description of a silent frosty night and advances into a meditation on the relationship between the quiet development of frost and the soft breathing of his sleeping son. The poem concludes with Coleridge's resolve to raise the boy as a "child of nature," and reinforce during the child's education the sympathies the poet has detected.

Frost at Midnight
Samuel Taylor Coleridge

The Frost performs its secret ministry,
Unhelped by any wind. The owlet's cry

Came loud—and hark, again! loud as before.
The inmates of my cottage, all at rest,
Have left me to that solitude, which suits
Abstruser musings: save that at my side
My cradled infant slumbers peacefully.
'Tis calm indeed! so calm, that it disturbs
And vexes meditation with its strange
And extreme silentness. Sea, hill, and wood,
This populous village! Sea, and hill, and wood,
With all the numberless goings-on of life,
Inaudible as dreams! the thin blue flame
Lies on my low-burnt fire, and quivers not;
Only that film, which fluttered on the grate,
Still flutters there, the sole unquiet thing.
Methinks, its motion in this hush of nature
Gives it dim sympathies with me who live,
Making it a companionable form,
Whose puny flaps and freaks the idling Spirit
By its own moods interprets, every where
Echo or mirror seeking of itself,
And makes a toy of Thought.

 But O! how oft,
How oft, at school, with most believing mind,
Presageful, have I gazed upon the bars,
To watch that fluttering *stranger*! and as oft
With unclosed lids, already had I dreamt
Of my sweet birth-place, and the old church-tower,
Whose bells, the poor man's only music, rang
From morn to evening, all the hot Fair-day,
So sweetly, that they stirred and haunted me
With a wild pleasure, falling on mine ear
Most like articulate sounds of things to come!
So gazed I, till the soothing things, I dreamt,
Lulled me to sleep, and sleep prolonged my dreams!
And so I brooded all the following morn,
Awed by the stern preceptor's face, mine eye
Fixed with mock study on my swimming book:
Save if the door half opened, and I snatched
A hasty glance, and still my heart leaped up,
For still I hoped to see the *stranger's* face,
Townsman, or aunt, or sister more beloved,
My play-mate when we both were clothed alike!

 Dear Babe, that sleepest cradled by my side,
Whose gentle breathings, heard in this deep calm,
Fill up the interspersèd vacancies
And momentary pauses of the thought!
My babe so beautiful! it thrills my heart
With tender gladness, thus to look at thee,
And think that thou shalt learn far other lore,
And in far other scenes! For I was reared
In the great city, pent 'mid cloisters dim,
And saw nought lovely but the sky and stars.
But *thou*, my babe! shalt wander like a breeze
By lakes and sandy shores, beneath the crags
Of ancient mountain, and beneath the clouds,
Which image in their bulk both lakes and shores
And mountain crags: so shalt thou see and hear
The lovely shapes and sounds intelligible

Of that eternal language, which thy God
Utters, who from eternity doth teach
Himself in all, and all things in himself.
Great universal Teacher! he shall mould
Thy spirit, and by giving make it ask.

 Therefore all seasons shall be sweet to thee,
Whether the summer clothe the general earth
With greenness, or the redbreast sit and sing
Betwixt the tufts of snow on the bare branch
Of mossy apple-tree, while the nigh thatch
Smokes in the sun-thaw; whether the eave-drops fall
Heard only in the trances of the blast,
Or if the secret ministry of frost
Shall hang them up in silent icicles,
 Quietly shining to the quiet Moon.

William Blake (1757–1827) was the third principal poet of Romanticism's early phase in England. Not only a poet, but also a painter, engraver, and visionary mystic, Blake hand-illustrated a series of lyrical and epic poems that comprise, arguably, one of the most original bodies of artistic work in the Western cultural tradition. Blake developed an etching technique called "illustrated printing," in which each page of the book appeared in monochrome from a plate containing both text and illustration. Although largely ignored during his lifetime, Blake now enjoys the reputation of one of the earliest and best figures of Romanticism (see Fig. **14.1**). His *Songs of Innocence and of Experience* (Fig. **14.24**) provide us with masterpieces of lyric poetry and illustration. The designs and poetry contain rhythmic subtlety and delicate beauty that combine on the page to create a deep harmony of word and image.

14.24 William Blake, "The Blossom," from *Songs of Innocence and Experience*, 1789. Relief etching with watercolor on paper. Yale Center for British Art.

MASTERWORK

AUSTEN—*PRIDE AND PREJUDICE*

Pride and Prejudice (1813) contains little of the satire of works of the same period, but an ironic and sympathetic view of human nature and its propensity for comic incongruity. The narrative, which Austen originally titled "First Impressions," describes the clash between Elizabeth Bennet, the daughter of a country gentleman, and Fitzwilliam Darcy, a rich and aristocratic landowner. Austen reverses the convention of first impressions: "pride" of rank and fortune, and "prejudice" against Elizabeth's inferiority of family, hold Darcy aloof; while Elizabeth is equally fired both by the pride of self-respect and by prejudice against Darcy's snobbery. Ultimately they come together in love and self-understanding.

In the story, as summarized in *The Bloomsbury Guide to English Literature* (Prentice Hall, 1990), Mr and Mrs Bennet belong to the minor gentry and live at Longbourn, near London. Mr Bennet is witty and intelligent, and bored with his foolish wife. They have five daughters, whose marriage prospects are Mrs Bennet's chief interest in life, since the estate is "entailed"—i.e. by the law of the period it will go on Mr Bennet's death to his nearest male relation, a sycophantic clergyman called Mr Collins. The main part of the story is concerned with the relationship between the witty and attractive Elizabeth Bennet and the haughty and fastidious Fitzwilliam Darcy, who at first considers her beneath his notice and later, on coming to the point of asking her to marry him, finds that she is resolutely prejudiced against him.

Elizabeth is subjected to an insolent offer of marriage by Mr Collins and the arrogant condescension of his patroness, Lady Catherine de Bourgh, Darcy's aunt. In the end, chastened by finding in one another a fastidiousness and pride that equal their own and despite a family scandal, they are united.

The central comedy of *Pride and Prejudice* lies in the fully developed character that reveals a sense of human realities and values. For example, in the character of Mr Bennet, Austen makes a symbolic comment on intelligence that exists without will or drive. In her two opposing protagonists, Darcy and Elizabeth, who reflect the title of the book, Austen reveals character overlaid with class superciliousness and character abounding in independence and sharpness of mind that acts with prejudgment, wrongheadedness, and self-satisfaction. In all situations, the author remains detached, witty, and good-humored. The disturbances that upset things in the worlds Austen creates are, in sum, minor intrusions in an unshakable moral universe in which one can point out an entire range of human frailties and yet not despair.

Jane Austen (1775–1817) lived and worked in the high years of the major English Romantics, but she shunned the Romantic cult of personality and remained largely indifferent to Romantic literature. She looked back to neoclassicism and the comedy of manners as her sources, and her work portrays middle-class people living in provincial towns and going about the daily routine of family life—a life of good breeding, wit, and a reasonable hope that difficulties can be resolved in a satisfactory manner. She occasionally portrayed disappointments in love and threatened or actual seduction, but, somehow, these seem less important than the ongoing and routine conversations and rituals of daily life. Merely because she portrayed a quiet form of life does not mean, however, that her characters lack depth or interest. She explored human experience deeply and with humor. She proved that one does not require spectacular events in order to provide engaging art.

Her early years produced a variety of works that parody the sentimental and romantic clichés of popular fiction. In her second period of writing, from 1810 on, she crowned her career with works such as *Emma* (1815), *Persuasion* (1818), and *Mansfield Park* (1813). *Emma* shows Austen's ability to remain detached from her heroine, Emma Woodhouse, who represents self-deception, as she misreads evidence, misleads others, and discovers her own feelings only by accident. In her other works, Austen portrayed many gentle and self-effacing characters in the mode of her earlier masterpiece *Pride and Prejudice* (1813).

The *Sturm und Drang*, pre-Romantic movement in Germany led to an early Romantic style characterized by innovation in content and a preoccupation with mysticism, the subconscious, and the supernatural. In France, the movement's early phase witnessed influential historical and theoretical writings. By the year 1805 and

continuing into the 1830s, a second phase of Romantic literature arose characterized by nationalism. This produced an outpouring of work emulating native folklore, folk ballads and poetry, folk dance, and music, as well as a return to medieval and Renaissance themes. Out of this direction came the historically imaginative works of Sir Walter Scott (1771–1832), considered the inventor of the historical novel. He also wrote full-length narrative poems such as *The Lay of the Last Minstrel* (1805) and *The Lady of the Lake* (1810). We probably remember him best, however, for his novel of English history, *Ivanhoe* (1819), a romance dealing with the life of the fictional, chivalrous, Saxon knight, Sir Wilfred of Ivanhoe.

At the same time, English Romantic poetry achieved a high point in the works of Lord Byron, John Keats, and Percy Bysshe Shelley. George Gordon, Lord Byron (1788–1824) led a colorful and dramatic private life, supported the nationalist aspirations of the Greeks, and produced masterful, energetic verse. *Don Juan* (1819–24; dahn JOO-uhn), his greatest poem, rambles with rich irony through human frailties. The epic poem uses *ottava rima* (an Italian form composed of eight 11-syllable lines, rhyming ABABABCC) in sixteen cantos—a seventeenth remained unfinished. The poet uses the rhyme scheme to express different moods. The poem comprises a comic tale of the charming Don Juan, whom we follow through adventures with women, war, pirates, and politics in a timeless struggle between nature and civilization. Byron's hero, a "natural man," has instincts toward love and life constantly frustrated by brutality, hypocrisy, and conventionality.

Percy Bysshe Shelley (1792–1822) wrote in a more meditative and lyrical vein, with the passions of Romanticism never far below the surface. His poems reflect his passionate search for personal love and social justice. His works represent some of the greatest writing in the English language. Shelley married Mary Wollstonecraft Godwin, daughter of Mary Wollstonecraft (p. 442). Mary Wollstonecraft Shelley earned her own fame as a Romantic writer with her novel *Frankenstein* (1818). Percy's works include "Ode to the West Wind" which invokes the spirit of the West Wind, "Destroyer and Preserver," through passionate language and symbolic imagery. The ode introduced a new form of stanza, consisting of five sonnets, each of which has four units of three lines each.

John Keats (1795–1821) devoted his life to perfecting poetry characterized by vivid imagery, sensuous appeal, and expression of philosophy through classical legend. We remember him for poems such as "Ode on a Grecian Urn" and "Ode to a Nightingale," which comprise essentially lyric meditations on an object or quality that prompts the poet to confront the conflicting impulses of his inner being and of the wider world around him.

Ode on a Grecian Urn
John Keats

Thou still unravish'd bride of quietness,
 Thou foster-child of silence and slow time,
Sylvan historian, who canst thus express
 A flowery tale more sweetly than our rhyme:
What leaf-fring'd legend haunts about thy shape
 Of deities or mortals, or of both,
 In Tempe or the dales of Arcady?
 What men or gods are these? What maidens loth?
What mad pursuit? What struggle to escape?
 What pipes and timbrels? What wild ecstasy?

Heard melodies are sweet, but those unheard
 Are sweeter; therefore, ye soft pipes, play on;
Not to the sensual ear, but, more endear'd,
 Pipe to the spirit ditties of no tone:
Fair youth, beneath the trees, thou canst not leave
 Thy song, nor ever can those trees be bare;
 Bold Lover, never, never canst thou kiss,
Though winning near the goal—yet, do not grieve;
 She cannot fade, though thou hast not thy bliss,
 For ever wilt thou love, and she be fair!

Ah, happy, happy boughs! that cannot shed
 Your leaves, nor ever bid the Spring adieu;
And, happy melodist, unwearied,
 For ever piping songs for ever new;
More happy love! more happy, happy love!
 For ever warm and still to be enjoy'd,
 For ever panting, and for ever young;
All breathing human passion far above,
 That leaves a heart high-sorrowful and cloy'd,
 A burning forehead, and a parching tongue.

Who are these coming to the sacrifice?
 To what green altar, O mysterious priest,
Lead'st thou that heifer lowing at the skies,
 And all her silken flanks with garlands drest?
What little town by river or sea shore,
 Or mountain-built with peaceful citadel,
 Is emptied of this folk, this pious morn?
And, little town, thy streets for evermore
 Will silent be; and not a soul to tell
 Why thou art desolate, can e'er return.

O Attic shape! Fair attitude! with brede
 Of marble men and maidens overwrought,
With forest branches and the trodden weed;
 Thou, silent form, dost tease us out of thought
As doth eternity: Cold Pastoral!
 When old age shall this generation waste,
 Thou shalt remain, in midst of other woe
Than ours, a friend to man, to whom thou say'st,
 "Beauty is truth, truth beauty,"—that is all
 Ye know on earth, and all ye need to know.

Emily Brontë (BRAHN-tee; 1818–48) wrote the stormily Romantic *Wuthering Heights*, while her sister Charlotte (1816–55) produced the more sophisticated

Jane Eyre. New possibilities for the novel opened through the pen of the French writer Honoré de Balzac (aw-naw-RAY duh bahl-ZAHK; 1799–1850), whose great cycle of novels, part of his projected and only partially completed *Comédie humaine*, sought to survey contemporary society from the palace to the gutter. The heroes and heroines of Balzac's works represent people whose experiences reveal how society really works. In that respect, Balzac emerges as a forerunner of realism in literature, a style we examine in the next chapter.

Charles Dickens (1812–70) had a similar aim in his novels. The best of them, such as *Bleak House*, deliver up a cross-section of the teeming society of Victorian England. His best-known works, of course, include *A Tale of Two Cities*, *Oliver Twist*, and *A Christmas Carol*. Dickens wrote dazzlingly ingenious and entertaining plots, and through this complexity he captures the interdependence of rich and poor and the endless ramifications of every individual act.

Charles Baudelaire (bohd-LAIR; 1821–67) pursued the Romantic interest in the morbid, the pathological, and the bizarre. His first cycle of love poems, "Black Venus," ranks among the best erotic poems in the French language, all of which found their way into his sole collection of poetry, *Les Fleurs du mal* (*Flowers of Evil*). The work comprises six sections, each of which has a theme. They shift in style from rhetorical to impressionistic, from abstract to intensely physical. Baudelaire's poems run the gamut from banality to originality, prosaic to melodic, and in so doing emphasize his view of the interdependence of opposites.

American Renaissance

The Romantic movement gave rise to a period in American literature called the American Renaissance. It reflected a nationalistic spirit and lasted from the 1830s until the end of the Civil War in 1865. In the vanguard of this movement, the writers Henry Wadsworth Longfellow, Oliver Wendell Holmes, and James Russell Lowell, all aristocrats called Brahmins, sought to create an American literary tradition based on European models. Henry Wadsworth Longfellow (1807–82) taught at Harvard (as did Holmes and Lowell) and adapted European methods of storytelling. His poem, "Paul Revere's Ride," an American favorite since its inception, collected in Longfellow's *Tales of a Wayside Inn* (1861), uses anapestic tetrameter to suggest the galloping of a horse. The narrator, the landlord of an inn, remembers the famous "midnight ride" of Paul Revere, who warns the Americans of the impending British invasion of the Revolutionary War. Although historically inaccurate, the poem established the legend of Paul Revere in the American consciousness.

The American Renaissance showed strong influences of transcendentalism, a New England movement that numbered among its members Ralph Waldo Emerson and Henry David Thoreau. These writers, among others, helped to establish a new national culture based on native elements, from which they argued for reforms in church, state, and society, out of which rose the abolition movement and various utopian communities. The abolition movement included Harriet Beecher Stowe, whose work we examined in the Theatre section. The transcendentalists shared an idealistic mindset based on a belief in the essential unity of all creation, the fundamental goodness of humanity, and the supremacy of insight over logic and experience for the revelation of the most profound truths. Samuel Taylor Coleridge was particularly influential on this movement.

Apart from the transcendentalists, the American Renaissance also gave rise to several imaginative writers including Nathaniel Hawthorne, Herman Melville, and Walt Whitman. Outside the New England circle of writers, Edgar Allan Poe also proved influential and important. Nathaniel Hawthorne (1804–64), a novelist and short-story writer, rose strongly as a master of the allegorical and symbolic tale. *The Scarlet Letter* (1850) provides us with a classical moral study of Hester Prynne, a young woman who has given birth to an illegitimate child and been forced to wear the scarlet letter A on her dress as a punishment for her adultery. Herman Melville (1819–91) wrote novels of the sea, among which number his best-known work, *Moby Dick* (1851). Walt Whitman (1819–92) revolutionized American literature with *Leaves of Grass* (1855), a collection of poems that utilized unconventional language and subjects that caused suppression of the book on grounds of indecency. Edgar Allan Poe (1809–49), a poet, critic, and short-story writer gained fame for his cultivation of mystery and the macabre in fiction. His poem "The Raven" brought him great fame on its publication in 1845. His writing contains an interesting duality that swings from idealism and vision, with a sensitivity to women, to escapism in the form of macabre thoughts, impulses, and fears. His titles read like a who's who of nerve-wracking wickedness and anguish hovering on the edge of death: *The Fall of the House of Usher*, *The Masque of the Red Death*, *The Tell-Tale Heart*, and *The Pit and the Pendulum*.

The Raven
Edgar Allan Poe

Once upon a midnight dreary, while I pondered, weak and
 weary,
Over many a quaint and curious volume of forgotten lore,
While I nodded, nearly napping, suddenly there came a
 tapping,

As of some one gently rapping, rapping at my chamber
 door.
"'Tis some visitor," I muttered, "tapping at my chamber
 door—
 Only this, and nothing more."

Ah, distinctly I remember it was in the bleak December,
And each separate dying ember wrought its ghost upon the
 floor.
Eagerly I wished the morrow;—vainly I had sought to
 borrow
From my books surcease of sorrow—sorrow for the lost
 Lenore—
For the rare and radiant maiden whom the angels name
 Lenore—
 Nameless here for evermore.

And the silken sad uncertain rustling of each purple curtain
Thrilled me—filled me with fantastic terrors never felt
 before;
So that now, to still the beating of my heart, I stood
 repeating,
"'Tis some visitor entreating entrance at my chamber
 door—
Some late visitor entreating entrance at my chamber
 door;—
 This it is, and nothing more."

Presently my soul grew stronger; hesitating then no longer,
"Sir," said I, "or Madam, truly your forgiveness I implore;
But the fact is I was napping, and so gently you came
 rapping,
And so faintly you came tapping, tapping at my chamber
 door,
That I scarce was sure I heard you"—here I opened wide
 the door;—
 Darkness there, and nothing more.

Deep into that darkness peering, long I stood there
 wondering, fearing,
Doubting, dreaming dreams no mortals ever dared to
 dream before;
But the silence was unbroken, and the stillness gave no
 token,
And the only word there spoken was the whispered word,
 "Lenore!"
This I whispered, and an echo murmured back the word,
 "Lenore!"—
 Merely this, and nothing more.

Back into the chamber turning, all my soul within me
 burning,
Soon again I heard a tapping somewhat louder than before.
"Surely," said I, "surely that is something at my window
 lattice:
Let me see, then, what thereat is, and this mystery
 explore—
Let my heart be still a moment and this mystery explore;—
 'Tis the wind and nothing more."

Open here I flung the shutter, when, with many a flirt and
 flutter,

In there stepped a stately raven of the saintly days of yore;
Not the least obeisance made he; not a minute stopped or
 stayed he;
But, with mien of lord or lady, perched above my chamber
 door—
Perched upon a bust of Pallas just above my chamber door—
 Perched, and sat, and nothing more.

Then this ebony bird beguiling my sad fancy into smiling,
By the grave and stern decorum of the countenance it wore.
"Though thy crest be shorn and shaven, thou," I said, "art
 sure no craven,
Ghastly grim and ancient raven wandering from the Nightly
 shore—
Tell me what thy lordly name is on the Night's Plutonian
 shore!"
 Quoth the Raven, "Nevermore."

Much I marvelled this ungainly fowl to hear discourse so
 plainly,
Though its answer little meaning—little relevancy bore;
For we cannot help agreeing that no living human being
Ever yet was blest with seeing bird above his chamber
 door—
Bird or beast upon the sculptured bust above his chamber
 door,
 With such name as "Nevermore."

But the raven, sitting lonely on the placid bust, spoke only
That one word, as if his soul in that one word he did
 outpour.
Nothing further then he uttered—not a feather then he
 fluttered—
Till I scarcely more than muttered, "other friends have
 flown before—
On the morrow he will leave me, as my hopes have flown
 before."
 Then the bird said, "Nevermore."

Startled at the stillness broken by reply so aptly spoken,
"Doubtless," said I, "what it utters is its only stock and
 store,
Caught from some unhappy master whom unmerciful
 Disaster
Followed fast and followed faster till his songs one burden
 bore—
Till the dirges of his Hope that melancholy burden bore
 Of 'Never—nevermore'."

But the Raven still beguiling all my fancy into smiling,
Straight I wheeled a cushioned seat in front of bird, and
 bust and door;
Then upon the velvet sinking, I betook myself to linking
Fancy unto fancy, thinking what this ominous bird of
 yore—
What this grim, ungainly, ghastly, gaunt and ominous bird
 of yore
 Meant in croaking "Nevermore."

This I sat engaged in guessing, but no syllable expressing
To the fowl whose fiery eyes now burned into my bosom's
 core;

This and more I sat divining, with my head at ease reclining
On the cushion's velvet lining that the lamplight gloated o'er,
But whose velvet violet lining with the lamplight gloating o'er,
She shall press, ah, nevermore!

Then methought the air grew denser, perfumed from an unseen censer
Swung by Seraphim whose footfalls tinkled on the tufted floor.
"Wretch," I cried, "thy God hath lent thee—by these angels he hath sent thee
Respite—respite and nepenthe, from thy memories of Lenore!
Quaff, oh quaff this kind nepenthe and forget this lost Lenore!"
Quoth the Raven, "Nevermore."

Prophet!" said I, "thing of evil!—prophet still, if bird or devil!—
Whether Tempter sent, or whether tempest tossed thee here ashore,
Desolate yet all undaunted, on this desert land enchanted—
On this home by horror haunted—tell me truly, I implore—
Is there—is there balm in Gilead?—tell me—tell me, I implore!"
Quoth the Raven, "Nevermore."

"Prophet!" said I, "thing of evil—prophet still, if bird or devil!
By that Heaven that bends above us—by that God we both adore—
Tell this soul with sorrow laden if, within the distant Aidenn,
It shall clasp a sainted maiden whom the angels name Lenore—
Clasp a rare and radiant maiden whom the angels name Lenore."
Quoth the Raven, "Nevermore."

"Be that word our sign in parting, bird or fiend," I shrieked, upstarting—
"Get thee back into the tempest and the Night's Plutonian shore!
Leave no black plume as a token of that lie thy soul hath spoken!
Leave my loneliness unbroken!—quit the bust above my door!
Take thy beak from out my heart, and take thy form from off my door!"
Quoth the Raven, "Nevermore."

And the Raven, never flitting, still is sitting, still is sitting
On the pallid bust of Pallas just above my chamber door;
And his eyes have all the seeming of a demon's that is dreaming,
And the lamplight o'er him streaming throws his shadow on the floor;
And my soul from out that shadow that lies floating on the floor
Shall be lifted—nevermore!

Emily Dickinson (1830–86) wrote poetry in a distinctive voice that appeared strange to her contemporaries, but gradually won the hearts of lovers of poetry everywhere. She lived a withdrawn life, thinking about success and fame, but having to settle for "fame of my mind." Observations by Lesli Camhi indicate that "The Puritan sense of spiritual mystery inhabiting the circumstances of everyday life informs her minute observations of nature. Her meter is adapted from eighteenth-century hymns."[2] She wrote intensely personal poems from an uncommon perspective, typically asking us to see the world from a different angle—perhaps to see something common as if we had not seen it before. Her poetic philosophy emerges in "Tell all the Truth but tell it slant" in which she describes truth as a "superb surprise," too bright and dazzling for us to absorb—we must find it in a roundabout way, allowing it to dazzle and delight us "gradually." Thus, to tell the truth, we must "slant" it so that we approach it not directly on, but from a slanted, non-threatening angle.

Tell all the Truth but tell it slant
Emily Dickinson

Tell all the Truth but tell it slant—
Success in circuit lies
Too bright for our infirm Delight
The Truth's superb surprise

As Lightning to the Children eased
With explanation kind
The truth must dazzle gradually
Or every man be blind.

In 1862, Dickinson wrote to a literary expert, Thomas Wentworth Higginson, requesting his opinion of her work. He advised her not to publish, but recognized her originality. In 1890, four years after her death, Higginson and Mable Loomis Todd edited and published Dickinson's poems in a volume entitled *Poems by Emily Dickinson*.

Emily Dickinson and Walt Whitman (1819–92) together formed the beginning of a "true" American poetic. They stood far from their English predecessors, and we can trace an identifiable "American" poetry to them. Whitman used predominately lengthy free-verse lines—a first for American literature. His style in such works as *Leaves of Grass* (1855) was to change American literature forever.

CHAPTER REVIEW

CRITICAL THOUGHT

Many people believe that the Romantic age has never ended and point to the self-centered, nonrationalistic emotionalism of today's attitudes and arts. We might wish to test that assertion, or at least check its partial validity on things we contact daily. For example, how about a daily soap opera, a favorite song (rock or otherwise), or even a TV talk show? If we take the situation apart and describe its component parts, moods, and attitudes, do we come up with something restrained, idealized, simple, and carefully structured, or do we end up with unrestrained emotions, complexity, lifelikeness, and fragmentation? Are we riding a pendulum on one end of the classical/anti-classical spectrum, or are we hanging on somewhere in the middle, swinging toward one extreme or the other?

SUMMARY

After reading this chapter, you will be able to:

- Understand the impact of technology on the social setting of the nineteenth century.
- Discuss the philosophies of Kant and Hegel, illustrating why they are called "idealist."
- Characterize the art and architecture of the Romantic style with references to specific qualities in specific works and artists' visions.
- Describe the literary works of major writers of the Romantic age.
- Identify general characteristics of Romanticism in music and apply them to specific musical genres and composers.
- Explain the conditions of theatre and dance in the Romantic age, including genres, theories, and specific artists and works.
- Apply the elements and principles of composition to analyze and compare individual works of art illustrated in this chapter.

CYBERSOURCES

http://www.artcyclopedia.com/history/romanticism.html
http://www.greatbuildings.com/buildings.html
http://www.classicalarchives.com/
http://www.gutenberg.net/

15 REALISM, IMPRESSIONISM, AND BEYOND

OUTLINE

VIEW

A QUICKENING PACE

We are about to enter a time when the pace of life picks up appreciably. Rather than spending an entire chapter on one or two styles, we will find ourselves faced with seven or eight.

The late nineteenth century begins to look more like our own time than the time before it. Even some of the same comparisons with previous times emerged—for example, we in the late twentieth and early twenty-first centuries have often been compared to the Roman Empire. That is exactly the comparison that the aesthetes (see Aestheticism, p. 488) saw themselves. Their behavior might remind us of our time as well—outrageous behavior, drug use, sexual license, and so on. The idea of the past as a safe place where all was as it should be doesn't always hold up under scrutiny.

KEY TERMS

REALISM
An artistic and literary style based on the theory that the method of presentation should be true to life.

NATURALISM
An even more faithful and unselective representation of reality than realism.

IMPRESSIONISM
Applying to art, music, and literature, implies an approach that evokes subjective and sensory impressions.

POST-IMPRESSIONISM
A diverse art style in which the essentials of perception are portrayed through concentration on light, atmosphere, and color.

CUBISM
A style that violates the usual concepts of two- and three-dimensional space and involves the use of geometric shapes to represent objects and figures.

EXPRESSIONISM
A style in visual and performing arts that seeks to express the artist's emotions rather than accurately represent form.

15.1 Claude Monet, *Rouen Cathedral, the Portal, Morning Sun, Harmony in Blue*, 1893. Oil on canvas, 35½ × 24½ ins (91 × 63 cm). Musée d'Orsay, Paris.

CONTEXTS AND CONCEPTS

As the nineteenth century wears on, the pace quickens. Turmoil and flux increase as Europe's population leaves in droves for other corners of the globe. Business and industry continue their technological and industrial revolution, and individual workers strive for greater rights and rewards. Nationalism rises, and science explodes. Philosophy and psychology take fire and influence the arts, whose reactions against Romanticism turn particularly "modernist."

Contexts

European Migration

During the eighteenth and nineteenth centuries seventy million people emigrated from Europe to other continents, mostly to North America, but also to Siberia, Latin America, and Australia. By 1900 the total European population outside of Europe numbered approximately 560 million and represented more than one-third of the world's entire population. Not all European countries participated in this migration equally—for example, France, which early adopted birth control practices, barely reproduced at replacement level, but the declining death rate resulting from better medicine and a number of other factors, allowed France's population to grow. Nevertheless, it contributed little to the great movement of European migration.

The populations of most other European countries, on the other hand, exploded and led to migration on a massive scale. Among the first to contribute to the emigration stood the British and the Irish. In the mid-nineteenth century, Ireland contributed nearly half of the immigrants to the United States, and in four successive waves (1850, 1870, 1885, and 1910) thirteen million English and Scots left their native lands. Two-thirds of them came to the United States, half that many to Canada, and the remainder to Australia and South Africa. In the same period six million Germans left home (most of them for the United States), and two million Scandinavians did the same. Sixteen million Italians left Italy—nearly 750,000 people left the country in 1913

GENERAL EVENTS

- Emigration from Europe, 1800s
- Rise of nationalism in Europe, 1870s–1914
- Genetics, 1901
- Unification of Germany, 1871
- Photoelectricity, 1905
- Pasteurization, 1867
- Einstein, 1879–1955
- X-rays, 1895
- Model of atom, 1911
- Brooklyn Bridge, 1883
- Superconductivity, 1911

1850	1875	1900	1925
PAINTING & SCULPTURE			
Courbet (**15.7**), Millet (**15.8**), Manet (**15.10**), Daumier (**15.9**), Rodin (**15.16**)	Monet (**15.1**, **15.12**), Morisot (**15.14**), Cassatt (**15.15**), Renoir (**15.13**), Seurat (**15.18**), Gauguin (**15.20**), van Gogh (**15.21**)	Cézanne (**15.19**), Picasso (**15.22**, **15.23**), Duchamp (**15.24**), Boccioni (**15.25**), Beckmann (**15.26**), Matisse (**15.27**), Kandinsky (**15.28**)	
ARCHITECTURE			
	Burnham and Root (**15.29**)	Sullivan (**15.30**), Gaudí (**15.31**)	
THEATRE			
	Ibsen, Chekhov, Maeterlinck	Shaw	
MUSIC & DANCE			
Franck	Bizet, Debussy, Moscagni, Puccini, Saint-Saëns, Leoncavallo	Diaghilev, Ravel, Stravinsky, Schoenberg, Nijinsky, Duncan, Jazz	
LITERATURE			
Zola, Dostoyevski, Flaubert, Rossetti	Chopin	Freud, Proust, Joyce, Woolf, Stein	
CINEMA			
	Lumière brothers	Méliès, Porter, Pathé, Mack Sennett comedies, Chaplin, Armat, Griffith	

Timeline 15.1 The beginnings of modernism.

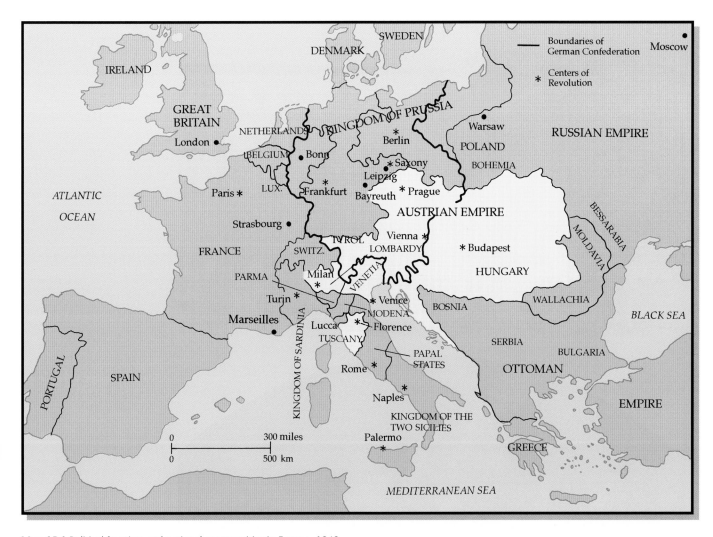

Map 15.1 Political frontiers and national communities in Europe, 1848.

alone—half of them going to North and South America and the other half to other parts of Europe. Central and Eastern Europeans contributed nine million people to the waves of emigration. By the end of the nineteenth century, Europeans had, literally, populated the globe.

Workers and Socialism

The major results of industrialization witnessed the growth of the working class, the development of its organizational forms, and its links to other elements in society who, to varying degrees, did not wish to integrate with bourgeois society (Figs **15.2** and **15.3**).

The organization of the working class came in three spurts. The first, from 1864 to 1893, witnessed powerful popular movements and brutally repressed mass strikes. During this period, the International Working Men's Association (1864) and the Socialist (or Second) International (1889) emerged. The second spurt, which occurred between 1893 and 1905, saw the rise of trade unions and the emergence of nation-states and political parties. The last spurt, which lasted from 1905 until World War I, included a general expansion of the labor and socialist movements.

The International Working Men's Association, founded in London in 1864, drew much support across Europe. Intended as a worldwide workers' party through which workers could derive a sense of solidarity in their struggle to improve their conditions, the movement split in 1869, with the followers of Karl Marx going in one direction, and the others, known as the "anti-authoritarian faction," going in another. Within twenty years, the movement had splintered into national groups, for the simple reason that the different forms of action and militancy could not develop according to a single model. The movement polarized around two centers: unions and political parties.

The socialist creed continued to spread through the organization of the Second International in 1889–91, a loose federation of organizations. According to its

15.2 Käthe Kollwitz, *The Weaver's Cycle: March of the Weavers*, 1897. Etching, 8⅜ × 11⅝ ins (21.3 × 29.5 cm). University of Michigan Museum of Art. Purchase.

15.3 Ford Madox Brown, *Work*, 1852–65. Oil on canvas, 4 ft 6½ ins × 6 ft 5⅛ ins (1.38 × 1.96 m). Manchester City Art Gallery, UK.

agenda, in order to be called a socialist, an individual had to work for the collective ownership of the means of production and to recognize the need for political and parliamentary action. Strikes formed the main weapon of the union movement in Europe, but by the beginning of the twentieth century, the labor movement in Europe proved relatively impotent in the face of rising nationalism and imperialism, central to which stood the German Reich—or state.

The German Reich

As we have seen in preceding chapters, unlike much of the rest of Europe, Germany remained a series of independent states under individual rule. However, on 18 January 1871, twenty-five German states, including three city-states, joined together to create a unified German Reich (state) with William I, King of Prussia, as Kaiser (KYZ-er). An authoritarian state, its government had no responsibility to the parliament. The previous state of

Prussia dominated the remaining members of the Reich, and that gave the new state a particular civilization and type of government—a conservative business class and the domination of the civil service by a powerful professional military. Bismarck, the prime minister of the Reich, and a Prussian, began a *Kulturkampf* (campaign for secularization), which attacked Catholics, expelled the Jesuits, and placed controls on the Roman clergy. However, because such a campaign also alarmed the Protestants, it did not succeed. After two attempts to assassinate the Kaiser occurred, Bismarck dissolved the Reichstag (parliament) and instituted anti-socialist laws. Despite the crash of the Viennese stock market, German industrial expansion continued, and heavy industry became more highly concentrated. The country grew more and more urban, and the population expanded quickly. Agriculture modernized, and Germany, practicing a form of state capitalism, became the second most powerful nation on earth. The German aristocracy joined forces with the richest industrialists against socialism and trade unionism.

Bismarck's foreign policy sought to consolidate Germany's position in Europe by forging a set of contradictory treaties. In 1879 Germany entered an alliance with Austria-Hungary, in 1881 Bismarck engineered the Three Emperors' League, and in 1882 he produced the Triple Alliance among Germany, Austria-Hungary, and Italy. German nationalism strengthened when Kaiser William II took the throne in 1888 and began his search for Germany's "place in the sun." However, during this time, socialist influence increased and, in 1912, the Social Democratic Party (SPD) grew to the largest group in the Reichstag. One of its major objectives, which it tried to accomplish by demonstrations and strikes, was universal suffrage in those areas of Germany where three classes—aristocracy, bourgeoisie, and workers—still existed. This demand proved an important point in the SPD's acceptance of Germany's entry into World War I under a government of national unity on 4 August 1914. People expected the "Great War" to last for three or four months and end by Christmas. It didn't.

A Scientific Explosion

So much happened in science in the last quarter of the nineteenth century and the first decade of the twentieth century that we can merely scratch the surface.

In 1900, no law had been discovered to account for the phenomenon of heat and light radiation by a solid, white-hot body. In that year, Max Planck (plahnk; 1858–1947) guessed that radiation did not occur in a continuous fashion but in small discrete units, separate quantities or quanta. This theory, which enabled scientists to explain heat radiation, turned physics upside down. Building on this theory, Albert Einstein (YN-styn; 1879–1955) explained in 1905 the photoelectric effect, by showing that light, which comprises both waves and particles, moves by quanta—tiny packets of light, later called photons. Nils Bohr (1885–1962) used this quantum theory to build a model of an atom, in 1911, describing the movement of electrons within an atom. This model enabled him to achieve remarkable results in the fields of the spectroscopy of gaseous matter and of X-ray physics.

In September 1895, Wilhelm Conrad Röntgen (also spelled Roentgen; pronounced RENT-guhn; 1845–1923) discovered X-rays—he called the rays "X" because of their then unknown nature. "X" remained undefined until 1912, when Max von Laue (LOW-eh; 1879–1960) managed to diffract the rays through a lattice of crystal. X-rays are electromagnetic waves with very short wavelengths that pass through material normally opaque to light, and their discovery gained Röntgen a Nobel Prize for Physics in 1901. In 1911 Heike Kamerlingh Onnes (HY-kuh KAH-mur-ling OH-nes) of the Netherlands discovered superconductivity—the property of certain metals or alloys, at very low temperatures, to lose their resistance to electricity. It took until 1986 for research in superconductivity to lead to the development now being seen in contemporary physical processes.

In 1865, the Moravian-born botanist Gregor Johann Mendel (MEN-dul; 1822–84) demonstrated that hereditary characteristics transmit via distinct elements—today called genes. Mendel's findings, the discovery of chromosomes in 1888 and of mutations in 1901, founded the science of genetics. The gene itself emerged in 1909, when the Danish botanist Wilhelm Johannsen (1857–1927) coined the name "genes" for the hereditary units that produce the physical characteristics of an organism.

In microbiology, the second half of the century produced the work of Frenchman Louis Pasteur (1822–95), who explained the fermentation process as the result of the action of microscopic living organisms. Pasteur extended his research to include bacteria, thus beginning the field of bacteriology, and he promulgated the idea that living beings contain in themselves the means of fighting disease. Thus, the immune system became a serious subject for scientific study. Birth itself emerged from scientific experimentation in the early twentieth century, with the invention of *in vitro* cultivation—a method in which a living organism is sustained outside of its natural environment—in 1907.

Nietzschean Philosophy

If science experienced an explosion, then we might characterize approaches to philosophy and psychology

TECHNOLOGY

COCA-COLA

Sugar, caffeine, and vegetable extracts are some of the ingredients of the world's most popular soft drink, although the exact proportions of these ingredients remain one of the corporate world's most jealously guarded secrets. Dr John S. Pemberton (Fig. 15.4) never patented his original formula, which he concocted in 1886 in Atlanta, Georgia.

Pemberton, a pharmacist, developed a variety of chemical compounds for treating various human ailments—for example, Globe of Flower Cough Syrup, Indian Queen Hair Dye, and Triplex Liver Pills—and he spent much of his time in his chemical laboratory looking for new flavors to make his pharmaceutical products more tasty. Around 1880 he began to experiment with a "soft" drink that could be sold at the food soda fountain of drug stores. In 1886 he discovered a syrup that, when mixed with carbonated water, made a thirst-quenching drink. He added caffeine and vegetable extracts, for flavor, and mixed the brew in a brass kettle.

The first person to test the new drink was William Venable, the resident "soda jerk" of Jacob's Drugstore in Atlanta. Apparently, Venable liked what he drank and bought the mix on a trial basis. His customers loved it, and wanted to ask for it by name. One of Pemberton's partners, Frank Robinson, suggested Coca-Cola, and the next day, an elaborate script logo was produced. It and the product remain the same today.

15.4 Dr John S. Pemberton of the Coca-Cola corporation.

in the late nineteenth century as a firestorm. The provocative German thinker, philosopher, and poet Friedrich Nietzsche (NEE-che; 1844–1900) illustrates this. Nietzsche, a classical philologist, voiced the sentiments of the radical moralist. He attacked all the accepted ideas of his time and argued for a revision of all values. He attacked rationalism and contemporary morality, characterizing Christianity and other religions as contributors to the formation of a "slave morality." He saw contemporary democracy and its sympathy for the weak and helpless as rule by mass mediocrity. Instead, he championed the "superman," the superior individual with the vision and courage to produce a "master" morality.

Religious female relatives raised Nietzsche after his father's death and this, according to some, accounted for his attacks on religion and women in his writings. His brilliance brought him the appointment as professor of Greek at the University of Basel in 1869, but ten years later he resigned the post because of poor health and, for the next ten years, led a mostly solitary life. In January 1889 he suffered a complete mental collapse from which he never recovered, although he lived for another eleven years.

Soon after going to Basel, he published an intuitive philosophical investigation of the spiritual background of Greek tragedy, entitled *The Birth of Tragedy from the Spirit of Music* (1872). Three years later he wrote *Untimely Opinions* in which he attacked the smug conceit of Bismarck's Germany. Perhaps his best-known work, *Thus Spake Zarathustra* (1883–92), comprises a series of rhapsodical sermons by an imaginary prophet and written in poetic prose modeled after the Bible. Here is a short excerpt:

Thus Spake Zarathustra
(excerpt)
Friedrich Nietzsche

When Zarathustra had spoken these words, he again looked at the people, and was silent. "There they stand," said he to his heart; "there they laugh: they understand me not; I am not the mouth for these ears.

Must one first batter their ears, that they may learn to hear with their eyes? Must one clatter like kettledrums and penitential preachers? Or do they only believe the stammerer?

They have something whereof they are proud. What do they call it, that which maketh them proud? Culture, they call it; it distinguisheth them from the goatherds.

They dislike, therefore, to hear of 'contempt' of themselves. So I will appeal to their pride.

I will speak unto them of the most contemptible thing: that, however, is THE LAST MAN!"

And thus spake Zarathustra unto the people:

It is time for man to fix his goal. It is time for man to plant the germ of his highest hope.

Still is his soil rich enough for it. But that soil will one day be poor and exhausted, and no lofty tree will any longer be able to grow thereon.

Alas! there cometh the time when man will no longer launch the arrow of his longing beyond man—and the string of his bow will have unlearned to whizz!

I tell you: one must still have chaos in one, to give birth to a dancing star. I tell you: ye have still chaos in you.

Alas! There cometh the time when man will no longer give birth to any star. Alas! There cometh the time of the most despicable man, who can no longer despise himself.

Lo! I show you THE LAST MAN.

Some people label many of his ideas fascistic—supportive of a philosophy or system of government that advocates dictatorship of the far right and belligerent nationalism, and the followers of Adolf Hitler claimed him as their inspiration and prophet. Perhaps an irony rests in the fact that Nietzsche himself opposed nationalism, armies, the German Empire, politics, and racism, especially anti-Semitism. Understanding and interpreting Nietzsche remains exceedingly difficult because of the fact that he often wrote in hyperbole—by overstating his case in order to get a reaction—and whatever he wrote, he wrote with verve and caustic wit. He reportedly warned a friend that it was not desirable for his readers to agree with him. He accepted the idea of human helplessness in a mechanical world operating under inexorable law, but he rejected Schopenhauer's pessimism. Instead, he preached courage in the face of the unknown and found this humanity's highest attribute. After a long selective process, Nietzsche believed that courage would produce a race of supermen and superwomen.

Freudian Psychology

One of the towering figures of modern times, the Austrian Sigmund Freud (froyd; 1856–1939) developed what he

15.5 Max Halberstadt, photograph of Sigmund Freud, c. 1926. Courtesy of W. Ernest Freud, by arrangement with Mark Patterson and Associates and the Freud Museum, London.

called "psychoanalysis"—the probing of the human "unconscious"—in the study of human behavior by exploring the world of dreams (Fig. **15.5**). Psycho–analysis is a method of understanding psychological and psychopathological phenomena, and at the same time a method of treating mental illness. Freud developed his theories around 1885 in Vienna, and although he did not invent the idea of the psychic unconscious, he undertook a systematic exploration of it. At first his ideas met considerable skepticism because of their novel propositions regarding sexuality. However, psychoanalysis gradually gained an important place in medicine and psychology.

Freud's principal work, *The Interpretation of Dreams* (1900), showed that the discoveries of psychoanalysis about dreaming and symbols apply to literature as well as to psychology and psychiatry. His ideas significantly influenced twentieth-century literature, and some of the misinterpretations of his ideas led to the exploration of the creative imagination.

Freud's impact on literature falls into three areas. The first, called literary surrealism, explores the idea of breaking human psychological defenses and giving uncensored expression to the irrational symbolic modes of the unconscious. The second area concerns an aspect of what, in the Introduction to this text, we called "contextual criticism." Here, biographers and critics "psychoanalyze" writers, and other artists, in order to explain literary works in terms of the writer's "conditioning." The final area consists of writers, particularly novelists and dramatists, conceiving and presenting their characters in psychoanalytical terms. This is especially true of the "stream-of-consciousness" school (see p. 516), in which the character's inner monologue imposes on the reader the job of finding the person in the midst of the material comprising his or her personal experience.

Concepts

Aestheticism

In the late nineteenth century, at approximately the same time that functionalism (see below) appeared, a philosophical artistic thrust occurred called **aestheticism** (not to be confused with asceticism), characterized by the slogan **"art for art's sake."** We will encounter this slogan several times in this chapter. Those who championed this cause reacted against Victorian notions that a work of art must have uplifting, educational, or otherwise socially or morally beneficial characteristics, as one might argue, for example, for the spiritual considerations of a work like

15.6 Henry O. Tanner, *The Banjo Lesson*, 1893. Oil on canvas, 48 × 35½ ins (122 × 89 cm). Hampton University Museum, Hampton, Virginia.

Henry Tanner's *The Banjo Lesson* (Fig. **15.6**). Proponents of aestheticism held that artworks stand independent and self-justifying, with no reason for being other than being beautiful. The playwright Oscar Wilde said in defense of this viewpoint: "All art is quite useless." His statement meant that exquisite style and polished device had greater importance than utility and meaning. Thus, form rides victorious over function. The aesthetes, as proponents of aestheticism were called, disdained the "natural," organic, and homely in art and life and viewed art as the pursuit of perfect beauty and life—a quest for sublime experience. In the Dance section of the last chapter we met Théophile Gautier, whom many cite as the inventor of the phrase "art for art's sake." People like Gautier saw the nineteenth century as akin to the Roman Empire (see Chapter 4) and celebrated the *fin-de-siècle* (fehn duh see-EHK-uhl; French for "end of the century") and the decay of civilization with flamboyant behavior, drug-taking, and sexual license. We have come to call writers of this persuasion, "Decadents."

Functionalism

Also in the nineteenth century, separate but related approaches in the social sciences, philosophy, and art appeared, introduced by sociologists, who called the separate approaches functionalism. The sociologists Herbert Spencer (1820–1903) and Émile Durkheim (1858–1917) applied a biological metaphor to society, seeing it as an interrelated organism, each of whose elements contributed to the stability and survival of the whole. Louis Sullivan's maxim "Form follows function" (see p. 504) epitomized functionalism in the arts. By that maxim, Sullivan meant that purpose should serve as the first—but not the only—consideration in design. This principle, which also implied that beauty resides in the purity of unornamented form, applied in a great deal of "modernist" design, particularly after World War I.

THE ARTS: REALISM, IMPRESSIONISM, AND BEYOND

In the last half of the nineteenth and early twentieth centuries, without the sea anchor of academicism to hold them in place, the arts took increasingly individualistic directions, with new approaches developing fairly rapidly. That poses a challenge for us because we have chosen in this book to organize the Arts sections by discipline: painting, music, literature, and so on. Thus, in each of these upcoming parts of this chapter, we find several styles. After discussing a half-dozen or so styles in

painting and sculpture, we move to theatre (then to music, and so on) where some of the same style terms reappear. If we do not stay aware, this irregular recurrence of styles might confuse us: not every style applies to every discipline. It might seem less confusing to change the organization of the book, here, to a stylistic mode and, thus, when a style occurs, discuss its relationship to each discipline in a single, unified treatment (as we do with painting and sculpture) rather than returning to it repeatedly as we change sections. We have nonetheless chosen to keep the basic organizing principle of disciplines intact: we can regard the current organization as a means of review and comparison of various styles and thereby gain a greater understanding of how the disciplines themselves changed during this period.

Painting and Sculpture

Realism

The style we call "realism" ran through the 1840s, 1850s, and 1860s. Its central figure, Gustave Courbet (koor-BAY; 1819–77), was influenced by the innovations of Corot (see Chapter 14) in terms of the play of light on surfaces. But, unlike Corot, he aimed to make an objective and unprejudiced record of the customs, ideas, and appearances of contemporary French society. *The Stone Breakers* (Fig. **15.7**) first displayed his philosophy to the full. Courbet painted two men as he had seen them working beside a road. The work is lifesize, and, while the treatment seems objective, it makes a sharp comment on the tedium and laborious nature of the task. A social realist, Courbet remained more intent on social message than on meditative reaction. Therefore, his work appears less dramatic and nostalgic than that of others.

Jean-François Millet (mee-LAY; 1814–75) belonged to a group of painters called the Barbizon School, which focused upon a realistic-Romantic vision of landscape, and typically used peasants as its subject matter. The Barbizon School did not espouse socialism, but it did exalt the honest, simple life and work on the land, as contrasted with the urban bourgeois life. Millet's *Woman Baking Bread* (Fig. **15.8**) expresses these themes, and the peasant emerges as an heroic figure. The vantage point the painter has chosen enhances this quality. Seen from slightly below, the peasant woman has an added height and dominance which emphasize her grandeur.

15.7 Gustave Courbet, *The Stone Breakers*, 1849. Oil on canvas, 5 ft 3 ins × 8 ft 6 ins (1.6 × 2.59 m). Formerly Gemäldegalerie, Dresden, Germany (destroyed 1945).

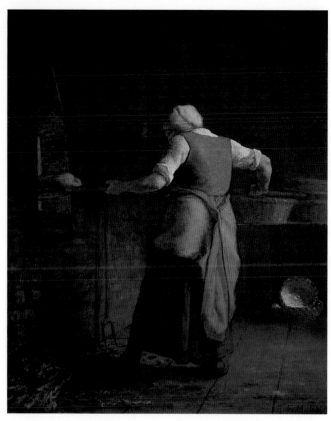

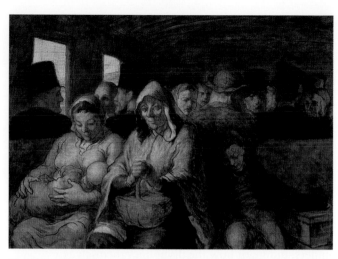

15.9 Honoré Daumier, *The Third-Class Carriage*, c. 1862. Oil on canvas, 25¾ × 35½ ins (65.4 × 90.2 cm). Metropolitan Museum of Art, New York, H.O. Havemeyer Collection, bequest of Mrs H.O. Havemeyer, 1929 (29.100.129).

15.8 Jean-François Millet, *Woman Baking Bread*, 1853–4. Oil on canvas, 21¾ × 18 ins (55 × 46 cm). Collection, State Museum Kröller-Müller, Otterlo, The Netherlands.

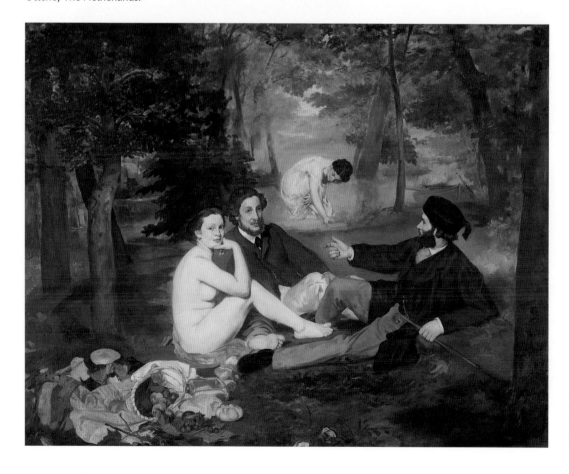

15.10 Edouard Manet, *Déjeuner sur l'herbe* (*The Picnic*), 1863. Oil on canvas, 7 ft × 8 ft 10 ins (2.13 × 2.69 m). Louvre, Paris.

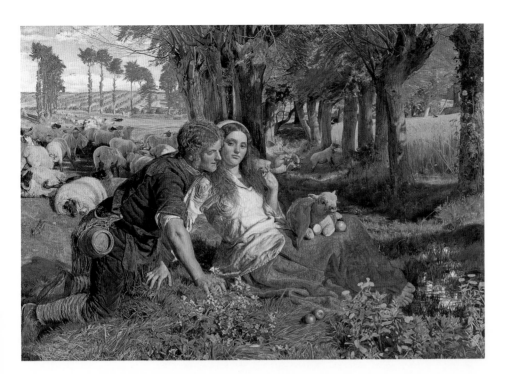

15.11 William Holman Hunt, *The Hireling Shepherd*, 1851. Oil on canvas, 30⅛ × 43⅛ ins (76.4 × 109.5 cm). Manchester City Gallery, England.

Edouard Manet (mah-NAY; 1832–83) strove to paint "only what the eye can see." Yet his works go beyond a mere reflection of reality to a larger artistic reality, one which suggests that a painting has an internal logic different from the logic of familiar reality. Manet liberated the painter's art from competition with the camera. *Déjeuner sur l'herbe* (Fig. **15.10**), in which Manet sought to "speak in a new voice," shocked the public when first shown at the Salon des Refusés in 1863. He uses pastoral setting, like one we might find in Watteau, for example, but the people emerge real and identifiable: Manet's model, his brother, and the sculptor Leenhof. The apparent immorality of a naked frolic in a Paris park outraged the public and the critics. Had his figures been classical nymphs and satyrs, all would have been well. But the intrusion of reality into the sacred mythical setting, not to mention the nudity of a common woman while her male companions have their clothes on, proved unsettling for the public.

Honoré Daumier (dohm-YAY; 1808–79) often depicted urban scenes, for example *The Third-Class Carriage* (Fig. **15.9**). The painting shows the interior of a large, horse-drawn bus in Paris. Daumier puts the viewer in the seat opposite a grandmother, her daughter, and two grandchildren. Together, they form a strong compositional triangle that contrasts them with the people behind them. Some scholars suggest that the painting makes a comment on urban alienation, which became an important topic in art after 1880.

The first important African American painter, Henry O. Tanner (1859–1937), although somewhat later, painted in a similar style. He studied at the Philadelphia

Academy of Fine Arts with the American realist painter Thomas Eakins (1844–1916), who encouraged both African Americans and women at a time when professional careers were essentially closed to them. *The Banjo Lesson* (see Fig. **15.6**) presents its images in a strictly realistic manner, without sentimentality. The painter achieves focus through the contrast of clarity in the central objects and less detail in the surrounding areas. In many respects this technique follows Corot. Tanner skillfully captures an atmosphere of concentration and shows us a warm relationship between teacher and pupil.

Pre-Raphaelites

Associated with realism, a movement in Victorian England called the **Pre-Raphaelites** began in 1848 in order to advance the naturalistic approach of artists of the early Renaissance in Northern Europe (see Chapter 11). They saw the contemporary trend of academic historic painting as unimaginative and artificial, and sought to establish a new moral seriousness and sincerity in painting. They allied themselves with a school of writers whom we will discuss in the Literature section of this chapter. A good example of their work comes from one of their leaders, William Holman Hunt (1827–1910), *The Hireling Shepherd* (Fig. **15.11**). The artist painted the landscape portions of the painting outdoors—a new procedure—while leaving room for the figures, which he painted in the studio. The work shows a hired farmhand neglecting his responsibilities while he discusses with a young lady a death's-head moth that he holds in his left hand. Meanwhile, his sheep (or rather, his employer's

sheep) wander off into an adjacent meadow full of green corn that could possibly make them sick or kill them. Hunt used the scene to symbolize and satirize, as he later explained, pastors who neglect the real needs of their flock in favor of discussing worthless theological matters. The painting also serves a didactic function—one of the basic characteristics of the Pre-Raphaelite movement: it teaches a moral lesson about the risks of temptation. The symbolism of the young lady as a representative of Eve comes clearly across as she feeds an apple to the lamb on her lap while distracting the hireling from his responsibilities.

Impressionism

The realists' search for spontaneity, harmonious colors, subjects from everyday life, and faithfulness to observed lighting and atmospheric effects led to the development of a style used by a small group of painters in the 1860s, and described by a hostile critic in 1874 as "**impressionism**." The "impressionists" created a new way of seeing reality through color and motion. Their style emerged in competition with the newly invented technology of the camera, and these painters tried to outdo photography by portraying those essentials of perception that the camera cannot capture. They emphasized the presence of color within shadows and based their style on an understanding of the interrelated mechanisms of the camera and the eye: vision consists of the result of light and color making an "impression" on the retina.

The style lasted only fifteen years in its purest form, but it profoundly influenced all painting that followed. Working out-of-doors, the impressionists concentrated

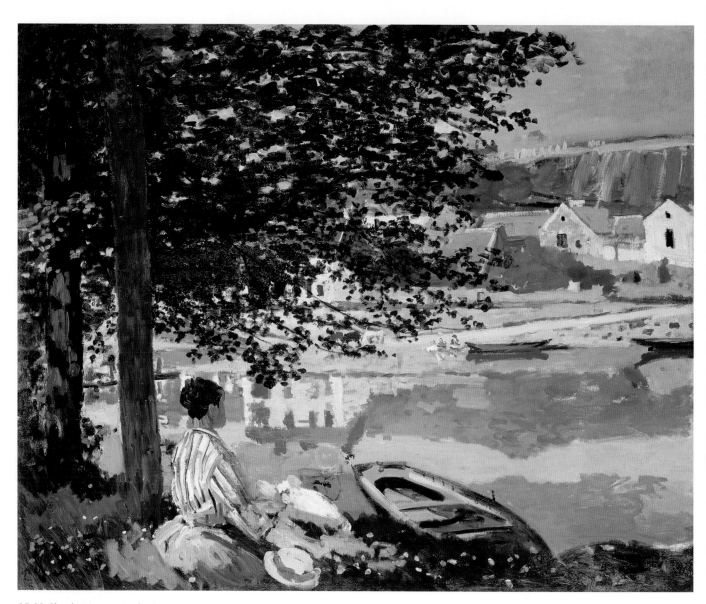

15.12 Claude Monet, *On the Seine at Bennecourt*, 1868. Oil on canvas, 32¹⁄₁₆ × 39⅜ ins (81.5 × 100.7 cm). The Art Institute of Chicago (Mr. & Mrs. Potter Palmer Collection).

MASTERWORK

RENOIR—*LE MOULIN DE LA GALETTE*

The impressionist Pierre-Auguste Renoir (ren-WAHR; 1841–1919) specialized in painting the human figure and sought out beauty in the human body. His paintings sparkle with the joy of life. In *Le Moulin de la Galette* (Fig. **15.13**), he depicts the bright gaiety of a Sunday afternoon crowd in a popular Parisian dance venue. The artist celebrates the liveliness and charm of these everyday folk as they talk, crowd the tables, flirt, and dance. Warmth infuses the setting. Sunlight and shade dapple the scene and create a sensation of floating in light.

A casualness appears here, a sense of life captured in a fleeting and spontaneous moment, and of a much wider scene extending beyond the canvas. Rather than to a formally composed scene like that in David's *Oath of the Horatii* (see Fig. **13.13**), Renoir invites us into the action. People go about their everyday lives with no sense of the painter's presence. As opposed to the realism of the classicist who seeks the universal and the typical, the realism of the impressionist seeks "the incidental, the momentary, and the passing."

Le Moulin de la Galette captures the enjoyment of a moment outdoors. The colors shimmer, and although Renoir skillfully plays off highlights against dark tones, the uniform hue of the lowest values is not black but blue. In short, the beauty of this work exemplifies Renoir's statement, "The earth as the paradise of the gods, that is what I want to paint."

15.13 Pierre-Auguste Renoir, *Le Moulin de la Galette*, 1876. Oil on canvas, 4 ft 3½ ins × 5 ft 9 ins (1.31 × 1.75 m). Louvre, Paris.

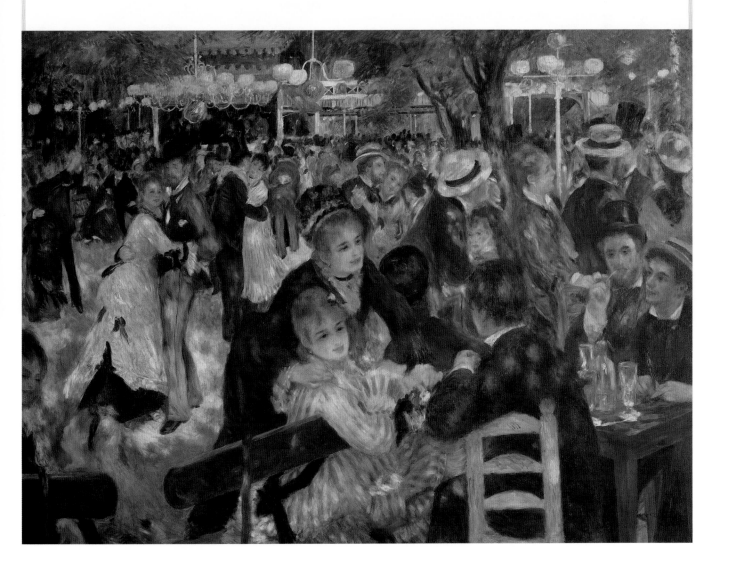

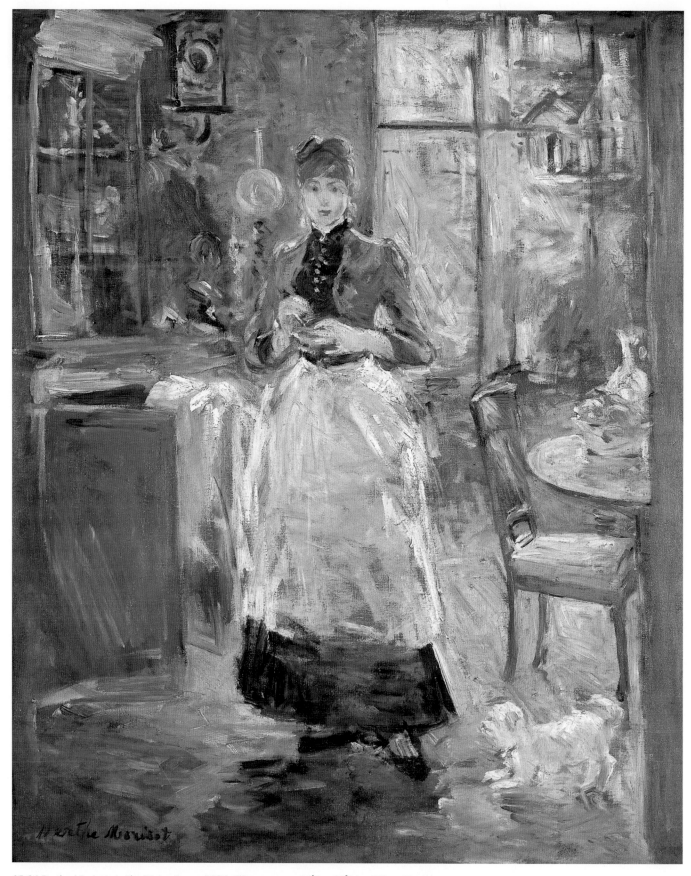

15.14 Berthe Morisot, *In the Dining Room*, 1886. Oil on canvas, 24⅛ × 19¾ ins (61 × 50 cm).
National Gallery of Art, Washington D.C. (Chester Dale Collection).

on the effects of natural light on objects and atmosphere. Their experiments resulted in a profoundly different vision of the world around them and way of rendering that vision. For them, the painted canvas was, first of all, "a material covered with pigments"—small "color patches," which together create lively, vibrant images.

Impressionism was as collective a style as any we have seen thus far. In an individualistic age, this style reflected the common concerns of a relatively small group of artists who met frequently and held joint exhibitions. The subjects painted constitute impressions of landscapes, rivers, streets, cafés, theatres, and so on.

Two individuals, Claude Monet (klohd moh-NAY) and Pierre-Auguste Renoir (see Masterwork, p. 493), brought impressionism to its birth. They spent the summer of 1866 at Bougival on the River Seine, working closely together, and from that collaboration came the beginnings of the style. In his paintings, Claude Monet (1840–1926) tried to find an art of modern life by recording everyday themes with on-the-spot, objective observations. He sought to achieve two aims: representation of contemporary subject matter and optical truth—the way colors and textures really appear to the eye. Monet's paintings reflect an innocent joy in the world around him and an intensely positive view of life. He had no specific aesthetic theory—in fact, he detested theorizing—but he did seek to bring realism to its peak. His work encompasses scientific observation, the study of optics, and other aspects of human perception. Monet translated objects into color stimuli.

Monet's *On the Seine at Bennecourt* (Fig. **15.12**) illustrates these concerns. It conveys a pleasant picture of the times, an optimistic view rather than the often pessimistic outlook of the Romantics. This effected a new tone for a new era. Although the scene reflects a landscape panorama, lack of atmospheric or linear perspective brings the entire painting to the foreground without deep space. The scene shines bright, alive, and pleasant; we find comfort in its presence.

One of the original group of impressionists, Berthe Morisot (bairt mohr-ee-ZOH; 1841–95), used a gentle introspectiveness, often focusing on family members, and her view of contemporary life edges with pathos and sentimentality. In *In the Dining Room* (Fig. **15.14**), she gives a penetrating glimpse into psychological reality. The servant girl has a distinct personality, and she stares back at the viewer almost impudently. The painting captures a moment of disorder—the cabinet door stands ajar with what appears to be a used table cloth flung over it. The little dog playfully demands attention. Morisot uses delicate, loose, and casual brushstrokes.

In 1877, another woman joined the impressionists. Mary Cassatt (kuh-SAT; 1845–1926) came to Paris from Philadelphia, a minor center for artists at the time.

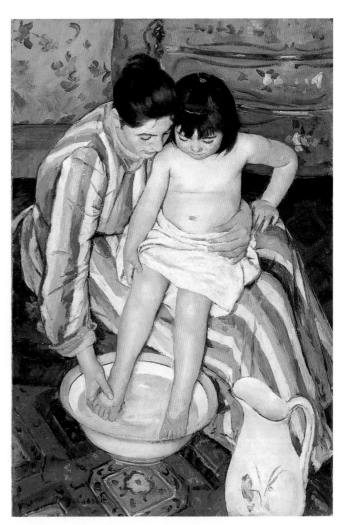

15.15 Mary Cassatt, *The Child's Bath*, 1891. Oil on canvas, 39½ × 26 ins (100.3 × 66.1 cm). The Art Institute of Chicago (Robert A. Waller Fund).

Thanks to her financial independence, she overrode her family's objections to a career deemed unsuitable for a woman, especially a woman of wealth. In fact, her wealth and connections with wealthy collectors in the United States helped the impressionists gain exposure and acceptance in this country. In *The Child's Bath* (Fig. **15.15**), she depicts her favorite subjects—women and children. In this painting, Cassatt's brushwork remains far less obvious than that in other impressionist works, and this helped conventional viewers to understand the work and relate closely to the scene. Painted in clear, bright colors, Cassatt's subjects do not make eye contact with the viewer. Their purposeful forms awaken interest, rather than emotions.

The surface and textural concerns of the impressionist appear in the work of the century's most remarkable sculptor, Auguste Rodin (roh-DAN; 1840–1917). Although his style resists easy classification, we find

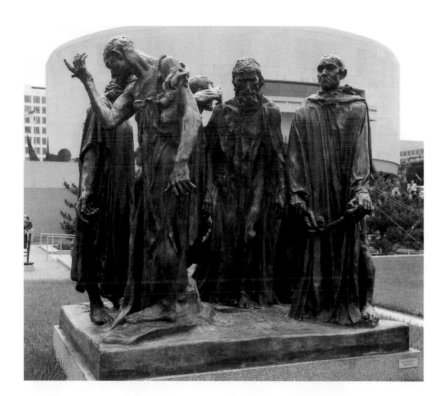

15.16 Auguste Rodin, *The Burghers of Calais*, 1866. Bronze, 6 ft 10½ ins (2.1 m) high. Hirshhorn Museum and Sculpture Garden, Smithsonian Institution, Washington D.C.

A DYNAMIC WORLD

JAPANESE PAINTING

The flat color areas that provided the Japanese influence on post-impressionism can be seen in a work from the mid-nineteenth century by Ando Hiroshige (hee-roh-SHEE-gee), *Maple Leaves at Mama, Tekona Shrine and Mama Bridge* (Fig. **15.17**). In this strongly colored landscape, Hiroshige shows deep space in a novel fashion, using the foreground to "frame" the distance. Hiroshige uses neither linear nor atmospheric perspective to achieve the illusion of deep space, and yet the portrayal appears rational. Hiroshige uses a clever manipulation of hue, value, and contrast to keep interest and control. By using complementary colors of red in the leaves and green in the distance, Hiroshige strikes a harmonious visual chord, and creates a counterpoint to hold our vision stable in the center of the work.

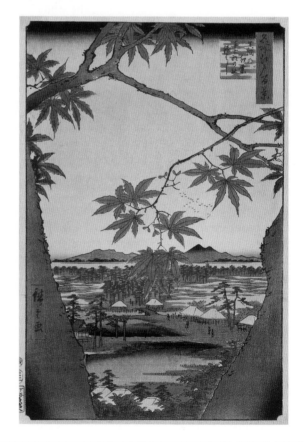

15.17 Ando Hiroshige, *Maple Leaves at Mama, Tekona Shrine and Mama Bridge*. Series: *Meisho Edo Hyakkei (100 Views of Edo)*, No. 94, c. 1856–9. Polychrome wood-block print, 13¾ × 9¾ ins (35 × 24 cm). British Museum, London.

plenty of idealism and social comment—for example, in his powerful work *The Burghers of Calais* (kah-LAY; Fig. **15.16**). Commissioned by the city of Calais, France, as a public monument, the work honors six leading citizens (burghers) who, in 1347, offered themselves as hostages to the English King Edward III, who had laid siege to the city. The burghers stood ready to sacrifice their lives if the city would be spared. Edward III, impressed with their courage, spared both the burghers and Calais. Rodin uses impressionistic textures: his surfaces appear to shimmer as light plays on their irregularities, but they are more than reflective surfaces. They give his works dynamic and dramatic qualities. Although Rodin worked fairly realistically, he nevertheless created a subjective reality beyond the surface, and the subjectivity of his viewpoint emerges even more clearly and dramatically in his pessimistic later sculptures.

Post-Impressionism

In the last two decades of the nineteenth century, impressionism evolved gently into a collection of rather disparate styles called simply "**post-impressionism.**" In subject matter, post-impressionist paintings appeared similar to impressionist paintings—landscapes, familiar portraits, groups, and café and nightclub scenes—but the post-impressionists gave their subject matter a complex and profoundly personal significance.

The post-impressionists, deeply concerned about capturing sensory experience, maintained the contemporary philosophy of art for art's sake and rarely attempted to sell their works. They did wish to share their subjective impressions of the real world, but moved beyond the Romantic and impressionistic world of pure sensation. They found more interest in the painting as a flat surface carefully composed of shapes, lines, and colors, an idea that became the foundation for most of the art movements that followed. The post-impressionists called for a return to form and structure in painting, characteristics they believed lacking in the works of the impressionists. Taking the evanescent light qualities of the impressionists, they brought formal patterning to their canvases. They used clean color areas, and applied color in a systematic, almost scientific manner. They

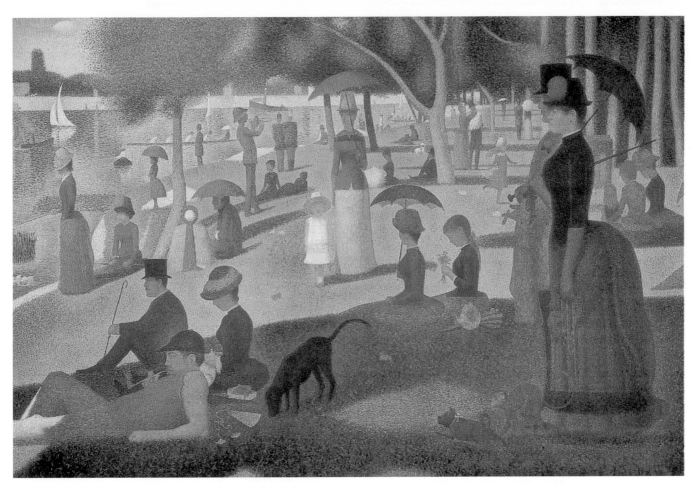

15.18 Georges Seurat, *A Sunday Afternoon on the Island of La Grande Jatte*, 1884–6. Oil on canvas, 6 ft 9¾ ins × 10 ft 1¼ ins (2.07 × 3.08 m). Art Institute of Chicago (Helen Birch Bartlett Memorial Collection).

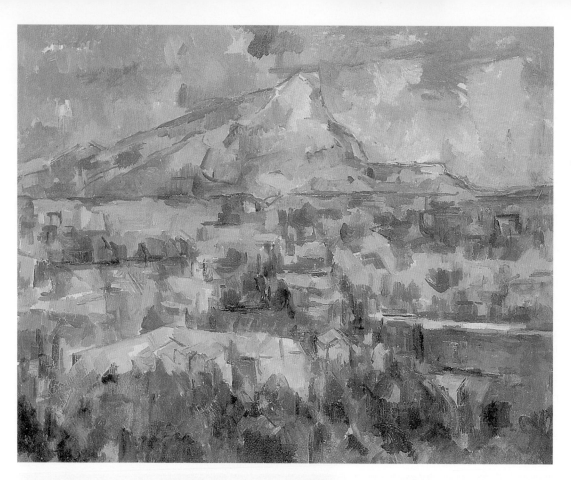

15.19 Paul Cézanne, *Mont Sainte-Victoire seen from Les Lauves*, 1902–04. Oil on canvas, 27½ × 35¼ ins (69.8 × 89.5 cm). Philadelphia Museum of Art (George W. Elkins Collection).

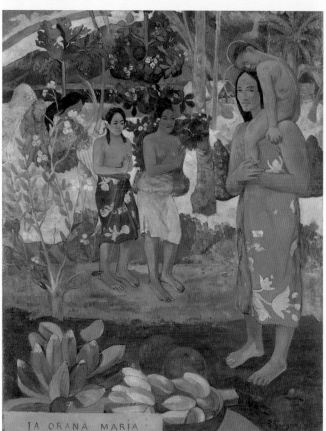

15.20 Paul Gauguin, *La Orana Maria* ("We Hail Thee Mary"), c. 1891–2. Oil on canvas, 44¾ × 34½ ins (113.7 × 87.7 cm). The Metropolitan Museum of Art, New York. Bequest of Samuel A. Lewisohn, 1951 (51.112.2).

sought to return painting to traditional goals while retaining the clean palette of the impressionists.

Georges Seurat (sur-AH; 1859–91), often described as a "neo-impressionist"—he called his approach and technique "divisionism"—departed radically from existing painting technique with his experiments in optics and color theory. We call his patient and systematic application of specks of paint **pointillism**, because the artist applies paint with the point of the brush, one small dot at a time. *A Sunday Afternoon on the Island of La Grande Jatte* (Fig. **15.18**) illustrates both his theory of color perception and his concern for the accurate depiction of light and colorations of objects. The composition of this work shows attention to perspective, and yet it willfully avoids three-dimensionality. Japanese influence appears here, as it did in much post-impressionist work. Color areas stay fairly uniform, figures flattened, and outlining is continuous. Throughout the work we find conscious systematizing. The painting divides into proportions of three-eighths and halves, which Seurat believed represented true harmony. He also selected his colors by formula. For Seurat, the painter's representation of physical reality simply constituted a search for a superior harmony, for an abstract perfection.

Paul Cézanne (say-ZAHN; 1839–1906), considered by many the father of modern art, illustrates concern for formal design, and his *Mont Sainte-Victoire seen*

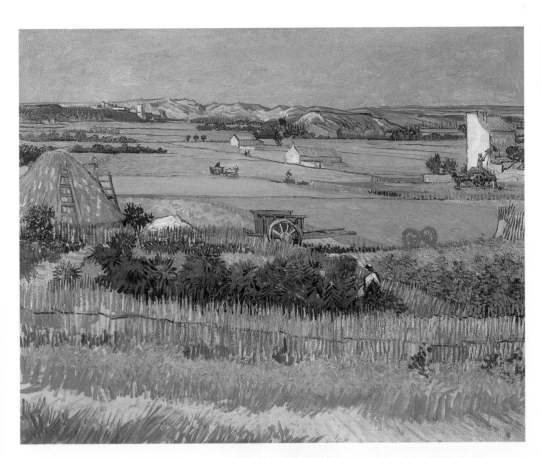

15.21 Vincent van Gogh, *Harvest at La Crau* ("The Blue Cart"), 1888. Oil on canvas, 28½ × 36¼ ins (72.5 × 92 cm). Rijksmuseum Vincent van Gogh, Amsterdam, Netherlands.

from Les Lauves (Fig. **15.19**) shows a nearly geometric configuration and balance. Foreground and background tie together in a systematic manner so that both join in the foreground to create patterns. Shapes are simplified, and outlining is used throughout. Cézanne believed that all forms in nature are based on geometric shapes—the cone, the sphere, and the cylinder. Employing these forms, he sought to reveal the enduring reality that lay beneath surface appearance. Cézanne tried to invest his paintings with a strong sense of three-dimensionality. His use of colored planes reminds us of Seurat's use of colored dots. He took great liberty with color and changed traditional ways of rendering objects, utilizing the cones, cylinders, and other geometric shapes just mentioned.

Paul Gauguin (goh-GAN; 1848–1903) brought a highly imaginative approach to post-impressionist goals. An artist without training, and a nomad who believed that European society and all its works were sick, Gauguin devoted his life to art and to wandering, spending many years in rural Brittany and the end of his life in Tahiti and the Marquesas Islands. The first picture Gauguin painted in Tahiti, *La Orana Maria* ("We Hail Thee Mary"; Fig. **15.20**), portrays Mary as a strong Polynesian woman, and the Christ Child as a completely relaxed boy of perhaps two or three years of age. In Tahiti, Gauguin believed he could re-enter the Garden

of Paradise, and the rich, warm colors and decorative patterns suggest that life in this "uncivilized" world is, indeed, sweet and innocent. The table piled high with fruit illustrates that the people of this garden, like Adam and Eve in the Garden of Eden, need only pick the fruit off the trees. The table stands closest to the viewer, and it, and its promise, appear to invite the viewer to leave the industrialized world for a more peaceful one.

Vincent van Gogh (1853–90) took yet another, unique approach in his intense emotionalism in pursuing form. Van Gogh's turbulent life included numerous short-lived careers, impossible love affairs, a tempestuous friendship with Gauguin, and, finally, serious mental illness. Biography emerges essential here because van Gogh gives us one of the most personal and subjective artistic viewpoints in the history of Western art. Works such as *Harvest at La Crau* ("The Blue Cart"; Fig. **15.21**), which van Gogh produced when he was living in the southern French town of Arles, reflects an interest in *complementary colors* (colors on opposite sides of the color wheel—see the Introduction). Unlike Seurat, for example, who applied such colors in small dots, van Gogh, inspired by Japanese prints, placed large color areas side by side. Doing so, he believed, expressed the quiet, harmonious life of the rural community. Notice that the brushwork in the foreground stays active while the fields in the background appear smooth. Subtle

15.22 Pablo Picasso, *Youth Riding*, 1905. Sketch. Private collection. © Succession Picasso/DACS 2005.

diagonals break the predominantly horizontal line of the work, giving the painting, overall, a tranquil atmosphere.

Cubism

The years between 1901 and 1912 witnessed an emerging approach to pictorial space, called **cubism**. Cubist space violated all usual concepts of two- and three-dimensional perspective. Until this time, the space within a composition had been thought of as an entity separate from the main subject of the work—if the subject were removed, the space would remain, unaffected.

The artists Pablo Picasso (1881–1973) and Georges Braque (brahk, 1882–1963) changed that relationship. In their view the artist should paint "not objects, but the space they engender." The area around an object became an extension of the object itself, and if the object were removed, the space around it would collapse. Cubist space, typically quite shallow, gives the impression of reaching forward out of the frontal plane toward the viewer.

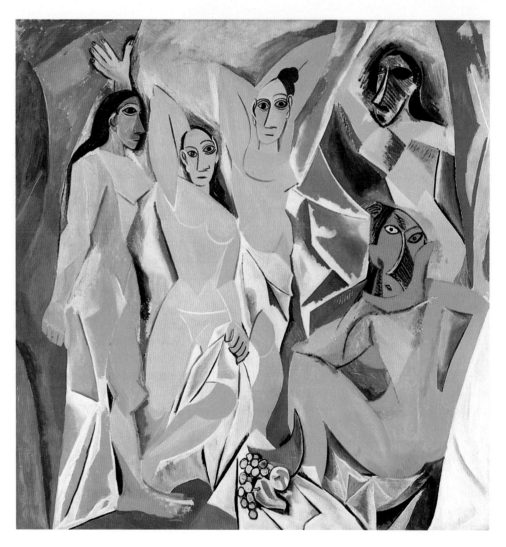

15.23 Pablo Picasso, *Les Demoiselles d'Avignon*, 1907. Oil on canvas, 8 ft × 7 ft 8 ins (2.44 × 2.34 m). The Museum of Modern Art, New York (acquired through the Lillie P. Bliss Bequest). Photo: © 1998 The Museum of Modern Art, New York. © Succession Picasso/DACS 2005.

Essentially, the style developed as the result of independent experiments by Braque and Picasso with various ways of describing form. At this time Albert Einstein proposed newly evolving notions of the time–space continuum. We do not know whether the Theory of Relativity influenced Picasso and Braque, but it was being talked about at the time, and it certainly helped to make their works more acceptable. The results of both painters' experiments brought them to remarkably similar artistic conclusions.

Picasso influenced the arts of the twentieth century more than any other painter. Born in Spain, in 1900 he moved to France, where he lived for most of his life. In Paris he was influenced by Toulouse-Lautrec (too-LOOZ loh-TREK) and the late works of Cézanne, particularly in organization, analysis of forms, and use of different points of view. Very early on Picasso began to identify deeply with society's misfits and cast-offs. In the period from 1901 until around 1904 or 1905, known as Picasso's Blue Period, these oppressed subjects appear in paintings, in which blue tones predominate. In his Rose Period (Fig. **15.22**), from 1904 to 1906, he became more concerned with make-believe, which he expressed as portraits of circus performers, than with the tragedy of poverty. *Les Demoiselles d'Avignon* (Fig. **15.23**) has become the single most discussed image in modern art. Its simplified forms and restricted color were adopted by many cubists, as they reduced their palettes in order to concentrate on spatial exploration. A result of personal conflicts on the part of the artist, combined with his ambition to be recognized as the leader of the **avant-garde**, the painting deliberately breaks with the traditions of Western illusionistic art. The painter denies both classical proportions and the organic integrity and continuity of the human body.

Les Demoiselles d'Avignon (Avignon in the title refers to a street in Barcelona's red-light district) is aggressive and harsh, like the world of the prostitutes who inhabit it. Forms emerge simplified and angular, and colors remain restricted to blues, pinks, and terracottas. Picasso breaks his subjects into angular wedges which convey a sense of three-dimensionality. We do not know whether the forms protrude out or recess in. In rejecting a single viewpoint, Picasso presents "reality" not as a mirror image of what we see in the world, but as images reinterpreted within the terms of new principles. Understanding thus depends on knowing rather than seeing. The large canvas measures 8 feet by 7 feet 8 inches (2.44 × 2.34 meters)—and its effect suggests great violence.

Like Picasso, Braque took a new approach to spatial construction and reduced objects to geometric shapes, drawing upon the ideas of Cézanne. Braque's geometric forms first inspired the term "cubist." Unfortunately, the label has led many observers to look for solid cubic shapes rather than for a new kind of space "which was only visible when solid forms became transparent and lost their rigid cubical contours."[1]

Mechanism and Futurism

Themes dealing with mechanism proved popular in the early twentieth century, as life became more and more dominated by machines. A brief movement in Italy, mechanism, sought to express the spirit of the age by capturing speed and power through representation of vehicles and machines in motion. Mechanistic themes appear clearly in the works of Marcel Duchamp (doo-SHAWM; 1887–1968), often associated with the **Dada** movement (Chapter 16) and whose famous *Nude Descending a Staircase, No. 2* (Fig. **15.24**) some call

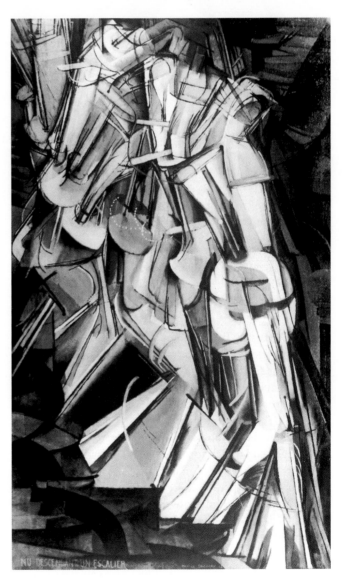

15.24 Marcel Duchamp, *Nude Descending a Staircase, No. 2*, 1912. Oil on canvas, 58 × 35 ins (147 × 89 cm). Philadelphia Museum of Art (Louise and Walter Arensberg Collection). © Succession Marcel Duchamp/ADAGP, Paris and DACS, London 2005.

found in the noise, speed, and mechanical energy of the modern city a unique exhilaration that made everything of the past drab and unnecessary. The movement was particularly strong in Italy and among Italian sculptors. In searching for new dynamic qualities, the Italian futurists in the visual arts found that many new machines had sculptural form. Their own sculptures followed mechanistic lines and included representations of motion.

Umberto Boccioni's (boh-CHOH-nee) *Unique Forms of Continuity in Space* (Fig. **15.25**) takes the mythological subject of Mercury, messenger of the gods (compare Bologna's *Mercury*, Fig. **10.24**), and turns him into a futuristic machine. We recognize the overall form and the outlines of the myth move our thoughts in a particular direction. Nonetheless, this remains primarily an exercise in composition. The intense sense of energy and movement results from the variety of surfaces and curves that flow into one another in a seemingly random, yet highly controlled, pattern. The work creates an overall impression of the motion of the figure rather than of the figure itself.

Expressionism

"Expressionism" traditionally refers to a movement in Germany between 1905 and 1930. Broadly speaking,

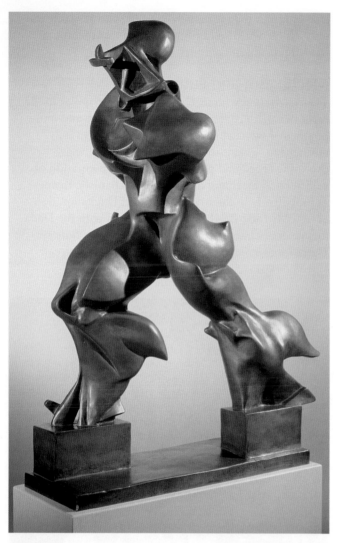

15.25 Umberto Boccioni, *Unique Forms of Continuity in Space*, 1913. Bronze (cast 1931), 3 ft 7⅞ ins (1.1 m) high. Tate Gallery, London.

"proto-Dadaist." To Duchamp, apparently, men and women were machines that ran on passion as fuel. Like those of the Dadaists, many of Duchamp's works also exploit chance and accident.

Sculptors now turned to further explorations of three-dimensional space and what they could do with it. Technological developments and new materials also encouraged the search for new forms to characterize the age. This search resulted in a style called "**futurism**," which constituted really more of an ideology than a style. Futurism encompassed more than just the arts, and it sought to destroy the past—especially the Italian past—in order to institute a totally new society, a new art, and new poetry. Its basis lay in "new dynamic sensations." In other words, the objects of modern life, such as "screaming automobiles" that run like machine guns, have a new beauty—speed—more beautiful than even the most dynamic objects of previous generations. Futurists

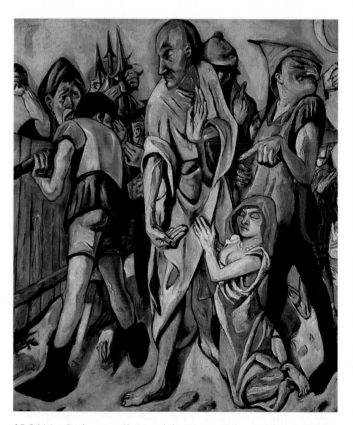

15.26 Max Beckmann, *Christ and the Woman Taken in Adultery*, 1917. Oil on canvas, 4 ft 10¼ ins × 4 ft 1⅛ ins (1.49 × 1.27 m). Saint Louis Art Museum (Bequest of Curt Valentin). © DACS 2005.

however, it includes a variety of approaches, mostly in Europe, that aimed at eliciting in the viewer the same feelings the artist felt in creating the work—a sort of joint artist/viewer response to elements in the work of art. Any element—line, form, color—might be emphasized to elicit this response. The subject matter itself did not matter. What mattered was that the artist consciously tried to stimulate in the viewer a specific response similar to his or her own. The term **expressionism** as a description of this approach to visual art and architecture first appeared in 1911. It emerged following six years of work by an organized group of German artists who called themselves *Die Brücke* (dee brook-uh; "The Bridge"). Trying to define their purposes, the painter Ernst Ludwig Kirchner (KIRSH-nur; 1880–1938) wrote: "He who renders his inner convictions as he knows he must, and does so with spontaneity and sincerity, is one of us." They intended to protest against academic naturalism. They used simple media such as woodcuts and created often brutal, but nonetheless powerful effects that expressed inner emotions.

The early expressionists maintained **representationalism** to a degree, but later expressionist artists, for example those of the Blue Rider group between 1912 and 1916, created some of the first completely abstract or **nonobjective** works of art. Color and form emerged as stimuli extrinsic to subject matter, and without any natural spatial relationships of recognizable objects, paintings took a new direction in internal organization.

In Max Beckmann's *Christ and the Woman Taken in Adultery* (Fig. **15.26**), the artist's revulsion against physical cruelty and suffering transmits through distorted figures crushed into shallow space. Linear distortion, changes of scale and perspective, and a nearly Gothic spirituality communicate Beckmann's reactions to the horrors of World War I. In this approach, the meaning of the painting—the painter's meaning—transmits by very specific visual communication.

Fauvism

Closely associated with the expressionist movement was the style of the *fauves* (the French word for "wild beasts"). The label appeared in 1905 from a critic in response to a sculpture which seemed to him "a Donatello in a cage of wild beasts." Violent distortion and outrageous coloring mark the work of the fauves, whose two-dimensional surfaces and flat color areas were new to European painting.

The best-known artist of this short-lived movement, Henri Matisse (mah-TEES; 1869–1954), tried to paint pictures that would "unravel the tensions of modern existence." In his old age, he made a series of very joyful designs for the Chapel of the Rosary at Venice, not as exercises in religious art but as expressions of joy and the nearly religious feeling he had for life.

The *Blue Nude* (Fig. **15.27**) illustrates the wild coloring and distortions in the paintings of Matisse and the other fauves. The painting takes its name from the energetically applied blues, which occur throughout the figure as dark accents. For Matisse, color and line comprised indivisible devices, and the bold strokes of color in his work both reveal forms and stimulate a purely aesthetic response. Matisse literally "drew with color." He did not intend, of course, to draw a nude as he

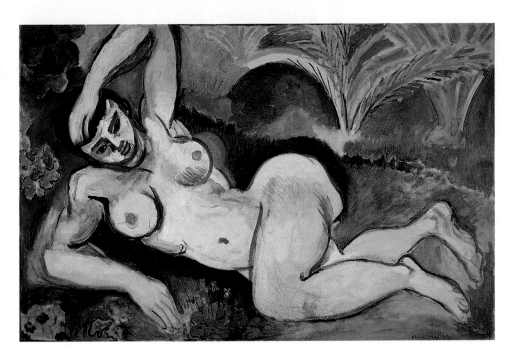

15.27 Henri Matisse, *Blue Nude* (*Souvenir de Biskra*), 1907. Oil on canvas, 3 ft ¼ in × 4 ft 7¼ ins (92.1 × 140.4 cm). Baltimore Museum of Art (The Cone Collection, formed by Dr Claribel Cone and Miss Etta Cone of Baltimore, Maryland). © Succession H. Matisse/DACS 2005.

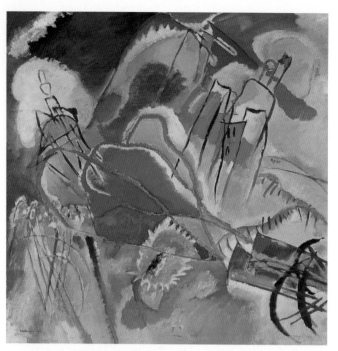

15.28 Vasily Kandinsky, *Improvisation No. 30 (Warlike Theme),* 1913. Oil on canvas, 43¼ × 43¾ ins (109.8 × 111 cm). The Art Institute of Chicago (Arthur Jerome Eddy Memorial Collection). © ADAGP, Paris and DACS, London 2005.

saw it in life. Rather, he tried to express his feelings about the nude as an object of aesthetic interest. Thus Matisse, along with the other fauve painters, represents one brand of expressionism, along with others, including the Bridge and Blue Rider groups, and artists such as Kandinsky (kuhn-DEEN-skee; Fig. **15.28**), Rouault (roo-OH), and Kokoschka (koh-KOHSH-kuh).

Architecture

A new age of experimentation also took nineteenth-century architects in a different direction—upward. The skyscraper arose in response to the need to create additional commercial space on the limited land space in burgeoning urban areas. Burnham and Root's Monadnock Building in Chicago (Fig. **15.29**) serves as an early example. Although this prototypical "skyscraper" is all masonry—that is, it is built completely of brick and requires increasingly thick supportive walls toward its base—it formed part of the trend in architecture to combine design, materials, and new concepts of space.

When all these elements finally combined, the skyscraper emerged, almost exclusively in America. Architects erected buildings of unprecedented height without increasing the thickness of lower walls by using

structural frameworks—first of iron, later of steel—and by treating walls as independent partitions. Each story rested on horizontal girders. The concept of the skyscraper could not be realized comfortably, however, until the invention of a safe and reliable elevator.

One of the most influential figures in the development of the skyscraper and philosophies of modern architecture was Louis Sullivan (see Profile, opposite), the first truly "modern" architect. Working in the last decade of the nineteenth century in Chicago, then the most rapidly developing metropolis in the world, Sullivan designed buildings of great dignity, simplicity, and strength. Most important, however, he created a rubric for modern architecture with his theory that form flowed from function. As Sullivan said to an observer of the Carson, Pirie, and Scott building (Fig. **15.30**): "It is evident that we are looking at a department store. Its purpose is clearly set forth in its general aspect, and the form follows the function in a simple, straightforward way."

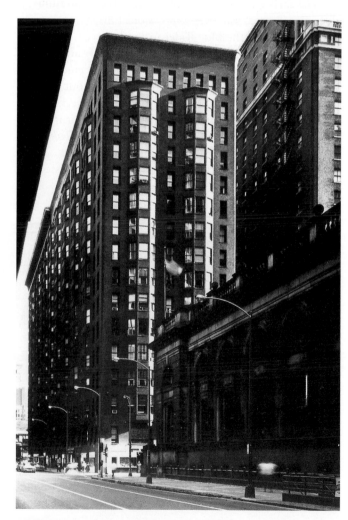

15.29 Daniel Hudson Burnham and John Wellborn Root, the Monadnock Building, Chicago, 1889–91.

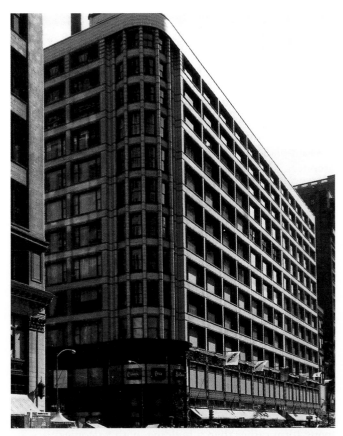

15.30 Louis Henry Sullivan, Carson, Pirie, and Scott Department Store, Chicago, 1899–1904.

In the 1890s and early 1900s a "new" art phenomenon occurred in Europe. Called "New Art" or **Art Nouveau** (ahrt noo-VOH), it grew out of the English **Arts and Crafts Movement**, emerging initially in response to a world's fair, the Paris Universal Exposition of 1889. Encompassing art, architecture, and design, Art Nouveau comprised a variety of examples, but typically it reflected the lively, serpentine curve known as the "whiplash." Overall, the style pursued a fascination with plant and animal life and organic growth. The influence of Japanese art rests in evidence in Art Nouveau's undulating curves. In addition, the style incorporates organic and often symbolic motifs, treating them in a linear, relief-like manner. Turning to the Paris Universal Exposition, the story of Art Nouveau emerges: the fair's best known example, the Eiffel Tower, designed by a civil engineer, Gustave Eiffel (1832–1923), comprised the winning entry in a contest for a monument to symbolize French industrial progress. At 984 feet (300 meters), the tower stood as the tallest structure in the world at that time, with its iron latticework resting on four huge legs reinforced by trussed arches similar to those Eiffel had used on his railroad bridges. The Eiffel Tower raised great concern in many quarters about its influence on the

PROFILE

LOUIS SULLIVAN (1856–1924)

Born in Boston, Louis Sullivan became one of the leaders in modern architectural design in the United States. He studied briefly at the Massachusetts Institute of Technology and worked for W. le Baron Jenney, an architectural pioneer in the use of the steel skeleton type of building construction, before finishing his education at the École des Beaux-Arts in Paris.

At age twenty-five, Sullivan entered into a partnership with the engineer Dankmar Adler (1844–1900) in Chicago, and the next fourteen years, in partnership with Adler, proved the most productive period of Sullivan's career. Between 1886 and 1890 he redesigned the interior of the huge masonry Auditorium building in Chicago, and over the next four years, Sullivan designed two buildings—the Wainwright Building in St Louis and the Guaranty Building in Buffalo—in which he initiated a new set of aesthetics for tall, steel-frame office buildings.

Sullivan rejected historic styles and proposed organically designed buildings as expressive of their nature and function as living things are of theirs, and his philosophy was summarized in the phrase "form follows function." His pioneering work made him the father of the modern skyscraper, and, although his designs thrust upward in vertical composition, he embellished them with lively, plantlike ornament very much like Art Nouveau (noo-VOH).

By 1893, however, his star had begun to fade. His colorful Transportation Building at the Columbian Exposition of that year brought little praise, and at the same time, the country experienced a depression, and Sullivan ended his partnership with Adler. Uncompromising in attitude, Sullivan received very few commissions after the dissolution of the partnership. Nonetheless, he built the Carson, Pirie, and Scott Department Store in Chicago (1899–1904; see Fig. **15.30**), replete with strong verticals and horizontals contrasting with lush cast iron foliage, and he also designed a few midwestern banks. He died in poverty in Chicago on 24 April 1924, but his influence continued in the twentieth century, principally through the success of his young pupil Frank Lloyd Wright.

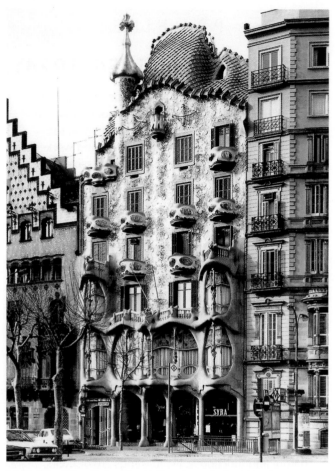

15.31 Antoni Gaudí, Casa Battló, Barcelona, Spain, 1904–06.

1867–1942), whose many works include the famous entrance portals for the Paris Métro (subway). In Spain, the man perhaps best remembered as a champion of the style, Antoni Gaudí (gow-DEE; 1852–1926), transformed its characteristics into remarkable constructions that, perhaps, represent not Art Nouveau but a unique style of their own. Gaudí's approach took architecture in an astonishing direction: that of hand-crafted buildings made without plans other than what resided in the head of the architect, and this effect clearly resonates from Casa Batlló (Fig. **15.31**).

Born in Reus, Spain, the son of a coppersmith, Antonio Gaudí studied at the Escola Superior d'Arquitectura in Barcelona and designed his first major commission for the Casa Vincens in Barcelona using a Gothic Revival style that set a precedent for his future work. As his career developed Gaudí emphasized more and more the sensuous, curving design that made him the leading exponent of the Spanish Art Nouveau movement. In what appears like complete whimsy, Gaudí juxtaposes unrelated forms and systems to confuse the established visual order. Casa Battló, aside from having seven recognizable stories, nearly defies description. Its evocative curves and nearly surreal textures create a language all their own. The building seems almost a living form rather than a building, with balconies that remind the viewer of childhood fantasies and cookie constructions.

Theatre

Realism and Naturalism
In line with trends in the other arts, a conscious movement toward realism in the theatre emerged around the middle of the nineteenth century, and by 1860 dramatic literature strove for truthful portrayal. Realists stressed objectivity and knowledge of the real world as possible only through direct observation. (Corot's and Manet's approaches to painting stressed a similar viewpoint, as did writers such as Dostoyevski and Kate Chopin [see Literature section].) Thus, everyday life, with which the playwright was directly familiar, became the subject matter of drama. Interest shifted from the past to human motives and experience, or, more likely, idealized versions of these. Exposure to such topics on the stage did not prove particularly pleasant, and many play-goers objected that playwrights turned the theatre into a "sewer or a tavern." Playwrights countered the criticisms by saying that the way to avoid such ugly depictions on the stage was to change society.

The acknowledged master of realist drama, Norway's Henrik Ibsen (1828–1906), built powerful problem-dramas around carefully selected detail and plausible

future of art in conjunction with the industrial age. Art Nouveau constituted one response. It sought to reflect modernism but to do so without losing a pre-industrial sense of beauty. As a consequence, the use of organic forms and traditional materials such as wood and stone emerged.

The issues addressed by Art Nouveau ranged beyond the borders of France. In fact, a Belgian, Victor Horta (1867–1947), launched the style. It spread throughout Europe, recognized by a variety of names in various countries: in Italy, *Stile floreale* ("floral style") and *Stile Liberty* (after the Liberty Department Store in London); in Germany, *Jugenstil* ("Youth Style"); in Spain, *Modernismo* (Modernism); in Vienna, *Secessionsstil* (after the secession from the Academy led by Gustave Klimt); in Belgium, *Paling Style* ("Eel Style"), and in France, a number of names including *moderne*. Eventually the name Art Nouveau settled on the movement after a shop in Paris (La Maison de l'Art Nouveau) that opened in 1895.

In France, where in Paris and Nancy the style proliferated, it had the name *Style Guimard* after its leading practitioner, Hector Guimard (ghee-MAHR;

character-to-action motivations. His plays usually bring to conclusion events that began well in the past, with meticulous exposition. Ibsen's concern for detail carries to the scenery and costumes, and his plays contain detailed descriptions of settings and properties, all of which are essential to the action. The content of many of Ibsen's plays was controversial, and most deal with questions about moral and social issues that remain difficult today. In his late plays, however, Ibsen abandoned realism in favor of symbolist experiment.

Realism spread widely, finding expression in the work of Anton Chekhov (CHEHK-hawf; 1860–1904), although, like Ibsen, Chekhov incorporates symbolism into his works. Many people regard him as the founder of modern realism. He drew his themes and subject matter from Russian daily life, and they provide accurate portrayals of frustration and the depressing nature of existence. His structures flow in the same apparently aimless manner as the lives of his characters. While short on theatricality and compact structure, his skillfully constructed plots give the appearance of actuality.

His masterpiece, *Uncle Vanya* (1897), provides deep insights into aimlessness and hopelessness. Uncle Vanya (Ivan Voynitsky) endures bitter disappointment when he realizes he has wasted his life tending to the business affairs of his former brother-in-law (Serebryakov), a second-rate academic. Meanwhile, Sonia, Serebryakov's daughter and Vanya's assistant, carries the torch of unrequited love for a local doctor. Vanya tries to shoot Serbryakov but misses. The play moves on, and nothing changes. Vanya cannot give up the work to which he has devoted his life, regardless of that work's meaninglessness.

The Irish writer George Bernard Shaw (1856–1950) embodied the spirit of nineteenth-century realism, although his career overlapped the nineteenth and twentieth centuries. This witty, brilliant artist stood above all a humanitarian, and although many Victorians considered him a heretic and a subversive (because of his devotion to socialism), his faith lay in humanity and its infinite potential.

Shaw's plays deal with the unexpected, and they often appear contradictory and inconsistent in characterization and structure. In his favorite device he built up a pompous notion and then destroyed it. For example, in *Man and Superman*, when a respectable Victorian family learns that their daughter is pregnant, they react with predictable indignation. A character who appears to speak for the playwright comes to the girl's defense, attacking the family's hypocrisy and defending the girl. She, however, explodes in anger, not against her family, but against her defender. She had been secretly married all the time, and, as the most respectable of the lot, she condemns her defender's (and possibly the audience's) freethinking.

Shaw opposed the doctrine of "art for art's sake," and he insisted that art should have a purpose. He believed that plays made better vehicles for social messages than speeches or pamphlets. Although each play usually has a character who acts as the playwright's mouthpiece, Shaw does more than sermonize. His characters probe the depths of the human condition, often discovering themselves through some lifelike crisis.

Naturalism, a style closely related to realism, also flourished in the same period. Émile Zola (1840–1902), a leading proponent, proved more a theoretician and novelist than a playwright. Both realism and naturalism insisted on a truthful depiction of life, but naturalism went on to insist on the basic principle that heredity and environment determine behavior. Absolute objectivity, not personal opinion, formed naturalism's goal.

Symbolism

Late in the nineteenth century, and very briefly, an anti-realistic literary movement called "symbolism," also known as "neo-Romanticism," "idealism," or "impressionism" arose. The **symbolist movement** found brief popularity in France, and has recurred occasionally in the twentieth century. Symbolism avows that we grasp truth only by intuition, not through the senses or rational thought. Thus, ultimate truths can be suggested only through symbols, which evoke in the audience various states of mind that correspond vaguely with the playwright's feelings.

One of the principal dramatic symbolists, the Belgian Maurice Maeterlinck (mah-tur-LANK; 1862–1949), believed that every play contains a "second level" of dialogue that speaks to the soul. Through verbal beauty, contemplation, and a passionate portrayal of nature, great drama conveys the poet's idea of the unknown. Therefore, plays that present human actions can only, through symbols, suggest higher truths gained through intuition. The symbolists did not deal at all with social problems. Rather, they turned to the past and tried to suggest universal truths independent of time and place, as Maeterlinck did, for example, in *Pelléas and Mélisande* (1892).

Expressionism

We have seen expressionism at work in the visual arts, and later we will see it at work in literature and cinema. Now we examine it in theatre. As always seems the case, visual art styles filter slowly into the theatre. The painter's expressionistic revolt against naturalism translated to the theatre most effectively in scenic design. For playwrights, expressionism proved merely an extension of realism

or naturalism, but it allowed them to express their reactions to the universe more fully. August Strindberg (1849–1912), for example, turned inward to the subconscious mind (see Freudian Psychology, p. 487) in expressionistic plays such as *The Ghost Sonata* (1907). In so doing, he created a "presentational" rather than "representational" style.

The plays of Ernst Toller (TAHW-luhr; 1893–1939) typify German expressionistic disillusionment after World War I. Toller's personal struggles, his communist idealism, and his opposition to violence reflect in the heroine of *Man and the Masses* (1923). Sonia, a product of the upper class, leads a strike for peace. Her desire to avoid violence and bloodshed puts her at odds with the mob spirit (the "Nameless One"), who seeks just those results, and to destroy the peace the strike intends to achieve. Sonia suffers imprisonment and a death sentence for leading the disastrous strike.

Expressionism also found its way to America. Elmer Rice's *Adding Machine* (1923) introduces the viewer to Mr Zero, a cog in the great industrial machinery of twentieth-century life, who stumbles through a pointless existence. Finding himself replaced by an adding machine, he goes berserk, kills his employer, and is executed. Adrift in the hereafter, his narrow-mindedness makes it impossible for him to understand the happiness offered to him there. He becomes an adding machine operator in heaven.

Eugene O'Neill (1888–1953), one of America's greatest playwrights, created plays that encompassed a variety of genres, themes, and styles. One drama, *The Hairy Ape* (1922), further exemplifies expressionism. Written in eight scenes, it reveals the story of Yank Smith, a brutish coal stoker on a transatlantic ocean liner. Yank despises and bullies everyone around him, believing himself superior to all. On the ship, a beautiful millionaire's daughter sees Yank and recoils from him, finding him and his brutish ways thoroughly repulsive. Devastated, Yank vows revenge. When the ship reaches New York, Yank plots to destroy the factory owned by the girl's father. His plans fail, however. Wandering into a zoo, feeling deep alienation from humanity, Yank releases an ape, for whom Yank feels kinship, from its enclosure. The ape promptly kills him.

O'Neill wrote from an intensely personal point of view that appeared driven by his own tragic and angry family relationships: his father (a famous actor) and his mother both loved and tormented each other; his older brother died young from the effects of alcoholism, tormenting Eugene in the process. His plays explored what at the time constituted revolutionary techniques—such as expressionistic dialogue and spoken asides—that the theatre later adopted as standard.

Music

Impressionism

The anti-Romantic spirit also produced a style of music analogous to that of the impressionist painters. A free use of chromatic tones marked later nineteenth-century style, even among the Romantics. However a parting of the ways occurred, the effects of which still permeate contemporary music. Some composers made free use of chromatic harmony and key shifts but stayed within the parameters of traditional major/minor tonality. Others rejected traditional tonality completely, and a new **atonal** harmonic expression came into being. This rejection of traditional tonality led to impressionism in music.

Impressionist music can best be found in the work of its primary champion, the Frenchman Claude Debussy (deh-BYOO-see; 1862–1918), although he did not like to be called an "impressionist"—the label, after all, had been coined by a critic of the painters and was meant to be derogatory. He associated with the symbolist poets and created fleeting moods and gauzy atmospheres. Debussy maintained that he represented "an old Romantic who has thrown the worries of success out the window," and he sought no association with the painters. We can, however, draw similarities. His use of tone color has been described as "wedges of color," much like those the painters provided with individual brushstrokes. Oriental influence also appears, especially in Debussy's use of the Asian six-tone scale. He wished above all to return French music to fundamental sources in nature and move it away from the heaviness of the German tradition. He delighted in natural scenes, as did the impressionist painters, and he sought to capture the effects of shimmering light in music.

Unlike his predecessors, Debussy reduced melodic development to limited short motifs, and in perhaps his greatest break with tradition he moved away from traditional progressions of chordal harmonies. Debussy considered a chord strictly on the merits of its expressive capabilities, apart from any idea of tonal progression within a key. As a result, gliding chords—the repetition of a chord up and down the scale—became a hallmark of musical impressionism. **Dissonance** and irregular rhythm

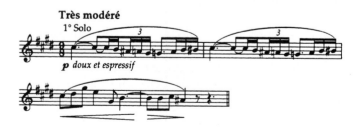

15.32 Claude Debussy, *Prelude to The Afternoon of a Faun*, opening theme.

and meter further distinguish Debussy's works. Here, again, form and content subordinate to expressive intent. His works suggest rather than state, leaving the listener only with an impression, perhaps even an ambiguous one.

Freedom, flexibility, and nontraditional timbres mark Debussy's compositions, the most famous of which, *Prélude à l'après-midi d'un faune* ("Prelude to The Afternoon of a Faun"; a faun is a mythological creature with the body of a man and the horns, ears, tail, and sometimes the legs, of a goat), based on a poem by Mallarmé (mah-larh-MAY), uses a large orchestra, with emphasis on the woodwinds, most notably in the haunting theme running throughout (Fig. **15.32**). Two harps also play a prominent part in the texture, and antique cymbals are used to add an exotic touch near the end. Although freely ranging in an irregular ⁹⁄₈ meter and having virtually no tonal centers, the *Prélude* does have the traditional ABA structure. On a more subdued scale, we find Debussy's tonal colorings and gliding chords evident and combined with a simple visual image in the easily accessible piece, *Claire de Lune* ("Moonlight").

Naturalism

Romanticism in all the arts saw many counter-reactions, and late nineteenth-century opera proved no exception. In France, an anti-Romantic movement called "naturalism" developed. It opposed stylization, although it maintained exotic settings, and included brute force and immorality in its subject matter. The best operatic example of naturalism is Georges Bizet's (bee-ZAY) *Carmen* (1875). Unlike earlier Romantic operas, *Carmen* employs a prose rather than poetic text. Set in Spain, it portrays its scenes naturalistically with colorful and concise music. The libretto comes from a literary classic, a story by Prosper Mérimée, whose heroine, Carmen, a seductive employee in a cigarette factory in nineteenth-century Seville (Fig. **15.33**), flirts with Don José, a soldier, and so enraptures him that he deserts from the army to follow her to her haunt, a disreputable tavern, and then to a mountain pass where gypsy smugglers have their hideout. Carmen soon tires of Don José, however, and becomes interested in the toreador Escamillo. On the day of a bullfight in Seville, Carmen arrives with Escamillo, welcomed as a hero. After Escamillo enters the bullring, Don José appears, dishevelled and distraught. He pleads with Carmen to return to him, and when she refuses, he stabs her with a dagger. Emerging from his bullfight, Escamillo finds Don José weeping over Carmen's dead body.

Carmen began as *opéra comique*. When Bizet first wrote his score, he used spoken dialogue, and so *Carmen* opened at the Opéra-Comique in Paris on 3 March 1875, and, incidentally, still plays that way in that house. Elsewhere, however, recitatives prepared by another composer replaced the dialogue. As we now hear it, *Carmen* differs in a further way from its introduction—today a number of ballet sequences, using background music from other Bizet compositions, are interpolated. As an *opéra comique* in 1875, *Carmen* had no ballets.

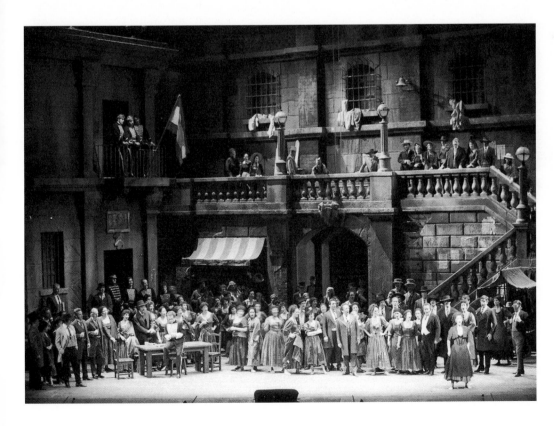

15.33 Georges Bizet, *Carmen*, 1875. José Carreras as Don José and Agnes Baltsa as Carmen in this 1986–7 New York production.

Carmen herself comprises a fascinating character. Bizet uses her as a symbol of "Woman," and every passage he gave her to sing represents a new mask, mirroring the man she addresses. Bizet's sympathetic portrayal shows uncanny naturalism in her change of tone as she addresses the passers-by, José, the smugglers, and Escamillo. To each of the men she seems a different woman, changing the sound of her voice, the character of her melody, her mood, her tempo.

Much in *Carmen* disturbed audiences in 1875. The vivid portrayal of a character as immoral as Carmen shocked them. Never before had an opera presented girls onstage smoking cigarettes, and some listeners objected to the music, thinking it too Wagnerian, because Bizet assigned such importance to the orchestra and occasionally used a *Leitmotif* technique. Nevertheless, *Carmen* was by no means the total failure that some of Bizet's early biographers suggested. Some critics hailed it, a publisher paid a handsome price for the publication rights, and the opera company kept it in its repertory the following season.

Bizet's naturalism was similar to that of Italian *verismo* (vair-EEZ-moh) opera, which emerged at the turn of the twentieth century. The spirit of *verismo*—of **verisimilitude** or true-to-life settings and events—shows the same hot-blooded vitality implicit in Pietro Mascagni's statement about his new opera *Il Piccolo Marat* (1921): "I have written the opera with clenched fists, like my spirit! Do not look for melody; do not look for culture: in *Marat* there is only blood!" The works of Mascagni, Puccini (poo-CHEE-nee; Fig. **15.34**), Leoncavallo (lay-ohn-kah-VAHL-loh), and others exemplify this *verismo* tradition in musical drama, which concentrates on the violent passions and common experiences of everyday people. Adultery, revenge, and murder form frequent themes. Mascagni's *Cavalleria Rusticana*, Leoncavallo's *I Pagliacci*, and to some extent Puccini's *Tosca* represent the best-known examples of this style.

Nontraditionalism

If painting and sculpture took a path that diverged radically from their heritage, so did music. Its new directions parted with past traditions in three ways.

The first was rhythmic complexity. Since the Middle Ages, tradition had emphasized the grouping of beats together in rhythmic patterns, called "meter." The characteristic accents of double and triple meters helped to unify and clarify compositions, as well as to give them certain flavors. For example, triple meter, with its one-two-three, one-two-three accent patterns, created lilting dance rhythms, which the waltz characterized. The alternating accents of double meter, one-two, one-two, or one-two-three-four, suggested the regularity of a march. But modern composers did away with these patterns and the regularity of accents, choosing instead to employ complex, changing rhythms which virtually obscure meter, or even the actual **beat**.

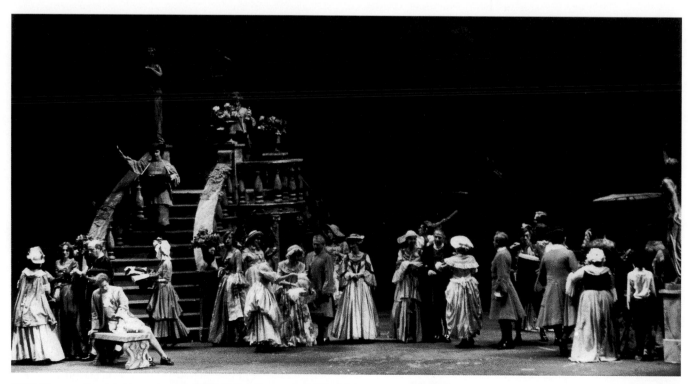

15.34 Giacomo Puccini, *Manon Lescaut*, 1893. Opera Company of Philadelphia.

PROFILE

IGOR STRAVINSKY (1882–1971)

The son of an opera singer, Igor Stravinsky responded early in life to his musical surroundings. He started to compose before he had received any formal training, but when he began studying music in his early twenties, he did so with a master, the renowned Russian composer Nikolai Rimsky-Korsakov (1844–1908).

Born near St Petersburg, Russia, Stravinsky developed an early affinity for Russian folk music. Before age thirty, he had written his ballet score *The Firebird* (1910). Two more ballets followed in quick succession—*Petrushka* in 1911 and *The Rite of Spring* in 1913. His use of dissonance, complexity, and changing rhythms in the latter separated Stravinsky from all previous traditions and placed him in the vanguard of modern music.

He left Russia before World War I and lived in France, where he wrote a variety of compositions, including *The Soldier's Tale* (1918). An interest in religion emerges in the 1930 *A Symphony of Psalms*.

In 1939 Stravinsky left France and moved to the United States, where he became a citizen in 1945. This change in citizenship appears to have marked a change in his interest in Russian folklore, as well. When in his seventies, he began to experiment with the twelve-tone method of composition. By the time of his death in 1971, Stravinsky's influence on contemporary music had reached legendary status in Europe, Britain, and the United States. Stravinsky moved musical mountains, combining drama, ballet, art, and music, and, thus, laid a foundation for a culmination of the arts for the twentieth century.

The second change consisted of a focus on dissonant harmonies. Before the late nineteenth century, **consonance** provided the norm, and dissonances were expected to be brief and passing, then return to consonance. In the late nineteenth century significant tampering with that principle occurred, however. By the twentieth century, composers used more and more dissonance, without necessarily resolving it.

A third change involved a rejection of traditional **tonality**, or sense of key, altogether. Traditional thinking held that one note, the *doh*, or tonic, of a scale, was the most important. All music was composed in a specific key. Modulations into distant or related keys occurred, but the tonic of the basic key served as the touchstone to which everything related. Many composers now chose to pursue other paths. One rid music of any tonal center. Thus, no one tone had more importance than the others. All twelve semitones of the chromatic scale in effect became equal. The systems that resulted from this new tonality were called **twelve-tone** composition.

Another path, of German-Italian influence, built upon the works of Richard Wagner and was called the "cosmopolitan" style. The principal composer in this group was César Franck (frahnk; 1822–90). The works of Camille Saint-Saëns (ka-MEE san-SAHNS; 1835–1921) represent the more classically oriented style that continued into the twentieth century.

The French composer Maurice Ravel (rah-VEL; 1875–1937) began as an impressionist, but his style became more and more classical as years went by. Even in his earlier works, however, Ravel did not adopt Debussy's complex sonorities and ambiguous tonal centers. Ravel's *Boléro* (1928) exhibits strong primitive influences and the relentless rhythm of certain Spanish dance music. More typical works of Ravel—for example, his Piano Concerto in G—use Mozart and traditional classicism as their models. Thus, some composers stayed completely within established neoclassical conventions of Western music well into the twentieth century.

Another nontraditionalist, Igor Stravinsky (struh-VIN-skee; 1882–1971), came to prominence with *The Firebird* (1910). *The Rite of Spring* (1912–13) created an even greater impact. Stravinsky wrote both works for the ballet. *The Firebird*, a commission for the Russian impresario Serge Diaghilev, premièred successfully at the Paris Opéra. Another commission, *The Rite of Spring*, created a riot because of its revolutionary orchestrations and driving, primitive rhythms.

Why was *The Rite of Spring* so controversial? The third of his ballet commissions for Diaghilev, subtitled "Pictures of Pagan Russia," it depicts the cruel rites of spring that culminate in the sacrifice of a virgin, who dances herself to death accompanied by frenetic music. Those compelling rhythms give the work its impressive character. Rapid, irregular mixtures of very short note values create an almost intolerable tension, or at least a tension intolerable to the public of that day. The melodic material is quite unconventional—short driving motifs

that stop short of thematic fulfillment. Such melodies as exist remain short and fragmentary.

The movement that drew the most attention in the first half of the twentieth century grew out of German Romanticism, but it took a radical turn into atonality. At the root of the movement was Arnold Schoenberg (SHURN-bairk; 1874–1951). Between 1905 and 1912 Schoenberg moved away from the gigantic post-Romantic works he had been composing and began to adopt a more contained style, writing works for smaller ensembles, and treating instruments in a more individual manner. His orchestral works of this period display swiftly alternating timbres, in contrast with the massive orchestral texture of his earlier works. They also employ increased complexity in their rhythms, harmonies, and fragmented melodies.

Although the word "atonality," meaning without tonality, describes Schoenberg's works, he preferred the term "pantonality"—inclusive of all tonalities. In his compositions Schoenberg used any combination of tones without having to resolve chord progressions, a concept he called "the emancipation of dissonance."

Jazz

Undoubtedly the most significant African American contribution to American music, and, in turn, a uniquely American contribution to the world of music, jazz began near the turn of the century, and from there went through many changes and forms. Jazz includes many sophisticated and complicated styles, but all of them feature improvised variations on a theme.

The earliest form, *blues*, went back to the rhythmic music of the slaves, and consisted of a repeated line, with a second, concluding line (AAB). This was music of oppression, and early singers, such as Bessie Smith (1894–1937), evoked an emotional quality which the instruments tried to imitate.

At approximately the same time came ragtime, a piano style with a strict, two-part form. Syncopation played an important role in this style, whose most famous exponent was Scott Joplin (1868–1917). New Orleans, the cradle of jazz, also produced traditional jazz, which featured improvisational development from a basic, memorized chordal sequence. Later, in the thirties and forties came swing, bebop, and cool jazz.

Dance

Ethnic Foundations

At this point we must pause in our heretofore chronological development of what we call *theatre dance* to inject a brief examination of *ethnic* and *folk* dance (see the Introduction). The need for a diversion occurs because at the point in history treated by the current chapter, the folk tradition emerged as a fundamental element in dance directions for the twentieth century.

An expression in rhythmic movement, dance can represent an individual experience, a group experience, and also a cultural mirror. When dance as a simple emotional expression develops into a design—a planned pattern of rhythms, steps, gestures, and so on—it becomes a specific dance. Several dances of the same type become a dance form such as ballet. In general, we can divide dance into two broad categories, *communal dance* and *theatre dance*, and we have already seen how the former can develop into the latter. The dance we discussed relative to ancient Greece reflected more a communal type of dance called *ritual dance*, a planned and conscious effort organized for a specific purpose. Later, in Renaissance France, we saw how another form of communal dance, *social dance*, actually became a form of theatre dance, the ballet. A third type of communal dance, which we discussed in the introduction, called *folk dance*, predominated in the Middle Ages.

We might see folk dance as the basis of all other dance forms, including ballet and *modern dance*, which we discover emerging momentarily. Intermingling with folk dance, and technically a variant, is *ethnic* dance. Both folk and ethnic dance share peasant culture origins, but ethnic dance reflects more selectivity and artistic consciousness than folk dance. Perhaps the oldest and most illustrative example of ethnic dance in the West, a theatre dance form that has retained its folkloric base, *Spanish* dance exhibits a physical expression of the sensuality of love and its passions. In Spanish dance, the footwork takes center stage: the striking of the toe, the heel, and the full sole in a variety of tonic and rhythmic combinations, accented by clicking castanets and guitar. Proud carriage of the head and torso, as much as movements, project essential emotions. Ethnic and folk traditions such as Spanish dance—and, indeed, many others—played a vital role in the emergence of much of twentieth-century dance, beginning with the Russian traditions of Diaghilev's *Ballets russes* (bah-LAY roos).

Ballet

Two major revolutions in dance occurred in the early twentieth century. Sergei Diaghilev (DYAH-gee-lef; 1872–1929) largely created one of them. When Diaghilev arrived in St Petersburg, Russia, in 1890 to study law, he soon became friends with several artists. In 1898, Diaghilev's artist friends launched a new magazine, *World of Art*, and appointed him editor. His entrepreneurial and managerial talents made the venture a success.

Thus began a career in artistic management that would shape the ballet world of the twentieth century. In producing outstanding works that employed the finest

choreographers, Diaghilev played a tremendously important role in bringing the art of Paris and Munich to Moscow and St Petersburg and vice versa.

Once Diaghilev had successfully produced opera outside of Russia, he took Russian ballet to Paris. In 1909, he opened the first of his many *Ballets russes*. The dancers included the greatest dancers of Russia, among them Anna Pavlova and Vaslav Nijinsky (Fig. **15.36**). For the next three years, Diaghilev's ballets were choreographed by Mikhail Fokine (foh-KEEN), whose original approach stood in marked contrast to the evening-long spectaculars of Petipa (see Chapter 14). Fokine's work stood in line with the theatrical and musical theories espoused by Wagner and others. Specifically, he too believed in the artistic unity of all production elements—costumes, settings, and music, to which, of course, he added dancing. Dancing, in turn, he felt, should blend harmoniously with the theme and subject of the production.

Success grew as much from the integration of superb music, costume, and set design as from Fokine's choreography. Leon Bakst's costumes and sets exhibited consummate artistry, as their exquisite line and style, shown in Figure **15.35**, demonstrate. Bakst's vibrant colors and rich textures greatly influenced fashion and interior decoration of the period.

Diaghilev was not content to allow Nijinsky to remain just his *premier danseur*. He insisted that Nijinsky choreograph as well, which partially accounted for Fokine's departure. In 1912 Nijinsky (ni-ZHIN-skee) choreographed the controversial *Prélude à l'apres-midi d'un faune* with music by Debussy. The choreography

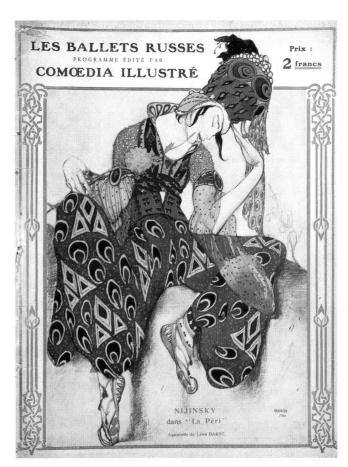

15.35 Leon Bakst, costume design, *Les Ballets russes—Comœdia Illustré*, "Nijinsky dans La Péri," 1911. Victoria & Albert Museum, London.

exploded with sexual suggestion, and the "obscenity" of the performance caused an uproar. Nijinsky's choreography was strangely angular in contrast to Debussy's music. The dancing suggested the linear qualities of a Greek frieze. A year later, the unveiling of Nijinsky's choreography of Stravinsky's *Rite of Spring* caused an actual riot, as mentioned previously.

Although the controversy had more to do with the music than with the dancing, the choreography also shocked, hinting at deep primordial forces, especially in the scene in which a virgin dances herself to death to satisfy the gods. Nijinsky's decision to marry in 1913 caused a rift with Diaghilev, a homosexual, and Diaghilev dismissed him from the company.

Diaghilev's new choreographer, Léonide Massine (lay-oh-NEED mah-SEEN), took the company (and ballet in general) in new directions. Previously the *Ballets russes* had featured picturesque Russian themes. Now it turned to themes emerging in the visual arts, for example, cubism and surrealism. *Parade* in 1917 found dancers in huge skyscraper-like cubist costumes designed by Pablo Picasso. The music, by Eric Satie (1866–1925), included sounds of typewriters and steamship whistles.

15.36 Vaslav Nijinsky as Petrushka, 1911. The New York Public Library.

In 1924, Diaghilev hired a new choreographer who provided a force in ballet for the next 60 years. George Balanchine came to Diaghilev from St Petersburg and choreographed ten productions for him over the next four years. Two of these continue to be danced—*The Prodigal Son*, composed by Prokofiev, and *Apollo*, composed by Stravinsky. When Diaghilev died in 1929, his company died with him, and an era ended. Ballet had been reborn as a major art form, a blending of choreography, dancing, music, and visual art—a rival to opera as a "perfect synthesis of the arts."

Modern Dance

While Diaghilev continued within balletic traditions, others did not. The most significant of these, the remarkable and unrestrained Isadora Duncan (1878–1927), by 1905 had gained notoriety for her barefoot, deeply emotional dancing. Considered controversial among balletomanes and reformers alike, she danced, as even Fokine saw, a confirmation of his own beliefs.

Although an American, Isadora Duncan achieved her fame in Europe. Her dances formed emotional interpretations of moods suggested to her by music or by nature. Her dance was personal. Her costume was inspired by Greek tunics and draperies, and, most significantly, she danced in bare feet. This break with convention continues to this day as a basic condition of the modern dance tradition she helped to form.

Literature

Realism

We have seen how realism took hold as a style in painting and theatre. Realism as a literary style held that art should depict life with absolute honesty—show things "as they really are." In pursuit of that goal, realists looked for specific, verifiable details rather than for sweeping generalities, and they valued impersonal, photographic accuracy more than the individual interpretation of experience. The triumph of realism, which began in the eighteenth century, came to full flower in the nineteenth and early twentieth centuries, influenced by the growth of science and by a revolt against the sweeping emotionalism of Romanticism. Because realists sought to avoid idealism and Romantic "prettifying," they tended to stress the commonplace and, often, sordid and brutal aspects of life. They also attempted to impose or convey their morals, value systems, and judgments—a characteristic that, among others, separated them from the naturalists.

Considered the father of the modern novel, Russian novelist Feodor Dostoyevski (dohs-tuh-YEF-skee; 1821–81), born and raised in Moscow, lost both his parents as a teenager—his father murdered by his own serfs—and although interested in literature early on, he did not begin writing until he had finished military school and a two-year stint in the army. In 1846 he published a short story, "Poor Folk," which made him an instant success. He then associated with a group of political revolutionaries and utopian reformers, and with the group's arrest, Dostoyevski received the death sentence—pardoned by the Czar at the last moment. Apparently, the Czar had planned to pardon the prisoners all along, but he let the matter proceed, right up to the point where they stood before the firing squad, more as a whimsical joke than anything else. Dostoyevski was sent to Siberia for five years and then forced back into the army. In 1859 he was finally pardoned, but these experiences, plus the fact that he suffered from epilepsy, left him bitter. He believed that his imprisonment gave him an opportunity to expiate his sins, and his beliefs that humans required penitence and that salvation comes through suffering reached the point of obsession and recur constantly in his novels. Like Nietzsche, he believed that European materialism had led to decadence and decline.

We know Dostoyevski best for two works from among his many: *The Brothers Karamazov* and *Crime and Punishment*. *Crime and Punishment* (1866), a psychological novel, explores multiple personality—the hidden and confused motivations of human behavior—and explores a constant theme—moral redemption through suffering. Perhaps the most outstanding characteristic of the novel emerges as its capacity to force the reader to think seriously about the many problems it presents. Dostoyevski accomplishes this by refusing to allow us to confuse oversimplification with deep thought. For example, in tackling the issue of distinguishing between morality and respectability, Dostoyevski gives us one truly good character, the prostitute Sonia, who at the same time represents the most openly disreputable, and contrasts her with a truly evil character, Raskolnikov's sister, the most respectable of the characters. Thus, he forces us to see that morality consists of what a person is, while respectability represents the front that we put up in public, and that there need not be any connection between the two. He also shows that morality and respectability are not opposites, because, that, too, would be an oversimplification. The work forces us, through the objectively detailed manner of the realist, to think seriously about money, social position, sanity and insanity, and, above all, about crime and punishment. Dostoyevski presents these issues with such compelling insight that we cannot escape them or explain them away with superficial responses.

The American writer, Kate Chopin (shoh-PAN; 1851–1904), known as a local colorist, interpreted New Orleans culture in her works, which expressed concern

for women's freedom and foreshadowed twentieth-century feminism. Her novel *The Awakening* (1899) relates a realistic tale about the sexual and artistic awakening of a young mother who abandons her family and later commits suicide. People at the time found it highly controversial because it treated frankly the subjects of female sexuality and an adulterous relationship between a married woman and a younger, unmarried man.

The foremost exponent of the French realist movement, Gustave Flaubert (Floh-BAIR; 1821–80), suffered from a nervous disorder. Trained as a lawyer, he left that profession to write. For five years he worked on his masterpiece, *Madame Bovary* (1857). The novel, which carried the subtitle "Provincial Customs," takes a relatively commonplace story of adultery and transforms it into a deep exploration of the human condition. Its central character, a bored and unhappy middle-class wife, Emma Bovary, acts out her dissatisfaction in romantic fantasies and an ultimately disastrous love affair. She cannot discern between the abstractions of passion and happiness and concrete reality, and thereby destroys her life. She neglects material reality—money—and ends up financially destitute. Finally, she commits suicide.

In Italy we find the *verismo* movement of literary realism that paralleled the *verismo* movement in opera we discussed in the Music section. As with all realism, the Italian *verismo* writers—exemplified by Luigi Capuana (kahp-oo-AHN-ah; 1839–1915) and Grazia Deledda (day-LAY-dah; 1871–1936; Deledda won the 1926 Nobel Prize for Literature)—sought to express an objective presentation of life, usually life among the lower social classes. They used direct, unadorned language, true-to-life dialogue, and explicit descriptive detail. Deledda wrote more than forty novels, and she often used the Sicilian landscape as a metaphor for the difficulties in her characters' lives, discussing how the ancient customs of Sicily often conflict with modern mores, forcing her characters to work through solutions to their moral issues. *Verismo* faded as a style in the 1920s, but we will see it again after World War II, particularly in the innovative and influential cinema style of neo-realism (see Chapter 17).

Pre-Raphaelites

The Pre-Raphaelite movement in literature paralleled that of the Pre-Raphaelite painters, and they linked poetry, painting, and social idealism. They combined subtle approaches to contemporary society with a new type of medievalism, by which they could use medieval settings as a context to explore sex and violence. They could also turn finely wrought poetry to religious ends, and the poetry of Christina Rossetti (1830–94) probably represents the original aims of the Pre-Raphaelites more clearly than any of her contemporaries. Rossetti (also

noted as a Victorian writer) excelled in works of fantasy, religious poetry, and poems for children. Her poem "Goblin Market" (1862) unfolds through 567 irregularly rhyming lines and tells the story of Laura, who falls under the spell of the goblins and eats the fruit they sell. Her sister, Lizzie, resists the "fruit-call" as she watches Laura get sick from the indulgence. At last, Lizzie goes back to the goblins' den to buy more fruit for Laura. She endures an assault by the malevolent goblins without tasting a drop of the "goblin pulp and goblin dew," thus winning a victory that redeems Laura and drives the goblins from the glen. Here are the first thirty-one lines:

Goblin Market
Christina Rossetti

Morning and evening
Maids heard the goblins cry:
"Come buy our orchard fruits,
Come buy, come buy:
Apples and quinces,
Lemons and oranges,
Plump unpeck'd cherries,
Melons and raspberries,
Bloom-down-cheek'd peaches,
Swart-headed mulberries,
Wild free-born cranberries,
Crab-apples, dewberries,
Pine-apples, blackberries,
Apricots, strawberries;—
All ripe together
In summer weather,—
Morns that pass by,
Fair eves that fly;
Come buy, come buy:
Our grapes fresh from the vine,
Pomegranates full and fine,
Dates and sharp bullaces,
Rare pears and greengages,
Damsons and bilberries,
Taste them and try:
Currants and gooseberries,
Bright-fire-like barberries,
Figs to fill your mouth,
Citrons from the South,
Sweet to tongue and sound to eye;
Come buy, come buy."

Naturalism

The tradition of realism in literature extended to a movement called naturalism, which aimed at an even more faithful, unselective representation of reality, presented without moral judgment. Naturalism differed from realism in its assumption of scientific determinism, which led naturalistic authors to emphasize the accidental, physiological nature of their characters rather than their moral or rational qualities. The naturalists saw individual characters as helpless products of heredity and

environment, motivated by strong instinctual drives from within, and assaulted by social and economic pressures from without.

Naturalism began in France, where the leading exponent of the movement, Émile Zola (zoh-LAH; 1840–1902), wrote the essay "Le roman expérimental" ("The Experimental Novel"; 1880) which became the manifesto for the movement. Unable to pass his *baccalauréat* examination, Zola spent two years unemployed. Eventually he secured a clerical post in a shipping firm, which he hated, and in 1862 he moved to the sales department of the publishing house of Louis-Christophe-François Hachette. Hachette encouraged Zola in his writing. Zola's first book, published in 1864, comprised a collection of short stories. In 1865, he wrote a sordid autobiographical novel, *La confession de Claude*, which landed him in trouble with the police and led to his departure from Hachette.

Zola put his "scientific" theories into practice in a gruesome novel, *Thérèse Raquin* (1867), but his *L'Assommoir* ("The Drunkard"; 1877), a study of alcoholism, made him the best-known writer in France. Zola held a credulous faith in science and accepted scientific determinism as fact. He argued that naturalism was indigenous to French life and believed that human nature was completely determined by heredity. He died under mysterious circumstances, overcome by carbon monoxide fumes in his sleep.

Impressionism

The impressionists in literature, like those in painting and music that we have already studied, tried to depict scenes, emotions, and character details in order to create vivid, subjective sensory impressions rather than objective reality. One of the techniques to arise in the impressionists' works, that of **"stream of consciousness,"** takes the flow of numerous impressions—visual, auditory, physical, psychological, and so on—to create the sense of consciousness of the characters. Writers sought to capture the fullness, speed, and subtlety of the human mind by incorporating bits and pieces of incoherent thought, truncated language, and free association of ideas and images. Two writers stand out in this regard: James Joyce (*Ulysses*; 1922) and Virginia Woolf (*The Waves*; 1931).

James Joyce (1882–1941) was born in Dublin, Ireland, and had tried several occupations, including teaching, when he began writing a lengthy naturalistic novel about his own life. He interrupted that project to publish the stories that made up *Dubliners* (1914). Beset with financial difficulties, he continued to write. Living in Italy when that country entered World War I, Joyce took his family to Zurich, Switzerland where he began work on *Ulysses*. Living off a series of grants, he published episodes from the book in *The Little Review* in 1918.

15.37 Sylvia Beach and James Joyce in Paris.

The episodes continued until the work was banned in December 1920. In 1922, Sylvia Beach (Fig. **15.37**), who owned the Paris bookshop Shakespeare and Co., published the entire novel, which, because of its constant troubles with the censors, became famous immediately. Joyce constructed the novel as a modern parallel to Homer's *Odyssey*, with the action set in Dublin on a single day (June 16, 1904). The three main characters—Stephen Dedalus, Leopold Bloom, and Molly Bloom—stand as modern counterparts to Homer's Telemachus, Ulysses, and Penelope, and the novel's events reflect the major events in Odysseus' journey home from the Trojan War. Joyce renders deeply three-dimensional characters and imbues the work with humor. Above all, as we noted earlier, stands Joyce's use of the impressionistic device of stream of consciousness.

Virginia Woolf (1882–1941), who committed suicide during World War II, stood as one of the most gifted and innovative of the stream-of-consciousness writers. She wrote intensely subjective explorations, and worked toward high condensation and glimpses of moments of experience rather than attempting the illusion of a total picture. She advocated freedom for the novelist to capture the "shower of atoms" and the discontinuity of experience, and she pictured men and women as enclosed

in their "envelope" of consciousness from birth to death. In *A Room of One's Own* (1929) she spoke out for women's liberation. The experimental, impressionistic novel *The Waves* (1931) presents her at her complex and innovative best. In this work she strives for capturing the poetic rhythm of life, turning away from traditional focus on character and plot. The book consists of dramatic and occasionally narrative monologues that trace six friends through seven stages of their lives—from childhood to old age. Each position corresponds to a position of the sun and the tides.

Symbolism

Another literary movement of the late nineteenth century, symbolism, constituted a conscious and deliberate attempt to use symbols because, as its proponents believed, the transient objective world is not true reality but a reflection of the invisible absolute. Symbolists rebelled against the techniques of the realists, which were designed to capture the transient world, believing instead that the inner eternal reality could only be suggested. They achieved intensity and complexity by using condensed syntax and minor images centered around one main metaphor, so that one sense impression translated into another and both became symbols of the original impression. Their writing often seemed arcane because they wished it to be "an enigma for the vulgar." They rejected sociological and ethical themes, and held that art pursues sensations of beauty quite separate from moral or social responsibility. The symbolists subscribed to the theory of "art for art's sake"—any theme or perception was appropriate as long as it captured the writer's subtle intuitions and contributed to an overall design. They despised their environment and middle-class morality, often flaunting their perversions and despair, but they freed literature from its conventional subject matter and emphasized technique. Of those who used symbolist techniques, Marcel Proust stands out.

French novelist Marcel Proust (proost; 1871–1922) constituted a legend in French literary circles. Reclusive, frail, and asthmatic, he was allergic to noise, to light, and to dust, and he kept his room soundproofed, overheated, and in semi-darkness. He spent long periods in bed, during which he wrote the long novels on which he thrived. He was, in fact, a bold literary experimenter, able to put in writing remarkable sensory and imaginative experience. His magnum opus, *Remembrance of Things Past*, published in sixteen volumes between 1913 and 1927, sought to write the past—time lost and apparently irrecoverable—into permanence. Time becomes an ever-present fact as the memory of the narrator shuttles back and forth without regard for chronology. Proust explores the distinctions between mechanical and psychological time by drawing upon his own past experiences, and as he juxtaposes past against present, he shows us the fraudulent values of high society and strips away its glitter. Proust uses the techniques of the symbolists—metaphor, symbol, and image—to achieve his ends as he tries to recreate the atmosphere of the mind, and thus we find his main themes—love, art, human ways of seeing and feeling life, homosexuality, rituals of the aristocracy, and architecture. In a sense, all of civilization trudges across his pages.

Futurism

Futurism in literature closely allied itself with the futurism of the visual arts. It violently rejected tradition and sought to give a formal expression to the energy and dynamism of mechanism. The movement rose in Italy with a manifesto by Filippo Marinetti (1876–1944), who coined the term. It spread to England and Russia. In the latter case, futurism took a radical turn in social and political outlook. Russian futurists attacked writers such as Dostoevski (above), calling for new techniques in the writing of poetry. Rejection of logical sentence construction and traditional grammar and syntax typified futurism in Italy, England, France, and Russia. Futurists regularly used strings of incoherent words, stripped of their meaning, for the effects of their sounds alone. The Russian futurists actively and early supported the Bolshevik Revolution of 1917 and gained, as a result, a number of important cultural posts. Their approach, however, proved too unstable to support a long-lasting movement, and by 1930 their influence had ebbed close to extinction.

Expressionism

Whether in visual art, theatre, cinema, or literature, the expressionists turned to non-naturalistic techniques in order to express the subconscious thoughts and emotions of the artist and the inner realities of life. Primarily an outcry against materialism, urbanization, and industrialization of pre-World War I Europe, it forged a number of social protests. Expressionist writers pursued general truths rather than specific situations, and, thus, their characters exhibit the characteristics of symbols—of types—rather than the characteristics of fully developed individuals. We have also seen this in the theatre. Expressionist poets used non-referential themes in seeking an "ecstatic, hymnlike lyricism" that had great associative power. Their approach stripped poetry down to strings of nouns with only a few adjectives or infinitive verbs. They eliminated narrative and description in order to get to the nub of feeling. Again, they sought to express their horror of urban life, and they frequently turned to apocalyptic scenes of civilization's destruction. Its intensely personal approach tended toward vagueness, which made their works seem inapproachable. As might be expected, that

led to its demise, although in Germany, expressionism died at the hands of the Nazis, who labeled it as decadent and outlawed its publication or exhibition.

Cubism

The spatial structures of cubism in painting found their way to literature as well. In the case of literature, abstraction of structure expressed itself in the narrative, and written attempts to reproduce the visual effects of Picasso and Braque resulted in bizarre associations and dissociations in imagery. Particularly, cubist writers sought to present simultaneous occurrences of points of view toward the material. Perhaps the best-known of the writers attempting cubist techniques, Gertrude Stein (stine; 1874–1946), a good friend of Picasso, experimented in the style, creating in, for example *Tender Buttons* (1914), obscure and unfathomable passages with an occasional, memorable turn of phrase. Here is an excerpt:

Tender Buttons
Gertrude Stein

OBJECTS

A CARAFE, THAT IS A BLIND GLASS.

A kind in glass and a cousin, a spectacle and nothing strange a single hurt color and an arrangement in a system to pointing. All this and not ordinary, not unordered in not resembling. The difference is spreading.

GLAZED GLITTER.

Nickel, what is nickel, it is originally rid of a cover.

The change in that is that red weakens an hour. The change has come. There is no search. But there is, there is that hope and that interpretation and sometime, surely any is unwelcome, sometime there is breath and there will be a sinecure and charming very charming is that clean and cleansing. Certainly glittering is handsome and convincing.

There is no gratitude in mercy and in medicine. There can be breakages in Japanese. That is no programme. That is no color chosen. It was chosen yesterday, that showed spitting and perhaps washing and polishing. It certainly showed no obligation and perhaps if borrowing is not natural there is some use in giving.

Cinema

On 23 April 1896, at Koster and Bial's Music Hall in New York, the Leigh Sisters performed their umbrella dance. Then the astonished audience saw waves breaking upon the shore. Thus launched a new process for screen projection of movies—the Vitascope. Invented by Thomas Armat (although Thomas Edison has received much of the credit), the Vitascope was the latest in centuries of experiments on how to make pictures move. Relying on the "persistence of vision"—the continuance of a visual image on the retina for a brief time after the removal of the object—and basic photographic techniques, the Vitascope captured real objects in motion and presented those images on a screen.

Technological experiments in rapid-frame photography were common in the last half of the nineteenth century, but it remained for Thomas Armat and others to perfect a stop-motion device essential to screen projection. Two Frenchmen, the Lumière (loo-mee-AIR) brothers, usually receive credit for the first public projection of movies on a large screen in 1895. By 1897, the Lumières had successfully exhibited their *cinématographie* all over Europe, and their catalogue listed 358 films. Essentially, the Lumière brothers originated documentary film. They called their brief pieces *actualités* (ahk-tyoo-ah-lee-TAY), and shot them in single takes. Fundamentally early newsreels, they often contained several different sequences without any cutting within a sequence. Thus, they represent the technique called the "sequence shot" (a complex action photographed in a continuous take, without cuts). The Lumières opened in America three months after the première of the Vitascope. Later that year, the American Biograph made its début using larger film and projecting twice as many pictures per minute, creating the largest, brightest, and steadiest picture of all.

At that point, movies did nothing more than record everyday life. It took Georges Méliès (may-lee-ES; 1861–1938) in France and Edwin S. Porter (1870–1941) in the United States to demonstrate the narrative and manipulative potential of the cinema. Between 1896 and 1914, Méliès turned out more than a thousand films. Méliès's crude narratives required using more than one shot. To accomplish tying together several shots into a sequence, Méliès, along with others, pioneered the style of "cutting to continuity." His narrative segments connect via a fade-out of one segment and a fade-in of the next, usually showing the same characters in a different location and different time. Edwin S. Porter, in charge of the Edison Company Studios, studied the narrative attempts of Méliès. Then, acting as his own scriptwriter, cameraman, and director, he spliced together old and freshly shot film into *The Life of an American Firefighter*. In 1903 Porter made *The Great Train Robbery*, the most popular film of the decade. It ran a total of twelve minutes and entranced the popular audience which flocked to electric theatres to see movies that could excite and thrill them with stories of romance and adventure. The movies opened a window to a wider world for the poor of America.

By 1910, the young film industry counted a handful of recognized stars who had made more than four hundred films for the screen's first mogul, Charles Pathé (pah-TAY). Short films remained the staple of the industry, but a growing taste emerged for more spectacular fare, especially in Europe. The Italian film *Quo Vadis* appeared in 1912, complete with lavish sets, chariot races, Christians, lions, and a cast of hundreds. A full two hours long, it proved a huge success.

Lawsuits over patents and monopolies marked the first decade of the century. In order to escape the constant badgering of Thomas Edison's lawyers, independent film-makers headed west to a sleepy California town called Hollywood, where, among other things, the weather, the natural light, and the exotic, varied landscape proved much more conducive to cinematography. By 1915 over half of all American movies originated in Hollywood.

That year also witnessed the release of D.W. Griffith's *The Birth of a Nation* (Fig. **15.38**), which ran for three hours. Popular and controversial, the film was destined to become a landmark in cinema history. It unfolds the story of two families during the Civil War and the Reconstruction period. Now condemned for its depiction of leering, bestial blacks rioting and raping white women,

and for the rescue of whites by the Ku Klux Klan, the film nonetheless contains great artistry. Griffith defined and refined nearly every technique in film-making: the fade-in, fade-out, long shot, close-up, moving camera, flash-back, **crosscutting**, and juxtaposition. In addition, Griffith virtually invented film editing and preshooting rehearsals.

As if *The Birth of a Nation* were not colossal enough, Griffith followed it in 1916 with *Intolerance*, a $2 million epic of ancient Babylon, biblical Judea, sixteenth-century France, and contemporary America. As the film progressed, brilliant crosscutting increased at a frantic pace to heighten suspense and tension. However, audiences found the film confusing. It failed miserably at the box office, and the failure ruined Griffith financially.

The same era produced the Mack Sennett comedies, which featured the hilarious antics and wild chase scenes of the Keystone Kops. Sennet was one of Griffith's partners in the Triangle Film Company. A third partner, Thomas Ince, brought to the screen the prototypical cowboy hero, William S. Hart, in such works as *Wagon Tracks*.

German expressionism made its mark on film as well as in the visual and performing arts and literature. The

15.38 D.W. Griffith, *The Birth of a Nation*, 1915.

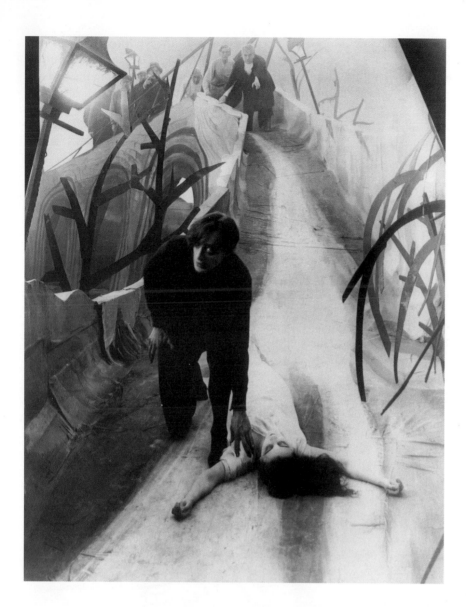

15.39 Robert Wiene, *The Cabinet of Dr Caligari*, 1919.

visual composition, strongly influenced by expressionist stagecraft, tried to convey through décor the subjective mental state of the protagonist. German expressionism emphasized visual design, and, as we have seen in painting and theatre, the style focuses on anxiety and terror. In film, the sets reflect a deliberate artificiality: flat and obviously painted with no attempt at lifelikeness through perspective or scale. Expressionist film directors intended settings to represent a state of mind rather than a place, with an emphasis on diagonal lines in order to suggest instability and anguish. In 1919, expressionist cinema's most masterful example, Robert Wiene's (veen; 1881–1938) *The Cabinet of Dr Caligari* (Fig. **15.39**), astounded the film-going public. Macabre sets, surrealistic lighting effects, and distorted properties all combined to portray a menacing post-World War I German world. In the film—a morbid depiction of

horror, menace, and anxiety—a madman relates to a madwoman his understanding of how he came to be in the asylum. The shadowy lighting and distorted streets and buildings on the set represent projections of his insane universe. The film's other characters also form visual symbols created through makeup and dress.

Nothing better represents the second decade of the twentieth century, however, than the work of the genius Charlie Chaplin, the "little fellow." Chaplin's characters represent all of humanity, and he communicates through the silent film as eloquently and deeply as anyone ever has. In an era marked by disillusionment, Chaplin represented resilience, optimism, and an indomitable spirit. By the end of World War I Chaplin shared the limelight with that most dashing of American heroes, Douglas Fairbanks.

CHAPTER REVIEW

CRITICAL THOUGHT

We can identify how the arts interrelate by taking examples from more than one general grouping and comparing them. For example, we have become accustomed in this text to referring to painting, sculpture, and architecture not only by their individual names but also by the term "visual arts." Another grouping of arts, called the "performing arts," includes music, theatre, dance, and film. In these arts, the basic visions of composer, playwright, and choreographer are interpreted and performed by other artists, who lend some of their own vision to the artwork. Thus, we can find a useful means of comparison if we take an example of visual art and compare it with an example of performing art. Perhaps groupings such as "visual" and "performing" can assist us to master the complexities of a chapter containing so many diverse styles.

We also need now to exercise judgment and perception by comparing the individual works of one grouping and representing a given style to works from another grouping representing the same or a different style. For example, how does the impressionist painting of Monet reflect the same characteristics as Debussy's music and Virginia Woolf's writing?

SUMMARY

After reading this chapter, you will be able to:

- Understand how styles such as impressionism, expressionism, and realism are applied to visual and performing arts.
- Characterize the ideas of Nietzsche and Freud.
- Describe the social, political, and economic condition of the world at the end of the nineteenth century.
- Explain how realism, naturalism, and symbolism manifested themselves in theatre and literature.
- Discuss the state of film and dance at the end of the nineteenth century by citing specific individuals, events, and characteristics.
- Apply the elements and principles of composition to analyze and compare individual works of visual art illustrated in this chapter.

CYBERSOURCES

http://www.artcyclopedia.com/history/realism.html
http://www.artcyclopedia.com/history/impressionism.html
http://www.artcyclopedia.com/history/post-impressionism.html
http://www.artcyclopedia.com/history/expressionism.html
http://www.artcyclopedia.com/history/fauvism.html
http://www.artcyclopedia.com/history/art-nouveau.html
http://www.greatbuildings.com/buildings.html
http://www.classicalarchives.com/
http://www.gutenberg.net/

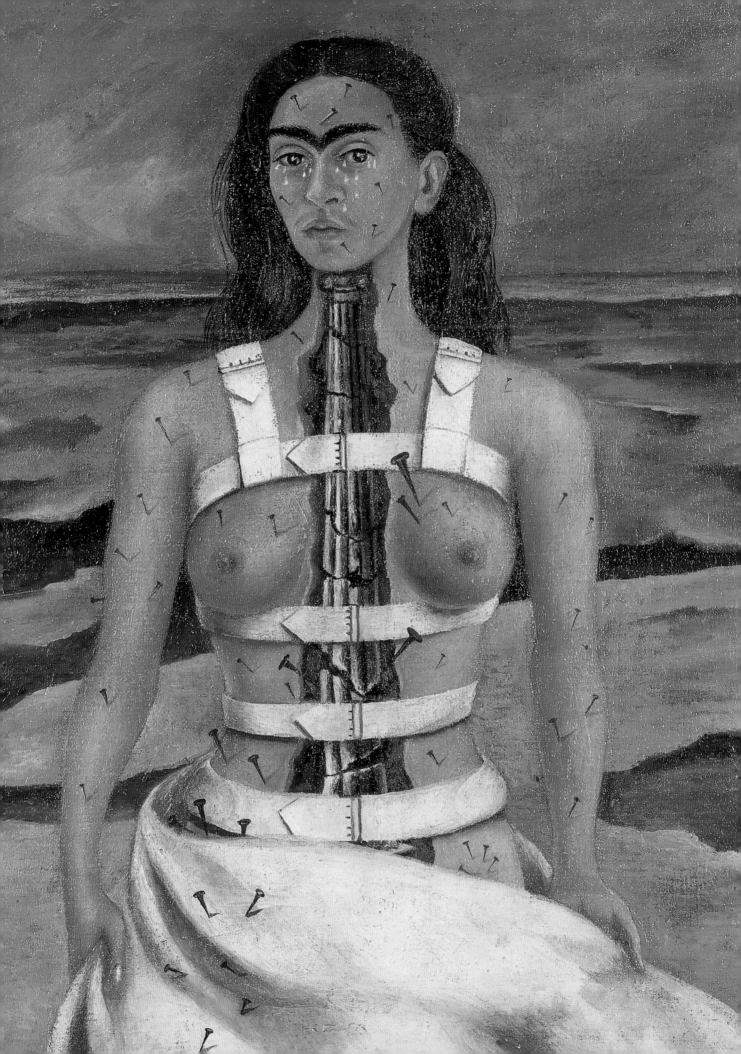

16 MODERNISM

OUTLINE

VIEW

DREAMS AND EXPECTATIONS

Probably every generation experiences deprivations, uncertainties, anxieties, and what it sees as a collapse of its expectations. Of course, different generations have different expectations, especially about what constitutes deprivation and/or needs. In most cases, collapsing dreams result from two tendencies recognized thousands of years ago as primary obstacles to healthy living: self-pity and fear. Both the Old and New Testaments of the Bible point out those conditions, and Aristotle spoke of them when he described the desired outcomes of Greek tragedy—the purgation of pity and fear. Many dreams collapsed with the onset of World War I in 1914, and expectations collapsed again with the stock market crash of 1929, which gave rise to the Great Depression, whose deprivations, in turn, did much to cause World War II. Reactions to these shattered dreams took artistic, as well as political form: specifically, art that denied art and art that emphasized shock. The modern age had arrived.

KEY TERMS

PRAGMATISM
A philosophy for which the criterion for truth consists in the workability of an idea.

EXISTENTIALISM
A philosophical doctrine and literary and dramatic movement that insists on the existence of individuals as basic and important.

ABSTRACT ART, ABSTRACTION, NONREPRESENTATIONALISM
Art which depicts the essence of a thing rather than its actual appearance.

DADA
An artistic and literary movement emphasizing the discovery of reality through the abolition of traditional cultural and aesthetic forms. Derision, shock, irrationality, and chance play major roles.

SURREALISM
An artistic style emphasizing discovery of reality through reliance on the subconscious.

ABSURDISM
A style dealing with life's apparent meaninglessness and the difficulty or impossibility of human communication.

16.1 Frida Kahlo, *The Broken Column*, 1940. Oil on canvas, 15¾ × 12¼ ins (40 × 31 cm). Museo Dolores Olmedo Patiño, Mexico.

CONTEXTS AND CONCEPTS

Contexts

"Make it new," said the poet Ezra Pound, and the arts of the early part of the turbulent twentieth century pursued a seemingly inexhaustible quest for originality and freshness. The age witnessed the worst and the best of humanity's capabilities (Fig. **16.2**). In the aftermath of World War I, many believed that any culture that could produce the wanton destruction wrought by the war must be abandoned, if not destroyed, and the appeal of communism as an alternative to capitalistic democracy captivated many liberals. The conflicts and unresolved issues resulting from "the peace" after World War I soon, however, led the world into another war.

Some time before 1914, Europe and the rest of the Western world seem to have gone astray. Societies believed they stood on the edge of the best that science and invention could offer, and that competitive struggle would produce desirable, positive results. The war changed that.

The Modern World in Conflict
Toward World War I

We noted in Chapter 15 the way in which Germany developed during the last quarter of the nineteenth century under Chancellor Bismarck and Kaiser William II. One of Bismarck's main policies sought to maintain the balance of power in Europe. France, which had been isolated and weakened in the last quarter of the century, posed no threat, but Bismarck saw that the major danger to European stability lay in the two multinational empires—the Ottoman Empire and the Austro-Hungarian Empire. The Turks controlled part of the Balkans, and both Austria-Hungary and Russia wanted this area in their hegemony. In Austria-Hungary, the Slav minority, discreetly supported by the Russians, pushed for independence. Through diplomatic maneuvering,

GENERAL EVENTS

■ Triple Entente, 1904–07 ■ Balkan wars, 1912–13 ■ Nuclear weapons, 1945

■ German rearmament, 1920s–30s ■ First computers, 1946

■ World War I, 1914–18 ■ Great Depression, 1929–34

■ Russian Revolution, 1917 ■ Japanese invasion of Manchuria, 1932

■ Treaty of Versailles, 1919 ■ World War II, 1939–45

■ League of Nations, 1919 ■ Pearl Harbor, 1941

1900	1920	1940	1950
	PAINTING, PHOTOGRAPHY, & SCULPTURE		
Kahlo (**16.1**), Malevich (**16.7**), de Chirico (**16.10**), O'Keeffe (**16.11**), Lipchitz (**16.19**)	Mondrian (**16.8**), Ernst (**16.9**), Davis (**16.12**), Wood (**16.13**), Douglas (**16.14**, **16.15**), Rivera (**16.16**), Brancusi (**16.18**), Lange (**16.20**), Man Ray (**16.22**)	Adams (**16.21**)	
	ARCHITECTURE		
Gilbert (**16.25**)	Wright (**16.23**, **16.24**), Le Corbusier (**16.26**), Gropius (**16.27**)		
	THEATRE		
Strindberg, Toller, Rice	Brecht, Pirandello	Camus	
	MUSIC & DANCE		
Ives	W. Schuman, Prokofiev, Hindemith, Bartók, Berg, Webern, Beach	Copland, Graham	
	LITERATURE & PHILOSOPHY		
Dewey, Yeats, Gide, Tzara, Sandburg	Lawrence, Kafka, Faulkner, Eliot, Pound, Auden, Hughes, Frost, Yeats, Hemingway, Breton	Sartre, De Beauvoir	
	CINEMA		
Wiene	Lange, Eisenstein, Disney	Ford, Welles	

Timeline 16.1 Modernism.

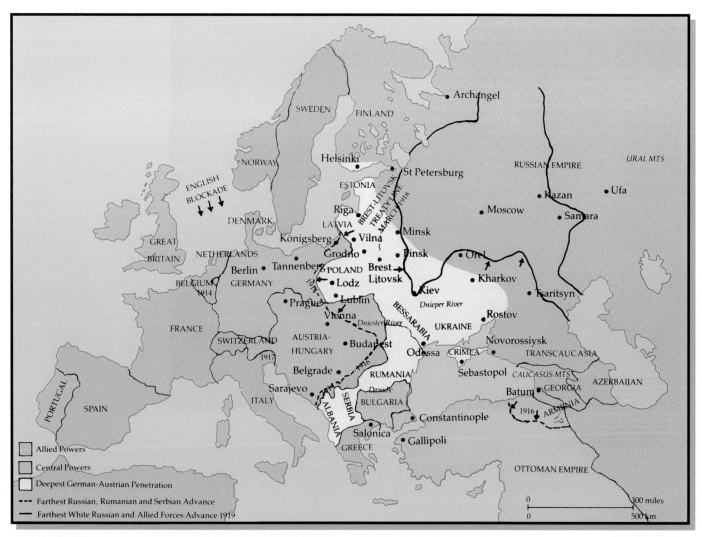

Map 16.1 World War I and its aftermath in Europe.

Bismarck kept the lid on any potential confrontation between Austria-Hungary and Russia, but in 1890 William II forced Bismarck to resign and broke with Bismarck's policies, forging an alliance with Austria-Hungary. In response, Russia, which needed French capital to develop its industries, formed an alliance with France.

Europe now found itself split into two camps. Germany joined with Austria-Hungary and Italy to form the Triple Alliance, which held a military advantage over the other camp, the Triple Entente (the Allies) of Great Britain, France, and Russia, which were unable to coordinate their military affairs. The Triple Alliance stepped up the pressure on its temporarily weaker opponent, particularly in Morocco, where the Kaiser wanted to stop French advancement, and at the same time Austria-Hungary, with the unconditional support of the Kaiser, decided to extend its territory and influence in the Balkans.

At the beginning of 1914, the Balkans remained the sole sensitive area of Europe. Russia had one ally left in the area, Serbia, and gave it unconditional support. The Austro-Hungarian Empire, encouraged by the Bulgarians, looked for a pretext to remove the one final obstacle to its own interests in the Balkan peninsula. Ten years of tension had caused all the powers to increase their armed forces and to align themselves in such a way that any confrontation would lead to an irreversible chain reaction. War was not imminent, but the precarious alliances and interests of the two coalitions made it impossible to stop the mobilization process if something might occur to set it in motion.

That something occurred on 28 June 1914. An Austrian archduke was assassinated in Sarajevo, and Austria-Hungary held the Serbs responsible. William II promised to support the Austro-Hungarians in case of war. One month later, on 28 July, Austria-Hungary declared war on Serbia. On 1 August Germany declared

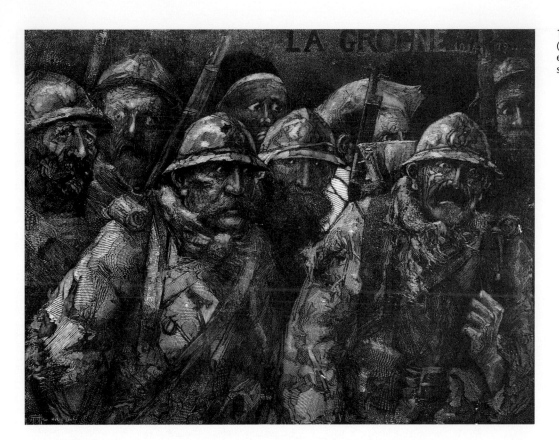

16.2 L. Ruffe, *La Grogne* (*Grumbling*), c. 1917. Wood-engraving of World War I soldiers.

war on Serbia's ally, Russia. On 3 August Germany declared war on France and invaded Belgium. On 4 August Britain declared war on Germany.

The Great War

Between 1914 and 1918 the military commands of both sides changed strategies repeatedly. On one hand, they would pursue a "strong point" strategy, in which they attacked the enemy in order to break its resistance, then they would switch to a "weak point" strategy, which aimed to disorganize the enemy and reduce the number of its allies. All of which resulted in three years of bloody trench warfare with little resolution.

The situation began to change in 1917. What had been a European conflict took on global dimensions when Britain mounted offensives in Egypt, Iraq, and elsewhere in the Arab world. Then Japan and China entered the conflict. Finally, Germany's submarine attacks, which came as a result of its policy of unrestricted naval warfare, brought the United States into the war on 6 April 1917.

Both sides used strategies designed to disrupt the other side's efforts. This, as we noted, comprised the "weak point" strategy. The main thrust of the Triple Alliance Powers (Germany, *et al.*) consisted of trying to provoke non-Russian nationalities into rebelling against the Czarist empire. The Allies pursued the same strategy by promising independence (on victory) to every oppressed minority in central Europe—for example, the Croats, Slovenes, Czechs, and Slovaks—which weakened enemy morale somewhat, but proved not much of a factor, although it was more effective against the Ottoman Empire. In Armenia, nearby Russian advances led to a massacre that killed over a million people in 1915, and Arab uprisings led by the Englishman T.E. Lawrence, Lawrence of Arabia, eventually led to the reconstitution of Syria—a nation fragmented for several centuries.

The Allies attempted to destroy the Triple Alliance's seaborne trade and thus to destroy the foundations of their economies: a strategy that provoked Germany into unlimited submarine warfare. This in turn had the unfortunate effect of provoking the United States into entering the war on the side of the Allies. In the end, the effects of the weak point strategy proved difficult to evaluate, although it does appear to have caused the United States to enter the war, which proved decisive in an Allied victory. The deterioration of the Russian economy and the resultant shortages played a major role in the Russian Revolution in 1917. Eventually, however, the victory came by military rather than economic means. In 1917 things began to go badly for Germany and her partners on the western front, and by 1918 the Germans realized that they could no longer hope to turn things in their own favor. The first armistices were signed at the end of October and in November 1918.

Revolution and Civil War in Russia

A combination of military defeats, shortages, and hatred of the aristocracy made an explosive combination for Russia, and in an uprising that lasted for five days in Petrograd, the revolution triumphed and Czar Nicholas II abdicated. A power-sharing government emerged made up of former members of the Russian Duma (parliament) and a Soviet of Workers and Soldiers' Deputies (Fig. 16.3). Under the leadership of Alexander Kerensky, this alliance between the bourgeois and proletarian revolutions proved incapable of either winning or ending the war and unable to put into effect the necessary reforms to transform the social order.

The revolution, which had both political and social consequences, gave a temporary incentive for states of the old empire to seek independence, something that the Bolsheviks hinted at in a declaration of the people's right to self-determination. Once the revolution had succeeded, however, Lenin and Stalin put the clamps on the nationalist movements, and at the end of the world war and the revolution, only the Baltic States, Poland, and Finland had preserved their independence.

The Aftermath

After months of negotiations, a series of agreements called the Treaty of Versailles formally ended the war. Almost immediately, the belligerents contested these agreements, and after twenty years the treaty stood totally repudiated. It failed for four reasons. The first reason we call the "principle of nationalities." For centuries, the three great empires—the Austro-Hungarian, Russian, and Ottoman—had within them groups of oppressed minorities under a dominant community that gave them only minimal rights. These groups had tried to gain independence throughout the nineteenth century, and during the war, as part of its weak point strategy, the Allies tried to exploit this ideal. However, within the empires, the minorities intermingled, and it proved impossible to draw up political borders that coincided exactly with ethno-linguistic territories. In one case, the problem sought resolution by a massive repatriation: 400,000 Turks moved from Macedonia to Turkey, and 1,300,000 Greeks moved from Asia Minor to Greece. That did little to dampen Greek and Turkish ill-feeling, and elsewhere ethnic populations simply stayed

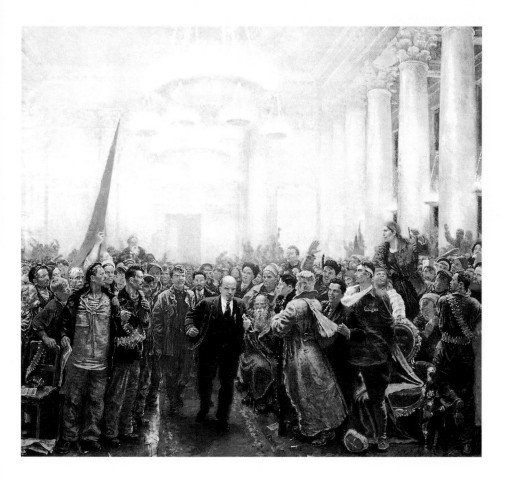

16.3 Alexandr Nikolayevich Samochvalov, *V.I. Lenin Entering the Second All Russian Congress*, 1940. Oil on canvas, 9 ft 3⅜ ins × 11 ft 7⅜ ins (2.83 × 3.54 m). Russian State Museum, St Petersburg.

put. Large German populations became included in Czechoslovakia, and others found themselves in Poland. This "principle of nationalities" later gave Hitler one of his most effective propaganda themes.

The second reason the treaty failed had to do with the problem of non-European territories. German colonies and non-Turkish territories of the Ottoman Empire were divided up between the victors, and from that time onward, the Middle East became a thorn in the side of both France and Britain.

The third reason had to do with Germany itself. Judged responsible for the war, the allies disarmed her and condemned her to pay reparations, establishing a set of fifty-year payment plans which they then revised and abandoned. Even though the Allies had not come close to invading Germany, the Treaty of Versailles regarded Germany as the guilty party. That label and the crippling reparations seemed to all Germans as unfair, and the rejection of the Versailles *diktat* formed the Nazis' first priority.

Finally, neither the League of Nations nor the allies had the power to enforce either the territorial divisions or the payment of reparations stipulated in the treaty. The United States refused to ratify the treaty, and the new League of Nations, the forerunner of the United Nations, had no means of external action. As early as 1920 the Turks rebelled against the terms of the treaty and forced a revision, called the Treaty of Lausanne. Between 1935

and World War II, Hitler did everything he could simply to abolish the treaty unilaterally. He reintroduced military service, remilitarized the left bank of the Rhine River, annexed the German border region of Bohemia, and made a claim on the Polish corridor. The spirit of the Versailles Treaty was simply anathema to the Nazis.

Between the Wars
The Great Depression
The crisis that began in the United States reflected not only the deep strains and stresses in world capitalism, but also a continuation of problems occurring in Europe since the second half of the nineteenth century. Low consumer spending, currency crises, and credit and international trade problems combined in a sequence of events that accelerated after the end of the Great War. Inflation, which had been spectacular in Germany, ruined people almost everywhere. International currencies teetered with extreme fragility, and the power of banks increased. Then, a wave of speculation on Wall Street caused the stock market to crash on 24 October 1929 (Fig. **16.4**), and stocks and shares plummeted until 1932.

The crisis spread throughout the world, and bankruptcies mushroomed in any country whose credit system had ties to the United States. The crisis in business and banking caused an industrial crisis, which, in turn, affected agriculture. Agricultural prices fell by fifty percent in the United States. In 1932 alone, forty million

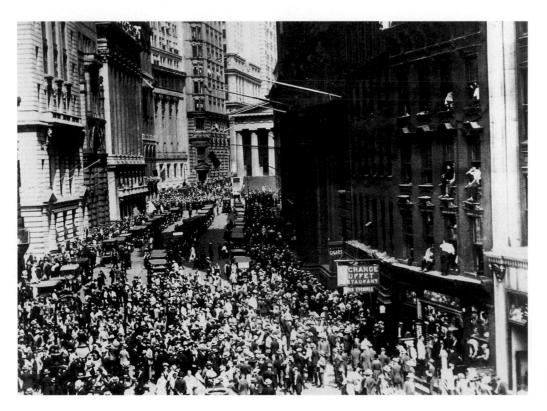

16.4 Wall Street, during the collapse of share prices on the New York Stock Exchange, 25 October 1929 (Black Friday).

people remained out of work and on the dole, and the lack of any social security system in many countries increased human tragedy.

Social and political unrest increased. Around the world protest marches and uprisings occurred by people who could not understand a system by which, for example, farmers burned corn to maintain prices while children starved. Confidence in the "free enterprise" system shook deeply, and a call to get the economy moving at any cost reverberated around the world. New political forces came to power, and businessmen, farmers, and workers demanded government intervention.

Spurred on by violence in the streets, different countries adopted different solutions, depending on the depth of the crisis and the influence and make-up of the various factions in society. The United States witnessed the New Deal; Germany saw Nazism; France and Spain experienced the Popular Front. Many countries returned to protectionism, and devalued their currencies. Nothing, however, seemed to work. Wealthier nations then turned to public works, as in the United States, increases in wages, as in France, or closer links with colonies, as in Britain, while countries such as Italy, Germany, and Japan chose the path of rearmament and preparation for war, which seemed to some countries the only logical way out of the crisis.

Hitler's Conquests

On 30 January 1933, Adolf Hitler (1889–1945) became chancellor of Germany. It took less than a year for him to have his party declared the only legal one and to bring all sectors of public life into line through an orchestrated campaign of intimidation and violence (Fig. **16.5**). Once assured of compliance at home, Hitler had the means to effect the final blows against the hated Treaty of Versailles. He reintroduced compulsory military service and rearmed the Rhineland. Making such a show of strength enabled Hitler to assess the lack of resolve on the part of France and Britain and to achieve a *rapprochement* (rah-prohsh-MAHW) with the states of central and southeastern Europe. He also aided Franco's forces in the Spanish Civil War and formalized an Axis with Benito Mussolini ("Il Duce") and Italy.

Although supposedly disarmed, Germany stood actually militarily superior to the rest of Europe, and Hitler could, therefore, effect a solution to what he saw as the "problem of Greater Germany." The first step meant annexation of lands inhabited by Germans, and in the spring of 1938 the Wehrmacht, Germany's war machine, moved into Austria, earning only a mild rebuke from Paris and London. In the classic act of "appeasement," British prime minister Neville Chamberlain negotiated the Munich Agreement, which effectively dismantled Czechoslovakia and added the

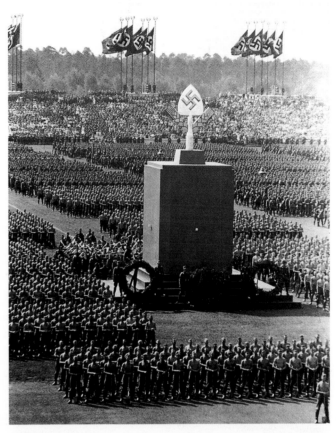

16.5 Nazi Party labor convention at Nuremberg, 7–13 September 1937.

Sudetenland to Hitler's growing list of annexations to the Reich. In March 1939 Bohemia-Moravia disappeared from the map of Europe, and Germany grew accordingly. Hitler had completed the second stage of his campaign for *Lebensraum* (living room) in the east.

When Hitler turned toward Poland, however, neither Paris nor London could retreat for fear of losing further face with the threatened smaller countries of Europe. Britain joined France in guarantees to Poland, with the Soviets also included. Poland balked at the prospect of Soviet forces within its borders, and the negotiations ground on. Meanwhile, talks began in Moscow that led to a secret Nazi–Soviet non-aggression pact, which effectively divided Poland between Germany and the Soviet Union. Hitler offered an agreement to Britain in which they would divide the world between them, but the British refused. On 1 September 1939, Hitler invaded Poland, and war again engulfed Europe. Three years later, Japan attacked Pearl Harbor, and World War II reached around the globe.

World War II

After success in Poland, Germany launched a *Blitzkrieg* (BLITS-kreeg; "lightning war") in the spring of 1940, in which it seized the Danish straits, the Norwegian coast,

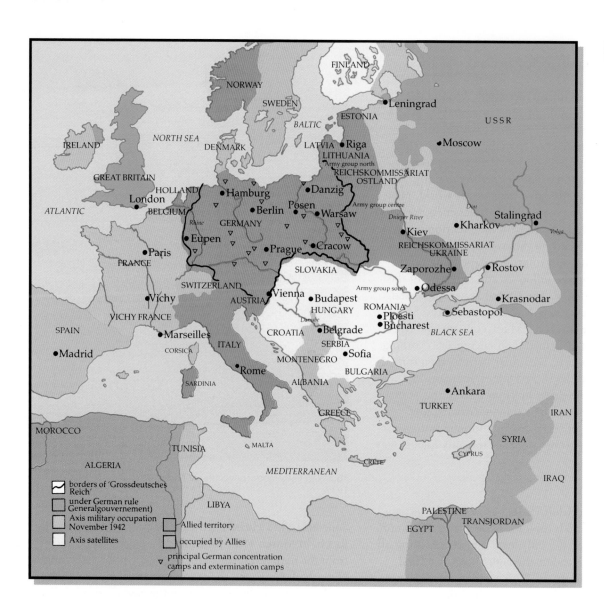

Map 16.2 World War II in Europe.

Map labels: FINLAND · NORWAY · SWEDEN · BALTIC · ESTONIA · LENINGRAD · USSR · IRELAND · NORTH SEA · DENMARK · LATVIA · Riga · Moscow · LITHUANIA · Army group north · REICHSKOMMISSARIAT OSTLAND · GREAT BRITAIN · HOLLAND · Hamburg · Danzig · London · BELGIUM · Berlin · Posen · Warsaw · Army group centre · Don · Stalingrad · ATLANTIC · Rhine · GERMANY · Dnieper River · Volga · Kharkov · Eupen · Kiev · REICHSKOMMISSARIAT UKRAINE · Paris · Prague · Cracow · Rostov · FRANCE · SLOVAKIA · Zaporozhe · Vienna · Army group south · Odessa · Krasnodar · SWITZERLAND · AUSTRIA · Budapest · ROMANIA · Sebastopol · Vichy · HUNGARY · Ploesti · VICHY FRANCE · Danube · Bucharest · BLACK SEA · SPAIN · CROATIA · Belgrade · Madrid · CORSICA · ITALY · SERBIA · Sofia · MONTENEGRO · Rome · SARDINIA · ALBANIA · BULGARIA · Ankara · GREECE · TURKEY · IRAN · MOROCCO · MALTA · SYRIA · CYPRUS · ALGERIA · TUNISIA · CRETE · IRAQ · MEDITERRANEAN · LIBYA · PALESTINE · TRANSJORDAN · EGYPT

Legend:
- borders of 'Grossdeutsches Reich'
- under German rule (Generalgouvernement)
- Axis military occupation November 1942
- Axis satellites
- Allied territory
- occupied by Allies
- principal German concentration camps and extermination camps

the Netherlands, Belgium, and France in a period of six weeks. After heavily bombing Britain, Hitler turned his focus to the Mediterranean and the Balkans. In a fateful move, Operation Barbarossa, the German invasion of the Soviet Union, began on 22 June 1941. Despite the tremendous amount of territory involved and the severity of the Russian winter, German forces continued to advance until November 1942, when they had reached the Caucasus Mountains and the River Volga.

Depending on a number of factors—for example the Nazis' racial doctrines that led to the Holocaust—conquered areas suffered under varying degrees of oppression and economic exploitation. Millions of individuals, including some six million Jews, died in the Reich's concentration camps.

At the end of 1942, fortunes began to change. British and American forces landed in North Africa, and British Field Marshal Montgomery won an important victory at El Alamein. At the same time, Hitler's General Paulus

surrendered at Stalingrad. The war on several fronts gave the Allies superiority, and Hitler's decision to break his treaty with Stalin and invade Russia ultimately proved catastrophic. Using North Africa as a base, the Allies invaded Italy and brought about the fall of Mussolini. The Red Army began counterattacking, and the draining of German forces to the eastern front left Hitler vulnerable to a European invasion that commenced on D-Day, 6 June 1944. By the fall of that year, Germany's Fortress Europe began crumbling, with many of its allies forced to sign armistices.

Hitler's scientists had made enormous strides in rocketry, and the unmanned rocket-bombs the V1 and V2 had rained terror on Britain from Belgium. However, even these, and German counteroffensives in the Ardennes and Budapest, could not halt the Allied advance, and Germany collapsed from both east and west as the Allies and Soviets headed through Germany toward Berlin. On 30 April 1945, Hitler committed suicide in his

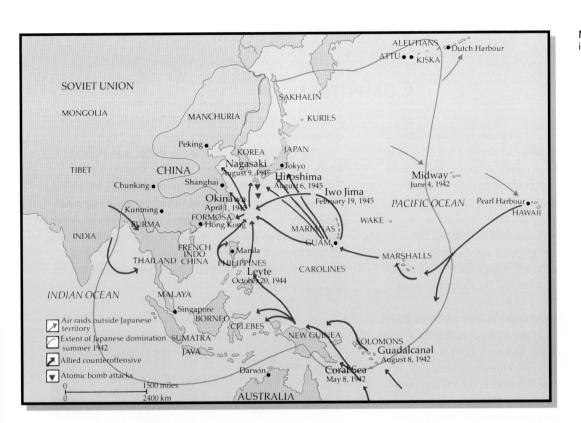

Map 16.3 World War II in the Pacific.

Berlin bunker. The task of negotiating with the Allies fell to Admiral Doenitz, and unconditional surrender occurred on 8 May 1945.

The Japanese attack on Pearl Harbor on 7 December 1941 illustrates the eagerness with which the Japanese approached war with the United States, which had opposed the Japanese invasion of China. In addition, the Japanese were determined to seize the resources of Indochina and the Dutch East Indies after their rulers had fallen to Germany in 1940. In moves as swift and decisive as the German *Blitzkrieg*, the Japanese swept through the eastern Pacific and threatened India and Australia. Perhaps expecting the United States to seek a peaceful solution, the Japanese got, instead, an all-out response that included the bombing of Tokyo as early as 1942. Decisive United States' victories at Midway and the Coral Sea weakened the Japanese forces to the point that the overextended communications and forces of the "Empire of the Sun" could not prevent a three-year pincer movement, as American forces strategically leap-frogged Japanese concentrations and worked their way toward the Philippines. Japanese resistance remained stubborn and fanatical, however: *Kamikaze* (kah-mih-KAH-zee) pilots committed suicide by crashing their planes into American ships, and ground forces fought to the death rather than be dishonored by surrender. At the beginning of 1945, American forces had inched their way to Iwo Jima and Okinawa, where they won strategic victories and gained bases from which bombers could reach Japan

for saturation bombing, and ships could intercept supplies heading to Japan.

Nonetheless, Japan refused to surrender, and it still held Indochina, the Dutch East Indies, and the coast of China. The American high command did not expect to launch an invasion of Japan until 1946, and believed that such an invasion would cost the lives of a million American men. Resolution came when President Truman decided to drop two atomic bombs: one on Hiroshima on 6 August 1945, and one on Nagasaki on 9 August 1945. In the meantime, Russia entered the war in Asia and invaded the Japanese-held areas of Manchuria and Korea. Emperor Hirohito intervened personally and forced his ministers and military leaders to accept surrender. The surrender document, signed on the deck of the battleship *Missouri* in the Bay of Tokyo on 2 September 1945, brought an end to World War II. Japan never admitted to surrendering. Japanese authorities merely said to the Japanese people that the war had "ended."

Science and War

The possibilities of a nuclear bomb and its world-changing consequences came as a result of a number of factors and individuals. In the 1930s, the situation across the world stood, as we have already discussed, in flux, and in different parts of Europe and in America, physicists worked separately, but aware of each other's progress, to find ways to split the atom and so create large quantities of energy. Later, during World War II, in

TECHNOLOGY

COMPUTERS

Early in the 1930s, a German engineer named Konrad Zuse made a computer that operated in binary mode. This was called the Z1, and it was followed by Z2 and Z3, a relay computer that could perform a multiplication in three or four seconds. Hindered by the slowness of his machines, Zuse suggested to the German government that electromechanical relays should be replaced by electronic tubes, but Hitler, bent on winning the war, reduced funds to the project, which Zuse continued working on until 1944, when all his machines were destroyed in the bombing of Berlin.

The first true binary computer was made in 1939 at the Bell Laboratories in the United States by a mathematician, George R. Stibitz. Called the Model 1 Relay Computer or Complex Number Calculator, it consisted of a logical mechanism in which the data output consisted of the sum of the data entered. Telephone relays in the computer functioned in the binary "all or nothing mode"—that is, it used only the digits 1 and 0. Stibitz assembled the computer in a weekend using a few discarded relays, two lightbulbs, and fragments of a tobacco jar.

In the same year, an Iowa State College professor, John Atanasoff, applied the principles of vacuum tubes to digital calculation. The result, designed to solve the complex equations used in physics, became known as the ABC (Atanasoff Berry Computer). However, neither Atanasoff nor Iowa State registered a patent; thus, the invention of the tube computer was long attributed to J. Presper Eckert for his ENIAC (Electronic Numerical Integrator and Calculator).

The first fully automatic calculator was Harvard Mark 1, at that time called the IBM Automatic Sequence Controlled Calculator (Fig. **16.6**). Financed by IBM and developed by Howard Aiken of Harvard University, it weighed five metric tons and contained 500 miles (805 kilometers) of wire. It included a clock to synchronize sequences and registers—that is, a device used by the computer to store information for high-speed access.

16.6 The Harvard Mark I calculator (1944) from the IBM Corporation.

Germany and the United States, these scientists worked feverishly against each other to create an atomic bomb.

The British scientist Sir James Chadwick discovered the neutron in 1932. He split this electrically charged neutral particle in the atom by bombarding it with alpha rays from radium. The Italian-born Enrico Fermi (FAIR-mee) continued the work on nuclear fission, and was able to split uranium. In 1938 Fermi won the Nobel Prize for Physics, and Mussolini allowed him to go to Sweden to collect his prize. After the prizegiving, however, Fermi defected to the United States, where he continued his work to create an atomic pile that could sustain a chain reaction and create a constant flow of energy.

In 1939 three physicists, including Albert Einstein, wrote to President Roosevelt to warn of Germany's progress toward developing a nuclear reactor. As a result, the United States government supported Fermi's research, and in 1942, the first nuclear reaction occurred. It lasted twenty-eight minutes. From that point, a team of scientists, including Fermi, worked at Los Alamos, New Mexico, and by August 1945, Fermi's nuclear reactor had become the world's most destructive bomb. After the war, Fermi's discovery was harnessed to create energy, nuclear devices for medicine, and other peaceful applications. Like the bomb itself, nuclear energy has proved a mixed blessing.

Concepts

Pragmatism

Philosophy had lost credit in the nineteenth century. Unlike their former colleagues in the sciences, philosophers came to be seen as useless appendages to social progress. People began to believe that sensory and intellectual powers could not solve the problems posed by philosophy.

Early in the twentieth century, a reorientation occurred. A new philosophy, *pragmatism*, emerged in America, championed by John Dewey (1859–1952). Pragmatism abandoned the search for final answers to great problems, such as the existence of immortality, and instead contented itself with more modest goals in the realm of social experience. Pragmatism pursued such issues as what moral and aesthetic values might occur in a democratic, industrialized society, and how one might achieve the highest personal fulfillment through education. For the pragmatist, the criterion for truth consists of the workability of an idea. If an idea works, it is true. The truth of an idea, then, can be tested by its consequences; an idea void of results is inconsequential, thus meaningless. Pragmatism ignores ideas that are so metaphysical that they contain no practical value. If an idea has no *cash value*, as the philosopher William James put it—no practical aspect or useful consequential element—then we must repudiate it.

Dewey's concept of "art as experience" proves enlightening, challenging, and sometimes frustrating. "Experience," fundamental to Dewey's philosophy in all areas, appears most significant in his philosophy of aesthetics. Human experience, as interpreted by his aesthetics, presents a significant challenge to philosophy. According to Dewey, the philosopher needs to go to aesthetic experience in order to understand experience in general. Dewey builds on Hegel's concept of truth as a whole, and shares Schelling's belief that aesthetic intuition constitutes "the organ of philosophy," and so aesthetics emerges as "the crown of philosophy."

Existentialism

Existentialism insists on the actual existence of individuals as basic and important—rather than relying on theories and abstractions. The ideas basic to existentialism came from ancient times, but Sören Kierkegaard (SUHR-en KYAIR-kuh-gawr; 1813–55), a Danish philosopher, shaped them into a modern statement. He did not, however, use the term existentialism. The German philosopher Karl Jaspers (1883–1969) actually coined the word as a pejorative term for those he wished to separate from his own views. Philosophers applied it to Kierkegaard retrospectively. Few thinkers who hold existential views actually accept the term "existentialist." Philosophers such as Karl Jaspers and Martin Heidegger (HY-deg-ur) worked with the idea, and it occurs in the writings of Feodor Dostoyevski, for example (see Chapter 15), and Franz Kafka (see p. 553). Existentialism became associated with a literary school in the 1940s with the writings of Jean-Paul Sartre (SAHR-truh) among others.

Existentialism centers on the doctrine that human beings are what they make of themselves. Not predestined by God, society, or biology, they have free will and the responsibility that goes with it. If people refuse to make choices or allow outside forces to determine them, existentialists regard them as contemptible. Existentialists stress humankind's basic elements, such as the irrationality of unconscious and subconscious acts, and they consider life dynamic and in a constant state of flux. Human life constitutes not an abstraction but a series of consecutive movements. Existentialists insist on the concrete rather than the abstract, on existence itself rather than the idea of existence. Christian existentialism holds that the positive act of the will is a matter of religious choice and must ultimately lead to God.

Existentialists believe, then, that in an absurd universe without meaning or purpose, individuals have freedom of choice and must take absolute responsibility for their actions. Thus, the individual must find meaning in his or her own existence rather than in some externally imposed dogma. Jean-Paul Sartre stated the existentialist position succinctly: "Existence precedes essence." In other words, we develop our essential natures by the choices we make in life. Our tentative existence causes anxiety or "existential dread"—the fear of nothingness that makes us face our limitless and frightening freedom and responsibility. So, we have a choice, again: choose an "authentic" life or submit to despair. Kierkegaard criticized the rationalism of Hegel, claiming that religious belief required a "leap of faith" in the face of the world's absurdity. Later, the statement expanded to include the concept of "authenticity": humans could choose to act authentically, intelligently, and responsibly, or inauthentically, refusing to exercise their freedom, thereby lowering themselves into common conformity.

Albert Camus (kah-MOO; 1913–60), illustrated the existentialist viewpoint in his essay "The Myth of Sisyphus" (1942). It develops a sympathetic analysis of contemporary nihilism and raises the nature of the absurd. Camus argues that life has no meaning even though humans try to find answers to unanswerable questions. He uses the Greek myth of Sisyphus, condemned by the gods to roll a boulder up a hill for eternity, as a metaphor for humanity's eternal struggle against the essential absurdity of life. Death cuts short

our plans, but, as for Sisyphus, suicide is not an option. The only option remaining requires us to rebel by rejoicing in the act of rolling the boulder up the hill. When we joyfully accept the struggle against defeat, we gain fulfillment and identity and overcome the nothingness of existence.

Jean-Paul Sartre formed with Simone de Beauvoir (see p. 555), another existentialist writer, a romantic and intellectual union that remained lifelong. Sartre's first novel, *Nausea* (1938), employed the phenomenological method, which proposes careful, unprejudiced description rather than deduction. His later novel, *Being and Nothingness* (1943), more fully expressed his philosophical system, as does his short work, *Existentialism and Humanism* (1946). Sartre places human consciousness, or no-thingness, in opposition to being, or thingness. Consciousness, as not-matter, escapes determinism and thus forms the source of freedom. With freedom comes the responsibility for giving meaning to human endeavor, which otherwise remains futile.

Abstraction

The concept of **abstraction** plays a fundamental role in modernism. Specifically, abstraction constitutes the process of arriving at a universal from specifics. Some people see abstraction as the defining human characteristic that separates human intellect from the instinctive behavior of animals. Certainly, abstraction lies at the core of mathematics as well as much of modern art. Mathematicians, for example, abstract the numerical and geometrical qualities of objects from the objects themselves. The process involves observation that specific objects or phenomena share common abstract properties. The correlations deriving from such observations lead to specific axioms basic to mathematics. Abstraction lies at the heart of number theory, set theory, and artificial intelligence.

In philosophy, abstraction has often played a significant, if occasionally controversial, role. Aristotle derived the concept of categories by which he classified the things of the world by their particular characteristics and common properties. The concept also figures in the philosophical system of Kant, as well as in logic in general. In medieval times, the debate over whether objects actually have abstract qualities or reflect only the words we must use to understand them centered around the concept of universals. In modern times, abstraction has witnessed challenges from perspectives that discount universals and generalized abstractions, preferring, instead to focus on concrete particulars, as in existentialism, for example.

In art, abstraction typically takes one of two directions: either the reduction of natural images into shapes suggested by them, but not faithfully representing

them; or the reliance on pure form and color without representational reference.

Modernism

Modernism in Western culture constitutes a general tendency to reject traditional conventions and forms in favor of innovation and experimentation, particularly as those innovations and experiments relate to societal change and technology. It encompasses a broad range of meanings, including the arts.

Modernism in the arts developed in reaction to Romanticism, exemplified by Géricault (see Fig. 14.4), and realism, exemplified by Manet (see Fig. 15.10). Modernism rejected conventional narrative content and modes of expression to depict a world seen as altogether new and constantly in flux. We find modernism emerging in literature in the "stream of consciousness" technique of writers such as Virginia Woolf (see Chapter 15). In the words of art critic Harold Rosenberg, modernism created the "tradition of the new." As a movement, modernism has no coherence. Rather, it constitutes an approach to creation that broke old rules to express new thoughts and certain assumptions, often pessimistic, about the state of the world. We tend to view modernism as having begun around the end of the nineteenth century and lasting, as a dominant expression, until slightly after World War II.

We could also view modernism in a broader context as associated with a Renaissance concept of modernity that came into existence in the scientific revolution of the seventeenth century (see Chapter 12) and carried forward to the Enlightenment (see Chapter 13). In those terms, modernism comprised a concept that denied the authority of the past—specifically the notion that Western culture reached its peak in ancient Greece and Rome—and gave credence to the idea of progress, rationalism, and technology.

THE ARTS IN THE MODERN WORLD

Painting and Sculpture

A lot happened in the arts during the early to mid-twentieth century. At the root of the many directions art takes during this time rests the concept of *modernism*. The term was also applied to reforming tendencies in Christianity that sought to reconcile religious doctrine with scientific thought and social change. Modernism views the Bible, for example, as symbolically and morally, but not literally, true and stands at odds with the concept of "fundamentalism."

Abstraction

As we just noted, abstraction in art takes two general forms: (1) the reduction of images from the natural world into shapes suggested by, but not conventionally representational of, actual objects; (2) the "pure" use of color, line, shadow, mass, and other traditional, formal elements of painting and sculpture to create an image referring only to itself. In other words, abstract art seeks to explore the expressive qualities of formal design elements and materials in their own right. These elements stand apart from subject matter. The aesthetic theory underlying abstract art maintains that beauty can exist in form alone with no other quality needed. Many painters explored these approaches, and several groups, such as *De Stijl* (duh styl), the **suprematists**, the constructivists, and the **Bauhaus** painters, have pursued its goals. The works of Piet Mondrian (peet MOHN-dree-ahn) and Kasimir Malevich (mahl-YAY-vich) illustrate many of the principles at issue in abstract painting.

A work such as *Suprematist Composition: White on White* (Fig. **16.7**) by Kasimir Malevich (1878–1935) seems simple but confusing, even by abstract standards. For Malevich, such works go beyond reducing painting to its basic common denominator of oil on canvas. Rather, he sought basic pictorial elements that could "communicate the most profound expressive reality."

Mondrian (1872–1944) believed that straight lines and right angles represented the fundamental principles of life. A vertical line signified activity, vitality, and life, while a horizontal line signified rest, tranquility, and death. The crossing of the two in a right angle expressed the highest possible tension between these forces, positive and negative. Mondrian's exploration of this theory in *Composition in White, Black, and Red* (Fig. **16.8**) typifies all his linear compositions. The planes of the painting stay close to the surface of the canvas, creating, in essence, the shallowest space possible. Mondrian restricts the palette to three hues. Even the edges of the canvas take on expressive possibilities as they provide additional points of interaction between lines. Mondrian believed that he could create "the equivalence of reality" and make the "absolute appear in the relativity of time and space" by keeping visual elements in a state of constant tension.

Dada

The horrors of World War I caused tremendous disillusionment. One expression of this emerged in the birth of "Dada." (Considerable debate exists about when and how the word "dada"—French for "hobby-horse"— came to be chosen. The Dadaists themselves accepted it as two nonsense syllables, like one of a baby's first words.) During the years 1915 and 1916, many artists gathered in neutral capitals in Europe to express their disgust at the

16.7 Kasimir Malevich, *Suprematist Composition: White on White*, c. 1918. Oil on canvas, 31¼ × 31¼ ins (79.4 × 79.4 cm). Museum of Modern Art, New York. Acquisition confirmed in 1999 by agreement with the Estate of Kasimir Malevich and made possible with funds from the Mrs John Hay Whitney Bequest (by exchange).

16.8 Piet Mondrian, *Composition in White, Black, and Red*, 1936. Oil on canvas, 3 ft 4⅛ ins × 3 ft 5 ins (1.02 × 1.04 m). Museum of Modern Art, New York (Gift of the Advisory Committee). © 2005 Mondrian/Holtzman Trust c/o hcr@hcrinternational.com

direction Western societies were taking. Dada thus served as a political protest, and in many places the Dadaists produced more left-wing propaganda than art.

By 1916, a few works of art began to appear, many of them **found objects** and experiments in which chance played an important role. For example, Jean Arp (1888–1966) produced **collages** that he made by dropping haphazardly cut pieces of paper onto a surface and pasting them down the way they fell. Max Ernst (1891–1976) juxtaposed strange, unrelated items to produce unexplainable phenomena. This use of conventional items placed in circumstances that alter their traditional meanings characterizes Dadaist art. Irrationality, meaninglessness, and harsh, mechanical images occur as typical effects, as shown in *Woman, Old Man, and Flower* (Fig. **16.9**). This nonsensical world shows pseudo-human forms with their bizarre features and proportions to suggest a malevolent unreality. Dada emphasizes protest and leads to the idea that the arts must shock. Perhaps the most vivid exponent of Dada, Marcel Duchamp, produced proto-Dadaist expressions of futurism already seen in *Nude Descending a Staircase* (see Fig. **15.24**).

Surrealism

As the work of Sigmund Freud became popular, artists became fascinated by the subconscious mind. By 1924, a **surrealist** manifesto stated some specific connections between the subconscious mind and painting. Surrealists maintained that their works emerged by "pure psychic automatism," which sought to merge reason and unreason, consciousness and unconscious into an "absolute reality—a super-reality." Its advocates saw surrealism as a way to discover the basic realities of psychic life by automatic associations. Supposedly, a dream could transfer directly from the unconscious mind

16.9 Max Ernst, *Woman, Old Man, and Flower*, 1923–4. Oil on canvas, 3 ft 2 ins × 4 ft 3¼ ins (96.5 × 130.2 cm). Museum of Modern Art, New York. Purchase. © ADAGP, Paris and DACS, London 2005.

of the painter to canvas without control or conscious interruption. Surrealism came from Dada's preoccupation with the irrational and illogical, and reaches back to Marcel Duchamp.

Two directions of surrealist art emerged. The metaphysical fantasies of Giorgio de Chirico (KEE-ree-koh; 1888–1978), for example, present fantastic, hallucinatory scenes in a hard-edged, realistic manner. In works such as *Nostalgia of the Infinite* (Fig. **16.10**), strange objects appear irrationally juxtaposed: they come together as in a dream. These bizarre works reflect a world that human beings do not control. In them, "there is only what I see with my eyes open, and even better, closed."

Another surrealist of this same direction, Mexican painter Frida Kahlo (KAH-loh; 1907–54), created (more than one third are self-portraits) studies in great pain and suffering, both mental and physical. A bus crash at age eighteen resulted in the loss of her right leg. Works such as *The Broken Column* (see Fig. **16.1**) portray a nightmarish quality typical of surrealism: here a myriad of emotions, as the subject appears both as a sufferer and a savior. The broken column displayed in the open chasm of the torso juxtaposes a graphic architectural form, perhaps suggesting her own spine and brokenness, with her body itself, punctured by numerous nails and held together by a cloth harness. The self-portrait stands before a barren monochromatic landscape and darkened sky. The second direction of surrealism—the abstract—appears in works by Joan Miró (see Fig. **0.2**). These exhibit spontaneity and chance, using abstract images.

American Painting

Until the early twentieth century, painting in the United States had done little more than adapt European trends to the American experience. Strong and vigorous American painting emerged in the early twentieth century, however, and it encompasses so many people and styles that we will have to content ourselves with only a few representative examples.

An early group called "the Eight" appeared in 1908 as painters of the American "scene." Robert Henri, George Luks, John Sloan, William Glackens, Everett Shinn, Ernest Lawson, Maurice Prendergast, and Arthur B. Davies shared a warm and somewhat sentimental view of American city life, and they presented it both with and without social criticism. Although uniquely American in tone, the works of the Eight often revealed European influences, for example, of impressionism.

The modern movement in America owed much to the tremendous impact of the International Exhibition of Modern Art (called the Armory Show) in 1913. There, rather shocking European modernist works, such as Duchamp's *Nude Descending a Staircase, No. 2*

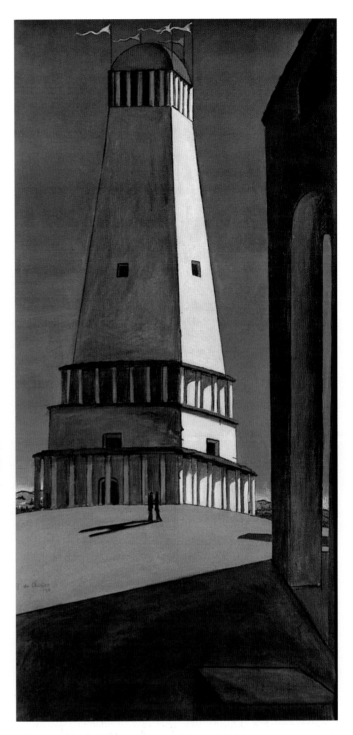

16.10 Giorgio de Chirico, *The Nostalgia of the Infinite*, c. 1913–14, dated 1911 on painting. Oil on canvas, 4 ft 5¼ ins × 2 ft 1½ ins (135.2 × 64.8 cm). Museum of Modern Art, New York. © DACS 2005.

PROFILE

GEORGIA O'KEEFFE (1887–1986)

American painter Georgia O'Keeffe, born near Sun Prairie, Wisconsin, grew up on the family farm in Wisconsin before deciding that she wanted to be an artist. She spent 1904–5 at the Art Institute of Chicago and 1907–8 at the Art Students League of New York, then supported herself by doing commercial art and teaching at various schools and colleges in Texas and the South. Her break came in 1916, when her drawings were discovered and exhibited by the famous American photographer Alfred Stieglitz, who praised and promoted her work vigorously. They maintained a lifelong relationship, marrying in 1924, and O'Keeffe became the subject of hundreds of Stieglitz's photographs. After meeting Stieglitz, O'Keeffe spent most of her time in New York, with occasional periods in New Mexico, but she moved permanently to New Mexico after her husband's death in 1946.

Her early pictures lacked originality, but by the 1920s she developed a uniquely individualistic style. Many of her subjects included enlarged views of skulls and other animal bones, flowers, plants, shells, rocks, mountains, and other natural forms. Her images have a mysterious quality about them, with clear color washes and a suggestive, psychological symbolism that often suggests eroticism. Her rhythms undulate gracefully. The works bridge the gap between abstraction and **biomorphic** form (see Fig. **16.11**).

Perhaps she created her best-known work in the 1920s, 1930s, and 1940s, but she remained active as a painter almost until her death in 1986. Her later works exalt the New Mexico landscape which she loved.

16.11 Georgia O'Keeffe, *Dark Abstraction*, 1924. Oil on canvas, 24⅞ × 20⅞ ins (63.18 × 53.02 cm). St Louis Art Museum (Gift of Charles E. and Mary Merrill). © ARS, New York and DACS, London 2005.

(see Fig. **15.24**) and the cubist work of Braque and Picasso (see Fig. **15.23**), first revealed themselves to the American public.

Georgia O'Keeffe (1887–1986), an American, proved one of the most original artists of the century. Her imagery draws on a wide variety of objects that she abstracts in a uniquely personal way. She takes, for example, an animal skull and transforms it into a form of absolute simplicity and beauty. In *Dark Abstraction* (Fig. **16.11**) an organic form becomes an exquisite landscape which, despite the modest size of the painting, appears monumental. Her lines flow gracefully upward and outward with a skillful blending of colors and rhythmic grace. The painting expresses a mystical reverence for nature, whatever we make of its subject matter. O'Keeffe creates a sense of reality that takes us beyond our usual perceptions into something much deeper.

Precisionists, such as Stuart Davis (1894–1964), took real objects and arranged them into abstract groupings, as in *Lucky Strike* (Fig. **16.12**). These paintings often use the strong, vibrant colors of commerical art (much like those of pop art in the 1960s). At every turn, this subject matter surprises us. At first we wonder at the frame within the frame. The gray textured border provides a strong color contrast to the interior form, which, were it not for the curved form at the top, would look very much like a

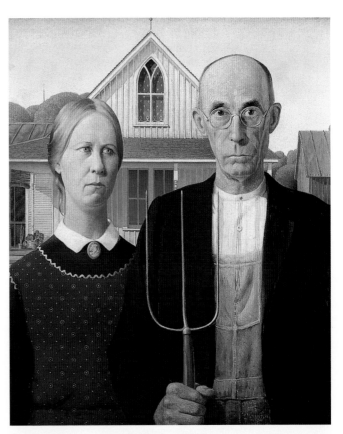

16.13 Grant Wood, *American Gothic*, 1930. Oil on beaver board, 29¼ × 24⅝ ins (74.3 × 62.4 cm). Friends of American Art Collection. The Art Institute of Chicago and VAGA. Photo: © 1998 The Art Institute of Chicago.

16.12 Stuart Davis, *Lucky Strike*, 1921. Oil on canvas, 33¼ × 18 ins (84.5 × 45.7 cm). Museum of Modern Art, New York. © Estate of Stuart Davis/VAGA, New York/DACS, London 2005.

window. The curve repeats in reverse near the bottom of the picture, and the slight slant of these two opposing lines encounters the reverse slant of the white and black arcs. The strength of this work lies in the juxtaposition of complementary colors, rectilinear and curvilinear forms, and opposing values, that is, lights and darks.

The *realist* tradition continued in the works of Grant Wood (1892–1942). The painting *American Gothic* (Fig. **16.13**) provides a wonderful celebration of the simple, hardworking people of America's heartland. A lyric spirituality lies behind the façade of this down-home illustration. The elongated forms pull up together into a pointed arch which encapsulates the Gothic window of the farmhouse and escapes the frame of the painting through the lightning rod (just as the Gothic spire released the spirituality of the earth into heaven at its tip). Rural American reverence for home and labor celebrates here with gentle humor.

The Harlem Renaissance

From 1919 to 1925, Harlem, a neighborhood in upper Manhattan, became the international capital of African American culture. "Harlem was in vogue," wrote the poet Langston Hughes (see p. 556). African American painters, sculptors, musicians, poets, and novelists joined in a remarkable artistic outpouring. Some critics at the time attacked this work as isolationist and conventional, and the quality of the **Harlem Renaissance** still stirs debate.

The movement took up several themes: glorification of the black American's African heritage, the tradition of black folklore, and the daily life of black people. In exploring these subjects, Harlem Renaissance artists broke with previous African American artistic traditions. But they celebrated black history and culture and defined a visual vocabulary for black Americans.

African American intellectuals such as W.E.B. Du Bois (doo-BOYS; 1868–1963), Alain Locke (1886–1954), and Charles Spurgeon spearheaded the movement. Among the notable artists appeared social documentarian

16.14 Aaron Douglas, *Aalta*, 1936. Oil on canvas, 23 × 18 ins (58.4 × 45.7 cm). African American Collection of Art, The Carl Van Vechten Gallery of Fine Arts, Fisk University, Nashville, Tennessee.

and photographer James van der Zee (1886–1983), painter William Henry Johnson (1901–70), painter Palmer Hayden (1890–1973), painter Aaron Douglas (1899–1979), and sculptor Meta Vaux Warrick Fuller (1877–1968).

Aaron Douglas, arguably the foremost painter of the Harlem Renaissance in highly stylized work, explores a palette of muted tones. Douglas was particularly well known for his illustrations and cover designs for many books by African American writers. His portrait of *Aalta* (Fig. **16.14**) exhibits warmth and relaxation, and its color and line express dignity, elegance, and stability. *Aspects of the Negro Life* (Fig. **16.15**), at the New York Public Library's Cullen branch, documents the emergence of an African American identity in four panels. The first portrays the African background in images of music, dance, and sculpture. The next two panels bring to life slavery and emancipation in the American South and the flight of blacks to the cities of the North. The fourth panel returns to the theme of music. The master of many styles, Douglas proved extremely effective in his realistic work.

Central American Painting

Diego Rivera (ree-VAY-rah; 1886–1957) revived the fresco mural as an art form in Mexico in the 1920s. Working with the support of a new revolutionary government, he produced large-scale public murals that picture contemporary subjects in a style that blends European and native traditions. The fresco painting *Enslavement of the Indians* (Fig. **16.16**) creates a dramatic comment on that chapter in Mexican history.

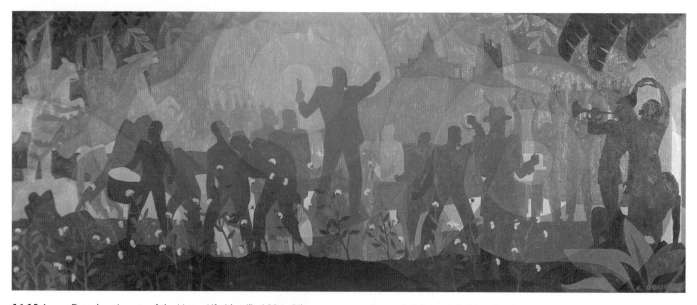

16.15 Aaron Douglas, *Aspects of the Negro Life* (detail), 1934. Oil on canvas, entire work 5 ft × 11 ft 7 ins (1.52 × 3.53 m). Schomburg Center for Research in Black Culture, New York Public Library, Astor, Lenox and Tilden Foundations.

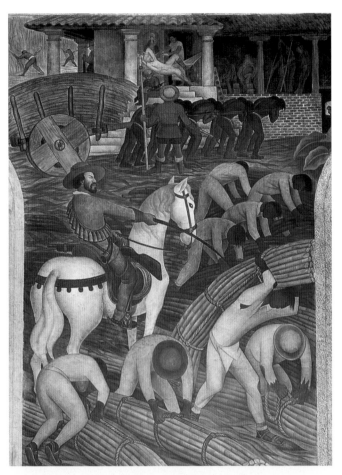

16.16 Diego Rivera, *Enslavement of the Indians*, 1930–1. Fresco. Palace of Cortez, Cuernavaca, Mexico.

The composition, not unlike that of Goya's *The Third of May 1808* (see Fig. **14.6**), takes a strong diagonal and sweeps it across the work, separating the oppressed from the oppressor, and providing a dynamic movement stabilized by the classically derived arcade framing the top of the composition. We already have noted another important Central American painter, Frieda Kahlo, who also represents surrealism (see Fig. **16.1**).

African and Primitive Influences

The direct influence of African art appears in the sculptures of Constantin Brancusi (BRAHN-koosh; 1876–1957). Yet beyond this, the smooth, precise surfaces of much of his work have an abstract, machined quality. Brancusi's search for essential form led to very economical presentations, often ovoid and simple, yet animate. Brancusi's *Mlle Pogany* (Fig. **16.18**), despite the superbly polished surface and accomplished curves which lead the eye inward, has an enigmatic character reminiscent of an African mask.

In 1925, Jacques Lipchitz (leep-SHEETS; 1891–1973) created a series of "transparents" made from cardboard cut and bent to approximate the cubism of Picasso's paintings. He thus opened up the interiors of these works, to achieve a radical new understanding of space: interior spaces need not be voids, but, rather, could become integral parts of the sculptural work itself. Thus, he arrived at the concept of **negative space**, which has played an important role in modern sculpture and architecture since that time.

A DYNAMIC WORLD

AFRICAN MASKS

Headdress masks are important in African ritual, and we can see the influence of this style in the work of some Western artists in the twentieth century. In Figure **16.17** we see an Igbo face mask from eastern Nigeria. This mask was created by the same tribe that made the *Igbo-Ukwu* roped pot on a stand (see Fig. **7.17**), some thousand years earlier. The ritual mask of Figure **16.17** is realistically styled and represents a beautiful and refined spirit. It could be one of a great group of spirits represented in Igbo masquerades. It has a shiny surface and careful detailing, and its patina comes from the process of smoking. Each element of facial tattoos, anatomical parts, and headdress shows care and skill in execution.

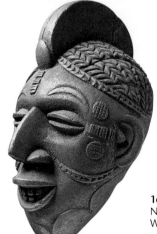

16.17 Igbo face mask from eastern Nigeria, twentieth century. Wood with smoke patina.

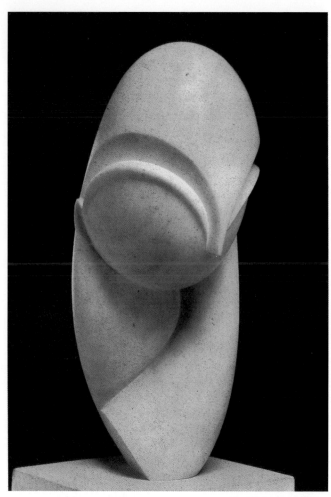

16.18 Constantin Brancusi, *Mlle Pogany*, 1931. Marble on limestone base, 19 ins (48 cm) high. Philadelphia Museum of Art (Louise and Walter Arensberg Collection). © ADAGP, Paris and DACS, London 2005.

Lipchitz's *Man with a Guitar* (Fig. **16.19**) predates his discovery of negative space, but clearly it reflects his interest in form, space, cubism, and archaic and primitive art. Here, these influences appear in the way forms combine to create a multifaceted shape that has the appearance of being viewed from several directions at once. At the same time, the work has an archaic, geometric solidity. The primitive influence appears in its proportions—an elongated torso and head and shortened legs. The interaction of angles and curves draws the viewer in to examine the work from many different observation points.

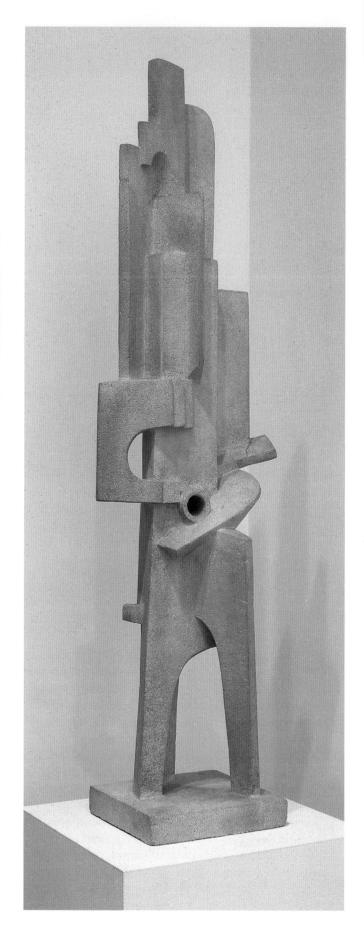

16.19 Jacques Lipchitz, *Man with a Guitar*, 1915. Limestone, 38¼ ins (97.2 cm) high. Museum of Modern Art, New York (Mrs Simon Guggenheim Fund) (by exchange).

MASTERWORK

DOROTHEA LANGE—*MIGRANT MOTHER*

Since the late nineteenth century, photographers had used photography to document social problems. During the Great Depression, a large-scale program in documentary photography began in the United States. Among the photographers using this approach, Dorothea Lange (1895–1965) helped develop an unsurpassed portrait of the nation. Noted for her ability to make strangers seem like familiar acquaintances, her work for the Farm Security Administration, including *Migrant Mother, Nipomo, California* (1936; Fig. **16.20**), graphically detailed the erosion of the land and the people of rural America during the Great Depression. Distressed by the Depression, she began photographing the poor and unemployed, bringing their plight to national attention.

16.20 Dorothea Lange, *Migrant Mother, Nipomo, California*, 1936. Library of Congress, Washington D.C.

Her photographs of California's migrant workers, captioned with their own words, were so effective that the state established migrant worker camps to alleviate the suffering.

In this poignant photograph, Florence Thompson, a thirty-two-year-old widow, looks past the viewer with a preoccupied, worried expression. With her furrowed brow and prematurely aged face, she captures the fears of an entire population of disenfranchised people. Two of her children lean on her for support, their faces buried disconsolately in their mother's shoulders. Lange consciously avoided including all of Thompson's children in the photograph because she did not wish to contribute to the widespread resentment of wealthier people in America about overpopulation among the poor.

Photography

After World War I, as photography entered its second century, significant aesthetic changes occurred. Early explorations of photography as an art form tended to employ darkroom techniques, tricks, and manipulation that created works appearing staged and imitative of sentimental, moralistic paintings. The followers of such an aesthetic believed that for photography to be art, it must look like "art."

During the early years of the twentieth century, however, a new generation of photographers arose who determined to take photography away from the previous, pictorial style and its soft focus, and toward a more direct, un-manipulated, and sharply focused approach. Called "straight" photography, it expressed what its adherents believed comprised photography's unique vision. The principal American force behind the recognition of photography as a fine art, Alfred Stieglitz (STEEG-lits; 1864–1946) gained recognition for his clarity of image and reality shots, especially of clouds and New York City architecture. In 1902, he formed the Photo-Secessionist group and opened a gallery referred to as 291 because of its address at 291 Fifth Avenue in New York City. In addition to showcasing photography, Stieglitz's efforts promoted many visual artists, including the woman who would become his wife, Georgia O'Keeffe (see Profile p. 538). He also promoted photography as a fine art in the pages of his illustrated quarterly, *Camera Work*.

Among the most famous of the adherents of straight photography, Ansel Adams (1902–84) emerged as a recognized leader of modern photography through his sharp, poetic landscape photographs of the American West (Fig. **16.21**). A well-known technical innovator, he pioneered the movement to preserve the wilderness.

16.21 Ansel Adams, *Mount Williamson in the Sierra Nevada*, 1945.

His work did much to elevate photography to the level of art. It emphasized sharp focus and subtle variety in light and texture, with rich detail and brilliant tonaldifferences. In 1941, he began making photomurals for the United States Department of the Interior, which forced him to master techniques for photographing the light and space of immense landscapes. He developed what he called the zone system, a means for predetermining the final tone of each part of the landscape.

We usually think of photography as pictures taken by a camera, as in the examples just seen. A photographer also, however, can build photographs, as in the photograms of Man Ray (1890–1976). Here we see the process not of taking pictures but of making them. In a photogram the artist places objects directly on the photographic paper and exposes them to light. Although not the first to make photograms, Man Ray has come to represent the process through his "Rayographs." In Figure **16.22** he creates an image by placing a piece of string, a pin, a magnifying glass, and a gyroscope on a photographic plate, pushing them around, and then exposing them. The resulting image reveals a spontaneous and witty side to Dada and surrealism, which the work also represents.

Architecture

Frank Lloyd Wright (1867–1959), one of the most influential and innovative architects of the twentieth century, wished to initiate new traditions. One such new tradition, the **prairie style**, Wright developed around 1900. In creating these designs, Wright drew on the flat landscape of the midwest as well as the simple horizontal and vertical accents of the Japanese style. Wright followed Louis Sullivan in his pursuit of form that expressed function, and he took painstaking care to devise practical arrangements for his interiors and to make the exteriors of his buildings reflect their interiors.

Wright also designed some of the furniture for his houses. In doing so, comfort, function, and integration with the total design were his chief criteria. Textures and colors in the environment duplicated in the materials, including large expanses of wood, both in the house and for its furniture. He made a point of giving furniture several functions. Tables, for example, might also serve as cabinets. He designed all spaces and objects precisely to present a complete environment. Wright believed that houses profoundly influence the people who live in them, and he saw the architect as a "molder of humanity." Wright's works range from the simple to the complex, from the serene (Fig. **16.23**) to the dramatic (see Fig. **16.24**), and from interpenetration to enclosure of

16.22 Man Ray, *Rayograph*, 1922. Gelatin silver print (photogram), 9⅜ × 6⁵/₁₆ ins (23.9 × 17.7 cm). Museum of Modern Art, New York. Gift of James Thrall Soby. © Man Ray Trust/ADAGP, Paris and DACS, London 2005.

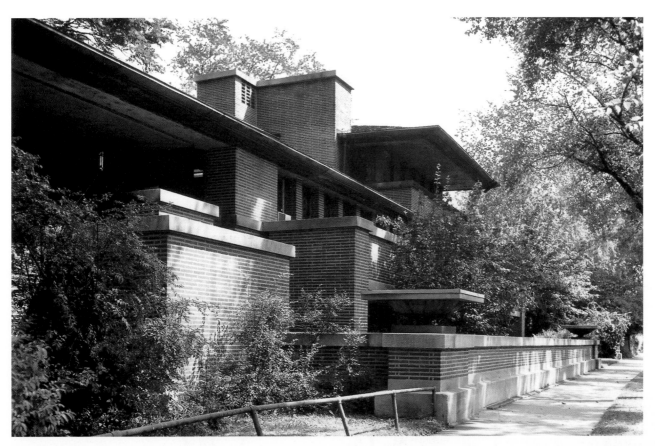

16.23 Frank Lloyd Wright, Robie House, Chicago, 1907–09. © ARS, New York and DACS, London 2005.

space. Always experimental, he explored the various interrelationships between space and geometric design.

Wright's insistence on the integration of the context of the building and the creation of indoor space—as an extension of outdoor space—led him to even more dramatic projects. The horizontality of the prairie style remains, but we see it in a completely different mode in the exciting Kaufmann House (see Fig. **16.24**).

Other new concepts in design appeared in the works of Le Corbusier (luh kor-boo-ZYAY; 1887–1965) during the 1920s and 1930s. Le Corbusier concerned himself with integrating structure and function, and he had an especial interest in poured concrete. He demonstrated his belief that a house served as "a machine to be lived in" in several residences of that period. By "machine," Le Corbusier did not mean something depersonalized. Rather, he meant that a house should be efficiently constructed from standard, mass-produced parts, and logically designed for use, on the model of an efficient machine.

Le Corbusier had espoused a domino system of design for houses, using a series of slabs supported on slender columns. The resulting boxlike building had a flat roof, usable as a terrace. The Villa Savoye (Fig. **16.26**)

combines these concepts in a building whose supporting structures free the interior from the necessity of weight-supporting walls. In many ways, the design of the Villa Savoye reveals a classical Greek inspiration, from its columns and human scale to its precisely articulated parts and coherent whole. The design shows crispness and functionality.

The Bauhaus (BOW-hows) represents a conscious attempt to integrate the arts into a unified statement. For the most part, the story of the Bauhaus and its goals emerges in the philosophy of its founder and primary visionary, Walter Gropius (VAHL-tur GROH-pee-us; 1883–1969). Although secular in spirit, the Bauhaus represents a vision of artistic accomplishments, such as seen in the great churches and palaces of the past—a true integration of vision wrapped in a common purpose. That vision may, in fact, have returned in the performance art of the last few years.

In Germany in the mid-1920s, and led by Walter Gropius and Adolph Meyer, the Bauhaus School of Art, Applied Arts, and Architecture approached aesthetics from the point of view of engineering. Experimentation and design based on technological and economic factors rather than on formal considerations. The Bauhaus

MASTERWORK

WRIGHT—KAUFMANN HOUSE

Frank Lloyd Wright remains one of the greatest American artists in any medium. His primary message stressed the relationship of architecture to its setting, a lesson that some modern architects seem to have forgotten. Wright's buildings seem to grow out of, and never violate, their environment. In fact, one of the tenets of Wright's aesthetic is the merging of internal and external environments, in which one flows seamlessly into the other.

One of his most inventive designs, the Kaufmann House, also known as Falling Water, at Bear Run, Pennsylvania (Fig. **16.24**), cantilevers over a waterfall, with exciting dramatic imagery. The inspiration for this house was probably the French Renaissance château of Chenonceaux, built on a bridge across the River Cher. However, "Falling Water" creates no house built on a

bridge. It erupts out of its natural rock site, and its beige concrete terraces blend harmoniously with the colors of the surrounding stone. Wright has successfully blended two seemingly dissimilar styles: the house stays a part of its context, yet it has the rectilinear lines of the International Style, which Wright usually opposed. He has taken those spare, sterile boxes and made them harmonize with their natural surroundings.

Wright's great asset, and at the same time his greatest liability—his myopic insistence on his own vision—meant he could work only with clients who would bend to his wishes. So, unlike many architects, whose designs are tempered by the vision of the client, what Wright built remained Wright's, and Wright's only.

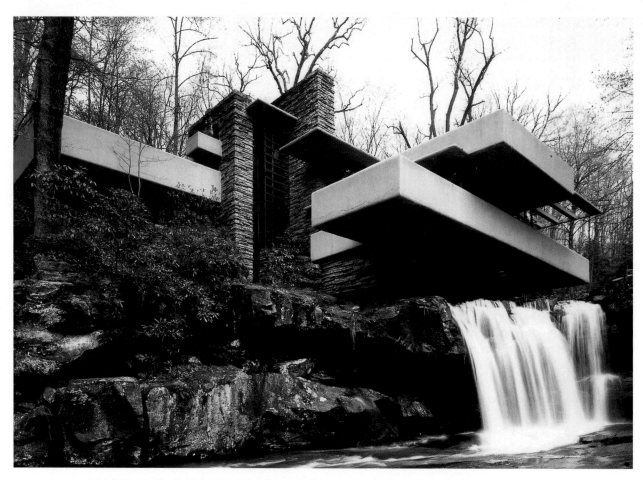

16.24 Frank Lloyd Wright, Kaufmann House (Falling Water), Bear Run, Pennsylvania, 1936–7.
© ARS, New York and DACS, London 2005.

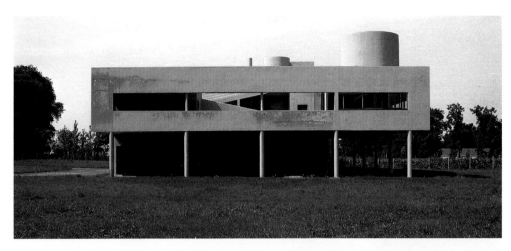

16.26 Le Corbusier, Villa Savoye, Poissy, France, 1928–30.
© FLC/ADAGP, Paris and DACS, London 2005.

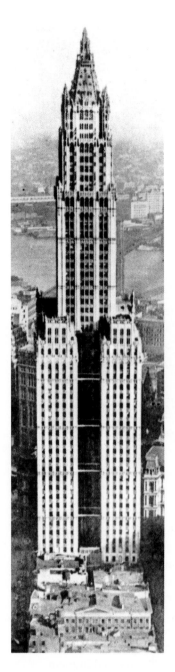

16.25 Cass Gilbert, The Woolworth Building, New York, 1913.

philosophy sought to establish links between the organic and technical worlds and thereby to reduce contrasts between the two. Spatial imagination, rather than building and construction, served as the Bauhaus objective. The design principles of Gropius and Meyer produced building exteriors completely free of ornamentation. Several juxtaposed, functional materials form the external surface, underscoring the fact that exterior walls are no longer structural, merely a climate barrier. Bauhaus buildings evolved from a careful consideration of what people needed their buildings to do, while, at the same time, the architects searched for dynamic balance and geometric purity (Fig. **16.27**).

In 1919 Walter Gropius wrote what has been called the "Bauhaus Manifesto." The major thrust of his ideas was that "all the arts culminate in architecture." Inspired by a vision of buildings as a new type of organic structure created by integrating all the arts and expressing the contemporary situation, Gropius sought in his new vision to bring back into the architectural environment the work of painters and sculptors—who, by the twentieth century, had been virtually excluded from the building crafts. Gropius wanted to create a new unity between art and technology, not by returning to the styles of the past, but, in fact, by abandoning contemporary artistic vocabulary—which he viewed as "sterile" and meaning-less—and evolving a new architectonic outlook.

Many traditional approaches to architecture continued through the period. Cass Gilbert's Woolworth Building (Fig. **16.25**) represents one such example. It has not only stimulated considerable discussion, including the appelation "Woolworth Gothic," but it has also inspired a wave of Gothic skyscrapers, including Howells and Hood's Tribune Tower in Chicago (1923–5).

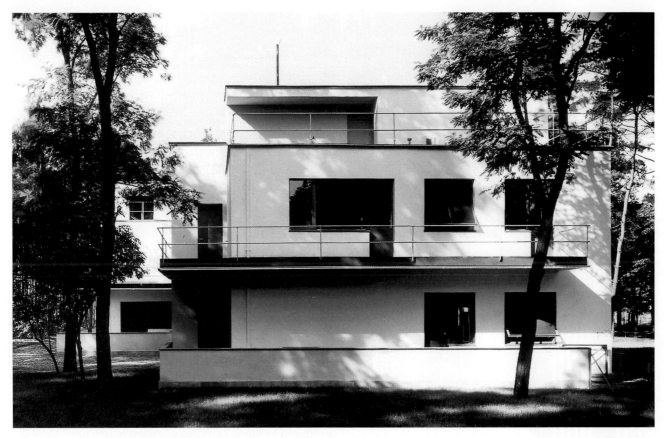

16.27 Walter Gropius, Professor Gropius's own house at Dessau, Germany, 1925.

Theatre

Epic Theatre

Theatre championing social action found a successful exponent in Bertolt Brecht (brehkht; 1898–1956) and his *epic theatre*. Although Brecht wrote many of his plays before World War II, they did not see production until after it. With his Berliner Ensemble, Brecht brought his theories and productions to a wide audience. Drawing heavily on the expressionists, Brecht developed complex theories about theatre and its relationship to life, and he continued to mold and develop these theories until his death.

Brecht revolted against dramatic theatre. Essentially, he tried to move the audience out of the role of passive spectator and into a more dynamic relationship with the play. To this end, Brecht postulated three circumstances—*historification*, *alienation*, and *epic*.

Historification removed events from the lifelike present to the past in order to make the actions presented seem strange. According to Brecht, the playwright should make the audience feel that if they had lived under the conditions presented in the play, they would have taken some positive action. Understanding this, the audience should see that things have changed since then and thus they too can make changes in the present.

Brecht believed the audience should not confuse the theatre with reality. The audience should always watch the play critically as a comment on life. In order for the spectators to judge the action in the play and apply it to life outside, however, they must be separated—or *alienated*—from the play's events, even though they might be emotionally involved in them. Historification was one kind of alienation. Other devices could also be used to make things strange, such as calling attention to the make-believe nature of a production or inserting songs, film sequences, and so on. Brecht did not subscribe to the idea of a unified production. Rather, he saw each element as independent, and thus each created a device employable to produce further alienation.

Finally, Brecht called his theatre "epic" because he believed that his plays resembled epic poems more than they did traditional drama. His plays present a story from the point of view of a storyteller, and they frequently involve narration and changes of time and place that might be accomplished with nothing more than an explanatory sentence.

Absurdism

Many artists of this period had lost faith in religion, science, and humanity itself. In their search for meaning, they found only chaos, complexity, grotesque laughter, and perhaps insanity.

The plays of Luigi Pirandello (peer-an-DEHL-lo; 1867–1936) obsessively ask the question "What is real?" with brilliant variations. In the psychological play, *Six Characters in Search of an Author* (1921), Pirandello sought to fragment reality by destroying conventional dramatic structures and adopting new ones. *Six Characters* employed a play within a play. Pirandello sought to achieve perfect unity between ideas and dramatic structure by transferring the dissociation of reality from the plane of content to that of form. *Right You Are If You Think You Are* (1917) presents a wife, living with her husband in a top-floor apartment and not permitted to see her mother. She converses with her daily, the mother in the street and the daughter at a garret window. Soon a neighbor demands an explanation from the husband. He answers, but so does the mother, who has an equally plausible but different answer. Finally, someone approaches the wife, the only one who can clear up the mystery. Her response, as the curtain falls: loud laughter! Pirandello expressed his dismay at an incomprehensible world in mocking laughter directed at those who thought they knew the answers.

Pirandello's work factored in the emergence of a movement called "**absurdism**." A philosophy that posited the essential meaninglessness—or unknowable meaning—of existence, and thus questioned the meaning of any action, was also emerging: "existentialism". It also contributed to absurdist style, especially in the literary arts.

From such antecedents came numerous dramas, the best-known of which were written by the French existentialist philosopher, writer, and playwright Jean-Paul Sartre (1905–80). Sartre held that no absolute or universal moral values existed and that humankind formed part of a world without purpose. Therefore, men and women had responsibility only to themselves. His plays attempted to draw logical conclusions from "a consistent atheism." Plays such as *No Exit* (1944) translate Sartre's existential views into dramatic form.

Albert Camus (kah-MOO; 1913–60) first applied the term "absurd" to the human condition. This he took to be a state somewhere between humanity's aspirations and the meaninglessness of the universe which is the condition of life. Determining which way to take a chaotic universe is the theme of Camus's plays, such as *Cross-Purposes* (1944). Absurdism continued as a theatrical genre after World War II, and will be discussed further in the next chapter with playwrights such as Samuel Beckett and Eugene Ionesco.

Music

Modern Traditionalism

Traditional tendencies continued through the 1930s and 1940s in various quarters, for example, in the music of the American William Schuman (1910–92). Schuman's symphonies have bright timbres and energetic rhythms, and focus on eighteenth- and nineteenth-century American folklore. The inspiration of the eighteenth-century American composer William Billings (1746–1800) figures prominently in Schuman's *William Billings Overture* (1943) and the *New England Triptych* (1956), based on three pieces by Billings. *American Festival Overture* (1939), perhaps his most famous work, relies on traditional tonality. Traditional tonality also appears in the works of the Russian composer Sergei Prokofiev (sair-GAY prah-KOH-fyef; 1891–1953). With all its traditional tonality, however, Prokofiev's *Steel Step* reflected the encroachment of mechanization of the 1920s. The machine as a symbol for energy and motion found its way into music, and in *Steel Step* Prokofiev intentionally dehumanized the subject of his music in order to reflect contemporary life.

In a completely opposite vein, Prokofiev created the engaging introduction to orchestral instruments, *Peter and the Wolf* (1936), in which he cleverly and memorably takes a simple fairy tale and assigns each character in the story a particular theme on a particular instrument.

The first major woman composer in the United States, Amy Beach (1867–1944) composed work based on the themes and techniques of the Romantic period and the European heritage. Her Violin Sonata in A Minor, Op. 34 (1896) seems reminiscent of Brahms or Dvořák, with suggestions of Hungarian or Slavonic dances. The sonata has four movements and lasts thirty minutes. The scherzo movement has a lighthearted and clever mood using a dance-and-trio formal organization of the European type, but with duple rather than triple meter. Beach employs a very tight organizational scheme. Each motif refers closely to motifs of the opening phrase. The work begins with a sprightly fiddle tune, interweaving with the piano, followed by two broad homophonic phrases in the piano. The violin then joins in over a drone in the piano. After a transition section the piece returns to earlier material and accelerates into a coda with violin trills and a cadence.

Departures

Paul Hindemith (HIN-duh-mith; 1895–1963) departed from traditional tonality in his compositions. He presented his systematized approach to problems of musical organization and their theoretical solutions in *The Craft of Musical Composition*. Hindemith's work reflects an extremely chromatic and almost atonal style.

Although his system of tonality used centers, it did not include the concepts of major and minor keys. He hoped that his new system would become a universal music language, but it did not.

Hindemith, however, had great influence on twentieth-century composition, both as a composer and a teacher. His works are broad and varied, encompassing nearly every musical genre, including ten operas, art songs, cantatas, chamber music, **requiems**, and symphonies. *Kleine Kammermusik für fünf Bläser*, a delightful composition for five woodwinds in five contrasting movements, has a very clear overall form and themes. Its dissonant harmonies and untraditional tonalities typify Hindemith's works. Yet Hindemith criticized "esoteric isolationism in music," and he tried to write works that the general public could understand and that the amateur musician could play.

The Hungarian composer Béla Bartók (BEL-luh BAHR-tohk; 1881–1945) took another nontraditional approach to tonality. He was interested in folk music, and a number of his compositions show those elements. Eastern European folk music does not use Western major/minor tonalities, and thus Bartók's interest in it and in nontraditional tonality in general went hand in hand. Bartók invented his own type of harmonic structure, which could accommodate folk melodies.

However, as nontraditional as some of Bartók's work remains, he also employs traditional devices and forms. He uses precise and well structured style, and occasionally uses sonata form. He often develops his works from one or two very short motifs, and his larger works unify by repeating thematic material. Bartók employs largely contrapuntal textures, with strong melodies but little conventional harmony, and dissonances occur frequently.

Bartók's employment of traditional devices always bent to his own desires and nearly always lay outside the traditional tonal system. He contributed significantly to string quartet literature, and his six quartets each set out a particular problem which he then solves, using simple motifs combined with complex tonality. One characteristic of his melodic development, octave displacement, has successive notes of a melody occurring in different octaves. This device apparently came from the folk music in which he was so interested. When peasants found the notes of a melody too high or low, they simply jumped up or down an octave so as to sing them comfortably.

Rhythm also forms a notable feature of Bartók's music. His works tend to have significant rhythmic energy; he employs devices such as repeated chords and irregular meters to generate dynamic rhythms. He also uses **polyrhythms**—various juxtaposed rhythms played at one time to create unique nonmelodic counterpoint.

Alban Berg (berkh; 1885–1935), a close friend and disciple of Schoenberg, based his compositions on serial technique. Berg's lyricism, however, despite their atonality, makes his works less disconnected than much **serial music**. Many of the characteristics of his work occur in his *Lyric Suite* (1927), a string quartet in six movements, based on several different tone rows.

The opening movement of the *Lyric Suite* starts with a brief chordal introduction, followed by the first tone row (the main theme, played by the first violin). The second theme, derived from the tone row, is more peaceful. Both themes then freely recapitulate, and the movement closes with a brief coda. The varied rhythm changes constantly between quadruple and duple meter. Much of the meaning of the piece depends on an accurate dynamic rendering by each of the four string players; Berg indicates the volume and articulation he requires in great detail. The remaining five movements use contrasting tempos, heightening the dramatic impact of the whole work.

The story for this piece—its "program"—alludes to an extramarital affair. This information, however, remained a secret for nearly fifty years. It was published for the first time only after the death of Berg's widow.

Anton Webern (VAY-burn; 1883–1945), a friend of Berg's, did not live to see the significant influence of his relatively small output of music on composers throughout the world in the 1950s and 1960s. His music is poetic, lyrical, and extremely original in its brevity, concentration, and quietude. His pieces typically last no more than two or three minutes. About half his compositions comprise choral works and songs; the rest written for chamber orchestra or small chamber groups— for example, his Quartet for Clarinet, Tenor Saxophone, Violin, and Piano, Op. 22 (1930). He adopted his teacher Schoenberg's twelve-tone system and built upon it to achieve a "melody built of tone colors." The second movement of Webern's Symphony, Op. 21 (1928), "Theme and variations," uses clarinet, bass clarinet, two horns, harp, and strings (no double bass). It illustrates Webern's distillation of musical materials to their essence. Each of the nine sections (theme, seven variations, and a coda) has exactly eleven measures. Further, each progresses to a midpoint at bar six and then mirrors itself to create a musical palindrome. The basic series (row) has exact symmetry. Webern, in turn, became a point of departure for later composers who were fascinated by his use of texture, tone color, dynamics, and register as unifying elements.

Charles Ives (1874–1954) was so experimental that many of his compositions were considered unplayable, and did not receive public performances until after World War II. Content to remain anonymous and disinclined to formulate a "system," as Schoenberg did, Ives went

unrecognized for many years. His melodies spring from folk and popular songs, hymns, and other, often familiar, material, which he treated in unfamiliar, complex ways. His very irregular rhythms often occur with only an occasional bar line to indicate an accent. His dissonant counterpoint frequently blurs one melodic line into another. Some of the **tone clusters** in his piano music prove unplayable without using a block of wood to depress all the keys at once. Ives' experiments, such as *The Unanswered Question* (1908), employ ensembles placed in various locations to create stereophonic effects. Ives' work reflects his idea that all music relates to life's experiences and ideas, some of which are consonant and some dissonant.

Aaron Copland (1900–91) integrated American idioms—jazz, dissonance, Mexican folk songs, and Shaker hymns—into his compositions. The last of these figure prominently in Copland's most significant work, *Appalachian Spring* (1944; Fig **16.28**). The theme and variations comprising the Shaker tune *Simple Gifts* reflect the Shaker text:

'Tis the gift to be simple, 'tis the gift to be free,
'Tis the gift to come down where we ought to be.

First written as a ballet, Copland later reworked it as a suite (set of movements) for symphony orchestra. Copland employed a variety of styles, some harmonically complex, some simple. He often used all the tones of the **diatonic** scale simultaneously, as he does in the opening chord of *Appalachian Spring*. His style nonetheless remains fairly traditionally tonal, and his unique use of rhythms and chords has been highly influential in twentieth-century American music.

Dance

Modern Dance

Despite the notoriety of the young feminist Isadora Duncan, her contemporary Ruth St Denis and her husband, Ted Shawn, laid more substantial cornerstones for modern dance in their Denishawn school. Much more serious than Duncan, Ruth St Denis numbered among her favorite books Immanuel Kant's *Critique of Pure Reason* and Alexandre Dumas's *Camille*. Her dancing began as a strange combination of exotic, oriental interpretations, and Delsartian poses. (Delsarte is a nineteenth-century system of gestures and postures that transmit feelings and ideas, originated by François Delsarte.) Ruth St Denis was a remarkable performer with a magnificently proportioned body. She manipulated it and various draperies and veils into presentations of line and form in such a graceful manner that the fabric appeared an extension of the dancer's body.

The Denishawn school took a totally eclectic approach to dance including all traditions, from formal ballet to oriental and American Indian dances. The touring company presented wildly varied fare, from Hindu dances to the latest ballroom crazes. Branches of the school formed throughout the United States, and the touring company occasionally appeared with the *Ziegfeld Follies*. By 1932, St Denis and Shawn had separated, and the Denishawn Company ceased to exist. Nevertheless, it left its mark on its pupils, if not always a positive one.

Among the first to leave Denishawn was Martha Graham (1893–1991), probably the most influential figure in modern dance (see Masterwork, p. 552). Although the term "modern dance" defies accurate definition, it remains the most appropriate label for the nonballetic tradition that Martha Graham came to symbolize. Graham found Denishawn unsatisfactory as an artistic base. She did maintain the primacy of artistic individualism, however. As she said, "There are no general rules. Each work of art creates its own code."

Yet, principally because it tried so hard to differ from formal ballet, modern dance also developed its own conventions. Ballet uses largely rounded and symmetrical movements, so modern dancers emphasized angularity and asymmetry. Ballet stressed leaps and based its line on toework, while modern dance hugged the floor and dancers went barefoot. As a result, the early works of Graham and others tended to be more fierce and earthy and less graceful. Beneath it all lay the desire to express emotion. Graham described her choreography as "a graph of the heart."

Graham's work progressed, through her own dancing and that of her company, as a reaction to specific artistic problems. Her early works were notorious for their jerks and tremblings, which Graham based on the natural act of breathing. She translated contractions and releases of inhaling and exhaling into a series of whiplash movements that expressly revealed energy and effort—unlike the ballet, which conceals effort. Gradually, her style became more lyrical in line and movement, but it never lost its foundation of passion (Fig. **16.28**).

Literature

Modernism

Modernism in literature, as in the other arts, represented a self-conscious break from traditional forms and subject matter in favor of a distinctly contemporary manner of expression. Early on, it had a radical and utopian emergence from new ideas in the sciences and social sciences, particularly Freudian psychoanalysis. We can find modernism in both fiction and poetry. In fiction, characters are involved in some kind of quest. They seek

MASTERWORK

MARTHA GRAHAM—APPALACHIAN SPRING

Social criticism as an artistic message came in with the Depression, and Martha Graham began to pursue topical themes. Her interest in the shaping of America led to her renowned dance piece *Appalachian Spring* (1944), set to the music of Aaron Copland (see the Music section of this chapter). *Appalachian Spring* deals, among other things, with the triumph of love and common sense over the fire and brimstone of American Puritanism. Martha Graham, herself, danced the principal role of The Bride, and the dancer/choreographer Merce Cunningham (see Chapter 17) danced the role of The Revivalist. Other roles in the dance include The Husbandman, The Pioneering Woman, and The Followers. Perhaps the best-known and best-loved of Graham's works, and the one with the finest score, *Appalachian Spring* takes as its pretext a wedding on the American frontier. The dance is like no actual ceremony or party, however. The movement not only expresses individual character and emotion, but it has a clarity, spaciousness, and definition that relate to the open frontier, which must be fenced and tamed.

Isamu Noguchi's (see p. 574) spare set (Fig. **16.28**) defines the stage: slim timbers that frame a house, a portion of wall, a bench, a platform with a rocker, a piece of fence, and a small, tilted disk. During the dance, the characters emerge to make solo statements; the action of the dance suspends while they reveal the content of their hearts. The Bride's two solos, for instance, suggest not only her joy but also her trepidation as she envisions her future. The four Followers rush about together with little steps and hops to provide a visual chorus of exclamations and "Amens." As Copland used American motifs in his score, so Graham drew subtly on steps from country dancing to express the frank vigor of these people.

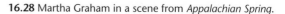

16.28 Martha Graham in a scene from *Appalachian Spring*.

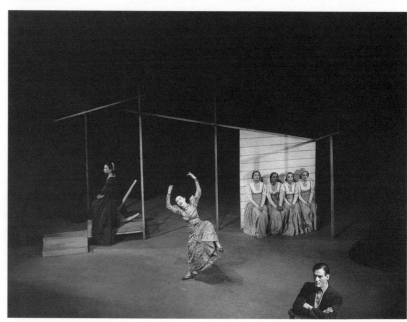

to pull themselves together, find meaning in a confusing world, and live all they can. The rationality of the Victorian period falls victim to a generation of individuals who seem easily seduced by trivial pleasures and lacking in ambition, motivation, or concern for the consequences of their actions. Modernist fiction writers sought to illustrate the disorder of their environment, raising their characters to a level of honor and dignity in a dishonorable and undignified world. In so doing, the modernists strove for "newness," originality, and boldness. Scholars generally date modernism in literature from approximately 1900 to 1945, with a division at 1922 with the publication of T.S. Eliot's poem *The Waste Land*.

Modernism, a widely diverse catch-all of approaches, included fiction writers like André Gide (zheed), D.H. Lawrence, Franz Kafka, Ernest Hemingway, and William Faulkner, to name but a few. They enriched subject matter and technique, challenging traditional forms of the novel, and traditional concepts of time and space. Edouard, a character in *The Counterfeiters* (1925) by André Gide (1869–1951), says: "My novel hasn't got a subject . . . 'slice of life,' the naturalistic school used to say. The great defect of that school is that it always cuts

its slice in the same direction; in time, lengthwise. Why not in breadth? Or in depth? As for me, I should not like to cut it at all. Police notwithstanding, I should like to put everything in my novel."

The novels of D.H. Lawrence (1885–1930), such as *Sons and Lovers* (1913) and *Women in Love* (1921), had more traditional technique. His rejection of contemporary mass culture and the materialistic society that produced it, together with his messianic faith in "natural" (which included "sexual") things, link him strongly with the Romantics of the nineteenth century. *Lady Chatterley's Lover* (1928) circulated widely, underground, until a New York legal decision in 1959 made it freely available. Lawrence wrote with a kind of poetic vividness, describing subjective levels of emotion and intuition. Underneath a surface realism, his works have complex and arcane metaphors and references to mythology.

The Austrian novelist Franz Kafka (KAHF-kuh; 1883–1924) lived and worked in Prague, now in the Czech Republic. Although he finished law school, he did not practice, but took a minor clerical position in the department of workmen's compensation, which made him tremendously aware of the bureaucracy and red tape which often strangle life. He never developed the ability to assert himself (writing but never publishing), and he could not bring himself to marry even though he became engaged several times. His early death resulted from tuberculosis, and he directed his executor to destroy all his manuscripts. Instead, his executor published them. Kafka never finished any of his novels, but even in their incomplete state, they captured the fancy of Europeans caught in a world of rising dictatorships. *The Trial* (1925) and *The Castle* (1926) portray an incomprehensible world of authority—for example, when the hero finds himself unexpectedly arrested. Unlike the stream-of-consciousness writers, Kafka explored the intangible inner world as if it were an outward reality. We never quite know for sure whether what takes place in the story represents actual reality or merely part of the character's fantasy. He portrays guilt-obsessed people who trip themselves up and never appear aware of their identity or relation to authority. His symbolic story *Metamorphosis* (1915) begins with one of the most famous sentences in Western literature: "As Gregor Samsa awoke one morning from uneasy dreams he found himself transformed in his bed into a gigantic insect."

In America, among the modernists came writers who produced powerful, vital novels of social realism, as exemplified by William Cuthbert Faulkner (1897–1962), who wrote both novels and short stories. In 1929 he published arguably his most admired work, *The Sound and the Fury*, in which he uses stream-of-consciousness techniques. His methods of narration include moving from the present to the past and presenting two or more seemingly unrelated stories juxtaposed against each other. He wrote more than twenty novels based on characters in the imaginary Southern Yoknapatawpha County.

Ernest Hemingway (1898–1961), American novelist, short-story writer, and Nobel Prize winner for his short novel, *The Old Man and the Sea* (1952), erased the dividing line between journalism and literature. His style characterizes the terse representation of simple acts, sparse dialogue, and understatement of emotion. His themes emphasize the sensual side of life, with overassertive males and two-dimensional women who exist for the pleasure of men. In the 1920s, while living in Paris, Hemingway associated closely with the leading poet of the early modernists, Ezra Pound.

Modernist poetry, as exemplified by Ezra Pound (1885–1972) and T.S. Eliot, reflected a movement called imagism. Imagism, which grew out of symbolism, utilized concrete language and figures of speech, modern subject matter, and metrical freedom. It avoided romantic or mystical themes. Formulated by Pound around 1912, the imagists' verse had succinctness and clarity with exact visual images comprising a total poetic statement. Pound's *Cantos* (the first of which appeared in 1917, the last in 1968) comprise a series of philosophical reveries. The early ones contained personal, lyrical references to Homer, Ovid, and Dante, in addition to numerous politicians and economists. They also contain memories of teenage trips to Europe. The *Pisan Cantos* (1948) reflect the author's incarceration in a prison camp and later in a hospital for the criminally insane. Those influenced by Pound's imagism included D.H. Lawrence and the poet T.S. Eliot.

T.S. Eliot (1888–1965), among others, reflects also the sobering effects of World War I, and *The Waste Land* (1922) presents a prevailing sense of disillusionment and fragmentation that represents the full emergence of modernism in poetry. Eliot dedicated his long, 433-line, five-part poem to Ezra Pound, who helped Eliot condense the original manuscript by nearly one half. The poem employs a series of fragmentary vignettes loosely linked by the legend of the search for the Holy Grail. It reveals a sterile world filled with panic and lust, with humans waiting for a sign or promise of redemption. We find modernism particularly in its self-awareness, introspection, and openness to the unconscious and to humankind's darker fears and instincts.

Two major poets of the period, William Butler Yeats (Yates; Fig. **16.29**) and Robert Frost (Fig. **16.30**) may or may not reflect the characteristics of modernism—lovers of literature debate the issue. Some critics believe that William Butler Yeats (1865–1939) provided a transition from the nineteenth century to twentieth-century modernism, as did Pablo Picasso in visual art. Others

16.29 William Butler Yeats (1865–1939).

maintain that he represents an entirely nineteenth-century mind-set—both sides often cite the same works to prove their point. In any case, it seems clear that Yeats' early works relied on Irish myth and legend and his later work dealt with more contemporary issues. His early work, according to some scholars, has a Pre-Raphaelite (see Chapter 15) tone. During the middle part of his career, Yeats did come under the influence of Ezra Pound, and his work reflected social irony, a certain harshness, and strong, supple rhythms. His later work turned mystical and spiritualistic. We glimpse this in his poem, "Sailing to Byzantium" (1927), a richly lyrical poem in which the poet rejects the sensual world for the "artifice of eternity." The poem has four stanzas. The lines appear freely composed, and the rhymes inexact, using an ABABABCC scheme. The first stanza has rich imagery of life and recreation. The second stanza describes the sad existence of an old man. In the third stanza the speaker asks the "sages standing in God's holy fire" to free him from his earthly body and desires. In the fourth he describes a bird of gold that can sing and entertains the Imperial court of Byzantium.

Sailing to Byzantium
William Butler Yeats

That is no country for old men. The young
In one another's arms, birds in the trees
—Those dying generations—at their song,
The salmon-falls, the mackerel-crowded seas,
Fish, flesh, or fowl, commend all summer long
Whatever is begotten, born, and dies.
Caught in that sensual music all neglect
Monuments of unageing intellect.

An aged man is but a paltry thing,
A tattered coat upon a stick, unless
Soul clap its hands and sing, and louder sing
For every tatter in its mortal dress,
Nor is there singing school but studying
Monuments of its own magnificence;
And therefore I have sailed the seas and come
To the holy city of Byzantium.

O sages standing in God's holy fire
As in the gold mosaic of a wall,
Come from the holy fire, perne in a gyre,
And be the singing-masters of my soul.
Consume my heart away; sick with desire
And fastened to a dying animal
It knows not what it is; and gather me
Into the artifice of eternity.

Once out of nature I shall never take
My bodily form from any natural thing,
But such a form as Grecian goldsmiths make
Of hammered gold and gold enamelling
To keep a drowsy Emperor awake;
Or set upon a golden bough to sing
To lords and ladies of Byzantium
Of what is past, or passing, or to come.

Some people compare Robert Frost (1874–1963) to T.S. Eliot and Ezra Pound. Others call him a traditionalist. We know him best for his use of colloquial language, familiar rhythms, and symbols from everyday life that express simple, New England values. He is a master of figures, which take words beyond their literal meaning. For

16.30 Robert Frost, 1874–1963.

example, in "The Road Not Taken" he uses the modernist technique of "non-closure/ambiguity." The poem ends without the speaker ever defining the "difference" that has been made in his/her life, or stating whether taking this selected path actually constitutes a "good" or "bad" thing. Because of the possibility of dual interpretations, the poem represents the modernist technique found in both modernist fiction and poetry.

The Road Not Taken
Robert Frost

Two roads diverged in a yellow wood,
And sorry I could not travel both
And be one traveler, long I stood
And looked down one as far as I could
To where it bent in the undergrowth;

Then took the other, as just as fair
And having perhaps the better claim,
Because it was grassy and wanted wear;
Though as for that, the passing there
Had worn them really about the same,

And both that morning equally lay
In leaves no step had trodden black
Oh, I kept the first for another day!
Yet knowing how way leads on to way,
I doubted if I should ever come back.

I shall be telling this with a sigh
Somewhere ages and ages hence:
Two roads diverged in a wood, and I—
I took the one less traveled by,
And that has made all the difference.

The spirit of modernism underpinned styles like imagism and styles we have seen in the other arts, which we can now examine with regard to literature. These include Dada, surrealism, and existentialism.

Dadaism
Dadaism comprised a nihilistic movement, as we saw in painting, based on principles of intentional irrationality, anarchy, and cynicism. Dadaists rejected all laws of beauty and social organization. In the United States, the group centered around Alfred Stieglitz's gallery, "291." Dada remained primarily a visual art phenomenon, with its literary output confined to a series of pamphlets and reviews published primarily in Germany and France, particularly by the poet Tristan Tzara (TSAHR-ah; 1896–1963), who wrote the first Dada texts, including "The First Heavenly Adventure of Mr Antipyrine" (1916) and the movement's manifesto, "Seven Dada Manifestos" (1924). Tzara's activities, particularly in Paris, consisted of outrageous acts designed to shock the public and attempts to destroy the structures of language. Perhaps

Dadaism's chief positive contribution lay in the fact that many Dadaists used the movement as a foundation for their later move to surrealism. Tzara, in fact, grew less nihilistic and later wrote rather lyrical poems that replaced Dada images and language with something more human, if somewhat difficult to comprehend.

Surrealism
Surrealism, despite its Dada roots, in literature as in visual art, expressed more positive sentiments, particularly between World War I and World War II. It nonetheless built upon a reaction against the horrors of World War I. According to the spokesman of the group, André Breton (breh-TAW; 1896–1966), himself a former Dadaist, writing in "The Surrealist Manifesto" (1924), surrealism sought to reunite the conscious and unconscious realms of experience so fully that the world of dream and fantasy would join the everyday rational world in "an absolute reality, a surreality." Breton's poetry utilized a juxtaposition of words determined by psychological (unconscious) thought processes. Surrealist writers favored automatic writing because it relied on the powers of the subconscious. Automatic writing constitutes writing produced without conscious intention, often even without awareness, as in telepathic or spiritualistic occurrences. The phenomenon can appear during alert or hypnotic states and results in unrelated words, fragments of poems, puns, obscenities, or, even, rational fantasies. Surrealism had widespread influence, including absurdism.

Existentialism
Based on existential philosophy, literary existentialism produced a wide body of very imaginative literature. We have already studied some of it with regards to drama in the Theatre section. Existentialist writers such as Simone de Beauvoir (boh-VWAHR; 1908–1986) exhibit a concern for "being" that contrasts with knowing and abstract concepts, which, according to existential belief, cannot capture the individual and specific. Beauvoir's treatise *The Second Sex* (1949) argued passionately, but in scholarly terms, for the abolition of what she called the myth of the "eternal feminine." Feminism of the 1960s took this work as a major touchstone. Her novels, however, exhibit existential themes. *The Mandarins* (1954) addresses in semi-autobiographical fashion the attempts of leftist intellectuals, after World War II, to leave their elite "mandarin" status and to engage in political activism. Beauvoir and her long-time companion, Jean-Paul Sartre (p. 533), form the basis for the two main characters, psychologist Anne Dubreuilh and her husband Robert. The fictional affair between Anne and the American Lewis Brogan reflects Beauvoir's own relationship with the novelist Nelson Algren.

The Chicago Renaissance

The years from 1912 to 1925 witnessed an outpouring of literary activity in Chicago, known as the Chicago Renaissance. The writers associated with this school realistically depicted the urban environment of the day in terms that condemned the loss of traditional rural values in an increasingly industrialized and materialistic American culture. They bemoaned the failure of the romantic notion that hard work would automatically yield wealth and spiritual rewards. Most of the writers came from small Midwestern towns and remained under the influence of a wave of regional writing that occurred in the 1890s in the United States. Among the outcomes of the Chicago Renaissance we find the re-establishment of journalism as a literary medium. Chief among the adherents of this movement, the poet, historian, novelist, and folklorist Carl Sandburg (1878–1967) represents a unique height in American literature. Among his wealth of works, the well-known *Chicago* (1914) gives us an ode to the city where Sandburg lived. The poem uses the literary device of apostrophe—in which the speaker turns from the audience as a whole to address a single person or thing—to describe the city in brief epithets in the opening and closing lines of the poem where he personifies the city in terms of the characteristics of its leading industries.

The Harlem Renaissance

Earlier in the chapter we introduced the Harlem Renaissance. Undoubtedly its best known figure, the poet Langston Hughes (1902–67; see Profile), caught with sharp immediacy and intensity the humor, pathos, irony,

PROFILE

LANGSTON HUGHES (1902–67)

Langston Hughes (Fig. **16.31**), often referred to as the "poet laureate of Harlem," portrayed the life of the ordinary African American in the United States, and his poetry has particular meaning to young people. He speaks of the basic qualities of life—love, hate, aspirations, and despair—yet he writes with a faith in humanity in general. He interprets all life as experienced in the real world as well as in idealism. At the same time, some of his work contains militant ideas that carry broad socio-political implications. He struggled within himself between what he wanted to write and what his audience expected him to write.

He was born in Joplin, Missouri, and soon after his birth his parents separated, his father, embittered by racial discrimination, moving to Mexico where he practiced law and pursued other business ventures. Langston was raised by his mother and grandmother. After his grandmother's death, he and his mother moved frequently, finally living in Cleveland, where he finished high school. An unhappy year with his father in Mexico followed, as did a year at Columbia University. Then he traveled in West Africa and Europe, finished a degree at Lincoln University in 1929, and settled in Harlem, which he called the "great dark city."

Hughes received considerable attention as a poet as early as 1921 with his poem "The Negro Speaks of Rivers." His poetry and his involvement in social causes were often intertwined, but although sometimes identified with the political left, he often defied political interpretation. Hughes experimented with numerous literary forms, and his collected works comprise no fewer than thirty-two books, including poetry, short stories, an autobiography, drama, and history. His fictional character Jesse B. Simple, who reveals the uncensored thoughts of a naive young urban youth, became a legend among African Americans. In his novel *Not Without Laughter*, —his first prose work—Hughes created a brilliant portrayal of an African American's passage into manhood.

16.31 Langston Hughes (1902–67).

and humiliation of being black in America. As early as 1921, Hughes received considerable attention with his poem "The Negro Speaks of Rivers," written the summer after his graduation from high school.

The Negro Speaks of Rivers
Langston Hughes

I've known rivers:
I've known rivers ancient as the world and older than the
 flow of human blood in human veins.
My soul has grown deep like the rivers.

I bathed in the Euphrates when dawns were young.
I built my hut near the Congo and it lulled me to sleep.

I looked upon the Nile and raised the pyramids
 above it.

I heard the singing of the Mississippi when Abe Lincoln
 went down to New Orleans, and I've seen its muddy
 bosom turn all golden in the sunset.

I've known rivers:
Ancient, dusky rivers.

My soul has grown deep like the rivers.

Cinema

Europe

Film-making revived and spread rapidly throughout Europe after World War I. The German director Fritz Lang's futuristic *Metropolis* (1926) tells the story of life in the twenty-first century. The significance of this film, that, like most of Lang's work, deals with fate and humankind's inevitable working out of its destiny, lies in its masterful visual composition. Critics called the plot ludicrous, but marveled at the photographic effects. In France, film found its first real aesthetic theorist in Louis Delluc, and came to be regarded as a serious art form.

In Russia Sergei Eisenstein (YZ-en-shtyn) wrote and directed the great film *Battleship Potemkin* (1925). This cruel story of the crew of the ship *Potemkin* contains one of the most legendary scenes in all cinema. A crowd of citizens is trapped on the great steps of Odessa between the Czar's troops and mounted Cossacks. The massacre scenes that follow contain truly riveting editing. The sequence showing the carnage consists of a **montage** of short, vivid shots—a face, a flopping arm, a slipping body, a pair of broken eye glasses—deftly combined into a powerful whole.

The rise of Nazism in Germany had virtually eliminated the vigorous German film industry by the late thirties. Fritz Lang, however, had already produced his psychological thriller *M*, which employed subtle and deft manipulation of sound, including a Grieg *Leitmotif*. Peter Lorre's performance as a child-murderer in this film launched his career.

The Rise of the Studio

Hollywood saw its heyday in the 1920s. Films remained silent, but the extravagance, star system, and legions of starlets dazzled the world. The 1920s marked the start of the big studio era with MGM, Paramount, Universal, Fox, and Warner Brothers all beginning at this time. Fantastic movie houses that rivaled baroque palaces in their opulence sprang up all over the United States.

This was the era of Fairbanks and Pickford and an immigrant Italian tango dancer, whom the studio named Rudolph Valentino, who thrilled women in movies such as *The Sheik*. After Valentino's death, John Gilbert and his co-star (and, for a time, fiancée) Greta Garbo became matinee idols. On the lighter side appeared Harold Lloyd, Buster Keaton, and Laurel and Hardy.

Although the soundtrack had been invented many years earlier, and short talking films had been released, *The Jazz Singer* in 1927 heralded the age of talkies with Al Jolson's famous line "You ain't heard nothin' yet!"

New Genres

The early thirties produced films about crime and violence. Films such as *Little Caesar* (1930), with Edward G. Robinson, kept Hollywood's coffers full during the Depression. But the gangster genre fell out of favor amid public cries that such glorified violence harmed American youth. The sexually explicit dialogue of Mae West added a titillating dimension to the cinema. But the Production Code—or censorship—strengthened, and West toned down.

The most popular star of the thirties, created by Walt Disney, Mickey Mouse led a parade of animated characters in films. The Western continued, and in 1939, John Ford's classic, *Stagecoach*, made John Wayne the prototypical cowboy hero. This superbly edited film exemplified the technique of **cutting within the frame**, which became a Ford trademark.

Chaplin continued to produce comedy into the thirties. *City Lights* (1931), a silent relic in an age of sound, emerged through its consummate artistry as a classic. The story depicts Chaplin's love for a blind girl, who erroneously believes he is rich. He robs a bank and pays for an operation that restores her sight. He is apprehended and sent to prison. Years later she happens to cross a tramp being chased by a group of boys. Amused and yet saddened, she offers the tramp a coin and a flower. At the touch of his hand, she recognizes him, but she is stunned that her imagined rich and handsome lover is really nothing more than a comical tramp. The film ends with the knowledge that their relationship is doomed. Among the great comic sequences in this film is a scene in which Chaplin swallows a whistle

at a society party, then, in a fit of hiccups, disrupts a musical performance and calls a pack of dogs and several taxicabs.

The epic of the decade, David O. Selznick's *Gone with the Wind*, a three-and-three-quarter-hour extravaganza, had an improbable plot and stereotypical characters. The performances of Clark Gable, Vivien Leigh, Leslie Howard, and Olivia de Havilland, along with its magnificent cinematography, have made this film eternally popular.

Social Commentary

In the midst of World War II, film underwent radical change in form and content. In 1940, Darryl Zanuck produced and John Ford directed a film that stunned even Hollywood: John Steinbeck's *Grapes of Wrath*, an artistic visualization of Steinbeck's portrayal of the Depression. Here social criticism merged with superb cinematography and compelling performances. *Grapes of Wrath* illustrates the importance of screenwriting in modern cinema. In the novel, Steinbeck frequently gives praise to the Joad family and their toughness of spirit. Thrown off their farm in the Great Depression, they struggled to find a new life in California where circumstances prove even more disastrous for them. In the movie version, however, John Ford chose not to use the device of the narrator, and, as is typical in drama and cinema, the characters must speak for themselves, and the writer's point of view must be transmitted in terms of characters' speech and actions. So, in *Grapes of Wrath*, Steinbeck's ideas emerge in the words of the characters: Pa Joad's wife responds to Pa Joad's admission that he thought the family was finished, "I know. That's what makes us tough. Rich fellas come up an' they die, an' their kids ain't no good, an' they out. They can't lick us. We'll go on forever Pa, 'cause we're the people."[1] Social commentary appeared again in 1941, with *How Green Was My Valley*, which dealt with exploited coal miners in Wales, and *Citizen Kane*, a grim view of wealth and power in the United States. This film, thought by some the best movie ever produced, blazed a new trail in its cinematic techniques. Orson Welles, its director and star, and Greg Toland, its cinematographer, brilliantly combined deep-focus photography, unique lighting effects, and rapid cutting.

CHAPTER REVIEW

CRITICAL THOUGHT

What is the relationship between poverty and crime? In the Great Depression, when so many people had so little of material value, people could safely leave their doors unlocked. What is poverty? Is it lack of material things or a condition of the human spirit? Or is there some connnection?

Some of the disillusionment of the world from World War I through World War II, with its dehumanization and broken promises, appears in the art of the period. Certainly the anti-art art called dada brings home that idea. We find, in addition, in the art of this time something more personal and unreflective of the world around it: we find artists

dabbling with the unconscious and subconscious mind. Some of the artists we have just studied do not care about our perceptions of the world we see around us, but care more about evocative images that stir something more primal in us.

When art gets so personal—or impersonal—it moves to a different (not necessarily deeper) plane. Sometimes it offers self-centered drivel, sometimes it can be more profound than "beautiful" or representational art, and sometimes we find it difficult to evaluate because the customary language of images no longer applies.

SUMMARY

After reading this chapter, you will be able to:

- Describe the economic, political, and military condition of the world from 1914 to 1945.
- Explain the philosophies of pragmatism and existentialism and apply the latter to developments in literature and theatre.
- Discuss major writers of fiction and poetry.
- Characterize new styles in visual art and architecture arising during the period, including specific reference to individuals, styles, and works of art.

- Identify composers who pursued traditional and nontraditional pursuits in music by noting their approach to tonality, rhythm, and so on.
- Understand the characteristics of expressionism, absurdism, and epic theatre, including specific playwrights and productions.
- Discuss modern dance and film by noting specific movements, ideas, and practitioners.
- Apply the elements and principles of composition to analyze and compare individual works of art and architecture illustrated in the chapter.

CYBERSOURCES

- **Cubism:** http://www.artcyclopedia.com/history/cubism.html
- **Futurism:** http://www.artcyclopedia.com/history/futurism.html
- **Dada:** http://www.artcyclopedia.com/history/dada.html
- **Surrealism:** http://www.artcyclopedia.com/history/surrealism.html
- **American Painting (Ashcan School):** http://www.artcyclopedia.com/history/ashcan-school.html

A PICTURE ESSAY

FROM PAST ...

16.32 Leonardo da Vinci, *Mona Lisa* c. 1503. Oil on panel, 38 × 21 ins (97.8 × 53.3 cm). Louvre, Paris.

16.34 Book cover, *Jane Eyre*, a novel written in 1874 by Charlotte Brontë. Jane Eyre is a strong-willed orphan who, after surviving several miserable years at a charity school, becomes the governess to a ward of the mysterious Mr Rochester. She and Mr Rochester fall in love, but before they can be married, it is revealed that he is already married and that his wife, who is insane, is confined in the attic of the estate. Jane leaves, but is ultimately reunited with Mr Rochester after learning of the death of his wife.

16.36 Akhenaton (King Amenhotep IV), from a pillar statue in the temple of Aton near the temple of Amun at Karnak, 1364–1347 B.C.E. Sandstone, 13 ft (3.96 m) high. Egyptian Museum, Cairo.

16.38 Great Pyramid of Cheops, Giza, Egypt, Dynasty IV, 2680–2565 B.C.E.

... TO PRESENT

16.33 Marcel Duchamp, *Mona Lisa (L.H.O.O.Q.)* 1930. Colour reproduction of the *Mona Lisa* by Leonardo da Vinci, with paint added. Private collection. Succession Marcel Duchamp/ADAGP, Paris and DACS, London 2005.

16.35 Poster advertising *Jane Eyre: The Musical* at Brooks Atkinson Theatre, New York 2000.

16.37 Scene from *Akhenaton*, an opera by Philip Glass at the ENO, London, 1987.

16.39 I.M. Pei, Grand Louvre Pyramid, addition to the Louvre, Paris, France, 1988.

17 FROM MODERNISM TO POSTMODERNISM AND BEYOND

OUTLINE

VIEW

THE END OF HISTORY

In the physical world, things have changed drastically since the time of our Paleolithic ancestors, and the pace of change seems to accelerate daily. In terms of the fundamentals of who we are as human beings, however, the changes seem almost superficial. The accumulation of material goods and the superficial gloss of technology may camouflage more important issues concerning what it means to be human and what it means to live a meaningful life. We can put a rover on Mars, but we cannot determine how to live in harmony with those around us. We can clone a sheep, but we cannot eradicate ignorance.

At least one contemporary historian and scholar has suggested that we have come to the end of history. That challenging theory invites us to consider whether anything really "new" has happened to humanity at any time in history. The answers to questions about ourselves and our relationships to other people and an ultimate creator or force beyond us seem just as mysterious today as at the dawn of history.

KEY TERMS

POSTMODERNISM
A broad description of cultural and artistic theory criticizing traditional culture, theory, and politics.

ABSTRACT EXPRESSIONISM
An art style characterized by nontraditional brushwork and nonrepresentational subject matter.

POP ART
Painting and sculpture employing subjects drawn from popular culture.

OP ART
Plays on the possibilities offered by optics and perception.

NEO-EXPRESSIONISM
A visual art movement characterized by nightmarish and often repulsive images.

HARD EDGE
An abstract painting style characterized by flat color areas separated by hard edges.

ENVIRONMENTAL ART
Art that attempts to create an inclusive experience for the viewer.

ALEATORY
Music in which the composer deliberately incorporates elements of chance.

17.1 Louise Nevelson, *Black Wall*, 1959. Wood, 9 ft 4 ins × 7 ft 1¼ ins × 2 ft 1½ ins (264 × 217 × 65 cm). Tate Gallery, London. © ARS, New York and DACS, London 2005.

CONTEXTS AND CONCEPTS

Contexts

Decolonization

Before the end of World War II, much of the globe, especially in what we call the Third World, existed under the colonial rule of outside nations. After World War II that order changed. During the late 1940s, decolonization sprang from nationalist wars of independence, although the Dutch and the British, for example, had actually planned for the independence of their colonies in Egypt, India, and Malaysia. In the 1950s, as the Cold War polarized the world, violent popular revolutions challenged the remnants of colonialism in North Africa and southeast Asia. By the 1960s several African countries had achieved independence with the more-or-less freely given consent of their previous overlords.

The effects of decolonization have been widespread and problematical. Violent conflicts among tribal powers, oppressive military dictatorships, suppression of human rights, the use of unusually cruel weapons of war, and famine, for example, have replaced the injustices of colonial rule. Even today, with Eastern Europe having thrown off communism, the absence of any strong central authority has resulted in an explosion of ethnic violence that had lain dormant under the Soviets. Everywhere, those who have struggled for "freedom" have begun to learn that "independence" does not constitute an automatic state of grace. Freedom has been confused with economic comfort, and when unrealistic expectations are not immediately fulfilled, disillusionment brings about more violent uprisings to no clear purpose.

GENERAL EVENTS

- Hiroshima, 1945
- Decolonization begins, late 1940s
- Korean War, 1950–53
- Cold War, 1950s–90s

- Cuban missile crisis, 1961
- Vietnam War, 1964–73
- Arab nationalism, late 1960s

- Fall of Berlin Wall, 1989
- Gulf War, 1990
- Demise of communism, 1990s
- World Trade Center and Pentagon attacks, 2001
- Iraq War, 2003–4

1945	1960	1975	THE PRESENT
PAINTING, PHOTOGRAPHY, & SCULPTURE			
Pollock (**17.3**), de Kooning (**17.4**), Rothko (**17.7**), Noguchi (**17.14**), Giacometti (**17.17**)	Nevelson (**17.1**), Lichtenstein (**17.9**), Frankenthaler (**17.5**), Oldenberg (**17.8**), Warhol (**17.10**), Vasarély (**17.11**), Stella (**17.12**), Kosuth (**17.13**), Hepworth (**17.15**), Calder (**17.16**), Smith (**17.19**), Dubuffet (**17.20**), Smithson (**17.21**), Christo (**17.22**), Chryssa (**17.23**), Clemente (**17.24**), Pfaff (**17.25**), Paik (**17.27**), Saar (**17.32**)	Bengalis (**17.26**), Marshall (**17.28**), Roberts (**17.29**) Tansey (**17.30**), Rothenberg (**17.31**), Ferrer (**17.33**), Bedia (**17.34**), Cooper (**17.37**)	
ARCHITECTURE			
Bunshaft (**17.38**), Johnson (**17.39**), Mies van der Rohe (**17.39**), Wright (**17.40**), Le Corbusier (**17.41**), Nervi (**17.42**), Fuller (**17.43**)	Bofill (**17.44**), Graves (**17.45**), Pelli (**17.47**)	Piano and Rogers (**17.46**), Didier + Scofido (**17.48**), Gehry (**17.49**), Hadid (**17.50**)	
THEATRE			
Williams, Beckett, Miller, Ionesco, Genet	Pinter	Stoppard, Anderson, Churchill, Kushner, Wilson	
MUSIC & DANCE			
Babbitt, Boulez, Cunningham, Cage, Parker, Gillespie	Foss, Stockhaussen, Berio, Reich, Davis	*Musique actuelle*, Penderecki, Rorem	
LITERATURE			
Nabokov, Lowell	Weisel, Plath, Márquez, Momaday	Morrison, Abu-Khalid, Pynchon, Khamis, Jones, Sontag, Walker	
CINEMA			
Rossellini, Kurosawa, Hitchcock, Fellini	Bergman	Spielberg, Lee	

Timeline 17.1 The late twentieth century to the present.

In 1952, Alfred Sauvy, using an analogy referring to the Third Estate at the time of the French Revolution, called the emerging states that belonged to neither the Western nor the Eastern bloc, the "Third World." A Third World Movement emerged from the Bandung Conference of 1955, with the goal of bringing together subjugated peoples and dominated states in a common defense of their political interests and national security. Today the countries of the Third World do not constitute a unified bloc—the extreme diversity of their social formations, cultures, and histories makes this impossible—but they have their own specific problems and strengths, and they represent pluralistic economic strategies and conditions that have yielded plural experiences and results.

The Cold War

After World War II, the United States and the Soviet Union dominated the world. The two former allies quickly grew apart as each sought to protect its sphere of influence from the other, and a period of tense conflict, sometimes called "peaceful coexistence," lasted for the next forty-five years.

The period of greatest conflict, the Cold War years of 1946–62, witnessed strain between the two great powers over the division of Germany and the Marshall Plan for the rebuilding of Europe. The antagonism took an extended military form in Korea (1950–53). Toward the end of the 1950s, with the United States and the Soviet Union experiencing the beginnings of détente, the scene of international conflict shifted to Southeast Asia. The changing power relations between the USA, the USSR, and China destabilized the region after the French defeat in the area. The United States wanted to create in South Vietnam a military state like that in South Korea, capable of resisting the communist insurgency. A strong anti-war movement in the United States and a strong offensive attack by the NLF (National Liberation Front), called the Tet Offensive, eventually spelled the end of American policy in South Vietnam.

After the late 1960s, another movement grew in importance: the rise of Arab nationalism in the Middle East. Defeat in the 1967 Arab–Israeli war and the death of Egypt's President Nasser in 1970 left the door open for the return of religious leaders to the political scene. Fundamentalist protest grew strong on the disillusionment with progress and on the failure of various attempts at social and economic development. Eventually, these protests turned into outbursts of violence and terror leading to the attacks on the World Trade Center on 11 September 2001 and the wars in Afghanistan and Iraq. The question remains unresolved as to whether democracy can take root in the Arab world.

European Unification

As the Soviet Union under Mikhail Gorbachev (gahr-bah-chawf) and world communism in general disintegrated in the early 1990s, the large conflicts turned upon economics. The nations of Western Europe moved slowly but systematically toward an economically unified European community. In 1992 that movement was called into question by the European Community, because many of the partners disagreed about goals and operating details. Germany struggled to overcome the economic drag of its reunification. Providing aid to the former Soviet Union presented additional challenges for the European Community as well as for the individual states there. The early years of the twenty-first century found Europe uniting in a political and economic sphere called the European Union and, with a few exceptions, merging previously national currencies into the Euro.

Science and Liberty

As science and technology race on, questions of ethics and governmental control stubbornly resist clear solution. These vital concerns set the stage for military ventures, civil technology, and fundamental issues of individual liberty and social order. The development of nuclear weapons maintained by major and minor powers—of which Israel, Iran, Pakistan, India, and North Korea are only a few—rocket technology and "Star Wars" defenses, threatened cultures by draining resources which might otherwise go to more civilized pursuits.

Who controls whom, how, and for what, remained critical issues as human knowledge and understanding of its applications expanded. Who should control decisions about prolonging life through mechanical means? Who should control the dissemination of birth control devices and drugs such as the "abortion pill"? Is there a right to die and who has it? Is there a right to live, and who has that? These represent a few of the difficult issues facing our pluralistic society with a rigid tradition of individual freedoms.

Concepts

Postmodernism

Postmodernism grew out of modernism in the second half of the twentieth century, from approximately 1970 onward, varying in its onset among the various arts. It continued some of the trends of modernism—for example, stylistic experimentation—but it disdained others, such as concern with purity of form. Perhaps most significantly, postmodernism questions the idea of *metanarrative*, or *grand narrative*: the attempt to explain all of human endeavor in terms of a single theory or principle, as exemplified by Marxism, Freudian

psychology, and "structuralism." (Structuralism holds that individual phenomena can be understood only within the context of the overall structures of which they form a part and that these structures represent universal sets of relationships that derive meaning from their contrasts and interactions within a specific context.) Such attempts to comprehensively account for human history and behavior are, according to postmodernism, posited in some respects in mutually incompatible terms. Postmodernism proposes to solve this contradiction by asserting that no final narrative exists to which one can reduce everything. Rather, a variety of perspectives on the world occur, none of which occupies a privileged position. This represents, arguably, a skeptical viewpoint stemming from the conviction that contemporary society is so hopelessly fractured—for example, by the commercialization and trivialization of culture—that no coherent comprehension of it is possible. Within certain fields such as feminism

and multiculturalism, postmodernism has created arguments between those who see it as supportive of their position (giving equal status with the prevailing Western narrative) and those who see postmodernism as so indiscriminate that it precludes any grounds for political action.

The term "postmodernism" ("pomo" for short, and as opposed to "postmodern" or "post-modernity," which represent historical references) refers to aesthetic and artistic styles, ideas, and themes. Some of its indicators include eclecticism, anachronism (in which works may reflect and comment on a wide range of stylistic expressions and cultural-historical viewpoints), mixed genres or voices in a single work, fragmentation, open forms that recognize the presence of the audience, and irony. Often postmodernism results in an embrace of normlessness and cultural chaos, as well as a conscious attempt to break down distinctions between "high art"

TECHNOLOGY

ROBOTS

Robots—at least as an idea—occur in ancient mythology, and as long ago as 1738 a Parisian inventor made an artificial duck that quacked, ate grain, swam, and flapped its wings. The word Robot was coined in 1923 in Karel Capek's (CHAH-pek) play *R.U.R.* (Rossum's Universal Robots), and it is the Czech word for worker. In the 1940s, Isaac Asimov, a science fiction writer, described the first benevolent robots, whose purpose was to serve humans.

The first actual robots derived from the work of Joseph Engelberger, a physicist devoted to Isaac Asimov, and the inventor George C. Devol. Engelberger had studied the development of digital controls, which had been used in World War II to aim and fire guns from ships, and which automatically adapted to changes in the position of the ship and the motion of the water. Devol had developed a Programmed Article Transfer device that Engelberger knew could become a robot. The two joined forces to create Unimates, robots that would replace humans in jobs that were tedious, limiting, and dangerous. After being turned down by everyone they approached, they eventually found a manufacturer willing to invest $25,000 in the experiment.

At first, the business was not successful, mainly because of the short-term view of economics taken by management (not the fear of losing jobs by labor). Today, Engelberger works to create and sell robots

designed for a service economy—for example, robots that can clean floors and toilets. One popular robot, called "Helpmate," is an all-purpose hospital aide that delivers meals, mail, and medicine, runs errands, gives directions, and speaks English (Fig. **17.2**). Engelberger's robots always conform to Asimov's three laws of robotics: (1) a robot must not harm a human being, nor through inaction allow one to come to harm; (2) a robot must always obey human beings, unless that is in conflict with the first law; (3) a robot must protect itself from harm, unless that is in conflict with the first or second laws.[1]

17.2 "Helpmate" robot being used to carry patients' meals at a hospital.

and popular culture—for example, performance art, which often involves a provocative mingling of musical, literary, and visual sources. The artist's self-conscious display of technique and artifice puts self-reference at the center of creation and presentation.

Pluralism

The term pluralism has fallen easily into the vocabulary of the postmodern world because it has about it an implied inclusiveness and cultural and artistic egalitarianism previously unknown. Nonetheless, pluralism remains a vague concept that, in reality, encompasses or reacts against several adjacent concepts including ethnocentrism and cultural relativism. Pluralism often implies ethnically-related activity—the acceptance and inclusion of works from various ethnicities outside the standard, previously accepted traditions of European or "Western" culture. In fact, the pluralism of the postmodern age has brought new emphasis on the arts of "ethnic minorities." Of course such arts date to earliest recorded history and often represent sophisticated techniques and profound visions. In the late twentieth and early twenty-first centuries, artists of minority ethnic and racial backgrounds gained inclusion in mainstream art circles, bringing to their works questions of identity and context. We will see this often in the chapter ahead. The emergence of emphasis on works of art from previously marginalized groups reflects an important conceptual shift within the various arts disciplines.

We need to note here that ethnic-centered emphasis and inclusion constitutes an opposite position from a concept that sounds almost the same: *ethnocentrism*. Ethnocentrism refers to the judging of other cultures by the standards and with the assumptions of one's own, and a belief in the superiority of one's own group to others. Although current vogue applies ethnocentrism to Western or Eurocentrism, in fact, ethnocentrism occurs throughout the world and throughout history. Nonetheless, through the nineteenth century, most of Western history and social science proceeded from ethnocentric assumptions, viewing smaller-scale non-Western cultures as "primitive," less complex, and less morally developed.

In reaction to ethnocentrism, *cultural relativism* arose, asserting that beliefs, values, customs, and other expressions of cultures must be understood and judged within their own context rather than from outside viewpoints. The term "relativism" plays an important role in this point of view, because it maintains that no absolutes exist relative to truths or values. Rather, all truth and value lies relative to one's own personal, cultural, or historical perspective. Further, the approach of cultural relativism plays a vital role in the concept of *multiculturalism*, which seeks to overcome the dominance of the Western cultural perspective, based on European civilization and Judeo-Christian religion, replacing it with expressions from a diversity of cultural and ethnic backgrounds. Some people argue that cultural relativism represents nonjudgmentality and, more importantly, a lack of critical insight that provides no basis for meaningful evaluation or cross-cultural analysis.

In the material ahead in this chapter, we will use the term "pluralism" as an organizing device that will allow us to examine artists and works of art by ethnic and racial topics rather than stylistic ones.

THE ARTS FROM MODERNISM TO POSTMODERNISM AND BEYOND

Depending largely on factors within each artistic discipline, modernism gave way to postmodernism in a sliding sort of fashion. Some people would allow that postmodernism developed immediately after World War II. Others would put its origins in the 1970s, and still others, somewhere in between, largely based on how postmodernism emerged in a particular discipline—for example, painting, music, dance, and literature. As we treat the arts, we will see examples of modernism in some disciplines extending later into the twentieth century than examples of postmodernism in other disciplines. So, in a sense, perhaps every point of view on the onset of postmodernism may be correct. In addition, some people might argue that postmodernism died with the turn of the millennium. Others might suggest that postmodernism has never existed at all. We will rely, however, on three main topics for organizing artistic matters, with some exceptions: 1) postwar modernism; 2) postmodernism; and 3) pluralism. We begin with painting and sculpture, in which a plethora of modern styles carried the visual arts well into the 1970s.

Painting and Sculpture

Postwar Modernism
Abstract Expressionism
The first fifteen years following the end of World War II witnessed a dominant style called "**abstract expressionism.**" The style originated in New York, and it spread rapidly throughout the world on the wings of modern mass communications. Two characteristics identify abstract expressionism: 1) nontraditional brushwork; 2) **nonrepresentational** subject matter. This complete freedom to reflect inner life led to the creation

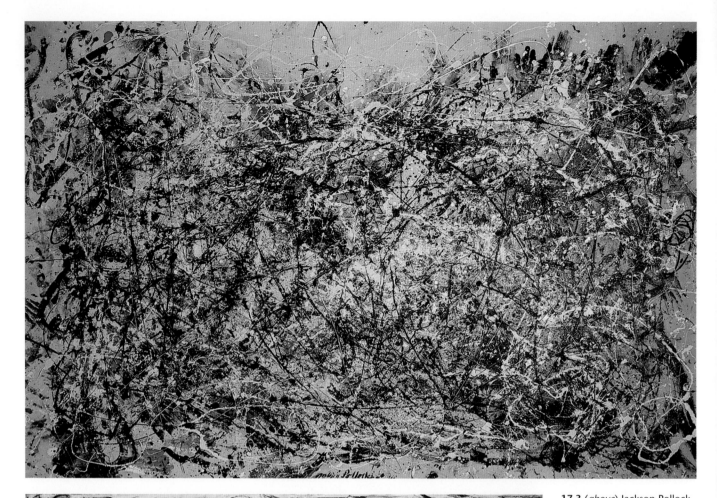

17.3 (*above*) Jackson Pollock, *Number 1*, 1948. Oil and enamel on canvas, 5 ft 8 ins × 8 ft 8 ins (1.73 × 2.64 m). Museum of Modern Art, New York. Purchase. © ARS, New York and DACS, London 2005.

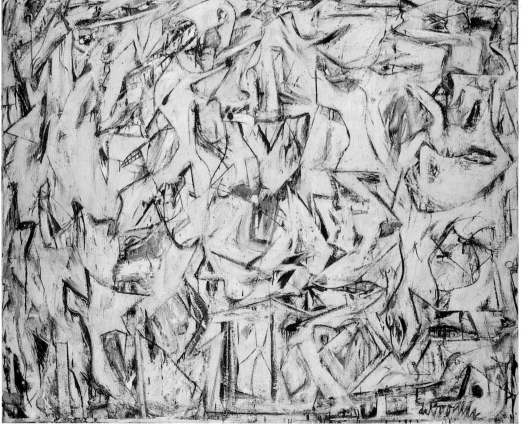

17.4 (*left*) Willem de Kooning, *Excavation*, 1950. Oil on canvas, 6 ft 8⅛ ins × 8 ft 4⅛ ins (2.04 × 2.54 m). Courtesy the Art Institute of Chicago (Collection Mr and Mrs F.C. Logan Prize, Gift of Mr and Mrs Edgar Kaufmann Jr and Mr and Mrs Noah Goldowsky). © Willem de Kooning Revocable Trust, ARS, New York, and DACS, London 2005.

of works with high emotional intensity. Absolute individuality of expression and the freedom to pursue irrationality underlie this style. This may have had some connection with the confidence inspired by postwar optimism and the triumph of individual freedom: as the implications of the nuclear age sank in, abstract expressionism all but ceased to exist.

The most acclaimed painter to create his own particular version of this style, Jackson Pollock (PAH-luhk; 1912–56), came upon his characteristic approach to painting only ten years before his death. Although he insisted that he had absolute control, his compositions consist of what appear simple dripping and spilling of paint onto huge canvases, which he placed on the floor in order to work on them. His work (Fig. **17.3**), often called "**action painting**," conveys a sense of tremendous energy. The viewer seems to feel the painter's motions as he applied the paint.

Willem de Kooning (VIHL-uhm duh KOHN-ing; 1904–97) took a different approach to abstract expressionism. Sophisticated texture and heightened focal areas (Fig. **17.4**) emerged as de Kooning reworked,

MASTERWORK

HELEN FRANKENTHALER—*BUDDHA*

Helen Frankenthaler is one of the most recognized and celebrated late twentieth-century artists. A second-generation abstract expressionist, she began her painting career just as an earlier group of artists, including Jackson Pollock, Willem de Kooning, and Mark Rothko, gained widespread public attention.

Her innovative technique, seen in *Buddha* (Fig. **17.5**), involved pouring paint directly onto the unprimed surface of a canvas, allowing the color to soak into its support, rather than painting on top of an already sealed canvas. This highly intuitive process, known as "stain painting," became the hallmark of her style and enabled her to create color-filled canvases filled with amorphous shapes that seemed to float on air. The image created thus has infinite potential meaning, apart from that suggested by whatever title Frankenthaler chooses, because the very freedom of the form means that viewers can choose their own associations. The viewer, however, finds direction in the sensual quality of the work, whose fluidity and nonlinear use of color give it softness and grace. In her art, the process of pouring paint onto and over the canvas, allowing the flowing pigment to create its own shapes and edges, became a literal metaphor for experiences of nature. As a consequence, the works maintain powerful allusive qualities, even the impression of infinite space.

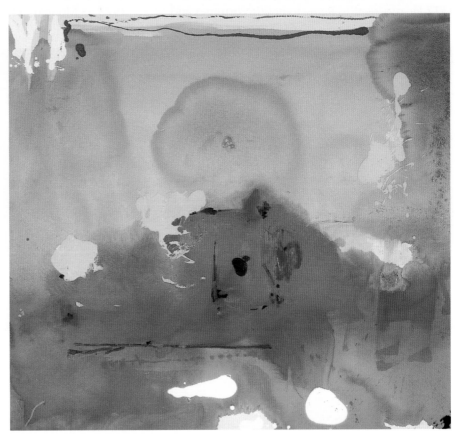

17.5 Helen Frankenthaler, *Buddha*, 1983. Acrylic on canvas, 6 ft 2 ins × 6 ft 9 ins (1.88 × 2.06 m). Private collection. Courtesy Andre Emmerich Gallery, New York.

PROFILE

PABLO PICASSO (1881–1973)

Born in Malaga, on the Mediterranean coast of Spain, Picasso studied at the Academy of Fine Arts in Barcelona but by this time had already mastered realistic technique, and had little use for school. At sixteen he had his own studio in Barcelona. In 1900 he first visited Paris, and in 1904 he settled there. His personal style began to form in the years from 1901 to 1904, a period often referred to as his Blue Period because of the pervasive blue tones he used in his paintings at that time. In 1905, as he became more successful, Picasso altered his palette, and the blue tones gave way to a terracotta color, a shade of deep pinkish red. At the same time his subject matter grew less melancholy and included dancers, acrobats, and harlequins. The paintings he did during the years between 1905 and 1907 belong to his Rose Period (see Fig. **15.22**).

Picasso played an important part in the sequence of different movements in the twentieth century. He said that to repeat oneself goes against "the constant flight forward of the spirit." Primarily a painter, he also became a fine sculptor, engraver, and ceramist. In 1917 Picasso went to Rome to design costumes and scenery for Sergei Diaghilev's *Ballets russes*. This work stimulated another departure in Picasso's work, and he began to paint the works now referred to as belonging to his classic period, which lasted from about 1918 until 1925.

At the same time as he worked on designs for the ballet, Picasso also continued to develop the cubist technique, which he had originally conceived with Georges Braque (see p. 500), making it less rigorous and austere. By the time he painted *Guernica*, his moving vision of the Spanish Civil War, the straight lines of early cubism had given way to curved forms. This huge painting (Fig. **17.6**), considered by many his masterpiece, formed Picasso's response to the 1937 bombing by the Nationalist forces of the small Basque town of Guernica. He completed this emotional political statement in the same year. In it, as in many of his later pictures, distortions of form approach surrealism, but Picasso never called himself a surrealist. Picasso continued to work with incredible speed and versatility—as painter, ceramist, sculptor, designer, and graphic artist—into his nineties. He died on 8 April 1973, in Mougins, France.

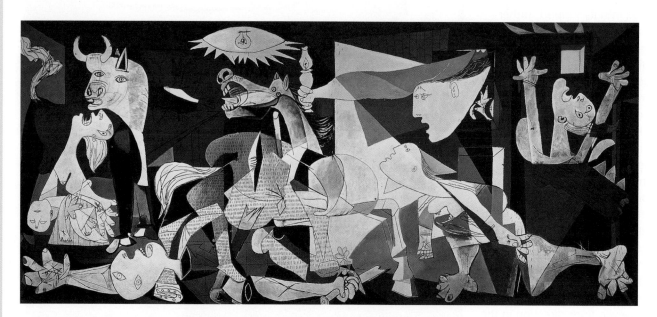

17.6 Pablo Picasso, *Guernica*, 1937. Oil on canvas, 11 ft 5½ ins × 25 ft 5¾ ins (3.5 × 7.8 m). Museo Nacional Centro de Arte Reina Sofia, Madrid. © Succession Picasso/DACS 2005.

scraped off, repainted, and painted again. Yet this laborious work produced works that express spontaneity and free action. The work has a ferocity and passion that tend to build in intensity as the eye moves from one focal area to the next.

Included among the work of the abstract expressionists, the *color-field* painting of Mark Rothko (1903–70) exhibits high individualism that follows a process of reduction and simplification (Fig. **17.7**). Rothko left all "memory, history, and geometry" out of his canvases. These, he said, were "obstacles between the painter and the idea." Rothko's careful juxtaposition of hues has a deep emotional impact on many viewers.

The abstract expressionist tradition continued in the work of Helen Frankenthaler (FRANK-en-thahl-ur; b. 1928), whose work we examine more closely in the Masterwork box associated with Figure **17.5**.

An explosion of styles followed the emotionalism of abstract expressionism: pop, op, hard edge, minimal, post-minimal, environmental, body, earth, video, kinetic, photorealist, and conceptual. We can describe only a few of these here.

Pop Art

Pop art, which evolved in the 1950s, concerned itself above all with representational images. The English critic Lawrence Alloway coined the term "pop," and it simply meant that the subjects of these paintings exist in popular culture. The treatments of pop art also came from mass culture and commercial design. These sources provided pop artists with what they took as the essential aspects of the visual environment that surrounded them. The pop artists themselves traced their heritage back to Dada (see Chapter 16), although much of the heritage of the pop tradition continues debatable.

The compelling paintings of Roy Lichtenstein (LIK-ten-styn; 1923–97) represent the most familiar examples of pop art (Fig. **17.9**). These magnified cartoon-strip paintings use the effect created by the dots of the screen used in color printing in comics. Using dot stencils about the size of a coin, Lichtenstein built his original subjects, up into stark and dynamic, if sometimes violent, images.

Common, everyday objects serve as models for Claes Oldenburg (b. 1929). *Two Cheeseburgers, with Everything* (Fig. **17.8**) presents an enigma to the viewer. What do we make of it? Does it celebrate the mundane? Or does it make a serious comment on our age? Certainly Oldenburg calls our attention to the qualities of design in ordinary objects by taking them out of their normal contexts and changing their scale.

In the 1960s Andy Warhol (1928–87) focused on popular culture and contemporary consumerism in his ultra-representational art. The very graphic *Green Coca-Cola Bottles* (Fig. **17.10**) represents his style. The

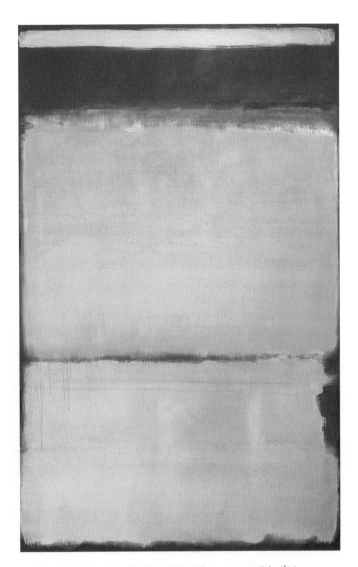

17.7 Mark Rothko, *Number 10*, 1950. Oil on canvas, 7 ft 6⅜ ins × 4 ft 9⅛ ins (2.3 × 1.45 m). Museum of Modern Art, New York (Gift of Philip Johnson). © Kate Rothko Prizel and Christopher Rothko/DACS 2005.

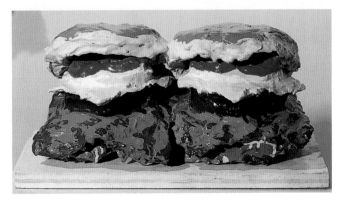

17.8 Claes Oldenberg, *Two Cheeseburgers, with Everything* (*Dual Hamburgers*), 1962. Burlap soaked in plaster, painted with enamel, 7 ins (17.8 cm) high. Museum of Modern Art, New York (Philip Johnson Fund).

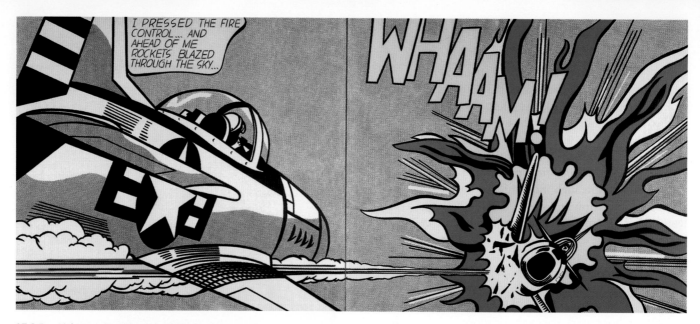

17.9 Roy Lichtenstein, *Whaam!*, 1963. Acrylic on canvas, 5 ft 8 ins × 13 ft 4 ins (1.73 × 4.06 m). Tate Gallery, London. © Estate of Roy Lichtenstein/DACS 2005.

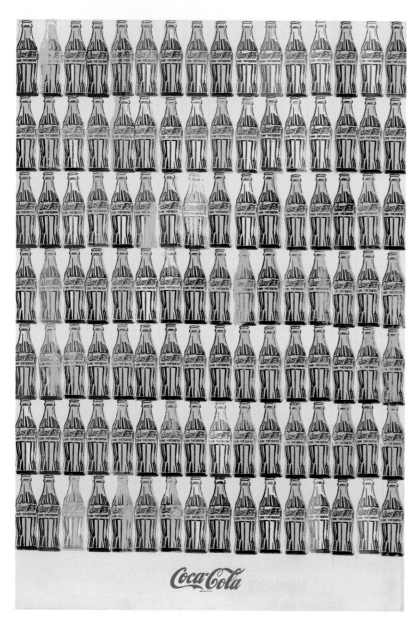

17.10 Andy Warhol, *Green Coca-Cola Bottles*, 1962. Oil on canvas, 6 ft 10 ins × 4 ft 9 ins (1.97 × 1.37 m). Whitney Museum of American Art, New York (purchase, with funds from the Friends of the Whitney Museum of American Art). © The Andy Warhol Foundation for the Visual Arts, Inc./ARS, New York and DACS, London 2005.

17.11 Victor Vasarély, *Arcturus II*, 1966. Oil on canvas, 5 ft 3 ins × 5 ft 3 ins (1.51 × 1.51 m). Hirshhorn Museum and Sculpture Garden, Smithsonian Institution, Washington, D.C. © ADAGP, Paris and DACS, London 2005.

Op Art

Op art plays on the possibilities offered by optics and perception. Emerging from work done in the 1950s, op art comprised an intellectually oriented and systematic style, very scientific in its applications. Based on perceptual tricks, the misleading images in these paintings capture our curiosity and pull us into a conscious exploration of what the optical illusion does and why it does it.

Victor Vasarély (vah-zah-ray-LEE; 1908–97) bends line and form to create a deceptive sense of three-dimensionality. Complex sets of stimuli proceed from horizontal, vertical, and diagonal arrangements. Using nothing but abstract form, Vasarély creates the illusion of real space.

The psychological effects of his images depend on extremely subtle repetition of shape and gradation of color. In *Arcturus II* (Fig. **17.11**), the symmetrical imagery seems to come into and out of focus because of the apparent brightness of the individual colors. Shape and color combine to create the optical experience, and what at first glance seems simple and straightforward, becomes complicated and deceptive. The more we look, the more we seem to "see things."

Hard Edge

Hard edge, or hard-edged abstraction, also came to its height during the 1950s and 1960s, in the work of Frank Stella (b. 1936), among others. Its flat color areas have hard edges which carefully separate one area from another. Essentially, hard edge constitutes an exploration of design for its own sake. Stella often abandoned the rectangular format of most canvases in favor of irregular shapes in order that his paintings bore no resemblance to

starkness and repetitiousness of the composition are broken up by subtle variations. The apparently random breaks in color, line, and texture create moving focal areas, none more important than another, and keep the viewer's eye moving continuously through and around the painting. In these subtle variations, the artist takes an almost cubistlike approach to the manipulation of space and image.

17.12 Frank Stella, *Tahkt-I-Sulayman I*, 1967. Polymer and fluorescent paint on canvas, 10 ft ¼ in × 20 ft 2¼ ins (3.04 × 6.15 m). Pasadena Art Museum, California (Gift of Mr and Mrs Robert A. Rowan). © ARS, New York and DACS, London 2005.

windows. The odd shape of the canvas thus formed part of the design itself, as opposed to constituting a frame or a formal border within which he executed the design.

Some of Stella's paintings have iridescent metal powder mixed into the paint, and the metallic shine further enhances the precision of the composition. *Tahkt-I-Sulayman I* (Fig. **17.12**) stretches just over 20 feet (6 meters) across, with interspersed surging circles and half-circles of yellows, reds, and blues. The intensity of the surface, with its jarring fluorescence, counters the grace of its form, while the variety of the repetitions enriches the simplicity of the painted shapes.

Photorealism and Conceptualism

Photorealism relates to pop art in that it, too, relies on pre-existing images. As we can guess from the name of the movement, it involves working directly from photographs, rather than from the original subjects. It came to the fore during the 1970s, in the work of people such as Richard Estes (b. 1932) and Chuck Close (b. 1940). Photorealism acknowledges the role that the camera plays in shaping our understanding of reality, and suggests obliquely that contemporary life often centers more around manufactured than natural objects.

Conceptual art challenges the relationship between art and life in a different way, and, in fact, challenges the definition of art itself. Essentially anti-art, like Dada, conceptual art attempts to divorce the imagination from

aesthetics. Ideas emerge as more important than visual appearances. It insists that only the imagination and not the artwork is art. Therefore, artworks can be done away with. The creative process needs only documentation by some incidental means—a verbal description, or a simple object such as a chair. But, of course, despite its claims, conceptual art depends on something physical to bridge the gap between the artist's imagination and the viewer's.

One and Three Chairs (Fig. **17.13**) by Joseph Kosuth (b. 1945) depicts three different realities. The first is that of the actual chair that sits between the photograph and the printed definition. The second reality is the lifesize photographic image of the same chair represented in the first reality. The third reality is the verbal description of the same chair. Using the third reality, we form in our mind an idea of the chair, and that might be termed a "conceptual reality." So the conceptual artwork, the combination of actuality, photo image, and verbal description, presents a relationship "between an object and communicative methods of signifying that object."[2]

Abstraction

Less concerned with expressive content than other sculptors, Isamu Noguchi (ee-SAH-moo noh-GOO-chee; 1904–88) began experimenting with abstract sculptural design in the 1930s. His creations go beyond sculpture to provide highly dynamic and suggestive set designs for the choreography of Martha Graham (see Chapter 16), with

17.13 Joseph Kosuth, *One and Three Chairs*, 1965. Wooden folding chair, 32⅜ ins (76.8 cm) high; photograph of chair, 36 × 24 ins (86.4 × 57.6 cm); photographic enlargement of dictionary definition of chair, 24 × 25 ins (57.6 × 60 cm). Museum of Modern Art, New York (Larry Aldrich Foundation Fund). © ARS, New York and DACS, London 2005.

17.14 Isamu Noguchi, *Kouros* (in nine parts), 1944–5. Pink Georgia marble, slate base, about 9 ft 9 ins (2.97 m) high. Metropolitan Museum of Art, New York (Fletcher Fund, 1953).

17.15 Dame Barbara Hepworth, *Sphere with Internal Form*, 1963. Bronze, 3 ft 4 ins (1.02 m) high. Collection, State Museum Kröller-Müller, Otterlo, The Netherlands.

17.16 Alexander Calder, *Spring Blossoms*, 1965. Painted metal and heavy wire, 4 ft 4 ins (1.32 m) high. Museum of Art, Pennsylvania State University. © ARS, New York and DACS, London 2005.

whom he associated for a number of years. Noguchi's *Kouros* figures (Fig. **17.14**) do seem abstractly related to archaic Greek sculpture, and they too exhibit exquisitely finished surfaces and masterly technique.

Another kind of abstraction of the human form appears in *Sphere with Internal Form* (Fig. **17.15**). Here Barbara Hepworth (1903–75) incorporates two sculptural devices—a small form resting inside a large, enclosing form, and the piercing of the form. Piercing gives the piece a sense of activity, as it admits light into the work and provides tonal contrasts.

The **mobiles** of Alexander Calder (1898–1976; Fig. **17.16**) finally put abstract sculpture into motion. Deceptively simple, these colorful shapes turn with the slightest air currents or by motors. Calder's pieces show us that sculpture can result from the movement of forms in undefined space.

The figures of Alberto Giacometti (jah-koh-MET-tee; 1901–66) mark a return to objectivity. Giacometti, a surrealist sculptor in the 1930s, continued to explore the likeness of the human figure and the depiction of surface, as Figure **17.17** shows. Here form reduces to its essence.

17.17 Alberto Giacometti, *Man Pointing*, 1947. Bronze, 6 ft 8½ ins (1.79 m) high. Museum of Modern Art, New York (Gift of Mrs John D. Rockefeller III). © ADAGP, Paris and DACS, London 2005.

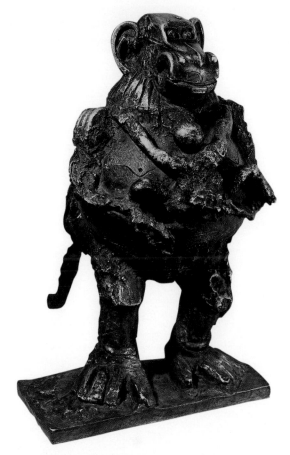

17.18 Pablo Picasso, *Baboon and Young*, 1951. Bronze (after original plaster with metal, ceramic elements, and two toy cars), 21 × 13¼ × 20¾ ins. Museum of Modern Art, New York (Mrs Simon Guggenheim Fund). © Succession Picasso/DACS 2005.

The tortured fragmentation of the figure makes an emotional statement about what it feels like to be human in the contemporary world.

Found Sculpture and Junk Culture

Yet another modernist approach to have emerged since World War II, found sculpture consists of objects taken from life and presented as art for their inherent aesthetic value and meaning. Perhaps developed out of cubist collages, the movement called "junk culture" also took natural objects and assembled them to create single artworks. Interpretations of this kind of assemblage art vary widely, but they usually imply the artist's value judgment on a culture relying on built-in obsolescence and throwaway materials.

In Figure **17.18** we see a treatment of found objects by Pablo Picasso. For *Baboon and Young*, he took a pair of his son's toy cars and incorporated them into a humorous parody.

Minimalism

In the late 1950s and 1960s, a style called "**minimalism**" in painting and sculpture sought to reduce the complexity of both design and content as far as possible. Instead, minimalist artists concentrated on nonsensual, impersonal, geometric shapes and forms. They wanted no communication passed between artist and respondent, no message conveyed. Rather, the minimalists, such as Toby Smith, wanted to present neutral objects free of their own interpretations and leave response and "meaning" entirely up to the viewer.

Primary Structures

The "**primary structures**" movement pursues two major goals: extreme simplicity of shapes and a kinship with

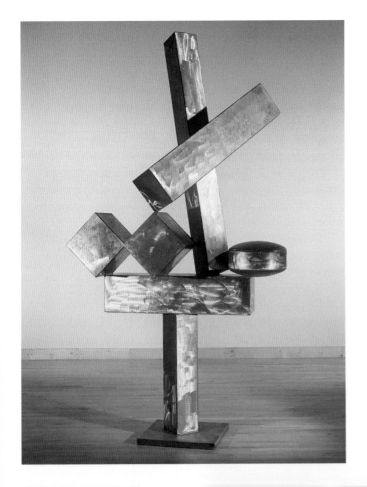

architecture. A space–time relationship distinguishes primary structures from other sculpture. Viewers are invited to share an experience in three-dimensional space in which they can walk around and/or through the works. Form and content reduce to their most "minimal" qualities.

Cubi XIX (Fig. **17.19**) by David Smith (1906–65) rises to nearly 10 feet (3 meters), and its seemingly precarious balance and its curious single cylinder convey a sense of urgency. Yet the work stays in perfect balance. The texture of the luminescent stainless steel has a powerfully tactile effect, yet it also creates a shimmering, almost impressionistic play of light. The forms constitute simple rectangles, squares, and a cylinder, and scale gives them a vital importance.

Louise Nevelson (1900–88) overcame the notion that sculpture was a man's profession because it involved heavy manual labor and became perhaps the first major woman sculptor of the twentieth century. In the 1950s, Nevelson began using found pieces of wood as her medium. At first miniature cityscapes, her work grew larger and larger. Painted a monochromatic flat black, *Black Wall* (see Fig. **17.1**) forms a relief-like wall unit,

17.19 (*above*) David Smith, *Cubi XIX*, 1964. Stainless steel, 9 ft 5 ins (2.87 m) high. Tate Gallery, London. © Estate of David Smith/VAGA, New York/DACS, London 2005.

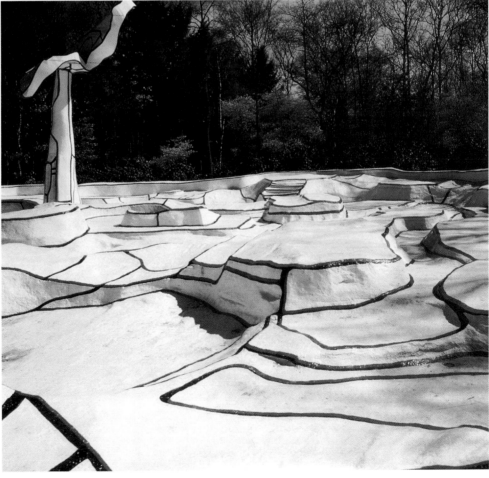

17.20 (*right*) Jean Dubuffet, *Jardin d'Émail*, 1973–4. Concrete, epoxy paint, and polyurethane, 66 ft 8 ins × 100 ft (20 × 30 m). State Museum Kröller-Müller, Otterlo, The Netherlands. © ADAGP, Paris and DACS, London 2005.

whose pieces suggest the world of dreams. Their meaning, however, remains a puzzle, although they make an intense appeal to the imagination.

Ephemeral and Environmental Art

Environmental art sets out to create an inclusive experience. In the *Jardin d'Émail* (zhahr-DAN day-MY; Fig. **17.20**) Jean Dubuffet (doo-boo-FAY; 1901–85) takes an area made of concrete and paints it with white paint and black lines. Surrounded by high walls, the whole construction has a capricious form. Inside the sculptural environment we find a tree and two bushes of polyurethane. Here Dubuffet has tried to push the boundaries of art to their known limits, perhaps. He has consistently opted for chaos, for *art brut*—the art of children, psychotics, and amateurs. The *Jardin d'Émail* represents one of several projects in which he has explored this chaotic, disorienting, and inexplicable three-dimensional form.

The dynamic and dramatic landscape of *Spiral Jetty* (Fig. **17.21**) by Robert Smithson (1928–73), in the Great Salt Lake of Utah, another example of environmental art, presents a number of concepts and ideas. The spiral shape represents the early Mormon belief that the Great Salt Lake connected to the Pacific Ocean by an underground canal, which from time to time caused great whirlpools on the lake's surface. In addition, the jetty attempts to change the quality and color of the water around it, thereby creating a color-shift, as well as making a linear statement. Finally, Smithson meant the design to be ephemeral as well as environmental. He knew that eventually the forces of wind and water would transform, if not obliterate, the project. And, in fact, high water has submerged the jetty in recent years.

Designed as transitory, **ephemeral** art makes its statement, then ceases to exist. Undoubtedly the largest works of sculpture ever designed followed that concept. *The Umbrellas, Japan–USA, 1984–91* (Fig. **17.22**) by Christo and Jeanne-Claude comprised an event and a process, as well as a sculptural work. Christo and Jeanne-Claude's works call attention to the experience of art, rather than any actual permanent form. At the end of a short viewing period, *The Umbrellas* were removed and the materials were recycled. Our illustration shows the Los Angeles half of the project. A valley in the prefecture of Ibaraki, Japan, had 1,340 blue umbrellas. The combined project stretched 30 miles (48 km). The artists pay all the expenses of their projects themselves.

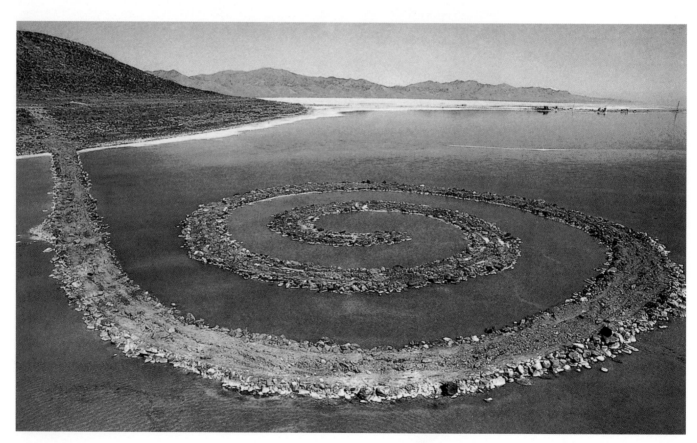

17.21 Robert Smithson, *Spiral Jetty*, 1969–70. Black rock, salt crystals, earth, and red water (algae), 160 ft (48.7 m) diameter; coil 1500 ft (457 m) long and 15 ft (4.6 m) wide. Great Salt Lake, Utah. © Estate of Robert Smithson/VAGA, New York/DACS, London 2005.

17.22 (*above*) Christo & Jeanne-Claude, *The Umbrellas, Japan–USA, 1984–91*. Valley north of Los Angeles, CA, 1,760 yellow umbrellas. © Christo 1991.

Light Art

Since the 1960s, the use of light as an element in sculpture has gained in popularity. Its adherents see light as an independent aesthetic medium, and they use it in a variety of innovative ways.

Typical of artists working with light, (Varda) Chryssa (b. 1933) creates technically precise blinking neon sculptures using very simple shapes. Neon, so indicative of the commercialism and mechanization of modern life, serves as a symbolic comment on the modern era. Chryssa's (KRIS-uh) innovative constructions, such as *Fragments for the Gates to Times Square* (Fig. **17.23**), explore the experience of contemporary technology. Here stark color and linearity couple with intriguing depth in multiple rows of tubing and reflection from the plexiglas cases. His works also explore environmental space in a highly theatrical fashion, in this case surrounding the viewer with a garish ambience like that of Times Square or the Las Vegas Strip.

17.23 Chryssa, *Fragments for the Gates to Times Square*, 1966. Neon and plexiglas, 6 ft 9 ins × 2 ft 10½ ins × 2 ft 3½ ins (206 × 88 × 70 cm). Whitney Museum of American Art, New York (gift of Howard and Jean Lipman).

Postmodernism
Neo-Expressionism

A controversial and momentarily successful movement has been called "**neo-expressionism.**" Like the expressionists, neo-expressionists seek to evoke a particular emotional response. One of its most notable adherents, the Italian Francesco Clemente (b. 1952), records images "that the rest of us repress." In *Untitled from White Shroud* (Fig. **17.24**), he forces the viewer to confront what may well represent repulsive images. The painting has nightmarish qualities, and yet the fluid, watercolor medium gives it a softened, translucent quality. The contrasts of the cool blues in the background and the bright red and yellow of the fishes capture our interest and successfully balance form and color.

Installations

"Environments" have expanded into room-size settings now called "installations." The installations of Judy Pfaff (b. 1946) employ a variety of materials, including those of painting, in order to shape and charge architectural space. The art historian H.W. Janson likens her work to "exotic indoor landscapes," and finds her spontaneous energy similar to that of Jackson Pollock's action painting (see Fig. 17.3). Nature seems to have inspired her installation *Dragon* (Fig. **17.25**). Swirling tendrils hang like brightly colored jungle foliage. Fiery reds predominate, although Pfaff uses the entire color spectrum. All this stands out against the white walls of the room. The sweeping diagonals seem carefully juxtaposed against linear verticals while, at the same

17.24 Francesco Clemente, *Untitled from White Shroud*, 1983. Watercolor. Kunsthalle, Basel, Switzerland.

17.25 Judy Pfaff, *Dragon*, mixed media. Installation view at 1981 biennial, Whitney Museum of American Art, New York.

17.26 Lynda Benglis, *Passat*, 1990. Aluminum, 78 × 52 × 27 ins (198 × 132 × 68.5 cm). Paula Cooper Gallery, New York (photograph by Douglas Parker). © Lynda Benglis/DACS, London/VAGA, New York, 2005.

time, a jumble of stringlike things in the far corner emanates confusion. The strong colors and proliferation of lines suggest that paint has been flung into space and, magically, suspended there.

Neo-Abstraction

By the mid-1980s, other young artists sought to make their mark by reacting against the postmodernist trends. Their work returned to abstract and near-abstract works, including hard edge. These **neo-abstractionists**, like the postmodernists, make up a loose confederation of mostly individualistic approaches. Like the postmodernists, the neo-abstractionists borrow freely from others by modifying or changing the scale, media, or color of older works to give them a new framework and, hence, new meaning. Occasionally, the new meanings include sarcasm and satire and often comment on the decadence of American society in the 1980s. The work of Lynda Benglis, a painter who turned to sculpture, also represents *process art*—taking molten materials, letting them flow freely on the floor, and then adding color and/or shape to them. *Passat* (Fig. **17.26**) illustrates her work, in which she shapes knots, bows, and pleats into insectlike sculptures in shiny metal.

Video Art

Video Composition X by Nam June Paik (Payk; b. 1932) turned a large room into a garden of shrubbery, ferns, and small trees. As one looked up from the greenery, thirty television sets all ran the same program in unison. Bill Viola's *He Weeps for You* featured a drop of water forming at the end of a thin copper pipe and then falling on a drumhead. The image was blown up on a large television screen, and the sound of the falling drop was amplified into a thunderous boom. MIT's *Centerbeam* consisted of a 220-foot (67-meter) long contraption using holograms, video, colored steam, and laser beams.

In fact, a wide-ranging genre of sculpture called "**video art**" emerged from the rebellions of the 1960s as a reaction against conventional broadcast television. Since then, inexpensive portable recording and playback video equipment has made it possible for this art form to flourish. Video art has moved from a nearly photojournalistic form to one in which outlandish experiments exploit new dimensions in hardware and imagery.

Nam June Paik, perhaps the most prominent of the video artists, pioneered the use of television imagery in performance and other multimedia art. It takes television well beyond its primary function of reproducing imagery. Indeed, Nam June Paik's video art creates its own imagery. In *TV Bra for Living Sculpture* (Fig. **17.27**), he creates interactive images of a performance of classical music and miniature televisions with their own images.

17.27 Nam June Paik, *TV Bra for Living Sculpture*, 1969. Performance by Charlotte Moorman with television sets and cello. Courtesy Holly Solomon Gallery, New York. Photo: Peter Moore © Estate of Peter Moore/VAGA, New York/DACS, London 2005.

The combined video and live situations function as a third, overriding experience. The bizarre effect startles, fascinates, and, unlike the moment captured in the illustration, constantly changes.

"New" Realism

The realistic style of the nineteenth century (see Chapter 15) returns from time to time, and we find its evidence in the work of a number of painters. The first of these, Kerry James Marshall, employs conventional techniques and traditional approaches to figure depiction to illuminate personal and historical African American narratives. He looks into the particulars of African American daily living, from ordinary interpersonal exchanges to specifically political interaction. He tries to suggest in his pictures something a little too right, too ordered. In *Den Mother* (Fig. **17.28**), such a sense of goodness pervades that we wonder if this could possibly be a portrait of a real individual, and in reality, Marshall has given us an archetype, an icon, *and* an oxymoron—an object more identifiable with white suburbs than black identity.

Mark Tansey (b. 1949) tries in his painting to find what he calls a new "technaphor"—"a metaphorical technique for connecting subject matter and ideas."

In *Soft Borders* (Fig. **17.30**), he takes four interrelated scenes, each seen from a different perspective, and brings them together. A small tribe of American Indians shares the mountain with a band of surveyors, a tourist group, and a toxic waste removal crew. Tansey describes the scene as "a short history of the West from four different points of view."

Julie Roberts (b. 1963), a Welsh painter, takes a restrained approach to both realism and the drama of human life. She leaves much to the viewer's imagination while creating an effective tension between the paint surface and the disturbing suggestions of the images. In *Sherlock Holmes Presumes* (Fig. **17.29**), Roberts takes the fictional characters familiar from Sir Arthur Conan Doyle's tales, creates a scene with dramatic lighting effects, and gives the portrayal a sense of tension and intrigue. Her colors remain true to life, but she treats the subjects with an exaggeration that takes the realism of the moment and pushes it to an extreme with heavy, unblended highlights and shadows. The painting presents what we might describe as an ultra-realistic scene, with overtones of old-time movies. Within an apparently straightforward approach we begin to find innumerable layers of meaning and directions in which our thoughts

17.28 Kerry James Marshall, *Den Mother*, 1996. Acrylic on paper mounted on wood, 41 × 40 ins (104.1 × 101.6 cm). Collection of General Mills Corporation, Minneapolis, Minnesota. The Jack Shainman Gallery, New York.

17.29 Julie Roberts, *Sherlock Holmes Presumes*, 2003. Oil on canvas, 22 × 21 ins (55.9 × 53.3 cm). Courtesy Sean Kelly Gallery, New York.

17.30 Mark Tansey, *Soft Borders*, 1997. Oil on canvas, 7 ft × 8 ft 8½ ins (2.13 × 2.65 m). Curt Marcus Gallery, New York.

might travel. Through her choice of line, form, texture, chiaroscuro, and dynamics the artist takes us into depths of imagination for which the rather simple content of the picture serves as an open portal. The work seeks a counterbalance between reality and fiction, blurring the line between the two. Roberts juxtaposes high drama, seriousness, and humor: "fun versus somberness," as the artist puts it. The artist, in fact, sees herself as a detective in researching her subjects.

Feminism

Feminism, as we noted earlier, represents a social, political, and cultural movement seeking equal rights and status for women in all spheres of life. More radically, it pursues a new order in which men no longer constitute the standard against which equality and normality are measured. Like postmodernism, feminism comprises a diverse ideology of wide-ranging perspectives on the origin and constitution of gender and sexuality, the historical and structural foundations of male power and women's subjugation, and the proper means of achieving women's emancipation.

During the 1970s feminist artists of the Women's Art Movement emerged. Substantially as a result of this movement, women began to achieve increased recognition in the American art world. Marches, protests, the organization of women's cooperative galleries, active promotion of women artists, critical exploration by

women art historians, and the development of a Feminist Art Program at the California Institute of the Arts, in 1971, brought about significant results. Illustrative of the social protests and marches are the "Guerilla Girls," a group of anonymous women artists who dressed in costume gorilla masks and plastered New York City with posters drawing the public's attention to the situation. Their chosen name is an appropriate play on words. *Guerilla*, Anglicized, sounds like "gorilla"; its origins could be French, "guerre"—"war"; Spanish, "guerra"—"war"; "guerrero"—"warrior."

One of the founders of the CalArts program, Judy Chicago, serves as an example of feminism in art. At the end of the 1960s she began to use feminine sexual imagery to reveal the sexism of the male-dominated art world. *The Dinner Party* records the names of 999 notable women, and pays homage to thirty-nine legendary women, including an Egyptian Queen and Georgia O'Keeffe (see Chapter 16). Each side of the triangular table has thirteen settings (the number of witches in a coven and the number of men at the Last Supper). The triangular shape symbolizes woman. During the French Revolution it stood for equality. Each of the place settings at the table features a runner in a style appropriate to the woman it represents, in addition to a large ceramic plate. Included are traditional women's art forms such as stitchery, needlepoint, and china painting, which Chicago wished to raise to the status given to painting and sculpture. Suggestions of female genitalia throughout the painting form the artist's comment that that was all the women at the table had in common.

Susan Rothenberg (b. 1945) made a major place in American painting following her first New York exhibition in 1976. Images of horses predominate her work, for example *Cabin Fever* (Fig. **17.31**). Rough brush strokes reveal the form, whose shading makes the image appear to separate from the canvas. Her use of acrylic and tempera paints gives the work its particular texture, and lends it vibrant appeal. Betye Saar (b. 1926) likewise has achieved great attention, and her mixed media composition *The Liberation of Aunt Jemima* (Fig. **17.32**) has become one of the most famous images in contemporary art. Aunt Jemima was a marketing symbol of surrogate motherhood applied to pancake flour and syrup. In the immediate years after World War II, Aunt Jemima—an African American woman dressed as "Aunt Jemima," demonstrating making pancakes with her brand of mix—was a staple at county fairs and public festivals around the country and as recognizable a corporate icon as Ronald McDonald.

17.31 Susan Rothenberg, *Cabin Fever*, 1976. Acrylic and tempera on canvas, 67 × 84 ins (170.2 × 213.3 cm). Collection of the Modern Art Museum of Fort Worth, Museum Purchase, Sid W. Richardson Foundation Endowment Fund and an anonymous donor. © ARS, New York and DACS, London 2005.

17.32 Betye Saar, *The Liberation of Aunt Jemima*, 1972. Mixed media assemblage, 11¾ × 8 × 2½ ins (29.8 × 20.3 × 6.3 cm). University of CA, Berkeley Art Museum. © Betye Saar, Courtesy Michael Rosenfeld Gallery, New York.

Pluralism
Latino painting

Rafael Ferrer (fay-RARE; b. 1933), born in Puerto Rico, creates an exotic, mysterious world of the tropics in *El Sol Asombra* (ail sohl ah-SOHM-brah; Fig. **17.33**). A lively palette dominates the painting, and the relationship of the central structure to those surrounding it gives the work a slightly unsettling sense of space. The painting has a surface flatness, given its simplified and flattened shapes and tonally even colors. Ferrer's use of light (from the blazing sun) energizes the composition and creates an inviting series of patterns. The title of the painting means "the sun with shade or shadow," and we suspect a play on words because, although the title describes the work accurately, mystery exudes from the juxtaposed lightness against the dark.

Jose Bedia (BAY-dee-ah; b. 1959), a Cuban painter and installation artist, draws the viewer into *Si se quiere, se puede* (*If you want to, you can*; Fig. **17.34**). The painting evokes ideas about leaving Cuba, and the image of a man on a boat shaped like an anvil, coupled with the title and the restricted palette, raises questions to which the viewer wants to respond. The flat starkness and black and blue palette of Bedia's rendering create a confrontational and engaging image. He leaves us pondering larger issues.

17.33 Rafael Ferrer, *El Sol Asombra*, 1989. Oil on canvas, 5 × 6 ft (1.52 × 1.83 m). Nancy Hoffman Gallery, New York.

585

17.34 Jose Bedia, *Si se quiere, se puede* (*If you want to, you can*), 1993. Acrylic on canvas, 5 ft × 7 ft 6 ins (1.52 × 2.29 m). Collection of Robertson, Stephens, Inc., San Francisco.

Native American Ceramics, Painting, and Photography

Pottery, the greatest of the prehistoric arts, continues today almost completely as an aesthetic activity. Early pottery vessels designed for everyday use, sublimated technique to practical concerns—potters sacrificed time taken for exquisite finishing techniques to getting the object into use. Clay bowls such as those made by Lucy Lewis (Fig. **17.35**) reflect the time-honored traditions of southwest art, but they rise in quality of finish and design to the status of high art, thus sustaining the culture.

In addition to the traditional materials of Native American art—indigenous, easily accessible materials—contemporary Native American artists also work in the media of traditional artists—for example, watercolor. In Figure **17.36**, one of the foremost Navajo painters, Harrison Begay, documents typical Native American life,

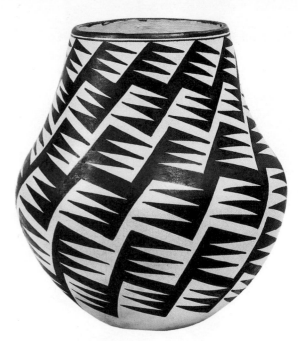

17.35 Lucy Lewis, ceramic bowl, from the Pueblo area, Acoma, New Mexico, 1969. National Museum of the American Indian, Smithsonian Institution, Washington D.C.

in this case, women picking corn. One typical aspect of Native American watercolor of the mid-twentieth century concerns the use of space—the painting stays on the surface plane and depicts only the important subjects with no background shown. We concern ourselves only with the women and the corn, and Begay adds no spatial environment. He renders the subjects in two dimensions. The only hint of space beyond the frontal plane lies in the diminutive size of the woman on the left. Begay leaves the horizon line (the viewer's eye level) at the bottom of the painting.

Using an 1898 field camera and shooting only one image of each location, Thomas Joshua Cooper, a member of the Cherokee nation, composes his images, such as *The Mid North Atlantic Ocean* (Fig. **17.37**), so that the scale of the composition is not always immediately apparent. The printing of the pieces further enhances the intensely emotive nature of his work. Renowned for his technical mastery of the photographic medium, Cooper uses subtly "under-painted" images with selenium and gold, resulting in blue and maroon tones in the photographic printing process. His painterly process ensures the uniqueness of each individual print. Cooper presents an image that comforts the viewer, in this case composing the picture with a stable (almost High Renaissance) triangle at the base of the image that counters the rolling sea.

17.36 Harrison Begay, *Women Picking Corn*, mid-twentieth century. Watercolor, 15 × 11½ ins (38.1 × 29.2 cm). National Museum of the American Indian, Smithsonian Institution.

17.37 Thomas Joshua Cooper, *Mid North-Atlantic Ocean, Punta de la Calera, The Isle of La Gomera*, 2002. Silver gelatin print, selenium and gold chloride toned, 31 × 39 ins (78¾ × 99 cm). Courtesy Sean Kelly Gallery, New York.

587

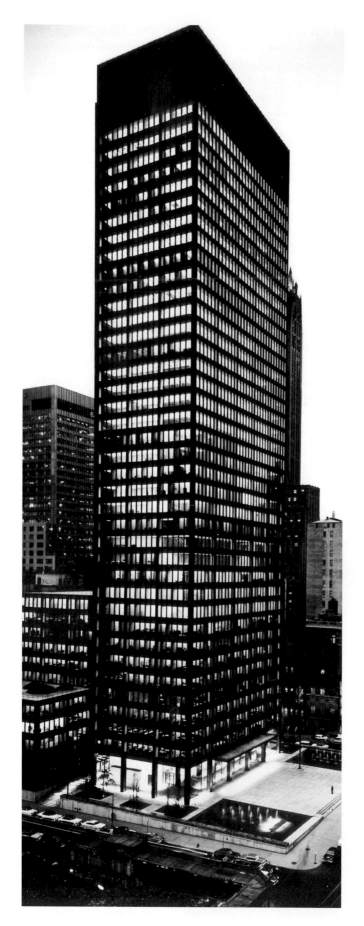

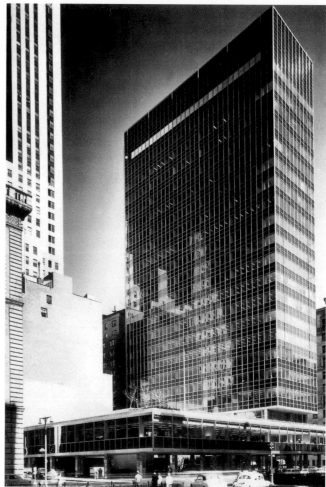

17.38 Gordon Bunshaft (Skidmore, Owings, and Merrill), Lever House, New York, 1950–2.

Architecture

Postwar Modernism

In a sense, the task of evaluating contemporary architecture is the most difficult of all the arts. In our day, the human element in artistic creation has been blurred by the contributions of architectural firms rather than individual architects. In addition, the contemporary observer sees a sameness in the glass and steel boxes of the **International Style** that dominate our cities and easily misses some truly unique approach to design visible in some housing project in an obscure location.

The ten-year break in architectural construction during World War II separated what came after from what went before. The continuing careers of architects who had achieved significant accomplishments before the war soon bridged the gap, however. The focus of new

17.39 Mies van der Rohe and Philip Johnson, Seagram Building, New York, 1958.

building shifted from Europe to the United States, Japan, and even South America. The overall approach still remained modern, or international, in flavor.

A resurgence of skyscraper building occurred in the 1950s. Lever House (1951–2) in New York City (Fig. **17.38**) illustrates the glass-and-steel box approach that began then and continues today. A very important consideration in this design lies in the open space surrounding the tower. Created by setting the tower back from the perimeter of the site, the open space around the building creates its own envelope of environment, or its *context*. Reactions against, and alternatives to, the all-over glazing of the Lever Building have occurred throughout the last fifty years—aluminum surfaces pierced by small windows, for example. An intensification of the glazed exterior has also occurred, where metalized rather than normal glass forms the surface. Such an approach has been particularly popular in the Sun Belt, because metalized glass reflects the sun's rays and their heat. Whatever the materials on the façade, however, the functional, plain rectangle of the International Style has continued as a standard architectural form.

The rectangle, which has so uniformly and in many cases thoughtlessly marked contemporary architecture, leads us to the architect who, before World War II, led its

advocates. Ludwig Mies van der Rohe (LOOT-vik mees vahn dair ROH-e; 1886–1969) insisted that form should not stand as an end in itself but that the architect should discover and state the function of the building. Mies pursued those goals, taking mass-produced materials—bricks, glass, and manufactured metals—at their face value and expressing their shapes honestly. This formed the basis for the rectangularization that constituted the common ground of twentieth-century architecture. We can trace his search for proportional perfection, perhaps, back to the German Pavilion of the Barcelona Exposition in 1929, and it consummated in large-scale projects such as New York's Seagram Building (Fig. **17.39**).

The simple straight line and functional structure basic to Mies' vision were easily imitated and readily reproduced. This multiplication of steel and glass boxes, however, has not overshadowed exploration of other forms. Contemporary design has ultimately answered in various ways the question put by Louis I. Kahn, "What form does the space want to become?"

In the case of Frank Lloyd Wright's Guggenheim Museum (Fig. **17.40**), space has become a relaxing spiral that reflects the leisurely progress one should make through an art museum. Eero Saarinen's (Ay-roh SAH-rin-en) Trans-World Airline Terminal emulates the shape

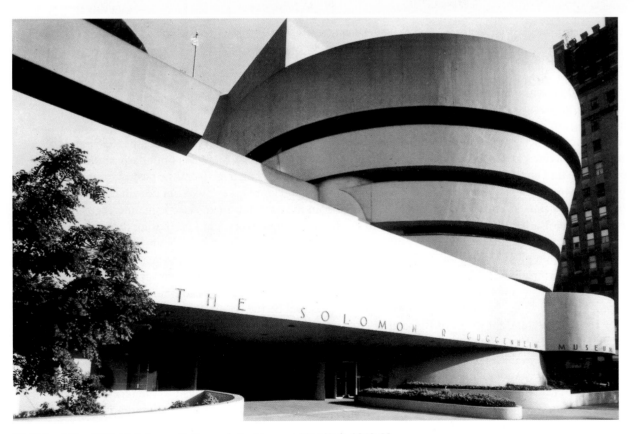

17.40 Frank Lloyd Wright, Solomon R. Guggenheim Museum, New York, 1942–59.

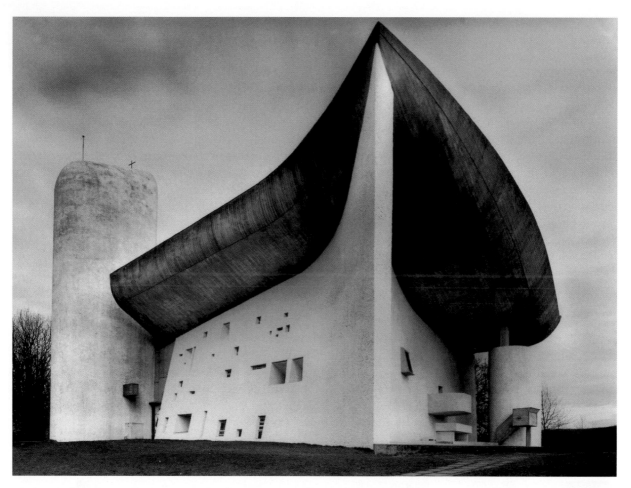

17.41 Le Corbusier, Notre Dame du Haut, Ronchamp, France, 1950–4, from the southeast.

of flight in its curved lines and spaces, carefully designed to accommodate large masses of people and channel them to and from waiting aircraft. (Shapes like this can occur only using modern construction techniques and materials such as **reinforced concrete**.) Le Corbusier's dynamic church, Notre Dame du Haut (Fig. **17.41**), more like a piece of sculpture than a building, also suggests flight. The function of this pilgrimage church cannot easily be surmised from its form. Rather, the juxtaposed rectilinear windows and curvilinear walls and the overwhelming roof nestled lightly on thin pillars above the walls appear a "pure creation of the spirit."

Two other noteworthy architects have their own signatures, the arch of Pier Luigi Nervi (pee-AIR loo-EE-jee NAIR-vee; 1891–1979), and the dome of Richard Buckminster Fuller (1895–1983). The unencumbered free space of their work contrasts sharply with the self-contained boxes of the International Style. Nervi's Small Sports Palace (Fig. **17.42**) and Fuller's Climatron (Fig. **17.43**) illustrate the practical need for free space. They also illustrate the trend toward spansion architecture, which stretches engineering to the limits of its materials.

Postmodernism

Postmodern, or "revisionist," architecture takes past styles and does something new with them. The Spanish architect Ricardo Bofill (BOH-feel; b. 1939) and the Italian Aldo Rossi (b. 1931) both derive much of their architectural language from the past. As Bofill remarked, his architecture takes "without copying, different themes from the past, but in an eclectic manner, seizing certain moments in history and juxtaposing them, thereby prefiguring a new epoch." We see this eclectic juxtaposition in his public housing development called, with typical grandiosity, the Palace of Abraxas (Fig. **17.44**). Here he suggests columnar verticality by glass bays and by the cornice/capitals over them which give the appearance of a dynamic classicism. In Japan, postmodern architects such as Arata Isozaki (b. 1931) portray in their buildings the restrained elegance and style of traditional Japanese art. In the United States, Michael Graves (b. 1934) has reacted to the repetitive glass, concrete, and steel boxes of the International Style by creating a metaphorical allusion to the keystone of the Roman arch (Fig. **17.45**). The bright red pilasters suggest

17.42 Pier Luigi Nervi, Small Sports Palace, Rome, 1957.

17.43 Richard Buckminster Fuller, Climatron, St Louis, 1959.

17.44 Ricardo Bofill, Palace of Abraxas, Marne-la-Vallée, near Paris, 1978–83.

17.45 Michael Graves, Portland Public Office Building, Portland, Oregon, 1979–82.

fluted columns, and fiberglass garlands recall both **Art Deco** and the rococo (see Chapter 13).

Postmodern architecture focuses on meaning and symbolism, and it embraces the past. The postmodernist seeks to create buildings "in the fuller context of society and the environment." Function no longer dictates form, and ornamentation returns to acceptability. The goals of postmodern architecture are social identity, cultural continuity, and sense of place.

We can see another clear repudiation of the glass-and-steel box of the International Style and other popular forms in mainstream architecture in the design for the Pompidou (pohm-pee-DOO) Center in Paris (Fig. **17.46**). Here the building turns inside out, with its network of ducts, pipes, and elevators color-coded and externalized, and its internal structure hidden. The interior spaces have no fixed walls, but temporary dividers allow any configuration wanted. The bright primary colors on the exterior combine with the serpentine, plexiglas-covered escalators to give a whimsical, lively appearance to a functional building. The Pompidou Center has become a tourist attraction rivaling the Eiffel Tower, and, while controversial, it has gained wide popular acceptance.

The eighty-eight-story Petronas Twin Towers (Fig. **17.47**) developed as an integral part of the Kuala Lumpur City Centre in Malaysia. Designed by Cesar Pelli and Associates, the Twin Towers symbolize strength and grace, using geometric principles typified in Islamic

17.46 Renzo Piano and Richard Rogers, Pompidou Center, Paris, 1971–8.

17.47 Cesar Pelli, Petronas Twin Towers, Kuala Lumpur City, 1997. Glass and steel, 1,483 ft (451.9 m) high.

architecture. The 1,483-foot (451.9 m) Twin Towers, until recently the world's tallest buildings, are linked by a 192-foot (58.4 m) double-decker skybridge at levels 41 and 42, situated 574 feet (175 m) above the street level. Apart from offices, the Twin Towers also house the Petronas' science center, an art gallery, and an orchestra hall. The project occupies the former Selangor Turf Club, a 100-acre site in the heart of Kuala Lumpur's Golden Triangle. Some 50 acres of the site have been turned into tropical parkland, with the other 50 acres allocated for commercial development.

Elizabeth Diller (b. 1955) and Ricardo Scofidio (b. 1942) together form Diller + Scofidio, a collaborative interdisciplinary studio involved in architecture, the visual arts, and the performing arts. Their Blur Building (Fig. 17.48), a media building for Swiss EXPO 2002, turns architecture into performance art. Blur Building constitutes a cloud measuring 300 feet (91.4 m) wide by 200 feet (61 m) deep hovering over Lake Neuchâtel in Yverdon-les-Bains, Switzerland, and floating at a height of 75 feet (22.9 m) above the water. The cloud consists of filtered lake water shot as a fine mist through a dense array of high-pressure fog nozzles. The artificial cloud creates a dynamic form that constantly changes shape in response to actual weather. A built-in weather station electronically adjusts the water pressure and temperature in thirteen zones according to shifting humidity, wind direction, and speed.

17.48 Diller + Scofidio, Blur Building, Yverdon-les-Bains, Switzerland, 2002.

The public can approach the cloud from the shore via a pedestrian ramp. Upon entering, the visitor finds visual and acoustical references slowly erased, leaving only an optical "white-out" and the "white noise" of pulsing fog nozzles. Sensory deprivation stimulates a sensory heightening: The density of air inhaled with every breath, the lowered temperature, the soft sound of water spray, and the scent of atomized water begin to overwhelm the senses. The public can circulate through the cloud, enter an interactive media space at its center, discover small media events distributed just outside in the fog, then proceed up and emerge, in the words of the architects, "like an airplane piercing a cloud layer" to the Angel Bar at the summit.

Born in Canada, Frank Gehry (GHAIR-ee; b. 1929) studied architecture at the Universities of Southern California and Harvard. Although his practice as an architect began in traditional commercial ventures, the late 1970s found him moving away from such approaches to one described as "deconstructed." Since the late 1970s his practice has focused on projects that center on artistry. His approach creates functional works of sculpture rather than buildings in the traditional sense. His early works witnessed an architectural language of plywood and corrugated metal. Later, these evolved into distorted but lucid concrete and metal. They reflect an aesthetic that appears somewhat disjointed, as if attempting to belong to a social context likewise disjointed.

The Walt Disney Concert Hall in Los Angeles, California (Fig. 17.49), suggests to some the sails of a ship. It can also suggest the turmoil of our times in its "visual chaos." This building, along with Gehry's Guggenheim Museum in Bilbao, Spain (1997), attempts to change the language of architecture. Both works stand like immense sculptures against the background of the city and continue a curvaceous, free-form style that has become the architect's signature. He utilized similar abstract, free-form components in other buildings such as the Gehry House in Santa Monica, California (1979) and the Fishdance Restaurant in Kobe, Japan (1986–9), which employs a similarly sleek curvaceous cladding. The forms of the building take on sculptured dimensions so complex that they required an advanced aerospace computer program to allow the contractor to build the building in a reasonable way. The sculptural design of Disney Hall may be so futuristic that it hearkens back to the style of futurism itself and Boccioni's *Unique Forms of Continuity in Space* (see Fig. **15.25**).

17.49 Frank Gehry, Walt Disney Concert Hall, Los Angeles, California, opened 2003.

Pluralism

Baghdad-born and London-based architect Zaha Hadid has produced numerous theoretical, architectural designs through the years, in which she abandoned the box of modern architecture in favor of nonlinear designs based on "algorithms of change." A mathematician turned architect, she creates architectural forms that exhibit a sense of dynamism and speed. The Lois and Richard Rosenthal Center for Contemporary Art in Cincinnati, Ohio (Fig. **17.50**) presents the viewer with a series of hovering horizontal galleries that appear to defy gravity. Hadid sees architecture as conceptual art in which the eyes of the viewer must remain forever busy. In a certain way, the building reflects her love of Frank Lloyd Wright's Guggenheim Museum in New York (see Fig. **17.40**). Although Wright's building has a circular, ramplike design, both works reflect the need to create a vertical museum on a cramped urban site. Hadid wanted the space to "roll down from the top" to the street level, which houses the public zones. Street level glass walls give the space a welcoming feel. Inside the building, the ramps connect like a jigsaw puzzle, comprising a series of varied angular galleries on six floors. Because the center does not have a permanent collection, exhibition spaces must remain flexible to accommodate temporary exhibitions.

Theatre

Postwar Modernism
Modern Realism

Modern realism flourished throughout the postwar era, most notably in the works of Tennessee Williams (1912–83) and Arthur Miller (b. 1915). Realism now included a great deal more than its nineteenth-century definition had allowed. It included more theatrical staging devices such as fragmented settings, and also many more nonrealistic literary and presentational techniques such as symbolism. As far as the theatre was concerned, stage realism and the realism of everyday life had parted company.

Tennessee Williams skillfully blended the qualities of realism with whatever scenic, structural, or symbolic devices he required to achieve the effects he wanted. His plays, such as *The Glass Menagerie* (1945) and *A Streetcar Named Desire*, deal sensitively with the psychological problems of ordinary people. One of his great interests and strengths, character development, often carries his plays forward as he explores the tortured lives and the illusions of his larger-than-life characters.

Arthur Miller probed both the social and the psychological forces that destroy contemporary people in plays such as *Death of a Salesman* (1949). Miller described the play as a tragedy about a man who gave his

17.50 Zaha Hadid, Lois and Richard Rosenthal Center for Contemporary Art, Cincinnati, Ohio, opened 2003.

life, "or sold it," in pursuit of the American dream. It tells the story of Willy Loman, who, having spent many years on the road as a traveling salesman, comes to realize his failure as a husband and father. Neither of his sons, Biff and Happy, has achieved any success, in either Loman's terms—being "well-liked"—or anyone else's. With his own career on the wane, Loman escapes into dreams of his idealized past. Ultimately, mocked by his son Biff over Willy's belief in "a smile and a shoeshine," his illusions shattered, Willy, bitter and broken, commits suicide.

Absurdism

Following the work of Pirandello, Camus, and Sartre came a series of absurdists who differed quite radically from them. While early absurdists strove to bring order out of absurdity, the plays of Samuel Beckett, Eugène Ionesco, and Jean Genet all tend to point only to the absurdity of existence and to reflect the chaos in the universe. Their plays are chaotic and ambiguous, and their absurd and ambiguous nature makes direct analysis

purely a matter of interpretation. *Waiting for Godot* (1958), the most popular work of Samuel Beckett (1906–89), has been interpreted in so many ways to suggest so many different meanings that it becomes an eclectic experience in itself. Beckett, like minimalist sculptors, left it to the audience to draw whatever conclusions they wished about the work confronting them. The plays of Eugène Ionesco (U-ZHEN ee-oh-NES-koh; 1912–94)—even more baffling—use nonsense syllables and clichés for dialogue, endless and meaningless repetition, and plots that have no development. He called *The Bald Soprano* (1950) an "antiplay." The absurdist movement has influenced other playwrights and production approaches, from Harold Pinter and Edward Albee to Tom Stoppard.

Postmodernism

As in literature, which we study later in this chapter, theatre reflected postmodernism early. In fact one might easily find in examining post-World War II absurdism, many of the characteristics that define postmodernism. In theatre as in literature, postmodernism reflects a reaction against an ordered view of the world and against fixed ideas about the form and meaning of texts. In examining postmodernism in theatre, we begin with a segue from absurdism, with some comments on Tom Stoppard, followed by an examination of perhaps the best example of postmodernism, performance art, and follow that with a section on Alternative Social Theatre.

In his plays, Czech-born British playwright Tom Stoppard (b. 1937) illustrates verbal brilliance, ingenious action, and structural dexterity. He uses irony as a fundamental force, as exemplified in his witty *Rosencrantz and Guildenstern Are Dead* (1966). Here Stoppard takes two minor characters from Shakespeare's *Hamlet* and places them at the center of a dramatic piece that supports his theme that humans comprise only minor characters in a greater scheme of things, controlled by incomprehensible forces. His *The Coast of Utopia* (2003) comprises an engrossing, lengthy (nine hour) trilogy about the intellectual forebears of the Russian Revolution. The first lines of the play—"Speaking of which"—suggest that we have stumbled upon characters onstage in the middle of a conversation. One of the central ideas of the play appears to be the very inadequacy of language itself and the futility of argumentative discourse.

Performance Art

Performance art pushes the envelope of theatrical production in a variety of directions. It is a type of performance that combines elements from fields in the humanities and arts, from urban anthropology to folklore, and dance to feminism. Performance art pieces called "happenings" grew out of the pop art movement of the 1960s and sought to critique consumer culture. European performance artists, influenced by Dada, tended more toward politics than their American counterparts. Many of the "happenings" centered on the idea that art and life should connect (a central concept in postmodernism). A hybrid, performance art has no "typical" artists. Two artists, however, can illumine the genre well enough for us to understand its essence.

Kathy Rose blends dance and film animation. In one New York performance, she creatively combined exotic dances with a wide variety of styles ranging from German expressionism to science fiction. The *New York Times* called her performance "visual astonishments." Perhaps the most successful of performance artists, Laurie Anderson, performs to large, enthusiastic audiences in basically commercial rock concert settings and has successfully marketed films and recordings of her work. Her seven-hour, four part, two-evening *United States* (Fig. **17.51**) relied upon a variety of technological effects, including an electronic harmonizer that transformed her voice into one with deep, male resonance that she called "the Voice of Authority . . . a corporate voice, a kind of 'Newsweekese.'" Through technology she delayed, altered, and combined tapes of her voice to sound like a chorus. The audio effects combined with intricate choreography, lighting changes, and complex visual imagery. This, and other performances, explores psychological and emotional aspects of North America, seeking not to understand the culture but submitting to the impossibility of understanding it.

Alternative Social Theatre

Among the avenues leading to theatre for and about particular social groups, we find *feminist, lesbian,* and *gay* theatre. *Feminist theatre* began as an alternative movement and proliferated during the 1970s. These activist women's productions tended to reflect radical techniques and agendas addressing women's subordinate position in the dominant culture. Their objective was political: to reform social and political systems and bring about women's equality. The feminist theatre also began as a voice of radical feminism and its early manifestos. Its adherents sought a political restructuring of cultural power. New York's It's Alright to be a Woman Theatre, for example, changed the political movement's consciousness-raising format to performance and used the new public forum to help validate women's personal lives.

Playwrights of the feminist theatre include Megan Terry and Roberta Sklar. At the Omaha Magic Theatre and the Women's Experimental Theatre (respectively), they brought to their productions many experimental

17.51 Laurie Anderson, *United States*, 1983. © Canal Street Communications.

innovations with theatrical form, including those of Bertolt Brecht. The visibility of women playwrights increased in the mainstream theatre of the 1980s and resulted in three Pulitzer Prizes during the decade: one each for Beth Henley (*Crimes of the Heart*, 1981), Marsha Norman (*Night Mother*, 1983), and Wendy Wasserstein (WAHS-er-steen) (*Heidi Chronicles*, 1989). Wasserstein's *Old Money* (2000), a comedy about life in New York, contemporary money, and class, doubles eight characters in the past and present.

Caryl Churchill (b. 1938), a leading British postmodern playwright, addresses controversial issues of gender identity, economic justice, and political alienation in many of her plays. Churchill combines these critiques with dramatic inventions that challenge the boundaries of traditional theatre, critiquing the economic and social status quo and often reflecting her dissatisfaction with twentieth-century gender politics through thick layers of somewhat difficult language and innovative theatrical devices. In *Top Girls* (1982), for instance, Churchill depicts a dinner party hosted by a British woman in the early 1980s. This successful woman invites to the party five famous and courageous women, all of whom happen to be dead. The women share their stories, exploring age-old dichotomies between women's internal and external definitions of success and achievement. *Top Girls* was followed by *Fen* (1982), *Serious Money* (1987), *Mad Forest* (1990), and *The Striker* (1997).

Lesbian Theatre refers to theatre for and by lesbians. Its presence dates essentially to 1968 and the alternative political theatre movement in Britain. One of the first important pieces of lesbian theatre came from the Gay Sweatshop, Britain's first gay theatre company. That play, *Any Woman Can* (1976), by Jill Posner, tells the story of "coming out." A separate women's company of the Gay Sweatshop produced its first piece, *Care and Control*, in 1977. This play, developed by the company and scripted by Michelene Wandor, documented problems faced by lesbian mothers in custody cases. Lesbian theatre expanded during the 1970s and 1980s and tended to isolate itself in lesbian audiences in search of promoting a sense of community. Recent work by American performers Split Britches takes an aggressive attitude toward sexuality.

Gay Theatre describes theatre work by male homosexuals and usually refers to works from the 1960s onward which feature overtly gay characters and situations and/or gay political protest. The liberalization of sexual attitudes in the period after World War II meant that sexuality could be explored as a central focus in drama. Actually, heterosexual playwrights such as Arthur Miller were among the first to include homosexual characters, although often from a negative perspective. Gay theatre's earliest works comprised low-budget productions in small theatres. One such theatre, Café Cino, in New York's Greenwich Village, produced the

works of gay playwrights Doric Wilson and William Hoffman. Off-Broadway also accounted for Mart Crowley's *The Boys in the Band* (1968). The 1970s witnessed the founding of many gay theatre production companies throughout the United States and in Great Britain, and the number and strength of gay companies has grown with the growing gay community. Much of the core of gay theatre has been socialist-political, but the AIDS epidemic has given it a new focus and objective: education. Among the latest to emerge as a figure in the gay theatre, Tony Kushner created a huge, multidisciplinary epic of gay sex and politics, *Angels in America* (Fig. **17.52**), which has been produced throughout the United States and Britain. The gay theatre occasionally reaches into mainstream, and plays such as *Torch Song Trilogy* and *La Cage aux Folles* were hits on Broadway.

Angels in America, a two-part, seven-hour drama, uses AIDS as a metaphor for the decay and salvation of America. The first part, "Millennium Approaches," ends with an angel crashing through a Manhattan ceiling to visit a man ravaged by AIDS. The second part, "Perestroika" (1992), resolves the drama of Part One in an uplifting and comic tone. Two AIDS-suffering but antithetical characters drive both plays. Prior Walter, a thirty-one-year-old free spirit, Roy Cohn, a right-wing cynic, and others collide throughout, and the playwright, Kushner, eventually brings all his characters' conflicts to a peaceful resolution.

Kushner began writing *Angels* in 1987 as a comedy about the migrations of Jews, Mormons, and gays, but it quickly grew to epic proportions with the subtitle "A Gay Fantasia on American Themes." The play won the 1993 Pulitzer Prize for drama and several Tony awards. In 1994, Kushner completed *Slavs*, a lengthy one-act play dealing with themes related to the dissolution of the Soviet Empire.

Pluralism
Latino Theatre

Theatre of the Spanish-speaking communities of America reflects and serves a diverse population. Among these, we will isolate three: *Chicano* theatre, *Nuyorican* theatre, and *Cuban-American* theatre. *Chicano theatre's* origins trace back to the arrival of the Spanish conquistadors of the sixteenth century. During the period of Spanish settlement and the centuries that followed, theatre played an important role in the culture. During the nineteenth century, both San Francisco and Los Angeles formed major centers of Hispanic theatre. The advent of the railroad tied California, Texas, and Mexico City together to serve, through theatre, the culture and traditions of the local ethnic communities. Many traveling companies made regular tours to and from Mexico City. By the

17.52 Scene from *Angels in America* ("Perestroika"), 1992. National Theatre, London, 1993.

1920s, flourishing Chicano theatres and productions explored the problems of adapting culturally and linguistically to a predominantly Anglo culture. Although Chicano theatre withered during the Great Depression and World War II, it rose during the civil rights struggles of the 1960s. In the summer of 1965, Luis Valdez joined Cesar Chavez to use improvisational theatre to underscore the plight of the migrant worker and give political impetus to the farm workers' strike in Delano, California. This led Valdez to form El Teatro Campesino (Farm Workers' Theatre).

Using Valdez as a model, a number of other Chicano theatre groups appeared during the 1960s and 1970s, including Jorge Huerta's (WAR-tah) Teatro de la Esperanza ("Theatre of Hope"). A number of Latino playwrights have emerged as well, and these include women such as Estela Portillo Trambley, whose works include *Puente Negro*, *Autumn Gold*, and *Sor Juana*.

Originally, Chicano theatre was written and performed in the linguistic tradition of the Chicano population. Later, however, Chicano playwrights turned more and more to English as their vehicle.

The curious label *Nuyorican theatre* applies to Puerto Rican culture in New York, which typically deals with bilingual and working-class situations. During the civil rights movements of the 1960s, young Puerto Rican writers and intellectuals began using the term as a means of affirming their own heritage as differing from Puerto Rico and the United States. This ethnic-consciousness produced a diversity of street theatre, prison productions, and small non-profit Hispanic theatres such as Teatro Repertorio Español and the Puerto Rican Traveling Theatre.

The term "Nuyorican" originally applied to the works of playwright–novelist Jaime Carrero in plays such as *Noo Jall* and *Pipo Subway No Sabe Reir*. Later Joseph Papp and a group of playwright–poets associated with the Nuyorican Poets' Cafe defined the term and developed it to exemplify the Nuyorican experience of working-class Puerto Ricans in New York. Reaction against the term grew when themes of crime, drugs, abnormal sexuality, and generally aberrant behavior became associated with the movement.

Cuban-American theatre emerged as early as the nineteenth century in the Cuban-American communities of New York and Ybor City-Tampa, when groups of professional and amateur players such as that of Luis Baralt produced melodramas to raise money to support the war for Cuban independence from Spain. In the early twentieth century, a popular form called *obra buffa cubana*, or Cuban blackface, was produced by a number of Hispanic theatres and traveling companies. The strength of Cuban-American production led to the establishment in Tampa of the only Hispanic (Cuban) Federal Theatre Project during the 1930s. The Cuban Revolution of 1959, which brought Fidel Castro and communism to power in Cuba, resulted in large-scale theatrical activity in Cuban-American communities throughout the United States, but principally in Miami and New York. This activity comprised primarily political theatre of exile, and its adherents include José Cid Perez and José Sanchez Boudy. Their work focuses on opposition to Castro and a nostalgic longing for a world left behind. More recent Cuban-American playwrights, born in the United States, include Ivan Acosta and Dolores Prida. These playwrights typically write in English as well as Spanish, and their themes include acculturation, bilingualism, culture conflict, and the generation gap between immigrants and their US-raised children.

Nilo Cruz (b. 1960), a Cuban-American playwright, came to America just before his tenth birthday on a Freedom Flight to Miami. He received a master's degree in play-writing at Brown University, and his work has been produced widely around the United States. Winner of a Pulitzer Prize in 2003, his *Anna in the Tropics* opens in 1929 with a mother and her daughters waiting expectantly for the arrival of a ship from Cuba which has on board a lector, someone who will read to them and their co-workers at a cigar-rolling factory in Tampa, Florida. Lectors comprise a long Cuban tradition as a way of enhancing manual labor with culture. Influenced by August Wilson (see below), Cruz focuses on his own community, using strongly-developed female characters to depict the varieties of Hispanic experience. The central character, Anna, is taken from Tolstoy's novel *Anna Karenina*, which Cruz weaves into the fabric of the play by use of the figure of the lector.

African American Theatre
African American theatre began in the United States in 1821 in New York, where the African Theatre, founded by William Henry Brown, produced Shakespearean drama for both blacks and whites. Between then and the 1940s, a variety of experiences, both positive and negative, ranged from plays by black playwrights performed by black companies and plays by white playwrights for black casts to the demeaning tradition of the minstrel show. The 1940s witnessed progress in training and production by the American Negro Theatre at the Harlem Liberty Theatre. After World War II, the civil rights movement gave additional impetus to African American playwrights, productions, and actors, and out of this grew the Black Liberation Movement of the 1960s.

The realistic tradition in modern theatre gave rise to a number of African American playwrights. Garland Anderson wrote *Appearances*, the first black play to open on Broadway, in 1925. Other playwrights included Langston Hughes (see p. 556), Paul Green (1894–1981), and, most notably, Lorraine Hansberry (1930–65), whose masterful play *A Raisin in the Sun* dealt with crisis and redemption in the life of a black family on the south side of Chicago.

The theatrical black liberation began in the 1960s. One manifestation of the civil rights movement of the 1950s and 1960s witnessed angry, militant blacks who espoused black consciousness. Many converted to the Black Muslim version of Islam, and many longed for a completely separate black nation. Radical groups talked about destroying Western society, and a number of African Americans turned toward Africa and sought a new identity in the Third World. In the 1980s, self-description changed from "black" to "African American."

Many of these ideas occurred in the dramatic works of playwrights such as LeRoi Jones (b. 1934), who

became Imamu Ameer Baraka. His theatrical visions in *Dutchman* and *A Black Mass* dramatize the dangers of blacks allowing whites into their private lives and call for racial separation. Charles Gordonne's *No Place to Be Somebody* renews Baraka's cause, and espouses violence as legitimate action in the penetrating story of a fair-skinned black searching for his own racial identity.

Many new black theatre companies also emerged in the sixties: The Negro Ensemble Company, for example, founded by Douglas Turner Ward. From that company came the moving production of *Home* (1979) by Samm-Art Williams (b. 1946).

[Home] traces the life of a Southern black, Cephus, from his farmboy youth, through escape to the big city, draft evasion and jail, joblessness and welfare, disease and despair, to his return to the honest labor and creative values on the farm. What makes *Home* more than a typical change-of-fortune melodrama are the poetic language and the conventions of its production format. Cephus is played by a single actor, but all the other roles—old, young, male, female, black, white—are played by two women who take on whatever role they wish by a simple costume addition. . . . Sometimes they are characters in Cephus's odyssey, other times they act as a chorus, helping the audience to collapse time and space and see the whole of Cephus's life from the larger viewpoint of American black history and culture. . . . The fact that the place itself never changes, though Cephus is constantly on the move, and the fact that the actors never change, though they play multitudes of different roles, suggest that "home" is right there all the time, ready to be grasped once the inner yearning is acknowledged, ready to be offered once others are willing to help, to extend themselves, to choose roles of grace instead of confrontation.[3]

The son of a white father and an African American mother, August Wilson (b. 1945) writes with an ear tuned to the rhythms and patterns of the blues and the speech of the black neighborhoods. Founder of the Playwrights Center in Minneapolis, his plays range from *Jitney* (1982) to a planned series of ten plays beginning with *Ma Rainey's Black Bottom* (1984). Wilson believes that the American black has the most dramatic story of all humankind to tell. His concern lies with the stripping away of important African traditions and religious rituals from blacks by whites. In plays such as *The Piano Lesson* (1987), he portrays the complexity of African American attitudes toward themselves and their past. The conflicts between black and white cultures and attitudes form the central core of Wilson's work and can be seen in plays such as *Fences* (1986).

Fences treats the lives of black tenement-dwellers in Pittsburgh in the 1950s. Troy Maxson, a garbage collector, takes great pride in his ability to hold his family together and to take care of them. As the play opens, Troy discusses his challenge to the union concerning blacks' access to doing the same "easy" work as whites. Frustrated, he believes that he has been deprived of the opportunities to get what he deserves—and this becomes a central motif. He describes his wrestling match with death in 1941 when he had pneumonia, and he also tells of his days in the Negro baseball leagues when he was not allowed to play in the majors—because of his race.

Native American Ritual/Theatre

The theatre of the Native American rises from communal celebrations and ancient rituals that reflect both religion and indigenous culture. The diversity of Native American tribal cultures has produced an equally diverse drama, which has at least two things in common: it is full of cosmic significance and it treats the "audience" as a participant rather than spectator. The varieties of Native American drama include one-person dramas of storytellers, improvisations of shamans, and the 100-hour-long celebrations of the Navajo chantways, which involve the entire community and comprise carefully designed costumes, words, gestures, movements, and songs. The potlatch drama of the coastal Northwest originally formed a mechanism for cementing the interrelationships of family and village by distribution of gifts by the wealthy.

Asian American Theatre

Ethnic Chinese theatres have existed in the United States since 1852, and Japanese theatres since the 1870s. In the 1960s, theatres dedicated to plays in English by Asian American playwrights began with the East-West Players in Los Angeles, the Asian American Theatre Workshop, and Yuriko Doi's Theatre of Yugen in San Francisco and in other theatres in Toronto and New York. Plays such as *M. Butterfly* (1988), in which Beijing Opera, an historic and highly conventionalized form, mixes with Puccini, have drawn some criticism from the Asian community for reinforcing stereotypes.

Yiddish and Hebrew Theatre

Throughout the years, Yiddish- and Hebrew-language theatre companies and productions have ebbed and flowed in the Jewish community, particularly in New York. These language-based productions decreased in the 1990s but themes surrounding the Jewish experience continue to find their way into mainstream theatre. A good example, *Ghetto* (1984), by Joshua Sobol (b. 1939), explores (much like the movie *Schindler's List*) life in the Jewish ghetto of Vilna during the Holocaust. Basically a tragedy with music, *Ghetto* theatricalizes history to illustrate the indomitable Jewish cultural spirit.

Music

In examining music since World War II, we will divide the subject matter into four general—and somewhat arbitrary—categories: Modernism, Postmodernism, Traditional Music, and Pluralism. These categories do not imply that all of a given composer's works fall into only one category, or that, particularly with regard to pluralism, a given work might not also be categorized by more than one term. In other words, the nature of the categories makes them unequal. They simply provide us with a convenient means of organization that can shed light on what happened and continues to happen in the music of our times.

Postwar Modernism

As we mentioned in the Getting Started section of the book, the arts do not relegate "old" styles to the trash heap of history. In fact, careful analysis of the twentieth century shows that while "new" styles appear, many "old" styles continue alongside—perhaps not in the spotlight, but persisting nonetheless. Modernism, a term we have used to describe works of art since Chapter 16, has not appeared in our discussions of music. We could have used it in the previous chapter but did not. We introduce it here in order to help us differentiate as best we can some general characteristics dividing music since World War II. If we typically use nonrepresentationalism as a touchstone in identifying works of "modern" visual art, we might, then, use atonality and twelve-tone composition to identify works of "modern" music. In addition, we might say, in general, that modern music begins with the invention of recording technologies. In fact, technological development has made possible many of the characteristics that distinguish both modern and postmodern music, as well as influencing traditional composition. The development of the synthesizer in the 1950s and the establishment of the Columbia-Princeton Electronic Music Center provided an opportunity for composers such as Milton Babbitt to pursue the application and further development of primarily *serial* techniques. Many aleatory composers found electronic sound a congenial way to achieve their musical goals.

After World War II, modern music developed along a number of distinct lines with increasing polarization. Among the different directions, we find two opposite occurrences, one toward control and formality, and the other toward less control to the point of randomness and total improvisation. For example, the serialism of Milton Babitt in America and Pierre Boulez (boo-LEHZ) in France represents the movement toward tighter control and predetermination of events. The improvisational works of Earle Brown (b. 1926) and the various approaches of John Cage exemplify a move away from composer control, leaving decisions to performers or to chance.

Since the early 1960s, electronic instruments for live performance have had a powerful influence on music composition. Live performances mixed with prerecorded tape appeared in the 1950s, and by the 1960s, composers commonly altered the sound of live performers by electronic means. Computer technology has often supplemented the composition and performance of music, and the options available through computer application now seem commonplace and endless.

In our examination of modernism in music since World War II, we will look at three topics: *serialism*, *aleatory* (chance) music, and *minimalism*.

Serialism

Postwar serialism reflected a desire to exert more control and to apply a predetermined hierarchy of values to all elements of a composition. Before the war, composers using the twelve-tone technique created a set, or row, of twelve pitches arranged in a specific order. Although the order could be manipulated in a number of ways, certain relationships between the pitches of the tone row remained constant and provided the underlying structure and much of the flavor of this style. To some extent, structural decisions occurred before the actual writing of the composition itself. The composer then subjected himself or herself to fairly strict limitations on the selection of pitches as the work progressed, since all pitch order was pre-established.

Proponents of the technique argued that composers have always worked within limitations of some kind and that the discipline required to do so forms an essential part of the creative problem-solving process. Opponents argued that writing music this way constituted more a mathematical manipulation that appealed to the intellect and less the function of a composer's ear.

Three Compositions for piano, by Milton Babbitt, written in 1947–8, provides one of the earliest examples of serial technique applied to elements other than pitch. In this work, rhythm and dynamics are also predetermined by serial principles.

Babbit's *Philomel* (1964), a nineteen-minute work, uses the text of contemporary poet John Hollander and treats the myth of Philomel and Tereus. Tereus has violated Philomel and cut out her tongue so she cannot tell her story. Undeterred, Philomel weaves a tapestry that shows Tereus' crime, and then serves Tereus his own son for dinner. Fleeing Tereus into the forest of Thrace, Philomel transforms into a nightingale, "the ruined bird whose song pours out of the darkness with a voice restored from incoherence." The work has three sections. The first treats Philomel's rediscovery of her voice:

developing from the vowel "ee" to the words "feel" and "tree" and so on leading to phrases and stanzas as she finds a new voice. The piece intersperses synthesized music with recorded sound (the soprano's own voice). The first section contains disjunct leaps across the full range of the soprano voice combined with wide arpeggios and many-voiced chords created by combining intervals from the twelve-tone series.

The desire constantly to create something new also intensified, at times superseding most other considerations. Karheinz Stockhausen (SHTOHK-howzen; b. 1928), for example, became more interested in the total manipulation of sound and the acoustic space in which the performance was to take place. His work *Gruppeu* (1957), for three orchestras, serves as an early example. As he became more and more interested in timbre modulation, his compositions—for example, *Microphonie I*—used electronic and acoustic sources.

Aleatory Music

While some composers developed techniques and even systems of highly controlled composition in the late 1940s, others went in the opposite direction. John Cage provided a major force in the application of **aleatory**, or chance, procedures to composition with works such as *Imaginary Landscape No. 4* for twelve radios and *The Music of Changes* (1951). Cage relied on the *I Ching*, or *Book of Changes*, for a random determination of many aspects of his works. (The *I Ching*, which dates from the earliest period of Chinese literature, contains a numerical series of combinations based on the throwing of yarrow sticks—not unlike the throwing of dice or coins.) The ultimate example of chance music, a piece that could be considered nonmusical—Cage's *4' 33"* (1952)—has a performer who makes no sound whatever. The sounds of the hall, audience, traffic outside—whatever occurs—form the content of the composition.

Cage toured Europe in 1954 and 1958 and probably influenced composers such as Boulez and Karlheinz Stockhausen to incorporate aspects of chance and indeterminacy into their music. Boulez's Third Piano Sonata and Stockhausen's *Klavierstück*, both dating from 1957, for example, give options to the performer concerning the overall form of the work or the order of specific musical fragments. But they are, for the most part, conventionally notated, and thus controlled.

Minimalism

Minimalism emerged from California in the mid-1960s as a near kin to the minimalism of the visual arts (see p. 576), with which minimalist composers had close associations. It comprises in part a reaction against the complexities of serialism and the randomness of aleatory music. Minimalist music characteristically has a steady pulse, transparent tonality, and repetition of short melodic patterns, as well as dynamic levels, textures, and harmonies that stay the same for long periods of time. The incessant repetition produces a pulsating and hypnotic quality.

Four minimalist composers of note have all drawn significant influence from non-Western thought, including African, Indian, and Balinese music. Terry Riley (b. 1935), Steve Reich (rysh; b. 1936), Philip Glass (b. 1937), and John Adams (b. 1935) each compose music that features simple forms, clarity, and understatement and attempts to reach the widest possible audience. After the early 1970s, minimalist music employed increasingly richer harmony, tone color, and texture, as reflected in John Adams' opera *Nixon in China* (1987). Terry Riley's *In C* (1964; Fig. **17.53**) has a score that fits entirely on one printed page. This piece, in seeming contradiction to our earlier claim, does utilize chance elements, with any number of instrumentalists playing the fifty-three melodic cells in order and at a pulse established by a pianist drumming out octave Cs. The decision to move on to the next motive lies in the hands of the individual musicians, and the piece does not end until all the musicians have finished the fifty-third cell. The piece usually lasts around forty-five minutes. Figure **17.53** shows twelve of the cells.

Postmodernism

As we noted in the Concepts section of this chapter, postmodernism involves an amalgam of possible characteristics, thus rendering the movement somewhat indefinable. Nonetheless, we might conclude that the difference between modernism and postmodernism in music rests in the attitude that modernism offers a comprehensive, absolute understanding of music, whereas postmodernism reflects a proliferation of smaller local narratives and points of view and an inherent skepticism characteristic of, as the writer Umberto Eco put it, our "age of lost innocence." In the postmodern world, music rarely gets composed for its own sake but, rather, for commissions, recording and concert fees, and record charts. Its shape appears to come from the domination of

17.53 Minimalist cells from Terry Riley's *In C*, 1964.

television, radio, and the internet as primary information sources. So, in effect, postmodern music challenges the very concept of "high art" or traditional Western concert music. Postmodernists would view "art music" as reflective of bourgeois (upper middle class) values. Finally, the aesthetic of postmodern music encompasses music from approximately 1960 to the present and employs an obvious use of mixed-media, irony, humor, and self-parody. Our examination will pause briefly on three topics: experimentation, improvisation and *musique actuelle*, and sound liberation.

Experimentation

Experimentation with **microtones** has been of interest to composers and music theorists throughout history, and many non-Western cultures employ them routinely. Microtones comprise intervals smaller than a half step. The traditional Western system divides the octave into twelve equal half steps. But why might the octave not be divided into twenty-four, fifty-three, ninety-five, or any number of parts? The possibilities are limited only by our ability to hear such intervals and a performer's ability to produce them. Alois Haba experimented in the early part of the century with quarter tones (twenty-four per octave) and sixth tones (thirty-six per octave) and Charles Ives did much the same thing. Musicians designed a number of instruments to produce microtones and experimented with them widely.

Composers also questioned the limitations of the traditional concert hall. Early work by Cage and others led to theatre pieces, multimedia or mixed media pieces, so-called danger music, biomusic, soundscapes, happenings, and total environments which might include stimulation of all the senses in some way. Thus they often obscured the distinctions between the composer and the playwright, the film-maker, the visual artist, and so on.

Theatre music, sometimes called "experimental music," may be relatively subtle, with performers playing or singing notated music and moving to various points on the stage, as in Luciano Berio's (b. 1925) *Circles* (1960). Or it may be more extreme, as in the works of La Monte Young, where the performer is instructed to "draw a straight line and follow it," or to exchange places with the audience. In Nam June Paik's *Homage to John Cage*, the composer ran down into the audience, cut off Cage's tie, dumped liquid over his head, and ran out of the theatre. Later he phoned with the message that the composition had ended. Needless to say, such compositions contain a considerable degree of indeterminacy.

Some works were never intended to be performed, but only conceptualized, such as Nam June Paik's *Danger Music for Dick Higgins*, which instructs the performer to "creep into the vagina of a living whale" or Robert Moran's *Composition for Piano with Pianist*, which instructs the pianist to climb into the grand piano.

Improvisation and *Musique Actuelle*

Composers such as Lukas Foss, who wrote a suite for soprano and orchestra that includes jazz improvisation, pursued an open, improvisatory tradition. Foss founded the Improvisation Chamber Ensemble, and a number of other improvisation groups sprang up in the United States during the 1960s. During this period, intense exploration of new sound possibilities using both conventional and electronic instruments also occurred. Electronically produced music, specifically the electronic altering of acoustically produced sounds, came to be called *musique concrète*.

In the late 1990s, improvised music, viewed as the cutting edge of musical style, took the name *musique actuelle* (mue-ZEEK akt-yoo-EL). It freely draws on jazz and rock and exudes vibrancy, liveliness, and personal expression. Its literal translation means "current," and it represents a number of subfactions. Illustrative of this approach, Gianni Gebbia's (JAHN-ee GHEHB-ee-ah) trio reflects one of the heroes of musique actuelle, Evan Parker. Gebbia's music integrates three strains, American jazz, free improvising, and traditional Sicilian music. Always in musique actuelle there appears a strain of humor—for instance, the vocalist in Gebbia's trio might alternate between phrases reminiscent of opera and phrases utilizing nasal whines and fearsome guttural groans in two simultaneous pitches.

Sound Liberation

The Polish composer Krzysztof Penderecki (KRIHS-tov pen-der-EHT-skee; b. 1933) is widely known for instrumental and choral works, including a major composition, the *Requiem Mass* (1985). Most notably, Penderecki has experimented with techniques to produce new sounds from conventional stringed instruments.

His *Polymorphia* (1961) uses twenty-four violins, eight violas, eight cellos, and eight double basses. He has invented a whole new series of musical markings listed at the beginning of the score. In performance, his timings are measured by a stop watch and have no clear meter. *Polymorphia* uses a free form, achieving its structure from textures, harmonies, and string techniques. The piece is dissonant and atonal.

It begins with a low, sustained chord. The mass of sound grows purposefully, with the entry of the upper strings, and then the middle register. Then comes a section of glissandos (slides), which can be played at any speed between two given pitches, or with what amounts to improvisation. A climax occurs, after which the sound tapers off. Then a number of pizzicato (plucked) effects are explored. Fingertips tap the instruments, and the

603

PROFILE

RICHARD DANIELPOUR (b. 1956)

Richard Danielpour can be characterized as a "traditionalist" composer. He studied at the New England Conservatory and the Juilliard School, and also trained as a pianist. Speaking of his rise in the ranks of recognized composers, Danielpour reflected, "From the beginning, it was agonizing. It was like waiting for a Polaroid to develop, but the Polaroid took 10 years instead of 30 seconds." Indicative of his standing in the music world is his collaboration with Nobel Prize-winning writer Toni Morrison on a piece titled "Sweet Talk," premiered by Jessye Norman at Carnegie Hall.

In the early 1980s Danielpour moved away from the complexities of Modernism toward a more accessible style. As a result, his music's large and romantic gestures, brilliant orchestrations, and vibrant rhythms appeal to a wide cross-section of the public. In this regard, some critics have compared him to Leonard Bernstein, Aaron Copland, Igor Stravinsky, Dmitri Shostakovich, and other twentieth-century masters. "As I got older, I was aware of a number of different strands coming together in my music, rather than seeing myself on a mission with one particular ax to grind," he said. He calls himself an assimilator rather than an innovator. By utilizing familiar and unthreatening styles as a basis for his compositions, Danielpour has been able to win over even conservative audiences.

In the process of finding the means to express his message, Danielpour draws from many resources. "For me style is not the issue," he said. "It's how well a piece is written on a purely technical level. If other composers see themselves as superior just because their music may be more 'original,' that's O.K. That's not what I'm about." His "American-sounding rhythmic swagger," easy lyricism, and keen understanding of instrumental color create an appealing formula.

Although reluctant to discuss his music's spiritual component, he tends to label supposedly abstract instrumental works with intriguing, metaphysical titles. The movements of his Piano Quintet, for example, are "Annunciation," "Atonement," and "Apotheosis." Such titles, he admits, can be distracting. "Maybe it would be better not to have any at all," he said. When he does discuss spirituality in music, he doesn't hesitate to place himself in good company. "Some of my favorite composers," he said, "are also philosopher-composers who find themselves addressing questions about life and death in the very music they write: Mahler, Shostakovich, Bernstein."

He speaks of the creative process in spiritual and perhaps eccentric terms. "Where is the music received from?" he asked. "Where do your dreams come from? Composing is like being in a waking dream. To me the where is not important. It's intuition that has to lead the way and thinking that has to follow it. To speak of the mind first is worthless."

Perhaps typical of all professionals in today's music world, he has a sense of the business side of music. He knows about contracts and commissions and how to be in the right place at the right time. Nonetheless, Danielpour insists that he is no more active in self-promotion than his colleagues.[4]

palms of the hands hit the strings, leading up to a second climax. After another section exploring bowed, sustained, and sliding sounds, a third climax occurs. After an almost total dearth of melody and defined pitch, the work ends with a somewhat surprising C major chord.

The American composer Elliott Carter (b. 1908) developed a highly organized approach toward rhythm, often called "metric modulation," in which the mathematical principles of meter, standard rhythmic notation, and other elements are carried to complex ends. Carter's use of pitch is highly chromatic and exact, and his music requires virtuoso playing both from the individual and the ensemble.

Eileen Taaffe Zwilich (b. 1939), who studied with Elliott Carter, earned her own place as an important composer. Her Symphony No. 1 (1983) won a Pulitzer Prize. The third movement of the symphony explodes with percussive effects, driving rhythms, juxtaposed timbres, dramatic dynamic changes, and a pyramidal climactic cadence. She has emerged as a national role model for women composers.

Traditional Music

Many so-called "mainstream," or traditionalist, composers continued writing throughout the 1960s and early 1970s. The source of much of this music is a

combination of nineteenth-century Romantic tradition, the folk styles of Bartók and Copland, the harmonies of Hindemith, the tonal systems of Debussy and Ravel, and the neoclassicism of Prokofiev and Stravinsky. By this period, a noticeable element of controlled indeterminacy had crept into the music, however. The late 1960s and 1970s brought a greater acceptance of varying aesthetic viewpoints and musical styles as avant-garde techniques joined the mainstream.

One of America's leading composers through the end of the century, Ned Rorem (b. 1923) remained fairly traditional in style, focusing on his forte, the art song, a piece for voice based on a poetic text. He also has written five operas and many instrumental works. His works set to music poems ranging from international sources to the American poet Walt Whitman and many twentieth-century poets. Originally, his instrumental style was neoclassical, but in the 1960s he adopted serial techniques. His art songs remain traditional in style, striving for vocal lines that complement the text with clarity and directness, with picturesque accompaniments. As an example, his "The Shield of Achilles" begins with quick piano figures evoking the hammer blows in the making of the mythical shield. The figures return later to suggest execution posts being driven into the ground during World War II. At times the accompaniment ceases, leaving the voice alone to convey the mood of the text.

Pluralism
African American Music—Jazz
Styles stemming from traditional jazz proliferated after World War II, moving away from the big bands to smaller groups and a desire for more improvisation within the context of the compositions. The term "be-bop" was coined as a result of the characteristic long-short triplet rhythm that ended many phrases, and the prime developers of this style were alto saxophonist Charlie "Bird" Parker (Fig. **17.54**) and trumpeter Dizzie Gillespie. The Cool Jazz style developed in the early 1950s with artists such as Miles Davis, and although the technical virtuosity of be-bop continued, a certain lyric quality, particularly in the slow ballads, developed and, more importantly, the actual tone quality, particularly of the wind instruments, provided a major distinction.

Were our space unlimited, we could look further into this African American form and include such gifted performers as Thelonius Monk, John Coltrane, and Cecil Taylor. John Coltrane, for example, whose personality and charisma projected to black Americans in his albums *A Love Supreme*, *Ascension Meditations*, and those that followed, has had a tremendous influence on black society in the United States. These works acted as a spiritual reservoir for black people and have been hugely influential on jazz ever since.

17.54 Saxophonist Charlie Parker in performance with Tommy Potter. Parker died prematurely in 1955, aged thirty-five, but by that time he was already a legendary figure.

Asian Composers
Japanese composer Toru Takemitsu (1930–96) enjoyed a fine reputation in the United States with his extremely personal music exploring timbre and space in large orchestral works. His music holds a great deal in common with traditional Japanese music, but he integrates Western elements as well. The acclaim with which his compositions have been received in the United States has also popularized the Japanese instruments, the *biwa* (a Japanese flute) and *shakuhachi* (a bamboo flute).

Chinese-born composer Tan Dun (b. 1957) likewise bridges the traditions of the orient with the West. A student of both the Beijing Conservatory and Columbia University, he composes in a multicultural manner that has gained him global recognition. His opera *Marco Polo* (1996) received great acclaim. *Symphony 1997: Heaven–Earth–Mankind*, a massive work, commemorates the reunification of Hong Kong with China on 1 July 1997. The work joins past and present, East and West, strictly notated concert music, and improvisation. From

this work, the piece "Opera in Temple Street" employs a cello solo, *bianzhong* bells (tuned bells hanging from a frame), cellos, and basses. The piece has recorded sounds of a traditional street opera in Hong Kong that yields to the orchestral players, who then give way to the *bianzhong*. The piece constitutes an allegory that introduces part two of the symphony: Earth.

In the first few seconds of the piece, we hear recorded clapping, cymbals, and drums calling attention to the players: actors (two men, one woman), who introduce themselves with poetry ("shiny pearls of light on flowers"/"gentlemen and ladies accompany the bridegroom"). Following that, a low-C drone comes from the live players: cellos, basses. Then the actors dance and sing, improvising on an old love-song from the bowed and plucked string instruments with percussion. The live drone vibrates and seems to engulf the song, symbolizing the present overtaking the past. The song, like the past, however, continues. Approximately two minutes into the piece, the bells overlap the fading song. The pace quickens. At four minutes into the piece, melodic motives emerge as the players take harder sticks to the bells and enhance the polyphony. Finally, the lowest bells add a bass pattern in duple rhythm, followed by a fadeout.

Native American Music

Native American music represents an important aspect of cultural reality. For example, the music of the Inuit people developed into a highly complex art form, exhibiting complex rhythms that use contrasting accents and meters. The tonal range of melodies tends to be limited, so that changes of pitch occupy only brief distances, thus creating a gentle, undulating quality. The style of Inuit music often has a declamatory element—similar to the operatic technique of recitative in Western music.

Northwest coast Native American music has a number of unique qualities. The first of these, the concept of ownership of a song, allows only the owner of a song to perform it. Another individual can, however, buy a song, inherit it, or even obtain it by murdering the owner, provided, of course, that the murderer could justify the claim. In addition, secret societies within the tribes own songs. In musical terms, northwest Native American music requires part singing, and in a similar style to some African music, music of these tribes makes use of parallel harmonies and drone notes. The rhythms of this music tend toward strongly percussive and intricate patterns.

The songs of the southwest Native Americans, especially the Pueblos, reveal complex tonal arrangements. Songs are based on six- or seven-note scales and appear to keep within a rather low register—the pitches stay among the low notes of the range. This stands in contrast to the music of the Plains Indians, who tend to use high pitches for their music. Nearly every social occasion, holy day, and ceremony has its own special music.

Dance

Modern

José Limón (lih-MOHN) and Martha Graham continued to influence dance well into the second half of the twentieth century. Limón's *Moor's Pavane* used Purcell's *Abdelazer* for its music. Based on Shakespeare's *Othello* and structured on the Elizabethan court dance, the *Pavane* represents an unusual dramatic composition that sustains tension throughout the piece.

Martha Graham's troupe produced a radical and controversial choreographer who broke with many of the traditions of modern dance. Like John Cage, with whom he closely associated, Merce Cunningham (b. 1919) incorporated chance, or aleatory, elements into his work. Cunningham uses the gestures of everyday activity as well as dance movements. He wants the audience to see dance in a new light, and, indeed, his choreography is radically different from anyone else's—elegant, cool, and severely abstract.

Works such as *Summerspace* and *Winterbranch* illustrate Cunningham's use of chance, or indeterminacy. To keep the dance fresh, he and his dancers rehearse different options and orders for sets. Then, sometimes by flipping a coin, he varies and intermixes parts in different orders from performance to performance. The same piece may appear totally different from one night to the next. Cunningham also uses stage space as an integral part of the performance and spreads the various focuses of a piece across various areas of the stage (unlike classical ballet, where the focus isolates on center stage or downstage center alone). Thus Cunningham allows people in the audience to choose where to focus rather than choosing their focus for them. Finally, he allows each element of the performance to go its own way. The dancers rehearse without music and learn the count without any reference to it. The music, which can be anything, is added later, sometimes only when the curtain goes up. As a result, no beat-for-beat relationship that audiences have come to expect between music and footfalls in ballet and much modern dance occurs.

Loose Time (2002) has a fiery and original impact. Intricate, explosive, and slightly sinister, it uses sixteen dancers. The musical score, by Christian Wolff, has no direct relationship to the onstage activity, and the dancers often move independently of each other, possibly suggesting the title: units moving in different sets of rhythms, moving according to loose time.

Since 1954, another graduate of Martha Graham's troupe (and also of Merce Cunningham's) has provided another strong direction in modern dance. The work of Paul Taylor (b. 1930) has a vibrant, energetic, and abstract quality that often suggests primordial rites. Taylor, like Cunningham, uses strange combinations of music and movement in ebullient and unrestrained dances such as *Book of Beasts*. Unlike Cunningham, however, Taylor often uses traditional music, like that of Beethoven. The combination of esoteric musical forms with his wild, emotional movements creates confrontational works that viewers find challenging.

In this tradition of individual exploration and independence, there have been many accomplished dancer/choreographers, among them Alwin Nikolais (NI-koh-ly). His works—he designs the scenery, costumes, and lights and composes the music as well as the choreography—are mixed-media extravaganzas that celebrate the electronic age with spectacles compared by many to early court masques. Often the display is so dazzling that the audience loses the dancers in the lighting effects and scenic environment.

Another important figure, Alvin Ailey, a versatile dancer, created a company known for its unusual repertoire and energetic free movements. Twyla Tharp and Yvonne Ranier have both experimented with space and movement. James Waring has added Bach and 1920s pop songs to florid pantomimes and abstractions using Romantic point work.

Ballet

Many contemporary ballet companies flourished around the world after World War II. International tours of Europe's great companies, among them the Bolshoi, Great Britain's Royal Ballet, the Stuttgart, and the Royal Danish companies, made frequent trips to the United States, while American companies, notably the New York City Ballet, the American Ballet Theatre, and Dance Theatre of Harlem, were well received abroad. Crowds of American dance enthusiasts visited the ballet houses of London, Moscow, Paris, and Vienna. In the United States and Canada, regional companies kept ballet traditions alive and fresh. Dance became one of this country's most popular and growing art forms, with the availability of quality works growing each year and the characteristics of classical dance changing quietly all the time. As a result, we have a challenge in seeing ballet as "modern," "postmodern," "traditional," or something else entirely. The choreographer William Forsythe (b. 1949), for example, pushed the frontiers of codified classical technique with a brilliantly innovative physical approach, combining that with a vivid theatrical imagination. Works such as the lyrical *Duo* and witty *N.N.N.N.* (2003) explore the human body as dancers slither, arc,

and angle through space while at the same time evoking classical ballet forms.

Postmodern

Rising in the 1960s, postmodern dance seeks the interrelationships between art and life. The Judson Dance Theatre comprised an informal collective of experimentalists who rejected traditional choreography and technique in favor of open-ended scores and ordinary movement. There are no "typical" adherents, but one example surely is Deborah Hay (b. 1942), one of the style's pioneers. Hay defines dance broadly as "the place where I practice attention. . . . It's a kind of alertness in my body that I have at no other time. So dance for me is about playing awake."[5]

Most of Hay's work is playful, and "Voil," a forty-minute solo piece, requires the dancer to gallop and prance, engage in awkward gesticulations, and do storytelling, vocalizations (tongue clicks and guttural rumblings), as well as other sorts of emotional outburst. The dance is "fierce, tentative, sorrowful, amazed, earnest, exasperated . . . [with] ugly faces and . . . silly kids' stuff."[6]

Pluralism
Jazz Dance

We defined this dance genre in the Getting Started section of the book. With its roots in the heritage of black music, jazz dance nonetheless draws upon the broad experiments of modern dance. Its sources include tribal Africa and the urban ghetto. Scholars do not agree on its forms, which may include salsa and hip-hop, and, like modern dance, its directions remain in flux. Nevertheless, this form has received significant attention throughout the United States (Fig. **17.55**). Choreographers such as Asadata Dafora Horton in the 1930s and Katherine Dunham and Pearl Primus in the 1940s pioneered the form.

Native American Dance

Most Native American dances have a religious or ritualistic context. Medicine men dance to seek aid for the sick; hunters dance to attract game; and farming tribes dance to bring rain or to make the corn grow or ripen. Some dances dramatize stories from the history or mythology of the tribe. Almost every occasion has an accompanying dance. Native Americans have separate dances for men and women as well as some in which men, women, and children take part. Dancers emphasize various movements of the feet and postures for the head (arms play a lesser role), and drums provide accompaniment. Each graceful movement reinforces the idea of oneness with the earth and the environment.

The southwest provides two fairly common ceremonials: one, with a line of male dancers, each

17.55 Choreographer: Jean Sabatine, *Nameless Hour*. Jazz Dance Theatre at Penn State. The Pennsylvania State University.

holding gourd rattles and singing to their own accompaniment; a second, with dancers bedecked with colorful Kachina masks. Usually Native American dances have serious purposes, but they often serve as occasions for fun and sociability, with clowns joining the dancers.

Literature

The *Encyclopedia of Literature* (Springfield, Massachusetts: Merriam Webster) dates the onset of postmodernism in literature to the 1940s. We noted in Chapter 16 that scholars date the end of modernism to around 1945. Thus, in picking up the thread of literature in the post-World War II world, and in keeping with development parallel to the other arts in this chapter, we begin the discussion with postmodernism and then finish with pluralism.

Postmodernism
Modernism in literature regarded language as a tool for dealing with philosophical origins—revealing truths about the world. Postmodernism, on the other hand, does not believe that language can reveal truths about the world, but rather, that systems like history and religion, that try to explain things, have only persuasive powers—not truth. In literature, postmodernism encompasses a variety of movements challenging the ideas and practices of modernism. Fundamentally, it has involved reacting against fixed ideas about the form and meaning of texts, especially in the use of *pastiche* and *parody*, the *absurd*, the *antihero*, and the *antinovel*. To illustrate postmodernism, we will comment on the writers Pynchon, Nabokov, and Sontag, and then examine three postmodern styles: concrete poetry, magic realism, and the confessionalists.

Thomas Pynchon (PIHN-chuhn; b. 1937), an American novelist and short-story writer, combines black humor and fantasy to portray human alienation in the chaos of modern society. His masterpiece, *Gravity's Rainbow* (1973) focuses on the idea of conspiracy, and Pynchon fills it with descriptions of paranoid fantasies, grotesque imagery, and esoteric mathematical language. The complex narrative relates the secret development and deployment of a rocket by the Nazis at the end of World War II. The hero, American intelligence officer Lieutenant Tyronne Slothrop, travels a nightmarish journey of "either historic discovery or profound paranoia," depending on the reader's—and the central character's—interpretation.

Vladimir Nabokov's (nuh-BAHW-kuhf or NAHB-uh-kahwf; 1899–1977) best-known novel, *Lolita* (1955), utilizes an antihero, the intellectual pedophile Humbert Humbert, to explore the topic of love in the light of lechery with stylish and intricate language and effects. *Pale Fire* (1962), however, extends Nabokov's mastery of unorthodox structure. It breaks down the boundaries between reality and fantasy. Written in both poetry and prose, it parodies literary scholarship, taking the form of a scholarly edition of a poem that tells the story through the foreword and notes. The plot centers on John Shade, whose last work, *Pale Fire*, has been edited by his next-door neighbor, Charles Kinbote. Both Shade and Kinbote teach at the Ivy League school, Wordsmith College. Kinbote, a refugee from the Eastern European country of Zembla, where a Russian-backed revolution has overthrown the monarchy, turns out to be the deposed king himself. He tries to persuade Shade to write a poetic lament for the Zemblian monarchy, describing his downfall. Zemblian extremists, looking to assassinate the former king, instead accidentally kill Shade. From there, things get very complicated as Kinbote sets about editing the poem and reacting to its content. As illusion intrudes upon reality, we become less sure whether Shade constitutes a madman who thought himself a poet or Kinbote a madman who thought himself a king. The

whole thing rings with an air of unreality. Nabokov uses a highly experimental structure with language loaded with external references.

Susan Sontag (b. 1933) has gained her reputation through essays on modern culture. Her novel, the historical romance *The Volcano Lover* (1992), portrays the unstable nature of her subject through an examination of a "collection of fates" set primarily in Naples in the eighteenth century (the title refers to the central character's explorations of Mount Vesuvius). Sontag follows the life of Sir William Hamilton, British Ambassador to the King in Naples, through his various collections, and notes how he treated people, particularly his passionate and notorious love, and her infatuation with Lord Nelson. Purportedly factual, the book utilizes a constant narrative in which Sontag eschews the use of quotation marks.

Concrete Poetry
Drawing on the influences of Dada, surrealism, and other early twentieth-century movements in art, **concrete poetry** has a strong visual element in which the poet's intent is conveyed through graphic patterns of letters, words, and symbols rather than through the conventional use of language to create expressive and evocative pictures. This differs from an earlier form of poetry, called "pattern poetry," in which words carry the major meaning (as in traditional poetry) but the poet shapes the poem's lines in such a way as to enhance the words' meaning. Concrete poetry relies so heavily on visual imagery that it cannot be read aloud with any sense of meaning. Its effects remain almost solely visual. Concrete poetry has much in common with *musique concrète* (see p. 603) in terms of its origins and experimental objectives. Typical of poets using this form are the Brazilians Haroldo and Augusto de Campos (KAHM-poosh; b. 1929 and 1931, respectively) who produced the first exposition of concrete poetry in 1956.

Magic Realism
Magic realism, a Latin-American literary movement, incorporates fantastic or mythic elements into otherwise realistic fiction. Perhaps the master of this form is Gabriel García Márquez (ghahr-SEE-ah MAHR-kays; b. 1928), a Columbian-born author and journalist who won the 1982 Nobel Prize for Literature. His best-known work, *One Hundred Years of Solitude* (1967), tells the story of Macondo and its founders, the Buendía family. An epic tale of seven generations, it spans the years of Latin-American history from the 1820s to the 1920s during which patriarch Arcadio Buendía built the utopian city of Macondo in the middle of a swamp. As time elapses, the city and the family slip into depravity. Finally, a hurricane totally obliterates the city. Complex fantasy combined with realism mark this book, making it a superb example of the magic realist genre.

Confessionalists
An important contribution to the postmodern movement comes from the confessional poets and writers who center upon autobiographical material (real or fictitious) which reveals intimate and hidden details of the subject's life. The revelation of such personal and often painful elements emerges particularly in the works of Sylvia Plath and Robert Lowell. Sylvia Plath (1932–63) wrote carefully crafted poems of deep personal imagery and intense focus. Many deal with themes such as alienation, death, and self-destruction. Little known at the time of her death by suicide, she had gained the status of a major contemporary poet by the 1970s. Robert Lowell (1917–77) won a 1947 Pulitzer Prize for his first major work, *Lord Weary's Castle*, which contained two of his most praised poems, "The Quaker Graveyard in Nantucket" and "Colloquy in Black Rock." Active in the civil rights and anti-war campaigns of the 1960s, he won a second Pulitzer Prize for literature in 1977.

Pluralism
African Americans
Contemporary African American writer Gayl Jones (b. 1949) grew up in the streets and segregated schools of Lexington, Kentucky. A graduate in English from Connecticut College and with two graduate degrees in writing from Brown University, she taught creative writing and African American literature at the University of Michigan from 1975 until 1983, when she left the United States. Her writings reflect black vernacular culture and treat the terror of constant sexual warfare, the obsessive extremes of sexuality and violence, and the joining of pleasure and pain. In her work, madness is not an ailment of an individual but of society. Her first novel, *Corregidora* (1975), tells the story of Ursa Corregidora, a descendant of the incest of the Portuguese slave owner of her maternal ancestors. Her husband's violence makes her incapable of having children, and she comes to the realization that "the ritual hatred for men found in the folklore of black women overlooks the perverse longing of all human beings for their own oppression."[7] Her second novel, *Eva's Man* (1976), was no less controversial. It tells the story of a horrendous sex crime committed by a woman who has been tormented by a lifetime of masculine sexual animosity. She recounts her story from a mental asylum and reveals the origins of her madness in everyday sexual violence.

Wit and irony mark the works of American author Alice Walker (b. 1944; Fig. **17.56**). In her novels, poetry, and critical writings she fights battles for the rights for blacks and women. However, she also satirizes political

17.56 Alice Walker reading excerpts from her Pulitzer Prizewinning novel *The Color Purple* in 1985.

activists just as much as their opponents. Her life and writing reflect the tensions and ideals of a "womanist"— a word she has coined for a black feminist. The "twin afflictions" of the civil rights and black power movements and the women's movement form the focus of her work. Her short stories indicate a preoccupation with "the oppressions, the insanities, the loyalties, and the triumphs of black women." She employs a subtle and experimental technique, and we can see some of that in the way that she weaves together the ritual of the marriage ceremony and the thoughts of her female character in "Roselilly" as a counterpoint to her theme of the distance between promise and fulfillment.

<div align="center">

Roselilly
Alice Walker

</div>

Dearly Beloved.
She dreams; dragging herself across the world. A small girl in her mother's white robe and veil, knee raised waist high through a bowl of quicksand soup. The man who stands beside her is against this standing on the front porch of her house, being married to the sound of cars whizzing by on highway 61.

We are gathered here
Like cotton to be weighed. Her fingers at the last minute busily removing dry leaves and twigs. Aware it is a superficial sweep. She knows he blames Mississippi for the respectful way the men turn their heads up in the yard, the women stand waiting and knowledgeable, their children held from mischief by teachings from the wrong God. He glares beyond them to the occupants of the cars, white faces glued to promises beyond a country wedding, noses thrust forward like dogs on a track. For him they usurp the wedding.

in the sight of God
Yes, open house. That is what country black folks like. She dreams she does not already have three children. A squeeze around the flowers in her hands chokes off three and four and five years of breath. Instantly she is ashamed and frightened in her superstition. She looks for the first time at the preacher, forces humility into her eyes, as if she believes he is, in fact, a man of God. She can imagine God, a small black boy, timidly pulling the preacher's coattail.

to join this man and this woman
She thinks of ropes, chains, handcuffs, his religion. His place of worship. Where she will be required to sit apart with covered head. In Chicago. a word she hears when thinking of smoke, from his description of what a cinder was, which they never had in Panther Burn. She sees hovering over the heads of the clean neighbors in her front yard black specks falling, clinging from the sky. But in Chicago. Respect, a chance to build. Her children at last from underneath the detrimental wheel. A chance to be on top. What a relief, she thinks. What a vision, a view, from up so high.

in holy matrimony
Her fourth child she gave away to the child's father who had some money. Certainly a good job. Had gone to Harvard. Was a good man but weak because good language meant so much to him he could not live with Roselilly. Could not abide TV in the living room, five beds in three rooms, no Bach except from four to six on Sunday afternoons. No chess at all. She does not forget to worry about her son among his father's people. She wonders if the New England climate will agree with him. If he will ever come down to Mississippi, as his father did, to try to right the country's wrongs. She wonders if he will be stronger than his father. His father cried off and on throughout her pregnancy. Went to skin and bones. Suffered nightmares, retching and falling out of bed. Tried to kill himself. Later told his wife he found the right baby through friends. Vouched for, the sterling qualities that would make up his character.

It is not her nature to blame. Still, she is not entirely thankful. She supposes New England, the North, to be quite different from what she knows. It seems right somehow to her that people who move there to live return home completely changed. She thinks of the air, the smoke, the cinders. Imagines cinders big as hailstones; heavy, weighing on the people. Wonders how this pressure finds its way into the veins, roping the springs of laughter.

If there's anybody here that knows a reason why
But of course they know no reason why beyond what they daily have to know. She thinks of the man who will be her husband, feels shut away from him because of the stiff severity of his plain black suit. His religion. A lifetime of black and white. Of veils. Covered head. It is as if her children are already gone from her. Not dead, but exalted on a pedestal, a stalk that has no roots. She wonders how to make new roots. It is beyond her. She wonders what one does with memories in a brand-new life. This had seemed easy, until she thought of it. "The reasons why … the people who" … she thinks, and does not wonder where the thought is from.

these two should not be joined
She thinks of her mother, who is dead. Dead, but still her mother. Joined. This is confusing. Of her father. A gray old man who sold wild mink, rabbit, fox skins to Sears, Roebuck. He stands in the yard, like a man waiting for a train. Her young sisters stand behind her in smooth green dresses, with flowers in their hands and hair. They giggle, she feels, at the absurdity of the wedding. They are ready for something new. She thinks the man beside her should marry one of them. She feels old. Yoked. An arm seems to reach out from behind her and snatch her backward. She thinks of cemeteries and the long sleep of grandparents mingling in the dirt. She believes that she believes in ghosts. In the soil giving back what it takes.

together
In the city. He sees her in a new way. This she knows, and is grateful. But is it enough? She cannot always be a bride and virgin, wearing robes and veil. Even now her body itches to be free of satin and voile, organdy and lily of the valley. Memories crash against her. Memories of being bare to the sun. She wonders what it will be like. Not to have to go to a job. Not to work in a sewing plant. Not to worry about learning to sew straight seams in working-men's overalls, jeans, and dress pants. Her place will be in the home, he has said, repeatedly, promising her rest she had prayed for. But now she wonders. When she is rested, what will she do? They will make babies—she thinks practically about her fine brown body, his strong black one. They will be inevitable. Her hands will be full. Full of what? Babies. She is not comforted.

let him speak
She wishes she had asked him to explain more of what he meant. But she was impatient. Impatient to be done with sewing. With doing everything for three children, alone. Impatient to leave the girls she had known since childhood, their children growing up, their husbands hanging around her, already old, seedy. Nothing about them that she wanted, or needed. The fathers of her children driving by, waiving, not waving; reminders of times she would just as soon forget. Impatient to see the South Side, where they would live and build and be respectable and respected and free. Her husband would free her. A romantic hush. Proposal. Promises. A new life! Respectable, reclaimed, renewed. Free! In robe and veil.

or forever hold
She does not even know if she loves him. She loves his sobriety. His refusal to sing just because he knows the tune. She loves his pride. His blackness and his gray car. She loves his understanding of her *condition*. She thinks she loves the effort he will make to redo her into what he truly wants. His love of her makes her completely conscious of how unloved she was before. This is something; though it makes her unbearably sad. Melancholy. She blinks her eyes. Remembers she is finally being married, like other girls. Like other girls, women? Something strains upward behind her eyes. She thinks of the something as a rat trapped, cornered, scurrying to and fro in her head, peering through the windows of her eyes. She wants to live for once. But doesn't know quite what that means. Wonders if she has ever done it. If she ever will. The preacher is odious to her. She wants to strike him out of the way, out of her light, with the back of her hand. It seems to her he has always been standing in front of her, barring her way.

his peace
The rest she does not hear. She feels a kiss, passionate, rousing, within the general pandemonium. Cars drive up blowing their horns. Firecrackers go off. Dogs come from under the house and begin to yelp and bark. Her husband's hand is like the clasp of an iron gate. People congratulate. Her children press against her. They look with awe and distaste mixed with hope at their new father. He stands curiously apart, in spite of the people crowding about to grasp his free hand. He smiles at them all but his eyes are as if turned inward. He knows they cannot understand that he is not a Christian. He will not explain himself. He feels different, he looks it. The old women thought he was like one of their sons except that he had somehow got away from them. Still a son, not a son. Changed.

She thinks how it will be later in the night in the silvery gray car. How they will spin through the darkness of Mississippi and in the morning be in Chicago, Illinois. She thinks of Lincoln, the president. That is all she knows about the place. She feels ignorant, *wrong*, backward. She presses her worried fingers into his palm. He is standing in front of her. In the crush of well-wishing people, he does not look back.

Toni Morrison (b. 1931), one of today's most celebrated authors, has written seven major novels: *The Bluest Eye* (1969), *Sula* (1973), *Song of Solomon* (1977), *Tar Baby* (1981), *Beloved* (1987), *Jazz* (1992), and *Love* (2003). She received the National Book Critics Award in 1977 for *Song of Solomon* and the 1988 Pulitzer Prize for *Beloved*.

Morrison's novel *Jazz* is meant to follow *Beloved* as the second volume of a projected trilogy, although *Jazz* doesn't extend the story told in *Beloved* in a conventional way. The characters are new, so is the location. Even the narrative approach is different. In terms of chronology, however, *Jazz* begins roughly where *Beloved* ended and continues the greater story Morrison wishes to tell of her

people passing through their American experience, from the days of slavery in the 1800s to the present.

Full of tragedy and humor, *Jazz* continues many themes set out in *Beloved*: the individuals' struggle to establish and sustain a personal identity without abandoning their own history, and the clash between individual and community interests. Reading like a blues ballad from the age it suggests, *Jazz* tells the story of a middle-aged couple—Joe Trace, waiter and door-to-door cosmetics salesman, and his wife, Violet, a home hairdresser—who migrate to Harlem from the rural South in the early 1900s and struggle with suffering and survival. The background portrays scenes of the brutal Virginia country life blacks endured as sharecroppers at the end of the nineteenth century. In contrast, Joe and Violet find the prospect of life in New York exciting, initially. Then reality sets in. Despite Joe's attachment to Violet, he falls in love with Dorcas, a teenager, and then kills her when she tries to leave him. No one wants to turn Joe in. At the funeral parlor, Violet attempts to slash Dorcas's face but is thrown out, running home and freeing her treasured birds. Later she establishes a relationship with Dorcas's mother.

Love typifies Morrison's style with its scope and complexity. On a large scale, it explores the consequences of desegregation: Is assimilation good or bad? Should black people have kept what they had? Where does racial uplift end and nationalism begin? Nonetheless, the novel also has a small and intimate level focusing on love: parental love, unbridled love, lust, celibacy, and the deepest of friendships. In Morrison's universe, even hate constitutes a form of love. All these themes wrap around a story about Bill Cosey, a charismatic black entrepreneur who ran a chic seaside resort for wealthy African Americans during segregation. When segregation ended and black people could spend their money in wider circles, the business faltered and ultimately failed. At the beginning of the novel, two feuding women now reside at the long-closed resort: Cosey's widow and his granddaughter. They set the current action in motion.

Native Americans

Since World War II, Native Americans struggled to avoid succumbing to a sense of despair about their culture's demise as it assimilated into the general American "melting pot." Writers in particular made the assault on such feelings a major focus of their works. In 1969, Scott Momaday's (b. 1934) novel *House Made of Dawn* won a Pulitzer Prize and made a new generation of Native American writers aware of a powerful message: people caught between cultures can, despite a variety of problems, find ways to survive.

A House Made of Dawn explores the story of a young Tano Indian named Abel who returns to his village in New Mexico's Cañon de San Diego in 1945 after army service in World War II only to discover that he has entered a hell between two cultures. His grandfather Francisco's world—and the world of Francisco's fathers before him—remains a world of seasonal rhythms, a harsh and beautiful place defined by unremitting poverty; a land with creatures, traditions, and ceremonies reaching back thousands of years. However, the urban world of postwar white America, with its material abundance and promises of plenty, draws Abel away from his people. The choice causes Abel great pain. He winds up in prison, wanders to Los Angeles, and catapults into a life of dissipation, disgust, and despair. Torn between pueblo and city, between ancient ritual and modern materialism, between starlight and streetlight, Abel drops further and further into a state of anguish. He must find a way to reaffirm the ancient ways and truths of his people while discovering a place for himself in a world greatly at odds with those truths. "May it be beautiful all around me," prays the Night Chanter. Abel persists in seeking a path to that beauty.

Paula Gunn Allen (b. 1939), a representative of many Native American writers, believes that Momaday's book created a new future for her: it "brought my land back to me." She believed that she and many Native Americans suffered from "land sickness"—a deep sense of exile caused by the loss of their land and birthright. In the passages of *House Made of Dawn* she found that she shared a familiarity with the places Momaday described: "I knew every inch of what he was saying." It gave her the strength and inspiration—the will—to continue. In her poem "Recuerdo" (1980) she created images of movement, loss, and of searching. She looked for a sense of "being securely planted."

Recuerdo
Paula Gunn Allen

I have climbed into silence trying for clear air
and seen the peaks rise above me like the gods.
That is where they live, the old people say.
I used to hear them speak when I was a child
and we went to the mountain on a picnic
or to get wood. Shivering in the cold air then
I listened and I heard.

Lately I write, trying to combine sound and memory;
searching for that significance once heard and nearly
 lost.
It was within the tall pines, speaking.
There was one voice under the wind—something in it
that brought me to terror and to tears. I wanted
to cling to my mother so she could comfort me,
explain the sound and my fear, but I simply sat,
frozen, trying to feel as warm as the campfire,
the family voices around me suggested I should.

Now I climb the mesas in my dreams.
The mountain gods are still, and still I seek.
I finger peyote buttons and count the stalks of
 sweetsage
given me by a friend—obsessed with a memory
that will not die.

I stir wild honey into my carefully prepared cedar tea
and wait for meaning to arise,
to greet and comfort me.

Maybe this time I will not away.
Maybe I will ask instead what that sounding means.
Maybe I will find that exact hollow
where terror and comfort meet.
Tomorrow I will go back and climb the endless
 mesas
of my home. I will seek thistles drying in the wind,
pocket bright bits of obsidian and fragments
old potters left behind.

The Middle East

The Middle East has produced two women writers of great vision and courage. Fawziyya Abu-Khalid (b. 1955) came from a Westernized upper-middle-class family in Saudi Arabia. While a young girl, she published her earliest poems in the local newspaper. She later included these in her first volume of poetry, published in Lebanon. That volume included a poem with the provocative title "Until When Will They Go on Raping You on Your Wedding Night?" Saudi Arabia banned both the book and the poem.

The United Arab Emirates produced the popular poet Zabyah Khamis (b. c. 1958). The security police briefly arrested her in 1987 apparently because of several articles, including one on the status of women, and poems critical of the UAE authorities. No charges ever resulted, but her arrest came amid a general clampdown on freedom of expression in several Gulf countries at the time. One of her recent collections, *Qasa'id Hubb* ("Love Odes"), uses traditional rhymes and meters.

Judaism

Following the horrors of World War II, artists have explored various media to document the barbarity of Nazism, from documentary film and harrowing nonfiction to the short stories and novels of writers such as Elie Wiesel (vee-ZEHL; b. 1928). Wiesel, a European Jew, survived incarceration in a concentration camp, and in his very moving autobiographical novel *Night* (1960) we get a strong impression of the conflict between faith and human evil. Set in the concentration camps of Auschwitz, Birkenau, and Buna, the story tells of Wiesel's imprisonment and how he overcame the odds through strength and a will to live. A second important character is Wiesel's father, who gave his son the strength to go on

without him and to save himself. (Wiesel's father died on a forty-mile march between camps in the dead of winter.) The work treats themes of death, hatred, faith, survival, perseverance, and loss of innocence. It paints from these themes a picture of life's unfairness, but it rises above life in its espousal that one should never lose faith.

Cinema

International Film and the Demise of the Studio

As Italy recovered from World War II, a new concept in film set the stage for many years to come. In 1945, Roberto Rossellini's (rohs-sel-LEE-nee) *Rome, Open City* showed the misery of Rome during the German occupation. Shot on the streets of Rome, it used hidden cameras and mostly non-professional actors and actresses. Technically, the quality of the work was somewhat deficient, but its objective viewpoint and documentary style changed the course of cinema and inaugurated an important style called **neo-realism**. The European art film tradition remained dominated by this style into the 1960s, with works such as Fellini's (fel-LEE-nee) *La Strada* (1954) and *La Dolce Vita* (1960).

The stunning artistry of Japanese director Akiro Kurosawa's (kyoo-rah-SAH-wah) *Rashomon* (1951) and *Seven Samurai* (1954) penetrated the human condition. In 1986 he directed the spectacular film *Ran*, based on Shakespeare's *King Lear*. Heavy symbolism marked the films of Sweden's Ingmar Bergman. In works such as *The Seventh Seal* (1957), *Wild Strawberries* (1957), and *The Virgin Spring* (1960), he delved into human character, suffering, and *motivation*. By the mid-1960s Bergman had assembled a team of actors who would appear in many of his subsequent films, among them Max von Sydow and Liv Ullmann. Autobiographical comments mark *Fanny and Alexander* (1982) and *After the Rehearsal* (1984). The same may be said about *The Best Intentions* (1992), about his parents' marriage, which Bergman wrote but did not direct.

International films and independent producers dominated from the 1960s on. Studios no longer undertook programs of film production, nor did they keep stables of contract players as they once did. Now each film constituted an independent project, whose artistic control rested in the hands of the director. A new breed of film-maker came to prominence.

More and more films emerged for very specific and sophisticated audiences, and even movies made for commercial success have elements aimed at those in the know. The original episode of *Star Wars* (Episode IV, 1977), for example, features a series of quotations from—

and satires of—old movies. Not recognizing these allusions does not hamper our enjoyment of the film, but knowing them certainly enhances the pleasure. The turn of the twenty-first century brought flashy editing alongside sensibilities reflecting the changing tastes of audiences and a Hollywood scramble to find newer and more intense styles.

Pluralism
Women Film Directors
Among the many fine women film directors we find Nancy Savoca and Beth B. One of the most distinctive voices in American independent cinema, Nancy Savoca (b. 1960) uses thoughtful and often humorous elements to examine women's lives. *Entertainment Weekly* (December 1997) called her film *True Love* one of the "50 Greatest Independent Films of All Time." In *True Love* Savoca fashioned a story of multicultural marriage, building on her own Sicilian–Argentinian background. The film has a keen attention to detail and a sense of ethnic ambience.

Through such diverse media as film, video, sculpture, and installation, Beth B (b. 1955) has created a body of works that defies the very act of classification. Typically, she creates provocative narratives that explore the violence that lies just below the surface of everyday life. Often working in *film noir*, she also creates videos that combine documentary, fiction, horror, and lyricism, with frequent references to arcane artistic figures and theories. B herself says, "People are comfortable when they can label and define you . . . but I don't want to be limited by boundaries."

African American Film-Makers
In the 1990s, independent films continued to predominate. Films by independent African American film-makers, with the exception of Spike Lee, have not shared the current explosion. Nonetheless, a good crop of African American artists made their mark, and these artists show proficiency in several genres. *Jump the Gun* (1997), by English director Les Blair, tells the story of city dwellers in post-apartheid South Africa. *A Woman Like That*, directed by David E. Talbert, is a comedy about an ill-fated attempt to recover lost love. *Fakin' Da' Funk*, directed by Tim Chey, and also a feature film, explores the identity crisis of a Chinese-American adopted by a black family. *Soul Food* tells George Tillman, Jr.'s story of a black family held together by a strong matriarch. Illustrative of documentaries directed by black artists, Keith O'Derek's *Straight from the Streets* centers on West Coast rappers, with interviews with Ice T, Ice Cube, Cypress Hill, Snoop Doggy Dogg, and Dr Dre.

CHAPTER REVIEW

CRITICAL THOUGHT

Some of the fundamental issues just covered include differences among abstract, nonobjective, conceptual, ephemeral, and "chance" art. Each of these approaches places the artwork in a different position between the artist and the respondent. In abstract works visual effects derive from objects in the "real world" but have been simplified or rearranged to satisfy the artists' purposes. The content in nonobjective art stays wholly subjective or invented, and the ability to respond to the form within the art stands as an absolute must, whereas in conceptual art the idea behind the work remains foremost and the product, somehow negligible. And so it goes. We have just explored well over a dozen different styles in fewer than sixty years. In point of fact, in the last one hundred years, more art has been produced in the Western world than in all the previous millennia combined! Perhaps in one hundred years much of what comprised this chapter will have faded from the scene, relegated to insignificance; but it is still too early for us to know, and immaterial to try to judge the effects of time.

SUMMARY

After reading this chapter, you will be able to:

- Discuss the conditions of world affairs from 1945 to the current year.
- Differentiate among all the visual art styles introduced in this chapter and identify major adherents and artworks, including ethnic considerations.
- Identify major writers and their works and styles.
- Characterize serialism, aleatory music, musique actuelle, electronic music, and other directions since World War II by noting specific composers and their works.

- Discuss late twentieth-century theatre genres, including alternative social theatre, performance art, and various ethnic theatre developments.
- Describe the major trends in cinema since World War II with specific references to international, ethnic, and other film-makers.
- Apply the elements and principles of composition to analyze and compare individual works of art and architecture illustrated in this chapter.

CYBERSOURCES

http://www.panix.com/~fluxus/FluX/ESH.html
http://www.judychicago.com/
http://www.audreyflack.com/
http://www.pixcentrix.co.uk/pomo/arts/arts.htm
http://www.pixcentrix.co.uk/pomo/arch/arch.htm

Notes

See Further Reading for full bibliographical details of all cited works.

Chapter 3
1. Hofstadter and Kuhns, *Philosophies of Art and Beauty*, p. 4
2. *Ibid.*
3. Fuller, *A History of Philosophy*, p. 172
4. Snell, *Discovery of the Mind: The Greek Origins of European Thought*, p. 247
5. *Ibid.*
6. Hamilton, trans. in *Three Greek Plays*
7. Hamilton, *op. cit.*
8. Arrowsmith, trans. in *The Complete Greek Tragedies*, vol. VI, New York: Random House, 1858

Chapter 4
1. Fuller, *op. cit.*, p. 266
2. "Rings around the Pantheon," *Discover*, March, 1985, p. 12
3. Andreae, *The Art of Rome*, p. 109
4. From material provided by Alan Pizer
5. Vergil, *The Aeneid*, trans. Theodore C. Williams, New York: Houghton Mifflin Co., 1938, p. 1

Chapter 5
1. McGiffert, *A History of Christian Thought*, p. 7

2. Fuller, *op. cit.*, p. 353
3. *Ibid.*
4. Hofstadter and Kuhns, *op. cit.*, p. 172
5. Barclay, *The Gospel of Luke*, pp. 15–16

Chapter 6
1. Roberts, *History of the World*, p. 321
2. Nicoll, *The Development of Theatre*, p. 48

Chapter 8
1. Transcribed by John Ockerbloom. A version from the MS in the British Museum edited by Grace Warrack, London: Methuen & Co. Ltd., 1901

Chapter 9
1. Hartt, *Italian Renaissance Art*, p. 187

Chapter 10
1. Stokstad, *Art History*, p. 712
2. Hartt, *op. cit.*, p. 592

Chapter 12
1. Père Menestrier, in Vuillier, *A History of Dance*, New York: D. Appleton and Co., 1897, p. 90

Chapter 14
1. Hofstadter and Kuhns, *op. cit.*, p. 381

2. Lesli Camhi, "Emily Dickinson," in Arkin and Schollar (eds.), *Longman Anthology of World Literature by Women 1875–1975*

Chapter 15
1. Hamilton, *Nineteenth and Twentieth Century Art: Painting, Sculpture, Architecture*, p. 211

Chapter 16
1. Giannetti, *Understanding Movies*, p. 360

Chapter 17
1. Valerie-Anne Giscard d'Estaing and Mark Young (eds.), *Inventions and Discoveries 1993*, New York: Facts on File Inc., 1993, p. 220
2. Wilkins and Schultz, *Art Past Art Present*, p. 506
3. Kernodle and Pixley, *Invitation to the Theatre*, pp. 287–8
4. *New York Times*, January 18, 1998, section 2, p. 41
5. *New York Times*, 30 May 1997
6. *Ibid.*
7. Arkin and Shollar (eds.), *Longman Anthology of World Literature by Women*, p. 1039

616

Glossary
With Pronunciations

abacus (A-buh-kuhs). The uppermost member of the capital of an architectural column; the slab on which the **architrave** rests.

absolute film (ab-suh-LOOT fihlm). A film that exists for its own sake: for its record of movement or form.

absolute music (ab-suh-LOOT myoo-zihk). Instrumental music free of any verbal reference or program.

absolute symmetry (ab-suh-LOOT SIHM-uh-tree). In visual art and architecture, when each half of a **composition** is exactly the same. See **symmetry**.

abstract (ab-STRAKT). Any art that does not depict objects from observable nature or transforms objects from nature into forms that resemble something other than the original model.

abstraction (ab-STRAK-shuhn). A thing, apart, that is, removed from real life. Also, an early to mid-twentieth century art movement that stressed non-**representation**.

abstract expressionism (ab-STRAKT-ehk-SPREH-shuhn-ihz-uhm). A mid-twentieth century visual art movement characterized by nontraditional brushwork, **nonrepresentational** subject matter, and **expressionist** emotional values.

absurdism (uhb-SUHRD-iz-uhm; uhb-ZUHRD-ihzm). In theatre and prose fiction, a philosophy arising after World War II in conflict with traditional beliefs and values and based on the contention that the universe is irrational and meaningless and that the search for order causes conflict with the universe. See **Theatre of the Absurd**.

academy (ah-KAD-uh-mee). From the grove (the Academeia) where Plato taught; the term has come to mean the cultural and artistic establishment which exercises responsibility for teaching and the maintenance of standards.

accent (AK-sehnt). In literature and music, a significant stress on the syllables of a **verse** or **tones** of a line, usually at regular intervals. In visual art and architecture, areas of strongest visual attraction.

action painting (AK-shuhn PAYNT-ihng). A form of **abstract expressionism**, in which paint is applied with rapid, vigorous strokes or even splashed or thrown on the canvas.

additive (AD-ih-tihv). In sculpture, those works that are built (See **sculpture**). In **color**, the term refers to the mixing of **hues** of light.

aerial perspective (AIR-ee-yuhl-puhr-SPEHK-tihv). Also known as atmospheric perspective. In visual art, the indication of distance in painting throught the use of light and atmosphere.

aesthetic (or esthetic) (ehs-THEHT-ihk). Relating to the appreciation of beauty or good taste or having a heightened sensitivity to beauty: a philosophy of what is artistically valid or beautiful.

aestheticism (ehs-THEH-tih-sihs-uhm). A late nineteenth-century arts movement that centered on the contention that art existed for its own sake, without need for social usefulness.

affective (uh-FEHK-tihv). Influenced by or resulting from the emotions.

aleatory (AY-lee-uh-tawr-ee). Dependent on chance. In music, using sounds chosen by the performer or left to chance. In film, composition on the spot by the camera operator.

allegory (AL-uh-gawr-ee). In literature and drama, a symbolic representation. The representation of abstract ideas or principles by characters, figures, or events in narrative, dramatic, or pictorial form. A fictional narrative that conveys a secondary meaning or meanings not explicitly set forth in the literal narrative.

alliteration (uh-lih-tuh-RAY-shuhn). In literature, the repetition of consonant sounds in two or more neighboring words or syllables.

altarpiece (AHL-turh-pees). A painted or sculpted panel placed above or behind an altar to inspire religious devotion.

ambulatory (AM-byoo-luh-tawr-ee). A covered passage for walking, found around the apse or choir of a church.

amphitheatre (AM-fih-thee-uh-turh) A building, typically Roman, that is oval or circular in form and encloses a central performance area.

antiphonal (an-TIH-fuh-nuhl) A responsive style of singing or playing, in which two groups alternate.

apse (aps) A large niche or niche-like space projecting from and expanding the interior space of an architectural form such as a basilica.

arcade (ahr-KAYD). In architecture, a series of arches placed side by side and supported by **columns**, **piers**, or pillars.

arch (ahrch). In architecture, a structural form taking on a curved shape.

archaic (ahr-KAY-ihk). A style of art and architecture dating to ancient, pre-classical Greece (mid-fifth century B.C.E.), typified by the **Doric order**, **post-and-lintel** structure, geometric designs (especially in pottery), free-standing statues (**kouros** and **kore**) with stiff, frontal poses.

architrave (AHR-kih-trayv). In **post-and-lintel** architecture, the lintel or lowermost part of an **entablature**, resting directly on the **capitals** of the **columns**.

arena theatre (uh-REE-nuh-THEE-uh-tuhr). In theatre, a stage–audience arrangement in which the stage is surrounded on all sides by seats for the audience.

aria (AH-ree-uh). In music, a highly dramatic **solo** vocal piece with musical accompaniment, as in an **opera**, **oratorio**, and **cantata**.

Art Deco (ahrt-deh-KOH). In visual art and architecture, a style prevalent between 1925 and 1940 characterized by geometric designs, bold colors, and the use of plastic and glass materials.

art for art's sake. A phrase coined in the early nineteenth century that expresses the belief that art needs no justification—that is, it needs to serve no political, didactic or other end. See **Aestheticism**.

articulation (ahr-tihk-yuh-LAY-shuhn). In the arts, the manner by which the various components of a work are joined together.

artifact (ahr-tuh-FAKT). A product produced by human craft, particularly one of archeological, artistic, or historical interest.

Art Nouveau (ahrt-noo-VOH). In architecture and design, a style prevalent in the late nineteenth and early twentieth centuries characterized by the depiction of leaves and flowers in flowing, sinuous lines (whiplash) treated in a flat, linear, and relief-like manner.

Arts and Crafts Movement. In architecture and the decorative arts, a movement particularly in England and the United States from about 1870–1920 characterized by simplicity of design and the handcrafting of objects from local materials.

art song (ahrt sawng). In music, a vocal composition, usually a lyric song intended for recital performance, typically accompanied by piano, in which the text is the principal focus.

asymmetry (ay-SIHM-uh-tree). In visual art, a sense of balance achieved by placing dissimilar objects or forms on either side of a central axis. Also called "psychological balance." Cf. **symmetry**.

atmospheric perspective (at-muhs-FEER-ihk-puhr-SPEHK-tihv). See **aerial perspective**.

atonality (ay-toh-NAL-ih-tee). In music, the absence of a tonal center and of **harmonies** derived from a **diatonic** scale corresponding to such a center. Typical of much twentieth-century music.

avant-garde (ah-vahnt-GAHRD). The vanguard or intelligentsia that develops new or experimental concepts, especially in the arts. These concepts and works are usually unconventional, daring, obscure, controversial, or highly personal ideas.

balance (bal-uhns). In visual art, the placement of physically or psychologically equal items on either side of a central axis. Or the compositional equilibrium of opposing forces. In literature, the syntactically parallel placement of similar, contrasting, or opposing ideas—for example, "To err is human; to forgive, divine."

ballet (ba-LAY). In dance, a **classical** or formal tradition resting heavily on a set of prescribed movements, actions, and positions. See **first position**; **second position**; **third position**; **fourth position**, and **fifth position**.

balloon construction (buh-LOON-cuhn-STRUHK-shuhn). In architecture, construction of wood using a skeletal framework. See **skeleton frame**.

baroque (buh-ROHK). A diverse artistic style taking place from the late sixteenth to early eighteenth century marked typically by complexity, elaborate form, and appeal to the emotions. In literature it witnessed bizarre, calculatedly ingenious, and sometimes intentionally ambiguous imagery.

barrel vault (tunnel vault) (BAR-uhl-vawlt). In architecture, a series of arches placed back to back to enclose space.

basilica (bah-SIHL-ih-kuh) In Roman times, a term referring to building function, usually a law court; later used by Christians to refer to church buildings and a specific form.

Bauhaus (BOW-hows). In design and architecture, a twentieth-century German school that consciously attempted to integrate the arts and architecture into a unified statement by seeking to establish links between the organic and technical worlds.

bearing wall (BAIR-ihng wahl). In architecture, construction in which the wall supports itself, the roof, and floors. See **monolithic construction**.

beat (beet). In music, the equal parts into which a measure is divided.

bel canto (behl-KAN-toh). In music, a style of operatic singing utilizing full, even tones and virtuoso vocal technique. Italian for "beautiful singing."

bilateral symmetry (by-LAT-uhr-uhl-SIHM-uh-tree). In visual art and architecture, when the overall effect of a composition is one of **absolute symmetry** even though clear discrepancies exist side to side. See **symmetry**.

binary (BY-nuh-ree). In music, having two sections or subjects.

biography (by-AHG-ruh-fee). In literature, a type of **nonfiction**, the subject of which is the life of an individual. See also **hagiography**.

biomorphic (by-oh-MAWR-fihk). In visual art, representing life-forms, as opposed to geometric forms.

bridge (brihj). In music, a section or passage, or in literature and drama a section, passage, or scene that serves as a transition between two other sections, passages, or scenes. In music, it occurs in the **exposition** of the sonata form between the first and second **themes**.

buttress (BUHT-rihs). In architecture, a structure typically brick or stone built against a wall, vault, or arch for reinforcing support.

Byzantine (BIHZ-uhn-teen). Relating to the Byzantine Empire. In architecture, a style dating to the fifth century characterized by a central dome resting on a cube and by extensive surface decoration. In painting, a **hieratic** style characterized by stylized, elongated frontal figures, rich color, and religious subject matter.

cadence (CAY-duhns). In music, a particular arrangement of chords to indicate the ending of a musical passage. In literature, a rhythmic sequence or flow of sounds in language; a particular rhythmic sequence of a particular author or literary composition. Or, the rising or falling order of strong, long, or stressed syllables and weak, short, or unstressed syllables. Or, an unmetrical or irregular arrangement of stressed and unstressed syllables in prose or free verse that is based on natural stress groups.

calotype (KAL-uh-typ). In photography, the first process invented to utilize negatives and proper positives. Invented by William Henry Fox Talbot in the late 1830s.

camera obscura (KAM-uh-ruh ahb-SKYUHR-uh). In visual art, a dark room or box with a small hole in one side, through which an inverted image of the view outside is projected on to the opposite wall, screen, or mirror. The image, then, can be traced. A prototype for the modern camera.

canon (KAN-uhn). In music, a composition in which a theme is repeated in additional voices with the separation of a phrase. In literature, an authoritative list of books accepted as Holy Scripture. Or the authoritative works of a writer; or a sanctioned or accepted group or body of related works.

cantata (kuhn-TAH-tuh). In music, a composition in several movements for orchestra and chorus often with a **sacred** text, and utilizing **recitatives, arias**, and choruses.

cantilever (KAN-tih-lee-vuhr). In architecture, a structural system in which an overhanging beam is supported only at one end.

capital (Kap-ih-tuhl). In architecture, the top part of a pillar or column. The transition between the top of a **column** and the **lintel**.

catharsis (kuh-THAHR-sihs). The purging of emotions (especially pity and fear) through art.

cella (CHEH-luh or CHAY-lah). The principal enclosed room of a temple; the entire body of a temple as opposed to its external parts.

chiaroscuro (kee-ah-ruh-SKOOR-oh). In visual art, the technique of using light and shade to develop three-dimensional form. In theatre, the use of light to enhance the three-dimensionality of the human body or the elements of scenery.

choreography (kohr-ee-AHGH-ruh-fee). In dance, the art of creation of a dance work. Also, the arrangement of patterns of movement in a dance.

chromatic scale (kroh-MAT-ihk-scayl). In music, a **scale** consisting of twelve **semitones** or half steps.

cinéma vérité (see-nay-MAH-vay-ree-TAY). In film, a style of presentation based on complete **realism** that uses **aleatory** methods, a minimum of equipment, and a **documentary** approach.

cire-perdue (lost wax) (sihr-pair-DOO). In sculpture, a method of casting metal in a mold, the cavity of which is formed of wax, which is then melted and poured away.

civilization (sih-vih-lih-ZAY-shuhn). The advanced state of human development wherein cities emerge, along with corresponding social, political, and cultural complexity, including the arts and sciences.

classic (KLAS-ihk). A work of art from ancient Greece and/or Rome. A work of art or artist of enduring excellence.

classical (KLAS-ih-kuhl). Adhering to traditional standards. May refer to a style in art and architecture dating to the mid-fifth century B.C.E. in Athens, Greece or ancient Rome, or any art that emphasizes simplicity, harmony, restraint, proportion, and reason. In Greek classical architecture, **Doric** and **Ionic orders** appear in **peripteral** temples. In vase painting, geometry remains from the **archaic style**, but figures have a sense of **idealism** and lifelikeness. In music, classical refers to a style of the eighteenth century that adhered to classical standards but had no known classical antecedents. See **neoclassicism**.

classicism (KLAS-uh-sihz-uhm). The principles, historical traditions, aesthetic attitudes, or style of the arts of ancient Greece and Rome, including works created in those times or later inspired by those times. Or, **classical** scholarship. Or, adherence to or practice of the virtues thought to be characteristic of classicism or to be universally and enduringly valid—that is, formal elegance and correctness, simplicity, dignity, restraint, order, and proportion.

clerestory (or clearstory) (KLIHR-stawr-ee). The upper portion of a wall containing windows, when it extends above any abutting aisles or secondary roofs: especially in the **nave, transept**, and **choir** of a church. Provides direct light into the central interior space.

coda (KOH-duh). In music, drama, and literature, the concluding portion of a work that typically integrates or rounds off previous ideas.

coffer (KAWF-uhr) A recessed panel in a ceiling.

cognitive (KAHG-nuh-tihv). Facts and objectivity as opposed to emotions and subjectivity. Cf. **affective**.

collage (koh-LAZH). In visual art, a composition of materials and objects pasted on a surface. In literature, a work composed of borrowed and original materials.

colonnade (KAHL-uh-nayd). In architecture, a series of **columns** placed at regular intervals usually connected by **lintels**.

colonnette (KAHL-uh-neht). A small column-like vertical element or narrow, engaged column; colonnettes are usually attached to piers in buildings such as Gothic cathedrals. Colonnettes are decorative features.

color (KUH-luhr). In visual art, the appearance of surfaces in terms of **hue, value**, and **intensity**. In music, the quality of a tone—also called **timbre**. In literature, the vividness or variety of emotional effects of language—for example, sound and image. See also **complementary color; primary color; secondary color; tertiary color**.

column (KAHL-uhm). In architecture, a supporting pillar consisting of a base, cylindrical shaft, and **capital**.

comedy (KAHM-uh-dee). The genre of dramatic literature that deals with the light or the amusing or with the serious and profound in a light, familiar, or satiric manner. Cf. **tragedy**.

composition (kahm-poh-ZIH-shuhn). In visual art and architecture, the arrangement of line, form, mass, and color. Also, the arrangement of the technical qualities of any art form.

compressive strength (kuhm-PREHS-ihv-strehngth). In architecture, the ability of a material to withstand crushing. See **tensile strength**.

concert overture (KAHN-suhrt OHV-uhr-chuhr). In music, an independent composition for orchestra in one movement, typically in **sonata form** and from the **Romantic** period.

concerto (kuhn-CHAIR-toh). In music, an extended composition for orchestra and one or more soloists, typically in three movements: fast, slow, and fast.

concerto grosso (kuhn-CHAIR-toh-GHROH-soh). In music, a composition for orchestra and a small group of instrumental soloists, typically late **baroque**.

concrete (KAHN-kreet). In architecture, a type of building material invented by the Romans made from lime, sand, cement, and rubble mixed with water and poured or molded when wet.

concrete poetry (kahn-KREET POH-uh-tree). In literature, poetry in which the poet's intent is conveyed by graphic patterns of letters, words, or symbols rather than by the meaning of words in conventional arrangement. The poet uses typeface and other typographical elements in such a way that chosen unities—letter fragments, punctuation marks, graphemes (letters), morphemes (any meaningful linguistic unit), syllables, or words—and graphic spaces form an evocative picture. See also **musique concrète**.

conjunct melody (KAHN-juhngkt; kuhn-JUHNGKT MEHL-oh-dee). In music, a melody comprising notes close together in the scale.

consonance (KAHN-soh-nuhns). In music, tones that sound agreeable or harmonious together, as opposed to **dissonance**. In literature, repetition of identical or similar consonants. In all arts, a feeling of comfortable relationship. Consonance may be both physical and cultural in its ramifications.

content (KAHN-tehnt). The subject matter or theme of a work of art as well as the artist's intent. Also the work's meaning to a respondent.

context (KAHN-tehkst). In architecture, the setting surrounding a building.

contrapposto, counterpoise (kahn-truh-POHS-toh; COWN-turh-poyz). In sculpture, the arrangement of body parts so that the weight-bearing leg is apart from the free leg, thereby shifting the hip/shoulder axis.

contrapuntal (kahn-truh-PUHN-tuhl). In music, relating to counterpoint or polyphony.

convention (kuhn-VEHN-shuhn). In all the arts, a generally accepted practice, technique, or device.

Corinthian order (kaw-RIHN-thee-uhn-AWR-duhr). One of three ancient Greek architectural orders (along with Doric and Ionic). Corinthian is the most ornate and is characterized by slender fluted columns with an ornate, bell-shaped capital decorated with acanthus leaves.

cornice (KAWR-nihs). A crowning, projecting, architectural feature.

counterpoint (KOWN-tuhr-point). In any art, the use of contrast in major elements. In music, the use of polyphony as a texture. In literature the term refers to metrical variation in poetry.

crosscut (KRAWS-cuht). In film, the technique of alternating between two independent actions that are related thematically or by plot to give the impression of simultaneous occurrence.

crossing (KRAWS-ihng). The area in a church where the transept crosses the nave.

cubism (KYOOB-ihz-uhm). An art style originated by Picasso and Braque around 1907 that emphasizes abstract structure rather than representationalism. Objects are depicted as assemblages of geometric shapes. The early mature phase (1909–11) is called analytical cubism. A more decorative phase called synthetic or collage cubism appeared around 1912. In literature, cubist writing uses abstract structure to replace the narrative.

cut (kuht). In film, the joining of shots together during the editing process. Examples are: jump cut, form cut, montage, crosscut, and cutting within the frame.

cutting within the frame. In film, a cut that changes the viewpoint of the camera within a shot by moving from a long or medium shot to a close-up, without cutting the film.

cyber art (SYB-uhr-ahrt). A late twentieth-century development that created artificial environments that viewers experienced as real space. It is also known as cyberspace, hyperspace, or virtual reality.

cycle (SY-kuhl). A group or series of works (plays, poems, novels, or songs) that embrace the same theme. In literature, the complete series of poetic or prose narratives (typically of different authorship) that deal with, for example, the actions of legendary heroes and heroines.

Dada or Dadaism (DAH-dah; DAH-dah-ihz-uhm). A nihilistic movement in the arts from around 1916 to 1920.

daguerreotype (duh-GHAIR-uh-typ). In photography, a process (or photograph made from it) using a light-sensitive, silver-coated metallic plate.

deconstruction (dee-kuhn-STRUHK-shuhn). A theory of criticism associated with French philosopher Jacques Derrida, that maintains that words can only refer to other words and tries to demonstrate how statements about any text subvert their own meanings, leading to the conclusion that there is no such thing as a single meaning in a work of art, nor can it claim any absolute truth.

dénouement (day-noo-MAHN). In theatre, film, and literature, the final resolution of a dramatic or narrative plot—that is, the events following the climax.

dentil (DEHN-tihl). In architecture, small rectangular blocks projecting like teeth from a molding or beneath a cornice.

deposition (deh-poh-ZIH-shuhn). A painting or sculpture depicting the removal of the body of Christ from the cross.

development (dih-VEHL-uhp-muhnt). In music, in sonata-form, the second section in which the

themes of the exposition are freely developed. See also recapitulation.

diatonic (dy-uh-TAHN-ihk). In music, relating to the seven tones of a standard scale without chromatic alterations.

diptych (DIHP-tihk) A painting on two hinged panels.

disjunct melody (dihs-JUHNKT MEHL-uh-dee). In music, melody characterized by skips or jumps in the scale. The opposite of conjunct melody.

dissonance (DIHS-uh-nuhns). In music or visual art, any harsh disagreement between elements of the composition—that is, discord. In music, a combination of sounds used to suggest unrelieved tension. Cf. consonance.

dome (dohm). In architecture, a circular, vaulted roof.

Doric order (DAWR-ihk-AWR-duhr). In architecture, the oldest and simplest of the three Greek architectural orders (along with Ionic and Corinthian). It is characterized by heavy columns with plain, saucer-shaped capitals and no base.

drama (DRAHM-uh). A verse or prose composition portraying life or character or telling a story involving conflicts and emotion usually for presentation in the theatre.

dramatic unities (druh-MAT-ihk YOON-uh-teez). In theatre, a classical and neoclassical convention requiring that a play reflect a time period not greater than a day, a place restricted to that within a day's travel, and a single action or plot line.

dynamics (dy-NAM-ihks). The various levels of loudness and softness of sounds; the increase and decrease of intensities.

editing (EHD-iht-ihng). In film, the composition of a finished work from various shots and soundtracks.

empathy (EHM-puh-thee). Identification with another's situation. In theatre and film, an emotional reaction to events witnessed on the stage or screen.

engaged column (ehn-GHAYJ-d KAHL-uhm). A column, often decorative, which is part of, and projects from, a wall surface.

engraving (ehn-GRAYV-ihng). In printmaking, an intaglio process in which sharp, definitive lines are cut into a metal plate.

entablature (ehn-TAB-luh-chuhr). The upper portion of a classical architectural order above the column capital.

entasis (ehn-TAY-sihs). The slight convex curving on classical columns to correct the optical illusion of concavity which would result if the sides were left straight.

ephemeral (ih-FEHM-uhr-uhl). In visual art, a work designed to last only a short time.

epic (EHP-ihk). In literature, a long narrative poem in elevated style celebrating heroic achievement. In film, a genre characterized by bold and sweeping themes and a protagonist who is an ideal representative of a culture.

essay (EHS-ay). In literature, a short composition treating a single subject usually from the personal point of view of the author.

etching (EHCH-ihng). In visual art, a type of intaglio printmaking in which the design comprises lines cut into a metal plate by acid.

exposition (ehk-spoh-ZIH-shuhn). In theatre, film, and literature, the aspect of plot in which necessary background information, introduction of characters, and current situation are detailed. In music, the first section of sonata form, in which the first subject (in the tonic key) and second subject (in the dominant key), sometimes also further subjects, are played and often repeated. See development and recapitulation.

Also, the first thematic statement of a fugue by all players in turn.

expressionism (ek-SPREHSH-uh-nihz-uhm). An artistic movement of the late nineteenth and early twentieth centuries that stresses the subjective and subconscious thoughts of the artist and seeks to evoke subjective emotions on the part of the respondent. The struggle of life's inner realities are presented by techniques that include abstraction, distortion, exaggeration, primitivism, fantasy, and symbolism.

fan vaulting (fanvawlt-ihng) An intricate style of traceried vaulting, common in the late English Gothic style, in which ribs arch out like a fan from a single point such as a capital.

farce (fahrs). In theatre, a light, comic work using improbable situations, stereotyped characters, horseplay, and exaggeration.

fenestration (fehn-ih-STRAY-shuhn). In architecture, an opening such as a window in a structure.

ferroconcrete (FAIR-oh-kahn-kreet). See reinforced concrete.

fiction (FIHK-shuhn). In literature a work created from the imagination of the writer.

fine art (fyn-ahrt). Those disciplines that create works (or the works themselves) produced for beauty rather than utility.

fluting (FLOO-tihng). In architecture, vertical grooves cut in the shaft of a column.

flying buttress (fly-ihng-BUH-truhs). A semidetached buttress.

focus (focal point; focal area) (FOH-kuhs). In visual art and architecture, an area of attention. In photography and film, the degree of acceptable sharpness in an image.

foil (foyl). In theatre, film, and literature, a character presented as a contrast to another character so as to point out or show to advantage some aspect of the second character.

folk dance (fohk dans). In dance, a body or group of dances performed to traditional music that is stylistically identifiable with a specific culture, for which it serves as a necessary or informative part.

foreground (FAWR-grownd). In two-dimensional art, an area of a picture, usually at the bottom, that appears closest to the viewer.

foreshadowing (fahwr-SHAD-oh-ihng). In visual art, the illusion depicted on a two-dimensional surface, in which figures and objects appear to recede or project sharply into space, often using the rules of linear perspective. In fictional film, theatre, and literature, the organization and presentation of events that prepare the viewer or reader for something that will occur later.

foreshortening (fahwr-SHOHWR-tuhn-ihng). Something that is compact, abridged, or shortened. In visual art, the compacting of three-dimensions by linear perspective in order to show depth of space.

form (fahwrm). In any art, a type or genre. Or, the shape, structure, configuration, or essence of something. Or, the organization of ideas in time or space.

formalism (FAHWR-muh-lihzm). Marked attention to arrangement, style, or artistic means (as in art or literature), usually with corresponding de-emphasis of content. Also applied to critics of literature who emphasize the formal aspects of a work.

found sculpture or object (fownd). In visual art, an object taken from life that is presented as an artwork.

framing tale (FRAY-mihng tayl) Overall unifying story within which one or more tales are related.

fresco (FREHS-koh). In painting, a work done on wet plaster with water-soluble paints. The image becomes part of the wall surface as opposed to

being painted on it. Also known as *buon fresco*, or "true fresco." Cf. **fresco secco**.

fresco secco (FREHS-koh SEHK-oh). In painting, a work done on dry plaster.

frieze (freez). In architecture, a plain or decorated horizontal part of an **entablature** between the **architrave** and **cornice**. Also, a decorative horizontal band along the upper part of a wall.

fugue (fyoog). In music, a **polyphonic** composition in which a **theme** or themes are stated successively in all voices.

full round (fuhl-rownd). In sculpture, works that explore full three-dimensionality and are meant to be viewed from any angle. See **sculpture**.

futurism (FYOO-chuh-rihz-uhm). An artistic movement that began in Italy around 1909 and espoused rejection of tradition so as to give expression to the dynamic energy and movement of mechanical processes.

genre (ZHAHN-ruh). A distinctive type or category or art, drama, literature, music, etc. characterized by a particular style, form, or content. Also, a style of painting representing an aspect of everyday life, such as a domestic interior, a still life, or a rural scene.

geodesic dome (jee-uh-DEHS-ihk). In architecture, a domed or vaulted structure of lightweight straight elements made up of interlocking polygons.

Gesamtkunstwerk (guh-ZAHMT-kuhnst-vuhrk). A complete, totally integrated artwork; associated with the music dramas of Richard Wagner in nineteenth-century Germany.

glyptic (GHLIHP-tihk). In sculpture, works emphasizing the qualities of the material from which they are made.

Gothic (gothic) (GHAHTH-ihk). In architecture, painting, and sculpture, a medieval style based on a pointed-**arch** structure and characterized by simplicity, verticality, elegance, and lightness. In literature, a style of fiction of the late eighteenth and early nineteenth centuries characterized by medieval settings, mysterious, and violent actions. In the mid-twentieth century, the term Southern Gothic was used to describe literary works characterized by grotesque, macabre, or fantastic incidents in an atmosphere of violence and decadence.

Gothic revival (GHAHTH-ihk). In architecture, a style that imitates the elements of **Gothic** architecture, popular in the United States and Europe from the late eighteenth to early twentieth centuries.

graphic arts (GHRAF-ihk ahrts). In visual art, a term referring to those media that use paper as a primary vehicle.

Greek cross (greek krahws). A cross in which all arms are the same length.

Greek revival (ghreek ree-VYV-uhl). In architecture, a style that imitates the elements of ancient Greek temple design. Popular in the United States and Europe during the first half of the nineteenth century.

Greek tragedy (ghreek TRAJ-uh-dee). The form of drama written by the three great Athenian tragedians, Aeschylus, Sophocles, and Euripides. See also **Tragedy**.

Gregorian chant (ghrih-GHAWR-ee-uhn-chant). In music, an unaccompanied, vocal, monophonic, and **consonant** liturgical chant named for Pope Gregory I (540–604 C.E.) and comprising a body of sacred—that is, religious—music. Chants were sung in a flexible **tempo** with unmeasured **rhythms** following the natural **accents** of normal Latin speech. Also called chant, plainchant, or plainsong.

groin vault (ghroyn vawlt). In architecture, a ceiling formation created by the intersection of two **tunnel** or **barrel** vaults.

hagiography (ha-jee-AHGH-ruh-fee; hay-). In literature, writings about or study of the lives of the Saints. A sacred form of **biography**.

hamartia (huh-MAHR-shuh). The "tragic flaw" in the character of the protagonist of a classical tragedy.

hard-edge (HAHRD-ehj). In painting, an **abstract** style begun in the 1950s and characterized by clearly defined geometric shapes and flat color areas with sharp edges.

Harlem Renaissance (HAHR-luhm). Also called the New Negro Movement. A period of outstanding artistic vigor centering in the African American enclave of Harlem in New York City during the 1920s.

harmony (HAHR-muh-nee). In music, the arrangement and progression of chords. In visual art, the relationship of like elements such as colors and repeated patterns. In literature, an arrangement of parallel passages for the purpose of showing agreement. Cf. **consonance** and **dissonance**.

Hellenistic (hehl-uh-NIHS-tihk). In visual art, architecture, and theatre, a style dating from the fourth to the second century B.C.E. that encompassed a diversity of approaches reflecting an increasing interest in the differences between individual humans and characterized by emotion, drama, and interaction of sculptural forms with the surrounding space. In architecture, it reflected a change in proportions from the **classical** and introduced the **Corinthian order**.

hierarchy (HY-uhr-ahrk-ee). Any system of persons or things that has higher and lower ranks.

hieratic (hy-yuhr-AT-ihk). A style of depicting sacred persons or offices, particularly in Byzantine art.

hieroglyph, hieroglyphic. (HY-roh-ghlihf; hy-roh-GHLIH-fihk). A picture or symbol of an object standing for a word, idea, or sound; developed by the ancient Egyptians into a system of writing.

high relief or haut-relief (HY ruh-leef; OH reh-LEEF). In sculpture, **relief** works in which the figures protrude from the background by at least half their depth.

High Renaissance (hy REHN-eh-sahns). A movement dating to the late fifteenth to early sixteenth centuries that followed **classical** ideals and sought a universal ideal through impressive themes and styles. In visual art, figures became types rather than individuals.

homophony (huh-MAH-fuh-nee). In music, a **texture** characterized by chordal development supporting one melody. Cf. **monophony** and **polyphony**.

horizon line (huh-RYZ-uhn-lyn). In visual art, a real or implied line across the picture plane, which, like the horizon in nature, tends to fix the viewer's vantage point.

hubris (HYOO-bris). Pride; typically the "tragic flaw" found in the protagonist of a classical tragedy. See *hamartia*.

hue (hyoo). In visual art, the spectrum notation of color; a specific pure color with a measurable wavelength. There are **primary hues, secondary hues**, and **tertiary hues**.

humanism (HYOO-muh-nihz-uhm). A philosophy concerned with human beings, their achievements, and interests, as opposed to abstract beings and problems of theology; a cultural and intellectual movement occurring during the **Renaissance** focusing on humans and their capabilities.

humanities (hyoo-MAN-ih-teez). The areas of learning (art, music, theatre, literature, film, dance, philosophy, and sometimes history) that investigate the human condition, its situations and concerns, as opposed to natural processes (the sciences).

hypostyle (HY-puh-styl). A building with a roof or ceiling supported by rows of **columns**, as in ancient Egyptian architecture.

iambic (y-AM-bihk). In literature, one of the four standard feet in poetry. A light syllable is followed by a stressed syllable. See **foot** and **meter**.

icon (Y-kahn). Greek for "image." An artwork whose subject matter includes idolatry, veneration, or some other religious content. Specifically, in visual art, an image or representation of a sacred personage.

idealism (y-DEE-uh-lihz-uhm). Artistic and literary theory or practice that values ideal or subjective visions of beauty rather than formal or realistic ones. Cf. **realism**.

idealization (y-dee-uh-lih-ZAY-shuhn). The portrayal of an object or human body in its ideal form rather than as a true-to-life portrayal.

idée fixe (ee-day-FEEX). In music and literature, a recurring **motif** or theme.

imagery (IHM-ihj-ree). In literature, depiction of objects, ideas, and feelings literally or through symbols or figurative language.

implied line (ihm-PLYD lyn). In visual art, a line in a composition that is not actually drawn but suggested by factors such as alignment of edges of objects.

impressionism (ihm-PREHSH-uh-nihz-uhm). A mid- to late-nineteenth century style originating in France. In painting it sought spontaneity, harmonious colors, subjects from everyday life, and faithfulness to observed lighting and atmospheric effects by seeking to capture the psychological perception of reality in color and motion. It emphasized the presence of color within shadows and the result of color and light making an "impression" on the retina. In music it freely challenged traditional tonality with new tone colors, oriental influence, and harmonies away from the traditional. Gliding chords—that is, repetition of a chord up and down the scale—was a hallmark.

intensity (ihn-TEHN-siht-ee). In visual art, the degree of purity of a **hue**. In music, theatre, dance, and film, that quality of **dynamics** denoting the amount of force used to create a sound or movement.

International Style (ihn-tuhr-NASH-uh-nuhl-styl). In architecture, a style, related to De Stijl in painting, emerging in Europe around 1910–20, in which structure and exterior design were joined into a form based on rectangular geometry and emerging from the basic function of the building. See **modernism**.

interval (IHN-tuhr-vuhl). In music, the difference (usually expressed in number of steps) between two pitches.

Ionic (Ionic order) (y-AHN-ihk). Relating to Ionia in ancient Greece. In architecture, one of three orders of Greek architecture (along with **Doric** and **Corinthian**), characterized by two opposed **volutes** in the **capital**. In literature, a foot of verse that comprises either two long and two short syllables or two short and two long syllables.

irony (Y-ruh-nee). In literature, words used to express something other than, and particularly the opposite of, the literal meaning.

jamb (jam). The upright piece forming the side of a doorway or window frame.

jazz (jaz). In music, a form of music native to America and calling on the African American heritage characterized by strong, flexible *rhythms*, **syncopation**, and improvisation.

jazz dance (jaz). In dance, a form arising partly

from African dance customs, and with a strong improvisational nature, that developed into American social and entertainment dances.

juxtapose (juhk-stuh-POHZ). Place side by side.

key (kee). In visual art, the relative lightness or darkness of a picture or the colors employed in it. See **value**. In architecture, the **keystone** in an **arch**. In music, a tonal system consisting of seven tones in fixed relationship to a **tonic**.

kouros (KOO-rohs). In sculpture, an archaic Greek statue of a standing nude male youth.

lancet window (lah-seht). A tall, narrow window whose top forms a lancet or narrow arch shaped like a spear.

lantern (LAN-tuhrn). A relatively small structure on the top of a **dome**, roof, or tower, frequently open to admit light into the area beneath.

Latin cross (la-tihn). A cross in which the vertical arm is longer than the horizontal arm, through whose midpoint it passes.

leitmotif or **leitmotiv** (lyt-moh-TEEF). In music and literature, a dominant recurring theme, phrase, or sentence often associated with a character, situation, or element, as in Wagnerian opera.

libretto (lih-BREHT-oh). In music and theatre, the text of an opera or any other kind of musical theatre.

line (lyn). In visual art, a long, thin mark, a color edge, or an implication of continuation. In music, a melody. In literature, a unit in the rhyming structure of verse formed by grouping a number of the smallest units of the rhythm—for example, syllables, stress groups, metrical feet—according to some principle characteristic of that type of verse.

linear perspective (LIHN-ee-uhr-puhr-SPEHK-tihv). In two-dimensional art, the creation of the illusion of distance through the convention of **line** and **foreshortening**.

linear sculpture (LIHN-ee-uhr-SKUHLP-chuhr). In sculpture, works that emphasize two-dimensional materials such as wire.

lintel (LIHN-tl). In architecture, a horizontal structural member typically of stone that spans the space between uprights such as **columns**.

loggia (LOHD-juh). A gallery open on one or more sides, sometimes with **arches** or with **columns**.

lost-wax (lawst-wax). See **cire-perdue**.

low comedy. In drama or literature a **comedy** with no purpose other than laughter-producing entertainment through, for example, sight gags, buffoonery.

low relief (loh-ruh-LEEF). Also called bas-relief. In sculpture, a **relief** work in which figures and forms project only slightly from the background. Cf. **high relief**.

lyric (LIHR-ihk). In literature, a verse or poem that could be sung to the accompaniment of a musical instrument (in ancient times, a lyre).

madrigal (MAD-rih-ghuhl). In music, a secular part song, originating in Italy, for two or three unaccompanied voices. In literature, a medieval short lyrical poem specifically about love. Common in the **Renaissance**.

magnitude (MAG-nuh-tood). In theatre and film, the scope of universality of the theme.

major scale (MAYJ-uhr skayl). In music, a series of seven different **tones** within an **octave**, with an eighth tone repeating the first tone an octave higher and comprising a specific pattern of whole and half steps.

Mannerism (MAN-uhr-ihz-uhm). A mid- to late-sixteenth-century art movement that takes its name from the mannered or affected appearance of the subjects in paintings. It has an intellectual component that distorts reality, alters space, and makes obscure cultural allusions. It contains anti-classical emotionalism and abandons classical balance and form while employing formality and geometry. In architecture, it utilized discomfiting designs of superficial detail and unusual proportions with strange juxtapositions of curvilinear and rectilinear items.

masonry (MAY-suhn-ree). In architecture, stone or brickwork.

mass (mas). In visual art and architecture, three-dimensional form having physical bulk. Also the illusion of such a form on a two-dimensional surface.

Mass (or mass) (mas). The liturgy of the Roman Catholic Eucharist (Mass). In music, a mass is a choral setting of the Mass. The Mass or mass each contains five sections: **Kyrie, Gloria, Credo, Sanctus,** and **Agnus Dei.**

medium (MEED-ee-yuhm). The process used by an artist. Also, in visual art, the binding agent that holds pigments together.

melismatic (meh-lihz-MA-tihk). Music where a single syllable of text is sung on many notes.

melodrama (MEHL-oh-drahm-uh). In theatre, a genre characterized by stereotyped characters, implausible plots, and emphasis on spectacle.

melody (MEHL-uh-dee). In music, a succession of individual tones that create a recognizable whole.

metaphor (MEHT-uh-fawr). In literature, a **figure of speech** that substitutes one word or phrase for another, suggesting a likeness between them. Or an implied comparison between two otherwise unlike elements, meaningful in a figurative rather than literal sense.

meter (MEE-tuhr). In music, the regular succession of rhythmical impulses or beats. In literature, a systematically arranged and measured rhythm in verse. Also in literature, a fixed metrical pattern or a verse form.

microtone (my-kroh-tohn). A musical interval smaller than a half-step.

mime (mym). In theatre, a type of Greek and Roman **farce**; or a performance using only body movement and gestures, without the use of words. In dance or theatre, actions that imitate human or animal movements.

minimalism (MIHN-uh-muh-lihz-uhm). A style in visual art and music dating to the 1950s and 60s. In visual art, it comprised a school of abstract art emphasizing simplification of form and concentrating on nonsensual, impersonal, geometric shapes and forms with no communication passing between artist and respondent. Interpretation was solely the province of the respondent. In music, minimalism was a school or mode of contemporary music characterized by simplified rhythms, patterns, and harmonies. It was a reaction against the complexity of **serialism** and the randomness of **aleatory** music. In literature, use of the fewest and barest essentials.

minor scale (MYN-uhr-skayl). In music, a **diatonic scale** with a half step between the second and third degrees and any of several intervals above the fifth.

mise-en-scène (meez-ahn-sehn). In theatre, film, and dance, the complete visual environment of the production, including scenery, lighting, properties, costumes, and physical structure of the theatre.

mobile (MOH-beel). A constructed structure whose components have been connected by joints to move by force of wind or motor.

modern (MAHD-uhrn). See **modernism**.

modern dance (MAHD-uhrn-dans). A form of concert dance relying on emotional use of the body, as opposed to formalized or conventional movement such as **ballet**, and stressing human emotion and the human condition.

modernism (MAH-duhr-nihz-uhm). In the arts, modernism developed as a wide-ranging reaction to **Romanticism** and **realism**. It rejected conventional narrative content and conventional modes of expression to depict a world seen as altogether new and constantly in flux. In architecture, a twentieth-century style characterized by the glass and steel rectangular skyscraper (also called **International Style**) but including a variety of explorations of space and line, including curvilinear treatments and highly symbolic exploration of form. In visual art, a variety of approaches following the introduction of **cubism** and other "modernist" works at the International Exhibition of Modern Art (called the Armory Show) in 1913. In dance, it characterizes the non**ballet** tradition emphasizing angularity and asymmetry.

modulate (MAHJ-uh-layt). In music, to change **pitch**, intensity or tone or to move from one **key** to another.

monolithic construction (mahn-oh-LIH-thihk-kuhn-STRUHK-shuhn). In architecture, a variation of **bearing-wall** construction in which the wall material is not jointed or pieced together.

monophony (muh-NAHF-uh-nee). In music, a texture comprising a single melodic line. Cf. **homophony**; **polyphony**.

monotheism (mah-noh-THEE-ih-zuhm). The belief that there is only one God.

montage (mahn-TAHZH). In the visual arts, the process of making a single composition by combining parts of other pictures so the parts form a whole, and yet remain distinct. In film, montage is a type of **cut** handled either as an indication of compression of elongation of time, or as a rapid succession of images to illustrate an association of ideas.

monumental (mohn-yoo-MENT-uhl). In visual art and architecture, works actually or appearing larger than life size.

mosaic (moh-ZAY-ihk). A decorative work for walls, vaults, floors, or ceilings, composed of pieces of colored material set in plaster or cement.

motet (moh-TEHT). In music, a **polyphonic** composition for choir based on a sacred Latin text (other than the **Mass**) and typically sung without accompaniment.

motif (or **motive**) (moh-TEEF; MOH-tihv) In visual art, music, theatre, film, dance, or literature, a short, recurring theme, idea, melody, or other element

movement (MOOV-muhnt). In music, a self-contained section of an extended composition such as a **symphony**.

musique actuelle (myoo-ZEEK-ak-CHWEHL). In music, an approach from the 1990s that comprises **improvised** music freely drawing on **jazz** and rock and eliciting vibrancy, liveliness, and personal expression. Its literal translation means "current," and it represents a number of sub-factions from various localities, always seeming to involve a strain of humor.

musique concrète (moo-ZEEK-kahn-KREHT). In music, a twentieth-century approach in which conventional and recorded sounds are altered electronically or otherwise and recorded on tape to produce new sounds.

myth (mihth). A narratively expanded **symbol** or a traditional story of historical events that serves to illustrate a cultural worldview, practice, or belief.

naturalism (NACH-uhr-uhl-ihz-uhm). In the arts, a style dating to the late nineteenth century that

rests on accurate, non-emotional recreation of elements from real life. It is related to **realism**.

nave (nayv). The great central space in a church, usually running from west to east, where the congregation sits.

negative space (NEHGH-uh-tihv spays). In sculpture, any empty space or opening in a work. In film, any empty or unfilled space in the **mise en scène**, often acting as a **foil** to the more detailed elements in a shot.

neo-abstraction (nee-oh-ab-STRAK-shuhn). From the mid-1980s, a conglomerate style, like **postmodernism**, comprising mostly individualistic approaches. It borrows freely form others by modifying or changing the scale, media, or color of older works to give them a new framework and, hence, new meaning, including sarcasm and satire typically aimed at the decadence of American society in the 1980s.

neo-Attic (nee-oh A-tik). Literally, "new Greek." A reintroduction of the **classical** Greek and **Hellenistic** elements of architecture and visual art.

neoclassicism (nee-oh-CLAS-uh-sihz-uhm). Adherence to or practice of the ideals and characteristics of **classical** art, literature, and music. In painting it emerged in the eighteenth century; in theatre, the sixteenth; and in music, the eighteenth century as **classicism** and in the early twentieth century as neoclassicism. In architecture it was eclectic; in painting, it reflected a perception of grandeur in antiquity with classical details, starkness of outline, and strong geometric composition. Likewise in sculpture. In theatre, the "**unities**" of time, place, and action were re-interpreted from the writings of Aristotle. In music, eighteenth-century **classicism** rejected the excessive ornamentation of the **baroque** seeking instead to achieve order, simplicity, and careful attention to **form** through variety and contrast in mood, flexibility of **rhythm**, **homophonic** texture, memorable **melody**, and gradual changes in dynamics. Twentieth-century neoclassicism in music is marked by emotional restraint, balance, and clarity.

neo-expressionism (nee-oh-ehk-SPREHSH-uhn-ihz-uhm. In painting, a controversial late-twentieth century movement that tends to record images society normally represses. It seeks to force the viewer to confront what might be considered repulsive images in order, like **expressionism**, to evoke a particular response in the viewer.

neo-realism (nee-oh-REE-uh-lihz-uhm). Post-World War II movement in art, film, and literature. In film, it used hidden cameras and emphasized an objective viewpoint and documentary style. It followed in the tradition of **verismo**, in which superficially naturalistic works are informed by a degree of populism and sentimentality.

New Wave (noo wayv). In film, a group of young French directors who came to prominence in the 1950s, the most widely known of whom are François Truffaut, Jean-Luc Godard, and Alain Resnais.

niche (neesh). A recess in a wall in which sculpture can be displayed.

nimbus (NIHM-buhs). The circle of radiant light around the head or figures of God, Christ, the Virgin Mary, and the saints.

nonobjective (nahn-uhb-JEHK-tihv). Without reference to reality; may be differentiated from **abstract**.

nonrepresentational (nahn-rehp-ree-zehn-TAY-shuhn-uhl). Without reference to reality; including **abstract** and **nonobjective**.

octave (AHK-tihv; -tayv). In music, eight **tones** comprising a **scale**. The **interval** between two **pitches**, one of which is double the frequency of the other. In literature, a stanza of eight lines.

oculus (AHK-yoo-luhs). A circular opening in the top of a dome.

ode (ohd). In literature, a ceremonious **lyric poem** uniting emotion and general dedication. The form usually exhibits an exaltation of feeling and style and has lines of varying lengths along with complex **stanza** forms.

op art (ahp-ahrt). A painting style from the late twentieth century that plays on the possibilities offered by optics and perception. Intellectually oriented and systematic, it uses perceptual tricks and misleading images to attract the viewer into a conscious exploration of what the optical illusion does and why it does it.

open form (OHP-uhn fawrm). In art, composition that allows the eye to escape the frame or a form with irregular contours leaving a sense of unresolved tension. In music, composition that does not return to the initial theme—for example **fugue** and **canon**. In film, stress on informal compositions and apparently haphazard design. The frame acts as a temporary masking that arbitrarily cuts off part of the action.

opera (AHP-uh-ruh; AHP-ruh). A theatrical presentation with drama set to music.

opera buffa (AHP-uh-ruh BOO-fuh; AHP-ruh-; OH-pair-uh-BOOF-fah). Comic opera that usually does not have spoken dialogue and typically uses satire to treat a serious topic with humor.

opéra comique (AHP-uh-ruh-kah-MEEK; AHP-ruh-; oh-pay-rah-kah-MEEK). Any opera, regardless of subject matter, that has spoken dialogue.

opera seria (AHP-uh-ruh-SIHR-ee-uh; OHP-air-uh-SAIR-). Serious opera, usually grand in scale and tragic in tone. Highly stylized treatment of heroic subjects such as gods and heroes of ancient times.

operetta (ahp-uh-REHT-uh). A type of opera that has spoken dialogue but usually refers to a style of opera characterized by popular themes, a romantic mood, and often a humorous tone. Frequently considered more theatrical than musical, its storyline is usually frivolous and sentimental.

opus (OH-pus). A single work of art.

oratorio (awr-uh-TAWR-ee-oh; -TOH-). In music, a semi-dramatic work,without acting, scenery, or costumes, often on a religious theme, for **orchestra**, choir, and soloists.

orchestra (AWRK-ih-struh). In music, a large instrumental ensemble divided into sections such as strings, woodwinds, brass, and percussion. In theatre, the section of seats on the ground floor of the auditorium directly in front of the stage. Also, the circular playing area of an ancient Greek theatre.

order (AWR-duhr). In architecture, one of the systems used by the Greeks and Romans to decorate and define their buildings. See **Corinthian order**, **Doric order**, and **Ionic order**.

organum (AWR-gah-nuhm). Singing together. Earliest form of polyphony in Western music, with the voices moving in parallel lines.

overture (OH-vur-chuhr). In music, a short instrumental composition intended as an introduction to a larger work. Or, as in **concert overture**, an instrumental composition intended as a stand-alone performance piece.

palette (PAL-eht). In visual art, the composite use of color by an artist in an artwork. Or, a flat piece of board or other material that a painter holds and on which pigments can be mixed. In music and literature, the range of qualities employed by a composer or writer in a particular work.

pantheon (PAN-thee-ahn). A Greek word meaning all the gods.

pantomime (PAN-tuh-mym). In theatre, a genre of Roman drama in which an actor played various parts, without words, with a musical background. In dance, the transmission of emotions and meaning through gesture.

pas de deux (pah-duh-DUH). In dance, a dance for two individuals, especially in **ballet**.

pathos (PA-thaws or PAY-thaws). The "suffering" aspect of drama usually associated with the evocation of pity.

pediment (PEHD-uh-muhnt). In architecture, a wide, low-pitched **gable** atop the façade of a Greek-style building. Also a similar triangular element used above door or window openings.

pendentive (pehn-DEHN-tihv). In architecture, a triangular section of vaulting used to anchor a dome to the rectilinear structure below it.

performance art (puhr-FAWRM-uhns ahrt). A genre of art comprising a multi-disciplinary, live, theatrical presentation, usually involving the audience. Typically involves non-theatre artists and a non-theatre environment.

performing arts (puhr-FAWR-mihng-ahrts). The arts, such as dance, theatre, and music, that are performed before an audience.

perspective (puhr-SPEHK-tihv). In two-dimensional art, the representation of distance and three-dimensionality on a two-dimensional surface. See **aerial perspective** and **linear perspective**.

Petrarchan sonnet (pih-TRAHR-kuhn; peh-; pee-). In literature, a poem of fourteen lines divided into an octave rhyming *abbaabba* and a sestet with a variable rhyme scheme—the latter can be *cdecde*, *cdcdcd*, or *cdcdce* or some other variation that never ends in a final couplet.

picaresque (pihk-uh-REHSK). In literature, a type of **novel** dealing with the episodic adventures of a rogue.

pietà (pee-ay-TAH). A painting or sculpture of the dead Christ supported by Mary.

pilaster (pih-LAS-tuhr). In architecture, a flat, vertical element projecting from a wall, and normally having a base, shaft, and **capital**.

plainchant (PLAYN-chant). See **Gregorian chant**.

plainsong (PLAYN-sawng). See **Gregorian chant**.

plastic (PLAS-tihk). In visual art and film: capable of being shaped or molded; or, three-dimensional.

plot (plaht). In theatre, film, and narrative literature, the structure of the work comprising **crises, climax, exposition, complication, and denouement, foreshadowing, discovery,** and **reversals**.

poetry (POH-uh-tree). One of the major divisions or **genres** of literature. A work designed to convey a vivid and imaginative sense experience through the use of condensed language selected for its sound and suggestive power and meaning, and employing specific technical devices, such as **meter, rhyme,** and **metaphor**. There are three major types of poetry—**narrative,** dramatic, and **lyric**.

point of view. In literature and film, the perspective from which a story is related to the reader or viewer.

pointillism (POYNT-ilh-lihz-uhm). A style of painting in which the paint is applied to the surface by dabbing the brush so as to create small dots of color.

polyphony (puh-LIHF-uh-nee). In music, a texture comprising two or more independent melodic lines sounded together. Cf. **monophony** and **homophony**.

polyrhythm (pah-lee-RIH-thuhm). The use of contrasting rhythms at the same time in music.

pop art (pahp-ahrt). A style of art that portrays everyday life and uses techniques from commercial art and popular illustration.

post-and-beam (pohst-and-beem). See **post-and-lintel**.

post-and-lintel (pohst-and-LIHNT-uhl). In architecture, a structural system in which horizontal pieces (**lintels**) are held up by vertical columns (posts); similar to post and beam structure, which usually utilizes wooden posts and beams held together by nails or pegs.

post-impressionism (pohst-ihm-PREHSH-uh-nihz-uhm). In visual art, a diverse style dating to the late nineteenth century that rejected the objective **naturalism** of **impressionism** and used form and color in more personal ways. It reflects an "**art for art's sake**" philosophy.

postmodernism (pohst-MAHD-uhrn). In visual art, architecture, dance, and literature, a diverse, highly individualistic style that rejects **modernism** and its principles. It is distinguished by eclecticism and anachronism, in which works may reflect and comment on a wide range of stylistic expressions and cultural-historical viewpoints, including breaking down the distinctions between "high art" and popular culture. Self-reference is often at the center of creation and presentation. One common theme is a basic concern for how art functions in society. In architecture, it seeks social identity, cultural continuity, and sense of place.

prairie style (PRAIR-ee-styl). In architecture, an early twentieth-century movement created by Frank Lloyd Wright that relies on strong horizontal lines, in imitation of the flatness of the American prairies and insists on integrating the context of the building and creating indoor space that is an extension of outdoor space.

precisionism (pree-SIH-zhuhn-ihz-uhm). In painting, an early to mid-twentieth century movement that arranged real objects into abstract groupings often using the strong, vibrant colors of commercial art.

pre-Columbian (pree-kuh-LUHM-bee-uhn). Originating in the Americas prior to the arrival of Columbus in 1492.

prelude (PRAY-lood). In music, a piece or movement serving as an introduction to another section or composition and which establishes the **key**—for example, one that precedes a **fugue**. Also, a similar but independent composition for piano. Also, the **overture** to an **opera, oratorio**, or **act** of an opera. Also, a short composition from the fifteenth and early sixteenth centuries, usually for keyboard.

Pre-Raphaelites (pree-RAHF-ee-uh-lyts; -RAYF-). A group of young British painters who rebelled against what they considered the unimaginative and artificial historical painting of the Royal Academy in the mid-nineteenth century. The name evokes the direct and uncomplicated portrayal of nature in Italian painting prior to the **High Renaissance** (one of whose titans was Raphael).

primary structures (PRYM-air-ee-STRUHK-chuhrs). From the late twentieth century, a movement in sculpture that pursues extreme simplicity of shapes and a kinship with architecture. Viewers are invited to share an experience in three-dimensional space in which they can walk around and/or through the works. Form and **content** are reduced to their most minimal qualities.

program music (PROH-gram-MYOOZ-ihk). Music intended to depict or suggest nonmusical ideas or images through a descriptive title or text. Cf. **absolute music**.

proportion (pruh-PAWR-shuhn). In visual art and architecture, the relation, or ratio, of one part to another and of each part to the whole with regard to size, height, width, length, or depth.

proscenium (proh-SEE-nee-uhm). In theatre, a form of theatre architecture in which a frame (arch) separates the audience from the stage; Also, the frame or arch itself; Also, in the Greek **classical** theatre, the area between the background (**skene**) and the **orchestra**.

protagonist (proh-TAG-uh-nihst). In theatre, film, and literature, the leading actor or personage in a play or narrative work—that is, the major **character** around whose decisions and actions the **plot** revolves.

psalmody (SAHL-moh-dee). A collection of psalms.

putti (POO-tee). Nude male children—usually winged—especially shown in Renaissance and later art.

quatrefoil (KWAH-truh-foyl). A carved ornament with four leaflets or lobes arranged around a common center.

radial symmetry (RAY-dee-uhl-SIHM-uh-tree). In visual art, the **symmetrical** arrangement of elements around a central point.

realism (REE-uhl-ihz-uhm). In visual art and theatre, a mid-nineteenth-century style seeking to present an objective and unprejudiced record of the customs, ideas, and appearances of contemporary society through spontaneity, harmonious colors, and subjects from everyday life with a focus on human motive and experience.

recapitulation (rih-cuh-pihch-uh-LAY-shuhn; ree). In **sonata form**, the third section in which the **exposition** is repeated, often with variations. See **development**.

recitative (rehs-ih-tuh-TEEV; rehch-). In music, (in **opera, cantata**, and **oratorio**), a vocal line that imitates the **rhythms** and **pitch** fluctuations of speech and often serving to lead into an **aria**.

reinforced concrete (ree-ihn-FAWRST; -FOHRST; -KAHN-kreet). In architecture, poured concrete containing steel reinforcing bars or mesh to increase its **tensile strength**.

relief (rih-LEEF). See **sculpture**.

Renaissance (rehn-uh-SAHNS). The humanistic revival of **classical** art, architecture, and literature originating in Italy in the fourteenth century and lasting through the sixteenth centuries that marked the transition from medieval to modern times. Painting had gravity and monumentality, using deep perspective and modeling, spatial naturalism, and strong, detailed, very human figures. Freestanding sculpture exhibited a focus on anatomy.

repetition (rehp-eh-TIH-shuhn). Reiteration of elements in a work of visual art, architecture, theatre, dance, film, music, and literature so as to create a sense of unity.

representational (rehp-rih-zehn-TAY-shuhn-uhl). In visual art and theatre, having the appearance of observable reality. Cf. **abstract** and **nonrepresentational**.

requiem (REHK-wee-uhm). In music, a composition for a **mass** for the dead.

rhythm (RIHTH-uhm). The relationship, either of time or space, between recurring elements of a **composition**. The regular or ordered **repetition** of dominant and subordinant elements or units within a design or composition.

ribbed vault (rihbd-vawlt). In architecture, a structure in which arches are connected by diagonal as well as horizontal members.

ritornello form (rih-tohr-NEHL-oh fawrm). In music, a type of composition usually in a **baroque concerto grosso**, in which the **tutti** plays a **ritornello**, alternating with one or more soloists playing new material.

ritual dance (RIH-choo-uhl dans). In dance, a group of dances that perform some religious, moral, or ethical purpose in a society.

rococo (ruh-KOH-koh; roh-koh-KOH). An eighteenth-century style in architecture and visual art, developed in France from the **baroque** and characterized by elaborate and profuse ornamentation, often in the form of shells, scrolls, and the like. In architecture it manifested itself in interior design and furniture. In painting and sculpture, a decorous style exhibiting intimate grace, charm, and delicate superficiality.

Roman classicism (ROHN-uhn-KLAS-uh-sihz-uhm). From the turn of the Common Era and the reign of Augustus Caesar, it copied **classical** Greek forms but added, in architecture, the round or **Roman arch**.

Romanesque (roh-muhn-EHSK). A style in visual art and architecture from the eleventh through early twelfth centuries in Europe characterized by rounded (Roman) arches on doorways and windows. It is massive, static, and comparatively lightless. In sculpture, it was fairly diverse, typically attached to Romanesque buildings, stone, and monumental.

Romanticism (roh-MAN-tuh-sihz-uhm). A philosophy as well as a style in all the arts and literature, dating to the late eighteenth through nineteenth centuries. In architecture it borrowed styles from previous eras while experimenting with modern materials. It also sought an escape to the past. In painting, the style turned to emotionalism, the picturesque, and nature. It fragmented images and dramatized with personal subjectivity. In theatre, the style resulted in dazzling scenery. In literature, music, and ballet, it sought the subjective and the colorful reflecting great diversity.

rondo (RAHN-doh; rahn-DOH). In music, a composition based on the alternation of a principal recurring theme and contrasting episodes—that is, a main theme (A) that returns several times in alternation with other themes (A B A C A, etc.). Often the last movement of a classical **symphony**, string quartet, and **sonata**.

sarcophagus (plural **sarcophagi**; sahr-KAHF-uh-guhs). A stone coffin.

satire (SA-tyr). In literature and drama, the use of ridicule, **irony**, or sarcasm to hold up to ridicule and contempt vices, follies, abuses, and so forth. Also, a work of literature that uses satire.

saturation (sach-uh-RAY-shuhn). In visual art, the degree of white present in a hue. The more white, the less saturated is the hue.

scale (skayl). In visual art and architecture, a building's size and the relationship of the building and its decorative elements to the human form. In music, an ascending or descending arrangement of pitches.

sculpture (SKUHLP-chuhr). A form of visual art or a three-dimensional artwork. Among the major types of sculpture are *full-round*, which is free-standing and fully three-dimensional; *relief*, which is attached to a larger background (see **low-relief** and **high-relief**; and *linear*, which emphases linear materials like wire. Among the methods of execution are *cast*: which is created from molten material in a mold (see **substitution**); *built* or assembled (see *additive*) which is created by the addition of, often, prefabricated elements; *carved* (see **subtraction**); and *manipulated*—that is, constructed by manipulating soft materials such as clay.

sentimental novel. In literature, a **novel** that seeks to exploit the reader's sense of tenderness, compassion, or sympathy through

disproportionately unrealistic views of the subject.

serialism (serial music; SIHR-ee-uh-lihz-uhm). In music, a mid-twentieth century type of composition based on the **twelve tone system**. In serialism the techniques of the twelve-tone system are used to organize musical dimensions other than pitch, for example, rhythm, dynamics, and tone color.

sfumato (sfoo-MAH-to). A smoky or hazy quality in a painting, with particular reference to Leonardo da Vinci's work.

shaft (shaft). The main trunk of a column.

Shakespearean sonnet (or English sonnet) (shayk-SPIHR-ee-uhn). A **poem** of fourteen lines grouped into three quatrains and a couplet with the rhyme scheme *abab cdcd efef gg*. See **Petrarchan sonnet; sonnet.**

skeleton frame (SKEHL-uh-tuhn-fraym). In architecture, construction in which a skeletal framework supports the building. See **balloon construction** and **steel-cage construction.**

sonata (suh-NAH-tuh). In music, an instrumental piece, usually in three or four movements and usually for one or two players.

sonata form (suh-NAH-tuh-fawrm). In music, a type of structure usually used in the first movement of a **sonata**. The three parts are the **exposition, development,** and **recapitulation.**

sonnet (SAHN-uht). In literature, a fixed **verse** form of Italian origin comprising fourteen lines usually of five-**foot** iambics rhyming according to a prescribed scheme. See **also Petrarchan sonnet; Shakespearean sonnet.**

steel-cage construction (steel-kayj-kuhn-STRUHK-shuhn). In architecture, construction using a metal framework. See **skeleton frame.**

stream of consciousness. In literature, a **narrative form** in fiction that attempts to capture the whole range and flow of a **character**'s mental processes.

strophic form (STRAH-fikh fawrm). Form of vocal music in which _all stanzas of the text are sung to the same music.

structuralism (STRUHK-chuhr-uh-lihz-uhm). A form of criticism associated with Roland Barthes that applies to artworks a broader significance, insisting that they can be understood only within the context of the overall structures—that is, universal sets of meaning—of which they are a part.

style (styl). The individual characteristics of a work of art that identify it with a particular artist, nationality, historical period, or school of artists.

stylized (STY-uh-lyzd). A type of depiction in which true-to-lifeness has been altered for artistic effect.

stylobate (STY-loh-bayt). The foundation immediately below a row of columns.

suite (sweet). In music, an instrumental composition, typically in two parts, arising from the **baroque** period and comprising a set of dance-inspired movements written in the same key but differing in tempo, meter, and character. Can employ **solo** instruments, small **ensembles,** or an **orchestra.**

suprematism (soo-PREHM-uh-tihz-uhm). In visual art, a school and theory of **geometric, abstract** art originating in Russia in the early twentieth century.

surrealism (suhr-REE-uh-lihz-uhm). A movement in art that developed in the 1920s in which artists and writers gave free rein to the imagination, expressing the subconscious through the irrational **juxtapositions** of objects and themes. The movement took two directions: **representational** and **abstract.**

symbol (SIHM-buhl). A form, image, or subject standing for something else.

symbolism (SIHM-buhl-ihz-uhm). The suggestion through imagery of something that is invisible or intangible.

symbolist movement (SIHM-buh-lihst). In visual art, theatre and literature from the late nineteenth to mid-twentieth centuries. Also known as neo-Romanticism, idealism, or **impressionism.** It held that truth can be grasped only by intuition, not through the senses or rational thought. Thus, ultimate truths can be suggested only through symbols, which evoke in the audience or reader various states of mind that correspond vaguely with the playwright's or writer's feelings.

symmetry (SIHM-ih-tree). In visual art, balancing of elements in design by placing physically equal objects on either side of a central axis. Cf. **asymmetry**

symphonic poem (sihm-FAHN-ik-POH-uhm). In music, a composition comprising an extended **movement,** based on an extramusical theme, for **symphony orchestra.** Also called a tone poem.

symphony (SIHM-fuh-nee). In music, an extended musical composition for **orchestra** usually consisting of three or four **movements.** Also, see **orchestra**

syncopation (sihng-kuh-PAY-shuhn). In music, the displacement of **accent** from the normally accented **beat** to the offbeat.

temperament (TEHM-pruh-mehnt). In music, a system of tuning. Equal temperament—the division of the octave into twelve equal intervals—is the most common way of tuning keyboard instruments.

tensile strength (TEHN-suhl-strehngth). In architecture and sculpture, the ability of a material to withstand twisting and bending.

text painting (tehkst paynt-ihng). See **word painting.**

texture (TEHKS-chuhr). In painting and sculpture, the two-dimensional or three-dimensional quality of the surface of a work. In music, the melodic and harmonic characteristics of a composition. In literature, the elements—for example, metaphors, imagery, meter, and rhyme—that are separate from the structure or argument of the work.

Theatre of the Absurd. A style of drama that emphasizes the absurdity of human existence through, for instance, illogical plots.

theatricalism (thee-AT-rih-kuh-lihz-uhm). A movement in theatre away from the realism and naturalism of the nineteenth century.

theatricality (thee-ya-trih-KAL-uh-tee). Exaggeration and artificiality. The opposite of lifelikeness.

theme (theem). The dominant idea of a work of art, music, film, dance, and literature. In music, a principal melodic phrase in a composition.

theme and variations (theem and vair-ee-AY-shuhns). In music, a form that takes a basic musical idea (theme) and repeats it over and over, each time making changes in the **melody, rhythm, harmony, dynamics,** or **tone color.** Can be an independent composition or part of a larger work.

timbre (TAM-bur). In music, the quality of a tone that distinguishes it from other tones of the same pitch. Also called color or tone color.

toccata (tuh-KAH-tah). A baroque keyboard composition intended to display technique.

tonality (toh-NAL-ih-tee). In music, the specific key in which a composition is written. See **key.** In the visual arts, the characteristics of **value.**

tone cluster (tohn-KLUHS-tuhr). In music, a dissonant group of closely spaced notes played at the same time. Common in twentieth-century music.

tone color (tohn KUHL-uhr). In music, the **timbre** of a voice or instrument.

tonic (TAHN-ihk). In music, the root tone (*do*) of a key.

tragedy (TRAJ-uh-dee). A serious drama or other literary work in which conflict between a **protagonist** and a superior force (often fate) concludes in disaster for the protagonist.

tragic flaw. A flaw that brings about a hero's downfall.

tragicomedy (traj-ih-KAHM-uh-dee). A drama combining the qualities of **tragedy** and **comedy.**

transept (TRAN-sehpt). The crossing arm of a cruciform church, at right angles to the nave.

triptych (TRIHP-tihk). An altarpiece or devotional picture composed of a central panel and two wings.

trompe l'oeil (trawmp-LOY). French for "trick the eye" or "fool the eye." A two-dimensional artwork, executed in such a way as to make the viewer believe that a three-dimensional object is being perceived.

trope (troph). A medieval dramatic elaboration of the Roman Catholic mass or other offices.

tunnel vault (TUHN-uhl vawlt). See **barrel vault.**

twelve-tone (twehlv-tohn). In music, relating to or based on an arrangement of the twelve chromatic tones. Also an atonal system of composition based on use of the twelve tones, invented in the 1920s by Arnold **Schoenberg,** who preferred the term "pan tonal."

tympanum (TIHM-puh-nuhm). The space above the door beam and within the arch of a medieval doorway.

value (VAL-yoo). Also value scale or **key.** In the visual arts, the range of tonalities from white to black or dark to light.

vanishing point (VAN-ihsh-ihng poynt). In **linear perspective,** the point on the horizon toward which parallel lines appear to converge and at which they seem to vanish.

variation (veh-ree-YAY-shuhn). Repetition of a theme with minor or major changes.

vault (vawlt). See **barrel vault.**

verisimilitude (vair-ih-sih-MIHL-ih-tood). In the arts and literature, the semblance of reality— that is, nearness to truth.

verismo (vay-REEZ-moh). In literature, **realism** as it developed in Italy in the late nineteenth and early twentieth century. Also a style of opera utilizing realistic librettos and production style.

video art (VIHD-ee-oh-ahrt). A wide-ranging, late twentieth-century **genre** that emerged from the rebellions of the 1960s as a reaction against conventional broadcast television, characterized by experiments exploiting new dimensions in hardware and imagery.

volute (vuh-LOOT). A spiral architectural element found notably on Ionic and other capitals, but also used decoratively on building façades and interiors.

wet-plate collodion process (weht playt cuh-LOHD-ee-uhn PRAH-sehs). In photography, a process, developed around 1850, that permitted short exposure times and quick development of the print.

woodcut (WUD-kuht). In printmaking, a **relief** printing technique in which the work is printed from a design cut into the plank (side) of the grain of a piece of wood.

wood engraving (wud ehn-GRAYV-ihng). In printmaking, a **relief** printing technique in which the work is printed from a design cut into the butt (end) of the grain of a piece of wood.

word painting (wuhrd payn-tihng). The use of language by a poet or playwright to suggest images and emotions; in music, the use of expressive melody to suggest a specific text.

Further Reading

General

Arkin, Marian, and Shollar, Barbara (eds.), *Longman Anthology of World Literature by Women*, New York: Longman, 1989

Bentley, Eric (ed.), *The Classic Theatre*, (4 vols), Garden City, NY: Doubleday Anchor Books, 1959

Braider, Christopher, *Refiguring the Real: Picture and Modernity in Word and Image: 1400–1700*, Princeton, NJ: Princeton University Press, 1993

Brockett, Oscar G., *History of the Theatre*, Boston: Allyn and Bacon, Inc., 1968

Chadwick, Whitney, *Women, Art, and Society*, New York: Norton, 1991

Chujoy, Anatole, *Dance Encyclopedia*, New York: Simon and Schuster, 1967.

Clough, Shepard B. et. al., *A History of the Western World*, Boston: D.C. Heath & Co., 1964

De la Crois, Horst, Tansey, Richard G., and Kirkpatric, Diane, *Gardner's Art Through the Ages* (9th ed.), San Diego, CA: Harcourt, 1991

Drinkwater, John, *The Outline of Literature*, London: Transatlantic Arts, 1967

Fuller, B.A.G., *A History of Philosophy*, New York: Henry Holt and Company, 1945

Garraty, John, and Gay, Peter, *A History of the World* (2 vols), New York: Harper & Row, 1972

Giscard d'Estaing, Valerie Anne, and Young, Mark (eds.), *Inventions and Discoveries 1993*, New York: Facts on File, Inc., 1993

Grout, Donald Jay, *A History of Western Music* (rev. ed.), New York: W.W. Norton & Co., Inc., 1979

Hartt, Frederick, *Art* (2 vols). Englewood Cliffs, NJ, and New York: Prentice Hall, Inc. and Harry N. Abrams, Inc., 1979

Hofstadter, Albert, and Kuhns, Richard, *Philosophies of Art and Beauty*, Chicago: University of Chicago Press, 1976

Honour, Hugh, and Fleming, John. *The Visual Arts: A History* (3rd ed.), Englewood Cliffs, NJ: Prentice Hall, Inc., 1992

Kamien, Roger, *Music: An Appreciation* (5th ed.), New York: McGraw-Hill, 1995

Kernodle, George and Portia, and Pixley, Edward, *Invitation to the Theatre* (3rd ed.), San Diego: Harcourt Brace Jovanovich, 1985

Lacy, Susan, *Mapping the Terrain: New Genre Public Art*, Seattle: Bay Press, 1995.

McNeill, William H., *The Shape of European History*, New York: Oxford University Press, 1974

Nicoll, Allardyce, *The Development of the Theatre* (5th ed.), London: Harrap & Co. Ltd, 1966

Ocvirk, Otto G., et al., *Art Fundamentals* (7th ed.), Madison, WI: Brown & Benchmark, 1994

Pfeiffer, John E., *The Creative Explosion*, New York: Harper & Row, 1982

Roberts, J.M., *History of the World*, New York: Alfred A. Knopf, Inc, 1976

Rohmann, Chris, *A World of Ideas*, New York: Ballantine Books, 1999.

Sadie, Stanley (ed.), *The New Grove Dictionary of Music and Musicians*, Washington, D.C.; London: Macmillan, 1980

Sperry, Roger, *Science and Moral Priority: Merging Mind, Brain, and Human Values*, New York: Columbia University Press, 1983

Sporre, Dennis J., *The Art of Theatre*, Englewood Cliffs, NJ: Prentice Hall, 1993

Sporre, Dennis J., *Perceiving the Arts*, 5th ed. Englewood Cliffs, NJ: Prentice Hall, Inc., 1997

Vidal-Naquet, Pierre (ed.), *The Harper Atlas of World History*, New York: Harper & Row, 1986

Stokstad, Marilyn, *Art History*, Upper Saddle River, NJ: Prentice Hall, 1995

Wilkins, David G., and Schultz, Bernard, *Art Past Art Present*, Englewood Cliffs, NJ, and New York: Prentice Hall Inc. and Harry N. Abrams, Inc., 1990

The Ancient World

Bataille, Georges, *Lascaux*, Switzerland: Skira, n.d.

Engel, Carl, *The Music of the Most Ancient Nations*, Freeport, NY: Books for Libraries Press, 1970

Frankfort, Henri, *Kingship and the Gods*, Chicago: University of Chicago Press, 1948

Graziosi, Paolo, *Palaeolithic Art*, New York: McGraw-Hill, 1960

Lange, Kurt, and Hirmer, Max, *Egypt*, London: Phaidon, 1968

Lloyd, Seton, *The Archaeology of Mesopotamia*, London: Thames & Hudson, 1978

Lommel, Andrea, *Prehistoric and Primitive Man*, New York: McGraw-Hill, 1966

Marshack, Alexander, *The Roots of Civilization*, New York: McGraw-Hill, 1972

Montet, Pierre, *Lives of the Pharaohs*, Cleveland: World Publishing Co., 1968

Moortgat, Anton, *The Art of Ancient Mesopotamia*, London: Phaidon, 1969

Murray, Margaret, *Egyptian Sculpture*, New York: Charles Scribner's Sons, 1930

Oppenheim, A. Leo, *Ancient Mesopotamia*, Chicago: University of Chicago Press, 1964

Powell, T.G.E., *Prehistoric Art*, New York: Frederick Praeger Publishers, 1966

Sachs, Curt, *The Rise of Music in the Ancient World*, New York: W.W. Norton & Co., 1943

Sandars, N.K., *Prehistoric Art in Europe*, Baltimore: Penguin Books, 1968

Smith, Hermann, *The World's Earliest Music*, London: W. Reeves, n.d.

Smith, W. Stevenson, *The Art and Architecture of Ancient Egypt*, Baltimore: Penguin Books, 1958

Archaic Greece and the Aegean

Beye, C.R., *Ancient Greek Literature and Society*, Ithaca: Cornell University Press, 1987

Boardman, J., *The Greeks Overseas*, Baltimore: Penguin, 1973

Boardman, J., Jasper, G., and Murray, O. (eds.), *The Oxford History of the Classical World*, Oxford: Oxford University Press, 1986

Finley, M.I., *Early Greece: The Bronze and Archaic Age*, New York: Norton, 1981

Graves, R., *The Greek Myths*, Garden City, NY: Doubleday, 1981

Groenewegen-Frankfort, H.A., and Ashmole, Bernard, *Art of the Ancient World*, Englewood Cliffs, NJ, and New York: Prentice Hall, Inc. and Harry N. Abrams, Inc., 1972

Janson, H.W., *A Basic History of Art* (4th ed.), Englewood Cliffs, NJ, and New York: Prentice Hall, Inc. and Harry N. Abrams, Inc., 1991

Snell, Bruno, *Discovery of the Mind: The Greek Origins of European Thought*, New York: Harper, 1960

Greek Classicism and Hellenism

Arnott, Peter D., *An Introduction to the Greek Theatre*, Bloomington, IN: Indiana University Press, 1963

Bieber, M., *The Sculpture of the Hellenistic Age*, New York: Columbia University Press, 1955

Boardman, J., et al., *Greek Art and Architecture*, New York: Abrams, 1967

Burcket, W., *Ancient Mystery Cults*, Cambridge, MA: Harvard University Press, 1987

Grant, M., *From Alexander to Cleopatra: The Hellenistic World*, London: Weidenfeld & Nicolson, 1982

Hamilton, Edith, *Three Greek Plays*, New York: W.W. Norton & Co., Inc., 1965

Kjellberg, Ernst, and Saflund, Gosta, *Greek and Roman Art*, New York: Thomas Y. Crowell Co., 1968

Morford, M.P.O., and Lenardon, P.J., *Classical Mythology*, New York: Longman, 1977

Richter, Gisela, *Greek Art*, Greenwich, CT: Phaidon, 1960

Robertson, Martin, *A Shorter History of Greek Art*, Cambridge, UK: Cambridge University Press, 1981

The Roman Period

Andreae, Bernard, *The Art of Rome*, New York: Harry N. Abrams, Inc., 1977

Balsdon, J.P.V.D., *Rome: The Story of an Empire*, New York: McGraw Hill, 1970

Brendel, O.J., *Etruscan Art*, Baltimore: Penguin, 1978

Crawford, M., *The Roman Republic*, Cambridge, MA: Harvard University Press, 1982

Grant, M., *Roman Literature*, New York: Penguin, 1964

Henig, Martin (ed.), *A Handbook of Roman Art*, Ithaca, NY: Cornell University Press, 1983

Kjellberg, Ernst, and Saflund, Gosta, *Greek and Roman Art*, New York: Thomas Y. Crowell Co., 1968

Ward-Perkins, J.B., *Roman Imperial Architecture* (2nd ed.), New York: Penguin, 1981

Judaism and Early Christianity

Achtemeier, Paul (ed.), *Harper's Bible Dictionary*. San Francisco: Harper & Row, 1985

Anderson, Bernhard, *Understanding the Old Testament*, Englewood Cliffs, NJ: Prentice Hall, 1975

Andreae, Bernard, *The Art of Rome*, New York: Harry N. Abrams, Inc., 1977

Barclay, William, *The Gospel of Luke*, Philadelphia: Westminster Press, 1975

Bevan, G.M., *Early Christians of Rome*, London: Society for Promoting Christian Knowledge, 1927

Brown, P., *Augustine of Hippo*, London: Faber, 1967

Chadwick, H., *The Early Church*, New York: Penguin, 1967

Epstein, Isidore, *Judaism*, Middlesex, UK: Penguin Books, 1968

Frend, W.H.C., *The Rise of Christianity*, Philadelphia: Fortress Press, 1983

Henig, Martin (ed.), *A Handbook of Roman Art*, Ithaca, NY: Cornell University Press, 1983

Johnston, Leonard, *A History of Israel*, New York: Sheed & Ward, 1963

McGiffert, Arthur, *A History of Christian Thought*, New York: Charles Scribner's Sons, 1961

Milburn, Robert, *Early Christian Art and Architecture*, Berkeley: University of California Press, 1988

Wheeler, Robert Eric Mortimer, *Roman Art and Architecture*, New York: Frederick Praeger Publishers, 1964

Byzantium and Islam

Armstrong, Karen, *Muhammad: A Western Attempt to Understand Islam*, San Francisco: HarperCollins, 1992

Bovini, G., *Ravenna Mosaics*, Greenwich, CT: New York Graphic Society Publishers, Ltd., 1956

Diehl, Charles, *Byzantium*, New Brunswick, NJ: Rutgers University Press, 1957

Dunlop, D.M., *Arab Civilization to A.D. 1500*, London: Longman, 1971

Esposito, John, *Islam: The Straight Path*, New York: Oxford University Press, 1991

Grabar, Andre, *The Art of the Byzantine Empire*, New York: Crown Publishers, Inc., 1966

MacDonald, William, *Early Christian and Byzantine Architecture*, New York: George Braziller, 1967

Mango, Cyril, *Byzantium*, New York: Charles Scribner's Sons, 1980

Rice, David Talbot, *The Art of Byzantium*, New York: Harry N. Abrams, Inc., n.d.

Sherrard, Philip, *Byzantium*, New York: Time Inc., 1966

Watt, W.M., *Muhammad: Statesman and Prophet*, New York: Oxford University Press, 1974

The Early Middle Ages

Beckwith, J., *Early Medieval Art*, New York: Praeger, 1973

Brondsted, Johannes, *The Vikings* (trans. Kalle Skov), New York: Penguin Books, 1960

Hoppin, Richard, *Medieval Music*, New York: W.W. Norton & Co., Inc., 1978

Jackson, W.T.H., *Medieval Literature: A History and a Guide*, New York: Collier Books, 1966

Knowles, David, *Christian Monasticism*, New York: McGraw-Hill, 1969

Rorig, F., *The Medieval Town* (trans. D.J.A.

Matthew), Berkeley: University of California Press, 1969

Strayer, Joseph, and Munro, Dana, *The Middle Ages*, Pacific Palisades: Goodyear Publishing Co., 1970

Tierney, Brian, and Painter, Sidney, *Western Europe in the Middle Ages*, New York: Alfred A. Knopf, 1974

Zarnecki, George, *Art of the Medieval World*, Englewood Cliffs, NJ: Prentice Hall, Inc., 1975

The High Middle Ages

Aston, M., *The Fifteenth Century: The Prospect of Europe*, New York: Harcourt, Brace, & World, 1968

Barraclough, G., *The Medieval Papacy*, New York: Harcourt, Brace, & World, 1968

Bishop, M., *Petrarch and His World*, Bloomington, Indiana University Press, 1963

Bony, Jean, *French Gothic Architecture of the Twelfth and Thirteenth Centuries*, Berkeley: University of California Press, 1983

Bruzelius, Carline A., *The 13th-Century Church at St-Denis*, New Haven, CT: Yale University Press, 1985

Crosby, Sumner McKnight, *The Royal Abbey of Saint-Denis*, New Haven: Yale University Press, 1987

Daly, Lowrie, *The Medieval University: 1200-1400*, New York: Sheed & Ward, 1961

Esser, Kajetan, *Origins of the Franciscan Order* (trans. Aedan Daly and Irina Lynch), Chicago: Franciscan Herald Press, 1970

Gottfried, Robert S., *The Black Death: Natural and Human Disaster in Medieval Europe*, New York: Free Press, 1983

Hofstatter, H.H., *Art of the Late Middle Ages* (trans. R.E. Wolf), New York: Abrams, 1968

Hoppin, Richard, *Medieval Music*, New York: W.W. Norton & Co., Inc., 1978

Hubert, J., Porcher, J., and Volbach, W.F., *The Carolingian Renaissance*, New York: George Braziller, 1970.

Jackson, W.T.H., *Medieval Literature: A History and a Guide*, New York: Collier Books, 1966

Janson, H.W., *A Basic History of Art* (4th ed.), Englewood Cliffs, NJ, and New York: Prentice Hall, Inc. and Harry N. Abrams, Inc., 1991

Kane, George, *Chaucer*, New York: Oxford University Press, 1984

Rorig, F., *The Medieval Town* (trans. D.J.A. Matthew), Berkeley: University of California Press, 1969

Singleton, Charles, *The Divine Comedy of Dante Alighieri* (6 vols), Princeton: Princeton University Press, 1972

Strayer, Joseph, and Munro, Dana, *The Middle Ages*, Pacific Palisades: Goodyear Publishing Co., 1970

Tierney, Brian, and Painter, Sidney, *Western Europe in the Middle Ages*, New York: Alfred A. Knopf, 1974

White, John, *Art and Architecture in Italy 1250–1400*, Baltimore: Pelican, 1966

Zarnecki, George, *Art of the Medieval World*, Englewood Cliffs, NJ: Prentice Hall, Inc., 1975

The Early Renaissance

Artz, Frederick, *From the Renaissance to Romanticism*, Chicago: University of Chicago Press, 1962

Brucker, Gene, *Renaissance Florence*, New York: Wiley, 1969

Burckhardt, Jakob, *The Civilization of the Renaissance in Italy*, New York: Harper Torchbooks, 1958

Cronin, Vincent, *The Florentine Renaissance*, New York: E.P. Dutton & Co., 1967

Fletcher, Jefferson, B., *Literature of the Italian Renaissance*, New York: The Macmillan Co., 1934

Gilbert, Creighton, *History of Renaissance Art Throughout Europe: Painting, Sculpture, Architecture*, New York: Harry N. Abrams, Inc., 1973

Hale, J.R., *Florence and the Medicis*, London: Thames & Hudson, 1977

Hartt, Frederick, *Italian Renaissance Art* (3rd ed.), Englewood Cliffs, NJ, and New York: Prentice Hall, Inc. and Harry N. Abrams, Inc., 1987

Keutner, Hubert, *Sculpture: Renaissance to Rococo*, Greenwich, CN: New York Graphic Society, 1969

King, Margaret, *Women of the Renaissance*, Chicago: University of Chicago Press, 1991

Kristeller, P.O., *Renaissance Thought: The Classic, Scholastic, and Humanist Strains*, New York: Harper Torchbooks, 1955

Staley, Edgcombe, *Famous Women of Florence*, London: Archibald Constable & Co., 1909

The High Renaissance and Mannerism

Artz, Frederick, *From the Renaissance to Romanticism*, Chicago: University of Chicago Press, 1962

Brown, Howard M., *Music in the Renaissance*, Englewood Cliffs, NJ: Prentice Hall, 1976

Campos, D. Redig de (ed.), *Art Treasures of the Vatican*, Englewood Cliffs, NJ: Prentice Hall, Inc., 1974

Cochrane, Eric, *The Late Italian Renaissance, 1525–1630*, New York: Harper Torchbooks, 1970

Fletcher, Jefferson, B., *Literature of the Italian Renaissance*, New York: The Macmillan Co., 1934

Gilbert, Creighton, *History of Renaissance Art Throughout Europe: Painting, Sculpture, Architecture*, New York: Harry N. Abrams, Inc., 1973

Hartt, Frederick, *Italian Renaissance Art* (3rd ed.), Englewood Cliffs, NJ, and New York: Prentice Hall, Inc. and Harry N. Abrams, Inc., 1987

Hay, Denys, and Law, John, *Italy in the Age of the Renaissance, 1380–1530*, London: Longman, 1989

Levey, Michael, *High Renaissance*, New York: Penguin, 1975

Oman, Sir Charles, *The Sixteenth Century*, Westport, CT: Greenwood Press, 1975

Plumb, J.H., *The Italian Renaissance*, New York: Harper Torchbooks, 1961

Stinger, Charles, *The Renaissance in Rome*, Bloomington: Indiana University Press, 1985

Stokstad, Marilyn, *Art History*, Upper Saddle River, NJ: Prentice Hall, 1995

Renaissance and Reformation in Northern Europe

Artz, Frederick, *From the Renaissance to Romanticism*, Chicago: University of Chicago Press, 1962

Bainton, Roland, *Here I Stand: A Life of Martin Luther*, New York: New American Library, 1950

Brion, Marcel, *Dürer, His Life and Work*, New York: Tudor Publishing, 1960

Brown, Howard M., *Music in the Renaissance*, Englewood Cliffs, NJ: Prentice Hall, 1976

Fenlon, Iain (ed.), *The Renaissance*, Englewood Cliffs, NJ: Prentice Hall, 1989

Gilbert, Creighton, *History of Renaissance Art Throughout Europe: Painting, Sculpture, Architecture*, New York: Harry N. Abrams, Inc., 1973

Hall, A. Rupert, *The Revolution in Science 1500–1750*, London: Longman, 1983

Oman, Sir Charles, *The Sixteenth Century*, Westport, CT: Greenwood Press, 1975

Smart, Alastair, *The Renaissance and Mannerism in Northern Europe and Spain*, London: Harcourt, Brace Jovanovich, Inc., 1972

Snyder, J., *Northern Renaissance Art*, Englewood Cliffs, NJ: Prentice Hall, 1985

Spitz, Lewis (ed.), *The Protestant Reformation*, Englewood Cliffs, NJ: Prentice Hall, Inc., 1966

Thompson, S. Harrison, *Europe in Renaissance and Reformation*, New York: Harcourt, Brace & World, 1963

The Baroque Age

Bazin, Germain, *The Baroque*, Greenwich, CN: New York Graphic Society, 1968

Boyd, M., *Bach*, London: Dent, 1983

Braider, Christopher, *Refiguring the Real: Picture and Modernity in Word and Image: 1400–1700*, Princeton, NJ: Princeton University Press, 1993

Friedrich, C.J., *The Age of the Baroque: 1610–1660*, New York: Harper Torchbooks, 1961

Grimm, Harold, *The Reformation Era*, New York: Macmillan Co., 1954

Hall, A. Rupert, *The Revolution in Science 1500–1750*, London: Longman, 1983

Held, Julius, and Posner, D., *Seventeenth and Eighteenth Century Art*, New York: Harry N. Abrams, Inc., n.d.

Ogg, D., *Europe in the Seventeenth Century* (rev. ed.), New York: Collier Books, 1968

Van Der Kemp, Gerald, *Versailles*, New York: The Vendome Press, 1977

Willey, B., *The Seventeenth-century Background*, New York: Columbia University Press, 1967

Wolf, J.B., *Louis XIV*, New York: Norton, 1968

The Enlightenment

Conisbee, P., *Painting in Eighteenth-century France*, Ithaca, NY: Cornell University Press, 1981

Hampson, N., *A Cultural History of the Enlightenment*, New York: Pantheon, 1968

Held, Julius, and Posner, D., *Seventeenth and Eighteenth Century Art*, New York: Harry N. Abrams, Inc., n.d.

Helm, Ernest, *Music at the Court of Frederick the Great*, Norman, OK: University of Oklahoma Press, 1960

Hubatsch, Walther, *Frederick the Great of Prussia*, London: Thames & Hudson, 1975

Keutner, Hubert, *Sculpture: Renaissance to Rococo*, Greenwich, CN: New York Graphic Society, 1969

Pignatti, Terisio, *The Age of Rococo*, London: Paul Hamlyn, 1969

Schonberger, Arno, and Soehner, Halldor, *The Rococo Age*, New York: McGraw-Hill, 1960

Waterhouse, E., *Painting in Britain 1530–1790* (4th ed.), New York: Penguin, 1978

The Romantic Age

Arkin, Marian, and Shollar, Barbara (eds.), *Longman Anthology of World Literature by Women*, New York: Longman, 1989

Booth, Michael, *Victorian Spectacular Theatre 1850–1910*, Boston: Routledge & Kegan Paul, 1981

Glasstone, Victor, *Victorian and Edwardian Theatres*, Cambridge, MA: Harvard University Press, 1975

Goethe, Johann Wolfgang von, *Faust: Part I* (trans. Philip Wayne), Baltimore: Penguin Books, 1962

Hamilton, George Heard, *Nineteenth and Twentieth Century Art: Painting, Sculpture, Architecture*, New York: Harry N. Abrams, Inc., 1970

Henderson, W.O., *The Industrialization of Europe, 1780–1914*, London: Thames & Hudson, 1969

Hewett, Bernard, *Theatre USA*, New York: McGraw-Hill Book Company, 1959

Hitchcock, Henry-Russell, *Architecture: Nineteenth and Twentieth Centuries*, Baltimore: Penguin, 1971

Katz, Bernard, *The Social Implications of Early Negro Music in the United States*, New York: Arno Press and *The New York Times*, 1969

Keck, George R., and Martin, Sherrill V., *Feel the Spirit*, New York: Greenwood Press, 1988

Krehbiel, Henry Edward, *Afro-American Folksongs*, New York: G. Schirmer, n.d. (c. 1914)

Maas, Jeremy, *Victorian Painters*, New York: G.P. Putnam's Sons, 1969

Muthesius, Stefan, *The High Victorian Movement in Architecture 1850–1870*, London: Routledge & Kegan Paul, 1972

Read, Benedict, *Victorian Sculpture*, New Haven: Yale University Press, 1982

Rowell, George, *The Victorian Theatre* (2nd ed.), Cambridge, UK: Cambridge University Press, 1978

Realism, Impressionism, and Beyond

Bohn, T.W., Stomgren, R.L., and Johnson, D.H., *Light and Shadows, A History of Motion Pictures* (2nd ed.), Sherman Oaks, CA: Alfred Publishing Co., 1978

Goldwater, R., *Symbolism*, New York: Harper & Row, 1979

Hamilton, George Heard, *Nineteenth and Twentieth Century Art: Painting, Sculpture, Architecture*, New York: Harry N. Abrams, Inc., 1970

Hayes, C.J.H., *A Generation of Materialism*, New York: Harper & Row, 1963

Henderson, W.O., *The Industrialization of Europe, 1780–1914*, London: Thames & Hudson, 1969

Hitchcock, Henry-Russell, *Architecture: Nineteenth and Twentieth Centuries*, Baltimore: Penguin, 1971

Leish, Kenneth W., *Cinema*, New York: Newsweek Books, 1974

Ostransky, Leroy, *Understanding Jazz*, Englewood Cliffs, NJ: Prentice Hall, Inc., 1977

Robinson, David, *The History of World Cinema*, New York: Stein & Day Publishers, 1973

Salzman, Eric, *Twentieth Century Music: An Introduction*, Englewood Cliffs, NJ: Prentice Hall, Inc., 1967

Tirro, Frank, *Jazz: A History*, New York: W.W. Norton & Co., Inc., 1977

Modernism

Arnason, H.H., *History of Modern Art*, Englewood Cliffs, NJ: Prentice Hall, Inc., 1977

Barrett, W., *Time of Need: Forms of Imagination in the Twentieth Century*, New York: Harper & Row, 1972

Giannetti, Louis, *Understanding Movies* (7th ed.), Englewood Cliffs, NJ: Prentice Hall, Inc., 1996

Golding, John, *Visions of the Modern*, Berkeley, CA: University of California Press, 1994

Griffiths, Paul, *A Concise History of Avant-Garde Music*, New York: Oxford University Press, 1978

Gropius, Walter (ed.), *The Theatre of the Bauhaus*, Middletown, CT: Wesleyan University Press, 1961

Gropius, Walter, *The New Architecture and the Bauhaus*, Cambridge, MA: M.I.T. Press, 1965

Hamilton, George Heard, *Nineteenth and Twentieth Century Art: Painting, Sculpture, Architecture*, New York: Harry N. Abrams, Inc., 1970

Hitchcock, Henry-Russell, *Architecture: Nineteenth and Twentieth Centuries*, Baltimore: Penguin, 1971

Knight, Arthur, *The Liveliest Art: A Panoramic History of the Movies* (rev. ed.), New York: Macmillan, Inc., 1978

Liddell Hart, B.H., *History of the Second World War*, New York: Putnam, 1971

Lippard, Lucy R., *Pop Art*, New York: Oxford University Press, 1966

Nyman, Michael, *Experimental Music: Cage and Beyond*, New York: Schirmer Books, 1974

Robinson, David, *The History of World Cinema*, New York: Stein & Day Publishers, 1973

Roters, Eberhard, *Painters of the Bauhaus*, New York: Frederick Praeger Publishers, 1965

Salzman, Eric, *Twentieth Century Music: An Introduction*, Englewood Cliffs, NJ: Prentice Hall, Inc., 1967

Shirer, William L., *The Rise and Fall of the Third Reich*, New York: Simon & Schuster, 1960

From Modernism to Postmodernism and Beyond

Arkin, Marian, and Shollar, Barbara (eds.), *Longman Anthology of World Literature by Women*, New York: Longman, 1989

Arnason, H.H., *History of Modern Art*, Englewood Cliffs, NJ: Prentice Hall, Inc., 1977

Brindle, Reginald Smith, *The New Music: The Avant-Garde Since 1945*, London: Oxford University Press, 1975

Coryell, Julie, and Friedman, Laura, *Jazz-Rock Fusion*, New York: Delacorte Press, 1978

Dallmayr, Fred R., *Critical Encounters: Between Philosophy and Politics*, Notre Dame, IN: University of Notre Dame Press, 1987

Ernst, David, *The Evolution of Electronic Music*, New York: Schirmer Books, 1977

Golding, John, *Visions of the Modern*, Berkeley, CA: University of California Press, 1994

Griffiths, Paul, *A Concise History of Avant-Garde Music*, New York: Oxford University Press, 1978

Hitchcock, Henry-Russell, *Architecture: Nineteenth and Twentieth Centuries*, Baltimore: Penguin, 1971

Knight, Arthur, *The Liveliest Art: A Panoramic History of the Movies* (rev. ed.), New York: Macmillan, Inc., 1978

Nyman, Michael, *Experimental Music: Cage and Beyond*, New York: Schirmer Books, 1974

Robinson, David, *The History of World Cinema*, New York: Stein & Day Publishers, 1973

Salzman, Eric, *Twentieth Century Music: An Introduction*, Englewood Cliffs, NJ: Prentice Hall, Inc., 1967

Index

Picture Credits and Literary Acknowledgments

Picture Credits

The author, the publishers, and Laurence King Publishing Ltd wish to thank the museums, galleries, collectors, and other owners who have kindly allowed their works to be reproduced in this book. Every effort has been made to contact the copyright holders, but should there be any errors or omissions, Laurence King Publishing would be pleased to insert the appropriate acknowledgment in any subsequent printing of this publication. In general, museums have supplied their own photographs; other sources are listed below.

Ansell Adams Publishing Rights Trust/Corbis: 16.21; AKG London: 1.3 (Erich Lessing), 1.4, 1.14 (Erich Lessing), 3.2 (Joseph Martin), 5.7 (Erich Lessing), 5.8, 7.2, 8.5, 9.11, 9.14, 9.17, 10.1, 10.2, 10.3, 10.11, 11.2, 11.10, 11.11, 11.13, 11.15, 11.19, 12.4, 12.5, 16.33; Ancient Art & Architecture Collection, London: 4.28 (C.M. Dixon), 5.2 (C.M. Dixon), 8.15, 12.28; Wayne Andrews, Chicago: 13.24; Arcaid, London: 16.40; The Architectural Association, London: 16.25, 17.38, 17.43; Archivi Alinari, Florence: 9.25; The Art Archive, London: 8.36, 16.38 (Dagli Orti); © Photo 1998 the Art Institute of Chicago. All rights reserved: 15.12, 15.15, 15.18, 16.13, 17.4; James Austin, Cambridge: 9.3; Alan Bedding: 16.34; Bibliothèque Nationale, Paris: 6.8, 6.9, 7.7 (detail), 7.24, 8.4, 8.8, 8.33, 13.5; Bildarchiv Foto Marburg, Germany: 3.26, 5.11, 5.25, 13.22; Bildarchiv Preussischer Kulturbesitz, Berlin: 1.15, 13.2; Bodleian Library, Oxford: 8.8; Bridgeman Art Library, London: 7.10, 8.6 (Private Collection), 8.16, 8.17, 8.25, 8.28 (Lauros/Giraudon), 8.35 (British Library), 11.5, 13.26, 14.1, 14.24 (Yale Center for British Art, Paul Mellon Collection), 15.6; British Library, London: 6.2, 6.10, 6.11, 7.4, 7.6, 7.9, 8.9, 8.40, 10.6; British Museum, London: 1.2, 2.20, 3.12, 4.31, 5.3, 7.11, 8.9, 15.17; © Cameraphoto Arte, Venice: 6.1, 6.6, 10.17; CNMHS/SPADEM, Paris: 7.22; Trudy Lee Cohen © 1986, Philadelphia: 15.34; Colorphoto Hans Heinz, Allschwil, Switzerland: 1.1, 1.5; © Donald Cooper/Photostage: 16.37, 17.52; Corbis: 4.29 (Bettman), 7.23, 7.25 (Bettman), 11.22 (Bettman), 12.38 (Michael Nicholson), 15.37 (Bettman), 16.28 (Bettman), 16.30, 17.56 (Bettman); James Davis Travel Photography: 17.47; Deutsches Archäologisches Institut, Rome: 4.33; Jean Dieuzaide, Toulouse: 7.19; Photo courtesy Diller + Scofidio: 17.48; Dorling Kindersley: 7.5, 10.42; Esto Photographics, Inc., New York: 17.39, 17.49 (© Lara Swimmer); Mary Evans Picture Library: 8.37, 10.39, 11.3, 11.4, 12.2; Fotografica Foglia, Naples: 3.9; Fotomas Index, London: 14.3; Fototeca Unione, Rome: 4.22; Alison Frantz, Princeton, NJ: 3.21, 6.4; Courtesy of the Freer Gallery of Art, Smithsonian Institution, Washington DC. (Purchase. F1930 60r): 6.33; Roland Halbe: 17.50; Sonia Halliday Photographs: 3.1, 6.23, 6.21, 8.2, 8.27, 8.28; Robert Harding Picture Library, London: 10.26; Clive Hicks, London: 7.14, 8.22; Hirmer Fotoarchiv, Munich: 1.6, 1.12, 1.13, 2.3, 2.19, 3.8, 3.17, 3.25, 6.7, 6.12, 6.22, 8.16, 16.36; Perry Hoberman © Canal Street Communications, New York: 17.51; Hulton Archive, London: 6.32, 11.20, 13.36, 14.34, 16.28, 17.30; Jahns/SOA Photo Agency & Gallery: 17.46; © Photo Josse, Paris: 6.14, 10.7, 10.41, 11.18, 11.25, 12.7, 12.10, 13.6, 13.13, 14.4, 14.5, 14.9, 15.10, 15.13; A.F. Kersting: 3.24, 8.1, 8.18, 8.20, 8.29, 8.30, 10.25, 10.34, 11.30, 12.30, 12.32, 13.19, 14.13; Ralph Liebermann, North Adams, MA: 15.31, 16.24, 17.41; © Araldo de Luca, Rome: 4.3; Paul M.R. Maeyaert: 1.11, 4.27, 7.15, 8.25, 12.27, 15.1, 16.39; © Manchester City Galleries: 15.11; Mansell Collection: 3.6; 3.11, 4.13; 4.14; 4.19; 4.24; 8.11; 9.10, 9.13, 9.19, 9.22, 9.23, 10.8, 12.18; Craig & Marie Mauzy, Athens: 2.2, 2.15, 3.3; Jean Mazenod, L'Art de l'Ancienne Rome, Editions Mazenod, Paris: 4.10; Metropolitan Museum of Art, New York: (Photo © 1996) 4.7, (Photo: © 1995) 13.14, (Photo © 1992) 15.9, 15.20; Gérard Monico, Saint-Denis, France: 8.23; Peter Moore © The Estate of Peter Moore: 17.27; Musei Capitolani, Rome/Barbara Malter: 4.30; © 2004 Digital Image, the Museum of Modern Art, New York/Scala, Florence: 0.6, 15.23, 16.7, 16.8, 16.9, 16.10, 16.12, 16.19, 16.22, 17.7, 17.8, 17.13, 17.17, 17.18; © National Commission for Museums and Monuments, Lagos/Laurence King Publishing: 3.10; National Film Archive, London: 15.38; New York Public Library: 11.24 (Cia Fornaroli Collection); Courtesy of the Oriental Institute, University of Chicago: 1.8; Photo Douglas Parker: 17.26; © Judy Pfaff: 17.25; © Vincenzo Pirozzi (fotopirozzi@inwind.it): 11.17; Josephine Powell, Rome: 6.5; © Quattrone, Florence: 7.2, 8.10, 8.12, 8.13, 9.6, 9.7, 9.9, 10.4, 10.9, 10.20, 10.22, 11.4, 12.6, 12.17, 16.32; Photo: Don Queralto. Image courtesy of George Adams Gallery, New York: 17.34; © Photo RMN/Hervé Lewandowski: 2.10, 6.13, 6.16, 7.12, 8.7, 13.12; Eric Robertson, New York: 16.17; Peter Sanders Photography: 6.5; Scala, Florence: 1.2, 2.1, 5.1, 5.9, 6.1, 6.4, 7.1, 8.1, 8.14, 9.8, 9.16, 10.10, 10.12, 10.16, 10.27, 10.38, 11.16, 11.40, 11.43, 12.1, 12.9, 12.21; Science Photo Library, London: 17.2 (Hank Morgan); Bob Shalkwijk, Mexico City: 16.16; Edwin Smith, Saffron Walden: 13.20, 13.21; Spectrum Colour Library, London:

8.24; © Steffans/SOA Photo Agency, London: 7.18; Tate Picture Library, London: 0.1, 15.25, 17.1, 17.9, 17.19; Telegraph Colour Library, London: 11.21 (T. Yamada); Vatican Museums: 3.5, 10.28; Roger Viollet: 8.19; Wolfgang Volz: 17.22; Weidenfeld & Nicolson, London: 13.23.

Literary Acknowledgments

Every effort has been made to contact copyright holders, but should there be any errors or omissions, Laurence King Publishing would be pleased to insert the appropriate acknowledgment in any subsequent printing of this publication. The author, the publishers, and Laurence King Publishing Ltd wish to thank the following for permission to use copyright material:

Academy for Ancient Texts: from *The Epic of Gilgamesh*, translated by Maureen Gallery Kovacs, electronic edition by Wolf Carnahan, 1998, at www.ancienttexts.org/library/mesopotamian/gilgamesh/tabl.htm
www.africawithin.com: "The Hymn to the Aton," accredited to Pharaoh Akhenaton
American Indian Studies Center: "Recuerdo" by Paul Gunn Allen from *Shadow Country* (1982), © 1982 Regents of the University of California
www.bartleby.com: from *Tender Buttons* by Gertrude Stein (1914), online edition, December 1995, © Bartleby.com, Inc.
www.eserver.org: from online translation of *Thus Spake Zarathustra* by Friedrich Nietzsche (1883–92)
www.fordham.edu: from *Alexiad*, Book X by Anna Comnena, translated by Elizabeth A. Dawes (1928), Fordham University online edition
www.gutenberg.net: from *Poetics*, Book V by Aristotle, translated by S.H. Butcher, Project Gutenberg online edition, 1999
Harcourt Inc.: from "Roselilly" from *In Love and Trouble: Stories of Black Women* (Harcourt Brace & Company, 1972), © 1972 and renewed 2000 by Alice Walker
Harvard University Press: "Tell all the truth but tell it slant" from *The Poems of Emily Dickinson*, edited by Thomas H. Johnson (Harvard University Press, 1955), © 1951, 1955, 1979 by the President and Fellows of Harvard College
Henry Holt & Company: "The Road Not Taken" from *Robert Frost: Selected Poems*, edited by Ian Hamilton (The Penguin Poets, 1987)
Houghton Mifflin Company: from the *Aeneid* by Vergil, translated by Theodore C. Williams (Houghton Mifflin Co., 1938)
Alix Ingber: translations of sonnets by Gutierre de Cetina, Luis de Gongora, and Lope de Vega, at www.sonnets.spanish.sbc.edu
The Internet Classics Library: from *On the Nature of Things* by Lucretius, translated by William Ellery Leonard, at www.classics.mit.edu
Carl Johengen: translation of "Sonnet XVI" from Benjamin Britten's *Seven Sonnets of Michelangelo*, no. 1, Op. 21, from www.recmusic.org/lieder/get_text.html
Linkoping University: "Hymn to Osiris" from *Egyptian Book of the Dead*, translated by E.A. Wallis Budge, at www.lysator.liu.se/~drokk/BoD/toc.html
Philip L. Miller: translation of "Der Erlkonig" by Johann Wolfgang von Goethe from *Ring of Words: An Anthology of Song Texts* (Bantam Books, 1963)
W.W. Norton & Company: extracts from *Agamemnon* and *Prometheus Bound* by Aeschylus from *Three Greek Plays*, translated by Edith Hamilton, © 1937 W.W. Norton, Inc., renewed © 1965 Doris Fielding Reid
Random House Inc.: "Canzone VI" from *The Sonnets of Petrarch*, edited by Joseph Auslander (Longmans, Green & Company, 1932); "The Negro Speaks of Rivers" from *The Collected Poems of Langston Hughes* (Alfred A. Knopf, 1994), © 1994 by The Estate of Langston Hughes
Simon & Schuster Inc.: "Sailing to Byzantium" from *The Collected Works of W.B. Yeats. Volume 1: The Poems. Revised*, edited by Richard J. Finneran, © 1928 by The Macmillan Company; copyright renewed © 1956 by Georgie Yeats
Diane Arnson Svarlien: translations from *Isthmian Odes* by Pindar, from Perseus Project, online at www.perseus.tufts.edu/PerseusInfo.html
Tahrike Tarsile Qur'an, Inc.: from *Holy Qur'an*, translated by M.H. Shakir (1985)
Thomson Learning: from *Home* (1979) by Samm-Art Williams, in *Invitation to the Theatre*, 3rd edition, by George and Portia Kernodle and Edward Pixley (Harcourt Brace Jovanovich, 1985)
The University of Chicago Press: from *Oration on the Dignity of Man* by Pico della Mirandola, in *The Renaissance Philosophy of Man*, edited by Ernst Cassirer, Paul Oskar Kristeller, and John H. Randall (University of Chicago Press, 1948); from *Hecuba* by Euripides, in *Complete Greek Tragedies*, edited by David Grene and Richmond Lattimore (University of Chicago Press, 1982)